The Visual Culture Reader

In response to rapid changes in the emerging interdisciplinary field of visual culture, this thoroughly revised and updated second edition of *The Visual Culture Reader* brings together key writings as well as specially commissioned articles covering a wealth of visual forms including photography, painting, sculpture, fashion, advertising, television, cinema and digital culture.

The *Reader* features an introductory section tracing the development of visual culture studies in response to globalization and digital culture, and articles grouped into thematic sections, each prefaced by an introduction by the editor.

Thematic sections include:

- Introductions/Provocations/Conversations
- Plug-in Theory
- Global/Digital
- Spectacle and Display
- Visual Colonialism/Visual Transculture
- The Gaze, the Body and Sexuality

Taken as a whole, these 60 essays provide a comprehensive response to the diversity of contemporary visual culture and address the need of our postmodern culture to render experience in visual form.

Essays by: Malek Alloula, Louis Althusser, Arjun Appadurai, Oriana Baddeley, Anne Balsamo, Roland Barthes, Geoffrey Batchen, Jean Baudrillard, Jonathan L. Beller, Suzanne Preston Blier, Lisa Bloom, Judith Butler, Anthea Callen, Thomas J. Campanella, Néstor García Canclini, Lisa Cartwright, Jill H. Casid, Wendy Hui Kyong Chun, Omayra Cruz, Guy Debord, René Descartes, W.E.B. Dubois, Frantz Fanon, John Fiske, Michel Foucault, Anne Friedberg, Coco Fusco, Tamar Garb, Raiford Guins, Judith Halberstam, Donna Haraway, N. Katherine Hayles, Amelia Jones, David Joselit, May Joseph, Jacques Lacan, Reina Lewis, Lev Manovich, Karl Marx, Carol Mavor, Anne McClintock, Marshall McLuhan, Tara McPherson, Kobena Mercer, Toby Miller, Nicholas Mirzoeff, Timothy Mitchell, W.J.T. Mitchell, Joanne Morra, Lisa Nakamura, Olu Oguibe, Lisa Parks, Adrian Piper, Ann Reynolds, Irit Rogoff, Andrew Ross, Ella Shohat, Marquard Smith, Terry Smith, Robert Stam, Marita Sturken, Michele Wallace, Thomas Waugh.

The

Visual

Culture

Reader

Second edition

Edited by

Nicholas Mirzoeff

Routledge
Taylor & Francis Group

LONDON AND NEW YORK

First published 1998
by Routledge
2 Park Square, Milton Park, Abingdon, Oxon, OX14 4RN

Simultaneously published in the USA and Canada
by Routledge
270 Madison Ave, New York, NY 10016

Reprinted 1998, 2001,

Second edition first published 2002

Reprinted 2004, 2005, 2006 (twice), 2007 (twice), 2008

Routledge is an imprint of the Taylor & Francis Group, an informa business

© 1998, 2002 Editorial matter and selection Nicholas Mirzoeff
© 1998, 2002 Chapters, individual contributors

Typeset in Perpetua by
Florence Production Ltd, Stoodleigh, Devon
Printed and bound in Great Britain by
TJ International Ltd, Padstow, Cornwall

British Library Cataloguing in Publication Data
A catalogue record for this book is available from the British Library

Library of Congress Cataloging in Publication Data
A catalog record for this book has been requested

ISBN 10: 0–415–25221–0 (Hbk)
ISBN 10: 0–415–25222–9 (Pbk)

ISBN 13: 978–0–415–25221–8 (Hbk)
ISBN 13: 978–0–415–25222–5 (Pbk)

Contents

Introductions/Provocations/Conversations

Plug-in theory

PART ONE
GLOBAL/DIGITAL

PART THREE
VISUAL COLONIALISM/VISUAL TRANSCULTURE

(a) Visual colonialism

(b) Identity and transculture

PART FOUR
THE GAZE, THE BODY AND SEXUALITY

Illustrations

Acknowledgements

Any large volume such as this is necessarily a collective enterprise. The field itself continues to expand and to demand new thought and new material. One source for the ideas in the new edition has been the visual culture listserv (go to yahoogroups.com and sign up for the visual_culture list: all *very* welcome), so many thanks to all there. Thanks to those who sent in ideas on the surveys, via email and in the many discussions that the book has inspired over the past five years. *The Reader* has been made possible first and foremost by the generosity of the contributors, to whom my sincere thanks. The team at Routledge battled with the mountain of text, permissions, pictures and emails, so a big hand to Kate Ahl, Rebecca Barden, Seonaid Whitley and the many others who have helped along the way. Kathleen and Hannah have endured all this in good heart and continue to be my reasons for living.

Permissions

Malek Alloula, from *The Colonial Harem*, Minneapolis, Minnesota University Press, 1986, pp. 3–15.

Louis Althusser, from 'Ideology and Ideological State Apparatuses', in *Essays in Ideology* (London: Verso, 1984), pp. 44–47.

Arjun Appadurai, 'The Global Now' from *Modernity at Large: Cultural Dimensions of Globalization*, University of Minnesota Press, 1996, pp. 2–11.

Oriana Baddeley, 'Engendering New Worlds: Allegories of Rape and Reconciliation' in Oriana Baddeley (ed.) 'New Art from Latin America: Expanding the Continent', *Art and Design Profile no. 37*, Art and Design, 1994, pp. 10–18.

Anne Balsamo, 'On the Cutting Edge: Cosmetic Surgery and Technological Production of the Gendered Body', *camera obscura 22*, Jan. 1992, pp. 207–14, 217–21, 225–26.

Roland Barthes, 'The Rhetoric of the Image' in *Image-Music-Text*, New York, Noonday 1977, pp. 32–37.

Geoffrey Batchen, 'Spectres of Cyberspace', *Afterimage* 23(3) Nov.–Dec. 1995, pp. 6–7.

Jean Baudrillard, 'Simulacra and Simulations' from *Selected Works*, Mark Poster (ed.) (Stanford/Polity, 1988), pp. 166–67.

Suzanne Preston Blier, 'Vodun Art, Social History and the Slave Trade', in *African Vodun: Art, Psychology and Power*, Chicago, Chicago University Press, 1995, pp. 23–31.

Lisa Bloom, 'Gender, Nationalism and Internationalism in Japanese Contemporary Art,' from *n.paradoxa* Vol. 5, 2000, pp. 35–42.

Judith Butler, 'Prohibition, Psychoanalysis and the Heterosexual Matrix', in *Gender Trouble: Feminism and the Subversion of Identity*, London and New York, Routledge, 1990, pp. 50–54.

Thomas J. Campanella, 'Eden by Wire: Webcameras and the Telepresent Landscape', in Ken Goldberg (ed.), *The Robot in the Garden: Telerobotics and Telepistemology in the Age of the Internet* (MIT Press, Cambridge and London, 2000), pp. 22–33, 35–40, 45–46.

Néstor Garcia Canclini, 'Remaking Passports: Visual Thought and the debate on multiculturalism', *Third Text* 28/29 (Autumn/ Winter 1994), pp. 139–46.

Guy Debord, *The Society of the Spectacle*, trans. Donald Nicholson-Smith (New York: Zone Books, 1994), pp. 12–16, 24.

René Descartes, 'Optics' in *Selected Philosophical Writings*, translated by John Cottingham, Robert Stoothoff and Dugald Murdoch (Cambridge, Cambridge University Press, 1988), pp. 57–63.

W.E.B. Dubois, from *The Souls of Black Folk* (London: Penguin Classics, 1989), pp. 3–5. Copyright (c) the Estate of W. E. B. DuBois 1903.

Frantz Fanon, *Black Skin White Masks*, trans. Charles Lam Markman (New York: Grove Weidenfeld, 1967) pp. 109–112.

John Fiske, 'Videotech' in *Media Matters: Race and Gender in US Politics*, (Minneapolis, Minnesota University Press, 1996), pp. 208–17.

Michel Foucault, 'Of Other Spaces', *Diacritics,* Spring 1986, pp. 22–27.

Anne Friedberg, 'The Mobilized and Virtual Gaze in Modernity: Flâneur/Flâneuse' in *Window Shopping: Cinema and the Postmodern* (Berkeley, University of California Press, 1993), pp. 15–32.

Coco Fusco, 'The Other History of Intercultural Performance' in *English is Broken Here*, (New York, New Press, 1995), pp. 37–41, 47–50.

Tamar Garb, 'The Forbidden Gaze: Women Artists and the Male Nude in Late Nineteenth-Century France' in Kathleen Adler and Marcia Pointon (eds), *The Body Images: The Human Form and Visual Culture Since the Renaissance* (Cambridge, Cambridge University Press, 1993), pp. 33–42.

Judith Halberstam, 'The Transgender Gaze in *Boys Don't Cry'*, *Screen* vol 42, number 3, Autumn 2001.

Donna Haraway,' The Persistence of Vision', in *Simians, Cyborgs and Women: The Reinvention of Nature* (London and New York, Routledge, 1991), pp. 188–96.

N. Katherine Hayles, 'Virtual Bodies and Flickering Signifiers', *October* 86 (Fall, 1993), pp. 69–91. Copyright 1993 by October Magazine, Ltd. and the Massachusetts Institute of Technology.

Amelia Jones, 'Technofeminism', from her *Body Art* (University of Minnesota Press, Minneapolis and London, 1998), pp. 197–205, 235–240.

David Joselit, 'The Video Public Sphere', from 'Art Journal', vol. 59, no 2 (Summer 2000): 46–53.

May Joseph, 'Kung-Fu Cinema and Frugality' in *Nomadic Identities: The Performance of Citizenship* (University of Minnesota Press, Minneapolis, 1999), pp. 49–68.

Michele Wallace 'The Prison House of Culture: Why African Art? Why the Guggenheim? Why Now?' in *Black Renaissance Noire*, vol. 1 no. 2 (Summer/ Fall 1997) 163–75.

Thomas Waugh, 'The Third Body: Patterns in the Construction of the Subject in Gay Male Narrative Film' in Martha Gever, Pratibha Parmar and John Greyson (eds), *Queer Looks: Perspectives on Lesbian and Gay Film and Video* (London and New York, Routledge, 1993), pp. 141–61.

Publisher's Note

References within each chapter are as they appear within the original complete work.

Introductions/Provocations/Conversations

Nicholas Mirzoeff

THE SUBJECT OF VISUAL CULTURE

D URING THE FIRST DAYS of the NATO attack on Serbia in April 1999, I was watching a CNN live report from Belgrade. The pictures showed a burning building somewhere in Belgrade while the anchor quietly relayed official communiqués. A little logo indicated that the pictures were coming from Serbian television. At this point, the surreal calm of the broadcast was suddenly disrupted. Serbian television, realizing that CNN were using their feed, switched to carrying the American images designated by the CNN logo. Thus CNN viewers were now watching Serbian television watch them watching. CNN had displayed the Serbian television logo as a warning, indicating to its American audience that the pictures were not entirely to be trusted. Well aware that its own viewers shared this skepticism, Serbian television switched feeds in order to assert to its domestic audience that because they were now watching what CNN viewers were watching, they should in fact trust the pictures. Serbian television used the global television station to vindicate its local coverage. The now angry anchor intervened and CNN stopped showing the pictures. The global corporation had lost control of the logos and hence the image. This, then, was a struggle about images as well as a struggle over terrain.

This little incident expressed the formal condition of contemporary visual culture that I call intervisuality, the simultaneous display and interaction of a variety of modes of visuality. CNN sees itself as the global surveillance channel for Western viewers. Like the jailer in the imaginary prison known as the Panopticon (see p. 397), the CNN camera is supposed to be invisible to participants in news events. This enables transmission from behind enemy lines or at the heart of an ongoing riot. In fact, this viewpoint is highly restricted, creating the opportunity for Serbian television to play its game with the logos. The switch in logos revealed that the images were not pure visibility but highly mediated representation. The logo itself is an expression of a chain of images, discourses and material reality, that is to say, an icon, representing both an older and a newer form of visuality than the

panopticon – older in the Christian icon, newer in the computer software icon. Finally, the rapid change of feed from Serbian television to CNN and back to the studio highlighted that the domain of the contemporary image is literally and metaphorically electric. NATO forces were directing the war using satellite images and photographs as highly accurate guides for missiles. However, the effectiveness of this strategy still depended on accurate interpretation of the image, as was made clear by the unintended bombing of the Chinese embassy in Belgrade – mistaken by US intelligence for a Serbian facility. The pilots who flew the missions were trained in flight simulators but were only allowed up in clear weather conditions so that they could accurately survey the terrain below.

This was a media war in all senses. On April 21, 1999 NATO planes attacked the television station belonging to Marija Milosevic, daughter of Serbian President Slobodan Milosevic, and in so doing also knocked out two other television stations transmitting from the same building. In the fire 123 episodes of *The Simpsons* as well as new episodes of *Chicago Hope* and *Friends* were destroyed, pitting the American armed forces against their own television networks. In a further twist, knowing that the Western media would carry photos of the damage, the government placed a poster in English directly in front of the damaged Usce building that housed the television stations. It showed a computer generated image of the Eiffel Tower in Paris seeming to collapse in flames under military attack. The destruction of global tourist symbols that was imagined in the science-fiction film *Independence Day* (1996) was now deployed in what one would hesitate to call 'reality,' were it not for the all-too-real consequences of the weapons being used on both sides. Agence France-Presse duly ensured that the image was seen around the world (*New York Times* April 22, 1999: A15). The caption read 'Just Imagine! Stop The Bombs.' It artfully mixed the Nike 'Just Do It' mantra with Arjun Appadurai's observation that in globalization, the imagination is a social fact (**Appadurai**: all bold-face references are to pieces in this Reader). The Serbian government was, of course, no friend to freedom of expression and closed down the independent radio station B-92, whose reports were not wholly favorable to the regime. B-92 quickly found a new home on the Dutch website Nettime. It continued to 'broadcast' but only to those with internet access. It is not too much to say that visuality – the intersection of power with visual representation – was literally being fought over here. All available media from the pilot's line of vision to satellite-directed machine vision, photography, digitally altered images and the global mass media were arenas of contestation. Visual culture is a tactic for those who do not control such dominant means of visual production to negotiate the hypervisuality of everyday life in a digitized global culture.

On September 11, 2001, the world became aware of just how dramatic the consequences of the militarization of the global imagination could be when hijacked airliners were crashed into the World Trade Center. This moment enacted in terrible reality the destruction of a national symbol that had been imagined first in cinema and then by the renegade Serbian state. A full history of the visual dimensions of the terrorist act would locate it as the most extreme possible outcome of the strategic manipulation of the image that began with the British government's media strategy during the 1982 Falklands war. It would then look at the well-orchestrated representation of the Gulf war of 1991, which the Kosovo war seemed to confirm as the new standard. Jonathan L. Beller describes 'how in tele-visual

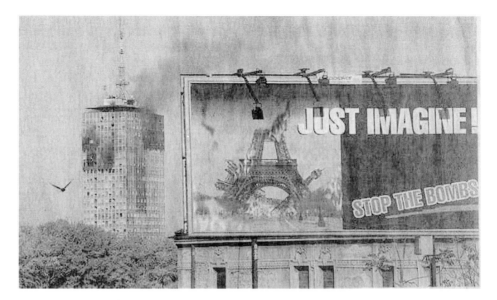

Figure 1.1 Serbian government poster, after NATO bombing, April 22, 1999
(April 2000 © Agence France Presse)

warfare the spectacular intensity of destruction as well as the illusion of its collec-
tive sanction creates certain subjective effects – a sense of agency and power which
compensates for the generalized lack of these in daily life' (Beller 1998: 55–56).
War is, then, the subject of these images but it is also a means of creating subjects,
visual subjects. In the Gulf war strategy, the agency belonged to the 'West,' seen
from the point of view of the weapons themselves. Pictures were transmitted
showing their 'view' of their targets right up until the moment of impact. This stun-
ning representation of war seemed to suggest a new surgical precision of warfare,
the endpoint of Walter Benjamin's famous comparison of the surgeon and the camera
operator. On September 11, the West discovered what it is like to be on the
receiving end of tele-visual war. As millions watched the destruction of the World
Trade Center live on television, it must be acknowledged that the sense of empow-
erment Beller describes was felt by some viewers, most notoriously in Palestine,
where there were public celebrations. This is not to argue that the United States
'deserved' the attack or that it was in any way justified but to call attention to the
way in which the Western notion of carefully controlled tele-visual war was appro-
priated and enlarged by those who engineered the attacks. The globalization of
culture turns out to be less predictable and far more dangerous than had been
supposed.

Visual events

In the first edition of this Reader, I argued that visual culture is concerned with
visual events in which the user seeks information, meaning or pleasure in an inter-
face with visual technology. This formula bears re-examination, given the rapid pace

of change. I continue to think that visual culture – rather than visual studies or other such formulations – is the right phrase for the discursive formation that this Reader seeks to represent. By retaining the term culture in the foreground, critics and practitioners alike are reminded of the political stakes inherent in what we do. For otherwise it can and has been argued that there is no particular need for visual culture as an academic subfield. Visual culture has come into a certain prominence now because many artists, critics and scholars have felt that the new urgency of the visual cannot be fully considered in the established visual disciplines. One way of connecting these different disciplinary dilemmas – whether in art history, film studies or cultural studies – is to emphasize the continuingly dynamic force of feminism (taken in the broad sense to incorporate gender and sexuality studies) to challenge disciplinarity of all kinds.

From these beginnings, visual culture is now an increasingly important meeting place for critics, historians and practitioners in all visual media who are impatient with the tired nostrums of their 'home' discipline or medium. This convergence is above all enabled and mandated by digital technology (**Cartwright**). The emergence of multi-media has created an apparent state of emergency in North American universities at the level of criticism, pedagogy and institutional practice. Responses include the creation of new centers and programs; the organizing of conferences and symposia; the installation of as-yet-unprofitable on-line courses; and the publication of a seemingly endless stream of papers. Behind all this activity lurks the fear of an emergent contradiction: digital culture promotes a form of empowered amateurism – make your own movie, cut your own CD, publish your own website – that cuts across professionalization and specialization, the twin justifications of the liberal arts university. Visual culture is not a traditional discipline, then, because before very long there may not be anything like the current array of disciplines. Rather it is one among a number of critically engaged means to work out what doing postdisciplinary practice might be like and, further, to try and ensure that it is not simply a form of pre-job training. That might mean, for example, trying to find ways to think about what digital culture does and why, rather than simply teaching software, either as practice or as what Lev Manovich calls 'software studies.'

The constituent element of visual culture's practice is the visual event. The event is the effect of a network in which subjects operate and which in turn conditions their freedom of action. What took place in the battle of logos during the NATO attack was a small example, and September 11 was the apogee of all such events. But as Michel Foucault argued in the 1970s, 'the problem is at once to distinguish among events, to differentiate the networks and levels to which they belong, and to reconstitute the lines along which they are connected and engender one another' (Foucault 2000: 116). He suggested that the study of events 'works by constructing around the singular event analyzed as process a "polygon" or, rather, "polyhedron" of intelligibility, the number of whose faces is not given in advance and never properly be taken as finite' (227). That is to say, in what Manuel Castells has called 'the network society' in which we live, events are not always fully knowable. As the popular version of chaos theory has it, the butterfly flaps its wings and that movement of air later culminates in a hurricane, but such chains of events cannot always be tracked. In a more everyday context, cause and effect continue to work much as they ever did. But today's global society is literally networked in

ways that are far clearer to the 400 million people worldwide who now have internet access – according to journalistic estimates in June 2001 – than they were to all but the most astute thinkers of the 1970s, with consequences that were not foreseeable at that time.

Let's think about how the televising of the Serbian war might be networked in the dynamically multifaceted way suggested by Foucault. At a theoretical level, we have learnt from the poststructuralist generation that, far from being an exception to normality, war is rather the clearest expression of that normality, whether in Foucault's analysis of power, Stuart Hall's post-Gramscian call for a cultural war of position, or Michel de Certeau's advocacy of guerilla-style 'tactics' as a means of engaging with everyday life. Clearly, as Paul Virilio once observed, 'there is no war without representation' (Virilio 1989: 6). But it is no longer simply the case that war is cinema, as Virilio asserted, if by cinema we refer to the classic Hollywood narrative film. The ability of CNN and other news stations to bring war to the living room, often on the same monitor used to play 'first person shooter' video games, or to watch videotape or DVD versions of films, is closely linked to the public sanction of war and its empowering, if necessarily transitory, sense of a collective and individual agency. The Serbian disruption of that viewing had to be removed from the audience's view to sustain the comforting illusion that 'we' are in charge and that no risk to any of 'us' (read American) is involved. War is also a gendered activity, rendering the subject masculine and its object feminine. When war was cinema and cinema war, it followed that the gaze in that cinema was male. The representation of war has recently been a central issue for both military strategy and film in different but related ways. Since the Vietnam war, the US military have dramatically changed their representations of their actions, following their belief that the war was lost in US public opinion rather than on the battlefield, despite the enormous effort to annihilate the Viet Cong. Converging with this military need to represent war differently, Hollywood cinema came to feel itself under threat from digital media, as the entire apparatus associated with celluloid film has become outdated. The Dogma 95 movement in Europe that refuses to use any form of special effect has been one early response to this crisis, which has yet to be played out in global cinema.

Stephen Spielberg's 1998 epic *Saving Private Ryan* addressed both the military and the cinematic need for a renewed mode of representation. The film was endlessly hyped for its realism, especially in representing the sounds of war. While the rediscovery of the epic format appeared to reinvigorate the film tradition, at the level of the plot, realism was hard to find in *Saving Private Ryan*. The dramatic opening segment showed Omaha Beach being captured in twenty minutes, an operation that actually took hours to complete and cost over a thousand American lives in the opening minutes of the landing alone. 'Realism,' then, was not an accurate depiction of the landing but the representation of the death of American soldiers with speaking roles. These deaths of the subsequently hyped 'greatest generation' stand in for the now unimaginable death of a contemporary American soldier-subject. Recent film scholarship has opened up new ways of thinking about the Second World War and its relationship to cinema. During the war, cinema audiences did not behave like the silent and immobile spectators of classic film theory. William Friedman Fagelson has excavated fascinating accounts of cinema audience behavior in wartime.

Films were subject to a 'call-and-response' audience that *Time* magazine noted: 'howled, hissed, and booed at pictures, demanded Westerns, carved their initials on seats, sometimes even fired buckshot at the screen' (Fagelson 2001: 94). A particularly demanding audience were the troops themselves, who saw films on ships and in rest areas behind the front lines, as well as at home. Soldiers critiqued the technical aspects of the representation of war and indulged in what one reporter called 'a torrent of verbal reaction that accompanies every foot of the film and affords a spectacle far exceeding any film drama in human interest and undistilled enjoyment' (Fagelson 2001: 99). Adding to this study of reception, John Bodnar (2001) argues that film represented Second World War as a 'people's war,' in the phrase of the time. The overt content of the films, although often mocked by the troops studied by Fagelson, created a context in which war goals included expanding democracy and prosperity at home. On the other hand, *Saving Private Ryan* seeks 'to preserve the memory of patriotic sacrifice more than it desires to explore the causes of the trauma and violence' (Bodnar 2001: 817), while at the same time forgetting 'a far-reaching contest over how to recall and forget the war' (815) from the late 1940s on. In this emergent view, the classic post-war cinema that generated so much of current theories of the gaze and spectatorship was also a displacement of a certain film practice that was participatory and progressive. After the events of September 11, it might have to be hazarded that it is now terrorism that is cinema. The visual drama of the events in New York played out as if cinematically directed. The largest possible target was hit with the most explosive force possible to produce the maximum effect on the viewer. At a symbolic level, the disaster was the result of the impact of the two dominant symbols of modernity's triumph over the limitations of body and space – the airplane and the skyscraper. The scenario made sense to the viewer precisely because we had all seen it before. Hollywood had turned to the terrorist as a substitute for the previously all-pervasive communist as its preferred villain from the collapse of the Soviet system in 1991 right up until the attacks. Many of the eyewitness accounts used the metaphor of cinema to try and verbalize the enormity of what had happened. Unpacking this metaphor is going to be an important task that will not be possible until the events in Afghanistan and elsewhere are completed.

This complicated, global proliferation of gazes and technologies makes it necessary to revise my earlier formulation that visual culture necessarily privileges the viewpoint of the consumer in a given visual event. This assertion was motivated by a political sense, learned from film theory, social art history and British cultural studies that this viewpoint had historically been obscured for reasons of race, class and gender. The difficulty presented by this approach was how to identify 'the' visual consumer. If one took the approach of Jonathan Crary, one could work with the ideal observer predicated by Western observational science (Crary 1991). This attention to the visual tracks changes in the understanding and interpretation of the processes of sight and seeks to map them onto visual representation. However, in a given moment of representation, all those historical factors necessarily elided by the formation of an idealized observer must come into play. Cultural studies work has been so aware of these problems that it has tended to work with a given group of observers in a method derived from anthropology known as participant observation. That is to say, the researcher does not pretend to the impossible position

of the ideal observer but involves her/himself into the group and uses that involve-
ment as the basis for interpretation through interviews and other forms of joint
participation. A very important variant of this approach has been the representation
of a previously marginalized point of view by an artist or writer who claims member-
ship in that subaltern group. Remarkably even these oppositional viewpoints have
become to some extent absorbed into the global network. The Serbian billboard
discussed above attempted to mobilize liberal and left-wing opinion in Europe for
its own ends, even though the Milosevic regime repressed precisely these points of
view in Yugoslavia. More generally, marketing in the highly competitive environ-
ment of late capital seeks out any specific group it can and makes use of formerly
resistant techniques to sell products. So Volkswagen produced a series of television
ads for cars in the US that were widely understood to feature gay men, creating a
meta-discussion about the ad and Volkswagen that benefited the manufacturer enor-
mously. Meanwhile all kinds of products and services are being promoted 'below
the line' – that is to say, using hand-distributed flyers or postcards, or even word
of mouth – techniques that were once reserved for underground nightclubs aimed
at specific subcultures, or political organizations. To be consumer-oriented is now
the mantra of global business. Without losing sight of the individual viewer, visual
culture must go back and forth across the interface that is now much more multi-
faceted than the object-screen-viewer triptych.

At the same time, it is becoming clear that what Kobena Mercer has called the
'mantra' of race, gender and class as the three lenses with which to study culture
is also in need of revision. This is not to say that any of the issues raised by these
analyses have disappeared or are no longer of importance but that the dominant
culture has found ways to negotiate them. To put it another way, the deployment
of race, gender and class no longer surprises people, whether they are supportive
or hostile. I shall take two examples from the semiotics of advertising – so forma-
tive for visual culture from Barthes's *Mythologies* to Berger's *Ways of Seeing* and
Williamson's *Decoding Advertisements* – local to where I am writing in Australia. In
these ads, racism and sexism can now be evoked directly or indirectly in ways that
are not secret and therefore resistant to decoding in the classic cultural studies
fashion. A 2001 ad for drinking milk features two building workers. One tells the
other that he has gone soft when he fails to leer at a passing woman, visually repre-
sented by the soft man being out of focus. He drinks milk, comes into focus, and
then performs an astonishing range of sexist catcalls, whistles and facial contortions
to another woman. In a discussion in the *Sydney Morning Herald* of this and similar
advertising, Julia Baird concluded that it was so over the top that a veneer of irony
protected the ad from a feminist critique (Baird 2001). The 2001 national election
campaign in Australia turned on the question of asylum seekers that the coalition
government of John Howard successfully portrayed as 'illegals' threatening the
Australian way of life. In a widely seen full-page newspaper advertisement, a picture
of Howard taken from below, standing in front of two Australian flags, with his jaw
jutting was completed with the quotation '*We* decide who comes to this country
and under what circumstances.' The photograph was more than faintly ridiculous,
reminiscent of Charlie Chaplin in *The Great Dictator*. But the message of the under-
lined 'we' was clear to all: we, the white people. In an effective strategy of
disavowal, Howard nonetheless repeatedly denied that the message was racist and

mobilized a degree of working-class resentment against intellectual elites for suggesting that it was. Both these examples suggest that questions of class, gender, sexuality and ethnicity are as important as ever as means of creating and contesting identity. At the same time by their careful strategy of at once invoking the forbidden and disavowing it, they anticipate and in a certain sense welcome their critique. Ambivalence and ambiguity, classic poststructuralist figures, are here invoked by a very conservative administration and an advertisement for milk. In both cases, if there was no frisson of conservative transgression of what have become mainstream norms, the message would not have been so effective. Ironically, then, the oppositional methods of cultural analysis and of visual representation that in many ways led to the emergence of visual culture are now its object of criticism.

Visual subjects

The 'media-environment' for war and its cognates in everyday life is the operating arena for a new visual subjectivity. This subjectivity is what is ultimately at stake for visual culture. By the visual subject, I mean a person who is both constituted as an agent of sight (regardless of his or her biological capacity to see) and as the effect of a series of categories of visual subjectivity. During the modern period a two-fold visual subject was predicated by the disciplinary society. That subject added to Descartes's early modern definition of self – 'I think therefore I am' (**Descartes**) – a new mantra of visual subjectivity: 'I am seen and I see that I am seen.' This sense of being the subject of surveillance provoked wide-ranging forms of resistance that were nonetheless, as Michel Foucault has argued, predicted by the operations of power. In 1786 the British philosopher Jeremy Bentham invented a perfect prison that he called the panopticon. The panopticon was an inspection house for the reformation of morals, whether of prisoners, workers or prostitutes by means of constant surveillance that the inmates could not perceive, a system summed up by Michel Foucault in the aphorism 'visibility is a trap.' In Foucault's view, the panopticon was a model for the disciplinary society at large but the practices of visibility were not part of his inquiry. Rather, he simply assumed with Bentham that a straight sight line equated to visibility. For visual culture, visibility is not so simple. Its object of study is precisely the entities that come into being at the points of intersection of visibility with social power.

To take two examples: the blind became an object of state concern at the beginning of the panoptic era, leading to the establishment of state institutions for the blind and Louis Braille's invention of a tactile language in 1826 from within the Paris Institute for the Blind. Panopticism created the blind as what has now become a 'natural' target of social and state concern precisely because seeing and being seen was the concern of the disciplinary nation-state. If in this instance panopticism was in a certain sense empowering, it was in many more controlling or repressive. One of the most important examples is 'race,' the visual network in which one person is designated as different from another by reason of physical or inherited characteristics. By the beginning of the twentieth century W.E.B. Dubois discerned what he famously called 'the color line,' an arbitrary division of people into racial types that took on the status of social fact (**Dubois**). So powerful was this means of seeing

that Ralph Ellison famously announced to a segregated United States in 1952 that the African American was an 'invisible man.' The color line had become impermeable. Panopticism, then, was a willed form of seeing in which the refusal to see certain objects or people was as constitutive of its success as the perception of self or others. This doubled sensation of seeing and being seen was reworked in a psychoanalytic context by Jacques Lacan. Lacan internalized the process of surveillance under the command of a sense of shame in his famous formula of the gaze as being a process in which 'I see myself seeing myself' (**Lacan**). In so doing, as his reference to Sartre's *Being and Nothingness* made clear, Lacan envisaged the subject monitoring itself for transgression. In the passage Lacan cites, Sartre describes vision as being like the voyeuristic pleasure of looking through a keyhole that is then disrupted by the feeling of being looked at by someone else, causing a sense of shame. This shame disciplines the gaze. Lacan turned this surveillance into self-surveillance, making each visual subject the locus of a panoptic drama of identity.

In advanced capitalist societies across the planet, people are now teaching themselves to be media. They attach digital camcorders to their eyes at any event of public or private importance and make endless overlapping records of their memories, which, like those of *Blade Runner*'s replicants, are given out in advance. As the success of *Shrek* brought a new wave of hyperreal digital animated features to North American multiplexes in the summer of 2001, it seemed that audiences were learning to see like computers. That is to say, following Donna Haraway's famous assertion that we are all now cyborgs, we need to know how the computer sees, to learn how to recognize its gaze and then to imitate it. In *Final Fantasy: The Spirits Within* (2001), the heroes battle the aliens for the possession of spirits, a formula echoed by *Ghosts of Mars* (2001). In short, can humans still be media? As this is still 'Hollywood,' the answer was never in doubt and audiences stayed away in droves. A younger generation takes the digital gaze for granted. On the Cartoon Channel, the hugely popular digitally animated figures of the Power Puff Girls deal up the punishment of bad guys once reserved for male superheroes alone. The Power Puff Girls lack the ripped muscles of earlier Avengers but are drawn in the style of Japanese *anime* with vast eyes perched on insignificant bodies. These digital eyes emit blasts of unspecified energy at their enemies, much like the mutants Cyclops and Storm in the 2000 hit film *The X-Men*, based on a long-standing Marvel Comics series. The Power Puff Girls are pixilated panopticism, in which the body is a vehicle for visual surveillance unhindered by a self or an identity.

Outside the world of superheroes and aliens, things are less certain (**Jones**). The boundaries of the visual subject are under erasure from within and without. Today it is possible to feel constantly under surveillance and that no one is watching at all as we move from the gaze of one camera to the next. For the crisis of the visual subject has been brought into sharp relief under the symbiotic influences of globalization and digital culture. In the short life of the Information Age, this is perhaps the most interesting moment in which to attempt digital criticism. During the internet boom years, comment seemed almost beside the point as vast sums were raised for ideas that barely filled a cocktail napkin. In 1999, Amazon.com was worth more money than General Motors, according to the stock market, despite never having earned a penny. During this period Allucquère Roseanne Stone argued that there were only two responses to the question 'what has been changed

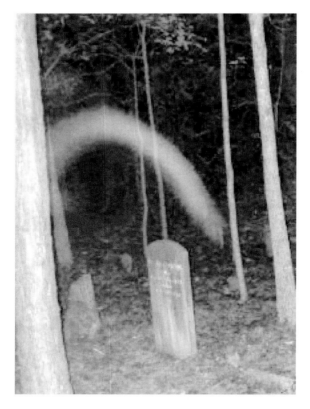

Figure 1.2 Digital ghost
(Courtesy of the International Ghost Hunters Society www.ighs.com)

by digital culture?' – everything or nothing. On the 'everything' side were Nicholas Negroponte, the MIT Media Lab, *Wired* magazine, endless websites and media commentators, all claiming that life was set to change beyond recognition but offering only such dreary carrots as smart refrigerators or customized digital newspapers. This small beer was easily decried by the 'nothing' crowd of academics and commentators, who were also able to point to a variety of technologies that anticipated some of the features of today's 'new' technology.

As the dust settles from the crash, it may now be possible to resolve some of these disputes. For example, Stone asserted that everyone is transgendered on-line, an assessment hotly disputed by those who pointed to very traditional sexual uses of the net. Yet from the failure of outraged conservatives to drive President Clinton from office, to the success of the film *Boys Don't Cry* (**Halberstam**) and the relaxed attitude of many younger people to experiments with sexual and gender identity, a change does seem to have taken place. On the other hand, as several essays in this Reader indicate (**Chun, Nakamura, Parks**), 'race' continues to be strongly marked in digital culture. Rather than asking whether digital culture has changed everything or not, we can now ask more specifically why it seems to have enabled or been a part of a shift in attitudes to gender and sexuality, but has not resulted in similar change with regard to ethnicity and 'race.' It seems that the endless repetition of visual selves has led to a greater degree of indifference as to sexual and

gender identity, while sustaining 'race' in difference. The ebb and flow of visual differentiation across the boundaries of identity is disorienting (a term that in itself seems to suggest an ethnic differentiation) and dizzying, a loss of difference that can end in the loss of the self. Paradoxical as it may seem, there is even a certain nostalgia for the sensation of surveillance, the odd pleasures of being watched.

Digiteyes

So the question becomes: what are the places and means by which identification and its correlatives such as disidentification, can find a purchase in the networked global culture of the present? The question of digital identity finds a metonym in the intensely popular webcam format (**Campanella**). In 1991 a Cambridge University laboratory put a real-time photographic image of its coffee maker on-line so that its staff could know whether coffee was available. Much to their surprise, thousands of other web surfers came to look. In the subsequent decade, webcams – as they have come to be known – have become one of the 'killer apps' of the net, offering a seeming infinity of views. Webcams come in two distinct types. First, as a gaze out on a particular view or geographic location, ranging from skyline views, to wilderness sites and traffic stops. These can be seen, as Bolter and Grusin have argued, as a remediation of television (Boulter and Grusin 1999: 208). There is nonetheless a far more personal dimension to such telemediation of exterior reality than is offered by television. In Don DeLillo's novel *The Body Artist* (2001), for example, a performance artist finds looking at a quiet stretch of road in Finland an effective balm for the pain of grieving. The choice of location to be viewed seems to be the viewer's not the network's for, although it is not possible to direct an exterior camera oneself, there are so many choices that no one feels constrained.

The second, more popular variety of webcam turns the gaze inwards on itself. Where Nicephore Niépce pointed his prototype camera out of his bedroom window in 1823 to create what is often celebrated as the first photograph (**Batchen**), webcam users make the bedroom interior the scene of the action. On popular sites like Jennicam or Anacam, the viewer sees the ostensibly private space of the photographer. The webcam depicts the interior of the closet, the most private domestic space, while *camera* is itself the Latin word for a room. Queer culture has, of course, theorized the closet as a space in which the queer subject hides his or her identity from the disciplinary gaze. Coming out is, then, both a risk and a necessary affirmation of the self. To stay in the closet is to destroy the self with deception and guilt. Webcam users do not come out of the closet but make their closet visible to anyone with internet access. For a fee, viewers are guaranteed constant access, the place of the panoptic jailer for $19.95 a month. Here the closet is not something to come out of but rather the closet-camera serves as a device to validate the desire and hence the very existence of the Western visual subject itself. In this evacuated version of visual subjectivity, the subject simply says: 'I want to be seen,' using the closeted camera to reveal and conceal at once. It is not surprising that young, white women have most quickly adopted the webcam format both because of the hypervisibility of the female body in consumer culture and because women since Lady Hawarden have queered photography by not looking out of its closet (**Mavor**).

For Jennifer Ringley of Jennicam, 'I am doing Jennicam not because I want other people to watch but because I don't care if people watch.' What matters, then, is the interiorized sensation of being monitored by a digital other that is enabled by the self. Ana, the host of Anacam, offers her artwork – made with Paint Shop Pro – in her gallery that declares: 'I'll be your mother, mirroring back 2 U.' This apparent parody of Barbara Kruger's already parodic postmodern theorizing of gender and desire creates a digital mirror stage. For this self-surveillance and self-display leads to a digitizing of desire. Natacha Merrit, author of the *Digital Diaries* (2000), a collection of images of staged sexual encounters in hotel rooms, claims that 'my photo needs and my sexual needs are one and the same' (Merrit 2000). Merrit uses only digital cameras in her practice, as if analog film is somehow inappropriate to this exchange of gazes. Digital desire dissolves the self – the I/eye so often evoked in theoretical discourse – at the heart of the subject and replaces it with an endlessly manipulable digital screen. A similar erasure was predicted by Foucault in the famous conclusion to his 1967 *Order of Things*, where he suggested that the human was about to be erased like a face in the sand. Sand, like the digital chip, is made of silicon. It is the unnerving task of the present to find out what comes next.

'I am not here and never have been'

These dramas were remarkably performed in June 2000, when the Royal Court Jerwood Theatre Upstairs, London, staged Sarah Kane's piece *4.48 Psychosis*. *4.48* was a visualized text of extraordinary power, exploring whether it is possible for the self to see itself when mind and body are not just separated but unrelated. The piece takes its title from the notion that at 4.48 in the morning the body is at its lowest ebb, the most likely time for a person to kill themselves. In a long meditation on the possibility of self-killing that is written in different voices but not as separately named characters, Kane mixes Artaud and Plato, a mix that can only be called performed deconstruction. Three actors perform on a stage whose emptiness was broken only by a table. The *mise-en-scène*, created by director James McDonald and designer Jeremy Herbert, placed a mirror the length of the stage at a forty-five degree angle facing the audience. The mirror made it possible for the actors to perform lying down and still be seen by the audience but at the same time it converted the entire performance space into a camera, mirroring the reflex lens. Within this camera space, a video was played at frequent intervals, showing the view from a London window, as traffic and pedestrians passed by. It was in effect a webcam. The webcam was projected onto the table, forming a screen that was visible in the mirror. The speech of the actors was broken at intervals by the white noise of a pixilated screen without a picture, like a television set that has lost reception. In short, *4.48 Psychosis* played out in the contested space of the contemporary visual subject represented as a camera, a dark room in which digital, performative and photographic renditions of exteriority were explored, compared and analyzed. In one monologue a character describes:

Figure 1.3 Sarah Kane
(Courtesy of www.Iainfisher.com)

> abstraction to the point of . . .
> dislike
> dislocate
> disembody
> deconstruct.
> (Kane 2000: 20)

The visual subject is no longer at home.

For in Kane's view, Cartesian reason was a barrier to understanding existence: 'And I am deadlocked by that smooth psychiatric voice of reason which tells me there is an objective reality in which my body and mind are one. But I am not here and never have been' (6). Kane simply asserts that in the hypervisual digital world, the single person split into two (mind/body) whose dissolution was prevented by the watchful gaze of the Christian Trinity no longer exists. Or in a Lacanian view, it is as if there was no mirror stage for Kane to identify herself as an image, only the indifferent reflection of the all-encompassing mirror of the mass media. The stage-long mirror is a visualization of both losses of identity. Now body and soul do not form a unit or even a schizophrenic network: they simply do not belong together: 'Do you think it's possible for a person to be born in the wrong body? (*Silence*) Do you think it's possible for a person to be born in the wrong era?' (13). Kane explores how metaphysical reason, personal love, and pharmacological psychiatry all attempt to close the gap in which the mind is a camera admitting light all too infrequently and with uncertain results (3):

> a consolidated consciousness resides in a darkened banqueting
> hall near the ceiling of a mind whose floor shifts as ten
> thousand cockroaches when a shaft of light enters as all
> thoughts unite in an instant of accord body no longer expellent
> as the cockroaches comprise a truth which no one ever utters.

The camera of the mind is deserted now, inhabited only by parasitic insects. Confronted by the indifferent surveillance of late capitalist society and an absent god, the subject disintegrates. At 4.48 'sanity visits/for one hour and twelve minutes' and as the performing voices suicide themselves, 'it is done.' The piece ends with a final aphorism:

> It is myself I have never met whose face is pasted on the
> underside of my mind.

There is a long pause and then an actor says: 'Please open the curtains.' The three performers silently move to the sides of the space and pull back black-painted shutters, opening the camera to the quiet West London light. There is no stage direction to indicate this anti-Platonic gesture which may read on the page as a banal *coup de théâtre* but the audience of which I was a part experienced it as shock. In 1839 Hippolyte Bayard performed a mimicry of mimesis when he photographed his *Self-portrait as a Drowned Man*, a knowing play on photography and death. On February 20, 1999 at the age of twenty-eight Sarah Kane had killed herself in a small room adjoining her hospital bedroom, her camera, her closet. The networked subject is everywhere on screen but no one is watching, least of all herself.

The transverse glance

Some critics might retort that that crisis affecting Kane is that of the white visual subject interpellated by its male gaze that has dominated Western thought since Descartes. At the same time, the non-white, queer, or otherwise subaltern subject is familiar with the indifference of disciplinary society. Global capital simply treats the West with the same indifference that it once reserved for its others. Why should the local issues of a British artist concern a globally oriented academy? Globalization cannot mean that Western scholars now have the entire globe as their domain as a form of intellectual empire. As Peter Hitchcock has argued, it is the task of African cinema 'to represent Africans to Africans' (Hitchcock 2000: 271); or by extension any of the world's variously orientalized and subaltern peoples should represent themselves to themselves. What matters is being constantly aware of the global dimensions to the work that one is doing (Appadurai). In visual culture, this means looking with a transverse glance from multiple viewpoints across and against the imperial perspective. That implies, for example, calling attention to the global aspirations of panopticism itself. The panopticon was created when Bentham copied a system his brother had used in Russia, in order to persuade the British government to replace its system of deportation to the new colony of Australia with a system of moral discipline derived from the Jesuit colonies in Paraguay (**Foucault**). That is to say, panoptic modernity was always a global system that affected different parts of the world unevenly.

This current moment of globalization is especially enacted on, through and by the female body. Global capital has changed not just relations of consumption but relations of production, as Gayatri Spivak has argued: 'The subaltern woman is now to a rather large extent the support of production,' through piece work, sweat shop labor

and reproductive labor in low-wage economies. This condition is acknowledged in the West by displacement. That is to say, as in the examples above from Jennicam to Sarah Kane, globalization within the West is culturally figured as feminine, which I take to be a contested cultural category rather than a biological given. At the same time, this gendered representation of contemporary culture, while of Western origin, has global effects. The contradiction of this moment can be expressed in many ways but here's one that I have used since 2000 that has become very acute since September 11. The Iranian video artist Shirin Neshat, working in exile in New York, is rightly becoming a global star for her explorations of the gendered divide in Islamic culture. Neshat's video work is lushly cinematic, creating ten-minute epics with casts of hundreds. Black veiled women hired on location pirouette at the edge of the sea in a disidentification with Orientalism that is nonetheless starkly beautiful. At the same time, after their takeover of power, the Taliban in Afghanistan held public destructions of artworks, television sets and videotapes, while forcibly constraining women to the home and making them literally invisible in public behind the veil. The Taliban's anti-modernity relied on the global media to disseminate their actions and discipline their own subjects, even as it disavows visual culture. For it was an open secret, reported in the Western media, that many Afghans continued to watch television and videos and these were of course the people least convinced by the Taliban. The paradox here is that the apparently head-on collision of contemporary ideologies between the feminist artist Neshat and the Taliban dictatorship of clerics both rely on nineteenth-century modes of visuality, Orientalism on the one side, panopticism on the other centered on the figure of the veiled woman, so familiar from imperial culture (**Alloulah**). In this light, the events of September 11 were literally reactionary, an attempt to eliminate transculture and recreate a starkly divided world of good and evil that has until the time of writing been disturbingly successful.

For all these haunting reminders of the past, I would still argue – now more than ever – that something new is being forged out of these multiple collisions of past with present and future. I am deliberately using what one might call a strategic optimism here to suggest that this moment that has been called 'post' so often is in fact a moment before. This is to say that the present is what Helen Grace has called a 'pre-history' to an emergent configuration that may be more than the constant revolutions of global capitalism (Grace 2000). It is a prehistory under the sign of what Mieke Bal has called the 'preposterous,' a curious elision of the post and the pre that can seem absurd (Bal 1999). It is what one might call preformative – something is beginning to be formed that is intensely performative. Visual culture can be seen as a ghost, returning from another moment of prehistory, the late 1950s and early 1960s. At that time, capitalism seemed every bit as hegemonic as it does today, only for a striking wave of change to break in the late 1960s and 1970s. It was heralded by writers like Daniel J. Boorstin and Marshall McLuhan calling attention to the increasingly visualized nature of contemporary society. It was in fact McLuhan who first used the term visual culture, in the sense in which it is used here, in his classic *Understanding Media* (1964).

If visual culture is a ghost, how does it see?[1] Unlike the disciplinary subject that sees itself seeing itself, its ghost sees that it is seen and thereby becomes visible to itself and others in the constantly weaving spiral of transculture, a transforming encounter that leaves nothing the same as it was before. Rather than retreat to the

digital closet of isolated being, these multiple viewpoints can help triangulate the viewer in relation to herself, the watchers and the watched. The scholarship of modern visuality has often wanted to constrain the unpredictable effects of the networked visual event into clear, geometric parameters, whether derived from art historical formalism, panoptic surveillance or Lacan's gaze theory. It is time, perhaps past time or just before time, to look with 'double vision' (Thomas and Losche 1999), 'parallax vision' (Mayne 1993) or 'multiple viewpoints' (**Mirzoeff**). This is the transient, transnational, transgendered way of seeing that visual culture seeks to define, describe and deconstruct with the transverse look or glance – not a gaze, there have been enough gazes already. There are several key components of the transverse glance. In the view of Fernando Ortiz, transculture is the product of an encounter between an existing culture or subculture and a newly arrived migrant culture that violently transforms them both and in the process creates a neo-culture that is itself immediately subject to transculturation (Ortiz 1995). This transculturation is in turn subject to difference and deferral. The difference is what James Clifford has called the Squanto effect, named for the Pequot Indian who met the Pilgrim Fathers just after his return from Britain, where he had learned English (Clifford 1988). In other words, cultures were never isolated islands, developing by themselves. The deferral comes from what Emmanuel Levinas called the ethical obligation to the Other that results from the 'face-to-face' encounter at the heart of transculture (Levinas 1997). I cannot privilege my own culture in this encounter but must defer and accept my responsibility to the Other. Ortiz wrote on and about the island of Cuba. Transculture and its accompanying transyness seem closer to Edouard Glissant's formulation of the archipelago, a series of connected islands. The virtue of the archipelago is that a series of very different entities can be connected. The transverse glance is not a gaze because it resists the imperial domain of gendered sexuality, using what Judith Halberstam calls in this volume 'the trans gaze.' If this seems a little utopian, let it also be said that this transverse practice is at all times at risk of being undercut by transnational capital.

For as many of the essays in this volume suggest, visual culture will best contribute to the working out of a new visual subjectivity by seeking to be active in ways that do not create additional value for transnational capital. Visual culture needs to retain its links to cultural studies in looking to find ways to interact with visual practice and cultural policy in the wide-ranging areas of its interest. Some might do this like Irit Rogoff by working with visual artists, others like Lisa Parks by visual activism, still others by transnational pedagogy. For Coco Fusco, performance is a medium that transforms viewer and performer, while Kobena Mercer and myself have argued for the diasporic viewpoint. And so on, for each contributor to this volume, another path. The tools for this work are readily to hand (at least for those in the West) in the form of brand-new but obsolescent visual and digital technologies such as non-broadcast quality video, CD-ROMs, analog photography and all computers not running Windows XP or OS X. 2. These products without function, in some cases literally without exchange value – ever tried to sell a four-year-old computer? – can be diverted to other uses beyond those of the global market. As more links are created in this network by the engagements of individuals or groups, it may be possible to look transversely across the gaze, across the color line, across surveillance and to see otherwise.

Introductions/Provocations/Conversations

This edition of the *Visual Culture Reader* offers a diverse group of introductory materials. The field of visual culture is now sufficiently well established and dynamic to sustain a plurality of views without fracturing into warring camps. Rather than the future of visual culture being in question, there is a space to debate what that future might be among the wide-ranging group of people who take an interest in it. The two Introductions and Provocations from the first (1998) *Visual Culture Reader* by Ella Shohat and Robert Stam and by Irit Rogoff have been widely cited in discussions of the field and are now indispensable to its theorization. Aside from the debate with *October* magazine, what has been so important about these essays has been their suggestion of complementary avenues for the development of the field. Rogoff's syllogism that 'if feminist deconstructive writing has long held the place of writing as the endless displacement of meaning, then visual culture provides the visual articulation of the continuous displacement of meaning in the field of vision and the visible,' is amply borne out in this volume and elsewhere. By the same token, Ella Shohat and Robert Stam called in 1998 for a reconceptualization of visual culture moving away from the Euro-american progression of realism/modernism/postmodernism to a polycentric globalized field of study. There is a good deal of agreement on these goals now, making it possible to at least envisage achieving their goal of a 'mutual and reciprocal relativization,' offering the chance of 'coming not only to "see" other groups, but also, through a salutary estrangement, to see how [each] is itself seen.'

In his remarkable essay 'Kino-I, Kino-World: notes on the cinematic mode of production,' written for this Reader, Jonathan L. Beller asks us to reconsider some of our most fundamental presuppositions about the place of the visual in culture. Rather than seeing visual culture as an offspring of late capitalism, Beller argues for a theory of the 'cinematic mode of production' in which 'looking is posited by capital as labor.' Beller extends Marx's classic theory of value in which profit is created by the extraction of a surplus value of work performed by the laborer over and above what is required to earn his/her wages and benefits. Now work is performed visually via the seeking of human attention – think of all those banner ads wanting you to 'click here' that literally earn someone two cents when you do, or the competition for television ratings that directly generate advertising revenues. In this view, the cinema does not reflect the social, it is the social, providing that we understand 'cinema' to mean the image-making apparatus in general. However, Beller does not assert that grasping his attention theory of value provides an answer to the riddle of globalization but simply that it has 'a germinal contribution to make to counter-hegemonic struggle.' Beller controversially argues that psychoanalysis, for so long the dominant theoretical model is cinema studies, is itself merely a symptom of the cinematic mode of production: '"Film" can be understood as the social relation which separates the visual component of human subjective activity from the body in its immediate environment, while "cinema" is the systemic organization of this productive separation.' In this sense, dream-work is in fact real work. By the same token, deconstruction is framed as a historical moment signifying a technological transformation in political economy (an argument in fact close to Derrida's own remarks in his 1994 treatise on globalization *Specters of Marx*).

In this essay, there is much excitement, much that needs building on and no doubt much to disagree with. But it is exhilarating to see the long stagnant pools of critical theory churned up so vigorously and with an energy that is both angry and focused.

These pieces are joined by a meditation on the status of visual culture by W.J.T Mitchell, entitled 'Showing seeing: a critique of visual culture.' Mitchell's book *Picture Theory* (1994) is widely held to be the first major publication in the field. Here he flows widely across theoretical, institutional and pedagogical questions in a piece that is bound to provoke wide-ranging discussion. I shall simply restrict myself to being among the first to quote what I suspect will be very often quoted phrases. First, linking together all these introductory pieces in some way, is Mitchell's observation that: 'the disciplinary anxiety provoked by visual studies is a classic instance of what Jacques Derrida has called "the dangerous supplement." Derrida is cited in all the essays in this section showing that – to parody Geoff Bennington – like deconstruction, visual culture is not what you think. At one level, it is rare to hear visual culture described as a deconstructive enterprise. At another it suggests that the work of visual culture holds a number of surprises in store. Mitchell himself suggests one when he writes in his 'Eight counter-theses on visual culture' that 'visual culture is the visual construction of the social, not just the social construction of vision.' To suggest only one possible interpretation of this remark: it turns out, then, that visual culture is not so much the descendant of the social history of art as its deconstructor.

Another discussion comes in a multi-authored piece by Raiford Guins, Joanne Morra, Marquard Smith and Omayra Cruz, who work in: film studies; a school of art publishing and music; a school of art, film and visual media; and a department of literature/cultural studies. This pluralism has produced an engaged and engaging approach that urges us to get away from the anthropological question 'what is visual culture?' and instead think about what it is that visual culture can articulate and for whom. In which 'district,' to use their term, should we work and using what archives? They rightly conclude: 'surely for the moment it is not so much what visual culture *is*, but rather what it can be enabled to *do* that matters.'

Using the VCR 2.0

This version of the Reader has been substantially redesigned and reworked following the suggestions of people who have read and used the book in its first incarnation. There are major changes in content as well as style and so it seemed appropriate to signal an upgrade in the title, meaning to suggest that the basis of the book will be familiar to readers but it offers a new and improved format. In general, this version is more open and wide-ranging than its predecessor. When *October* magazine launched its now notorious and ultimately self-destructive assault on visual culture in 1996, it seemed that there might be a repeat of the struggle over cultural studies in literature departments concerning visual culture in its various academic homes. Perhaps because visual culture is not so precisely located – at least in the United States – that did not happen. One of the most interesting developments has been

the very positive response to visual culture from artists and art schools, despite the occasional thundering from art historians that visual culture is the end of Art. Artists have of course been working with the end of modernist models of art for over thirty years now, so this is perhaps not so very surprising. More seriously, some have charged that visual culture is falling into the same trap as cultural studies by being too Western, too white and too Anglophone. Of course all of Anglophone academia is to some extent guilty of this charge. As visual culture programs or classes have been now established to my, no doubt limited, knowledge in the Czech Republic, Finland, Holland, Hungary, South Africa, Sweden, Tajikistan, Taiwan and Turkey, I am hopeful that it is at least to be found a moderate offender. As I argued above, the measure of visual culture's success in this regard will be the extent to which it learns to imagine the global in all aspects of its practice.

Given these positive changes, the model I have had in mind for this edition was that of a network in which readers and other users would bring their own ideas, readings and images to bear on the selections here. The sections are both intended to be productively interactive with each other and are better balanced among the various visual media. Responding to an often-made suggestion, I have also added a section of short clips from classic theoretical texts that might not be familiar to everyone and always bear re-examination. In terms of content, the questions of digital culture and globalization that loomed large in my introduction have of course had to be reflected in the new volume. In 1995 when the first edition was planned even Bill Gates did not think the internet was all that important. Perhaps by the next edition of this Reader it will not be. I have sought out both outstanding younger scholars and well-established figures to contribute essays to the new version, which contains much more original material than its predecessor. No single volume can adequately represent the polymorphous field that visual culture is becoming. I am also editing a new series called 'In·Sight: Routledge Visual Culture' which will offer readers and texts on specific subjects within visual culture. The first volume to be published will be *Feminism and Visual Culture*, edited by Amelia Jones (2002) and many others are planned. In addition the visual culture listserv continues to discuss these and other issues on a daily basis. This book has enabled teachers all over the world to create courses on visual culture and convince both their students and administrators that there really is a subject of this name. That alone justifies this renewed enterprise to my mind.

*

The presence of [. . .] denotes a cut made by the editor in the interests of length. Each part has a new introduction and there are updated bibliographies and web references.

Note

1 See my essay 'Ghostwriting: working out visual culture,' the *Journal of Visual Culture*, (vol. 1 no. 2): pp. 239–54, that is in a sense the ghost of this chapter.

References

Baird, Julia (2001) 'Sex is Back,' *Sydney Morning Herald* 12 November 2001.

Bal, Mieke (1999) *Quoting Caravaggio: Contemporary Art, Preposterous History*, Chicago and London, Chicago University Press.

Beller, Jonathan L. (1998) 'Identity Through Death/The Nature of Capital: The Media-Environment for *Natural Born Killers*,' *Post Identity*, vol. 1, no. 2 (Summer 1998), pp. 55–6.

Bodnar, John (2001) '*Saving Private Ryan* and Postwar Memory in America,' *American Historical Review*, vol. 106, no. 3 (June 2001): pp. 805–17.

Boulter, Jay David and Grusin, Richard (1999) *Remediation: Understanding New Media*, Cambridge, Mass. and London, MIT Press.

Clifford, James (1988) *The Predicament of Culture: Twentieth Century Literature, Ethnography and Art*, Cambridge, Mass.: Harvard University Press.

Crary, Jonathan (1991) *Techniques of the Observer*, Cambridge, Mass.: MIT Press.

Fagelson, William Friedman (2001) 'Fighting Films: The Everyday Tactics of World War Two Soldiers,' *Cinema Journal*, vol. 40, no. 2: pp. 94–112.

Foucault, Michel (2000) *Power*, James D. Faubion (ed.), Robert Hurley *et al.* (trans.), New York: New Press.

Grace, Helen (2000) *Before Utopia: A Non-Official Prehistory of the Present*, CD-Rom, Sydney: Pluto Press.

Hitchcock, Peter (2000) 'Risking the Griot's eye: Decolonisation and Contemporary African Cinema,' *Social Identities*, vol. 6, no. 3.

Johnson, Steven (1997) *Interface Culture: How New Technology Transforms the Way We Create and Communicate*, San Francisco: HarperEdge.

Kane, Sarah (2000) *4.48 Psychosis*, London: Methuen.

Mayne, Judith (1993) *Cinema and Spectatorship*, London and New York: Routledge.

Levinas, Emmanuel (1997) *Difficult Freedom: Essays in Judaism*, Baltimore, Md.: Johns Hopkins University Press.

Merrit, Natacha (2000) *Digital Diaries*, New York: Taschen.

Ortiz, Fernando (1995) *Cuban Counterpoint: Tobacco and Sugar*, Durham, N.C.: Duke University Press.

Spivak, Gayatri (1999) *A Critique of Postcolonial Reason*, Cambridge, Mass.: Harvard University Press.

Thomas, Nicholas and Losche, Dianne (1999) *Double Vision: Art Histories and Colonial Histories in the Pacific*, Cambridge: Cambridge University Press.

Virilio, Paul (1989) *War and Cinema: The Logistics of Perception*, trans. Patrick Camiller, London: Verso.

Further reading

Barnard, Malcolm (2000) *Approaches to Understanding Visual Culture*, London: Palgrave.

Bloom, Lisa (ed.) (1999) *With Other Eyes: Looking at Race and Gender in Visual Culture*, Minneapolis: University of Minnesota Press.

Cartwright, Lisa and Sturken, Marita (2001) *Practices of Looking: An Introduction to Visual Culture*, Oxford: Oxford University Press.

Cooke, Lynne and Wollen, Peter (eds) (1999) *Visual Display: Culture Beyond Appearances* (Discussions in Contemporary Culture, no. 10), New Press.

Doy, Gen (2000) *Black Visual Culture: Modernity and Postmodernity*, London: I.B. Tauris.

Evans, Jessica and Hall, Stuart (2000) *Visual Culture: The Reader*, London: Sage.

Heywood, Ian and Sandywell, Barry (eds) (1999) *Interpreting Visual Culture: Explorations in the Hermeneutics of the Visual*, London: Routledge.

Mirzoeff, Nicholas (1999) *An Introduction to Visual Culture*, London: Routledge.

Mitchell, W.J.T. (1994) *Picture Theory: Essays on Verbal and Visual Representation*, Chicago: University of Chicago Press.

Robertson, George, *et al.* (1996) *The Block Reader in Visual Culture*, London: Routledge.

Irit Rogoff

STUDYING VISUAL CULTURE

I raise my eyes and I see America.
 (Newt Gingrich, *New York Times*, 19 April 1995)

'And please remember, just a hint of starch in Mr. Everett's shirts.'
For one brief moment their eyes actually met, Blanche was the first to
look away. 'Yes ma'am.' After Grace left the kitchen, Blanche sat down
at the table. Was it just the old race thing that had thrown her off when
her eyes met Grace's? Her neighbor Wilma's father said he'd never in
his adult life looked a white person in the eye.
 (Barbara Neely, *Blanche on the Lam*, 1992)

His smoldering eyes saw right through my tremulous heart.
 (Barbara Cartland, *The Pirate's Return*, 1987)

HOW CAN WE CHARACTERIZE the emergent field 'visual culture'? To begin
with, we must insist that this encompasses a great deal more than the study
of images, of even the most open-ended and cross-disciplinary study of images. At
one level we certainly focus on the centrality of vision and the visual world in
producing meanings, establishing and maintaining aesthetic values, gender stereo-
types and power relations within culture. At another level we recognize that opening
up the field of vision as an arena in which cultural meanings get constituted, also
simultaneously anchors to it an entire range of analyses and interpretations of the
audio, the spatial, and of the psychic dynamics of spectatorship. Thus visual culture
opens up an entire world of intertextuality in which images, sounds and spatial
delineations are read on to and through one another, lending ever-accruing layers
of meanings and of subjective responses to each encounter we might have with film,
TV, advertising, art works, buildings or urban environments. In a sense we have

produced a field of vision version of Derrida's concept of *différance* and its achievement has had a twofold effect both on the structures of meaning and interpretation and on the epistemic and institutional frameworks that attempt to organize them. Derrida's conceptualization of *différance* takes the form of a critique of the binary logic in which every element of meaning constitution is locked into signification in relation to the other (a legacy of Saussurian linguistics' insistence on language as a system of negative differentiation). Instead what we have begun to uncover is the free play of the signifier, a freedom to understand meaning in relation to images, sounds or spaces not necessarily perceived to operate in a direct, causal or epistemic relation to either their context or to one another. If feminist deconstructive writing has long held the place of writing as the endless displacement of meaning, then visual culture provides the visual articulation of the continuous displacement of meaning in the field of vision and the visible.

This insistence on the contingent, the subjective and the constantly reproduced state of meanings in the visual field is equally significant for the institutional or disciplinary location of this work. If we do not revert to ascribing meaning exclusively to an author, nor to the conditions and historical specificities of its making, nor to the politics of an authorizing community, then we simultaneously evacuate the object of study from the disciplinary and other forms of knowledge territorialization. Perhaps then we are at long last approaching Roland Barthes's description of interdisciplinarity not as surrounding a chosen object with numerous modes of scientific inquiry, but rather as the constitution of a new object of knowledge. The following brief attempt to engage with the arena of visual culture will touch on some of these themes as well as on the thorny politics of historical specificity: its advantages, its limitations, and the dangers and freedoms inherent in attempting to move out of a traditional and internally coherent and unexamined model of what it means to be historically specific.

Vision as critique

In today's world meanings circulate visually, in addition to orally and textually. Images convey information, afford pleasure and displeasure, influence style, determine consumption and mediate power relations. Who we see and who we do not see; who is privileged within the regime of specularity; which aspects of the historical past actually have circulating visual representations and which do not; whose fantasies of what are fed by which visual images? Those are some of the questions which we pose regarding images and their circulation. Much of the practice of intellectual work within the framework of cultural problematics has to do with being able to ask new and alternative questions, rather than reproducing old knowledge by asking the old questions. (*Often in class the students complain that the language of theoretical inquiry is difficult, that 'it is not English.' They need considerable persuasion that one cannot ask the new questions in the old language, that language is meaning. In the end almost always their inherent excitement at any notion of 'the new' wins the day and by the end of the trimester someone invariably produces a perfectly formulated remark about discourse, representation and meaning usually followed by a wonder-filled pause at the recognition that they have just uttered something entirely 'different'.*)

By focusing on a field of vision and of visual culture operating within it, we create the space for the articulation of (but not necessarily the response to) such questions as: What are the visual codes by which some are allowed to look, others to hazard a peek, and still others are forbidden to look altogether? In what political discourses can we understand looking and returning the gaze as an act of political resistance? Can we actually participate in the pleasure and identify with the images produced by culturally specific groups to which we do not belong? These are the questions which we must address to the vast body of images that surrounds us daily. Furthermore we need to understand how we actively interact with images from all arenas to remake the world in the shape of our fantasies and desires or to narrate the stories which we carry within us. In the arena of visual culture the scrap of an image connects with a sequence of a film and with the corner of a billboard or the window display of a shop we have passed by, to produce a new narrative formed out of both our experienced journey and our unconscious. Images do not stay within discrete disciplinary fields such as 'documentary film' or 'Renaissance painting,' since neither the eye nor the psyche operates along or recognizes such divisions. Instead they provide the opportunity for a mode of new cultural writing existing at the intersections of both objectivities and subjectivities. In a critical culture in which we have been trying to wrest representation away from the dominance of patriarchal, Eurocentric and heterosexist normativization, visual culture provides immense opportunities for rewriting culture through our concerns and our journeys.

The emergence of visual culture as a transdisciplinary and cross-methodological field of inquiry means nothing less and nothing more than an opportunity to reconsider some of the present culture's thorniest problems from yet another angle. In its formulation of both the objects of its inquiry and of its methodological processes, it reflects the present moment in the arena of cultural studies in all of its complexities. How would I categorize this present moment? From the perspective I inhabit it seems to reflect a shift from a phase of intensely analytical activity we went through during the late 1970s and the 1980s, when we gathered a wide assortment of tools of analysis to a moment in which new cultural objects are actually being produced. While deeply rooted in an understanding of the epistemological denaturalization of inherited categories and subjects revealed through the analytical models of structuralist and poststructuralist thought and the specific introduction of theories of sexual and cultural difference, these new objects of inquiry go beyond analysis towards figuring out new and alternative languages which reflect the contemporary awareness by which we live out our lives. All around us fictions such as Toni Morrison's *Beloved*, autobiographies such as Sara Suleri's *Meatless Days*, films such as Terry Zwygoff's *Crumb* and complex multimedia art installations such as Vera Frenkel's *Transit Bar*, live out precarious and immensely creative relations between analysis, fiction and the uneasy conditions of our critically informed lives.

One of the most important issues cultural studies has taken on is to provide a 'hands-on' application of the epistemological shift which Gayatri Spivak has characterized thus: 'It is the questions that we ask that produce the field of inquiry and not some body of materials which determines what questions need to be posed to it.' In doing so we have affected a shift from the old logical-positivist world of cognition to a more contemporary arena of representation and of situated

knowledges. The emergence of a relatively new arena such as visual culture provides the possibility of unframing some of the discussions we have been engaged in regarding presences and absences, invisibility and stereotypes, desires, reifications and objectifications from the disciplinary fields – art history, film studies, mass media and communications, theoretical articulations of vision, spectatorship and the power relations that animate the arena we call the field of vision – which first articulated their status as texts and objects. Thereby unframing them from a set of conventional values as *either* highly valued *or* highly marginalized *or* outside of the scope of sanctioned vision altogether. Equally they are unframed from the specific histories of their making and the methodological models of analyses which have more recently served for their unmaking. The field that I work in, which labors heavy-handedly under the title of the critical theorization of visual culture (or visual culture for short) does not function as a form of art history or film studies or mass media, but is clearly informed by all of them and intersects with all of them. It does not historicize the art object or any other visual image, nor does it provide for it either a narrow history within art nor a broader genealogy within the world of social and cultural developments. It does not assume that if we overpopulate the field of vision with ever more complementary information, we shall actually gain any greater insight into it.

(*When I was training as an art historian, we were instructed in staring at pictures. The assumption was that the harder we looked, the more would be revealed to us; that a rigorous, precise and historically informed looking would reveal a wealth of hidden meanings. This belief produced a new anatomical formation called 'the good eye.' Later, in teaching in art history departments, whenever I would complain about some student's lack of intellectual curiosity, about their overly literal perception of the field of study or of their narrow understanding of culture as a series of radiant objects, someone else on the faculty would always respond by saying 'Oh, but they have a good eye.'*)

Nor does this field function as a form of art (or any other visual artefact) criticism. It does not serve the purpose of evaluating a project, of complementing or condemning it, of assuming some notion of universal quality that can be applied to all and sundry. Furthermore it does not aim at cataloguing the offenses and redressing the balances, nor of enumerating who is in and who is out, of what was chosen and what was discarded. These were an important part of an earlier project in which the glaring exclusions, erasures and distortions of every form of otherness – women, homosexuals and non-European peoples to mention a few categories – had to be located and named and a judgment had to be passed on the conditions of their initial exclusion. All of this, however, would constitute a 'speaking about': an objectification of a moment in culture such as an exhibition or a film or a literary text, into a solid and immutable entity which does not afford us as the viewing audience, the possibilities of play, the possibilities of rewriting the exhibition (or the site of any other artefact) as an arena for our many and different concerns. It would assume that the moment in culture known as the exhibition should ideally dictate a set of fixed meanings rather than serve as the site for the continuous (re)production of meanings.

In fact the perspectives that I would like to try and represent, the critical analysis of visual culture, would want to do everything to avoid a discourse which perceives

of itself as 'speaking about' and shift towards one of 'speaking to'. In the words of Trinh T. Min-ha, 'Tale, told, to be told/Are you truthful?', acknowledging the complexities inherent in any speech act does not necessarily mean taking away or compromising the qualities of a fine story.

> Who speaks? What speaks? The question is implied and the function named, but the individual never reigns, and the subject slips away without naturalizing its voice. S/he who speaks, speaks to the tale as S/he begins telling and retelling it. S/he does not speak about it. For without a certain work of displacement, 'speaking about' only partakes in the conservation of systems of binary opposition (subject/object, I/it, we/they) on which territorialized knowledge depends.

Trinh suggests here not merely that in reading/looking we rewrite ('speak about') the text. More importantly, she recognizes that in claiming and retelling the narratives ('speaking to'), we alter the very structures by which we organize and inhabit culture.

It is this questioning of the ways in which we inhabit and thereby constantly make and remake our own culture that informs the arena of visual culture. It is an understanding that the field is made up of at least three different components. First, there are the images that come into being and are claimed by various, and often contested histories. Second, there are the viewing apparatuses that we have at our disposal that are guided by cultural models such as narrative or technology. Third, there are the subjectivities of identification or desire or abjection from which we view and by which we inform what we view. While I am obviously focusing here on the reception rather than the production of images and objects or environments, it is clearly one of the most interesting aspects of visual culture that the boundary lines between making, theorizing and historicizing have been greatly eroded and no longer exist in exclusive distinction from one another.

For some years I have been wondering about the formation of a counter viewing position to that old art historical chestnut *the good eye.* Are we developing 'the mean eye, the jaundiced, skeptical eye?' Is the critical eye one that guards jealously against pleasure? Hardly so, if we are to engage with the fantasy formations that inform viewing subjectivities. For the moment, and following some of Laura Mulvey's later work within feminist film theory, I have settled on the notion of '*the curious eye*' to counter the 'good eye' of connoisseurship. Curiosity implies a certain unsettling; a notion of things outside the realm of the known, of things not yet quite understood or articulated; the pleasures of the forbidden or the hidden or the unthought; the optimism of finding out something one had not known or been able to conceive of before. It is in the spirit of such a 'curious eye' that I want to open up some dimension of this field of activity.

Perhaps one of the best indications of just how destabilizing this form of 'curiosity' for the not-yet-known can be, is the alarm which seems to be caused by the clearly emerging institutional formations of this new field of 'visual culture.' A recent issue of the journal *October* contained a questionnaire on the subject of this emergent arena of inquiry. All of the statements to which correspondents

were asked to reply indicated some profound sense of loss – the loss of historical specificities and of material groundings and of fixed notions of quality and excellence, etc., which the editors who had set them seem to view as the loss of the grounding navigational principles for their activities. Apparently the most alarming of all has been the infiltration of the field of art history by something termed the 'anthropological model.' I puzzled long and hard over both this analysis and the dread it seemed to provoke. I spoke to all my sophisticated cultural anthropologist acquaintances to try and understand what they may have foisted on us unawares. I read all the predictable responses to the questionnaire set by the *October* editors, and still not the slightest glimmer of comprehension emerged. Finally, reading through Tom Conley's very refreshing and extremely well-judged response 'Laughter and Alarm,' it seemed that all this fuss was being provoked by the growing presence or preference for a 'relativist' model of cultural analysis. As far as I could make out, the so-called 'relativism' of this assumed anthropological model involves a nontransferable specificity for the context of any cultural production. Thus the ability to establish a set of inherent values or criteria of excellence for images or cultural objects which would transcend the conditions of their making and constitute a metacultural relationality (as for example in the traditional modernist model for the historical avant-garde of Europe and the United States as a set of international, interlinked, innovative art movements sharing a particular confrontational spirit and a commitment to formal experimentation) is seemingly negated or sacrificed through this more current relational model.

Now, the editors of *October* who have articulated all of these anxieties about the erosion of good old art history through the encroaching dangers of so-called anthropological relativism are hardly an intellectually naïve lot; indeed they were in part responsible for acquainting my generation of art historians and critics with important analytical models and with important cultural criticism from both France and Germany as well as debates carried on in the US. Nor are they in any way provincial intellectuals, locked up within the confining frameworks of one single, national, cultural discussion. They are clearly more than aware that the notion of 'relativist' carries within it all kinds of intimations of cultural conservatism. One of the most publicized cases of polemics for and against historical relativism was the case of the 1980s German *Historikerstreit*, in which a group of conservative German historians such as Nolte and Broszat began making claims for a study of German fascism in the 1930s and 1940s as relational to all the other fascisms and totalitarian regimes around at that same historical moment. The German neo-conservative historians' project was underpinned by a politics that aimed at lessening guilt through undermining historical specificity both at the level of cause and of effect. The accusations of 'relativism' with which this writing project was greeted by more left-liberal historians in the West were due largely to the fact that much of this writing was aimed at a *re-evaluation*, in moralizing terms, of the events and policies of the period. Thus nationalist-socialist fascism was graded in relation to other Western fascisms and to Soviet totalitarian regimes and was found either to have been a response to them or to have similarities with them, or to compare not quite so horrifically with these other models. What it did not attempt was to reframe understandings of a very notion of fascism or to think it away from a national history, or to understand

it in relation to certain values and aesthetics within the modern period, or any of the other possibilities available for unframing a discussion of fascism and gaining an alternative set of understandings into it, of actually questioning the certainty that we *know* what fascism, the object of inquiry, is. Cultural specificity in this partic- ular historical discussion takes the form of two fixities: (a) a discrete, stable and clearly known object of study and (b) discrete, stable and fixed contexts (in this case of national cultures with clear lines of division between them) which contain and separate their histories. It presumes to know, in no uncertain terms, what a political movement is, where a national culture begins and ends, and it assumes that endlessly complex social, cultural, racial and sexual differences might actually coalesce around such a dramatic articulation of a subject known as 'fascism.' In contrast the cultural studies project which *October* characterizes as having been infil- trated by a so-called 'anthropological model' aims at establishing internal cultural specificities which can in turn attempt intercultural conversations while maintaining the necessary regard for the value and serious significance of *anyone*'s cultural production. There is a world of acute political difference between the politics of these two cultural/analytical projects which seem to be conflated here. So how to explain what is clearly a most confusing political slippage?

I could adopt a mean-spirited and pragmatic attitude and say that all this is simply about the loss of territories of knowledge and reputations established in given disciplinary fields which are being called into question (the fields, not the reputa- tions) by the emergence of other, newer fields. But that would be disrespectful to a publication that contributed much to my own intellectual development and it would only serve the purpose of personalizing a serious political issue and thereby devaluing its importance. To address the argument as presented in *October* both in its stated terms and with attention to the alarm underlying it is to take issue with the cautioning against undifferentiated relativism and unsituated knowledges being put forward by its editors. Clearly, notions of 'relativism' cannot be dragged around from one discussion to another with complete disregard to the politics that inform each of these. To unframe hierarchies of excellence and of universal value that priv- ilege one strand of cultural production while committing every other mode to cultural oblivion, as claims the not fully articulated accusation in *October*, does not mean that one is launching an undifferentiated universalism in which everything is equal to everything else. Rather it opens up the possibilities for analyzing the poli- tics that stand behind each particular relativist model and of differentiating between those rather than between the supposed value of objects and images. The history whose loss the editors of *October* seem to be lamenting has not disappeared, it has simply shifted ground. In visual culture the history becomes that of the viewer or that of the authorizing discourse rather than that of the object. By necessity this shift in turn determines a change in the very subject of the discussion or analysis, a shift in which the necessity for having the discussion in the first place and for having it in a particular methodological mode and at a particular time become part of this very discussion. This conjunction of situated knowledge and self-reflexive discourse analysis accompanied by a conscious history for the viewing subject hardly seems grounds for such a pessimistic lament, simply an opportunity for a bit of self- consciousness and a serious examination of the politics inherent in each project of

cultural assessment. (*The whole discussion reminds me of a dreadful sociology conference I attended a few years ago at Berkeley in which a very authoritative and very senior woman sociologist complained that without standards of excellence how would she be able to hire and fire people or accept or dismiss students? A fellow attendee at the conference who happened to be sitting next to me kept muttering under his breath in a very heavy Swedish accent 'Why don't you already stop hiring and firing?' Enough said.*)

Spectatorship in the field of vision

The space this investigation inhabits is the field of vision, which is a much wider arena than a sphere for the circulation of images or questions regarding the nature of representation. This space, the field of vision, is to begin with a vastly over-determined one. In the West, it bears the heavy burden of post-Enlightenment scientific and philosophical discourses regarding the centrality of vision for an empirical determination of the world as perceivable. In these analyses we find the gaze described as an apparatus of investigation, verification, surveillance and cognition, which has served to sustain the traditions of Western post-Enlightenment scientificity and early modern technologies. The limitations of such historical accounts of the field of vision as central to the continuing Western Enlightenment project (such as Martin Jay's exceptionally scholarly and informative recent book *Downcast Eyes*) is that it is vacated of any political dynamics or models of subjectivity. It becomes a neutral field in which some innocent objective 'eye' is deployed by an unsituated viewer. Therefore the kind of looking that was sanctioned and legitimated by scientific imperatives or the kind of surveillance which claimed its necessity through the establishment of civility through a rooting out of criminality, can now be understood through questions about who is allowed to look, to what purposes, and by what academic and state discourses it is legitimated. The recent spate of literature regarding 'vision' as it appears in numerous learned discourses does precisely the opposite of what 'visual culture' sets out to do. It reproduces a tedious and traditional corpus of knowledge and tells us how each great philosopher and thinker saw the concept of vision within an undisputed philosophical or other paradigm. Most ignominiously, feminist theorists such as Luce Irigaray (who in their writing undid territorialities of hierarchized, linear knowledge), get written into this trajectory in some misguided form of tribute to feminism via its inclusion within the annals of Western thought. By contrast, a parallel discussion in visual culture might venture to ask how bodies of thought produced a notion of vision in the service of a particular politics or ideology and populated it with a select set of images, viewed through specific apparatuses and serving the needs of distinct subjectivities.

The discussion of spectatorship *in* (rather than *and*) sexual and cultural difference, begun within feminist film theory and continued by the critical discourses of minority and emergent cultures, concerns itself with the gaze as desire, which splits spectatorship into the arena of desiring subjects and desired objects. Currently such binary separations have been increasingly tempered by the slippages between the ever-eroding boundaries of exclusive objecthood or coherent subjecthood.

At present we have arrived at an understanding that much of initial sexual and racial identity in the field of vision is formed through processes of negative differentiation: that whiteness needs blackness to constitute itself as whiteness; that masculinity needs femininity or feminized masculinity to constitute its masculinity in agreed upon normative modes; that civility and bourgeois respectability need the stereo-typical unruly 'others' – be they drunks or cultural minorities or anyone else positioned outside phantasmatic norms – to define the nonexistent codes of what constitutes 'acceptable' behavior. However, at the same time we have understood that all of these are socially constructed, 'performative' rather than essentially attrib-uted, and therefore highly unstable entities. Thus the field of vision becomes a ground for contestation in which unstable normativity constantly and vehemently attempts to shore itself up. Films such as *The Crying Game* or *The Last Seduction* played precisely with the erosion of assumptions that something – gender identity in both cases – 'looks like' that which names it and the cataclysmic results which such processes of destabilization produce. Spectatorship as an investigative field under-stands that what the eye purportedly 'sees' is dictated to it by an entire set of beliefs and desires and by a set of coded languages and generic apparatuses.

Finally the field of vision is sustained through an illusion of transparent space. This is the illusion of transparency which is claimed in the quote from Newt Gingrich with which I began this essay: 'I raise my eyes and I see America.' In this scenario, he has the ability to see. America – in all its supposed unity and homogeneity – is there available to his vision; it can be seen by him and the space between them is a transparent entity in which no obstacles obscure the directness and clarity of (his) vision. Politically and philosophically this condition has been best theorized by Henri Lefebvre in *The Production of Space* (1991) when he says:

> Here space appears as luminous, as intelligible, as giving action free rein. What happens in space lends a miraculous quality to thought, which becomes incarnate by means of a *design* (in both senses of the word). The design serves as a mediator – itself of great fidelity – between mental activity (invention) and social activity (realization); and it is deployed in space. The illusion of transparency goes hand in hand with a view of space as innocent, as free of traps or secret places. Anything hidden or dissimulated – and hence dangerous – is antagonistic to transparency, under whose reign everything can be taken in by a single glance from the mental eye which illuminates whatever it contemplates.

To some extent the project of visual culture has been to try and repopulate space with all the obstacles and all the unknown images, which the illusion of transparency evacuated from it. Space, as we have understood, is always differentiated: it is always sexual or racial; it is always constituted out of circulating capital; and it is always subject to the invisible boundary lines that determine inclusions and exclusions. Most importantly it is always populated with the unrecognized obstacles which never allow us to actually 'see' what is out there beyond what we expect to find. To repopulate space with all of its constitutive obstacles as we learn to recognize them and name them, is to understand how hard we have to strain to see, and how complex is the work of visual culture.

The visual conditions of historicizing

I have attempted to map out some constitutive components of the arena of visual culture. Most importantly I need to try to articulate the importance of its operations as a field of knowledge. In the first instance I would argue that the unframing operations I have described above might lead towards a new object of study which would be determined around issues. Those issues in turn are determined by the various urgent cultural conditions and cultural problematics with which we are faced every day. To be able to assemble a group of materials and a variety of methodological analyses around an issue that is determined out of cultural and political realities rather than out of traditions of learned arguments, seems an important step forward in the project of reformulating knowledge to deal responsibly with the lived conditions of highly contested realities, such as we face at the turn of this century in the West.

This is however also a cautionary moment: as we divest ourselves of historical periods, schools of stylistic or aesthetic affiliation, national cultural locations, or the limitations of reading objects through modes and conditions of production, we run the danger of divesting ourselves of self location. It is at this point that we enter perhaps the thorniest and most contentious aspect of this entire project, for it has become clear to each and every one of us – though we may belong to radically different collectives and cultural mobilizations within the arena of contemporary feminist, multicultural and critically/theoretically informed culture – that historic specificity is a critically important part of coming into cultural recognition and articulation. Every movement that has attempted to liberate marginalized groups from the oppressions of elision and invisibility has, to all intents and purposes, insisted on having something to say, on having a language to say it in, and on having a position from which to speak.

My own coming into critical consciousness took place within the feminist theory of the 1980s in Europe and the United States. Without doubt, the historical uncovering and location of earlier female subjects and their numerous histories and the insistence on speaking as women were a very important part of feminist critique, just as emergent cultural minority discourses are presently important in the rewriting of culture by previously colonized peoples. Having established these as both intellectually important and institutionally legitimate, the next phase moved to using gender as a category for the analysis of such categories as style or periodicity or such overall categories as 'modernism,' which enfold both. (*And this was not at all simple – I will never forget the comments of a Vassar art history professor after a lecture I gave there on the visual construction of masculinity and masculine artistic privilege through self-portraiture. He announced uncategorically that my few comments on the subsidiary female figures within these paintings were far more interesting than my efforts at theorizing the visual constructions of masculinity and that as a feminist art historian I should stick with those.*)

At stake therefore are political questions concerning who is allowed to speak about what. These can set up limitations to our intellectual capacity to engage with all the texts, images and other stimuli and frameworks we encounter; to break down the barriers of permissible and territorialized knowledge rather than simply redraw them along another formalized set of lines. The answer lies, to my mind at

least, in substituting the historical specificity of that being studied with the historical specificity of him/her/them doing the studying. In order to effect such a shift without falling prey to endless anecdotal and autobiographical ruminating which stipulates experience as a basis for knowledge, we attempt to read each culture through other, often hostile and competitive, cultural narratives. This process of continuous translation and negotiation is often exhausting in its denial of a fixed and firm position, but it does allow us to shift the burden of specificity from the material to the reader and protects us from the dangers of complete dislocation. Perhaps it might even help us to understand that at the very moment in which historical specificity can provide liberation and political strength to some of the dispossessed, it also imprisons others within an old binary structure that no longer reflects the conditions and realities of their current existence.

I should like to demonstrate this process by presenting a condensed version of a long project in which I have been involved over the past three years. The project is in several parts and involves different types of activity, both historical and critical, often involving a certain amount of fiction writing. The starting point for me has been my need to think through some issues regarding projects of public commemoration and the political uses they serve in different cultures at different times. My need to think through these problems, in relation to one another and against their official articulation by the commemorating culture, has to do with my location as a native of Israel, as someone who has for many years spent long periods of time in Germany and has been very involved with political culture on the German left, and most recently as a teacher and cultural organizer in the US where I have become acquainted with, and shaped by, discussions of multiculturalism and cultural difference. As a native of Israel I grew up in the shadow of a trauma, the genocide of European Jews during the Second World War and of its consequences in the establishment of the modern state of Israel. Simultaneously this history served in covert and unacknowledged ways to legitimate numerous acts of violence; against the indigenous population of Palestine and for the marginalization of Arab Jews, who were not perceived as part of this European horror, which perversely came to define rights of inclusion and participation within the Jewish state of Israel. Perhaps even more importantly, the plethora of commemoration practices of this horror within Israel became extremely important in maintaining a culture of constant and high anxiety within the population of the country, a kind of manifest haunting which could not be shaken despite all evidence of military and technological supremacy in the eastern Mediterranean. No matter how many battles were won and how many enemies vanquished, no matter how often the US assured the population of its undying support and loyalty, not to mention huge and constant influxes of cash and privileged markets, people in Israel have continued to live out their days driven by a fear of annihilation which the ever-present Holocaust monuments have sustained and maintained. So that has been one part of the political urgency of my project, to question the contemporary political uses of commemoration practices.

At the same time I have had to face the recent spate of commemoration activities in Germany and to contend with German discourses of guilt and of compulsory public memory. Operating in this other context, I understood that discourses of guilt and monumental public commemoration affect a form of historical closure. To begin with they assume that one can replace an absence (many millions of murdered

subjects) with a presence (a column or a statue or a complex conceptual set of public space interrogations). Second, the protagonists are frozen into binary, occupying positions of victim and perpetrator, both of whom have seemingly come to a miserable end. The newly hybridized and continuing cultural development of not only Jewish and German but also many other lives affected by the cataclysmic events of fascism and war, elsewhere around the globe and in relation to other geographies and cultures, is denied in its entirety. Finally the historic trauma of the Holocaust linked to the specter of European fascism becomes the index of all political horror and its consequence, imposing once again a Eurocentric index of measure and political identity on the very concept of political horror.

Viewed from the perspective of the US I have watched with dismay the emergence of more and more Holocaust museums across the country over the past four years. Situated within the contexts of the current culture wars exemplified by the multicultural contestation of the traditional and ongoing supremacy of European American cultural legacies, these museums have begun to take on an extremely disturbing dimension: a form of rewriting of the recent past in which a European account of horror would vie with the locally generated horror of slavery and the annihilation of native peoples. It also assumes the form of a 're-whitening' of the migrant heritage of the United States at a moment in which immigration is constantly discussed through non-European and racially marked bodies. This is disturbing in more ways that I can recount in this quick summary of a problematic, but primarily I have been thinking of the ways in which this account writes all of the Jewish world as European, which of course it never has been, and the ways in which it sets up contestations of horror within US histories, between Jewish, African-American and Native American populations.

As a culturally displaced person I move between all of these cultures and languages and inhabit positions within all of their political discourses. My displacement being neither tragic nor disadvantaged but rather the product of restless curiosity, I have an obligation to write all these problematics across one another and to see whether they yield insights beyond their specific cultural and political location. As anyone who inhabits an intercultural or cross-cultural position (which increasingly, with ever-growing self-consciousness, is most of us) knows, this constant translation and mediation process is a deeply exhausting business and one would like to put it to some productive use so that the permanent unease might unravel some other possible perspective on problems viewed almost exclusively from within each of the cultures involved. While I have had the opportunity to write each one within its own context, that was merely the reproduction of an analysis situated within a culture. What then are the possibilities of unframing these problematics and seeing how they interlink and inform one another? Perhaps even more importantly I would like to see if I can find a model of opening up a uniquely European horror to a relationality with all the political horror experienced by migrating populations elsewhere around the globe around the same time. I think that the loss of historical specificity in this instance will be compensated for by the undoing of an indexical hierarchy of horrors, in which one is culturally privileged over others. I hope that in the process some understanding of the degree to which 'Trauma' informs all of our originary myths, means that some patterns and symptoms are shared by the culture at large, even if its populations have radically

different specific histories. It might even help me to think through the constant state of cultural haunting, the underlying conditions of unease emanating from shared but denied histories between the West and non-West, that silently ruffle the surfaces of our daily lives.

That, in a nutshell, constitutes the political urgency of the specific project I am describing, and in writing projects published elsewhere, I hope to demonstrate a possible model for its exploration within the arena of visual culture. These have taken the form of long-term collaborations with conceptual artist Jochen Gerz, with video and multimedia artist Vera Frenkel, and with computer and electronic artist George Legrady. These are collaborations in which I approach the work with my specific issues at hand and invariably find in it a set of thoughts and images that allow me to formulate the next stage of my investigation. In turn my theoretical articulations locate the artists' work within a set of cultural debates in which the visual arts rarely find representation. It assumes the form of a practice, of a 'writing with' an artist's work rather than about it, a dehierarchization of the question of whether the artist, the critic or the historian, the advertising copywriter or the commercial sponsor, the studio or the director, has the final word in determining the meaning of a work in visual culture. (*Oddly this lesson was learned far from the field of dealing with contemporary objects, through Derek Jarman's extraordinary film* Caravaggio *which, more than anything I had encountered in the early 1980s, produced a model for 'contemporizing history' and reading historical artefacts through current preoccupations such as the instability of the sexual nature of gender categories. After seeing this film I experienced the very necessary delights of uncertainty, of never being quite sure of what I was looking at.*)

One of the many advantages of encountering and analyzing issues of commemoration across a broad range of visual representations that function in public and in private spaces, that tease the viewer with their reluctant visible presence or with their entire physical absence, that broadcast on monitors or lie within the bowels of the computer waiting to be unfolded in real time, is that they straddle the spatial trajectory between memory and commemoration: a trajectory that seems parallel to our dilemma within the intellectual work of the academy. In the unframed field of vision there exist possibilities for simultaneously remembering as we structure solid commemorative arguments, amass facts and juggle analytical models.

Ella Shohat and Robert Stam

NARRATIVIZING VISUAL CULTURE
Towards a polycentric aesthetics

Q UESTIONS OF MODERNISM and postmodernism are usually 'centered' within the limited and ultimately provincial frame of European art. The emerging field of 'visual culture', for us, potentially represents a break with the Eurocentrism not only of conservative 'good eye' art history but also with presumably radical, high-modernist avant-gardism, which perhaps explains the apoplectic reactions that 'visual culture' has sometimes provoked. In our view, 'visual culture' as a field interrogates the ways both art history and visual culture have been narrativized so as to privilege certain locations and geographies of art over others, often within a stagist and 'progressive' history where realism, modernism and postmodernism are thought to supersede one another in a neat and orderly linear succession. Such a narrative, we would suggest, provides an impoverished framework even for European art, and it collapses completely if we take non-European art into account.

Our purpose here is to recast these questions not only by stressing the aesthetic contributions of non-European cultures but also by insisting on the longstanding interconnectedness between the arts of Europe and those outside it. We want to address visual culture in a way that does not always assume Europe – taken here in the broad sense to include the neo-Europes that colonialism installed around the world – as the normative culture of reference. Traditional art history, in this sense, exists on a continuum with official history in general, which figures Europe as a unique source of meaning, as the world's center of gravity, as ontological 'reality' to the world's shadow. Endowing a mythical 'West' with an almost providential sense of historical destiny, Eurocentric history sees Europe, alone and unaided, as the motor, the *primum mobile*, for progressive historical change, including progressive change in the arts. An arrogant monologism exalts only one legitimate culture, one narrative, one trajectory, one path to aesthetic creation.[1]

Most writing on modernism, for example, restricts its attention to movements in European and North American capitals like Paris, London, New York and

Zurich, while consigning to oblivion similar modernist movements in such places as São Paolo, Havana, Mexico City and Buenos Aires (to speak only of Latin America). Periodization and theoretical formulations too have been relentlessly monochromatic. A single, local perspective has been presented as 'central' and 'universal,' while the productions of what is patronizingly called 'the rest of the world,' when discussed at all, are assumed to be pale copies of European originals, aesthetically inferior and chronologically posterior, mere latter-day echoes of pioneering European gestures. The dominant literature on modernism often regards Europe as simply absorbing 'primitive art' and anonymous 'folklore' as raw materials to be refined and reshaped by European artists. This view prolongs the colonial trope which projected colonized people as body rather than mind, much as the colonized world was seen as a source of raw material rather than of mental activity or manufacture. Europe thus appropriated the material and cultural production of non-Europeans while denying both their achievements and its own appropriation, thus consolidating its sense of self and glorifying its own cultural anthropophagy.

The notion of non-European cultural practices as untouched by avant-gardist modernism or mass-mediated postmodernism, we would argue, is often subliminally imbricated with a view of Africa, Latin America and Asia as 'underdeveloped' or 'developing,' as if it lived in another time zone apart from the global system of the late capitalist world. Such a view bears the traces of the infantilizing trope, which projects colonized people as embodying an earlier stage of individual human or broad cultural development, a trope which posits the cultural immaturity of colonized or formerly colonized peoples. As diplomatic synonyms for 'childlike,' terms like 'underdevelopment' project the infantilizing trope on a global scale. The Third World toddler, even when the product of a millennial civilization, is not yet in control of his body/psyche and therefore needs the help of the more 'adult' and 'advanced' societies.[2] Like the sociology of 'modernization' and the economics of 'development,' the aesthetics of modernism (and of postmodernism) often covertly assume a telos toward which Third World cultural practices are presumed to be evolving. Even such a generally acute cultural theorist as Fredric Jameson, in his writings on Third World literature and film, tends to underestimate the radical revisioning of aesthetics performed by Third World and diasporic artists. Although he is (thankfully) inconsistent on this point, Jameson in his unguarded moments seems to conflate the terms of political economy (where he projects the Third World into a less developed, less modern frame), and those of aesthetic and cultural periodization (where he projects it into a 'pre-modernist' or 'pre-postmodernist' past). A residual economism or 'stagism' here leads to the equation of late capitalist/postmodernist and precapitalist/pre-modernist, as when Jameson speaks of the 'belated emergence of a kind of modernism in the modernizing Third World, at a moment when the so-called advanced countries are themselves sinking into full postmodernity.'[3] Thus the Third World always seems to lag behind, not only economically but also culturally, condemned to a perpetual game of catch-up, in which it can only repeat on another register the history of the 'advanced' world. This perspective ignores the 'systems theory' that sees all the 'worlds' as coeval, interlinked, living the *same* historical moment (but under diverse modalities of subordination or domination). It also ignores the view that

posits the neologistic cultures of Latin America, for example – products of uneven development and of multifaceted transactions with other cultures, as the privileged scenes of copy and pastiche – as themselves the proleptic site of postmodernist practices.

A more adequate formulation, in our view, would see temporality as scrambled and palimpsestic in all the worlds, with the pre-modern, the modern, the postmodern coexisting globally, although the 'dominant' might vary from region to region. Thus the Pennsylvanian Dutch, who eschew all modern technology, and the cybernetic technocrats of Silicon Valley, both live in 'postmodern' America, while the 'stone-Age' Kayapo and sophisticated urban Euro-Brazilians both live in Brazil, yet the Kayapo use camcorders while the sophisticates adhere to supposedly 'archaic' Afro-Brazilian religions. Thus all cultures, and the texts generated by these cultures, we assume, are multiple, hybrid, heteroglossic, unevenly developed, characterized by multiple historical trajectories, rhythms and temporalities.

As seen through this grid, visual culture manifests what Canclini calls 'multi-temporal heterogeneity,' i.e. the simultaneous, superimposed spatio-temporalities which characterize the contemporary social text. The widely disseminated trope of the palimpsest, the parchment on which are inscribed the layered traces of diverse moments of past writing, contains within it this idea of multiple temporalities. The postmodern moment, similarly, is seen as chaotically plural and contradictory, while its aesthetic is seen as an aggregate of historically dated styles randomly reassembled in the present. For Bakhtin, all artistic texts of any complexity 'embed' semantic treasures drawn from multiple epochs. All artistic texts, within this perspective, are palimpsestic, analyzable within a millennial, *longue durée*. Nor is this aesthetic the special preserve of canonical writers, since dialogism operates within all cultural production, whether literate or non-literate, high-brow or lowbrow. European or non-European. Rap music's cut'n'mix aesthetic of sampling, for example, can be seen as a street-smart embodiment of this temporally embedded intertextuality, in that rap bears the stamp and rhythm of multiple times and meters. As in artistic collage or literary quotation, the sampled texts carry with them the time-connoted memory of their previous existences.

The palimpsestic multi-trace nature of art operates both within and across cultures. The multicultural dialogue between Europe and its others, for example, is not of recent date. Although a Eurocentric narrative constructs an artificial wall of separation between European and non-European culture, in fact Europe itself is a synthesis of many cultures, Western and non-Western. The notion of a 'pure' Europe originating in classical Greece is premised on crucial exclusions, from the African and Asiatic influences that shaped classical Greece itself, to the osmotic Sephardi-Judaic-Islamic culture that played such a crucial role during the so-called Dark Ages (an ethnocentric label for a period of oriental ascendancy), the Middle Ages, and the Renaissance. All the celebrated milestones of European progress – Greece, Rome, Christianity, Renaissance, Enlightenment – are moments of cultural mixing. The 'West' then is itself a collective heritage, an omnivorous *mélange* of cultures; it did not simply absorb non-European influences, as Jon Pietersie points out, 'it was constituted by them.'[4] Western art, then, has always been indebted to and transformed by non-Western art. The movement of aesthetic ideas has

been (at least) two-way, hence the Moorish influence on the poetry of courtly love, the African influence on modernist painting, the impact of Asian forms (Kabuki, Noh drama, Balinese theater, ideographic writing) on European theater and film, and the influence of Africanized forms on such choreographers as Martha Graham and George Ballanchine.

The debt of the European avant-gardes to the arts of Africa, Asia, and indigenous America has been extensively documented. Leger, Cendrars, and Milhaud based their staging of *La Création du Monde* on African cosmology. Bataille wrote about pre-Columbian art and Aztec sacrifices. Artaud fled France for the Mexico of the Tarahumara Indians; and the avant-garde generally cultivated the mystique of Vodun and of African art. The British sculptor Henry Moore, in this same vein, modeled his recumbent statues on the Chac Mool stone figures of ancient Mexico. Although it may be true that it was the 'impact of surrealism,' as Roy Armes suggests, 'that liberated the Caribbean and African poets of Negritude from the constraints of a borrowed language,' it was also African and Asian and American indigenous art that liberated the European modernists by provoking them to question their own culture-bound aesthetic of realism.[5]

While a Euro-diffusionist narrative makes Europe a perpetual fountain of artistic innovation, we would argue for a multidirectional flow of aesthetic ideas, with intersecting, criss-crossing ripples and eddies. Indeed, it could be argued that many of the highpoints of Western creativity – the Renaissance, modernism – have been those moments when Europe loses its sealed-off and self-sufficient character; moments when its art was most hybridized, most traversed by currents from elsewhere. European modernism, in this sense, constituted a moment in which non-European cultures became the catalysts for the supersession, within Europe, of a retrograde culture-bound verism, in which Africa, Asia, and the Americas stimulated alternative forms and attitudes.

Nor can one assume that 'avant-garde' always means 'white' and 'European,' nor that non-European art is always realist or pre-modernist.[6] Even the equation of 'reflexivity' with European modernism is questionable. Within the Western tradition reflexivity goes at least as far back as Cervantes and Shakespeare, not to mention Aristophanes. And outside Europe, the Mesoamerican *teoamoxtli* or cosmic books feature *mise-en-abîme* images of deerskin drawn upon the deerskins of which they are made, just as the Mayan *Popol Vuh* 'creates itself in analogy with the world-making it describes or narrates.'[7] African scholars, meanwhile, have discerned common elements in deconstruction and Yoruba *oriki* praise poetry, specifically indeterminacy, intertextuality and constant variability.[8] And for Henry Louis Gates, the Yoruba trickster-figure Eshu-Elegbara emblematizes the deconstructive 'signifying' of African-derived art forms.

Third World cinema too has been rich in avant-garde, modernist, and post-modernist movements. Quite apart from the confluence of Brechtian modernism and Marxist modernization in the 'new cinemas' of Cuba (Alea), Brazil (Guerra), Egypt (Chahine), Senegal (Sembene), and India (Sen), there have been many modernist and avant-garde films in the Third World, going all the way back to films like *São Paulo: Sinfonia de una Cidade* (São Paulo: Symphony of a City, 1928) and *Limite* (1930), both from Brazil, and forward through the Senegalese director Djibril Diop Mambete's *Touki-Bouki* (1973) and, from Mauritania, Med

Hondo's *Soleil O* (1970) and *West Indies* (1975) to the underground movements of Argentina and Brazil, through Kidlat Tahimik's anti-colonialist experiments in the Philippines. The point is not to brandish terms like 'reflexive' or 'deconstructive' or 'postmodern' as honorifics – you see, the Third World is postmodern too! – but rather to set the debates within a relational framework in terms of both space and time.

Our specific goal here is to interrogate the conventional sequencing of realism/modernism/postmodernism by looking at some of the alternative aesthetics offered by Third World, postcolonial, and minoritarian cultural practices: practices that dialogue with Western art movements but which also critique them and in some ways go beyond them. While much recent writing has been devoted to exposing the exclusions and blindnesses of Eurocentric representations and discourses, the actual cultural productions of non-Europeans have been ignored, a neglect which reinscribes the exclusion even while denouncing it, shifting it to another register. Part of the burden of this essay is to reframe the debates about modernism and postmodernism in visual culture by foregrounding certain alternative aesthetics associated with non-European and minoritarian locations. These aesthetics bypass the formal conventions of dramatic realism in favor of such modes and strategies as the carnivalesque, the anthropophagic, the magical realist, the reflexive modernist, and the resistant postmodernist. These aesthetics are often rooted in non-realist, often non-Western or para-Western cultural traditions featuring other historical rhythms, other narrative structures, other views of the body, sexuality, spirituality, and the collective life. Many incorporate non-modern traditions into clearly modernizing or postmodernizing aesthetics, and thus problematize facile dichotomies such as traditional/modern, realist/modernist, and modernist/postmodernist.

These movements have also been fecund in neologistic aesthetics, literary, painterly and cinematic: '*lo real maravilloso americano*' (Carpentier), 'anthropophagy' (the Brazilian Modernists), the 'aesthetics of hunger' (Glauber Rocha), '*Cine imperfecto*' (Julio García Espinosa), 'cigarette-butt aesthetics' (Ousmane Sembene), the 'aesthetics of garbage' (Rogerio Sganzerla), 'Tropicalia' (Gilberto Gil and Caetano Veloso), the 'salamander' (as opposed to the Hollywood dinosaur) aesthetic (Paul Leduc), 'termite terrorism' (Gilhermo del Toro), 'hoodoo aesthetics' (Ishmael Reed), the 'signifying-monkey aesthetic' (Henry Louis Gates), 'nomadic aesthetics' (Teshome Gabriel), 'diaspora aesthetics' (Kobena Mercer), '*rasquachismo*' (Tomas-Ibarra Frausto), and '*santeria* aesthetics' (Arturo Lindsay). Most of these alternative aesthetics revalorize by inversion what had formerly been seen as negative, especially within colonialist discourse. Thus ritual cannibalism, for centuries the very name of the savage, abject other, becomes with the Brazilian modernists an anti-colonialist trope and a term of value. (Even 'magic realism' inverts the colonial view of magic as irrational superstition.) At the same time, these aesthetics share the ju-jitsu trait of turning strategic weakness into tactical strength. By appropriating an existing discourse for their own ends, they deploy the force of the dominant against domination. Here we shall explore just a few of these aesthetics. In each case, we are dealing simultaneously with a trope – cannibalism, carnival, garbage – with an aesthetic movement, and implicitly with a methodological proposal for an alternative model for analyzing visual (multi) culture.

The archaic postmodern

Artistic modernism was traditionally defined in contradistinction to realism as the dominant norm in representation. But outside of the West, realism was rarely the dominant; hence modernist reflexivity as a reaction against realism, could scarcely wield the same power of scandal and provocation. Modernism, in this sense, can be seen as in some ways a rather provincial, local rebellion. Vast regions of the world, and long periods of artistic history, have shown little allegiance to or even interest in realism. Kapila Malik Vatsayan speaks of a very different aesthetic that held sway in much of the world:

> A common aesthetic theory governed all the arts, both performing and plastic, in South and South East Asia. Roughly speaking, the common trends may be identified as the negation of the principle of realistic imitation in art, the establishment of a hierarchy of realities where the principle of suggestion through abstraction is followed and the manifestation in the arts of the belief that time is cyclic rather than linear . . . This tradition of the arts appears to have been pervasive from Afghanistan and India to Japan and Indonesia over two thousand years of history.[9]

In India, a two-thousand year tradition of theater circles back to the classical Sanskrit drama, which tells the myths of Hindu culture through an aesthetic based less on coherent character and linear plot than on the subtle modulations of mood and feeling (*rasa*). Chinese painting, in the same vein, has often ignored both perspective and realism. Much African art, similarly, has cultivated what Robert Farris Thompson calls 'mid-point mimesis,' i.e. a style that avoids both illusionistic realism and hyperabstraction.[10] The censure of 'graven images' in Judeo-Islamic art, finally, cast theological suspicion on directly figurative representation and thus on the very ontology of the mimetic arts. Indeed, it was only thanks to imperialism that mimetic traditions penetrated the Islamic world. As appendages to imperial culture, art schools were founded in places like Istanbul, Alexandria, and Beirut, where the artists of the 'Orient' learned to 'disorient' their art by mimicking Mimesis itself in the form of the veristic procedures of Western art.

Just as the European avant-garde became 'advanced' by drawing on the 'archaic' and 'primitive,' so non-European artists, in an aesthetic version of 'revolutionary nostalgia,' have drawn on the most traditional elements of their cultures, elements less 'pre-modern' (a term that embeds modernity as telos) than 'para-modern.' In the arts, we would argue, the distinction archaic/modernist is often non-pertinent, in the sense that both share a refusal of the conventions of mimetic realism. It is thus less a question of juxtaposing the archaic and the modern than deploying the archaic in order, paradoxically, to modernize, in a dissonant temporality which combines a past imaginary communitas with an equally imaginary future utopia. In their attempts to forge a liberatory language, for example, alternative film traditions draw on para-modern phenomena such as popular religion and ritual magic. In Nigeria, filmmaker Ola Balogun explains, it is less appropriate to speak of 'performing arts' than to speak of 'ritual or folk performances or of communicative arts . . . ceremonies of a social or religious nature into which dramatic elements are incorporated.'[11] In some

recent African films such as *Yeelen* (1987), *Jitt* (1992), and *Kasarmu Ce* (This Land Is Ours, 1991), magical spirits become an aesthetic resource, a means for breaking away, often in comical ways, from the linear, cause-and-effect conventions of Aristotelian narrative poetics, a way of defying the 'gravity,' in both senses of that word, of chronological time and literal space.

The values of African religious culture inform not only African cinema but also a good deal of Afro-diasporic cinema, for example Brazilian films like Rocha's *Barravento* (1962) and Cavalcanti's *A Forca de Xango* (The Force of Xango, 1977), *Amuleto de Ogum* (Ogum's Amulet, 1975), Cuban films like *Patakin* and *Ogum*, and African-American films like Julie Dash's *Daughters of the Dust*, all of which inscribe African (usually Yoruba) religious symbolism and practice. Indeed, the preference for Yoruba symbolism is itself significant, since the performing arts are at the very kernel of the Yoruba religions themselves, unlike other religions where the performing arts are grafted on to a theological/textual core. The arts inform the religions in multifaceted ways. The arts – costume, dance, poetry, music – create the appropriate atmosphere for worship. The arts also inform cosmogony and theology. The figure of Olodumare, as creator of the universe, can be seen as the greatest artist, and many of the spirits (*orixás*) are not only artists (Ogum is the patron-deity of all those who work with metals, for example) but they also have artistic tastes. The notion that the classical Greek pantheon is noble and beautiful and at the very roots of Western civilization, while the gods of Africa are merely the vestigial superstitions of a backward people, also belongs in the trashcan of Eurocentric hierarchies. As poetic figures, the *orixás* now play an artistic role in Africa and the diaspora akin to the role of the classical deities of the Greek pantheon within literature, painting and sculpture. We are not here speaking of a discourse of the 'authentic,' but rather of a sophisticated deployment of cultural knowledges. The *orixás* permeate the sculpture of 'Mestre Didi,' the photography of Pierre Verger; the painting of Carybe, the plays of Wole Soyinka, and the music of Olodum, Ile Aiyé, and Timbalada, and recently of Paul Simon and David Byrne. Indeed, Arturo Lindsay speaks of a 'neo-Yoruba' genre of contemporary art.[12]

The question of the contemporary aesthetic implications of ancient African religions illustrates the pitfalls of imposing a linear narrative of cultural 'progress' in the manner of 'development' theory, which sees cultures as mired in an inert, pre-literate 'tradition,' seen as the polar antithesis of a vibrant modernity. Some recent African films scramble this binarism by creating a kind of village or extended family aesthetic which fosters a collective traditional space, but now within an overarching modernist or postmodernist frame. Jean-Pierre Bekolo's *Quartier Mozart* (1992), which portrays a Cameroon neighbourhood (the 'Mozart Quarter' of the title), never sutures us via point-of-view editing into the individual desires of single characters of either gender; sexuality, as in carnival, becomes a quasi-public affair. In the film's 'magical' format, a sorceress (Maman Thekla) helps a schoolgirl, 'Queen of the Hood,' enter the body of a man ('My Guy') in order to explore gendered boundaries. The sorceress takes the shape of 'Panka,' familiar from Cameroonian folklore, who can make a man's penis disappear with a handshake. While the magical devices of *Quartier Mozart* are on one level 'archaic' – in that they translocate traditional folktale motifs into a contemporary setting – the style is allusively postmodern (referring especially to Spike Lee and his witty direct-address

techniques), media-conscious (the neighborhood girls prefer Denzel Washington to Michael Jackson) and music-video slick.

Carnivalesque subversions

Another alternative aesthetic, and one that further problematizes the canonical narrativizing of art history, is the tradition of the 'carnivalesque.' Within the standard modernist narrative, the historical avant-gardes represent a radical break with the past, a decisive rupture with the mimetic tradition. In another perspective, however, the historical avant-gardes can be seen as a return to earlier traditions such as the Menippeia and the carnivalesque. As the transposition into art of the spirit of popular festivities, the carnivalesque forms a counter-hegemonic tradition with a history that runs (to speak only of Europe) from Greek Dionysian festivals (and classical Greece, we recall, was an amalgam of African, Asian, and Greek elements) and the Roman saturnalia through the grotesque realism of the medieval 'carnivalesque' (Rabelaisian blasphemies, for example) and baroque theater, to Jarry, surrealism, and on to the counter-cultural art of recent decades.

Given the decline of the carnival ethos and the emergence of an individualist society, carnival could no longer be a collective cleansing ritual open to all the people; it became a merely artistic practice, the instrument of a marginalized caste. Carnival shares with the avant-garde its impulse toward social, formal, and libidinal rebellion, but the modernist rebellion could no longer be allied with popular adversary culture. The elimination of carnival as a real social practice led to the development of salon carnivals, compensatory bohemias offering what Allon White calls 'liminoid positions' on the margins of polite society. Thus movements such as expressionism and surrealism took over in displaced form much of the grotesque bodily symbolism and playful dislocations – exiled fragments of the 'carnivalesque diaspora' (White) – which had once formed part of European carnival. Carnival, in this modified form, is present in the provocations of Dada, the dislocations of surrealism, in the hermaphrodytic torsos of Magritte, in the violations of social and cinematic decorum in Buñuel's *L'Âge d'Or*, in the travesty-revolts of Genet's *The Maids* or *The Blacks*, and indeed in the avant-garde generally. In fact, it is in its formal transgressions, and not only in its violations of social decorum, that the avant-garde betrays its link to the perennial rituals of carnival. (And carnival itself, as a counter-institutional mode of cultural production, can be seen as proleptic of the avant-garde.) Thus it is possible to see the more democratizing of the avant-garde movements – we are not speaking here of high-toned autotelic modernism – not so much as decisive breaks with tradition but rather as one of the perennial rediscoveries of the corporeal outrageousness and anti-grammaticality of the upside-down world of the carnivalesque.[13]

Although European real-life carnivals have generally degenerated into the ossified repetition of perennial rituals, it would be Eurocentric to speak of the 'end of carnival' as a resource for artistic renovation. First, nearly all cultures have carnival-like traditions. Among the Navajos (Dineh), special rituals exist for overturning good order and respectable aesthetics. The concept of *rasquachismo*

(from Nahuatl) similarly evokes deliberate bad taste and the ludic undermining of norms.[14] For the Hopi, ritual clowns are those who violate conventional expectations in a spirit of gay relativity.[15] Wherever one finds inequities of power, wealth, and status, one also finds a culture of the 'world upside down.' Thus the saturnalia of ancient Rome, carnival in the Caribbean, and the Feast of Krishna in India all translate popular rebelliousness through images of millenarian reversals. Second, in contemporary Latin America and the Caribbean, carnival remains a living, vibrant tradition, where a profoundly mestizo culture builds on indigenous and African traditional festivals to forge an immensely creative cultural phenomenon. It is not surprising, in this sense, that many Latin American theorists have seen the carnivalesque as a key to Latin American artistic production. What was remote and merely metaphoric for European modernism – magic, carnival, anthropophagy – was familiar and quasi-literal for Latin Americans. Indeed, many of the talismanic phrases associated with Latin American art and literature – 'magical realism,' 'quotidian surreality' – not only assert an alternative culture but also suggest the inadequacy of the high mimetic European tradition for the expressive needs of an oppressed but polyphonic culture. It was partly his contact with such festivals, and with Haitian *Vodun*, that led the Cuban writer Alejo Carpentier to contrast the quotidian magic of Latin American life with Europe's labored attempts to resuscitate the marvelous.[16] If the best that Europe can come up with is 'the intersection on a dissecting table of an umbrella and a sewing machine,' Carpentier suggests, the Americas could offer the explosive counterpoints of indigenous, African, and European cultures thrown up daily by Latin American life and art: counterpoints where the tensions are never completely resolved or harmonized, where the cultural dialogue is tense, transgressive, and endlessly surprising. Rather than merely reflect a pre-existing hybridity, the Brazilian cinema (of a Glauber Rocha for example) actively hybridizes, it stages and performs hybridity, counterpointing cultural forces through surprising, even disconcerting juxtapositions. At its best, it orchestrates not a bland pluralism but rather a strong counterpoint between in some ways incommensurable yet nevertheless thoroughly co-implicated cultures.

What Bakhtin calls 'carnivalization' is not an 'external and immobile schema which is imposed upon ready-made content' but 'an extraordinary flexible form of artistic visualization, a peculiar sort of heuristic principle making possible the discovery of new and as yet unseen things.'[17] As theorized by Bakhtin, carnival as an artistic practice transforms into art the spirit of popular festivities, embracing an anticlassical aesthetic that rejects formal harmony and unity in favor of the asymmetrical, the heterogeneous, the oxymoronic, the miscegenated. Carnival's 'grotesque realism' turns conventional aesthetics on its head in order to locate a new kind of popular, convulsive, rebellious beauty: one that dares to reveal the grotesquery of the powerful and the latent beauty of the 'vulgar.' In the carnival aesthetic, everything is pregnant with its opposite, within an alternative logic of permanent contradiction and nonexclusive opposites that transgresses the monologic true-or-false thinking typical of a certain kind of positivist rationalism. Carnival also proposes a very different concept of the body. Instead of an abstract rage against figuration – which Nicholas Mirzoeff sees as encoding hostility to the body itself – carnival proposes a gleefully distorted body of outlandish proportions.[18] The carnival

body is unfinished, elastic, malleable; it outgrows itself, transgresses its own limits and conceives new bodies. Against the static, classic, finished beauty of antique sculpture, carnival counterposes the mutable body, the 'passing of one form into another,' reflecting the 'ever incompleted character of being.'[19] By calling attention to the paradoxical attractiveness of the grotesque body, carnival rejects what might be called the 'fascism of beauty,' the construction of an ideal type or language of beauty in relation to which other types are seen as inferior, 'dialectical' variations.

This is hardly the place to survey the vast repertoire of the cinematic carnivalesque.[20] Suffice it to say that carnival has taken very diverse forms. There are films that literally thematize carnival (*Black Orpheus*, *A Propos de Nice*, *Xica da Silva*); films that anarchize institutional hierarchies (*Born in Flames*); films that foreground the 'lower bodily stratum' (George Kuchar, John Waters); films that favor grotesque realism (*Macunaima*) and anti-grammaticality (Bruce Conner, Rogerio Sganzerla); films that celebrate social and racial inversions (Alea's *The Last Supper*). Brazilian cinema especially has always been deeply impregnated by the cultural values associated with carnival. The '*chanchadas*' or *filmes carnavalescos* (carnivalesque films), the musical comedies popular from the 1930s through the 1950s, were not only released at carnival time but were intended to promote the annual repertory of carnival songs.[21] One *chanchada*, namely *Carnaval Atlantida* (1952) proposes a model of cinema based on sublime debauchery and carnivalesque irony. (Modernist reflexivity is not the special preserve of elite culture; it can also characterize popular and mass-mediated culture.) The film revolves around a Euro-Brazilian film director, Cecilio B. De Milho (Cecil B. De Corn), who finally abandons his plan for an epic production of the story of Helen of Troy. Hollywood-dictated standards, he discovers, with their ostentatious sets and the proverbial cast of thousands, are simply not feasible in a poor, Third World country. Against the overreaching De Milho, other characters argue for a more popular, less lofty adaptation, recommending that the director discard the proposed epic in favor of a carnival film. In one sequence, De Milho explains his conception of *Helen of Troy*. His elitist, grandiose vision is contrasted with the point of view of two Afro-Brazilian studio janitors and aspiring scriptwriters (Cole and Grande Otelo), through whose eyes we move from De Milho's 'scene' to the scene as they imagine it: the black singer Blecaute appears dressed in Greek costume, singing *Dona Cegonha*, a carnival samba written for that year's celebration, accompanied by Grande Otelo tripping over his toga. European themes, then, had to be parodically relocated within the context of Brazilian carnival. '*Helen of Troy* won't work,' De Milho is told, 'the people want to dance and move.' The Hollywood/Greek model is dropped in favor of an Africanized popular culture.

Carnival favors an aesthetic of mistakes, what Rabelais called a *gramatica jocosa* ('laughing grammar') in which artistic language is liberated from the stifling norms of correctness. Carnivalesque art is thus 'anti-canonical,' it deconstructs not only the canon, but also the generating matrix that makes canons and grammaticality. The concept of 'laughing grammar' reminds one of how black musicians have historically turned 'lowly' materials (washboards, tubs, oil drums) into vibrant musicality, or how jazz artists have stretched the 'normal' capacities of European

instruments by playing the trumpet 'higher' than it was supposed to go, by 'hitting two keys, mis-hitting keys (like Monk did), flubbing notes to fight the equipment.'[22] In such cases, the violation of aesthetic etiquette and decorum goes hand in hand with an implicit critique of conventional social and political hierarchies. Arthur Jaffa (director of photography for *Daughters of the Dust*) speaks of the cinematic possibilities of 'black visual intonation,' whereby 'irregular, nontempered (non-metronomic) camera rates and frame replication . . . prompt filmic movement to function in a manner that approximates black vocal intonation,' forging the filmic equivalent of the tendency in black music to 'treat notes as indeterminate, inherently unstable sonic frequencies rather than . . . fixed phenomena.'[23] The possibilities of an 'aesthetic of mistakes' are suggestively evoked in the work of pioneering African-American filmmaker William Greaves. In his reflexive *SymbioPsychoTaxiPlasm – Take One* (filmed in 1967 but still to be commercially released), the filmmaker-in-the-film becomes the catalyst whose very refusal to direct instigates a revolt (devoutly desired by the director) on the part of actors and crew. With the filming of 'Over the Cliff' in Central Park – consisting of endless reshooting of the same scene of marital breakup – as a decoy, the director provokes the crew and cast to film themselves arguing about the director's manipulative refusal to direct. With Miles Davis's *In a Silent Way* on the soundtrack, the film is built, like jazz itself, on signifying 'mistakes': the film runs out, the camera jams, the actors become restless and irritable. The film analogizes jazz's relation to the European mainstream by performing a filmic critique of dominant cinema conventions and subtly evoking, in a *tour de force* of improvisation, multiple resistances and insurgent energies against diverse authoritarianisms and oppressions.

Modernist anthropophagy

Another important aesthetic movement from a non-European location, and one that casts further doubt on linear stagist narratives of artistic progress, is the 'anthropophagic' movement from Brazil, a movement which was self-designated as 'modernist' yet which anticipated aspects of both postmodernity and postcoloniality. The currently fashionable talk of 'hybridity' and 'syncretism,' usually associated with 'postcolonial' theory, elides the fact that artists/intellectuals in Brazil (and the Caribbean) were theorizing hybridity over half a century earlier. The fact that the achievements of Brazilian artists like Oswald de Andrade and Mario de Andrade are not as well known as those of a James Joyce or an Alfred Jarry, has less to do with the originality of their intervention than with the inequitable distribution of artistic laurels around the world, where cultural prestige partially depends on the power of a country and the dissemination of its language. The Brazilian modernists of the 1920s wrote from the 'wrong' location and in the 'wrong' language.

The 'Modern Art Week' held in São Paulo in February 1922 was an attempt by Brazilian poets, musicians, and visual artists to break with the Europhile academicism of the time. The 'Anthropophagy' movement mingled homages to indigenous culture with aesthetic modernism. On one level, artists like Oswald de Andrade and Mario de Andrade qualify as early examples of James Clifford's

'ethnographic surrealism,' with its fascination with the primitive, with the difference that the Brazilian modernists were more 'inside' of the cultures they were investigating. Mario de Andrade's anthropological and musical researches, for example, became a way of probing, with mingled distance and identification, his own roots as an artist of indigenous, African, and European ancestry. The Brazilian movement not only called itself modernism (*modernismo*) but saw itself as allied and conceptually parallel to European avant-garde movements like futurism, Dada and surrealism. In two manifestos – 'Manifesto of Brazilwood Poetry' (1924) and 'Cannibalist Manifesto' (1928) – Oswald de Andrade pointed the way to an artistic practice at once nationalist and cosmopolitan, nativist and modern. In the earlier text, de Andrade called for an 'export-quality' poetry that would not borrow imported 'canned' European models but would find its roots in everyday life and popular culture. Where colonialist discourse had posited the Carib as a ferocious cannibal, as diacritical token of Europe's moral superiority, Oswald called in the 'Cannibalist Manifesto' for a revolution infinitely 'greater than the French revolution,' namely the 'Carib revolution,' without which 'Europe wouldn't even have its meager declaration of the rights of man.'[24] The cannibalist metaphor was also circulated among European avant-gardists; but cannibalism in Europe, as Augusto de Campos points out, never constituted a cultural movement, never defined an ideology, and never enjoyed the profound resonances within the culture that it did in Brazil. Although Alfred Jarry in his *Anthropophagie* (1902) spoke of that '*branche trop negligée de l'anthropophagie*' and in '*L'Almanach du Père Ubu*' addressed himself to '*amateurs cannibals*,' and although the Dadaists entitled one of their organs *Cannibale* and in 1920 Francis Picabia issued the '*Manifeste Cannibale Dada*,' the nihilism of Dada had little to do with what Campos called the 'generous ideological utopia' of Brazilian anthropophagy.[25] Only in Brazil did anthropophagy become a key trope in a longstanding cultural movement, ranging from the first 'Cannibalistic Review' in the 1920s, with its various 'dentitions,' through Oswald de Andrade's speculations in the 1950s on anthropophagy as 'the philosophy of the technicized primitive,' to the pop-recyclings of the metaphor in the tropicalist movement of the late 1960s.

There was, of course, a good deal of concrete interanimation between the Brazilian and European avant-gardes. Blaise Cendrars, Le Corbusier, Marinetti, and Benjamin Peret all went to Brazil, just as Oswald de Andrade, Sergio Millet, Paulo Prado, and other key figures in the Brazilian modernist movement made frequent trips to Europe. The Brazilian modernist painter Tarsila do Amaral studied with Fernand Leger, and she and her husband Oswald numbered Leger, Brancusi, Satie, Cocteau, Breton, Stravinsky, and Milhaud among their close friends. Oswald de Andrade saluted surrealism, in a self-mockingly patronizing and 'stagist' manner, as one of the richest 'pre-anthropophagic' movements. Although anthropophagy 'set its face against the Occident,' according to Andrade, it warmly 'embraces the discontented European, the European nauseated by the farce of Europe.'[26] The exoticizing metaphors of the European avant-garde had a strange way of 'taking flesh' in the Latin American context, resulting in a kind of ironic echo effect between the European and Latin American modernism. When reinvoiced in Brazil, all this became quite concrete and literal. Thus Jarry's 'neglected branch of anthropophagy' came to refer in Brazil to the putatively real cannibalism of the Tupinamba, and

surrealist 'trance writing' metamorphosed into the collective trance of Afro-Brazilian religions like *candomble*. Brazilian familiarity with the 'madness' of carnival, with African-derived trance religions, thus made it easy for Brazilian artists to assimilate and transform artistic procedures that in Europe had represented a more dramatic rupture with ambient values and spiritual traditions.

The Brazilian modernists made the trope of cannibalism the basis of an insurgent aesthetic, calling for a creative synthesis of European avant-gardism and Brazilian 'cannibalism,' and invoking an 'anthropophagic' devouring of the techniques and information of the super-developed countries in order the better to struggle against domination. Just as the aboriginal Tupinamba Indians devoured their enemies to appropriate their force, the modernists argued, Brazilian artists and intellectuals should digest imported cultural products and exploit them as raw material for a new synthesis, thus turning the imposed culture back, transformed, against the colonizer. The modernists also called for the 'de-Vespucciazation' of the Americas (the reference is to Amerigo Vespucci) and the 'de-Cabralization' of Brazil (referring to Pedro Cabral, Brazil's Portuguese 'discoverer'). The *Revista de Antropofagia* (Cannibalist Review) laments that Brazilians continue to be 'slaves' to a 'rotting European culture' and to a 'colonial mentality.'[27] At the same time, the notion of 'anthropophagy' assumes the inevitability of cultural interchange between 'center' and 'periphery,' and the consequent impossibility of any nostalgic return to an originary purity. Since there can be no unproblematic recovery of national origins undefiled by alien influences, the artist in the dominated culture should not ignore the foreign presence but must swallow it, carnivalize it, recycle it for national ends, always from a position of cultural self-confidence. (Anthropophagy in this sense is just another name for transcultural intertextuality, this time in the context of asymmetrical power relations.)

As exploited by the Brazilian modernists, the cannibalist metaphor had a negative and a positive pole. The negative pole deployed cannibalism to expose the exploitative social Darwinism of class society. But the positive pole was ultimately more suggestive: radicalizing the Enlightenment valorization of indigenous Amerindian freedom, it highlighted aboriginal matriarchy and communalism as a utopian model. De Andrade wanted to liberate culture from religious mortification and capitalist utilitarianism. Synthesizing insights from Montaigne, Nietzsche, Marx, and Freud, along with what he knew of native Brazilian societies, he portrayed indigenous culture as offering a more adequate social model than the European one, a model based on the full enjoyment of leisure. Playing on the Portuguese word 'negocio' – 'business,' but literally 'neg-ocio,' or the negation of leisure, de Andrade offered a proto-Marcusean encomium to 'sacer-docio' or 'sacred leisure.'[28] Here again we find a literalization of the metaphors of the European avant-garde. The Dadaists too had called for 'progressive unemployment' and Breton's surrealist 'rules' had forbidden regular work. Brazilian artist-intellectuals, however, had the advantage of being able to point to existing indigenous societies quite free both from work, in the occidental sense of salaried labor, and from coercive power. And these societies lived not in poverty but in material abundance.

Much later, the modernist movement came to inflect Brazilian cinema through the cultural movement called tropicalism, which emerged in Brazil in the late 1960s.

Indeed, a São Paulo art historian recycles cannibalist tropes to suggest that anthropophagy continues to empower artists: 'Brazilian art of the twentieth century is a totemic banquet in which Father-Europe is being devoured.'[29] Like Brazilian modernism (and unlike European modernism), tropicalism fused political nationalism with aesthetic internationalism. Here we will briefly cite just three of the many films influenced by both modernism and tropicalism. Joaquim Pedro de Andrade's *Macunaíma* (1969), based on Mario de Andrade's modernist classic, turns the theme of cannibalism into a springboard for a critique of repressive military rule and of the predatory capitalist model of the short-lived Brazilian 'economic miracle.' Nelson Pereira dos Santos *How Tasty Was My Frenchman* (1971) subverts the conventional identification with the European protagonists of captivity narratives by maintaining a neutral and ironic attitude toward the titular Frenchman's deglutition by the Tupinambá. Artur Omar's *Triste Tropico* (1974), finally, also draws on the taproot of anthropophagy. Best defined as a fictive anthropological documentary, the film's title, transparently alluding to Lévi-Strauss's ethnographic memoir about Brazil, triggers an evocative chain of cultural associations. While Lévi-Strauss went from Europe to Brazil only to discover the ethnocentric prejudices of Europe, the protagonist of *Triste Tropico* goes to Europe – and here his trajectory parallels that of innumerable Brazilian intellectuals – only to discover Brazil. Thus the film inserts itself into the ongoing discussion of Brazil's problematic cultural relationship to Europe, a discussion undergoing frequent changes of etiquette: 'indianism,' 'nationalism,' 'modernism,' 'tropicalism.'

Triste Tropico's opening shots – traffic in São Paulo, old family album photographs – lead us to expect a fairly conventional documentary. The off-screen narrator, speaking in the stilted delivery to which canonical documentaries have accustomed us, tells us about a certain Arthur Alvaro de Noronha, known as Dr Artur, who returned from studies in Paris to practice medicine in Brazil. Home-movie footage shows a man with his family; we infer that the man is Dr Artur. In Paris, we are told, the doctor became friendly with André Breton, Paul Eluard, and Max Ernst. This is our first clue that a truly surreal biography awaits us. As the film continues, the narration becomes progressively more improbable and hallucinatory. The doctor becomes involved with Indians, compiles an almanac of herbal panaceas, becomes an indigenous Messiah, and finally degenerates into sodomy (an exclamatory intertitle underlines the horror!) and cannibalism, thus recapitulating the trajectory of a certain body of colonialist literature. The descent of the story into this Brazilian *Heart of Darkness* coincides with our own descent into a tangled jungle of cinematic confusion. For the images gradually detach themselves from the narration, becoming less and less illustrative and more and more disjunctively chaotic. We begin to suspect that we have been the dupes of an immense joke, as if Borges had slyly rewritten Conrad and that the illustrious Dr Artur is merely the figment of the imagination of the director, whose name, we may remember, is also Artur.

The central procedure of *Triste Tropico* is to superimpose an impeccably linear (albeit absurd) narration on extremely discontinuous sounds and images. While the off-screen narration is coherent (within the limits of its implausibility), all the other tracks – image, music, noise, titles – form a serial chaos, an organized delirium of wildly heterogeneous materials: amateur movies, European travel footage, shots

of Rio's carnival, staged scenes, archival material, clips from other films, engravings, book covers, almanac illustrations. Within this audio-visual bricolage we encounter certain structured oppositions: some specifically cinematic (black/white versus color; old footage versus new) and some broadly cultural: coast and interior, 'raw' Brazil and 'cooked' Europe; Apollonian order and Dionysian frenzy; *la pensée sauvage* and *la pensée civilisée*, but presented in such a way as to offer what would now be called a postmodern take on structuralism.

The aesthetics of garbage

Another feature of alternative bricolage aesthetics is their common leitmotif of the strategic redemption of the low, the despised, the imperfect, and the 'trashy' as part of a social overturning. This strategic redemption of the marginal also has echoes in the realms of high theory and cultural studies. One thinks, for example, of Derrida's recuperation of the marginalia of the classical philosophical text; of Bakhtin's exaltation of 'redeeming filth' and of low 'carnivalized' genres; of Benjamin's 'trash of history' and his view of the work of art as constituting itself out of apparently insignificant fragments; of Camp's ironic reappropriation of kitsch; of cultural studies' recuperation of subliterary forms and 'subcultural styles'; and of visual culture's democratization of the field of art. In the plastic arts in the US, the 'garbage girls' (Mierle Laderman Ukeles, Christy Rupp, Betty Beaumont) deploy waste disposal as a trampoline for art. Ukeles, for example, choreographed a 'street ballet' of garbage trucks.[30] Joseph Cornell, similarly, turned the flotsam of daily life – broken dolls, paper cutouts, wine glasses, medicine bottles – into luminous, child-like collages. In the cinema, an 'aesthetics of garbage' performs a kind of ju-jitsu by recuperating cinematic waste materials. For filmmakers without great resources, raw-footage minimalism reflects practical necessity as well as artistic strategy. In a film like *Hour of the Furnaces*, unpromising raw footage is transmogrified into art, as the alchemy of sound-image montage transforms the base metals of titles, blank frames, and wild sound into the gold and silver of rhythmic virtuosity. Compilation filmmakers like Bruce Conner, Mark Rappaport, and Sherry Millner/Ernest Larsen rearrange and re-edit pre-existing filmic materials, while trying to fly below the radar of bourgeois legalities. Craig Baldwin, a San Francisco film programmer, reshapes outtakes and public domain materials into witty compilation films. In *Sonic Outlaws*, he and his collaborators argue for a media *détournement* which deploys the charismatic power of dominant media against itself, all the time displaying a royal disregard for the niceties of copyright. Baldwin's anti-Columbus quincentennial film *O No Coronado!* (1992), for example, demystifies the conquistador whose desperate search for the mythical Seven Cities of Cibola led him into a fruitless, murderous journey across what is now the American southwest. To relate this calamitous epic, Baldwin deploys not only his own staged dramatizations but also the detritus of the filmic archive: stock footage, pedagogical films, industrial documentaries, swashbucklers, and tacky historical epics.

In an Afro-diasporic context, the 'redemption of detritus' evokes another, historically fraught strategy, specifically the ways that dispossessed New World blacks have managed to transmogrify waste products into art. The Afro-diaspora,

coming from artistically developed African culture but now of freedom, education, and material possibilities, managed to tease beauty out of the very guts of deprivation, whether through the musical use of discarded oil barrels (the steel drums of Trinidad), the culinary use of throwaway parts of animals (soul food, *feijoada*), or the use in weaving of throwaway fabrics (quilting). This 'negation of the negation' also has to do with a special relationship to official history. As those whose history has been destroyed and misrepresented, as those whose very history has been dispersed and diasporized rather than lovingly memorialized, and as those whose history has often been told, danced, and sung rather than written, oppressed people have been obliged to recreate history out of scraps and remnants and debris. In aesthetic terms, these hand-me-down aesthetics and history-making embody an art of discontinuity – the heterogeneous scraps making up a quilt, for example, incorporate diverse styles, time periods and materials – whence their alignment with artistic modernism as an art of jazzy 'breaking' and discontinuity, and with postmodernism as an art of recycling and pastiche.[31]

Eduardo Coutinho's documentary *O Fio da Memoria* (The Thread of Memory, 1991), reflects on the sequels of slavery in Brazil. Instead of history as a coherent, linear narrative, the film offers a history based on disjunctive scraps and fragments. Here the interwoven strands or fragments taken together become emblematic of the fragmentary interwovenness of black life in Brazil. One strand consists of the diary of Gabriel Joaquim dos Saints, an elderly black man who had constructed his own dream house as a work of art made completely out of garbage and detritus: cracked tiles, broken plates, empty cans. For Gabriel, the city of Rio represents the 'power of wealth,' while his house, constructed from the 'city's leftovers,' represents the 'power of poverty.' Garbage thus becomes an ideal medium for those who themselves have been cast off and broken down; who have been 'down in the dumps'; who feel, as the blues line had it, 'like a tin can on that old dumping ground.' A transformative impulse takes an object considered worthless and turns it into something of value. Here the restoration of the buried worth of a cast-off object analogizes the process of revealing the hidden worth of the despised, devalued artist himself.[32] This recuperation of fragments also has a spiritual dimension in terms of African culture. Throughout West and Central Africa, 'the rubbish heap is a metaphor for the grave, a point of contact with the world of the dead.'[33] The broken vessels displayed on Kongo graves, Robert Farris Thompson informs us, serve as reminders that broken objects become whole again in the other world.[34]

At the same time, we witness an example of a strategy of resourcefulness in a situation of scarcity. The trash of the haves becomes the treasure of the have-nots; the dark and unsanitary is transmogrified into the sublime and the beautiful. What had been an eyesore is transformed into a sight for sore eyes. The burned-out light bulb, wasted icon of modern inventiveness, becomes an emblem of beauty. With great improvisational flair, the poor, tentatively literate Gabriel appropriates the discarded products of industrial society for his own recreational purposes, in procedures that inadvertently evoke those of modernism and the avant-garde: the formalists' 'defamiliarization,' the cubists' 'found objects,' Brecht's 'refunctioning,' the situationists' '*détournement*.'

As a diasporized, heterotropic site, the point of promiscuous mingling of rich and poor, center and periphery, the industrial and the artisanal, the organic and the

inorganic, the national and the international, the local and the global; as a mixed, syncretic, radically decentered social text, garbage provides an ideal postmodern and postcolonial metaphor. As a place of buried memories and traces, meanwhile, garbage exemplifies what David Harvey calls the 'time–space compression' typical of the acceleration produced by contemporary technologies. In Foucault's terms, garbage is 'heterochronic'; it concentrates time in a circumscribed space. (Archeology, it has been suggested, is simply a sophisticated form of garbology.) As time materialized in space, it is coagulated sociality, a gooey distillation of society's contradictions.

As the quintessence of the negative, garbage can also be an object of artistic ju-jitsu and ironic reappropriation. In aesthetic terms, garbage can be seen as an aleatory collage or surrealist enumeration, a case of the definitive by chance, a random pile of *objets trouvés* and *papiers collés*, a place of violent, surprising juxtapositions.[35] Garbage, like death and excrement, is also a great social leveler; the trysting point of the funky and the chi-chi, the terminus for what Mary Douglas calls 'matter out of place.' As the lower stratum of the socius, the symbolic 'bottom' of the body politic, garbage signals the return of the repressed. It is the place where used condoms, bloody tampons, infected needles, and unwanted babies are left: the ultimate resting place of all that society both produces and represses, secretes and makes secret. The final shot of Buñuel's *Los Olvidados*, we may recall, shows the corpse of the film's lumpen protagonist being unceremoniously dumped on a Mexico City garbage pile. Grossly material, garbage is society's id; it steams and smells below the threshold of ideological rationalization and sublimation. At the same time, garbage is reflective of social prestige; wealth and status are correlated with the capacity of a person (or a society) to discard commodities, i.e. to generate garbage. (The average American discards 5 pounds of garbage per day.) Like hybridity, garbage too is power-laden. The power elite can gentrify a slum, make landfill a ground for luxury apartments, or dump toxic wastes in a poor neighborhood.[36] They can even recycle their own fat from rump to cheek in the form of plastic surgery.

It is one of the utopian, recombinant functions of art to work over dystopian, disagreeable, and malodorous materials. Brazil's *udigrudi* (underground) filmmakers of the late 1960s were the first, to our knowledge, to speak of the 'aesthetics of garbage' (*estetica do lixo*). The valorization of 'sleaze, punk, trash, and garbage' that Jameson posits as characteristic of First World postmodernism, was already present in the palpably grubby 'dirty screens' of the Brazilian movement. (This historical priority confirms the Latin American conviction that Latin America, as a marginalized society caught in a peculiar realm of irony imposed by its neocolonial position, was postmodern *avant la lettre*.) The garbage movement's film manifesto, Sganzerla's *Red Light Bandit* (1968), began with a shot of young *favelados* dancing on burning garbage piles. The films were made in the São Paulo neighborhood called '*boca de lixo*' (mouth of garbage) a red-light district named in diacritical contrast with the high-class, red-light district called '*boca de luxo*' (mouth of luxury). For the underground filmmakers, the garbage metaphor captured the sense of marginality, of being condemned to survive within scarcity, of being the dumping ground for transnational capitalism, of being obliged to recycle the materials of the dominant culture.[37] The title of Eduardo Coutinho's (much later) 'garbage' documentary *Boca*

de Lixo (literally 'mouth of garbage', but translated as 'The Scavengers,' 1992) directly links it to the 'aesthetics of garbage,' since its Portuguese title refers to the São Paulo district where the 'garbage' films were produced. The film centers on impoverished Brazilians who survive thanks to a garbage dump outside of Rio, where they toil against the backdrop of the outstretched, ever-merciful arms of the Christ of Corcovado.

Jorge Furtado's *Isle of Flowers* (1989), meanwhile, brings the 'garbage aesthetic' into the postmodern era, while also demonstrating the cinema's capacity as a vehicle for political/aesthetic reflection. Rather than an aestheticization of garbage, here garbage is both theme and formal strategy. Described by its author as a 'letter to a Martian who knows nothing of the earth and its social systems,' Furtado's short uses Monty Python-style animation, archival footage, and parodic/reflexive documentary techniques to indict the distribution of wealth and food around the world. The 'isle of flowers' of the title is a Brazilian garbage dump where famished women and children, in groups of ten, are given five minutes to scrounge for food. But before we get to the garbage dump, we are given the itinerary of a tomato from farm to supermarket to bourgeois kitchen to garbage can to the 'Isle of Flowers.' Furtado's edited collage is structured as a social lexicon or glossary, or better surrealist enumeration of key words such as 'pigs,' 'money,' and 'human beings.' The definitions are interconnected and multi-chronotopic; they lead out into multiple historical frames and historical situations. In order to follow the trajectory of the tomato, we need to know the origin of money: 'Money was created in the seventh century before Christ. Christ was a Jew, and Jews are human beings.' As the audience is still laughing from this abrupt transition, the film cuts directly to the photographic residue of the Holocaust, where Jews, garbage-like, are thrown into death camp piles. (The Nazis, we are reminded, were no strangers to recycling.)

But this summary gives little sense of the experience of the film, of its play with documentary art form and expectations. First, the film's visuals – old TV commercials, newspaper advertisements, healthcare manuals – themselves constitute a kind of throwaway, visual garbage. (In the silent period of cinema, we are reminded, films were seen as transient entertainments rather than artistic durables and therefore as not worth saving; during the First World War they were even recycled for their lead content.) Second, the film mocks the positivist mania for factual detail by offering useless, gratuitous precision: 'We are in Belem Novo, city of Porto Alegre, state of Rio Grande do Sul. More precisely, at 30 degrees, 12 minutes and 30 seconds latitude south, and 51 degrees 11 minutes and 23 seconds longitude west.' Third, the film mocks the protocols of rationalist science, through absurd classificatory schemes ('Dona Anete is a Roman Catholic female biped mammal') and tautological syllogisms ('Mr' Suzuzki is Japanese, and therefore a human being'). Fourth, the film parodies the conventions of the educational film, with its authoritative voice-over and quiz-like questions ('What is a history quiz?'). Humor becomes a kind of trap; the spectator who begins by laughing ends up, if not crying, at least reflecting very seriously. Opposable thumbs and highly developed telencephalon, we are told, have given 'human beings the possibility of making many improvements in their planet', a shot of a nuclear explosion serves as illustration. Thanks to the universality of money, we are told, we are now 'Free!' – a snippet of the

'Hallelujah Chorus' celebrates the thought. Furtado invokes the old carnival motif of pigs and sausage, but with a political twist; here the pigs, given equitable distribution down the food chain, eat better than people.[38] The tomato links the urban bourgeois family to the rural poor via the sausage and the tomato within a web of global relationality. In this culinary recycling, we are given a social examination of garbage; the truth of a society is in its detritus. The socially peripheral points to the symbolically central.

In all these films, the garbage dump becomes a critical vantage point from which to view society as a whole. The garbage dump shows the endpoint of an all-permeating logic of commodification, logical telos of the consumer society, and its ethos of planned obsolescence. Garbage becomes the morning after of the romance of the new. In the dump's squalid phantasmagoria, the same commodities that had been fetishized by advertising, dynamized by montage, and haloed through backlighting, are now stripped of their aura of charismatic power. We are confronted with the seamy underside of globalization and its facile discourse of one world under a consumerist groove. Garbage reveals the social formation as seen 'from below.' As the overdetermined depot of social meanings, garbage is the place where hybrid, multi-chronotopic relations are reinvoiced and reinscribed. Polysemic and multivocal, garbage is seen literally (garbage as a source of food for poor people, garbage as the site of ecological disaster), but it is also read symptomatically, as a metaphorical figure for social indictment (poor people treated like garbage; garbage as the 'dumping' of pharmaceutical products or of 'canned' TV programs; slums (and jails) as human garbage dumps). These films reveal the 'hidden transcripts' of garbage, reading it as an allegorical text to be deciphered, a form of social colonics where the truth of a society can be 'read' in its waste products.

Towards a polycentric visual culture

The visual, in our view, never comes 'pure,' it is always 'contaminated' by the work of other senses (hearing, touch, smell), touched by other texts and discourses, and imbricated in a whole series of apparatuses – the museum, the academy, the art world, the publishing industry, even the nation state – which govern the production, dissemination, and legitimation of artistic productions. It is not now a question of replacing the blindnesses of the 'linguistic turn' with the 'new' blindnesses of the 'visual turn.' To hypostasize the visual risks of reinstalling the hegemony of the 'noble' sense of sight (etymologically linked to wisdom in many languages) over hearing and the more 'vulgar' senses of smell and taste. The visual, we would argue, is 'languaged,' just as language itself has a visual dimension. Methodological grids, or 'new objects of knowledge,' furthermore, do not supersede one another in a neat, clear-cut progression. They do not become extinct within a Darwinian competition. They do not die; they transform themselves, leaving traces and reminiscences. The visual is also an integral part of a culture and of history, not in the sense of a static backdrop (rather like second unit background footage in a Hollywood matte shot), but rather as a complexly activating principle. The visual is simply one point of entry, and a very strategic one at this historical moment, into a multidimensional world of intertextual dialogism.

We have called here for a polycentric, dialogical, and relational analysis of visual cultures existing in relation to one another. We have tried to project one set of histories across another set of histories, in such a way as to make diverse cultural experiences concurrent and relatable within a logic of co-implication. Within a poly-centric approach, the world of visual culture has many dynamic locations, many possible vantage points. The emphasis in 'polycentrism' is not on spatial or primary points of origins or on a finite list of centers but rather on a systematic principle of differentiation, relationality, and linkage. No single community or part of the world, whatever its economic or political power, should be epistemologically privileged.

We do not see polycentrism as a matter of first defining modernism as a set of attributes or procedures, and then 'finding' these attributes in the cultural produc-tions from other locations. It is not a matter of 'extending the corpus' or 'opening up the canon' in an additive approach, but rather of rethinking the global relation-alities of artistic production and reception. For us, art is born *between* individuals and communities and cultures in the process of dialogic interaction. Creation takes place not within the suffocating confines of Cartesian egos or even between discrete bounded cultures but rather between permeable, changing communities. Nor is it a question of a mindless 'anthropological' leveling which denies all criteria of aesthetic evaluation but rather of historically grounded analyses of multicultural rela-tionality, where one history is read contrapuntally across another in a gesture of mutual 'haunting' and reciprocal relativization.

Our larger concern has been not to establish priority – who did what first – but rather to analyze what mobilizes change and innovation in art. It has become a commonplace to speak of the exhaustion (and sometimes of the co-optation) of the avant-garde in a world where all the great works have already been made. But in our view aesthetic innovation arises, not exclusively but importantly, from multi-cultural knowledges. It emerges from the encounter of a Picasso with African sculpture for example; from the comings and goings between Europe and Latin America of an Alejo Carpentier; from the encounter of a Rushdie with the West; from the encounter of a Mario de Andrade simultaneously with surrealism, on the one hand, and Amazonian legend on the other. Innovation occurs on the borders of cultures, communities, and disciplines. 'Newness enters the world,' according to Salman Rushdie, through 'hybridity, impurity, intermingling, the transformation that comes of new and unexpected combinations of human beings, ideas, politics, movies, songs [from] . . . Melange, hotchpotch, a bit of this and a bit of that.'[39]

Central to a truly polycentric vision is the notion of the mutual and reciprocal relativization, the 'reversibility of perspectives' (Merleau-Ponty); the idea that the diverse cultures should come to perceive the limitations of their own social and cultural perspective. Each group offers its own exotopy (Bakhtin), its own 'excess seeing,' hopefully coming not only to 'see' other groups, but also, through a salutary estrangement, to see how it is itself seen. The point is not to embrace completely the other perspective but at least to recognize it, acknowledge it, take it into account, be ready to be transformed by it. By counterpointing embodied cultural perspectives, we cut across the monocular and monocultural field of what Donna Haraway has characterized as 'the standpoint of the master, the Man, the One God, whose Eye produces, appropriates and orders all difference.'[40] At the same time, historical configurations of power and knowledge generate a clear asymmetry within

this relativization. The culturally empowered are not accustomed to being rela-
tivized; the world's institutions and representations are tailored to the measure of
their narcissism. Thus a sudden relativization by a less flattering perspective is expe-
rienced as a shock, an outrage, giving rise to a hysterical discourse of besieged
standards and desecrated icons. A polycentric approach, in our view, is a long-
overdue gesture toward historical equity and lucidity, a way of re-envisioning the
global politics of visual culture.

Notes

1 We do not equate 'European' with 'Eurocentric,' any more than feminism equates
 'masculine' with 'phallocentric.' The term 'Eurocentric' does not have to do with
 origins but with epistemologies. See Robert Stam and Ella Shohat, *Unthinking
 Eurocentrism: Multiculturalism and the Media*, London: Routledge, 1994.
2 See Carl Pletsch, 'The Three Worlds, or the Division of Social Scientific Labor,
 circa 1950–1970,' *Comparative Studies in Society and History*, vol. XXIII, no. 4
 (1981), pp. 565–90.
3 Fredric Jameson, *The Geopolitical Aesthetic: Cinema and Space in the World System*,
 Bloomington and London: Indiana University Press and British Film Institute,
 1992, p. 1.
4 Jan Pietersie, 'Unpacking the West: How European is Europe?' Unpublished
 paper given to us by the author.
5 See Roy Armes, *Third World Filmmaking and the West*, Berkeley: University of
 California Press, 1987.
6 We have in mind both the 'Third World allegory' essay and *The Geopolitical
 Aesthetic*.
7 See Brotherston, *Book of the Fourth World*, p. 48.
8 See Karin Barber, 'Yoruba Oriki and Deconstructive Criticism,' *Research in African
 Literature*, vol. 15, no. 4 (Winter 1984).
9 Quoted in Armes, op. cit., p. 135.
10 See Robert Farris Thompson, *African Art in Motion: Icon and Act*, Berkeley:
 University of California Press, 1973.
11 Ola Balogun, 'Traditional Arts and Cultural Development in Africa,' *Cultures*, no.
 2, 1975, p. 159.
12 See Arturo Lindsay, *Santería Aesthetics in Contemporary Latin American Art*, Washing-
 ton and London: Smithsonian, 1996, Preface, p. xx. For more on representations
 of Afro-Brazilian religions in Brazilian art, see Robert Stam, *Tropical Multi-
 culturalism: A Comparative History of Race in Brazilian Cinema and Culture*, Durham:
 Duke University Press, 1997.
13 For more on carnival, see Mikhail Bakhtin, *Rabelais and His World*, trans. Helene
 Iswolsky, Cambridge, Mass.: MIT Press, 1968. See Robert Stam, *Subversive
 Pleasures: Bakhtin, Cultural Criticism, and Film*, Baltimore: Johns Hopkins University
 Press, 1989.
14 Lucy Lippard, *Mixed Blessings: New Art in a Multicultural Age*, New York: Pantheon,
 1990, p. 201.
15 Ibid., p. 202.
16 See Alejo Carpentier, 'De lo Real Maravilloso Americano,' *Cine Cubano*,
 no. 102, (1982), pp. 12–14.

17 Mikhail Bakhtin, *Problems of Dostoevsky's Poetics*, trans. Caryl Emerson, Minneapolis: University of Minnesota Press, 1984, p. 166.

18 See Nicholas Mirzoeff, *Bodyscape: Art, Modernity, and the Ideal Figure*, London: Routledge, 1995.

19 Bakhtin, *Rabelais*, p. 32.

20 See Robert Stam, *Subversive Pleasures: Bakhtin, Cultural Criticism and Film*, Baltimore: Johns Hopkins University Press, 1989.

21 See Joao Luiz Vieira, *Hegemony and Resistance: Parody and Carnival in Brazilian Cinema*, PhD dissertation, New York University, 1984. See also Joao Luiz Vieira and Robert Stam, 'Parody and Marginality,' in Manuel Alvarado and John O. Thompson (eds) *The Media Reader*, London: British Film Institute, 1989.

22 Arthur Jaffa, in Gina Dent (ed.) *Black Popular Culture*, p. 266.

23 Ibid., pp. 249–54.

24 For an English version of the 'Cannibalist Manifesto,' see Leslie Bary's excellent introduction to and translation of the poem in *Latin American Literary Review*, vol. XIX, no. 38 (July–December 1991).

25 Augusto de Campos, *Poesia, Antipoesia, Antropofagia*, São Paulo: Cortez e Moraes, 1978, p. 121.

26 See Maria Eugenia Boaventura, *A Vanguarda Antropofagica*, São Paulo: Attica, 1985, p. 114.

27 For more on modernist 'anthropophagy,' see Robert Stam, 'Of Cannibals and Carnivals,' in R. Stam, *Subversive Pleasures*, op. cit.

28 See Pierre Clastres, *Society Against the State*, New York: Zone Books, 1987.

29 See Paulo Herkenhoff, 'Having Europe for Lunch: A Recipe for Brazilian Art,' *Polyester*, vol. II, no. 8 (Spring) 1984.

30 See Lucy Lippard, 'The Garbage Girls,' in *The Pink Glass Swan: Selected Feminist Essays on Art*, New York: The New Press, 1995.

31 The African-American environmental artist known as 'Mr Imagination' has created 'bottle-cap thrones, paintbrush people, cast-off totems, and other pieces salvaged from his life as a performing street artist.' See Charlene Cerny and Suzanne Seriff (eds) *Recycled Reseen: Folk Art from the Global Scrap Heap*, New York: Harry N. Abrams, 1996.

32 My formulation obviously both echoes and Africanizes the language of Fredric Jameson's well-known essay 'Third World Literature in the Era of Multinational Capitalism,' *Social Text*, no. 15 (Fall) 1986.

33 See Wyatt MacGaffey, 'The Black Loincloth and the Son of Nzambi Mpungu,' in *Forms of Folklore in Africa: Narrative, Poetic, Gnomic, Dramatic*, Austin: University of Texas Press, 1977, p. 78.

34 See Robert Farris Thompson and Joseph Cornet, *The Four Moments of the Sun: Kongo Art in Two Worlds*, Washington: National Gallery, 1981, p. 179.

35 For a survey of recycled art from around the world, see Charlene Cerny and Suzanne Seriff, *Recycled, Reseen: Folk Art from the Global Scrap Heap*, New York: Abrams, 1996.

36 For more on the discourse of garbage, see Michael Thompson, *Rubbish Theory: The Creation and Destruction of Value*, Oxford: Oxford University Press, 1979; Judd H. Alexander, *In Defense of Garbage*, Westport, Conn.: Praeger, 1993; William Rathje and Cullen Murphy, *Rubbish! The Archeology of Garbage*, New York: Harper Collins, 1992; and Katie Kelly, *Garbage: The History and Future of Garbage in America*, New York: Saturday Review Press, 1973.

37 Ismail Xavier, *Allegories of Underdevelopment: From the 'Aesthetics of Hunger' to the 'Aesthetics of Garbage'*, PhD dissertation, New York University, 1982.

38 The pig, as Peter Stallybrass and Allon White point out, was despised for its specific habits: 'its ability to digest its own and human faeces as well as other "garbage", its resistance to full domestication; its need to protect its tender skin from sunburn by wallowing in the mud.' See *The Politics and Poetics of Transgression*, Ithaca: Cornell University Press, 1986.

39 See Salman Rushdie, 'In Good Faith: A Pen against the Sword,' *Newsweek*, 12 Feb. 1990, p. 52. Interestingly, Europe itself has begun to recognize the artistic value of these hybrid cultures. It is no accident, in this sense, that Nobel Prizes in literature are now going to postcolonial and minority writers, or that the most recent Cannes Film Festival accorded special honors to the Egyptian Chahine and the Iranian Kiorostami.

40 See Donna Haraway, 'Situated Knowledges: The Science Question in Feminism and the Privilege of Partial Perspective,' in Andrew Feenberg and Alastair Hannay (eds), *Technology and the Politics of Knowledge*, Bloomington: Indiana University Press, 1995, p. 184.

Jonathan L. Beller

KINO-I, KINO-WORLD
Notes on the cinematic mode of production

But all the story of the night told over,
And their minds transfigured so together,
More witnesseth than fancies images,
And grows to something of great constancy;
But, howsoever, strange and admirable.
A Midsummer Night's Dream (the movie)

The cinematic mode of production

THE TERM 'CINEMATIC MODE of production' (CMP) suggests that cinema and its succeeding, if still simultaneous, formations, particularly television, video, computers and internet, are deterritorialized factories in which spectators work, that is, in which they perform value-productive labor. In the cinematic image and its legacy, that gossamer imaginary arising out of a matrix of socio-psycho-material relations, we make our lives. This claim suggests that not only do we confront the image at the scene of the screen, but we confront the logistics of the image wherever we turn – imaginal functions are today imbricated in perception itself. Not only do the denizens of capital labor to maintain themselves as image, we labor in the image. The image, which pervades all appearing, is the *mise-en-scène* of the new work.

What is immediately suggested by the CMP, properly understood, is that a social relation which emerged as 'the cinema' is today characteristic of sociality generally. As Pierre Boulez says, 'Art transforms the improbable into the inevitable.'[1] Although it first appeared in the late nineteenth century as the built-in response to a technological oddity, cinematic spectatorship (emerging in conjunction with the clumsily cobbled together image-production mechanisms necessary to that situation)

surreptitiously became the formal paradigm and structural template for social, that is, becoming-global, organization generally. By some technological sleight of hand, machine-mediated perception is now inextricable from your psychological, economic, visceral and ideological dispensations. Spectatorship, as the fusion and development of the cultural, industrial, economic and psychological, quickly gained a handhold on human fate and then became decisive. Now, visuality reigns and social theory needs to become film theory.

At the moment, in principle, that is, in accord with the principles of late capitalism, to look is to labor. The cinematicization of the visual, the fusion of the visual with a set of socio-technical institutions and apparatuses, gives rise to the advanced forms of networked expropriation characteristic of the present period. Capitalized machinic interfaces prey on visuality. Recently, corporations such as FreePC, which during the NASDAQ glory days gave out 'free' computers in exchange for recipients' agreement to supply extensive personal information and to spend a certain amount of time online, strove to demonstrate in practice that looking at a screen can produce value. Almost a decade ago, I argued that the historical moment had arrived which allowed us to grasp that looking is posited by capital as labor. If, in the early 1990s, the idea was difficult for academics to fathom, corporations have been faster on the uptake. What I call 'the attention theory of value' finds in the notion of 'labor,' elaborated in Marx's labor theory of value, the prototype of the source of all value production under capitalism today: value-producing human attention. Attention, in all forms imaginable and yet to be imagined (from assembly-line work to spectatorship to internet-working and beyond), is that necessary cybernetic relation to the *socius* for the production of all value for late capital. At once the means and archetype for the transfer of attentional biopower (its conversion into value and surplus value) to capital, what is meant today by 'the image' is a cryptic synonym for these relations of production. The history of the cinema, its development from an industrial to an electronic form, is the open book in which the history of the image as the emergent technology for the leveraged interface of bio-power and the social mechanism may be read.

The world-historical restructuring of the image as the paradigmatic social relation is currently being acted upon in practice by large corporations. However seductive the appearance and however devastating the consequences of the capitalization and expropriation of the image relation (of the imaginary) may be for the vast majority on the planet, this exploitation is in keeping with the developmental logic of capital and must therefore be understood as business as usual. For the new thing that is the image and its attendant attentional productivity sustains the perpetuation of extant waged, gendered, nationalized and enslaved labor. That extraordinary innovation goes hand in glove, or better, tongue in cheek, with the intensification of world oppression may conveniently be understood in Guiseppe Lampedusa's assessment of the dialectics of domination, 'Things must change in order to stay the same.' The image structures the visible and the invisible, absorbs freeing power and sucks up solidarity time. The mode of domination shifts in order to maintain hierarchical society. As spectators begin to value their attention (their attending), corporations struggle to get more of what they previously got for nothing. Last year, for example, in the *San Jose Mercury News* Mypoints.com advertised with the copy 'We'll pay you to read this ad.' At the same moment another

website banner displayed disembodied roving eyes with the caption 'We'll pay you for your attention.' It should come as no surprise that 'bellwether' internet company Yahoo, which has always considered itself a media company, recently hired Terry Semel, former chief of Warner Brothers studio, to head its operations.

The failure of some of these dotcom corporations should not lead us to believe that this new era of corporate designs on our attention was a temporary speculative error. As Jeff Bezos, founder of Amazon.com, is (understandably) fond of pointing out, 'just because 2,700 automobile manufacturers folded in the early twentieth century doesn't mean that the car was a bad idea [sic]' (it was). Besides, in hindsight, mass-media corporations have long given out 'free' content over the airways in exchange for viewer attention that would then be marketed to advertisers. Remember television? Additionally, as Ben Anderson has forcefully suggested with respect to print media, even those contents for which we paid a delivery surcharge in coin had a productive effect, and therefore something like a production agenda, far in excess of the single instance of consumption. Imagine, communities, nay, nations, being produced by simply reading the newspapers! Rey Chow's brilliant critique of Anderson in *Primitive Passions*, in which Lu Xun's traumatic encounter with the cinematic image marks the founding moment of Chinese literary modernism, places visuality at the center of emergent nationalism, and suggests that modern literature is a consequence of the blow dealt to language by the technological onslaught of images.[2] Thus the entire history of modernity stands ready for a thorough reconceptualization as film practice. Stated differently, because of the transformation of sociality by and as visuality, film theory is today confronted with the task of writing a political economy of culture as mode of production.

Nowadays, as it enlists viewers to build the pathways for its infrastructure, both as fixed capital and in themselves, Corporate America consciously recognizes that ramifying the sensual pathways to the body can produce value, even if the mechanisms of value production have not been fully theorized. Sensuo-perceptual contact between body and social mechanism, what Sean Cubitt refers to as 'cybertime,' provides opportunities for value-extraction for capital. That gap between the practice of stealing human attention and a radical theory of this practice exists in part because there is no money in theorizing the mechanisms of value production as a dialectical relation, just as for Marx there was money neither in the labor theory of value nor in Marxism. Put another way, the generalized blindness with respect to the economicization of the senses is constitutive of hegemony. This leveraged theft of sensual labor is the postmodern version of capital's dirty secret; the spectator is the Lukacsian subject-object of history.

The history of advertising, with its utilization of psychoanalysis and statistics to sell product, elucidates the uses capital makes of cultural theory. At the level of engagement with the body (as desiring subject, as unit of the mass market) there are plenty of theories, but at the level of profit-taking, pragmatics provides the bottom line. Advertising power-houses use psychoanalytic techniques under the rubric of 'theater of the mind,' and only the marginalized think to argue with success. Thus the logistics of social production in general, and the conceptualizations thereof, remain difficult to grasp, profitably buried as they are under the surface of simulation. Probably the most eloquent and realistic image of the current situation of social production via the image as the pre-eminent social relation publicly available is to

be found in the late-capitalist social realist film, *The Matrix* (1999). That film depicts a situation in which the computerized (incorporated) control of the sensual pathways to our body have reduced us, from the point of view of the system, to sheer biopower, the dry-cells enlisted by the omnipresent spectacle to fuel an anti-human artificial intelligence. Whatever life-energy we put into the world is converted into the energy to run the image-world and its illusory logic while we remain unknowingly imprisoned in a malevolent bathosphere, intuiting our situation only through glitches in the program. Our desires for deviance, our bouts with psychopathology, even our fantasies of wealth and power represent such glitches, but as is well known to advertisers, media moguls and cold war policymakers alike, these mini-revolutions can also readily be made to turn a profit for Big Capital.

Such a relation of the senses and particularly of the visual to production did not emerge overnight, and providing a theoretical and historical account is one principal purpose of my theory of cinema. Looking has long been posited as labor by capital, in the present moment it is being presupposed as such. The lagging of a critical theory of the mode of exploitation behind the practice of exploitation is no longer tenable, if it ever was. Overcoming this epistemic lag-time is another aim here, one bound up in the revolutionary potential contained in understanding how the world goes on as it does and in whose interests. The transformative saturation of the visual realm, which gives rise to the terms 'virtual reality,' but also 'visuality,' was itself produced. The transformation of the visual from a zone of unalienated creative practice to one of alienated labor is the result of capital accumulation, i.e., the historical agglomeration of exploited labor. By the 'alienation of vision' I do not mean that there have not existed prior scopic regimes which structured sight, rather I have in mind the Marxist notions of separation and expropriation endemic to commodification. This estrangement of the visual, its new qualities of 'not belonging to me' characteristic of the cinema and its dissociation from 'natural language,' are simultaneous with the semi-autonomization of the visual – what we call 'visuality.' Furthermore, the maintenance and intensification of the transformed situation of 'visuality' remain essential to capital's expansion and valorization. But despite the world-historical truth of this claim it remains difficult to write sentences written in the key of Marx: 'Communism is the riddle of history solved and knows itself to be this solution.' The streamlined, scaled-back, post-modernized equivalent reads, 'The attention theory of value is the riddle of post-global capitalism properly posed, and has a germinal contribution to make to counter-hegemonic struggle.' At the most basic level, grasping mediation as the extraction of productive labor (value) from the body radically alters the question of visual pleasure by contaminating it with the question of murder.

Materially speaking industrialization enters the visual as follows. Early cinematic montage extended the logic of the assembly-line (the sequencing of discreet, programmatic machine-orchestrated human operations) to the sensorium and brought the industrial revolution to the eye. Cinema welds human sensual activity, what Marx called 'sensual labor,' in the context of commodity production, to celluloid. Instead of striking a blow to sheet metal wrapped around a mold or tightening a bolt, we sutured one image to the next (and, like workers who disappeared in the commodities they produced, we sutured ourselves into the image). We manufactured the new commodities by intensifying an aspect of the old ones,

their image-component. Cinema was to a large extent the hyper-development of commodity fetishism, that is, of the peeled-away, semi-autonomous, psychically charged image from the materiality of the commodity. The fetish character of the commodity drew its energy from the enthalpy of repression – the famous non-appearing of the larger totality of social relations. With important modifications, the situation of workers on a factory assembly line foreshadows the situation of spectators in the cinema. 'The cut,' already implicit in the piecemeal production assembly-line work, became a technique for the organization and production of the fetish character of the commodity and then part of a qualitatively new production regime long misnamed consumerism. Consumers produced their fetishes in the deterritorialized factory of the cinema. As in the factory, in the movie theater we make and remake the world and ourselves along with it.

Of course the interiorization of the dynamics of the mode of production is a lot more complex than the sketch above might allow. Cinema took the formal prop-erties of the assembly line and introjected them as consciousness. This introjection inaugurated huge shifts in language function. Additionally, the shift in industrial rela-tions that is cinema indicates a general shift in the organization of political economy, and this change does not occur because of a single technology. The development of cinema marks deep structural shifts and accommodations in a complex and varie-gated world. Certainly, the world-historical role for cinema demands a total reconceptualization of the imaginary. The imaginary, both as the faculty of imagi-nation and in Althusser's sense of it as ideology, the constitutive mediation between the subject and the real, must be grasped as a work in progress, provided, of course, that one sees the development of capitalism as progress. Numerous works on the mediatic organization of the Western imaginary exist and the scale of its restruc-turing by technology is being more and more clearly grasped. Heidegger's works on technology and the world picture could be read this way as could the work of someone like Baudrillard.

In *The Imaginary Signifier: Psychoanalysis and the Cinema*,[3] Christian Metz speaks of the three machines of cinema – the outer machine (the cinema industry), the inner machine (the spectator's psychology) and the third machine (the cinematic writer) – and proposes that 'the institution [the coordination of the three machines] has filmic pleasure alone as its aim' (7). Metz argues that 'cinema is a technique of the imaginary' (3) and indeed modifies spectators through a system of 'financial feed-back' (91). These claims are appropriate to the moment of psychoanalytic theories of the cinema in which the cinema is believed to engage the dynamics of an existing psyche. However, the scope of today's (counter)revolution – a revolution which at first glance might appear merely as a technological shift – emerges from a reversal of these very terms: *the imaginary is a technique of cinema*, or rather, of mediation gen-erally. Such a reversal de-ontologizes the unconscious and further suggests that the unconscious is cinema's product: its functions, which is to say, its existence as such, emerge out of a dynamic relation to technology/capital (technology being under-stood here as sedimented, alienated species being). Thus Metz's sense of what the spectator does in the cinema, 'I watch, and I help' (93), can be grasped as an intu-ition about the labor required for the modification of a cybernetic body organized through financial feedback. This labor is human attention building a new form of sociality: hardware, software and wetware. At nearly the same moment of the

Metzian shift, albeit with different purposes in mind than my own, Jean-Louis Commoli, in his canonical essay 'Machines of the visible,' comes out and in an echo of the Althusserian theory of the subject, says explicitly that 'the spectator . . . works.'[4] However, the participatory and even contestatory roles of spectators in the 1970s and 1980s were understood as an artifact of the technology, a necessary mode of engagement with a commercially available pleasure rather than a structural shift in the organizational protocols of globalizing capital.

More recently, Regis Debray, in *Media Manifestos* gives an account of the fundamental shifts in the social logic of mediation wrought by the emergence of the current 'mediasphere,' what he calls 'the videosphere.'[5] The videosphere, which Debray dates from the mid-nineteenth century, succeeds the logosphere and the graphosphere. For Debray:

> The sphere extends the visible system of mediation to the invisible macrosystem that gives it meaning. We see the microwave oven but not the immense grid of electric power that it is plugged into. We see the automobile but not the highway system, gasoline storage facilities, refineries, petroleum tankers, no more than we see the factories and research installations upstream and all the maintenance and safety equipment downstream. The wide-bodied jet hides from view the planetary spider's web of the international civil aviation organization, of which it is but one strictly teleglided element. To speak of the videosphere is to be reminded that the screen of the television receiving signals is the head of a pin buried in one home out of millions, or a homing device, part of a huge organization without real organizers – of a character at once social, economic, technological, scientific, political – much more in any event than a network of corporate controlled production and programming of electronic images.
>
> (*MM*, 33)

Debray, for whom ' "ideology" could be defined as the play of ideas in the silence of technologies' (*MM*, 31), invokes the term ' "medium" in the strong sense [of] *apparatus-support-procedure*' (*MM*, 13, italics in original) to foreground the technological basis of mediation and to denature consciousness. Thus for Debray, 'our study borders more directly on a sociology of artistic perception' (*MM*, 136). He writes, 'Our history of visual efficacies needs to be written in two columns: the one that takes account of the material equipment or "tool kit" enabling the fabrication, display, and distribution of objects of sight, and the other which chronicles the belief systems in which they were inscribed' (*MM*, 136). 'The mediological approach . . . would consist in *multiplying the bridges that can be thrown up between the aesthetic and technological*' (*MM*, 137). *Media Manifestos* makes explicit that what has been at stake in mediation has been the mode of inscription and the functionality of signs – their organizing force. Although Debray is committed to thinking ' "the becoming-material" forces of symbolic forms' (*MM*, 8) and retains a sense of the violence inherent in mediation ('transmission's rhyme with submission,' *MM*, 46), and is further aware that technology is the repressed of the history of consciousness, he is no longer interested in production *per se*. This weakness, consistent with

his devolving relation to Marxism, renders the passages on ethics in this work lame, and very nearly posits technology as fully autonomous ('A good politics can no more prevent a mass medium from functioning according to its own economy than it can prevent a severe drought,' *MM*, 124). Without the standpoint of production, in which mass media and even droughts are seen as the product of human activity, the new order of consciousness, even when understood as such, cannot be adequately challenged.

My own work, noted below, specifically addresses the cinematic image as machinic interface with the *socius* emerging as a response to the crisis for capital known as 'the falling rate of profit.' I continue to see the commodity form, the money system, and capital's violent hierarchical domination as the limit questions faced by our species. The crisis that is the falling rate of profit, in my view, results in the century-long fusing of culture and industry, deepening, to borrow Stephen Heath's words, the relation of 'the technical and the social *as cinema*.'[6] Cinema, becomes a means to extend the range and effect of capitalized machinery. The cinematic mode of production becomes the necessary means of extending the work day while reducing real wages. 'Elevating' commodity production to the visual realm, cinema extracts human labor and pays in fun (enjoy[n]ment). Cultural pathways, including those mapped under the categories of race, gender, sexuality, and nation, are thus being subsumed as media of capitalist domination – zones of oppression which capital exploits for its own purposes. Thus in an act mimetic of the relation between cinema and culture, where cinema subsumes culture and renders it productive for capitalism, the concept of the CMP would organize the major theoretical contributions of the works cited above, as well as many others here overlooked, under its own rubric.[7] In what follows I highlight some of cinema's horizons of transformation, while suggesting that 'theory' as the critical thought which follows on the heels of philosophy's demise was film theory all along.

So not just psychoanalytic film theory but psychoanalysis as proto-film theory

The CMP would argue that cinema was, in the twentieth century, the emerging paradigm for the total reorganization of society and (therefore) of the subject. From a systemic point of view, cinema arises out of a need for the intensification of the extraction of value from human bodies beyond normal physical and spatial limits and beyond normal working hours – it is an innovation that will combat the generalized falling rate of profit. Understood as a precursor to television, computing, email and the world wide web, cinema can be seen as part of an emerging cybernetic complex, which, from the standpoint of an emergent global labor force, functions as a technology for the capture and redirection of global labor's revolutionary social agency and potentiality.

Utilizing vision and, later, sound, industrial capital develops a new, visceral and complex machinery capable of interfacing with bodies and establishing an altogether (counter)revolutionary cybernesis. This increasing incorporation of bodies by capital co-opts the ever-increasing abilities of the masses to organize themselves. As a deterritorialized factory running on a new order (the superset) of socially productive

labor – attention – cinema as a sociological complex inaugurates a new order of production along with new terms of social organization, and thus of domination. 'Cinema' is a new social logic, the film theater the tip of the iceberg, the 'head of the pin.' The mystery that is the image announces a new symptom for analysis by contemporary political economy. Production enters the visual and the virtual enters reality. Labor as dissymmetrical exchange with capital is transacted across the image.

Under the rubric of the CMP, 'cinema' refers not only to what one sees on the screen or even to the institutions and apparatuses which generate film but to that totality of relations which generates the myriad appearances of the world on the 6 billion screens of 'consciousness.' Cinema means the production of instrumental images through the organization of animated materials. These materials include everything from actors, to landscapes, to populations, to widgets, to fighter-planes, to electrons. Cinema is a material practice of global scope, the movement of capital in, through and as image. 'Cinema' marks the changeover to a mode of production in which images, working in concert, form the organizational principles for the production of reality. The whole regime of classical value production extends itself into the visual. The new orders of interactivity (ATM, internet, cell, GPS) testify to the deep entrenchment and central role of the capitalization of images in the organization of society. As Warren Sack muses, 'Children born now will wonder how previous generations just sat in front of the screen without anything to do.' And yet something was being done. What is so far not at all clearly grasped with respect to the central role of image technologies in social organization, and may be first recognized in its mature form in the cinema, is *media's capitalization* of the aesthetic faculties and imaginary practices of viewers. Below I will indicate the co-extensive world-historical determinants for the simultaneous socio-technological articulation of consciousness and cinema, and further suggest that not only are consciousness and cinema mutually determined by the constraints of capitalist production but that they increasingly function on a continuum.[8]

For a first-order approximation of the cinematization of social relations one might turn to the cinematic dynamics of social production implicit in (posited by) the shifting terms of the interpellation of subjects by an increasing number of institutions and apparatuses (the state, multinational corporations, politicians, 'the media,' boards, offices, etc.) variously invested in the expansion of capital. Take, for example, the observation common during the last couple of decades that everyone is concerned with their 'image.' The term is no mere figure of speech, but rather a 'condensation,' in Freud's sense, a matrix of partially unconscious forces that means something else. What is meant by this condensed metaphor, produced and utilized by contemporary consciousness neurotically and now psychotically pursuing the conditions for its own perpetuation, can only be fully elaborated if we take consciousness itself as the desperate measure to account for the dreams dreamt by, in, through, and as the contemporary world system. In doing so, I am in no way endeavoring to delimit the variations of consciousness which are possible from the outset, nor to patronize what can be thought and felt. Rather, in the context of the production and reproduction of society under capitalist domination, I am trying to register the shifting terms of language-function and subject formation in the emerging media-environment. Tracing the increasing marginalization of language by images in 'Language, images and the postmodern predicament,' Wlad

Godzich puts it thus: 'Where with language we have a discourse on the world, with human beings facing the world in order to name it, photography substitutes the simple appearance of things; it is a discourse of the world. . . . Images now allow for the paradox that the world states itself before human language.'[9] To register the crisis that the proliferation of images poses for language and thus for the conscious mind would be to agree with Godzich that today language is outpaced by images. 'Images are scrambling the function of language which must operate out of the imaginary to function optimally.'[10] The overall effect is the radical alienation of consciousness, its isolation and separation, its inability convincingly to language reality and thus its reduction to something on the order of a free-floating hallucination, cut away as it is from all ground.

This demotion of language and of its capacity to slow down the movement of reality suggests, when linked to the rise of image technologies, that the radical alienation of language, that is, the alienation of the subject and its principal means of self-expression and self-understanding, is a structural effect of the intensification of capitalism and, therefore, an instrumental strategy of domination. Bodies become deprived of the *power* of speech. This image-consciousness or, better, image/consciousness participates in the rendering of an intensified auratic component, theorized as 'simulation' or 'the simulacrum,' to nearly every aspect of social existence in the technologically permeated world. Beyond all reckoning, the objective world is newly regnant with an excess of sign value or, rather, with values exceeding the capacities of the sign. Such a promiscuity of signification, what Baudrillard called 'the ecstasy of communication,' implies, in short, the radical instability and unanchoredness and inconsistency of consciousness such that consciousness becomes unconsciousness by other means. Although the critique of metaphysics, under the sign of 'deconstruction,' imputes a certain transhistoricity to these excesses of the sign, and generates its *jouissance* through the truth effect produced by its analytical erasure of the metaphysical securities of ground and presence, we must now recognize deconstruction as an historical phenomenon of the 1970s and 1980s and pose the question of the very historicity of its critique. In light of the CMP, deconstruction appears not as an advance in intellectual history which reveals the misapprehended truth (under erasure) of all previous eras, but as a philosophico-linguistic turn brought about in relation to a socio-technological transformation in political economy. The CMP's account of the crisis of metaphysics might assert that all that is solid melts into cinema. It is the visual economy and the transformation of labor that liquidates being. The withering away of the state of being under the analysis of the political economy of the signifier finds its historical conditions of possibility for its deconstructive neurosis in the delimitation of the province of language by the image. Language just can't process all that visuality – it's like trying to eat your way out of a whale, which, of course, is somewhere you don't belong in the first place. That's why 'you' is such a hard thing 'to be.'

Thus to 'win the imaginary for the symbolic,' as Metz described the task of film theory, means today codifying the cinematicity of domination for consciousness.[11] A rendering that reveals cinema as a new paradigm of socio-material organization would answer Fredric Jameson's thoughtful imperative: 'Perhaps today, where the triumph of more utopian theories of mass culture seems complete and virtually hegemonic, we need the corrective of some new theory of manipulation, and of a

properly postmodern commodification,'[12] with an analysis of the image as the cutting edge of capital, and 'media-ocracy' as the highest stage of capitalism (to date). To rethink the paradigm that is the cinema means to inscribe the material basis of visuality in the unthought of the image and to disrupt its affect of immediacy, plenitude and truth. This inscription of the materiality of the virtual must traverse not just technology as it is ordinarily understood, but social relations: psychology, migration, the masses. Though not everything is an image, nearly everything is con(s)t®ained by them.

In considering the retooling of human thinking which, along with industrial and technological transformations, led up to cinema as it came to be during the twentieth century, let me pursue my reversal of the assumption that historically cinema and cinematic form emerges out of the unconscious (creating, for example, images 'cut to the measure of male desire,' as Laura Mulvey says of film images of women), by saying that *the unconscious emerges out of cinema* (male desire is cut to the measure of cinema). This reversal restores a lost dimension of the dialectical development of each. The coincidence of Freud's theory of the unconscious (1895) with the Lumiere brothers' first film (1895) is no mere coincidence. Theorists of suture, sexuality and more recently Hitchcock (Zizek) assert that cinema engages the architecture of the unconscious in a kind of play. This engagement with an actually existing unconscious is not unlike what Sartre in 'Why write?' called, somewhat filmically, the 'directed creation'[13] engaged in by a perceiver but with somewhat fewer degrees of freedom. To the situation of Sartre's technologically embedded perceiver as '*director* of being' (italics mine), in which 'our car or our airplane . . . organizes the great masses of the earth,' Stephen Heath asserts that cinema adds the following delimitations: 'The passage from views [early French films were listed in catalogues as views] to the process of vision [in cinema] is essentially that of the coding of relations of mobility and continuity.'[14] In other words, cinema *codifies* technological movement and juxtaposition for and as consciousness. Through the simultaneous processes of delimiting the significance of movement and developing conventions for the production of continuity, what is often referred to by the misleading term 'film language' is created. But perhaps, following my suggestion that it is the unconscious which emerges out of cinema, it is just as illuminating here to think of the cinematic apparatus not as a late blooming technology for imaginary titillation through an industrial interface with the unconscious, but indeed as the precursor of and model for the unconscious as it is has been theorized during the course of the twentieth century. As the circulation of programmatic images increases, there's more unconscious around.

One could take Adorno's observation about the culture industry as 'psychoanalysis in reverse' as a thesis on the history of consciousness – in which industrial culture produces not just the modern psyche but psychoanalysis itself (cinema's third machine, the expanded version). In an essay entitled 'The unconscious of the unconscious: the work of consciousness in the age of technological imagination,' I use this approach to consciousness as besieged by the rising imaginary as I work my way through a rather specialized form of consciousness, specifically, a theory of consciousness – the one given voice in Jacques Lacan's famed Seminar XI, *The Four Fundamental Concepts of Psychoanalysis*.[15] Writ large and too briefly, my argument is that if, as Lacan says, the unconscious, in a most cinematic fashion, first appears 'through the structure of the gap' (*FFCP*, 29), that is, in the cut between words,

then the unconscious of the unconscious is cinema. The unconscious appears through the breakdown of the symbolic order (parapraxis in Freud), but is theorized in Lacan as being inaugurated scopically (the *objet petit a* is, after all, an image). On the whole, this situation of linguistic breakdown conforms to Godzich's description of language confronted by images. Add to that the fact that Lacan's figures for the unconscious often involve technologies of visual reproduction, and one begins to feel that the technological is the repressed of the theory of the unconscious. Thus when in 'The *network* of signifiers' (italics mine) Lacan writes:

> Last time, I spoke to you about the concept of the unconscious, whose true function is precisely that of being in profound, initial, inaugural relation with the function of the concept of the *Unbegriff* – or *Begriff* of the original *Un,* namely the cut.
> I saw a profound link between this cut and the function as such of the subject, of the subject in its constituent relation to the signifier itself.
> (*FFCP*, 43)

'the cut' is no mere figure, it is a technical function as well as a cipher of cinematic logic. The optics of the cut undermine the unquestioned legitimacy of the signifier's denotation. Likewise, what Lacan calls 'the pulsative function' (*FFCP*, 43) of the unconscious is formally inseparable from the persistence of vision – where the unlanguageable medium exerts its invisible pressure on the appearance of things.

If the cinematic cut is paradigmatic of the appearance of the unconscious, then Lacan's comments on the structure and function of the unconscious are a proto-theory of cinema, an earlier endeavor 'to win the imaginary for the symbolic.' It is a theory of cinema and of cinematic effects that does not recognize itself as such. To say that 'cinema is the unconscious of the unconscious' means psychoanalysis appears as a form of thought which takes cinema as its paradigm, albeit unconsciously. I find in Lacan's endeavor to language the image (the imaginary) a response to a crisis – the increasing cinematicity of the world. 'The unconscious' is the misrecognition *(méconnaissance)* of cinema. This reading conveniently links the emergence of the modern subject, psychoanalytic theory, mediation and economics.

Throughout the *Four Fundamental Concepts* the unconscious is described in cinematic tropes, 'the cut,' 'montage,' and is figured through technological devices for the creation and reproduction of visual images: paintings, photographs, films. If, as I argue, the image is a cut in language, and if psychoanalysis appears as a film theory of the imaginary, then psychoanalytic film criticism would be less like an invention or an elaboration of psychoanalysis and more like the cipher of an archeological discovery – the discovery of the cinematicity of the unconscious. It is less that film theory turned to Lacan and more that the salmon of psychoanalysis returned to spawn in the filmic waters of its origins. As Slavoj Zizek says, 'the symptom,' which in my discussion of Lacan is psychoanalysis itself, 'as a "return of the repressed" is precisely . . . an effect which precedes its cause (its hidden kernel, its meaning) and in working through the symptom we are precisely "bringing about the past" – we are producing the symbolic reality of past, long-forgotten traumatic events.'[16] By taking the cinematic image as it appears in Lacan, which it does with some regularity, as something like a dream element in the discourse of psychoanalysis, it is indeed

possible to show psychoanalysis as symptomatic of the trauma induced by the emerging organization of visuality under the paradigm of cinema. Noting the appearance of cinema and things cinematic in Lacan helps to build an analysis of psychoanalysis that functions in accord with the principles of psychoanalysis while leading beyond them. The process of such an approach would at once allow the claims of psychoanalysis regarding the structuring of the subject to stand while retroactively showing that cinema is, to play on a formulation of Lacan, 'in it more than it'; in other words, that it is, finally, *psychoanalysis itself that is the symptom* – of cinema.

Materiality and dematerialization

Very likely, revolutionary Soviet filmmakers, particularly Dziga Vertov and Sergei Eisenstein, were painfully aware of capital's encroachment on the visual, precisely because they fought capital on its most advanced front. These directors went directly to the evolving properties of the visual to combat capital expansion. Vertov's decodification of commodity reification in *Man with a Movie Camera,* his 'communist decoding of the world,' tracks process of industrial assemblage. The image composes itself in such a way that objects become legible as process. At the same time the image tracks (represents) its own conditions and strategies of production, and effectively reveals that the image is built like a commodity. In *Man with a Movie Camera* industrial culture attains the visual and cinema is grasped as the necessary medium for the decodification of objectification under capitalism – the rendering of objects and images as social relations.

The easy legibility of this relation between image-objects and the process of their assemblage so carefully articulated by Vertov quickly falls back into the unthought of the image during the course of film history. However, the structure of the image thus revealed nonetheless continues to pertain.[17] For his part, Eisenstein, an engineer by training, works, early on, with the industrial application of visual technology. He deploys it in accord with the logic of Pavlovian behaviorism and Taylorization, and takes the image as a technology for 'the organization of the audience with organized material,' effectively grasping cinema as a social machine for engineering the *socius*. For Eisenstein, a film is 'a tractor ploughing over the audience's psyche.' Even though not conceived precisely in these terms, in the films of Eisenstein, for the first time, image machines are slated to function for the configuration, extraction and application of what Marx termed 'sensuous labor.'[18] The films were to release the necessary energy for the proletariat to continue that labor-intensive project called revolution.

Whereas in Vertov the audience must be shown going to the theater in order to develop a critical relation to ambient images, and in Eisenstein the director controls the effect of the image on the audience by rigidly controling their organization according to a sequencing of conditioned reflexes, some seventy years later in Oliver Stone's *Natural Born Killers* the images come to viewers higgledy-piggledy.[19] Here the image, rather than a mere outgrowth of industrial society, has folded itself back into the fabric of the *socius*. Viewers do not encounter the techno-imaginary only on the screen, its logic is already inside them. This enfolding of the image into the social fabric was already implicit in Vertov; the Kino-Eye project

was to make new films every day and was to be part of the quotidian apprehension of sociality. Film was to forever alter perception. However, in something like an ironic fulfillment of Marxist utopian poetics, *NBK* marks the technological realization of this condition of ubiquitous, ambient, instrumental images and the fusion of perception with technology, because the mediations presented in the film are those of capital. The images do not foster dialectical thinking; rather, they are the raw material of the dialectic itself – the modality of capital's articulation of the viewer. The images are capital's cutting edge. They dream us while we dream for them.

In *NBK* we may mark an evolutionary moment in the history of cinema. Instead of, as in Vertov, merely positing a new order of consciousness mediated by images, the money-driven image is shown to envelop consciousness. In *NBK* the image, through an increase in sheer quantity, achieves a shift in quality, realizing a change of state in which images themselves become the *mise-en-scène* for action. *Natural Born Killers,* in which two young lovers rescue one another from drudgery and oppression, become mass murderers and then celebrities, is about the conditions of personality formation in such a media-environment. Accordingly, in the opening credits of *NBK,* Micky and Mallory are driving through a mediascape in which natural landscapes fuse seamlessly with computer generated imagery, resulting in hallucinatory shifts in context and scale. This world is not virtual in the sense that it is make-believe or pretend, but virtualized by virtue of becoming bereft of its traditional standards, properties and proportions, all of which have been geographically, temporally, perceptually and proprioceptually transformed by media capital. In this new world, where nature is not nature (but always already mediation) and people are 'naturally' born killers, the image of a nuclear explosion or of two open-mouthed hippos having intercourse in a swamp are of the same order: they are pure affect machines. They are on parity here; each exists here as an intensity in an endless series of dematerialized flows. The images come out of the walls and the woodwork and their omnipresence alters the significance, that is, the signification, of each and all forever.

It is the image as the context for action which not only renders ethics virtual but allows Micky and Mallory to accelerate the logic of capital in the creation of their personalities. Instead of stealing the lives of others over an extended period of time, as do plant bosses, plantation owners and stockholders in order to establish themselves as social agents, Micky and Mallory use weapons to appropriate the value of individual lives all at once. Micky and Mallory see through the media and having internalized its vision, act out its very logic. They are, in short, higher iterations of capital. Because they have tele-vision (they are television incarnate), that is, because their sight is televisual, they see everything as if it were already an image, people included. The depthlessness and ostensible immateriality of others accelerates the rapidity with which others can be liquidated and their subjective potential profitably taken. They convert people into spectacle.

Such a conversion process depends upon an evacuation of the Other and is in accord with an intensification of the constitutive relation in the formation of the subject described by the Lacanian theory of the *objet petit a.* As is the case with *Psycho*'s Norman Bates, whose name I have long been convinced is the jump-cut version of the phrase 'The Normal Man Masturbates,' desire's short-cutting around the social prohibitions that give the Other subjective amplitude, and its unrepressed taking of Others as image-objects, outside the socially prescribed codes laid out in

psychoanalytic theory, leads to psychosis and murder. Of course these short cuts (the knife in the bath) are symptomatic of over-'objectification' and are a cultural tendency of capitalist reification. The object is deep frozen as image and drained of all subjective content. In *Natural Born Killers,* identity based on mass murder made possible through the taking of the Other as image is the logical outcome of the constitutive relation between the subject and the *objet a,* a relation of capital from an earlier social moment, now placed under the pressure of an intensifying capitalism where language can no longer fill in the troublesome image of the Other. Subjects assert themselves in the liquidation of other subjects by taking these others as images. Self is produced and maintained today through an intensification of the annihilating function of the gaze. With the deepening penetration of materiality by media, a process which really means the intensifying mediation of materiality, a dematerialization of the object-world occurs. The more deeply entrenched in material structures capitalist mediation becomes, the more everything tends toward the image. Here is Guy Debord:

> Every given commodity fights for itself, cannot acknowledge the others, and attempts to impose itself everywhere as if it were the only one. The spectacle, then, is the epic poem of this struggle, an epic which cannot be concluded by the fall of any Troy. The spectacle does not sing the praises of men and their weapons, but of commodities and their passions. In this blind struggle every commodity, pursuing its passion, unconsciously realizes something higher: the becoming-world of the commodity, which is also the becoming-commodity of the world. Thus by means of a ruse of commodity logic, what's specific in the commodity wears itself out in the fight while the commodity-form moves toward its absolute realization. [20]

This passage might well be taken as a thesis on the philosophy of cinema history, that is, a meditation on the adventures of the medium *par excellence* for the epic poem of the commodity. It also provides a chilling image for the struggles of cinematic-cybernetic 'subject': us. For it is finally we ourselves, the Kino-Is, who engage in a pathological life-and-death struggle with/as the commodity form. However, if Debord's attention to the spectacular and the visual as the paramount field of capital exploitation is to be properly understood, then that which he calls 'a ruse of commodity logic,' which over time allows for the liquidation of the specific materialities of commodities as it brings the commodity-form toward 'its absolute realization' (as image), must be shown in its socially productive aspect. The spectacle means not just commodification but production. Psychopathology, which, if you will excuse me, all of you are guilty of, is a means of production, which is to say that you, kino-you, are a means of production.

Visual economy

To understand the material history of the spectacle, one must show 1) the emergence of cinema out of industrial capitalism, 2) the reorganization of the *socius,* the

subject, and the built environment by the image in circulation, and 3) the utter reconfiguration of capital-logic and hence of labor and accumulation in and as visuality. If the spectacular, the simulated and the virtual are not somehow eminently productive of culture, and if culture is not, again, somehow, eminently productive of capital (in the strict sense of 'productive' as utilized by political economy) then all the hoopla over postmodernism is simply wrong.

Let me, then, add a few more periodizing markers to our time-line in order to show the general fit of cinema with cultural shifts. What I call 'the cinematic mode of production' begins with the codification of early cinema and psychoanalysis (but also behaviourism) and culminates, as it were, in the postmodern and the advance of new media. Thus the CMP begins with the historical moment in which the concrete technology of cinema is codified simultaneously with the abstract, socio-subjective and bureaucratic technologies of monopoly capital (Edison) and continues into the present.[21] Thus, the CMP spans the three fundamental movements in capitalism as specified by Ernest Mandel, beginning in the shift from steam-driven motors to electric and combustion motors, and continuing through the changeover to electronic and nuclear-powered apparatuses that is still occurring. Cinema thus spans the three great machine ages, each one marking, for capital, a dialectical expansion over the previous stage. These stages are, associated with market capitalism, the monopoly stage or the stage of imperialism, and postmodernity or the stage of neo-imperialism, and what one might call neo-totalitarianism, respectively.[22] Somewhat crudely put, it could be said that cinema has its origins in the shift from market to monopoly capital and reconstitutes itself in the shift from monopoly to multinational capitalism. Another useful index of the character of these transformations in the evolving logics of capitalized production and circulation is the mode of image making itself, the indexicality of the photograph, the analog electronic signal, and the digital image.

The CMP would propose that both cinema and capital employ the same abstract, that is, formal structures to realize their functions – the becoming-image of the world (the IMAX-NASA image of earth), or rather the dematerialization of the commodity necessary for the making of this film, is *also necessary for capital development*. Capital's fundamental transformation during the twentieth century is cinematic, that is, it becomes visual. Cinema, and the circulation of the image, provide the archetype for capital production and circulation generally. My analysis of the structure and dynamics of the cinematic apparatus is nothing less than an exploration of the industrial extension of capital's 're-mediation' and reconfiguration of the functioning of the body through the historically achieved interface known as the image. The mining of human bodies of their power has always been the goal of capital. The continuing 'liberation of the productive forces' depends upon the non-liberation of the producers.

This tendency towards the dematerialization of social relations (meaning abstraction, codification through visuality, the increasing leverage of exchange-value over use-value) is accelerated by this selfsame cinematic technology, which, it must immediately be said, anchors itself in place through ever more rigid material constraints (poverty, dependence, psychosis). The mediation and modulation of appearance becomes an essential dimension of social organization, structuring the beliefs, desires and proprioception of image-consumers in ways productive for

capital expansion. Much of this social programming (for that is what it is, even if the results are somewhat indeterminate) occurs outside of the current (possible?) purview of semiotics, meaning to say in zones which elude or exceed meaning even as they structure practice.

Already in the nineteenth century, the commodity had a pronounced visual-libidinal component – a fetish character. If in Freud the fetish arouses and cancels the knowledge of castration, in Marx it arouses and cancels the knowledge of alienated production. In the commodity, this beacon of quashed subjectivity ('the feminine'?) scintillated in the material, making overtures towards becoming animate. Such a beckoning presence of impacted subjectivity in the commodity-form underlies the modernist theories of collecting as redemption – a messianic endeavor to remove objects from commodity circulation and revive them in a more benevolent setting.[23] Cinema, which is technologically on a continuum with industry, latches on to a nascent aspect of the commodity in circulation – the productive potential of its fetish character – and circulates it through the sensorium with a new intensity: the objects 'speak.'[24] In other words, the affective dimension of the commodity is emphasized and rendered more eloquent. If one views the mechanically reproduced image as a new order of reification, a qualitative shift in the shine as well as in the materiality of the commodity-form, then cinema as an industry is the productive orchestration of images and therefore, necessarily, the consequent extraction and management of human subjective potential.

Both the fetish character of the commodity and what Baudrillard calls simulation, two perceptual phenomena which are predominantly visual in the first instance, have been theorized to a greater or lesser extent as artifacts of reification under the capitalist regime of dissymmetrical exchange. In brief, these arguments can be grasped as follows: the ascendancy of exchange-value over use-value (the domination and tendency towards liquidation of the latter by the former) warps the visuo-perceptual field in and as an expression of the psycho-libidinal dimensions of alienation. In the classical four-fold account of alienation from Marx's *Economic and Philosophic Manuscripts of 1844*, humans are alienated from their products, from the work process, from each other and from the species. The alienation of sensual labor leads to an alienation of the senses. The very effacement and naturalization of the historical production of alienation leaves its auratic or phantasmagoric impress on the sensorium. Objects have a new pyrotechnics.

When in capitalist production, worker's product confronts him or her as 'something alien,' a new order of perceptuo-imaginary pyrotechnics is inaugurated, the order which leads Marx to introduce the category of fetishism. This consequence of alienation is precisely the phantasmagoria of the object, the part which stands out in place of the whole as a totality of process, the supplemental excesses of a history rendered invisible yet smoldering within the material. The fetish is the severance of community *appearing* as an object. It is the activity which the object undertakes as a medium for severing consumer from community. It is violated subjective and intersubjective activity. Of course it is essential to recall here that the experience of this phenomenon is not without its pleasures, its ecstasy. Indeed one might see in commodity fetishism a kind of severance pay, a pleasure in the mode of Platonic longing for a lost wholeness, in which commodity as missing piece promises wholeness, completion, repletion. This relation between human beings which first appears

on a massive scale during the industrial revolution as a thing, finds its higher articulation in the spectacle which Debord describes as the false community of the commodity.

If one wanted to trace the cultural logic of the spectacle, the place to look for a formal precursor is in the operations and movements of money. According to Georg Simmel in *The Philosophy of Money*, law, intellectuality and money 'have the power to lay down forms and directions for contents to which they are indifferent.'[25] So it is with film. It might be said here that money, as an evolving medium which leaves its imprint on all aspects of cerebral activity, and which is an empty form that can take on any contents, assumes film-form, while capital as an evolving system of organization, production *and exploitation*, becomes cinematic. Historically, of course, capital precedes cinema as we commonly understand the term. Money is the medium for regulating wage labor (the spread and development of the money-form coincides with the putting in place of a global working class) while capital denotes the *system* of dissymmetrical exchange. 'Film' can be understood as the social relation which separates the visual component of human subjective activity from the body in its immediate environment, while 'cinema' is the systemic organization of this productive separation.

If the commodity-object is an impacted social relation in which the subjective contribution of the human worker is effaced, so much the more for the image. Andy Warhol registers this change in much of his work, but perhaps never more elegantly than in the Campbell's Soup silk screens. These soups are indeed condensed: objects formed by the condensation of farming technologies, migrant labor, canning process, trucking, warehousing and supermarketing. Warhol grasps the mass-produced object as an icon of reification, effectively peeling the label from the can, and allowing it to circulate unencumbered. This free-floating signifier of an already reified condensation dramatizes the mode of appearance for the soup, a soup which as long as it is to remain a commodity must also remain invisibly locked in a hermetic tin. In increasing the distance between the label and the use-value, Warhol registers the ascendance of image over materiality, distancing yet further whatever human subjective elements comprise the soup proper while dramatizing the subjective pyrotechnics of the image-commodity itself. Where once a portrait would have been displayed, there hangs an image of a commodity, itself a higher order of commodity.

Warhol underscores the ascendant dimension of the commodity-image by *reproducing* it, not as an anonymous designer, but as an artist. By inscribing the image at a distance, he also inscribes its social effects, he becomes the representative of a representation. Like previous art icons, Warhol is an author of an imagistic relation, but unlike others he is an author who does not immediately appear to create an original text, he only grasps it through reproduction. In the postmodern the image always occurs twice, the first time as commodity, the second as art.

As importantly as the subjective labor which goes into the production of images – in both the objectification that becomes the referent and the imagification that becomes the image in circulation, *human subjectivity is bound to the image in its very circulation,* and that in two very different ways. 1) Our gazes accrete on the image and intensify its power. Take, for example, the case of a work of Vincent Van Gogh. The 50 million-dollar fetish character is an index of visual accretion, that is, of alienated sensual labor resultant from the mass mediation of the unique work of art.

All that looking sticks to the canvas and increases its value. To develop that relation has been the job of the painter, and remains the strategy of producers of unique works of art. The traditional labor theory of value cannot explain this hysterical production of value, only a theory which accounts for the systemic alienation of the labor of looking can. Equally significant, 2) in viewing the image we simultaneously and micrologically modify ourselves in relation to the image as we 'consume' it – a misnomer if there ever was one, since images equally, or almost entirely, consume us.[26] If this production of both value and self (as worker, as consumer, as fecund perceiver) through looking is indeed the case, then the emergence of visual culture must be set in relation to the development and intensification of commodity fetishism.

Globalization, affect and negation

The assertion that global production is co-ordinated through the screen of capital (the screens of the many capitals) is operationally correct, and, if one considers the role of CNN, international cable stations, Bloomberg machines, computers, Hollywood film, international advertising, etc., may perhaps seem intuitively obvious. However, this operational category must become analytical (Metz's project again, but now in a politico-economic key). The development of a new order of visuality and of a visual *economy* is signaled here by a qualitative shift in the character of capital. This shift is colloquially known – at least by the theory crowd – as postmodernism. It is arguable that even in its early stages capital was already cinematic: 'capital,' in the work of Marx, was the screen of appearance for all politico-economic and therefore social metamorphosis. In Marx's representation *(Darstellung)* of capital process, all that is solid melts into air precisely on the screen of capital; each moment of production as well as of world history is marched across the frame that capital provides. In short, like Vertov's *Man with a Movie Camera,* Marx's 'capital' films social practice, and in fact, that is, in practice, it was precisely through the framework of capital that the social was grasped.[27] Cinema is first posited by capital, and then presupposed.

As noted, photography and the cinematic apparatus are no mere perks or spin-offs of industry as Tang was to the space program. Visual technologies developed the key pathways for capital expansion, increasing as they do the speed and intensity of commodity circulation, as well as historically modifying the visual pathway itself, transforming the character of sight. The visual as a productive relation for capital clears the way for the institution of what Fredric Jameson identifies as 'constitutive features of postmodernism': 'a new depthlessness,' 'a weakening of historicity,' 'a whole new type of emotional ground tone' under the heading of 'intensities,' 'the deep constitutive relationships of all this to a whole new technology which is itself a figure for a whole new economic world system' and 'mutations in the lived experience of built space itself.'[28] This cultural sea change known as postmodernism may be defined as the subsumption of formerly semi-autonomous cultural sphere by capital. This subsumption of culture registers the change of state necessary to 'economic growth,' or simply 'development' (neo-imperialism) in the latter twentieth century. Culture became a scene, and is fast

becoming the principal scene (the *mise-en-scène*) of economic production. It should be noted that the postmodern 'special effects' mentioned by Jameson above, though they impact every aspect of human culture, are predominantly visual in their first instance. Without the reorganization of the visual, the massive, global immiseration that currently exists could not be effected. The postmodern distortions, which are actually spatial, temporal and corporeal *transformations,* and hence new forms of social relations, are created and sustained through a generalized extension of the capacity to mediate vision and to prolong the interface between human beings and social machines.

The new order of visuality marks a transformation of that relationship between bodies and machines previously epitomized by the assembly line. Visual images of cybernetics such as those found in *Robocop* or *Terminator* are actually the interfaces themselves. The hypothesis here is that the principle locus of the dissymmetrical exchange (exploitation) characteristic of Money-Capital-Money where the second M is larger than the first is the imaginary. Labor is done in what Althusser calls 'an imaginary relation to the real,' but in an utterly transformed because massively mediated imaginary and with effects that are no less material for all that. The large-scale technological mediation of the imaginary is also a material shift.

Jean-Joseph Goux positions what might be recognized as the imaginary in relation to economic production thus: 'consciousness (social or individual) . . . [i]s *constituted* in its very form, in its *mode of reflection,* by and in the process of social exchange.'[29] Goux's work, which in ways similar to my own delineates the homologous structures of psychoanalysis and political economy, lacks for all of its undeniable brilliance, a materialist theory of mediation. Goux lacks an answer to the question 'how do you get capitalism into the psyche, and how do you get the psyche into capital?'[30] He argues that 'the affective mode of exchange,' meaning the symbolic, is a function of 'the dominant form of exchange,' meaning capital. The expression of the imaginary is therefore a function of the dominant mode of exchange. While Goux's statement is accurate, what is left out is that it requires the history of twentieth-century visuality to make it so. The twentieth century is the cinematic century, in which capital aspires to the image and the image corrodes traditional language function and creates the conceptual conformation, that is the very form, of the psyche as limned by psychoanalysis. The cinematic image, as mediator between these two orders of production (political economy and the psycho-symbolic) better describes the historically necessary, mutual articulation of consciousness and capital expansion than does Goux's provocative but abstract idea of the 'socio-genetic process' in which social forms mysteriously influence one another or take on analogical similarities. Goux's theory of mediations itself lacks a general theory of mediation. It is only by tracing the trajectory of the capitalized image and the introjection of its logic into the sensorium that we may observe the full consequences of the dominant mode of production (assembly-line capitalism) becoming 'the dominant mode of representation' as cinema: the automation of the 'subject' by the laws of exchange. This transformed situation of the subject demands a thoroughly new epistemology almost as urgently as it demands new forms of transcendence.

If we combine such a thesis with Guy Debord's insight that 'the spectacle is the guardian of sleep,'[31] then it becomes clear that the terrain of cinematics is at once

macro- and microscopic, that is world-systemic, economic and historical, as well as individual, perceptual and psychological. What was already true for Lacan, albeit ontologically, here takes on its world-historical character: the dominant mode of representation induces unconsciousness. Cinema is an orchestration of the unconscious and the unconscious is a scene of production. Dream-work turns out to be real work. It is important to remember here that the category 'cinema' is now detached from the film industry and its array of institutions and provides a figure for the orchestration of material production by images. Indeed with even greater range and significance than war or the automobile,[32] as the predominantly visual mediation of material relations cinema ceaselessly co-ordinates global economic forces with the extremely local (meaning regional, but also interior to particular individuals) productions of affect, trajectories of desire and proprioception.

How does this cybernesis function? Antonio Negri describes postmodernism as the '"real subsumption" of society in capital' and affirms that the 'form of value is the very "communication" which develops among productive forces.'[33] He then raises the following question:

> If 'communication' constitutes the fabric of production and the substance of the form of value, if capital has become therefore so permeable that it can filter every relation through the material thicknesses of production, if the labouring processes extend equally as far as the social extends, what then are the consequences that we can draw with respect to the law of value?[34] (139)

Negri's stunning 'Twenty theses on Marx' from which this passage was taken, ultimately answers the question by calling for the radical wresting of 'social cooperation' (labor) from 'productive command' (capital). These extremely promising categories and the work which informs their constitution demand significant attention. However encouraging Negri's assertion is, that the history of the proletarian power is asymmetrical with the history of capitalist power and that what he calls 'the proletariat' has therefore never been in lockstep with capitalist exploitation, Adorno and Horkheimer's critique of the culture industry is not adequately dispensed with in Negri's model.

Adorno and Horkheimer's critique, in which human interiority has been effectively liquidated and replaced by the culture industry: – 'the inflection on the telephone or in the most intimate situation, the choice of words in conversation, and the whole inner life . . . bear witness to man's attempt to make himself a proficient apparatus, similar (even in emotions) to the model served up by the culture industry' – has been criticized for an inadequate account of different modes of reception and use of mass mediated cultural production by the incredible variety of consumers extant, but Negri himself almost inadvertently proposes a grim addendum to the Frankfurt school architectonic that 'Amusement under late capitalism is the prolongation of work.'[35] In his words, with respect to the development of capital, 'every innovation is the secularization of revolution.'[36] This statement, meant to underscore the creative and liberatory power of workers, strikes me as also providing the appropriate negative dialectic for thinking about image-culture as a system: the creativity of the masses, their quests for empowerment, fulfillment

and, why not say it, 'freedom' are absorbed and rendered productive for capital.[37] What a century ago I.P. Pavlov observed as 'the freedom reflex' is harnessed by capital for alienated production. New affects, aspirations and forms of interiority are experiments in capitalist productivity.

With this recuperative aspect of capital in mind, along with the rise of the emergence of visuality as I have described it thus far, it would be important not to abandon the dialectics of negation. Thus far, only the negative dialectic allows us to think the political economy of the visual and hence the paradigm of a global dominant. Negation, however, has very serious limits which may ultimately include it as among the psychopathological strategies of the Kino-I thinker.[38] In conceiving the cinematicity of production, the fabrication of affect as well as the valorization of images by watching them must be grasped as a new order of production slated by the emerging visual economy. The cinematicity of capital dialectically reordains the categories of political economy, meaning that it leaves its older forms extant (wage labor, circulation, capital, use-value, exchange-value, etc.) while bringing them to a higher level of articulation. It also, in ways which exceed the scope of this essay, reordains the key operators of race, gender, sexuality and nation. The commodified object tends toward the image, money tends toward film and capital tends toward cinema. People are slotted in according, value-producing media for the new visual economy, as if living in accord with preordained scripts or programs. Thus, as I have only suggested here, the labor theory of value which has been in Marxism the basis on which capital was valorized during the production process and also the basis on which revolutionary action was predicated, must be reformulated as the attention theory of value, that is, as *the productive value of human attention*. This reformulation leaves labor as a subset of value-productive attention while positing the development of a new order for cementing of the *socius*. Furthermore it accounts for the capitalization of forms of interstitial human activity ('women's' work, 'desiring-production,' survival) which previously fell beyond the purview of the formal scene of value production, the workplace. Additionally, such a new order of production not only extends the working day and therefore combats the falling rate of profit, it instantiates new orders of commodities such as air, time and vision itself, whose values are measured, for example, by a statistical estimate of the size and now the 'quality' of an audience.[39]

Visual, psychological, visceral and haptic events are the pathways for new kinds of work, new kinds of machine/body interfaces, which simultaneously instantiate an effective reality or media-environment for the subject-form (and its fragments) as a context for its action, and valorize capital investment. The more an image is watched, the more value accrues to it. This is a cybernetic model but here cinematized vision is the key pathway of a cybernetic capitalism and the image is the key interface. In short, by bringing the industrial revolution to the eye, cinema subsumes the environment and realizes what theorists of modernity already recognized as a second nature, the naturalization of the alienated human production of practically everything. When appearance itself is production, the ostensible immediacy of the world always already passes through the production system. Cinema is a deterritorialized factory which extends the working day in space and time while introjecting the systems language of capital into the sensorium. Cinema means a fully-mediated *mise-en-scène* which provides humans with the contexts and options

for response. As cinema mediates the apparent world it also structures perception. The becoming-images of the objective world mean that cinematic practices of assemblage and reception (programs for sensual labor) characterize daily life, and not just the concrete interface with the screen. The generalized movement of commodities through the sensorium and of the sensorium through commodities is cinematic. Thus cinema means mediation between the world system and the very interiority of the spectator. It is the global expansion as well as the corkscrewing inwards of the viral logic of the commodity-form.[40]

Notes

1 Noted in Zygmunt Bauman, *The Individualized Society*, Cambridge: Polity Press, 2001, p. 32.

2 Rey Chow, *Primitive Passions: Visuality, Sexuality, Ethnography, and Contemporary Chinese Cinema*, New York: Columbia University Press, 1995.

3 Christian Metz, *The Imaginary Signifier: Psychoanalysis and the Cinema*, trans. Celia Britton *et. al.*, Bloomington: Indiana University Press, 1982.

4 Jean-Louis Commoli, 'Machines of the Visible,' in *The Cinematic Apparatus*, Teresa de Lauretis and Stephen Heath (eds), p. 140. See also the following essays from the same volume: Stephen Heath, 'The Cinematic Apparatus: Technology as Historical and Cultural Form,' and Teresa de Lauretis, 'Through the Looking Glass.' For a broader theory of the social organization of the imaginary see, Cornelius Castoriadis, trans. Kathleen Blamey, *The Imaginary Institution of Society*, Cambridge, Mass.: MIT Press, 1998.

5 See Regis Debray, *Media Manifestos,* trans. Eric Rauth, London and New York: Verso, 1996. Hereafter cited parenthetically as *MM*.

6 Heath, op.cit. p. 6.

7 See my essays 'Cinema, Capital of the Twentieth Century,' *Postmodern Culture*, vol. 4 no. 3, May 1994; 'The Spectatorship of the Proletariat,' *boundary 2*, vol. 22, no. 3, Fall 1995: pp. 171–228; 'Capital/Cinema,' in *Deleuze and Guattari: New Mappings in Politics/Philosophy/Culture*, eds Eleanor Kaufman and Kevin Heller, Minneapolis: University of Minnesota Press, 1998; 'Identity Through Death/The Nature of Capital: The Media-Environment for *Natural Born Killers*,' *Post-Identity*, vol. 1, no. 2, Summer 1998, pp. 55–67; and 'Dziga Vertov and the Film of Money,' *boundary 2*, vol. 26, no. 3, Fall 1999, pp. 151–200 (http://128.220.50.88/journals/boundary/v026/26.3beller.html).

8 By 'consciousness,' I am referring of course to modern(ist) consciousness' i.e., modern subjectivity – a mode of knowing *vis à vis* a way of being presently in decline.

9 Wlad Godzich, 'Languages, Images and the Postmodern Predicament,' in *Materialities of Communication*, eds Hans Ulrich Gumbrecht and K. Ludwig Pfeiffer, Stanford: Stanford University Press, 1994, pp. 367–8.

10 Godzich, p. 369.

11 Metz, p. 3.

12 Fredric Jameson, *Late Marxism: Adorno, or, the Persistence of the Dialectic*, London and New York: Verso, 1990.

13 Sartre's description of the role of the subject as partner in aesthetic (and ontological) creation is already cinematic. 'It is the speed of our car or our airplane

which organizes the great masses of the earth. With each of our acts, the world reveals to us a new face. But if we know that we are *directors of being,* we also know that we are not its producers. If we turn away from this landscape, it will sink back into its dark permanence, At least it will sink back, there is no one mad enough to think that it is going to be annihilated. It is we who shall be annihilated, and the earth will remain in its lethargy until another consciousness comes along to awaken it. Thus, to our inner certainty of being "revealers" is added that of being inessential in relation to the thing revealed [my italics]' (in *Critical Theory Since Plato,* ed. Hazard Adams, New York: Harcourt Brace Jovanovich, 1971, p. 1059).

14 Stephen Heath, *Questions of Cinema,* p. 26.

15 Jacques Lacan, *The Four Fundamental Concepts of Psychoanalysis,* ed. Jacques-Alain Miller, trans. Alan Sheridan, New York: W.W. Norton, 1981. Hereafter cited parenthetically as *FFCP* in the body of the text. One might today propose reading consciousness itself precisely as dream. Such an approach is already implicit in Paul Valéry's comment that each epoch dreams the next. My essay is as yet unpublished.

16 Slavoj Zizek, *The Sublime Object of Ideology*, London and New York: Verso, 1989, pp. 56–7.

17 See my essay, 'Dziga Vertov and the Film of Money,' cited above.

18 See my essay, 'The Spectatorship of the Proletariat,' cited above.

19 See my essay, 'Identity through Death/The Nature of Capital: The Media Environment for *Natural Born Killers,*' cited above.

20 Guy Debord, *Society of the Spectacle,* no. 66.

21 The institutional history of Hollywood provides fertile ground for thinking further about the relationship between vertical and horizontal integration at the level of film production and distribution (capital in the traditional sense) on the one hand, and the (always incomplete) codification of the image-system called cinema on the other. See for example, Charles Musser, *Before the Nickelodeon: Edwin S. Porter and the Edison Manufacturing Company* and David Bordwell, Janet Staiger and Kristin Thompson, *The Classical Hollywood Cinema: Film Style and Mode of Production to 1960.* In another vein see Terry Ramsaye, *A Million and One Nights: A History of the Motion Picture Through 1925*, New York, Simon & Schuster, 1926. See also Thomas Schatz, *The Genius of the System,* New York: Pantheon, 1988.

22 Ernest Mandel, *Late Capitalism,* London: 1978, p. 118, cited in Fredric Jameson, *Postmodernism or, the Cultural Logic of Late Capitalism*, Durham, N.C.: Duke University Press, 1991, p. 35.

23 See Walter Benjamin, 'Unpacking My Library,' in *Illuminations,* or 'Eduard Fuchs: collector and historian,' in *The Essential Frankfurt School Reader,* eds Andrew Arato and Eike Gebhardt, New York: Continuum, 1987.

24 This of course is more true in the silent era, that is, in the early modern. With talkies, the visual objects are more properly spoken for.

25 George Simmel, *The Philosophy of Money,* pp. 441–2.

26 Arjun Appadurai correctly takes issue with the 'optical illusion . . . fostered by neoclassical economics of the last century or so . . . that consumption is the end of the road for goods and services, a terminus for their social life, a conclusion of some sort of material cycle,' in 'Consumption, duration and history,' in David Palumbo-Liu and Hans Ulrich Gumbrecht, eds, *Streams of Cultural Capital,* Stanford: Stanford University Press, 1997, p. 23. Appadurai is correct to note

that commodities have an afterlife following their material consumption, and further correct to figure these misapprehensions regarding this consuming productivity as optical.

27 Thus, with the emergence of cinema proper, that is, when, historically, industrial capitalism produces cinematic capitalism we confront a classically dialectical case of sublation *(Aufheben)* in which the categories money and capital give way to the categories film and cinema while still retaining their logically prior identities and properties. The instantiation of these categories and the world-historical events which make their instantiation possible are inexorably linked. The dominant mode of representation is also an organization of material practices.

28 *Postmodernism,* 6 (see note 22).

29 Jean-Joseph Goux, *Symbolic Economies: After Marx and Freud,* trans. Jennifer Curtiss Gage, Ithaca, NY: Cornell University Press, 1990, p. 86. The passage reads as follows: '[S]ocial consciousness objectively comprises the complex process of symbolization in all spheres of vital activities (economic, legal, signifying, libidinal), and on the process of symbolization will depend, among other things, *the dominant mode of representation itself* – the dominant and dominated form of social consciousness. To show how the very form of social consciousness in a given mode of production and exchange is determined by the signifying, intersubjective, "affective" mode of exchange, as a function of the dominant form of exchange – how it is determined by the mode of symbolizing, conditioned by the economic process – is to become able to consider consciousness (social or individual) no longer as a simple mirror, an unvarying agency of reflection, but rather as *constituted* in its very form, in its *mode of reflection,* by and in the process of social exchange.' For Goux the 'process of social exchange' rather than 'the mode of production' is the significant matrix of relations which will exercise its overdetermination effects on consciousness. This difference with classical Marxism is significant because it registers a slippage between the two categories, one which allows the mode of exchange to be taken as the mode of production and vice versa. This back-and-forth movement coincides precisely with my argument that the dominant mode of production has become an image based mode of exchange.

30 'Just as the genesis of the money form is the construction that accounts for the enigmatic disjunction between money and the commodity (a disjunction, moreover, which is required for the capitalist mode of production to be established), so the psychic apparatus is the construction that accounts for the distance between nonlinguistic forms of consciousness and linguistic forms of consciousness' *(Symbolic Economies,* p. 77).

31 Guy Debord, *Society of the Spectacle,* Red and Black, 1977; #21.

32 The three things that in 'The Culture Industry: Enlightenment as Mass Deception' 'keep the whole thing together.' The passage reads: 'No mention is made of the fact that the basis on which technology acquires power over society is the power of those whose economic hold over society is the greatest. A technological rationale is the rationale of domination itself. It is the coercive nature of society alienated from itself. Automobiles, bombs and movies keep the whole thing together until their leveling element shows its strength in the very wrong which it furthered. It has made the technology of the culture industry no more than the achievement of standardization and mass production, sacrificing whatever involved a distinction between the logic of the work and that of the social system. This is the result not of a law of movement in technology as such but of its function in

today's economy' (Theodore Adorno and Max Horkheimer, *Dialectic of Enlightenment*, New York: Continuum, 1991, p. 121). See also Elaine Scarry, *The Body in Pain*, especially the chapter entitled 'War as Injuring.' See also Kristin Ross, *Fast Cars, Clean Bodies: Decolonization and the Reordering of French Culture*, Cambridge: MIT Press, 1995, in which Ross argues that 'the car is the commodity form as such in the twentieth century'(p. 6). Additionally, see Paul Virilio, *War and Cinema*, London: Verso, 1989 and Virilio, *The Vision Machine*, Bloomington: Indiana University Press, 1994.

33 Antonio Negri, 'Twenty Theses on Marx,' trans. Michael Hardt, *Polygraph 5: Contesting the New World Order*, p. 139. Here is the relevant passage: 'When the capitalist process of production has attained such a high level of development so as to comprehend every even small fraction of social production, one can speak, in Marxian terms, of a "real subsumption" of society in capital. The contemporary "mode of production" is this "subsumption." What is the form of value of the 'mode of production which is called the "real subsumption?" It is a form in which there is an immediate translatability between the social forces of production and the relations of production themselves. In other words, the mode of production has become so flexible that it can be effectively confused with the movements of the productive forces, that is with the movements of all the subjects which participate in production. It is the entirety of these relations which constitutes the form of value of the "real subsumption." We can develop this concept affirming that this form of value is the very "communication" which develops among productive forces' (p. 139).

34 Negri, p. 139. Note Negri's own periodization of the three moments of class struggle.

35 Adorno and Horkheimer, p. 137. See also passage on p. 124 on *Gesamtkunstwerk*.

36 Negri, pp. 146–7.

37 Negri of course intends to foreground something quite different: that the proletariat is the motor force of history, its creative agent, not capital. Further, for Negri, the innovation of the proletariat is a kind of continuing revolution against capitalism.

38 The task of negation includes the necessity of needing to adopt the standpoint of domination, for example, as in this essay. Such a move, even with negation as the goal, runs the very serious risk of presenting a uniform, undifferentiated *socius* everywhere subject to the same law, of being unable to observe what is at variance with the law. In giving the comprehensive theory here it has been necessary to adopt the standpoint of full comprehension – that of capital. In my view it is pathological, even suicidal to remain here. The negative critique must impel the shattered subject to new forms of contemporary affirmation. Elsewhere I have tried to think many of these issues through from a more affirmative subaltern perspective. See my forthcoming book, *Visual Transformations in Philippine Modernity: Notes Toward an Investigation of the World-Media-System*, in which I confront the logistics implied by the CMP in the context of Filipino struggles which of necessity restore categories of race, gender, and nation to analytic prominence.

39 Robin Andersen complicates the picture significantly: 'Manufacturers and the agency representative are no longer satisfied simply with quantity – the number of people watching TV shows. Now they are concerned with audience "quality" as well. And there is a fundamental connection between programming environment and audience quality. A "quality" audience is one that has been primed, with

appropriate programming, to be more receptive to advertising messages' *Consumer Culture and TV Programming*, Boulder, Col.: Westview Press, 1995, p. 4. Andersen adds that 'It is a Hollywood joke that broadcasters are selling eyeballs to advertisers. It is fair to say, then, that in selling commercial time to advertisers to sell products, broadcasters are also selling a product – their audiences' (p. 5). What needs to be theorized is that the audience is not just one commodity among many, but a unique commodity in the sense that labour is a unique commodity – that is, it is *the* commodity capable of producing surplus value through dissymetrical exchange with capital.

40 In keeping with Rosa Luxemburg's *The Accumulation of Capital*, New Haven: Yale University Press, 1951, in which capital always needs a periphery for expansion, we could say that the Third World, and the Unconscious, to name the two most significant peripheries of the dominant, are new frontiers of cinematic capitalism. In its translation of image into action and action into image, cinema transforms the perceptual field, the sensorium and the significance of objects. I have already suggested, however telegraphically, that the rise of image culture parallels and indeed induces the rise of the unconscious. This takes place in the transition from the first to the second machine age. I would also like to propose that in the transition from the second to the third machine age, the increased quantity of images induces another crisis in language compared to which the coming of the unconscious was only a preamble. This second crisis would of course be the moment of deconstruction and the demise of the subject. The philosophical explication of the holes in language which began to appear everywhere in the 1960s (an event which can only be explained via a materialist history and not an intellectual history) is directed less against the unconscious and more pointedly against unconsciousness itself. To take this thought a step farther, deconstruction's continual railing against the unthought ought to be allied with the rejection of a continual production of the unconsciousness of the laboring Third World or of the laboring Third World as the unconscious. Here it would be necessary to break with a strict geographical conceptualization of Third Worldness in order to apprehend it as the impoverished and othered dimensions of human becoming. For the rendering of vast regions of human experience invisible is the essential condition for the production of whatever consciousness is attendant to the public sphere. It would be important then in this context to see a computer made in Malaysia as a new kind of orientalist image, produced in 'the orient,' but functioning for purposes which utterly occlude the landscape of its production.

W.J.T. Mitchell

SHOWING SEEING
A critique of visual culture

W**HAT IS 'VISUAL CULTURE'** or 'visual studies'?[1] Is it an emergent disci-
pline, a passing moment of interdisciplinary turbulence, a research topic, a
field or subfield of cultural studies, media studies, rhetoric and communication, art
history, or aesthetics? Does it have a specific object of research, or is it a grab-bag
of problems left over from respectable, well-established disciplines? If it is a field,
what are its boundaries and limiting definitions? Should it be institutionalized as an
academic structure, made into a department or given programmatic status, with all
the appurtenances of syllabi, textbooks, prerequisites, requirements, and degrees?
How should it be taught? What would it mean to 'profess' visual culture in a way
that is more than improvisatory?

I have to confess that, after almost ten years of teaching a course called 'Visual
Culture' at the University of Chicago, I still do not have categorical answers to all
these questions.[2] What I can offer is my own take on where the field of visual studies
is going today, and how it might avoid a number of pitfalls along the way. What
follows is based mainly on my own formation as a literary scholar who has been
involved as a migrant worker in the fields of art history, aesthetics, and media
studies. It is also based on my experience as a teacher attempting to awaken students
to the wonders of 'visuality,' practices of seeing the world and especially the seeing
of other people. My aim in this course has been to overcome the veil of familiarity
and self-evidence that surrounds the experience of seeing, and to turn it into a
problem for analysis, a mystery to be unraveled. In doing this, I suspect that I am
rather typical of those that teach this subject, and that this is the common core of
our interest, however different our methods or reading lists might be. The problem
is one of staging a paradox that can be formulated in a number of ways: that vision
is itself invisible; that we cannot see what seeing is; that the eyeball (*pace* Emerson)
is never transparent. I take my task as a teacher to be to make seeing show itself,
to put it on display, and make it accessible to analysis. I call this 'showing seeing,'

a variation on the American elementary school ritual called 'show and tell,' and I will return to it at the conclusion of this paper.

The dangerous supplement

Let me begin, however, with the gray matters – the questions of disciplines, fields, and programs that are intersected by visual studies. I think it's useful at the outset to distinguish between 'visual studies' and 'visual culture' as, respectively, the field of study and the object or target of study. Visual studies is the study of visual culture. This avoids the ambiguity that plagues subjects like 'history,' in which the field and the things covered by the field bear the same name. In practice, of course, we often confuse the two, and I prefer to let 'visual culture' stand for both the field and its content, and to let the context clarify the meaning. I also prefer visual culture because it is less neutral than 'visual studies,' and commits one at the outset to a set of hypotheses that need to be tested – for example, that vision is (as we say) a 'cultural construction,' that it is learned and cultivated, not simply given by nature; that therefore it might have a history related in some yet to be determined way with the history of arts, technologies, media, and social practices of display and spectatorship; and (finally) that it is deeply involved with human societies, with the ethics and politics, aesthetics and epistemology of seeing and being seen. So far, I hope (possibly in vain) that we are all singing the same tune.[3]

The dissonance begins, as I see it, when we ask what the relation of visual studies is to existing disciplines such as art history and aesthetics.[4] At this point, certain disciplinary anxieties, not to mention territorial grumpiness and defensiveness, begin to emerge. If I were a representative of cinema and media studies, for instance, I would ask why the discipline that addresses the major new art forms of the twentieth century is so often marginalized in favor of fields that date to the eighteenth and nineteenth centuries.[5] If I were here to represent 'visual studies' (which I am) I might see the triangulation of my field in relation to the venerable fields of art history and aesthetics as a classic pincer movement, designed to erase visual studies from the map. The logic of this operation is easy enough to describe. Aesthetics and art history are in a complementary and collaborative alliance. Aesthetics is the theoretical branch of the study of art. It raises fundamental questions about the nature of art, artistic value, and artistic perception within the general field of perceptual experience. Art history is the historical study of artists, artistic practices, styles, movements, and institutions. Together, then, art history and aesthetics provide a kind completeness; they 'cover' any conceivable question one might have about the visual arts. And if one conceives them in their most expansive manifestations, art history as a general iconology or hermeneutics of visual images, aesthetics as the study of sensation and perception, then it seems clear that they already take care of any issues that a 'visual studies' might want to raise. The theory of visual experience would be dealt with in aesthetics; the history of images and visual forms would be dealt with in art history.

Visual studies, then, is from a certain familiar disciplinary point of view, quite unnecessary. We don't need it. It adds on a vague, ill-defined body of issues that are covered quite adequately within the existing academic structure of knowledge.

And yet, here it is, cropping up as a kind of quasi-field or pseudo-discipline, complete with anthologies, courses, debates, conferences, and professors. The only question is: what is visual studies a symptom of? Why has this unnecessary thing appeared?

It should be clear by this point that the disciplinary anxiety provoked by visual studies is a classic instance of what Jacques Derrida called 'the dangerous supplement.' Visual studies stands in an ambiguous relation to art history and aesthetics. On the one hand, it functions as an internal complement to these fields, a way of filling in a gap. If art history is about visual images, and aesthetics about the senses, what could be more natural than a subdiscipline that would focus on visuality as such, linking aesthetics and art history around the problems of light, optics, visual apparatuses and experience, the eye as a perceptual organ, the scopic drive, etc.? But this complementary function of visual studies threatens to become supplementary as well, first, in that it indicates an incompleteness in the internal coherence of aesthetics and art history, as if these disciplines had somehow failed to pay attention to what was most central in their own domains and, second, in that it opens both disciplines to 'outside' issues that threaten their boundaries. Visual studies threatens to make art history and aesthetics into subdisciplines within some 'expanded field' of inquiry whose boundaries are anything but clear. What, after all, can 'fit' inside the domain of visual studies? Not just art history and aesthetics, but scientific and technical imaging, film, television, and digital media, as well as philosophical inquiries into the epistemology of vision, semiotic studies of images and visual signs, psychoanalytic investigation of the scopic 'drive,' phenomenological, physiological, and cognitive studies of the visual process, sociological studies of spectatorship and display, visual anthropology, physical optics and animal vision, and so forth and so on. If the object of 'visual studies' is what Hal Foster calls 'visuality,' it is a capacious topic indeed, one that may be impossible to delimit in a systematic way.[6]

Can visual studies be an emergent field, a discipline, a coherent domain of research, even (*mirabile dictu*) an academic *department*? Should art history fold its tent, and, in a new alliance with aesthetics and media studies, aim to build a larger edifice around the concept of visual culture? Should we just merge everything into Cultural Studies? We know very well, of course, that institutional efforts of this sort have already been under way for some time at places like Irvine, Rochester, Chicago, Wisconsin, and no doubt others of which I am unaware. I have been a small part of some these efforts, and have generally been supportive of institution-building efforts. I am mindful, however, of the larger forces in academic politics which have, in some cases, exploited interdisciplinary efforts like cultural studies in order to down-size and eliminate traditional departments and disciplines, or to produce what Tom Crow has called a 'de-skilling' of whole generations of scholars.[7] The erosion of the forensic skills of connoisseurship and authentication among art historians in favor of a generalized 'iconological' interpretive expertise is a trade-off that ought to trouble us. I want both kinds of expertise to be available, so that the next generation of art historians will be skilled with *both* the concrete materiality of art objects and practices *and* with the intricacies of the dazzling PowerPoint presentation that moves effortlessly across the audio-visual media in search of meaning. I want visual studies to attend *both* to the specificity of the things we see, *and* to the fact that most of traditional art history was already mediated by highly imperfect representations such as the lantern slide, and before that by engraving, lithographs, or verbal description.[8]

So if visual studies is a 'dangerous supplement' to art history and aesthetics, it seems to me important neither to romanticize nor to underestimate the danger, but also important not to let disciplinary anxieties lure us into a siege mentality, circling our wagons around 'straight art history,' or narrow notions of tradition.[9] We might take some comfort from the precedent of Derrida's own canonical figure of the dangerous supplement, the phenomenon of *writing*, and its relation to speech, to the study of language, literature, and philosophical discourse. Derrida traces the way that writing, traditionally thought of as a merely instrumental tool for recording speech, invades the domain of speech once one understands the general condition of language to be its iterability, its foundation in repetition and re-citation. The authentic *presence* of the voice, of the phonocentric core of language, *immediately* connected to meaning in the speaker's mind, is lost in the traces of writing, which remain when the speaker is absent – and ultimately even when he is present. The whole onto-theological domain of originary self-presence undermined and restaged as an effect of writing, of an infinite series of substitutions, deferrals, and differentials.[10] This was heady, intoxicating and dangerous news in the 1970s when it hit the American academy. Could it be that not only linguistics, but all the human sciences, indeed all human knowledge, was about to be swallowed up in a new field called 'grammatology'? Could it be that our own anxieties about the boundlessness of visual studies are a replay of an earlier panic brought on by the news that there is 'nothing outside the text'?

One obvious connection between the two panic attacks is their common emphasis on *visuality* and *spacing*. Grammatology promoted the visible signs of written language, from pictographs to hieroglyphics to alphabetic scripts to the invention of printing and finally of digital media, from their status as parasitical supplements to an original, phonetic language-as-speech, to the position of primacy, as the general precondition for all notions of language, meaning, and presence. Grammatology challenged the primacy of language as invisible, authentic speech in the same way that iconology challenges the primacy of the unique, original artifact. A general condition of iterability or citationality – the repeatable acoustic image in one case, the visual image in the other – undermines the privilege of both visual art and literary language, placing them inside a larger field that, at first, seemed merely supplementary to them. 'Writing,' not so accidentally, stands at the nexus of language and vision, epitomized in the figure of the rebus or hieroglyphic, the 'painted word' or the visible language of a gesture-speech that precedes vocal expression.[11] Both grammatology and iconology, then, evoke the fear of the visual image, an iconoclastic panic that, in the one case, involves anxieties about rendering the invisible spirit of language in visible forms, in the other, the worry that the immediacy and concreteness of the visible image is in danger of being spirited away by the dematerialized, visual copy – a mere image of an image. It is no accident that Martin Jay's investigation of the history of philosophical optics is mainly a story of suspicion and anxiety about vision, or that my own explorations of 'iconology' tended to find a fear of imagery lurking beneath every theory of imagery.[12]

Defensive postures and territorial anxieties may be inevitable in the bureaucratic battlegrounds of academic institutions, but they are notoriously bad for the purposes of clear, dispassionate thinking. My sense is that visual studies is not quite

as dangerous as it has been made out to be (as, for instance, a training ground to 'prepare subjects for the next phase of global capitalism')[13] but that its own defenders have not been especially adroit in questioning the assumptions and impact of their own emergent field either. I want to turn, then, to a set of fallacies or myths about visual studies that are commonly accepted (with different value quotients) by both the opponents and proponents of this field. I will then offer a set of counter-theses which, in my view, emerge when the study of visual culture moves beyond these received ideas, and begins to define and analyze its object of investigation in some detail. I have summarized these fallacies and counter-theses in the following broadside (followed by a commentary). The broadside may be handy for nailing up on the doors of certain academic departments.

Critique: myths and counter-theses

Ten myths about visual culture

1 Visual culture entails the liquidation of art as we have known it.
2 Visual culture accepts without question the view that art is to be defined by its working exclusively through the optical faculties.
3 Visual culture transforms the history of art into a history of images.
4 Visual culture implies that the difference between a literary text and a painting is a non-problem. Words and images dissolve into undifferentiated 'representation.'
5 Visual culture implies a predilection for the disembodied, dematerialized image.
6 We live in a predominantly visual era. Modernity entails the hegemony of vision and visual media.
7 There is a coherent class of things called 'visual media.'
8 Visual culture is fundamentally about the social construction of the visual field. What we see, and the manner in which we come to see it, is not simply part of a natural ability.
9 Visual culture entails an anthropological, and therefore unhistorical, approach to vision.
10 Visual culture consists of 'scopic regimes' and mystifying images to be overthrown by political critique.

Eight counter-theses on visual culture

1 Visual culture encourages reflection on the differences between art and non-art, visual and verbal signs, and ratios between different sensory and semiotic modes
2 Visual culture entails a meditation on blindness, the invisible, the unseen, the unseeable, and the overlooked; also on deafness and the visible language of gesture; it also compels attention to the tactile, the auditory, the haptic, and the phenomenon of synesthesia.

3 Visual culture is not limited to the study of images or media, but extends to everyday practices of seeing and showing, especially those that we take to be immediate or unmediated. It is less concerned with the meaning of images than with their lives and loves.

4 There are no visual media. All media are mixed media, with varying ratios of senses and sign-types.

5 The disembodied image and the embodied artifact are permanent elements in the dialectics of visual culture. Images are to pictures and works of art as species are to specimens in biology.

6 We do not live in a uniquely visual era. The 'visual' or 'pictorial turn' is a recurrent trope that displaces moral and political panic onto images and so-called visual media. Images are convenient scapegoats, and the offensive eye is ritually plucked out by ruthless critique.

7 Visual culture is the visual construction of the social, not just the social construction of vision. The question of visual *nature* is therefore a central and unavoidable issue, along with the role of animals as images and spectators.

8 The political task of visual culture is to perform critique without the comforts of iconoclasm.

Note: most of the fallacies above are quotations or close paraphrases of statements by well-known critics of visual culture. A prize will be awarded to anyone who can identify all of them.

Commentary

If there is a defining moment in the concept of visual culture, I suppose it would be in that instant that the hoary concept of 'social construction' made itself central to the field. We are all familiar with this 'Eureka!' moment, when we reveal to our students and colleagues that vision and visual images, things that (to the novice) are apparently automatic, transparent, and natural, are actually symbolic constructions, like a language to be learned, a system of codes that interposes an ideological veil between us and the real world.[14] This overcoming of what has been called the 'natural attitude' has been crucial to the elaboration of visual studies as an arena for political and ethical critique, and we should not underestimate its importance.[15] But if it becomes an unexamined dogma, it threatens to become a fallacy just as disabling as the 'naturalistic fallacy' it sought to overturn. To what extent is vision *unlike* language, working (as Roland Barthes observed of photography) like a 'message without a code'?[16] In what ways does it *transcend* specific or local forms of 'social construction' to function like a universal language that is relatively free of textual or interpretive elements? (We should recall that Bishop Berkeley, who first claimed that vision was like a language, also insisted that it was a universal language, not a local or national language).[17] To what extent is vision *not* a 'learned' activity, but a genetically determined capacity, and a programmed set of automatisms that has to be activated at the right time, but that are not learned in anything like the way that human languages are learned?

A dialectical concept of visual culture leaves itself open to these questions rather than foreclosing them with the received wisdom of social construction and linguistic models. It expects that the very notion of vision as a *cultural* activity necessarily entails an investigation of its non-cultural dimensions, its pervasiveness as a sensory mechanism that operates in animal organisms all the way from the flea to the elephant. This version of visual culture understands itself as the opening of a dialogue with visual *nature*. It does not forget Lacan's reminder that 'the eye goes back as far as the species that represent the appearance of life,' and that oysters are seeing organisms.[18] I does not content itself with victories over 'natural attitudes' and 'naturalistic fallacies,' but regards the seeming naturalness of vision and visual imagery as a problem to be explored, rather than a benighted prejudice to be overcome.[19] In short, a dialectical concept of visual culture cannot rest content with a definition of its object as the 'social construction of the visual field,' but must insist on exploring the chiastic reversal of this proposition, *the visual construction of the social field*. It is not just that we see the way we do because we are social animals, but also that our social arrangements take the forms they do because we are seeing animals.

The fallacy of overcoming the 'naturalistic fallacy' (we might call it 'the naturalistic fallacy fallacy,' or 'naturalistic fallacy²') is not the only received idea that has hamstrung the embryonic discipline of visual culture.[20] The field has trapped itself inside of a whole set of related assumptions and commonplaces that, unfortunately, have become the common currency of both those who defend and attack visual studies as a dangerous supplement to art history and aesthetics. Here is a resumé of what might be called the 'constitutive fallacies' or myths of visual culture, as outlined in the broadside above.

1 That visual culture means an end to the distinction between artistic and non-artistic images, a dissolving of the history of art into a history of images. This might be called the 'democratic' or 'leveling' fallacy, and it is greeted with alarm by unreconstructed high modernists and old fashioned aesthetes, and heralded as a revolutionary breakthrough by the theorists of visual culture. It involves related worries (or elation) at the leveling of semiotic distinctions between words and images, digital and analog communication, between art and non-art, and between different kinds of media, or different concrete artifactual specimens.

2 That it is a reflex of, and consists in a 'visual turn' or 'hegemony of the visible' in modern culture, a dominance of visual media and spectacle over the verbal activities of speech, writing, textuality, and reading. It is often linked with the notion that other sensory modalities such as hearing and touch are likely to atrophy in the age of visuality. This might be called the fallacy of the 'pictorial turn,' a development viewed with horror by iconophobes and opponents of mass culture, who see it is as the cause of decline in literacy, and with delight by iconophiles who see new and higher forms of consciousness emerging from the plethora of visual images and media.

3 That the 'hegemony of the visible' is a Western, modern invention, a product of new media technologies, and not a fundamental component of human cultures as such. Let's call this the fallacy of technical modernity, a received idea which never fails to stir the ire of those who study non-Western and non-

modern visual cultures, and which is generally taken as self-evident by those who believe that modern technical media (television, cinema, photography, the internet) simply *are* the central content and determining instances of visual culture.

4 That there are such things as 'visual media,' typically exemplified by film, photography, video, television, and the internet. This, the fallacy of the 'visual media,' is repeated by both sides as if it denoted something real. When media theorists object that it might be better to think of at least some of these as 'audio-visual' media, or composite, mixed media that combine image and text, the fall-back position is an assertion of the dominance of the visual in the technical, mass media. Thus it is claimed that 'we watch television, we don't listen to it,' an argument that is clinched by noting that the remote control has a mute button, but no control to blank out the picture.

5 That vision and visual images are expressions of power relations in which the spectator dominates the visual object and images and their producers exert power over viewers. This commonplace 'power fallacy' is shared by opponents and proponents of visual culture who worry about the complicity of visual media with regimes of spectacle and surveillance, the use of advertising, propaganda, and snooping to control mass populations and erode democratic institutions. The split comes over the question of whether we need a discipline called 'visual culture' to provide an oppositional critique of these 'scopic regimes,' or whether this critique is better handled by sticking to aesthetics and art history, with their deep roots in human values, or media studies, with its emphasis on institutional and technical expertise.

It would take many pages to refute each of these received ideas in detail. Let me just outline the main theses of a counterposition that would treat them as I have treated the naturalistic fallacy fallacy, not as axioms of visual culture, but as invitations to question and investigate.

1 The democratic or 'levelling' fallacy. There is no doubt that many people think the distinction between high art and mass culture is disappearing in our time, or that distinctions between media, or between verbal and visual images, are being undone. The question is: is it true? Does the blockbuster exhibition mean that art museums are now mass media, indistinguishable from sporting events and circuses? Is it really that simple? I think not. The fact that some scholars want to open up the 'domain of images' to consider both artistic and non-artistic images does not automatically abolish the differences between these domains.[21] One could as easily argue that, in fact, the boundaries of art/non-art only become clear when one looks at both sides of this evershifting border and traces the transactions and translations between them. Similarly, with semiotic distinctions between words and images, or between media types, the opening out of a general field of study does not abolish difference, but makes it available for investigation, as opposed to treating it as a barrier that must be policed and never crossed. I have been working between literature and visual arts, and between artistic and non-artistic images for the last three decades, and I have never found myself confused about which was

which, though I have sometimes been confused about what made people so
anxious about this work. As a practical matter, distinctions between the arts
and media are ready-to-hand, a vernacular form of theorizing. The difficulty
arises (as Lessing noted long ago in his *Laocoon*), when we try to make these
distinctions systematic and metaphysical.[22]

2 The fallacy of a 'pictorial turn.' Since this is a phrase that I have coined,[23] I'll
try to set the record straight on what I meant by it. First, I did not mean to
make the claim that the modern era is unique or unprecedented in its obses-
sion with vision and visual representation. My aim was to acknowledge the
perception of a 'turn to the visual' or to the image as a *commonplace*, a thing
that is said casually and unreflectively about our time, and is usually greeted
with unreflective assent both by those who like the idea and those who hate
it. But the pictorial turn is a *trope*, a figure of speech that has been repeated
many times since antiquity. When the Israelites 'turn aside' from the invisible
god to a visible idol, they are engaged in a pictorial turn. When Plato warns
against the domination of thought by images, semblances, and opinions in the
allegory of the cave, he is urging a turn away from the pictures that hold human-
ity captive and toward the pure light of reason. When Lessing warns, in the
Laocoon, about the tendency to imitate the effects of visual art in the literary
arts, he is trying to combat a pictorial turn that he regards as a degradation of
aesthetic and cultural proprieties. When Wittgenstein complains that 'a picture
held us captive' in the *Philosophical Investigations*, he is lamenting the rule of a
certain metaphor for mental life that has held philosophy in its grip.

　　The pictorial or visual turn, then, is not unique to our time. It is a repeated
narrative figure that takes on a very special form in our time, but which seems
to be available in its schematic form in an innumerable variety of circum-
stances. A critical and historical use of this figure would be as a diagnostic tool
to analyze specific moments when a new medium, a technical invention, or a
cultural practice erupts in symptoms of panic or euphoria (usually both) about
'the visual.' The invention of photography, of oil painting, of artificial perspec-
tive, of sculptural casting, of the internet, of writing, of mimesis itself are
conspicuous occasions when a new way of making visual images seemed to
mark a historical turning point for better or worse. The mistake is to construct
a grand binary model of history centered on just one of these turning points,
and to declare a single 'great divide' between the 'age of literacy' (for instance)
and the 'age of visuality.' These kinds of narratives are beguiling, handy for
the purposes of presentist polemics, and useless for the purposes of genuine
historical criticism.

3 It should be clear, then, that the supposed 'hegemony of the visible' in our
time (or in the ever-flexible period of 'modernity,' or the equally flexible
domain of 'the West') is a chimera that has outlived its usefulness. If visual
culture is to mean anything, it has to be generalized as the study of all the
social practices of human visuality, and not confined to modernity or the West.
To live in any culture whatsoever is to live in a visual culture, except perhaps
for those rare instances of societies of the blind, which for that very reason
deserve special attention in any theory of visual culture.[24] As for the question
of 'hegemony,' what could be more archaic and traditional than the prejudice

in favor of sight? Vision has played the role of the 'sovereign sense' since God looked at his own creation and saw that it was good, or perhaps even earlier when he began the act of creation with the division of the light from the darkness. The notion of vision as 'hegemonic' or non-hegemonic is simply too blunt an instrument to produce much in the way of historical or critical differentiation. The important task is to describe the specific relations of vision to the other senses, especially hearing and touch, as they are elaborated within particular cultural practices. Descartes regarded vision as simply an extended and highly sensitive form of touch, which is why (in his *Optics*) he compared eyesight to the sticks a blind man uses to grope his way about in real space. The history of cinema is in part the history of collaboration and conflict between technologies of visual and audio reproduction. The evolution of film is in no way aided by explaining it in terms of received ideas about the hegemony of the visible.

4 Which leads us to the fourth myth, the notion of 'visual media.' I understand the use of this phrase as a shorthand figure to pick out the difference between (say) photographs and phonograph records, or paintings and novels, but I do object to the confident assertion that 'the' visual media are really a distinct class of things, or that there is such a thing as an exclusively, a purely visual medium.[25] Let us try out, as a counter-axiom, the notion that all media are mixed media, and see where that leads its. One place it will not lead us is into misguided characterizations of audio-visual media like cinema and television as if they were exclusively or 'predominantly' (echoes of the hegemonic fallacy) visual. The postulate of mixed, hybrid media leads us to the specificity of codes, materials, technologies, perceptual practices, sign-functions, and institutional conditions of production and consumption that go to make up a medium. It allows us to break up the reification of media around a single sensory organ (or a single sign-type, or material vehicle) and to pay attention to what is in front of us. Instead of the stunning redundancy of declaring literature to be a 'verbal and not a visual medium,' for instance, we are allowed to say what is true: that literature, insofar as it is written or printed, has an unavoidable visual component which bears a specific relation to an auditory component, which is why it makes a difference whether a novel is read aloud or silently. We are also allowed to notice that literature, in techniques like ekphrasis and description, as well as in more subtle strategies of formal arrangement, involves 'virtual' or 'imaginative' experiences of space and vision that are no less real for being indirectly conveyed through language.

5 We come finally to the question of the power of visual images, their efficacy as instruments or agents of domination, seduction, persuasion, and deception. This topic is important because it exposes the motivation for the wildly, varying political and ethical estimations of images, their celebration as gateways to new consciousness, their denigration as hegemonic forces, the need for policing and thus reifying the differences between 'the visual media' and the others, or between the realm of art and the wider domain of images.

While there is no doubt that visual culture (like material, oral, or literary culture) can be an instrument of domination, I do not think it is productive to single

out visuality or images or spectacle or surveillance as the exclusive vehicle of polit-
ical tyranny. I wish not to be misunderstood here. I recognize that much of the
interesting work in visual culture has come out of politically motivated scholar-
ship, especially the study of the construction of racial and sexual difference in the
field of the gaze. But the heady days when we were first discovering the 'male gaze'
or the feminine character of the image are now well behind us, and most scholars
of visual culture who are invested in questions of identity are aware of this.
Nevertheless, there is an unfortunate tendency to slide back into reductive treat-
ments of visual images as all-powerful forces and to engage in a kind of iconoclastic
critique which imagines that the destruction or exposure of false images amounts
to a political victory. As I've said on other occasions, 'Pictures are a popular political
antagonist because one can take a tough stand on them and yet, at the end of the
day, everything remains pretty much the same. Scopic regimes can be overturned
repeatedly without any visible effect on either visual or political culture.'[26]

I propose what I hope is a more nuanced and balanced approach located in the
equivocation between the visual image as instrument and agency, the image as a
tool for manipulation, on the one hand, and as an apparently autonomous source
of its own purposes and meanings on the other. This approach would treat visual
culture and visual images as 'go-betweens' in social transactions, as a repertoire
of screen images or templates that structure our encounters with other human
beings. Visual culture would find its primal scene, then, in what Emmanuel Levinas
calls the face of the Other (beginning, I suppose, with the face of the Mother): the
face to face encounter, the evidently hard-wired disposition to recognize the eyes
of another organism (whlat Lacan and Sartre call the gaze). Stereotypes, caricatures,
classificatory figures, search images, mappings of the visible body, of the social
spaces in which it appears would constitute the fundamental elaborations of visual
culture on which the domain of the image – and of the Other – is constructed.
As go-betweens or 'subaltern' entities, these images are the filters through which
we recognize and of course misrecognize other people. They are the paradoxical
mediations which make possible what we call the 'unmediated' or 'face to face'
relations that Raymond Williams postulates as the origin of society as such. And
this means that 'the social construction of the visual field' has to be continuously
replayed as 'the visual construction of the social field,' an invisible screen or lattice-
work of apparently unmediated figures that makes the effects of mediated images
possible.

Lacan, you will recall, diagrams the structure of the scopic field as a cat's cradle
of dialectical intersections with a screened image at its center. The two hands that
rock this cradle are the subject and the object, the observer and the observed. But
between them, rocking in the cradle of the eye and the gaze, is this curious inter-
mediary thing, the image and the screen or medium in which it appears. This
phantasmatic 'thing' was depicted in ancient optics as the 'eidolon,' the projected
template hurled outward by the probing, seeking eye, or the simulacrum of the
seen object, cast off or 'propagated' by the object like a snake shedding its skin in
an infinite number of repetitions. See David Lindbergh, *Ancient Optical Theory: Optics
from Al-Kindi to Kepler* (Chicago: University of Chicago Press, 1981). Both the
extramission and intramission theory of vision share the same picture of the visual
process, differing only in the direction of the flow of energy and information. This

ancient model, while no doubt incorrect as an account of the physical and physio-logical structure of vision, is still the best picture we have of vision as a psycho-social process. It provides an especially powerful tool for understanding why it is that images, works of art, media, figures and metaphors have 'lives of their own,' and cannot be explained simply as rhetorical, communicative instruments or epistemo-logical windows onto reality. The cat's cradle of intersubjective vision helps us to see why it is that objects and images 'look back' at us; why the 'eidolon' has a tendency to become an idol that talks back to us, gives orders, and demands sacri-fices; why the 'propagated' image of an object is so efficacious for propaganda, so fecund in reproducing an infinite number of copies of itself. It helps us to see why vision is never a one-way street, but a multiple intersection teeming with dialec-tical images, why the child's doll has a playful half-life on the borders of the animate and inanimate, and why the fossil traces of extinct life are resurrected in the beholder's imagination. It makes it clear why the questions to ask about images are not just 'what do they mean?' or 'what do they do?' but 'what is the secret of their vitality?' and 'what do they want?'

Showing seeing

I want to conclude by reflecting on the disciplinary location of visual studies. I hope it's clear that I have no interest in rushing out to establish programs or departments. The interest of visual culture seems to me to reside precisely at the transitional points in the educational process – at the introductory level (what we used to call 'Art Appreciation'), at the passageway from undergraduate to graduate education, and at the frontiers of advanced research.[27] Visual studies belongs, then, in the freshman year in college, in the introduction to graduate studies in the humanities, and in the graduate workshop or seminar.

In all of these locations I have found it useful to return to one of the earliest pedagogical rituals in American elementary education, the 'show and tell' exercise. In this case, however, the object of the show and tell performance is the process of seeing itself, and the exercise could be called 'showing seeing.' I ask the students to frame their presentations by assuming that they are ethnographers who come from, and are reporting back to, a society that has no concept of visual culture. They cannot take for granted that their audience has any familiarity with everyday notions such as color, line, eye contact, cosmetics, clothing, facial expressions, mirrors, glasses, or voyeurism, much less with photography, painting, sculpture or other so-called 'visual media.' Visual culture is thus made to seem strange, exotic, and in need of explanation.

The assignment is thoroughly paradoxical, of course. The audience does in fact live in a visible world, and yet has to accept the fiction that it does not, and that everything which seems transparent and self-evident is in need of explanation. I leave it to the students to construct an enabling fiction. Some choose to ask the audience to close their eyes and to take in the presentation solely with their ears and other senses. They work primarily by description and evocation of the visual through language and sound, telling 'as,' rather than 'and' showing. Another strategy is to pretend that the audience has just been provided with prosthetic visual organs,

but do not yet know how to see with them. This is the favored strategy, since it allows for a visual presentation of objects and images. The audience has to pretend ignorance, and the presenter has to lead them toward the understanding of things they would ordinarily take for granted.

The range of examples and objects that students bring to class is quite broad and unpredictable. Some things routinely appear: eye-glasses are favorite objects of explanation, and someone almost always brings in a pair of 'mirror shades' to illustrate the situation of 'seeing without being seen,' and the masking of the eyes as a common strategy in a visual culture. Masks and disguises more generally are popular props. Windows, binoculars, kaleidoscopes, microscopes, and other pieces of optical apparatus are commonly adduced. Mirrors are frequently brought in, generally with no hint of an awareness of Lacan's mirror stage, but often with learned expositions of the optical laws of reflection, or discourses on vanity, narcissism, and self-fashioning. Cameras are often exhibited, not just to explain their workings, but to talk about the rituals and superstitions that accompany their use. One student elicited the familiar reflex of 'camera shyness' by aggressively taking snapshots of other members of the class. Other presentations require even fewer props, and sometimes focus directly on the body-image of the presenter, by way of attention to clothing, cosmetics, facial expressions, gestures, and other forms of 'body language.' I have had students conduct rehearsals of a repertoire of facial expressions, change clothing in front of the class, perform tasteful (and limited) evocations of a striptease, put on make-up (one student put on white face paint, describing his own sensations as he entered into the mute world of the mime; another introduced himself as a twin, and asked him to ponder the possibility that he might be his brother impersonating himself; still another, a male student, did a cross-dressing performance with his girlfriend in which they asked the question of what the difference is between male and female transvestism). Other students who have gifts with performance have acted out things like blushing and crying, leading to discussions of shame and self-consciousness at being seen, involuntary visual responses, and the importance of the eye as an expressive as well as receptive organ. Perhaps the simplest 'gadget-free' performance I have ever witnessed was by a student who led the class through an introduction to the experience of 'eye contact' which culminated in that old first-grade game, the 'stare-down' contest (the first to blink is the loser).

Without question, the funniest and weirdest show and tell performance that I have ever seen was by a young woman whose 'prop' was her nine-month-old baby boy. She presented the baby as an object of visual culture whose specific visual attributes (small body, large head, pudgy face, bright eyes) added up, in her words, to a strange visual effect that human beings call 'cuteness.' She confessed her inability to explain cuteness, but argued that it must be an important aspect of visual culture, because all the other sensory signals given off by the baby – smell and noise in particular – would lead us to despise and probably kill the object producing them, if it were not for the countervailing effect of 'cuteness.' The truly wondrous thing about this performance, however, was the behavior of the infant. While his mother was making her serious presentation, the baby was wiggling in her arms, mugging for the audience, and responding to their laughter – at first with fright, but gradually (as he realized he was safe) with a kind of delighted and aggressive showmanship. He began 'showing off' for the class while his mother tried, with frequent

interruptions, to continue her 'telling' of the visual characteristics of the human infant. The total effect was of a contrapuntal, mixed media performance which stressed the dissonance or lack of suturing between vision and voice, showing and telling, while demonstrating something quite complex about the very nature of the show and tell ritual as such.

What do we learn from these presentations? The reports of my students suggest that the 'showing seeing' performances are the thing that remains most memorable about the course, long after the details of perspective theory, optics, and the gaze have faded from memory. The performances have the effect of acting out the method and lessons of the curriculum, which is elaborated around a set of simple but extremely difficult questions: What is vision? What is a visual image? What is a medium? What is the relation of vision to the other senses? To language? Why is visual experience so fraught with anxiety and fantasy? Does vision have a history? How do visual encounters with other people (and with images and objects) inform the construction of social life? The performance of 'showing seeing' assembles an archive of practical demonstrations that can be referenced within the sometimes abstract realm of visual theory. It is astonishing how much clearer the Sartrean and Lacanian 'paranoid theories of vision' become after you have had a few performances that highlight the aggressivity of vision. Merleau-Ponty's abstruse discussions of the dialectics of seeing, the 'chiasmus' of the eye and the gaze, and the entangling of vision with the 'flesh of the world,' become much more down to earth when the spectator/spectacle has been visibly embodied and performed in the classroom.

A more ambitious aim of 'showing seeing' is its potential as a reflection on theory and method in themselves. As should be evident, the approach is informed by a kind of pragmatism, but not (one hopes) of a kind that is closed off to speculation, experiment, and even metaphysics. At the most fundamental level, it is an invitation to rethink what theorizing is, to 'picture theory' and 'perform theory' as a visible, embodied, communal practice, not as the solitary introspection of a disembodied intelligence.

The simplest lesson of 'showing seeing' is a kind of de-disciplinary exercise. We learn to get away from the notion that 'visual culture' is 'covered' by the materials or methods of art history, aesthetics, and media studies. Visual culture starts out in an area beneath the notice of these disciplines – the realm of non-artistic, non-aesthetic, and unmediated or 'immediate' visual images and experiences. It comprises a larger field of what I would call 'vernacular visuality' or 'everyday seeing' that is bracketed out by the disciplines addressed to visual arts and media. Like ordinary language philosophy and speech act theory, it looks at the strange things we do while looking, gazing, showing, and showing off – or while hiding, dissembling, and refusing to look. In particular, it helps us to see that even something as broad as 'the image' does not exhaust the field of visuality; that visual studies is not the same thing as 'image studies,' and that the study of the visual image is just one component of the larger field. Societies which ban images (like the Taliban) still have a rigorously policed visual culture in which the everyday practices of human display (especially of women's bodies) are subject to regulation. We might even go so far as to say that visual culture emerges in sharpest relief when the second commandment, the ban on the production and display of graven images, is observed most literally, when seeing is prohibited and invisibility is mandated.

One final thing the 'showing seeing' exercise demonstrates is that visuality, not just the 'social construction of vision,' but the visual construction of the social, is a problem in its own right that is approached, but never quite engaged by the traditional disciplines of aesthetics and art history, or even by the new disciplines of media studies. That is, visual studies is not merely an 'indiscipline' or dangerous supplement to the traditional vision-oriented disciplines, but an 'interdiscipline' that draws on their resources and those of other disciplines to construct a new and distinctive object of research. Visual culture is, then, a specific domain of research, one whose fundamental principles and problems are being articulated freshly in our time. The showing seeing exercise is one way to accomplish the first step in the formation of any new field, and that is to rend the veil of familiarity and awaken the sense of wonder, so that many of the things that are taken for granted about the visual arts and media (and perhaps the verbal ones as well) are put into question. If nothing else, it may send us back to the traditional disciplines of the humanities and social sciences with fresh eyes, new questions, and open minds.

Notes

1 I am grateful to Jonathan Bordo, James Elkins, Ellen Esrock, Joel Snyder, and Nicholas Mirzoeff for their valuable comments and advice.

2 For anyone interested in my previous stabs at them, however, see 'What is Visual Culture?' in *Meaning in the Visual Arts: Essays in Honor of Erwin Panofsky's 100th Birthday*, ed. Irving Lavin (Princeton: Princeton University Press, 1995) and 'Interdisciplinarity and Visual Culture,' *Art Bulletin* 77: 4 (December 1995).

3 If space permitted, I would insert here a rather lengthy footnote on the many kinds of work that have made it possible to even conceive of a field such as 'visual studies.'

4 This paper was first written for a conference on 'Art History, Aesthetics, and Visual Studies,' held at the Clark Institute, Williamstown, Mass., in May 2001.

5 For a discussion of the peculiar distancing between Visual Studies and Cinema Studies, see Anu Koivunen and Astrid Soderbergh Widding, 'Cinema Studies into Visual Theory?' in the on-line journal *Introduction*, at http://www.utu.fi/hum/etvtiede/preview.html. Other institutional formations that seem notably excluded are visual anthropology (which now has its own journal, with articles collected in *Visualizing Theory*, ed. Lucien Taylor (New York: Routledge, 1994), cognitive science (highly influential in contemporary film studies), and communications theory and rhetoric, which have ambitions to instal visual studies as a component of introductory college-level writing programs

6 In *Vision and Visuality* (Seattle: Bay Press, 1986).

7 See Crow's response to the questionnaire on visual culture in *October* no. 77 (Summer 1996).

8 For a masterly study of art historical mediations, see Robert Nelson, 'The Slide Lecture: The Work of Art History in the the Age of Mechanical Reproduction,' *Critical Inquiry* 26: 3 (Spring 2000).

9 I'm alluding here to a lecture entitled 'Straight Art history' given by O.K. Werckmeister at the Art Institute of Chicago several years ago. I have great respect for Werckmeister's work, and regard this lecture as a regrettable lapse from his usual rigor.

10 See Derrida, 'The Dangerous Supplement,' in *Of Grammatology* trans. Gayatri Spivak (Baltimore: Johns Hopkins University Press, 1978).

11 For further discussion of the convergence of painting and language in the written sign, see 'Blake's Wondrous Art of Writing,' in *Picture Theory* (Chicago, 1994).

12 Jay, *Downcast Eyes*; Mitchell, *Iconology*.

13 A phrase that appears in the *October* questionnaire on visual culture.

14 This defining moment had been rehearsed, of course, many times by art historians in their encounters with literary naiveté about pictures. One of the recurrent rituals in teaching interdisciplinary courses that draw students from both literature and art history is the moment when the art history students 'set straight' the literary folks about the non-transparency of visual representation, the need to understand the languages of gesture, costume, compositional arrangement, and iconographic motifs. The second, more difficult moment in this ritual is when the art historians have to explain why all these conventional meanings don't add up to a linguistic or semiotic decoding of pictures, why there is some non-verbalizable surplus in the image.

15 See Norman Bryson, 'The Natural Attitude,' chapter 1 of *Vision and Painting: The Logic of the Gaze* (New Haven: Yale University Press, 1983).

16 See Barthes, *Camera Lucida*, New York: Hill & Wang, 1982.

17 *A New Theory of Vision* (1709).

18 Lacan, 'The Eye and the Gaze,' in *Four Fundamental Concepts of Psychoanalysis* (New York: W.W. Norton, 1977), 91.

19 Bryson's denunciation of 'the natural attitude' which he sees as the common error of 'Pliny, Villani, Vasari, Berenson, and Francastel,' and no doubt the entire history of image theory up to his time. *Vision and Painting*, 7.

20 I owe this phrase to Michael Taussig, who developed the idea in our joint seminar, 'Vital Signs: The Life of Representations,' at Columbia University and NYU in the fall of 2000.

21 I am echoing here the title of James Elkin's recent book, *The Domain of Images*.

22 See the discussion of Lessing in *Iconology*, chapter 4.

23 *Picture Theory*, chapter 1.

24 See Jose Saramago's marvelous novel *Blindness* (New York: Harcourt, 1997), which explores the premise of a society suddenly plunged into an epidemic of blindness spread, appropriately enough, by eye contact.

25 See *Picture Theory* for a fuller discussion of the claim that 'all media are mixed media,' and especially the discussion of Clement Greenberg's search for optical purity in abstract painting. Indeed, unmediated vision itself is not a purely optical affair, but a coordination of optical and tactile information.

26 'What do pictures want?' *October* no. 77.

27 It may be worth mentioning here that the first course in Visual Culture ever offered at the University of Chicago was the 'Art 101' course I gave in the fall of 1991 with the marvelous assistance of Tina Yarborough.

Raiford Guins, Joanne Morra, Marquard Smith and Omayra Cruz

CONVERSATIONS IN VISUAL CULTURE[1]

Questioning the question: What is it?

WHAT IS VISUAL CULTURE? Such a question is complicated by the enormity of what visual culture can be understood to entail. After all, both the terms 'visual' and 'culture' have the potential to cover an already broad and extending diversity of experiences. In this instance, it is neither inappropriate to cite Martin Jay's observation that: 'Anything that can imprint itself on the retina has seemed fair game for the new paradigm, which prides itself on its democratic inclusivity' (1996: 42); nor is it inappropriate to cite Raymond Williams' renowned maxim that: 'Culture is one of the two or three most complicated words in the English language' (1976: 87). The expansiveness of these two terms is testament to the dynamics that have come to characterize two major conversations that we perceive to currently dominate the discourse of visual culture. For both proponents of and antagonists towards visual culture, these conversations revolve around the ontology of visual culture. The first conversation pertains to its definition. The second concerns its status.

With regards to the question 'What is it?' – on which the first conversation hinges – a series of questions have been asked: Is it a subject? Is it a discipline? Is it an object? Is it a field? Is visual culture an arena or an area? These questions are born of the necessary but dubious pleasures of definition, of staking a claim to knowledge patterned after the drive to classify. Invoking the question, 'What is it?' may be thought of in at least three ways. First, it may simply express a practical interest which asks: How is visual culture to be identified'? What are its composite parts? How does it account for itself? It says: I am interested in this thing called visual culture. Second, the question 'What is it?' resonates with a more sinister tone. It plays a notable part in the historical treatment of persons who have not conformed to sexual or gender normative standards, as well as racialized discourses that have

called the humanity of various individuals into question. For example, according to James W. Cook Jr's analysis of P.T. Barnum's 'What Is It'?' exhibition, Barnum used the term 'nondescript' to advertise his infamously dehumanizing display of an African American man marketed as a missing link. William Henry Johnson, who for decades played Barnum's 'What Is It?', was offered up as a liminal space over which the nation's conflicting ideologies during the late antebellum and Reconstruction eras could be voiced without any clear reference to US slavery. In short, 'What is it?' is, in this second sense, hardly an innocent question. It can either point to an entity, that has not yet been classified, that fails to confirm existent categorizing impulses, or that achieves 'the most liminal sense of *resisting* classification, or *straddling* descriptive boundaries' (1996: 147). This last point offers something other than the delimiting restrictions that one might first expect from the practice of classification. As Michel Foucault pointed out long ago in *The Order of Things* and *The Archaeology of Knowledge* as well as elsewhere, it is the clashing practice of organizing knowledge itself that puts the structure of knowledge under pressure.

This leads us to our third engagement with the question, 'What is it?', which is where we would like to begin our intervention into these debates. Specifically, how ought we to extricate ourselves from a potentially counterproductive ontological colossus while maintaining its myriad possibilities? Simply stated, we would like to pose the question 'What is it?' differently. We propose that the question may be asked from an epistemological rather than an ontological perspective. Such a shift involves drawing on the conversations surrounding visual culture's ontology to create an opening, an engagement with the question as a mode of speculative, self-reflective epistemology. As an epistemological question, 'What is it?' involves not an answer, but an interrogation of the query itself as it pertains to the formation of visual culture.[2]

To a certain extent, the work of delimiting visual culture has long been under way since the expansiveness associated with the term exerts a generative influence on the second conversation we have identified: its status. This second, more practical and institutionally minded conversation asks: Where does it go? Or more specifically, where is the study of visual culture to be housed, and how? From a different angle, where ought not and is not visual culture being allowed to dwell? The conversation around visual culture's status is primarily a matter of disciplinarity, of location – that is, of belonging. So where does visual culture belong given that the disciplines with which it has been associated – such as art history, media, film, architecture, and cultural studies – entail distinct histories, methodologies, formal interests, archives, and modalities of engagement? In addition, materially speaking, these disciplines do not generally share funding, space in the university, or even publication forums.

Where visual culture is located institutionally has been and arguably will continue to form the basis of its constitution as an academic discipline or field of study – which does not limit what visual culture might be able to *do*. People in the disciplines with which visual culture is associated do not always see eye to eye either with each other or with it. Indeed, they need not. Rather than accepting this potential impasse, perhaps visual culture can best be conceived of as a *district* within which, currently, a number of disciplinary interests reside. Anyone familiar with the workings of US and UK education or voting districts (or boroughs) is aware of their

frequently shifting parameters.[3] Formed for various political purposes, districts are a means of managing the administration of groups that may be, though are often not, homogenous. Although such groupings may coincide with established communities, and may from time to time promote the emergence of community, they need not be based on community. In the district of visual culture, we are neighbors. Some neighbors are friends, and to the rest it is worthwhile to be civil. Within this metaphorics, visual culture can be considered an epistemological district. An epistemological district would be an approach to the production of *relational* visual knowledges brought together to meet the needs of its disciplinary constituents. It is thus not based on an attempt to classify objects that are properly the domain of visual culture.

One might be inclined to argue that the last thing visual culture requires is additions to the fray of terms that are being contested under its name. However, following Williams's trajectory in *Keywords*, one is confronted with the question of what, more than vocabulary, can we bring to the practice of defining anything, much less so slippery and seductive an entity as visual culture. This said, our additions to the strategic vocabulary currently in place to address visual culture are the aforementioned use of the term district, and the forthcoming discussions of articulation and archives as a means of considering some of the circumstances that inform the complex constitution of visual culture today.

District, articulation and archives

A suggestion: visual culture can at this tumultuous moment in its history and ever-increasing institutionalization and formalization, continue to learn a great deal from other cross-disciplinary programs and fields currently districted within the Western academy. Ethnic, disability, African-American, queer, gender, and especially cultural studies offer visual culture ways (read epistemologies), in addition to those already historically specific to it, to critique the disparate range of subjects related to, emanating from, and working through the broadest possible notions of visuality and visual culture.

Cultural studies is privileged here because of its pronounced position as one of the main disciplines against which visual culture is being defined – art history being another (and this too will soon be discussed). Cultural studies is called upon to highlight the emergence of visual culture as a site for cross-disciplinary analysis. This has recently been noted in texts by Mirzoeff (1999), Evans and Hall (1999), and Sturken and Cartwright (2001). Our understanding of visual culture is to some extent contingent upon this relationship with cultural studies, and it is one from which we draw freely.

To this end, Stuart Hall's interpretation of 'articulation' is employed in a consideration of how and what visual culture can learn from cultural studies. In our attempt to articulate visual culture we proceed not to ask how visual culture *resembles* cultural studies, but rather how visual culture *articulates* its many diversified fields of vision and visual worlds. In examining this, we only ever suggest that different ideas, objects, and practices can be utilized to make connections within visual culture. Hall adopts the process of articulation to enable a complex discussion of the dynamic

between hegemonic and counter-hegemonic structuring of ideology that neither reduces the socio-political sphere to the level of discourse nor subsumes it to the banality of economic overdetermination. Epistemologically, articulation diverges from the bias that privileges the lasting as somehow more important and more real than transitory or ephemeral unities. Hall most clearly demonstrates this is in an interview with Lawrence Grossberg entitled 'On Postmodernism and Articulation.' He suggests that the English meanings of the term 'articulation' refer to both a practice of uttering or speaking something, and a very material form of connection – as in an articulated lorry (the relationship between a truck and its detachable load). The concept thus involves a sense of the productivity of language as related to material circumstance – and the agility and fleetingness of both. As Hall states:

> An articulation is thus the form of the connection that *can* make a unity of two different elements under certain conditions. It is a linkage which is not necessary, determined, absolute and essential for all time. You have to ask, under what circumstances *can* a connection be forged or made? [. . .] Thus, a theory of articulation is both a way of understanding how ideological elements come, under certain conditions, to cohere together with a discourse, and a way of asking how they do or do not become articulated, at specific conjunctures, to political subjects.
> (Grossberg 1996: 142–3)

By taking Hall's approach to articulation and translating it into a discussion of visual culture, it becomes possible to maintain that visual culture ought not be understood as merely an arbitrary formation. Visual culture is in large part a discursive construct, yet its discursive parameters have a complex history that is based on more than the material circumstances of its existence within institutions organized along strict rather than fluidic disciplinary lines. In terms of a discussion of visual culture, articulation provides a way of acknowledging the consequences of what are often strategic and transient interdisciplinary alliances and cross-identifications.

Articulation is a concept that we consider to be particularly suitable, perhaps necessary, to a discussion of visual culture. Our suggestion is not unique. Articulation is a word already used to discuss visual culture. For example, Irit Rogoff writes: 'If feminist deconstructive writing has long held the place of writing as the endless displacement of meaning, then visual culture provides the *visual articulation* of the continuous displacement of meaning in the field of vision and the visible' (1998: 15, italics added). Hall also takes great care to explicate his use of articulation as a process of linkage, wherein the connections made are historically located, transitory, and non-essentialist. The epistemological tools offered by Hall's 'articulation' and 'linkage' and Rogoff's 'displacement of meaning' can lead to an interrogation of the ways in which new knowledges are formed for visual culture. As a prelude to such a step, one should ask if the conjoining of these tools is viable and useful. If so, then what are the effects of these linkages and displacements in the practice of articulating visual culture's epistemological districts? One possible effect is the way in which the concept of linkage allows us to transform the question which haunts the present debates on visual culture from, What elements are enveloped

under the auspices of visual culture? to the discursive question of, What allows for a sense of heterogeneous unities to be achieved from such an articulation?

Hall purports that in order to make an articulation, one has to ask 'under what circumstances *can* a connection be forged or made?' (Grossberg 1996: 142). Within the academy, the conditions affecting visual culture result from its location and the rubric under which it is welcomed. We have put forward the 'district' metaphor rather than 'arena' or 'housing' because a district is neither lasting nor consistent. Moreover, it does not intrinsically posit a community. A district is not impermeable and concrete, but loosely organized according to various ideological shifts. Earlier we suggested that the broadest possible notion of the visual be implemented when districting visual culture; and it is now time for that earlier proposition to be transposed into this present discussion of articulation.

On the one hand, we are left to consider how investigations of visual culture and inquiries into the visual ought not to function in a limiting capacity; one that returns to the habitual act of a bounded and finite field. (Although, it must be noted that the 'disciplining' of visual culture will inevitably lead to such demarcations, even within an interdisciplinary framework.) To conceive of visual culture as confined to a static disciplinary regime is to impose restrictions. To district visual culture according to a specific medium or to center it exclusively on a thematics, such as a concern for consumption over production of the image, circumvents certain possibilities. On the other hand, one has no difficulty expanding even Jay's elastic, 'Anything that can imprint itself on the retina,' to include the more abstract and metaphorical uses of the visual and its related historical concept of vision, as well as their impact upon social and subjective formations. The possible benefits of a broad usage of 'the visual' are not *a priori* determined by what already counts as visual culture, but by *how* something becomes, and is articulated as visual culture.

On this question of history, the *October* 'Questionnaire' on visual culture, for example, worries over an elision of 'the model of history' within visual culture, and its replacement with 'the model of anthropology' (*October* 1996: 25). The 'Questionnaire' warns against this shift from an historical to a more cultural model of understanding social and subjective formation largely derived from the perspective of anthropology. The most important stake in such a shift, one that is not necessarily rendered apparent in the questions, is the relationship of culture to history. To return to Williams's definition of 'culture' in *Keywords*, our contemporary use of the term is a modern invention of the late eighteenth and nineteenth century. If we recognize Williams's historicization of culture, and relationship to history, then the name of visual culture already speaks its reliance on history. However, if history is not acknowledged as an integral component of any discussion of culture, visual or otherwise, then it would be invaluable for visual culture to put forth a concept of history that precedes and parallels the modern construction of the notion of culture, as well as any investigation of culture. Here, art history, with its reliance on history, and its interrogation of its own understanding of history, becomes a toolbox from which to borrow concepts of history and historiography for visual culture. Depending on where one wishes to borrow, history is of utmost importance and necessary to visual culture. It allows fertile analysis of vision and visual representation within an historical framework. The districting,

articulation and archives of visual culture depend upon historical investigation for epistemological, and by extension, ontological renegotiation.

To develop this suggestion, a discussion of archive is required. Jacques Derrida, for instance, and Walter Benjamin, Siegfried Kracauer, Aby Warburg and Michel Foucault before him, have considered the problematic of the archive in ways that can enable an articulation of the districts of visual culture, its linkages and displacements. In *Archive Fever,* Derrida formulates the duality of the archive as both a commencement in 'the *physical, historical* or *ontological* sense,' and the place of order and jurisprudence in which laws find 'consignation' in a heterogeneous 'topology' (1996: 2–3). For our purposes, the archive becomes a strategy for recognizing the mobile structures of visual culture as possibility. If visual culture functions as an archive, heterogeneous visual consignations are structurally, discursively, legally, historically, materially, and ontologically determined and overdetermined. They adhere to and resist their disciplinary habitats, thereby articulating and districting new knowledges. Each encounter with an archive reanimates it differently.

To unify according to the structure of archives and articulation forces a plurality of linkages across disciplinary boundaries. This does not entail a 'free-for-all.' Visual culture's propensity to form links across these boundaries raises the following questions: What happens to the boundaries crossed? Relatedly, can they be maintained? At another level, what happens to the knowledges and methodologies within those boundaries? Borders that are traversed are transformed. The intersection of boundaries constitutes a form of union, which as Hall suggests, reconfigures how the disparate elements can be known. Knowledges may be lost; new knowledge may be created. What warrants an articulation is the recognized, if not habitual boundaries, that are discomfited, overcome, and transformed anew. Therefore, visual culture is concerned with districting and archiving contingent and heterogeneous gatherings, and the mutations resulting from such consignations. Visual culture has the capacity to be articulated and practiced within and between existing disciplinary boundaries.

Visual culture exists. We speak of it. We participate in it. To articulate, district and archive visual culture is to enunciate the connections that it has generated and generates, with an eye towards the contingency that was and is both its limitation and its condition of possibility. Surely for the moment, it is not so much what visual culture *is*, but rather what it can be enabled to *do* that matters.

Notes

1 The four of us come from a film studies program; a school of art, publishing and music; a school of art, film and visual media; and a department of literature with a cultural studies component. It is in bringing together these fairly diverse fields of study that we suggest visual culture may be considered via the conversations that take place around it, and that it can generate between and within disciplines.

2 Prior to answering the question 'What is visual culture?', it is useful to note the problems associated with its naming. The difficulties in naming are illustrated by two very different takes on it: Michael Ann Holly's interrogation 'What does visual culture study?' (1996: 40); and Geoff Waite's separation of 'visual studies (our subject) [and] visual culture (our object)' (1996: 63). One of the interesting

points about this example is the fact that visual culture is being used both as a noun – an object of study – and as a verb – the practice of studying. This careful and intentional use of the term visual culture is testament to the problematic of naming a difference. Often this difference appears as a slippage and interchangeability between the names visual culture, visual studies, and visual cultural studies (which may also be included in this grouping). Both of these situations highlight an ontological crisis of nomenclature associated with visual culture.

3 We acknowledge the danger of comparing a suspect political process to the workings of the academy. However, a sensitive use of districting and its practices may still produce worthwhile if unexpected epistemological gains.

References

Cook, James W. Jr. (1996) 'Of Men, Missing Links, and Nondescripts: The Strange Career of P.T. Barnum's "What Is It?" Exhibition' in Rosemarie Garland Thomson (ed.) *Freakery: Cultural Spectacles of the Extraordinary Body,* New York: New York University Press.

Derrida, Jacques (1996) *Archive Fever: A Freudian Impression,* trans. Eric Prenowitz, Chicago: University of Chicago Press.

Evans, Jessica and Hall, Stuart (1999) *Visual Culture: A Reader,* London: Sage.

Grossberg, Lawrence (1996) 'On postmodernism and articulation: an interview with Stuart Hall' in David Morley and Kuan-Hsing Chen (eds), *Stuart Hall: Critical Dialogues in Cultural Studies*, London: Routledge.

Holly, Michael Ann (1996) 'Saints and Sinners,' *October* 77, Summer: 39–41.

Jay, Martin (1996) 'Visual Culture and Its Vicissitudes,' *October* 77, Summer: 43–4.

Mirzoeff, Nicholas (1999) *An Introduction to Visual Culture,* London: Routledge.

October (1996), 'Visual Culture Questionnaire,' *October* 77, Summer: 25–70.

Rogoff, Irit (1998) 'Studying Visual Culture' in N. Mirzoeff (ed.) *An Introduction to Visual Culture*, London; Routledge.

Sturken, Marita, and Cartwright, Lisa (2001) *Practices of Looking: An Introduction to Visual Culture*, Oxford: Oxford University Press.

Waite, Geoff (1996) 'The Paradoxical Task . . . (Six Thoughts),' *October* 77, Summer: 63–7.

Williams, Raymond (1976) *Keywords: A Vocabulary of Culture and Society*, London: Fontana Press.

Plug-in theory

Introduction to Plug-in theory

■ Nicholas Mirzoeff

T HE INTENT OF THIS SECTION of the Reader is to add a range of often-cited theoretical materials to back up the longer excerpts and essays in other sections, though it can also be read in its own right. I have tried to pick some key moments in the theorization of visual culture that can be 'plugged in' to other readings. These clips are on the whole much shorter than elsewhere, although I have added some of the materials from the first edition of the Reader to this section.

• **Descartes**'s theory of optics is the visual dimension to what has so often been referred to in recent critical work as the Cartesian self. It is included here, then, not so much as a gesture to the history of optics but as a still active part of contemporary critical discourse. Descartes's work was both more skeptical of vision and placed more reliance on it than that of his classically trained predecessors.

• **Marx** is back in vogue these days, being cited in the *New Yorker* magazine and *Wall Street Journal* as an early prophet of globalization. The notion of commodity fetishism that Marx introduces here is certainly indispensable to consumer culture. Arguing that our desire for commodities is not connected to their usefulness, Marx defines them as 'sensuous things which are at the same time suprasensual or social. In the same way, the impression made by a thing on the optic nerve is perceived not as a subjective excitation of the nerve but as the objective form of the thing outside the eye.' Visual culture, then, transforms the physical into the social. By contrast, the commodity-form – what we see in advertisements or on the shelf – generates its own autonomous life, entering into relations both with other commodity-forms and with people. This unreal relation that is nonetheless 'inseparable from the production of commodities' is what Marx called fetishism.

- Fetishism is not a neutral term. Long before Marx's appropriation of the term, Europeans had called African religion 'fetishism,' meaning by this a derogatory (and inaccurate) description of the supposed African belief in the powers of inanimate objects. The long history of slavery and colonialism that produced such attitudes generated W.E.B. **Dubois**'s famous concept of 'double-consciousness.' That is to say, writing as he was in the first years of the twentieth century, Dubois perceived that the African American was regarded as a 'problem' by his 'white' peers. This 'color-line' created what Dubois called a 'second sight': 'It is a peculiar sensation, this double-consciousness, this sense of always looking at oneself through the eyes of others ... One ever feels his twoness, – an American, a Negro.' The color-line was visualized as a social fact and became one that Dubois rightly predicted would be one of the key problems of the century.

- The two-fold nature of looking described by Dubois was later theorized as the 'gaze' by the psychoanalyst Jacques **Lacan**. Although his work was extremely controversial in clinical psychoanalysis, Lacan's theories have had enormous influence in visual culture. Lacan argued that all seeing is the intersection of the gaze and the subject of representation, that is to say, the viewer: 'in the scopic field, the gaze is outside, I am looked at, that is to say, I am a picture.' The effects of the gaze can be felt in the sensation of being looked at, that can also be a sexual or gender surveillance, or the racialized distinction highlighted by Dubois. The consequence is 'a fracture, a bi-partition, a splitting of the being' from which Lacan draws wide consequences in terms of philosophical knowledge and gender identification. What we call vision takes place at the screen, the point of intersection between the subject and the gaze that becomes a quite crucial 'locus of mediation.' These ideas were indispensable to the formation of film theory in the 1970s, perhaps especially Laura Mulvey's theory of the gendered gaze in which the 'masculine' actively looks, while the 'feminine' is that which is looked at.

- Frantz **Fanon** was a practicing psychoanalyst from the Caribbean island of Martinique, then a French colony. His work in Algeria and his personal experience of the Caribbean were combined in his theoretical work, such as this excerpt from *Black Skin, White Masks*. Fanon recalls a moment in his childhood when another (white) child calls out to his mother on seeing the young Fanon: 'Look! A Negro.' Lacan's theory of the gaze and Dubois's analysis of the formation of double-consciousness meet in this moment, emblazoned on Fanon's memory. 'Race' is not inherent but is added to our bodies by the careful surveillance by others. What is especially chilling about Fanon's recollection is that it was a child policing the color line, so early are these distinctions socialized into people.

- Marshall **McLuhan**'s essay 'Woman in a Mirror' uses psychoanalysis to work on what Marx would have called commodity fetishism. McLuhan reads an advertisement for nylons like a Picasso painting to show that it works on an unconscious association of the rearing stallion as a sexualized symbol of 'brutal violation' with the image of the 'familiar Hollywood Bergman type ... of

"good girl". Referring to Ingrid Bergman, star of *Casablanca*, McLuhan points out that this technique of juxtaposition permits the advertiser to say 'what could never pass the censor of consciousness.' Or at least not in 1951. Our current culture considers itself far more sophisticated and mature, ironizing both the hard sell and the sexualized 'come-on' of advertising. But the products themselves still sell rather well.

- Roland **Barthes** used an everyday commodity to exemplify his analysis of the rhetoric of the image. He challenged those who saw the image as an 'extremely rudimentary system in comparison with language' in his reading of another advertisement, this time for pasta. He describes at least four kinds of sign at work in the simple image that can variously be described as linguistic or iconic. In addition to these layers, a third term can be discerned that Barthes called a 'message without a code,' the directness of the relationship between the objects themselves and their representations. At a certain point, it is necessary to recognize the image as an image. Within the visual image is a structural split analogous to that between the signifier (pattern of letters and sounds) and signified (the meaning) in a word. The literal message of the object's existence becomes what Barthes called the 'support' for the cultural meanings to be deduced within it. The literal meaning is thus denoted, whereas the symbolic meaning is connoted and thereby opens itself to dispute and debate.

- In his theory derived from both Marx and Lacan, the French philosopher Louis **Althusser** called this process 'interpellation.' Althusser wanted to question the 'obviousness' of each person thinking themselves to be an individual subject. Rather than taking place at some exalted philosophical or religious level, Althusser argues that it is a social process but one that is constitutive of what it is to be a social being. He names this interactive category 'ideology' that causes us to recognize the 'obvious' as 'true.' When someone comes to the door and says 'It's me,' we accept this and immediately find that it is true. Althusser generates a first principle from this notion that: 'all ideology hails or interpellates concrete individuals as concrete subjects.' This theory of interpellation continues to underwrite much contemporary work in identity politics, especially in the examination of moments that refuse to be 'obvious.'

- *Society of the Spectacle*, by the founder of the Situationist International, Guy Debord, was perhaps the first text to emphasize the visual spectacle of everyday life in late capitalism. For Debord, 'all that once was directly lived has become mere representation.' The spectacle, as he termed it, was a fallen state, 'an inversion of life.' For all his anger, Debord's analysis was acute. He saw that the spectacle was not simply an accumulation of images but 'a social relationship that is mediated by images.' This relationship was global and at root economic: 'the spectacle is *capital* accumulated to the point where it becomes image.' Read together in the later 1960s and early 1970s, Althusser and Debord contributed to a revision of Marx's critique of capital that was enormously influential on the formation of British cultural studies, especially in the work of Stuart Hall, Dick Hebdige and Angela McRobbie (to name but three).

- The philosophy of Jean **Baudrillard** has become widely cited in the mass media, as well as in academic circles, for his prescient evocation of the contemporary moment as being the era of the simulacrum. In Baudrillard's view, representation precedes reality in what he has famously called 'the precession of simulacra.' In this environment the real dissolves into the hyperreal, a culture in which Disneyland is not a distraction from reality, it is what is left of reality: 'it is a question of substituting signs of the real for the real itself.' Baudrillard consistently enrages his critics by denying the surface appearance of events, as in his pamphlet 'The Gulf War Never Happened,' but his insights are not so easy to dispose of.

- In her landmark study *Gender Trouble* (1990), the philosopher Judith **Butler** challenged the then conventional view that while gender was cultural, sex was natural. Rather she insisted that all questions of gendered and sexualized identity were the product of a certain performance, within a necessarily limited range of possibilities. Building on the psychoanalyst Joan Riviere's refusal to 'draw the line between genuine womanliness and the "masquerade,"' Butler argues that 'gender is not written on the body' but rather is a 'stylized repetition of acts.' Through such repetition, gender comes to seem 'natural' but it can also be challenged. In the decade since Butler's book was published, drag has become sufficiently widely accepted that the conservative mayor of New York Rudolph Giuliani — who in other contexts likes to censor art — jumps into high heels at every opportunity. Today gender is normally in trouble, thanks in some considerable part to Judith Butler's work.

- N. Katherine **Hayles** holds PhD degrees in both science and humanities, placing her in the perfect situation to analyze the new technological culture. In her already classic reading of information as culture, Hayles argues that information is structured around the alternance of pattern and randomness. It is important to realize, however, that information can be both pattern *and* randomness. What is striking is the interface created by information media, a complex space 'in which discursive formations based on pattern and randomness jostle and compete with formations based on presence and absence.' Thus the era of information technology changes both the body of the user and the means of representation, a connection Hayles calls 'the virtual body and the flickering signifier.'

Further reading

Althusser, Louis (1977) *Essays on Ideology*, London: Verso.

Barthes, Roland (1977) *Image Music Text*, New York: Hill & Wang.

Baudrillard, Jean (1988) *Jean Baudrillard: Selected Writings*, Mark Poster (ed.), Stanford: Stanford University Press.

Butler, Judith (1990) *Gender Trouble*, London and New York: Routledge, 2nd edn 1999.

Debord, Guy (1994) *The Society of the Spectacle,* New York: Zone Books.

Derrida, Jacques (1994) *The Derrida Reader*, Lincoln: University of Nebraska Press.

Fanon, Frantz (1967) *Black Skin, White Masks*, New York: Grove Press.

Foucault, Michel (1972) *The Archaeology of Knowledge*, London: Tavistock.

Hayles, N. Katherine (1999) *How We Became Posthuman*, Chicago: University of Chicago Press.

Lacan, Jacques (1977) *Ecrits: A Selection*, London: Tavistock.

Lyotard, Jean-François (1989) *The Lyotard Reader*, Oxford and New York: Blackwell.

McLuhan, Marshall (1967) *The Mechanical Bride: Folklore of Industrial Man*, New York: Vanguard.

Mulvey, Laura (1989) 'Visual Pleasure and Narrative Cinema,' in *Visual and Other Pleasures*, Bloomington and London: Indiana University Press.

Voice of the Shuttle: extensive references to contemporary theoretical work online at http://vos.ucsb.edu/

René Descartes

OPTICS

Discourse One: Light

THE CONDUCT OF OUR LIFE depends entirely on our senses, and since sight is the noblest and most comprehensive of the senses, inventions which serve to increase its power are undoubtedly among the most useful there can be. And it is difficult to find any such inventions which do more to increase the power of sight than those wonderful telescopes which, though in use for only a short time, have already revealed a greater number of new stars and other new objects above the earth than we had seen there before. Carrying our vision much further than our forebears could normally extend their imagination, these telescopes seem to have opened the way for us to attain a knowledge of nature much greater and more perfect than they possessed . . . But inventions of any complexity do not reach their highest degree of perfection right away, and this one is still sufficiently problematical to give me cause to write about it. And since the construction of the things of which I shall speak must depend on the skill of craftsmen, who usually have little formal education, I shall try to make myself intelligible to everyone; and I shall try not to omit anything, or to assume anything that requires knowledge of other sciences. This is why I shall begin by explaining light and light-rays; then, having briefly described the parts of the eye, I shall give a detailed account of how vision comes about; and, after noting all the things which are capable of making vision more perfect, I shall show how they can be aided by the inventions which I shall describe.

Now since my only reason for speaking of light here is to explain how its rays enter into the eye, and how they may be deflected by the various bodies they encounter, I need not attempt to say what is its true nature. It will, I think, suffice if I use two or three comparisons in order to facilitate that conception of light which seems most suitable for explaining all those of its properties that we know

through experience and for then deducing all the other properties that we cannot observe so easily. In this I am imitating the astronomers, whose suppositions are almost all false or uncertain, but who nevertheless draw many very true and certain consequences from them because they are related to various observations they have made.

No doubt you have had the experience of walking at night over rough ground without a light, and finding it necessary to use a stick in order to guide yourself. You may then have been able to notice that by means of this stick you could feel the various objects situated around you, and that you could even tell whether they were trees or stones or sand or water or grass or mud or any other such thing. It is true that this kind of sensation is somewhat confused and obscure in those who do not have long practice with it. But consider it in those born blind, who have made use of it all their lives: with them, you will find, it is so perfect and so exact that one might almost say that they see with their hands, or that their stick is the organ of some sixth sense given to them in place of sight. In order to draw a comparison from this, I would have you consider the light in bodies we call 'luminous' to be nothing other than a certain movement, or very rapid and lively action, which passes to our eyes through the medium of the air and other transparent bodies, just as the movement or resistance of the bodies encountered by a blind man passes to his hand by means of his stick. In the first place this will prevent you from finding it strange that this light can extend its rays instantaneously from the sun to us. For you know that the action by which we move one end of a stick must pass instantaneously to the other end, and that the action of light would have to pass from the heavens to the earth in the same way, even though the distance in this case is much greater than that between the ends of a stick. Nor will you find it strange that by means of this action we can see all sorts of colours. You may perhaps even be prepared to believe that in the bodies we call 'coloured' the colours are nothing other than the various ways in which the bodies receive light and reflect it against our eyes. You have only to consider that the differences a blind man notices between trees, rocks, water and similar things by means of his stick do not seem any less to him than the differences between red, yellow, green and all the other colours seem to us. And yet in all those bodies the differences are nothing other than the various ways of moving the stick or of resisting its movements. Hence you will have reason to conclude that there is no need to suppose that something material passes from objects to our eyes to make us see colours and light, or even that there is something in the objects which resembles the ideas or sensations that we have of them. In just the same way, when a blind man feels bodies, nothing has to issue from the bodies and pass along his stick to his hand; and the resistance or movement of the bodies, which is the sole cause of the sensations he has of them, is nothing like the ideas he forms of them. By this means, your mind will be delivered from all those little images flitting through the air, called 'intentional forms',[1] which so exercise the imagination of the philosophers. You will even find it easy to settle the current philosophical debate concerning the origin of the action which causes visual perception. For, just as our blind man can feel the bodies around him not only through the action of these bodies when they move against his stick, but also through the action of his hand when they do nothing but resist the stick, so we must acknowledge that the objects of sight can be perceived not only by means of

the action in them which is directed towards our eyes, but also by the action in our eyes which is directed towards them. Nevertheless, because the latter action is nothing other than light, we must note that it is found only in the eyes of those creatures which can see in the dark, such as cats, whereas a man normally sees only through the action which comes from the objects. For experience shows us that these objects must be luminous or illuminated in order to be seen, and not that our eyes must be luminous or illuminated in order to see them. But because our blind man's stick differs greatly from the air and the other transparent bodies through the medium of which we see, I must make use of yet another comparison.

Consider a wine-vat at harvest time, full to the brim with half-pressed grapes, in the bottom of which we have made one or two holes through which the unfermented wine can flow. Now observe that, since there is no vacuum in nature (as nearly all philosophers acknowledge), and yet there are many pores in all the bodies we perceive around us (as experience can show quite clearly), it is necessary that these pores be filled with some very subtle and very fluid matter, which extends without interruption from the heavenly bodies to us. Now, if you compare this subtle matter with the wine in the vat, and compare the less fluid or coarser parts of the air and the other transparent bodies with the bunches of grapes which are mixed in with the wine, you will readily understand the following. The parts of wine at one place tend to go down in a straight line through one hole at the very instant it is opened, and at the same time through the other hole, while the parts at other places also tend at the same time to go down through these two holes, without these actions being impeded by each other or by the resistance of the bunches of grapes in the vat. This happens even though the bunches support each other and so do not tend in the least to go down through the holes, as does the wine, and at the same time they can even be moved in many other ways by the bunches which press upon them. In the same way, all the parts of the subtle matter in contact with the side of the sun facing us tend in a straight line towards our eyes at the very instant they are opened, without these parts impeding each other, and even without their being impeded by the coarser parts of the transparent bodies which lie between them. This happens whether these bodies move in other ways – like the air which is almost always agitated by some wind – or are motionless – say, like glass or crystal. And note here that it is necessary to distinguish between the movement and the action or tendency to move. For we may very easily conceive that the parts of wine at one place should tend towards one hole and at the same time towards the other, even though they cannot actually move towards both holes at the same time, and that they should tend exactly in a straight line towards one and towards the other, even though they cannot move exactly in a straight line because of the bunches of grapes which are between them. In the same way, considering that the light of a luminous body must be regarded as being not so much its movement as its action, you must think of the rays of light as nothing other than the lines along which this action tends. Thus there is an infinity of such rays which come from all the points of a luminous body towards all the points of the bodies it illuminates, just as you can imagine an infinity of straight lines along which the actions coming from all the points of the surface of the wine tend towards one hole, and an infinity of others along which the actions

coming from the same points tend also towards the other hole, without either impeding the other.

Moreover, these rays must always be imagined to be exactly straight when they pass through a single transparent body which is uniform throughout. But when they meet certain other bodies, they are liable to be deflected by them, or weakened, in the same way that the movement of a ball or stone thrown into the air is deflected by the bodies it encounters. For it is very easy to believe that the action or tendency to move (which, I have said, should be taken for light) must in this respect obey the same laws as the movement itself. In order that I may give a complete account of this third comparison, consider that a ball passing through the air may encounter bodies that are soft or hard or fluid. If the bodies are soft, they completely stop the ball and check its movement, as when it strikes linen sheets or sand or mud. But if they are hard, they send the ball in another direction without stopping it, and they do so in many different ways. For their surface may be quite even and smooth, or rough and uneven; if even, either flat or curved; if uneven, its unevenness may consist merely in its being composed of many variously curved parts, each quite smooth in itself, or also in its having many different angles or points, or some parts harder than others, or parts which are moving (their movements being varied in a thousand imaginable ways). And it must be noted that the ball, besides moving in the simple and ordinary way which takes it from one place to another, may move in yet a second way, turning on its axis, and that the speed of the latter movement may have many different relations with that of the former. Thus, when many balls coming from the same direction meet a body whose surface is completely smooth and even, they are reflected uniformly and in the same order, so that if this surface is completely flat they keep the same distance between them after having met it as they had beforehand; and if it is curved inward or outward they come towards each other or go away from each other in the same order, more or less, on account of this curvature . . . It is necessary to consider, in the same manner, that there are bodies which break up the light-rays that meet them and take away all their force (namely bodies called 'black,' which have no color other than that of shadows); and there are others which cause the rays to be reflected, some in the same order as they receive them (namely bodies with highly polished surfaces, which can serve as mirrors, both flat and curved), and others in many directions in complete disarray. Among the latter, again, some bodies cause the rays to be reflected without bringing about any other change in their action (namely bodies we call 'white'), and others bring about an additional change similar to that which the movement of a ball undergoes when we graze it (namely bodies which are red, or yellow, or blue or some other such color). For I believe I can determine the nature of each of these colors, and reveal it experimentally; but this goes beyond the limits of my subject. All I need to do here is to point out that the light-rays falling on bodies which are colored and not polished are usually reflected in every direction even if they come from only a single direction . . . Finally, consider that the rays are also deflected, in the same way as the ball just described, when they fall obliquely on the surface of a transparent body and penetrate this body more or less easily than the body from which they come. This mode of deflection is called 'refraction.'[2]

[. . .]

Discourse Four: The senses in general

Now I must tell you something about the nature of the senses in general, the more easily to explain that of sight in particular. We know for certain that it is the soul which has sensory awareness, and not the body. For when the soul is distracted by an ecstasy or deep contemplation, we see that the whole body remains without sensation, even though it has various objects touching it. And we know that it is not, properly speaking, because of its presence in the parts of the body which function as organs of the external senses that the soul has sensory awareness, but because of its presence in the brain, where it exercises the faculty called the 'common' sense. For we observe injuries and diseases which attack the brain alone and impede all the senses generally, even though the rest of the body continues to be animated. We know, lastly, that it is through the nerves that the impressions formed by objects in the external parts of the body reach the soul in the brain. For we observe various accidents which cause injury only to a nerve, and destroy sensation in all the parts of the body to which this nerve sends its branches, without causing it to diminish elsewhere. – . . .[3] We must take care not to assume – as our philosophers commonly do – that in order to have sensory awareness the soul must contemplate certain images[4] transmitted by objects to the brain; or at any rate we must conceive the nature of these images in an entirely different manner from that of the philosophers. For since their conception of the images is confined to the requirement that they should resemble the objects they represent, the philosophers cannot possibly show us how the images can be formed by the objects, or how they can be received by the external sense organs and transmitted by the nerves to the brain. Their sole reason for positing such images was that they saw how easily a picture can stimulate our mind to conceive the objects depicted in it, and so it seemed to them that the mind must be stimulated to conceive the objects that affect our senses in the same way – that is, by little pictures formed in our head. We should, however, recall that our mind can be stimulated by many things other than images – by signs and words, for example, which in no way resemble the things they signify. And if, in order to depart as little as possible from accepted views, we prefer to maintain that the objects which we perceive by our senses really send images of themselves to the inside of our brain, we must at least observe that in no case does an image have to resemble the object it represents in all respects, for otherwise there would be no distinction between the object and its image. It is enough that the image resembles its object in a few respects. Indeed the perfection of an image often depends on its not resembling its object as much as it might. You can see this in the case of engravings: consisting simply of a little ink placed here and there on a piece of paper, they represent to us forests, towns, people, and even battles and storms; and although they make us think of countless different qualities in these objects, it is only in respect of shape that there is any real resemblance. And even this resemblance is very imperfect, since engravings represent to us bodies of varying relief and depth on a surface which is entirely flat. Moreover, in accordance with the rules of perspective they often represent circles by ovals better than by other circles, squares by rhombuses better than by other squares, and similarly for other shapes. Thus it often happens that in order to be more perfect as an image and to represent an object better, an engraving ought not to resemble it. Now we must

think of the images formed in our brain in just the same way, and note that the problem is to know simply how they can enable the soul to have sensory awareness of all the various qualities of the objects to which they correspond – not to know how they can resemble these objects. For instance, when our blind man touches bodies with his stick, they certainly do not transmit anything to him except in so far as they cause his stick to move in different ways according to the different qualities in them, thus likewise setting in motion the nerves in his hand, and then the regions of his brain where these nerves originate. This is what occasions his soul to have sensory awareness of just as many different qualities in these bodies as there are differences in the movements caused by them in his brain.

<div align="center">[. . .]</div>

Notes

1 A reference to the scholastic doctrine that material objects transmit to the soul 'forms' or 'images' (Fr. *espèces*, Lat. *species*) resembling them.
2 Discourses Two and Three are omitted here.
3 There follows an account of the function of the nerves and animal spirits in producing sensation and movement. Cf. *Treatise on Man*, AT XI 132 ff and *Passions*.
4 See note 1 above.

Karl Marx

THE FETISHISM OF THE COMMODITY

[...]

A COMMODITY APPEARS, at first sight an extremely obvious, trivial thing. But its analysis brings out that it is a very strange thing, abounding in metaphysical subtleties and theological niceties. So far as it is a use-value, there is nothing mysterious about it, whether we consider it from the point of view that by its properties it satisfies human needs, or that it first takes on these properties as the product of human labor. It is absolutely clear that, by his activity, man changes the forms of the materials of nature in such a way as to make them useful to him. The form of wood, for instance, is altered if a table is made out of it. Nevertheless the table continues to be wood, an ordinary, sensuous thing. But as soon as it emerges as a commodity, it changes into a thing which transcends sensuousness. It not only stands with its feet on the ground, but, in relation to all other commodities, it stands on its head, and evolves out of its wooden brain grotesque ideas, far more wonderful than if it were to begin dancing of its own free will.[1]

The mystical character of the commodity does not therefore arise from its use-value. Just as little does it proceed from the nature of the determinants of value. For in the first place, however varied the useful kinds of labor, or productive activities, it is a physiological fact that they are functions of the human organism, and that each such function, whatever may be its nature or its form, is essentially the expenditure of human brain, nerves, muscles and sense organs. Secondly, with regard to the foundation of the quantitative determination of value, namely the duration of that expenditure or the quantity of labor, this is quite palpably different from its quality. In all situations, the labor-time it costs to produce the means of subsistence must necessarily concern mankind, although not to the same degree at different stages of development.[2] And finally, as soon as men start to work for each other in any way, their labor also assumes a social form.

Whence, then, arises the enigmatic character of the product of labor, as soon as it assumes the form of a commodity? Clearly, it arises from this form itself. The equality of the kinds of human labor takes on a physical form in the equal objectivity of the products of labor as values; the measure of the expenditure of human labor-power by its duration takes on the form of the magnitude of the value of the products of labor; and finally the relationships between the producers, within which the social characteristics of their labors are manifested, take on the form of a social relation between the products of labor.

The mysterious character of the commodity-form consists therefore simply in the fact that the commodity reflects the social characteristics of men's own labor as objective characteristics of the products of labor themselves, as the socio-natural properties of these things. Hence it also reflects the social relation of the producers to the sum total of labor as a social relation between objects, a relation which exists apart from and outside the producers. Through this substitution, the products of labor become commodities, sensuous things which are at the same time supra-sensible or social. In the same way, the impression made by a thing on the optic nerve is perceived not as a subjective excitation of that nerve but as the objective form of a thing outside the eye. In the act of seeing, of course, light is really transmitted from one thing, the external object, to another thing, the eye. It is a physical relation between physical things. As against this, the commodity-form, and the value-relation of the products of labor within which it appears, have absolutely no connection with the physical nature of the commodity and the material [*dinglich*] relations arising out of this. It is nothing but the definite social relation between men themselves which assumes here, for them, the fantastic form of a relation between things. In order, therefore, to find an analogy we must take flight into the misty realm of religion. There the products of the human brain appear as autonomous figures endowed with a life of their own, which enter into relations both with each other and with the human race. So it is in the world of commodities with the products of men's hands. I call this the fetishism which attaches itself to the products of labor as soon as they are produced as commodities, and is therefore inseparable from the production of commodities.

[. . .]

Notes

1 One may recall that China and the tables began to dance when the rest of the world appeared to be standing still – *pour encourager les autres*.*

2 Among the ancient Germans the size of a piece of land was measured according to the labour of a day; hence the acre was called *Tagwerk*, *Tagwanne* (*jurnale*, or *terra jurnalis*, or *diornalis*), *Mannwerk*, *Mannskraft*, *Mannsmaad*, *Mannshauet*, etc. See Georg Ludwig von Maurer, *Einleitung zur Geschichte der Mark-, Hof-, usw. Verfassung*, Munich, 1854, p. 129 ff.

* 'To encourage the others.' A reference to the simultaneous emergence in the 1850s of the Taiping revolt in China and the craze for spiritualism which swept over upper-class German society. The rest of the world was 'standing still' in the period of reaction immediately after the defeat of the 1848 Revolutions.

W.E.B. Dubois

DOUBLE CONSCIOUSNESS

BETWEEN ME AND THE OTHER WORLD there is ever an unasked question: unasked by some through feelings of delicacy; by others through the difficulty of rightly framing it. All, nevertheless, flutter round it. They approach me in a half-hesitant sort of way, eye me curiously or compassionately, and then, instead of saying directly, How does it feel to be a problem? they say, I know an excellent colored man in my town; or, I fought at Mechanicsville; or, Do not these Southern outrages make your blood boil? At these I smile, or am interested, or reduce the boiling to a simmer, as the occasion may require. To the real question, How does it feel to be a problem? I answer seldom a word.

And yet, being a problem is a strange experience, – peculiar even for one who has never been anything else, save perhaps in babyhood and in Europe. It is in the early days of rollicking boyhood that the revelation first bursts upon one, all in a day, as it were. I remember well when the shadow swept across me. I was a little thing, away up in the hills of New England, where the dark Housatonic winds between Hoosac and Taghkanic to the sea. In a wee wooden schoolhouse, something put it into the boys' and girls' heads to buy gorgeous visiting-cards – ten cents a package—and exchange. The exchange was merry, till one girl, a tall newcomer, refused my card, – refused it peremptorily, with a glance. Then it dawned upon me with a certain suddenness that I was different from the others; or like, mayhap, in heart and life and longing, but shut out from their world by a vast veil. I had thereafter no desire to tear down that veil, to creep through; I held all beyond it in common contempt, and lived above it in a region of blue sky and great wandering shadows. That sky was bluest when I could beat my mates at examination-time, or beat them at a foot-race, or even beat their stringy heads. Alas, with the years all this fine contempt began to fade; for the worlds I longed for, and all their dazzling opportunities, were theirs, not mine. But they should not keep these prizes, I said; some, all, I would wrest from them. Just how I would do it I could never decide:

by reading law, by healing the sick, by telling the wonderful tales that swam in my head, – some way. With other black boys the strife was not so fiercely sunny: their youth shrunk into tasteless sycophancy, or into silent hatred of the pale world about them and mocking distrust of everything white; or wasted itself in a bitter cry, Why did God make me an outcast and a stranger in mine own house? The shades of the prison-house closed round about us all: walls strait and stubborn to the whitest, but relentlessly narrow, tall, and unscalable to sons of night who must plod darkly on in resignation, or beat unavailing palms against the stone, or steadily, half hopelessly, watch the streak of blue above.

After the Egyptian and Indian, the Greek and Roman, the Teuton and Mongolian, the Negro is a sort of seventh son, born with a veil, and gifted with second-sight in this American world, – a world which yields him no true self-consciousness, but only lets him see himself through the revelation of the other world. It is a peculiar sensation, this double-consciousness, this sense of always looking at one's self through the eyes of others, of measuring one's soul by the tape of a world that looks on in amused contempt and pity. One ever feels his twoness, – an American, a Negro; two souls, two thoughts, two unreconciled strivings; two warring ideals in one dark body, whose dogged strength alone keeps it from being torn asunder.

[. . .]

Jacques Lacan

WHAT IS A PICTURE?

Being and its semblance · *The lure of the screen* · Dompte-regard *and* trompe-l'œil[1] · *The backward glance* · *Gesture and touch* · Le donner-à-voir *and* invidia[2]

TODAY, THEN, I MUST KEEP to the wager to which I committed myself in choosing the terrain in which the *objet a* is most evanescent in its function of symbolizing the central lack of desire, which I have always indicated in a univocal way by the algorithm $(-\phi)$.

I don't know whether you can see the blackboard, but as usual I have marked out a few reference-points. *The* objet a *in the field of the visible is the gaze.* After which, enclosed in a chain bracket, I have written:

$$\left\{ \begin{array}{l} \textit{in nature} \\ \textit{as} = (-\phi) \end{array} \right.$$

We can grasp in effect something which, already in nature, appropriates the gaze to the function to which it may be put in the symbolic relation in man.

Below this, I have drawn the two triangular systems that I have already introduced – the first is that which, in the geometral field, puts in our place the subject of the representation, and the second is that which turns *me* into a picture. On the right-hand line is situated, then, the apex of the first triangle, the point of the geometral subject, and it is on that line that I, too, turn myself into a picture under the gaze, which is inscribed at the apex of the second triangle. The two triangles are here superimposed, as in fact they are in the functioning of the scopic register.

I must, to begin with, insist on the following: in the scopic field, the gaze is outside, I am looked at, that is to say, I am a picture.

This is the function that is found at the heart of the institution of the subject in the visible. What determines me, at the most profound level, in the visible, is the gaze that is outside. It is through the gaze that I enter light and it is from the gaze that I receive its effects. Hence it comes about that the gaze is the instrument through which light is embodied and through which – if you will allow me to use a word, as I often do, in a fragmented form – I am *photo-graphed*.

What is at issue here is not the philosophical problem of representation. From that point of view, when I am presented with a representation, I assure myself that I know quite a lot about it, I assure myself as a consciousness that knows that it is only representation, and that there is, beyond, the thing, the thing itself. Behind the phenomenon, there is the noumenon, for example. I may not be able to do anything about it, because my *transcendental categories*, as Kant would say, do just as they please and force me to take the thing in their way. But, then, that's all right, really – everything works out for the best.

In my opinion, it is not in this dialectic between the surface and that which is beyond that things are suspended. For my part, I set out from the fact that there is something that establishes a fracture, a bi-partition, a splitting of the being to which the being accommodates itself, even in the natural world.

This fact is observable in the variously modulated scale of what may be included, ultimately, under the general heading of mimicry. It is this that comes into play, quite obviously, both in sexual union and in the struggle to the death. In both situations, the being breaks up, in an extraordinary way, between its being and its semblance, between itself and that paper tiger it shows to the other. In the case of display, usually on the part of the male animal, or in the case of grimacing swelling by which the animal enters the play of combat in the form of intimidation, the being gives of himself, or receives from the other, something that is like a mask, a double, an envelope, a thrown-off skin, thrown off in order to cover the frame of a shield. It is through this separated form of himself that the being comes into play in his effects of life and death, and it might be said that it is with the help of this doubling of the other, or of oneself, that is realized the conjunction from which proceeds the renewal of beings in reproduction.

The lure plays an essential function therefore. It is not something else that seizes us at the very level of clinical experience, when, in relation to what one might imagine of the attraction to the other pole as conjoining masculine and feminine, we apprehend the prevalence of that which is presented as *travesty*. It is no doubt through the mediation of masks that the masculine and the feminine meet in the most acute, most intense way.

Only the subject – the human subject, the subject of the desire that is the essence of man – is not, unlike the animal, entirely caught up in this imaginary capture. He

maps himself in it. How? In so far as he isolates the function of the screen and plays with it. Man, in effect, knows how to play with the mask as that beyond which there is the gaze. The screen is here the locus of mediation.

[. . .]

Notes

1 The sense of the verb *dompter* is 'to tame,' 'to subdue.' The reference, then, is to a situation in which the gaze is tamed by some object, such as a picture. Lacan has invented the phrase *dompte-regard* as a counterpart to the notion of *trompe-l'oeil*, which has of course passed into the English language [Tr.].

2 *Donner-à-voir* means literally 'to give to be seen' and, therefore, 'to offer to the view.' The Latin *invidia*, translated as 'envy,' derives, as Lacan points out, from *videre*, to see.

Frantz Fanon

THE FACT OF BLACKNESS

'**D**IRTY NIGGER!' Or simply, 'Look, a Negro!'
I came into the world imbued with the will to find a meaning in things, my spirit filled with the desire to attain to the source of the world, and then I found that I was an object in the midst of other objects.

Sealed into that crushing objecthood, I turned beseechingly to others. Their attention was a liberation, running over my body suddenly abraded into nonbeing, endowing me once more with an agility that I had thought lost, and by taking me out of the world, restoring me to it. But just as I reached the other side, I stumbled, and the movements, the attitudes, the glances of the other fixed me there, in the sense in which a chemical solution is fixed by a dye. I was indignant; I demanded an explanation. Nothing happened. I burst apart. Now the fragments have been put together again by another self.

As long as the black man is among his own, he will have no occasion, except in minor internal conflicts, to experience his being through others. There is of course the moment of 'being for others,' of which Hegel speaks, but every ontology is made unattainable in a colonized and civilized society. It would seem that this fact has not been given sufficient attention by those who have discussed the question. In the *Weltanschauung* of a colonized people there is an impurity, a flaw that outlaws any ontological explanation. Someone may object that this is the case with every individual, but such an objection merely conceals a basic problem. Ontology – once it is finally admitted as leaving existence by the wayside-does not permit us to understand the being of the black man. For not only must the black man be black; he must be black in relation to the white man. Some critics will take it on themselves to remind us that this proposition has a converse. I say that this is false. The black man has no ontological resistance in the eyes of the white man. Overnight the Negro has been given two frames of reference within which he has had to place himself. His metaphysics, or, less pretentiously, his customs and the sources on which they

were based, were wiped out because they were in conflict with a civilization that he did not know and that imposed itself on him.

The black man among his own in the twentieth century does not know at what moment his inferiority comes into being through the other. Of course I have talked about the black problem with friends, or, more rarely, with American Negroes. Together we protested, we asserted the equality of all men in the world. In the Antilles there was also that little gulf that exists among the almost-white, the mulatto, and the nigger. But I was satisfied with an intellectual understanding of these differences. It was not really dramatic. And then. . . .

And then the occasion arose when I had to meet the white man's eyes. An unfamiliar weight burdened me. The real world challenged my claims. In the white world the man of color encounters difficulties in the development of his bodily schema. Consciousness of the body is solely a negating activity. It is a third-person consciousness. The body is surrounded by an atmosphere of certain uncertainty. I know that if I want to smoke, I shall have to reach out my right hand and take the pack of cigarettes lying at the other end of the table. The matches, however, are in the drawer on the left, and I shall have to lean back slightly. And all these movements are made not out of habit but out of implicit knowledge. A slow composition of my *self* as a body in the middle of a spatial and temporal world — such seems to be the schema. It does not impose itself on me; it is, rather, a definitive structuring of the self and of the world — definitive because it creates a real dialectic between my body and the world.

For several years certain laboratories have been trying to produce a serum for 'denegrification'; with all the earnestness in the world, laboratories have sterilized their test tubes, checked their scales, and embarked on researches that might make it possible for the miserable Negro to whiten himself and thus to throw off the burden of that corporeal malediction. Below the corporeal schema I had sketched a historico-racial schema. The elements that I used had been provided for me not by 'residual sensations and perceptions primarily of a tactile, vestibular, kinesthetic, and visual character,'[1] but by the other, the white man, who had woven me out of a thousand details, anecdotes, stories. I thought that what I had in hand was to construct a physiological self, to balance space, to localize sensations, and here I was called on for more.

'Look, a Negro!' It was an external stimulus that flicked over me as I passed by. I made a tight smile.

'Look, a Negro!' It was true. It amused me.

'Look, a Negro!' The circle was drawing a bit tighter. I made no secret of my amusement.

'Mama, see the Negro! I'm frightened!' Frightened! Frightened! Now they were beginning to be afraid of me. I made up my mind to laugh myself to tears, but laughter had become impossible.

I could no longer laugh, because I already knew that there were legends, stories, history, and above all *historicity*, which I had learned about from Jaspers. Then, assailed at various points, the corporeal schema crumbled, its place taken by a racial epidermal schema. In the train it was no longer a question of being aware of my body in the third person but in a triple person. In the train I was given not one but two, three places. I had already stopped being amused. It was not that I was finding

febrile coordinates in the world. I existed triply: I occupied space. I moved toward the other . . . and the evanescent other, hostile but not opaque, transparent, not there, disappeared. Nausea. . . .

I was responsible at the same time for my body, for my race, for my ancestors. I subjected myself to an objective examination, I discovered my blackness, my ethnic characteristics; and I was battered down by tom-toms, cannibalism, intellectual deficiency, fetichism, racial defects, slave-ships, and above all else, above all: 'Sho' good eatin'.'

On that day, completely dislocated, unable to be abroad with the other, the white man, who unmercifully imprisoned me, I took myself far off from my own presence, far indeed, and made myself an object. What else could it be for me but an amputation, an excision, a hemorrhage that spattered my whole body with black blood? But I did not want this revision, this thematization. All I wanted was to be a man among other men. I wanted to come lithe and young into a world that was ours and to help to build it together.

[. . .]

Note

1 Jean Lhermitte, *L'Image de notre corps* (Paris, Nouvelle Revue critique, 1939), p. 17.

Marshall McLuhan

WOMAN IN A MIRROR

Just another stallion and a sweet kid?

What was that sound of glass? A window
gone in the subconscious? Or was it Nature's
fire-alarm box?

The ad men break through the mind again?

The Senate sub-committee on mental
hygiene reports that it wasn't loaded?

The Greeks manage these matters in myths?

THIS AD EMPLOYS (Figure 13.1) the same technique as Picasso in *The Mirror*. The differences, of course, are obvious enough. By setting a conventional day-self over against a tragic night-self, Picasso is able to provide a time capsule of an entire life. He reduces a full-length novel (or movie) like *Madame Bovary* to a single image of great intensity. By juxtaposition and contrast he is able to 'say' a great deal and to provide much intelligibility for daily life. This artistic discovery for achieving rich implication by withholding the syntactical connection is stated as a principle of modern physics by A.N. Whitehead in *Science and the Modern World*.

> In being aware of the bodily experience, we must thereby be aware of aspects of the whole spatio-temporal world as mirrored within the bodily life. . . . my theory involves the entire abandonment of the notion that simple location is the primary way in which things are involved in space-time.

Which is to say, among other things, that there can be symbolic unity among the most diverse and externally unconnected facts or situations.

The layout men of the present ad debased this technique by making it a vehicle for 'saying' a great deal about sex, stallions, and 'ritzy dames' who are provided with custom-built allure.

Superficially, the ad shows a horse, which suggests classical sculpture, and a woman as serenely innocent as a coke-ad damsel. The opposition of the cool elements, phallic and ambrosial, provides a chain reaction. The girl in the ad is the familiar Hollywood Bergman type of 'somnambule,' or the dream walker. Stately, modest, and 'classical,' she is the 'good girl,' usually counter-pointed against the 'good-time girl,' who is wide awake and peppy. The stately dream girl comes trailing

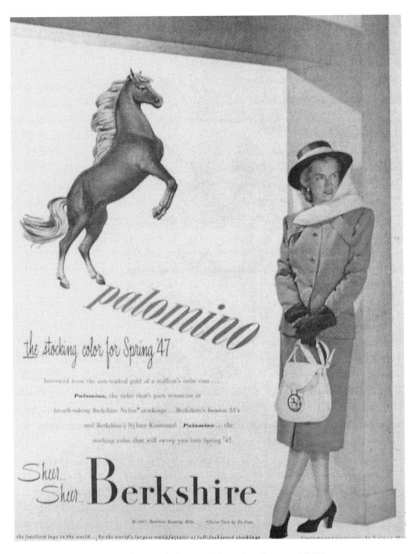

Figure 12.1 Advert for Berkshire Nylon Stockings, 1947

clouds of culture as from some European castle. Effective advertising gains its ends partly by distracting the attention of the reader from its presuppositions and by its quiet fusion with other levels of experience. And in this respect it is the supreme form of cynical demagogic flattery.

The color in the original ad is described as 'borrowed from the sun-soaked gold of a stallion's satin coat . . . the color that's pure sensation . . . for the loveliest legs in the world.' The rearing horse completes the general idea. Many ads now follow this method of gentle, nudging 'subtlety.' Juxtaposition of items permits the advertiser to 'say,' by methods which *Time* has used to great effect, what could never pass the censor of consciousness. A most necessary contrast to 'raging animality' is that a girl should appear gentle, refined, aloof, and innocent. It's her innocence, her obvious 'class' that's terrific, because dramatically opposed to the suggestion of brutal violation. Describing his heroine in *The Great Gatsby*, Scott Fitzgerald notes:

> Her face was sad and lovely with bright things in it, bright eyes and a bright passionate mouth . . . a promise that she had done gay, exciting things just awhile since and that there were gay, exciting things hovering in the next hour.

She sits down at the table 'as if she were getting into bed.'

This sort of thing in Fitzgerald pretty well does what the present ad does. When Gatsby kisses this girl there is a kind of breathless round-up of the ad man's rhetoric.

> His heart beat faster and faster as Daisy's white face came up to his own. He knew that when he kissed this girl and forever wed his unutterable vision to her perishable breath, his mind would never romp again like the mind of God. So he waited, listening for a moment longer to the tuning-fork that had struck upon a star. Then he kissed her. At his lips' touch she blossomed for him like a flower, and the incarnation was complete.

It would seem to take a certain amount of theology to bring off these masterpieces of sentimental vulgarity. A kind of spectacular emptying out of established meanings and significances is necessary to the great thrills. Something important, a man or a thought, must be destroyed in order to deliver the supreme visceral wallop. In the present ad it is 'refinement,' 'naturalness,' and 'girlish grace' which are offered up. In one movie ad the woman says: 'I killed a man for this kiss, so you'd better make it good.' Romantic formula for fission?

Roland Barthes

RHETORIC OF THE IMAGE

ACCORDING TO AN ANCIENT etymology, the word *image* should be linked to the root *imitari*. Thus we find ourselves immediately at the heart of the most important problem facing the semiology of images: can analogical representation (the 'copy') produce true systems of signs and not merely simple agglutinations of symbols? Is it possible to conceive of an analogical 'code' (as opposed to a digital one)? We know that linguists refuse the status of language to all communication by analogy – from the 'language' of bees to the 'language' of gesture – the moment such communications are not doubly articulated, are not founded on a combinatory system of digital units as phonemes are. Nor are linguists the only ones to be suspicious as to the linguistic nature of the image; general opinion too has a vague conception of the image as an area of resistance to meaning – this in the name of a certain mythical idea of Life: the image is re-presentation, which is to say ultimately resurrection, and, as we know, the intelligible is reputed antipathetic to lived experience. Thus from both sides the image is felt to be weak in respect of meaning: there are those who think that the image is an extremely rudimentary system in comparison with language and those who think that signification cannot exhaust the image's ineffable richness. Now even – and above all if – the image is in a certain manner the *limit* of meaning, it permits the consideration of a veritable ontology of the process of signification. How does meaning get into the image? Where does it end? And if it ends, what is there *beyond*? Such are the questions that I wish to raise by submitting the image to a spectral analysis of the messages it may contain. We will start by making it considerably easier for ourselves: we will only study the advertising image. Why? Because in advertising the signification of the image is undoubtedly intentional; the signifieds of the advertising message are formed *a priori* by certain attributes of the products and these signifieds have to be transmitted as clearly as possible. If the image contains signs, we can be sure that in advertising these signs are full, formed with a view to the optimum reading: the advertising image is *frank*, or at least emphatic.

The three messages

Here we have a Panzani advertisement: some packets of pasta, a tin, a sachet, some tomatoes, onions, peppers, a mushroom, all emerging from a half-open string bag, in yellows and greens on a red background.[1] Let us try to 'skim off' the different messages it contains.

The image immediately yields a first message whose substance is linguistic; its supports are the caption, which is marginal, and the labels, these being inserted into the natural disposition of the scene, '*en abyme*'. The code from which this message has been taken is none other than that of the French language; the only knowledge required to decipher it is a knowledge of writing and French. In fact, this message can itself be further broken down, for the sign *Panzani* gives not simply the name of the firm but also, by its assonance, an additional signified, that of 'Italianicity.' The linguistic message is thus twofold (at least in this particular image): denotational and connotational. Since, however, we have here only a single typical sign,[2] namely that of articulated (written) language, it will be counted as one message.

Putting aside the linguistic message, we are left with the pure image (even if the labels are part of it, anecdotally). This image straightaway provides a series of discontinuous signs. First (the order is unimportant as these signs are not linear), the idea that what we have in the scene represented is a return from the market. A signified which itself implies two euphoric values: that of the freshness of the products and that of the essentially domestic preparation for which they are destined. Its signifier is the half-open bag which lets the provisions spill out over the table, 'unpacked.' To read this first sign requires only a knowledge which is in some sort implanted as part of the habits of a very widespread culture where 'shopping around for oneself' is opposed to the hasty stocking up (preserves, refrigerators) of a more 'mechanical' civilization. A second sign is more or less equally evident; its signifier is the bringing together of the tomato, the pepper and the tricoloured hues (yellow, green, red) of the poster; its signified is Italy or rather *Italianicity*. This sign stands in a relation of redundancy with the connoted sign of the linguistic message (the Italian assonance of the name *Panzani*) and the knowledge it draws upon is already more particular; it is a specifically 'French' knowledge (an Italian would barely perceive the connotation of the name, no more probably than he would the Italianicity of tomato and pepper), based on a familiarity with certain tourist stereotypes. Continuing to explore the image (which is not to say that it is not entirely clear at the first glance), there is no difficulty in discovering at least two other signs: in the first, the serried collection of different objects transmits the idea of a total culinary service, on the one hand as though Panzani furnished everything necessary for a carefully balanced dish and on the other as though the concentrate in the tin were equivalent to the natural produce surrounding it; in the other sign, the composition of the image, evoking the memory of innumerable alimentary paintings, sends us to an aesthetic signified: the '*nature morte*' or; as it is better expressed in other languages, the 'still life';[3] the knowledge on which this sign depends is heavily cultural. It might be suggested that, in addition to these four signs, there is a further information pointer, that which tells us that this is an advertisement and which arises both from the place of the image in the magazine and from the emphasis of the labels (not to mention the caption). This last information, however,

is co-extensive with the scene; it eludes signification in so far as the advertising nature of the image is essentially functional; to utter something is not necessarily to declare *I am speaking*, except in a deliberately reflexive system such as literature.

Thus there are four signs for this image and we will assume that they form a coherent whole (for they are all discontinuous), require a generally cultural knowledge, and refer back to signifieds each of which is global (for example, *Italianicity*), imbued with euphoric values. After the linguistic message, then, we can see a second, iconic message. Is that the end? If all these signs are removed from the image, we are still left with a certain informational matter; deprived of all knowledge, I continue to 'read' the image, to 'understand' that it assembles in a common space a number of identifiable (nameable) objects, not merely shapes and colors. The signifieds of this third message are constituted by the real objects in the scene, the signifiers by these same objects photographed, for, given that the relation between thing signified and image signifying in analogical representation is not 'arbitrary' (as it is in language), it is no longer necessary to dose the relay with a third term in the guise of the psychic image of the object. What defines the third message is precisely that the relation between signified and signifier is quasi-tautological; no doubt the photograph involves a certain arrangement of the scene (framing, reduction, flattening) but this transition is not a *transformation* (in the way a coding can be); we have here a loss of the equivalence characteristic of true sign systems and a statement of quasi-identity. In other words, the sign of this message is not drawn from an institutional stock, is not coded, and we are brought up against the paradox (to which we will return) of a *message without a code*. This peculiarity can be seen again at the level of the knowledge invested in the reading of the message; in order to 'read' this last (or first) level of the image, all that is needed is the knowledge bound up with our perception. That knowledge is not nil, for we need to know what an image is (children only learn this at about the age of four) and what a tomato, a string-bag, a packet of pasta are, but it is a matter of an almost anthropological knowledge. This message corresponds, as it were, to the letter of the image and we can agree to call it the literal message, as opposed to the previous symbolic message.

If our reading is satisfactory, the photograph analysed offers us three messages: a linguistic message, a coded iconic message, and a non-coded iconic message. The linguistic message can be readily separated from the other two, but since the latter share the same (iconic) substance, to what extent have we the right to separate them? It is certain that the distinction between the two iconic messages is not made spontaneously in ordinary reading: the viewer of the image *receives at one and the same time* the perceptual message and the cultural message, and it will be seen later that this confusion in reading corresponds to the function of the mass image (our concern here). The distinction, however, has an operational validity, analogous to that which allows the distinction in the linguistic sign of a signifier and a signified (even though in reality no one is able to separate the 'word' from its meaning except by recourse to the metalanguage of a definition). If the distinction permits us to describe the structure of the image in a simple and coherent fashion and if this description paves the way for an explanation of the role of the image in society, we will take it to be justified. The task now is thus to reconsider each type of message so as to explore it in its generality, without losing sight of our aim of understanding

the overall structure of the image, the final inter-relationship of the three messages. Given that what is in question is not a 'naive' analysis but a structural description,[4] the order of the messages will be modified a little by the inversion of the cultural message and the literal message; of the two iconic messages, the first is in some sort imprinted on the second: the literal message appears as the *support* of the 'symbolic' message. Hence, knowing that a system which takes over the signs of another system in order to make them its signifiers is a system of connotation,[5] we may say immediately that the literal image is *denoted* and the symbolic image *connoted*.

Notes

1 The *description* of the photograph is given here with prudence, for it already constitutes a metalanguage.
2 By *typical sign* is meant the sign of a system in so far as it is adequately defined by its substance: the verbal sign, the iconic sign, the gestural sign are so many typical signs.
3 In French, the expression *nature morte* refers to the original presence of funereal objects, such as a skull, in certain pictures.
4 'Naive' analysis is an enumeration of elements, structural description aims to grasp the relation of these elements by virtue of the principle of the solidarity holding between the terms of a structure: if one term changes, so also do the others.
5 Cf. R. Barthes, *Eléments de sémiologie, Communications* 4, 1964, p. 130 [trans. *Elements of Semiology*, London 1967 & New York 1968, pp. 89–92].

Louis Althusser

IDEOLOGY AND IDEOLOGICAL
STATE APPARATUSES

[. . .]

T HIS THESIS IS SIMPLY a matter of making my last proposition explicit: there
is no ideology except by the subject and for subjects. Meaning, there is no
ideology except for concrete subjects, and this destination for ideology is only made
possible by the subject: meaning, *by the category of the subject* and its functioning.

By this I mean that, even if it only appears under this name (the subject) with
the rise of bourgeois ideology, above all with the rise of legal ideology,[1] the cate-
gory of the subject (which may function under other names: e.g., as the soul in
Plato, as God, etc.) is the constitutive category of all ideology, whatever its deter-
mination (regional or class) and whatever its historical date — since ideology has no
history.

I say: the category of the subject is constitutive of all ideology, but at the same
time and immediately I add that *the category of the subject is only constitutive of all
ideology insofar as all ideology has the function (which defines it) of 'constituting' concrete
individuals as subjects.* In the interaction of this double constitution exists the func-
tioning of all ideology, ideology being nothing but its functioning in the material
forms of existence of that functioning.

In order to grasp what follows, it is essential to realize that both he who is
writing these lines and the reader who reads them are themselves subjects, and
therefore ideological subjects (a tautological proposition), i.e. that the author and
the reader of these lines both live 'spontaneously' or 'naturally' in ideology in the
sense in which I have said that 'man is an ideological animal by nature.'

That the author, insofar as he writes the lines of a discourse which claims to be
scientific, is completely absent as a 'subject' from 'his' scientific discourse (for all
scientific discourse is by definition a subject-less discourse, there is no 'Subject of

science' except in an ideology of science) is a different question which I shall leave on one side for the moment.

As St Paul admirably put it, it is in the 'Logos,' meaning in ideology, that we 'live, move and have our being.' It follows that, for you and for me, the category of the subject is a primary 'obviousness' (obviousnesses are always primary): it is clear that you and I are subjects (free, ethical, etc.). Like all obviousnesses, including those that make a word 'name a thing' or 'have a meaning' (therefore including the obviousness of the 'transparency' of language), the 'obviousness' that you and I are subjects – and that that does not cause any problems – is an ideological effect, the elementary ideological effect.[2] It is indeed a peculiarity of ideology that it imposes (without appearing to do so, since these are 'obviousnesses') obviousnesses as obviousnesses, which we cannot *fail to recognize* and before which we have the inevitable and natural reaction of crying out (aloud or in the 'still, small voice of conscience'): 'That's obvious! That's right! That's true!'

At work in this reaction is the ideological *recognition* function which is one of the two functions of ideology as such (its inverse being the function of *misrecognition* – *méconnaissance*).

To take a highly 'concrete' example, we all have friends who, when they knock on our door and we ask, through the door, the question 'Who's there?', answer (since 'it's obvious') 'It's me.' And we recognize that 'it is him,' or 'her.' We open the door, and 'it's true, it really was she who was there.' To take another example, when we recognize somebody of our (previous) acquaintance ((*re*)-*connaissance*) in the street, we show him that we have recognized him (and have recognized that he has recognized us) by saying to him 'Hello, my friend,' and shaking his hand (a material ritual practice of ideological recognition in everyday life – in France, at least; elsewhere, there are other rituals).

In this preliminary remark and these concrete illustrations, I only wish to point out that you and I are *always already* subjects, and as such constantly practice the rituals of ideological recognition, which guarantee for us that we are indeed concrete, individual, distinguishable and (naturally) irreplaceable subjects. The writing I am currently executing and the reading you are currently[3] performing are also in this respect rituals of ideological recognition, including the 'obviousness' with which the 'truth' or 'error' of my reflections may impose itself on you.

But to recognize that we are subjects and that we function in the practical rituals of the most elementary everyday life (the hand-shake, the fact of calling you by your name, the fact of knowing, even if I do not know what it is, that you 'have' a name of your own, which means that you are recognized as a unique subject, etc.) – this recognition only gives us the 'consciousness' of our incessant (eternal) practice of ideological recognition – its consciousness, i.e. its *recognition* – but in no sense does it give us the (scientific) *knowledge* of the mechanism of this recognition. Now it is this knowledge that we have to reach, if you will, while speaking in ideology, and from within ideology we have to outline a discourse which tries to break with ideology, in order to dare to be the beginning of a scientific (i.e. subject-less) discourse on ideology.

Thus in order to represent why the category of the 'subject' is constitutive of ideology, which only exists by constituting concrete subjects as subjects, I shall

employ a special mode of exposition: 'concrete' enough to be recognized, but abstract enough to be thinkable and thought, giving rise to a knowledge.

As a first formulation I shall say: *all ideology hails or interpellates concrete individuals as concrete subjects*, by the functioning of the category of the subject.

Notes

1 Which borrowed the legal category of 'subject in law' to make an ideological notion: man is by nature a subject.
2 Linguists and those who appeal to linguistics for various purposes often run up against difficulties which arise because they ignore the action of the ideological effects in all discourses – including even scientific discourses.
3 NB: this double 'currently' is one more proof of the fact that ideology is 'eternal,' since these two 'currentlys' are separated by an indefinite interval; I am writing these lines on 6 April 1969, you may read them at any subsequent time.

Guy Debord

THE SOCIETY OF THE SPECTACLE

[. . .]

1 THE WHOLE LIFE OF THOSE SOCIETIES in which modern conditions of production prevail presents itself as an immense accumulation of *spectacles*. All that once was directly lived has become mere representation.

2 Images detached from every aspect of life merge into a common stream, and the former unity of life is lost forever. Apprehended in a *partial* way, reality unfolds in a new generality as a pseudo-world apart, solely as an object of contemplation. The tendency toward the specialization of images-of-the-world finds its highest expression in the world of the autonomous image, where deceit deceives itself. The spectacle in its generality is a concrete inversion of life, and, as such, the autonomous movement of non-life.

3 The spectacle appears at once as society itself, as a part of society and as a means of unification. As a part of society, it is that sector where all attention, all consciousness, converges. Being isolated – and precisely for that reason – this sector is the locus of illusion and false consciousness; the unity it imposes is merely the official language of generalized separation.

4 The spectacle is not a collection of images; rather, it is a social relationship between people that is mediated by images.

5 The spectacle cannot be understood either as a deliberate distortion of the visual world or as a product of the technology of the mass dissemination of images. It is far better viewed as a *weltanschauung* that has been actualized, translated into the material realm – a world view transformed into an objective force.

6 Understood in its totality, the spectacle is both the outcome and the goal of the dominant mode of production. It is not something *added* to the real world – not a decorative element, so to speak. On the contrary, it is the very heart

of society's real unreality. In all its specific manifestations – news or propaganda, advertising or the actual consumption of entertainment – the spectacle epitomizes the prevailing model of social life. It is the omnipresent celebration of a choice *already made* in the sphere of production, and the consummate result of that choice. In form as in content the spectacle serves as total justification for the conditions and aims of the existing system. It further ensures the *permanent presence* of that justification, for it governs almost all time spent outside the production process itself.

7 The phenomenon of separation is part and parcel of the unity of the world, of a global social praxis that has split up into reality on the one hand and image on the other. Social practice, which the spectacle's autonomy challenges, is also the real totality to which the spectacle is subordinate. So deep is the rift in this totality, however, that the spectacle is able to emerge as its apparent goal. The language of the spectacle is composed of *signs* of the dominant organization of production – signs which are at the same time the ultimate end-products of that organization.

8 The spectacle cannot be set in abstract opposition to concrete social activity, for the dichotomy between reality and image will survive on either side of any such distinction. Thus the spectacle, though it turns reality on its head, is itself a product of real activity. Likewise, lived reality suffers the material assaults of the spectacle's mechanisms of contemplation, incorporating the spectacular order and lending that order positive support. Each side therefore has its share of objective reality. And every concept, as it takes its place on one side or the other, has no foundation apart from its transformation into its opposite: reality erupts within the spectacle, and the spectacle is real. This reciprocal alienation is the essence and underpinning of society as it exists.

9 In a world that *really* has been turned on its head, truth is a moment of falsehood.

10 The concept of the spectacle brings together and explains a wide range of apparently disparate phenomena. Diversities and contrasts among such phenomena are the appearances of the spectacle – the appearances of a social organization of appearances that needs to be grasped in its general truth. Understood on its own terms, the spectacle proclaims the predominance of appearances and asserts that all human life, which is to say all social life, is mere appearance. But any critique capable of apprehending the spectacle's essential character must expose it as a visible negation of life – and as a negation of life that has *invented a visual form for itself.*

11 In order to describe the spectacle, its formation, its functions and whatever forces may hasten its demise, a few artificial distinctions are called for. To analyze the spectacle means talking its language to some degree – to the degree, in fact, that we are obliged to engage the methodology of the society to which the spectacle gives expression. For what the spectacle expresses is the total practice of one particular economic and social formation; it is, so to speak, that formation's *agenda.* It is also the historical moment by which we happen to be governed.

12 The spectacle manifests itself as an enormous positivity, out of reach and beyond dispute. All it says is: 'Everything that appears is good; whatever is

good will appear.' The attitude that it demands in principle is the same passive acceptance that it has already secured by means of its seeming incontrovertibility, and indeed by its monopolization of the realm of appearances.

13 The spectacle is essentially tautological, for the simple reason that its means and its ends are identical. It is the sun that never sets on the empire of modern passivity. It covers the entire globe, basking in the perpetual warmth of its own glory.

14 The spectacular character of modern industrial society has nothing fortuitous or superficial about it; on the contrary, this society is based on the spectacle in the most fundamental way. For the spectacle, as the perfect image of the ruling economic order, ends are nothing and development is all – although the only thing into which the spectacle plans to develop is itself.

15 As the indispensable packaging for things produced as they are now produced, as a general gloss on the rationality of the system, and as the advanced economic sector directly responsible for the manufacture of an ever-growing mass of image-objects, the spectacle is the *chief product* of present-day society.

[. . .]

34 The spectacle is *capital* accumulated to the point where it becomes image.

Jean Baudrillard

SIMULACRA AND SIMULATIONS

The simulacrum is never that which conceals the truth – it is the truth which conceals that there is none.
The simulacrum is true.

<div align="right">Ecclesiastes</div>

IF WE WERE ABLE TO TAKE as the finest allegory of simulation the Borges tale where the cartographers of the Empire draw up a map so detailed that it ends up exactly covering the territory (but where, with the decline of the Empire this map becomes frayed and finally ruined, a few shreds still discernible in the deserts – the metaphysical beauty of this ruined abstraction, bearing witness to an imperial pride and rotting like a carcass, returning to the substance of the soil, rather as an aging double ends up being confused with the real thing), this fable would then have come full circle for us, and now has nothing but the discrete charm of second-order simulacra.

Abstraction today is no longer that of the map, the double, the mirror or the concept. Simulation is no longer that of a territory, a referential being or a substance. It is the generation by models of a real without origin or reality: a hyperreal. The territory no longer precedes the map, nor survives it. Henceforth, it is the map that precedes the territory – *precession of simulacra* – it is the map that engenders the territory and if we were to revive the fable today, it would be the territory whose shreds are slowly rotting across the map. It is the real, and not the map, whose vestiges subsist here and there, in the deserts which are no longer those of the Empire, but our own. *The desert of the real itself.*

In fact, even inverted, the fable is useless. Perhaps only the allegory of the Empire remains. For it is with the same imperialism that present-day simulators try to make the real, all the real, coincide with their simulation models. But it is no longer a question of either maps or territory. Something has disappeared: the

sovereign difference between them that was the abstraction's charm. For it is the difference which forms the poetry of the map and the charm of the territory, the magic of the concept and the charm of the real. This representational imaginary, which both culminates in and is engulfed by the cartographer's mad project of an ideal coextensivity between the map and the territory, disappears with simulation, whose operation is nuclear and genetic, and no longer specular and discursive. With it goes all of metaphysics. No more mirror of being and appearances, of the real and its concept; no more imaginary coextensivity: rather, genetic miniaturization is the dimension of simulation. The real is produced from miniaturized units, from matrices, memory banks and command models – and with these it can be reproduced an indefinite number of times. It no longer has to be rational, since it is no longer measured against some ideal or negative instance. It is nothing more than operational. In fact, since it is no longer enveloped by an imaginary, it is no longer real at all. It is a hyperreal: the product of an irradiating synthesis of combinatory models in a hyperspace without atmosphere.

In this passage to a space whose curvature is no longer that of the real, nor of truth, the age of simulation thus begins with a liquidation of all referentials – worse: by their artificial resurrection in systems of signs, which are a more ductile material than meaning, in that they lend themselves to all systems of equivalence, all binary oppositions and all combinatory algebra. It is no longer a question of imitation, nor of reduplication, nor even of parody. It is rather a question of substituting signs of the real for the real itself; that is, an operation to deter every real process by its operational double, a metastable, programmatic, perfect descriptive machine which provides all the signs of the real and short-circuits all its vicissitudes. Never again will the real have to be produced: this is the vital function of the model in a system of death, or rather of anticipated resurrection which no longer leaves any chance even in the event of death. A hyperreal henceforth sheltered from the imaginary, and from any distinction between the real and the imaginary, leaving room only for the orbital recurrence of models and the simulated generation of difference.

[. . .]

Judith Butler

PROHIBITION, PSYCHOANALYSIS AND THE HETEROSEXUAL MATRIX

[P]UBLISHED IN 1929, Joan Riviere's essay, 'Womanliness as a Masquerade'[1] introduces the notion of femininity as masquerade in terms of a theory of aggression and conflict resolution. This theory appears at first to be far afield from Lacan's analysis of masquerade in terms of the comedy of sexual positions. She begins with a respectful review of Ernest Jones's typology of the development of female sexuality into heterosexual and homosexual forms. She focuses, however, on the 'intermediate types' that blur the boundaries between the heterosexual and the homosexual and, implicitly, contest the descriptive capacity of Jones's classificatory system. In a remark that resonates with Lacan's facile reference to 'observation,' Riviere seeks recourse to mundane perception or experience to validate her focus on these 'intermediate types': 'In daily life types of men and women are constantly met with who, while mainly heterosexual in their development, plainly display strong features of the other sex.' What is here most plain is the classifications that condition and structure the perception of this mix of attributes. Clearly, Riviere begins with set notions about what it is to display characteristics of one's sex, and how it is that those plain characteristics are understood to express or reflect an ostensible sexual orientation. This perception or observation not only assumes a correlation among characteristics, desires, and 'orientations,' but creates that unity through the perceptual act itself. Riviere's postulated unity between gender attributes and a naturalized 'orientation' appears as an instance of what Wittig refers to as the 'imaginary formation' of sex.

And yet, Riviere calls into question these naturalized typologies through an appeal to a psychoanalytic account that locates the meaning of mixed gender attributes in the 'interplay of conflicts.' Significantly, she contrasts this kind of psychoanalytic theory with one that would reduce the presence of ostensibly 'masculine' attributes in a woman to a 'radical or fundamental tendency.' In other words, the acquisition of such attributes and the accomplishment of a heterosexual

or homosexual orientation are produced through the resolution of conflicts that have as their aim the suppression of anxiety. Citing Ferenczi in order to establish an analogy with her own account, Riviere writes:

> Ferenczi pointed out . . . that homosexual men exaggerate their hetero-sexuality as a 'defence' against their homosexuality. I shall attempt to show that women who wish for masculinity may put on a mask of womanliness to avert anxiety and the retribution feared from men.
>
> (Riviere 1986: 35)

It is unclear what is the 'exaggerated' form of heterosexuality the homosexual man is alleged to display, but the phenomenon under notice here might simply be that gay men simply may not look much different from their heterosexual coun-terparts. This lack of an overt differentiating style or appearance may be diagnosed as a symptomatic 'defense' only because the gay man in question does not conform to the idea of the homosexual that the analyst has drawn and sustained from cultural stereotypes. A Lacanian analysis might argue that the supposed 'exaggeration' in the homosexual man of whatever attributes count as apparent heterosexuality is the attempt to 'have' the Phallus, the subject position that entails an active and hetero-sexualized desire. Similarly, the 'mask' of the 'women who wish for masculinity' can be interpreted as an effort to renounce the 'having' of the Phallus is order to avert retribution by those from whom it must have been procured through castra-tion. Riviere explains the fear of retribution as the consequence of a woman's fantasy to take the place of men, more precisely, of the father. In the case that she herself examines, which some consider to be autobiographical, the rivalry with the father is not over the desire of the mother, as one might expect, but over the place of the father in public discourse as speaker, lecturer, writer – that is, as a user of signs rather than a sign-object, an item of exchange. This castrating desire might be under-stood as the desire to relinquish the status of woman-as-sign in order to appear as a subject within language.

Indeed, the analogy that Riviere draws between the homosexual man and the masked woman is not, in her view, an analogy between male and female homo-sexuality. Femininity is taken on by a woman who 'wishes for masculinity,' but fears the retributive consequences of taking on the public appearance of masculinity. Masculinity is taken on by the male homosexual who, presumably, seeks to hide – not from others, but from himself – an ostensible femininity. The woman takes on a masquerade knowingly in order to conceal her masculinity from the masculine audience she wants to castrate. But the homosexual man is said to exaggerate his 'heterosexuality' (meaning a masculinity that allows him to pass as heterosexual?) as a 'defense,' unknowingly, because he cannot acknowledge his own homosexu-ality (or is it that the analyst would not acknowledge it, if it were his?). In other words, the homosexual man takes unconscious retribution on himself, both desiring and fearing the consequences of castration. The male homosexual does not 'know' his homosexuality, although Ferenczi and Riviere apparently do.

But does Riviere know the homosexuality of the woman in masquerade that she describes? When it comes to the counterpart of the analogy that she herself sets up, the woman who 'wishes for masculinity' is homosexual only in terms of

sustaining a masculine identification, but not in terms of a sexual orientation or desire. Invoking Jones's typology once again, as if it were a phallic shield, she formulates a 'defense' that designates as asexual a class of female homosexuals understood as the masquerading type: 'his first group of homosexual women who, while taking no interest in other women, wish for "recognition" of their masculinity from men and claim to be the equals of men, or in other words, to be men themselves' (Riviere 1986: 37). As in Lacan, the lesbian is here signified as an asexual position, as indeed, a position that refuses sexuality. For the earlier analogy with Ferenczi to become complete, it would seem that this description enacts the 'defence' against female homosexuality *as sexuality* that is nevertheless understood as the reflexive structure of the 'homosexual man.' And yet, there is no clear way to read this description of a female homosexuality that is not about a sexual desire for women. Riviere would have us believe that this curious typological anomaly cannot be reduced to a repressed female homosexuality or heterosexuality. What is hidden is not sexuality, but rage.

One possible interpretation is that the woman in masquerade wishes for masculinity in order to engage in public discourse with men and as a man as part of a male homoerotic exchange. And precisely because that male homoerotic exchange would signify castration, she fears the same retribution that motivates the 'defenses' of the homosexual man. Indeed, perhaps femininity as masquerade is meant to deflect from male homosexuality – that being the erotic presupposition of hegemonic discourse, the 'hommo-sexuality' that Irigaray suggests. In any case, Riviere would have us consider that such women sustain masculine identifications not to occupy a position in a sexual exchange, but, rather, to pursue a rivalry that has no sexual object or, at least, that has none that she will name.

Riviere's text offers a way to reconsider the question: What is masked by masquerade? In a key passage that marks a departure from the restricted analysis demarcated by Jones's classificatory system, she suggests that 'masquerade' is more than the characteristic of an 'intermediate type,' that it is central to all 'womanliness':

> The reader may now ask how I define womanliness or where I draw the line between genuine womanliness and the 'masquerade.' My suggestion is not, however, that there is any such difference; whether radical or superficial, they are the same thing.
>
> (Riviere 1986: 38)

This refusal to postulate a femininity that is prior to mimicry and the mask is taken up by Stephen Heath in 'Joan Riviere and the Masquerade' as evidence for the notion that 'authentic womanliness is such a mimicry, *is* the masquerade.' Relying on the postulated characterization of libido as masculine, Heath concludes that femininity is the denial of that libido, the 'dissimulation of a fundamental masculinity.'[2]

Femininity becomes a mask that dominates/resolves a masculine identification, for a masculine identification would, within the presumed heterosexual matrix of desire, produce a desire for a female object, the Phallus; hence, the donning of femininity as mask may reveal a refusal of a female homosexuality and, at the

same time, the hyperbolic incorporation of that female Other who is refused – an odd form of preserving and protecting that love within the circle of the melancholic and negative narcissism that results from the psychic inculcation of compulsory heterosexuality.

One might read Riviere as fearful of her own phallicism – that is, of the phallic identity she risks exposing in the course of her lecture, her writing, indeed, the writing of this phallicism that the essay itself both conceals and enacts. It may, however, be less her own masculine identity than the masculine heterosexual desire that is its signature that she seeks both to deny and enact by becoming the object she forbids herself to love. This is the predicament produced by a matrix that accounts for all desire for women by subjects of whatever sex or gender as origi- nating in a masculine, heterosexual position. The libido-as-masculine is the source from which all possible sexuality is presumed to come.

Here the typology of gender and sexuality needs to give way to a discursive account of the cultural production of gender. If Riviere's analysand is a homosexual without homosexuality, that may be because that option is already refused her; the cultural existence of this prohibition is there in the lecture space, determining and differentiating her as speaker and her mainly male audience. Although she fears that her castrating wish might be understood, she denies that there is a contest over a common object of desire without which the masculine identification that she does acknowledge would lack its confirmation and essential sign. Indeed, her account presupposes the primacy of aggression over sexuality, the desire to castrate and take the place of the masculine subject, a desire avowedly rooted in a rivalry, but one which, for her, exhausts itself in the act of displacement. But the question might usefully be asked: What sexual fantasy does this aggression serve, and what sexu- ality does it authorize? Although the right to occupy the position of a language user is the ostensible purpose of the analysand's aggression, we can ask whether there is not a repudiation of the feminine that prepares this position within speech and which, invariably, re-emerges as the Phallic-Other that will phantasmatically confirm the authority of the speaking subject?

We might then rethink the very notions of masculinity and femininity constructed here as rooted in unresolved homosexual cathexes. The melancholy refusal/domination of homosexuality culminates in the incorporation of the same- sexed object of desire and re-emerges in the construction of discrete sexual 'natures' that require and institute their opposites through exclusion. To presume the primacy of bisexuality or the primary characterization of the libido as masculine is still not to account for the construction of these various 'primacies.' Some psychoanalytic accounts would argue that femininity is based in the exclusion of the masculine, where the masculine is one 'part' of a bisexual psychic composition. The coexis- tence of the binary is assumed, and then repression and exclusion intercede to craft discretely gendered 'identities' out of this binary, with the result that identity is always already inherent in a bisexual disposition that is, through repression, severed into its component parts. In a sense, the binary restriction on culture postures as the precultural bisexuality that sunders into heterosexual familiarity through its advent into 'culture.' From the start, however, the binary restriction on sexuality shows clearly that culture in no way postdates the bisexuality that it purports to repress: It constitutes the matrix of intelligibility through which primary bisexuality

itself becomes thinkable. The 'bisexuality' that is posited as a psychic foundation and is said to be repressed at a later date is a discursive production that claims to be prior to all discourse, effected through the compulsory and generative exclusionary practices of normative heterosexuality.

[. . .]

Notes

1 Joan Riviere (1986) 'Womanliness as a Masquerade,' in Victor Burgin, James Donald, Cora Kaplan (eds), *Formations of Fantasy*, London: Methuen, pp. 35–44.
2 Stephen Heath, 'Joan Riviere and the Masquerade', ibid., pp. 45–61.

N. Katherine Hayles

VIRTUAL BODIES AND
FLICKERING SIGNIFIERS

We might regard patterning or predictability as the very essence and
raison d'être of communication . . . communication is the creation of
redundancy or patterning.

Gregory Bateson, *Steps to an Ecology of Mind*

THE DEVELOPMENT OF INFORMATION THEORY in the wake of World
War II left as its legacy a conundrum: even though information provides the
basis for much of contemporary US society, it has been constructed never to be
present in itself. In information theoretic terms, as we saw in [Hayles'] chapter 1,
information is conceptually distinct from the markers that embody it, for example
newsprint or electromagnetic waves. It is a pattern rather than a presence, defined
by the probability distribution of the coding elements composing the message. If
information is pattern, then noninformation should be the absence of pattern, that
is, randomness. This commonsense expectation ran into unexpected complications
when certain developments within information theory implied that information
could be equated with randomness as well as with pattern.[1] Identifying information
with *both* pattern and randomness proved to be a powerful paradox, leading to the
realization that in some instances, an infusion of noise into a system can cause it to
reorganize at a higher level of complexity.[2] Within such a system, pattern and
randomness are bound together in a complex dialectic that makes them not so much
opposites as complements or supplements to one another. Each helps to define the
other; each contributes to the flow of information through the system.

Were this dialectical relation only an aspect of the formal theory, its impact
might well be limited to the problems of maximizing channel utility and minimizing
noise that concern electrical engineers. Through the development of information
technologies, however, the interplay between pattern and randomness became a
feature of everyday life. As Friedrich Kittler has demonstrated in *Discourse Networks*

1800/1900, media come into existence when technologies of inscription intervene between the hand gripping the pen or the mouth framing the sounds and the production of the texts. In a literal sense, technologies of inscription are media when they are perceived as mediating, inserting themselves into the chain of textual production. Kittler identifies the innovative characteristics of the typewriter, originally designed for the blind, not with speed but rather with 'spatially designated and discrete signs,' along with a corresponding shift from the word as flowing *image* to the word 'as a geometrical figure created by the spatial arrangements of the letter keys' (here Kittler quotes Richard Herbertz).[3] The emphasis on spatially fixed and geometrically arranged letters is significant, for it points to the physicality of the processes involved. Typewriter keys are directly proportionate to the script they produce. One keystroke yields one letter, and striking the key harder produces a darker letter. The system lends itself to a signification model that links signifier to signified in direct correspondence, for there is a one-to-one relation between the key and the letter it produces. Moreover, the signifier itself is spatially discrete, durably inscribed, and flat.

How does this experience change with electronic media? The relation between striking a key and producing text with a computer is very different from the relation achieved with a typewriter. Display brightness is unrelated to keystroke pressure, and striking a single key can effect massive changes in the entire text. The computer restores and heightens the sense of word as image — an image drawn in a medium as fluid and changeable as water.[4] Interacting with electronic images rather than with a materially resistant text, I absorb through my fingers as well as my mind a model of signification in which no simple one-to-one correspondence exists between signifier and signified. I know kinesthetically as well as conceptually that the text can be manipulated in ways that would be impossible if it existed as a material object rather than a visual display. As I work with the text-as-flickering-image, I instantiate within my body the habitual patterns of movement that make pattern and randomness more real, more relevant, and more powerful than presence and absence.

The technologies of virtual reality, with their potential for full-body mediation, further illustrate the kind of phenomena that foreground pattern and randomness and make presence and absence seem irrelevant. Already an industry worth hundreds of millions of dollars, virtual reality puts the user's sensory system into a direct feedback loop with a computer.[5] In one version, the user wears a stereovision helmet and a body glove with sensors at joint positions. The user's movements are reproduced by a simulacrum, called an avatar, on the computer screen. When the user turns his or her head, the computer display changes in a corresponding fashion. At the same time, audiophones create a three-dimensional sound field. Kinesthetic sensations, such as G-loads for flight simulators, can be supplied through more extensive and elaborate body coverings. The result is a multisensory interaction that creates the illusion that the user is *inside* the computer. From my experience with the virtual reality simulations at the Human Interface Technology Laboratory and elsewhere, I can attest to the disorienting, exhilarating effect of the feeling that subjectivity is dispersed throughout the cybernetic circuit. In these systems, the user learns, kinesthetically and proprioceptively, that the relevant boundaries for interaction are defined less by the skin than by the feedback loops connecting body and simulation in a technobio-integrated circuit.

Questions about presence and absence do not yield much leverage in this situation, for the avatar both is and is not present, just as the user both is and is not inside the screen. Instead, the focus shifts to questions about pattern and randomness. What transformations govern the connections between user and avatar? What parameters control the construction of the screen world? What patterns can the user discover through interaction with the system? Where do these patterns fade into randomness? What stimuli cannot be encoded within the system and therefore exist only as extraneous noise? When and how does this noise coalesce into pattern? Working from a different theoretical framework, Allucquère Roseanne Stone has proposed that one need not enter virtual reality to encounter these questions, although VR brings them vividly into the foreground. Merely communicating by email or participating in a text-based MUD (multi-user domain) already problematizes thinking of the body as a self-evident physicality.[6] In the face of such technologies, Stone proposes that we think of subjectivity as a multiple warranted by the body rather than contained within it. Sherry Turkle, in her fascinating work on people who spend serious time in MUDs, convincingly shows that virtual technologies, in a riptide of reverse influence, affect how real life is seen. 'Reality is not my best window,' one of her respondents remarks.[7]

In societies enmeshed within information networks, as the U.S. and other first world societies are, these examples can be multiplied a thousandfold. Money is increasingly experienced as informational patterns stored in computer banks rather than as the presence of cash; surrogacy and in vitro fertilization court cases offer examples of informational genetic patterns competing with physical presence for the right to determine the 'legitimate' parent; automated factories are controlled by programs that constitute the physical realities of work assignments and production schedules as flows of information through the system;[8] criminals are tied to crime scenes through DNA patterns rather than through eyewitness accounts verifying their presence; access to computer networks rather than physical possession of data determines nine-tenths of computer law;[9] sexual relationships are pursued through the virtual spaces of computer networks rather than through meetings at which the participants are physically present.[10] The effect of these transformations is to create a highly heterogeneous and fissured space in which discursive formations based on pattern and randomness jostle and compete with formations based on presence and absence. Given the long tradition of dominance that presence and absence have enjoyed in the Western tradition, the surprise is not that formations based on them continue to exist but that these formations are being displaced so rapidly across a wide range of cultural sites.

These examples, taken from studies of information technologies, illustrate concerns that are also appropriate for literary texts. If the effects that the shift toward pattern/randomness has on literature are not widely recognized, perhaps it is because they are at once pervasive and elusive. A book produced by typesetting may look very similar to one generated by a computerized program, but the technological processes involved in this transformation are not neutral. Different technologies of text production suggest different models of signification; changes in signification are linked with shifts in consumption; shifting patterns of consumption initiate new experiences of embodiment; and embodied experience interacts with codes of representation to generate new kinds of textual worlds.[11] In fact, each

category – production, signification, consumption, bodily experience, and representation – is in constant feedback and feedforward loops with the others.

As the emphasis shifts to pattern and randomness, characteristics of print texts that used to be transparent (because they were so pervasive) are becoming visible again through their differences from digital textuality. We lose the opportunity to understand the implications of these shifts if we mistake the dominance of pattern/randomness for the disappearance of the material world. In fact, it is precisely because material interfaces have changed that pattern and randomness can be perceived as dominant over presence and absence. The pattern/randomness dialectic does not erase the material world; information in fact derives its efficacy from the material infrastructures it appears to obscure. This illusion of erasure should be the *subject* of inquiry, not a presupposition that inquiry takes for granted.

To explore the importance of the medium's materiality, let us consider the book. Like the human body, the book is a form of information transmission and storage, and like the human body, the book incorporates its encodings in a durable material substrate. Once encoding in the material base has taken place, it cannot easily be changed. Print and proteins in this sense have more in common with each other than with magnetic encodings, which can be erased and rewritten simply by changing the polarities. (In Hayles' (1990) chapter 8 we shall have an opportunity to see how a book's self-representations change when the book is linked with magnetic encodings.) The printing metaphors pervasive in the discourse of genetics are constituted through and by this similarity of corporeal encoding in books and bodies.

The entanglement of signal and materiality in bodies and books confers on them a parallel doubleness. As we have seen, the human body is understood in molecular biology simultaneously as an expression of genetic information and as a physical structure. Similarly, the literary corpus is at once a physical object and a space of representation, a body and a message. Because they have bodies, books and humans have something to lose if they are regarded solely as informational patterns, namely the resistant materiality that has traditionally marked the durable inscription of books no less than it has marked our experiences of living as embodied creatures. From this affinity emerge complex feedback loops between contemporary literature, the technologies that produce it, and the embodied readers who produce and are produced by books and technologies. Changes in bodies as they are represented within literary texts have deep connections with changes in textual bodies as they are encoded within information media, and both types of changes stand in complex relation to changes in the construction of human bodies as they interface with information technologies. The term I use to designate this network of relations is *informatics*. Following Donna Haraway, I take *informatics* to mean the technologies of information as well as the biological, social, linguistic, and cultural changes that initiate, accompany, and complicate their development.[12]

I am now in a position to state my thesis explicitly. The contemporary pressure toward dematerialization, understood as an epistemic shift toward pattern/randomness and away from presence/absence, affects human and textual bodies on two levels at once, as a change in the body (the material substrate) and as a change in the message (the codes of representation). The connectivity between these changes is, as they say in the computer industry, massively parallel and highly interdigitated. My narrative will therefore weave back and forth between the represented

worlds of contemporary fictions, models of signification implicit in word processing, embodied experience as it is constructed by interactions with information technologies, and the technologies themselves.

[. . .]

Notes

1 The paradox is discussed in N. Katherine Hayles, *Chaos Bound: Orderly Disorder in Contemporary Literature and Science* (Ithaca: Cornell University Press, 1990), pp. 31–60.

2 Self-organizing systems are discussed in Grégoire Nicolis and Ilya Prigogine, *Exploring Complexity: An Introduction* (New York: Freeman and Company, 1989); Roger Lewin, *Complexity: Life at the Edge of Chaos* (New York: Macmillan, 1992); and M. Mitchell Waldrop, *Complexity: The Emerging Science at the Edge of Order and Chaos* (New York: Simon and Schuster, 1992).

3 Friedrich A. Kittler, *Discourse Networks, 1800–1900*, trans. Michael Metteer (Stanford: Stanford University Press, 1990), p. 193.

4 The fluidity of writing on the computer is eloquently explored by Michael Joyce in *Of Two Minds: Hypertext Pedagogy and Poetics* (Ann Arbor: University of Michigan Press, 1995).

5 Howard Rheingold surveys the new virtual technologies in *Virtual Reality* (New York: Summit Books, 1991). Also useful is Ken Pimentel and Kevin Teixeira, *Virtual Reality: Through the New Looking Glass* (New York: McGraw-Hill, 1993). Benjamin Woolley takes a skeptical approach toward claims for the new technology in *Virtual Worlds: A Journey in Hyped Hyperreality* (Oxford: Blackwell, 1992).

6 Allucquère Roseanne Stone, *The War of Desire and Technology at the Close of the Mechanical Age* (Cambridge: MIT Press, 1995).

7 Sherry Turkle, *Life on the Screen: Identity in the Age of the Internet* (New York: Simon and Schuster, 1995).

8 In *The Age of the Smart Machine: The Future of Work and Power* (New York: Basic Books, 1988), Shoshana Zuboff explores, through three case studies, the changes in US workplaces as industries become informatted.

9 Computer law is discussed in Katie Hafner and John Markoff, *Cyberpunk: Outlaws and Hackers on the Computer Frontier* (New York: Simon and Schuster, 1991); also informative is Bruce Sterling, *The Hacker Crackdown: Law and Disorder on the Electronic Frontier* (New York: Bantam, 1992).

10 Turkle documents computer network romances in *Life on the Screen*. Nicholson Baker's *Vox: A Novel* (New York: Random House, 1992) imaginatively explores the erotic potential for better living through telecommunications; and Rheingold looks at the future of erotic encounters in cyberspace in 'Teledildonics and Beyond,' *Virtual Reality*, pp. 345–77.

11 Among the studies that explore these connections are Jay Bolter, *Writing Space: The Computer, Hypertext, and the History of Writing* (Hillsdale, NJ: Lawrence Erlbaum, 1991); Michael Heim, *Electric Language: A Philosophical Study of Word Processing* (New Haven: Yale University Press, 1987); and Mark Poster, *The Mode of Information: Poststructuralism and Social Context* (Chicago: University of Chicago Press, 1990).

12 Donna Haraway, 'A Manifesto for Cyborgs: Science, Technology, and Socialist Feminism in the 1980s,' *Socialist Review* 80(1985): 65–108; see Donna Haraway, 'The High Cost of Information in Post World War II, Evolutionary Biology: Ergonomics, Semiotics, and the Sociobiology of Communications Systems,' *Philosophical Forum* 13, nos. 2–3 (1981–82): 244–75.

PART ONE

Global/Digital

Introduction to part one

■ Nicholas Mirzoeff

T HE QUESTION OF GLOBALIZATION and its representations is clearly going to
be central to intellectual and political debate for the foreseeable future, even
as the nature of what is happening seems to shift on an all but daily basis. The
global 'war on terrorism' that is ongoing as I write could not have been predicted
prior to September 11 and other such developments will no doubt occur. However,
it is clear that this moment of globalization is characterized over a longer span by
the transformation of culture by digital technology. The contradictions produced by
this process can be exemplified in the Cyber Towers housing complex with T-1 access
to the internet recently built in Bangalore, India. It is physically adjacent to 'Third
World' housing but is conceptually part of the global digital sphere. The success of
globalization as a capitalist enterprise will depend in considerable part on its being
able to sustain such apparent dichotomies without provoking a reaction from the
excluded. In 'Imagining globalization,' therefore, we look first at the different ways
in which globalization has been imagined and the place of imagination as a global
practice. In the second section, 'Space, identity, and digital culture,' we consider
how space has been shaped and deployed in digital culture.

(a) Imagining globalization

One of the first scholars to highlight globalization as a critical question was the
Indian sociologist Arjun **Appadurai**. In the introduction to his already classic study
Modernity at Large: Cultural Dimensions of Globalization (1996), Appadurai con-
structed what he called 'a theory of rupture that takes media and migration as its
two major, and interconnected, diacritics and explores their joint effect on the *work
of the imagination*.' Emphasizing that the imagination is no longer confined – if

indeed it ever was – to the creative artist but that it is now a 'social fact,' Appadurai in effect calls for a revaluation of the work of the image. Visual culture is a key part of the response to that demand. He stresses that the self-imaging and work of the imagination in everyday lives across the globe contradict any view of the electronic media as simply pacifying the masses.

Appadurai argues that 'the widespread appearance of various kinds of diasporic public spheres . . . constitute one special diacritic of the global modern.' The subsequent essays in this section examine different examples of these diasporic public spheres in the visual arts, as indeed do many of the other essays in this volume (**Joseph, Joselit, Shohat** and **Stam, Wallace, Nakamura, Fusco, Piper**). Néstor García **Canclini** asks 'what type of visual thinking can speak today significantly in the discordant dialogue between fundamentalism and globalization?' Aware that Latin American art history has been excluded as exotic or primitive from that 'history of art as the history of nations,' Canclini emphasizes that not only is this an ignorant account of Latin American culture, it is now an irrelevance in the age of deterritorialized art and the cosmopolitan artist. Drawing directly on Appadurai's work, Canclini turns his attention to art like the airmail paintings of Eugenio Dittborn that stem from identities that are 'polyglot and migrant, they can function in diverse and multiple contexts and permit divergent readings from their hybrid constitution.' This effort is in tension both with attempts to sustain the national and with more nuanced strategies to recognize a multiculturalism that nonetheless situates its practitioners as subalterns. For the Argentinine artist Sebastián López this amounts to saying 'the universal is "ours," the local is "yours."'

In a characteristically brilliant essay, Kobena **Mercer** looks at the collision of the diasporic and the local in recent British art. He shows how the creation of 'young British artists' (yBA) and their counterparts at the International Institute of Visual Arts (inIVA) in Britain were 'the fallout of two contradictory responses to globalization as a new phase of capitalist modernization.' Arguing that the corporate rhetoric of visible multiculturalism has undercut radical demands for representation rather than simple inclusion, Mercer satirizes the 'pathetic nationalism' of the yBAs, while noting that the goals of cultural practice have had to change. This new problematic is summed up by Mercer as 'a scenario in which the longstanding metaphor of minority "invisibility" has given way to a new and wholly unanticipated predicament of "hypervisibility."' That is to say, with art galleries, movies and television shows alike now being careful to ensure at least token participation by blacks and other minorities, there is a new visibility of diaspora peoples even as long-standing problems of racism and underrepresentation remain substantially the same in Britain. This situation is named 'multicultural normalization' by Mercer. In response black British artists have tried to elude this normalization with disruptive strategies such as Chris Ofili's now notorious use of elephant dung in his paintings. For such artists and their supporters the poststructuralist critique of representation is part of the problem rather than the solution, dismissed as 'boring.' Mercer thus situates 'inIVA's unpopularity as an outcome of its association with the bureaucratic institutionalization of cultural theory.' Attempting to go beyond this impasse involves both recovering 'the genealogy of the mixed times and spaces inhabited by

diaspora artists,' and an understanding that 'a certain Britishness was always already hybridized in the encounter with Asian, African and Caribbean diasporas.' This reminder is salutary at a time when conservative leaders refer to Britain as a 'foreign land' and British immigration officials refuse entry to anyone who appears to be Roma (aka 'gypsy') at special checkpoints in Prague airport.

My own essay, taken from the edited volume, *Diaspora and Visual Culture: Representing Africans and Jews* (2000), develops Mercer's call for a genealogy of diaspora by examining the historical and critical interaction between African and Jewish diasporas. It is motivated by the belief that diaspora is an inevitably plural noun, meaning that diasporas cannot be properly understood in isolation. Diaspora generates what I call a 'multiple viewpoint' in any diasporic visual image. This view-point incorporates Derrida's *différance*, the painter R.B. Kitaj's 'many views' of diaspora, and what Ella Shohat and Robert Stam have called a 'polycentric vision,' in which the visual is located '*between* individuals and communities and cultures in the process of dialogic interaction' (**Shohat and Stam**). The multiple viewpoint moves beyond the one-point perspective of Cartesian rationalism in the search for a forward-looking, transcultural and transitive place from which to look and be seen. In the contemporary moment, when imagination itself 'is neither purely emancipa-tory nor entirely disciplined but is a space of contestation in which individuals and groups seek to annex the global into their own practices of the modern' (**Appadurai**), changing the way in which people see themselves is in all senses a critical activity.

Lisa **Bloom's** essay on 'Gender, nationalism, and internationalism in Japanese contemporary art' is an example of what she calls, borrowing from Inderpal Grewal and Caren Kaplan, 'transnational feminist cultural studies.' The phrase is suggestive of the difficulties critical work has encountered in attempting to refashion itself from local to global perspectives. Bloom has encountered these problems at first hand teaching visual culture in Japan, where the notion of *Nihonjinron* – 'the master narrative celebrating Japanese uniqueness' – complicates efforts to think about diversity. While some intellectuals are drawn to the very Western theories of multi-culturalism that scholars like Mercer are now critiquing, there are new initiatives to consider the tension between 'advanced countries advocating globalization and the third world's adherence to ethnicity.' Rather than offer a global solution, Bloom stresses the local happenstance that enabled her to undertake this study. Feminist art and art criticism in Japan have been connected to Japan's imperial history by both its supporters and critics. Bloom emphasizes the importance of 'connecting a critique of Japan's emperor system and its hierarchy to the effects this system has had on the lives of women in Japan and Asia.' Japanese artists dealing with such themes are marginalized in favor of splashy shows of French Impressionism. So while Western artists are comfortable in their subject position as artists, in Japan and else-where in Asia simply being a contemporary artist is a problem. Add to that the com-plex historical tensions between Japan and other East Asian nations, and it is perhaps less surprising that Bloom found a 'hostility to art work and scholarship that deals with issues of gender, race and nation' that are so central to Western concerns. These difficulties suggest that 'there is a lot for visual critics . . . to learn' from such inter-sections. Working them out is the challenge for visual culture's next decade.

Further reading

Appadurai, Arjun (1996), *Modernity at Large: Cultural Dimensions of Globalization*, Minneapolis: University of Minnesota Press.

Bhabha, Homi (1994), *The Location of Culture*, London: Routledge.

Bloom, Lisa (1999), *With Other Eyes: Looking at Race and Gender in Visual Culture*, Minneapolis: Minnesota University Press.

Canclini, Néstor García (1995), *Hybrid Modernities: Strategies for Entering and Leaving Modernity*, Minneapolis: University of Minnesota Press.

Lull, James (2000), *Media, Communication, Culture: A Global Approach* (2nd edn), New York: Columbia University Press.

Mercer, Kobena (1994), *Welcome to the Jungle: New Positions in Black Cultural Studies*, London: Routledge.

Spivak, Gayatri Chakravorty (1999), *A Critique of Postcolonial Reason*, Cambridge, Mass.: Harvard University Press.

Rogoff, Irit (2000), *Terra Infirma: Geography's Visual Culture*, London: Routledge.

(b) The space of the digital

The digital is all about space. During the gold rush years of digital culture, cyberspace came to have an apparent physical geography to match its virtual counterpart. It was a global hierarchy whose downtown was in MIT and Silicon Valley, with all-powerful suburbs in Redmond (home of Microsoft) and with blue-collar districts in locales such as Bangalore, India. The global class system created by this remapping of physical and virtual space had paradoxical consequences. In 2000, 'white' people were in a minority in Silicon Valley, squeezed between the South Asian software engineers produced by India's elite institutes of technology and the Latina/o workers who kept the place running. In a number of East Asian countries, ground-up cyber cities were begun ranging from Malaysia's Cyberjaya, which claimed it would be the first green city, to Indonesia's Cyber City, which was to be built on a disused airport, symbolizing the transition from mass physical transport to high bandwidth virtual teletransport. The websites of these proposed capitals of the era of electronic reproduction are not being updated now and it is unclear what is happening on the ground.

In these new spaces, what happens to identity, that place from which a person says 'I' and imagines a 'we'? In the first days of cyberculture, there was a utopian sense that fixed, corporeal markers of identity were open to free-flowing change in cyberspace. On-line it seemed that one could adopt a new gender or sexual identity without risk, or refuse to be named by a racialized identity, or look at the world from the perspective of another person. The hope was that this temporary shift, mostly enacted through text-only role-playing games or in chat rooms, might in turn have a positive effect in real life. In her 1997 book *Life on Screen*, analyst Sherry Turkle claimed that people were gaining therapeutic benefits from such role play, which is itself a therapeutic exercise after all. To some extent such hopes have been realized. For many young people who are (or think that they might be) queer, the

internet has proved to be an important resource, offering contacts, information, support and a certain form of sexual experience. In his series of postings entitled 'Voices from the Hellmouth' at the techie site slashdot.com, Jon Katz has detailed how many frustrated and alienated teenagers responded to his article on the Columbine High School shootings. Katz described how high schools decided to target their already marginalized geeks, Goths and digital freaks as if they were all likely to reenact the events of Columbine. He was greeted with an avalanche of email from teenagers in high school and those recalling the misery of those days. Some postings compared the list to Stonewall, the now legendary 1969 fightback by harassed gays and lesbians against the police in New York. That view, which saw the emergence of a new on-line identity, was swamped by a far more prevalent one: that in a few years, all the geeks would be making far more money than their current harassers. A common scenario was the now-persecuted geek pulling up to a McDonalds in his (gender intended) expensive car and being served by a jock, prep or other bully. It is not my intent to decry what is clearly a satisfactory and non-violent means of turning the tables. Rather it perhaps suggests the limits of cyberspace for the creation of new identities. For a certain minority, cyberspace is liberatory, creating parallels with other minority groups. For the majority, digital culture was the pathway to a new car – with fries.

The internet crash puts a question mark over all that fast money. For the first time since the shares began soaring in the early 1990s, it might be possible to ask seriously what cyberspace is for, where it came from, what its limits are and who can use it? Looking back at Michel **Foucault's** 1967 essay 'Of Other Spaces' today, one cannot help but be struck by his apparent prescience in writing: 'We are at a moment, I believe, when our experience of the world is less that of a long life developing through time than that of a network that connects points and intersects with its own skein.' He then argues that in this network 'the site has been substituted for extension' so that 'space takes for us the form of relations between sites.' While these expressions seem to predict the internet, it might be more accurate to say that they were indicative of the kind of thinking that made something like the internet possible. Foucault cast his own gaze backwards, analyzing the spaces that he called 'heterotopias,' places where the sites in a culture are 'simultaneously represented, contested and inverted.' Examples like the hospital, the prison and the elderly home are 'heterotopias of deviation' that delimit, define and contain the boundaries of a culture. Clearly cyberspace is a form of heterotopia that causes us to re-examine the very question of space in itself.

Pursuing the examination of this space, Geoffrey **Batchen** compares and contrasts nineteenth-century representations of space in photography and stereoscopy with early predictions of the imminent emergence of Virtual Reality or VR. VR was supposed to be a fully immersive environment with which the user would ultimately be able to interact fully. It has faded from view as the technology stubbornly refuses to develop fast enough for the attention span of cyberjournalism. Such accounts, as Batchen argues, 'leave no room for complexity; for the complexity of the operations of both power and history; [and] for the complexity and diversity of cyberspace itself.' Comparing the dynamics of virtual reality to that of the

invention of photography, Batchen suggests that such questions of space and identity are 'not something peculiar to a particular technology or to postmodern discourse but is rather one of the fundamental conditions of modernity itself.' And the new cyberhistory, encompassing Victorian scientists like Charles Babbage and Ada Lovelace, the telegraph and the rise of electricity, seems to bear Batchen's theory out.

As Wendy Hui Kyong **Chun** notes in her essay, taken from her forthcoming book, 'like all explorations, charting cyberspaces entailed uncovering what was always already there and declaring it "new."' Drawing on Foucault's discussion of the mirror as a heterotopia, Chun argues that the computer 'enables one to see oneself . . . where one is not.' Rather than concentrate on the distinction between the 'virtual' and 'real' self, Chun examines how 'these images become spectacles in their own right.' Noting that the web has engendered fantasies of perfect 'passing,' she shows that, just as Foucault's 'perfect' heterotopias were dependent on an active forgetting of Native American and indigenous presence, so too does web passing depend on an illusion that the user is fully in control of the system. Critiquing the widespread notion that the web user is the contemporary equivalent of the *flâneur*, the dandy who sees without being seen, Chun argues that 'every spectator is also a spectacle, given that everyone automatically produces traces.' She suggests that a better, if less flattering name, for on-line spectators would be that of *badaud*, that is a gawker or rubberneck. The gawker is so caught up in the ecstasy of what is being seen that s/he becomes a spectacle, while fantasizing that s/he is a *flâneur*. These fantasies were enabled by the founding imaginary rendition of cyberspace in cyberpunk fiction, such as the novels of William Gibson and Neal Stephenson. Preceding the mass-user internet by a number of years, these novels created a desire for cyberspace that was based on what Chun calls a 'high tech orientalism.' This formula for navigation-by-difference emerged in a period of US pessimism that imagined a Japanese-dominated future as in effect synonymous with the emergence of a high tech society. Although this vision was of the future, it was based on the nineteenth-century colonial past in which (white) settlers conquered the frontier. In short, Chun's essay suggests that for all the futuristic talk associated with the internet, the dominant models of internet use rely on nineteenth-century ideas of the colonizing subject and skate over the implications of the largely independent ways computers actually exchange data.

By the same token, Lisa **Nakamura** explodes one of the myths of the new internet identity as circulated by advertising, that there is no difference between people on-line. In a certain sense, a virtual company exists only in its media. More conventional companies that use information technology have picked up on this idea to sell the theory that on the net 'there are only minds,' to quote an MCI ad, 'uninfluenced by the rest of it.' Nakamura shows that, on the contrary, the depiction of 'race' in such advertising is 'designed to stabilize contemporary anxieties that networking technology and access to cyberspace may break down ethnic and racial differences.' This advertising hinges on the contradiction that the erasure of 'race,' as Nakamura argues, 'can only be understood in terms of its presence.' This conundrum has haunted many artists and filmmakers trying to deal with representations of ethnicity

but is used by advertisers to create both a positive image of high technology as ecological and responsible and at the same time to reinforce power differentials between first and third world peoples as being natural because they are visible. One striking example cited by Nakamura shows a camel driver seated on his animal in the shade of the Great Pyramids of Giza. As she rightly says: 'great pains are taken in this ad to make the camel rider seem real, truly different from us, and "authentic" in order to build up an idealized Other whose unspoiled nature shores up the tourist's sense that he is indeed seeing the "real" thing.' IBM's ad offers a view that no tourist on the ground could see for the pyramids are now located in close proximity to the Cairo suburbs that have been digitally erased from the background of the image. The only camel drivers in the area are there to offer rides to tourists that always mysteriously culminate in a visit to a souvenir shop the driver happens to know. This is Orientalism lite, a visibly recognizable symbol carefully detached from any trace of its local context in the patronizing confidence that viewers will not know the difference, The text of this and other IBM ads produced subaltern citizens 'who miraculously speak like "us" but still look like "them."' Here, then, is the cyber version of the project of (neo) colonial mimicry identified by Homi Bhabha in which the raced and ethnic body of the subaltern is made to perform the labor desired by the colonizer but is nonetheless still visibly 'different.'

In this view, then, digital technology is in some senses enabling the completion of epistemological and political projects that have a long history in ways that are sometimes obviously suspect and sometimes not. In Thomas **Campanella's** view, the creation of the webcamera is one stage in a long history of the abnegation of distance that marks an important if not final step towards the enactment of telepresence. Telepresence would be a reciprocal relationship between observer and observed such that 'the observer is telepresent in the remote environment, and the observed environment is telepresent in the physical space in which the observer is viewing the scene.' A conventional photograph, then, allows only for a small degree of telepresence for the observer, in conditions dictated by the photographer, while the observed is not telepresent at all. Campanella notes that the same pyramids discussed by **Nakamura** were a popular subject for stereoscopic cards in the nineteenth century (discussed by **Batchen**) as the illusion of three dimensions created by the stereoscope enhanced the experience for the viewer. To what extent are the small fixed images offered by webcameras an improvement on the stereoscope? Your answer to this question will indicate with some accuracy where you stand in the whole digital debate. If you think it is hardly different at all, you are a cyberskeptic. If it seems radically new, you are a cyberutopian. Campanella admits that the webcamera offers 'only the most basic variety of telepresence.' But he points to the NASA Pathfinder mission to Mars in 1997 as an example of what might be achieved. When Martian images were posted to the NASA server more than 45 million viewers logged on to see them, generating 80 million hits a day during the first week of operation. These pictures were 'fresh and clear enough to afford a convincing spatial sense of another world.' At the same time, the event was a defining moment for the internet itself as its users, not the commercial companies seeking to sell things, made the net do something different. Of course doubts persist and are inherent to the medium. When

Campanella views a water buffalo drinking at an African game reserve, he wonders: 'Were those animals pixelated a day or a month ago and long vanished?' Just as Victorians gazing at the earliest photographs realized that reality had been newly defined in ways they were not sure they liked, so we look at webcameras and ask: 'What is the integrity of the knowledge received from a webcamera and how are we to verify it?' To which one should perhaps add: and how is this knowledge different from that produced by an analog camera?

In her essay, Lisa **Parks** suggests that these epistemological and historical questions will require political and cultural answers as well as academic ones. In her consideration of the Digital Earth Project, Parks shows what is at stake for visual culture in working with the digital. The Digital Earth is envisioned as 'a virtual environment that encompasses the entire planet and enables a user to explore vast amounts of information gathered about the earth.' As the first mover of the project was former US Vice-President Al Gore and its major backers are global corporations, it is not surprising that the project currently lacks a critical edge. But rather than write the project off as another corporate hype, Parks argues that 'the project should be re-fashioned as an interdisciplinary "contact zone" that will not only extend public access to satellite and digital technologies, but help erode the science/culture divide.' By borrowing the notion of a contact zone from the post-colonial critic Mary-Louise Pratt, Parks recognizes the neo-colonial aspects of digital culture highlighted by Lisa Nakamura. At the same time she acknowledges, in the manner of Thomas Campanella, that a new form of visual culture has been created by the satellite representation of earth and its digital reconfigurations: 'the orbital view can provide an unearthly platform from which to evaluate and complicate the truth status of what appears in the frame; it can lead to cultural excavation or infusion of the world's chaos and complexity.' But the digital rendering of this view is so seamless that such possibilities within the frame seem to be elided. Parks calls for a contestation of what she calls visual capital: 'a system of social differentiation based upon users/viewers' relative access to technologies of global media. . . . For in an age of technologized vision, how, what, and when one sees/ knows increasingly determines one's place within a broader system of power relations.' The Digital Earth is an example, of course, of the immense visual capital of the US. But Parks exploits the project's own rhetoric to call for a wider involvement of artists, critics and even broadcasters, forging a 'contact zone to foster intellectual interdisciplinarity and collaborative work across the science/culture divide.' This project will run into charges of being either insufficiently far-reaching or hopelessly ambitious. Those who want a thorough-going transformation of late capitalist society will certainly be in the former camp but they have little by way of practical strategies to offer. On the other side will be those who will say that neither government nor business will ever respond to such a challenge. But what Parks – like the other essays in this section – offers is the possibility of a specific place to begin to try to effect change. Here visual culture becomes not simply oppositional but engaged in trying to shape and form cultural policy in the vital but poorly understood area of the digital image.

Further reading

Bachelard, Gaston (1964), *The Poetics of Space*, New York: Orion.

Bell, David and Kennedy, Barbara M. (2000), *The Cybercultures Reader*, London: Routledge.

Druckery, Timothy (ed.) (1999), *Ars Electronica: Facing the Future*, Cambridge, Mass.: MIT Press.

Druckery, Timothy and Weibel, Peter (eds) (2001), *net condition (Electronic Culture: History, Theory, and Practice)*, Cambridge, Mass.: MIT Press.

Kolko, Beth E., Nakamura, Lisa, and Rodman, Gil (2000), *Race in Cyberspace*, London: Routledge.

Lovejoy, Margot (1996), *Postmodern Currents: Art and Artists in the Age of Electronic Media*, New York: Prentice Hall.

Lunenfeld, Peter (ed.), *The Digital Dialectic*, Cambridge, Mass.: MIT Press.

Manovich, Lev (2001), *The Language of New Media*, Cambridge, Mass.: MIT Press.

Pratt, Mary-Louise (1992), *Imperial Eyes: Travel-Writing and Transculturation*, London and New York: Routledge.

Rush, Michael (1999), *New Media in Late Twentieth-Century Art*, London: Thames & Hudson.

Turkle, Sherry (1997), *Life on Screen: Identity in the Age of the Internet*, New York: Touchstone.

Sites

(all http://www unless otherwise indicated)

MongrelX.org: British-based digital activism collective

RTMark.com: corporate sabotage and digital activism

Rhizome.com: indispensable breaking news in new media

Slashdot.com: tech news, ideas and gossip

Guerillagirls.com: cultural conscience of the internet

Cyberjaya-msc.com/: information and news on the planned digital city in Malaysia

Corp-compass.com/Cybercity_indonesia.htm: information on the planned digital city in Indonesia

(a) Imagining globalization

Arjun Appadurai

HERE AND NOW

[. . .]

ALL MAJOR SOCIAL FORCES HAVE precursors, precedents, analogs and sources in the past. It is these deep and multiple genealogies . . . that have frustrated the aspirations of modernizers in very different societies to synchronize their historical watches. This [Appadurai's] book, too, argues for a general rupture in the tenor of intersocietal relations in the past few decades. This view of change – indeed, of rupture – needs to be explicated and distinguished from some earlier theories of radical transformation.

One of the most problematic legacies of grand Western social science (Auguste Comte, Karl Marx, Ferdinand Toennies, Max Weber, Émile Durkheim) is that it has steadily reinforced the sense of some single moment – call it the modern moment – that by its appearance creates a dramatic and unprecedented break between past and present. Reincarnated as the break between tradition and modernity and typologized as the difference between ostensibly traditional and modern societies, this view has been shown repeatedly to distort the meanings of change and the politics of pastness. Yet the world in which we now live – in which modernity is decisively at large, irregularly self-conscious, and unevenly experienced – surely does involve a general break with all sorts of pasts. What sort of break is this, if it is not the one identified by modernization theory. . . ?

Implicit in this book is a theory of rupture that takes media and migration as its two major, and interconnected, diacritics and explores their joint effect on the *work of the imagination* as a constitutive feature of modern subjectivity. The first step in this argument is that electronic media decisively change the wider field of mass media and other traditional media. This is not a monocausal fetishization of the electronic. Such media transform the field of mass mediation because they offer new resources and new disciplines for the construction of imagined selves and imagined

worlds. This is a relational argument. Electronic media mark and reconstitute a much wider field, in which print mediation and other forms of oral, visual, and auditory mediation might continue to be important. Through such effects as the telescoping of news into audio-video bytes, through the tension between the public spaces of cinema and the more exclusive spaces of video watching, through the immediacy of their absorption into public discourse, and through their tendency to be associated with glamour, cosmopolitanism, and the new, electronic media (whether associated with the news, politics, family life, or spectacular entertainment) tend to interrogate, subvert, and transform other contextual literacies. In the chapters that follow, I track some ways in which electronic mediation transforms preexisting worlds of communication and conduct.

Electronic media give a new twist to the environment within which the modern and the global often appear as flip sides of the same coin. Always carrying the sense of distance between viewer and event, these media nevertheless compel the transformation of everyday discourse. At the same time, they are resources for experiments with self-making in all sorts of societies, for all sorts of persons. They allow scripts for possible lives to be imbricated with the glamour of film stars and fantastic film plots and yet also to be tied to the plausibility of news shows, documentaries, and other black-and-white forms of telemediation and printed text. Because of the sheer multiplicity of the forms in which they appear (cinema, television, computers, and telephones) and because of the rapid way in which they move through daily life routines, electronic media provide resources for self-imagining as an everyday social project.

As with mediation, so with motion. The story of mass migrations (voluntary and forced) is hardly a new feature of human history. But when it is juxtaposed with the rapid flow of mass-mediated images, scripts, and sensations, we have a new order of instability in the production of modern subjectivities. As Turkish guest workers in Germany watch Turkish films in their German flats, as Koreans in Philadelphia watch the 1988 Olympics in Seoul through satellite feeds from Korea, and as Pakistani cabdrivers in Chicago listen to cassettes of sermons recorded in mosques in Pakistan or Iran, we see moving images meet deterritorialized viewers. These create diasporic public spheres, phenomena that confound theories that depend on the continued salience of the nation-state as the key arbiter of important social changes.

Thus, to put it summarily, electronic mediation and mass migration mark the world of the present not as technically new forces but as ones that seem to impel (and sometimes compel) the work of the imagination. Together, they create specific irregularities because both viewers and images are in simultaneous circulation. Neither images nor viewers fit into circuits or audiences that are easily bound within local, national, or regional spaces. Of course, many viewers may not themselves migrate. And many mass-mediated events are highly local in scope, as with cable television in some parts of the United States. But few important films, news broadcasts, or television spectacles are entirely unaffected by other media events that come from further afield. And few persons in the world today do not have a friend, relative, or coworker who is not on the road to somewhere else or already coming back home, bearing stories and possibilities. In this sense, both persons and images often meet unpredictably, outside the certainties of home and the cordon sanitaire

of local and national media effects. This mobile and unforeseeable relationship between mass-mediated events and migratory audiences defines the core of the link between globalization and the modern. In the chapters that follow, I show that the work of the imagination, viewed in this context, is neither purely emancipatory nor entirely disciplined but is a space of contestation in which individuals and groups seek to annex the global into their own practices of the modern.

Ever since Durkheim, and the work of the *Années Sociologiques* group, anthropologists have learned to regard collective representations as social facts — that is, to see them as transcending individual volition, as weighted with the force of social morality, and as objective social realities. What I wish to suggest is that there has been a shift in recent decades, building on technological changes over the past century or so, in which the imagination has become a collective, social fact. This development, in turn, is the basis of the plurality of imagined worlds.

On the face of it, it seems absurd to suggest that there is anything new about the role of the imagination in the contemporary world. After all, we are now accustomed to thinking about all societies as having produced their versions of art, myth, and legend, expressions that implied the potential evanescence of ordinary social life. In these expressions, all societies showed that they could both transcend and reframe ordinary social life by recourse to mythologics of various kinds in which social life was imaginatively deformed. In dreams, finally, individuals even in the most simple societies have found the space to refigure their social lives, live out proscribed emotional states and sensations, and see things that have then spilled over into their sense of ordinary life. All these expressions, further, have been the basis of a complex dialogue between the imagination and ritual in many human societies, through which the force of ordinary social norms was somehow deepened, through inversion, irony, or the performative intensity and the collaborative work demanded by many kinds of ritual. All this is the surest sort of knowledge bequeathed to us by the best of canonical anthropology over the past century.

In suggesting that the imagination in the postelectronic world plays a newly significant role, I rest my case on three distinctions. First, the imagination has broken out of the special expressive space of art, myth, and ritual and has now become a part of the quotidian mental work of ordinary people in many societies. It has entered the logic of ordinary life from which it had largely been successfully sequestered. Of course, this has precedents in the great revolutions, cargo cults, and messianic movements of other times, in which forceful leaders implanted their visions into social life, thus creating powerful movements for social change. Now, however, it is no longer a matter of specially endowed (charismatic) individuals, injecting the imagination where it does not belong. Ordinary people have begun to deploy their imaginations in the practice of their everyday lives. This fact is exemplified in the mutual contextualizing of motion and mediation.

More people than ever before seem to imagine routinely the possibility that they or their children will live and work in places other than where they were born: this is the wellspring of the increased rates of migration at every level of social, national, and global life. Others are dragged into new settings, as the refugee camps of Thailand, Ethiopia, Tamil Nadu, and Palestine remind us. For these people, they move and must drag their imagination for new ways of living along with them. And then there are those who move in search of work, wealth, and opportunity often

because their current circumstances are intolerable. Slightly transforming and extending Albert Hirschman's important terms *loyalty* and *exit*, we may speak of diasporas of hope, diasporas of terror, and diasporas of despair. But in every case, these diasporas bring the force of the imagination, as both memory and desire, into the lives of many ordinary people, into mythographies different from the disciplines of myth and ritual of the classic sort. The key difference here is that these new mythographies are charters for new social projects, and not just a counterpoint to the certainties of daily life. They move the glacial force of the habitus into the quickened beat of improvisation for large groups of people. Here the images, scripts, models, and narratives that come through mass mediation (in its realistic and fictional modes) make the difference between migration today and in the past. Those who wish to move, those who have moved, those who wish to return, and those who choose to stay rarely formulate their plans outside the sphere of radio and television, cassettes and videos, newsprint and telephone. For migrants, both the politics of adaptation to new environments and the stimulus to move or return are deeply affected by a mass-mediated imaginary that frequently transcends national space.

The second distinction is between imagination and fantasy. There is a large and respectable body of writing, notably by the critics of mass culture of the Frankfurt School and anticipated in the work of Max Weber, that views the modern world as growing into an iron cage and predicts that the imagination will be stunted by the forces of commoditization, industrial capitalism, and the generalized regimentation and secularization of the world. The modernization theorists of the past three decades (from Weber by way of Talcott Parsons and Edward Shils to Daniel Lerner, Alex Inkeles, and many others) largely accepted the view of the modern world as a space of shrinking religiosity (and greater scientism), less play (and increasingly regimented leisure), and inhibited spontaneity at every level. There are many strands in this view, strands that link theorists as different as Norbert Elias and Robert Bell but there is something fundamentally wrong with it. The error works on two levels. First, it is based on a premature requiem for the death of religion and the victory of science. There is vast evidence in new religiosities of every sort that religion is not only not dead but that it may be more consequential than ever in today's highly mobile and interconnected global politics. On another level, it is wrong to assume that the electronic media are the opium of the masses. This view, which is only beginning to be corrected, is based on the notion that the mechanical arts of reproduction largely reprimed ordinary people for industrial work. It is far too simple.

There is growing evidence that the consumption of the mass media throughout the world often provokes resistance, irony, selectivity, and, in general, *agency*. Terrorists modeling themselves on Rambo-like figures (who have themselves generated a host of non-Western counterparts), housewives reading romances and soap operas as part of their efforts to construct their own lives; Muslim family gatherings listening to speeches by Islamic leaders on cassette tapes; domestic servants in South India taking packaged tours to Kashmir: these are all examples of the active way in which media are appropriated by people throughout the world. T-shirts, billboards, and graffiti as well as rap music, street dancing, and slum housing all show that the images of the media are quickly moved into local repertoires of irony, anger, humor, and resistance.

Nor is this just a matter of Third World people reacting to American media, but it is equally true of people throughout the world reacting to their own national, electronic media. On these grounds alone, the theory of media as the opium of the people needs to be looked at with great skepticism. This is not to suggest that consumers are *free* agents, living happily in a world of safe malls, free lunches, and quick fixes. As I suggest in chapter 4, consumption in the contemporary world is often a form of drudgery, part of the capitalist civilizing process. Nevertheless, where there is consumption there is pleasure, and where there is pleasure there is agency. Freedom, on the other hand, is a rather more elusive commodity.

Further, the idea of fantasy carries with it the inescapable connotation of thought divorced from projects and actions, and it also has a private, even individualistic sound about it. The imagination, on the other hand, has a projective sense about it, the sense of being a prelude to some sort of expression, whether aesthetic or otherwise. Fantasy can dissipate (because its logic is so often autotelic), but the imagination, especially when collective, can become the fuel for action. It is the imagination, in its collective forms, that creates ideas of neighborhood and nationhood, of moral economies and unjust rule, of higher wages and foreign labor prospects. The imagination is today a staging ground for action, and not only for escape.

The third distinction is between the individual and collective senses of the imagination. It is important to stress here that I am speaking of the imagination now as a property of collectives, and not merely as a faculty of the gifted individual (its tacit sense since the flowering of European Romanticism). Part of what the mass media make possible, because of the conditions of collective reading, criticism, and pleasure, is what I have elsewhere called a 'community of sentiment' (Appadurai 1996), a group that begins to imagine and feel things together. As Benedict Anderson (1983) has shown so well, print capitalism can be one important way in which groups who have never been in face-to-face contact can begin to think of themselves as Indonesian or Indian or Malaysian. But other forms of electronic capitalism can have similar, and even more powerful effects, for they do not work only at the level of the nation-state. Collective experiences of the mass media, especially film and video, can create sodalities of worship and charisma, such as those that formed regionally around the Indian female deity Santoshi Ma in the seventies and eighties and transnationally around Ayatollah Khomeini in roughly the same period. Similar sodalities can form around sport and internationalism, as the transnational effects of the Olympics so clearly show. Tenements and buildings house video clubs in places like Kathmandu and Bombay. Fan clubs and political followings emerge from small-town media cultures, as in South India.

These sodalities resemble what Diana Crane has called 'invisible colleges' in reference to the world of science, but they are more volatile, less professionalized, less subject to collectively shared criteria of pleasure, taste, or mutual relevance. They are communities in themselves but always potentially communities for themselves, capable of moving from shared imagination to collective action. Most important, as I will argue in the conclusion to this chapter, these sodalities are often transnational, even postnational, and they frequently operate beyond the boundaries of the nation. These mass-mediated sodalities have the additional complexity that, in them, diverse local experiences of taste, pleasure, and politics can crisscross with

one another, thus creating the possibility of convergences in translocal social action that would otherwise be hard to imagine.

No single episode captures these realities better than the now mindnumbing Salman Rushdie affair, involving a banned book, a religiously mandated death sentence, and an author committed to personal voice and aesthetic freedom. *The Satanic Verses* provoked Muslims (and others) across the world to debate the politics of reading, the cultural relevance of censorship, the dignity of religion, and the freedom of some groups to judge authors without independent knowledge of the text. The Rushdie affair is about a text-in-motion, whose commoditized trajectory brought it outside the safe haven of Western norms about artistic freedom and aesthetic rights into the space of religious rage and the authority of religious scholars in their own transnational spheres. Here, the transnational worlds of liberal aesthetics and radical Islam met head-on, in the very different settings of Bradford and Karachi, New York and New Delhi. In this episode, we can also see how global processes involving mobile texts and migrant audiences create implosive events that fold global pressures into small, already politicized arenas . . ., producing locality in new, globalized ways.

This theory of a break – or rupture – with its strong emphasis on electronic mediation and mass migration, is necessarily a theory of the recent past (or the extended present) because it is only in the past two decades or so that media and migration have become so massively globalized, that is to say, active across large and irregular transnational terrains. Why do I consider this theory to be anything more than an update of older social theories of the ruptures of modernization? First, mine is not a teleological theory, with a recipe for how modernization will universally yield rationality, punctuality, democracy, the free market, and a higher gross national product. Second, the pivot of my theory is not any large-scale project of social engineering (whether organized by states, international agencies, or other technocratic elites) but is the everyday cultural practice through which the work of the imagination is transformed. Third, my approach leaves entirely open the question of where the experiments with modernity that electronic mediation enables might lead in terms of nationalism, violence, and social justice. Put another way, I am more deeply ambivalent about prognosis than any variant of classical modernization theory of which I am aware. Fourth, and most important, my approach to the break caused by the joint force of electronic mediation and mass migration is explicitly transnational – even postnational – as I suggest in the last part of this book. As such, it moves away dramatically from the architecture of classical modernization theory, which one might call fundamentally realist insofar as it assumes the salience, both methodological and ethical, of the nation-state.

We cannot simplify matters by imagining that the global is to space what the modern is to time. For many societies, modernity is an elsewhere, just as the global is a temporal wave that must be encountered in *their* present. Globalization has shrunk the distance between elites, shifted key relations between producers and consumers, broken many links between labor and family life, obscured the lines between temporary locales and imaginary national attachments. Modernity now seems more practical and less pedagogic, more experiential and less disciplinary than in the fifties and sixties, when it was mostly experienced (especially for those outside the national elite) through the propaganda apparatuses of the newly

independent nation-states and their great leaders, like Jawaharlal Nehru, Gamal Abdel Nasser, Kwame Nkrumah, and Sukarno. The megarhetoric of developmental modernization (economic growth, high technology, agribusiness, schooling, militarization) in many countries is still with us. But it is often punctuated, interrogated, and domesticated by the micronarratives of film, television, music, and other expressive forms, which allow modernity to be rewritten more as vernacular globalization and less as a concession to large-scale national and international policies. As I suggested earlier, there was something of this experiential quality for those (such as myself) born into the ruling classes of the new nations in the fifties and sixties, but for many working people and the poor, this experiential engagement with modernity is a relatively recent fact.

These subversive micronarratives also fuel oppositional movements, ranging from the Shining Path in Peru to Habitat for Humanity, from green movements in Europe to Tamil nationalism in Sri Lanka, from Islamic groups in Egypt to breakaway nationalist guerrillas in Chechnya. In these movements, some of which are repressive and violent while others are democratic and peaceful, we can see that electronic mass mediation and transnational mobilization have broken the monopoly of autonomous nation-states over the project of modernization. The transformation of everyday subjectivities through electronic mediation and the work of the imagination is not only a cultural fact. It is deeply connected to politics, through the new ways in which individual attachments, interests, and aspirations increasingly crosscut those of the nation-state.

The diasporic public spheres that such encounters create are no longer small, marginal, or exceptional. They are part of the cultural dynamic of urban life in most countries and continents, in which migration and mass mediation coconstitute a new sense of the global as modern and the modern as global. Mira Nair's film *Mississippi Masala*, for example, is an epic of diaspora and race redoubled, exploring how Indians transformed and displaced by race relations in Uganda deal with the intricacies of race in the American South, all the time retaining their sense of Indianness-in-motion. The viewing of cricket matches between India and Pakistan by migrants in the Gulf states from these countries . . . is about the peculiarities of diasporic nationalism in an emergent Indian Ocean politics. The intense battles over the English language and about immigrant rights now heating up (again) in the United States are not just one more variant on the politics of pluralism: they are about the capability of American politics to contain the diasporic politics of Mexicans in Southern California, Haitians in Miami, Colombians in New York, and Koreans in Los Angeles. Indeed, as I will propose in my concluding observations, it is the widespread appearance of various kinds of diasporic public spheres that constitute one special diacritic of the global modern.

[. . .]

References

Anderson, Benedict (1983) *Imagined Communities*, London: Verso.
Appadurai, Arjun (1996) *Modernity at Large*, Minneapolis: University of Minnesota Press.

Néstor Garcia Canclini

REMAKING PASSPORTS
Visual thought in the debate on multiculturalism

H OW DO WE INTERPRET the changes in contemporary visual thought? One of the greatest difficulties rests in the fact that tendencies do not develop from one paradigm to the next. We are not displacing ourselves from one type of rationality and visuality to another as in the Renaissance or in the transition from classicism to romanticism, nor as in the substitution that happened amongst the avant-gardes throughout the twentieth century. A real reorganisation has emerged from the intersection of multiple, simultaneous processes. Rather than changing, art appears to be vacillating. I am going to linger over one of those fluctuations which I consider to be crucial in the debate on identities: I am referring to the oscillation between a national visuality and the deterritorialised and transcultural forms of art and communication. Concerning the basis of this analysis, we might ask ourselves what type of visual thinking can speak today significantly in the discordant dialogue between fundamentalism and globalisation.

How are artists thinking?

This is difficult to answer if we consider that the polemic at the core of the modern aesthetic, that opposition between romanticism and classicism, persists even into postmodernity. For the romantics, art is a production of the intuitive and solitary genius; in the same way, reception is defined as an act of unconditional contemplation, the empathy of an individual sensitive disposition which allows itself to be penetrated by the mysterious eloquence of the work. Classical thought, by contrast, always works to subordinate sensibility and intuition to the order of reason: artistic production should be a way of presenting multiple meanings and expand the world in relation to its forms; we the spectators see those images in diverse ways – from the different codes imprinted in us by our social and

educational structures – searching for the geometry of the real or expressionistic-ally lamenting its loss.

The history of modern art, written as the history of avant-gardes, has contributed to the maintenance of this disjunction: on one hand, Surrealism, Pop Art and 'Bad Painting', for example; and on the other, Constructivism, the Bauhaus, Geometricism and all the self-reflexive artists from Marcel Duchamp to the Conceptualists, for whom art is a mental activity. The disillusioned farewell to the avant-gardes did not end this dichotomy; some postmoderns nostalgically pursue the order of Hellenic or Renaissance symmetry (even if it is under the sceptical-ironic form of the ruin); others place their irrationalist vocation in the enigmatic exuberance of rituals and tribal objects. In the former case, the artist as archaeolo-gist or restorer of classical harmony; in the second, as a 'magician of the earth'. Such work, part of the hypothesis of contemporary epistemology, at least since Gaston Bachelard and Claude Lévi-Strauss, argues that the theory of art stems from the dilemma between rationalism and irrationalism. I agree with Michel Serres when he said that Bachelard is the last romantic (his cultural psychoanalysis adopted a non-positivist polysemy of meaning) and the first Neo-classicist (because he reunited 'the clarity of form for freedom and the density of content for understanding').[1] His new scientific spirit coincides, up to a point, with that of Lévi-Strauss when he demonstrated that the difference between science and magic, or between science and art, is not the distance between the rational and the pre-rational, but between two types of thought, one expressed in concepts and the other submerged in images. Magic and art are not weak or babbling forms of science, but – together with it – strategic and distinct levels in which nature and society allow themselves to be attacked by questions of knowledge.[2]

The second hypothesis is that a theory of art capable of transcending the antag-onism between thought and intuition could contribute to a re-elaboration of the dilemmas of the end of the century, when all the sociocultural structures are destabilized and we ask ourselves if it is possible to construct imaginaries that do not empty into irrational arguments. We need to discover if the actual organisation of the aesthetic field (producers, museums, galleries, historians, critics and the public) contributes, and in what way, to the elaboration of shared imaginaries. It is not only the wit of a picture or the will of the artist that is inserted in or isolated from social history; it is also the interaction between the diverse members of the field (as both cultural system and market) which situates the significance of art in the vacillating meaning of the world.[3] In posing the problem in this way, it is possible to include in the question something about how art thinks today, even its innova-tive gestures: what capacity to think about a world orphaned of paradigms do transgressive or deconstructive works possess that are submitted to the order of the museums and the market?

Our third hypothesis is that this contribution of art is enabled by tendencies which are not only dedicated to thinking about the national but also to multi-culturalism and globalisation. It seems unattractive to elaborate this theme from the perspective of Latin American art, because many artists are moving in that direc-tion; but the strategies of the market, of international exhibitions and of the critics almost always banish it to the margins as the magic realism of local color. Even when our people migrate extensively and a large part of our art work and literature

is dedicated to *thinking* about the multicultural, Latin America continues to be interesting only as a continent of a violent nature, of an archaicism irreducible to modern nationality, an earth fertilised by an art conceived as tribal or national dreaming and not as thinking about the global and the complex.

How is the nation thinking, how is the market thinking?

Are the artists thinking the nation or thinking for it? When one observes, for example, the stylistic uniformity of French Baroque, Mexican Muralism or American Pop, one might ask if the artists of those currents thought the nation in their work or if they left the pre-existing cultural structure to shape the configuration. Individual differences in creative gestures are undeniable, but in the larger trajectory of these movements there has prevailed the enunciation of an 'ideology of images,' a national community, that has proclaimed the heroism of the citizen, from David and Duplessis in pre-Revolutionary France,[4] across the reiterations of Diego Rivera, Siqueiros and their innumerable followers in Mexican legends, and through the work of Jasper Johns, Claes Oldenburg, Rauschenberg and others in the imaginary of the American consumer.

It is not possible to enter here into a debate on how far the possessions or patrimony of a nation condition fine art discourses and to what degree personal innovations evade such conditioning.[5] Rather, I am interested in emphasising that the modern history of art has been practised and written, to a great extent, as a history of the art of nations. This way of suppressing the object of study was mostly a fiction, but it possessed a verisimilitude over several centuries because the nations appeared to be the 'logical' mode of organisation of culture and the arts. Even the vanguards that meant to distance themselves from the sociocultural codes are identified with certain countries, as if these national profiles would help to define their renovative projects: thus, one talks about Italian Futurism, Russian Constructivism and the Mexican Muralist School.

A large amount of actual artistic production is made as an expression of national iconographic traditions and circulates only in its own country. In this way fine art remains one of the nuclei of the national imaginary, scenarios of the dedication and communication of signs of regional identities. But a sector, increasingly more extensive in the creation, the diffusion and the reception of art, is happening today in a deterritorialised manner. Many painters whom critical favour and cultural diplomacy promote as the 'big national artists,' for example Tamayo and Botero, manifest a sense of the cosmopolitan in their work, which partly contributes to their international resonance. Even those chosen as the voices of more narrowly defined countries – Tepito or the Bronx, the myths of the Zapotecos or the Chicano Frontier – become significant in the market and in the exhibitions of American art in so far as their work is a 'transcultural quotation.'[6]

It is not strange that time and again international exhibitions subsume the particularities of each country under conceptual transnational networks. The shows in the Georges Pompidou Centre, 'Paris–Berlin' and 'Paris–New York,' for example, purported to look at the history of contemporary art not suppressing national patrimonies but distinguishing axes that run through frontiers. But it is

above all the art market that declassifies national artists, or at least subordinates the local connotations of the work, converting them into secondary folkloric references of an international, homogenised discourse. The internal differences of the world market point less to national characteristics than to the aesthetic currents monopolised by the leading galleries, whose headquarters in New York, London, Paris, Milan and Tokyo circulate work in a deterritorialised form and encourage the artists to adapt to different 'global' publics. The art fairs and the biennials also contribute to this multicultural game, as one could see in the last Venice Biennale, where the majority of the fifty-six countries represented did not have their own pavilion: most of the Latin Americans (Bolivia, Chile, Colombia, Costa Rica, Cuba, Ecuador, El Salvador, Mexico, Panama, Paraguay and Peru) exhibited in the Italian section, but that mattered little in a show dedicated, under the title 'Puntos cardinales del arte/Cardinal Points of Art,' to exhibiting what today is constituted as 'cultural nomadism.'[7]

As these international events and the art magazines, the museums and the metropolitan critics manage aesthetic criteria homologous to the criteria of the market, so the artists who insist on national particularity rarely get recognition. The incorporation for short periods of some territorial movements into the mainstream, as happened with Land Art, or recently, with marginal positions, such as the Chicanos and Neomexicanists, does not negate the above analysis. The short-term speculations of the art market and their 'innovative and perpetual turbulence'[8] is as harmful in the long run to national cultures as to the personal and lengthy productions of artists; only a few can be adopted for a while to renovate the attraction of the proposition. It is in this sense that thinking today for much visual art means to be thought by the market.

From cosmopolitanism to globalisation

References to foreign art accompany the whole history of Latin American art. Appropriating the aesthetic innovations of the metropolises was a means for much art to rethink its own cultural heritage: from Diego Rivera to Antonio Berni, innumerable painters fed on Cubism, Surrealism and other Parisian vanguards to elaborate national discourses. Anita Malfatti found in New York Expressionism and Berlin Fauvism the tools to reconceptualise Brazilian identity, analogous to the way Oswald de Andrade utilised the Futurist Manifesto to re-establish links between tradition and modernity in São Paulo.

This cosmopolitanism of Latin American artists resulted, in most cases, in the affirmation of the self. A national consciousness has existed, torn by doubts about our capacity to be moderns, but capable of integrating into the construction of repertoires of images the journeys, the itinerant glances, which would differentiate each people. The foreign 'influences' were translated and relocated in national matrices, in projects which united the liberal, rationalist aspiration for modernity with a nationalism stamped with the Romantic, by which the identity of each people could be one, distinctive and homogeneous.

The pretension of constructing national cultures and representing them by specific iconographies is challenged in our time by the processes of an economic and

symbolic transnationalisation. Arjun Appadurai groups these processes into five tendencies:

1 the population movements of emigrants, tourists, refugees, exiles and foreign workers;
2 the flows produced by technologies and transnational corporations;
3 the exchanges of multinational financiers;
4 the repertoires of images and information distributed throughout the planet by newspapers, magazines and television channels;
5 the ideological models representative of what one might call Western modernity: concepts of democracy, liberty, wellbeing and human rights, which transcend the definitions of particular identities.[9]

Taking into account the magnitude of this change, the deterritorialisation of art appears only partly the product of the market. Strictly speaking, a part is formed by a greater process of globalisation of the economy, communications and cultures. Identities are constituted now not only in relation to unique territories, but in the multicultural intersection of objects, messages and people coming from diverse directions.

Many Latin American artists are participating in the elaboration of a new visual thought which corresponds to this situation. There is no single pathway for this search. One is amazed that the preoccupation with decentring the artistic discourse from national niches crosses as much through the expressionistic Romantics as those who cultivate rationalism in conceptual practices and installations.

I agree with Luis Felipe Noé and his defence of an aesthetic that 'doesn't need a passport.' We cannot, he says, interrogate identity as a simple reaction against cultural dependency: to pose it in that way is like proposing 'to reply to a policeman who requires documents of identity or like a functionary who asks for a birth certificate.' For this reason, he affirms that the question whether there exists a Latin American art is one that is 'absurdly totalitarian.'[10]

Rather than devote ourselves to the nostalgic 'search for a non-existent tradition' he proposes we take on the diverse Baroque nature of our history, reproduced in many contemporary painters by 'an incapacity to make a synthesis faced with the excess of objects.'[11] He pleads for an expressionistic painting, like that of his own work: trying to feel oneself primitive in the face of the world, but transcended not so much by nature as by the multiplicity and dispersion of cultures. In this way, his paintings escape from the frame, reach from ceiling to floor, in tempestuous lands that 'rediscover' the Amazons, historical battles, the glance of the first conquistador.

In another way, of a conceptual character, Alfredo Jaar realises an analogical search. He invented a Chilean passport, in which only the covers replicated the official document. Inside, each double page opened to show the barbed wire of a concentration camp which receded towards an infinity uninterrupted by the mountains. The scene could be in his native Chile or in Hong Kong – where he made a documentary for the Vietnamese exiles – or in any of those countries where people speak seven languages and which repeat the phrase 'opening new doors,' written

in the sky of this closed horizontal: English, Cantonese, French, Italian, Spanish, German and Japanese. They correspond to certain nations with harder migration problems and with a more restrictive politics of migration. As the document of identification, at the same time national and individual, the passport is made to locate the origin of the traveller. It enables the passage from one country to another, but also stamps people by their place of birth and at times impedes them from change. The passport, as a synthesis of access entrapment, serves as a metaphor to men and women of a multicultural age, and amongst them to artists for whom 'their place is not within any particular culture, but in the interstices between them, in transit'.[12]

How can we study this delocalised art? By contrast to those explanations referring to a geographic milieu or a social unity, many actual artistic works need to be seen 'as something transported'. Guy Brett used this formula for the 'airmail' paintings of Eugenio Dittborn, those 'fold-up and compartmented rafts' that one receives in order to return: they are for 'seeing between two journeys'.[13] They are supported by a poetic of the transitory, in which their own peripheric nation – in this case Chile, the same as Jaar – can be the point of departure, but not the destination. Neither is any metropolis, as believed by some cosmopolitan Latin Americans, because the 'airmail' paintings, said Roberto Merino, also change metropolises into places of transit. Without centre, without hierarchical trajectories, these works, like those of Felipe Ehrenberg, Leon Ferrari and many others who make postal art, speak about Chile, Mexico or Argentina but overflow their own territories, because the works' journeys make its external resonance a component of the message.

Figure 20.1 Guillermo Kuitca, installation at IVAM Centro del Carme, Valencia, Spain, 1993 (From *Third Text: Third World Perspectives on Contemporary Art and Culture*, 28/29 Autumn/Winter 1994)

Dittborn used to include little houses in his paintings. The same tension between the journey and the period of residence is encountered in the maps and beds of Guillermo Kuitca. His images name at the same time the relation between particular territories and deterritorialisation. On one hand, street maps like that of Bogotá, whose streets are not drawn in lines but in syringes, or the maps of apartments made with bones, reflectors which illuminate uninhabited beds, the recording machines and the microphones without personages which allude to the terror in Argentina. 'During the time of the Malvinas I started to paint little beds . . . it was a period of depression and what I wanted to transmit in the work was that I was staying quiet with the paintbrush in my hand, and, to produce the painting, what was moving was the bed.'[14]

The quietude of the brush while the context was transformed, while people travel. In painting over the mattress maps of Latin America and Europe, Kuitca reconfigures the tensions of many exiles: from Europe to America, from one America to another, from America again to Europe. Is it for this reason that the 'beds are without homes'?[15] To organise the world, Kuitca poses it at the same time as travel and rest: the maps of cities on the mattresses seem intended to disrupt rest. He wants to reconcile the romantic sense, uncertain or simply a painful journey with the organised space of a regular mattress, or conversely, exasperate the rigorous geometry of the maps, superimposing them over the territory of dreams. The map as a ghost, or the bed as a root: bedmaps, in this way migrates the person who looks for roots.

Who gives passports?

These works do not allow us to interrogate them for social identities and the identity of art. But they attempt to be an art that recognises the exhaustion of ethnic or national mono-identities, which thinks to represent very little but talks about local and non-temporal essences. The material that creates their icons are not uniquely persistent objects, the monuments and rituals that gave stability and distinction to the culture are also related to passports, the beds with maps, the vibrant images of the media. Like today's identities, their works are polyglot and migrant, they can function in diverse and multiple contexts and permit divergent readings from their hybrid constitution.

But these multicultural reformulations of visual thinking are in conflict with at least three tendencies in the artistic camp/context. In the first place, in front of the inertia of the artist, intermediaries and public that continue to demand from art that it is representative of a pre-nationalised globalised identity. In the second place, the artist who relativises national traditions has difficulty being accommodated by state promotion which expects work from its creators that has the capacity to show to the metropolis the splendor of many centuries of national history.

Finally, the Latin American artists who work with globalisation and multi-culturalism interact with the strategy of museums, galleries and critics of the metropolis who prefer to keep them as representatives of exotic cultures, of ethnic alterity and Latin otherness, that is, in the margins. In the US, George Yúdice observes, the multicultural politics of the museums and universities has been useful

Figure 20.2 Luis Felipe Noé, *Algún día de estos* [One of These Days], 1963 (Courtesy of the Museo de Arte Contemporánea, Buenos Aires)

more to the recognition of difference than as an interlocutor in a dialogue of equality, to situate them as a subaltern corner of the *American way of life*. 'If before, they asked Latin Americans to illustrate pure surrealism, as in the case of Alejo Carpentier, with his "marvellous realism" or his *santería*, now today they are asking that Latin Americans become something like "Chicano" or "Latino".'[16] Also, in Europe, the mechanisms of determination of artistic value hope that Latin Americans act and illustrate their difference: in a recent multicultural exhibition that took place in Holland, *Het Klimaat* (The Climate), the catalogue maintained that 'for the non-Western artist or intellectual it is above all essential to create and recreate the historical and ideological conditions that more or less provide the possibility to exist.' The Argentinian artist Sebastián López challenged this 'condescending point of view' which relegates foreign artists to exhibiting their work in the alternative circuits:

> While the European artist is allowed to investigate other cultures and enrich their own work and perspective, it is expected that the artist from another culture only works in the background and with the artistic traditions connected to his or her place of origin (even though many Dutch managers of cultural politics, curators, dealers were ignorant of these traditions and their contemporary manifestations). If the foreign artist does not conform to this separation, he is considered inauthentic, Westernised, and an imitator copyist of 'what we do'. The universal is 'ours, the local is yours.'[17]

Thinking today is, as always, thinking difference. In this time of globalisation this means that visual thinking transcends as much the romantic conceit of nationalism as the geometric orders of a homogeneous transnationalism. We need images

of transits, of crossings and interchanges, not only visual discourses but also open, flexible reflections, which find a way between these two intense activities: the nationalist fundamentalism which seeks to conjure magically the uncertainties of multiculturalism, and on the other, the globalising abstractions of the market and the mega exhibitions, where one loses the will and desire for reformulating the manner in which we are thought.[18]

Notes

This paper was first presented at the 17th Symposium of Art History, hosted by the Instituto de Investigaciones Estéticas de la UNAM and the Comité Internacional de Historia del Arte, in Zacatecas, 23–28 September, 1993.

1 Michel Serres, 'Análisis simbólico y método estructural', in Andrea Bonomi *et al.* (eds.) *Estructuralismo y filosofía*, Nueva Vision, Buenos Aires, 1969, p. 32.
2 Claude Lévi-Strauss, *El pensamiento salvaje*, FCE, Mexico, 1964, pp. 30–33.
3 For this form of enquiry we should not forget the founding work of Rudolf Arnheim, *El pensamiento visual*, Eudeba, Buenos Aires, 1971, which connects well with the contributions of Howard S. Becker, Pierre Bourdieu and Fredric Jameson, whose possible complement I discussed in *Culturas híbridas: Estrategías para entrar y salir de la modernidad*, Grijalbo-CNCA, Mexico, 1990, chs 1 and 2.
4 As expressed by Nicos Hadjinicolau (*Historia del arte y lucha de clases*, 5th edn, Siglo Veintuno, Mexico, 1976, ch. 5), but this author relates 'ideology in the image' to social class and dismisses the nationalist differences that also have an effect on styles. Although I do not have space here to develop this critique, I want to say at least that a non-reductionist sociological reading, besides social class, ought to take into account other groups that organise social relations: nation, ethnicity, generation, etc.
5 I analysed this theme in 'Memory and Innovation in the Theory of Art,' in *South Atlantic Quarterly*, Duke University Press, vol. 92, no. 3, 1993.
6 See *Art from Latin America: The Transcultural Meeting*, exhibition catalogue; exhibition curated by Nellie Richard, the Museum of Contemporary Art, Sydney, 10 March–13 June 1993.
7 The formula belongs to the curator of the Biennial Achille Bonito Oliva, quoted by Lilia Driben, 'La XLV Bienal de Venecia, los puntos cardinales del arte nómada de 56 países', *La Jornada*, 23 August 1993, p. 23.
8 See the illuminating chapter on this theme, 'Le marché et le musée', in Raymonde Moulin, *L'Artiste, l'institution et le marché*, Flammarion, Paris, 1992.
9 Arjun Appadurai, 'Disjuncture and Difference in the Global Cultural Economy', in Mike Featherstone (ed.), *Global Culture: Nationalism, Globalization and Modernity*, Sage Publications, London, Newburg Park-New Delhi, 1990.
10 Luis Felipe Noé, 'Does Art from Latin America Need a Passport?' in Rachel Weiss and Alan West (eds), *Being America, Essays on art, literature and identity from Latin America*, White Pine Press, New York, 1991.
11 Luis Felipe Noé, 'La nostalgia de la historia en el proceso de imaginacíon plástica de América Latina', in *Encuentro artes visuales e identidad en América Latina*, Foro de Arte Contemporáneo, Mexico, 1982, pp. 46–51.

12 Adriana Valdés, 'Alfredo Jaar: imágenes entre culturas,' *Arte en Colombia Internacional*, 42, December 1989, p. 47.

13 Guy Brett and Sean Cubitt, *Camino Way. Las pinturas aeropostales de Eugenio Dittborn*, Santiago de Chile, 1991.

14 Martín Rejtman, 'Guillermo Kuitca, Mirada interior,' *Claudia*, Buenos Aires, November 1992, no. 3, p. 68. Reproduced by Marcelo B. Pacheco in 'Guillermo Kuitca: inventario de un pintor,' *Un libro sobre Guillermo Kuitca*, IVAM Centre del Carme, Valencia, 1993, p. 123.

15 The phrase is from Jerry Saltz, 'El toque humano de Guillermo Kuitca,' in *Un libro sobre Guillermo Kuitca*, op. cit.

16 George Yúdice, 'Globalizacíon y nuevas formas de intermediacíon cultural,' paper presented at the conference 'Identidades, políticas e integración regional,' Montevideo, 22–23 July 1993.

17 Sebastián López, 'Identity: Reality or Fiction,' *Third Text*, 18, 1992, pp. 332–34, cited by Yúdice, op. cit. See also the issue of *Les Cahiers du Musée National d'Art Moderne* dedicated to the exhibition 'Les magiciens de la terre,' no 28, 1989, especially the articles by James Clifford and Lucy Lippard.

18 Translated from the Spanish by E.P. Quesada.

Kobena Mercer

ETHNICITY AND INTERNATIONALITY
New British art and diaspora-based blackness

N OW THAT THE 'YOUNG BRITISH ARTIST' (yBa) phenomenon is mostly tired and expired it seems timely to ask: what was all that about? To tell the story as a simple sequence that starts with the 1988 'Freeze' exhibition, organised by Damien Hirst and other Goldsmiths' students in a Docklands warehouse, and that ends with the Royal Academy of Art's 1998 'Sensation' exhibition of Charles Saatchi's collection, is to collude with mythology. Taking account of the aesthetic, cultural and, above all, ideological aspects of 'the myth of the young British artist,'[1] this article considers the curious position(s) of diaspora artists amidst the contradictory forces of art world globalization and regressive localism which, I shall argue, are the key factors in critically understanding recent shifts around cultural identity.

Viewed as an artistic phenomenon, New British Art was neither new nor British. Loosely defined to include renewed interest in painting (Gary Hume, Richard Patterson) and sculpture (Anya Gallacio, Jake and Dinos Chapman), it was characterised, above all, by neo- or post-conceptualist approaches to the installation genre. The choice of medium, whether film (Douglas Gordon), video (Gillian Wearing) or photography (Sam Taylor-Wood), was secondary to the provocative and irreverent 'attitude' whereby, as Michael Bracewell observed, 'the new generation of British artists had taken irony and punning – on materials, roles and titles – as the keynote of their projects.'[2] This much vaunted matter of 'attitude,' however, would be more usefully described generationally rather than nationally, for its hyper-ironic ambiguities actually originated in the aesthetics of abjection that first emerged among American artists such as Mike Kelley, Sean Landers and Sue Williams.

Hal Foster argues that the early Nineties 'cult of abjection' signalled a generational reaction against an impasse in which art became embroiled in the 'culture wars.' He suggests that an interest in abjection – that which is expelled from identity as an unrepresentable excess or remainder – led younger artists to break out of the left/right stalemate over identity politics in favour of a 'return of the real.'[3]

Reactivating the 'crux' of 1960s pop, minimalist and conceptualist strategies, with a knowingly inter-textual twist absorbed from such 1980s appropriation artists as Cindy Sherman, the neo- or post-conceptualist outlook has brought about a massive disarticulation of the values that made questions of representation central to the critical ambitions of various twentieth-century avant-gardes.

While the consequences of this displacement cannot be underestimated – rejecting high seriousness for ephemerality and fun, for example – it would be mistaken to view yBa irreverence as merely the antipolitical animus of Thatcher's children. Whereas Andrew Renton wrote in *Technique Anglais* (1991), that 'a certain kind of irresponsibility seems to me to be a very key concept that brings these people together aesthetically,'[4] Angela McRobbie has observed that, 'The don't care attitude had the effect of freeing artists from the burden of being classified in terms of great, good, mediocre or bad.'[5]

Viewed as a *cultural* phenomenon, the yBa mytheme did indeed reveal unresolved faultlines in Nineties Britain. As it developed from an underground 'scene,' comprising entrepreneurial dealers, quick-witted curators and an overabundance of unemployed art school graduates, the yBa won widespread media attention. Its arrival as news item was marked by tabloid outcries over Rachel Whiteread's public commission, *House* (1993), and by further controversy when pop group KLF burned a million pounds after she won the Tate Gallery's 1994 Turner Prize.

With 'the appropriation of Damien Hirst's tanked-halves aesthetic to advertise Ford cars,' a network of new connections between art markets, youth cultures, urban spaces and cultural industries had emerged as a 'creative *menage-à-trois* between popular culture, fine art and metropolitan fashionability.'[6] By virtue of an unprecedented synergy (to use marketing-speak) between these hitherto disparate elements, the yBa meshed with other strands in popular culture – laddism, football, BritPop. It was repackaged for mass consumption as a rerun of the Swinging Sixties. Notwithstanding the invention of the Sixties myth by two American journalists, the highly 'retro' Nineties version equally centred on London as the creative hub for trends in music, fashion, art and design. Brand new, you're retro, one might say, for it was precisely the all-pervasive retro-ness that characterised the Britishness of New British Art in this much hyped moment of going overground.

In contrast to what was called 'pathetic art' or 'loser art' in the US, which overlapped with the slacker or grunge aesthetic in youth culture, yBa Britishness revealed itself in the jokey way it practised 'the conceptual gag with an ironic punchline.'[7] Sarah Lucas's *Two Fried Eggs and a Kebab* (1992) was a visual pun on a pathetic male colloquialism for breasts and vagina. Gavin Turk's *Pop* (1993) was a life-size waxwork of the artist posing as Sid Vicious, after the manner of Andy Warhol's *Triple Elvis* (1964). A lot of it was hilarious, some of it was silly, and as Bracewell noted, 'in a media-literate age of some sophistication, the immediacy or obscurity of British neo-conceptualism was either the first test of its intentions or the last.' He adds, 'Whether this was a rampant complicity with the branding of meaning invoked by cultural commodification, or a grapeshot expression of violent alienation in the face of it, remained the fulcrum on which much of its ambiguity – in terms of a generational solidarity – was balanced.'[8]

In the thick of this promiscuous interplay between a neo-conceptual cleverness and a nudge-wink vernacular, some artists accentuated the ambivalence to offer wry

insights on everyday life. Taking Royal Ascot horseracing as subject-matter in *Race, Class, Sex* (1992), Mark Wallinger addressed national identity in the realm of sports, as did Roddy Buchanan's photographs of Glasgow soccer fans wearing Inter-Milan strips. Gillian Wearing's *Dancing in Peckham* (1995) brought a deadpan populism to a playful neo-conceptualist questioning of vox-pop authenticity.

However, as Simon Ford argues, 'the question of whether the myth of the yBa is nationalistic does not exhaust itself with an examination of individual works: how the work is used and promoted abroad should also be taken into account.'[9] Over and above the pastiche patriotism that often surfaced as the jokey signature of a self-deprecating Englishness, the London-centred localism of the New Brit Art 'scene' gradually became the touchstone of an official institutional ideology. With salon-style annual exhibitions, such as Saatchi's 'Young British Artists' (1992–97) and the Arts Council's touring 'British Art Shows' (1993–96), a new private-public sector partnership pattern took hold. This in turn led to the export-driven promotional aims of British Council sponsored exhibitions such as 'General Release' (1995) at the Venice Biennale.

With the spate of exhibitions marked by 'Live/Life' (Musée d'Art Moderne, Paris, 1996), 'Brilliant!' (Walker Art Center, Minneapolis, 1995) and 'Pictura Britannica' (Museum of Contemporary Art, Sydney, 1997), however, the limitations of relying on highly stereo-typed invocations of Britishness to market the yBa internationally became all too apparent, as Patricia Bickers astutely observed.[10] Foreign audiences were undoubtedly entertained by its quirky cultural specificity, but relative indifference to the hype in New York or the German-hosted 'Documenta X' (1997) made one wonder whether it was not the British themselves who really needed to believe in it.

Such underlying insecurities about Britishness received momentary relief with the arrival of New Labour, which added a final twist to the tale by assimilating the yBa to its cultural industries marketing pitch dubbed Cool Britannia (ouch!). While the volatile mix of Blairite populism is examined below, at this stage it is precisely the discrepancy between parochial yBa inwardness and art world internationalism that obliges us to interrogate the ideology of New British Art as a defensive and, above all, regressive response to the bewildering effects of globalization.

Whatever happened to the new internationalism?

Once seen as a local response to art world globalisation, the nationalistic content beneath the cheeky neo-conceptual irony revealed itself by contrast with a countervailing tendency which emerged at the same time, but which, it seems fair to say, did not win out, namely the so-called new internationalism.

In 1994 the Institute of International Visual Arts (inIVA) was established by the Arts Council in the aftermath of a failed attempt to convert London's Roundhouse into a black arts centre. Seen from abroad, inIVA is unique. Unlike European countries in which multicultural arts policy is either non-existent (Germany, France) or only relatively recent (Holland), it shows how far UK policy has come in what Gavin Jantjes optimistically described as 'the long march from "ethnic arts" to "new internationalism".'[11] Closer to home, however, inIVA has been ignored or disparaged

either on account of its state subsidy which is at odds with entrepreneurialism, or more importantly, on account of the vagueness with which it has implemented its mission to 'promote the work of artists, academics and curators from a plurality of cultures.' Critic Niru Ratnam regards inIVA's founding decision not to be associated with a dedicated exhibition venue as an evasion of the difficult question of 'how [to] exhibit, rather than write about, art that addresses identity politics.'[12]

Considering the discrepancy between yBa localism and inIVA's pluralism, we get a glimpse into the perplexing conditions occupied by diaspora artists such as Steve McQueen, Chris Ofili, Hamad Butt and Perminder Kaur. Making artistic choices fully congruent with the return to the 'crux' of Pop, Minimalism and Conceptualist, their highly individualized projects mark out a strong contrast with the collectivist ethos of the Eighties, as writers such as Stuart Morgan noted.[13] However, to reduce such generational shifts to a before-and-after story about the fate of identity politics is to fail to recognise that the goalposts of cultural practice have themselves radically shifted. Individual choices are conditioned by structural changes in institutional policy and ideology, and such altered art world outlooks have arisen, in part, because the critique of multiculturalism debated so vehemently in the Eighties was not entirely unsuccessful, even though the resulting consequences were entirely unpredicted.

One of the distinctive features of the contemporary international art world is that although cultural difference is now more visible than ever before, the unspoken rule is that you would look a bit dumb if you made a big issue out of it. How did this Janus-like turnaround come about? Following the controversial 'Magiciens de la terre' exhibition in 1989, a slew of large-scale survey exhibitions such as 'The Other Story' (1989) and 'The Decade Show' (1990) inaugurated the blockbuster model of multicultural inclusion as a problem-solving response to criticisms of ethnocentric exclusion. As the multicultural paradigm passed through the fashion cycle, the institutional embrace of cultural difference reached saturation point with hostile responses to the 1993 Whitney Biennial exhibition. After 'the Other is in,' as Coco Fusco once observed, there was a subsequent reaction, in Britain at least, in which alterity was booted back out again.[14] Taking a global view, however, what emerged was a complex compromise between ethnicity and internationality.

On the one hand, the over-inclusive mega-exhibition became paradigmatic for the expanding circuit of biennales which extended beyond the Euro-American axis to include geopolitical spaces in Australia, Latin America, South Africa, Korea and Turkey. In this respect, the outward face of globalisation installed an ideology of corporate internationalism whose cumulative effect was to *sublate* the discourse of multiculturalism. Cultural difference was acknowledged and made highly visible as the sign of a 'progressive' disposition, but radical difference was gradually detached from the political or moral claims once made in its name, such as the demand for recognition at stake in Eighties debates on 'black representation.'

The moment of sublation simultaneously cancels and preserves the antagonism of thesis and antithesis; but far from arriving at a happy synthesis, what we witness in the dialectical mis-match between inIVA's critical pluralism and yBa 'don't care' localism is a lingering tension around questions of responsibility that made matters of representation crucial to the articulation of aesthetics and politics throughout twentieth-century art movements. Local disdain towards inIVA's approach must be

seen through the lens of post-Thatcherite ideology. Artist Stuart Brisley revealed its outlook when he remarked that New British Art 'has a particular energy because . . . it doesn't suffer from the constraints of state patronage. There is an atmosphere of libertarianism and a release from social responsibilities.'[15] Gallerist Jay Jopling provided further insight when he said, 'I'm not at all interested in issue-based art . . . I am interested in art which has a certain degree of universality and is able to transcend certain cultural and generational differences.'[16] While the yBa's populist edge defined itself against Eighties multiculturalism,[17] we can see in the British art world habitus the fallout of two contradictory responses to globalization as a new phase of capitalist modernization.

Viewed as a branding campaign in the transnational marketplace, the yBa's pathetic neo-nationalism must be understood as a paradoxical attempt to hook up with global flows of art world capital, not by joining in and moving outward to embrace new art from Hong Kong, or Africa, or Scandinavia, but by standing apart and turning inward to promote its own cultural identity as an 'extra added value.' Rather than align itself with corporate internationalism by confidently welcoming the differences of 'others,' the yBa stridently asserted its own cultural distinctiveness such that it moved forward to embrace the challenges of globalisation only by moving backwards and ever inwards into its own ethnicity. The arsey-versey dynamic of 'regress as progress'[18] pinpoints the yBa's reliance on outmoded stereotypes of Britishness, whether Tommy Cooper or the Sex Pistols. Such jokeyness unwittingly betrayed what Stuart Hall described as,

> one of the most profound historical facts about the British social formation: that it had never, ever, properly entered the era of modern bourgeois civilization . . . It never transformed its old industrial and political structures. It never became a second capitalist-industrial-revolution power, in the way the US did, and by another route (the 'Prussian' route), Germany and Japan did. Britain never undertook that deep transformation which, at the end of the nineteenth century, remade both capitalism and the working classes. Consequently, Mrs Thatcher knows, as the left does not, that there is no serious political project in Britain today which is not also about constructing a politics and an image of what *modernity* would be like for our people.[19]

Hall's concept of regressive *modernisation,* far from applying to Thatcherism alone, helps us to grasp how New Labour's project to modernise all aspects of society nonetheless resulted in the retro-centric idiom of Cool Britannia. It also illuminates the way New British Art dealt with the collapse of the critical distance between mass culture and avant-garde ambition under postmodernism, namely by withdrawing and retreating from 'difference' into an identity politics of its own: come back to what you know. And where did that leave African and Asian artists? Highly visible yet evasively mute.

Multicultural normalization

Amidst the uneven coexistence of corporate internationalism and regressive localism, the Nineties generation of black British artists were neither invisible nor excluded from the hyper-ironic 'attitude' in which the yBa was immersed, but enjoyed access to an art world in which ethnicity was admitted through an unspoken policy of integrated casting.

Like their trans-Atlantic counterparts, such as Kara Walker, Michael Ray Charles and Ellen Gallagher, they arrived into a habitus in which the de-funding of public subsidy gave the market a greater role in distributing opportunities for hitherto 'minority' artists. Whereas Howardena Pindell's late Eighties research found that few New York galleries and museums represented Latin, Asian, Native or African American artists,[20] today one would be hard pressed to find a commercial gallery or public museum that did not represent at least one or two 'artists of color.' Diversity is now normal, not 'special.'

Taking stock of this unprecedented turnaround in art world attitudes, Jean Fisher argues that, 'cultural marginality [is] no longer a problem of invisibility but one of excess visibility in terms of a reading of cultural difference that is too easily marketable.'[21] Cultural difference appears more visibly integrated into mainstream markets than ever before, but it is accompanied by a privatised ethos in which it is no longer an 'issue' for public debate. How have these changes influenced the choices diaspora artists make? To explore this question it is necessary to take account of parallel changes in black popular culture, not only because some artists take it as source material for conceptual inquiry, but because the visible integration of cultural difference into the global spheres of postmodern capitalism, whether Benetton, Nike or Coca Cola, informs the cultural horizon against which diaspora art practices are widely interpreted.

Taking account of hip-hop in the music industry, of black-themed cinema in Hollywood, and the plethora of African American images on US network television, especially Rupert Murdoch's Fox channel, Herman Gray observed that, 'given the level of saturation of the media with representations of blackness, the mediascape can no longer be characterized using terms such as invisibility. Rather, we might well describe ours as a moment of *hyperblackness*.'[22] The marked degree of concurrence between the observations of Gray and Fisher allows us to suggest that US-centred globalization has moved the goalposts around the rights and wrongs of 'black representation' so profoundly that we now have a scenario in which the long-standing metaphor of minority 'invisibility' has given way to a new and wholly unanticipated predicament of 'hypervisibility.'

Associated with Ralph Ellison's modernist classic, *Invisible Man* (1952), the trope of invisibility addressed the demand for recognition that Frantz Fanon articulated in *Peau noir, masques blanc* (1952). Voiced in relation to the clear cut political boundaries of colonial domination or supremacist racism, the metaphor posited an equivalence between political empowerment and public visibility. While this overarching equation was held together during late modernity, such that struggles for voice and for visibility meant that blackness embodied a diacritical 'difference' as a source of protest or resistance in relation to the culturally dominant, the era of postmodernity has given rise to the post-Civil Rights predicament which has torn

such equivalences apart. Visibility has been won, in the African American world, through complicity with the compromise formation of cultural substitutionism. 'Hyperblackness' in the media and entertainment industries serves not to critique social injustice, but to cover over and conceal increasingly sharp inequalities that are most polarised *within* black society itself, namely between a so-called urban underclass and an expanded middle class that benefited from affirmative action.

The sociological dimension in black Britain is quite distinct, although the underlying discrepancy whereby media-visible figures like Ian Wright co-exist with the Stephen Lawrence inquiry points to similar turmoil. Henry Louis Gates observed, 'there you have the central contradictions of post-Thatcherite England: the growing cultural prominence of black culture doesn't mean that racism itself has much abated.'[23] In the realm of the visual arts, the highly vocal dissidence of Eighties artists and arts activists like Keith Piper and Eddie Chambers sought visibility against exclusionary boundaries that regulated access to the art world such that black artists were burdened with the responsibility of speaking on behalf of the socially excluded. Although Fisher regards their efforts as a 'limited success,'[24] I would argue that it was the *institutional response* to the agenda, during the late Eighties moment that brought about a sea-change in the 'relations of representation,'[25] that created the scenario in which Nineties black artists sought distance from the hyper-politicization of difference.

Seemingly released from the 'burden of representation,' black artists now enjoy a sense of permission that contrasts with the gravitas associated with the frontier-effects of institutional racism 15 years ago. However, having won such individual freedom of expression (which was always normative for Euro-American modernisms), the pendulum swung to the opposite extreme, such that difference was almost unmentionable. What arose was a trade-off whereby the 'excess visibility' associated with both multicultural exhibitionism, and its sublation into corporate internationalism, was offset by a mute or evasive positioning on the part of younger artists who no longer felt 'responsible' for a blackness that was itself increasingly hypervisible in the global market of multicultural commodity fetishism.

Despite the variety of individual artistic concerns, the generational shift was of a piece with the overall loss of direction consequent upon the collapse of clear-cut frontiers in cultural politics. The neo-black subject of the Nineties, born under a bad sign of global risk and uncertainty, faced the false choice of three new identity options: neo-assimilationist, closet resegregationist, or genuinely confused! Moreover, when so-called Generation X fully embraced the mass consumption of ironic and parodic hyperblackness in gangsta rap, club culture or designer label clothing, all common currency in global youth culture, the ground was pulled from under the diacritical or even 'oppositional' positioning of blackness. It was this gradual de-coupling of political empowerment and cultural visibility that ushered in a new regime of *multicultural normalisation*.

Norms are slippery things. Not as formal as rules or laws, they require social consent and psychic investment in order to regulate structural contradictions and social antagonisms. But what happens when hitherto contested notions of cultural difference become socially normative? Be as visibly different as you want to be, says the all inclusive idiom of free market enterprise, but woe betide you if you try and make any critical or dissident claim on the basis of your pathetic little identity, says

the social authoritarianism of neo-liberal managerialism. The art world mirrors this Janus-like constellation. Its growing informality among younger audiences is said to have overcome modernism's great divide between fine art and everyday life, although the production of such we-feeling is nonetheless accompanied by the managerialist rhetoric of making 'tough choices.' Under such circumstances, the now-you-see-it, now-you-don't equivocation around difference, often employed in framing the projects of contemporary diaspora artists, is understandable as a response to another interrelated process. To the extent that diversity is increasingly administered as a social and cultural norm of postmodernity, it has become part of the establishment. Artists have therefore sought to slip out of its tendency towards fixity in the visual management of cultural difference.

In neo-conceptualist installations using wax-print fabric, such as *Double Dutch* (1994), Yinka Shonibare eludes the heavy handed approach to ethnic authenticity in official multiculturalism by unravelling the intercultural story woven into the threads of his found object. Seen as exotically 'African,' the material originated in Indonesian batik, was reinvested for mass manufacture by Dutch and English textile industries, was exported to West and Central African markets as luxury goods, and then appropriated by Afro-Americans as a badge of counter-modern blackness.[26]

Chris Ofili's paintings, such as the *Captain Shit* series (1997–98), are engorged upon a carnivalesque repertoire of art historical allusions, all of which are embedded in a self-deprecating take on the foibles of black macho in gangsta nihilism or blax-ploitation hyperbole. Whereas Shonibare is happy to describe his outlook as that of a 'postcolonial hybrid,'[27] the story of Ofili's scholarship year in Zimbabwe, and his discovery of elephant dung, did the rounds so often as to become a bit of a joke, although it alludes to David Hammons's *arte povera* of unwanted 'waste' materials.[28] The subtle interplay of sacred and profane in Ofili's devotion to decorative beauty,[29] is covered over by the artist's willingness to play along with the jokey yBa demeanor. When adjectives like 'funkadelic' arise in critic's responses, on the other hand, one wonders whether, rather than engage with Ofili's interests, the concern lies with is conveying a post-boomer whiteness that is *au fait* with the black vernacular – a whiteness of the sort Quentin Tarantino enacted in *Pulp Fiction* (1993) in a frenzy of over-identification with the abjected 'nigga.'

Steve McQueen's early trilogy, *Bear* (1993), *Five Easy Pieces (1994)* and *Stage* (1996), seemed to offer critical distance by creating subtle provocation around the intimacy and anxiety of bodies in the spatial cube of video installation. Taking up much debated fears and fantasies around the black male body – which today, in the form of Nike's Michael Jordan jump-man logo, makes hyperblackness a visual cliché as lame as Linford's lunchbox – McQueen's post-Minimalist approach emptied the image of such stereotypical investments. Arousing intense yet undefinable feeling, the work called for careful critical response; but when asked, in a broadly sympathetic interview, whether *Just Above My Head* (1997) dealt with 'questions of visibility,' McQueen seemed irritated at the mere mention of the idea and replied, 'When I walk out into the street or go to the toilet, I don't think of myself as black. Of course, other people think of me as black when I walk into a pub. Obviously being black is part of me like being a woman is part of you.'[30] An equally tetchy tone came across when he announced, 'Just like everyone else I want people to

Figure 21.1 Steve McQueen, *Bear*, 1993, 16mm film/video transfer (still)
(Photo courtesy of the artist and Anthony Reynolds Gallery, London)

think beyond race, nationality and all that kind of crap. This debate is tired, ugly and beat up . . . it is boring.'[31]

'Playing dumb . . . and taking your knickers down has become an attractive move in the face of the institutionalisation of critical theory,' quips John Roberts,[32] whose neo-populist reading of New British Art, although intrinsically problematic, nonetheless pinpoints some possible reasons for McQueen's boredom and spleen. Roberts perceives the yBa's dumb pose as a knowingly 'philistine' rejection of the textualist 'politics of representation' associated with the impact of poststructuralist theory over the past twenty years. The rapid incorporation of cultural studies into Nineties higher education both neutralized its critical ambitions and made it a target for the 'cynical reason' of the shortlived British journal *The Modern Review*. Relatedly, to the extent that the postcolonial vocabulary, characterized by such terms as diaspora, ethnicity and hybridity, has successfully displaced earlier immigration narratives of assimilation, adaptation and integration, its broad influence has extended to the apparatus of 'bureaucratic multiculturalism' it once sought to critique.

For diaspora artists engaged in neo- or post-conceptualist practices, an impasse had arisen in art's relationship to (postcolonial) theory. Renée Green mused, 'There's a certain power dynamic that occurs in terms of how the artists are positioned that disturbs me. I would like to restructure this dynamic so that it doesn't feel like art is merely a decorative element – something which is tagged on to the "heavier ideas."'[33] When art is reduced to visualising theory, or worse, when the aesthetic encounter is over-determined in advance, McQueen's annoyance is intelligible as an attempt to evade ideological capture. Arising from both the institutional incorporation of critical theory's once adversarial idiom, and the market's preferred solution, which is to imply that the way to a race-free future is to simply stop talking

about divisive matters of 'difference,' these hidden pressures call for a more empathic understanding of McQueen's post-identitarian predicament when he says:

> I'm in a position I am because of what other people have done and I'm grateful, for sure. But at the same time, I am black, yes. I am British as well. But as Miles Davis said, 'So what?' I don't say that flippantly but like anyone else I deal with certain things in my work because of who I am. I make work in order to make people think.[34]

Cosmopolitan locales

Precariously poised between the art market's corporate transnationalism and the inward provincialism of the London 'scene,' diaspora artists inhabit the contradictory conditions of post-Empire Britain. 'Capitalism only advances, as it were, on contradictory terrain. It is the contradictions which it has to overcome that produce its own forms of expansion', Stuart Hall has said on the subject of globalisation and ethnicity.[35] The particularities of Britain's skewed insertion into the world system of modernity enable the contradictory coexistence of regressive neo-nationalism and multicultural normalisation within its art world.

In his insightfully wide ranging story of 'the pop cultural constitution of Englishness,' Michael Bracewell evokes British modernity as a century-long 'retreat from Arcady,' which engendered a quintessential ambivalence best encapsulated when Noel Coward quipped, 'I am England, and England is me. We have a love-hate relationship with each other.'[36] Revealingly, Bracewell depicts New British Art as a loser in an either/or play-off between such ambivalent ironies of Englishness and the bland multiculti-commodification of 'difference' in US-centred global capitalism:

> With . . . the replacement of Englishness, as a current cultural term, with the multiculturalism of Britishness, the baton in the cultural relay race between fine art, literature, music, film and drama, could be said to have been exchanged for a basketball and a pair of Nikes.[37]

While sympathetic towards 'the creative marriage' of African American-originated dance culture and the legacy of sixties psychedelia which he hears in Goldie's drum 'n' bass (whose coexistence alongside BritPop's retro-centric ironies echoes the art world tensions we have examined), Bracewell's telling distinction between Britishness and Englishness is left symptomatically unresolved. In his ambivalently open-ended conclusions, Morrisey's 'Hang the DJ,' which 'sings of England and something black, absurd and hateful at its heart,'[38] allows the *sotto voce* suggestion that multicultural otherness is an obstacle to the completion of English ethnicity. Although it stops short of Enoch Powell's discourse on 'alien cultures,' what we see acknowledged in this irresolution is the open wound of whiteness otherwise fetishistically covered over and smoothed out by the managerial feel-good factor of Cool Britannia.

In an art world habitus shot through with these simmering tensions, we may understand inIVA's unpopularity as an outcome of its association with the bureaucratic institutionalisation of cultural theory. By virtue of its free-floating placelessness, or rather its reluctance to author a distinct curatorial signature, inIVA effectively withdrew from a public debate about misperceptions of minority artists. The Roundhouse project failed because black artists could not agree on a common purpose for it. Commenting that, among arts administrators, 'The resounding response was "whatever you do, don't build a black art gallery,"' inIVA's director Gilane Tawadros disclosed the reasoning behind the organisation's obedience. She states: 'There was a time when it was important to make black artists visible in the same way that women artists were making themselves visible, but that time has passed. You cannot differentiate black art history from white. These things come together and both their currencies are intimately intertwined.'[39]

While entirely valid and necessary as a starting point for a more inclusive account of contemporary art which assumes cultural mixing, or hybridity, as a cornerstone feature of modernism and modernity, the problem is that the story of how 'that time has passed,' and the whys and wherefores of its passing, were not opened up for public discussion. By retreating from the challenge of examining why nobody likes 'black art' as a classificatory or curatorial category, Tawadros's evasive positioning reciprocally mirrors and inverts Steve McQueen's, suggesting that inIVA too was vulnerable to hidden pressures. Whereas one tactic sought resolution by simply not talking about 'it,' another tactic was to talk about 'it' all too much, using the language of postcolonial theory to cover over and conceal unresolved tensions in the art world's management of cultural difference. In this way, inIVA went along with the decoupling of aesthetic interests and social responsibility that made matters of representation crucial to the counter-modern traditions of the various Caribbean, African and Asian diasporas for whom Britain was also a place called home, whose cold comforts Perminder Kaur evoked in her *Cot* (1993).

While the subversive potential once invested in concepts of hybridity has been tempered by pre-millennial downsizing, the grey area of complicity that Nikos Papastergiadis perceives between identity-driven demands for minority representation and market-based adaptation to diversity suggests that the outcomes of social agonism over norms can never be guaranteed in advance.[40] Such inIVA exhibitions as 'Aubrey Williams' (1998) have drawn attention to the Caribbean Artists Movement (CAM), a loose network of artists, writers, students and teachers who met at the West Indian Students Centre in London between 1966 and 1972. Although primarily literary in orientation, with Edward Kamau Brathwaite, Andrew Salkey and John La Rose as its organizers, CAM articulated an 'outernationalist' outlook among the post-independence generation. While some participants returned to the Caribbean to influence cultural policy, others remigrated to North America, and yet others stayed on to shape the black British arts sector in the Seventies.

The CAM story was simultaneously culturally nationalist, exilically internationalist, and Black Atlanticist, and as such it offers a vivid example of Homi Bhabha's 'vernacular cosmopolitanism,'[41] although the modest localism of the narrative might not fulfil the more bombastic claims that postcolonial theory sometimes aspires to. For me, the value of Ann Walmsley's lucid documentation lies in its provision of a genealogy of the mixed times and spaces inhabited by diaspora

artists.[42] This is a starting point for the 'homework' which visual studies has yet to catch up with in terms of researching the distinct art-historical milieux out of which Asian, African and Caribbean artists in Britain crisscrossed paths with various critical modernisms.

Jean Fisher is an important contemporary art critic who has given time and trouble to these genealogical matters that form part of the unexplored historical context of black British visual practices.[43] However, the proposed distinction between hybridity and syncretism misleadingly contrasts different colonial attitudes to cultural mixing, without recognizing that the mix among Anglophone, Franco-phone and Hispanic dispositions is precisely what makes 'the Caribbean' a diasporic location where the encounter with difference is a regulating convention of everyday life, i.e. a norm. To regard 'the Caribbean' as the name of a habitus in which hybridity is normal is not to say that everywhere else is like that now, but that the worlding of the ethnic signifier may take forms other than prevailing trends towards market-based multicultural normalization.

What I liked about the trans-localism of the CAM story was that it was made possible by London's cosmopolitan status as a world city, which in my view makes CAM the site of a specifically British vernacular modernism. To the extent that this would imply that a certain Britishness was *always already* hybridized in the encounter with Asian, African and Caribbean diasporas, it confirms Stuart Hall's account of the postcolonial as the time of a double inscription, in which elements hitherto banished to the constitutive outside of society return through the gaps in the signi-fying chain of cultural identity to decentre its symbolic authority.[44]

Doing our 'homework' means opening out such stories so that they 'belong' not just to British artists and audiences, but to anyone interested in art's ability to survive the wreckage of modernity. Telling these stories reactivates ideas of syncretism, creolité and metissage which are all conceptually hybrid. To paraphrase Johnny Rotten, one might say that such postcolonial hybrids are the flowers in the dustbin of art's history.

Notes

1 Simon Ford, 'The Myth of the Young British Artist' (1996), in Duncan McCorquodale, Naomi Siderfin and Julian Stallabrass (eds), *Occupational Hazard: Critical Writing on Recent British Art*, London: Black Dog, 1998, pp. 132–41.

2 Michael Bracewell, *England is Mine: Pop Life in Albion from Wilde to Goldie*, London: Harper Collins, 1997, pp. 229–30.

3 Hal Foster, *The Return of the Real: The Avant-Garde at the End of the Century*, Cambridge, Mass.: MIT Press, chapters 5 and 6, especially fn. 52, p. 283.

4 Cited in Ford, op. cit., p. 133.

5 Angela McRobbie, 'But is it art?', *Marxism Today*, November–December, 1998, p. 56.

6 Bracewell, op. cit., pp. 231, 229.

7 Ibid., p. 230.

8 Ibid.

9 Ford, op. cit., p. 135.

10 Patricia Bickers, 'How Others See Us: Towards a History of Recent Art from Britain,' in Bernice Murphy (ed.), *Pictura Britannica: Art From Britain*, Sydney: Museum of Contemporary Art, 1997, pp. 65–88. New Labour's reasoning behind 'Cool Britannia' is illuminated by Mark Leonard, *Britain TM: Renewing Our Identity*, London: Demos, 1997.

11 Gavin Jantjes, 'The Long March from "Ethnic Arts" to "New Internationalism,"' in Ria Lavrijsen (ed.) *Cultural Diversity in the Arts*, Amsterdam: Royal Tropical Institute, 1993, pp. 59–66.

12 Niru Ratnam, 'Invisible INIVA,' *Art Monthly*, no. 211, November 1997, p. 16.

13 Stuart Morgan, 'The Elephant Man,' *Frieze*, no. 15, March–April 1994, pp. 40–43.

14 Coco Fusco, 'Fantasies of Opportunity' [1988], in *English is Broken Here*, New York: New Press, 1994.

15 Cited in Ford, op. cit., p. 135.

16 Ibid., p. 139.

17 When 'fashion becomes the dictator as to how long an issue can be sustained in the public eye . . . whatever progress can be made in an "in" area, like multiculturalism, will be lost as soon as the issue is no longer "fresh,"' writes David Barrett, 'First Generation Reproduction' [1996], in Murphy (ed.), op. cit., p. 126.

18 Peter Suchin, 'After a Fashion: Regress as Progress in Contemporary British Art,' in McCorquodale *et al.* (eds), op. cit., pp. 96–111.

19 Stuart Hall, 'Gramsci and us' [1987], in *The Hard Road to Renewal*, London: Verso, 1988, p. 164.

20 Howardena Pindell, 'Art (World) & Racism,' *Third Text*, no. 3/4, Spring–Summer 1988, pp. 157–90. Similar shifts in the UK are examined in Janice Cheddie, 'Storm Damage,' *make*, no. 76, June–July 1997, pp. 15–16.

21 Jean Fisher, 'The Syncretic Turn: Cross-Cultural Practices in the Age of Multiculturalism,' in Melina Kalinovska (ed.), *New Histories,* Boston: Institute of Contemporary Arts, 1996, p. 35.

22 Herman Gray, *Watching 'Race': Television and the Struggle for Blackness*, Minneapolis: University of Minnesota Press, 1995, p. 230.

23 Henry Louis Gates Jr, 'Black London,' *The New Yorker*, April 28–May 5 1998, p. 199.

24 Fisher, op. cit., p. 35.

25 Stuart Hall, 'New Ethnicities,' in *Black Film/British Cinema*, ICA Documents no. 7, London: Institute of Contemporary Art, 1988.

26 See my 'Art That is Ethnic in Inverted Commas,' *frieze*, no. 35, November–December 1995, and 'Inter-Culturality is Ordinary' in Ria Lavrijsen (ed.) *Intercultural Arts Education and Municipal Policy*, Amsterdam: Royal Tropical Institute, 1997.

27 Yinka Shonibare, 'Fabric, and the Irony of Authenticity,' in Nikos Papastergiadis (ed.), *Annotations,* no. 2, London: inIVA, 1996, p. 40.

28 Kelly Jones, 'In the Thick of It: David Hammons and Hair Culture in the 1970s,' *Third Text*, no. 44, Autumn 1998, pp. 17–24.

29 See texts by Godfrey Worsdale, Lisa Corrin and Kodwo Eshun in *Chris Ofili*, exhibition catalogue, Serpentine Gallery, London, and Southampton City Art Gallery, 1998.

30 In Patricia Bickers, 'Let's Get Physical,' *Art Monthly*, no. 202, December–January 1996–7, p. 4.

31 Iwona Blazwick, in 'Oh My God! Some notes from a conversation with Jaki Irvine and Steve McQueen,' *make*, no. 74, February–March 1997, p. 7.

32 John Roberts, 'Mad For It! Philistinism, the Everyday and the New British Art,' *Third Text*, no. 35, Summer 1996, p. 29.

33 Renée Green, 'Artist's Dialogue,' in Alan Read (ed.) *The Fact of Blackness: Frantz Fanon and Visual Representation*, Seattle: Bay Press, 1996, p. 146.

34 In Bickers, op. cit., p. 5.

35 Stuart Hall, 'The Local and the Global Pt 1: Globalisation and Ethnicity,' in Anthony King (ed.), *Culture, Globalisation and the World System*, Binghamton: State University of New York, 1991, p. 29. Neo-liberal wishes for a race-free future are critically dissected in Paul Gilroy, *Joined-up Politics and Post-Colonial Melancholia*, ICA Diversity Lecture, London: Institute of Contemporary Arts, 1999.

36 Bracewell, op. cit., pp. 211, 212; Coward, cited p. 222.

37 Ibid., p. 231.

38 Ibid. Tony Parsons cited p. 222.

39 In Nikos Papastergiadis, 'Global Proposals: A Conversation with Gilane Tawadros,' in *Dialogues in Diaspora*, London: Rivers Oram, 1998, p. 136.

40 See Nikos Papastergiadis, *The Complicities of Culture: Hybridity and 'New Internationalism'*, Cornerhouse Communiqué no. 4, Manchester: Cornerhouse Gallery, 1994; and 'Back to Basics: British Art and the Problems of a Global Frame,' in Murphy, op. cit., pp. 124–45.

41 Homi Bhabha, 'Beyond the Pale: Art in the Age of Multicultural Translation,' in Elisabeth Sussman *et al.* (eds), *1993 Biennial Exhibition*, New York: Whitney Museum of American Art/Abrams, 1993.

42 Ann Walmsley, *The Caribbean Artists Movement 1966–1972: A Literary and Cultural History*, London and Port of Spain: New Beacon, 1992.

43 Insights from 'The Syncretic Turn' are expanded in Jean Fisher, 'The work between us,' in Okwui Enwezor (ed.), *Trade Routes: History and Geography*, catalogue to the 2nd Johannesburg Biennale, Greater Johannesburg Metropolitan Council and Prince Claus Fund, 1997.

44 Stuart Hall, 'When Was the Post-Colonial? Thinking at the Limit,' in Lidia Curti and Iain Chambers (eds), *The Post-Colonial Question*, London and New York: Routledge, 1996. Relatedly, see Bruce Robbins and Pheng Cheah (eds), *Cosmopolitics: Thinking and Feeling Beyond the Nation*, Minneapolis: University of Minnesota Press, 1998.

Nicholas Mirzoeff

THE MULTIPLE VIEWPOINT
Diaspora and visual culture

The Jew and I: Since I was not satisfied to be racialized, by a lucky turn
of fate, I was humanized. I joined the Jew, my brother in misery.

Frantz Fanon (Fanon 1967: 122)

Kishinev and St Louis – the same soil, the same people. It is a distance
of four and half thousand miles between these two cities and yet they
are so close and so similar to each other.

The Forward, 1917 (quoted in Takaki 1995)

WHEN MARSHALL McLUHAN first coined the phrase 'global village' in the
1950s, it must have had a comforting ring. It implies that despite the aston-
ishing proliferation of new technologies, life in the information age will have the
same sense of belonging and rootedness that goes along with village life. From our
fin-de-siècle perspective, the information age seems much less optimistic. In place of
firm notions of identity has come an era of mass migrations, displacements, exile
and transition. Capitalism has become postnational, operating in the blocs consti-
tuted by such agreements as the North American Free Trade Association, GATT
and the European Union. From France to Rwanda and the Middle East, virulent
right-wing nationalist movements have sprung up in response to these challenges to
the nation-state. On the other hand, artists, critics and writers have re-examined
the cultures of diaspora as a means of understanding and even embracing the new
modes of postnational citizenship. For, as Arjun Appadurai has observed, '[i]n
the postnational world we are seeing emerge, diaspora runs with, and not against,
the grain of identity, movement and reproduction' (Appadurai 1993: 803). From
academic journals like *Transition* and *Diaspora* to popular music anthems like Soul II
Soul's *Keep On Movin'*, artworks like Vera Frenkel's . . . *from the Transit Bar* and films

such as *Mississippi Masala*, the idea that culture must be based in one nation is increasingly being challenged. Now it is time to look at the way that culture crosses borders and oceans with ease in a constant state of evolution.

The new insistence on the diasporic in the work of such critics as Rey Chow (1993), James Clifford (1997), Paul Gilroy (1993), Stuart Hall (1990) and others results from a changed perception of the nature and meaning of diaspora itself. In the nineteenth century, diaspora peoples were seen as a disruption to the natural economy of the nation-state. Diaspora peoples themselves envisaged an end to diaspora whether in Theodore Herzl's Zionism or Marcus Garvey's return to Africa. For the self-conceived domestic population, diaspora peoples were an excess to national need, to be disposed of by migration, colonial resettlement or ultimately by extermination. Diaspora was something that happened to 'them' not 'us.' That comforting division no longer holds good. Olabiyi Babalola Yai tells us that the Yoruba peoples of West Africa consider themselves to be a permanently diasporic people, a consequence no doubt of the experiences of slavery and colonization (Yai 1994). In the late twentieth century, that feeling has gone global. Whereas nineteenth-century diasporas revealed interconnected nations, our current experience is of an increasingly interdependent planet.

There is a growing sense that we now find ourselves at, to use Stuart Hall's phrase, 'the in-between of different cultures.' This essay is dedicated to thinking through what that in-between looks like in the African and Jewish diasporas. It is motivated by the belief that diaspora is an inevitably plural noun, meaning that diasporas cannot be properly understood in isolation. As the citations at the head of this chapter indicate, Africans and Jews have long looked to each other for an explanation of what it means to be in diaspora, an understanding that is now in urgent need of renewal. For the inability of traditional politics to cope with the postnational world has been accompanied by a remarkable efflorescence of cultural work of all kinds dedicated to understanding the genealogy of the new global culture and its potential to transform the way we look at ourselves and at others.

There is, however, a problem concerning the representation of diasporas. Diaspora cannot by its very nature be fully known, seen or quantified, even – or especially – by its own members. The notion of diaspora and visual culture embodies this paradox. A diaspora cannot be seen in any traditional sense and it certainly cannot be represented from the viewpoint of one-point perspective. The nation, by contrast, has long been central to Western visual culture. While we have become accustomed to thinking of the nation-state as an 'imagined community' (Anderson 1992), it can nonetheless call on a range of geographical sites, monuments and symbols to create a powerful visual rhetoric of nationality. The nineteenth-century creation of an extensive museum culture based on the idea of unfolding national histories gave institutional force to this vision of national culture (Sherman and Rogoff 1994; Clifford 1991). A distinction was made between historical objects which were displayed in national museums and the disinterested category of art, both of which excluded diaspora peoples. Museums served to emphasize the Western notion that history logically tended towards the dominance of the imperial powers, while art collections served to reinforce the perceived 'superiority' of Western culture. Diaspora peoples have been marginalized by this visualization of national cultures in museums, while consistently using visual means to represent

their notions of loss, belonging, dispersal and identity. For example, the Border Art Workshop/Taller de Arte Frontizero and the collaborative work of Guillermo Gómez-Peña and Coco Fusco have provided a powerful alternative way of conceiving the US/Mexican relationship to the xenophobic simplicities of Ross Perot and California's Governor Pete Wilson (Fusco 1995: 145–201). In the academy, art history's notion of stylistic influence is another case in point. A successful attribution of stylistic influence relies on a clear visual homology between a source and its descendant together with evidence that the source was known to the artist. Martin J. Powers argues that '[w]hat we call "style" is an important means whereby social groups project their constructed identities and stake their claims in the world. It may have been precisely for this reason that nineteenth- and much of twentieth-century art history stressed the "national" and personal element in style, since it was thought to be the visual counterpart of some internal essence' (Powers 1995: 384). That essence was, of course, race. Powers does not mean to suggest that all art history must be rejected as racist but that, when we are involved in cross-cultural work, the traditional tools of the discipline must be handled with the greatest of care. Writing the history of diaspora visual cultures will, then, pose important methodological questions for both diaspora studies and the visual disciplines.

Diasporas and intervisuality

In much diaspora scholarship, the Jewish diaspora has been taken as the 'ideal type' of the experience (Clifford 1997: 247–8), leading other diasporic experience to be mapped against this model. However, diasporas are rarely considered in tandem. For Jews, the parallel has often been to compare 'Jewish' (nomadic) culture with 'Greek' (national) culture in a tradition stemming from Matthew Arnold's *Culture and Anarchy* (1864) via James Joyce's formulation of the neologism 'jewgreek.' In the case of the African diaspora, the key question has been continuity with African traditions, rather than relations with other diaspora groups (Thompson 1983). Recent discussions of African-Jewish relations have thus concentrated almost exclusively on the case of North America since the Civil Rights era of the 1960s (Salzmann 1992). Even in this limited geographic space, Africans and Jews have been encountering one another since the seventeenth century, meaning that the hybridity generated by diaspora is not just an interaction with the 'host' nation but among diasporas themselves. For much of this time, Africans and Jews have seen their histories as mirroring one another. The nineteenth-century African diaspora theorist Edward Wilmot Blyden stated the parallel directly: 'The Hebrews could not see or serve God in the land of the Egyptians; no more can the Negro under the Anglo-Saxon.' In the contemporary world in which the dominant tension between center and periphery has been replaced by a global pattern of flows and resistances (Appadurai 1996), both Africans and Jews can benefit from renewing their sense of diaspora culture with reference to the other as well as the self. It is no coincidence that Paul Gilroy, who has taken a strong position against essentialist notions of African identity, has also brought the African-Jewish comparison to the heart of his work (Gilroy 1993: 205–16), implying a challenge to the historians of the Jewish diaspora to follow suit. The complete history of such parallel diasporas is beyond

the scope of this book and probably beyond any one individual writer. What can be achieved is the reopening of a discussion and the beginnings of new patterns of thought. By bringing together the work of a variety of scholars working on the visual cultures of African and Jewish diasporas, this book offers the reader an opportunity to undertake the traditional art historical task to 'compare and contrast.'

More importantly, it highlights new ways of thinking of diaspora as becoming, in the lineage of Stuart Hall's now classic essay 'Cultural Identity and Diaspora.' For Hall, 'diaspora identities are those which are constantly producing and reproducing themselves anew, through transformation and difference.' This insight was in part inspired by Jacques Derrida's notion of *différance*, a state between differing and deferring. For Derrida himself, this implies that Jewishness, as opposed to Judaism, is 'open to a future radically *to come*, which is to say indeterminate, determined only by this opening of the future to come' (Derrida 1996: 70). Similarly, the Jewish-American artist R.B. Kitaj notes in his *Diasporist Manifesto*: 'I try to be, along with many artists, forward-looking' (Kitaj 1989: 65).[1] Diaspora has long been understood as determined by the past, by the land which has been lost. More exactly, W.E.B. Dubois's concept of 'double consciousness' has dominated understandings of diaspora: 'One ever feels his twoness – an American, a Negro; two souls, two thoughts, two unreconciled strivings; two warring ideals in one dark body, whose dogged strength alone keeps it from being torn asunder' (Dubois 1989 [1903]: 5). Dubois saw this double consciousness as the defining problem of the twentieth century and so it has proved. This tension can in part be understood as a dialectic between past and present. It may be possible, by developing the notion of the future into the diaspora identity, to discover additional dimensions to diaspora consciousness. If it can now be rethought as an indeterminate future to come, that will imply a significant reevaluation of diasporas past, present and future to which this volume can only contribute.

However, debate over the African and Jewish diasporas has instead been dominated by the highly effective and notorious preaching of Minister Louis Farrakhan of the Nation of Islam (Berman 1994). Farrakhan straightforwardly asserts that: 'Some of the biggest slave merchants were Jews. The owners of the slave ships were Jews. . . . It's been a master-slave relationship' (Gardell 1996: 260). Although historians have shown the absolute inaccuracy of such statements (Faber 1998), their work has had little effect on the impact of Farrakhan's comments, not least because of persistent racism in some sections of the Jewish community. His goal is not to change the academic consensus on slavery but for the Nation of Islam to take over the metaphorical place of the Jews in modern American popular culture: 'I declare to the world that the people of God are not those who call themselves Jews, but the people of God who are chosen in this critical time in history are you, the black people of America, the lost, the despised, the rejected' (Gardell 1996: 258). Farrakhan's argument is, in effect, that the present relative wealth of American Jews by comparison with African-Americans invalidates any claim that they might have to be the people of God. This message has found a significant audience in the world of rap and hip-hop, where many performers have turned to the Nation of Islam. One of the most notorious Farrakhan aides, Khallid Abdul Mohammad, has performed with rap group Public Enemy and the LA gangsta rapper Ice Cube. Rap now sells extensively to white teenagers in the suburbs but individual artists continue

to base their claim to authenticity or 'realness' on their roots in the black ghetto. While not every American Jew has achieved great wealth, few can claim 'realness' on this level. However, this is not a sociological debate, as evidenced by the success of the suburban Jew turned rapper, Adam Horowitz of the Beastie Boys. What is at stake is the claim to a metaphorical and rhetorical position as the absolute Diaspora, perceived as a singular and exclusive condition. Both Farrakhan's supporters and some of those who use him as demon figure use the Other diaspora as a means of disciplining their own. That is to say, in a world marked by hybridity and diversity, the absolute evil of the Other is perhaps the only means by which the integrity of the same can be sustained. As long as 'realness' is perceived solely in performative terms of the 'origin' of diaspora, this debate will continue to be as unproductive as it has been to date. In some senses, it could be argued that the tensions between Africans and Jews in the United States stem from this insistence that diaspora is only about origins and the past. Both groups claim to have suffered most in diaspora and at the same time to assert a crucial place in modern 'Americanness.' To adopt Gilroy's distinction, both groups need to reassert their 'routes' over their 'roots,' while also paying attention both to those places where African and Jewish routes have overlapped in the past and to ways in which they might again merge in the future.

For the notion of a 'route' may be too singular. In his *Diasporist Manifesto* Kitaj defines the diasporist as instead appearing in 'every polyglot matrix,' an appropriately fractal metaphor for these complicated times. He later glossed the 'polyglot' to mean 'Jew, Black, Arab, Homosexual, Gypsy, Asian, emigré from despotism, bad luck etc.,' divorcing the idea of diaspora from any essentialist notion of 'race' or ethnicity (Kitaj 1989: 75). By extending the categories of the diasporist beyond the dispersed nation-state, Kitaj challenges us to rethink the notion of authenticity, as applied both to national and diaspora cultures. It further opens diaspora to categories beyond the national, especially sexual minorities. Indeed, it almost suggests that diaspora is becoming a majority condition in global capitalism. This polymorphous notion of diaspora transforms the visual image itself for: 'the Diasporist painting I have always done also often represents more than one view' (Kitaj 1989: 73). Kitaj's sense of the multiplicity of diaspora is not limited to his own art but, as the essays in this collection show, is also part of the revision of modernism commonly known as postmodernism. Diaspora generates what I shall call a 'multiple viewpoint' in any diasporic visual image. This viewpoint incorporates Derrida's *différance*, Kitaj's many views and what Ella Shohat and Robert Stam have called a 'polycentric vision' in which the visual is located '*between* individuals and communities and cultures in the process of dialogic interaction' (**Shohat** and **Stam**). The multiple viewpoint moves beyond the one-point perspective of Cartesian rationalism in the search for a forward-looking, transcultural and transitive place from which to look and be seen. In the contemporary moment, when imagination itself 'is neither purely emancipatory nor entirely disciplined but is a space of contestation in which individuals and groups seek to annex the global into their own practices of the modern' (Appadurai 1996: 4), changing the way in which people see themselves is in all senses a critical activity.

For those contemporary artists, critics and historians concerned with diaspora, the key question thus becomes determining what such multiple viewpoints look like

now, in the past and in the future. Indeed, the multiple viewpoint has much to offer all those seeking new ways to formulate key questions of the gaze and spectatorship. Just as theories of hybridity and *mestizaje* developed in the Caribbean, India and Latin America, now seem the most contemporary tools with which to examine the 'West,' so may visual theory developed in rethinking diaspora contribute to the ongoing rethinking of the visual that has come to be termed visual culture. Such questions, by their nature, are unlikely to produce an answer in the form of traditional 'evidence.' Homi Bhabha has situated his influential endorsement of hybridity under the sign of a double negative, 'neither the one, nor the other.' He nonetheless hopes that a new art may emerge from the working through of these contradictions, provided that it

> demands an encounter with 'newness' that is not part of the continuum of past and present. It creates a sense of the new as an insurgent act of cultural translation. Such art does not merely recall the past as social cause or aesthetic precedent; it renews the past, refiguring it as a contingent 'in-between' space, that innovates and interrupts the performance of the present. The 'past-present' becomes part of the necessity, not the nostalgia, of living.
>
> (Bhabha 1994: 7)

From the fragments of the past-present — that is to say double consciousness — Bhabha sees the creation of multiple diaspora futures, futures forged from memory and experience but not dependent on them. This kind of work cannot be done by standard histories and realist representations. It is what Jean-François Lyotard meant when he called the sublime the modern mode of presenting the unpresentable. This, then, is the postmodern diasporic dilemma: how can something be visualized that is adequate to guide us round what is so widely felt to be new, when all that is available is the discredited apparatus of the modern? One method of constructing answers to that question lies in writing diasporist genealogies of the present that refigure the past in order to facilitate the theoretical and phenomenological understanding of the multiple viewpoint of diaspora. Such work entails a certain risk, described by Iain Chambers as 'embracing a mode of thought that is destined to be incomplete' (Chambers 1994: 70). Any writing that addresses the future must, by its very nature, fail to fully succeed.

The diasporic visual image is necessarily intertextual, in that the spectator needs to bring extra-textual information to bear on what is seen within the frame in order to make full sense of it. However, in the visual image, intertextuality is not simply a matter of interlocking texts but of interacting and interdependent modes of visuality that I shall call intervisuality. From a particular starting point, a diasporic image can create multiple visual and intellectual associations both within and beyond the intent of the producer of that image. Robert Farris Thompson's example of the yodel shows how even a certain sound becomes the gateway to a multiple viewpoint on the African diaspora.[2] The yodel is 'a chest/head, high low snap across an octave [that] is one of the hallmarks of the singing of rainforest pygmies in Central Africa.' Thompson hears the echo of that yodel in Kongo music and from there in the Mississippi Delta blues, a sound that resonated with the wail of a steam engine:

'By the 1940s, if your ear were culturally prepared, you could hear a lonesome train whistle in the night and immediately think of black people, on the move. From Memphis to Mobile. Goin' to Chicago, sorry that I can't take you' (Thompson 1989: 98). The American railway was the means by which the Great Migration of African-Americans from South to North took place, as depicted by Jacob Lawrence in his series painting *The Migration of the Negro* (1940). This modern diaspora inevitably evoked the forced transatlantic diaspora of slavery that had brought Africans to America, creating musics like the blues, jazz and soul in which the train was both inspiration and subject-matter. In short, the train whistle had become what Mikhail Iampolski has called a 'hyperquote,' an artifact generating multiple intertextual references (Iampolski 1998: 35). Learning to hear under Thompson's tuition, one could even go further. The American railroads were built by Africans, Chicanos, Chinese, Irish, Japanese and other immigrants, each with their own song expressing the pain of the work. Frederick Douglass heard echoes of African song in Irish ballads (Takaki 1995: 21–2). Others have made a similar connection to the Yiddish music of eastern Europe. As has been widely noted, the train itself is a privileged site in the creation of Western visual culture, for the view from the train window was the first perception of the moving image that later became institutionalized as cinema. The train, to use Stephen Heath's distinction, was where the seen first became the scene. By the 1940s, the railway had been transformed from a symbol of European progress to the facilitator of the Holocaust, with special meaning for Jews, gypsies, gays, the disabled and the other victims of slaughter. This resonance informs work as various as R.B. Kitaj's painting *The Jewish Rider*, Vera Frenkel's installation piece and web site . . . *from the Transit Bar* and Claude Lanzmann's epic documentary *Shoah*. Diasporas do not occur one by one but inevitably overlap, creating poly-valent symbols that are sometimes shared, sometimes contested. Diaspora moves like that, adjacently and in free-style.

Diaspora politics

There is, however, a danger that diaspora can be taken as truly 'authentic,' a new universalism in contrast to the formal structures of national culture. It certainly seems to come packaged in an attractive 'alternative' wrapping, promising inter-disciplinary and cross-cultural ideas that hope to resist the normalizing tendencies of the critical process. However, the attractions of the nomad lifestyle are as clear to elites as to popular and critical groups. Almost all Americans now seek a connec-tion to alterity, as evidenced by every recent US president discovering their 'Irish' roots on the campaign trail. Suddenly, diaspora as a subject position has become fashionable, leaving the historical diaspora communities with some quandaries. In an age when the most marked diaspora is that of capital, we are all the 'wretched of the earth.' Cyberprophet Jacques Attali heralds the emergence of a new class he calls 'liberated nomads bound by nothing but desire and imagination, greed and ambition'(Owen 1996: 31). This new superclass will use their 'nomadic objects' like laptops with radio faxmodems, cellular phones and DAT recorders to regulate a workforce compelled to be nomadic in pursuit of ever-diminishing employment. As diaspora becomes a way of life, it is emerging as a fragmented class-riven norm,

rather than the romanticized refuge of the persecuted. In Latin America, hybridity under the name *mestizaje* is already a central element of government strategy, as Sean Cubitt explains:

> When presidents in Bolivia or Brazil want to lay claim to legitimacy in a continent whose cultures and economies are overlays of indigenous, colonial and slave populations, they claim *mestizaje*: no longer the property of resistance, this hybridity is the authority of rule – like Clinton's saxophone, it marks a place between, a fictive and utopian space, a territory of meeting, empathy, commonality.
>
> (Cubitt 1995: 71)

Thus the claim to hybridity that may seem to be the mark of resistance in the former colonial powers can be the sign of political authority in some former colonies. The Latin American experience can stand as a useful corrective to some of the more present-centered approaches all too common in today's cultural studies. Even if that work often refers only to Great Britain, it ignores Britain's ethnic diversity in the eighteenth century, whose visibility was diminished in the nineteenth century through intermarriage but far from eradicated, as historians have recently argued (Wilson 1995). Further, as Robert Young has shown, hybridity was a central goal of nineteenth-century imperial administrators (Young 1995). Caution is therefore required in making exclusively positive use of such terms as hybridity and diaspora.

Indeed, the African critic V.Y. Mudimbe has recently critiqued the new focus on diaspora culture as being governed by an unthinking continuity with the nineteenth-century nation state: '[O]ur contemporary thought seems to be a thought of exile, a thought hiding behind a nostalgia for the recent past, a thought speaking from spaces and cultures that no longer exist and were dead long before the death of the long nineteenth century' (Mudimbe 1995: 983). Mudimbe might perhaps have had in mind James Clifford's earlier celebration of the traveler or Paul Gilroy's focus on the sailor as a hero of diaspora narratives. At the same time, this re-emergence of nineteenth century discursive practice as a motive force of late twentieth-century culture was by no means self-evident until the end of the Cold War. Mudimbe's critique thus highlights the ways in which the postmodern permits a rereading of the modern in the light of the failure of modernist grand narratives. It suggests that the nation-state depended on its diasporic others as a means of negative differentiation. That is to say, diaspora peoples like Africans, Armenians, gypsies and Jews were the definition of what a nation was not and, as a consequence, were the target of sustained nationally organized terror throughout the modern period. Simply inverting the terms to privilege the diasporic over the national will not, in Mudimbe's view, change the fundamental structure of the discourse. The contained dialogue of the past with the present needs to be broken by the indeterminate figure of the future.

One way to think through this problem was supplied by Jean-François Lyotard in his response to the Heidegger affair. In 1987, Victor Farias published a book called *Heidegger and Nazism*, which demonstrated that the German philosopher Martin Heidegger had far more extensive connections with the Nazi party than had previously been thought (Steiner 1995: 177–88). Although Heidegger's Nazi past

was no secret – Jean-Paul Sartre had refused to meet him for this very reason – the charges took on greater importance due to the centrality of Heidegger's thought in French poststructuralism. Could it in some way be said that poststructuralism's questioning of Western philosophy was tainted by association with Nazism? For those opposed to poststructural thought, the answer was simply 'yes,' forcing many into equivocal defenses of Heidegger. By contrast, Lyotard realized that the crisis in modern thought was precisely that Heidegger was at one and the same time a great thinker and someone who had a 'deliberate, profound [and] persistent' involvement with National Socialism. Consistent with his earlier assertion that we have paid too high a price for the sustainment of modernism's grand narratives, Lyotard argued that this contradiction in Heidegger was most strikingly apparent in his inability to understand those who are not authentic to his twin principles of Being (*Dasein*) and people (*Volk*). Lyotard names these people 'the jews': 'They are what cannot be domesticated in the obsession to dominate, in the compulsion to control domain, in the passion for empire. . . . "The jews," never at home wherever they are, cannot be integrated, converted or expelled. They are also always away from home when they are at home, in their so-called own tradition' (Lyotard 1990: 22). For both Kitaj and Lyotard, then, the diasporists or 'the jews' are the sign that modern aspirations to a fully authentic national culture can never be realized. The past cannot be synthesized into the present without creating a remainder.

One incident may serve to indicate how much work there is to be done. In 1995 Ethiopian Israelis vehemently protested when it was revealed that Israeli authorities had been disposing of Ethiopian blood donations motivated by an unfounded fear of AIDS. There is no more charged symbol in African and Jewish history than blood. Since the early Christian era, Jews have been slandered with the infamous blood libel, that is to say, the belief that Jews murder Christians in order to make various religious uses of their blood. Far from being restricted to medieval persecutions, the blood libel revived periodically throughout modern history, with a rash of cases in the late nineteenth century. Both the Spanish Inquisition and the Nazis sought to keep the blood of their Gentile population 'pure' of contamination by Jewish blood. So intense was this passion that the Inquisition 'investigated' the Virgin Mary herself in order to prove her racial purity. This same doctrine lay behind much of the racist practice of the American South, where individuals were defined as 'black' by the 'one drop of blood' rule. In other words, anyone who had any African ancestry whatsoever was perceived as black. By this logic of course the entire world population is black, but logic has had little role to play in such debates. One would therefore imagine that it ought to have been impossible for Israeli 'white' Jews to believe that 'black' Jews had contaminated blood. It seems that the myths of hundreds of years of diaspora have not been ended by forty years of statehood nor are diasporists themselves immune to such mistaken but powerful myths. Blood is a powerful symbol that is remarkably intervisual in ways that cannot always be contained.

While blood insists on the singular and the unique, for the diasporist multiplicity is the key to identity, interpretation and visual pleasure. The intervisual encounter continues to produce new transcultural meanings for diasporic cultures. In Mathieu Kossovitz's striking film *La Haine* (*Hate*) (1995), depicting life in the Parisian projects, there is a moment in which the polyphony of diaspora is actively

visualized. After a riot in which one young Arab man is left in a coma, Sayid and his friends Vinz and Hubert are killing time in their project when a DJ opens his windows and begins to play. He scratches up a break beat and overlays it with the chorus from Edith Piaf's *Je Ne Regrette Rien*. The trio – composed of one Arab, one Jew and one black African – are mesmerized by the sound. The transcultural mix incorporates African-American hip-hop beats with classic French cabaret singing to create a new mix that, just for a moment, transforms the empty space of the housing project into a place where people from different backgrounds can belong. This brief moment of optimism is offset by a violent and ultimately fatal series of confrontations between the young men and the police. It is in the interstices of such moments, at once contradictory, polyphonic and utopian, that the investigation of the visual cultures of diaspora will go on.

Notes

1 Interestingly, Kitaj hints that he was also influenced by deconstruction: 'Thirty years later, I've learnt of the Diasporists of the Ecole de Yale [de Man and his students] and their crazed and fascinating Cult of the Fragment (based on their French Diasporist mentor)' (Kitaj 1989: 59).

2 While this is not the place to pursue the argument, Derrida has shown that sound is incorporated into any 'pictogram' in alphabetic societies: 'the sound may also be an atomic element itself entering into the composition' (Derrida 1976: 90). In other words, it is entirely consistent with the logic of phonocentric culture to begin with a sound in pursuing the visual image.

Bibliography

Anderson, Benedict (1992) *Imagined Communities*, 2nd edn, London: Verso.
Appadurai, Arjun (1993) 'The Heart of Whiteness,' *Callaloo* 16.4: 796–807.
—— (1996) *Modernity at Large*, Minneapolis: University of Minnesota Press.
Berman, Paul (1994) *Blacks and Jews: Alliances and Arguments*, New York: Delacorte Press.
Bhabha, Homi (1994) *The Location of Culture*, London and New York: Routledge.
Boyarin, Jonathan (1993) *Storm from Paradise*, Minneapolis: Minnesota University Press.
Chambers, Iain (1994) *Migrancy Culture Identity*, London: Routledge.
Chow, Rey (1993) *Writing Diaspora*, Bloomington: Indiana University Press.
Clifford, James (1991) *The Predicament of Culture*, Cambridge Mass.: Harvard University Press.
—— (1997) *Routes: Travel and Translation in the Late Twentieth Century*, Cambridge, Mass.: Harvard University Press.
Cubitt, Sean (1995) 'Dispersed Visions: "About Place,"' *Third Text* 32 (Autumn): 65–74.
Derrida, Jacques (1976) *Of Grammatology*, Baltimore: Johns Hopkins Press.
—— (1996) *Archive Fever: A Freudian Impression*, Chicago: Chicago University Press.
Dubois, W.E.B. (1989 [1903]), *The Souls of Black Folk*, London: Penguin.
Faber, Eli (1998) *Jews, Slaves and the Slave Trade: Setting the Record Straight*, New York: New York University Press.
Fanon, Frantz (1967) *Black Skin, White Masks*, New York: Grove Weidenfeld.

Fusco, Coco (1995) *English Is Broken Here: Notes in Cultural Fusion in the Americas*, New York: New Press.

Gilman, Sander (1991). *The Jew's Body*, New York: Routledge.

Gilroy, Paul (1993) *The Black Atlantic: Modernity and Double Consciousness*, Cambridge, Mass.: Harvard University Press.

Hall, Stuart (1990) 'Cultural Identity and Diaspora,' reprinted in Nicholas Mirzoeff (ed.) *Diaspora and Visual Culture, Representing Africans and Jews*, London: Routledge.

Iampolski, Mikhail (1998) *The Memory of Tiresias: Intertextuality and Film*, Berkeley: University of California Press.

Kitaj, R.B. (1989) *First Diasporist Manifesto*, London: Thames & Hudson.

Lippard, Lucy (1990) *Mixed Blessings: New Art in a Multicultural America*, New York: Pantheon.

Lyotard, Jean-François (1990) *The Postmodern Condition*, Minneapolis: University of Minnesota Press.

Mayne, Judith (1993) *Cinema and Spectatorship*, New York: Routledge.

Mbembe, Achille (1995) 'Figures of the Subject in Times of Crisis,' *Public Culture* 7: 323–52.

Mudimbe, V.Y. (1995) 'Introduction' to *Nations, Identities, Cultures*, special issue of *South Atlantic Quarterly*, 94:4 (Fall).

Owen, Frank (1996) 'Let Them Eat Software,' *Village Voice*, 6 February.

Powers, Martin J. (1995) 'Art and History: Exploring the Counterchange Condition,' *Art Bulletin* vol. lxxvii no. 3 (September 1995): 382–87.

Said, Edward (1993) *Culture and Imperialism*, New York: Alfred Knopf.

Salzmann, Jack (ed.) (1992) *Bridges and Boundaries: African Americans and American Jews*, New York: George Brazilier.

Sherman, Daniel and Rogoff, Irit (1994) *Museum Culture*, Minneapolis: University of Minnesota Press.

Steiner, Wendy (1995) *The Scandal of Pleasure*, Chicago: University of Chicago Press.

Takaki, Ronald (1995) 'A Different Mirror,' in *Points of Entry: Tracing Cultures*, San Francisco: The Friends of Photography.

Thompson, Robert Farris (1983) *Flash of the Spirit: African and Afro American Art and Philosophy*, New York: Random House.

—— (1989) 'The Song That Named the Land: The Visionary Presence of African-American Art,' in Robert V. Rozelle, Alvia Wardlaw and Maureen A. McKenna (eds), *Black Art Ancestral Legacy: The African Impulse in African-American Art*, New York: Harry N. Abrams/Dallas Museum of Art.

Wilson, Kathleen (1995) 'Citizenship, Empire and Modernity in the English Provinces 1720–90,' *Eighteenth Century Studies*.

Yai, Olabiyi Babalola (1994) 'In Praise of Metonymy: The Concepts of "Tradition" and "Creativity" in the Transmission of Yoruba Artistry over Time and Space,' in Roland Abioudun, Henry J. Drewal, and John Pemberton III (eds), *The Yoruba Artist: New Theoretical Perspectives on African Arts*, Washington DC: Smithsonian Institution Press, pp. 107–15.

Young, Robert (1995) *Colonial Desire: Hybridity in Theory, Culture and Race*, London: Routledge.

Lisa Bloom

GENDER, RACE AND NATION IN JAPANESE CONTEMPORARY ART AND CRITICISM

W HEN I BEGAN FORMULATING my ideas for this article, I was looking for ways to link the challenges and opportunities facing feminist artists and critics in Japan with the current uneven state of feminist practices in the art world and academe in the USA.[1] However, given the enormity of this topic, I thought that it might be more effective to first focus on the discussions emerging from work done in Japan by my peers on feminism, nationalism and a new kind of feminist transnationalism in the arts that stimulated my interest to begin with, and leave to the end the ways this work has made me rethink some of the issues of feminism, art theory, and cultural difference in the US. Since my goal was to stimulate discussions and not arrive at any ready-made conclusions, I thought the fewer direct comparisons on the basis of nation alone the better. Certainly the limits of doing that kind of comparative analysis between the US and Japan have already been convincingly argued against in recent books such as *Japan Made in the USA*, a critical analysis by leading Japanese and American scholars on how *New York Times* reporters often reproduce the 'Japan is behind the US model' in their foreign coverage of Japan.[2]

This article stems from my ongoing work editing a multidisciplinary feminist anthology on feminism, colonialism, and nationalism in visual culture that was just published this fall under the title, *With Other Eyes: Looking at Race and Gender Politics in Visual Culture* (University of Minnesota Press, 1999). The anthology is an intervention in current debates over future directions in art history and Women's Studies and represents writing by two generations of feminist scholars working between art history, Women's Studies and the humanities internationally. The essays in the anthology are examples of how recent work coming out of feminist visual cultural studies puts into practice the writing and teaching of a different kind of feminist art history and art criticism.

My approach in the anthology, as an editor, as well as in this essay is similar to other feminists who are currently writing on what Inderpal Grewal and Caren Kaplan call 'transnational feminist cultural studies.'[3] Like them, I, too, am uneasy with a feminism which claims to be innocent of any colonial or racial overtones. In the area of feminist scholarship, work on sex tourism, development issues, labor movements and women's labor has created a context to discuss both power relations between women as well as what constitutes feminist practices in a transnational world of globalizing economic structures and vast movements of populations, cultural products, labor, etc. However, not only does one need to think about how new forms of imperial practices that are gendered are being enacted within global economic structures in the arts – for example in the arena of international art exhibitions – but also how these operate nationally. Nationalist right-wing art critics in both countries remind us only too often that there is a colonial and racial context that remains real, which they will all too freely draw on and powerfully exploit to their own end.

Teaching visual culture in the first Women's Studies Ph.D. program in Japan for the past year, has made me question some of the issues of feminism, and the specificity of location regarding the writing, teaching and exhibiting of international contemporary feminist art and video in both the USA and Japan. My situation in Japan is a relatively unusual one, since the university where I teach prioritises interdisciplinarity, a notion of internationalism that I will return to, and women's studies over more discipline-bound approaches to visual culture. The emphasis on feminist approaches that foreground issues of race and colonialism in an innovative curriculum is the result of the efforts of a top feminist administrator, Noriko Mizuta, and a mentoring system rather than any student, faculty, or community pressure or affirmative action policies, strategies which would be more frequently be the case in the USA. Similarly, the diversity of both the faculty and students who are mostly from different parts of East and Southeast Asia is due not to outside community pressure but to an institutional mandate of internationalism determined in part by the Ministry of Education (*Monbusho*). And, one cannot think of the international (*kokusaika*) as practiced at certain international Japanese universities since the 1980s without also addressing the ways its reinscribes the discourse called *Nihonjinron*, 'the master narrative celebrating Japanese uniqueness' in both art institutions and universities, and the interests of the stale to engineer a society of homogeneous citizens which ignores both Japan's trade with citizens of other countries and cultures and the diversity of people within Japan. So successful is this national fiction of homogeneous Japan that most Japanese people in Japan feel uneasy mixing with people from other cultures and societies. International schools and universities are at best one site at which citizens are beginning to deal with issues of diversity and difference, and one of the starting points for thinking about multilingualism and multiculturalism in relation to internationalism in Japan. Ideas of multiculturalism now attracting attention in Japan significantly draw on theories and models imported from the West rather than from Japan's former colonized occupied territories of East Asia.[4] For example, in the case of more progressive intellectuals in Japan, there is currently a lot of interest in multicultural theories and policies stemming from immigrant cultures such as the United States, Canada, and Australia. However, it would be a mistake to assume such theories would or could be accepted intact since

the context in Japan is so different.[5] However, such models are used strategically as a way to counter more conservative examples of citizenship and immigration policies.

Nevertheless, there remains considerable interest in Japan on the part of intellectuals to consider the problem of Japanese identity and the nation-state in Japan and the question of why Asia is so seldom discussed within the Japanese discourse of multiculturalism and multilingualism. This is important since 'Japanese' society is not homogeneous but made up of many communities divided by ethnicity, citizenship, and place of residence. 'Japanese' society as a whole does not consist only of people of Japanese descent living in Japan but also East Asians from its former colonies and occupied territories, Ainu, Okinawans, people of foreign ancestry living in Japan, as well as Japanese living abroad. For example, at the Ritsumeikan University International Institute of Language and Cultural Studies in Kyoto there is a 10 year ongoing research project concerned with 'considering the problem of forming a new identity for the 21st century which transcends the nation-state and current "*boundaries*."'[6] As Nishikawa Nagao, the Director of the Institute put it,

> How can we overcome the oppositional relationship of advanced countries advocating globalization and the third world's adherence to ethnicity, or the majority advocating multiculturalism and the minority adhering to its own culture? What role does the concept of the creole play in this? Furthermore, in a country like Japan, a country that has linked America and Europe to Asia in the 20th century world-system, what is the significance of thinking of these sort of problems?[7]

The invitation I received to teach feminism and visual culture in relation to questions of nationalism and multiculturalism at a new international university in Japan stems in part from such questioning. However, such an opening could be possible only at a new university where there is a key feminist administrator from a generation that contested some of the official masculinist ideologies and arrangements of postwar Japan and now has the power to implement her ideas. Also, it is significant that there is no art or art history department established at this school, since the scholarly field of art history in Japan has mostly ignored the issue of gender and race and its importance to the field.[8] Just as a tradition bound and nationalist notion of Japanese art dominates, so too does a more canonical and mainstream approach to Western art. Megumi Kitahara, a Japanese feminist art critic, has written at length about her concern with a heightened Japanese nationalist presence in the arts, citing the different writings of both Haruo Sanda, a journalist, and Inaga Shigemi, an art historian who is a Professor at the International Japanese Cultural Center in Kyoto. Both these men published articles that openly displayed a rift between a Japanese art establishment and those curators, art historians and artists who espouse feminism and multiculturalism. Whereas Haruo Sanda attacked feminists for importing Western thought and for the low aesthetic quality of feminist art work, Inaga Shigemi criticized feminist art historians who want to rethink the history of Japanese art history in terms of both Japan's colonial past as well as from the perspective of gender as 'masochistic.'[9] In response to Sanda's and Shigemi's public criticisms of feminist artists, critics and art historians, Kitahara wrote

Figure 23.1 Yoshiko Shimada, *Shooting Lesson* (1992), etching
(Courtesy of the artist)

why did Haruo Sanda and Inaga Shigemi attack feminist art historians at
the same time? One of the reasons is the drastic increase in exhibitions
on gender in Japan recently. Also we have to think of the effect that the
rise of neo-nationalism in Japan amongst Japanese politicians and histo-
rians is having on art critics and historians now.[10]

Given this highly charged political context, issues concerning the Emperor are
especially contentious for art historians rethinking the discipline of Japanese art
history, according to Megumi Kitahara who writes,

the construction of Japanese art history is closely related to the creation
of the Emperor system. In order to create Japanese art history, we use
the power of the emperor. . . To make certain exhibitions important,
we say the Emperor saw that exhibition.[11]

Kitahara also sees a tension between a certain kind of Japanese nationalism and
more critical approaches to the nation as evidenced by the court case filed against
the Toyama Public Museum of Art for purchasing the works of Japanese contem-
porary artist Nobuyuki Ohura. Ohura's use of cutup images of the Emperor in his
photomontages were seen as so blasphemous, so much so that even catalogues of
his works have been burned by the museum sponsoring the exhibition.

One response to the court case has been the work of Yoshiko Shimada who
used an image of the late Emperor Hirohito in one of her art works in 1993 for a

larger piece of work which deals with Japanese war crimes in Asia, a piece that feminist art critic, Hagiwara Hiroko, has written about in greater detail.[12] In the piece entitled *A Picture to be Burnt* (1993), Shimada uses an iconic image of Emperor Hirohito in a military uniform, which the artist then disfigures by covering the whole piece in red, and putting an x through it, and then burning out its eyes. Given the prior fate of Nobuyuki Ohura's catalogue which Shimada references in the title of her piece, it is not surprising that the only place that this piece is reproduced is outside of Japan, on the cover of a 1994 issue of *Asian Art News*, a publication in English from Hong Kong.

What is particularly significant is how artists including Shimada and Ohura, among others,[13] are using their art work as a way to critique the crucial role the state plays in shaping the content of Japan's national history by also setting limits on the style in which the past is remembered. Since for them the function and institution of memory, and thereby of history, is a critical mechanism through which the present gets constructed for younger generations. What I find significant about Shimada's work, as well as the writing on Shimada by Rebecca Jennison[14] and Hiroko Hagiwara is how a kind of transnational feminist art work and visual cultural criticism puts weight on connecting a critique of Japan's Emperor System and its hierarchy to the effects this system has had on the lives of women in Japan and Asia. Since the institution of 'Motherhood' still remains as one of the most contentious issues for even contemporary Japanese feminists, Shimada's critical reframing of stills from old films and official photographs that sanctified the image of motherhood in Japan during the 1930s and 1940s in her art work series *White Aprons*, *Past Imperfect*, *Shooting Lesson*, *Mother and Child* and other work of hers from 1993 is unusual. Shimada explains the impetus behind why she did this work:

> *Shooting Lesson* is one of the first works I have done relating war and women. I was looking through old propaganda photographs during the war, and this photograph struck me as something peculiar, women in white aprons shooting. My mother's generation of women always told us about the hardship of the war, how they suffered. But here is a photograph of Japanese women in the Japanese colony of North Korea practicing shooting to protect themselves and their families from anti-Japanese Korean farmers. If the Japanese women were wearing military uniforms I would not have been so shocked, but I did not expect that the women would be wearing white aprons – symbols of maternal love and care. In this image, what I had previously thought as two opposite entities, motherhood and Imperialism, seemed to merge together in, what for me, was a surprising image of the Japanese Imperial system.[15]

To give you a greater sense of the range of her work on this issue, I want to contrast *Shooting Lesson* with another of her pieces *Mother and Child* from 1993. In this work, she points out the inequalities between Japanese mothers during the war. If the official state ideology was *hakko Ichiu* which meant eight worlds under the one universe of the Emperor's love, Shimada's work shows the ways that this ideal failed for certain women. For Shimada, not all Japanese mothers' lives were, in the end, saved by the gigantic will of the state. That is why she contrasts the fates of different

Figure 23.2 Yoshiko Shimada, *Mother and Child* (1993), etching
 (Courtesy of the artist)

mothers: on the top, she shows the Empress, Hirohito's wife, holding the current Emperor Akihito; the middle part of the work represents compliant Japanese mothers who were encouraged to produce soldiers for the nation-state proudly sacrificing their sons, and at the bottom, she reproduces a photograph of a mother and baby killed in an Osaka air raid.

As I was envisaging how Shimada's work and the feminist art criticism surrounding it was practicing feminism differently, I was struck by the wider implications of Shimada's critique of the sanctity of motherhood and its connection to a

nationalist ideology. Not only was her work meant to make more complex the history of this institution of motherhood as it is understood within Japan, but its implications are much more wide-ranging and significant. As Hiroko Hagiwara put it:

> In her prints, installations and performances Shimada deals with issues of Japanese war crimes in Asia, for which even ordinary Japanese women were responsible, and with Asian women's experiences, which made a remarkable contrast with those of Japanese women. To focus on differences between 'Japan and Asia' is the artist's far-sighted strategy to position Japan in Asia.[16]

Though Shimada has a small following in Japan amongst feminist and leftist critics and curators, her work was also attacked indirectly (not by name) by Japanese journalist Haruo Sanda, cited earlier, for not being 'Japanese' enough.[17] Her feminist perspective, political emphasis in situating Japan within Asia, and her method of using found images which she alters is highly unusual in Japan. So too is Tomiyama Taeko's work. She is a Japanese printmaker and painter of an older generation than Shimada whose work has also been extensively written about by Rebecca Jennison and Hiroko Hagiwara. Writing about the difficulties she has encountered exhibiting her work in Japan, the artist claims that:

> Working on a theme related to South Korea brought me up against a wall of prejudice in the art world of Japan. The 'Oriental Art' typified by Lee Dynasty ceramics or calligraphy might be alright, but in a Western oriented art world, modern Asia was not a subject for art. It was next to impossible to find galleries that would exhibit my pictures, aimed as they were at calling back to mind a war that everyone wanted to forget, a colonial past that no one wanted to deal with.[18]

Tokyo based curator, Toshio Shimizu explains further:

> The Japanese public prefers exhibitions of French Impressionism over any other kind of art, and wealthy collectors in the past have spent huge sums of money on paintings by impressionist masters. The Japanese avant-garde reacted quickly to changes in art movements abroad, first in France and then in the United States. Even today Japanese contemporary art is generally considered to be directly influenced by European and American trends.[19]

Shimizu points out that the reverse was true with respect to Asia. Until recently, outside of very limited circles. there was little information on Asian art available in Japan. The situation began to change in the 1990s when six major exhibitions of Korean art were held in Japanese public museums during the first half of the decade, with the most recent being an exhibition of Korean residents in Japan.[20] According to Raiji Kuroda, a curator at the new Fukuoka Asian Art Museum,[21] the most symbolic event of the boom was a symposium in Tokyo entitled *The Potential of Asian Thought* organized by the Japan Foundation which invited Chinese, and Southeast

Asian speakers rather than only artists and curators from North America and Western European countries. Still, Japan's historically colonialist attitude towards Asian culture has made at least some South-East Asian curators cautious about whether Japanese interest in Asia will turn out to be another form of cultural hegemony. As Apinan Poshyananda, the Thai art critic and curator, put it at the 1994 symposium in Tokyo, the 'Japan-led or Japan-determined Asian Spirit will have to be scrutinized closely by her neighbours and cousins' to see whether it is not merely 'the display of cultural hegemony to exhibit superiority of one culture over another through art exchange programs.' Though in certain instances Poshyananda's reservations might ring true, the recent construction of the '*Asian*' Museum this year in Fukuoka City with Raiji Kuroda as one of its curators, suggests that a more thoughtful approach to the issue of situating Japan within Asia is emerging. Raiji Kuroda writes:

> In order to renovate the concept of 'contemporary art' in Asia, it is important to understand the art movements of each country, in their socio-historical contexts and backgrounds, not by comparison with the mainstream of Japanese or western history. Secondly, we must define contemporary art by the degree it reflects the present situation, and not through individuality, originality or how avantgardist it may appear.[22]

How has the longtime emphasis on more avantgardist forms of Western art, the silence on feminism, and the limited interest in East Asia in mainstream Japanese museums historically affected the development of feminist art historical scholarship in Japan? Why didn't feminist artists and art historians turn until recently to the issue of rethinking Japanese feminism from a perspective which takes into account Japan's colonial history? One reason among others offered by Megumi Kitahara is that feminist scholarship has probably been more influenced by other factors outside the field, for example, the end of the cold war and the debates within Japan around the Korean comfort women issue which began in 1991 when three Korean comfort women filed a landmark lawsuit against Japan for drafting them during the Pacific war. Remarking on the temporal coincidence between these two events, Chungmoo Choi a guest editor of the journal *Positions*, writes that

> during the cold war, not only was debate on Japan's colonialism suppressed under USA hegemony, but so was discussion of such heinous crimes as the experiments on live human subjects for the development of biological warfare by Japanese Army Unit 731.[23]

Now that rethinking Japan's colonial past has become a part of a greater feminist project in Japan that extends beyond the arts, more feminist scholarship in English that deals with questions of race and colonialism, such as the work of Griselda Pollock, Gayatri Spivak, Trinh T. Minh-ha, Lisa Lowe, Rey Chow and others has been recently translated into Japanese and there seems to be a greater international exchange recently between feminist scholars who are working on these issues.[24]

It is also worth pointing out that doing work on feminism in the arts in Japan is very different institutionally than in the USA. There is only one women's studies

program at this university, but women's studies courses on the arts exist in Western Civilization, Communication, and American and English literature departments, among others. With the exception of the exhibition of the work of Yayoi Kusama, there is very little known in the USA about Japanese feminist artists. This lack is reflective not only of feminism's institutional situation in the USA and Japan but also how it is frequently perceived by opinion-makers and journalists in both countries. For example, one independent feminist forum is the Tokyo-based *Image and Gender Research Group* which was founded in 1995 and has been successful in creating an innovative monthly lecture series in feminist theory and the arts as well as workshops on institutional policy issues, such as sexual harassment. It, too, has attracted negative attention from the same male critics mentioned earlier.[25] One of the arguments against the group by Haruo Sanda who refers to the group as a 'political sect' is a right wing nationalist one – similar to a critique of multiculturalism and multilingualism – that is feminism too is seen simply as another borrowed idea from the West of little concern to authentic Japanese intellectuals and ordinary citizens. It is significant that many of the feminist curators, art critics and art historians in the group, though they have travelled and in some cases lived outside of Japan and speak several languages, have nevertheless chosen to work in Japan in an attempt to intervene in the art establishment here as well as to offer a much needed forum for younger feminists working in the arts. In some cases, those who have remained have only gained recognition abroad and have to exhibit or publish their work outside of Japan to gain attention.

My participation and involvement in the *Image and Gender Research Group* has made me realize how different feminist artists and critics' groups are in the two countries. Perhaps the hostility to art work and scholarship that deals with issues of gender, race and nation is more overt in Japan, and that has made Japanese feminist art critics, academics, activists, curators, publishers, and artists more able to bridge constituencies, and academic divisions more easily and communicate with each other more intensely than women artists, curators, and critics do in the USA. This uneven dialogue between feminists in the USA is perhaps one of the consequences of a fractured feminist art community divided along ethnic, racial, national, and class lines, as well as a certain kind of USA parochialism that results in part from the overspecialisation of scholars in the academy, the separation of the art schools and art departments from women's studies, ethnic studies, and area studies departments on university campuses.

A major driving force behind a shift amongst Japanese feminists in Japan towards a more complex notion of feminist art in relation to race, ethnicity and nationalism has begun to unleash a new form of transnational feminism which is very different than the older European-based notion of a cosmopolitan feminism and its problematic Eurocentrism. If USA feminists are to contribute to developing a new feminist transnationalism in the arts – they might begin by engaging more seriously with the work of feminist artists, curators, and critics from Southeast and East Asia as well as Japan, and work harder at making connections between USA based artists and critics and those feminists in Asia, Australia and Japan. There is a lot for visual cultural critics like myself to learn. For example, part of the rethinking needed is to recognize that the internal dynamics of feminist art practices and academe in the USA is not a smooth or a simple art history but one that has very distinct regional

locations (in which New York based artists tended to be favoured) and that this was the direct result of a Eurocentric cosmopolitanism which excluded Chicanos, African Americans, or Asian Americans. However, it is not perhaps by chance that some of the most influential practices in Japan can also be found in artists and cultural critics located on the West coast of the USA who are also elaborating a new kind of feminism in relation to issues of multiculturalism and transnationalism. I am thinking of the art work of Hung Liu and Yong Soon Min, as well as some of the feminist cultural critics such as Lisa Yoneyama, Tessa Morris-Suzuki, Dorinne Kondo, Miriam Silverberg, Hyun Sook Kim, Chungmoo Choi, and others who are currently writing for the journal *Positions*. What connects their work is a concern with how visual culture – photographs and films – represents contentious sites where national history is written and the significance and impact of new and old politics of remembering and forgetting on the lives of women in Asia, Japan, and their diasporas.

Notes

1 Colleagues and friends have inspired and assisted this article at various stages. I especially want to thank Rebecca Jennison for her invaluable feedback as well as for including this essay as a paper in the panel that she organized, 'Different Locations: Contemporary Visual and Performance Artists Seeking Alternatives in Japan' for the College Art Association that took place in Los Angeles, Cal., in February 1998. Please note all Japanese names are given in English form with the first name first, in Japan, the surname is usually placed first.

 Special thanks to Yong Soon Min and Connie Samaras for inviting me to present a version of this paper for the University of California at Irvine's Colloquium, 'Straddling the Pacific Rim: Politics of Representation on the Move,' in February of 1998. My special thanks to Apinan Poshiyananda and Raiji Kuroda for their response to an earlier version of the paper. I also wish to thank Jonathon Mark Hall, Suresht Bald, Megumi Kitahara, Roddey Reid, and Yoshiko Shimada for extremely attentive and helpful comments, Material support has also been important. A travel fund from my research budget at Josai International University made it possible for me to travel to the USA in February of 1998 to present this paper at the College Art Association Conference in Los Angeles and at the University of California at Irvine's Colloquium.

2 Zipangu (ed.), *Japan Made in USA* (New York and Japan, 1998).

3 See Caren Kaplan and Inderpal Grewal, 'Transnational Feminist Cultural Studies: Beyond the Marxism/Poststructuralism/Feminism Divides' in *Between Woman and Nation: Nationalisms, Transnational Feminisms and the State* (Durham: 1999) pp. 349–63.

4 This has its parallel in the USA since the USA has also drawn little on intellectuals located in its former colonies or occupied territories.

5 For a more detailed discussion of this specific issue as well as an excellent overview on the overall issue of citizenship and internationalism in Japan, see Tessa Morris-Suzuki, *Reinventing Japan: Time, Space, Nation.* (London: An East Gate Book, 1998) pp. 185–209.

6 Nishikawa Nagao, 'The 20th Century: How Do We Get Over It?', *Ritsumeikan University International Institute of Language and Culture Studies*, Kyoto, Japan, p. 5 (translation: James W. Hove).

7 Ibid.

8 For further background on the important ways that art historians are currently rethinking Japanese art history, see Kojin Karatani, 'History as museum: Okakura Tenshin and Ernest Fenollosa' and the published proceedings from the December 1997 conference, *The Present, and the Discipline of Art History in Japan* (Tokyo: Tokyo National Research Institute of Cultural Properties, 1999). For further discussion about how the issue of gender has been largely ignored within the field of Japanese art history, see Chino Kaori's article 'The Importance of Gender in Japanese Art Historical Discourse,' in *The Present, and the Discipline of Art History in Japan*, pp. 46–47, as well as Inaga Shigemi's critical response to Kaori's paper in *Aida*, 1998. vol. 20.

9 Inaga Shigemi, 'To Kitahara, Megumi Reading Art Activism # 22' (Letters to Editor section), *Impaction* 112, 1999, pp. 170–73; Haruo Sanda, *Live and Review*, 1997. Regarding Shigemi's use of the term 'masochism,' it is important to point out how that term is also frequently used by Japanese nationalists who blame Japanese people for supporting Korean comfort women.

10 Megumi Kitahara, 'The Debate around "Just Only": Gender Difference in the Japanese Art World from 1997–1998,' *Impaction* 110 (1998), pp. 96–107. (This article is from a series of 22 articles that Megumi Kitahara published on art activism in this journal.) Kitahara uses the term 'just only gender differences' to differentiate her use of the term from Inagi Shigemi's, who she claims deploys the term to invalidate feminist scholarship in art history altogether by referencing post-structuralist debates on essentialism outside of Japan.

11 Interview with Megumi Kitahara, November 14, 1999.

12 Hiroko Hagiwara, 'Comfort Women: Women of Conformity: the work of Shimada Yoshiko,' Griselda Pollock (ed.) *Generations and Geographies of the Visual Arts* (London and New York: Routledge, 1996) pp. 253–4.

13 Also see the work of photographer Ishikawa Mao and sculptor Tomotori Mitako. Ishikawa Mao's work is on the symbolism of the hinamaru in Okinawa in the late 1980s. Tomotori Mitako's work deals with the resurgence of Ainu identity politics in the 1990s after Ainu citizens were deprived of access to the rivers and forests which sustained their lives. For further information on Tomotori Mitako, see Megumi Kitahara, 'Cutting in the Memory: Tomotari Mitako's Nibutani Project,' *Impaction*, no. 25, p. 130.

14 Rebecca Jennison, '"Post-Colonial" Feminist Locations: The Art of Tomiyama Taeko and Shimada Yoshiko,' *USA-Japan Women's Journal*, English Supplement, no. 12, 1997, pp. 84–108.

15 Shimada Yoshiko, 'Sleeping with your Enemy: Japanese Women and Power in Recent History,' presentation given at the 1999 College Art Association Conference in Los Angeles on February 13, 1999.

16 Hagiwara Hiroko, 'Comfort Women: Women of Conformity: the Work of Shimada Yoshiko,' Griselda Pollock (ed.) *Generations and Geographies in the Visual Arts* (London and New York: Routledge, 1996), p. 254.

17 Haruo Sanda, *Live and Review*, 1997. Haruo Sanda's criticism followed the exhibition *Gender Beyond Memory: The Works of Contemporary Women Artists*, curated by the feminist critic, Michiko Kasahara in 1996 at the Tokyo Metropolitan Museum of Photography, which included Yoshiko Shimada's work. Haruo Sanda's criticism of Yoshiko Shimada resonates with the return of expressions such as *hikokumin*, literally meaning 'non nationals' which was a term of abuse applied to Japanese

citizens who showed insufficient enthusiasm for their nation's effort during World War II. This neo-nationalism has also manifested itself in recent legal policy changes in Japan during August of 1999 regarding symbols of the Japanese national heritage. Recent bills that legalized the Hinomaru flag as the national flag of Japan and the *Kimigayo* as the official national anthem have been seen as highly controversial. Both were key touchstones of Japanese national unity during World War II; the *Kimigayo* is seen as especially problematic since it was a song to admire the Emperor as a living god during World War II. It is also significant that both were proposed as bills days after a high school principal in Hiroshima Prefecture committed suicide on February 28, 1999 after being seen as disloyal to the nation for refusing to obey an education board order that the flag be raised and the *Kimigayo* be sung at the school's graduation. See 'Flag, anthem views vary among pollees,' *Japan Times*, August 6, 1999, p. 1.

18 Tomiyama Taeko, 'Shadows from a Distant Scene,' in the catalogue: *Silenced by History*: *Tomiyama Taeko's Work*, pp. 59–60.

19 Toshio Shimizu, 'Territory of the Mind: Japan and Asia in the 1990s,' *Art Asia Pacific*, p. 40.

20 *Areum Art Network*: *The Art Exhibition of Korean Residents in Japan*, November, 1999.

21 Interview with Raiji Kuroda, June 1999. See the catalogue for the *Commemorative Exhibition of the Inauguration of Fukuoaka Asian Art Museum, The 1st Fukuoka Asian Art Triennial 1999*, March 6th–June 6th, 1999.

22 Raiji Kuroda, 'Practice of Exhibitions in Global Society for Asians, by Asians, and Some Associated Problems,' Jean Fisher (ed.) *Global Visions: Towards a New Internationalism in the Visual Arts* (London: Kala Press, 1994), p. 148.

23 Chungmoo Choi, 'Guest editor's Introduction,' the special issue on the comfort women: colonialism, war and sex, *Positions: East Asia Cultures Critique*, vol. 5, no. 1, Spring 1997, v.

24 See the special issue on Gender and Imperialism, Brett de Bary (ed.), *USA–Japan Women's Journal*, English Supplement, no. 12, 1997.

25 Haruo Sanda, *Live and Review*, 1997.

(b) The space of the digital

Michel Foucault

OF OTHER SPACES[1]

T HE GREAT OBSESSION of the nineteenth century was, as we know, history: with its themes of development and of suspension, of crisis and cycle, themes of the ever-accumulating past, with its great preponderance of dead men and the menacing glaciation of the world. The nineteenth century found its essential mythological resources in the second principle of thermodynamics. The present epoch will perhaps be above all the epoch of space. We are in the epoch of simultaneity: we are in the epoch of juxtaposition, the epoch of the near and far, of the side-by-side, of the dispersed. We are at a moment, I believe, when our experience of the world is less that of a long life developing through time than that of a network that connects points and intersects with its own skein. One could perhaps say that certain ideological conflicts animating present-day polemics oppose the pious descendants of time and the determined inhabitants of space. Structuralism, or at least that which is grouped under this slightly too general name, is the effort to establish, between elements that could have been connected on a temporal axis, an ensemble of relations that makes them appear as juxtaposed, set off against one another, implicated by each other – that makes them appear, in short, as a sort of configuration. Actually, structuralism does not entail a denial of time; it does involve a certain manner of dealing with what we call time and what we call history.

Yet it is necessary to notice that the space which today appears to form the horizon of our concerns, our theory, our systems, is not an innovation; space itself has a history in Western experience and it is not possible to disregard the fatal intersection of time with space. One could say, by way of retracing this history of space very roughly, that in the Middle Ages there was a hierarchic ensemble of places: sacred places and profane places; protected places and open, exposed places; urban places and rural places (all these concern the real life of men). In cosmological theory, there were the supercelestial places, as opposed to the celestial, and the

celestial place was in its turn opposed to the terrestrial place. There were places where things had been put because they had been violently displaced, and then on the contrary places where things found their natural ground and stability. It was this complete hierarchy, this opposition, this intersection of places that constituted what could very roughly be called medieval space: the space of emplacement.

This space of emplacement was opened up by Galileo. For the real scandal of Galileo's work lay not so much in his discovery, or rediscovery, that the earth revolved around the sun, but in his constitution of an infinite, and infinitely open space. In such a space the place of the Middle Ages turned out to be dissolved, as it were; a thing's place was no longer anything but a point in its movement, just as the stability of a thing was only its movement indefinitely slowed down. In other words, starting with Galileo and the seventeenth century, extension was substituted for localization.

Today the site has been substituted for extension which itself had replaced emplacement. The site is defined by relations of proximity between points or elements; formally, we can describe these relations as series, trees, or grids. Moreover, the importance of the site as a problem in contemporary technical work is well known: the storage of data or of the intermediate results of a calculation in the memory of a machine; the circulation of discrete elements with a random output (automobile traffic is a simple case, or indeed the sounds on a telephone line); the identification of marked or coded elements inside a set that may be randomly distributed, or may be arranged according to single or to multiple classifications.

In a still more concrete manner, the problem of siting or placement arises for mankind in terms of demography. This problem of the human site or living space is not simply that of knowing whether there will be enough space for men in the world – a problem that is certainly quite important – but also that of knowing what relations of propinquity, what type of storage, circulation, marking, and classification of human elements should be adopted in a given situation in order to achieve a given end. Our epoch is one in which space takes for us the form of relations among sites.

In any case I believe that the anxiety of our era has to do fundamentally with space, no doubt a great deal more than with time. Time probably appears to us only as one of the various distributive operations that are possible for the elements that are spread out in space.

Now, despite all the techniques for appropriating space, despite the whole network of knowledge that enables us to delimit or to formalize it, contemporary space is perhaps still not entirely desanctified (apparently unlike time, it would seem, which was detached from the sacred in the nineteenth century). To be sure a certain theoretical desanctification of space (the one signaled by Galileo's work) has occurred, but we may still not have reached the point of a practical desanctification of space. And perhaps our life is still governed by a certain number of oppositions that remain inviolable, that our institutions and practices have not yet dared to break down. These are oppositions that we regard as simple givens: for example between private space and public space, between family space and social space, between cultural space and useful space, between the space of leisure and that of work. All these are still nurtured by the hidden presence of the sacred.

Bachelard's monumental work and the descriptions of phenomenologists have taught us that we do not live in a homogeneous and empty space, but on the contrary in a space thoroughly imbued with quantities and perhaps thoroughly fantasmatic as well. The space of our primary perception, the space of our dreams, and that of our passions hold within themselves qualities that seem intrinsic: there is a light, ethereal, transparent space, or again a dark, rough, encumbered space; a space from above, of summits, or on the contrary a space from below, of mud; or again a space that can be flowing like sparkling water, or a space that is fixed, congealed, like stone or crystal. Yet these analyses, while fundamental for reflection in our time, primarily concern internal space. I should like to speak now of external space.

The space in which we live, which draws us out of ourselves, in which the erosion of our lives, our time, and our history occurs, the space that claws and gnaws at us, is also, in itself, a heterogeneous space. In other words, we do not live in a kind of void, inside of which we could place individuals and things. We do not live inside a void that could be colored with diverse shades of light, we live inside a set of relations that delineates sites which are irreducible to one another and absolutely not superimposable on one another.

Of course one might attempt to describe these different sites by looking for the set of relations by which a given site can be defined. For example, describing the set of relations that define the sites of transportation, streets, trains (a train is an extraordinary bundle of relations because it is something through which one goes, it is also something by means of which one can go from one point to another, and then it is also something that goes by). One could describe, via the cluster of relations that allows them to be defined, the sites of temporary relaxation – cafes, cinemas, beaches. Likewise one could describe, via its network of relations, the closed or semi-closed sites of rest – the house, the bedroom, the bed, etc. But among all these sites, I am interested in certain ones that have the curious property of being in relation with all the other sites, but in such a way as to suspect, neutralize, or invert the set of relations that they happen to designate, mirror, or reflect. These spaces, as it were, which are linked with all the others, which however contradict all the other sites, are of two main types.

First there are the utopias. Utopias are sites with no real place. They are sites that have a general relation of direct or inverted analogy with the real space of society. They present society itself in a perfected form, or else society turned upside down, but in any case these utopias are fundamentally unreal spaces.

There are also, probably in every culture, in every civilization, real places – places that do exist and that are formed in the very founding of society – which are something like counter-sites, a kind of effectively enacted utopia in which the real sites, all the other real sites that can be found within the culture, are simultaneously represented, contested, and inverted. Places of this kind are outside of all places, even though it may be possible to indicate their location in reality. Because these places are absolutely different from all the sites that they reflect and speak about, I shall call them, by way of contrast to utopias, heterotopias. I believe that between utopias and these quite other sites, these heterotopias, there might be a sort of mixed, joint experience, which would be the mirror. The mirror is, after all, a utopia, since it is a placeless place. In the mirror, I see myself there where I am not, in an unreal,

virtual space that opens up behind the surface; I am over there, there where I am not, a sort of shadow that gives my own visibility to myself, that enables me to see myself there where I am absent: such is the utopia of the mirror. But it is also a heterotopia in so far as the mirror does exist in reality, where it exerts a sort of counteraction on the position that I occupy. From the standpoint of the mirror, I discover my absence from the place where I am, since I see myself over there. Starting from this gaze that is, as it were, directed toward me, from the ground of this virtual space that is on the other side of the glass, I come back toward myself; I begin again to direct my eyes toward myself and to reconstitute myself there where I am. The mirror functions as a heterotopia in this respect: it makes this place that I occupy at the moment when I look at myself in the glass at once absolutely real, connected with all the space that surrounds it, and absolutely unreal, since in order to be perceived it has to pass through this virtual point which is over there.

As for the heterotopias as such, how can they be described, what meaning do they have? We might imagine a sort of systematic description – I do not say a science because the term is too galvanized now – that would, in a given society, take as its object the study, analysis, description, and 'reading' (as some like to say nowadays) of these different spaces, of these other places. As a sort of simultaneously mythic and real contestation of the space in which we live, this description could be called heterotopology. Its *first principle* is that there is probably not a single culture in the world that fails to constitute heterotopias. That is a constant of every human group. But the heterotopias obviously take quite varied forms, and perhaps no one absolutely universal form of heterotopia would be found. We can however classify them in two main categories.

In the so-called primitive societies, there is a certain form of heterotopia that I would call crisis heterotopias, i.e., there are privileged or sacred or forbidden places, reserved for individuals who are, in relation to society and to the human environment in which they live, in a state of crisis: adolescents, menstruating women, pregnant women, the elderly, etc. In our society, these crisis heterotopias are persistently disappearing, though a few remnants can still be found. For example, the boarding school, in its nineteenth-century form, or military service for young men, have certainly played such a role, as the first manifestations of sexual virility were in fact supposed to take place 'elsewhere' than at home. For girls, there was, until the middle of the twentieth century, a tradition called the 'honeymoon trip' which was an ancestral theme. The young woman's deflowering could take place 'nowhere' and, at the moment of its occurrence the train or honeymoon hotel was indeed the place of this nowhere, this heterotopia without geographical markers.

But these heterotopias of crisis are disappearing today and are being replaced, I believe, by what we might call heterotopias of deviation: those in which individuals whose behaviour is deviant in relation to the required mean or norm are placed. Cases of this are rest homes and psychiatric hospitals, and of course prisons; and one should perhaps add retirement homes that are, as it were, on the borderline between the heterotopia of crisis and the heterotopia of deviation since, after all, old age is a crisis, but is also a deviation since, in our society where leisure is the rule, idleness is a sort of deviation.

The *second principle* of this description of heterotopias is that a society, as its history unfolds, can make an existing heterotopia function in a very different fashion; for each heterotopia has a precise and determined function within a society and the same heterotopia can, according to the synchrony of the culture in which it occurs, have one function or another.

As an example I shall take the strange heterotopia of the cemetery. The cemetery is certainly a place unlike ordinary cultural spaces. It is a space that is however connected with all the sites of the city-state or society or village, etc., since each individual, each family has relatives in the cemetery. In Western culture the cemetery has practically always existed. But it has undergone important changes. Until the end of the eighteenth century, the cemetery was placed at the heart of the city, next to the church. In it there was a hierarchy of possible tombs. There was the charnel house in which bodies lost the last traces of individuality, there were a few individual tombs, and then there were the tombs inside the church. These latter tombs were themselves of two types, either simply tombstones with an inscription, or mausoleums with statues. This cemetery housed inside the sacred space of the church has taken on a quite different cast in modern civilizations, and curiously, it is in a time when civilization has become 'atheistic' as one says very crudely, that Western culture has established what is termed the cult of the dead.

Basically it was quite natural that, in a time of real belief in the resurrection of bodies and the immortality of the soul, overriding importance was not accorded to the body's remains. On the contrary, from the moment when people are no longer sure that they have a soul or that the body will regain life, it is perhaps necessary to give much more attention to the dead body, which is ultimately the only trace of our existence in the world and in language. In any case, it is from the beginning of the nineteenth century that everyone has a right to her or his own little box for her or his own little personal decay; but on the other hand, it is only from the start of the nineteenth century that cemeteries began to be located at the outside border of cities. In correlation with the individualization of death and the bourgeois appropriation of the cemetery, there arises an obsession with death as an 'illness'. The dead, it is supposed, bring illnesses to the living, and it is the presence and proximity of the dead right beside the houses, next to the church, almost in the middle of the street, it is this proximity that propagates death itself. This major theme of illness spread by the contagion in the cemeteries persisted until the end of the eighteenth century, until, during the nineteenth century, the shift of cemeteries toward the suburbs was initiated. The cemeteries then came to constitute, no longer the sacred and immortal heart of the city, but 'the other city,' where each family possesses its dark resting place.

Third principle. The heterotopia is capable of juxtaposing in a single real place several spaces, several sites that are in themselves incompatible. Thus it is that the theater brings onto the rectangle of the stage, one after the other, a whole series of places that are foreign to one another; thus it is that the cinema is a very odd rectangular room, at the end of which, on a two-dimensional screen, one sees the projection of a three-dimensional space; but perhaps the oldest example of these heterotopias that take the form of contradictory sites is the garden. We must not forget that in the Orient the garden, an astonishing creation that is now a

thousand years old, had very deep and seemingly superimposed meanings. The traditional garden of the Persians was a sacred space that was supposed to bring together inside its rectangle four parts representing the four parts of the world, with a space still more sacred than the others that were like an umbilicus, the navel of the world at its center (the basin and water fountain were there); and all the vegetation of the garden was supposed to come together in this space, in this sort of microcosm. As for carpets, they were originally reproductions of gardens (the garden is a rug onto which the whole world comes to enact its symbolic perfection, and the rug is a sort of garden that can move across space). The garden is the smallest parcel of the world and then it is the totality of the world. The garden has been a sort of happy, universalizing heterotopia since the beginnings of antiquity (our modern zoological gardens spring from that source).

Fourth principle. Heterotopias are most often linked to slices in time – which is to say that they open onto what might be termed, for the sake of symmetry, heterochronies. The heterotopia begins to function at full capacity when men arrive at a sort of absolute break with their traditional time. This situation shows us that the cemetery is indeed a highly heterotopic place since, for the individual, the cemetery begins with this strange heterochrony, the loss of life, and with this quasi-eternity in which her permanent lot is dissolution and disappearance.

From a general standpoint, in a society like ours heterotopias and heterochronies are structured and distributed in a relatively complex fashion. First of all, there are heterotopias of indefinitely accumulating time, for example museums and libraries. Museums and libraries have become heterotopias in which time never stops building up and topping its own summit, whereas in the seventeenth century, even at the end of the century, museums and libraries were the expression of an individual choice. By contrast, the idea of accumulating everything, of establishing a sort of general archive, the will to enclose in one place all times, all epochs, all forms, all tastes, the idea of constituting a place of all times that is itself outside of time and inaccessible to its ravages, the project of organizing in this way a sort of perpetual and indefinite accumulation of time in an immobile place, this whole idea belongs to our modernity. The museum and the library are heterotopias that are proper to Western culture of the nineteenth century.

Opposite these heterotopias that are linked to the accumulation of time, there are those linked, on the contrary, to time in its most fleeting, transitory, precarious aspect, to time in the mode of the festival. These heterotopias are not oriented toward the eternal, they are rather absolutely temporal [*chroniques*]. Such, for example, are the fairgrounds, these marvelous empty sites on the outskirts of cities that teem once or twice a year with stands, displays, heteroclite objects, wrestlers, snakewomen, fortune-tellers, and so forth. Quite recently, a new kind of temporal heterotopia has been invented: vacation villages, such as those Polynesian villages that offer a compact three weeks of primitive and eternal nudity to the inhabitants of the cities. You see, moreover, that through the two forms of heterotopias that come together here, the heterotopia of the festival and that of the eternity of accumulating time, the huts of Djerba are in a sense relatives of libraries and museums. For the rediscovery of Polynesian life abolishes time; yet the experience is just as much the rediscovery of time, it is as if the entire history of humanity reaching back to its origin were accessible in a sort of immediate knowledge.

Fifth principle. Heterotopias always presuppose a system of opening and closing that both isolates them and makes them penetrable. In general, the heterotopic site is not freely accessible like a public place. Either the entry is compulsory, as in the case of entering a barracks or a prison, or else the individual has to submit to rites and purifications. To get in one must have a certain permission and make certain gestures. Moreover, there are even heterotopias that are entirely consecrated to these activities of purification – purification that is partly religious and partly hygienic, such as the hammam of the Moslems, or else purification that appears to be purely hygienic, as is Scandinavian saunas.

There are others, on the contrary, that seem to be pure and simple openings, but that generally hide curious exclusions. Everyone can enter into these heterotopic sites, but in fact that is only an illusion: we think we enter where we are, by the very fact that we enter, excluded. I am thinking, for example, of the famous bedrooms that existed on the great farms of Brazil and elsewhere in South America. The entry door did not lead into the central room where the family lives, and every individual or traveler who came by had the right to open this door, to enter into the bedroom and to sleep there for a night. Now these bedrooms were such that the individual who went into them never had access to the family's quarters; the visitor was absolutely the guest in transit, was not really the invited guest. This type of heterotopia, which has practically disappeared from our civilizations, could perhaps be found in the famous American motel rooms where a man goes with his car and his mistress and where illicit sex is both absolutely sheltered and absolutely hidden, kept isolated without however being allowed out in the open.

The last trait of heterotopias is that they have a function in relation to all the space that remains. This function unfolds between two extreme poles. Either their role is to create a space of illusion that exposes every real space, all the sites inside of which human life is partitioned, as still more illusory (perhaps that is the role that was played by those famous brothels of which we are now deprived). Or else, on the contrary, their role is to create a space that is other, another real space, as perfect, as meticulous, as well arranged as ours is messy, ill constructed, and jumbled. This latter type would be the heterotopia, not of illusion, but of compensation, and I wonder if certain colonies have not functioned somewhat in this manner. In certain cases, they have played, on the level of the general organization of terrestrial space, the role of heterotopias. I am thinking, for example, of the first wave of colonization in the seventeenth century, of the Puritan societies that the English had founded in America and that were absolutely perfect other places. I am also thinking of those extraordinary Jesuit colonies that were founded in South America: marvelous, absolutely regulated colonies in which human perfection was effectively achieved. The Jesuits of Paraguay established colonies in which existence was regulated at every turn. The village was laid out according to a rigorous plan around a rectangular place at the foot of which was the church; on one side, there was the school; on the other, the cemetery; and then, in front of the church, an avenue set out that another crossed at right angles; each family had its little cabin along these two axes and thus the sign of Christ was exactly reproduced. Christianity marked the space and geography of the American world with its fundamental sign. The daily life of individuals was regulated, not by the whistle, but by the bell. Everyone was awakened at the same time, everyone began work at the same time;

meals were at noon and five o'clock; then came bedtime, and at midnight came what was called the marital wake-up, that is, at the chime of the churchbell, each person carried out her/his duty.

Brothels and colonies are two extreme types of heterotopia, and if we think, after all, that the boat is a floating piece of space, a place without a place, that exists by itself, that is closed in on itself and at the same time is given over to the infinity of the sea and that, from port to port, from tack to tack, from brothel to brothel, it goes as far as the colonies in search of the most precious treasures they conceal in their gardens, you will understand why the boat has not only been for our civilization, from the sixteenth century until the present, the great instrument of economic development . . . but has been simultaneously the greatest reserve of the imagination. The ship is the heterotopia *par excellence*. In civilizations without boats, dreams dry up, espionage takes the place of adventure, and the police take the place of pirates.

Note

1 This text, entitled 'Des Espaces Autres,' and published by the French journal *Architecture-Mouvement-Continuité* in October 1984, was the basis of a lecture given by Michel Foucault in March 1967. Although not reviewed for publication by the author and thus not part of the official corpus of his work, the manuscript was released into the public domain for an exhibition in Berlin shortly before Michel Foucault's death. Attentive readers will note that the text retains the quality of lecture notes. It was translated by Jay Miskowiec.

Geoffrey Batchen

SPECTRES OF CYBERSPACE

A NEW SPECTRE is haunting Western culture – the spectre of Virtual Reality. Not here yet but already a force to be reckoned with, the apparition of VR is ghost-like indeed. Even the words themselves have a certain phantom quality. Virtual Reality – a reality which is apparently true but not *truly* True, a reality which is apparently real but not *really* Real. The term has been coined to describe an imagined assemblage of human and machine so intertwined that the division between the two is no longer discernible. In VR, so it is said, the human will be irresistibly melded to the morphology of its technological supplement. The resulting biomorph will inhabit a world beyond the surface of the screen, living behind or perhaps even *within* that boundary which has traditionally been thought to separate reality from its representation. The cybernaut won't just step into the picture; he/she/it will become the picture itself.

Various combinations of technology promise to induce this assemblage, but its principal spatial and temporal horizons are provided by a computer-generated, interactive virtual environment known as cyberspace. It is the three-dimensional simulation offered by this cyberspace that seemingly lies at the heart of VR's projected field of dreams. For, according to at least one critic: 'these new spaces instantiate the collapse of the boundaries between the social and technological, biology and machine, natural and artificial that are part of the postmodern imaginary.'

This particular imaginary has tended to attract contradictory responses, sometimes from the same commentators. One response laments the possible loss of the human, the body, community, sexual difference, reality, and all those other privileged foundations of a modern Cartesian epistemology. The other celebrates this same loss on behalf of the disabled, the military, world communication, the sexually promiscuous, the leisure industry, medicine, and a host of other presumed benefactors.

Figure 25.1 'Cybernauts of the nineteenth century'

What is interesting about both arguments is the assumption that VR's promised implosion of reality and representation is in some way a new, even revolutionary phenomenon. It is, after all, only because a completely plausible VR is not yet here, not yet actual, that critics feel moved to speak about its *potential* for social change, whether they think that change is likely to be destructive or liberatory. The inference is that, even in the imaginary, cyberspace represents the possibility of a distinctive and definitive move beyond the modern era. Postmodernism has at last been given a technological face, the inscrutable space-age visage of the VR headset. But what character can be ascribed to this particular physiognomy? What is new about a desire that already seems so strangely familiar? How is a virtual reality different from the one which for so long we have simply and complacently called 'the Real'?

Such questions suggest that, to look ahead, it might also be necessary to look back – an analytical gesture that would of course replicate the forward but inward stare of the fully equipped VR cybernaut. Conjoining a future that is already here with a past that continually returns, the spectral matter of cyberspace is perhaps something that can be conjured only through a reflexive repetition of its own peculiar trajectory through space and time.

However, this trajectory is itself a matter of some debate. In *Cyberspace: First Steps* Michael Benedikt, for example, wants us to go back beyond William Gibson's *Neuromancer* of 1984 and seek the historical origins of cyberspace in our culture's

displacement from 'the temperate and fertile plains of Africa two million years ago – from Eden if you will.' David Tomas looks a little closer to home, measuring cyberspace against the 'master space' of a Euclidean world-view that is as much social as it is geometric. While conceding that VR is 'new' and 'postindustrial,' Tomas argues that cyberspace also represents a ritual process of contesting cultural knowledge that is as old as society itself. In a 1995 essay for the Canadian journal *Public*, Dale Bradley also points to the generative accumulations of the postindustrial state, insisting that:

> it is the social space of late capitalism which . . . constitutes the surface of emergence for cyberspace. . . . cyberspace is the embodiment or concretization of a logic of control already existent in the power rela-tions that define late capitalism and the modern welfare state.

Some of VR's historians prefer to concentrate on the story of its technological rather than its social development. This doesn't necessarily make the tale any simpler. Howard Rheingold, for example, traces 'the first virtual reality' to the development of tools 30,000 years ago in an upper paleolithic cave. Nevertheless, he then goes on to spend most of his book, *Virtual Reality*, recounting his personal experience of more recent experiments involving computers and scientific visual-ization. Allucquère Rosanne Stone also concentrates on questions of technology. She is perhaps the most ubiquitous of VR's historians, having already provided the medium with a number of informative if competing 'origin myths.' In one of these, she divides the history of cyberspace into four successive epochs, beginning with the introduction of printed texts in the mid-1600s, then jumping to the develop-ment of electronic communication systems like the telegraph in the first years of the twentieth-century. This is followed by the rapid expansion of computerized information technology in the 1960s and then finally by the new sense of commu-nity given representation by Gibson's 1984 science fiction novel. Not content with this already complex historical stratification, Stone provided yet another at a 1991 symposium in San Francisco. In this case she specifically traced the genealogy of Virtual Reality back to the invention of the stereoscope in 1838.

This last point of origin is a particularly intriguing one. Conceived in the 1830s by Charles Wheatstone and David Brewster (who in 1815 had also invented the kaleidoscope), the stereoscope was, according to Jonathan Crary, 'the most signifi-cant form of visual imagery in the nineteenth century, with the exception of photographs.' American critic Oliver Wendell Holmes provides us with a number of stirring accounts of stereoscopy written in the 1850s and 1860s. These descrip-tions speak of the stereograph as producing 'a dream-like exaltation in which we seem to leave the body behind us and sail away into one strange scene after another, like disembodied spirits.' Holmes describes this cyber-like stereoscopic experience in equally ecstatic detail in an essay published in 1859:

> Oh, infinite volumes of poems that I treasure in this small library of glass and pasteboard! I creep over the vast features of Rameses, on the face of his rockhewn Nubian temple; I scale the huge mountain-crystal that calls itself the Pyramid of Cheops. I pace the length of the three Titanic

stones of the wall of Baalbec, – mightiest masses of quarried rock that man has lifted into the air. . . . [I] leave my outward frame in the arm-chair at my table, while in spirit I am looking down upon Jerusalem from the Mount of Olives.

Here we have a description of an early nineteenth-century technology of seeing that would appear to parallel closely the VR experience that so many commenta-tors want to call 'revolutionary' and 'altogether new.' Nor do the parallels end there. Charles Babbage (1792–1871), inventor of the first analytical machine or computer (based in turn on his 1822 Difference Machine), was also the first person to sit for a stereoscopic portrait (taken by Henry Collen, probably in 1841, for Charles Wheatstone). We can presume that he was therefore also one of the earliest stereo-cybernauts. But what was the nature of the space he explored? And how does this stereo-space relate to the computer-induced environment we now want to privi-lege with the name of cyberspace?

Julian Bleecker is one critic who argues that the implications of stereoscopy and VR are 'fundamentally different.' While agreeing that there are some 'initial simi-larities' between the two, in a 1992 essay for *Afterimage* he draws a contrast between the stereoscope's emergence out of scientific investigations of vision physiology and VR's involvement with the computerized organization and dissemination of infor-mation. Bleecker takes a dark view of VR's easy assimilation into military, corporate, and consumerist machinations, concluding that it has become a 'metonym for the influential and hegemonic state of the information distribution apparatus.' Predictably enough, this simplistic sketch of the relationship between power and technology ends with a paean to the anti-technological innocence of the Australian Aborigine – or at least to those virtual primitives portrayed in Wim Wenders' 1991 film *Until the End of the World*.

The problem with Bleecker's account is that it leaves no room for complexity; for the complexity of the operations of both power and history, for the complexity and diversity of cyberspace itself (in which systems established by the Pentagon have already been taken over by undergraduates and Chiapis rebels alike as Multiple User Dialogue and e-mail services), and, last but not least, for the complexity of Aboriginal culture (which has for some time been quietly producing some of the most interesting film and television in Australia).

Nevertheless, Bleecker's dire warnings do at least turn our discussion to the question of cyberspace and politics, to the question of cyberspace *as* a politics. In this regard, it is interesting to note that technologies such as stereoscopy are but one manifestation of a general dissolution in the years around 1800 of the bound-aries between observer and observed, subject and object, self and other, virtual and actual, representation and real – the very dissolution which some want to claim is peculiar to a newly emergent and postmodern VR. We can find this same dis-ruption, for example, inscribed within apparently 'realist' image-making processes like photography. Conceived in the 1790s but only placed on the market in 1839, the concept-metaphor of photography centered on the virtual image produced by a mirrored surface exposed to the perspectival order of the camera's optical geometry. However photography's many inventors never seemed able to define satisfactorily exactly what the photograph was. For with photography they found

themselves having to describe something altogether new to them, an apparently interconstitutive relationship involving both a viewer and a thing viewed, representing and being represented, fixity and transience, nature and culture – such that all of these terms are radically reconfigured. This conundrum is embodied in the eventual choice of 'photography' as the word for this relationship. Operating simultaneously as verb and noun, photography describes a form of 'writing' that produces while being produced, inscribing even as it is inscribed. It is as if photography can only be properly represented by way of a Mobius-like enfoldment of One within its Other.

Seen in the context of its own convoluted etymological history, photography is in its turn strikingly reminiscent of the paradoxical play of disciplinary power that Michel Foucault has associated with panopticism. Conceived by Jeremy Bentham in 1791 (i.e. in the same decade that photography is also conceived), the Panopticon is, for Foucault, the exemplary technological metaphor for the operations of modern systems of power. The circular architecture of this new notion of the prison allowed each prisoner to be continually surveyed by a single viewer standing in a central tower. Thanks to a bright light shining from the top of the tower, the warder remained invisible to those in the cells. The tower could even be left empty with no detrimental effect on the process of surveillance. As the prisoner never knows if he is being watched or not, he must assume that it is always so. He is thereby forced to survey and discipline himself. Continually projecting himself into a space between tower and cell, the panoptic subject becomes both the prisoner and the one who imprisons, both the subject and the object of his own gaze. As Foucault says, 'he becomes the principle of his own subjection.'

Remember that, for Foucault, panopticism is not just an efficient piece of prison design but also 'the diagram of a mechanism of power reduced to its ideal form.' His own work returned again and again to such diagrams of power, always finding within them a peculiarly modern configuration of human subjectivity. Positioned as both the subject and object of knowledge, this modern human is, he says, an undoubtedly 'strange empirico-transcendental doublet.' As an effect of and vehicle for the exercise of power/knowledge, the modern human subject is, in other words, a being produced within the interstices of a continual negotiation of virtual and real.

Such a notion is hardly peculiar to Foucault. Jacques Lacan reiterates something of this same conceptual economy in his 1936 meditations on the 'Mirror Stage.' This is what he called that inevitable phase in our infant development where, by being brought face to face with the image of a virtual Other, we learn to recognize ourselves as a self. According to Lacan's description of the Mirror Stage, our unconscious efforts to incorporate a perceived difference between real and virtual result in our becoming an irretrievably split being, a creature always in the process of being divided from itself. The way Lacan tells it, the production of this split subjectivity centers on

> a series of gestures in which [the child] experiences in play the relation between the movements assumed in the image and the reflected environment, and between this virtual complex and the reality it reduplicates – the child's own body, and the persons and things, around him.

To become a complete subject in a world of differentiations, the child has no choice but to invent a cyberspace of which it becomes the convulsive possession. Thus, in Lacan's schema, a never-resolved assemblage of virtual and real is what makes up the very fabric of human subjectivity.

This story is surely rehearsed every time we, as adults, confront ourselves in an actual mirror, there to be faced with an apparently real but completely inverted replica. We raise a hand and find ourselves in perfect harmony with the opposite hand of our replicant self, the one floating before us in virtual space. This replicant is a separate entity, but is also inseparable from our other 'real' self. In order to coincide with this self-same simulacra, the body must break the boundary of its skin and simultaneously occupy both sides of its senses. It must somehow incorporate this divided self and be both before and behind the mirror, be both subject and object of its own gaze. When we move through the world, it is as the embodied enactment of this continual double gesture.

These selected examples, no more than cursorily sketched here, suggest that a comprehensive account of the history and cultural implications of cyberspace has yet to be written. However, one could already argue that the problematic of a 'virtual reality' (and the threatened dissolution of boundaries and oppositions it is presumed to represent) is not something peculiar to a particular technology or to postmodern discourse but is rather one of the fundamental conditions of modernity itself. Thus, those that lament VR's destruction of the body, the human, and so on, are in fact mourning a Cartesian reality and subject that have already been under erasure for nigh on 200 years.

This image of cyberspace as something that has for some time already been with us returns my paper to its beginnings, to VR's present haunting of Western cultural discourse. For if we are properly to characterize cyberspace as a postmodern phenomenon, it must be as part of a postmodernism that does not come after the modern so much as assertively re-enacts modernism's desire to fold back in on itself. Like VR, this viral postmodernism takes nourishment from an inseparable host, replicating itself as an aberrant form of the other and thereby leaving us with a troubling because all too faithful repetition of the same. It is here then, here in the complex interweave of this entanglement – here within the spacing of One with its Other – that the political and historical identity of cyberspace might best be sought.

Wendy Hui Kyong Chun

OTHERING SPACE

E ARLY ON, CYBERSPACE SUPPOSED 'OPENNESS' and endlessness was key
to imagining it as a terrestrial version of outer space. Constructed as an elec-
tronic frontier, cyberspace managed global fiber optic networks by transforming
nodes, wires, cables and computers into an infinite enterprise/discovery zone. Like
all explorations, charting cyberspace entailed uncovering what was always already
there and declaring it 'new.' It entailed obscuring already existing geographies and
structures so that space becomes vacuous yet chartable, unknown yet populated and
populatable. Like the New World and the frontier, settlers claimed this 'new' space
and declared themselves its citizens.[1] Advocacy groups, such as the Electronic
Frontier Foundation, exploited the metaphor of the frontier in order to argue that
cyberspace lies both outside and inside the United States. Moreover, cyberspace as
a terrestrial yet ephemeral outer-space turned our attention away from national and
local fiber optic networks already in place and towards dreams of global connec-
tivity and post-citizenship. Those interested in 'wiring the world' reproduced – and
still reproduce – narratives of 'darkest Africa' and of civilizing missions. These
benevolent missions, aimed at alleviating the disparity between connected and
unconnected areas, covertly, if not overtly, conflate spreading the light with making
a profit.[2] Through this renaming, cyberspace both remaps the world and makes it
ripe for exploration once more.

Cyberspace as a frontier structures electronic networks as an 'other space,' as
a heterotopia.[3] According to **Foucault**, in 'Of Other Spaces,' heterotopias are 'like
counter-sites, a kind of effectively enacted utopia in which the real sites, all the
other real sites that can be found within the culture, are simultaneously represented,
contested, and inverted. Places of this kind are outside of all places, even though it
may be possible to indicate their location in reality.' Cyberspace lies outside of all
places and its location cannot be indicated definitively, yet it does exist. One can
view documents and conversations that take place in cyberspace, even if cyberspace

makes phrases such as 'taking place' catachrestic. Moreover, cyberspace as a hetero-
topia simultaneously represents, contests and inverts public spaces and place. On
the one hand, as Manovich (2001: 258) argues, the lack of 'space' in cyberspace
reflects the general American apathy towards communal or public spaces:

> The spatialized Web envisioned by VRML [Virtual Reality Markup
> Language] (itself a product of California) reflects the treatment of space
> in American culture generally, in its lack of attention to any zone not
> functionally used. The marginal areas that exist between privately owned
> houses, businesses and parks are left to decay. The VRML universe, as
> defined by software standards and the default settings of software tools,
> pushes this tendency to the limit: it does not contain space as such but
> only objects that belong to different individuals.

On the other hand, although this lack of interest in marginal areas reflects American
possessive individualism, the lack of decay within them reverses our usual under-
standing of how spaces operate – these spaces may be marginal but they are not
decrepit. As well, decayed 'places' are not those marginal non-spaces in between
privately owned pages, but rather those pages that are no longer updated, pages
that list last year's lectures as next year's coming events. More importantly, the
visibility and portability of VRML and HTML code complicates the separation of
public from private objects and spaces. Given that one can easily copy and replicate
another's 'private object,' especially since one downloads what one views, the
'ownership' of virtual items is not so easy to define. The rampant copying neces-
sary to the functioning of electronic communications troubles the simple idea of
'owning' a text. Unlike a physical object, such as a book, I can quickly 'copy' your
program and we can both use it simultaneously – possession is not exclusive.

 Cyberspace's status as a counter-site does mean that it is a no-place. As the
MCI commercial insists, the internet is not a utopia, and Foucault uses mirrors to
illustrate the relation between utopias and heterotopias:

> I believe that between utopias and these quite other sites, these hetero-
> topias, there might be a sort of mixed, joint experience, which would
> be the mirror. The mirror is, after all, a utopia, since it is a placeless
> place. In the mirror, I see myself there where I am not, in an unreal,
> virtual space that opens up behind the surface; I am over there, there
> where I am not, a sort of shadow that gives my own visibility to myself,
> that enables me to see myself there where I am absent: such is the utopia
> of the mirror. But it is also a heterotopia in so far as the mirror does
> exist in reality, where it exerts a sort of counteraction on the position
> that I occupy. From the standpoint of the mirror I discover my absence
> from the place where I am since I see myself over there. Starting from
> this gaze that is, as it were, directed toward me, from the ground of
> this virtual space that is on the other side of the glass, I come back toward
> myself; I begin again to direct my eyes toward myself and to reconsti-
> tute myself there where I am. The mirror functions as a heterotopia in
> this respect: it makes this place that I occupy at the moment when I look

at myself in the glass at once absolutely real, connected to all the space
that surrounds it, and absolutely unreal, since in order to be perceived
it has to pass through this virtual point which is over there.

The jacked-in computer screen enables one to see oneself – or at the very least
one's words or representations – where one is not. In terms of 'live chat,' one
participates in a conversation that takes place in the virtual space of a chat room.
In terms of 'homepages,' one makes a home in a place where one physically is not,
often inhabiting it with imaginary or representative images of oneself or one's posses-
sions. At the same time, being in real-time or immersive 'cyberspace' marks one's
absence from one's actual physical location: when one is on a MOO such as
LambdaMoo, one is supposedly in a living room, hot tub, sex room, night club.
Howard Rheingold, explaining virtual community, declares that 'we do everything
people do when people get together, but we do it with words on computer screens,
leaving our bodies behind' ('Slice' n.p.). This disappearing body supposedly enables
infinite self-recreation and/or disengagement and begs the question 'Where am I
really?'[4] If I am single-mindedly participating in an on-line conversation, am I not
absent from my physical location? Do I shuttle between various 'windows' – RL
(real life) and VR (virtual reality)? Further, if I am a female paraplegic on-line, but
a male psychiatrist off-line, who am I really? These questions, which led Sherry
Turkle and Sandy Stone to theorize on-line interactions as normalizing or dissemi-
nating multiple personality disorder, focus attention on the relation between the
mirror and real images, thus overlooking the ways in which these images become
spectacles in their own right.

In the early to mid-1990s, cyberspace was also marked as a heterotopia of
compensation – as a space for economic, social or sexual redress.[5] According to
Sherry Turkle, young adults who inhabit multi-user domains (MUDs) often build
virtual representations of economic rewards that have been denied to them in real
life. If in real life their college education has not enabled their entry into well
paying jobs, 'MUDs get [them] back to the middle class' (240). Rather than signaling
the end of 'difference,' cyberspace enables virtual passing (**Piper**). It allows us to
compensate for our own body by passing as others online. Although MUDs have
faded with the rise of the WWW, the structure of virtual passing, whether in terms
of chat rooms or websurfing, remains in place. This virtual passing promises to
protect our 'real' bodies and selves from the consequences of such public partici-
pation, from the glare of publicity. If those 'in the public eye' have had to trade
their privacy for public exposure, if they have spread their images at the risk of
reducing their entire existence to proliferating images, cyberspace, by denying
indexicality, seems to enable unscathed participation. Such passing enables a flight
to a simpler, less encumbered and arbitrary space in which one's representation
need not mirror one's actual image or circumstance. By passing in cyberspace, one
supposedly escapes from representation and representivity. Passing enables an imita-
tion indistinguishable from the 'real thing,' yet completely separate from the real
thing – one passes when one's inner and outer identities cannot or do not coincide,
or when one does not want them to coincide.

Cyberspace as a heterotopia of compensation follows in the tradition of other
compensatory spaces such as the colonies. Drawing on Puritan societies in New

England and on Jesuits of Paraguay, Foucault argues that compensatory hetero-topias represent a space of pure order. They are 'as perfect, as meticulous, as well arranged as ours is messy, ill constructed, and jumbled.' They are 'absolutely perfect other spaces.' Foucault describes the Jesuit colonies in South America as 'marvelous, absolutely regulated colonies in which human perfection was effectively achieved . . . in which existence was regulated at every turn' ('Of Other Spaces' p. 229). The WWW's transformation into an e-commerce paradise exemplifies the portrayal of the internet as an absolutely perfect other space. On-line, there are no crowds or obnoxious salespeople – no parking lots or mall corridors to negotiate. Also, unlike a store, everything is displayed; everything is findable, searchable and orderable.

Foucault, however, glosses over the fact that this placing of pure order simul-taneously obfuscates – if not annihilates – other spaces/places already in existence, namely Native America in his example. (Hart and Negri[6] similarly point out that the US view of empire as ever expanding depends on the deliberate and brutal igno-rance of Native America). These other spaces, however, do not completely dissolve, but rather continually threaten 'pure order.' Puritan societies had to defend them-selves against indigenous populations that threatened their colony, keeping their utopia from ever being effectively realized. This subordination of Native America thus grounds notions of the open frontier, of possibilities. Regardless – and perhaps because of – the difficulty of maintaining heterotopias Foucault settles on the figure of the boat as 'the heterotopia *par excellence.*' The boat is exemplary because it is 'a floating piece of space, a place without a place, that exists by itself, that is closed in on itself and at the same time is given over to the infinity of the sea and, from port to port, from tack to tack, from brothel to brothel, it goes as far as the colonies in search of the most precious treasures they conceal in their gardens.' Foucault's privileging of the boat and nautical navigation resonates with Wiener's privileging of kybernete or governors. Most importantly for Foucault, 'in civilizations without boats, dreams dry up, espionage takes the place of adventure, and the police take the place of pirates.'[7]

Cyberspace, then, offers wet dreams of exploration and piracy. According to David Brande, cyberspace, by proffering of limitless opportunity and open spaces, reinvigorates capitalism (100–102). Cyberspace ends the narratives of the end, ends narratives of postmodern/postindustrial society's ennui and exhaustion. Through its use of nautical navigation, cyberspace also proffers direction and orientation in a world disoriented by technological and political change, disoriented by increasing surveillance and mediation. However, cyberspace also disseminates what it would eradicate; it reflects back what it would deny. Cyberspace perpetuates the differ-ences and contingencies it seeks to render accidental. 'Passing' in cyberspace does not adequately protect viewers from becoming spectacles, from being in public. Rather, in order to maintain the fiction of the all-powerful user who *uses*, rather than *is used by* the system, narratives on and about cyberspace focus the user's gaze away from his or her own vulnerability and towards the spectacle of the other.

Gawkers

Convincing the user that s/he is not a spectacle, that s/he does not have to become data in order to access data, requires on- and off-line intervention. Browsers deliberately conceal the constant exchange of information between so-called 'clients' and 'hosts' required by various internet protocols to work by offering us spinning globes and lighthouses at which to gaze as time goes by. Sustaining the fiction of users as spectators rather than spectacles also happens at the level of critical theory. Recent attempts to understand the position of the user as a *flâneur* or an explorer, for instance, move the focus away from user as spectacle to user as spectator. Lev Manovich for instance offers a provocative analysis of the ways in which users emerge from two major phenotypes: *flâneurs* and explorers. Drawing a trajectory from the novels of Fenimore Cooper and Mark Twain, he argues that game users mimic explorers in their navigation of a virtually empty and adventure filled space. Drawing a trajectory from Baudelaire's *flâneur*, he argues that the WWW and/or email user, like the *flâneur*, is the perfect spectator, who feels at home only among crowds, only while moving. To make this argument, he conflates Geert Lovink's concept of the current net user/listserv poster/data accumulator as a 'data dandy' with his notion of the reincarnated *flâneur* who, 'finds peace in the knowledge that she can slide over endless fields of data locating any morsel of information with the click of a button, zooming through file systems and networks, comforted by data manipulation operations at her control' (274). Although these two phenotypes are compelling, it is also important, as Manovich himself argues, to see the limitations of these phenotypes and these categorizations, especially since, as *flânerie* depended in large part on Fenimore Cooper's portrayal of the frontier, a *flâneur* would never post.

The ability to observe, to be the perfect spectator, depends on the ability to see, but not be seen, the ability to 'read' others and uncover their traces, while leaving none of its own. Baudelaire argues that:

> For the perfect *flâneur*, . . . it is an immense joy to set up house in the heart of the multitude, amid the ebb and flow. . . . To be away from home, yet to feel oneself everywhere at home; to see the world, to be at the center of the world, yet to remain hidden from the world – such are a few of the slightest pleasures of those independent, passionate, impartial [!!] natures which the tongue can but clumsily define. The spectator is a *prince* who everywhere rejoices in his incognito. . . .
>
> (as quoted by Benjamin in *Arcades*, 443)

However, can you have a *flâneur* on the internet – a detached observer who remains hidden from the world while at the center, given that every spectator is also a spectacle, given that everyone automatically produces traces? Do we have something like a *flâneur* who operates and moves with search engines, or does the act of searching not entail more active observation, observation that follows along the lines of American hard-boiled detective fiction, rather than the calm indifference of nineteenth-century armchair detectives? Does the act of searching not also belie the traceless detective, since every search must produce a return address?[8] As an

observer *par excellence*, the *flâneur* attempted to assert independence from and offer insight into the urban scenes he witnessed. As Tom Gunning argues, 'the *flâneur* flaunted a characteristic detachment which depended on the leisurely pace of the stroll and the stroller's possession of a fund of knowledge about the city and its inhabitants' (28). In the so-called information super-highway, strollers are road kill, or at least a *source* for knowledge.

Rather than the *flâneur*, the gawker is a better model for users.[9] Whereas the simple *flâneur* is always in possession of his individuality, the individuality of the gawker (the *badaud*, which Kevin McLaughlin and Howard Eiland translate as rubbernecker), according to Benjamin, disappears. Prefacing Victor Fournel's description of the *badaud* with 'remarkable distinction between *flâneur* and rubberneck (*badaud*)' Benjamin quotes:

> Let us not, however, confuse the *flâneur* with the rubberneck: there is a subtle difference. . . . The average *flâneur* is always in full possession of his individuality, while that of the rubberneck disappears, absorbed by the external world, . . . which moves him to the point of intoxication and ecstasy. Under the influence of the spectacle, the rubberneck becomes an impersonal being. He is no longer a man – he is the public; he is the crowd.
>
> (*Arcades*, 429)

The gawker, caught by visual forms of the commodities, becomes a spectacle just by standing and staring. The intense spectacularity of the object at which it gazes enables the gawker to forget its own status as a spectacle. Like the lurker, it is inundated with information; like the lurker, it is the object of someone else's gaze. Indeed, the myth of users as super-agents, who supposedly dismantle and engage code, who are active rather than passive, who are explorers rather than explored, has emerged in order to compensate for the vulnerable position of the lurker or networked user. This myth works by convincing the lurker, or *badaud*, that s/he is a *flâneur* who leaves no traces as s/he observes. When not 'lurking,' s/he is the useful *flâneur*, the active searcher of information. This role emphasizes user control, while at the same time lending itself to fantasies of paranoid spectatorship. If the user is watching (either through cam sites) or deliberately seeking information, is someone not deliberately seeking our own information? Such a positing, of course, overlooks the systemic and involuntary dissemination of information in favor of a paranoid logic that insists on agency and conspiracy.

In order to circumvent this paranoid doubt, or any admission of vulnerability, internet promoters promised spectacular spectacles, or at the very least sites that emphasized the agency of the user, and not the server. Literary representations of cyberspace in particular promised the spectacular and, along with early net theory, which celebrated the user and focused on its divided subjectivities, allowed us to deny our own involuntary representations. The activity of the network was glossed over by some fantasy of a frontier, some fantasy of others as data. Faced with 'new' encounters between computer and humans, human and humans, cyberpunk literature, which originated the *desire for* cyberspace if not cyberspace itself, responded with a seductive orientation that denied representation through dreams

of disembodiment. Much cyberpunk uses unnerving yet ultimately readable 'savage' 'otherness' in order to create the mythic user. These narratives, which are the flip side to *agoraphobic* reaction formations, *romanticize* networks, gritty city streets and their *colorful* inhabitants. In them, bad-ass heroines and geek-cool hackers navigate through disorienting urban and virtual as urban landscapes, populated by noble and not so noble others. Rather than looking backwards to happier and simpler times, they look forward to edgy and vaguely dystopian ones, in which familiar markers have been altered enough to disorient as well as orient (in Gibson's cyberspace trilogy, *Neuromancer*, for instance, Atlanta has become the end point of BAMA – the Boston-to-Atlanta metropolitan axis). Rather than offering happy consensus-driven spaces in which differences disappear, they offer spaces pockmarked by racial and cultural differences, which may be vaguely terrifying, but are ultimately readable and negotiable. Rather than brush aside fear of strange locations, strangers and their dark secrets by insisting that we are all the same, they, like the detective fiction on which they are often based, make readable, traceable and solvable the lawlessness and cultural differences that supposedly breed in crowds and cities.

The retreat to understanding the 'savage' as a way to confront disorienting crowds links together the would be cyberspace hero/ine with the emerging nineteenth-century detective, while at the same time calling into question the importance of *emptiness* to the frontier. It is not simply, as Hardt and Negri argue, that

> the North American terrain can be imagined as empty only by willfully ignoring the existence of the Native Americans – or really conceiving them as a different order of human being, as subhuman, part of the natural environment . . . the Native Americans were regarded as merely a particularly thorny element of nature, and a continuous war was aimed at their expulsion and/or elimination (170).

It is also that the Native Americans were considered prototypical American explorers, doomed to be replaced by white Americans. Benjamin, quoting from C.G. Jung, notes that:

> in the American hero-fantasy, the Indian's character plays a leading role . . . Only the Indian rites of initiation can compare with the ruthlessness and savagery of rigorous American training. . . . In everything on which the American has really set his heart, we catch a glimpse of the Indian. His extraordinary concentration on a particular goal, his tenacity of purpose, his unflinching endurance of the greatest hardships – in all this the legendary virtues of the Indian find full expression.
>
> (*Arcades*, 440)

This model of the noble and legendary savage, ingested by the American hero, repeats itself in nineteenth-century adaptations of Cooper's works, for both the Parisian detective – urban spectator *par excellence*, also the *flâneur* with an industrious gleam – and the Parisian criminal are based upon models of the 'good' and 'bad' savage. This model is also repeated in cyberpunk fiction, which seeks to classify and navigate through landscapes by reducing others to their markers of difference

in ways that make discrimination invisible and difference noble. In the end, these spaces, for all their unfamiliarity, and all their inhabitants, can be reduced to humanly accessible information – to a vast virtual library. Indeed what makes these public spaces 'navigable' yet foreign, readable yet cryptic are differences, differences which, rather than indicating discrimination or exclusion, serve simply as an information marker, as yet another database category. Thus these narratives imagine a world dominated by 'global' difference in order to dispel the hostility and invasiveness of such a world. Difference thus grounds cyberspace as a 'navigable space,' because difference is the marker by which we steer, and sometimes conquer.

This navigate-by-difference narrative is what I call high tech Orientalism, a strategy that seeks to orient the reader to a technology-overloaded present/future (which is portrayed as belonging to the Japanese or other Far Eastern countries) through the promise of readable difference, and through a conflation of information networks with urban landscape. It is no accident that William Gibson's novels, which are perhaps the most influential examples of high tech orientalism are also influential 'pre-visions' of cyberspace. Gibson's work was certainly not the first to parallel physical and virtual spaces – such metaphorization was key to early cinematic representations of computers such as Steven Lisberger's 1982 feature *Tron*. Mainstream cinema arguably drove the spatialization of information (Gibson himself considers his work to be in dialogue with visual forms of popular culture). Since information networks and data are invisible, cinema offered, and continues to offer, visual parallels consistent with its usual conflation of seeing with knowing (in order to understand computer networks, one must be able to visualize them). Iain Softley's 1995 *Hackers*, like many Hollywood movies, maps information flow onto city traffic (these visualizations are always disparaged by the so-called 'true' hacker community as inadequate and reductive). But spatializing is not necessarily orientalizing: pleasure and power marks the difference between the mere spatialization of information and high tech orientalism. High tech Orientalism is pleasurable – it offers the pleasure of exploring, the pleasure of 'learning,' and the pleasure of being somewhat overwhelmed, but ultimately 'jacked-in.' It consistently carries with it the promise of intimate knowledge, of sexual concourse with the 'other,' which renders it comprehensible and enjoyable, and, in many cases this intimate knowledge is compensation for *lack* of mastery. The drive towards knowledge not only structures the plot of many cyberpunk novels, it also structures the reader's relation to the text, for the reader is always 'learning,' while reading these texts that, in their first sections, relentlessly seek to confuse the reader. The reader eventually emerges as a hero/ine for having figured out the landscape, for having navigated these fast-paced and initially unfriendly texts, since, the many unrelated plots come together at the end and revelations abound. This readerly satisfaction generates pleasure and desire for these never realizable, yet always seemingly approaching, vaguely dystopian futures. This explains why these texts have inspired such utopian longings. It is not simply that all cyberpunk fans in Silicon Valley are 'bad readers,' for they do not necessarily desire the future as described by these texts. Rather, they long for the ultimately steerable yet sexy cyberspace, which always seems so approachable, even as it slips from the future to past.

Although high tech Orientalism may offer a way to navigate through the future, or more properly represent the future as something that can be navigated, it is not

simply 'a western style for dominating, restructuring, and having authority over the Orient' (Said, 2). If Edward Said's groundbreaking interrogation of Orientalism examined it in a period of colonial control, high tech Orientalism takes place in a period of US anxiety and vulnerability. As David Morley and Kevin Robins argue, techno-orientalism engages the economic crises of the 1980s, which supposedly threatened to 'emasculate' the West (in 1985, Japan became the world's largest creditor nation and threatened to 'say no'). Faced with a 'Japanese future,' high tech Orientalism resurrects the frontier – in a virtual form – in order to secure open space for America. As opposed to openly racist science fiction of the early to mid-twentieth century that featured the 'yellow peril,' cyberpunk fiction does not advocate white supremacy or resurrecting a strong United States of America. It rather offers representations of survivors, of savvy-navigators who can open closed spaces.

In its representation of a Japanese future pockmarked by other types of primitive difference, high tech Orientalism clearly exaggerates American powerlessness and thus also conveniently releases US corporations and government from responsibility for the dystopian near future. Japanese *zaibatsus* rather than American multinationals have reduced men to machines. Japanese *yakuza*, not US criminals, run the drug trade and underground clinics. And if Africa is still depressed and 'dark' – it is not due to Western imperialism, but rather simply the way it is. These novels offer a global vision, in which the US has disappeared but inequities due to irresponsible globalization have not. Cyberpunk, however, is not simply a form of US apologetics and it is also immensely popular in Japan. In Mamoru Oshii's *anime* (animated cartoon) *Ghost in the Shell* series, the future remains Japanese, but the dystopian influences of technology are traced back to America. *Ghost in the Shell*, however, is not a native 'refutation' of Gibson's Orientalism, but rather stems from what Toshiya Ueno calls the 'japanoid image' and it too relies on its Eastern natives, who are this time Hong Kong Chinese.

To be clear, I am not implying that cyberspace can only be understood as an Orientalist space, but rather, that cyberspace has been constructed as such in influential off-line representations that have impacted, if not shaped, popular off- and on-line conceptions of the internet. Importantly, all cyberpunk is not Orientalist. Key cyberpunk writers, such as Pat Cadigan, create their futures without pinning them to all things Oriental (carrying only the obligatory references to fast-food sushi). Cadigan, at the same time, however, does not equate jacking into the net (or perhaps more properly being jacked by the net) with bodiless exultation and jacking in can kill. Although not traditionally considered cyberpunk, Octavia Butler's *Patternmaster* series also exposes exactly how disruptive and controlling mind-to-mind communications can be: empaths regularly commit suicide. As well, in her *Parable* series, Butler presents 'cyberspace' technologies as middle-class toys, rather than tools that are 'detourned' by the oppressed – a representation Gibson's fiction disseminates and which Samuel R. Delany criticizes as deliberately nostalgic.[10] In Butler's fiction, one cannot navigate by or romanticize difference. Lastly, high tech Orientalism does not seal fiber optic networks. The virtual, rather than closing off meaningful contact, can inaugurate it.

In order to dispel Orientalist dreams of cyberspace, we must not simply argue that others are selves too. Rather, we must displace this disembodied binary by

examining the ways in which the self is always compromised both on- and off-line. Indeed, Gibson's texts, which are often uncritically read/viewed as celebrations of cyberspace, also critique dreams of disembodiment precisely through their portrayal of cyberspace as enabling/being enabled by Orientalism. (In order to see these texts as simply promoting high tech Orientalism, one must conflate the narrator and author.) Cyberpunk texts also focus on the limits of subjectivization, by portraying their protagonists as passive. Their actions respond to others; their perceptions come to them. Thus, analyzing the importance of Orientalism to cyberspace does not dismiss cyberspace and electronic communications as inherently Oriental, but rather seeks to understand how narratives of and on cyberspace seek to manage and engage interactivity. In order to displace high tech Orientalism, we must also debunk myths of the frontier and the *value* of open space – myths that also buttress the internet as a new utopian space – without retreating to the metaphor of the marketplace. In other words, we must engage the 'newness' and disruption with which high tech Orientalism initially grapples, without falling into dreams of super-agency or without covering over our vulnerability with dreams of our 'usefulness.'

Notes

1 For settlers' claims, see John Perry Barlow, 'A Declaration of the Independence of Cyberspace,' (February 1996). http://www.eff.org/~barlow/Declaration-Final.html (accessed 10/3/2002). Cleo Odzer, *Virtual Spaces: Sex and the CyberCitizen*. New York: Berkley Books, 1997, and Howard Rheingold, *A Slice of Life in My Virtual Community*. Big Dummies' *Guide to the Internet: A Round Trip Through Global Networks, Life in Cyberspace and Everything'*. Textinfo Edition 1.02 (September 1993). http://www.hcc.hawaii.edu/bdgtti/bdgtti-1.02_18.html# SEC191 (accessed 6/1/99).

2 For *Wired*'s version of the civilizing mission, see Jeff Greenwald's 'Wiring Africa,' *Wired* 2.06 (June 1994). http://www.wired.com/wired/archive/2.06/africa. html (accessed 10/3/2002). John Perry Barlow's 'Africa Rising,' *Wired* 6.01 (January 1998). http://www.wired.com/wired/archive/6.01/barlow.html (accessed 10/3/2002). Nicolas Negroponte's 'The Third Shall be First,' *Wired* 6.01 (January 1998). http://www.wired.com/wired/archive/6.01/ negroponte.html (accessed 5/1/99), and Neal Stephenson's 'Mother Earth Mother Board.' *Wired* 4.12 (December 1996) http://www.wired.com/ wired/archive/4.12/ffglass.html (accessed 10/3/2002).

3 In defining cyberspace as a heterotopia instead of a utopia, I am responding to critics of the internet, such as James Brook and Iain A. Boal. 'Preface.' *Resisting the Virtual Life: The Culture and Politics of Information*. Eds. James Brook and Iain A. Boal. San Francisco: City Lights, 1995, vii-xv. Kevin Robins. 'Cyberspace and the World We Live In.' *Cyberspace/Cyberbodies/Cyberpunk: Cultures of Technological Embodiment*. Eds. Michael Featherstone and Roger Burrows. London, Thousand Oaks, and New Delhi: SAGE Publications, 1995, 135–155. Brook, Boal, and Robins insist that the internet is not a utopia, and that the mythology of the internet must be de-bunked/de-mystified. Whereas they seek to put 'sociology before mythology' and look at its relation to the 'real world,' I argue that its mythology is precisely what links it to the real world, not as a regression or

fantasy, but rather as a public space. This is not to say that sociology is not important. This is to say that it must not be an either/or, but both at once.

4 For more on the question of 'where am I really?' see Sherry Turkle's *Life on the Screen Identity in the Age of the Internet*. New York: Simon and Schuster, 1995, and Allucquère Roseanne Stone, *The War of Desire and Technology at the Close of the Mechanical Age*. Cambridge, MA: MIT, 1995. Many have also critiqued the notion of the disappearing or virtual body. For instance, Vivian Sobchack concentrates on the ways in which pain reminds us that we are not simply virtual bodies (see 'Beating the Meat/Surviving the Text, or How to Get Out of this Century Alive,' *Cyberspace/Cyberbodies/Cyberpunk: Cultures of Technological Embodiment*. Eds. Michael Featherstone and Roger Burrows. London, Thousand Oaks, and New Delhi: SAGE Publications, 1995, 205–214). For more on the virtual/non-virtual body, see Anne Balsamo's 'Forms of Technological Embodiment: Reading the Body in Contemporary Culture,' *Cyberspace/Cyberbodies/Cyberpunk: Cultures of Technological Embodiment*. Eds. Michael Featherstone and Roger Burrows. London, Thousand Oaks, and New Delhi: SAGE Publications, 1995, 215–237; Michelle Kendrick's 'Cyberspace and the Technological Real,' *Virtual Realities and Their Discontents*. Ed. Robert Markley. Baltimore and London: Johns Hopkins UP, 1996, 143–160; Katie Argyle and Rob Shields' 'Is There a Body on the Net?' *Cultures of Internet: Virtual Spaces, Real Histories, Living Bodies*. Ed. Rob Shields. London, Thousand Oaks, and New Delhi: SAGE Publications, 1996, 58–69; Theresa M. Senft's 'Introduction: Performing the Digital Body – A Ghost Story,' *Women and Performance* Issue 17 http://www.echonyc.com/~women/Issue17/introduction.htm (accessed 6/8/99); and the articles collected in Part I: 'Self, Identity and Body in the Age of the Virtual' in *Virtual Politics: Identity and Community in Cyberspace*. Ed. David Holmes. London, Thousand Oaks, and New Delhi: SAGE Publications, 1997.

5 Foucault categorizes heterotopias into crisis heterotopias (the boarding school and honeymoon), heterotopias of deviance (rest homes and prisons), heterotopias of illusion (nineteenth-century brothels), and, most important for our purposes, heterotopias of compensation (colonies). 'Of Other Spaces.' Trans. A. M. Sheridan Smith. *diacritics* (Spring 1986): 22–7.

6 Hardt, Michael and Negri, Antonio (2000) *Empire*, Cambridge, Mass. and London: Harvard University Press.

7 Boats, of course, also have an alternate history that places them as dystopian heterotopias. The Middle Passage and the Vietnamese boat people also show the dreams enabled by boats as nightmares. Neal Stephenson plays on both images of boats in *Snow Crash*: New York: Bantam Books, 1992.

8 Using a service, like the anonymizer, allows users to cover their tracks by erasing all record of interactions between an individual client and their site. Servers that track users therefore supposedly reach a 'dead end' at the anonymizer. Installing a tracking program on the user's computer can circumvent this erasure that supposedly protects the user. Also, the user must trust that such sites actually erase all traces.

9 In making this argument, I am drawing from Tom Gunning's analysis of early cinemagoers in 'From the Kaleidoscope to the X-ray: Urban Spectatorship, Poe, Benjamin and Traffic is Souls (1913).' *Wide Angle* 19:4. 25–63.

10 See Mark Dery's 'Black to the Future: Interviews with Samuel R. Delany, Greg Tate, and Tricia Rose.' *SAQ* 92:4 (Fall 1993): 735–778.

References

Benjamin, Walter (1999) *The Arcades Project*, Trans. by Howard Eilan and Kevin McLaughlin, Cambridge, Mass. and London: Harvard University Press.

Brande, David, 'The business of cyberpunk: symbolic economy and ideology' in William Gibson's *Virtual Realities and Their Discontents*, ed. Robert Markley, Baltimore and London: Johns Hopkins University Press, 1996, 79–106.

Butler, Judith *Bodies That Matter: On the Discursive Limits of 'Sex'*. NY: Routledge, 1993.

Butler, Octavia *Mind of My Minds*. New York: Warner Books, 1977.

—— *Parable of the Sower*. New York: Warner Books, 1993.

—— *Parable of the Talents*. New York: Warner Books, 2000.

Cadigan, Pat *Synners*. New York: Bantam Books, 1991.

Gibson, William. *Count Zero*. New York: Ace Books, 1986.

—— *Mona Lisa Overdrive*. Toronto and New York: Bantam Books, 1988.

—— *Neuromancer*. New York: Ace Books, 1984.

Kapor, Mitchell and Barlow, John Perry. 'Across the Electronic Frontier.' (July 1990). http://www.eff.org/Publications/John_Perry_Barlow/HTML/eff.html. Accessed October 3, 2002.

Kawash, Samira. *Dislocating the Color Line: Identity, Hybridity, and Singularity in African-American Literature*. Stanford: Stanford University Press, 1997.

Manovich, Lev (2001) *The Languages of New Media*, Cambridge, Mass. and London: MIT Press.

Morley, David and Robins, Kevin. 'Techno-Orientalism: Futures, Foreigners and Phobias.' *New Formations* (Spring 1992): 136–156.

Piper, Adrian. 'Passing for White, Passing for Black.' *Transition* 58 (1993): 4–32.

Robinson, Amy. 'It Takes One to Know One: Passing and Communities of Common Interest.' *Critical Inquiry* 20:4 (1994): 715–36.

Said, Edward (1978) *Orientalism*, New York: Vintage.

Rheingold, Howard (2000) *The Virtual Community: Homesteading on the Electronic Frontier*, Cambridge: MIT Press. Reprint of 1992 edition.

Lisa Nakamura

'WHERE DO YOU WANT TO GO TODAY?'
Cybernetic tourism, the Internet, and transnationality

There is no race. There is no gender. There is no age. There are no infirmities. There are only minds. Utopia? No, Internet.

— 'Anthem,' television commercial for MCI

THE TELEVISION COMMERCIAL 'Anthem' claims that on the Internet, there are no infirmities, no gender, no age, that there are only minds. This pure, democratic, cerebral form of communication is touted as a utopia, a pure no-place where human interaction can occur, as the voice-over says, 'uninfluenced by the rest of it.' Yet can the 'rest of it' be written out as easily as the word *race* is crossed out on the chalkboard by the hand of an Indian girl in this commercial?

It is 'the rest of it,' the specter of racial and ethnic difference and its visual and textual representation in print and television advertisements that appeared in 1997 by Compaq, IBM, and Origin, that I will address in this chapter. The ads I will discuss all sell networking and communications technologies that depict racial difference, the 'rest of it,' as a visual marker. The spectacles of race in these advertising images are designed to stabilize contemporary anxieties that networking technology and access to cyberspace may break down ethnic and racial differences. These advertisements, which promote the glories of cyberspace, cast the viewer in the position of the tourist, and sketch out a future in which difference is either elided or put in its proper place.

The ironies in 'Anthem' exist on several levels. For one, the advertisement positions MCI's commodity – 'the largest Internet network in the world' – as a solution to social problems. The advertisement claims to produce a radical form of democracy that refers to and extends an 'American' model of social equality and equal access. This patriotic anthem, however, is a paradoxical one: the visual images of diversity (old, young, black, white, deaf, etc.) are displayed and celebrated as spectacles of difference that the narrative simultaneously attempts to erase by claiming that MCI's product will reduce the different bodies that we see to 'just minds.'

The ad gestures towards a democracy founded upon disembodiment and uncontaminated by physical difference, but it must also showcase a dizzying parade of difference in order to make its point. Diversity is displayed as the sign of what the product will eradicate. Its erasure and elision can only be understood in terms of its presence; like the word 'race' on the chalkboard, it can only be crossed out if it is written or displayed. This ad writes race and poses it as both a beautiful spectacle and a vexing question. Its narrative describes a 'postethnic America,' to use David Hollinger's phrase, where these categories will be made not to count. The supposedly liberal and progressive tone of the ad camouflages its depiction of race as something to be eliminated, or made 'not to count,' through technology. If computers and networks can help us to communicate without 'the rest of it,' that residue of difference with its power to disturb, disrupt, and challenge, then we can all exist in a world 'without boundaries.'

Another television commercial, this one by AT&T, that aired during the 1996 Olympics asks the viewer to 'imagine a world without limits – AT&T believes communication can make it happen.' Like 'Anthem,' this narrative posits a connection between networking and a democratic ethos in which differences will be elided. In addition, it resorts to a similar visual strategy – it depicts a black man in track shorts leaping over the Grand Canyon.

Like many of the ads by high tech and communications companies that aired during the Olympics, this one has an 'international' or multicultural flavor that seems to celebrate national and ethnic identities. This world without limits is represented by vivid and often sublime images of displayed ethnic and racial difference in order to bracket them off as exotic and irremediably other. Images of this other as primitive, anachronistic, and picturesque decorate the landscape of these ads.

Microsoft's recent television and print media campaign markets access to personal computing and Internet connectivity by describing these activities as a form of travel. Travel and tourism, like networking technology, are commodities that define the privileged, industrialized first-world subject, and they situate him in the position of the one who looks, the one who has access, the one who communicates. Microsoft's omnipresent slogan 'Where do you want to go today?' rhetorically places this consumer in the position of the user with unlimited choice; access to Microsoft's technology and networks promises the consumer a 'world without limits' where he can possess an idealized mobility. Microsoft's promise to transport the user to new (cyber)spaces where desire can be fulfilled is enticing in its very vagueness, offering a seemingly open-ended invitation for travel and new experiences. A sort of technologically enabled transnationality is evoked here, but one that directly addresses the first-world user, whose position on the network will allow him to metaphorically go wherever he likes.

This dream or fantasy of ideal travel common to networking advertisements constructs a destination that can look like an African safari, a trip to the Amazonian rain forest, or a camel caravan in the Egyptian desert. The iconography of the travelogue or tourist attraction in these ads places the viewer in the position of the tourist who, in Dean MacCannell's words, 'simply collects experiences of difference (different people, different places)' and 'emerges as a miniature clone of the old Western philosophical subject, thinking itself unified, central, in control, etc., mastering Otherness and profiting from it' (xv). Networking ads that promise the viewer control and mastery over technology and communications discursively and

Figure 27.1 Grand Canyon, advert for Compaq

visually link this power to a vision of the other which, in contrast to the mobile and networked tourist/user, isn't going anywhere. The continued presence of stable signifiers of otherness in telecommunications advertising guarantees the Western subject that his position, wherever he may choose to go today, remains privileged.

An ad from Compaq (Figure 27.1) that appeared in the *Chronicle of Higher Education* reads 'Introducing a world where the words "you can't get there from here" are never heard.' It depicts a 'sandstone mesa' with the inset image of a monitor from which two schoolchildren gaze curiously at the sight. The ad is selling 'Compaq networked multimedia. With it, the classroom is no longer a destination, it's a starting point.' Like the Microsoft and AT&T slogans, it links networks with privileged forms of travel, and reinforces the metaphor by visually depicting sights that viewers associate with tourism. The networked classroom is envisioned as a glass window from which networked users can consume the sights of travel as if they were tourists.

Another ad from the Compaq series (Figure 27.2) shows the same children admiring the networked rain forest from their places inside the networked classroom, signified by the frame of the monitor. The tiny box on the upper-right-hand side of the image evokes the distinctive menu bar of a Windows product, and frames the whole ad for its viewer as a window onto an 'other' world.

The sublime beauty of the mesa and the lush pastoral images of the rain forest are nostalgically quoted here in order to assuage an anxiety about the environmental effects of cybertechnology. In a world where sandstone mesas and rain forests are becoming increasingly rare, partly as a result of industrialization, these ads position networking as a benign, 'green' type of product that will preserve the beauty of nature, at least as an image on the screen. As John Macgregor Wise puts it, this is part of the modernist discourse that envisioned electricity as 'transcendent, pure and clean,' unlike mechanical technology. The same structures of metaphor that allow this ad to dub the experience of using networked communications 'travel' also enable it to equate an image of a rain forest with Nature (with a capital *N*).

Figure 27.2 Rainforest, advert for Compaq

The enraptured American schoolchildren, with their backpacks and French braids, are framed as user-travelers. With the assistance of Compaq, they have found their way to a world that seems to be without limits, one in which the images of nature are as good as or better than reality.

The virtually real rain forest and mesa participate in a postcyberspace paradox of representation – the locution 'virtual reality' suggests that the line or 'limit' between the authentic sight/site and its simulation has become blurred. This discourse has become familiar, and was anticipated by Jean Baudrillard pre-Internet. Familiar as it is, the Internet and its representations in media such as advertising have refigured the discourse in different contours. The ads that I discuss attempt to stabilize the slippery relationship between the virtual and the real by insisting upon the monolithic visual differences between first- and third-world landscapes and people.

This virtual field trip frames Nature as a tourist sight and figures Compaq as the educational tour guide. In this post-Internet culture of simulation in which we live, it is increasingly necessary for stable, iconic images of Nature and the Other to be evoked in the world of technology advertising. These images guarantee and

gesture toward the unthreatened and unproblematic existence of a destination for travel, a place whose beauty and exoticism will somehow remain intact and attractive. If technology will indeed make everyone, everything, and every place the same, as 'Anthem' claims in its ambivalent way, then where is there left to go? What is there left to see? What is the use of being asked where you want to go today if every place is just like here? Difference, in the form of exotic places or exotic people, must be demonstrated iconographically in order to shore up the Western user's identity as himself.

This idyllic image of an Arab on his camel, with the pyramids picturesquely squatting in the background, belongs in a coffee-table book (see Figure 27.3). The timeless quality of this image of an exotic other untouched by modernity is disrupted by the cartoon dialogue text, which reads 'What do you say we head back and download the results of the equestrian finals?' This dissonant use of contemporary vernacular American technoslang is supposed to be read comically; the man is meant to look unlike anyone who would speak these words.

The gap between the exotic Otherness of the image and the familiarity of its American rhetoric can be read as more than an attempt at humor, however. IBM, whose slogan 'solutions for a small planet' is contained in an icon button in the lower left hand side of the image, is literally putting these incongruous words into the Other's mouth, thus demonstrating the hegemonic power of its 'high speed information network' to make the planet smaller by causing everyone to speak the *same* language – computer-speak. His position as the exotic Other must be emphasized and foregrounded in order for this strategy to work, for the image's appeal rests upon its evocation of the exotic. The rider's classical antique 'look and feel' atop his Old Testament camel guarantee that his access to a high speed network will not rob us, the tourist/viewer, of the spectacle of his difference. In the phantasmatic world of Internet advertising, he can download all the results he likes, so long as his visual appeal to us, the viewer, reassures us that we are still in the position of the tourist, the Western subject, whose privilege it is to enjoy him in all his anachronistic glory.

These ads claim a world without boundaries for us, their consumers and target audience, and by so doing they show us exactly where and what these boundaries really are. These boundaries are ethnic and racial ones. Rather than being effaced, these dividing lines are evoked over and over again. In addition, the ads sanitize and idealize their depictions of the Other and Otherness by deleting all references that might threaten their status as timeless icons. In the camel image, the sky is an untroubled blue, the pyramids have fresh, clean, sharp outlines, and there are no signs whatsoever of pollution, roadkill, litter, or fighter jets.

Including these 'real life' images in the advertisement would disrupt the picture it presents us of an Other whose 'unspoiled' qualities are so highly valued by tourists. Indeed, as Trinh Minh-Ha notes, even very sophisticated tourists are quick to reject experiences that challenge their received notions of authentic Otherness. Trinh writes, 'the Third World representative the modern sophisticated public ideally seeks is the *unspoiled* African, Asian, or Native American, who remains more preoccupied with his/her image as the *real* native – the *truly different* – than with the issues of hegemony, feminism, and social change' (88). Great pains are taken in this ad to make the camel rider appear real, truly different from us, and 'authentic' in order to build an idealized Other whose unspoiled nature shores up the tourist's sense that he is indeed seeing the 'real' thing. In the post-Internet world of simulation,

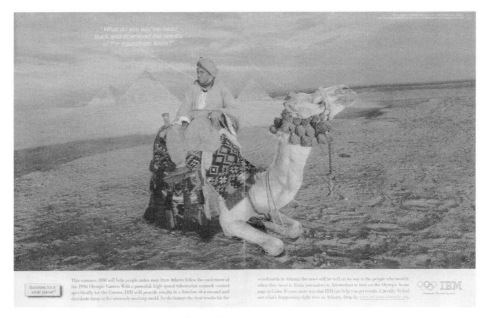

Figure 27.3 Arab and camel, advert for IBM

'real' things are fixed and preserved in images such as these in order to anchor the Western viewing subject's sense of himself as a privileged and mobile viewer.

Since the conflicts in Mogadishu, Sarajevo, and Zaire (images of which are found elsewhere in the magazines from which these ads came), ethnic difference in the world of Internet advertising is visually 'cleansed' of its divisive, problematic, tragic connotations. The ads function as corrective texts for readers deluged with images of racial conflicts and bloodshed both at home and abroad. These advertisements put the world right; their claims for better living (and better boundaries) through technology are graphically acted out in idealized images of Others who miraculously speak like 'us' but still look like 'them.'

The Indian man (pictured in an IBM print advertisment that appeared in *Smithsonian*, January 1996) whose iconic Indian elephant gazes sidelong at the viewer as he affectionately curls his trunk around his owner's neck, has much in common with his Egyptian counterpart in the previous ad. (The ad's text tells us that his name is Sikander, making him somewhat less generic than his counterpart, but not much. Where is the last name?) The thematics of this series produced for IBM plays upon the depiction of ethnic, racial, and linguistic differences, usually all at the same time, in order to highlight the hegemonic power of IBM's technology. IBM's television ads (there were several produced and aired in this same series in 1997) were memorable because they were all subtitled vignettes of Italian nuns, Japanese surgeons, and Norwegian skiers engaged in their quaint and distinctively ethnic pursuits, but united in their use of IBM networking machines. The sounds of foreign languages being spoken in television ads had their own ability to shock and attract attention, all to the same end – the one phrase that was spoken in English, albeit heavily accented English, was 'IBM.'

Thus, the transnational language, the one designed to end all barriers between speakers, the speech that everyone can pronounce and that cannot be translated or

incorporated into another tongue, turns out not to be Esperanto but rather IBM-speak, the language of American corporate technology. The foreignness of the Other is exploited here to remind the viewer – who may fear that IBM-speak will make the world smaller in undesirable ways (for example, that they might compete for our jobs, move into our neighborhoods, go to our schools) – that the Other is still picturesque. This classically Orientalized Other, such as the camel rider and Sikander, is marked as sufficiently different from us, the projected viewers, in order to encourage us to retain our positions as privileged tourists and users.

Sikander's cartoon-bubble, emblazoned across his face and his elephant's, asks, 'How come I keep trashing my hardware every 9 months?!' This question can be read as a rhetorical example of what postcolonial theorist and novelist Salman Rushdie has termed 'globalizing Coca-Colonization.' Again, the language of technology, with its hacker-dude vernacular, is figured here as the transnational tongue, miraculously emerging from every mouth. Possible fears that the exoticism and heterogeneity of the Other will be siphoned off or eradicated by his use of homogeneous technospeak are eased by the visual impact of the elephant, whose trunk frames Sikander's face. Elephants, rain forests, and unspoiled mesas are all endangered markers of cultural difference that represent specific stereotyped ways of being Other to Western eyes. If we did not know that Sikander was a 'real' Indian (as opposed to Indian-American, Indian-Canadian, or Indo-Anglian) the presence of his elephant, as well as the text's reference to 'Nirvana,' proves to us, through the power of familiar images, that he is. We are meant to assume that even after Sikander's hardware problems are solved by IBM's 'consultants who consider where you are as well are where you're headed' he will still look as picturesque, as 'Indian' as he did pre-IBM.

Two other ads, part of the same series produced by IBM, feature more ambiguously ethnic figures. The first one of these depicts a Latina girl who is asking her teacher, Mrs. Alvarez, how to telnet to a remote server. She wears a straw hat, which makes reference to the Southwest. Though she is only eight or ten years old, her speech has already acquired the distinctive sounds of technospeak – for example, she uses 'telnet' as a verb. The man in the second advertisement, an antique-looking fellow with old fashioned glasses, a dark tunic, dark skin, and an untidy beard proclaims that 'you're hosed when a virus sneaks into your hard drive.' He, too, speaks the transnational vernacular – the diction of Wayne and Garth from *Wayne's World* has sneaked into *his* hard drive like a rhetorical virus. These images, like the preceding ones, enact a sort of cultural ventriloquism that demonstrates the hegemonic power of American technospeak. The identifiably ethnic faces, with their distinctive props and costumes, that utter these words, however, attest to the importance of Otherness as a marker of a difference that the ads strive to preserve.

This Origin ad appeared in *Wired* magazine, which, like *Time, Smithsonian*, the *New Yorker*, and *The Chronicle of Higher Education* directs its advertising toward upper-middle-class, mainly white readers (see Figure 27.4). In addition, *Wired* is read mainly by men, it has an unabashedly libertarian bias, and its stance toward technology is generally utopian. Unlike the other ads, this one directly and overtly poses ethnicity and cultural difference as part of a political and commercial dilemma that Origin networks can solve. The text reads, in part,

[We] believe that wiring machines is the job, but connecting people the art. Which means besides skills you also need wisdom and understanding.

An understanding of how people think and communicate. And the wisdom to respect the knowledge and cultures of others. Because only then can you create systems and standards they can work with. And common goals which all involved are willing to achieve.

The image of an African boy, surrounded by his tribe, seemingly performing a *Star Trek* Vulcan mind meld with a red-haired and extremely pale boy, centrally situates the white child, whose arm is visible in an unbroken line, as the figure who is supposedly as willing to learn as he is to teach.

However, the text implies that the purpose of the white boy's encounter with an African boy and his tribe is for him to learn just enough about them to create the 'systems and standards that THEY can work with.' The producer of marketable knowledge, the setter of networking and software-language standards, is still defined here as the Western subject. This image, which could have come out of *National Geographic* any time in the last hundred years, participates in the familiar iconography of colonialism and its contemporary cousin, tourism. And in keeping with this association, it depicts the African as unspoiled and authentic. Its appeal to travel across national and geographical borders as a means of understanding the Other, 'the art of connecting people,' is defined as a commodity which this ad and others produced by networking companies sell along *with* their fiber optics and consulting services.

The notion of the computer-enabled 'global village' envisioned by Marshall McLuhan also participates in this rhetoric that links exotic travel and tourism with technology. The Origin image comments on the nature of the global village by making it quite clear to the viewer that despite technology's claims to radically and instantly level cultural and racial differences (or in a more extreme statement, such as that made by 'Anthem,' to literally cross them out) there will always be villages full of 'real' Africans, looking just as they always have.

It is part of the business of advertising to depict utopias: ideal depictions of being that correctively reenvision the world and prescribe a solution to its ills in the form of a commodity of some sort. And like tourist pamphlets, they often propose that their products will produce, in Dean MacCannell's phrase, a 'utopia of difference,'

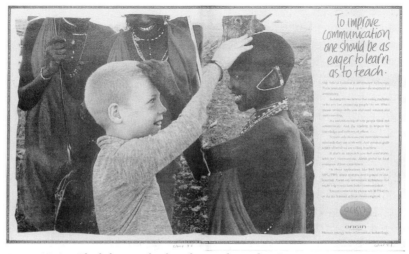

Figure 27.4 Black boy and white boy, advert for Origin

such as has been pictured in many Benetton and Coca-Cola advertising campaigns.

Coca-Cola's slogan from the seventies and eighties, 'I'd like to teach the world to sing,' both predates and prefigures these ads by IBM, Compaq, Origin, and MCI. The Coca-Cola ads picture black, white, young, old, and so on holding hands and forming a veritable Rainbow Coalition of human diversity. These singers are united by their shared song and, most important, their consumption of bottles of Coke. The viewer, meant to infer that the beverage was the direct cause of these diverse Coke drinkers overcoming their ethnic and racial differences, was given the same message then that many Internet related advertisements give us today. The message is that cybertechnology, like Coke, will magically strip users down to 'just minds,' all singing the same corporate anthem.

And what of the 'rest of it,' the raced and ethnic body that cyberspace's 'Anthem' claims to leave behind? It seems that the fantasy terrain of advertising is loath to leave out this marked body because it represents the exotic Other which both attracts us with its beauty and picturesqueness and reassures us of our own identities as '*not* Other.' The 'rest of it' is visually quoted in these images and then pointedly marginalized and established *as Other*. The iconography of these advertising images demonstrates that the corporate image factory *needs* images of the Other in order to depict its product: a technological utopia of difference. It is not, however, a utopia *for* the Other or one that includes it in any meaningful or progressive way. Rather, it proposes an ideal world of virtual social and cultural reality based on specific methods of 'Othering,' a project that I would term 'the globalizing Coca-Colonization of cyberspace and the media complex within which it is embedded.'

Acknowledgements

I would like to thank the members of the Sonoma State University Faculty Writing Group: Kathy Charmaz, Richard Senghas, Dorothy Freidel, Elaine McHugh, and Virginia Lea for their encouragement and suggestions for revision. I would also like to thank my research assistant and independent study advisee at Sonoma State, Dean Klotz, for his assistance with permissions, research, and all things cyber. And a very special thanks to Amelie Hastie and Martin Burns, who continue to provide support and advice during all stages of my work on this topic.

References

Hollinger, David (1995) *Postethnic America: Beyond Multiculturalism,* New York: Basic Books.

McCannell, Dean (1989) *The Tourist: A New Theory of the Leisure Class,* New York: Schocken Books.

McLuhan, Marshall (1964) *Understanding Media: The Extensions of Man*, Cambridge: MIT Press.

Rushdie, Salman (1997) 'Damme, this is the Oriental scene for you!' *New Yorker,* 23 and 30 June, 50–61.

Trinh Minh-ha (1989) *Woman, Native, Other: Writing Postcoloniality and Feminism,* Bloomington: University of Indiana Press.

Wise, John Macgregor (1997) 'The virtual community: politics and affect in cyberspace,' paper delivered at the American Studies Association Conference, Washington DC.

Thomas J. Campanella

EDEN BY WIRE
Webcameras and the telepresent landscape

Hello, and welcome to my webcam; it points out of my window here in Cambridge, and looks toward the centre of town . . .[1]

Wake up to find out that you are the eyes of the World.[2]

THE SUN NEVER SETS on the cyberspatial empire; somewhere on the globe, at any hour, an electronic retina is receiving light, converting sunbeams into a stream of ones and zeros. Since the popularization of the Internet several years ago, hundreds of 'webcameras' have gone live, a globe-spanning matrix of electro-optical devices serving images to the World Wide Web. The scenes they afford range from the sublime to the ridiculous – from toilets to the Statue of Liberty. Among the most compelling are those webcameras trained on urban and rural landscapes, and which enable the remote observation of distant outdoor scenes in real or close to real time. Webcameras indeed constitute something of a grassroots global tele-presence project. William J. Mitchell has described the Internet as 'a worldwide, time-zone-spanning optic nerve with electronic eyeballs at its endpoints.'[3] Webcameras are those eyeballs. If the Internet and World Wide Web represent the augmentation of collective memory, then webcameras are a set of wired eyes, a digital extension of the human faculty of vision.

Before the advent of webcameras, the synchronous observation of remote places (those farther than the reach of mechano-optical devices such as telescope or binoculars) was impossible for the average person – even the computer literate. To watch the sun set over Victoria Harbor in Hong Kong would have required physically being in Hong Kong, unless you happened to tune in to a live television broadcast from the harbor's edge (an unlikely event, as sunsets generally do not make news). Now it is possible to log into one of several webcameras in that city and monitor the descendent sun even as the morning's e-mail is read (Figure 28.1). We can, at the

12:28:45 30-MAR-1999
PETRUS CAM

Figure 28.1 View of harbor and the Hong Kong Convention and Exhibition Centre
from webcamera at Pacific Place. Courtesy Hong Kong Tourist
Association (http://www.hkta.org).

same time, watch the sun rise over Chicago, or stream its noonday rays over Paris, simply by opening additional browser windows and logging into the appropriate sites. As little as a decade ago, this would have been the stuff of science fiction.

Of course, remote observation through a tiny desktop portal will never approach the full sensory richness of a sunset over the South China sea; *telepresence* is an ambitious term. Webcameras may not cure seasonal affective disorder; yet, there is something magical – even surreal – about watching the far-off sun bring day to a city on the far side of the planet. That we can set our eyes on a sun-tossed Australian street scene, from the depths of a New England winter night, is oddly reassuring – evidence that the home star is burning bright and heading toward our window.

The abnegation of distance

Webcameras enable us to select from hundreds of destinations, and observe these at any hour of the day or night. The power to do so represents a quantum expansion of our personal space-time envelope; webcameras are a relatively simple technology, yet they are changing the way we think about time, space and geographic

distance. As byte-sized portals into far-off worlds, webcameras demonstrate effectively how technology is dwindling the one-time vastness of the earth.

The story of technology is largely one of abnegating distance – time expressed in terms of space. For most of human history, communication in real time was limited to the natural carrying range of the human voice, or the distance sound-producing instruments (drums, horns, bells, cannon, and the like) could be heard. Visual real-time communication over wide areas could be achieved using flags, smoke signals or, as Paul Revere found effective, a lantern in a belfry. However, such means were restricted by atmospheric conditions and intervening topography. Asynchronous messages – using the earlier innovations of language, writing, and printing – could conceivably be carried around the globe by the fifteenth century; but doing so took years. Transportation and communications remained primitive well into the nineteenth century, effectively limiting the geographic 'footprint' of the average person to the proximate landscape of his birth. The space-time envelope of the typical peasant, for example, was restricted to the fields and byways of her village and surrounding countryside; that of the medieval townsman by the ramparts of the city in which he lived. Travel, even between settlements, was costly and dangerous; those who took to the roads were often criminals and outcasts from society. Indeed, the etymological source of the word *travel* is the Old French *travailler* or 'travail' – to toil and suffer hardship.

It was not until about 1850 that technology began to profoundly alter the spatial limits of the individual, collapsing distance and expanding the geography of daily life. The development of the locomotive and rail transport in this period had the greatest impact on notions of time and space. The railroad destroyed the tyranny of vastness and the old spatial order; it was a technology that, as Stephen Kern has put it, 'ended the sanctuary of remoteness.'[4] Once-distant rural towns suddenly found themselves within reach of urban markets, if they were fortunate enough to be positioned along the new 'metropolitan corridor' (towns bypassed, conversely, often found themselves newly remote, a particularly tough fate for places previously well-served by canal or stage).[5] Rail transport also brought about a new temporal order: Countless local time zones made the scheduling of trains a logistical nightmare, and eventually led to the adoption of a uniform time standard in the United States.[6]

Subsequent advances in transportation technology – fast steamers, the Suez Canal and eventually the airplane – osculated the great distances separating Europe, Asia, and America. Circumnavigation of the globe itself, a dream of ages, became reality not long after Jules Verne's *Around the World in Eighty Days* was published in 1873. Inspired by the novel, American journalist Nellie Bly became, in 1890, the first to circle the earth in less than the vaunted eighty days.[7] In the following two decades, this figure – and the scale of the globe itself – progressively shrank. A journey to China – once an impossibility for all but the most intrepid seafarers – had become, by 1936, a two-day flight by Pan American 'China Clipper.' With the arrival of commercial jet aviation in the 1960s, traversing the earth was reduced to a day's travel and a middle-class budget.

The abnegation of distance by electricity was somewhat less romantic, but no less profound. Innovations such as the telegraph, 'wireless' and radio neutralized distance by making communication possible irrespective of space and intervening geography. Immediate, synchronous, real-time communication could take place via

'singing wires' or even thin air. The first electric telegraph line linked Baltimore and Washington in 1844, and two decades later the first transatlantic cable went into operation – the alpha segment of today's global telecommunications network. Marconi discovered that telegraphic signals could be transmitted via electromagnetic waves, and in 1902 succeeded in sending the first transatlantic wireless message. The telephone, which spanned the United States by 1915, brought the power of distant synchronous communication into the kitchen. It made the electronic abnegation of space routine, and prompted predictions of home-based work and 'action at a distance' as early as 1914.[8]

The more recent development of the networked digital computer has further neutralized distance and geography. The globe-spanning Internet, described as a 'fundamentally and profoundly antispatial' technology, has in effect cast a great data net over the bumps, puddles, and irregularities of the physical world. The 'cyber-space' of the Net operates more or less independently of physical place, terrain, geography and the built landscape.[9] This was partly by design. The origins of the Internet may be traced to ARPANET, a Cold War initiative of the United States Department of Defense intended to create a multinodal knowledge-sharing infrastructure that could withstand nuclear attack; if any one part of the system was destroyed by an ICBM – for example New York or Washington – data would simply re-route itself around the blockage.

If the Net and the 'mirror world' of cyberspace is spatially abstract, webcameras can be interpreted as mediating devices – points of contact between the virtual and the real, or spatial 'anchors' in a placeless sea.[10] Webcameras open digital windows onto real scenes within the far-flung geography of the Internet. The networked computer enables the exchange of text-based information with distal persons or machines; webcameras add to that a degree of real-time *visual* knowledge. As Garnet Hertz put it, webcameras constitute an attempt 'to re-introduce a physical sense of actual sight into the disembodied digital self.'[11] In a rudimentary way, they make us *telepresent*, in places far removed from our bodies.

Varieties of telepresence

The term *telepresence*, like its cousin *virtual reality*, has been applied to a wide range of phenomena, and often inaccurately. It was coined in 1980 by Marvin Minsky, who applied it to teleoperation systems used in remote object-manipulation applications. As Jonathan Steuer has defined it, telepresence is 'the experience of presence in an environment by means of a communication medium.' Put another way, it is the mediated perception of 'a temporally or spatially distant real environment' via telecommunications. Telepresence is reciprocal, involving both the observer and the observed. In other words, the observer is telepresent in the remote environment, and the observed environment is telepresent in the physical space in which the observer is viewing the scene.[12]

The genealogy of visual synchronicity begins with the development of simple optical devices to augment sight, such as the telescope, binoculars, microscope, the *camera lucida*, and the *camera obscura* (*asynchronous* co-presence, on the other hand, can be traced back to scenic depictions by primitive cave painters, though its modern

roots lie with the discovery of photography and the later development of the stere-oscope. This latter technology provided an illusion of a third dimension, dramatically increasing the sense of immersion into the photographic scene; by the turn of the century, stereoscopic cards were immensely popular, and depicted such exotic land-scapes as the Pyramids of Giza).[13]

Synchronous visual co-presence *by means of electricity* was a dream long before it became reality. One fanciful depiction, published in an 1879 edition of *Punch*, imagined an 'Edison Telephonoscope' enabling family members in Ceylon to be telepresent in a Wilton Place villa.[14] The first experiments in transmitting still images via telegraph took place in the 1840s, with Alexander Bain's proposal for a trans-mission system based on the electrochemical effects of light. Twenty years later, Abbe Caselli devised a similar system that used rotating cylinders wrapped with tin foil to transmit and receive photographs and handwritten notes.[15] As early as the 1880s, photographs had been transmitted via radio signal in England; by 1935, Wirephotos enabled the rapid transmission of photographs around the globe.[16]

The electrical transmission of *live* images was first explored by the German physicist Paul Nipkow in the 1880s. Nipkow understood that the electrical conduc-tivity of selenium – itself discovered in 1817 – changed with exposure to light, and that all images were essentially composed of patterns of light and dark. Based on this principle, he devised an apparatus to scan (using a rotating, perforated 'Nipkow disk') a moving image into its component patterns of light and dark, and convert this into electrical signals using selenium cells. The signals would then illuminate a distant set of lamps, projecting the scanned image on a screen. Nipkow's ideas, which remained theoretical, provided the basis for the early development of tele-vision, which by the 1920s was transmitting live images overseas.

Until the advent of the Net, television remained the closest thing to telepresence most people would ever experience. Even with the development of videoconfer-encing technology in the last decade, access to the hardware and software required to experience even basic telepresence was limited to a privileged few. Proprietary videoconferencing systems were costly and required specialized installation and service. The arrival of the World Wide Web, by providing inexpensive and ready access to a global computer network, made telepresence a reality for anyone with a modem, a PC, and a video camera. The World Wide Web, enabling webcameras as well as simple desktop videoconferencing applications such as CUSeeMe, brought telepresence to the grassroots.

Admittedly, webcamera technology as it exists today affords only the most basic variety of telepresence. The simple observation of distal scenes, even in real time, hardly satisfies most definitions of telepresence. David Zeltzer has argued that a sense of 'being in and of the world' – real or virtual – requires no less than a '"bath" of sensation,' and this can be achieved only when we are receiving a high-band-width, multisensory stream of information about the remote world – something hardly provided by most webcamera sites.[17] According to Held and Durlach, 'high telepresence' requires a transparent display system (one with few distractions), high resolution image and wide field of view, a multiplicity of feedback channels (visual as well as aural and tactile information, and even environmental data such as moisture level and air temperature), and a consistency of information between these. Moreover, the system should afford the user dexterity in manipulating or

moving about the remote environment, with high correlation, between the user's movements and the actions of the remote 'slave robot.'[18] Sheridan similarly proposed three 'measurable physical attributes' to determine telepresence: extent of sensory information received from the remote environment; control of relation of sensors to that environment (the ability of the observer to modify his viewpoint); and the ability to modify the telepresent physical environment.[19]

With sluggish images appearing in a tiny box on a desktop, webcameras hardly constitute full sensory immersion in a distant world, let alone mobility and engagement in that world. While it is true that some of the more sophisticated webcamera sites offer a modicum of telerobotic interactivity, these tend to be clumsy and difficult to use – particularly when a number of users are fighting for the controls.[20] Webcameras afford what might be described as 'low telepresence' or 'popular telepresence.' But their limitations are at least partially compensated by the vast extent of the webcam network, which itself can be seen as enabling remote-world mobility simply by providing such a wide range of geographic destinations.

Coffee pot to deep space

The accessibility of the Net and the simplicity of webcamera technology produced, in less than a decade, a network of independent cameras spanning the globe. As networking technology evolved, it was discovered that a sensory device affixed to a server could distribute real-time visual information to a large number of people. In 1991 a pair of Cambridge University computer scientists, Quentin Stafford-Fraser and Paul Jardetzky, attached a recycled video camera to an old computer and video frame-grabber, and aimed it at a coffee pot outside a computer lab known as the Trojan Room. They wrote a simple client-server program to capture images from the camera every few minutes and distribute them on a local network, thus enabling people in remote parts of the building to check if there was coffee available before making the long trek downstairs.[21] Later served over the Internet (and still in operation) the Trojan Room Coffee Cam became the Internet's first webcamera.

Inspired by Coffee Cam, Steve Mann – at the time a graduate student at the MIT Media Lab – devised a wireless head-mounted webcamera unit in the early 1990s that fed a chain of images via radio to a fixed base station and server. His 'experiment in connectivity' enabled anyone logged into his website to simultaneously share his field of vision, or trace his movements in space through the day by examining continuously archived images. Mann's unit evolved from early experiments by Ivan Sutherland, in which half-silvered mirrors in a head-mounted display enabled the wearer to see a virtual environment imposed upon actual scenes. The WearCam enabled Mann to in effect *become* a webcamera, blurring the line between reality and virtuality, presence and telepresence.[22]

Webcamera technology is simple enough to allow even individuals with minimal computer experience to set one up, and many have done so, displaying prosaic views of driveways, backyards, and streets. A simple 'golfball' camera such as the ubiquitous Connectix Quickcam can be used to supply images to a frame-grabber at a predetermined interval or as requested by a client. Assigned a unique IP (Internet protocol) address, the captured frame is then served over the World Wide Web

and made available to one or more websites. Most webcameras capture and send a single frame at a time, while more sophisticated sites 'push' a continuous stream of images to the client, thus providing a moving picture. Most live-streaming web-camera feeds are sluggish and temperamental, but they offer a compelling near-live glimpse into a remote place.

By 1995, dozens of webcameras were feeding pixels to armchair voyeurs around the world. Following the geography of the Net itself, the early webcameras were located mainly in the United States, Europe, and Japan. More recently, such devices have appeared in places farther off the digital mainline – including Pakistan, Russia, Poland, Mexico, Chile, Brazil, Croatia, Colombia, South Africa, and the Czech Republic. The geography of webcameras now extends to space itself. A number of telerobotic webcamera-equipped telescopes are in operation in the United States and Europe. These include relatively simple units such as one developed by the Remote Access Astronomy Project (RAAP) at the University of California, Santa Barbara (allowing high school students to remotely observe the heavens for science projects), to more sophisticated devices such as the Bradford Robotic Telescope in the United Kingdom, and the powerful 3.5-meter Apache Point telescope in New Mexico – operated via the Internet by researchers at the University of Chicago and elsewhere. An interface program called Remark affords seamless control of the Apache Point instrument, replicating a sense of 'being at the telescope' (and creating in effect two 'piggybacked' sets of telepresent space – that of the telescope itself and that of the celestial world glimpsed by its lens and the attached camera).[23]

Near-real-time satellite images of the earth are available over the Net, generated by the geostationary GOES-8 and GOES-10 satellites operated by the National Oceanic and Atmospheric Administration.[24] Plans for an even more sophisticated earth-observing satellite were unveiled by vice president Al Gore in the spring of 1998. The satellite, to bear the name 'Triana' in honor of Columbus's navigator, would provide 'the ultimate macro world view,' feeding high-resolution images to three earth stations, where they would be compiled into a full-disk portrait of the home planet and made continuously available to viewers on the Net. Pointing out that the last full-round images of the earth came two decades ago during the Apollo mission, Gore urged support and Congressional approval for the orbiting web-camera, noting that the $50 million project would both afford 'a clearer view of our own world' and encourage 'new levels of understanding' of the planet and its 'natural and cultural systems.'[25]

One of the most spectacular moments in webcamera-enabled telepresence took place in July of 1997, during the Mars Pathfinder mission. A remarkable stream of images, transmitted from the spacecraft itself and continually updated to the Mars Pathfinder website, stunned the Net world. Though not real-time in the strictest sense, the images of the Red Planet and its rock-strewn surface were fresh and clear enough to afford a convincing spatial sense of another world. More than 45 million viewers logged into the Jet Propulsion Laboratory sites during the first week of the operation – an Internet record – and over 80 million hits a day were recorded in the first week of the operations. One writer described the Pathfinder landing as a 'defining moment for the Net,' and compared it to similarly definitive moments in the evolution of other media – the outbreak of the Civil War and newspaper; Pearl Harbor and radio; the Kennedy assassination and television. Had these images not

been so readily available on the Internet, it is likely that the Pathfinder landing would have remained an abstraction; television coverage of the event was typically brief and superficial.[26]

[. . .]

Desktop sublime

Digital technology, including webcameras, is being applied to the task of returning us to the mythic garden, albeit in a disembodied state. In this country, the relationship between nature, culture, and technology has long been a site of conflict and contradiction. From the earliest days of the Republic, Americans have rhapsodized the virtues of agrarianism, pastoral nature and the Arcadian 'middle landscape' between wilderness and the city.[27] Distrustful of the urban even as it urbanized, America looked to the natural world as both a source of national identity and moral salvation. This was, after all, 'nature's nation.'[28]

The opposition of the machine and the garden, technology and nature, became one of the central dialectics in American history. The machine, representing civilization and the city, appeared to fundamentally threaten the sanctity of the natural world (in which, found the Transcendentalists, lay enlightenment). But the tension between machine and garden also yielded a great paradox: technology was condemned on the one hand as spoiler of the garden, yet embraced on the other as the very means of getting 'back to nature.' Even Thoreau was conflicted on the subject. He lived deliberately at Walden Pond 'to hear what was in the wind,' but the wind often carried the whistle of a locomotive on the nearby Fitchburg line. For Thoreau, the train was a herald of the rushed, restless life of the city; with its passage 'So is your pastoral life whirled past and away.' But Thoreau was drawn to the machine: 'I watch the passage of the morning cars,' he wrote, 'with the same feeling that I do the rising of the sun'; 'I am refreshed and expanded when the freight train rattles past me.'[29]

Even as technology abrogated the garden, Americans employed it to return to nature. The interurban trolleys delighted city dwellers with Sunday jaunts to open fields at the end of the line; railroad companies pushed track high into newly minted national parks like Yellowstone, Glacier, and Yosemite. The automobile yielded an 'autocamper' craze. Motorists took to the muddy roads of America in their Model T Fords, seeking Arcadia and an unspoiled view. By the 1930s in Westchester County, New York, an entire park system had been built – featuring such landmark roads as the Bronx and Hutchinson River parkways – to accommodate auto-borne day-trippers in their quest for nature.

In a similar vein, the networked digital computer has also been made to yield new glimpses of the mythic garden. We have used the affordances of virtual reality and globe-spanning networks to both create simulacra of nature in cybernetic space, as well as to bring remote real environments into closer view. One of the most compelling examples of a virtually real organic environment is Char Davies' 'Osmose' project, an installation meant to abrogate the 'Cartesian split between mind and body' that, according to the artist, has dominated conceptions of virtual reality and cyberspace. Described as 'an inspired silicon dream about nature, life,

and the body,' Osmose plunges the user (the 'immersant') in an alter-space meant not so much to mimic nature as to evoke its layered, sensory richness. As Davies has put it, Osmose is intended to 'distill or amplify certain interpretive aspects' of the natural world. The immersant, outfitted with a headmounted VR display driven by a Silicon Graphics Onyx engine, wanders through a sequence of 'phosphorescent' spaces – the Grid, the Clearing, the Forest, the Leaf, the Pond – a garden of light framed by 'stands of softly glowing, semitransparent trees.[30]

While Osmose uses virtual reality to bathe the viewer in a pseudo-organic world, the Black Rock Forest project offers 'immersion' in a forest in the Hudson River highlands of New York. An array of environmental sensors provides a real-time data portrait of the living woodland and its ecosystems; information about air quality, stream flows and water temperature, precipitation, and soil acidity is relayed via the Internet to remote users around the world. The effort was meant to situate abstract environmental issues within the context of metropolitan New York, and underscore the connections between an apparently remote forest and the city 40 miles to its south. By tapping into the project website, urban students could learn about Black Rock Forest and request detailed information about the status of its constituent ecosystems in real time.[31]

Webcameras offer a modest degree of telepresence in numerous nonurban, even wilderness spaces around the world. While the subject of most outdoor webcameras is the urban built environment, many take in remote, natural landscapes; these

Figure 28.2 View of Mt. Everest from the Everest Live webcamera, Autumn 1998. Copyright 1998 Everest Live Executive Committee (http://www. m.chiba-u.ac.cp/class/respir/eve_e.htm)

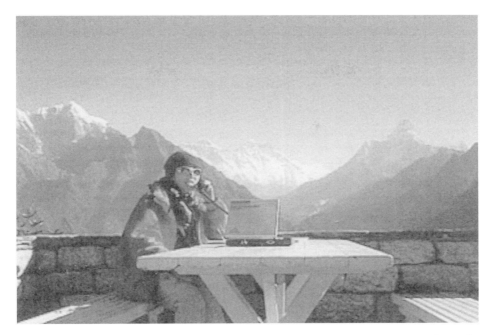

Figure 28.3 Satellite phone used to relay camera images of Mt. Everest to the web-server in Kathmandu, and then onto the Internet. The unit was powered by solar panels. © 1998 Everest Live Executive Committee (http://www.m.chiba-u.ac.jp/class/respir/eve_e.htm)

offer the desk-bound Dilbert a glimpse of scenes ranging from suburban backyards to Everest itself. Some of the most compelling webcameras in operation are those that have been installed atop high mountain summits, such as on the summits of Mt. Washington in New Hampshire and Oregon's Mt. Hood. Others are trained on famous mountains, including Pikes Peak, Italy's Mt. Vesuvius, Yosemite's Half Dome, and Popocatépetl in Mexico; and at least four webcameras are aimed at Mt. Fuji. A Japanese organization maintains a webcamera in the Himalayas, which serves a shot of Mt. Everest, one of the most remote places on earth (Figure 28.2). Captured by a video camera from a window in the Hotel Everest View at Khumbu, Nepal (elevation 3883 meters), the images are relayed by microwave telephone to a Net connection in Kathmandu, and from there to a webserver in Japan (Figure 28.3).[32]

Other remote landscapes have been placed newly within teach via webcamera. The frozen expanse of Mawson Station in Antarctica is within digital reach via webcamera at an Australian research base. Real-time temperature and wind speed data is also supplied, reminding viewers of the inconceivable wildness of the scene they are observing (a webcamera at a second Australian base, Davis Station, had been knocked off its mount by a blizzard, yet continued to pump images of its battered surrounds). Equally remote are African landscapes made desktop-telepresent via webcameras in the Djuma and Sabi Sabi Game Reserves, and Kruger National Park. The cameras, mounted in weather- and creature-proof housings, take in water holes frequented by wildlife. They are illuminated at night by a

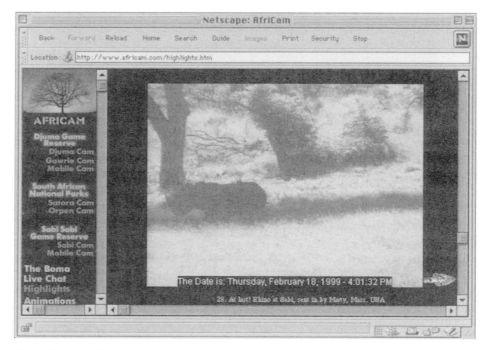

Figure 28.4 AfriCam image showing rhinoceros at Sabi Sabi Game Reserve, 18 February 1999. © AfriCam (http://www.africam.com)

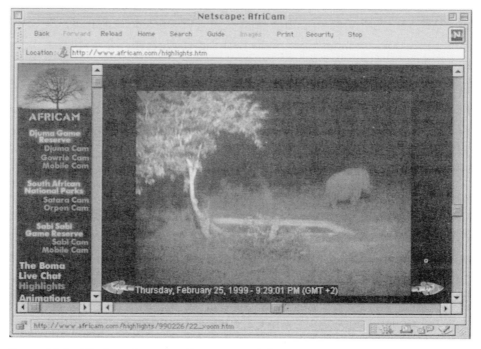

Figure 28.5 Elephant departing Gowrie waterhole, Djuma Game Reserve, 25 February 1999. © AfriCam (http://www.africam.com)

floodlight (which 'does not bother the animals,' we are assured), enabling insomniac Net surfers in New York to catch a drinking elephant (Figures 28.4 and 28.5).[33] It is not uncommon to see such animals within the camera's range, if images archived from days past are to be believed.

Indeed, webcameras bring newly to the fore issues of verisimilitude and truthfulness in representation. It is common knowledge that digital images are easily manipulated; are those we receive via webcamera suspect, too? Doubt creeps in with every mouse-click, and, for me, seems to increase proportionally with distance. Have we really been afforded the power to watch African water buffaloes wallow in real time, as I am now doing while writing this in a Hong Kong office? Or were those animals pixelated a day or a month ago, and long vanished? Like the solar disk plunging into the South China sea on my desktop, this is a scene almost too incredible to be real. The reload button is tapped expectantly, hoping it will yield evidence of life – a shift in position, a newly alighted bird, an insect on the lens. My buffalo remain improbably still. I click my way to a sun-bleached water hole at Djuma. The camera's on-screen clock tells me the view is indeed being refreshed, every few minutes; but I can detect no traces of movement. All is inscrutable and still, like a scene from a Doris Lessing novel.[34]

For better or worse, we have come to trust the images delivered to us by the evening news as authoritative (the films *Wag the Dog* and *Capricorn One* were captivating precisely because they suggested otherwise). Webcameras, a grassroots phenomenon largely ungoverned by norms or regulations, has been free to expand into a populist, globe-spanning broadcast medium – a shadow of the Net itself. But such free-form evolution has come at a cost. It is difficult, if not impossible, to separate truth from fiction, to determine with certainty which webcameras are conveying accurate visual information, and which are frauds passing off still images or a Quicktime movie as just-captured reality. This is an epistemological issue. What is the integrity of the knowledge received from a webcamera, and how are we to verify it? To an extent, those webcameras that afford telerobotic interactivity enable us to make inquiries as to the truthfulness of the view – though here, too, a savvy programmer could easily create a simulacra of telerobotic response. The most reliable means of checking the verity of our telepresent landscape may well be the sun itself – the most ancient of our chronographic aids.

[. . .]

'I'll be watching you'

Webcameras do not always generate such enthusiasm. The specter of surveillance and the violation of privacy are real and vexing issues, and the possibility of Orwellian over-exposure has made many people anxious and fearful of webcameras. Ubiquitous surveillance was the subject of the popular 1998 film *The Truman Show*, in which the feckless hero (Jim Carey) is, since birth, the unwitting star in his own quotidian drama. Tiny cameras, ingeniously concealed in dashboard radios, lawnmowers, and bathroom mirrors, relay a perpetual stream of images to voyeurs in televisionland – unbeknownst to him. Unfortunately, the technological aspects of the film are well within reach. Remarkably small cameras are available from security supply houses,

along with tiny transmitters and dummy appliances in which to conceal them (one company gleefully advertises a wall clock, concealing a tiny video camera, as an ideal solution for keeping an eye on employees).

Then again, surveillance is nothing new. Video cameras are a ubiquitous part of the urban landscape, so much so that we scarcely notice them; we are watched constantly, and have been for years. Supermarkets, convenience store, elevators, automated teller machines, and office lobbies are all monitored via camera by persons unseen.[35] Public spaces such as tunnels and bridges, toll booths, college campuses, streets and public squares are, increasingly, also being watched. In the United Kingdom, home of Bentham's Panopticon, dozens of town centers are patrolled by video cameras, and Liverpool police recently began using a system of 20 cameras to produce full color, highly magnified nocturnal images.[36]

Surveillance has also moved beyond the visual. In 1996 Redlands, California, installed an 'Urban Gunshot Location System,' consisting of a matrix of sound sensors at intersection in the city enabling police to instantaneously detect and locate gunfire.[37] Of course, such applications are intended to serve the interest of public health and safety; but surveillance is by nature a clandestine act, and the risks of abuse, of invasions of personal and group privacy, are very real. Astonishing abuses have already been committed. Several years ago a minuscule hidden camera was discovered in a locker room of Boston's Sheraton Hotel, recording employees in various states of undress (the hotel claimed it suspected employee drug use); in California a J. C. Penny clerk filed suit when she learned that a guard had been zooming a ceiling-mounted security camera on her breasts.[38]

The growing popularity of webcameras has raised the prospect of similar mischief. At first it would seem like anger misplaced – protest should be aimed at the 'glass ceiling domes of wine-dark opacity' of institutional surveillance, rather than the innocuous home-rigged webcamera aimed out a kitchen window.[39] Steve Mann has argued, institutions and the government have for years been 'shooting' cameras at us; what webcameras enable is a chance to 'shoot back' at Big Brother.[40] Then again, when one considers the enormous potential audience at the receiving end of a webcamera, the seemingly innocent device on the window ledge becomes a threat indeed – Little Brother is also watching, and he is hitched to a global network, indeed, persons in webcamera view are *theoretically* exposed to millions of users on the Net, not just a half-awake night guard at a security desk. Even if no one is watching – and most of the time no one is – the mere presence of a webcamera compromises personal space. In a feedback thread on the Trinity Square Street-Cam site in Colchester, United Kingdom, one woman wrote: 'Big brother is watching us and we don't like it! We have no choice but to be in view going to work. . . . We are ANNOYED!'

Notes

1 Caption on Sam Critchley's CamCam page, a webcamera site in Cambridge, UK (http://www.pipex.net/~samc/).
2 Lyrics from the Grateful Dead anthem 'Eyes of the World' by Robert Hunter.
3 William J. Mitchell, *City of Bits: Space, Place, and the Infobahn* (Cambridge: MIT Press, 1995), p. 31.

4 Stephen Kern, *The Culture of Time and Space* (Cambridge: Harvard University Press, 1983), p. 213.

5 See John R. Stilgoe, *Metropolitan Corridor: Railroads and the American Scene* (New Haven: Yale University Press, 1983).

6 Kern, pp. 12–14. November 18, 1883, the day the new national standard was imposed, became known as 'the day of two noons.'

7 Kern, p. 213.

8 'Action at a distance,' *Scientific American*, 77 (1914): 39.

9 Mitchell, *City of Bits*, p. 8.

10 The term is from David Gelernter's *Mirror Worlds* (New York: Oxford University Press, 1991).

11 Garnet Hertz, 'Telepresence and Digital/Physical Body: Gaining a Perspective' (http://www.conceptlab.com/interface/theories/reality/index.html).

12 Jonathan Steuer, 'Defining Virtual Reality: Dimensions Determining Telepresence,' *Journal of Communications* 42 (Autumn 1992): 75–8.

13 Don Gifford, *The Farther Shore: A Natural History of Perception* (New York: Atlantic Monthly Press, 1990), 31.

14 See Mitchell, *City of Bits*, pp. 32, 46.

15 Brad Fortner, 'Communication Using Media.'

16 Gifford, *The Farther Shore*, p. 26.

17 David Zeltzer, 'Autonomy, Interaction, and Presence,' *Presence*, 1: 128.

18 Richard M. Held and Nathaniel I. Durlach, 'Telepresence,' *Presence*, 1: 109–11.

19 Thomas B. Sheridan, 'Musings on Telepresence and Virtual Presence,' *Presence*, 1: 120–22.

20 For a collection of examples see http://mitpress.mit.edu/telepistemology. Some of the better known telerobotic webcamera sites include the Keio Mt. Fuji Server (http://www.flab.mag.keio.ac.jp/fuji/); the Virtual Artists Rundle Street VA RoboCam in Adelaide, Australia (http://robocam.va.com.au/); the SchoolNet Robotics Webcam at Carleton University (http://webcam.engsoc.carleton.ca/); the EyeBot Project (http://www.dma.nl/eyebot/); the Interactive Model Railroad (http://rr-vs.informatik.uni-ulm.de/rr/); and the Light on the Net Project (http://light.softopia.pref.gifu.jp/), which enables the user to turn on or off a panel of lights in real time.

21 Quentin Stafford-Fraser, 'The Trojan Room Coffee Pot: A (non-technical) Biography.' (http://www.cl.cam.ac.uk/coffee/qsf/coffee.html).

22 Steve Mann, 'Wearable Computing: A First Step Toward Personal Imaging,' *Computer*, 30: 2 (February 1997).

23 See UC Santa Barbara Remote Access Astonomy Project website (http://www.deepspace.uc-sb.edu/rot.htm); Bruce Gillespie, Robert Loewenstein and Don York, 'Remote Observing at Apache Point,' 1995 (http://www.apo.nmsu.edu/NMOpaper/paper.html).

24 See Geostationary Satellite Browser Server (http://www.goes.noaa.gov).

25 Douglas E. Heimburger, 'Talking at Innovation Summit, Gore Calls for an Earth-viewing Satellite,' *The Tech* (17 March 1998). Gore's proposal was summarily dismissed by some as an exercise in 'planetary navel-gazing' and a waste of taxpayer money. See Gabriel Schoenfeld, 'Machines with a High Calling,' *Wall Street Journal*, 6 July 1998, and Joe Sharkey, 'Step Right Up and See Grass Grow and Paint Dry,' *New York Times*, 22 March 1998.

26 See NASA press release 24 June 1997; Amy Harmon, 'Mars Pathfinder Landing was Defining Moment for Net,' *New York Times*, 14 July 1997.

27 See Leo Marx, *The Machine in the Garden: Technology and the Pastoral Ideal in America* (New York: Oxford University Press, 1964).

28 See Perry Miller, 'Nature and the national ego,' *Errand into the Wilderness* (Cambridge: Belknap Press of Harvard University Press, 1956).

29 Henry David Thoreau, *Walden and Other Writings*, ed. William Howarth (New York: Modern Library, 1981), pp. 16, 104–11.

30 Margaret Wertheim, 'Osmose,' *Metropolis* (September 1996): 58.

31 See Herbert Muschamp, 'In Cyberspace, Seeing the Forest for the Trees,' *New York Times*, 25 February 1996.

32 Unfortunately this camera no longer appears to be in operation (http://www.m.chiba-u.ac.jp/class/respir/eve_e.htm),

33 AfriCam website (http://africam.mweb.co.za/djuma.htm).

34 To be fair, the Africam site is among the more sophisticated and well-maintained webcamera sites in operation. The developers make it clear to visitors that their cameras are not in a zoo. 'There are no guarantees that you will see animals when you look through our cameras, but when you do, you will see them as they should be seen – in their natural environment, on their terms.' See Africam website (http://africam.com).

35 See Phil Patton, 'Caught,' *WIRED* 3.01, and John Whalen, 'You're Not Paranoid: They Really Are Watching You,' *WIRED* 3.03.

36 You Don't Have to Smile,' *Newsweek*, 17 July 1995, 52.

37 It should be noted that local community activists have praised the system, which appears to have had a positive impact. See 'Gunfire Detection Sensor Tested,' *Trenton Times*, 7 January 1996.

38 'You Don't Have to Smile,' *Newsweek* (17 July 1995).

39 Patton, 'Caught,' *WIRED* 3.01.

40 See Steve Mann, 'Privacy Issues of Wearable Cameras Versus Surveillance Cameras,' 1995 (http://www.wearcam.org/netcam_privacy_issues.html).

Lisa Parks

SATELLITE AND CYBER VISUALITIES
Analyzing 'digital earth'

I<small>T'S IMPORTANT TO REMEMBER</small> in this Information Age dominated by discussions of 'cyber this and cyber that' that the world's first satellites were being developed in US Defense Department labs around the same time computer networks were. Both satellites and computer networks became the quintessential strategic technologies, emerging at the peak of the Cold War. As the computer historian Paul Edwards writes 'Of all the technologies built to fight the Cold War, digital computers have become its most ubiquitous, and perhaps its most important, legacy.'[1] Edwards suggests that computers helped create and sustain a 'closed-world discourse' by 'allowing the practical construction of central real-time military control systems on a gigantic scale' and by 'facilitating the metaphorical understanding of world politics as a sort of system subject to technological management.'[2] If computers closed the world in, as Edwards suggests, satellites opened it up, connecting people across vast spaces, exposing the earth as it had never been seen before, and revealing its "origins" in deep space.'[3] While Defense Department engineers tinkered with computers in closed-off labs, NASA very publicly displayed the first satellites (Explorer, Echo, Telstar), showcasing their fiery launches, encouraging amateur satellite-gazing, and promising the world would become a smaller and more intimate place.[4] Satellites only supported such fantasies of global unity during the Cold War, however, because they also offered the possibility of planetary omniscience.[5]

More recently, NASA has done away with space-age spectacles and has tried to reinvent itself in the digital age. As Jodi Dean explains, 'Positive associations with the space program [that were] prevalent in the sixties have been transferred to computers and networked communications technologies. . . . With the Internet, we bring everything to us, without ever having to go anywhere.'[6] If there is one project that encapsulates the convergence of satellite and computer technologies as well as NASA's attempt to make itself relevant to the information economy it is

the Digital Earth Project. First introduced by former US Vice President Al Gore in 1998, the Digital Earth is envisioned as a virtual environment that encompasses the entire planet and enables a user to explore vast amounts of information gathered about the earth.[7] It includes a user interface, an enormous networked database of geospatial information (satellite images, photographs, computer models, digital animation, etc.), and software for integrating and displaying information from multiple sources. Gore compared the Digital Earth to the world wide web, suggesting it would be a 'grassroots effort' and he insisted the Digital Earth would stimulate the next burst of expansion on the web.[8] The project has continued under the Bush administration, and it is led by an inter-agency working group at NASA's Goddard Space Flight Center.[9] It involves state agencies and officials, private corporations, cartographers, geologists, photo interpreters, astronomers, computer experts, and a handful of television producers, museum curators and educators.

Although this public–private consortium has solicited the participation of other nation-states. Gore has used the Digital Earth first and foremost as a platform to support various Clinton administration initiatives ranging from the commercialization (and declassification) of satellite imaging and global positioning systems (GPSs) to the continuing expansion and privatization of his other pet project, the 'Information Superhighway.' In this chapter, I examine the Digital Earth website, publicity and prototypes to discuss some of the ideological underpinnings of its early incarnations. Embedded within the project's mission are the very discourses of electronic global unity celebrated by experimental broadcasters who during the 1960s linked the planet in *Our World*, the first live global satellite TV show ever. The Digital Earth project reinforces what I call the 'as the earth spins' discourse of early live global TV, which suggests that just as the world rotates on its axis, the Western spectator could be anywhere and everywhere upon it.[10] The call for a Digital Earth also incorporates recent efforts by archaeologists to use remote sensing satellites and GPS receivers to unpack layers of the earth and pinpoint the bedrock of Western civilization. Finally, the desire for a Digital Earth resonates with the work of astronomers who have used Hubble Space Telescope imagery as 'cosmic sonograms' to construct the early earth's stages of development. What the Digital Earth adds to these other satellite televisualities is an interface that would provide regular public access to satellite images as well as other forms of digital media. But instead of designing user interfaces that might serve broad public interests by extending visual literacy, encouraging intercultural dialogues, or spurring political debate, the Digital Earth has thus far been guided most forcefully by US corporate and scientific interests which imagine the user as having the world at his/her fingertips. I argue that the project should be refashioned as an interdisciplinary 'contact zone' that will not only extend public access to satellite and computer technologies, but help to erode the science/culture divide.

Palm planet

During the 1960s the 'pale blue dot' photos of the Earth snapped by Apollo astronauts were thought of as rare treasures that dramatized the fragility and uniqueness of the planet. Since then thousands of earth observation satellites have been deployed

in space, their automated gaze constantly photographing and scanning the earth as they pass overhead. In part, it is the plethora of satellite data accumulated over the past thirty years that motivated Gore's proposal for the Digital Earth. As he explains, 'we have more (satellite) information than we know what do with.' Landsat, for instance, is capable of taking photos of the complete earth every two weeks and has been doing this for twenty years.[11] The Digital Earth puts to use decades of satellite images funded by taxpayer dollars ranging from the public Landsat images to recently declassified spy images of the Corona Project.[12]

In addition to satellite imagery, the Digital Earth will include various forms of visual, oral, and written culture, immersing the user quite literally within an information landscape. Describing a hypothetical user, Gore explains:

> After donning a head-mounted display, she sees Earth as it appears from space. Using a data glove, she zooms in, using higher and higher levels of resolution, to see continents, then regions, countries, cities, and finally individual houses, trees and other natural and man-made objects. Having found an area of the planet she is interested in exploring, she takes the equivalent of a 'magic carpet ride' through a 3-D visualization of the terrain. . . . She is not limited to moving through space, but can also travel through time. After taking a virtual field trip to Paris to visit the Louvre, she moves backward in time to learn about French history, perusing digitized maps overlaid on the surface of the Digital Earth, newsreel footage, oral history, newspapers and other primary sources. The time-line, which stretches off in the distance, can be set for days, years, centuries or even geological epochs. . . . [13]

While Gore's portrait of the user/navigator is somewhat provocative in that it places a girl at a web interface imagined as a site of education (rather than commerce), his description forecasts the kind of world this project is likely to construct – one of Eurocentrism, cultural elitism, and sanitized history. The girl navigator is invoked simultaneously in a liberal feminist gesture of 'equal access' to the project interface, and as sign of paternalist protectionism with respect to what she is allowed to see and where she is allowed to go. What is not anticipated is that the girl spectator/navigator might stumble in the Digital Earth upon historical trauma – such as the conflicts of the French Revolution or the stolen artifacts of colonized territories kept as treasures in the Louvre, or that she might take a 'magic carpet ride' through war-torn regions like the Balkans or Central Africa. Gore imagines a neat and clean, antiseptic planet displayed through high-tech, high-speed interfaces where signs of struggle are submerged or kept out of view.

This publicity for the Digital Earth resonates with glossy advertisements for computer technologies and networks that address consumers as world tourists. Ads from companies such as MCI, Microsoft, AT&T, Compaq and IBM promulgate naïve fantasies of a 'global village,' promoting visions of cyberspace that magically elide racial and ethnic differences as well as history. Lisa Nakamura suggests that Microsoft's 'Where Do You Want to Go Today?' ad campaign 'promises the consumer a "world without limits" where he can possess an idealized mobility.' She continues, 'Ethnicity in the world of Internet advertising is visually "cleansed" of divisive, problematic and

tragic connotations.'[14] Since these ads are often read alongside news coverage of war and bloodshed in the former Yugoslavia, Central Africa, or Iraq, they function 'as corrective texts for readers. . . . [for they] put the world right; their claims for better living (and better boundaries) through technology are graphically acted out in idealized images of Others who miraculously speak like "us" but still look like "them." '[15]

Since the Digital Earth is a federally funded public initiative, it ostensibly should serve the public interest, but so far it has been shaped most forcefully by corporate visions. Very few public interest groups or activist social organizations have actually been involved in the Digital Earth project, which is a point to which I shall return later. Perhaps this is not surprising, though, since Al Gore has been the official guru of on-line commercialism all along, first offering the metaphor of an 'Information Superhighway' to augur free-flowing e-commerce, and then pushing 'the Digital Earth' to further elaborate what media critic Dan Schiller has called 'digital capitalism.' Digital capitalism emerges with the neoliberal deregulation of new media technologies during the 1990s, which made the high-tech sector 'free to physically transcend territorial boundaries and, more important, to take economic advantage of the sudden absence of geopolitical constraints on its development.'[16] The goal, Schiller explains, is to develop an economy-wide network that is 'the central production and control apparatus of an increasingly supranational market system.'[17] Gore admits that the project is designed to stimulate a new phase of the information economy through partnerships of government and commerce. In classic neoliberalist rhetoric he proclaims, 'Working together, we can help solve many of the most pressing problems facing our society, inspire our children to learn more about the world around them, and accelerate the growth of a multi-billion dollar industry.'[18]

This collusion of corporate and governmental agencies in the formation of the internet and the Digital Earth is not just economic and organizational, however. It is encoded in the visual discourses of project prototypes and publicity as well. To reinforce this point and to provide a more concrete sense of how the Digital Earth is currently taking shape, I want briefly to discuss two prototype interfaces, one sponsored by NASA and one by SRI International, which have been made available on the project website. The Digital Earth Work Bench, developed at NASA's Goddard Space Center, is an interactive interface that allows users to retrieve, view and compare earth-related information. Using the Work Bench the user (whether a grade school student or a geophysicist) can navigate the globe and view satellite imagery and topography of any location on the Earth. According to the prototype's website, 'Using intuitive hand movements, Digital Earth explorers can literally grab the computer-generated Earth with their hands – like a real life globe – and bring it close to their faces for close examination, move it away for full planet views, or set it spinning on its axis.'[19] The prototype website features eight sample visualizations, actual screen captures from the Work Bench interface, including a zoom from orbit to the Washington monument, a computer simulation of a hurricane's connection to outer space where elements of the magnetosphere and the sun are revealed, and an animation showing the Yellowstone National Park forest fires during the summer months of 1991.

In the prototype sequence featuring a digital zoom from an orbital position to the Washington Monument, the software automatically loads Landsat and aerial

images as we zoom in and the user manually adds an Ikonos satellite image and 3D model of the Washington Monument. The use of this particular sequence as a Digital Earth prototype speaks to the nationalistic underpinnings of this project as it posits a time/space continuum between an indistinct and transitory orbital space and the material and official space of US government, architecture, and history. Although the Digital Earth user could hypothetically 'go anywhere in the world,' this proto-type land-locks the user in the nation's capital and focuses his/her gaze upon a familiar monument. The fact that the digital zoom takes the world navigator directly to Washington DC is not unlike CNN's promise to offer a 'global television net-work' while focusing almost exclusively on American news and events. The prototype could also be read as an inversion of an American astronaut staking a US flag on the moon thirty years ago. As one NASA spokesman says, 'We have landed on the moon, we must now understand our footing on earth.'[20] If this NASA proto-type is any indication, the understanding of 'our footing on earth' involves naturalizing national and corporate control over cyberspace.

The second prototype is an interface developed by SRI International called Terravision II. SRI is a non-profit research firm that became a partner in the Digital Earth Project after holding contracts with the Department of Defense for decades. Its Terravision interface is, in fact, the byproduct of a 1980s Defense Department contract designed to test high-speed data networks.[21] Its non-profit status is mis-leading since it has generated innumerable patents, more than twenty profitable spinoff companies in recent years (so many that its nickname has become 'spinoff city'), and in 2000 SRI excluding its subsidiaries generated $164 million.[22] Consistent with the logic of digital capitalism – that is, of generating an economy-wide network that supports corporate processes – SRI describes itself as 'a pioneer in the creation and application of innovative solutions for businesses, governments, and other organizations.'[23] Its mission statement emphasizes the company's commit-ment 'to discovery and to the application of science and technology for knowledge, commerce, prosperity, and peace.'[24]

The Terravision interface claims to 'allow users to navigate, in real time, through a 3-D graphical representation of a real landscape created from elevation data and aerial images of that landscape.' One online demonstration called 'From space to Menlo Park' features a continuous digital zoom from orbit to a position hovering over the SRI's research facilities. In a *Technology Review* discussion of the interface, the author queries, 'Ever wonder what it's like to be a bird?' and then describes the Terravision II visualization system which allows users to 'fly over the surface of the earth' through the computer screen.[25] While the Work Bench features a zoom into the national monument, this visualization invites the user to hover over the research headquarters of one of the Digital Earth's corporate companions. The sequence rein-forces one of the 'fundamental hypotheses for the Digital Earth Community' – that the project 'requires selective breeding, by a consortium of commerce and govern-ment, to impart the qualities desired for the general population.'[26]

Both the Work Bench and Terravision II interfaces foreground the user's shifting spatial position, seamlessly moving her from a global to a local perspective. But in these demonstrations the local is conflated with the national (in the Washington Monument) and the corporate (SRI headquarters), and the Digital Earth with its generic VRML displays of the earth's surface threatens to erase completely the

specificities and subtleties of located or inhabited space (unless, of course, the user reads it into the image). What is being articulated here, then, is a kind of neo-imperialism in which the distinctions between outer, global and cyberspaces are collapsed in a way that encourages the user to imagine herself as occupying all of these spaces at once (much like the US government or a high tech firm). These Digital Earth prototypes interpellate the user as if he/she were 'returning home' after an individualized tour around the world, coming back to recognize and become one with the national and corporate entities that made such a journey possible in the first place. Such discourses of recentralization are often encoded in the visual realm when the media infrastructure is itself decentralized (and thus threatens to become deterritorialized or beyond state and corporate control).[27] The prototypes not only reinforce linear conceptions of time-space and movement (which is ironic given that digital technologies offer the possibility to do otherwise), but also greatly reduce each of these spatial domains. For each of these spaces – global, outer, cyber, national, and corporate – is defined by ongoing social, economic, political, and cultural struggle. The Digital Earth conceals these struggles, however, and instead naturalizes these spaces as the rightful property of the spectator/navigator. This discourse of ownership and control through vision and movement is further underscored by the Work Bench interface which invites the user to pick up the planet, play with it, and spin it around in her own palm as if it were her own bouncing ball.

This ability to assert individual control over the entire planet can be seen as an extension of Western cultural practices such as placing a globe in the home, putting a copy of *The Family of Man* on the coffee table, or subscribing to *National Geographic*. All of these practices are symptoms of a system of global cultural capital – that is, they correspond with the consumer's class and educational status, and they are intended to convey an alleged knowledge of and familiarity with the world, or 'world-liness.'[28] In the information age, there is a tendency to imagine the computer as a catch-all replacement for such practices, for it is often fetishized as the capacity to place the entire world in one's fingertips or palm. Now there are entire lines of computer products that are even named after the hand such as Palm Pilot and Handspring. Such brands are designed not only to celebrate users' mobility, but also to construct users' manipulation and control of the world by referencing to the hand.

Still, what is interesting about the Digital Earth is that it re-articulates cyber and satellite visualities as the domain of citizens' hands rather than that of military officials' and scientific experts' eyes. In other words, these interfaces transform satellite images into tactile fields of public cultural engagement. This in itself is significant since for decades they have been under the exclusive purview of the state, scientists, and corporations. Thus, while the user interface design of the prototypes may privilege national and corporate imperatives and work to legitimate them, the Digital Earth is one of the only federally sponsored websites that structures public access to satellite images as a cultural experience. These prototypes are particularly unusual as sites of public culture because they combine satellite vision and inter-activity, and this combination of practices, which amounts to a kind of 'ground control,' has historically been beyond public reach.

The problem, of course, is that satellite vision in these sequences is rendered so seamlessly with other perspectives that it can hardly be recognized as such. The

orbital gaze is obscure as it becomes part of a more generalized cyber-visuality in which multiple views from different apparatuses are undetectably combined in a sequence of fluid motion. Both of these prototypes mix various media formats and visualizing practices including satellite imaging, aerial photography, digital animation, mapping, and 3D modeling within the same viewing experience yet because of digitization the differences between them are invisible. In this sense, the Digital Earth is an appropriate site to consider what Nicholas Mirzoeff refers to as 'intervisuality' – that is, the practice of thinking and analyzing across and between media rather than focusing upon the unique properties of each medium. Moreover, the visual hybridity of the Digital Earth suggests the need for new theories of spectatorship which take account of the growing overlap of vision and navigation. Increasingly, we see not just to take in the view, but also to locate or orient ourselves whether with browsers in digital environments or GPS receivers in physical terrains. Certainly this relationship between vision and mobility will be further compounded with the emergence of new wireless screens, which enable multimedia viewing in transit.

Technological convergences provide useful opportunities to re-evaluate existing media theories. In this case, we might reconsider, for instance, whether the radical potential of interactivity suggested by George Landow is as progressive as he imagines if one is 'reading' a Digital Earth with only sanitized accounts of the past, or whether Anne Friedberg's 'mobilized virtual gaze' is truly mobile or virtual if it lands only in themuseums and vaults of Western culture, or if Jody Berland's post-panoptic observer (of the satellite perspective) necessarily reinforces the visual privilege of Western states and corporations if it exposes events that call their authority and/or policies into question. The satellite vantage point – what I call the orbital view – and the Digital Earth's recirculation of it are important because they embed a cultural politics of self-reflexivity, re-viewing, and positionality within the social construction of technologies that are seemingly so 'omniscient' and 'objective.' In some cases the orbital view can provide an unearthly platform from which to evaluate and complicate the truth status of what appears in the frame; it can lead to cultural excavation or infusion of the world's chaos and complexity. But when it is combined so seamlessly with other views and perspectives (some of which do not even exist since they are digital composites) its critical potential diminishes. In the Digital Earth, the orbital gaze becomes the originary point for a tunnel vision made possible by the digital zoom. It is not used to elicit interpretation of what appears in frame, but rather to trigger the user's desire to get closer to the earth and hone in on a given object or site.

In the Digital Earth's transitions from orbit to the ground, views and places morph into one another. The details and specificities of positioning and production are sacrificed for smooth vision. As Vivian Sobchack suggests, however, the morph 'makes formally visible the very formlessness at its center' and in doing so 'also makes visible our national and political sense that although there is power, there is no center, that centers no longer have substance (at least as we once believed).'[29] This smooth vision from orbit to the Washington Monument or SRI headquarters can be read as symptomatic of the deterritorialization of power in the context of globalization and digitization. To reassert their power (or to centralize themselves) within this context, the state and the corporation must reinvent themselves in digital

forms and from global views. In the Digital Earth, they simulate themselves as their most symbolic material form (the national monument and the research headquarters) and use satellite vision to convey their global presence, as if the monument and the lab were popping out of the planet to greet the orbital gaze.

Such cyber visualities not only conceal the complexity, unpredictability, struggle and trauma in the world, they suppress the gargantuan apparatus which includes the launching of satellites, the formation of high-speed networks, the development of rendering and animation software, the digitization of visual and sound archives, and the creation of servers. Indeed, satellite and computer technologies are combined in the Digital Earth to interpellate a spectator/user with immense visual capital. By visual capital, I am referring to a system of social differentiation based upon users'/viewers' relative access to technologies of global media (whether satellite television relays, satellite images of the planet, computer models of the earth, or access to the world wide web). This concept technologizes and globalizes Pierre Bourdieu's term 'cultural capital' to consider how the globalization of media technologies and culture has established hierarchies of knowledge/power and modes of social differentiation based on peoples' relative access to screen interfaces and imaging technologies.[30] For in an age of technologized vision, how, what, and when one sees/knows increasingly determines one's place within a broader system of power relations. We need to consider what it means for one nation or one individual to be able to access and control over so many modes of visual representation. For while projects like the Digital Earth claim to offer global visual mobility for all, they are designed and structured in ways that suppress *most worldviews* in the interest of promoting and preserving US digital capitalism. This is especially problematic since technologized vision of the world has come to stand in for knowledge itself. As a result, education, socialization, and economics are increasingly tied to the screen, reinforcing assumptions that the world that is 'screened' is the one that is 'known.' While this may greatly oversimplify processes by which knowledge and culture are acquired by privileging the visual sense above all else, it is in part because of the scientific rationalist quest to control the globe through vision that global cultural capital now accrues in such a way.[31]

Indeed, the very capacity to imagine a Digital Earth is symptomatic of the immense visual capital of the US. It has enormous reserves of satellite image data collected for decades over the skies of sovereign nations usually without their permission or consent. It has national and corporate archives of photography, motion pictures, television, maps, and other visual materials. It has commercial television and telecommunications networks that stretch around the planet. In this sense, we might pose the question, can we be sure that the Digital Earth will in the long run differ from an unlikely bedfellow like Planet Hollywood? Is the Digital Earth the Hollywood-ization of scientific visualization?

The Digital Earth as a 'contact zone'

A contact zone, according to Marie Louise Pratt, is an ambivalent space that, on the one hand, offers perspectives of 'copresence, interaction, interlocking understanding and practices,' and, on the other hand, is a site of tension where 'disparate

cultures meet, clash, and grapple with each other.'[32] In cultural studies the phrase has been adopted to encourage interdisciplinary critical thinking. I want to briefly address the issue of interdisciplinarity. And I want to do so by calling for the emancipation of the Digital Earth from the tight grip of the state, the corporation and the science lab. Since Gore announced the Digital Earth initiative in 1998, it has also been influenced by the Earth Sciences Enterprise, a NASA working group (and a scientific discipline) that imagines the planet as an integrated system that can be seen, studied and managed using satellite observation and computer models. The Digital Earth has been described by NASA's office of Earth Science as a 'collabatory – a laboratory without walls for research scientists seeking to understand the complex interaction between humanity and our environment.'[33] Earth Sciences, perhaps best exemplified by NASA's Mission to Planet Earth program, emerged over the past three decades alongside new satellite and computer technologies and the global environmental movement. The aim of earth system science is to use satellite data to 'build a comprehensive predictive models of the earth's physical, chemical, and biological processes.'[34] These models can then be used to study large-scale earth systems and to better predict and manage these processes in the present and future. In her critique of earth observation, Karen Litfin warns, 'The earth system science view of global change highlights atmospheric physics, geophysics, and chemistry, thus rendering human beings virtually invisible . . . human agency vanishes and global change is reduced to physical processes. . . . '[35] I want to suggest that precisely because humans only appear in satellite images abstracted as heat/light frequencies or as tiny dots in vast landscapes, it is imperative that we cultural/media studies scholars critically examine their use. What does it mean for earth scientists to be producing knowledges about the global environment and managing the planet without seeing people as anything more than myriad shades of red in an infrared satellite image?[36] We need to retrain our eyes to see the human in these abstractions and to use such images to bear witness to world events such as those in the former Yugoslavia and Central Africa, particularly since Western states have looked the other way. If the Digital Earth is to become a useful global database, it should register a range of events seen via satellite, not just pretty green forests and indigo oceans.

Although satellite earth observation has occurred for several decades, only recently have these images been made available to the general public. Now, in addition to the Digital Earth, commercial satellite operators such as Orbimage and Earthwatch, state agencies such as NASA, USGS, and GIS, and public interest groups such as the Federation of American Scientists (Public Eye project) and Remote Sensing.org make satellite images of the planet available on the internet. John Pike of the Public Eye project, a public interest organization, recently purchased satellite images of political 'hot spots' and held press conferences designed to contest official US state knowledges and policies about certain areas including nuclear facilities in Pakistan, Chinese bombers faced toward Taiwan, and Area 51 in New Mexico. This is a major transformation since for decades satellite images have only been seen by the eyes of state intelligence officials, scientists and natural resource developers. As argued earlier, the Digital Earth project, then, represents the possibility of expanding public access to satellite information that has long been restricted. The viability of such a project, however, will depend on whether new forms of

visual literacy are also made available. Will the Digital Earth interface actually encourage and require users to understand how to read and interpret satellite images? Or will it pigeonhole the user into US national monuments and corporate science labs?

The project's viability will also be contingent upon its inclusion of nations and peoples from around the world and its involvement of those in the arts and humanities. In any project that makes claims to represent the world, it is important to consider how many developing countries have been invited to contribute to and help design the Digital Earth. In the 1960s, Western leaders promised to use satellites to create a 'global village' but ended up using them in ways that reinforced global inequalities, carving the earth into spheres of north and south, developed and underdeveloped, and fast and slow. Although the Digital Earth community has held meetings in China and Canada to 'promote awareness' of the project, it is still unclear how leaders, scientists and companies from outside the US will participate in its development. This is especially important since the project involves establishing new digital standards and architecture for the next generation of the global information economy.

It is also crucial that the Digital Earth's leaders recognize the need to form partnerships with those in the digital arts and humanities who for decades have been creating interfaces, hypertexts and visualizations, as well as historical and critical interpretations, while scientists and engineers have been developing computer applications. The only participant from an 'entertainment' perspective that has been invited to the Digital Earth planning meetings is CBS TV's Dan Dubno. Dubno has discussed the project's usefulness to television, claiming 'As the Digital Earth emerges, broadcast and webcast journalists will have vast sources of new and current information to better inform the public.'[37] While Dubno encourages project leaders to 'avail themselves of the experience broadcasters have had in presenting geographically referenced information in clear and compelling ways,' these broadcasters are situated within institutions that pressure them to find ways to make network television news coverage more profitable.

Simply put, there is not enough interaction between those in the arts and humanities and those in the sciences; and if there ever was a project that should work through this dividing line it is the Digital Earth. The project could become a contact zone to foster intellectual interdisciplinarity and collaborative work across the science/culture divide. It would be fascinating, for instance, to see an interdisciplinary scholar such as Peter Redfield, whose book *Space in the Tropics* offers an eclectic anthropology of outer space technologies, tropical imaginaries and colonialism in French Guiana. Redfield provides an analytical model he calls 'thinking through the world,' reminding us that 'carefully positioned, theoretically informed description brings into view objects that are otherwise too often lost between the fault lines of knowledge.'[38] Constance Penley is another interdisciplinary scholar who engages with culture/science issues in her clever book *NASA/TREK*, which provides framework for complicating scientific 'takes' on the world using television fiction and fandom.[39] Finally, in their book *Cosmodolphins*, Danish feminists Mette Bryld and Nina Lykke use the cyborg metaphor to analyze the entangled stories of space flight, New Age spirituality and dolphin mythology.' which they read 'as significant post-World War II narratives of quests for a wild elsewhere.'[40]

Such scholars, who have spent years 'thinking through the world' in provocative and imaginative ways, would have much to contribute to the content and form of the Digital Earth.

Perhaps the Digital Earth should not only include 'objective' maps and satellite images, but with growing consumer uses of digital photography, video and GPS, it could include digital diaries, home pages and what I have called 'personal plots' as well.[41] GPS and video can be used to display the politics of positionality, as a means of storytelling, and to map embodied experience. In this digital age when the past, present and future or global, national, and local can be seamlessly collapsed into a digital morph, personalized media, mapping, and description become important means of contesting official representations of space which often suppress the historical and the social. Furthermore, why should the Digital Earth project not include (and even fund) works such as Swiss artist Ursula Biemann's digital video 'Remote Sensing,' which uses satellite imagery as a way of examining the global sex trade in parts of the world ranging from South America to eastern Europe, or Slovenian artist Marko Pheljan's project, makrolab, which is a globally migrating installation and experiment in telecommunication, meteorology and data collection? Why should the Digital Earth's user interfaces and visualizations be designed by corporate leaders and scientists rather than artists? The challenge of the Digital Earth is ultimately that of interdisciplinarity: Will the scientists and corporate executives invite the arts and humanities to be part of the digital future?

Given the imperialistic potential of the Digital Earth project, we need more cultural criticism, public debate and media activism around satellite and computer technologies. Long perceived as nothing more than relay towers in outer space, satellites are now used in the production of at least four forms of media: satellite broadcasting, remote sensing, astronomical imaging and GPS mapping. We need to use these forms of visual culture to engage more carefully with (and in some cases contest) 'objective' and 'official' knowledges that are produced and circulated via satellite but that often neglect public interests (even though they are subsidized in one way or another by taxpayers). What the Digital Earth claims to add to earth sciences is 'world culture' and 'world history,' but to do so it must incorporate those from the arts and humanities. Perhaps Gore's vision of the Digital Earth project is so provocative because it posits a synthesis of earth sciences and earth culture (and this is a challenge that scientists and humanists have had a hard time reconciling). Unless those at the helm of the project open dialogues across disciplines, the Digital Earth runs the risk of reducing the planet's hybridity and complexity to a series of smooth and antiseptic digitized domains that can be folded within corporate and scientific practices geared toward greater planetary management and control. How will we be sure that the differences and contradictions of the world's cultures and histories are incorporated in the Digital Earth if it is guided by such a model? As Armand Mattelart reminds us, 'The globalization of image flows has no democratic virtue in itself; it only acquires it if individual participation is not limited to the role of voyeur of the world and its great social imbalances.'[42] We need to imagine the Digital Earth as a 'contact zone' for cultural studies and earth science – to mobilize playful semiotic practices, interpretations, and alternative visions within these digital domains, to disrupt its tendency to produce the 'vertigo of a flawless world.'[43]

Note: Earlier versions of this paper were presented in 2000 at the International Cultural Studies Conference in Birmingham, England; the Global Visual Cultures Conference at the University of Wisconsin-Madison, and the Gendering Cyberspace Conference in Odense, Denmark. I would like to thank Anil de Mello, Nicholas Mirzoeff, Nina Lykke, Rosi Braidotti, Mischa Peters, Ursula Biemann, and Wolfgang Ernst for providing thoughtful comments, helpful insights, and encouraging words.

Notes

1 Paul Edwards, *The Closed World Computers and the Politics of Discourse in Cold War America,* Cambridge, Mass.: MIT Press, 1996, p. ix.

2 Edwards, p. 7.

3 As satellites were launched during the 1960s, scientists and military strategists were busy designing and building what was then known as the Advanced Research Project Network or Arpanet. Janet Abbate's account of the origins of the Internet suggests that the project was designed to 'favor military values, such as survivability, flexibility, and high performance over commercial goals, such as low cost, simplicity, or consumer appeal.' Janet Abbate, *Inventing the Internet,* Cambridge, Mass.: MIT Press, 1999, p. 3. Satellites were designed with the same kinds of imperatives.

4 See Lisa Parks, 'Technology in the Twilight: A Cultural History of the First Earth Satellite,' *Technology and Humanities Review,* Fall 1997.

5 Although satellites and computer networks have distinct institutional, technical, and socio-cultural histories, it is important to consider their parallel development. The internet is now used to track the location of satellites in orbit and it has become the most widely used means of accessing satellite images of the earth and outer space. Satellites are now used to link different parts of the world wide web, and satellites will be a key means of datastreaming with the full-scale development of broadband and wireless technologies in the next 5–10 years. Further, a host of internet start-ups have emerged to capitalize on the commercialization of the Internet and satellite technologies including Earthwatch and Orbimage. For further discussion of this relationship see Gary Dorsey, *Silicon Sky: How One Small Start Up Went Over the Top to Beat the Big Boys into Satellite Heaven*, Reading, Mass.: Perseus Books, 1999, in which he explains the formation of Orbital – a satellite company designed for the computer age.

6 Jodi Dean, *Aliens in America: Conspiracy Cultures from Outerspace to Cyberspace*, Ithaca: Cornell University Press, 1998, p. 68.

7 'The Digital Earth,' http://www.digitalearth.gov/, accessed on June 5, 2000.

8 Al Gore, 'The Digital Earth: Understanding Our Planet in the 21st century,' speech at California Science Center, January 31, 1998. Available at http://digital earth.gsfc.nasa.gov/VP19980131.html, accessed on June 13, 2000.

9 Bryant Jordan, 'Digital Earth Lives On,' FCW.com, March 12, 2001, available at http://fcw.com/fcw/articles/2001/0312/pol-diearth-03-12-01.asp, accessed on July 17, 2001.

10 Lisa Parks, 'As the Earth Spins: NBC's *Wide Wide World* and Early Live Global TV,' *Screen,* winter 2001.

11 Al Gore, op. cit.

12 The Corona Project was a top-secret US spy satellite project that began in 1958
 and continued through 1972. Many Corona satellite photos were declassified in
 1995 by the Clinton administration. For further discussion of the Corona Project
 see, Curtis L. Peebles, *The Corona Project: America's First Spy Satellites*, US Naval
 Institute, 1997; and *Eye in the Sky: The Story of the Corona Spy Satellites,* Dwayne
 Day, John Logsdon, Brian Latell (eds), Washington DC: Smithsonian Institution
 Press, 1999; and Cloud, J.G. and K.C. Clarke, 'Through a Shutter Darkly: The
 Tangled Relationships Between Civilian, Military, and Intelligence Remote
 Sensing in the Early American Space Program,' in *Secrecy and Knowledge Production,*
 Judith Reppy (ed.), Ithaca, New York: Cornell University Press, 1999. Also see,
 geographer Keith Clark's Project Corona website: http://www.geog.ucsb.edu/
 ~kclarke/Corona/Corona.html. The history of the Corona Project has also been
 the subject of documentaries aired on the Discovery Channel including *Eye in the
 Sky,* 1997.

13 Al Gore, op. cit.

14 In such ads, Nakamura continues, 'Travel and tourism like networking tech-
 nology, are commodities that define the privileged, industrialized first-world
 subject, and they situate him in the position of the one who looks, the one who
 has access, the one who communicates.' Lisa Nakamura, '"Where Do You Want
 to Go Today?" Cybernetic tourism, the Internet and Transnationality,' in *Race in
 Cyberspace*, eds Beth E. Kolko, Lisa Nakamura, and Gilbert B. Rodman, New York:
 Routledge, 2000, p. 17.

15 Ibid., pp. 21–2.

16 Dan Schiller, *Digital capitalism: Networking the global market system,* Cambridge,
 Mass.: MIT Press, 1999, p. 205. For a critique of Gore's 'Information Super-
 highway' concept see, Herbert I. Schiller, 'The Global Information Highway:
 Project for an Ungovernable World,' in *Resisting the Virtual Life: The Culture and
 Politics of Information*, San Francisco: City Lights Books, 1995, pp. 17–33.

17 Schiller, p. xiv.

18 Speech by Al Gore, 'Our Mandate For Change,' 1998. Cited in Foresman.

19 Digital Earth Prototypes, available at http:www.digitalearth.gov/prototypes.
 html, accessed on June 13, 2000.

20 Tim Foresman, NASA Office of Earth Science, 'Digital Earth Vision: Formulating
 a Blueprint for the Future,' paper presented at Digital Earth Community Meeting,
 January 12–13, 2000, Santa Barbara, California.

21 Personal interview, SRI headquarters, May 1999.

22 SRI FAQs, available at http://www.sri.com/strength/facts.html, accessed on
 June 21, 2001.

23 SRI International homepage, available at http://www.sri.com/, accessed on June
 21, 2001.

24 Ibid.

25 Deborah Kreuze, 'Think Globally, Act Digitally,' *Technology Review*, March/April
 1999, available at http://www.techreview.com/articles/ma99/benchmark1.
 htm, accessed June 13, 2000.

26 Foresman, op. cit.

27 I use the term deterritorialization in this context to invoke the meaning devel-
 oped by Deleuze and Guattari. Deterritorialization involves detachment from
 place as a way of dislocating (if temporarily) state and corporate power. For
 further discussion of the (multiple meanings of the term deterritorialization see,

Gearóid Ó Tuathail, 'Borderless Worlds? Problematizing Discourses of De-territorialization,' in *GEOPOLITICS*, 4 (2), 2000, Also available at: http://www.majbill.vt.edu/geog/faculty/toal/papers/Borderless.htm, accessed on June 20, 2001.

28 The National Geographic Society has in fact supported the Digital Earth with $5-10 million; see Foresman.

29 Vivian Sobchack, cited in Edward Branigan's 'Narrative Futures.'

30 For a discussion of cultural capital, see Pierre Bourdieu's *Distinction: A Social Critique of Judgment and Taste,* Cambridge, Mass.: Harvard University Press, 1987.

31 In the late twentieth century, technologized vision of the world has come to stand in for knowledge itself. As a result, practices of education and socialization are increasingly tied to the screen, reinforcing assumptions that if the world is 'screened' it is 'known.' While this may greatly oversimplify processes by which knowledge and culture are acquired by privileging the visual sense above all else, whether we like it or not it is increasingly through the realm of the visual that cultural capital accrues.

32 Mary Louise Pratt, *Imperial Eyes: Travel Writing and Transculturation*, London: Routledge, 1992, p. 7.

33 Foresman, op. cit.

34 Cited in Karen Litfin, 'The Gendered Eye in the Sky: A Feminist Perspective on Earth Observation Satellites,' *Frontiers*, 18(2) (May–August, 1997), p. 26.

35 Ibid.

36 This is of course changing, however, because of higher image resolution and also because of different uses of satellite images ranging from refugee relief efforts to 'crime mapping.'

37 See, for instance, Dan Dubno, 'Towards a Digital Earth,' http://www.cbsnews.com/now/story/0,1597,71237-412,00.shtml, accessed on June 2, 2000.

38 Peter Redfield, *Space in the Tropics: From Convicts to Rockets in French Guiana*, Berkeley: University of California Press, 2000, p. xv.

39 Constance Penley, *NASA/TREK: Popular Science and Sex in America*, London: Verso, 1997.

40 Mette Bryld and Nina Lykke, *Cosmodolphins: Feminist Cultural Studies of Technology, Animals and the Sacred*, New York: Zed Books, 2000, p. 8.

41 Lisa Parks, 'Plotting the Personal: Global Positioning Satellites and Interactive Media,' *Ecumene: A Journal of Cultural Geographies*, 8(2), 2001, pp. 209–22.

42 Armand Mattelart, *Mapping World Communication*, Minneapolis: University of Minnesota Press, p. 3.

43 Jean Baudrillard, *Simulations*, New York: Semiotext(e), 1983, p. 63.

PART TWO

Spectacle and display

Introduction to part two

■ Nicholas Mirzoeff

I N 1967 G U Y D E B O R D named Western modernity as the 'society of the spectacle' (Debord), highlighting the new prominence of media and advertising in what Marshall McLuhan had just termed the 'global village.' The spectacle was analyzed in certain of its component parts by other intellectuals of the period. The sociologist Pierre Bourdieu looked at museum displays and exhibitions in 1960s France and concluded that, far from making culture available to all, they generated further 'cultural capital' for the social elite. Other groups stayed away from museums from which they felt excluded. And Michel Foucault added to the spectacle and display his notion of surveillance, the means by which modern societies both controlled their mass populations and improved them. For example, any consideration of the chaos caused by unregulated traffic in early twentieth-century cities makes the current mass of signs, rules and regulations seem actively desirable by contrast. A quarter of a century after this analysis of the spectacle was formed, it can be said that while contemporary society is still certainly centered around the spectacle and display, the older modes of analyzing it are no longer quite adequate. In the case of museums, when museum blockbuster shows attract crowds running into the hundreds of thousands on a regular basis, and over a million in some cases, either the museum is now part of popular culture or the social elite has vastly expanded. Unsurprisingly, such a dramatic shift has attracted the attention of some leading cultural theorists, such as Toby **Miller**, Andrew **Ross** and Michele **Wallace**, whose work is represented here. At the same time, the disciplinary surveillance of the modern period has given way to the indifferent automated recordings of video and webcamera, while the key media of display – film and television – have been radically reconfigured by globalization and digital culture. Thus, when those formed by the visual theory of the 1970s object that they have already done what visual culture is seeking to do, both sides are right. It has been done before, but the nature of spectacle and the

means by which it has displayed have changed in form, content and context, requiring that it be done again.

(a) Spectacle, display, surveillance

Following Foucault, it has become common for historians of museum culture to compare the establishment of museums to that of disciplinary institutions, like prisons and asylums, at the general level. Here Toby **Miller** directly interweaves his study of the Fremantle Prison Museum in Australia with the legendary Frederick Wiseman documentary *Titicut Follies* that detailed life in a Massachusetts insane asylum. Miller describes his method as being 'to crosscut between film and museum,' following Wiseman's practice of making '"an editorial point in the spirit of expository cinema" rather than allowing "events to unfold according to their own rhythm."' Miller treats his writing like film, cutting back and forth and allowing his audience to make their own judgment of his work. Wiseman's film was both praised for its implied criticism of state policy and attacked for invading the privacy of the inmates, something that the panoptic institution does as a matter of course. Miller compares the difficulties encountered by Wiseman in having his film shown in public with the repackaging of a former prison as a museum site, departing from the historical coincidence that both prison and asylum were constructed around the same time in the 1850s. But far from limit himself to a simple one-on-one comparison, Miller finds six headings under which to interpret a crucial sequence in the film and then the prison museum, ranging from the religious to the cosmetic and exhortatory. Where the law tries to fix single meanings, the cultural critic multiplies them.

In her essay 'Visual Stories,' Ann **Reynolds** examines the means by which museums sought to educate their audience into a certain form of looking that has interesting analogies with popular culture. The mass media and museums combined to teach post-war consumers in the United States into making 'extra-visual leaps' to explain what they saw. Venues as apparently distinct as the Museum of Natural History in New York City and magazines aimed at young girls like *My Weekly Reader* taught their viewers to translate 'visible differences into markers of information that were literally invisible.' Reynolds details how Alfred Parr redesigned the Museum of Natural History from 1946 onwards into a form of scientific show-and-tell, guiding the visitor through a series of dioramas and display cases to build up a mental 'picture' of the usually unseen workings of nature.

By contrast to Reynolds' interplay of the personal and the professional, Andrew **Ross** examines 'the use of statistics to organize moral and political dissent in general, and to make arguments about selection and representation in exhibitions in particular.' Ross draws on the well-known case of the Guerrilla Girls, a group of anonymous activists wearing gorilla masks, who publicize statistics regarding the numbers of people of color and women in given exhibitions and galleries, to examine the strengths and weaknesses of judging visual culture by the numbers. There is an inherent tension in contemporary museums between the current desire to justify the

existence of museums by attendance figures and the traditional notion that art should edify a cultural elite. At the same time, statistics are a crucial and contested feature of American life, especially in the area of affirmative action. Ross notes that 'the Guerilla Girls numbers have been taken as a direct assault on the traditions of connoisseurship.' These numbers speak to a certain 'vision of cultural justice,' while also necessarily evoking the 'quantitative mentality of modern bureaucracy.' Ross highlights the dilemmas of the museum as a public institution in an era of privatization and suggests that the traditional defense of 'artistic freedom' should be set aside in favor of an effort fully to democratize the museum. As government loses interest in culture, 'the larger task will be to create and promote new versions of the "public" that are inclusive, that have popular appeal, and that are elastic enough to accommodate the vast energies of a strong democracy of opinion.'

Certainly specific locales have been able to create such a public. Marita **Sturken**'s study of the Vietnam Veterans Memorial, adapted from her important book *Tangled Memories*, shows how the Wall has become the focus of 'a contested form of remembrance' for issues as diverse as the war, modernist sculpture, race and gender (Sturken 1997). She shows that Maya Lin's wall of names was initially perceived as a 'black gash of shame,' a comment in which 'a racially coded reading of the color black as shameful was combined with a reading of a feminized earth connoting a lack of power.' Consequently, the realist sculptor Frederick Hart was commissioned to create a rival monument to the soldiers that in turn led women service personnel to dedicate a Vietnam Women's Memorial. In time, however, the Wall has now come to be the most popular tourist destination in Washington, a place where 'visitors can speak to the dead (where by implication the dead are present).' These visitors often leave flowers or mementoes, or take rubbings of individual names, turning the Wall into an altar. This remembering is also a 'form of forgetting' as there is no mention of the three million Vietnamese who lost their lives in the war. This blind spot is not accidental but a necessary part of the successful American memorial.

The concluding two essays in this section thus highlight the importance of 'race' and its representation in surveillance and display in the contemporary United States. In her essay 'The Prison House of Culture,' Michele **Wallace** pursues a crucial example of this more inclusive public by looking at the problems inherent in any display of art or visual materials from formerly colonized nations, in this case from Africa. It is difficult to find non-judgmental language to express this concept given that, as Wallace notes, 'the practice of African art discourse, to the degree that such a thing could be said to exist, had been plagued by Eurocentrism, phallocentrism and solipsism.' In the West, the problem of what constitutes an art object has largely been elided by the self-fulfilling condition that anything displayed in an art gallery or museum can be considered art. But Manthia Diawara has argued that museum display displaces the conceptual possibility of black modernity in the lifeless display of objects in antiseptic cases. In the new Sainsbury galleries of African art at the British Museum, for instance, objects are arranged solely by materials so that fabrics or pottery from vastly different cultures and traditions are placed next to each other for a comparison that is as meaningless as it is unrewarding. Wallace wants to reclaim the objects from both the modernism crowd

and the anthropology constituency, arguing instead for what she calls: 'the myriad signs that "difference" is finally irreducible.' Taking the traveling 1995–96 exhibition *Africa: The Art of a Continent* as a case study, Wallace deftly locates the show in a weave of museological, art historical and personal discourse to argue that:

> European modernism was not just a matter of inanimate African art objects, violently kidnapped and forced into the unempathic cultural context of the ethnographic museum. The importation of African cultural values was part of the picture as well, facilitated by the presence of African bodies and the will of the African spirit.

The challenge here is as multiple as the mix Wallace examines – to rethink modernism, museum display, the nature of the art object and perhaps above all to put living bodies back into the questions.

In his essay 'Videotech,' John **Fiske** considers the racialized parameters of the video surveillance culture that has come into being in the United States. He notes that technology may in itself be neutral but in a given context it takes on new meanings so that, for example, 'video works particularly effectively in the monitoring of race relations.' The efficiency of computers in tracking data means that our patterns of consumption, once held up by theorists like Michel de Certeau as an unknowable point of resistance, are now entirely transparent. However, Fiske argues that the new surveillance is far from neutral: 'Surveillance technology enhances the construction of whiteness as the space from which the other is viewed.' Drawing a distinction between 'videohigh' technology that is ultimately suspect because it may have been manipulated and 'videolow' that is perceived as authentic precisely because of its poor quality – like George Halliday's famous video footage of Rodney King being assaulted by the LAPD – Fiske correctly anticipated that the rapid spread of the medium would eliminate this margin of disciplinary error. In the 2001 Australian election campaign, much turned on the coalition government claim that a group of asylum seekers had deliberately thrown their children in the sea in order to compel the Australian Navy to rescue them. Such people, it was argued, did not deserve asylum. After much delay, a grainy video was produced that provided no evidence whatsoever for this claim. Various extra-visual arguments were adduced, such as a threat to throw in the children, and far from damaging the government, the return of this issue to prominence ensured its re-election. Videolow has been disciplined in its turn. None the less, Fiske argues that 'the handheld home video camera has a mobility that makes it a good guerilla weapon' and if a video had been taken by the asylum seekers, it would certainly have set up an interesting counterpoint. The next section will develop this line of thought by examining how spectacle is displayed in the era of digital media.

Further reading

Bennet, Tony (1996) *The Birth of the Museum: History, Theory and Politics*, London and New York: Routledge.

Bourdieu, Pierre (1987) *Distinction: A Social Critique of the Judgment of Taste*, Cambridge, Mass.: Harvard University Press.

de Certeau, Michel (1984) *The Practice of Everyday Life*, Berkeley and Los Angeles: University of California Press.

Diawara, Manthia (1992) *African Cinema: Politics and Culture*, Indianapolis: Indiana University Press.

Duncan, Carol (1995) *Civilizing Rituals: Inside Public Art Museums*, London and New York: Routledge.

Fiske, John (1996) *Media Matters: Race and Gender in US Politics*, Minneapolis: University of Minnesota Press.

Foucault, Michel (1977) *Discipline and Punish: The Birth of the Prison*, New York: Vintage.

Miller, Toby (1998) *Technologies of Truth*, Minneapolis: University of Minnesota Press.

Ross, Andrew (1998) *Real Love*, New York: New York University Press.

Ross, Kirsten (1995) *Fast Cars, Clean Bodies: Decolonization and the Reordering of French Culture*, Cambridge, Mass.: MIT Press.

Sturken, Marita (1997) *Tangled Memories: The Vietnam War, the AIDS Epidemic and the Politics of Remembering*, Berkeley and Los Angeles: University of California Press.

Wallace, Michele and Dent, Gina (1999), *Black Popular Culture*, New York: New Press.

(b) Cinema after film, television after the networks

One of the most striking aspects of the present moment in visual culture is the convergence of formerly distinct visual media and practices caused and enabled by digital technology. What is still called film, for example, is increasingly likely to be seen either on video or DVD. Film editing and post-production is now almost entirely digital in Hollywood, with the final step being a transfer back to film. In 2000, the animated feature *Titan AE* was screened at its premiere as a broadband download off the internet. The most recent episode of the *Star Wars* series was shot by George Lucas on new Sony digital cameras. In similar fashion, digital media are taking over photography. An experimental digital camera has produced images with a higher resolution than traditional film, even as consumers are turning to digital point-and-shoot cameras for the conveniences of home printing and editing. Television has radically changed in the West since the introduction of cable and satellite television ended the dominance of the traditional networks. These new delivery systems are also bringing television to global audiences. The Star satellite, for example, allows Rupert Murdoch's News Corporation to provide television pictures to China and East Asia, an audience so vast that the broadcaster is more than happy to exchange for editorial control over news content. Prior to the technology crash of 2000, it seemed likely that television and film would also migrate

to the internet. The web has become an important location for alternative film, with sites like adam.com offering a wide range of independent shorts. Television came and went from the net with the boom but it is clear that television's conception of itself has been changed by the web. Now news programs, for example, use the screen like a web page, offering text and graphics to supplement the familiar alternation of talking heads and location reports. Videophones and portable satellite links have also offered new possibilities for reporting that skirt the operations of national censors.

In this quickly changing context, what does it mean to study 'film' or 'new media'? What are the implications both for academic structures and research of these changes and what kind of new histories do we need to have in order to account for them? The essays in this section open some routes into this emerging network. Anne **Friedberg**'s important work has shown that visual convergence is not simply a digital effect but rather a phenomenon with a long and complex history. In this extract from her pioneering study *Window Shopping: Cinema and the Postmodern* (1993), Friedberg sets the late nineteenth-century 'frenzy of the visible' that has long been identified as a key agent of the invention of cinema in the context of 'the historical framework of precinematic mobile and virtual gazes.' She begins this study by a reading of Foucault's theory of panopticism. She notes that the cinematic spectator has often been compared to the powerful jailer of the panoptic system who sees without being seen, but highlights the 'limited and preordained scope' of this spectatorship, which confers only an '*imaginary* visual omnipotence.' For whereas the jailer is in fact in charge of the prison, the film spectator has historically been unable to affect the image in any way. Friedberg suggests that now-forgotten technologies such as the panorama and diorama aimed to give the observer a sense of 'virtual spatial and temporal mobility' by creating a powerful illusion of travel and movement to other countries and time periods. As these technologies advanced a paradox was created that 'as the "mobility" of the gaze became more "virtual" . . . the observer became more immobile.' The special effects of the diorama and ultimately the cinema required a static observer, who deployed what Friedberg calls the 'mobile virtual gaze' in order to have 'visual mastery over the constraints of space and time.' No such manipulation was possible within the panopticon. So while both panoptic and dioramic (cinematic) systems required immobility, only the latter added 'a notion of journey' to that of confinement.

In his well-known essay 'What Is Digital Cinema?', first published in 1995 and revised for this volume, Lev **Manovich** similarly locates film as being the creation of 'the same impulse which engendered naturalism, court stenography and wax museums,' that is to say, the documentation of reality. Manovich argues that the digital manipulation of film is similar to pre-cinematic practices in which images were painted or otherwise hand-manipulated. Provocatively, he suggests that 'cinema can no longer be clearly distinguished from animation.' Western cinema as a practice did everything it could to distance and distinguish itself from the evidently artificial processes of animation. One could contrast here the Western attempt to blend special effects as seamlessly as possible into the narrative with Indian cinema's open artifice in its representation of the divine. Digital cinema, by contrast, creates

a new realism in which we are shown things that look as if this was exactly what happened, even though we know it to be impossible. Further, the technical processes of editing, filming and generating special effects are now all collapsed by the computer into different versions of 'cut and paste.' Manovich argues that cinema originated in animation, pushed it away during the 'classic' cinema period, only to now become nothing more than a sub-set of animation. While the visual format of cinema has remained that of photography, digital cinema has evolved new formats such as the music video and computer games that do not adhere to the realism of photography. Intriguingly, recent films like *Lara Croft: Tomb Raider* (2001) have brought this new visual field back into cinema, suggesting that the loop is now folding back on itself.

Acknowledging a debt to Friedberg, Lisa **Cartwright** asks what might happen to the academic practice of film studies in this era of digital convergence. She queries whether film studies is 'really about the study of film,' suggesting that it has 'always been as much about the experience and conditions of duration, spatiality, perception, attention and sound in modernity as it has been about film images.' Cartwright cautions that a comparative approach, following the ongoing conver-gence of media, does not in itself 'give us the tools to make sense of the constellation of images and looking practices it generates.' For example, ultrasound is used to create images, colliding data from different senses into a new form. Arguing for a complex understanding of the virtual and the sensual, Cartwright suggests that the 'obvious visual-ness of the cinema distracts us from the fact that the medium has trained us in a sensory disintegration that makes the virtual possible as fundamen-tally *not* visual experience.' She pursues this idea through a fascinating discussion of medical imaging that implies that the key nexus of what is being called visual culture is not the image itself but the networked intersection between the technology, the user and the object being viewed.

These intersections do not take place in the abstract space of 'spectatorship' but in specific locales that reconfigure the uses of any given image. In a remark-able essay, May **Joseph** examines the transnational impact of Bruce Lee and kung–fu cinema in the context of 1970s state socialism in Tanzania. In Tanzania at that time, the philosophy of *ujamaa* or self-reliance found an unexpected counterpoint in the self-reliance endorsed by kung-fu movies. In this moment the urban tensions in Dar es Salaam between Africans and Asians could be displaced into what Joseph calls 'a realm of visual modernity through the rhetoric of frugality and a radically new technology of self.' She emphasizes, however, that Western notions of the resis-tance inherent to youth culture do not translate directly to the heterogeneous postcolonial context. Bruce Lee's first Hollywood film *Enter the Dragon* (1973) was a smash hit in Tanzania, even though its 'tensions of race, gender, ethnicity, and masculinity' created an ambiguous form of visual pleasure for the Tanzanian audi-ence. Joseph deftly unpicks these threads in an analysis ranging from Mao to Foucault and blaxploitation movies. By the end of her piece, the notion of the film as a coherent self-contained 'text' seems inadequate to deal with the meeting of political philosophy, visual pleasure, transnational identifications and disidentifica-tions that were mobilized by kung-fu cinema. In an intriguing closing, Joseph

suggests that the Tanzanian project should not simply be dismissed as a failure but instead opens up ways to think about the 'desire, longing, and imaginative reinventions that fill up the abstract spaces of state formation.'

David **Joselit** develops this line of analysis in a Western context in his description of what he terms the 'video public sphere.' Joselit argues that television has forged a connection between the personal and the political, exemplified in the nonstop scandal-mongering of cable news channels in the United States. This public sphere – to borrow a phrase from Jurgen Habermas's influential description of private individuals coming together to form a public – is, however, strongly limited by the number of narrative patterns permitted. That is to say, when a politician goes on television after a misdemeanour the only question available is as to whether his (usually) apology was 'good' enough. Joselit wants to break out of this closed circuit by considering television in conjunction with video art. He shows that the limited realm of 'split-identification' offered by television viewing was directly examined by video artists like Bruce Nauman, Peter Campus and Dan Graham in literally closed-circuit installations. Commercial television and video art share a medium but are rarely discussed together, implying the need for a far-ranging study of such 'cohabitation' that would include 'home movies, digital film, commercial television, Internet broadcasts and visual art.'

One such cohabitation is examined by Tara **McPherson** in her obituary for internet television. Started with great fanfare and seemingly endless venture capital, on-line television stations like Pseudo and Den went down in the crash of 2000 (although Pseudo came back in October 2001). Combining Joseph's injunction to re-examine the spaces of failure with Joselit's examination of the video public sphere, McPherson looks at what Pseudo TV hailed as a 'major deconstruction of television.' She shows how the minimal interactivity promoted by such stations – buying the clothes worn by television stars online, for example – is at once somewhat ridiculous and none the less close to the experience of web surfing. McPherson explores the experience of using the web, using phenomenology and television studies to delineate its liveness and mobility. All the endless choices do not seem to add up to very much real change while at the same time manifesting a clear desire for change on the part of the user. Perhaps one option would be for activists to create focused net television stations to challenge the national and global information monopolies. One such 'station' is Gritalia, supplying information and news to Italy's gay community, a useful resource in an officially Catholic culture. Now we know that internet television was not the future of television, and there must be some doubt as to the future(s) of the internet itself. What may be important in the end is not the medium – despite McLuhan – but the message its users are conveying that saturation by information is no cure for existential anxiety.

Further reading

Cartwright, Lisa (1995) *Screening the Body: Tracing Medicine's Visual Culture*, Minneapolis: University of Minnesota Press.

Clavert, Clay (2000) *Voyeur Nation: Media, Privacy, and Peering in Modern Culture*, Boulder, Col.: Westview Press.

D'Agostino, Peter and Tafler, David (1995) *Transmission: Toward a Post-Television Culture*, New York: Sage.

Friedberg, Anne (1993) *Window Shopping: Cinema and the Postmodern*, Berkeley and Los Angeles: University of California Press.

Joselit, David (2001) *Infinite Regress*, Cambridge, Mass.: MIT Press.

Joseph, May (1999) *Nomadic Identities: The Performance of Citizenship*, Minneapolis: University of Minnesota Press.

MacCabe, Colin (1999) *The Eloquence of the Vulgar: Language, Cinema and the Politics of Culture*, London: BFI Publishing.

Manovich, Lev (2001) *The Languages of New Media*, Cambridge, Mass.: MIT Press.

Marling, Karal Ann (1995) *As Seen on TV: The Visual Culture of Everyday Life in the 1950s*, Cambridge, Mass.: Harvard University Press.

Mayne, Judith (2000) *Framed: Lesbians, Feminists and Media*, Minneapolis: University of Minnesota Press.

Slater, Don and Miller, Daniel (2000) *The Internet: An Ethnographic Approach*, New York: Berg.

Sobchack, Vivian (1996) *The Persistence of History: Cinema, Television and the Modern Event*, London: Routledge.

Virilio, Paul (2000) *The Information*, London: Verso.

Sites

Webfilm: www.atom.com

Web TV: www.pseudo.com relaunched version. See www.gritalia.net for 'Italian gay web television.'

(a) Spectacle, display, surveillance

Toby Miller

HISTORICAL CITIZENSHIP AND THE FREMANTLE PRISON FOLLIES
Frederick Wiseman comes to Western Australia

The concept of the museum in the modern age, and it is a distinctive concept, is that it is public property. This is a founding event in the history of the modern museum from the French Revolution on, the assertion of the principle that the people through the government exert collective ownership of cultural property. I think that is a tremendously important and founding principle of democracy and of modernity.

(Bennett in Puplick and Bennett 74)

The defendant did not comply with conditions imposed on the privilege of making the film, that, through his wide ranging photography, he abused the privilege by showing identifiable inmates naked or in other embarrassing situations, and that each individual portrayed was only important to the film as an inmate suffering from some form of mental disease and undergoing a particular type of custody or treatment, it was held that in the circumstances the final decree should prohibit showing of the film to the general public in order to protect the inmates' right of privacy . . . but that, since the film gave a striking and instructive picture of the life and problems at the institution, the final decree, in the public interest, should permit showing of the film to specialized audiences of persons with a serious interest in rehabilitation and with potential capacity to be helpful.

(*Judgment in Commonwealth and Others v.*
Frederick Wiseman and Others 252)

THE TWO GENRES DISCUSSED in this chapter are critical sites for the production of truth. The museum stands as an Enlightenment object dedicated to the

curation of other objects. It embodies the selection and control of an artifactual national past and lessons in how people should access that past. The direct-cinema documentary, by contrast, is wobbly, a handheld, fast-speed film made with light sound-recording equipment that redefined the notion of screen actuality in the ten years to 1970 through its technical and textual innovation and its desire to shock viewers. One genre locates its authoritativeness in monumentalism, the other in realism. The approach combines Frederick Wiseman's *Titicut Follies*, recently seen in cinemas after twenty-five years of incarceration; the Fremantle Prison Museum, recently seen on visitor tours after 140 years of incarcerating; and their collective implications for our understanding of ethical zones.

My method is to crosscut between film and museum, following Wiseman's practice of making 'an editorial point in the spirit of expository cinema' rather than allowing 'events to unfold according to their own rhythm' (Nichols 1991: 41). This effect also plays on a continuing trope of Australian cultural interpretation and production: the examination of convict themes in literature and cinema to identify the self-society dialectic of exiles' reaction to their carceral introjection from Europe's Industrial Revolution. In terms of governmentality, the public museum embodies a critical shift of focus away from the intramural world of the princely museum. Prior to the Enlightenment, royal collections are meant to express the monarch's grandeur and induce a sense of insignificance in the viewer. But the public site of modernity calls out for identification and a mutual, municipal ownership that hails visitors as participants in the collective exercise of power. And just as the Fremantle Prison Museum is a popular public site, so it has been suggested that more people have seen Wiseman's work than any other body of documentary, apart from World War II news-reels, because he rates well on television (G. Turner 1993: 60–62, 74–75, 98; T. Bennett 1995: 166; B. Grant 1992: 7; Bear 1994: 62). The irony is that the aura of immediacy, of an urgent address to citizenship, is greater in a 1960s film than in a 1990s site visit.

Titicut Follies

> Another observation about the film: it is true.
> 'Statement' 3

The first thing to note about *Titicut Follies* is that it was made three decades ago, but became available for public viewing in 1992, the only film in U.S. history to suffer legal restraints on its exhibition for reasons other than obscenity or national security (Anderson and Benson 1988: 59). The second thing to note is that the text deals with the occupants of a hospital for the criminally insane. These occupants include doctors, warders, volunteers, filmmakers, and, perhaps least spectacularly, forced residents. Some of the above comments could also be made about Fremantle Prison.

The initial fuss arose because a former social worker read a newspaper report of the film that indicated male genitals were prominently displayed. The fuss developed over the issue of privacy for the inmates and the career hopes of those responsible for them. While this was happening, *Titicut Follies* was judged Best Film

at the Mannheim International Film-week and Best Film Dealing with the Human Condition at Florence's Festival Dei Popoli in 1967 (Zipporah 1991: 9). Twenty years later, it was used as evidence to reform the prison it represents – the Massachusetts Correctional Institution at Bridgewater (MCI). And five years after that, it was safe for release.

This is a text of impact. It strikes at the fault lines that mark the uneasy inter-section of public and private, where the shrinelike qualities of incarceration meet the forgetfulness of a public that sets aside its sullied linen. As a viewer, you have two opportunities to be offended here – at least two. First, you can be offended because of the depiction of madness, and criminal madness at that. Second, you can be offended because of the depiction of dicks, and criminal dicks at that. I leave it up to you to find other ways to be offended.

Titicut Follies is difficult to follow. It moves backward and forward from a revue party of song and dance to interviews between doctors and patients, exercise-yard demagoguery, appeals to release boards, funerals, lady-of-the-manor largesse, cell time, acts of resistance and response, strip searches, nudity, monologues, bath time, and a recurring hallway wander, a leitmotiv of Wiseman's work. Because of this complexity, the spectator to the *Follies* is required to read keenly through an array of sequences that fold back onto one another. The *Follies* is not a horror film; in fact much of it is tame and oblique. But it decidedly deals with the abject, what we'd rather get behind us. This associational narration works by prodding recol-lection and fear, suggestion through confrontation. Wiseman sees his work as open-ended. It interrogates ideological institutions but offers no options for doing things any other way. That is for the spectator to decide. Viewers are offered not so much a document of policy as an invitation to citizenship.

I am particularly concerned with a notorious sequence in the second reel, usually categorized as part six of the text (shots seventy-four to ninety-seven in the *Theoretical* count by Cunningham 1979: 137-39). After a psychiatrist has told the inmate Mr. Malinowski, 'If you don't eat food we are going to feed you with tube,' the prisoner is seen in close-up. Then we zoom out to a medium shot of the screws as they apply restraints to his wrists and flank him before cutting to a close-up of the psychiatrist sniffing liquid food. As the naked Malinowski is placed face up on a table, the zoom closes in on the shrink, smoking an endlessly ashing cigarette while he greases appliances and shoves the tube into the patient-prisoner's nose, whose groin and eyes alone are covered. Then this scene is abruptly interlaced for just two seconds with an extreme close-up of Mr. Malinowski being shaved. His eyes are open. A fly is on his brow and soap on his jaw. Then we are jagged back to the cigarette and its therapist prior to a series of edits between invasion and torpor, until what is clearly the work of a mortician sees cotton buds make their way into Malinowski's eyes. This is followed by parallel movements between psychiatrist and mortician: one finishes with a fed Malinowski, the other with a dead one. The sequence reestablishes an equilibrium of sorts through a lingering view of the door behind which Malinowski's coffin has been slid into a cooler. It is a juxtaposition that invites some normalcy, but in fact is nothing of the sort, as the rapid montage effect might indicate if we think it through in terms of pace rather than image. Instead of a relief, a movement into the quotidian, this is the end of Mr. Malinowski. He is being shaved for his burial.

How might we read this? I will divide the options into the religious, psycho-analytic, cosmetic, exhortatory, voyeuristic, and anthropological. The point I am trying to establish is that we can do a lot more with such a segment than was allowed by the furor in courts of law, that sought, as we shall see, so fixed a meaning for the film (without great success).

The religious

Mr. Malinowski has fallen from grace. Attempts to redeem him fail, so *he* must die publicly that *we* might live in normalcy, confirmed in a previously passive distaste for the abjection of madness, a displeasure now rendered active. His passing, a regrettable but necessary corollary of a failure to participate fully in the dietetic economy, signals the way forward for the rest of us: obedience. He starved that we might eat.

The psychoanalytic

The psychiatrist has the phallic authority of the Father's law. If his sons disobey him or act independently, they will be symbolically castrated and any right of autonomy over their bodies removed. Punitive, retributive force must be swiftly and overtly exercized in response to such insurrection. Further transgressions will be dealt with by the ultimate sanction. Remember, many of these men are sex offenders (some are not, and some are in prison awaiting trial, a wait of years in some cases). The suggestion is there – confirmed in one instance – that incest is afoot. This funda-mental taboo must not be broken, because it distinguishes fathers from others and protects their line from violation and despoliation.

The cosmetic

We dress death. The passing of a life, however flawed its performance may have been, is to be noted and respected. Part of that respect involves dressing the body, its face as well as the rest, to restore the normalcy that attended its mythic inno-cence at birth. The signs of degeneration that designated a failure of lucidity can be allowed no life after death.

The exhortatory

Something is rotten in the state of Massachusetts. The medical staff treat people as objects to be manipulated and despised, turned into creatures without a soul. Bridgewater requires investigation urgently; we must know about any similar breaches of humanitarian principles. Punishment and treatment should be distilla-tions from a caring cup of humanness. MCI is aberrant. It departs from correct methods of control, treatment, and rehabilitation, deeming those classified as civically incapable in a way that hypocritically denies civic conscience.

The voyeuristic

This process is sick. It's wrong to show people so degraded. The film is deriving pleasure from the pain of others. Why are we looking at this degradation? How do the relatives feel? We should turn away from such nonsense (it's too much fun).

The anthropological

Which Malinowski is in shot? (Even Barry Keith Grant, author of the key study on Wiseman's work, seems unsure about Mr. Malinowski, whose name appears spelled differently several times within a single paragraph of his *Voyages of Discovery* [1992: 48–49].) Consider the following precepts of Bronislaw Malinowski's theoretial work, what he called the 'General Axioms of Functionalism':

> Culture is essentially an instrumental apparatus by which man is put in a position the better to cope with the concrete specific problems that face him in his environment in the course of the satisfaction of his needs. . . . It is a system of objects, activities, and attitudes in which every part exists as a means to an end. (150)

For Wiseman, the textuality of film must be dedicated to institutions: the public institutions of his first dozen and most recent films, the private institutions of his next few, the international reach of the ones after that, and the impact those institutions have on bodies and their means of sense making. It is for us to determine whether these institutions, which framed and then concluded the life of a Malinowski, are functional, and in whose interests they function.

That depends on who is looking. *Bad Timing: A Sensual Obsession* (Nicolas Roeg, 1980) contains a series of controversial cuts between Milena (Theresa Russell) having her stomach pumped in a hospital and Alex (Art Garfunkel) 'ravishing' her body in an apartment. If Roeg hadn't seen *Titicut Follies* or Wiseman's *Hospital* (1970), then I'm one of the unlucky monkeys from the latter's horrifying investigation of animal experimentation, *Primate* (1974). Part of the reason for the controversy surrounding both sequences is the operation of the look. Its controlling power is a recurring theme in *Titicut Follies,* but not in neat shot-reverse-shot form. The eye-line match is more common, across shots of about half a minute's duration (Grant 1991: 57). Looks are exchanged between guards and guards, guards and prisoners, prisoners and prisoners, psychiatrists and prisoners, psychiatrists and psychiatrists, and *all* of the above – but especially the prisoners/inmates/patients – with the camera, and hence with the ultimate disciplinary gaze in cinema, that of the spectator.

As spectators, we are looking at what is locked away, to protect us from physical and psychic darkness. The double effect of the musical revue sequence is to equate madness with the unacceptable side to playfulness, drawing out the implications of a tightly policed but essentially nominalist distinction between madness and entertainment. What is presented is utterly mad. The maddest person of the lot is a leeringly unphlegmatic screw, whose delight in tomfoolery is equaled only by his craving for attention. Consider the impact of his singing a duet of 'I Want

to Go to Chicago Town' with an inmate (black, and of course unable to go fucking anywhere) alongside Wiseman's sequence of a few minutes before in which the same guard mocks a black man for his color (Armstrong 1989: 22, 30).

As Christopher Ricks has argued, 'Wiseman's art constitutes an invasion of privacy,' the privacy of the viewers, their right to be left undisturbed in any passive denial of the sometimes unsightly grout that holds their social world in a normal grid (1989: 161). Not surprisingly, the film has had an unstable career; it moves dramatically along the track of political rectitude. At one moment, *Titicut Follies* is the darling of civil libertarians: Wiseman speaks out against the state, offering a voice to those silenced by the bonds of prison power. At another, the film is evil, because it invades the privacy of men too abject and incompetent to know the concept or seek to guard it. Some history to the film's career can explain this lineage.

In 1959, Wiseman was teaching a summer seminar in legal medicine at Boston University. His class toured MCI-Bridgewater:

> I took my students on visits to places that, either as prosecutors they might be sending people, or as defence attorneys their clients might end up. [At Bridgewater they saw] . . . [l]onely, isolated men, inadequate medical and psychiatric facilities. Buildings dating from around 1855 [the same decade as Fremantle Prison], poorly heated and totally inadequate for that kind of care. But mainly isolated people without any contact with each other and desolate, wasted faces.
>
> (Wiseman quoted in Taylor 1988: 99)

Six years later, he sought approval from the superintendent to make a documentary. After initial difficulties, permission was given, perhaps because it was thought exposing life at the institution would produce additional resources from a potentially chastened state government. Filming commenced in April 1966, just as the staff and inmates were about to perform their annual revue, the 'Titicut Follies.' The title derived from the Native American name for the area. Twenty-nine days of shooting, followed by eleven months of editing, saw eighty thousand feet of film compressed into thirty-two thousand, with an eventual running time of eighty-four minutes. During the edit, the institution entered the headlines because of the escape of Albert DeSalvo, 'the Boston Strangler.' Meanwhile, *Titicut Follies* was being shown in rough-cut form to various representatives of the state of Massachusetts, notably Attorney General Elliot Richardson.

In September 1967, a review of the film was published in advance of its premiere at a New York festival. A former social worker used this review to frame a letter of complaint to various civil liberties luminaries and the governor of Massachusetts about the representation of full-frontal male nudity. The state then claimed the right to censor the film, which was news to Wiseman. It raised some very interesting questions of image ethics: Who owns the ethical subjectivity of nonpersons, people who have relinquished their civil rights? With legal threats afoot, Wiseman engaged Alan Dershowitz as his lawyer. Dershowitz claimed that oral consent from inmates was sufficient, and Wiseman also flourished those written consents he *had* obtained. New York's Channel 13 showed excerpts. An injunction was granted preventing screenings in Massachusetts, but in New York, attempts to prevent a showing at

the film festival were unsuccessful. Then the film had a commercial release in the city. Further hearings were under way in Massachusetts, but they were brought into question when it was discovered one of Wiseman's collaborators had recorded and photographed the proceedings. Judge Kalus called the film 'a nightmare of ghoulish obscenities.' Sensational allegations about the film emerged: a prisoner was masturbating through the pocket of his trousers (who isn't?) and another man's raised hand was parodying the pope (same query) (Kalus quoted in 'Statement' 3; Taylor 1988: 101). A formal case began in November 1967. Wiseman was accused of breaching an oral contract permitting the state right of veto over material; invading the privacy of an inmate, James Bulcock; and misdirecting profits (the state wanted moneys held in trust for the inmates).

Meanwhile, prison guards were conducting their own case against the film. And in 1968, it was banned in Massachusetts over the oral contract and privacy issues. (As Wiseman points out, this is some privacy in an institution that incarcerates people precisely to deny them privacy and invites ten thousand people a year to observe it as part of making them good social work students or functionaries [1976: 69–71].) In appeals, Wiseman gained support from the American Orthopsychiatric Association and the American Sociological Association. The defense was partially successful: *Titicut Follies* could be shown in Massachusetts to qualified therapists. Screenings had to be accompanied by a statement that Bridgewater had been reformed. (Wiseman's fabulously laconic way of complying is to restate the court order twice at the conclusion of the film, once as a quotation and once as his own words, recalling the faux 'happy ending' to Hitchcock's *The Wrong Man* [1956]: Henry Fonda's character is acquitted of trumped-up charges, but this righteous denouement does not prevent his wife, played by Vera Miles, from losing her sanity in the face of all that has gone before.)

In 1969, guardians of thirty-five inmates at Bridgewater filed suit against the director. In 1971, screening restraints were diminished, and Wiseman won against the guardians the following year. The Civil Liberties Union of Massachusetts finally supported unrestricted viewing in 1974, when the state of Massachusetts passed new privacy provisions in its General Laws to deal with such invasions as the *Follies*. Three years later, the first public screening in the state was permitted. Then a university student who had appeared in the film in a somewhat different life protested that his privacy had been violated. In 1980, the state again sought to outlaw *Titicut Follies*. The year 1987 found Wiseman once more petitioning for the right to exhibit, with network TV screening segments; reports emerged that five inmates had died in Bridgewater that year, three by their own hands, and Wiseman appeared as an interviewee on an episode of ABC's *Nightline* to discuss the institution. In 1988, the state tried to locate men who had been in the film by placing advertisements in newspapers. Respondents were interviewed by an officer of the court to decide whether they were competent to give consent; the official recommended unrestricted release. The following year, a conference held on the grounds of the hospital included a screening, with Wiseman there for the first time in twenty-three years. The state was no longer opposed to public exhibition, but two inmates were, and the judge presiding decided identities should be facially blurred for any screening. Wiseman successfully appealed (Anderson and Benson 1988: 80 and 1991: 161–73; Grant 1992: 50). Having established the trace of *Titicut Follies*,

I want now to consider the wider implications of Wiseman's work for contemporary citizenship and our understanding of Fremantle Prison.

[. . .]

Museum truth

> When Millbank Penitentiary opened in 1817, a room festooned with chains, whips and instruments of torture was set aside as a museum. . . . Thus did a new philosophy of punishment committed to the rehabilitation of the offender through the detailed inspection and regulation of behaviour distance itself from an earlier regime of punishment which had aimed to make power manifest by enacting the scene of punishment in public. The same period witnessed a new addition to London's array of exhibitionary institutions . . . Madame Tussaud set up permanent shop. . . . As the century developed, the dungeons of old castles were opened to public inspection, often as the centerpieces of museums.
>
> (Bennett 1995: 153)

Two relatively discrete political rationalities inform the museum. The first governs legislative and rhetorical form. The second determines the internal dynamics of a pedagogic site. Certain difficulties emerge from the different dictates of these rationalities. Whereas the genre of the museum calls upon democratic rhetoric associated with access, an open space for the artifactually occasioned site of public *discussion,* the pedagogic site functions in a disciplinary way to forge public *manners:* a contradiction between exchange and narration, reciprocity and imposition. The twin rationalities oppose an Opportunity for the pubic to deliberate on some aspect of cultural history and an opportunity for museum magistrates to give an ethically incomplete citizenry a course of instruction. Of course, this binary can itself be made more subtle. Consider the varied histories that underpin Holocaust memorials in the United States: to remember the dead, to remember the self as survivor or liberator, to draw tourists, to be community centers, to stress religious or ideological affiliations, and to obtain votes. All these decisions are made 'in political time, contingent on political realities' (Young 1992: 58).

Tony Bennett argues that the early life of museums was predicated on universalisms about 'Man' and democracy. The traces of that legacy are in fundamental conflict with the histories of social movements constitutively excluded from singular but totalizing forms of museum narration (the great-white-hunter brand of colonial recollection). Hence the continuous critiques of museums since the rise of these movements. The museum is not so much a space of confinement as a space of education. In both its arrangement of things and its instructions to the public on how to approach collections, the museum hails its audience as respectful trainees. They learn to look and not touch, to walk about calmly and gently, and to distinguish the graceful from the riotous. These are modes of conduct related to behavior in a space, rather than internal reactions to art on a wall or in a display case (T. Bennett 1995: 1, 7, 90–91, 97, 102–3). (In *Ferris Bueller's Day Off* [John Hughes, 1986], we are given a high-art diegetic insert, as the unruly, fun-loving teens move respect-

fully around the Chicago Art Institute's impressionist collection, finding themselves to be mature subjects in the process. Something similar is happening when Andreas Huyssen takes his five-year-old son to a museum and the little boy is reprimanded for touching and reclining on artworks. Huyssen reads this symptomatically, as a sign of institutions seeking to reinstate the dissociated organic aura of art [1988: 178–79]. I think it's a lesson in manners, part of the museum's mission as an ethical workplace.)

The museum seeks to attract newcomers and to draw reactions that will be taken into the exterior world through a temporary, voluntary enclosure of visitors that combines information and entertainment, instruction and diversion. Museums stop us at the present, pointing out the hectic pace of the modern by freezing its 'unceasing dispersal of space and time' in the calibrated space of an archive (Tagg 1992: 364). This complex relationship is further complicated by buildings with prior lives. Britain's Imperial War Museum was once Bethlehem Mental Hospital ('Bedlam'), but it now introjects and projects a different form of madness and imposition. Yorkshire's Eden Camp offers visitors a brief stay behind the barbed wire that housed prisoners of war from 1942 to 1948, giving two hundred thousand people a year an exact experience of 'the conditions in which prisoners lived.' Nazi Germany's *Konzentrationslager* at Dachau is also now a museum (Boniface and Fowler 1993: 105). Fremantle Prison Museum achieves a physical unity between its former and current careers, performing successive functions of incarceration/correction and incorporation/education. In this sense it has gone beyond dividing the rowdy from the respectable, in its initial personality, to become an ethical technology for demonstrating that process *and* quietly replicating it as a mimetic space for exercising the mild-mannered gaze. This is the gaze of the decent person, who is being seen and heard as much as she is watching and listening, both at the time of her visit and at later moments that narrativize the visiting experience for others.

It is the task of museums to bring public attention to what has previously been concealed, to take the secrets of an elite into the populace at large. Instead of *objec*tifying that population, as per the public executions of eighteenth-century Europe, the museum *sub*jectifies people, offering them a position *in* history and a relationship *to* that history. Since its origins in the French Revolutionary administration's designation of the Louvre as a national space, the museum has been associated with virtuous government or elite beneficence disbursed from on high. As I indicated above, its universal address characteristically obliterates difference or, more often, caricatures it through racist and imperialist appropriation and scientism, sexist exclusion or mystification, and class-based narratives of progress. The entire project of 'discovery' also infantilizes the visitor, of course. The characteristics of the museum era are very much about mastery, over the physical environment and other countries. These scientific and imperial triumphs target more than the visitor, for they also infantilize those beyond such discourses or subject to them. This rhetoric of universal uplifts into trouble when it encounters 'excellence'-inflected definitions of heritage and the aura of leading museums as prestigious clubs (Duncan 1991: 88; T. Bennett 1995: 97; Jordanova 1991: 22, 32; Price 1994: 25, 30). These contradictions were made overt at the Whitney Museum of American Art's 1994–95 exhibit 'Black Male: Representations of Masculinity in Contemporary Art.' Upon exiting the third-floor elevator, visitors faced a wall lined with Fred Wilson's

installation *Guarded View* (1991), which presents four headless black male figures dressed in the guard uniforms of the Jewish Museum, the Whitney, the Metropolitan Museum of Art, and the Museum of Modern Art. Of course, the exhibit itself was invigilated primarily by African Americans! An 'in your face' confrontation of the distinctions between museum labor and museum delectation was powerfully brought out by Wilson's text, its location, and the power relations of the space, which validated its commentary.

This complex generic heritage places the citizen-addressee at a site such as Fremantle in a complicated position. Consider the Western Australian State Planning Commission's 1988 *Draft Conservation and Management Plan* for the Prison. The *plan* begins by dividing possible futures for the area into the grand binary of citizenship: 'opportunity' and 'responsibility.' The prison is announced as critical to the state's heritage, a 'cultural asset [whose] recycling is a major responsibility.' Virtually all colonial convict establishments around the world had been decommissioned and destroyed by 1988. In contrast, here was a functioning relic, 'possibly the State's most important heritage item.' So this zone describes the 1850s (as noted earlier, MCI-Bridgewater and Fremantle Prison are both creatures of that decade). The 1980s idea, following desires expressed by the city of Fremantle, was that the former prison be an *economic* site once the last prisoners had gone, a 'city within a city' (Fremantle 1988: 1–3). It became a leased profit-making venture reporting to a trust and a state government authority. That public erasure of history – where a disciplining tenet of capitalism becomes a commodity itself and also a site for the controlled functioning of public memory – has corollaries in its historiographic bearings.

I leave it to the reader to unpack the meanings available from an official description of the prison's nineteenth-century architectural significance:

> As part of the changing attitude of Britain toward colonial administration, the Women's Prison indicated the new values attached to the imprisoning of women. It had its own walls, more intricate and delicate ornament, individual yards to cells and generally a less restricting environment. It was later adapted for use as a facility for the 'mentally confused.' (3.1)

The document continues. We are told more about 'evolving policy': incremental increases to exercise space and the development of plans for rehabilitation. This is now a zone of the 1900s. This is the modern. Australia has become a federation of states, recently cast off from its constitutional status as a colony of Great Britain, and well free of the direct association of working people with forced convict immigration. It is now possible to recognize human labor as reusable and capable of ethical improvement. The state is coming to be lovable for its forgiveness and its powers of transmogrification, that special ameliorating capacity to build new persons where once dross alone resided. But we are, significantly, seeing this occur in buildings described as 'fine examples of the Royal Engineers' Georgian Style' (3.1).

Of course, something else is going on here, a process with which we are all too familiar from the history of aesthetics. First, a feeling, sensate (perhaps male?) romantic figure locates and luxuriates in the radiance of an object of beauty. This romantic soul goes guarantor of the experience, his 'otherworldly' take on the

sublime itself in no need of vindication. Second, this transcendence is transferred. No longer the processual quality that derives from the meeting of a will and a text, the transcendence detaches itself from a specific human agent and becomes a quality of the object observed, the text. Now, the aesthetic is an *object* (the text) and no longer a *practice* (the romantic soul *and* the text). As an object, it becomes available for redisposal as a method of pedagogic formation. New people are to be formed through the experience of being led to the aesthetic sublime in interaction with this text.

Thirty years ago, most prisons from the convict era in Australia were in disuse or had been transformed for other purposes. Since then, many have become museums, both sites of national significance and local historical-society displays. These two forms serve dual functions: the historicization of Australia and the differentiation of contemporary penology from its uncivilized origins in a developmentalist narrative (Bennett 1995: 154–5). This relates to the sense of filling in place and time in Australian social narratives, the popular argument that 'Australia has a blank where its historical consciousness might have been,' to use Stephen Bann's telling phrase (1991: 103).

And so it is here. The actual use and exchange value of 'the Royal Engineers' Georgian Style' as a site of human labor and human incarceration are lost in history. They have attained 'Architectural and Technological Significance' (Fremantle 1988: 3.1), that is, sign value. But such processes of reification always have targets for humanization, ironically enough. And here, we are told the very architecture is a '*demonstration of a way of life*' (3.2), a central aspect – both material and cultural-cartographic – of Fremantle. The State Planning Commission advises that the prison buildings 'represent a well integrated element in the fabric of the city' (3.3). Now, this plan was being promulgated in 1988, the two-hundredth anniversary of the English invasion of Australia and the year the prison was 'occupied' (a quaint term to describe a reversal of control by people whose lives were contained within the prison), set alight in violent protest at the conditions of everyday life. We find no reference to these conditions in the text, no reference to tiny rooms, pails for shit, or the two open toilets among several hundred men left out in the elements for nine hours a day, each day of the year. I mean, why would you mention that in such a document? It's hardly a question of historical significance, is it, if it fails to provide an opportunity to refer to 1988 as a moment of colonial architecture or applied Enlightenment penology? If we spoke of texts as occupied sites, then the labor that made them might also be reasserted, which would undo the hierarchies that tend architectural history.

We can see more of the same in policies recently adopted by Western Australia's Building Management Authority (James Semple Kerr). The Authority allocates the prison 'significance' on the basis of international and national comparisons and a reading of the thirteen reports written about it. This significance is again to do with the prison's location among imperial and colonial public works: its degree of intactness, the symbolism of its development (acknowledging convict labor in an anonymous way), the authorship-functions of its (specified, named) engineers and governors, its artworks, and finally its landscape value (1992: 4). Now this document makes concessions to recent prison life, to the complexities of a graffito that reads 'Jim Brown is well liked because he is gorgeous,' supplemented by 'but not

as gorgeous as Billy Little.' These graffiti come from a guard's watchtower post (16). And the Authority endorses Aboriginal participation in determining the direction and textuality of the site's heritage (21). But it is ultimately dedicated to a reificatory and nonrelational historicity.

What is implied about the ethical zone of the present? To find out, let's look at the pamphlet thoughtfully provided by the prison manqué and its double interpellation through the first-person plural. The pamphlet calls this place the 'most wonderful monument of our history.' It says, 'We trust that you enjoy your visit.' The first 'we' ('our history') is the people of Western Australia, historical citizens who securely look back in wonderment at the human cruelty and architectural grandeur of their predecessors. These citizens have not been prisoners, of course, although there may be convict lineage somewhere. The second 'we' ('We trust') is the managers of the prison now, 'many of whom were prison officers.' Redundancy becomes a heritage-inspired line on a curriculum vitae. This is advertised as a splendid continuity, a means to 'maintain this most wonderful monument of our history.' Between these 'we' categories, it becomes possible, within just fifty lines of writing in a pamphlet, to say what I have just quoted *and* to highlight spaces the prison once set aside for flogging and hanging. That's the section of the document ending, 'We trust that you enjoy your visit.'

The 1992–93 state budget allocated A$2.5 million to continue conservation works at the prison. What was being conserved? I think it's an ethical zone dividing the rotten from the good, the past from the present, the oppressive from the enlightened, the contemporary law abider from the historic lawbreaker, and, critically, the museum visitor from the *contemporary citizen*. The zone operates through a strange structural homology, strange in that it might be expected to produce some identification with imprisonment and a sense of responsibility for the process. But nothing of the sort occurs with many visitors. The homology is what Barbara Kirshenblatt-Gimblett has dubbed the intercalculation of 'two different quotidians' (1991: 410). The prisoner's day is redisposed for the tourist, crushed into an hour. It becomes a voluntary sentence, undergone to differentiate the good from the bad in society and its governmental-carceral history.

When I toured the prison, I saw spaces dedicated to mass nudity, strip searching, public showering and shitting, freezing cold, boiling heat, and constant surveillance. I was reassured at every point that this was the past. I was shown murals done by prisoners telling Aboriginal stories, but not told the appalling statistics of the incarceration of Aboriginal Australians, who make up 3 percent of the state's population and 40 percent of its prisoners (although one guide reportedly informs visitors that Aboriginal Australians kill themselves when imprisoned because they are kept from the call of the wild; tell that to the Royal Commission into Black Deaths in Custody that investigated this trend in prisons and police lockups across the country in the late 1980s). I did hear my guide refer to 'en suites' in the new prison contained in what she termed 'so-called cells,' and my fellow trippers saying of the prisoners' art, '*so* talented even though they were in here.' This was prior to our being given a technical discussion of systems for murdering people in the prison through capital punishment (which ended in the 1960s). In short, I saw a space that spoke of the history you can see – in a seemingly much older frame – in *Titicut Follies*. But unlike *Titicut Follies*, *this* space spoke entirely of the past: no tasks confronted the contem-

porary citizen. At Fremantle Prison, and in the domain of punishment now, there is no work to be done. Mistreatment of prisoners is a thing of the past, subject to progressive eradication up to November 1991. Then the *civiliter mortuus* (civilly dead) were transferred to a new-era facility, more thoroughly, electronically, panoptic. Visitors to the museum are, paradoxically, disarticulated from the materiality of what is done to prisoners in their name, unlike the shock of horror and complicity engendered by archival footage from MCI. The museum space has less of the aura of its recent past than does a film that came out the same year – or didn't – as *Sergeant Pepper's.*

Life inside new-era prison facilities is investigated in John Hillcoat's documentary-drama *Ghosts of the Civil Dead* (1989), a remorselessly rugged, massively violent, and quite internal text that imprisons audiences as completely as it does warders and inmates. The film is a fiction based on three years of research into American and Australian prisons. Its Central Industrial Prison is a maximum-security, high-technology site of surveillance where prisoners are drugged, beaten, and sent into a vicious camaraderie. Euphemistically described as a 'New Generation Facility,' Central Industrial is designed for madness. The narrative concerns events leading up to a 'lockdown,' when the authorities impose total control over all activity and any sense of the human subject and its differences is lost. *Ghosts* uses the voice-over of a guard and the decay of an inmate to encourage our belief in a conspiracy to deaden resistance through a complex of invigilation, violence, drugs, and sex. The visceral brutality of every character inshot – apart from the reporter who introduces the text – is all-imposing. The action takes place within the plastic-fluoro world of the prison. Exterior shots showing the building in the complete stillness of the desert develop rather than relieve the claustrophobia engendered by what we see inside. At a time when privately run correctional institutions were first appearing in Australia, the text raised issues connected to contemporary policy (once success in Rio de Janeiro, Montreal, and Berlin gained it a belated local release).

As a visitor to the old Fremantle space, by contrast to the viewer of such films, you don't have to worry. Another ethical zone is upon you that encourages consideration of how people were once 'treated' by the state. The prison is like the coda the courts required to the *Follies,* stating, 'That was then and something else is now.' The zone values the contemporary and will not criticize it. Once we were wrong, which merely serves to confirm that we are now right. And so this might be a useful point to resume the reading options outlined in the discussion of Mr. Malinowski, redisposed from Bridgewater to Fremantle.

The religious

The prison is a shrine commemorating crime and justice meted out in concert with the revised Judeo-Christian ethic of nineteenth-century England: progressive incarceration. Here, redemption can be earned and granted. It is significant that Father Brian Gore spoke to the question of Aboriginal incarceration when decommissioning the prison.

The psychoanalytic

The social represses its antisocial side. But this is not merely a suppression of sons who have transgressed the law of the Father-state. It represses guilt-laden reminders to those outside the prison but inside the law. Why else would Western Australia need to lock up so many Aboriginal people who have survived genocide?

The cosmetic

Georgian engineering, combined with prison graffiti and heritage historicizing, make for an aesthetic experience. They underwrite the essentially fetishized nature of the visiting experience, designed to calibrate a social space that is disarticulated from current penal practice. Instead, it is a *cordon sanitaire*, a cleansed, beatified, and beautified object of architectural and commemorative interest.

The exhortatory

I don't think we can make this category work here, unless one can be exhorted to feel nothing about the ramifications of the past for the present and the consequences of writing teleological history. Jacques Derrida is quite right to require of a monument that 'imposes itself by recalling and cautioning' that it also 'tell us, teach us, or ask us something about its own possibility' (1994: 230). The prison museum authorities, like the many museum officials who call for 'pastoral care' and 'total immersion experiences' (quoted in Sorensen 1991: 66), have not read him.

The voyeuristic

It is hard to conceive of a more gruesome voyeurism than *Titicut Follies*. The gallows experience at Fremantle, with reenacted furnishings, stories of interstate travel by anonymous hangmen, and the ghoulish delight in alterity expressed by visitors, must approximate.

The anthropological

Perhaps all of the above combines in the seamless weave prescribed for cultural theory by the other (Bronislaw) Malinowski, for if there is some truth in functionalist anthropology – useful positive description among the blindness to disruption, systemic change, and categorical inequality – it lies in revealing methods of deploying the past that instantiate the present as a 'good' moment. We can analyze the prison tour as a technology for writing unpleasant history best left behind, unrelated to the responsibilities of today. As such, its design and life are distant from recent attempts by other museums to hand back their artifactual past to indigenous peoples or cede authority to explain and display them (one thinks here of the

Museum of the American Indian and a range of sites that give Australian Aboriginal peoples control over the museum presentation of their material culture). The 'touch and go' of metropolitan life is, assuredly, held up and reordered here by a 'cognitive map.' But that map describes a cordon between us and the past, a cordon policed by the Fremantle Prison Trust (a quite staggeringly oxymoronic syntagm). The trust rejects 'freely accessible' cell blocks because it has its own 'plan to develop the interpretation of the prison' (Archibald 1992). The zone and its 'trust' guarantee we remain purely historical citizens.

The Fremantle Prison Museum needs to he criticized at both performative and constative levels. It *is* its contents; it performs them. But it also enacts a conceptual argument about respect for the present even as it zones the past as a discontinuous, fetishized prior domain. The museum actively memorializes the mistreatment of potential and actual 'bad' visitors at the same time it cuddles the 'good' among us with reassurances about improved treatment of others. The curricular mission of museums is conventionally associated with 'planning for enlightenment of individuals.' But this is now under attack for its passive-aggressive inclinations (Soren 1992: 91). Tony Bennett (1990) is right to insist that curators decline to organize 'a representation claiming the status of knowledge,' moving instead toward a view of themselves as holding 'a technical competence whose function is to assist groups outside the museum to use its resources to make authored statements about it' (51). In 1994, the Film and Television Institute at Fremantle screened a season of cinema thematized around women, prison, and mental illness, in conjunction with the local Arts Centre's *Absence of Evidence* event detailing the history of female prison inmates. This was an innovative mixture of international soap opera, melodrama, and arthouse cinema with regional artistic commemoration: local citizenship at work making a counterauthorization of the past, mixing genres, histories, and texts in a technology of public discussion.

The threat of just such contemporary citizenship saw a concerted effort by the state of Massachusetts to hold *Titicut Follies* from public view. That text conspicuously compressed space and time to interpellate its audience, and it continues to do this. The Fremantle Prison Trust has a less transparent modus operandi. It simply translates the citizen through time, while remaining in one place. History can be brought safely up to date, up to November 1991, because it starts and ends in a monument to 'Georgian Style,' a preemancipatory legacy that moves in a grand narrative of Whiggish historiography. This monument is a zone, disengaged from the present in the name of preserving the past *as the past*. It is resisted by former prisoners, who are renowned for refusing to wear identification stickers when they return as visitors. They are forced back to the official tour whenever they 'break away,' for what are termed 'safety reasons' (Treweek 1992). Like the reserve collection of art museums or library rare-book rooms, these supplemental public sites remind us of the provisionality of open access to the past. They are the unfulfilled promise of museum modernity, the exclusions that define what counts as the public record (Tagg 1992: 362). Restrictions on former residents recall the locations where my friend's students had undertaken their shackled and manacled instruction. That in turn draws us back to the anonymous 'Comment' on the first *Follies* case published by the *Columbia Law Review* in 1970. In querying the judges' privacy criticisms of

the film, it argued that the 'only interests clearly protected are the dignity of the Commonwealth and the public image of her agents' (359).

That intertext encourages us to walk away from the conventional binary of museum discourse between populist entertainment and *étatiste* instruction, no longer apt polarities of museum policy and practice. In place of diversion versus elevation, interactivity at the site of the museum should be our underpinning philosophy. This would merge the 'resonance' and 'wonder' that Greenblatt commends as the way to comprehend museums: a compound that locates us in the present as part of our social formation, even as it asks us to pause and be struck with the singular occasion of our visit (1991: 42)

Bibliography

Anderson, Carolyn and Thomas W. Benson, 'Direct cinema and the myth of informed consent: the case of *Titicut Follies*,' *Image Ethics: The Moral Rights of Subjects in Photographs, Film, and Television*, ed. Larry Gross, John Stuart Katz, and Jay Ruby, New York: Oxford University Press, 1988, 58–90.

—— *Documentary Dilemmas: Frederick Wiseman's Titicut Follies*, Carbondale: Southern Illinois University Press, 1991.

Archibald, Jenny, 'Promising prison,' *Fremantle Herald*, 21 October 1992: n.p.

Armstrong, Dan, 'Wiseman's realm of Transgression: *Titicut Follies*, the symbolic father, and the spectacle of confinement,' *Cinema Journal* 29, no. 1 (1989): 20–35.

Bann, Stephen, 'On living in a new country,' *The New Museology*, ed. Peter Vergo, London: Reaktion, 1991, 99–118.

Bear, Liza, 'Veteran Wiseman discusses unique documentary style,' *Film Journal* 97, no. 9 (1994): 20, 62.

Bennett, Tony, *The Birth of the Museum: History, Theory, and Politics*, London: Routledge, 1995.

—— 'The political rationality of the museum,' *Continuum 3*, no. 1 (1990): 35–55.

Boniface, Priscilla and Peter J. Fowler, *Heritage and Tourism in 'the Global Village,'* London: Routledge, 1993.

'Comment: the "Titicut Follies" case: limiting the public interest privilege,' *Columbia Law Review* no. 70 (1970): 359–71.

Commonwealth and Others v. Frederick Wiseman and Others. 356 Mass. 1969.

Cunningham, Stuart, *A Theoretical Critique of 'Direct' Documentary: The Case of Frederick Wiseman*, unpublished master's thesis, McGill University, 1979.

Derrida, Jacques, 'To do justice to Freud: the history of madness in the age of psychoanalysis,' trans. Pascale-Anne Brault and Michael Naas, *Critical Inquiry* 20, no. 2 (1994): 227–66.

Duncan, Carol, 'Art museums and the ritual of citizenship,' *Exhibiting Cultures: The Poetics and Politics of Museum Display*, ed. Ivan Karp and Steven C. Lavine, Washington, DC: Smithsonian Institution Press, 1991, 88–103.

Fremantle Prison Management Committee, *Fremantle Prison Draft Conservation and Management Plan*, Perth: State Planning Commission, 1988.

Grant, Barry Keith, 'Point of view and spectator position' in Wiseman's *Primate* and *Meat*, *Wide Angle* 13, no. 2 (1991):56–67.

—— *Voyages of Discovery: The Cinema of Frederick Wiseman*. Urbana: University of Illinois Press, 1992.

Greenblatt, Stephen, 'Resonance and wonder,' *Exhibiting Cultures: The Poetics and Politics of Museum Display*, ed. Ivan Karp and Steven C. Lavine, Washington DC: Smithsonian Institution Press, 1991, 42–56.

Huyssen, Andreas, *After the Great Divide: Modernism, Mass Culture and Postmodernism*, London: Macmillan, 1988.

Jordanova, Ludmilla, 'Objects of knowledge: a historical perspective on museums,' *The New Museology*, ed. Peter Vergo, London: Reaktion, 1991, 22–40.

Kerr, James Semple, *Fremantle Prison: A Policy for Its Conservation*, Perth: Building Management Authority of Western Australia, 1992.

Kirshenblatt-Gimblett, Barbara, 'Objects of ethnography,' *Exhibiting Cultures: The Poetics and Politics of Museum Display*, ed. Ivan Karp and Steven C. Lavine, Washington, DC: Smithsonian Institution Press, 1991, 386–443.

Nichols, Bill, *Representing Reality: Issues and Concepts in Documentary*, Bloomington: Indiana University Press, 1991.

Price, Clement Alexander, *Many Voices, Many Opportunities: Cultural Pluralism and American Arts Policy*, New York: American Council for the Arts/Allworth, 1994.

Puplick, Christopher, and Tony Bennett, '"Arts National" programme on museums: a discussion with Christopher Puplick and Tony Bennett held following the delivery of "Thanks for the Memories," August 1989,' *Culture and Policy* 1, no. 2 (1990): 67–74.

Ricks, Christopher, 'Wiseman's witness,' *Grand Street* 8, no. 2 (1989): 160–71.

Soren, Barbara, 'The museum as curricular site,' *Journal of Aesthetic Education* 26, no. 3 (1992): 91–101.

Sorenson, Colin, 'Theme parks and time machines,' *The New Museology*, ed. Peter Vergo, London: Reaktion, 1991, 60–73.

Tagg, John, 'A discourse (with shape of reason missing),' *Art History* 15, no. 3 (1992): 351–73.

Taylor, Charles, 'Titicut Follies,' *Sight and Sound* 57, no. 2 (1988): 98–103.

Treweek, Ann, 'Ex-prisoners flock to visit Fremantle Jail: bleak, bucket-toilet cells shock most jail visitors,' *Sunday Times* 6 December 1992: n.p.

Turner, Graeme, *National Fictions: Literature, Film and the Construction of Australian Narrative*, 2nd edn, Sydney: Allen & Unwin, 1993.

Wiseman, Frederick, 'Frederick Wiseman replies,' *Frederick Wiseman*, ed. Thomas R. Atkins, New York: Simon & Schuster, 1976. 69–73.

Young, James E., 'Holocaust memorials in America: public art as process,' *Critical Issues in Public Art: Content, Context, and Controversy*, ed. Harrier F. Senie and Sally Webster, New York: Iconeditions, 1992. 57–70.

Zipporah Films, *Award Winning Documentaries by Frederick Wiseman*, Fall 1991/92, Cambridge, Mass., 1991.

Ann Reynolds

VISUAL STORIES

A working country is hardly ever a landscape. The very idea of land-
scape implies separation and observation. It is possible and useful to
trace the internal histories of landscape painting, landscape writing, land-
scape gardening and landscape architecture, but in any final analysis we
must relate these histories to the common history of a land and its
society.

(Raymond Williams, *The Country and the City*)

A *MY WEEKLY READER* 'Your Read and Study Guide' from 1966 posed these
questions to nine-year-old schoolchildren: 'Study the designs of the super-
jets on this page and on the front page. How are the two planes alike? How
do the two designs differ?' One child penciled in this answer: 'They are pointed on
the front. They have different wings and engens [*sic*].'[1] She drew two of her conclu-
sions from the visual evidence provided by the accompanying images, but her third
answer required a conceptual leap since no significant differences between the
engines of the two superjets are visible in either set of images. Evidently the student
had been taught to attribute information to images through conceptually related
visual cues, in this case the different shapes of the wings. This visible difference
between the jets acted as a marker of an invisible difference, and allowed looking
to yield information, although this information was not actually visible in the images.

Another *My Weekly Reader* article and study guide from the same year uses images
in a similar manner. The article, entitled 'Packaged Power,' contains illustrations
of familiar objects such as clocks, cars, pencil sharpeners, and television sets. Each
one is depicted as a simplified, blue silhouette while its battery appears as a black-
and-white photographic image inside. The study guide asks students to name all
the objects and then to extend their awareness of what was inside these objects to
other objects used in their daily lives: 'What battery-driven toy have you enjoyed?'

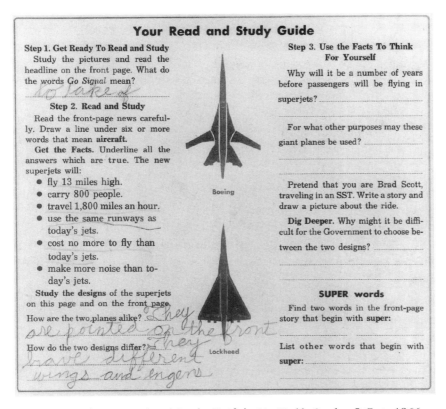

Your Read and Study Guide

Step 1. Get Ready To Read and Study

Study the pictures and read the headline on the front page. What do the words *Go Signal* mean? *to take of*

Step 2. Read and Study

Read the front-page news carefully. Draw a line under six or more words that mean **aircraft**.

Get the Facts. Underline all the answers which are true. The new superjets will:

- fly 13 miles high.
- carry 800 people.
- travel 1,800 miles an hour.
- use the same runways as today's jets.
- cost no more to fly than today's jets.
- make more noise than today's jets.

Study the designs of the superjets on this page and on the front page.

How are the two planes alike? *They are pointed on the front*

How do the two designs differ? *They have different wings and engens*

Boeing

Lockheed

Step 3. Use the Facts To Think For Yourself

Why will it be a number of years before passengers will be flying in superjets? ____

For what other purposes may these giant planes be used? ____

Pretend that you are Brad Scott, traveling in an SST. Write a story and draw a picture about the ride.

Dig Deeper. Why might it be difficult for the Government to choose between the two designs? ____

SUPER words

Find two words in the front-page story that begin with **super**: ____

List other words that begin with **super**: ____

Figure 31.1 'Your Read and Study Guide', *My Weekly Reader*, 5 Oct. 1966
(Courtesy of Ann Reynolds)

'What other "cordless" products have you used?' and 'What electric products in your home may be "cordless" in the future?'[2] The last two questions imply that a product's cordlessness is visual evidence of the presence of a battery inside, but this evidence or marker makes sense only after students have been provided with the illustrated look inside the silhouetted objects. Again, the designers of *My Weekly Reader* translated visible differences into markers of information that was literally invisible. And students were expected to make conceptual leaps in order to put what they had learned to good use.

The steps involved in making the conceptual or extra-visual leaps prompted by 'marked' images need not be spelled out or even directly acknowledged in order for the lesson to be effective. In the case of the superjet example, the student made the connection between visible differences in wings and invisible differences in engines without needing any intermediary directions. Such successful leaps, when demanded and performed week after week, begin to seem self-evident, especially when the lessons provide no forum for students to challenge the way the questions and their appropriate responses connect images and information.

The enhancement of visual images with additional layers of information does not result, however, in seeing more, but only differently. Usually extra-visual leaps occur at the expense of aspects of these same images the lesson makers have

determined to be irrelevant or detrimental to their educational aims. For example, a *My Weekly Reader* article on the Milwaukee Public Museum's soon-to-be completed diorama of a buffalo hunt provides an inventory of the items the diorama will contain, detailed descriptions of how each element and special effect is created, and general information on the importance of the buffalo to the Plains Indians.[3] The magazine also contains two photographic views of the diorama, completed and under construction. The study guide's choices of possible responses to its question 'If you could go to the new museum in Milwaukee, what might you see there?' are limited to those concerning how the diorama was created, such as 'a diorama with a painted foreground,' 'eight live buffalo,' and 'two horses made in papier-mâché.'[4] Another question, 'What sound effects might you hear at the exhibit?,' continues this line of inquiry, while others separately address the historical relationship between the buffalo and the Indian with no reference to the diorama at all, as if the subject of the diorama and the diorama itself had no related educational function. *My Weekly Reader*'s presentation of the diorama solely as a product of artifice unravels the diorama's illusionistic mysteries, but it ignores the museum curator's probable aim to teach the child about the subject of the diorama *through* the visual, audio, and textual elements of the diorama itself. As a result, the magazine's lesson on the buffalo seems more complete and direct than the museum curator's efforts because, in the former, visual fantasy appears to give way to hard 'facts.'

The articles and answers from *My Weekly Reader* that I have been using to describe the pedagogical process of extra-visual leaps come from my own copies of the magazine. I remember as a child I did not look forward to completing the 'Read and Study Guides' even though I usually answered them correctly. Their questions still make me uncomfortable, but as an adult, I am much better prepared to consider why this might be so.

The creators of the *My Weekly Reader* did not develop these questions and lessons for me alone. They reached a large number of elementary school students; many US public school systems subscribed to the magazine in the 1960s. Once one understands the basic principles behind these lessons – and the creators of *My Weekly Reader* certainly did not invent them – one can also begin to recognize these same pedagogical principles at work in many other places, albeit sometimes in either more complicated or less obvious configurations.

An examination of the pedagogical philosophy of one man, Alfred Parr, and his ground-breaking proposals for the Felix Warburg Man and Nature Hall at the American Museum of Natural History in New York illustrates the ways in which educational institutions encourage extra-visual leaps. The history of the development and refinement of Parr's basic educational aims and the hall designers' accommodation of them through several types of visual display provide striking examples of how and why public educational institutions addressed the complex relationship between vision and education during and after the Second World War in the United States. Through a historical analysis of such a well-documented case, the reasons why such lessons might have made at least some members of their audience uncomfortable can also be addressed.

Parr believed that many of the AMNH's public exhibits, particularly the dioramas, taught nothing at all and were hopelessly out of date in terms of contemporary

scientific knowledge. Shortly after he took office as director of the museum in March 1942, he began to promote his ideas for a new introductory hall, which he believed would offer a totally new educational model for natural history museums. He stated in a letter to a colleague that his new hall, like the rest of the museum, should no longer depend on a strictly chronological format since such a model inevitably commences by taking the visitor 'back to the thing that occupies the remotest possible position in time and space from the moment and the place in which he is living and from the phenomena with which he is familiar and concerned in his own life.'[5] According to Parr, the introductory hall:

> should be the hall in which we meet our public on the basis of its common experience, which is a point from which we have to start if we wish to guide our visitor from his own knowledge into ours and from his own everyday experience into the new experience which science may have to offer him.[6]

Basically, Parr planned to ease the visitor's transition from a 'common' or shared set of everyday experiences to a new set of scientific experiences by explaining the latter in terms of the former. He described everyday experience as present and immediate, and not something consciously understood to be a result of or even a part of a historical continuum. He identified a corollary to this quality of 'present-ness' in what he called the 'contemporary dynamics of nature,' which he also claimed could not be adequately apprehended through historical schemes:

> If you want to express it in terms of the physicist you may say that the historical rate of change (geologically speaking) is so slow in relation to the rates of change of contemporary dynamic processes that in historical perspective we can regard all the processes as being in instantaneous equilibrium with their own cause. Then the historical picture can, with more than adequate accuracy, be described as a series of equilibrium states, which means that to interpret any one of the states we can disregard the historical factor.[7]

For Parr, the 'contemporary dynamics of nature' were nature's own version of everyday experiences like those of museum visitors; these dynamics could be made to be immediately relevant without forcing visitors to deal with distant or abstract historical factors first.

Parr also used the term 'contemporary dynamics of nature' as a synonym for 'ecological subjects,' and early on, he often openly referred to the new introductory hall as an 'Ecological Hall.' This provisional title came as no surprise to his staff given his well-known commitment to ecology, but many of AMNH's scientists strongly opposed his decision to use ecology as the guiding organizational principle for public exhibition halls. One scientist claimed that such a principle lacked intrinsic unity, since it necessarily required information from various scientific disciplines and a grouping together of specimens usually displayed in separate halls. Parr countered this particular criticism with an alternate definition of unity and a restatement of his general educational aims:

I have always been considerably disturbed by the lack of unity in the particular kind of *a priori* displays you suggest. It has always seemed to me that the introduction and importance of alfalfa at one point, rabbits in Australia, Japanese beetles, force of gravitation and so on at other points, merely give us tidbits of knowledge from all corners of the world and from all types of situations, which can never form an integrated totality in nature. . . . By showing all the disciplines in separate treatment it fails to show how they depend upon each other and how they supplement each other in the explanation of the totality of nature, which is very far from being merely the sum of its parts.[8]

As plans for the introductory hall progressed, Parr increasingly referred to the AMNH's explanation of the 'totality of nature' as the 'story' it should tell. The term 'story' makes one of its earliest appearances in the concluding paragraph to a lengthy, internal memo concerning the museum's exhibitions in general:

We have a great story to tell, yet the simple truth of the matter is that we tell it so incredibly badly that few of our visitors ever get the idea that there is a story here at all. . . . In planning a hall the first question should be – not what objects do we want to place in the hall – but what STORY DO WE WANT THE HALL TO TELL. The objects should be used to drive home the salient points of the story and should (exceptions of course) no longer, except for study purposes, be regarded as sufficient unto themselves. The second question in planning a hall should be: what is the very best method we can devise for telling the particular story to the average visitor?[9]

This aim to tell a story, and to tell it so well that the visitor would recognize its unifying presence and message, goes hand in hand with Parr's desire to reveal the presence of science within and the relevance of science to everyday experience, since for him storytelling embodied the repetitive rhythm of the familiar and the everyday and could easily describe nature's cycles and systems. Such scientific storytelling would not need to refer to the complete sets of specimens or stages that taxonomic or evolutionary narratives did. In the new halls, fewer and more familiar objects would play multiple roles in depicting both the cyclical and historical events that comprise the total story of nature, which Parr believed the museum was obligated to tell.[10] The same objects and images would appear in more than one display case and in a variety of combinations, and their repeated appearances would encourage visitors physically to double back as well as move forward among the individual exhibits rather than to 'progress' sequentially through them. Through repeated viewings of these same objects and images from different perspectives and in various combinations, visitors would recognize that more was going on in these familiar things than met the eye. Gradually the pieces of the story of nature previously unknown or unacknowledged, such as evolutionary and geological changes, and other normally invisible processes, would come into view. And visitors would move beyond merely recognizing specific forms in a taxonomic chain to achieve an awareness of how the forms functioned within a total ecological system.

In keeping with his commitment to thread scientific understanding through the experiences of everyday life, Parr also determined early on that the new introductory hall should tell the story of the local landscape (see Figure 31.2). The idea, as Parr stated it in a memo, was to grasp the total story as it existed within a particular location but

> not to tie it [the hall] too specifically with the details of any particular location, but to design it so that it will give the visitor a feeling of familiarity with the landscape because it will represent any landscape he might be likely to see on a Sunday's drive.[11]

He did not want to provide a slavish copy of a specific place, but he insisted that the hall's designers work from a real landscape; otherwise they would fail to create the necessary 'true illusion.'[12]

By distinguishing between specificity of representation and true illusionism, Parr acknowledged the traditional goals of diorama construction. The chosen site was to be painstakingly reproduced in its particulars – local specimens, samples, and views – and these elements were to be artfully recombined in order to create a perfected

The Story of the
LANDSCAPE
by Henry K. Svenson
and Farida A. Wiley

Figure 31.2 'The Story of the Landscape,' cover of the guidebook to the Warburg Hall (Courtesy of the Department of Library Services, American Museum of Natural History)

totality that both generally alluded to the original site and convinced the visitor of its visual truth on its own illusionistic terms. But, in representing such a local and familiar site, one that could be visited over and over again, unlike the sites depicted in the museum's old dioramas, which were frequently remote and outside most visitors' everyday experience, Parr ensured that the hall's display images could never be regarded as just pretty pictures. Visitors would be motivated to learn more from the hall's images because they already had some experience of them as familiar places; they could more readily connect what they saw and learned in the hall to the actual places and things to which the hall's images referred. For Parr, telling the story of the local landscape provided the key to maintaining both a constant connection between representation and referent and a unity that many of his scientist colleagues feared would be lacking in an ecological hall.

By 1946, Parr had settled on the Pine Plains Valley and Mount Stissing area of upstate New York as his particular model for the new hall's local landscape, and the finished hall, called the Felix Warburg Memorial Hall of Man and Nature, opened on May 14, 1951.[13] All of the press releases and most newspaper reviews of the hall noted the innovative aspects of the hall's displays. Some of these displays were innovative for innovation's sake; after all, Parr wanted the new hall to provide a provocative first glimpse of the 'museum of natural history of the future' that would generate renewed outside financial support. But most of these innovations functioned as means toward Parr's stated educational aim to 'tell the total story of the local landscape.'

Figure 31.3 Entrance to the Warburg Hall (Courtesy of the Department of Library Services, American Museum of Natural History)

The hall's entrance directs the visitor in on a diagonal. A curve of wood panelling stretches out from the entrance door frame to promote this diagonal orientation, and the hall's initial diorama counters this diagonal with an orientation parallel to the lines suggested by the outward curve of the doorway. All of these axially aligned curves and diagonals initiate a rather unorthodox pattern of meandering movement through the hall. As for the visual aims of the individual displays, the deliberately 'off-kilter' framing of the entrance calls attention to the activity of framing itself and along with it, point of view.

The first diorama the visitor sees at the entrance is entitled *An October Afternoon near Stissing Mountain*. This group contains an image just as aesthetically pleasing and visually complex as many of the museum's earlier dioramas, and its brilliant, autumnal colors and picturesque composition are calculated to lure the museum visitor into the darkened hall. Yet the designers of this group are not aiming for the same kind of mysterious verisimilitude that they achieved in the earlier dioramas; the view depicted is obviously not equivalent to what the naked eye would perceive at the actual site, and the mechanics of the illusionistic process are also quite evident.

The animal, bird, insect, plant, and soil specimens occupy an unusually narrow strip of foreground space trapped between the background mural on the diorama's back wall and the glass front of the display case. And because the foreground area is so narrow, the mural is not much more than arm's length from the viewer. Even the artist's individual brush strokes are visible.

The illusionistic space depicted in the mural is also rather shallow because it recedes from right to left at a slight angle across and back, rather than gradually backward through an established middle ground to the mountains depicted in the background. When examining the mural artist's black-and-white preparatory photographs taken at the site one recognizes that he has mixed together several of the most picturesque views of the background and almost completely eliminated the middle ground areas, so that the space appears to move up from the foreground and diagonally across the background along several different orthogonals. These strategies for compressing several sweeping landscape views to fit the limited area of a showcase were commonly used in creating the background murals for the museum's earlier dioramas, but here the artist seems to push the distorting process beyond the point of creating a mysteriously real effect. The results of these distortions heighten the dramatic picturesqueness of the scene when visitors view it from the entrance, but when they move into the space of the hall and approach the display, parts of the scene appear to be closer than they would actually be at the site or even in an accomplished, highly illusionistic landscape painting. Even if the viewers cannot identify specifically what causes the spatial distortions in the diorama's overall image, the visual effects are slightly disorienting, and they call attention to the fact that what the viewer is looking at is a *landscape*, a construction made manifest through various points of view.

To eliminate the discomfort caused by the image's lack of visual coherence, visitors can either retreat to the entrance – not a very likely reaction – or move even closer to the display so that its overall image is no longer in view. Such close proximity invites inspection of the individual elements in the scene and their identifying labels which run along the lower edge of the case. Thus the diorama's artists used beauty as a device for drawing visitors in, made the slightly distanced space of

purely aesthetic entertainment an uncomfortable one, and, as a result, encouraged a closer and longer inspection of both the image and its lessons. At least it is certain that the visitors were looking at the diorama differently, which was an important first step.

To quote again one of Parr's remarks made during the hall's early planning stages:

> The explanation of the totality of nature . . . is very far from being merely the sum of its parts. It seemed to me that the unity of the hall would be very plain, in that it was provided by the very landscape itself taken as a whole, as the visitor would first see it when he enters and would have it more or less before his eyes all the time in the form of a central topographic scale model. In other words, the central theme would be our effort to analyze and explain this landscape and all it contains.[14]

Visitors came to this topographic model of the Pine Plains Valley and Mount Stissing area immediately after viewing the initial diorama. This map was visible from many parts of the hall, and since the case it occupied was the only freestanding one in the hall, it anchored the other visual displays by its large physical presence and by offering the only complete view of the region. The rest of the displays are fragmentary, but through the foregrounding of the very devices of illusionism, each transformed the visitor's eyes into magnifying glasses, microscopes, or scalpels, which could reveal the invisible workings of a familiar yet superficially understood natural world. The story of the local landscape unfolded through the visitor's deepening visual understanding of this world.

For example, in a set of display cases entitled *Life in the Soil*, vertical cutaways of the soil strata underneath the surface of wood and farmlands offer little of the familiar space above ground for visitors to examine. But the display designers make up for this loss by providing visual access to this normally invisible world below the surface during winter and spring: earthworms, chipmunk and mole burrows and nests, a yellow jacket nest, an ant nest, a hibernating frog, and other forms of underground life and activity. These glimpses into life in the soil restore missing bits of the cyclical story of active and hibernating life of many species.

Other aspects of the soil's story are presented differently. Labeled, blown-up photographs of microscopic images of root systems detail the ways these systems absorb nutrients from the soil, and comparisons of soil profile specimens demonstrate the various effects of soil conservation. All of these displays contain enough formal similarities, such as the primarily vertical orientation of their images, the identical colors of their backgrounds, and similar kinds of specimens, to encourage visitors to make visual and then conceptual associations back and forth across the space of the hall. These associations add up to a fairly complete understanding of the soil of the local landscape and of soil in general.

Another example – by far the most visually unsettling – of spatial manipulation used by the hall's artists, depended on a new type of visual display called a mirrorscope. Each of the mirrorscope display cases contains a miniature diorama mounted on the bottom of an individual case, directly below and behind a rectangular opening

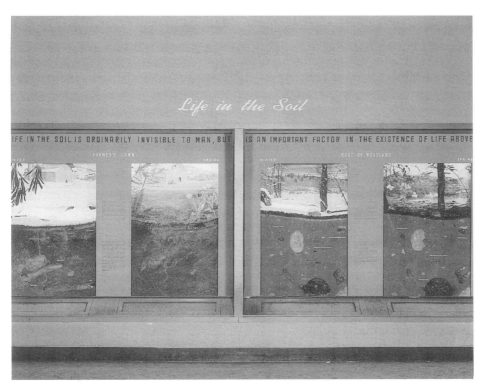

Figure 31.4 'Life in the Soil' (Courtesy of the Department of Library Services, American Museum of Natural History)

positioned in the wall at eye level. The visitor peers into the opening and down a dark, horizontal tunnel to view a tilted mirror-reflection of the diorama below. Viewers might not initially realize they are looking at a reflection. Eventually, they perceive how the mirrorscope works because of the unconventional diagonal orientation of the mirrored image. This contrived image calls attention to its reflective process, and reminds visitors that the dioramas are highly artificial images that indirectly reflect larger three-dimensional sites elsewhere.

From a distance these mirrorscopes appear to be small black holes, which disrupt the larger images in the displays that contain them. The viewer must move in quite close to these displays to see what is inside the holes; the mirrorscope images encourage, much more insistently, the same type of movement that the initial diorama does. The hall's designers also use this combination of two nested, but differently scaled, views to represent the relationship between local geological conditions and the overall trajectory of geological history and evolution. In one display, the former is represented by a cross-section of the Pine Plains Valley region running the entire length of the display case, and the latter consists of a timeline of the earth's history located under this cross-section, which also runs the length of the case. Small mirrorscope views of the local landscape during the Devonian, Pleistocene, and Triassic eras, located at the corresponding points on the timeline, physically link the general and the specific histories of the local landscape together. The contrasting visual experiences of the display indicate the local landscape's

geological history, as well as geological history overall, and both kinds of history are given equal importance.

Another type of display could be called a 'picture diagram' because it consists of one or more miniature dioramas placed inside and set back behind a larger diagrammatic image painted on the outer display case wall. The diagrammatic components illustrate ubiquitous natural or agricultural processes which are either visually imperceptible or occur over an extended period of time and thus could not be represented in one view. This type of display aims to identify the presence and effects of such processes in the local landscape. For example, the hall's 'picture diagram' of the water cycle contains a miniature diorama depicting the Pine Plains Valley region inside a two-dimensional, diagrammatic picture of a similar, but more simplified landscape format. Both images contain an arrangement of clouds, a source of light coming from the right, a valley flanked by rises on either side, and a view of distant mountains in the background. In the outer diagram, the sun and its rays, clouds, precipitation, and evaporating water are schematically sketched in a limited range of colors on the blue background of the display case wall, and arrows indicate the counter-clockwise movements of water through the various stages that make up the water cycle. Both the central diorama and the surrounding diagrammatic picture are labeled at all of the same points; these labels, plus the general resemblance between the two compositions, link them together formally and then conceptually. Thus the presence of a 'contemporary dynamic of nature' in the local landscape is made visible through these formal analogies.

All of the exhibition strategies developed by the Warburg Hall designers offered museum visitors visual access to the normally unseen workings of nature or to the distant historical and geological past of the region through what were then deliberately unusual display techniques. These strategies were also meant to transform the daily activity of vision itself into a more self-conscious activity, extending it beyond its natural limits in time and space. Parr believed that the hall's lessons would be effective because they began with and always referred back to an already familiar site, the local landscape. But in order to benefit from these lessons, the museum visitors had to project what they had seen in the hall onto the local landscape itself, and these projections depended on conceptual associations or extra-visual leaps. One cannot see, for example, the life under the soil or the geological past of a particular site through looking alone; the soil and the landscape must be marked as carriers of this invisible information through related visual cues. The Warburg Hall displays, just like the lessons from *My Weekly Reader*, call attention to such cues and offer views of the usually unseen aspects of familiar objects and sites; the visitor may then extrapolate from what was seen when confronting the local landscape itself.

Although Parr selected 'common experience' as the starting point for his lessons, he did not assume that the AMNH's entire audience came to the museum with the same set of experiences. His early characterization of the visitor's 'feeling of familiarity with the landscape because it will represent any landscape he might be likely to see on a Sunday's drive' indicates that he had one particular group of visitors in mind: city dwellers. According to Parr, this group viewed the local landscape at a leisurely distance from their cars or picnic blankets, whereas the local inhabitants of the Pine Plains Valley and Mount Stissing area, whom Parr identified as mostly farmers, did not.[15] Thus his goal of creating a 'true illusion' of the local

landscape from a generalized copy of a real landscape was based on an outsider's understanding of 'truth.' Parr had another reason for making the museum's landscape unrecognizable in specific terms: 'We do not wish to have any libel suits from the unintelligent farmer we propose to include.'[16] He knew that local farmers would be the only visitors able to recognize a slavish copy of property they owned; their particular familiarity with the local landscape was a liability if represented.

The city dweller's passive experience of the local landscape represented everything Parr believed to be wrong with the way museum visitors experienced the museum's old halls. So, by broadening and transforming their common experience into a more clearly self-conscious educational activity, he was able to address this old pedagogical problem of passivity. Parr's selection of the urban audience as his primary target group for the Warburg Hall was also strategic, since most of the wealthy former and potential donors to the museum belonged to this group.

Although Parr's choice of audience conformed to his general educational and financial goals for the AMNH, several crucial effects of his choice are troubling. His understanding of the urban visitor's experience of rural, upstate New York became the visual starting point for every museum visitor. And since this initial point of view was never explicitly identified with any particular segment of the museum's audience anywhere in the Warburg Hall, it seemed to be a self-evident choice, universally shared.

Because Parr was also committed to telling the 'total story of the local landscape,' he had to include man's participation in the appearance and productivity of the land. But he did not want to burden his targeted city audience with any but the most general aspects of these parts of the story because he realized that they would primarily still remain consumers of what they saw. The completed hall contained only a few displays dealing with crop cultivation and animal husbandry – but every one privileged general principles over detailed explanations of the farmer's practical problems, and most emphasized products over production. Even when production was the subject of a particular display, as in the presentation of the history of farming in New York State, all of the textual information was addressed to the layperson.

One might ask, at this point, 'What did the farmer learn when looking at these types of displays?' or 'How was his or her "common experience" as a producer or laborer being transformed?' Nowhere were these questions addressed in the hall. So, not only was the Warburg Hall's visual story of the local landscape partial, but the community of mutual understanding and interdependence promoted through the hall was limited, as it was based on the interests of residents of a single geographic region and, primarily, the middle and upper classes, who occupied only one position in the region's agricultural economy.[17]

Parr developed plans for the Warburg Hall long before the end of the Second World War; by the war's end, his pedagogical ambitions had outgrown teaching museum visitors about the relevance of science to their local, everyday lives. In his 1947 essay, 'Towards New Horizons,' published in the museum's annual report, he described the postwar moment in much the same terms as Karl Mannheim described the pre-war period in his text *Ideology and Utopia*, although where Mannheim identified *ideology*'s work in building a national and global community, Parr used *education*:

> The greater the mental confusion of the times, the greater the challenge
> to education, and the greater the value of teaching properly conceived
> and directed towards the elucidation of the problems which disturb the
> world. . . . In a world beset by hostility and want, the natural history
> museums have an opportunity, never before equaled, to serve the devel-
> opment of peace and of a better life for all by bringing their educational
> facilities and their scientific knowledge to bear upon the task of creating
> a better understanding of our own problems in relation to the country
> that surrounds us and supports us, and of the problems of other nations
> in relation to their natural circumstances, to one another, and to us.[18]

After the war was over, Parr and the museum president F.T. Davison increas-
ingly described the ecological story of natural history as an antidote to totali-
tarianism.[19] Over and over again in his writings, Parr proposed 'a total conception
of the whole of nature as a balanced system,' as a model for social cooperation
which, when understood and 'cultivated' locally, could create a model for world
peace. During this same period, Parr suggested that the term '"expedition," with
its romantic associations with the idea of distant and long voyages' should be replaced
by such words as '"survey" or "field work" to describe the manner in which the task
of exploration is carried forward today,' since he felt that thorough scientific research
could be conducted in one's own backyard.[20] There are even a few subtle indica-
tions of this larger purpose of global awareness in the Warburg Hall, though its
displays ostensibly address only the problems of the local landscape.[21] Displayed
world maps, for example, indicate where soil conditions in upstate New York occur
globally as well as nationally.

The wedding of rarified science to everyday life in the design of the Warburg
Hall represents a significant ideological shift in the museum's educational agenda,
not just a simple effort toward better education. What Parr represented as an effi-
cient or 'economical' model for understanding the total story of the local landscape,
and ultimately of man and nature was, in fact, a model for naturalizing an economic
structure of interdependence; twenty years of financial instability had demonstrated
how much the museum depended on this economic structure for its own survival
and growth.

Parr's desire to enlarge his public's visual understanding of the 'familiar'
included social and political aims that could only be accomplished through dazzling,
truly extra-visual and clearly ideological leaps, which started and ended with the
experiences of only a segment of that public. Such disparities could easily have
caused visitors some discomfort, especially if they were not members of that chosen
segment of the public.

Perhaps the *My Weekly Reader* 'Read and Study Guides' made me uncomfortable
because I wasn't among their ideal or 'targeted' audience.[22] When faced with an
institutionalized and pervasive pedagogical device like extra-visual leaps, individuals
are prone to blame themselves for feelings of discomfort, or to credit these feel-
ings to those of inadequacy, especially since such devices do not value subjective
responses, and thus provide no place for them. Part of my intention in this essay is
to posit the value of using such subjective responses as the only way we have of
differentiating ourselves and who we are from the institution's version of who we

should be. Discomfort may be our only motivation to look harder at the agendas of pedagogical institutions and their devices, no matter how subtle. An assumption of universal appeal always masks a much more considered selectivity.

Notes

1 'U.S. Gives Go Signal for Superjets,' and 'Your Read and Study Guide,' *My Weekly Reader* 48, no. 4 (5 October 1966), pp.1, 8.
2 'Packaged Power,' and 'Your Read-Study Guide,' *My Weekly Reader* 48, no. 6 (19 October 1960), pp.1, 8.
3 'Where the Buffalo Roam,' *My Weekly Reader* 48, no. 7 (26 October 1966), p. 1.
4 'Your Read-Study Guide: "Where the Buffalo Roam,"' *My Weekly Reader* 48, no. 7 (26 October 1966), p.8.
5 Alfred Parr, Letter to Dr Edwin H. Colbert, 9 September 1942, pp.1–2, Archives of AMNH.
6 Ibid., p.1.
7 Ibid., p.2.
8 Alfred Parr, letter to Dr William K. Gregory, 8 October 1942, p.1, Archives of AMNH.
9 Memo concerning exhibitions, Plan and Scope Committee, *c.* July 1942, pp.7–8, Archives of AMNH.
10 Alfred Parr, 'Towards New Horizons,' *American Museum of Natural History Annual Report* 78 (July 1946–June 1947), p.16.
11 Alfred Parr, 'Hall of the Local Landscape,' 25 September 1946, p.1, Archives of AMNH.
12 Alfred Parr, letter to Mrs Paul Moore (13 January 1943), p.1, Archives of AMNH.
13 The hall was named in memory of the father of the hall's major financial backer and a trustee of the museum, Frederick M. Warburg.
14 Alfred Parr, letter to Gregory, p.1.
15 Alfred Parr, letter to Moore, p.1.
16 Ibid., pp.1–2.
17 Alfred Parr shared his utopian faith in the capacity of storytelling to produce a unified community with Walter Benjamin, yet the differences in their explanations of the relationship between storytelling and the economic structure of the communities they shaped reveals the one-sided nature of Parr's understanding of the practice. In 1936, Benjamin described storytelling as part of a pre-industrial past in which production and consumption were shared equally as experiences:

> the art of storytelling is coming to an end. Less and less frequently do we encounter people with the ability to tell a tale properly. More and more often there is embarrassment all around when the wish to hear a story is expressed. It is as if something that seemed inalienable to us, the securest among our possessions, were taken from us: the ability to exchange experiences.
> (Benjamin, 'The Storyteller,' *Illuminations*, New York, Schocken Books, 1969, p. 83)

18 Alfred Parr, 'Towards New Horizons,' *American Museum of Natural History Annual Report* 78 (July 1946–June 1947), pp. 9–10.

19 F.T. Davison, 'Report of the President,' *American Museum of Natural History Annual Report* 81 (July 1949–June 1950).

20 Alfred Parr, 'The Museum Explores the World – Report of the Director,' *American Museum of Natural History Annual Report* 83 (July 1951–June 1952), pp.10–11.

21 The *My Weekly Reader* article 'U.S. Gives Go Signal for Superjets' contains some evidence of a similar, albeit unacknowledged, slide from national to global concerns. The title represents the competition between two companies to produce the jets as a national one, yet the article's author uses terms usually reserved for describing the then current international 'space race' to portray the stakes involved.

22 Even without the benefit of extensive research, I can draw some general conclusions concerning *My Weekly Reader*'s ideal audience in the 1960s based on the types of subjects consistently represented in the magazine and the manner in which they were addressed: enormous numbers of articles on NASA and technological innovations generally; studies of rural areas of the United States; and biographical essays on representational painters of the nineteenth century, such as Winslow Homer and contemporary artists, such as Norman Rockwell and the Wyeths. Examples of avant-garde culture, if mentioned at all, were treated as humorous curiosities akin to rare and odd-looking animals from exotic places. Girls like me, longing to learn about big cities and looking for images of how cultural life is lived there, particularly by women, could not help but be disappointed.

Andrew Ross

THE GREAT UN-AMERICAN NUMBERS GAME

[. . .]

THERE ARE MANY LESSONS to be drawn from the history of artworld activism in the period since the late 1960s. My interest here lies primarily in the use of statistics to organize moral and political dissent in general, and to make arguments about selection and representation in exhibitions in particular. How do we explain the current urgency of this phenomenon in cultural affairs, in that realm of social activity where quantitative reasoning is supposed to have least influence and where aesthetic taste and qualitative value hold most sway? Although it is far from restricted to the hothouse of the North American artworld, it's fair to say that in the example of the Guerrilla Girls we have one of the cleanest, most concise, and most visible displays of this criterion of judging by the numbers. To many eyes, it has produced a standoff between a disinterested principle of selection and one based on accountability to particular group identities. For the most part, this is perceived as a confrontation that has emerged only very recently – the inevitable result of a cash between the upsurge in identity politics, whereby different minority groups demand recognition and parity of representation in the public sphere, and an older, prevailing tradition of assessment that was less conscious of, or intrinsically blind to, its record of exclusions. On the contrary, the discrepancy between these two principles of selection is not simply of recent origin; it can be traced back to the goals articulated in the foundation of the great public museums in the nineteenth century. For the most part, I will focus my discussion on the art museum.

In two recent influential books, Tony Bennett *(The Birth of the Museum)* and Carol Duncan *(Civilizing Rituals)* have documented how the public museums were instituted by bourgeois reformers with the intent of providing a means of self-improvement to the mass of the population.[1] At a time when culture was being drawn into the province of government, museums and other public institutions like

parks, libraries, and symphony halls were intended to serve as instruments of peaceable self-reform for urban populations that were becoming increasingly unmanageable. To perform their function in an educative manner, museum collections had to be fully representative of art history: their precursors had been the collections of Renaissance princes, absolute monarchs, and aristocratic gentlemen, which had aimed more at the singular, the exotic, and the wondrous – the Cabinet of Curiosities – rather than at extensive historical coverage. In many instances (in the Met as well as in more provincial institutions) this coverage would be provided initially by plaster-of-paris replicas. Thus was born not only the principle of universal representation according to the canons of art-historical taste, but also the impossible ideal of the complete collection, as defined, again, by the prevailing aesthetic sense. According to Bennett, this goal of telling the story of Man on the basis of his universality could never be satisfied by any particular display of Man, which would always fall short, as a result of exclusions and bias. So too, there was a contradiction between the use of the museum as a vehicle for universal education and its use as a means of reforming the manners and conduct of its new audiences; one goal addressed its audience as an undifferentiated group, the other actively differentiated its audience according to their level of social and cultural refinement.[2] Despite its universalist intentions, usage of the art museum, then and now, has always been confined to socially upscale populations. Casual visitors to Washington's museum mall soon discover that the big draws are the Air and Space Museum, the most popular in the world, and the Natural History Museum, where the main attraction – the spectacle of the Hope Diamond in a display case – generates the longest line of all. By contrast, one can stroll unimpeded through the miles of uncluttered art gallery corridors and enjoy the relative solitude that art appreciation is supposed to foster and that truly popular art education can only disturb and despoil. The nineteenth-century story was not terribly different. Despite conservatives' fears that the newly admitted masses would desecrate the art on display and generally run riot, the forbidding architectural milieu of the temple-museums and the austere tenor of their educational paternalism were sufficiently off-putting to the majority, while trustee elites privately fostered policies that discouraged popular use. It did not help matters, for example, that the religiously minded trustees of institutions like the Met closed the museum on Sundays, the only day of recreation for the working class. Bending to criticism of this twenty-year policy, the trustees opened the doors in 1891 with the public aim of seducing people away from Coney Island. No doubt they were relieved, but hardly surprised, when the initially large Sunday attendance fell off rather quickly, and the museum resumed its air of an exclusive preserve for urban elites.

Unlike in France, where the king's royal collection had become nationalized in the Louvre, or in England, where bourgeois reformers created national museums *in opposition to* the vast collections of the aristocracy (King Charles's collection had been dispersed by the Puritans), the great American civic museums of New York, Boston, Chicago, and Philadelphia were created by prosperous Protestant elites intent on securing their country's symbolic prestige in the world of industrial nations. The collections were built up through extraordinary gifts from those storied tycoons who effected a massive relocation of art objects from Europe in the later decades of the century. The major museum bequests of the millionaires made front

page news and brought them great social status. Thus was the WASP heritage of high European culture established as the American national patrimony.[3]

While the great museums had to retain their public credibility – building on public land, accepting public monies, and advertising their role in public education – they were dependent on the private bequests and were controlled by the interests of their millionaire benefactors. These moguls were accustomed to sit on the self-perpetuating boards of trustees, and many of them maintained their own rooms, with the right to display their own art, in an arrangement that made buildings like the Met appear more like mausoleums to enshrine their benefactors' fame than the people's museums they were supposed to be. The public excesses of the Gilded Age tycoons were eventually curbed in the nation at large. As Duncan notes, one result was the new policy in most museums of discouraging restricted bequests (revived again in recent decades), and, more generally, the advent of professional curatorial control over collections.[4] But there was little decline in the influence of the family names associated with bequests to the nation's blue-chip cultural establishments – Astor, Vanderbilt, Girard, Lowell, Peabody, Rockefeller, Carnegie, Morgan, Stanford, Frick, Corcoran, Gardner, Getty, Mellon, Huntingdon, Widener, Kress, and Altman. For this class, ties to the elite institutions of the arts and higher education have continued to be an obligatory mark of prestige and social standing. Policing of taste in many of these institutions was preserved through the board of trustees, where, in New York City to this day, the same Social Register names appear on the boards of the likes of MOMA, the Metropolitan, the Juilliard, the New York Philharmonic Orchestra, Lincoln Center, the New York Public Library, and the big-league foundations. They are accustomed to dining regularly, after hours, amid the opulent furniture of palaces like the Met, at fund-raising parties that are as integral to the social season of the wealthy as to the economic health of the high-end arts. It is hardly surprising, then, that the intimate involvement of these institutions with wealthy patrons has sustained the latter's often arbitrary influence over taste and exhibition selection, and that the public mandate of the museums often appears to be a facade.

This historical tradition of sustaining private interest in the name of public enlightenment was extended to the artworld as a whole with the creation of an international art market as early as the 1930s. Under modernism's aesthetic banner of pure formalism, works of art would now work their way from one autonomous sphere to another – from the commerce-free studio through the commodity-saturated marketplace and prestige-rich collection into the canonical museum – without becoming soiled with the taint of dollar value.[5] No doubt this system also depended on the development of advanced security systems. Electronic surveillance has only recently displaced an armed security presence in some galleries and museums. (. . .) Most of the time, however, security is achieved through self-discipline. (. . .) Indeed the entire tradition of art appreciation and connoisseurship, as it has evolved, is exemplary of the self-discipline and self-surveillance that are the favored modes of behavioral management in advanced liberal societies.

But security is not there simply to protect art or regulate moral behavior through self-fashioning, it is also there to boost the spectator's estimate of the value of art. Who hasn't heard the story that the Mona Lisa became a truly valuable work of art only after it had been stolen? In the age of the grand purchase, the huge sums of

money raised by museums to acquire art treasures are presented as acts of public service, often attended by a sense of nationalistic urgency if the work is able to augment the nation's cultural capital. This nationalism is ever more pronounced in excolonizing countries, whose patrimony is partly a result of the imperial pillage of other countries' artifacts. (To this day the illicit antiquities trade continues this plunder, particularly of the Third World, and often in the service of providing cultural diversity for Western institutions.) The patrimony principle also supports the tax-evasive habits of the wealthy, for whom their collection of art is often supervised by a lawyer's assessment of the future state of taxation policies and death duties. In this way the principle of accumulation is fully aided and abetted by the state's fiscal recognition of the artworld as a medium for transferring, circulating, and generating capital. At the heart of this process is the use of art institutions to negotiate private investments in the name of public interest. Under these circumstances, it is clear how and why a bullish art market, of the sort sustained in the 1980s, requires an increase in the number of museums. Indeed, the museum-building boom of the last two decades has been matched only by the growth of prisons in certain countries and regions. Almost every North American city and many in Europe initiated a museum-building or -renovation project during the 1980s, usually in the name of civic-mindedness or provincial pride, but also in response to the demands created by the collectors' market. Indeed, the new museum became the prestige building type of the era, identified with a star architect – Meier, Pei, Hollein, Kahn, Sterling, Venturi.[7] In many cases the building opens with virtually no collection and functions as a lavish advertisement for prospective bequests.

One of my reasons for outlining this history of private influence on the development of museums is to remind us that the business of cultural advocacy is not a recent tendency in the history of museums. Cultural claims, in both the public and private interest, have always been strongly promoted and endorsed by and through the museum. Initially, these were presented in the universalist guise of displaying the glories of national or world civilizations. The favored version was an evolutionary, and hence scientific, narrative of aesthetic and technological progress. This presented a linear, affirming genealogy for the currently existing nation-state, with its currently existing racial and class hierarchies.[8] No less disinterested were museum officials' conceptions of their public culture as a mass civilizing medium, in direct competition with other institutions. Some of these rivals were public, in the case of universities, but most were commercial, in the case of palaces of consumption like the grand department store, or spectacles of performance like the popular theater, circus, and fairground. This public mission of the nineteenth-century museum no more stood on its own then than it does today, where the museum's place in the tourist circuit of airport, hotel, restaurant, and shopping is as important as its place at the end of the institutional circuit that runs through the artist's studio, the gallery, the auction house, and the private collection. Nor were the boundaries of public, commercial, and popular so distinct that they constituted entirely separate spheres. With Sears, Bonwit Teller, Filene's, Marshall Field's, Macy's, Montgomery Ward, and Saks on one side and Barnum and Bailey on the other, the competition for mass taste was too attractive for museum administrators to pass up.[9] Nostalgia and spectacle contended with historical aura for the audience's attention. Didacticism made its bed alongside the diorama, integrating what

had been separated to some degree, at the great fairs, where the popular genres of burlesque and carnival that flourished on the fringe in the midway often commented parodically on the official exhibits inside the gates.

Above all, the state has always been an interested agent in this process, from the early nineteenth century need for national collections to compete in the league of civilized nations to the most recent flaps over 'historical revisionism' in the nation's official institutions of record at the Smithsonian. Bennett argues that the opening of the nineteenth-century museum's doors to the public was a significant administrative move in the modern state's bid to employ culture as a means of social management. The good conduct of the popular classes must come from self-reform, many reformers concurred, and libraries and museums were designated to be as necessary to moral health as good sanitation. Such public facilities would distract the dissolute away from the alehouse and other disorderly sites of free assembly. The museum was to be a 'passionless reformer,' in the words of George Brown Goode, assistant secretary of the Smithsonian in 1895 at the time he wrote the influential *Principles of Museum Administration*.[10]

Concomitant with the development of liberal society, the vital mission of such institutions was to educate the citizens of popular classes in the habits of self-discipline and self-regulation. This could succeed only if the artifacts of power were on permanent display – nothing could be hidden from view in this transfer of culture from the aristocratic few to the many. In this respect, the museum's commitment to exhibition and display had more in common with the fairs and Great Expositions than with the library or the public park. Bennett's analysis of the function of public exhibition runs parallel with Foucault's discussion of the institutions of punishment and incarceration. For Foucault, the spectacle of trial and sentencing had become newly public at a time when the spectacle of punishment was being withdrawn from public display behind the penitentiary walls. Bennett places the emergence of the museum in the context of public health policy, alongside the state's programs of sanitation. In accord with the administrative principle of 'governing at a distance,' these programs were designed to harness the concept of the free, self-civilizing individual to a policy of morally reforming the otherwise ungovernable populace. The unruly sphere of popular recreation was vilified in favor of civic instruction, moral uplift, and refinement of taste. Bennett, then, shows how the nineteenth-century museum was introduced as a space where the reform of taste and manners could be presented as a voluntary revision of behavior. Even better, this would take place in environments where costly property would be imbued with new levels of respect.

Thus was the new etiquette of cultural power established. It has not been altered substantially. The significance, for example, of throwing open the doors becomes heightened at moments when the museum is targeted by outsiders or insurgents as an elite fortress. When members of the Art Workers' Coalition were laying siege to the Met in 1971, the director, Thomas Hoving, saw that it was necessary to give the protesters free run of the Great Hall to stage their demonstrations:

> We allowed them to do it. And I insisted upon the same type of para-phernalia that groups of that nature demand upon Establishment institutions, which threw them offAnd they came, and they had

their series of lectures in the Great Hall, and no member of the public really looked or cared, and they closed up shop after two or three hours 'cause it was obviously a fizzle. What they wanted to do was for us to close down the Museum and bar the gates so they could be photographed 'locked out,' which we decided would be really rather politically unsophisticated. And quite frankly, since that time we haven't really heard anything of them.[11]

In a somewhat less cynical vein, Dillon Ripley, secretary of the Smithsonian, decided that the institute's museums should be opened to the mass of protesters, many of them African American, who arrived to camp out in the Washington Mall as part of the Poor People's Campaign in 1968. In doing so, Ripley rejected patrician concerns about a possible security threat posed by this population of museum novitiates, and correctly interpreted the historical function of his institution's open invitation to self-civilize.[12]

As for the etiquette of behavior within the museum, most of its codes are still extant and have become refined over the years. Let me quote from the opening of a popular manual, entitled *How to Visit a Museum*:

> There is no right or wrong way to visit a museum. The most important rule you should keep in mind as you go through the front door is to follow your own instincts. Be prepared to find what excites you, to enjoy what delights your heart and mind, perhaps to have aesthetic experiences you will never forget. You have a feast in store for you and you should make the most of it. Stay as long or as short a time as you will, but do your best at all times to let the work of art speak directly to you with a minimum of interference or distraction.[13]

The book offers commonsense advice about how to match the conventions of art appreciation with the physical constraints of the museum environment. In general, the tips are about how to manage your time to maximum aesthetic effect by individualizing each available moment, breaking away from the oppressive, mechanistic routines of the tour guide, or avoiding the press of the crowd:

> It is difficult to stand in front of an individual work for longer than a few seconds when people are milling around you, pushing and shoving to get on with the show . . . Kandinsky once wrote scornfully of the 'vulgar herd' that strolls through museums and pronounces the pictures 'nice' or 'splendid.' Then they go away, he added, 'neither richer nor poorer than when they came.' Whenever you feel that way, do your best to shut out the sense of being with other people. It takes concentration, but it can be done. It helps when there are breathing spaces in the crowd, and for a minute or two you can be alone. It is wise to take advantage of these 'gaps,' moving across a room quickly and forgetting about seeing each work in sequence. There are also tricks one can try, like going to a popular exhibition a half-hour before it closes, when audiences will have thinned out.

Enlisting the support of a great artist's disdain for the 'vulgar herd,' this text illustrates well the principle of the self-maximization of the civilizing effect – the aim being to become 'richer' rather than 'poorer' as a result. The reader is encouraged to emulate those connoisseurs who shun the museum literature and guides and who are comfortably at home in these vast, templed environments. Less well educated visitors are likely to feel alienated by the sanctimonious atmosphere, tending to stick close to family or friends while their visits, so vital to the museums' attendance figures, are mass processed by guides.[14] Nothing is more clear than that the public's visits are differentiated by cultural class, even in minority or community arts museums. For each social group, a calculus of profit is at play, at once individualizing and massifying, whereby maximum use is extracted from managing quality aesthetic time.

Bennett locates the origins of this principle in the nineteenth-century school of utilitarianism, according to which public institutions were viewed as a means of multiplying the utility of culture. Statistical accounting was paramount in ensuring the maximum distribution of culture among the populace, especially in the provinces, where curators circulated artifacts from metropolitan museum collections in order to spread the effect. In this context, the museum's function ran parallel with the flood of data collecting and numerical analysis that sustained the demographic inquiries of the Victorian period. The United States in particular was undergoing the largest documented population growth of modern times. The warm patriotism associated with surging numbers, seen as the engine of democracy in the first century of the Republic, was joined now by a post-Malthusian suspicion about the burdens and potential dangers posed by population growth, reinforced by a nativist hostility to the new urban working class, swelling with immigrants.

Counting by numbers

To assess how museums today are responding to claims based on statistics of group representation, we might note, first of all, the many contexts in which 'the numbers game' is played out in North American public life in the 1990s. Casual perusal of any daily newspaper will reveal the steady attention to the authority of quantitative analysis, from the blizzard of data breakdowns in the financial pages to the latest cost-benefit analysis from a medical expert showing exactly how many years longer we will live if we run two and a half miles more each week. The current fiscal climate, devotionally bound to the gospel of the balanced budget, is the prevailing pressure system, deeply affecting the treatment of almost every story in the news. The bruises left by the cruel passage across the political landscape of *The Bell Curve*'s linking of race and IQ are all too apparent. The debate about the role of Scholastic Aptitude Test scores in education simmers on. As a legacy of the 'regulatory reform' initiatives of the Contract with America, Congress has established statistical risk assessment at the heart of government as the new primary form of administrative rationality. We have recently been informed, without too much fanfare, that 1 percent of the U.S. population owns 40 percent of its wealth – a sobering statistic redolent of the days of the robber barons in the late nineteenth century. On the culture front, the much disputed 69 cents a year that taxpayers used to set aside for funding of the arts through the NEA and the NEH has long since attained a

TOP TEN WAYS TO TELL IF YOU'RE AN ART WORLD TOKEN:

10. Your busiest months are February (Black History Month), March (Women's History), April (Asian-American Awareness), June (Stonewall Anniversary) and September (Latino Heritage).

9. At openings and parties, the only other people of color are serving drinks.

8. Everyone knows your race, gender and sexual preference even when they don't know your work.

7. A museum that won't show your work gives you a prominent place in its lecture series.

6. Your last show got a lot of publicity, but no cash.

5. You're a finalist for a non-tenure-track teaching position at every art school on the east coast.

4. No collector ever buys more than one of your pieces.

3. Whenever you open your mouth, it's assumed that you speak for "your people," not just yourself.

2. People are always telling you their interracial and gay sexual fantasies.

1. A curator who never gave you the time of day before calls you right after a Guerrilla Girls demonstration.

A PUBLIC SERVICE MESSAGE FROM **GUERRILLA GIRLS** CONSCIENCE OF THE ARTWORLD
532 LaGUARDIA PLACE, #237 • NY, NY 10012

Figure 32.1 Guerrilla Girls poster

bizarre status in public opinion. And on the museum front, the furor about historical revisionism bears the memory of the flap over the *Enola Gay* exhibit at the Smithsonian's Air and Space Museum, which revolved around a revised estimate of the number of Americans allegedly spared by the decision to use the atomic bomb in the war against Japan. Drawing on current historical scholarship, curators of the exhibit had suggested a number of 63,000 instead of the quarter million estimate preferred by the Air Force Association and by veterans in general, in an incident that had incinerated over 140,000 Japanese civilians after the Second World War had ended in all but name. The Smithsonian unconditionally surrendered to pressure from the vets to edit the narrative, and another act of what scholars have labeled 'historical cleansing' was accomplished.

The most significant level of attention to numbers, however, has been in the prolonged backlash against affirmative action programs, selected as a 'wedge' issue by the New Right to appeal to white voters. Affirmative action, the statistical machinery that emerged from reformed race policy in the 1960s, successfully broke open the occupational caste system but arguably failed, in the abdication of the liberal will to push any further, to break up the de facto segregation of so many sectors of social and economic life. While corporate institutions and businesses have benefited by acquiring a dash of diversity for their statistical profiles, national social statistics continue to show a marked deterioration in the quality of life – income, health, housing, educational opportunity for most minority communities (see Figure 32.1). Nonetheless, affirmative action and other claims for group cultural rights are

seen by many as a natural extension of the representative democratic process, by which the demographics of gender, race, or ethnic characteristics are more equitably represented in public, institutional life.

Those of us employed in North American higher education are all too aware that our own workplace has been established as a front line in some of the most significant struggles over these claims to cultural justice. Notwithstanding the initial benefits achieved in education by policies of affirmative action, it pains to watch the lifeblood of institutional racism and sexism pulsing on, in tune to the heartbeat of corporate logic, which increasingly governs the administrative direction of our colleges and universities. All of us also know what a genuine difference it makes to have a threshold number of students and faculty of color in formerly white classrooms and faculty meetings. The conversation *is* different, in ways that diverge from comparable shifts in gender ratios. In 1997, when the first decisions against affirmative action went into effect in state university systems in California and Texas, it became clear what a disastrous effect these legal changes had wrought, not just on minority acceptance rates, but also on minority applications.

While the principle of group representation and participation has had some impact on all cultural institutions, those under the aegis of the arts are predominantly governed by principles of *taste*, and therefore do not carry quite the same legal (however now besieged) commitment to opportunity associated with public education. Consequently, the Guerrilla Girls' numbers have been taken as a direct assault on the traditions of connoisseurship. While numbers cannot speak for themselves, they carry moral power as a stand-in for some vision of cultural justice that is still incomplete and ideally would no longer have to respond to number-based demands for group representation. On the other hand, their proximity to the quantitative mentality of modern bureaucracy resonates with the history of the state's use of statistics as a medium of social control, stabilizing disorder, normalizing behavior, rationalizing inequality, and, most relevant here, managing diversity by defining identities and their share of public resources and representation. In the United States, the exemplary statistical state, the dominion of numbers has come to pervade institutional life, masquerading (like its judicial counterpart, the rule of law) as a neutral arbiter of competing claims on resources and rights. Consequently, such claims are often obliged to appeal to the statistical format in advance of any other moral language. Numbers invariably speak louder than opinions.

While the democratic validity of a principle like threshold representation is obvious, inclusion by numbers is no guarantee of cultural accountability. No one, for example, can expect women artists to automatically represent the experience of their gender (or of women of different ethnicities and classes) any more than they can be assumed to lack the capacity to speak to male experience. As in other areas of social life, naturalizing the link between the identity of artists and the content of their work erodes the challenge of empathy across our cultural differences that is so crucial to a multiethnic society.

It's even worse in Europe

Unlike neoliberal market economics, which has penetrated societies all around the world, this model of group representation is not very exportable, and more often

than not escapes comprehension as it crosses national boundaries. In most non-American contexts, the Guerrilla Girls' graphs and charts would be viewed as the perverse product of an alien culture. In the sphere of the arts this disparity is even more evident, given the vestigial appeal of aesthetic taste over and above all other principles of evaluation, given the successful importation, in many countries, of the backlash against 'political correctness,' and given the varying regional components of cultural politics, quite dissimilar in countries that do not share the colonial, slavery, and immigrant histories of nation-states in North America and Latin America. Insouciance is the more likely response to the Guerrilla Girls poster that proclaims, 'It's Even Worse in Europe' (Figure 32.2).

Listen, for example, to the response of Jean Clair, the curator of the 1995 Venice Biennale, to a question posed by an *Artforum* interviewer about group representation as it pertains to the exclusively Euro-American composition of Clair's selections:

> The notion of art is strictly Western. It has no pertinence outside our culture. The issue of political correctness is thoroughly foreign to me. What strikes a European as more important are the ethnic wars dragging us back to the situation of 1914. That's why I'm tempted to evoke the refusal of representation in extra-Occidental cultures, especially Islam. You make an image and you're likely to have your throat cut. This is the kind of cultural problem that leads to religious wars, and it's happening right now.

How are you going to resolve this? asks the interviewer, bearing in mind that the 1995 Biennale was supposed to be a centennial celebration: 'A sensational solution would be to invite the faculty at the Ecole des beaux arts in Algiers, where the director has already been assassinated, to teach in Venice. But they would probably all be killed.' Clair's ultimate solution, as he describes it, to the absence of non-Occidental representation was to show Helmut Newton's *Sie kommen,* 'a diptych of five magnificent women, eugenic prototypes, nude in one photo, dressed as executives in the other – and photographs by Gaëtan Gatian de Clérambault, the 1930s French psychiatrist who was fascinated by the draped fabric worn by Muslim women.'[15] There's no doubt that this was a bold and inventive juxtaposition, or that it spoke, however indirectly, to current realities in European political culture.

Enviously recalling the Biennale's origins as an 'enormous popular fair' with up to 500,000 visitors, Clair cites this particular exhibit in the context of his desire to expand the Biennale audience beyond the circle of the international artworld cognoscenti. In this respect, he is speaking the language of the contemporary curator, duty-bound to attract huge audiences, often through the mounting of much criticized but very popular blockbuster exhibitions. This prevailing trend covets the theme park audiences that museums have always imagined they could attract, though traditionally this has been done through appeals to instruction and enlightenment rather than to outright entertainment. Today, the seduction of the weekend tourist is urged at the very moment that neo-statist conceptions of public culture as a medium for educating the popular classes have lost most of their credence. So, too, it is important to see how Clair's timely nostalgia for the popular fairs of yore

IT'S EVEN WORSE IN EUROPE.

A PUBLIC SERVICE MESSAGE FROM

GUERRILLA GIRLS
CONSCIENCE OF THE ART WORLD

532 LaGUARDIA PL. #237 • NY, NY 10012

Figure 32.2 Guerilla Girls poster

emerges in direct opposition to what he means by political correctness – the crusade on the part of advocates like the Guerrilla Girls to make exhibition culture more fully representative of and accountable to a broader range of individuals and communities.

Notwithstanding their daring juxtaposition, Clair's selections of Newton and Clérambault reaffirm the aesthetic classification of fine art just as they confine the location of their interest to Orientalist Europe. Western by Clair's definition, the select delineation of art is preserved here, rather than expanded, as it had been in the popular turn-of-the-century Expositions universelles, where the criterion was inclusiveness – the display of a worldwide spectrum of artifacts, technologies, and handicrafts, however colonial in arrangement. In addition, the cultural practices that typify non-Western societies – relating to custom, tradition, or heritage, and lived daily rather than museumified – become potential objects of voyeurism for Clérambault, the Orientalist Frenchman, as much a national European 'type' as Newton, the German aesthete. Ostensibly, the veiled Moroccans and the eugenic nudes are intended to contrast the non-Occidental 'refusal of representation' with the utter visibility of Western representation. Yet in both cases, images of women are chosen as examples of effrontery to the masculine gaze. In the case of Clérambault, the Muslim veil is not so much a refusal of representation as an

exotic obstacle in the path of the photographer's access to a colonized culture (even if cited as ocular proof of his bizarre theories, advanced in his courses at the Ecole des beaux arts from 1923 to 1926, that styles of clothing could yield insights into the essence of racial identities).[16] Perhaps these photographs (numbering in the thousands and taken on trips to Morocco during and directly after World War I) do recall the Muslim taboo on figural depictions of the human body, but they equally remind us that the veil also has the function, in this period of colonial history, of defying the occupier who is intent on unveiling, violating, and possessing a culture, illustrated most commonly by the female body. Moreover, since all veiled women are the same, ultimately they have to be represented in a group setting, or serially shot and quantified, as if unresponsive to the individualizing portraiture of Western photography.[17]

As for Newton's women, these 'magnificent' specimens of the race are corporate horsewomen of the apocalypse – inevitable, unstoppable, invincible. With nothing to conceal and everything to gain, they are a collective illustration, again, of some castrating superfemale order, too large, too much in charge, except of course in the iconographic repertoire of the masochist. Whether as Clérambault's exotic guardians of private space or Newton's monstrously perfect invaders of public space, neither of these sets of images are quite what the Guerrilla Girls have in mind when they stake their claim, based on the principle of group demographics, for the right to represent and be represented. The group imagery of the masked Girls can easily be distinguished from the principle of grouping among the women of Clérambault and Newton. In addition, their use of gender imagery provides a different gloss on the iconographies of concealment and domination, transforming the exoticism of the former into a carnivalesque threat. Strength in numbers contrasts with the unnatural perfection of the clone.

Bearing in mind Clair's comment about the history of the popular fair, I find it worth remarking that the products of women's labor were more widely exhibited in the great expositions of the late nineteenth and early twentieth centuries than in museums of the time. In order to justify the status of world fair, the fairs had to be inclusive enough to display the diversity of the imperial world's industrial and craft production. The principle of ethnic representation was acknowledged, but only if the conventions of representing ethnicity as a fixed identity in the colonial chain of being, running from civilization to barbarism, were respected. Take the story of Ota Benga, the first Central African forest hunter to take up residence in the United States. Before he shared a cage with a pet chimpanzee in the Bronx Zoo (he committed suicide thereafter), Benga was exhibited at the 1905 World's Fair in St. Louis. An accomplished mimic, he ran into serious trouble when he began to impersonate the marching bands and American Indians, thereby refusing to behave like a pygmy and upsetting the rules of display.[18] Then, as now, artists and performers charged with representing an ethnic group or community are often heavily constrained by conventions of authenticity. This often takes the form of complying with some expectation of 'exotic' art that contrasts with Euro-American aesthetics. Sometimes this regulation is sanctioned directly by the state, in the case of the Indian Arts and Crafts Act of 1991, legislated with a particular view of recognizably 'Indian art' in mind – quite removed, say, from the important critical work of Native artists who challenge the stereotypes of Indian authenticity, like Jimmie Durham, James Luna, or Edgar Heap Of Birds (all of whom are conspicuously absent from the

National Museum of the American Indian). Non-Anglo artists are often under great pressure from curators to produce art that is recognizably *different* from, and un-observant of, the influence of Western art history.

In other cases, the regulation can be self-imposed on the part of communities themselves. The 'Black Male' show, for example, which preceded the 1995 Whitney Biennial, was frequently charged by black commentators with failing to represent more 'traditional' features of black masculinity. In response to the call for artworld diversity, the evolving community arts movement has produced its own commodity practitioners defined by the iconography and demands of ethnic authenticity, such as the 'professional Chicano artist,' so ruthlessly satirized by Guillermo Gómez-Peña and others. The struggle to produce transcultural art based on the experience of 'border-crossing' has been the single most significant challenge, as Gómez-Peña puts it, to 'the anachronistic myth that as "artists of color" we are only meant to work within the boundaries of our "ethnic communities."'[19]

The principles of exhibition

If the nineteenth-century museum was intended as an agent of cultural administration for an emergent mass urban population, there's no evidence that its principles of exhibition acknowledged in any way the claims for group cultural rights that have become such a contested feature of cultural institutions in the last twenty-five years. The nineteenth-century museum had no such brief for cultural pluralism, and even less for the principle of demographic representation. After all, it evolved in an institutional climate where scientific racism prevailed – sanctioning a hierarchy of races and ethnic identities – and indeed was actively championed by the officers and curators of institutions like Chicago's Field Museum, the American Museum of Natural History and the Smithsonian itself. Nonetheless, the museum's promise of a complete field of representation in its displays and its mandate to be universally accessible to the public provided the framework for later claims about cultural rights and equal representation. These claims became more and more visible in the climate of cultural politics that evolved in the wake of the civil rights movement.

The use of political arithmetic in government has not changed in the last century. Then as now, the federal system used census numbers as the proportional basis for distributing resources and political representation. What *is* new is the concept of using that same principle as a basis for claims to cultural rights and representation. Proportional entitlement and representation is now applied to the sphere of culture, not without much resistance, but nonetheless with considerable success. Why is this so? At least three reasons apply.

First is the democratic significance of numbers. Despite the fact that the culture of the arts is still governed by concepts of aesthetic *taste* and *quality*, and that the sphere of culture in general is supposed to be exempt from the numerical bottom line applied in most other sectors of society, the democratic connotation of numbers is too powerful to resist. Just as the arithmetic of the state was described by early statisticians like Adolphe Quételet as the creation of 'moral statistics,' so the principle of demographic representation is applied to cultural institutions today as a moral corrective in the direction of numerical equality. If, in the nineteenth century,

the useful effects of art on the population could be quantified, then it is not such a great leap to suggest that the quantitative spread of the population be reflected in the selection and public display of art itself. What could be the moral basis, in a statistical democracy, for any other principle of representation?

The second reason relates to the history of cultural rights claims in the period since the Civil Rights Act. From the time of the passing of the Fourteenth Amendment in 1868 until the first affirmative action programs a century later, a dominant civil claim was the putative right of the individual to be treated apart from his or her race. This interpretation while rarely observed in practice, is now nostalgically upheld by opponents of affirmative action as the true liberal basis of the so-called color-blind Constitution. Since the introduction of affirmative action programs designed to breach the walls of occupational racial exclusion, race- and gender-based interpretations of group rights have become more common. Consequently, proportional representation has been sanctioned either through affirmative action's appeal to the compensatory principle of remedial justice or, more radically, according to some principle of mirror representation whereby the distribution of opportunity and representation is seen to be proportionate to the existing racial and gender composition of society, and any deviation from that ratio is perceived as discriminatory. While these principles have been besieged in recent years, their appeal to the statistical ethos of representative government is a very powerful one. All institutions that depend on the public status of their activities have been obliged to respect this ethos in their attempts to create more diversity among their participants.

The third reason involves the claim of cultural institutions like the museum to represent the world, the nation, the community, or some surveyable field of the arts. In the case of the art museum, the claim to universal representation has always been shaky but intrinsic to its public function. In the last two decades, as critical anti-institutional art has flourished, the institutional authority of the museum has been rather successfully demystified, along with its curatorial powers to represent and exhibit art with unimpeachable taste. With the collapse of the claim to represent according to authoritative taste, pressure to acknowledge some principle of representative diversity, proportional or not, has been unceasing.

Most of the controversy that results from this pressure has been associated with temporary exhibits, or with the kind of periodic surveys presented by the various Biennales and by *Documenta* at Kassel. At the Whitney, for example, much of the controversy was defused after the selection of its Biennial artists was entrusted to the singular, subjective taste of an individual staff curator, or in the case of the 1997 Biennial, to one insider – Lisa Phillips from the Whitney – and one outsider – Louise Neri from *Parkett* magazine. One result of the increased political significance of the temporary exhibit or survey has been that the role of the curator has been transformed from aesthetic arbiter to cultural mediator, brokering the interests of artists, dealers, collectors, and trustees. Ultimately, the curator can act as a broker for cultural ethnicity if he or she has ties to ethnic communities pushing for greater representation.[20] This is less likely to happen at the blue-chip museums than at minority museums operating under the wing of large institutions, like the Smithsonian's Anacostia Museum, or functioning autonomously as neighborhood or community museums, like New York's Museo del Barrio, the Studio Museum in Harlem, the

Afro-American Historical and Cultural Museum in Philadelphia, the Museum of the National Center of Afro-American Artists in Boston, or the Rhode Island Heritage Society. While the growth of the latter has inspired the community arts movement and given legitimacy to the principle of community self-representation, it has also served the cause of diversity management all too well, relieving establishment institutions like MOMA and the Met of the obligation to confront cultural diversity more fully within their own walls.

Recent talk about the crisis of the museum has been tied to the crisis of the principle of institutional representation, urgently felt across the spectrum of education as in the arts. As I have argued, this crisis ought to be seen in the light of the modern history of representative democracy in the United States, with its vast statistical machinery. In modern times, that process has proven faithful to the precept of proportional demographics on the one hand, while exercising care, on the other, not to disturb the liberal credo of meritocratic entitlement with any suggestion of a system of opportunity tied to quotas – currently the dirtiest word in U.S. political culture. Just as important, however, the crisis over institutional representation has its roots in the museum's origins and its ambitious goal of universal coverage.

The strange death of public culture

The museum's predicament is also typical of the plight of public culture in the age of privatization. One of the most abused terms in our political lexicon, the concept of the public has long been associated with decline, depreciation, and loss – there always is a more expansive public that was enjoyed in days of yore. Many of the institutions perceived as guardians of public culture have often appealed cynically to evidence of cultural decline – usually by vilifying popular culture – in order to reinforce their access to subsidies, resources, and privileges. It's also true that if these institutions have cried wolf once too often in the past, there really is a new kind of wolf at the door today, as the race toward privatization quickens. While public culture in the United States has usually depended on a mix of government, nonprofit, and private funding, the market-driven tilt toward corporate sponsorship is now transforming the face of the arts and education. In response to the massive cuts in social services, nonprofit sponsors are increasingly inclined to encourage art that is community-oriented or that addresses social problems from which the state has withdrawn the aid of its depleted welfare service agencies. On the other hand, the pressure of corporate sponsorship has boosted the merchandizing of culture, even through cable shopping networks (now in the business of serving as museum stores), to a degree that public art may soon be seen as a series of branding opportunities.

In response, the defense of the *status quo ante bellum* in public arts funding has all too often rested on hackneyed appeals to the Romantic safe haven of 'artistic freedom,' eternally secure against philistines and barbarians. Whatever its worth as a measure of protection for artists against the interests of the state or the powerful and wealthy, the cult of artistic freedom has also nurtured the myth of the 'artist in quarantine,' regally immune to public accountability and accessible public dialogue. It has also sustained the arrogant gulf that separates fine arts communities

from those who work in the cultural marketplace, in media, fashion, graphic arts, design, and journalism – that sphere of cultural labor that, in spite of its commercial overlordship, has released some of the most vital social and political energies of this century at the same time it has marginalized so many others.

With the evaporation of any substantial challenge to market civilization, economic elites have less and less need for public culture to serve as a cloak of respectability for their wealth and status. Nor does the transnational nature of their power require public culture to assume a national form in order to compete for prestige in the league of nations. So too, the reliance of anti-imperialist nationalists on their national cultures to resist the global flows of cultural product has often served as a way to suppress internal minorities or preserve the power balance between metropolitan and provincial culture. Such attempts to defend the national patrimony have been outflanked by the omnivorous appetite of the globalizing culture industries for incorporating local and regional differences.

In response, some versions of public culture have gone supranational – utilizing preexisting networks of communication, like the international art market/circuit, or new technologies, like the Internet. Within the nation-state itself, where the cynical use of the Culture Wars to villainize dissenters shows no sign of abating, the response cannot be single-minded. Even for those who decide to devote their energies exclusively to the preservation of public cultural institutions, public culture will never be the same, nor should it be. The current crisis of its institutions should not be regarded as an occasion for retrenchment, but as an opportunity for us to overhaul, modernize, redefine, and fully democratize their structures. You don't have to be a conspiracy theorist to see that the race to privatization is occurring at the very moment when genuine attempts are being made to democratize public culture and diversify its participants, its content, and its reach into a wide range of communities. Claims for diversity and cultural equity are less likely to be met by corporate sponsorship, unless they coincide with a particular multicultural profile suggested by the market research division.

Some elements of the older version of public culture have to remain in place. Without the appeal to universal representation, however impossible and incomplete in practice, we will lose the basis, in a statistical democracy, for demanding that exhibits, collections, and programs be inclusive and diverse. In this respect, the effective graphic impact of the Guerrilla Girls report cards are indispensable billboards for advertising the progress (or retrenchment) of claims for equity. Such notices are a public reminder of how much remains to be done to attain anything close to a critical mass of underrepresented artists and voices. Ultimately, however, these claims have a limited effect on the business structure of the artworld – the gallery system, the art market, the glorification of authorship, the control of access and participation, and the use of fine art values to police class divisions. From this angle, elevating women and minority artists into the pantheon of the masters may be a matter of fine-tuning rather than a structural overhaul. The fact that the memory, let alone the vestigial reality, of the alternative arts space movement has taken such a beating makes it all the more difficult to imagine and reconstruct alternatives. The perils of co-option – relentlessly cautioned by the alternative arts movement – are no longer even fit for discussion among younger artists whose formation postdates the early 1980s.

On the one hand, then, we must be conscious of the injustices involved in propping up institutions like museums that have a history of transforming cultural rights into social privileges and treating open access as a means of behavior control, and that are even now recruiting the voices of the socially marginalized to pretty up the statistics required by diversity managers. On the other hand, we must be opportunistic, as always, under conditions not of our own making, in making use of the resources that are available. This has to involve creative attempts to use the new patterns of sponsorship to change the frankly elitist relationship between institutions and their audiences, between artists and their publics, between art and popular culture. These new funding patterns offer a potential vehicle for democratizing those relationships at the same time as they threaten to deliver the artworld into exactly the kind of corporate overlordship that governs aesthetics in the culture and media industries. From the perspective of the state, public culture is no longer viable as an instrument of popular reform. The evolution of highly controlled and managed forms of popular entertainment, from Coney Island to pay-per-view televised sport, has resolved the problems of civic disorder posed by unsupervised free assembly. Having entered the field in the nineteenth century with a fierce reforming mission that has long since lost its zeal, government is retreating from the province of culture in a manner not unlike that of a colonial power withdrawing from its provincial possessions in the hope that regional market brokers will remain friendly to its will. The national patrimony will remain a concern – the legacy of the *Enola Gay* will not fade quickly. In the meantime, we will continue to lock horns over the politics of inclusion – who's in, who's out. We must also continue to ask whether the vast resources of museums might be better utilized than in authoritative presentations of exhibits to passive spectators. But the larger task will be to create and promote new versions of the 'public' that are inclusive, that have popular appeal, and that are elastic enough to accommodate the vast energies of a strong democracy of opinion.

Notes

1 Tony Bennett, *The Birth of the Museum: History, Theory, and Politics* (London: Routledge, 1996); and Carol Duncan, *Civilizing Rituals: Inside Public Art Museums* (London: Routledge, 1995). My descriptive account of the nineteenth-century museum draws liberally on their work.

2 Bennett, *Birth of the Museum*, 91ff.

3 Duncan, *Civilizing Rituals*, 48–71.

4 Ibid., 63.

5 Michael Fitzgerald, *Making Modernism: Picasso and the Creation of the Market for Twentieth-Century Art* (New York: Farrar, Straus and Giroux, 1995).

6 Until recently, security guards have been the only people of color, aside from school groups, likely to be seen in museums. Notable among the artists who have focused on security components of the museum institution are Julia Scher and Fred Wilson.

7 Reesa Greenberg, 'The exhibition redistributed,' in Reesa Greenberg, Bruce Ferguson, Sandy Nairne, eds, *Thinking about Exhibitions* (New York: Routledge, 1995), 362.

8 Neil Harris, 'A historical perspective on museum advocacy,' in *Cultural Excursions: Marketing Appetites and Cultural Tastes in Modern America* (Chicago: University of Chicago Press, 1990), 82–95.

9 Neil Harris, 'Museums, merchandising, and popular taste,' in *Cultural Excursions*, 56–81.

10 Bennett, *Birth of the Museum*, 59–87. George Brown Goode's classic volume is *The Principles of Museum Administration* (York: Coultas and Volans, 1895).

11 Quoted in Faye Levine, *The Culture Barons: An Analysis of Power and Money in the Arts* (New York: Thomas Crowell, 1976), 150.

12 Faith Davis Ruffins, 'Mythos, memory, and history,' in Ivan Karp, Christine Mullen Kreamer, and Stephen Lavine, eds, *Museums and Communities* (Washington, DC: Smithsonian Institution Press, 1992), 574.

13 David Finn, *How to Visit a Museum* (New York: Harry Abrams, 1985), 10.

14 The different kinds of social access experienced in museum going by disparate groups is examined in Pierre Bourdieu, Alain Darbel, *et al.*, *The Love of Art: European Art Museums and Their Public* (Palo Alto: Stanford University Press, 1969).

15 Jean Clair, interview by Lauren Sedosky, *Artforum*, April 1995, 26, 106.

16 Leslie Camhi, 'Stealing femininity: department store kleptomania as sexual disorder,' *Differences* 5, 1 (1993): 26–50.

17 See Malek Alloula, *The Colonial Harem*, trans. Myrna Godzich and Wlad Godzich (Minneapolis: University of Minnesota Press, 1986), 7–15, and introduction by Barbara Harlow.

18 Philips Verner Bradford and Harvey Blume, *Ota Benga: The Pygmy in the Zoo* (New York: Dell/Delta, 1992). Thanks to Steve Feld for this example. See his 'Pygmy POP: a genealogy of schizophrenic mimesis,' *Yearbook for Traditional Music*, vol. 28 (New York: International Council for Traditional Music, 1996), 1–35.

19 Guillermo Gómez-Peña, *Warrior for Gringostroika* (Saint Paul: Graywolf Press, 1993), 33.

20 Maria Ramirez, 'Brokering identities: art curators and the politcs of cultural representation,' in Greenberg, Ferguson, and Nairne, *Thinking About Exhibitions*, 21–38.

Marita Sturken

THE WALL, THE SCREEN AND
THE IMAGE
The Vietnam Veterans Memorial

T HE FORMS REMEMBRANCE takes indicate the status of memory within a
given culture. In these forms, we can see acts of public commemoration as
moments in which the shifting discourse of history, personal memory, and cultural
memory converge. Public commemoration is a form of history-making, yet, it can
also be a contested form of remembrance in which cultural memories slide through
and into each other, merging and then disengaging in a narrative tangle.

With the Vietnam War, discourses of public commemoration are inextricably
tied to the question of how war is brought to closure in American society. How,
for instance, does a society commemorate a war for which the central narrative is
one of division and dissent, a war whose history is still formative and highly
contested? The Vietnam War, with its lack of a singular, historical narrative defining
clear-cut purpose and outcome, has led to a unique form of commemoration.

Questions of public remembrance of the Vietnam War can be examined
through the concept of the screen: a screen is a surface that is projected upon; it is
also an object that hides something from view, that shelters or protects. The kinds
of screens that converge in the case of the Vietnam Veterans Memorial in
Washington, DC, both shield and are projected upon: the black walls of the memo-
rial act as screens for innumerable projections of memory and history – of the United
States' participation in the Vietnam War and the experience of the Vietnam veterans
since the war.

A singular, sanctioned history of the Vietnam War has not coalesced, in part
because of the disruption of the standard narratives of American imperialism, tech-
nology, and masculinity that the war's loss represented. The history of the Vietnam
War is still being composed from many conflicting histories, yet particular elements
within the often opposing narratives are uncontested – the divisive effect the war
had on American society and the marginalization of the Vietnam veteran. This essay
is concerned with how narratives of the war have been constructed out of and within

the cultural memory of the Vietnam Veterans Memorial. I shall examine how the screens of the memorial act to eclipse – to screen out – personal and collective memories of the Vietnam War in the design of history, and how the textures of cultural memory are nevertheless woven throughout, perhaps over and under, these screens.

The status of a memorial

Although now administered under the aegis of the National Parks Service of the federal government, the impetus for the creation of the Vietnam Veterans Memorial came from a group of Vietnam veterans who raised the funds and negotiated a site on the Washington Mall. Situated on the grassy slope of the Constitutional Gardens near the Lincoln Memorial, the Vietnam Veterans Memorial, which was designed by Maya Lin, consists of a V shape of two walls of black granite set into the earth at an angle of 125 degrees. Together, the walls extend almost 500 feet in length, with a maximum height of approximately 10 feet at the central hinge. These walls are inscribed with 58,196 names of men and women who died in the war, listed chronologically by date of death, with opening and closing inscriptions. The listing of names begins on the right-hand side of the hinge and continues to the end of the right wall; it then begins again at the far end of the left wall and ends at the center again. Thus, the name of the first American soldier killed in Vietnam, in 1959, is on a panel adjacent to that containing the name of the last American killed in 1975. The framing dates of 1959 and 1975 are the only dates listed on the wall; the names are listed alphabetically within each 'casualty day,' although those dates are not noted. Eight of the names on the wall represent women who died in the war. Since 1984 the memorial has been accompanied by a flag and a figurative sculpture of three soldiers, both facing the memorial from a group of trees south of the wall. In 1993 a statue commemorating the women who served in Vietnam was added 300 feet from the wall.

The memorial functions in opposition to the codes of remembrance evidenced on the Washington Mall. Virtually all the national memorials and monuments in Washington are made of white stone and constructed to be seen from a distance. In contrast, the Vietnam Veterans Memorial cuts into the sloping earth: it is not visible until one is almost upon it; if approached from behind, it seems to disappear into the landscape. Although the polished black granite walls of the memorial reflect the Washington Monument and face the Lincoln Memorial, they are not visible from the base of either structure. The black stone creates a reflective surface, one that echoes the reflecting pool of the Lincoln Memorial, and allows the viewers to participate in the memorial; seeing their own image reflected in the names, they are implicated in the listing of the dead. The etched surface of the memorial has a tactile quality, and viewers are compelled to touch the names and make rubbings of them.

Its status as a memorial, rather than a monument, situates the Vietnam Veterans Memorial within a particular code of remembrance. Monuments and memorials can often be used as interchangeable forms, but there are distinctions in intent between them. Arthur Danto writes: 'We erect monuments so that we shall always

remember, and build memorials so that we shall never forget.'[1] Monuments are not generally built to commemorate defeats; the defeated dead are remembered in memorials. Whereas a monument most often signifies victory, a memorial refers to the life or lives sacrificed for a particular set of values. Memorials embody grief, loss, and tribute. Whatever triumph a memorial may refer to, its depiction of victory is always tempered by a foregrounding of the lives lost.

Memorials are, according to Charles Griswold, 'a species of pedagogy' that 'seeks to instruct posterity about the past and, in so doing, necessarily reaches a decision about what is worth recovering.'[2] The Lincoln Memorial is a funereal structure that gains its force from its implicit reference to Lincoln's untimely death. It embodies the man and his philosophy, with his words on its walls. The Washington Monument, by contrast, operates purely as a symbol, making no reference beyond its name to the mythic political figure. The distinction between the two outlines one of the fundamental differences between memorials and monuments: memorials tend to emphasize specific texts or lists of the dead, whereas monuments are usually anonymous.

The Vietnam Veterans Memorial is unmistakably representative of a particular period in Western art. In the uproar that accompanied its construction, it became the focus of a debate about the role of modernism in public sculpture. Just one month prior to the dedication of the memorial in November 1982, Tom Wolfe wrote a vitriolic attack on its design in the *Washington Post*, calling it a work of modern orthodoxy that was a 'tribute to Jane Fonda.'[3] Wolfe and other critics of modernism compared the memorial to two infamously unpopular, government-funded public sculptures: Carl Andre's *Stone Field Piece* (1980) in Hartford, Connecticut, and Richard Serra's *Tilted Arc* (1981) in downtown Manhattan. Andre's work, which consists of thirty-six large boulders positioned on a lawn near Hartford's city hall, is widely regarded with derision by residents as a symbol of the misguided judgements of their city government.[4] Serra's now notorious *Tilted Arc*, an oppressive, leaning slab of Cor-Ten steel that bisected the equally inhospitable Federal Plaza, inspired several years of intense debate and was dismantled in March 1989 after workers in the Federal Building petitioned to have it removed.[5] In the media, these two works came to symbolize the alienating effect of modern sculpture on the viewing public and people's questioning of the mechanisms by which tax-funded sculpture is imposed upon them.

In situating the Vietnam Veterans Memorial purely within the context of modernism, however, Wolfe and his fellow critics ignore fundamental aspects of this work, an omission which, it might be added, the sketches of the design may have aided. The memorial is not simply a flat, black, abstract wall; it is a wall inscribed with names. When members of the 'public' visit this memorial, they do not go to contemplate long walls cut into the earth but to see and touch the names of those whose lives were lost in this war. Hence, to call this a modernist work is to overemphasize its physical design and to negate its commemorative purpose.

Modernist sculpture has been defined by a kind of sitelessness. Yet, the Vietnam Veterans Memorial is a site-specific work that establishes its position within the symbolic history embodied in the national monuments on and around the Washington Mall. Pointing from its axis to both the Washington Monument and Lincoln Memorial, the Vietnam Veterans Memorial references, absorbs, and reflects

these classical forms. Its black walls mirror not only the faces of its viewers and passing clouds but the obelisk of the Washington Monument, thus forming a kind of pastiche of monuments. The memorial's relationship to the earth shifts between context and decontextualization, between an effacement and an embracement of the earth; approached from above, it appears to cut into the earth; from below, it seems to rise from it. The site specificity of the Vietnam Veterans Memorial is crucial to its position as both subversive of and continuous with the nationalist discourse of the mall.

It is as a war memorial that the Vietnam Veterans Memorial most distinguishes itself from modernist sculpture. As the first national memorial to an American war built since the Second World War memorials, it makes a statement on war that diverges sharply from the traditional declarations of prior war memorials. The Vietnam Veterans Memorial Fund (VVMF), which organized the construction of the memorial, stipulated only two things in its design – that it contain the names of all of those who died or are missing in action, and that it be apolitical and harmonious with the site. Implicit within these guidelines was the desire that the memorial offer some kind of closure to the debates on the war. Yet, with these stipulations, the veterans set the stage for the dramatic disparity between the message of this memorial and that of its antecedents. The stipulation that the work not espouse a political stand in regard to the war – a stipulation that, in the ensuing controversy, would ultimately appear naive – ensured that in the end the memorial would not glorify war.

The traditional war memorial achieves its status by enacting closure on a specific conflict. This closure contains the war within particular master narratives either of victory or the bitter price of victory, a theme dominant in the 'never again' texts of First World War memorials. In declaring the end of a conflict, this closure can by its very nature serve to sanctify future wars by offering a complete narrative with cause and effect intact. In rejecting the architectural lineage of monuments and contesting the aesthetic codes of previous war memorials, the Vietnam Veterans Memorial refuses to sanction the closure and implied tradition of those structures. Yet, it can be said to both condemn and justify future memorials.

The black gash of shame

Before the memorial was completed, its design came under attack not only because of its modernist aesthetics but, more significant, because it violated unspoken taboos about the remembrance of wars. When it was first unveiled, the design was condemned by certain veterans and others as a highly political statement about the shame of an unvictorious war. The memorial was termed the 'black gash of shame and sorrow,' a 'degrading ditch,' a 'tombstone,' a 'slap in the face,' and a 'wailing wall for draft dodgers and New Lefters of the future.' These dissenters included a certain faction of veterans and members of the 'New Right,' ranging from conservative activist Phyllis Schlafly to future presidential candidate Ross Perot, who had contributed the money for the design contest. Many of these critics saw the memorial as a monument to defeat, one that spoke more directly to a nation's guilt than to the honor of the war dead and the veterans.

The criticism leveled at the memorial's design showed precisely how it was being 'read' by its opponents, and their readings compellingly reveal codes of remembrance of war memorials. Many saw its black walls as evoking shame, sorrow, and dishonor and others perceived its refusal to rise above the earth as indicative of defeat. Thus, a racially coded reading of the color black as shameful was combined with a reading of a feminized earth connoting a lack of power. Precisely because of its deviation from traditional commemorative codes – white stone rising above the earth – the design was read as a political statement. In a defensive attempt to counter aesthetic arguments, an editorial in the *National Review* stated:

> Our objection . . . is based upon the clear political message of this design. The design says that the Vietnam War should be memorialized in black, not the white marble of Washington. The mode of listing the names makes them individual deaths, not deaths in a cause: they might as well have been traffic accidents. The invisibility of the monument at ground level symbolizes the 'unmentionability' of the war . . . Finally, the V-shaped plan of the black retaining wall immortalizes the antiwar signal, the V protest made with the fingers.[6]

This analysis of the memorial's symbolism, indeed a perceptive reading, points to several crucial aspects of the memorial: its listing of names does emphasize individual deaths rather than the singular death of a body of men and women; the relationship of the memorial to the earth does refuse to evoke heroism and victory. Yet these conservative readings of the memorial, though they may have been accurate in interpreting the design, did not anticipate the effects of the inscription of names.

The angry reactions to the memorial design go beyond the accusation of the elite pretensions of abstraction – the uncontroversial Washington Monument itself is the epitome of abstraction. Rather, I believe that the memorial's primary (and unspoken) subversion of the codes of war remembrance is its antiphallic presence. By 'antiphallic' I do not mean to imply that the memorial is somehow a passive or 'feminine' form, but rather that it opposes the codes of vertical monuments symbolizing power and honor. The memorial does not stand erect above the landscape; it is continuous with the earth. It is contemplative rather than declarative. The V shape of the memorial has been interpreted by various commentators as V for Vietnam, victim, victory, veteran, violate, and valor. Yet one also finds here a disconcerting subtext in this debate in which the memorial is seen as implicitly evoking castration. The V of the two black granite walls, it seems, is also read as a female V. The 'gash' is not only a wound, it is slang for the female genitals. The memorial contains all the elements that have been associated psychoanalytically with the specter of woman – it embraces the earth; it is the abyss; it is death.

Indeed, some of the criticism of the memorial was direct in calling for a phallic memorial. James Webb, who was a member of the Fund's sponsoring committee, wrote:

> Watching then the white phallus that is the Washington Monument piercing the air like a bayonet, you feel uplifted. . . . That is the political message. And then when you peer off into the woods at this black slash

of earth to your left, this sad, dreary mass tomb, nihilistically commem-
orating death, you are hit with that message also. . . . That is the tragedy
of this memorial for those who served.[7]

To its critics, this antiphallus symbolized this country's castration in an unsuccessful
war, a war that 'emasculated' the United States. The 'healing' of this wound would
therefore require a memorial that revived the narrative of the United States as a
technologically superior military power and rehabilitated the masculinity of the
American soldier.

The person who designed this controversial, antiphallic memorial was unlikely
to reiterate traditional codes of war remembrance. At the time her anonymously
submitted design was chosen by a group of eight art experts, Maya Ying Lin was a
21-year-old undergraduate at Yale University. She had produced the design as a
project for a funerary architecture course. She was not only young and uncreden-
tialed but also Chinese-American and female. Initially, the veterans of the VVMF
were pleased by this turn of events; they assumed that the selection of Lin's design
would only show how open and impartial their design contest had been. However,
the selection of someone with 'marginal' cultural status as the primary interpreter
of a controversial war inevitably complicated matters. Eventually, Maya Lin was
defined, in particular by the media, not as American but as 'other'. This otherness
became an issue not only in the way she was perceived by the media and some of
the veterans, it became a critical issue of whether or not that otherness had informed
the design itself. Architecture critic Michael Sorkin wrote:

> Perhaps it was Maya Lin's 'otherness' that enabled her to create such a
> moving work. Perhaps only an outsider could have designed an environ-
> ment so successful in answering the need for recognition by a group of
> people – the Vietnam vets – who are plagued by a sense of 'otherness'
> forced on them by a country that has spent ten years pretending not to
> see them.[8]

Lin's marginal status as a Chinese-American woman was thus seen as giving her
insight into the marginal status experienced by Vietnam veterans, an analogy that
noticeably erased other differences in race and age that existed between them.

When Lin's identity became known, there was a tendency in the press to
characterize her design as passive, as having both a female and an Asian aesthetic.
There is little doubt that in its refusal to glorify war, it is an implicitly pacifist
work, and, by extension, a political work. In its form, the memorial is emphatic-
ally antiheroic. Yet as much as it is contemplative and continuous with the earth,
it can also be seen as a violent work that cuts into the earth. Lin has said, 'I wanted
to work with the land and not dominate it. I had an impulse to cut open the earth
. . . an initial violence that in time would heal. The grass would grow back, but
the cut would remain, a pure, flat surface, like a geode when you cut into it and
polish the edge.'[9] The black walls cannot connote a healing wound without also
signifying the violence that created that wound, cutting into the earth and splitting
it open.

Trouble began almost immediately between Maya Lin and the veterans. 'The fund has always seen me as a female – as a child', she has said. 'I went in there when I first won and their attitude was – O.K. you did a good job, but now we're going to hire some big boys – boys – to take care of it.'[10] Lin was situated outside the veterans' discourse, because she was a woman and an Asian-American and because of her approach to the project. She had made a decision deliberately not to inform herself about the war's political history to avoid being influenced by debates about the war. According to veteran Jan Scruggs, who was the primary figure in getting the memorial built,

> She never asked, 'What was combat like?' or 'Who were your friends whose names we're putting on the wall?' And the vets, in turn, never once explained to her what words like 'courage,' 'sacrifice,' and 'devotion to duty' really meant.[11]

In the larger political arena, discourses of aesthetics and commemoration were also at play. Several well-placed funders of the memorial, including Ross Perot, were unhappy with the design, and Secretary of the Interior James Watt withheld its permit. It became clear to the veterans of the VVMF that they had either to compromise or to postpone the construction of the memorial (which was to be ready by November 1982, in time for Veterans Day). Consequently, a plan was devised to erect a statue and flag close to the walls of the memorial; realist sculptor Frederick Hart was chosen to design it. (Hart was paid $330,000, compared to the $20,000 fee that Maya Lin received for her design from the same fund).[12]

Hart's bronze sculpture, placed in a grove of trees near the memorial in 1984, consists of three soldiers – one black, one Hispanic, and one white – standing and looking in the general direction of the memorial. The soldiers' military garb is realistically rendered, with guns slung over their shoulders and ammunition around their waists, and their expressions are somewhat bewildered and puzzled. Hart, one of the most vociferous critics of modernism in the debate over the memorial, said at the time:

> My position is humanist, not militarist. I'm not trying to say there was anything good or bad about the war. I researched for three years – read everything. I became close friends with many vets, drank with them in bars. Lin's piece is a serene exercise in contemporary art done in a vacuum with no knowledge of its subject. It's nihilistic – that's its appeal.[13]

Hart bases his credentials on a kind of 'knowledge' strictly within the male domain – drinking with the veterans in a bar – and unavailable to Maya Lin, whom he had on another occasion referred to as 'a mere student.' She describes the addition of his statue as 'drawing mustaches on other people's portraits.'[14] Hart characterizes Lin as having designed her work with no 'knowledge' and no 'research,' as a woman who works with feeling and intuition rather than expertise. He ultimately defines realism as not only a male privilege but also an

aesthetic necessity in remembering war. Ironically, the conflict over Lin's design forestalled any potential debate over the atypical expression of Hart's soldiers.

The battle over what kind of aesthetic style best represents the Vietnam War was, quite obviously, a battle of the discourse of the war itself. In striving for an 'apolitical' memorial, the veterans of the VVMF had attempted to separate the memorial, itself a contested narrative, from the contested narratives of the war, ultimately an impossible task. The memorial could not be a neutral site precisely because of the divisive effects of the Vietnam War. Later, Maya Lin noted the strange appropriateness of the two memorials: 'In a funny sense the compromise brings the memorial closer to the truth. What is also memorialized is that people still cannot resolve that war, nor can they separate issues, the politics, from it.'[15] However, after Lin's memorial had actually been constructed, the debate about aesthetics and remembrance surrounding its design simply disappeared. The controversy was eclipsed by a national discourse on remembrance and healing. The experience of viewing Lin's work was so powerful for the general public that criticism of its design vanished.

The Vietnam veteran: the perennial soldier

The incommunicability of the experience of the Vietnam veterans has been a primary narrative in Vietnam War representation. This silence has been depicted as a consequence of an inconceivable kind of war, one that fit no prior images of war, one that the American public would refuse to believe. The importance of the Vietnam Veterans memorial lies in its communicability, which in effect has mollified the incommunicability of the veterans' experience.

Though the Vietnam Veterans Memorial most obviously pays tribute to the memory of those who died during the war, it is a central icon for the veterans. It has been noted that the memorial has given them a place — one that recognizes their identities, a place at which to congregate and from which to speak. Vietnam veterans haunt the memorial, often coming at night after the crowds have dispersed. Many veterans regard the wall as a site where they visit their memories. Hence, the memorial is as much about survival as it is about mourning the dead. The construction of an identity for the veterans has become the most conspicuous and persistent narrative of the memorial. The central theme of this narrative is the veterans' initial marginalization, before the memorial's construction generated discussion about them.

Unlike the Second World War veterans, Vietnam veterans did not arrive home en masse for a celebration. Some of the most difficult stories of the veterans' experience are about their mistreatment upon their return, and these incidents serve as icons for the extended alienation and mistreatment felt by the veterans. Many veterans ended up in underfunded and poorly staffed Veterans' Administration Hospitals. They were expected to put their war experiences behind them and to assimilate quickly back into society. That many were unable to do so further exacerbated their marginalization — they were labeled social misfits and stereotyped as potentially dangerous men liable to erupt violently at any moment.

The scapegoating of the veteran as a psychopath absolved the American public of complicity and allowed the narrative of American military power to stand. Implied

within these conflicting narratives is the question of whether or not the veterans are to be perceived as victims or complicit with the war. Peter Marin writes, 'Vets are in an ambiguous situation – they were the agents and victims of a particular kind of violence. That is the source of a pain that almost no one else can understand.'[16] Ironically, their stigma has resulted in many Vietnam veterans' assumption of hybrid roles; they are both, yet neither, soldiers and civilians.

Although the marginalization of the Vietnam veterans has been acknowledged in the current discourse of healing and forgiveness about the war, within the veterans' community another group has struggled against an imposed silence: the women veterans. Eight women military nurses were killed in Vietnam and memorialized on the wall. It is estimated that 11,500 women, half of whom were civilians and many of whom were nurses, served in Vietnam and that 265,000 women served in the military during the time period of the Vietnam War. The experience of the women who served in Vietnam was equally affected by the difference of the war: an unusually large proportion of them, three-quarters, were exposed to hostile fire. Upon their return, they were not only subject to post-traumatic stress like the male veterans but they were also excluded from the veteran community. Many have since revealed how they kept their war experience a secret, not telling even their husbands about their time in Vietnam.

These women veterans were thus doubly displaced, unable to speak as veterans or as women. In response, several women veterans began raising funds for their own memorial, and in November 1993, the Vietnam Women's Memorial was dedicated near the Vietnam Veterans Memorial. The statue, which was designed by Glenna Goodacre, depicts three uniformed women with a wounded soldier. The two women who direct the VWMP, Diane Carlson Evans and Donna Marie Boulay, say that it is Hart's depiction of three men who make the absence of women so visible, and that they would not have initiated the project had Lin's memorial stood alone. Says Evans, 'The wall in itself was enough, but when they added the men it became necessary to add women to complete the memorial.'[17] Hence, the singular narrative of Hart's realist depiction is one of both inclusion and exclusion.

One could argue that the widespread discourse of healing around the original memorial led women veterans to speak of their memorial as the beginning rather than the culmination of a healing process. Yet the radical message of commemorating women in war is undercut by the conventionality of the statue itself. A contemporary version of the *Pietà*, the statue presents one woman nurse heroically holding the body of a wounded soldier, one searching the sky for help, and one looking forlornly at the ground. Benjamin Forgery, who called this memorial in the *Washington Post* 'one monument too many,' has criticized the women's memorial for cluttering up the landscape with 'blatheringly sentimental sculpture.' He wrote that the sculptor's 'ambition is sabotaged by the subject and the artist's limited talent – compared with Michelangelo's Christ figure, this GI is as stiff as a board. The result is more like an awkward still from a *M*A*S*H* episode.'[18]

The decision to build the women's memorial was not about aesthetics (except in so far as it reaffirms the representational aesthetic of Hart's statue) but about recognition and inclusion. However, by reinscribing the archetypal image of woman as caretaker, one that foregrounds the male veteran's body, the memorial

reiterates the main obstacle to healing that women veterans face in recognizing their needs as veterans. Writes Laura Palmer, 'After all, these women had *degrees* in putting the needs of others before their own.'[19]

The difficulty of adequately and appropriately memorializing the women veterans falls within the larger issue of masculine identity in the Vietnam War. The Vietnam War is depicted as an event in which American masculinity was irretrievably damaged, and the rehabilitation of the Vietnam veteran is thus also a reinscription of American masculinity. This has also taken the form of re-enacting the war at the memorial itself, through the Veterans' Vigil of Honor, which keeps watch there, and the 'battles' over its construction and maintenance. As a form of re-enactment, this conflation of the memorial and the war is a ritual of healing, although one that appears to be stuck in its ongoing replay, with a resistance to moving beyond narratives of the war. For the men of the Veterans' Vigil, only the war can provide meaning. In refighting that war every day, they are also reinscribing narratives of heroism and sacrifice. But, for others, there is a powerful kind of closure at the memorial. The one story for which the memorial appears to offer resolution is that of the shame felt by veterans for having fought in an unpopular war, a story that is their primary battle with history.

The memorial as a shrine

The Vietnam Veterans Memorial has been the subject of an extraordinary outpouring of emotion since it was built. Over 150,000 people attended its dedication ceremony and some days as many as 20,000 people walk by its walls. It is presently the most visited site on the Washington Mall with an estimated 22 to 30 million visitors. People bring personal artifacts to leave at the wall as offerings, and coffee-table photography books document the experiences of visitors as a collective recovery from the war. It has also spawned the design or construction of at least 150 other memorials, including the Korean War Veterans Memorial, which was dedicated in July 1995.

The rush to embrace the memorial as a cultural symbol reveals not only the relief of voicing a history that has been taboo but also a desire to reinscribe that history. The black granite walls of the memorial act as a screen for myriad cultural projections; it is easily appropriated for a variety of interpretations of the war and of the experience of those who died in it. To the veterans, the wall makes amends for their treatment since the war; to the families and friends of those who died, it officially recognizes their sorrow and validates a grief that was not previously sanctioned; to others, it is either a profound antiwar statement or an opportunity to recast the narrative of the war in terms of honor and sacrifice.

The memorial's popularity must thus be seen in the context of a very active scripting and rescripting of the war and as an integral component in the recently emerged Vietnam War nostalgia industry. This sentiment is not confined to those who wish to return to the intensity of wartime; it is also felt by the news media, who long to recapture their moment of moral power – the Vietnam War was very good television. Michael Clark writes that the media nostalgia campaign,

healed over the wounds that had refused to close for ten years with a balm of nostalgia, and transformed guilt and doubt into duty and pride. And with a triumphant flourish it offered us the spectacle of its most successful creation, the veterans who will fight the next war.[20]

Though the design of Maya Lin's memorial does not lend itself to marketable reproductions, the work has functioned as a catalyst for much of this nostalgia. The Vietnam Veterans Memorial is the subject of no fewer than twelve books, many of them photography collections that focus on the interaction of visitors with the names. The memorial has tapped into a reservoir of need to express in public the pain of this war, a desire to transfer the private memories of this war into a collective experience. Many personal artifacts have been left at the memorial: photographs, letters, poems, teddy bears, dog tags, combat boots and helmets, MIA/POW bracelets, clothes, medals of honor, headbands, beer cans, plaques, crosses, playing cards. At this site, the objects are transposed from personal to cultural artifacts, as items bearing witness to pain suffered.

Thus, a very rich and vibrant dialogue of deliberate, if sometimes very private, remembrance takes place at the memorial. Of the approximately 40,000 objects that have been left at the wall, the vast majority have been left anonymously. Relinquished before the wall, the letters tell many stories:

> Dear Michael: Your name is here but you are not. I made a rubbing of it, thinking that if I rubbed hard enough I would rub your name off the wall and you would come back to me. I miss you so.

> Dear Sir: For twenty-two years I have carried your picture in my wallet. I was only eighteen years old that day that we faced one another on that trail in Chu Lai, Vietnam. Why you didn't take my life I'll never know. You stared at me for so long, armed with your AK-47, and yet you did not fire. Forgive me for taking your life, I was reacting just the way I was trained, to kill VC.

Hence, the memorial is perceived by visitors as a site where they can speak to the dead (where, by implication, the dead are present). Many of these letters are addressed not to visitors but to the dead, though intended to be shared as cultural memory. Many of the artifacts at the memorial also represent a catharsis in releasing long-held objects to memory: a can of C-rations, a 'short stick,' worn Vietnamese sandals, a grenade pin. For those who left these objects, the memorial represents their final destination and a relinquishing of memory.

The National Park Service, which is now in charge of maintaining the memorial, operates an archive of the materials that have been left at the memorial. Originally, the Park Service classified these objects as 'lost and found.' Later, Park Service officials realized the artifacts had been left intentionally, and they began to save them. The objects thus moved from the cultural status of being 'lost' (without category) to historical artifacts. They have now even turned into artistic artifacts; the manager of the archive writes:

> These are no longer objects at the Wall, they are communications, icons possessing a subculture of underpinning emotion. They are the products of culture, in all its complexities. They are the products of individual selection. With each object we are in the presence of a work of art of individual contemplation. The thing itself does not overwhelm our attention since these are objects that are common and expendable. At the Wall they have become unique and irreplaceable, and, yes, mysterious.[21]

Labeled 'mysterious,' and thus coded as original works of art, these objects are given value and authorship. Some of the people who left them have since been traced. This attempt to tie these objects and letters to their creators reveals again the shifting realms of personal and cultural memory. Assigned authorship and placed in an historical archive, the objects are pulled from cultural memory, a realm in which they are presented to be shared and to participate in the memories of others.

The memorial has become not only the primary site of remembrance for the Vietnam War, but also a site where people pay homage to many current conflicts and charged public events. Artifacts concerning the abortion debate, the AIDS epidemic, gay rights, and the Persian Gulf War have all been left at the memorial. Hence, the memorial's collection inscribes a history not only of the American participation in the Vietnam War but also of national issues and events since the war. It is testimony to the memorial's malleability as an icon that both prowar and antiwar artifacts were left there during the Persian Gulf War.

One of the most compelling features of the Vietnam Veterans Memorial collection is its anonymity, mystery, and ambiguity. It appears that many of the stories behind a substantial number of artifacts may never be known, and that the telling of these stories to history was never the purpose of their being placed at the memorial. Though couched within an official history and held by a government institution, these letters and offerings to the dead will continue to assert individual narratives, strands of cultural memory that disrupt historical narratives. They resist history precisely through their obscurity, their refusal to yield specific meanings.

The construction of a history

The politics of memory and history of the Vietnam Veterans Memorial shift continuously in a tension of ownership and narrative complexity. Who, in actuality, is being allowed to speak for the experience of the war? Has the Vietnam Veterans Memorial facilitated the emergence of the voices of veterans and the families and friends of veterans in opposition to the voice of the media and the government? The process of healing can be an individual process or a national or cultural process; the politics of each is quite difference.

Much of the current embrace of the memorial amounts to historical revisionism. The period between the end of the war and the positioning of the memorial as a national wailing wall has been long enough for memories and culpability to fade. Ironically, the memorial allows for an erasure of many of the specifics of history. It is rarely noted that the discussion surrounding the memorial never mentions the

Vietnamese people. This is not a memorial to their loss; they cannot even be mentioned in the context of the Mall. Nor does the memorial itself allow for their mention; though it allows for an outpouring of grief, it does not speak to the intricate reasons why the lives represented by the inscribed names were lost in vain.

Thus, remembering is in itself a form of forgetting. Does the remembrance of the battles fought by the veterans in Vietnam and at home necessarily screen out any acknowledgment of the war's effect on the Vietnamese? In its listing of the US war dead, and in the context of the Mall, the memorial establishes Americans, rather than Vietnamese, as the primary victims of the war. For instance, questions about the 1,300 American MIAs are raised at the memorial, yet in that space no mention can be made of the 300,000 Vietnamese MIAs. Does the process of commemoration necessitate choosing sides?

Artist Chris Burden created a sculpture in 1991, *The Other Vietnam Memorial*, in reaction to the memorial's nonacknowledgment of the Vietnamese. Burden's piece consists of large copper leaves, 12 by 8 feet, arranged as a kind of circular standing book, on which are engraved 3 million Vietnamese names to commemorate the 3 million Vietnamese who died in the war. He says: 'Even though I feel sorry for the individuals named on [the Vietnam Veterans Memorial], I was repulsed by the idea. I couldn't help but think that we were celebrating our dead, who were aggressors, basically, and wonder where were the Vietnamese names?'[22] Burden's listing of names is not unproblematic; he was unable to get the actual listing of names, so he took 4,000 names and repeated them over and over again. However, Burden's sculpture exposes a fundamental limit of commemoration within nationalism. Why must a national memorial re-enact conflict by showing only one side of the conflict? What is the memory produced by a national memorial?

The memorial's placement on the Washington Mall inscribes it within nationalism, restricting in many ways the kinds of memory it can provide. Its presence indicates both the limitations and the complexity of that nationalist discourse. Lauren Berlant writes:

> When Americans make the pilgrimage to Washington they are trying to grasp the nation in its totality. Yet the totality of the nation in its capital city is a jumble of historical modalities, a transitional space between local and national cultures, private and public property, archaic and living artifacts . . . it is a place of national *mediation*, where a variety of nationally inflected media come into visible and sometimes incommensurate contact.[23]

The memorial asserts itself into this 'jumble of historical modalities,' both a resistant and compliant artifact. It serves not as a singular statement but a site of mediation, a site of conflicting voices and opposing agendas.

However, the act of commemoration is ultimately a process of legitimation and the memorial lies at the center of a struggle between narratives. It has spawned two very different kinds of remembrance: one a retrenched historical narrative that attempts to rewrite the Vietnam War in a way that reinscribes US imperialism and the masculinity of the American soldier; the other a textured and complex discourse of remembrance that has allowed the Americans affected by this war – the veterans,

their families, and the families and friends of the war dead – to speak of loss, pain, and futility. The screens of the memorial allow for projections of a multitude of memories and individual interpretations. The memorial stands in a precarious space between these opposing interpretations of the war.

Notes

1 Arthur Danto, 'The Vietnam Veterans Memorial,' *The Nation*, August 31, 1985, p. 152.
2 Charles Griswold, 'The Vietnam Veterans Memorial and the Washington Mall,' *Critical Inquiry*, Summer 1986, p. 689.
3 Tom Wolfe, 'Art Disputes War,' *Washington Post*, October 13, 1982, p. B4.
4 Kenneth Baker, 'Andre in Retrospect,' *Art in America*, April 1980, pp. 88–94.
5 See Robert Storr, '"Tilted Arc": Enemy of the People,' in Arlene Raven (ed.), *Art in the Public Interest* (Ann Arbor: University of Michigan Press, 1989).
6 'Stop That Monument,' *National Review*, September 18, 1981, p. 1064.
7 Quoted in Mary McLeod, 'The Battle for the Monument,' in Helene Lipstadt (ed.), *The Experimental Tradition* (New York: Princeton Architectural Press, 1989), p. 125.
8 Michael Sorkin, 'What Happens When a Woman Designs a War Monument?', *Vogue*, May 1983, p. 122.
9 Quoted in 'America Remembers: Vietnam Veterans Memorial,' *National Geographic*, May 1985, p. 557.
10 'An Interview With Maya Lin,' in Reese Williams (ed.), *Unwinding the Vietnam War* (Seattle: Real Comet Press, 1987), p. 271.
11 Jan Scruggs and Joel Swerdlow, *To Heal a Nation* (New York: Harper & Row, 1985), p. 79.
12 Mary McLeod, op. cit., p. 127.
13 'An Interview With Frederick Hart,' in Reese Williams (ed.), *Unwinding the Vietnam War* (Seattle: Real Comet Press, 1987), p. 274.
14 Quoted in Rick Horowitz, 'Maya Lin's Angry Objections,' *Washington Post*, July 7, 1982, p. B1.
15 Quoted in Scruggs and Swerdlow, op. cit., p. 133.
16 Peter Marin, 'Conclusion,' in Harrison Salisbury (ed.), *Vietnam Reconsidered* (New York: Harper & Row, 1984), p. 213.
17 Quoted in Benjamin Forgery, 'Battle Won for War Memorials,' *Washington Post*, September 20, 1991.
18 Benjamin Forgery, 'One Monument Too Many,' *Washington Post*, November 6, 1993, p. D7.
19 Quoted in Laura Palmer, 'How to Bandage a War,' *New York Times Magazine*, November 7, 1993, p. 40.
20 Michael Clark, 'Remembering Vietnam,' *Cultural Critique* 3, Spring 1986, p. 49.
21 David Guynes, quoted in Lydia Fish, *The Last Firebase* (Shippensburg, Pa.: White Mane, 1987), p. 54.
22 Quoted in Robert Storr, 'Chris Burden,' *MoMA Members Quarterly*, Fall 1991, p. 5.
23 Lauren Berlant, 'The Theory of Infantile Citizenship,' *Public Culture* 5, 1993, p. 395.

Michele Wallace

THE PRISON HOUSE OF CULTURE
Why African art? Why the Guggenheim?
Why now?

What, after all, does it matter that this pair of concepts – Africa, art –
was not used by those who made these objects? They are still African;
they are still works of art. Maybe what unites them as African is our
decision to see them together, as the products of a single continent.
Maybe it is we, and not their makers, who have chosen to treat these
diverse objects as art. But it is also our show; it has been constructed
for us now, in the Western world.

> Kwame Anthony Appiah, *Africa: The Art of a Continent*[1]

That tribal art influenced Picasso and many of his colleagues in signifi-
cant ways is beyond question. But that it caused no fundamental change
in the direction of modern art is equally true. Picasso himself put it
succinctly when he said: 'The African sculptures that hang around . . .
my studios are *more witnesses than models*.' That is, they more bore witness
to his enterprise than served as starting points for his imagery.

> William Rubin, *Primitivism in Twentieth Century Art*[2]

The primitive does what we ask it to do. Voiceless, it lets us speak for
it. It is our ventriloquist's dummy – or so we like to think.

> Marianna Torgovnick, *Gone Primitive*[3]

DUE, IN PART, TO THE GLOOMY JUDGMENTS of African culture by such
18th-century philosophers as Kant, Hegel, Hume, and Rousseau, African art
has only been considered art – a sign of individual genius, sophistication, and
creativity – for less than a hundred years in the West. For the record, the legend
goes that Henri Matisse, Georges Braque, and Pablo Picasso were the first to cham-
pion its greatness, albeit in a narrowly qualified way. Of course, they were inspired

by the densely packed collections of 'artifacts, tribal objects and curiosities' at the *Expositions Universelles* of 1889, 1897, and 1900, as well as the craze for colonial exhibitions of 'native' populations of all sorts, across Europe and the US.[4]

It is crucial to consider the creation by Matisse, Braque, Picasso, and others of a new Modernist vision in art from the aesthetic lessons of African sculpture (as well as Native American and Oceanic objects) within the context of an increasing flow of popular cultures from the New World. Around the turn of the century, there was already a steady – although much less well documented – flow of highly stylized popular cultural imagery of blacks in such arenas as advertising, sheet-music covers, ephemera, and illustrations.[5] Europeans were also increasingly given the opportunity to see real-life black Americans in performance in touring blackface minstrelsy troupes, in bands of jubilee singers sometimes raising money for worthy causes, as in the case of the Fisk University Jubilee Singers, and sometimes just supporting themselves, as was the case with the hundreds of spin-offs.

No one has really thoroughly investigated the extent to which various and sundry black performers from the US toured Europe, the Pacific Islands, and even South Africa, but such books as Henry Sampson's *The Ghost Walks: A Chronological History of Blacks in Show Business*, as well as other recent research on black performance history, hint at the considerable dimensions of this phenomenon.[6] I wouldn't be surprised to learn as well that there were also parallel performance practices streaming into Europe from its various colonial possessions, and would love to find out more about this. We know at least from recent scholarship that extravaganzas of human display – from Buffalo Bill's 'Wild West Show' (which toured the world) to the ethnographic spectacles organized by such entrepreneurs as Imre Kiralfy for the White City, a permanent exhibition site from 1908 to 1914 in London – were commonplace during the years immediately preceding and following the turn of the century.[7]

The point here is related to the one that James Clifford makes in *The Predicament of Culture* when he invokes the body of Josephine Baker in the context of the development of Modernism in Paris in the 1920s: these African art objects were not being examined in splendid isolation.[8] Indeed, they were forced to operate upon Europeans in a context literally swarming with activity, insight, and myriad visual imagery generated by parallel and related cultural practices stemming from the impact of the presence of colonized subjects within the purview of their various empires. These phenomena included not only the various performance practices of the colonized and the formerly enslaved that managed to travel to Europe, but also cultural perspectives generated by aestheticisms of orientalism and primitivism that were already in place as part of the philosophical and ideological logic of imperialism, colonialism, and domination.[9]

Nonetheless, art-historical expertise has conventionally depoliticized the moment of Modernist catharsis and transformation by placing it very precisely in or around 1906, the year that Picasso began work on the celebrated inaugural canvas of the conjunction of primitivism and Modernism, *Les Demoiselles d'Avignon*.[10] You can take your pick of originary scenarios from the copious art-historical literature. The Matisse story goes as follows:

> On his way to pay a visit to Gertrude Stein in the Rue de Fleurus, [he] noticed a 'Negro' object in the window of Emile Heymann's shop of

exotic curiosities at 87 Rue de Rennes, and bought it for a few francs. Upon arriving at the Stein apartment he showed it to Picasso, who while looking at it displayed a certain enthusiasm.[11]

We date this event by the fact that Picasso had just finished his extraordinary portrait of Gertrude Stein. Whereas, according to Colin Rhodes in his brief but dense little book, *Primitivism and Modern Art*, it is 'now generally accepted that it was probably the Fauve painters Maurice de Vlaminck and André Derain who first acquired African pieces in Paris early in 1906 . . . and that they were quickly followed by Matisse, who had become interested in West African sculpture after a trip to North Africa, in March 1906.'[12]

As for a more subjective account, Picasso's lavish epiphanies, as reported by André Malraux and Françoise Gilot, begin to hint at Modernism's anxiety of influence around tribal objects, and their association with their presumably primitive and uncivilized African creators. Picasso has said:

> When I became interested forty years ago in Negro art and I made what they refer to as the Negro Period in my painting, it was because at the time I was against what was called beauty in the museum. At that time, for most people a Negro mask was an ethnographic object. When I went for the first time, at Derain's urging, to the Trocadéro museum, the smell of dampness and rot there stuck in my throat. It depressed me so much I wanted to get out fast, but I stayed and studied. Men had made those masks and other objects for a sacred purpose, a magic purpose, as a kind of mediation between themselves and the unknown hostile forces that surround them, in order to overcome their fear and horror by giving it a form and image. . . . I knew I had found my way. Then people began looking at those objects in terms of aesthetics.[13]

A far cry still from the respect this art deserved, such views were nevertheless better than the way the rest of the official white world of scholarship and expertise felt about it. Traditionally, the study of 'fetishes' and 'tribal objects' was left to anthropologists, geologists, archaeologists, and naturalists.[14] Its distribution and circulation were left to looters, from military men to missionaries, under cover of imperialist occupation, and the collectors and dealers who relentlessly pursued them.

Indeed, the fate of these objects was not unrelated to the fate of the human bodies also removed from Africa under less than ideal circumstances — some of them sold or just handed over and some of them kidnapped. Whereas the slaves might expire on the trek the coast, or in the arduous middle passage,[15] lots of African objects, many of them made of wood or equally perishable materials, were destroyed by the fires of zealous missionaries, or even by their African patrons (not necessarily their skillful creators) when they had outlived their ritual usefulness.

As a sideshow to the general chaos that accompanied Europe's annexation and colonization of the African continent in the late 19th century, the best and/or the most interesting (we can only but vainly hope) African objects were salvaged for exhibition or sale, even as entire villages of Africans (as well as Native Americans, Pacific Islanders, and Eskimos or Inuits) were sometimes shipped over to Europe,

England, and the US and placed on display in zoos and circuses.[16] No doubt, many of the objects that made it either to the New World, Britain, or Europe were probably destroyed one way or the other. It is not too surprising then that until very recently, the practice of African art discourse, to the degree that such a thing could be said to exist, had been plagued by the Eurocentrism, phallocentrism, and solipsism that had always marked other Western discourses about Africa.

For instance, following the sacking of Benin by the British in 1897, when close to 1,000 intricate bronzes that had originally hung on the wooden pillars of the palace were discovered, it was a while before the speculation died down that these works must have been made by visiting Europeans. Also, the monuments and pyramids found in what is now the South of Egypt, formerly the black kingdom of Nubia, were repeatedly credited to the fairer-skinned (and thus presumably more talented) Egyptians.[17]

In 1910, when the German ethnographer Leo Frobenius found a nearly life-size bronze Ife head in a naturalistic style in the grove of Olokun (the Yoruba sea goddess), he decided that Olokun was Poseidon, and that the head was in fact from the long-lost colony of Atlantis. We could easily fill a book or two with documented examples of the kind of racism that passed for scholarly expertise.[18]

As a consequence, there is and continues to be, especially in this country, an appalling chasm in regard to the study and appreciation of African art. Consider for a moment the arrogance of a CD-ROM set called *The History of Art*, starting out with a volume on 'Ancient Greece' that doesn't even bother to acknowledge the existence of Africa, except through its references to Egypt as the decadent negative of the glorious humanism of Greek art.[19] Moreover, this disdain for African art isn't just a white thing.

Consequently brought low by all this mess, some colored Americans don't have much use for African art either. Some of the various comments I've heard from blacks in relation to the Guggenheim exhibition have been, 'I was infuriated by the wall labels,' or 'The Guggenheim is just trying to get credit for being multicultural when they have never done anything for artists of color.'

'They should hang a big sign over the, whole show saying, "This work is all stolen!"' said one of the organizers of a conference on the arts in Africa at the Brooklyn Academy of Music, in conjunction with the Guggenheim exhibition. Was she suggesting that great art can't be claimed or assimilated unless we know precisely who did it because it lacks the essentializing aura of the individual artist? I don't think so. After all, if rap artists can sample copyrighted materials, why can't we sample this unsigned but neither unloved nor unlamented work for whatever – contemplation, meditation, images, role models, philosophical insight?

Rather, the devastating and traumatic emotional consequences of their transport – just how these objects came to be in our midst – can outweigh their beauty and spiritual power for some descendants of the survivors of our holocaust. Also, I think the woman was actually trying to make the kind of distinction Manthia Diawara, Director of the Africana Studies Program at New York University, was getting at in his talk at the same conference about working on a documentary profile of the life of Sekou Touré, former president of Guinea.

A group involved in a *coup d'état* to overthrow Touré was arrested by him, Diawara explained to me, and ultimately executed, for their alleged, although never

proven, participation in an art smuggling scheme. The irony is that at the same time that some newly liberated Muslim African nations declared it illegal to export traditional African art objects in order to increase the wealth of the state, they also forbade the use of them for worship in a traditional context.

According to Diawara, the works collected at the Guggenheim and in other museums serve to displace black modernity. From this perspective, these nameless objects, having no authors and no continuity with known traditions, alienated from their own intended functions in antiseptic plexiglass exhibition cases, are at once lifeless and immortal, like the albatross around the neck of the mariner in the Coleridge poem. The greatest difference, then, between the bodies of our ancestors and these tribal objects is that the bodies were allowed to die (therefore enabling us to replace them), whereas the tribal objects can never die, given their curious half-life on the back shelves of Western art. Presumably as a consequence, black art as a discourse with self-defining agency is prevented from existing both in the present and the past.

My take is both different and the same for one reason only: I am the daughter of a black feminist artist, Faith Ringgold, who considered African art pivotal to her creative development. Just as Black Power and black cultural nationalism were in their ascendancy in the late 1960s and early 1970s, and everybody was talking about going back to Africa for its music, its dance, its food, its people, its clothing, its air – indeed, everything but its visual art – a small circle of black intellectuals and artists got interested in these objects as 'art' – that is, as signs of an African genius, sophistication, and talent to be drawn upon as models for our own African American creativity. In other words, I see the down side but I see the up side too.

What exists in American, European, African, and Asian collections should probably be considered no more than the tip of the iceberg as far as production is concerned. If we can say that only 10% of silent films have survived, then maybe 1% or less of the objects we now describe as African art are still in existence. It might even be useful to think of them as ruins, the product of archaeological excavation, the better part of which no longer exists. The museum and gallery collections should be regarded as our best clues to the actual dimensions of visual art activity prior to the 1950s or 1960s in Africa. Its study should be formulated, at least for the citizens of the Diaspora and all of our friends, in the context of mourning the soul death of our ancestors and, admittedly, as a sign of our cultural decimation.[20] Such was, perhaps, the thinking of the former director of the Museum for African Art, Susan Vogel, when she selected Maya Lin, the creator of the Vietnam Memorial in Washington, DC, to design their new space in SoHo. The walls are dark and the rooms womblike, a perfect place to have a good cry.

In recent decades, particularly in the US, a generation of scholars who combine the tools of anthropology, political geography, archaeology, art history, and deconstruction in a kind of cultural studies of the ethnographic have been making significant headway toward integrating divergent discourses with the unvarnished truth about the various colonial histories of the acquisition of African art. A particular publication that may have speeded the entire process along was Martin Bernal's Black Athena, with its reinterpretation of the links between the Greco-Roman world and the African and Semitic worlds. Subsequent investigational exhibitions at such institutions as the Brooklyn Museum, the Metropolitan, the Smithsonian, and

particularly the Museum for African Art, have gradually altered the landscape, although usually not in a way that can help us with the problem of what to say about African art's impact on Modernism. To spell out this impact is important not only because Western culture of the Modernist variety continues to dominate the world's vision, but also because this missing link to the characteristic structures and relations between visual discourses will help us to better comprehend the entire program's ongoing and dynamic effectiveness (hegemony) in the present.

This project has been left in the not always capable hands of those who come to it from the Modernist side: Hal Foster in *Re-Coding*, James Clifford in *The Predicament of Culture*, Sally Price in *Primitive Art in Civilized Places*, Marianna Torgovnick in *Gone Primitive: Savage Intellects, Modern Lives*, as well as, most infamously, William Rubin in *Primitivism in 20th Century Art*, the two-volume catalogue which accompanied the exhibition of the same name at the Museum of Modern Art in 1984. All the same, not nearly enough scholars, intellectuals and artists have taken up the question of 'primitivist modernism,' given its potential importance to multiculturalism.

Within this context, *Africa: The Art of a Continent* presents quite a conundrum in that it works as a microcosm of the problem with the field of African art. On the one hand, there is the legacy of African art as a constituent element in modernism. On the other hand, there is the archaeological, anthropological, social science-y approach to African art, which sees it as an artifact of culture with a small 'c,' and therefore a gateway to the more mysterious side of history, sometimes called prehistory, before the world's great written traditions began to keep the records to which we still refer.

The Modernist people think the social science folks are too dismissive of aesthetic value, and the social science folks think the Modernists don't care a fig for history, much less for the subjectivities and agency of the original makers of this work. The usefulness of the social science model is included in the late discovery of structural anthropology that its field of operation is that which is ultimately unknowable or untotalizable about cultural difference. The fact I love, but which many seem to hate, is that cultures come in an endless combinatory variety of arbitrary meaningfulness. For this reason as well, I love all the myriad signs that 'difference' is finally irreducible – such as those on display at the Guggenheim.

There are those who will be enraged by this exhibition's overt display of ignorance, and the vast, unapologetically white walls of Frank Lloyd Wright's structure, almost blinding in the daylight. It is correct to say that this is not your ideal didactic exhibition, but what fascinates me is the extraordinary opportunity given us to fill in our own narratives, to contemplate precisely that which is not known about African art, in the way in which a Toni Morrison or a Charles Johnson has done for slavery and the Middle Passage.

According to Harvard philosopher Kwame Anthony Appiah, the concepts of both Africa and art are first, inventions of the West, second, relatively recent in origin, and third, not relevant to the actual creation of the works in the exhibition. 'So we might as well face up to the obvious problem,' Appiah writes, 'neither Africa nor art – the two animating principles of this exhibition – played a role as ideas in the creation of the objects in this spectacular show.'[21] Good point, I suppose, but still, I am not quite so willing or ready to yield all rights to a continental philosophy or aesthetics solely to the West.

The Harvard Black Studies threesome of Henry Louis Gates, Jr., Kwame Anthony Appiah, and Cornel West served as special consultants for the exhibition, and each wrote a short essay for the catalogue, of which Appiah's is the most interesting. This may be as good a time as any to alert you to the fact that there are almost as many kinds of Afrocentrism as there are types of toothpaste, and some of them have about as much in common with Leonard Jeffries's or even Molefi Asante's way of thinking as you would expect to find between caviar and filet mignon. Appiah, the least well-known of the threesome at Harvard, is a leading figure in this context. A professor of philosophy and African American studies, he was born in Ghana, is Asante by birth, and is best known for his reflections on the genetic indeterminacy of racial identity.

To even call whatever these folks stand for 'Afrocentrism' is stretching it a lot, given that they don't necessarily buy into the essentialist rhetoric of margins vs. centers, or even the very notion of a fixed identity. In any given number, *Transition* is just as likely as not to have more articles authored by phenotypically white folk than black. But they do seem to have the will to reclaim Africa from the more provincial, xenophobic, and occasionally hate-mongering Afrocentrists we spawn so easily on this continent – the point being, I believe, not only the preservation of the creative legacy of the African continent, but also, finally, casting some light upon its present grievous political and economic condition, which continues to go largely unremarked in the US.

Yet Appiah may be more willing to yield the right of way to the West in regard to aesthetics precisely because he is African, not African American, and no poor dispossessed African either. Moreover, he is a member of the aristocracy of one of the most prominent ethnicities in his notion of Africa not as a continent, but as a bursting bundle of ethnicities, tribes, and nations. As an Asante, he grew up surrounded by the treasures of Asante art, and knowing that they were his birthright. If one gets rid of both the notion of Africa and of aesthetics, quite naturally the claim of any African American to African art seems perversely illegitimate in comparison to Appiah's, and, after all, the art is both material property as well as symbolic legacy.

But I believe that such concepts as art and Africa are a little more complicated, more 'cooked' than raw, and as such many different hands have contributed to the present recipe. Africa and Europe are not on opposite sides of the world but nearly attached by land; they were never unknown to one another. The continent of Africa is part of the 'Old World,' not the New.

Given this scenario, in which blacks haven't necessarily had more of a notion of what to really make of the presence of African art in European and American museums than most whites, how are we to interpret the obvious shortcomings of the Guggenheim exhibition? Having originated at the Royal Academy of Arts in London in 1995 and travelled first to the Walter-Gropius-Bau in Berlin, *Africa: The Art of a Continent* was curated by a white artist, Tom Phillips, one of the 80 members of the not-at-all progressive Royal Academy, with the aid of a curatorial advisory committee with such heavyweights as Michael Kan, director of the Detroit Institute of Arts, Frank Herreman of the Museum for African Art in SoHo, and the highly respected Ekpo Eyo, Professor of Archaeology at the University of Maryland, and the former director of the Nigerian National Museum and the Federal Department of Antiquities.

Yet one African art insider tells me disdainfully, 'They didn't talk to any of the people they needed to talk to, and the exhibition shows it.' Other sources inform me that Susan Vogel, former Director of The Museum for African Art, and one of the chief proponents of new approaches to African art, wasn't able to remain on the advisory committee for the exhibition because of her insistence that it include contemporary African art. She was the curator of the stellar exhibition *Africa Explores: 20th Century African Art*[22] back in 1993, jointly held at the New Museum and the Museum for African Art. On the other hand, the Guggenheim's chief curator for the exhibition, Jay Levinson, while both smart and charming, is no African art expert (he did the Columbus Centennial exhibition at the Smithsonian and will do the big Chinese exhibition planned next summer for the Guggenheim). Did the Gugg make a booboo, or was this just their awkward way of proclaiming their new interest in increasing their audience of color from a level of nil?

Including a display of over 500 mostly eye-popping traditional African art objects from Egypt to Zimbabwe, the aggregate of which is guaranteed to defy all ready generalizations about the unity of African culture, the hyperbolic ultra-Modernist space of Frank Lloyd Wright's Guggenheim confronts and commingles with African art on a gargantuan scale for the first time since the Primitivism show at the Museum of Modern Art in 1984, in which masterpieces of Modernism were coupled with similar works of African, Native American, and Oceanic art.

I never saw the Modernism show. I was in Oklahoma at the time, and wouldn't have dreamed of flying back to see it then, although I could kick myself now for having missed what must have been the spectacle of a lifetime. By way of compensation, I have spent a considerable amount of time with the two accompanying volumes of essays published by MOMA. Most of the essays endlessly equivocate about whether African art influenced Modernist art. The arguments vacillate between the assumption that if a particular artist hadn't seen a particular 'tribal' object before he did the painting or sculpture in question, then clearly we are talking affinities rather than influences, in combination with the repeated, seemingly contradictory concessions that yes, there were definitely some clear influences.[23]

Needless to say, this was not the high road even in 1984, and no major museum in 1997, at least in the US, would ever again make the mistake of doing such an exhibition, in which the 'tribal' arts were hierarchically compared to the superlative accomplishments of the West. The chart Alfred Barr used to illustrate the various contributing factors that made up European Modernism, and which accompanied a 1937 Cubist exhibition, definitely won't do any more either.[24] At the same time, there hasn't been any new breakthrough synthesis of Modernism and African, Oceanic and Native American art perspectives to take their place. Even at the time of the Primitivism show, the widespread critique still centered around substituting for a Modernist bent the much more politically correct focus on the works' original intentions in African society.

Clearly, the West was profoundly affected by visions of new people and places embodied in these objects, but just exactly how did this work? How should or can it be described, given our conventional descriptions of aesthetic schools, influences, and progressive development? Yes, Modernism was a heady, no-fault combination of New World, African, Far-, Near-. and Middle Eastern imperialism, exploration,

and exploitation further accelerated by such spectacular adventure-promoting inventions as the steam engine, the railroad, electricity, telegraph, telephone, the light bulb, film, photography, and sound recordings, but there is also the fact that, to put it indelicately, cultures steal from one another. When they do so, they don't leave an IOU so you can collect later, either. It is what culture is, what culture was perhaps invented by its willing subjects to do.

At the beginning of *The Prison House of Language*, cultural theorist Frederic Jameson talks about how one discursive model supersedes another. It doesn't occur all at once. First, there has to be a good deal of mucking about trying to make the previous model fit the new circumstances. In the 19th century, the dominant Western paradigm in visual culture was mimetic. Although the world is populated by multitudes of people who are still pretty stuck on the realism model, in fact, around the turn of the century, European Modernism had already begun to embrace new models of ideal form that drew upon anything handy. The response was not the immediate replacement of one model by the other but rather the endless recombination of the various elements of the two, to which we owe many of the treasures of European Modernism found in the museums of the world today.

I would argue that the mix that made European Modernism was not just a matter of inanimate African art objects, violently kidnapped and forced into the unempathic cultural context of the ethnographic museum. The importation of African cultural values was part of the picture as well, facilitated by the presence of African bodies and the will of the African spirit, in both New World and Old. While these immigrants almost never succeeded in continuing their visual forms, they did manage to bring their music and their dance with them, or at least to adapt them to the new circumstances. It was called gospel, blues, jazz, samba, calypso, and so on.

On the African side, who can be sure? Perhaps in the 18th and 19th centuries, their artists (and I will persist in thinking there were such people in all civilizations worthy of the name), under cover of religious ritual, were having a Renaissance somehow prompted by their sorrow over the loss of our ancestors?

The story is: the show was well worth seeing. Aside from the astonishing beauty, poetry, and blues-laden sadness of the objects, there were the dozen or so loans from African museums and collections, a rarity in exhibitions of this kind. Included in this category were the Lydenburg Heads (*c.* 500–700 CE) from the Eastern Transvaal, the cave painting of the Linton Panel and the 'Rock Engraving of a Giraffe' of the San, dated back as far as 3000 BCE. I was most fascinated by the magnificent Kongo crucifixes from Zaire.

The usual suspects were in evidence in all their brilliance: the Benin and Ife bronzes, the Nok terra cottas, the Akan gold weights, the Yoruba, Igbo, Baule, Dogon, and Luba wood sculpture, the Dan, Bamana, and Senufo masks, as well as the perfunctory nods to the masterpieces of Egypt, old Nubia, and Ethiopia, which gave this exhibition the right to claim that it spanned the continent. There are those who may complain that the exhibition was too much of a grab bag (such as Holland Cotter in the *New York Times*), and I definitely see the point, but it isn't as if the Guggenheim were showing us African art for the first or the last time. Indeed, the Metropolitan, The Museum of Natural History, and the Brooklyn Museum (and

that's just New York), despite their paternalistic rhetoric, are excellent sources of permanent displays of African art. Try them. After all, no matter what anybody else tells you, the art in question is really the art of living.

Notes

1 Tom Phillips, ed., *Africa: The Art of a Continent*. Munich/New York: Prestel & the Guggenheim Museum, 1996, 8.
2 William Rubin, ed., *Primitivism in 20th Century Art: Affinities of the Tribal and the Modern*. New York: Museum of Modern Art, 1984, 17.
3 Marianna Torgovnick, *Gone Primitive: Savage Intellects, Modern Lives*. Chicago: University of Chicago Press, 1990, 9.
4 Rubin, 125–64. In this essay by Jean-Louis Paudrat, which details the progress of the earliest importations of African art objects into Europe, he remarks as well of the Exposition Universelle of 1889, 'The duplication of a few dwellings claimed to be typical of Senegal, Gabon, or the Congo also caught the public's fancy. On the square of the "Pahouin" village, a few Okande, Aduma, or Vili tribesmen could be seen, performing dances or engaging in craftsmanship. Some of them would carve on demand exotic ivory souvenirs.'

 For insight into the US context at the time, see Phillips Verner Bradford and Harvey Blume's *Ota Benga: The Pygmy in the Zoo* (New York: Delta, 1992) for an informative and well-written account of the adventures of a Pygmy from what was then called the 'Belgian Congo,' who was exhibited at the Bronx Zoo, the Museum of Natural History, and the 1904 St. Louis Fair, and who ended his life by suicide despite having found a fair home among the black community in Lynchburg, Virginia. The fascinating thing about this account is the endeavour to imagine the experience from the point of view of Ota Benga himself, as someone who imagined himself to be in charge of his own life.

 Also, for a sampling of information about the various fairs around the world, see Burton Benedict, *The Anthropology of World's Fairs: San Francisco's Panama Pacific International Exposition of 1915* (Berkeley, Cal.: The Lowie Museum of Anthropology and University of California at Berkeley, 1983); Paul Greenhalgh, *Ephemeral Vistas: The Expositions Universelles, Great Exhibitions and the World's Fairs, 1851–1939* (Manchester: Manchester University Press, 1988); Fatimah Tobing Rony, *The Third Eye: Race, Cinema, and Ethnographic Spectacle* (Durham, NC: Duke University Press, 1996); and Robert Rydell, 'The Culture of Imperial Abundance: World's Fairs in the Making of American Culture' in *Consuming Visions: Accumulation and Display of Goods in America, 1880–1920*, ed. Simon Bronner (Winterthur/New York: Winterthur Museum/Norton, 1989).
5 Jan Nederveen Pieterse, *White on Black. Images of Africa and Blacks in Western Popular Culture* (New Haven, Conn.: Yale University Press, 1992) and Raymond Bachollet et al., *NegriPub: L'Image des noirs dans la publicité* (Paris: Editions Somogy, 1992).
6 Henry Sampson, *The Ghost Walks: A Chronological History of Blacks in Show Business, 1865–1910* (Metuchen, NJ: Scarecrow Press, 1988); Ike Simond, *Old Slack's Reminiscence, and Pocket History, of the Colored Profession from 1865 to 1891* (Bowling Green, Oh.: Popular Press/Bowling Green University Press, 1974); Robert Toll, *Blacking Up: The Minstrel Show in Nineteenth Century America* (New York: Oxford University Press, 1974); Mel Watkins, *On The Real Side: Laughing, Lying and*

Signifying – The Underground Tradition of African-American Humor That Transformed American Culture, From Slavery to Richard Pryor (New York: Simon & Schuster, 1994); and Allen Woll, *Black Musical Theatre: From Coontown to Dreamgirls* (Baton Rouge: Louisiana State University Press, 1989).

7 Amy Kaplan and Donald E. Pease, eds, *Cultures of United States Imperialism* (Durham, NC: Duke University Press, 1993); Paul Greenhalgh, *Ephemeral Vistas*, p. 90; Patricia Leighten, 'The White Peril and L'Art Nègre: Picasso, Primitivism, and Anticolonialism,' *The Art Bulletin*, December 1990, 72:4, pp. 610–30.

8 James Clifford, *The Predicament of Culture: Twentieth Century Ethnography, Literature, and Art*. Cambridge, Mass.: Harvard University Press, 1988, pp. 196–202.

9 Edward Said's *Orientalism* (New York: Pantheon, 1978) is the crucial work on the history of orientalism, although his approach is decidedly Middle Eastern and literary, not visual. Such works as *Unthinking Eurocentrism: Multiculturalism and the Media* by Ella Shohat and Robert Stam (New York: Routledge, 1994), *Orientalism: History, Theory and the Arts* by John MacKenzie (Manchester: Manchester University Press, 1995), and 'The Imaginary Orient' by Linda Nochlin in *Art in America* (May 1983) serve to fill the gap. As for primitivism, aside from the works already mentioned, I would recommend as well the recent double issue of *Wide Angle*, 'Movies Before Cinema Part I and Part II,' vol. 18: 2 and 3.

10 Two really useful feminist interpretations of *Les Demoiselles d'Avignon* are by Anna Chave in *October* and Ann Gibson, 'The Avant-Garde,' in *Critical Terms in Art History* (Chicago: University of Chicago Press, 1996).

11 Rubin, 216.

12 Colin Rhodes, *Primitivism and Modern Art*, London: Thames & Hudson, 1994, 111.

13 Rubin, 255.

14 Annie E. Coombes, *Reinventing Africa: Museums, Material Culture and Popular Imagination* (New Haven: Yale University Press, 1994); Alison Griffith, '"Journeys for Those Who Cannot Travel": Promenade Cinema and the Museum Life Group,' *Wide Angle* 18:3 (July 1996), 53–84.

15 See Tom Feelings's stunning collection of drawings, *The Middle Passage* (New York: Dial, 1995), as well as Sam Anderson's vivid and imaginative little book *The Black Holocaust for Beginners* (New York: Writers and Readers, 1995).

16 Alison Griffith and Fatimah Tobing Rony, 'Those Who Squat and Those Who Sit: Iconography of Race in the 1895 Films of Felix-Louis Regnault,' *Camera Obscura* 28, 263–189; Deborah Willis and Carla Williams, *Reimaged Memories and Desire: The Black Female Body* (work-in-progress), chapters on 'The History of Human Display' and 'Orientalism,' Temple University Press, forthcoming.

17 Sylvia Hochfield and Elizabeth Riefstahl, *Africa in Antiquity: The Arts of Ancient Nubia and the Sudan* (New York: Brooklyn Museum, 1978).

18 *Art of a Continent*, 122.

19 *History Through Art*, Power-CD, CD-ROM, 1994.

20 I should note here that cultural decimation of this and related kinds (loss of land, country, language, cultural heritage, family) is much more common than is usually considered in the context of African American discourse, and is by no means unbearable, or even the worst thing that can happen.

21 *Art of a Continent*, 6.

22 Susan Vogel, ed., *Africa Explores: 20th Century African Art* (New York: Museum for African Art, 1993).

23 In particular, I would point out Rubin's celebrated argument about 'affinities' in the introductory essay in *Primitivism in 20th Century Art*.
24 Plate 86 (101), Charles Harrison *et al.*, *Primitivism, Cubism, Abstraction: The Early Twentieth Century* (London: Open University, 1993).

John Fiske

VIDEOTECH

T HE RODNEY KING video was significant not just because its eighty-one seconds of electronic reality condensed four hundred years of racial history into the nation's experience of contemporary race relations, but also because, technologically, it operated at a crucial turning point in the flow of knowledge and visibility.

We live in a monitored society. In Liverpool, England, two youths abducted a two-year-old from a shopping mall. Video cameras in the mall watched and recorded their every move (as of every other shopper) and outside in the street more cameras recorded them (and all the other pedestrians). The videotapes played a vital role in helping police identify and catch the criminals. Thousands of other actions, interactions, and identities were also recorded by those cameras, a plethora of potential knowledge of people who did not know they were known. In Minneapolis, USA, the Mall of America uses 109 cameras to monitor its customers and staff: each of them can zoom in on an object as small as an ID card. David Guterson described in *Harper's* the giddy power he felt as he watched the bank of monitors in its security room.[1] Suddenly, a security guard noticed something of interest occurring in one of the parking lots, and zoomed in on a couple making love in their car: although their passion may have been all-consuming, they were not, so a guard was dispatched to put an end to such inappropriate behavior. Earlier, Guterson had himself been monitored, and had been chided by the mall's public relations officer, who had seen him talking to a garbage cleaner on one of the concourses. Not to be outdone by its famous mall, the city of Minneapolis plans to cover all its downtown streets with video monitoring to improve its traffic management. The cameras will see more than traffic jams.

Outside the Ronald Reagan Office Building in downtown Los Angeles, Mike Davis asked a homeless African-American why he never went into the shopping mall that occupied the building's lower floors. The answer was predictable: he knew that cameras would instantly identify him as an inappropriate person in that

precisely monitored place, and that security guards would rapidly escort him outside.[2] Gated and guarded neighborhoods throughout L.A.'s suburbs have video cameras at their entries. An African-American professor told me how monitored he feels as he passes them, knowing that they see his Blackness and accord it special attention.

Information technology is highly political, but its politics are not directed by its technological features alone. It is, for instance, a technical feature of the surveillance camera that enables it to identify a person's race more clearly than his or her class or religion, but it is a racist society that transforms that information into knowledge. The video camera directs its gaze impartially on Black and white, the criminal and the law-abiding, the welcome and the unwelcome. But African-Americans entering a Korean grocery store or an exclusive housing development know that the impartiality stops at the moment when the electronic signal is turned into knowledge; they know that they are seen differently from whites. Social differences that are embodied, such as those of race and gender, are the ones that are most efficiently monitored; because in today's public life racial difference is seen to pose a greater threat to the dominant order than gender difference, video works particularly effectively in the monitoring of race relations.

The video camera is efficient in the information-gathering phases of surveillance, but in storage and retrieval the computer is king. As its sophistication increases, so does our power to know each individual and to track his or her movements through the places and times of ordinary life. The economics of everyday life are where this power is most efficiently applied. Our social security numbers document how much money we earn, and where and how we earn it; they record our loans, mortgages, and pension plans. In the sphere of consumption, our credit card numbers are routinely used to track our purchase of goods and services, and how we move around the neighborhood and the country as we make them; the last four numbers of our zip codes document where we live and the demographics of our neighbors. All this knowledge is combined to produce a 'consumer profile' that serves, in the domain of economics, as a social identity. If this surveillance is confined to the economic, its effects are unlikely to be worse than annoying (soliciting phone calls or junk mail) and may be helpful (catalogs matched to our tastes do save us trips to the mall).

A consumer profile, however, is only part of an individual's social identity; the same information technologies could readily supplement it with a 'political profile,' should one be needed. The magazines we subscribe to, the causes we donate to, the university courses we register for, the books we purchase and the ones we borrow from the library are all recorded, and recorded information is always potentially available. A Korean studying in the United States told me that agents of his government's secret police had warned him that his work was becoming too radical; one of the means by which they had identified him as worthy of special monitoring was through his library loans. Such a profile of what goes on inside our heads can be enhanced by knowledge of where our bodies move. Many parking garages record the license plate numbers of every car that enters; some traffic lights are equipped with cameras to record those who run red lights; the City of London is planning to video-record every car entering it to improve its security against terrorists. In the United States, hydroponic gardening stores have been video-monitored by the DEA,

and repeat customers have had their homes searched for marijuana plants. Any of our movements that the monitoring agency might consider abnormal could be fed into a political profile.

Norms are crucial to any surveillance system, for without them it cannot identify the abnormal. Norms are what enable it to decide what information should be turned into knowledge and what individuals need to be monitored. The massed information that is recorded about the majority may never be known in all its details, but it is still used to produce the norms that are necessary to identify the dissident and the dangerous. The power to produce and apply norms, as Foucault tells us, is a crucial social power. It is not hard to imagine circumstances in which political profiles of those who, by some standards, would be judged 'not normal' could be as useful to government agencies as consumer profiles are to commercial ones.

The monitoring of the conforming white middle classes may not bear too heavily upon us, for it is our behaviour that provides the norms against which others are evaluated. But the equivalent video tracking of African-Americans or Latino/as oppresses them every time they enter a store or shopping mall, or visit a gated neighborhood. Such monitoring does not need to be technological: Joe Soto, for instance, has filed a civil rights lawsuit against the Utah Highway Patrol, claiming that he has been stopped repeatedly solely because he is a Latino driving a Cadillac. In Tinicum, Pennsylvania, just outside Philadelphia, Black motorists have filed a similar class action suit against the local police department, and all Black motorists know that the odds of their being pulled over increase if they drive through white suburbs (it is worth recalling here that the Rodney King incident began with a traffic stop). Ice-T's anger at being pulled out of his car and made to kiss the pavement because he is Black is not just individual, but communal; not just personal, but political. To be seen to be Black or Brown, in all but a few places in the United States, is to be seen to be out of place, beyond the norm that someone else has set, and thus to be subject to white power. In these conditions being seen is, in itself, oppressive.

In no suburb is whiteness more thoroughly normalized than in Simi Valley. As its mayor has said, 'There is no question, in this community, that somebody out of the ordinary sticks out quickly. And people are very quick to report anything suspicious, very quick to call the police, and expect them to be there.'[3] He has no need to specify that being 'out of the ordinary' includes being Black when his constituents are as effective deniers and recoders of racism as the Arkins:

> 'We like living in a place with educated people, people who believe as we do,' said Brian Arkin, '. . . but I don't believe skin color is a criteria [sic] . . . There's a black person up our street and we say "Hi" like he's a normal person,' Mr. Arkin continued. 'This isn't about race, it's about whether you let your property run down.' 'Or whether you sell drugs out of your house,' his wife, Valerie interjected.[4]

We can now enlarge on William Buckley's comment: this cannot be a racist society if we love Bill Cosby, appoint Clarence Thomas, and say 'Hi' to a Black man as though he were a normal person.

Video technology may not be essential – Simi Valley residents can spot some-body out of the ordinary with their naked eyes – but it is efficient. It is particularly effective in racial surveillance, because racial difference from the white norm is so visible. Surveillance technology enhances the construction of whiteness as the space from which the other is viewed, and its development is so significant because it technologizes and thus extends a power application that is already widespread. A new technology does not, of itself, determine that it *will* be used or *how* it will. Similarly, technology may limit what can or cannot be seen but it does not dictate the way it is watched. Technology may determine what is shown, but society deter-mines what is seen. The camera always shows racial difference, for instance; who sees it, however, is a function of social factors. Fewer European than African-Americans saw the race of Anita Hill and of Bill Cosby, but all whites saw the Blackness of Willie Horton. A general principle emerges here. When social differ-ence advances the interests of the powerful it will be recognized by them; when, however, their interests are promoted by alliances that cross the social difference at issue, it will be overlooked by them. When it serves the interests of power to 'other' those whom it monitors, the social differences between the seer and the seen will loom large; when, however, the other is to be enrolled in a temporary alliance with 'us,' the differences shrink into insignificance.

Part of the reason for the rapid extension of surveillance technology is the perfect match between technology's ability to see racial difference and the need of whiteness to monitor it. Whiteness always needs to see its difference from the other, even when it suits its purposes to overlook or deny it, for, paradoxically, 'color blindness' can be strategically effective only if it sees what it pretends not to. While denying that Clarence Thomas's race had anything to do with his nomi-nation, Bush used his 'color blindness' to advance his reactionary white strategy. Less intentionally, liberal white viewers of *The Cosby Show* and of the Thomas-Hill hearings could also be 'blind' to racial difference when it was in their interests to be so. Members of disempowered races, however, cannot afford the luxury of color blindness, for their social survival depends upon racial awareness. They need to see racial difference constantly in order to defend themselves against the power inscribed in it, and consequently they are at times able to make tactical uses of the technology whose strategy is normally hostile to them. Black viewers of both *The Cosby Show* and the hearings, therefore, were constantly aware of the Blackness of the figures on the screen, and of their difference from the whiteness of most television. Similarly, in the Murphy Brown-Dan Quayle debate, video technology showed racial difference to everyone in the audience, but who was 'blind' to it and who saw it was determined by social factors. Although the powerful have privileged access to technology, their access is not exclusive; although they exert powerful control over its social uses, their control is not total. Indeed, video technology often carries traces of the marginalized that verbal discourse represses more efficiently. Putting an event into any discourse always involves centering some elements and marginalizing or repressing others: because verbal language obeys no laws other than those that society has produced to organize it, putting an event into verbal discourse is a *purely* social process.

The camera, however, obeys the laws of optics and electronics as well as those of discourse. I do not wish to suggest that the laws of optics and electronics are

objective and exist in nature only, for they are products of a particular scientific way of knowing: they have been 'discovered' and elaborated in order to enhance our ability to increase our control over nature and to understand those of its resources that we can turn to our own advantage. The power of scientific knowledge and its instrumental technologies is inextricably part of the domination of the world's physical and social resources by European-derived nations. No knowledge system is nonpolitical. But because the laws of optics or of physics have a grounding in nature, their politics are less immediate than those of discourse, and work rather on the level of the macropolitics of global capitalism as a system than on the more immediate level of the political struggles within it.

The laws of discourse, however, are more immediately political than those of optics and electronics. The saying 'The camera cannot lie' is inaccurate and out of date but not stupid, for it does point to key differences between words and photography in terms of the immediacy and totality of the social control that can be exerted over them. The fact that the optical camera is, in part, subject to the laws of nature does lend a sense of objectivity that carries an injunction to believe what it shows. The camera always tells us more than it needs to; a photograph always carries more information than is necessary to make its point. These bits of unnecessary information function to substantiate the 'truth injunction' of the photograph, but they also, simultaneously, undercut it: they can remind us that the event being photographed, like any other, can always be put into discourse differently. They are the traces through which the repressed alternatives can be recovered, and their inevitability makes the camera much less efficient than verbal discourse in repressing the stories it does not wish us to know. The camera finds it much harder than verbal discourse to keep the traces of these discursive alternatives on its unregarded margins.

Electronic photography may appear even more 'objective' than optical photography. When Roland Barthes wrote of the 'photographic paradox' by which the camera appeared to produce 'a message without a code,' he was writing of optical photography.[5] In his account, the truth injunction of photography results from the laws of optics appearing to overpower those of semiotics or discourse, which, until the invention of the camera, were in total control of every message. The camera, however, limited the semiotic control over encoding the message to two points of human intervention in the process – the choice of angle, framing, focus, or film stock when the photograph is taken, and the darkroom processes as it is developed and printed. In low-tech electronic photography even these choices appear to be reduced, for the darkroom is eliminated, and the choices at the moment of shooting are reduced to those of framing, angle, and distance (in most home video cameras, at least, everything else is taken care of automatically).

But even processes as technological as those of video never operate outside of social determinants. The credibility of video depends upon the social domain of its use. In the domain of the low (low capital, low technology, low power), video has an authenticity that results from its user's lack of resources to intervene in its technology. When capital, technology, and power are high, however, the ability to intervene, technologically and socially, is enhanced. The videohigh of Rodney King was a product of capital, technology, and social power that lay beyond the reach of the videolow. Because technology requires capital, it is never equally

distributed or apolitical. George Holliday owned a camera, but not a computer enhancer; he could produce and replay an electronic image, but could not slow it, reverse it, freeze it, or write upon it, and his videolow appeared so authentic to so many precisely because he could not. The enhanced clarity of the videohigh lost the authenticity of the low but gained the power to tell its own truth in its own domain of the courtroom and the jury room. And that domain was, in this case, the limit of its victory.

The time gap between the writing and the reading of the previous paragraph may well have made it out of date. The video 'toaster' has already brought electronic manipulation of the image within the price range of many amateurs. And electronic manipulation leaves no trace of its operation. This has the legal profession worried, and many legal scholars would agree with Christine Guilshan when she writes, 'Today . . . the veracity of photographic evidence is being radically challenged. Computer imaging techniques are rapidly emerging which call into question the belief that photographs are neutral records of reality.'[6] When hooked up to a computer, the video camera provides not a photograph, but bits of visual information that can be undetectably enhanced, deleted, or rearranged – just like words. Guilshan's anxieties are those of the power bloc, not of the people: she is not concerned that powerful institutions such as the FBI or the media can manipulate images, for she has faith that their guidelines will prevent the ability being misused; what worries her is what might happen when the 'average citizen' has this capability.

It remains to be seen whether technological development will reduce the sense of authenticity that low-tech video still carries. We might hope that it does not, for this authenticity of the videolow allows the weak one of their few opportunities to intervene effectively in the power of surveillance, and to reverse its flow. George Holliday was not alone in grasping it. In Saint Paul, a Hmong teenager, Billy Her, was arrested for assaulting the police. Two days later, a videotape anonymously mailed to the police department resulted in the arresting officer's suspension from duty, because it showed him striking Billy Her repeatedly but gave no evidence of Billy Her attacking the police.[7] On her national talk show, Oprah Winfrey screened an amateur videotape showing Texas police punching Chon Soto as he was trying to attend his hometown city council meeting, where he was signed up to speak.[8] His friends told Oprah that they had expected the city council meeting to be heated, that they had had problems at previous meetings, and so they had asked Raoul Vasquez to bring his video camera to this one. Viewers never learned what was so heatedly disputed, nor why only nineteen members of the public were to be allowed to attend the meeting. The camera showed, however, that the police were white and the citizens were Latino, and its microphone caught Latino-accented voices raised in protest. The police claimed that Chon Soto was trying to force his way into the meeting; the camera showed that the only force involved was applied by the police. Chon Soto was hospitalized, and, after the video was played on local TV stations, the chief of police was suspended.

Video plays such an important role in our culture because in its low- and high-tech forms it spreads far up and down our social hierarchy. But videolow does not always oppose videohigh; indeed, often the two work complicitly. Network television has developed a whole genre of programs to incorporate videolow into its

high-capital, high-tech system. Shows such as *I Witness Videos* and *America's Funniest Home Videos* extend the reach of the high into the domain of the low, to turn it to a profit and to use its stories as they think best. Many of the *I Witness Videos* reproduce the forms of official news – people with video cameras are often present when disasters occur, whereas news crews typically arrive afterward. But like the Rodney King video, their lower-quality images, poor but closely involved vantage points, moments of loss of technical control (blurred focus, too-rapid pans, tilted or dropped cameras), and their reduced editing all serve to reveal the discursive control that official news exerts over the events it reports. Videolow shows that events can always be put into discourse differently from videohigh, and this enhances its sense of authenticity. Local news stations now solicit videolow from their viewers; they use their viewers' ubiquity to extend their monitoring reach and intensify our system of surveillance, to capture the immediate and the authentic, and to pull their viewers into an alliance with the station. Some are also experimenting with reducing the official 'news crew,' to a single reporter with a camcorder to cut costs, increase flexibility, and, they hope, gain a sense of authenticity.

Videolow is not only incorporable into the interests of the dominant, it often intentionally serves them and extends their surveillance. The day *The Oprah Winfrey Show* screened the videolow of the police roughing up Chon Soto it also screened others that were shot in order to assist in the policing of our society. A doctor who has mounted a video camera on his dashboard patrols the late-night roads of Chicago looking for drunk drivers. We watched him find one, follow them, videotaping all the time, and then call the police on his CB radio and offer them his video as evidence. The *New York Times* tells of a civilian video patrol in Methuen, Massachusetts, that tapes prostitutes and their clients as a community effort to clean up their neighborhood.[9] The report on their activities claims that everywhere individuals are using video cameras to document car thefts, drug deals, prostitution, and other unwelcome or illegal street activity. Gerald Arenberg, the director of the National Association of Chiefs of Police, told the reporter, 'Ever since the Rodney King incident, anyone who has a camcorder is using it.' Matt Reskin, director of a national organization that promotes community policing programs, agrees with police officers that video is a useful amateur policing tool. *The Oprah Winfrey Show* gave further examples, among them a video of a student party that got out of hand and vandalized a car, and, more to our point here, one showing the beating of Reginald Denny from ground level as the news helicopter videoed it from on high. The police used this videolow to help identify and arrest the suspects, and the cameraman, who was Black, had to go into hiding because, as he said, 'Threats started to come through the neighborhood, and gang members showed up looking for me.' Although the politics of technology itself may be distant, those of its uses are immediate.

The users of videolow to extend disciplinary surveillance can be countered, as we have seen, by those who turn the cameras back upon the surveillers. Across the nation, 'videoactivists' or 'videoguerrillas' are using the technology, particularly in conjunction with local-access cable channels, for explicit social criticism. The police are central agents in the surveillance system, so they are often the target of videoactivism. In Berkeley, California, for example, an organization called Copwatch uses video cameras and human eyes to monitor the police, particularly in their dealings

with homeless people and African-Americans, in the belief that watching police behavior is the best way to prevent police brutality. The mainstream media can be as active surveillers as the police, and in Rochester, New York, a video collective followed local TV news crews, videoed them videoing events, talked to people they interviewed and to those they chose not to, and, on the local-access channel, showed not only that events could look very different but that the differences between high and low discourses were obviously political. The cops in Berkeley and the news crews in Rochester did all they could to prevent their actions being videoed.

A step higher up the technical, social, and institutional hierarchy is Paper Tiger Television, a video collective dedicated to criticizing the mainstream media, to providing alternate information, and to increasing popular skepticism about officially mediated knowledge. Longtime video activist Dee Dee Halleck describes the deliberately low-tech, low-budget style of Paper Tiger as it

> proudly flaunts the 'cheap art' of its graphics and its production 'values.' Paper Tiger uses hand-painted backdrops for sets, hastily scribbled felt-tip credits, and transitions that make no attempt to disguise the technology. On-air dialogue with the control room is amplified. 'Cue Herb, Daniel!' gets mixed into the overall sound track. The Paper Tiger aesthetic expanded from crayons and paints to include crude but inspired chroma key effects, such as Joan Braderman sliding down the Carrington banister in 'Joan Does Dynasty' and John Walden's hugging of Ted Koppel in 'From Woodstock to Tiananmen Square.' Many Paper Tiger programs that critique TV use simple TV effects in ways that expose mystified constructions in both television form and ideological content.[10]

Deep Dish Television has grown out of Paper Tiger; it brings satellite distribution to local video activists so that their work need not be limited to their local public-access channels. Of course, high-tech satellite time is high cost and Deep Dish can afford only two hours a week, which means that much low-tech communication by mail and telephone is needed to supplement it, to ensure that local stations are ready to receive and tape its offerings. Perhaps the biggest success of Deep Dish occurred during the Gulf War, when the official media were harnessed so closely to the White House and the Pentagon that echoes of dissenting voices and views were almost entirely eliminated from the nation's screens. Deep Dish called for other video coverage and received hundreds of tapes from all over the country. It organized them into four half-hour programs and uplinked them to the satellite nine days before the war began. It is impossible to know the full extent of the program's reach, because Deep Dish has no full record of who receives its programs and encourages people to dub them and show them whenever and wherever they wish. But it is known that many public access and public television stations screened the programs, often repeatedly; more than a thousand copies were mailed out in less than a month. In Britain, Channel 4 edited the programs into a one-hour special, which it aired in prime time; in Japan, the programs served as a focal point for antiwar activism.

The better access one has to capital and to the institutional power that goes with it, the better use one can make of video technology. But video has low-tech

and high-tech forms and thus contradictory uses. It can be used both to bring us knowledge and to know us, to give us access to one system of power-knowledge while subjecting us to another. It is an instrument of both communication and surveillance. It can be used by the power bloc to monitor the comings and goings of the people, but equally its cameras can be turned 180 social degrees, to show the doings of the power bloc to the people.

Video monitoring and video knowledge are directed upon the body, for it is there that power is made visible. The strategizing of social alliances, the intentions and internal lives of people, and the abstract lines of social power all lie beyond video's capabilities. Video knowledge is that of the application of power to the body; its terrain is that in which broad social interests appear in their embodied form. Policing the social body is a paradigmatic example, for the physical contact between police officer and the individual suspect-citizen-disorderly body is an event that is both significant and videoknowable. The police use video surveillance for their purposes, from identifying bank robbers to monitoring Mayor Marion Barry receiving drugs and sex in their setup; they used it to identify the suspects in the Reginald Denny beating, and then, in the initial court hearing, they covertly videotaped a suspect's friends who attended in order to identify yet more potential suspect criminals (they knew, evidently, that friends of suspects were also suspect, particularly if Black).

Armies of law enforcement agencies and security services use millions of video cameras to monitor the places and the people they are hired to protect. But video technology still allows, on occasion, those who are normally monitored to monitor the monitors. This technological engagement in the social struggle never takes place on equal terms. Opportunistic tactics are set against strategically deployed power; the handheld home video camera has a mobility that makes it a good guerrilla weapon, whereas carefully located surveillance cameras are typical of a powerful strategy that is well planned and highly efficient, but cumbersome.

Notes

1 David Guterson (1993) 'Enclosed, Encyclopedic, Endured' *Harper's*, August, 55.
2 Mike Davis, *Junkyard of Dreams*, video for Channel 4, London (undated).
3 Quoted in *New York Times*, 4 May, 1992, A15; cited in Thomas Dunn (1993) 'The New Enclosures: Racism in the Normalized Community' in *Reading Rodney King Reading Urban Uprising*, Robert Gooding-Williams (ed.), New York: Routledge, p. 189.
4 Ibid.
5 Roland Barthes (1977) 'The Photographic Paradox' in *Image-Music-Text*, London: Fontana, pp. 15-32.
6 Christine Guilshan (1992) 'A Picture Is Worth a Thousand Lies: Electronic Imaging and the Future of the Admissibility of Photographs into Evidence', *Rutgers Computer and Technology Law Journal* 18 (1): 366.
7 *St. Paul Pioneer Press*, 20 December, 1992, C1.
8 *The Oprah Winfrey Show*, 26 February, 1993.
9 *New York Times*, 21 March, 1993, 15A.
10 Dee Dee Halleck, paper in *Leonardo: Journal of the International Society for the Arts, Sciences and Technology* (forthcoming).

(b) Cinema after film, television after the networks

Anne Friedberg

THE MOBILIZED AND VIRTUAL GAZE IN MODERNITY
Flâneur/Flâneuse

The second half of the nineteenth century lives in a sort of *frenzy of the visible*. It is, of course, the effect of the *social multiplication of images:* ever wider distribution of illustrated papers, waves of print, caricatures, etc. The effect also, however, of something of a geographical extension of the *field of the visible* and the representable: by journeys, explorations, colonizations, the whole world becomes visible at the same time that it becomes appropriatable.

(Jean-Louis Comolli, 'Machines of the Visible'
(emphasis added))

In societies where modern conditions of production prevail, all of life presents itself as *an immense accumulation of spectacles. Everything that was directly lived has moved away into a representation.*

(Guy Debord, *Society of the Spectacle* (emphasis added))

[I]N THE NINETEENTH century, a wide variety of apparatuses extended the 'field of the visible' and turned visualized experience into commodity forms. As print was disseminated widely, new forms of newspaper illustration emerged; as lithography was introduced, the caricatures of Daumier, Grandville, and others burgeoned; as photography became more widespread, the evidentiary means of public and family record were transformed. The telegraph, the telephone, and electricity increased the speed of communications, the railroad and steamship changed concepts of distance, while the new visual culture – photography, advertising, and shop display – recast the nature of memory and experience. Whether a 'frenzy of the visible,' or 'an immense accumulation of spectacles,' everyday life was transfigured by the 'social multiplication of images.'

Yet there remains a historiographical debate about whether this new predominance of the visible produced a crisis of confidence in the eye itself, or whether it was the coincident increase in optical research which produced this frenzy of visual cultures. The same historiographic debate pervades the history of the arts; either the invention of photography produced a crisis that led to continued optical research, or the nineteenth-century obsession with optical research produced a crisis that led to photography. In order to organize the vast historical process that led to the emergence of the cinema it is necessary to enter into this debate, a dispute that festers at the roots of modernity.

In this chapter, I begin by describing the 'observer' in modernity, situating the emergence of the cinema in the historical framework of precinematic mobile and virtual gazes. Such a 'situated' approach to the cinematic apparatus necessitates an account of the imbrication of images in the social relations of looking. The flâneur will serve as a model for an observer who follows a style of visuality different from the model of power and vision so frequently linked with modernity – what Michel Foucault dramatically described as 'un régime panoptique.'[1] The trope of flânerie delineates a mode of visual practice coincident with – but antithetical to – the panoptic gaze. Like the panopticon system, flânerie relied on the visual register – but with a converse instrumentalism, emphasizing mobility and fluid subjectivity rather than restraint and interpellated reform.

The panoptic gaze has been invoked by feminist theorists to underline the one-way power of gendered looking, where women have internalized the voyeuristic gaze and are always subjectively 'objects of the look.'[2] As we examine divergent models of the observer in modernity, a refutation of theories of the panoptic gaze will have significant ramifications on accounts of gendered spectatorship. The panoptic gaze may indeed suggest a model for the increased priority of the visual register, but there were alternative gazes that, while still reordering the importance of the visual, produced different – more fluid – forms of subjectivity.

Gender, to follow Teresa de Lauretis's recent formulation, 'is the product of various social technologies' that include '*cinema* . . . institutionalized discourses, epistemologies, and critical practices, *as well as practices of daily life*' (emphasis added).[3] And although gender seems a necessary component of debates about the role of vision in modernity and postmodernity, genealogies of the nineteenth-century observer have, as we shall see, retained a resistance to the gendered subject. Once we establish the flâneur's mobility, we will see the necessity of charting the origins of his female equivalent, the flâneuse.

Modernity and the 'panoptic' gaze

It is in this *episteme*, as Foucault would have it, that new modes of social and political control were institutionalized by 'un régime panoptique.' Foucault places the panoptic model in a pivotal position in the epistemological shift from eighteenth-century empiricism to the invention of a transcendental concept of 'man.' In a dramatic passage in *The Order of Things*, he describes this transition as 'the threshold of modernity.' Foucault finds the origins of modernity in the reordering of power and knowledge and the visible.[4]

The panopticon

Jeremy Bentham's panopticon device (1791) provided the model for Foucault's characterization of panoptic power and the 'disciplines' of imagined scrutiny.[5] (*Discipline* has been the common English translation for Foucault's term, *surveiller*.) Invoked as a philosophic model for the scopic regime of power through the visual register, the panopticon was an apparatus – a 'machine of the visible,' to use Comolli's phrase – which controlled the seer–seen relation. In the panopticon, an *unseen seer* surveys a confined and controlled subject. The panopticon produces a subjective effect, a 'brutal dissymmetry of visibility'[6] for both positions in this dyad: the *seer* with the sense of omnipotent voyeurism and the *seen* with the sense of disciplined surveillance.

Foucault described the panopticon as an 'architectural mechanism,'[7] a 'pure architectural and optical system' that did not need to use force because the 'real subjection is born *mechanically* from a *fictitious relation*.'[8] The panopticon structure was then, in a sense, a 'building-machine' that, through its spatial arrangement, established scopic control over its inhabitants.

The architectural system of the panopticon restructured the relation of jailer to inmate into a scopic relation of power and domination. The panopticon building was a twelve-sided polygon. Using iron as a skeleton, its internal and external skin

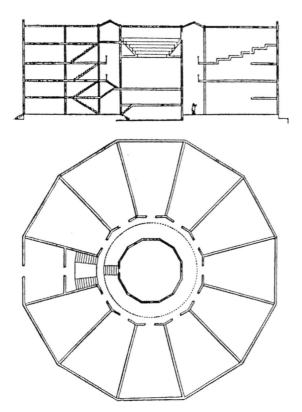

Figure 36.1 Jeremy Bentham, section and plan of the Panopticon Building, 1791

was glass. The central tower was pierced by windows that provided a panoramic view of separate peripheral cells. Light from the outer walls illuminated each cell. The panoptic subject was placed in a state of 'conscious and permanent visibility.'[9] The panopticon prison was thought of as a spatial reformatorium that could change and 'correct' subjectivity by architectural means. As Foucault describes it:

> The *seeing machine* was once a sort of dark room into which individuals spied; it has become a transparent building in which the exercise of power may be supervised by society as a whole.[10]

Prisoners were objects of an *imagined* scrutiny, where the internalized sense of surveillance changed the disposition of external power:

> He who is subjected to a field of visibility, and who knows it, assumes responsibility for the constraints of power . . . he becomes the principle of his own subjection. By this very fact, the external power may throw off its physical weight; *it tends to the non-corporeal;* and, the more it approaches this limit, the more constant, profound and permanent are its effects.[11]
>
> (emphasis added)

Foucault uses the panoptic model to illustrate how, when power enters the visual register, it 'tends to the non-corporeal.' In the panopticon prison, confinement was successfully maintained by the barrier walls of the prison, but the subjective changes in the inmate were to be produced by the incorporation of the imagined and permanent gaze of the jailer. Bentham's panopticon was designed for other uses than the prison – the factory, the asylum, the hospital – but all of these uses were for institutions where enclosure was a priority.

Hence, the panopticon model has served as a tempting originary root for the inventions that led to the cinema, an apparatus that produces an even more 'mechanically . . . fictitious relation' and whose 'subjection' is equally internalized. Feminist theorists have invoked the 'panoptic' implant as a model for the ever-present 'male gaze,' while 'apparatus' film theories relied more on the immobility and confined spatial matrix of the prison. The prisoners in Plato's cave provide, in Jean-Louis Baudry's emphatic account, an origin for cinematic spectatorship with immobility as a necessary condition.

As an analogy for cinematic spectation, the model of the panoptic guard (the *unseen seer* in the position of omnipotent voyeurism) is not literal, but figurative and metaphoric. Like the central tower guard, the film spectator is totally invisible, absent not only from self-observation but from surveillance as well. But unlike the panoptic guard, the film spectator is not in the position of the central tower, with full scopic range, but is rather a subject with a limited (and preordained) scope. The film spectator's position is one of such *imaginary* visual omnipotence. It is the condition of invisibility which is the premise, in the argument of Baudry, for the spectator-subject's confusion of representation and self-generated perception, what Baudry deemed an 'over-cathexis' with representation, a position that guarantees the dependence on the constructed view provided by representation.[12]

The panoptic model emphasizes the subjective effects of imagined scrutiny and 'permanent visibility' on the *observed*, but does not explore the subjectivity of the *observer*.

In re-examining the emergence of the cinema, one can trace the roots of an instrumentalization of visual culture which is coincident with, but also different from, the paradigm of panoptic visuality. A brief comparison of the panopticon (1791) with two other important devices – the panorama (1792) and the diorama (1823) – will suggest alternative models for visuality.

The panorama and the diorama were building-machines with a different objective: designed to *transport* – rather than to *confine* – the spectator-subject. As we shall see, these devices produced a spatial and temporal mobility – if only a 'virtual' one. The panoramic and dioramic observer was deceptively accorded an *imaginary* illusion of mobility. In Walter Benjamin's conversely demonstrative rhetoric, cinematic spectatorship functioned as an explosive ('dynamite of a tenth of a second') that freed the spectator from the 'prison-world' (*Kerkerwelt*) of nineteenth-century architectural space.[13]

Modernity and the 'virtual' gaze

The panorama

> At leisure let us view from day to day,
> As they present themselves, *the spectacles*
> *Within doors:* troops of wild beast, bird and beasts
> Of every nature from all climes convened,
> And, next to these, *those mimic sights that ape*
> *The absolute presence of reality*
> Expressing as in mirror sea and land,
> And what earth is, and what she hath to shew –
> *I do not here allude to subtlest craft*,
> By means refined attaining purest ends,
> But imitations fondly made in plain
> Confession of man's weakness and his loves.
> Whether the painter – *fashioning a work*
> *To Nature's circumambient scenery*
> (William Wordsworth, *Prelude*, 1805,
> Seventh Book, lines 244–57, emphasis added)

As Wordsworth notes, the panorama was not the 'subtlest craft' for presenting 'the absolute presence of reality.' But its 'spectacles/Within doors' of 'every nature from all climes' used 'circumambient scenery' to create an artificial elsewhere for the panoramic spectator.

The panorama was a 360-degree cylindrical painting, viewed by an observer in the center. The illusion presented by the panorama was created by a combination of realist techniques of perspective and scale with a mode of viewing that placed the spectator in the center of a darkened room surrounded by a scene lit from above.

The panorama was first patented by the Irishman Robert Barker, who took out a patent for panoramic painting in Edinburgh in 1787 and opened the first completely circular panorama in Leicester Square in London in 1792. (Recall the years of Bentham's work on the panopticon, from 1787 to 1791.) Barker's inspiration for the panorama came, according to an anecdote told by historian Olive Cook, in a manner worthy of comparison to Bentham's panopticon prison:

> The invention of the Panorama is usually attributed to Robert Barker, an Edinburgh painter. In about 1785 he was put into prison for debt and was confined to a cell lit by a grating let into the wall at the junction of wall and ceiling. One day he was reading a letter and to see more clearly carried it below the grating. *The effect when the paper was held in the shaft of light falling from the opening was so astonishing that Barker's imagination was set working on the possibilities of controlled light flung from above upon pictures of large dimensions.*[14]
>
> <div align="right">(emphasis added)</div>

If 'controlled light' served to survey and measure the wards in the panopticon prison, in an opposite way it also served to create the visual illusions of the panorama.

The panorama did not physically *mobilize* the body, but provided virtual spatial and temporal mobility, bringing the country to the town dweller, transporting the past to the present. The panoramic spectator lost, as Helmut Gernsheim described, 'all judgement of distance and space' and 'in the absence of any means of comparison with real objects, a perfect illusion was given.'[15] The panorama offered a spectacle in which all sense of time and space was lost, produced by the combination of the observer in a darkened room (where there were no markers of place or time) and presentation of 'realistic' views of other places and times.

The ideology of representation in the panoramic painting must be placed in the context of the concurrent reconceptualization of the idea of the horizon and of perspective (the first hot air balloon was launched in 1783 and aerial balloonists found vistas that radically changed the landscape perspective) and the 'cult of immensity' in painting, where scale was a factor in the concept of illusionist immersion. In addition, the panorama developed out of the context of earlier 'screen' entertainments.

The 'magic lantern' devices of Athanasius Kircher, Johannes Zahn, and others introduced a form of projected entertainment spectacle that relied on controlled light projected through glass slides: drawn figures of skeletons, demons, and ghosts appeared on a screen surface. In his text of 1646, *Ars Magna Lucis et Umbrae*, Kircher (1601–80) – a Roman Catholic priest – published his procedures for projecting ghostly apparitions. Whether, as Musser argues, Kircher sought to demystify the 'magic' of the lantern or whether, to the contrary, he trained a new legion of mystifiers, the eerie effects produced by these luminous projections established an early link between two potentially competing systems of subjective interpellation: religion and optics. Kircher concealed the lantern from his audiences by placing it on the other side of the screen. He could change the distance of the lantern, vary the sizes of his figures. Musser traces the roots of cinema in these forms of late eighteenth-century forms of 'screen practice.' These entertainments – shadow plays, phantasmagorias, lantern displays – relied on dark rooms and projected light.

Philip Jacob de Loutherbourg, a French-born painter and stage designer who came to England in 1771, had designed a viewing system, the *eidophusikon* (1781), which also relied on spectators in a darkened auditorium viewing an illuminated (10 foot by 6 foot) translucent screen, with light projected from behind. The eidophusikon spectacle produced simulations of sunsets, fog, and dawn accompanied by sound effects and harpsichord music. In Paris, a device called the phantasmagoria similarly relied on a lantern with lens to project drawings of celebrities from Voltaire to Rousseau to Marat. Étienne-Gaspard Roberton – a self-styled *aéronaute* to whom the invention of the parachute is attributed – devised a magic lantern show set in a Capuchin monastery. The phantasmagoria made its début in Paris from 1797 to 1800, traveled to London from 1801 to 1803, and arrived in New York in 1803.

Phantasmagorias, panoramas, dioramas – devices that concealed their machinery – were dependent on the relative immobility of their spectators, who enjoyed the illusion of presence of virtual figures. These apparatuses produced an illusion of unmediated referentiality. Other optical entertainments that required viewing devices – the stereoscope, the phenakistoscope – were dependent on quite different optical principles and hence produced diverse subjective effects.

Benjamin saw a direct relation between the panoramic observer and the flâneur:

> The city-dweller . . . attempts to introduce the countryside into the city.
> In the panoramas the city dilates to become landscape, as it does in a subtler way for the *flâneur*.[16]

Before the advent of illustrated print journalism in the 1840s, the panorama supplied a visual illustration of places and events that one could read about in print. The panorama not only appealed to the public interest in battles and historical illustration, but also to a fascination with landscape art, travel literature, and travel itself. As Richard Altick argues, the panorama was the 'bourgeois public's substitute for the Grand Tour'.[17]

Dolf Sternberger has emphasized that the lure of these entertainments was not in their verisimilitude with reality, but rather in their deceptive skills, their very artificiality.[18] As an early epitome of the lure of artificiality, in 1823 Yorkshireman Thomas Hornor climbed the top of St Paul's with sketching implements and telescopes and sketched London in 360-degree detail. Hornor's gigantic rendering was housed in Decimus Burton's Colosseum. The building took years to build (1824–29) but, when finished, encased a panorama of remarkable verisimilitude: a simulated London viewed from the top of a simulated St Paul's. The rooftop location of this panorama necessitated a new design feature: the first hydraulic passenger lift ('ascending room') carried spectators who did not wish to climb the stairs. The elevator was a mechanical aid to mobility; the gaze at the end of this 'lift' was virtual.

The panorama was taken to Paris in 1799 by Robert Fulton, who had purchased the foreign patent rights. Two rotundas for the panorama were built in Paris on Boulevard Montmartre. In the interior were two paintings, one that displayed a view of Paris from the Tuilleries and another that showed the British evacuation during the Battle of Toulon in 1793. The immediate city – the Paris of only blocks

away – was presented to itself; but so was a distant city (Toulon) at a distant time (six years before). Sternberger has aptly named these panoramic paintings, 'captured historical moments(s).'[19]

In 1800, the Passage des Panoramas was built to connect the Palais Royal to the panorama on Boulevard Montmartre. The cylindrical panorama building was connected directly to the Passage des Panoramas – one entered through the arcade. The panorama was lit from above by the same glass and iron skylight as the arcade. . . .

The diorama

Louis Jacques Mandé Daguerre, later famed for his 1839 invention of a photographic process he named the daguerreotype, began his career as an assistant to the celebrated panorama painter, Pierre Prévost. In 1822, Daguerre debuted a viewing device that expanded upon the panorama's ability to transport the viewer, an apparatus he called the diorama.

Like the *diaphanorama* – in which translucent watercolors were illuminated from behind – the dioramic illusion relied on the manipulation of light through a transparent painting. Daguerre's visitors looked through a proscenium at a scene composed of objects arranged in front of a backdrop; after a few minutes, the auditorium platform was rotated 73 degrees to expose another dioramic opening. The diorama was designed to construct and restructure – through light and movement – the relation of the viewer to the spatial and temporal present. A scene was transformed through the manipulation of daylight, which shifted the temporal mood. The diorama differed significantly from the panorama: the diorama spectator was immobile, at the center of the building, and the 'views' were mobilized as the entire diorama building with its pulleys, cords, and rollers became a machine for changing the spectator's view.

When the diorama opened in Paris in 1822, it displayed two distant tableaux: 'The Valley of Sarnen,' a scene from Switzerland, and 'Interior of Trinity Church – Canterbury Cathedral,' a scene from England. Of the thirty-two scenes exhibited during the seventeen years of its existence, ten of the paintings were interiors of distant chapels or cathedrals. As a local newspaper account indicated: 'We cannot sufficiently urge Parisians who like pleasure without fatigue to make the journey to Switzerland and to England without leaving the capital.'[20]

Helmut and Alison Gernsheim extend this description of the diorama as a substitute for travel: 'The many foreign views, too, no doubt had a special appeal to the general public who, before the days of Cook's Tours, had little chance of travelling abroad.'[21]

Dioramas opened in other cities, in Breslau in 1826, in Berlin in 1827, in Stockholm in 1846, and in Frankfurt in 1852. (Thomas Cook's first guided tours of the continent were in 1855.) There were other variations on the diorama. The *pleorama*, which opened in Berlin in 1832, had the audience seated in a ship and taken for an hour's 'voyage,' as the illusion of movement was created by the backcloth moving slowly across the stage. This device emphasized the equation otherwise implicit between travel and viewing scenes of the distant and of the past.

In 1839, Daguerre's diorama on Rue Sanson in Paris was destroyed by fire. In that same year, he patented a technique for *fixing* images on copper plates, the 'daguerreotype.' Few dioramic or panoramic paintings survive. The illusions produced were dependent on the effects of artificial light, and many of the paintings, and the buildings which housed them, ended in flames. The 'captured historical moment' could be more securely impounded on a photographic plate. Benjamin will remark on this historical coincidence; photography emerged from the ashes of the diorama.

Both the panorama and its successor, the diorama, offered new forms of virtual mobility to their viewers. But a paradox here must be emphasized: as the 'mobility' of the gaze became more 'virtual' – as techniques were developed to paint (and then to photograph) realistic images, as mobility was implied by changes in lighting (and then cinematography) – the observer became more immobile, passive, ready to receive the constructions of a virtual reality placed in front of his or her unmoving body.

The panopticon versus the diorama

Like the panopticon, the diorama-building was an architectural arrangement with a center position for the *seer* with a view to 'cells' or 'galleries.' Yet unlike the observation tower of the panopticon, the diorama platform turned (the auditorium rotated 73 degrees) to mobilize the viewer. The diorama had a *collective observer*, a shared audience on the moving platform. Dioramas and panoramas were not directly instruments of social engineering (cf. Fourier's phalanstery) but were, nevertheless, conceived of as satisfying a social desire or curiosity – a desire to have visual mastery over the constraints of space and time. The technology of the diorama relied on spectator immobility, but offered a visual excursion and a virtual release from the confinements of everyday space and time.

But if the panopticon was dependent on the enclosure of the look, the inward measure of confined but visible subjects, the diorama was dependent on the imaginary expansion of that look. Unlike the jailer-surveyor, the dioramic spectator was not attempting mastery over human subjects, but was instead engaged in the pleasures of mastery over an artificially constructed world, the pleasure of immersion in a world not present.

In the diorama, the spectator sat on a darkened center platform and looked toward the brightness of the peripheral scenes: transparent paintings where light was manipulated to give the effect of time passing – a sunset, or the changing light of the day. In the panopticon, the role of light was to indict, to measure. In the diorama, light played a deceptive role. In the panopticon, there was no spatial illusion, no fooling with time. Both panoptic and dioramic systems required a degree of spectator immobility and the predominance of the visual function. And it is this notion of the confined *place* combined with a notion of *journey* that is present simultaneously in cinematic spectation.

[. . .]

Notes

1 Michel Foucault (1979) *Discipline and Punish*, translated by Alan Sheridan, New York: Pantheon Books. Originally published as *Surveiller et Punir* [Paris, 1975].

2 See Mary Ann Doane, Patricia Mellencamp, and Linda Williams (eds) (1984) *Re-vision*, Los Angeles: AFI, p. 14. John Berger (1972) *Ways of Seeing*, London: Penguin Books. Laura Mulvey (1975) 'Visual Pleasure and Narrative Cinema', *Screen* 16 (3), Autumn; Joan Copjec (1989) 'The Orthopsychic Subject', *October* 49, Summer: 53–71.

3 Teresa de Lauretis (1987) *Technologies of Gender*, Bloomington: Indiana University Press, p. 2.

4 Michel Foucault (1970) *The Order of Things: An Archaeology of the Human Sciences*, translated from *Les Mots et Les Choses*, New York: Random House, p. 319.

5 Jeremy Bentham (1962) *Panopticon, Works of Jeremy Bentham Published under the Superintendence of His Executor, John Bowring*, 11 vols, New York: Russell and Russell.

6 Jacques-Alain Miller (1987) 'Jeremy Bentham's Panoptic Device', translated by Richard Miller, *October* 41, Summer: 4.

7 Foucault, *Discipline and Punish*, p. 204.

8 Ibid., p. 205.

9 Ibid., p. 201.

10 Ibid., p. 207.

11 Ibid., pp. 202–3.

12 Jean-Louis Baudry, 'The Apparatus: Metapsychological Approaches to the Impression of Reality in the Cinema', translated by Jean Andrews and Bertrand Augst in *Narrative, Apparatus, Ideology*, p. 316.

13 Walter Benjamin (1969) 'The Work of Art in the Age of Mechanical Reproduction', in *Illuminations*, translated by Harry Zorn, New York: Schocken Books, p. 236.

14 Olive Cook (1963) *Movement in Two Dimensions*, London: Hutchinson and Co., p. 32.

15 Helmut Gernsheim and Alison Gernsheim (1968) *L.J.M. Daguerre: The History of the Diorama and the Daguereotype*, New York: Dover Publications, p. 6.

16 Benjamin, 'Paris – Capital of the Nineteenth Century', translated by Edmund Jephcott, in *Reflections*, New York: Harcourt Brace and Jovanovich, 1979, p. 150.

17 Richard D. Altick (1978) *The Shows of London*, Cambridge, MA: Harvard University Press, p. 180.

18 Dolf Sternberger (1977) *Panorama of the Nineteenth Century*, translated by Joachim Neugroschel, New York: Urizen Books, p. 13.

19 Ibid., p. 13.

20 Gernsheim and Gernsheim, *L.J.M. Daguerre*, p. 18.

21 Ibid.

Lev Manovich

WHAT IS DIGITAL CINEMA?

Cinema, the art of the index

MOST DISCUSSIONS OF CINEMA in the computer age have focused on the possibilities of interactive narrative. It is not hard to understand why: since the majority of viewers and critics equate cinema with storytelling, computer media is understood as something which will let cinema tell its stories in a new way. Yet as exciting as the ideas of a viewer participating in a story, choosing different paths through the narrative space and interacting with characters may be, they only address one aspect of cinema which is neither unique nor, as many will argue, essential to it: narrative.

The challenge which computer media poses to cinema extends far beyond the issue of narrative. Computer media redefines the very identity of cinema. In a symposium which took place in Hollywood in the spring of 1996, one of the participants provocatively referred to movies as 'flatties' and to human actors as 'organics' and 'soft fuzzies.'[1] As these terms accurately suggest, what used to be cinema's defining characteristics have become just the default options, with many others available. When one can 'enter' a virtual three-dimensional space, to view flat images projected on the screen is hardly the only option. When, given enough time and money, almost everything can be simulated in a computer, to film physical reality is just one possibility.

This 'crisis' of cinema's identity also affects the terms and the categories used to theorize cinema's past. The French film theorist Christian Metz wrote in the 1970s that 'Most films shot today, good or bad, original or not, "commercial" or not, have as a common characteristic that they tell a story; in this measure they all belong to one and the same genre, which is, rather, a sort of "super-genre" ["*sur-genre*"].'[2] In identifying fictional films as a 'super-genre' of twentieth-century cinema, Metz did not bother to mention another characteristic of this genre because

at that time it was too obvious: fictional films are *live action* films, i.e. they largely consist of unmodified photographic recordings of real events which took place in real physical space. Today, in the age of photorealistic 3D computer animation and digital compositing, invoking this characteristic becomes crucial in defining the specificity of twentieth-century cinema. From the perspective of a future historian of visual culture, the differences between classical Hollywood films, European art films and avant-garde films (apart from abstract ones) may appear to have less significance than this common feature: that they relied on lens-based recordings of reality. This chapter is concerned with the effect of computerization on cinema as defined by its 'super genre' as fictional live action film.[3]

During cinema's history, a whole repertoire of techniques (lighting, art direction, the use of different film stocks and lenses, etc.) was developed to modify the basic record obtained by a film apparatus. And yet behind even the most stylized cinematic images we can discern the bluntness, the sterility, the banality of early nineteenth-century photographs. No matter how complex its stylistic innovations, the cinema has found its base in these deposits of reality, these samples obtained by a methodical and prosaic process. Cinema emerged out of the same impulse which engendered naturalism, court stenography and wax museums. Cinema is the art of the index; it is an attempt to make art out of a footprint.

Even for the director Andrei Tarkovsky, film-painter par excellence, cinema's identity lay in its ability to record reality. Once, during a public discussion in Moscow sometime in the 1970s, he was asked whether he was interested in making abstract films. He replied that there can be no such thing. Cinema's most basic gesture is to open the shutter and to start the film rolling, recording whatever happens to be in front of the lens. For Tarkovsky, an abstract cinema is thus impossible.

But what happens to cinema's indexical identity if it is now possible to generate photorealistic scenes entirely in a computer using 3D computer animation; to modify individual frames or whole scenes with the help of a digital paint program; to cut, bend, stretch and stitch digitized film images into something which has perfect photographic credibility, although it was never actually filmed?

This article will address the meaning of these changes in the film-making process from the point of view of the larger cultural history of the moving image. Seen in this context, the manual construction of images in digital cinema represents a return to nineteenth-century pre-cinematic practices, when images were hand-painted and hand-animated. At the turn of the twentieth century, cinema was to delegate these manual techniques to animation and define itself as a recording medium. As cinema enters the digital age, these techniques are again becoming the commonplace in the film-making process. Consequently, cinema can no longer be clearly distinguished from animation. It is no longer an indexical media technology but, rather, a subgenre of painting.

This argument will be developed in two stages. I will first follow a historical trajectory from nineteenth-century techniques for creating moving images to twentieth-century cinema and animation. Next I will arrive at a definition of digital cinema by abstracting the common features and interface metaphors of a variety of computer software and hardware which are currently replacing traditional film technology. Seen together, these features and metaphors suggest a distinct logic of

a digital moving image. This logic subordinates the photographic and the cinematic to the painterly and the graphic, destroying cinema's identity as a media art.

A brief archaeology of moving pictures

As testified by its original names (kinetoscope, cinematograph, moving pictures), cinema was understood, from its birth, as the art of motion, the art which finally succeeded in creating a convincing illusion of dynamic reality. If we approach cinema in this way (rather than the art of audio-visual narrative, or the art of a projected image, or the art of collective spectatorship, etc.), we can see it superseding previous techniques for creating and displaying moving images.

These earlier techniques shared a number of common characteristics. First, they all relied on hand-painted or hand-drawn images. The magic lantern slides were painted at least until the 1850s; so were the images used in the Phenakistiscope, the Thaumatrope, the Zootrope, the Praxinoscope, the Choreutoscope and numerous other nineteenth-century pro-cinematic devices. Even Muybridge's celebrated Zoopraxiscope lectures of the 1880s featured not actual photographs but colored drawings painted after the photographs.[4]

Not only were the images created manually, they were also manually animated. In Robertson's Phantasmagoria, which premiered in 1799, magic lantern operators moved behind the screen in order to make projected images appear to advance and withdraw.[5] More often, an exhibitor used only his hands, rather than his whole body, to put the images into motion. One animation technique involved using mechanical slides consisting of a number of layers. An exhibitor would slide the layers to animate the image.[6] Another technique was slowly to move a long slide containing separate images in front of a magic lantern lens. Nineteenth century optical toys enjoyed in private homes also required manual action to create movement – twirling the strings of the Thaumatrope, rotating the Zootrope's cylinder, turning the Viviscope's handle.

It was not until the last decade of the nineteenth century that the automatic generation of images and their automatic projection were finally combined. A mechanical eye became coupled with a mechanical heart; photography met the motor. As a result, cinema – a very particular regime of the visible – was born. Irregularity, non-uniformity, the accident and other traces of the human body, which previously inevitably accompanied moving image exhibitions, were replaced by the uniformity of machine vision.[7] A machine which, like a conveyer belt, was now spitting out images, all sharing the same appearance, all the same size, all moving at the same speed, like a line of marching soldiers.

Cinema also eliminated the discrete character of both space and movement in moving images. Before cinema, the moving element was visually separated from the static background as with a mechanical slide show or Reynaud's Praxinoscope Theater (1892).[8] The movement itself was limited in range and affected only a clearly defined figure rather than the whole image. Thus, typical actions would include a bouncing ball, a raised hand or eyes, a butterfly moving back and forth over the heads of fascinated children – simple vectors charted across still fields.

Cinema's most immediate predecessors share something else. As the nineteenth-century obsession with movement intensified, devices which could animate more than just a few images became increasingly popular. All of them – the Zootrope, the Phonoscope, the Tachyscope, the Kinetoscope – were based on loops, sequences of images featuring complete actions which can be played repeatedly. The Thaumatrope (1825), in which a disk with two different images painted on each face was rapidly rotated by twirling a string attached to it, was in its essence a loop in its most minimal form: two elements replacing one another in succession. In the Zootrope (1867) and its numerous variations, approximately a dozen images were arranged around the perimeter of a circle.[9] The Mutoscope, popular in America throughout the 1890s, increased the duration of the loop by placing a larger number of images radially on an axle.[10] Even Edison's Kinetoscope (1892–6), the first modern cinematic machine to employ film, continued to arrange images in a loop.[11] Fifty feet of film translated to an approximately twenty-second-long presentation – a genre whose potential development was cut short when cinema adopted a much longer narrative form.

From animation to cinema

Once the cinema was stabilized as a technology, it cut all references to its origins in artifice. Everything which characterized moving pictures before the twentieth century – the manual construction of images, loop actions, the discrete nature of space and movement – all of this was delegated to cinema's bastard relative, its supplement, its shadow – animation. Twentieth-century animation became a depository for nineteenth-century moving image techniques left behind by cinema.

The opposition between the styles of animation and cinema defined the culture of the moving image in the twentieth century. Animation foregrounds its artificial character, openly admitting that its images are mere representations. Its visual language is more aligned to the graphic than to the photographic. It is discrete and self-consciously discontinuous: crudely rendered characters moving against a stationary and detailed background; sparsely and irregularly sampled motion (in contrast to the uniform sampling of motion by a film camera – recall Jean-Luc Godard's definition of cinema as 'truth 24 frames per second'), and finally space constructed from separate image layers.

In contrast, cinema works hard to erase any traces of its own production process, including any indication that the images which we see could have been constructed rather than recorded. It denies that the reality it shows often does not exist outside of the film image, the image which was arrived at by photographing an already impossible space, itself put together with the use of models, mirrors, and matte paintings, and which was then combined with other images through optical printing. It pretends to be a simple recording of an already existing reality – both to a viewer and to itself.[12] Cinema's public image stressed the aura of reality 'captured' on film, thus implying that cinema was about photographing what existed before the camera, rather than 'creating the "never-was"' of special effects.[13] Rear projection and blue screen photography, matte paintings and glass shots, mirrors and miniatures, push development, optical effects and other techniques which allowed film-makers to

construct and alter the moving images, and thus could reveal that cinema was not really different from animation, were pushed to cinema's periphery by its practitioners, historians and critics.[14]

In the 1990s, with the shift to computer media, these marginalized techniques moved to the center.

Cinema redefined

A visible sign of this shift is the new role which computer-generated special effects have come to play in Hollywood industry in the 1990s. Many blockbusters have been driven by special effects, feeding on their popularity. Hollywood has even created a new mini-genre of 'The Making of . . .' videos and books which reveal how special effects are created.

I will use special effects from 1990s Hollywood films to illustrate some of the possibilities of digital film-making. Until recently, only Hollywood studios had the money to pay for digital tools and for the labor involved in producing digital effects. However, the shift to digital media affects not just Hollywood, but film-making as a whole. As traditional film technology is universally being replaced by digital technology, the logic of the film-making process is being redefined. What I describe below are the new principles of digital film-making which are equally valid for individual or collective film productions, regardless of whether they are using the most expensive professional hardware and software or its amateur equivalents.

Consider, then, the following principles of digital filmmaking:

1 Rather than filming physical reality, it is now possible to generate film-like scenes directly in a computer with the help of 3D computer animation. Therefore, live action footage is displaced from its role as the only possible material from which the finished film is constructed.

2 Once live action footage is digitized (or directly recorded in a digital format), it loses its privileged indexical relationship to pro-filmic reality. The computer does not distinguish between an image obtained through the photographic lens, an image created in a paint program or an image synthesized in a 3D graphics package, since they are made from the same material – pixels. And pixels, regardless of their origin, can be easily altered, substituted one for another, and so on. Live action footage is reduced to be just another graphic, no different from images created manually.[15]

3 If live action footage was left intact in traditional film-making, now it functions as raw material for further compositing, animating and morphing. As a result, while retaining visual realism unique to the photographic process, film obtains the plasticity which was previously only possible in painting or animation. To use the suggestive title of a popular morphing software, digital film-makers work with 'elastic reality.' For example, the opening shot of *Forest Gump* (Robert Zemeckis, Paramount Pictures, 1994; special effects by Industrial Light and Magic) tracks an unusually long and extremely intricate flight of a feather. To create the shot, the real feather was filmed against a blue background in different positions; this material was then animated and

composited against shots of a landscape.[16] The result: a new kind of realism, which can be described as 'something which is intended to look exactly as if it could have happened, although it really could not.'

4 Previously, editing and special effects were strictly separate activities. An editor worked on ordering sequences of images together; any intervention within an image was handled by special effects specialists. The computer collapses this distinction. The manipulation of individual images via a paint program or algorithmic image processing becomes as easy as arranging sequences of images in time. Both simply involve 'cut and paste.' As this basic computer command exemplifies, modification of digital images (or other digitized data) is not sensitive to distinctions of time and space or of differences of scale. So, re-ordering sequences of images in time, compositing them together in space, modifying parts of an individual image, and changing individual pixels become the same operation, conceptually and practically.

Given the preceding principles, we can define digital film in this way:

digital film = live action material + painting + image processing + compositing + 2D computer animation + 3D computer animation

Live action material can either be recorded on film or video or directly in a digital format.[17] Painting, image processing and computer animation refer to the processes of modifying already existent images as well as creating new ones. In fact, the very distinction between creation and modification, so clear in film-based media (shooting versus darkroom processes in photography, production versus post-production in cinema) no longer applies to digital cinema, since each image, regardless of its origin, goes through a number of programs before making it to the final film.[18]

Let us summarize these principles. Live action footage is now only raw material to be manipulated by hand: animated, combined with 3D computer-generated scenes and painted over. The final images are constructed manually from different elements; and all the elements are either created entirely from scratch or modified by hand. Now we can finally answer the question 'What is digital cinema?' *Digital cinema is a particular case of animation which uses live action footage as one of its many elements*.

This can be reread in view of the history of the moving image sketched earlier. Manual construction and animation of images gave birth to cinema and slipped into the margins . . . only to reappear as the foundation of digital cinema. The history of the moving image thus makes a full circle. *Born from animation, cinema pushed animation to its boundary, only to become one particular case of animation in the end*.

The relationship between 'normal' film-making and special effects is similarly reversed. Special effects, which involved human intervention into machine recorded footage and which were therefore delegated to cinema's periphery throughout its history, become the norm of digital film-making.

The same logic applies for the relationship between production and post-production. Cinema traditionally involved arranging physical reality to be filmed though the use of sets, models, art direction, cinematography, etc. Occasional

manipulation of recorded film (for instance, through optical printing) was negligible compared to the extensive manipulation of reality in front of a camera. In digital film-making, shot footage is no longer the final point but just raw material to be manipulated in a computer where the real construction of a scene will take place. In short, the production becomes just the first stage of post-production.

The following example illustrates this new relationship between different stages of the film-making process. Traditional on-set filming for *Stars Wars: Episode 1 – The Phantom Menace* (George Lucas, 1999) was done in just sixty-five days. The post-production, however, stretched over two years, since 95 percent of the film (approximately 2,000 shots out of the total 2,200) was constructed on a computer.[19]

Here are two more examples further to illustrate the shift from re-arranging reality to re-arranging its images. From the analog era: for a scene in *Zabriskie Point* (1970), Michaelangelo Antonioni, trying to achieve a particularly saturated color, ordered a field of grass to be painted. From the digital era: to create the launch sequence in *Apollo 13* (Universal Studios, 1995; special effects by Digital Domain), the crew shot footage at the original location of the launch at Cape Canaveral. The artists at Digital Domain scanned the film and altered it on computer workstations, removing recent building construction, adding grass to the launch pad and painting the skies to make them more dramatic. This altered film was then mapped onto 3D planes to create a virtual set which was animated to match a 180-degree dolly movement of a camera following a rising rocket.[20]

The last example brings us to another conceptualization of digital cinema – as painting. In his book-length study of digital photography, William J. Mitchell focuses our attention on what he calls the inherent mutability of a digital image: 'The essential characteristic of digital information is that it can be manipulated easily and very rapidly by computer. It is simply a matter of substituting new digits for old. . . . Computational tools for transforming, combining, altering, and analyzing images are as essential to the digital artist as brushes and pigments to a painter.'[21] As Mitchell points out, this inherent mutability erases the difference between a photograph and a painting. Since a film is a series of photographs, it is appropriate to extend Mitchell's argument to digital film. With an artist being able easily to manipulate digitized footage either as a whole or frame by frame, a film in a general sense becomes a series of paintings.[22]

Hand-painting digitized film frames, made possible by a computer, is probably the most dramatic example of the new status of cinema. No longer strictly locked in the photographic, it opens itself towards the painterly. It is also the most obvious example of the return of cinema to its nineteenth-century origins – in this case, to hand-crafted images of magic lantern slides, the Phenakistiscope, the Zootrope.

We usually think of computerization as automation, but here the result is the reverse: what was previously automatically recorded by a camera now has to be painted one frame at a time. But not just a dozen images, as in the nineteenth century, but thousands and thousands. We can draw another parallel with the practice, common in the early days of silent cinema, of manually tinting film frames in different colors according to a scene's mood.[23] Today, some of the most visually sophisticated digital effects are often achieved using the same simple method: painstakingly altering by hand thousands of frames. The frames are painted over either to create mattes ('hand-drawn matte extraction') or to directly change the

images, as, for instance, in *Forest Gump*, where President Kennedy was made to speak new sentences by altering the shape of his lips, one frame at a time.[24] In principle, given enough time and money, one can create what will be the ultimate digital film: ninety minutes, i.e., 129,600 frames, completely painted by hand from scratch, but indistinguishable in appearance from live photography.

The concept of digital cinema as painting can be also developed in a different way. I would like to compare the shift from analog to digital film-making to the shift from fresco and tempera to oil painting in the early Renaissance. A painter making fresco has limited time before the paint dries; and once it is dried, no further changes to the image are possible. Similarly, a traditional film-maker has limited means to modify images once they are recorded on film. In the case of medieval tempera painting, this can be compared to the practice of special effects during the analog period of cinema. A painter working with tempera could modify and rework the image, but the process was quite painstaking and slow. Medieval and early Renaissance masters would spend up to six months on a painting a few inches tall. The switch to oils greatly liberated painters by allowing them to quickly create much larger compositions (think, for instance, of the works by Veronese and Titian) as well as to modify them as long as necessary. This change in painting technology led the Renaissance painters to create new kinds of compositions, new pictorial space and even narratives. Similarly, by allowing a film-maker to treat a film image as an oil painting, digital technology redefines what can be done with cinema.

If digital compositing and digital painting can be thought of as an extension of the cell animation techniques (since composited images are stacked in depth parallel to each other, as cells on an animation stand), the newer method of computer-based post-production makes film-making a subset of animation in a different way. In this method the live action, photographic stills and/or graphic elements are positioned in a 3D virtual space. This gives the director the ability freely to move the virtual camera through this space, dolling and panning. Thus cinematography is subordinated to 3D computer animation. We may think of this method as an extension of multiplane animation camera. However, if the camera mounted over a multiplane stand could only move perpendicularly to the images, now it can move in an arbitrary trajectory. The example of a commercial film which relies on this newer method which one day may become the standard of film-making (because it gives the director most flexibility) is Disney's *Aladdin*; the example of an independent work which fully explores the new aesthetic possibilities of this method without subordinating it to the traditional cinematic realism is *The Forest* by Tamas Waliczky (1994).

The reader who followed my analysis of the new possibilities of digital cinema may wonder why I have stressed the parallels between digital cinema and the pre-cinematic techniques of the nineteenth century but did not mention twentieth-century avant-garde film-making. Did not the avant-garde film-makers already explore many of these new possibilities? To take the notion of cinema as painting, Len Lye, one of the pioneers of abstract animation, was painting directly on film as early as 1935; he was followed by Norman McLaren and Stan Brackage, the latter extensively covering shot footage with dots, scratches, splattered paint, smears and lines in an attempt to turn his films into equivalents of abstract expressionist painting. More generally, one of the major impulses in all of avant-garde film-making, from

Leger to Godard, was to combine the cinematic, the painterly and the graphic – by using live action footage and animation within one film or even a single frame, by altering this footage in a variety of ways, or by juxtaposing printed texts and filmed images.

When the avant-garde film-makers collaged multiple images within a single frame, or painted and scratched film, or revolted against the indexical identity of cinema in other ways, they were working against 'normal' film-making procedures and the intended uses of film technology. (Film stock was not designed to be painted on.) Thus they operated on the periphery of commercial cinema not only aesthetically but also technically.

One general effect of the digital revolution is that avant-garde aesthetic strategies became embedded in the commands and interface metaphors of computer software.[25] In short, *the avant-garde became materialized in a computer*. Digital cinema technology is a case in point. The avant-garde strategy of collage re-emerged as a 'cut and paste' command, the most basic operation one can perform on digital data. The idea of painting on film became embedded in paint functions of film editing software. The avant-garde move to combine animation, printed texts and live action footage is repeated in the convergence of animation, title generation, paint, compositing and editing systems into single all-in-one packages. Finally, another move to combine a number of film images together within one frame (for instance, in Leger's 1924 *Ballet Méchanique* or in *A Man with a Movie Camera*) also become legitimized by technology, since all editing software, including Photoshop, Premiere, After Effects, Flame and Cineon, by default assumes that a digital image consists of a number of separate image layers. All in all, what used to be exceptions for traditional cinema became the normal, intended techniques of digital film-making, embedded in technology design itself.[26]

From kino-eye to kino-brush

In the twentieth century, cinema has played two roles at once. As a media technology, cinema's role was to capture and to store visible reality. The difficulty of modifying images once they were recorded was exactly what gave cinema its value as a document, assuring its authenticity. The same rigidity of the film image has defined the limits of cinema as I defined it earlier, i.e. the super-genre of live action narrative. Although it includes within itself a variety of styles – the result of the efforts of many directors, designers and cinematographers – these styles share a strong family resemblance. They are all children of the recording process which uses lens, regular sampling of time and photographic media. They are all children of a machine vision.

The mutability of digital data impairs the value of cinema recordings as documents of reality. In retrospect, we can see that twentieth-century cinema's regime of visual realism, the result of automatically recording visual reality, was only an exception, an isolated accident in the history of visual representation which has always involved, and now again involves the manual construction of images. Cinema becomes a particular branch of painting – painting in time. No longer a kino-eye, but a kino-brush.[27]

The privileged role played by the manual construction of images in digital cinema is one example of a larger trend: the return of pre-cinematic moving images techniques. Marginalized by the twentieth-century institution of live action narrative cinema which relegated them to the realms of animation and special effects, these techniques re-emerge as the foundation of digital film-making. What was supplemental to cinema becomes its norm; what was at its boundaries comes into the center. Computer media returns to us the repressed of the cinema.

As the examples discussed in this article suggest, the directions which were closed off at the turn of the century when cinema came to dominate the modern moving image culture are now again beginning to be explored. Moving image culture is being redefined once again; the cinematic realism is being displaced from being its dominant mode to become only one option among many.

Notes

1 Scott Billups, presentation during 'Casting from Forest Lawn (future of performers)' panel at 'The Artists Rights Digital Technology Symposium '96,' Los Angeles, Directors Guild of America, February 16 1996. Billups was a major figure in bringing Hollywood and Silicon Valley together by way of the American Film Institute's Apple Laboratory and Advanced Technologies Programs in the late 1980s and early 1990s. See Paula Perisi, 'The New Hollywood Silicon Stars,' *Wired* 3.12 (December, 1995), 142–5; 202–10.

2 Christian Metz, 'The Fiction Film and its Spectator: A Metapsychological Study,' in *Apparatus*, edited by Theresa Hak Kyung Cha (New York: Tanam Press, 1980), 402.

3 Cinema as defined by its 'super-genre' of fictional live action film belongs to media arts which, in contrast to traditional arts, rely on recordings of reality as their basis. Another term which is not as popular as 'media arts' but perhaps is more precise is 'recording arts.' For the use of this term, see James Monaco, *How to Read a Film*, revised edition (New York and Oxford: Oxford University Press, 1981), 7.

4 Charles Musser, *The Emergence of Cinema: The American Screen to 1907* (Berkeley and Los Angeles: University of California Press, 1990), 49–50.

5 Musser, *The Emergence of Cinema*, 25.

6 C.W. Ceram, *Archeology of the Cinema* (New York: Harcourt, Brace & World, 1965), 44–5.

7 The birth of cinema in the 1890s is accompanied by an interesting transformation: while the body as the generator of moving pictures disappears, it simultaneously becomes their new subject. Indeed, one of the key themes of early films produced by Edison is a human body in motion: a man sneezing, a famous bodybuilder Sandow flexing his muscles, an athlete performing a somersault, a woman dancing. Films of boxing matches play a key role in the commercial development of Kinetoscope. See Musser, *The Emergence of Cinema*, 72–9; David Robinson, *From Peep Show to Palace: the Birth of American Film* (New York: Columbia University Press, 1996), 44–8.

8 Robinson, *From Peep Show to Palace*, 12.

9 This arrangement was previously used in magic lantern projections; it is described in the second edition of Athanasius Kircher's *Ars magna* (1671). See Musser, *The Emergence of Cinema*, 21–2.

10 Ceram, *Archeology of the Cinema*, 140.

11 Musser, *The Emergence of Cinema*, 78.

12 The extent of this lie is made clear by the films of Andy Warhol from the first part of the 1960s – perhaps the only real attempt to create cinema without a language.

13 I have borrowed this definition of special effects from David Samuelson, *Motion Picture Camera Techniques* (London: Focal Press, 1978).

14 The following examples illustrate this disavowal of special effects; other examples can be easily found. The first example is from popular discourse on cinema. A section entitled 'Making the movies' in Kenneth W. Leish, *Cinema* (New York: Newsweek Books, 1974) contains short stories from the history of the movie industry. The heroes of these stories are actors, directors, and producers; special effects artists are mentioned only once. The second example is from an academic source: the authors of the authoritative *Aesthetics of Film* (1983) state that 'the goal of our book is to summarize from a synthetic and didactic perspective the diverse theoretical attempts at examining these empirical notions [terms from the lexicon of film technicians], including ideas like frame vs. shot, terms from production crews' vocabularies, the notion of identification produced by critical vocabulary, etc.' The fact that the text never mentions special effects techniques reflects the general lack of any historical or theoretical interest in the topic by film scholars. Bordwell and Thompson's *Film Art: An Introduction*, which is used as a standard textbook in undergraduate film classes, is a little better as it devotes three out of its five hundred pages to special effects. Finally, a relevant piece of statistics: a library of University of California, San Diego contains 4,273 titles catalogued under the subject 'motion pictures' and only 16 titles under 'special effects cinematography.' For the few important works addressing the larger cultural significance of special effects by film theoreticians, see Vivian Sobchack and Scott Bukatman (see below). Norman Klein is currently working on a history of special effects environments.
 Kenneth W. Leish, *Cinema* (New York: Newsweek Books, 1974); Jacques Aumont, Alain Bergala, Michel Marie, and Marc Vernet, *Aesthetics of Film*, trans. Richard Neupert (Austin: University of Texas Press, 1992), p. 7; David Bordwell and Kristin Thompson, *Film Art: An Introduction*, 4th edn (New York: McGraw-Hill, 1993); Vivian Sobchack, *Screening Space: The American Science Fiction Film*, 2nd edn (New York: Ungar, 1987); Scott Bukatman, 'The Artificial Infinite,' in *Visual Display*, eds Lynne Cooke and Peter Wollen (Seattle: Bay Press, 1995).

15 For a discussion of the subsumption of the photographic to the graphic, see Peter Lunenfeld, 'Art Post-History: Digital Photography and Electronic Semiotics,' *Photography After Photography*, eds V. Amelunxen, Stefan Iglhaut, Florian Rötzer, 58–66. München: Verlag der Kunst, 1995.

16 For a complete list of people at ILM who worked on this film, see *SIGGRAPH '94 Visual Proceedings* (New York: ACM SIGGRAPH, 1994), 19.

17 In this respect 1995 can be called the last year of digital media. At the 1995 National Association of Broadcasters convention Avid showed a working model of a digital video camera which records not on a video cassette but directly onto a hard drive. Once digital cameras become widely used, we will no longer have any reason to talk about digital media since the process of digitization will be eliminated.

18 Here is another, even more radical definition: digital film $= f(x, y, t)$. This definition would be greeted with joy by the proponents of abstract animation. Since a

computer breaks down every frame into pixels, a complete film can be defined as a function which, given horizontal, vertical, and time location of each pixel, returns its color. This is actually how a computer represents a film, a representation which has a surprising affinity with a certain well-known avant-garde vision of cinema! For a computer, a film is an abstract arrangement of colors changing in time, rather than something structured by 'shots,' 'narrative,' 'actors,' and so on.

19 Paula Parisi, 'Grand illusion,' *Wired* 7.05 (May 1999), 137.

20 See Barbara Robertson, 'Digital Magic: Apollo 13,' *Computer Graphics World* (August 1995), 20.

21 Mitchell, *The Reconfigured Eye*, Cambridge, Mass.: MIT Press, 7.

22 The full advantage of mapping time into 2-D space, already present in Edison's first cinema apparatus, is now realized: one can modify events in time by literally painting on a sequence of frames, treating them as a single image.

23 See Robinson, *From Peep Show to Palace*, 165.

24 See 'Industrial Light & Magic alters history with MATADOR,' promotion material by Parallax Software, SIGGRAPH 95 Conference, Los Angeles, August 1995.

25 See my 'Avant-Garde as Software,' in *Ostranenie*, edited by Stephen Kovats (Frankfurt and New York: Campus Verlag, 1999). (http://www.manovich.net)

26 For the experiments in painting on film by Lye, McLaren, and Brackage, see Robert Russett and Cecile Starr, *Experimental Animation* (New York: Van Nostrand Reinhold, 1976), 65–71, 117–28; P. Adams Smith, *Visionary Film*, 2nd edn (Oxford: Oxford University Press), 230, 136–227.

27 Dziga Vertov coined the term 'kino-eye' in the 1920s to describe the cinematic apparatus's ability 'to record and organize the individual characteristics of life's phenomena into a whole, an essence, a conclusion.' For Vertov, it was the presentation of film 'facts,' based as they were on materialist evidence, that defined the very nature of the cinema. See *Kino-Eye: The Writings of Dziga Vertov*, ed. Annette Michelson, trans. Kevin O'Brien (Berkeley: University of California Press, 1984). The quotation above is from 'Artistic Drama and Kino-Eye' (originally published in 1924), 47–9.

Lisa Cartwright

FILM AND THE DIGITAL IN VISUAL STUDIES
Film studies in the era of convergence

A S THE TWENTIETH CENTURY drew to a close, we were increasingly likely to encounter the cinema through other media – on television, home video, DVD, or the internet. Media and industry convergences of the late twentieth century were enacted in the rise of Home Box Office in the late 1970s; the emergence of home video in the 1980s; and the move from digital special effects to digital editing and projection across the last three decades. Web marketing and access to films on-line accompanied the rise of corporate conglomerates like Disney-Capital Cities-ABC in 1996, synergetic entities vertically integrated across categories as seemingly disparate as entertainment, information, food, and nuclear power, and with a formidable global reach. As *New Economist* editor Frances Cairncross announced, distance is dead in the free-market world where corporations build brave new markets with the dissolution of the nation-state and the wiring of the Third World.

Convergence of the media raises important issues for those of us in film studies. We find the defining object of our field, film, disintegrating into – or integrating with – other media. Of course, media convergence is not a new phenomenon. Film has never been an autonomous medium or industry. And the potential for global corporate expansion may have been brought to new heights but was not introduced by the internet. The film industry's intersections with television, consumer goods (through product tie-ins), the electrical and lighting industries, and even the make-up and fashion industries since the cinema's inception in the late nineteenth century all have been well documented. The difference in the convergence frenzy of the late 1980s and 1990s is that this phenomenon reached a fulness, a potential, captured in the word synergy, a corporate buzzword describing the exponential-growth effect that occurs with the integration of media and products – and corporate holdings – across industries. The actualization of science-fiction fantasies of convergence faced fewer technological limitations and a climate in which, to cite US

circumstances, federal checks on vertical integration were effectively sidestepped with the waves of media deregulation since the Reagan years and fulfilled in the global-free-market mentality of the Clinton era. At the level of the technical, convergence became a qualitatively different entity when computers could support those elements previously limited to the media technologies of film and television: high-quality image reproduction and real-time movement, with the latter still not brought up to the level of the cinema and television.

In the academy, the 1990s wave of media convergence has been paralleled by a teetering of film studies' institutional base as a field of its own. Film studies as a field has been under construction for a mere quarter-century, and the cinema itself is barely over a century old. The (debatable) destabilization of a young field has been effected in part through the rise of interdisciplinarity as a research and method-ological strategy in the late 1980s and 1990s. It was also facilitated by the rise to semi-institutionalization of the interdisciplinary fields of cultural studies and visual studies as logical homes for the study of the medium, the industry, the cultures of film. Film's institutionalization hinged on alliances forged among scholars trained in the traditional disciplines (history, the social sciences, English, the modern languages) over the object film and its social institution, the cinema. As David Rodowick reminds us, whereas film studies emerged in the 1960s and early 1970s alongside the disciplines of women's studies and Africana studies during a period of economic expansion, visual studies emerged in a climate of scarce resources for the humanities ('Visual Culture Questionnaire,' 60). The interdisciplinarity of cultural and visual studies fit the institutional imperative to downsize quite nicely. I will return to the economic point in a moment. For now, I want to stay with the emer-gence of film studies in the post-68 political climate. Women's and Africana studies programs were founded on a politics of identity and were supported by the advances of civil rights and liberation movements. Gender and ethnic studies have always been marked with their political roots and motivations. Film studies is set apart from these areas in that it is based upon an object of study and not a specific politics or the conditions of subjectivity. Film theory and criticism do have bases in the worker, student, and women's movements of the period. But the field of film studies was founded on other disciplines and imperatives as well, including the historical and philosophical study of film and the cinema. It is harder to tie the discipline to a politics as a motivation for its emergence.

The growth of film studies finds a more apt parallel in cross-disciplinary programs and departments defined by the neutral qualifier *comparative*, as in compar-ative literature, comparative studies, and a later formulation, comparative arts. As the term *comparative* gave way to *cultural* in some institutions (such as my own, where comparative literature became modern languages and cultures, and compar-ative arts became visual and cultural studies), film in some quarters came to be tied to the larger rubric of culture. England presents a different narrative, where cultural studies is of course an earlier and broader phenomenon than in the US, paralleling film studies' emergence as a field. The visual studies rubric for programs was also introduced earlier and more broadly in England than in the US. The term compar-ative had against it (or going for it, depending on one's view) apparent generic neutrality. It implied a degree of similarity among its objects (national literatures, for example). *Cultural* and *culture*, through the terms' associations with the specific

disciplinary and methodological orientations of British and, later, American (read US) cultural studies, have a political legacy and orientation that distinguishes cultural studies from the term's earlier use in anthropology. The two legacies of the term create some confusion, then, when we can trace in 'visual culture' both ways of thinking the term – the older anthropological way, and the cultural studies way.

Film studies, unlike these other categories, invokes in its very name a medium, an industry, and a specific set of material referents that make the field's life seemingly dependent on the duration of those entities. The argument can be made that literary studies has always similarly been associated with the study of particular material objects and has nonetheless survived the emergences and convergences of media, modes of inscription, and methods. But the history of print culture has been far longer and more materially varied. New objects and practices including film, television, and hypertext have readily been incorporated, as new varieties of text, into literary studies. The shorter and more medium-specific history of the cinema (the social institution) and film (the object) may in fact limit the material scope and hence the lifespan of film studies proper. This abbreviated life distinguishes the field from its more entrenched precedent and parallel, literary studies, and suggests film studies in the narrow sense could go the way of the study of dead languages.

That is, if film studies is really about the study of film. There are two directions I mean to take this caveat. The first concerns the entity film. If film has become a medium interlocked with and perhaps soon to be subsumed in the broader category of digital media, we need to re-conceive where and how we take up film as an object of study. This issue is only partly resolved by the game of renaming the field to correspond to its new objects (film and television studies, film and media studies, comparative media studies, visual studies). We also must examine the interdisciplinary fields where film has migrated and with whose objects and motivations it has converged. The view of art historian Christopher Wood that 'worrying about the name of the discipline is a pastime for bureaucrats' ('Visual Culture Questionnaire,' 70) made me envious of the complacency those in more stable fields can afford to have with respect to their institutional base. The stakes in naming are high when the objects, methods, or orientations of one's work may not be accommodated within the boundaries of the departmental home's title. Disciplinary naming gives shape to research agendas, canons, and how we enter into intellectual politics, determining our potential to carry on research in certain methodologies and not others, and with certain objects of study and not others. The situation of naming-as-discipline-building raises the questions, Which fields are equipped to support the study of film in its current and future status as a medium?, and industry?, and a culture? What will film scholars be authorized to study? What will film studies become in visual studies?

The second caveat concerns the degree to which film studies is about film. To put this another way, one of the objects of film study since the early history of the field in, for example, perceptual psychology or the filmology movement, has been the experience of populations or individual subjects with the medium's material and sensory conditions. Film studies has always been as much about the experience and conditions of duration, spatiality, perception, attention, and sound in modernity as it has been about film images and texts. This way of thinking film studies' objects, whether as spectator, observer, audience, community, body, population, or subject,

has grounded investigations launched through approaches as diverse as psycho-analysis, phenomenology, social-science audience research, historical analysis of the cinema as social institution, and reception studies. The list of film studies scholars who don't work on film is long. The television historian Lynn Spigel brought her training in psychoanalytic feminist film theory to bear on television history, producing a history of early television audiences solidly grounded in the film canon without ever taking on film. A more complex example: Anne Friedberg, a founder of a graduate program in visual studies at Irvine, has focused her major research of the last decade on the spectatorial conditions of the gaze and the observer in non-film contexts. Her current project, which considers the mirror as object and trope, was preceded by a book that traces the existence of a virtual gaze in the public urban spaces of modernity. Friedberg locates nineteenth-century modernity's observer in a virtual gaze experienced in the contexts of the panorama, the diorama, and window-shopping. Film theory is the foundation for Friedberg's investigation of the conditions of the *flâneur* and the *flâneuse*; her graduate work was in one of the founding film studies programs. But her object of study is a far cry from the material entity film, filmic images, and the conditions of film spectatorship specifically – except insofar as the latter is one of the contexts in which modernity's virtual gaze also lives. Friedberg's study advances film studies in a way that a study of film and cinema specifically could never have done. Her work allows us to get outside the conditions of film spectatorship to see how other gazes at work at the origins of the cinema shaped the conditions for film spectatorship into the twentieth-century. She identifies in the virtual gaze of postmodernity the conditions for the gaze most associated with new digital technologies, giving that gaze its history.

My own work in visual studies began with an investigation of film objects, albeit obscure ones (the early scientific medical films found in the scary basements of hospitals and medical museums). These very objects and the conditions of their production and use led me to question not only what we had come to accept as the material conditions of film at its origins, but also the accepted prehistory and early history of the cinema as an institution. This study led me to rethink the notion of the film archive as I found films alongside the detritus of medical museum displays and film equipment retro-fitted with medical equipment for purposes of visual experiment. This took me into the realm of a gaze that was markedly different from the ones being theorized around popular cinema.

Here I want to return to the issue of convergence. I take media convergence as a given, not because I believe it is a new phenomenon (I do not), but because as a reality of the late twentieth century it coincides precisely with the flux of inter-disciplinarity, and the reshaping and downsizing, that transformed the humanities in the 1990s. I accept technological convergence as a premise provisionally in order to move directly into the question of the institutional study of film and/as the broader categories of the digital and the visual. By institutional convergence I mean the vertical integration of disciplines and the simultaneous horizontal expansion of objects of study within a given area. Visual studies is the field that concerns me most in this integration of fields and disintegration of boundaries between objects of study. My questions will be along these lines: How did visual studies emerge as a discipline with film in its purview? How does the digital, an aspect of late-twentieth-century visual culture that emerged roughly simultaneous with visual

studies, figure into the field? What happens when film studies is embedded in or combined with visual studies? Some of these questions will be touched upon in the following pages.

It may he useful for me to explain that my lens for these questions is my job of ten years teaching film studies in a visual studies program that has grown and maintained privileged support during a period of dramatic downsizing of the humanities at my institution. I am nominally appointed in this program (which has no lines of its own). My primary undergraduate teaching responsibility is to an undergraduate film studies program (also with no lines of its own). In my institution, the film program has a major historical debt to the department of English, where my 'real' appointment officially resides. I will begin my discussion with a reading, through the lens of this particular institutional positioning, of the place of film studies in the infamous issue of *October* devoted to the concepts of visual culture and visual studies. A detour through this debate allows me quickly to identify some of the problems in thinking film's place in the current milieu of visual studies.

Where is film studies in visual studies?

In 1996, *October* published an issue with a questionnaire-and-selected-responses section devoted to an interrogation of 'the interdisciplinary project of visual culture.' The project, which was launched with four 'questions' (framed as general assertions) about visual culture and visual studies, piqued the interest of those of us at the University of Rochester teaching in the Program in Visual and Cultural Studies. As the only accredited graduate program of its kind in the country at the time, we were eager to see how a field whose development we had fostered would fare under the scrutiny of scholars across the contributing disciplines. I was surprised to find that the comments of only two film scholars were included in the nineteen responses published, and the representation of scholars who work on television and new media was even smaller (one of the film people constituted this category as well). About half of the responses were from art historians. The topics and selected responses were embedded in a set of essays devoted to discussions launched from art history, some of which more fully fleshed out the questionnaire topics' implied criticisms. These criticisms were not only of visual culture as a paradigm and visual studies as a discipline, but of the digital future for which visual studies helps us to prepare.

I want to emphasize that in what follows in this chapter, my aim is not to insist upon the interdisciplinarity of visual studies as liberating or even intellectually enriching. Rather, I want to make a more pragmatic argument for its necessity as both an outcome of and response to the broader conditions of media convergence (conditions that include technological advancement, global capitalism, and so on). Visual studies is one of the few places from which we can adequately address not only the current conditions of media convergence, but also its long and complex history. (Science and technology studies is another emergent discipline in which I believe this can be done well.) One of the framing topics of the *October* questionnaire implies that visual studies is complicit with the forces of globalization, the next phase of capitalism, and the disembodiment of the image. 'It has been suggested,' the editors of the survey submit, 'that the precondition for visual studies

. . . is a newly wrought conception of the visual as disembodied *image*, re-created in the virtual space of sign-exchange and phantasmatic projection.' This is followed by a claim that visual studies is, 'in its own modest way, produc[ing] subjects for the next stage of global capitalism' ('Visual Culture Questionnaire,' 25). My argument will be that visual studies has emerged, along with the disembodied image paradigm, not as cause but as a necessary product of the conditions decried in this passage; that visual studies exists as a necessary venue through which to both historicize and reroute the course of global media culture – a culture that is hardly restricted to the visual but must be accessed this domain.

But first to address problems with the hypothesis that the collapse of images – their disembodiment and release as free-floating entities in the virtual space of visuality – is best addressed by visual studies because the field is interdisciplinary. The case has been made that interdisciplinarity entails having the tools to analyze the array of image forms that make up the flux of contemporary culture, or that it enriches the discrete areas of study that contribute to visual studies. Keith Moxey has noted that in art history 'a failure to distinguish the study of art from the study of other kinds of images is often used as a criticism' of visual studies (Moxey, 4). He proposes in response to this criticism an embrace of a comparative approach that sees benefit in interdisciplinarity:

> Rather than view the rise of the study of varied and often popular forms of image production, one in which art is included in a spectrum of other kinds of visual products, as a potential threat to art as an institution, I would claim that the value of these visual juxtapositions lies in comparing and contrasting the ways in which the study of each genre, say painting, television, or advertising, makes use of different theories and methods in making meaning.

The comparative approach has served well as the model for programs like MIT's new masters in comparative media, where students train for the corporate workplace as well as for further academic study by analyzing new and old media alongside and in conjunction with one another. Graduates of this program are predicted to serve as critically informed liaisons between media services that have yet to be imagined and those who use these services, if not as industry moles who may use their historical knowledge and critical skills to alter the course of global capitalism's flows. Moxey, however, envisions a history for the comparative approach that would not necessarily ground a practice such as this, but is rather grounded in a kind of disciplinary boundary-crossing that finds its precedents in Warburg, and that locates a strictly art historical genealogy for visual studies. Like Thomas Dacosta Kaufmann and others before him, Moxey begins this lineage with Michael Baxandall (1972) and advances through Svetlana Alpers (1983) and W.J.T. Mitchell (1995). The term's rise is motivated by the concern to relate the production of art to the broader social context, but art stays center.

What are the places of film and media, and the particular evolution of the fields that study them, in this understanding of the development of visual studies as a discipline? Does film deserve its own origins story alongside art history's, with film as

its center? (I would be reticent to provide one.) The comparative approach and interdisciplinarity as models of thinking the field fail to provide an account of the dynamic of power that positions the discipline's constellation of objects and methods, making the art historian's gaze the one internalized among the field's populace. Visual studies, like any other discipline, has its own institutional gaze. The historical fact of media convergence in itself doesn't give us the tools to make sense of the constellation of images and looking practices it produces. Nor does it give us the ability to generate a full complement of genealogies and gazes, with each placing its own medium at the center.

Regarding interdisciplinarity, the *October* editors gave their respondents a brief genealogy to respond to:

> It has been suggested that the interdisciplinary project of 'visual culture'
> is no longer organized on the model of history (as were the disciplines
> of art history, architecture history, film history, etc.) but on the model
> of anthropology (25).

Film *history* and not film (or cinema) *studies* is referenced as an antecedent to visual *culture*. Visual *studies* is introduced in one of the four 'questions,' as an interdisciplinary rubric. In the other three topics, visual *culture* is the object of concern. As Douglas Crimp has noted in a sustained critique of this debate, *cultural studies, visual studies,* and *visual culture* are often used interchangeably. Objects of study (visual culture) and areas of research with discrete if intersecting objects and histories (visual studies, cultural studies) are collapsed. My concern here is with the choice of *history* and not *studies* to describe film as an original discipline and past model. This choice results in some crucial omissions in the evolution of film as a node in visual studies' emergence, and the relationship between film and media study. Unlike art history, film history has never been taken up as a rubric to designate departments, programs, or even a field. Film history is not a discipline in its own right, but names a particular methodology within the discipline of film (or cinema) studies, a field that has always incorporated an array of methodologies. Film history is sometimes posed against film theory in a binary abstraction of the field of film studies, with theory the location of the field's political life and history the realm of everything else. But history is only one of a number of fields of origin for film scholarship along with philosophy, communications, linguistics, rhetoric, English. literature, and sociology. All of these fields have contributed to the foundation of visual as well as film studies.

Art history is one field that has supported the study of film prior to and even after the establishment of departments and programs of film or cinema studies, and it tended to support a historical and aesthetic-philosophical approach to film. Sociology and communications accommodated the study of film as well, but in a context that was also receptive to the study of media, television, and (later) digital media. Television and digital media are areas that have become subgroups within film studies proper, as reflected in the Society for Cinema Studies' inclusion of them as special-interest areas in conferences and publications. But only rarely have they been taken up in art history – except where art history has transformed into visual studies.

Visual studies is at odds with an older model of art history, in its abandonment of history for an alliance with an anthropological notion of culture that finds its source in cultural studies, the *October* questionnaire and Foster in the same issue suggest. Visual studies does maintain ongoing allegiances with a political tradition of cultural analysis that can be traced back through two histories rooted in Left and feminist critical theory: Cultural studies with its British (and in some cases American) origins in the social sciences and communication, and psychoanalytic film theory. If British cultural studies is to be given the credit it deserves in the institutional emergence of visual studies, though, we should recognize the supporting role not only of anthropology but of communications and sociology, and the methodologies used in those fields, in visual studies' prehistory. Cultural studies early on shed the tight attachment to empirical research models in all of those fields, advancing models of ethnographic research that have been anathema even to politically sympathetic anthropologists. Likewise, psychoanalytic film theory (supported in the fields of languages and literature) is a model both adopted and reconfigured in visual studies. As Crimp points out, the fact that ethnographic and psychoanalytic approaches have faced off in cultural studies, as in Constance Penley's 1992 critique of Janice Radway's 1984 work on the popular romance (Crimp, 54), suggest that field can sustain and thrive in contestation over methodology. Disciplinary convergence does not mean a flattening of difference and a de-skilling of its labor force. A case can be made that methodology is in fact subject to internal 'quality checks' that result in more discerning producers. Sociologist Jackie Stacey, the cultural studies scholar whose *Star Gazing* reworked feminist psychoanalytic theory through sociology, is one of the few scholars who has had the prescience to introduce questions of gender and subjectivity in the discussions of media globalization that have taken place thus far. Her willingness to push the limits of methodological cross-analysis has been exemplary. As one of the most crucial visual studies issues for the decades to come, globalization demands attention at the level of subjects and practices and not only within the generic and disembodying terms that the conditions of globalization setup for us. Globalization is a process subject to influence and transformation, and is not solely a corporate world vision with its own momentum.

Television, as the model for media globalization as alienating force, requires more attention as we consider the forces of telecommunications and information flow in conjunction with the visual. Whereas film and digital media are mentioned with some frequency in the various commentaries published in the questionnaire, television is discussed tangentially, as specter of the contemporary conditions of media alienation. These references are through, for example, Susan Buck-Morss's identification of MTV as a form that produces subjects for global capitalism ('Visual Culture Questionnaire,' 30) and Emily Apter's mention of Baudrillard's bleak vision of America as a holographic landscape of flickering screens ('Visual Culture Questionnaire,' 26). The absence of television except as specter of late capitalism's threat of further image alienation is curious, given its status as a link between the cinematic culture that dominated the first half of the twentieth century and the digital media culture that came to the fore by the century's last decade. Not surprisingly, television studies have tended to rely on the methods of sociology and communications foundational to cultural studies, but it remains marginal to disciplines that shun low culture. Apter wants to know, will the 'oneiric, anamorphic,

junk-tech aesthetic of cyber-visuality find a place in the discipline of art history' or 'will it remain in the academic clearing house of cultural studies' ('Visual Studies Questionnaire,' 27). Dream, junk, and distortion evoke for me another historical moment well attended to by art history though – that of surrealism and all it contributed to our understanding not only of its social milieu but of scientific know-ledge and the transformation of knowledge in relation to materiality, experience, and psychic life. If what some would call the hyperreal is our moment's surreal, then it would seem that art history would be a logical place for its study. Television, text, content, image, and meaning have been overworked in cultural studies, leaving us with little analysis of television's place as an apparatus enmeshed in the produc-tion of conditions of materiality, experience and embodiment – the conditions so dramatically altered in the worlds of cyber-visuality.

In dwelling on absences I have yet to address the question of where film comes up in all of this. Tom Gunning and David Rodowick (the two film scholars responding to the *October* survey) raise the point that film is hardly limited to the sense of sight and the visual properties of images. Gunning, as a historian who has always considered the broader social conditions of the medium in relation to other media and art forms is, like Moxey, quick to note the benefits of interdisciplinarity. But he shifts the discussion from objects of study to modes of experience and percep-tion that unify the field; visual perception is that which also is signified in the 'visual' of visual studies. Gunning cautions that 'the greatest limitation visual studies might occasion would be reifying a division of the senses' (38). Thomas Crow makes an apparently similar point, asserting that 'the new rubric of visual culture . . . accepts without question the view that art is to be defined exclusively by its working exclusively through the optical faculties' (35). Elsewhere, he warns of the reduc-tion of art history to a history of images. Rodowick echoes this point with reference to film:

> In the minds of most people cinema remains a 'visual' medium. And more often than not cinema still defends its aesthetic value by aligning itself with the other visual arts and by asserting its self-identity as an image-making medium. Yet the great paradox of cinema . . . is that it is both temporal and 'immaterial' as well as a spatial medium (61).

Rodowick like Gunning allows us to move the discussion from image and image-making in emphasizing temporality and (im)materiality. He has his own sustained apparatus for approaching this, elaborated through an earlier essay on the figural, his reading of Deleuze, and his subsequent work on digital culture. I want to use his comment, though, as a segue because, unlike Gunning's note about the senses, it does not swing us from the object to experience, or film object to experiential subject. Instead, his comment hints at the problematic of the relationship between the two in terms of duration and (im)materiality. A number of the *October* ques-tionnaire contributors call for a return to the specificity of the materiality of visual objects – films, paintings, photographs, and so forth – lest we lose sight of the particularity of each category historical and present function. But the conditions of convergence (which I take as a premise) leave us ill-equipped to address not only the material conditions through which we encounter our objects, but our embodied

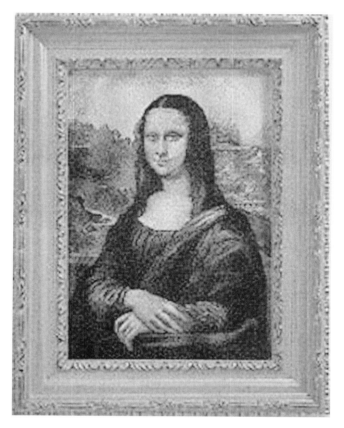

Figure 38.1 Mona Lisa as the first digital work of art

relationships to the equipment and information we encounter in the dynamic. An amusing and obvious side to media convergence and global flows of images is that not only new media and film but works of art from previous centuries are increasingly experienced as global media commodity. We see old paintings reproduced in slides and on the web, on T-shirts and mugs, in blockbuster exhibitions, behind plexiglass shields, and in news accounts of X-ray verification of a work's authenticity and value

I hesitate to illustrate these points because they are so trite and their images so cute. They lead me to suggest what is in the end the wrong point about the status of discrete media and of the image under the conditions of convergence. A more significant fact about convergence is that it is not only images themselves, or image types, that are reproduced, reconfigured, and freed for circulation as never before in the exploded realm of the visual. We also find that the registers of, for example, the visual and the aural converge in complex ways. My example is not the simplistic one of, say, film being also an aural medium, or the museum experience also encompassing touch and spatiality. What I want to get at is better illustrated by, for example, the relationship of sound and image in ultrasound. This is a medium that relies on sound waves we cannot hear to produce mundane graphic and numerical data that is then crunched to render a visual image in the last instance. Sound is not

in the service of subjective hearing, image does not represent anything in the realm of visuality, except in the most abstract and limited sense. The disintegration of sound, data, and image involves a kind of pulverization. We get not the sensorium of the IMAX theatre, with all senses and representational registers in their place, but a recircuiting of one register of information into another, one sensory experience into another.

Jonathan Crary begins to get at the problems with focusing on the image as if it were the necessary or primary concern in visuality when he begins his questionnaire response with the following disclaimer:

> Admittedly the terms 'vision' or 'visual' appear in the titles of certain texts I have written and courses I have taught. However, with increasing frequency they are terms that trouble me when I hear them deployed in the expanding visuality industry of conferences, publications, and academic offerings. One of the things I have tried to do in my work is to insist that historical problems about vision are distinct from a history of representational artifacts.
>
> ('Visual Culture Questionnaire,' 33)

Crary's point is that visual studies has emerged in part because of a collapse of a certain formulation of the spectator, that visual studies emerges exactly as its object disintegrates. He concludes by suggesting that the analysis of this shift would not entail analyzing the technological artifacts and techniques (computer graphics and virtual reality, for example) that are the artifacts of this shift. Rather, we would engage in 'the study of colorless, non-visual discursive and systemic formulations and their mutations' (34).

I want to suggest that to study the apparatus that produces these artifacts — computer graphics and virtual reality — in conjunction with their production and use in a system that enters users directly into the mechanisms of convergence — is precisely to study non-visual discursive formulations. Images and 'visual' experiences are only some of the by-products of the global media industry that has necessitated the field of visual studies. The visual has been late in coming in to the digital. The visual has always been almost an afterthought to the real transfiguring work of globalizing media cultures. Film studies has been one of the few areas of visual studies that has allowed us to get at the preconditions of the medium overridden by too much attention to image and artifact, precisely because film engaged the conditions of immateriality from the medium's beginnings. Film necessitated the interrogation of 'disembodied images' well before art history's objects did. I am not making the argument that film is not just visual but also aural and spatial, but that film has facilitated a certain sublimation, bypassing, and re-routing of visual-sensory experience by invoking the virtual. Our experiences with film have prepared us for our experiences with virtual media, allowing us to use images as expedient resources to access dynamics that engage something other than the experience of sight. The obvious visual-ness of the cinema distracts us from the fact that the medium has trained us in a sensory disintegration that makes the virtual possible as fundamentally *not* visual experience.

I will route my explanation of this cryptic argument through an analysis of a virtual project, the work and theory of a physician named Richard Robb. My intention

is to demonstrate that this rather phenomenally visual and image-based project, seen in its historical and projected future contexts, is in the end only marginally concerned with the visual. We need to start with the images, because they are the key entry point into the system Robb works with, though they are hardly its endpoint. The 'gaze' Robb offers us is not a visual dynamic but a relationship that takes us into the realm of representing the mechanisms of physiological and physical behaviors at the level of microscopic anatomy and biochemical systems. Perhaps the spectator as we knew it (figured on the model of visual perception) has collapsed, but the sensory disintegration that ensues from this collapse are precisely the conditions that support the kind of experience with and through media suggested in Robb's formulation, to which I now turn.

Optical virtuality

In 1964 Stan Van der Beek and Ken Knowlton at Bell Labs were among a group of computer scientists pushing the envelope of body-image construction on the computer. Some of the work they produced is documented in a series of films, titled *Poem Field*, made in the mid-1960s. These animated line-renderings viewed from the perspective of the late 1990s evoke the computer-aided design (CAD) drawings that cropped up in car advertisements of recent years, the ones that reveal the inner structure of the car in a rotating linear diagram (usually green). The jerky linear body-models progressed from rudimentary sketches to volumetric and fluid mobile forms over the years of their studies. Viewed through the lens of late-1990s medical imaging, it is easy to think of these images as exercises in the direction of the kinds of moving volumetric body simulations that wowed the medical industry in this decade. Like these medical volumetric motion renderings, behind these studies stood many hours of computation and data entry and analysis. They pointed in the direction of the multitude of *Terminator* bodies and medical Visible Humans, but their very unspectacular-ness suggests a different, much less glamorous purpose: an attempt at the computation level to make these bodies perform as bodies. The image – getting it to *look* right – was just a byproduct and sometimes even an annoyance. As is known in programming, getting objects to perform right in space can result in distortions of appearance. Images that perform like real bodies sometimes don't look like real bodies look.

Researchers in the field we have known as medical imaging since the early 1990s widely agree that if simulation is the goal, organs in the body must not only look realistic, they must *behave* realistically. These are two different, and not necessarily mutually supportive, goals. This move toward an interest in behavior simulation hints at the fact that medical imaging was already dead in the water when the field came into existence barely a decade ago. The objective of the post-visual era is reproducing behaviors and functions, not appearances – but through images nonetheless. (Enmeshing the experience of the observer with the object experienced is another level of convergence within this objective.) Simulated organs and tissue that stretch when pulled, react to gravity, respond to pressure, contract involuntarily, bleed when cut, and reattach when stitched are the goal of imaging specialists who want to make their entities behave 'in life-like appropriate ways.' The goal is to

reproduce physiology in the virtual image: movement, systems in process, and so forth. This concept also entails integrating the user's senses, the apparatus, and the simulated body, into a system that allows for the user to experience the sensations he or she generates in the virtual body-object: the user must feel that he or she has pressed, cut through, impacted the virtual body-object as if it were real. Altering the conditions of experience to make sight trigger the sensation of touch and spatiality is crucial to this goal. The orientation of sensory experience in this process does not simply shift (from sight to, say, sound and touch) in order to generate the desired experience. The idea is that the image can be a catalyst for other sorts of sensory experiences, in a kind of re-circuitry of the senses. This is echoed in another company's goal to allow users to feel organs (again in their words) 'deform in their forceps.' Anatomical form and visual appearance having been conquered and found lacking, physiological or behavioral realism is the new representational frontier into which the image is entered.

Virtual endoscopy will be my point of access into this post-visual domain of 'imaging' science. Endoscopy is the use of fine flexible tubing and minute fiber-optic lenses to enter and acquire visual data about the interiors of organs like the stomach or the organs of the reproductive system. Virtual endoscopy is the practice of simulating that optical journey. As I'll further explain, virtual endoscopy goes beyond the visual to include other sensory registers. Richard Robb, a researcher at the Mayo Clinic, describes virtual endoscopy as 'the fountainhead of an entire generation of new diagnostic opportunities' – a tall claim for a modality that emerged during an era in which we've seen a profusion of new biomedical imaging systems. Robb lays out what he calls a 'taxonomy for several generations of virtual imaging.' He shows five phases, beginning with the geometric modeling of 3D organ shapes, passing through the representations of physiological and physical behaviors described above, and ending with techniques for simulating microscopic anatomy (of glands and the neurovascular system) and biochemical systems – the simulation of the body experiencing shock, for example.

His plan is useful because it clearly maps out the goal of moving representations (of bodies in this case) along toward becoming not just images of bodies, but simulations at the level of function. A virtual endoscopic procedure at the final level of image representation, Robb explains, 'might eventually become indistinguishable from the actual patient.' In other words, the program's user would not be able to tell whether he or she was working on a real or simulated body. Clearly, in this case, the realism of the simulation depends on the user's realistic multi-sensory experience of the simulation as identical to a real body.

It is important to note that, as in any virtual reality system, it is not the simulation that is virtual (or virtually real) in this account, but the experience of the user. (Note: while spectator is no longer an adequate term for describing the multi-sensorial experience of the person engaged in VR, user is a more generic and equally inadequate term. It fails to describe what we might call for lack of a better set of terms the user-computer-object nexus. I don't have time to elaborate on this here. User is my shorthand.)

To understand this point about the term virtual being linked in most usages to the user not the body simulated, it is helpful to review as well Robb's account of the concept, which he lays out in detail. The term virtual endoscopy, he argues, is

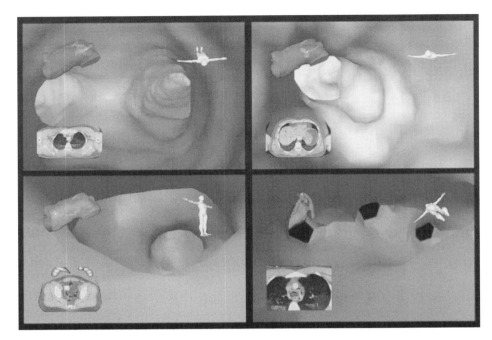

Figure 38.2 Four virtual endoscopic views of internal surfaces of anatomic models of
visible human male, including the trachea (upper left), esophagus (upper
right), colon (lower left), and aorta (lower right). Navigation guides
provide precise body orientation and both 3-D and 2-D anatomic location
of current viewpoint. Copyright Richard Robb.

not correct. What is commonly meant by *virtual* endoscopy is better captured, he
explains, in endoscopic *virtuality*. Whereas virtual means 'possessed of certain
virtues' and 'being such in effect,' virtuality means 'essence' and 'potential exis-
tence of.' Coupled with endoscopy, virtual means 'in effect visualizing the interior
of a hollow organ or cavity,' while virtuality would suggest 'the essence of visual-
izing the potentially existing interior of a body.' In other words, with the switch
to virtuality, the position we typically call the user is lifted out of the vague terri-
tory of the virtual. The user's experience is not had 'in effect' (or in the realm of
the virtual). It is the body operated upon that is understood to exist in the realm
of the potentially disembodied.

Robb's discrimination about terms clarifies an important misunderstanding
about what is meant by the term virtual, as it pertains to representation or image
side of the equation. Virtual medicine is not about treating real bodies in effect or
as if they were being treated, in the hazy realm of the virtual. Rather, virtual medi-
cine is the medical professional's (or VR user's) essential experience of treating
potentially existing bodies. What is disengaged from materiality is not the experi-
ence of the user, but the body acted upon – as representation.

The import of this sense of the virtual is captured in the work of Richard Satava,
a 'pioneer' in telepresence surgery, which involves using virtual reality (VR) to
perform surgery at a distance. Satava distinguishes between artificial and natural
virtual reality. Whereas artificial VR is completely synthetic and imaginary (placing

oneself inside a molecule, for example), natural VR imagines situations one could conceivably inhabit in one's own body and world. Satava insists that 'the day may come when it would not be possible to determine if an operation were being performed on a real or a computer-generated patient . . . the threshold has been crossed; and a new world is forming, half real and half virtual.'

This new world is the very same one imagined by Robb in his projection of a near future when a virtual endoscopic procedure might be indistinguishable from one performed on an actual patient. On one level, it is tempting to hypothesize about the position of the spectator in relationship to this new world of the half real, half virtual. In film studies and in visual culture studies, this claim opens up a whole new realm of spectatorship analysis, taking spectatorship out of the realm of the visual and into a more complexly constituted network of experience. How, we might ask, is the physician situated as a subject in relationship to this new sort of gaze, a relationship with the visual representation that propels the viewing subject into the realm of full sensory experience, and full bodily participation, but with his senses disintegrated and misrouted?

Questions like this signal an important domain, I argue, for visual studies not because the image holds new powers, but because it provides an expedient link into a kind of subjectivity that is quite radically different. If this is a new gaze, it is not one where the visual is terribly important.

I leave off my example having left much of what it suggests undeveloped, in order to return to some of the central questions of this paper. I have argued that with media convergence, film studies becomes a study of something else: a different configuration of media, different conditions of experience and subjectivity. I have also argued that film studies has never been about film (the medium, its social contexts, its spectator) alone, but has always been about conditions of sensory experience in modernity. The material conditions of film have left film scholars well prepared to take on questions of the materiality of virtual media and simulation precisely because, as Anne's Friedberg's work has shown, the filmic spectator has always been entered into a virtual world that is not limited to the experience of the cinema alone. If the image has migrated into the function of signifying something other than visual experience, it is still the specialist in visual analysis who is best equipped to understand the function of the visual to perform a different sort of work. Film studies is one of the areas of scholarship best equipped to address the conditions that underlie the more spectacular aspects of 'cyber-visuality,' precisely because its object has never been solely representation but the conditions of materiality and intersubjectivity that have always structured the field of vision.

References

Alpers, Svetlana (1983) *The Art of Describing: Dutch Art in the Seventeenth Century*. Chicago: University of Chicago Press.

Apter, Emily (1996) 'Visual Culture Questionnaire,' *October* 77 (Summer): 26–7.

Baxandall, Michael *(1972) Painting and Experience in Fifteenth-Century Italy: A Primer in the Social History of Pictorial Style*. Oxford: Clarendon Press.

Buck-Morss, Susan (1996) 'Visual Culture Questionnaire,' *October* 77 (Summer): 29–31.

Cairncross, Frances (1997) *The Death of Distance: How the Communication Revolution Will Change Our Lives*. Boston, MA: Harvard Business School Press.

Crary, Jonathan (1996) 'Visual Culture Questionnaire,' *October* 77 (Summer): 33–4.

Crimp, Douglas (1999) 'Getting the Warhol We Deserve,' *Social Text* 59: 54–5.

Crow, Thomas (1996) 'Visual Culture Questionnaire,' *October* 77 (Summer): 34–6.

Friedberg, Anne (1993) *Window Shopping: Cinema and the Postmodern*. Berkeley: University of California Press.

Friedberg, Anne (forthcoming) *The Virtual Window: From Alberti to Microsoft*. Boston, MA: MIT Press.

Gunning, Tom (1996) 'Visual Culture Questionnaire,' *October* 77 (Summer): 37–9.

Heller, Scott (1997) 'What Are They Doing to Art History?,' *Art News* 96 (January): 105.

Merril, Gregory L., Meglan, Dwight A. and Higgins, Gerald A (1996) 'Re-assignment of Physical and Physiological Attributes to the Visible Human,' paper presented at the Visible Human Project Conference. National Library of Medicine. National Institutes of Health, Bethesda, MD, 7 October.

Mitchell, W.J.T. (1995) 'What Is Visual Culture?,' in Irving Lavin (ed.) *Meaning in the Visual Arts: Views from the Outside: A Centennial Commemoration of Erwin Panofsky (1892–1968)*. Princeton, NJ: Princeton University Press.

Moxey, Keith (1999) 'Nostalgia for the Real,' paper delivered at the Summer Institute in Art and Visual Studies, University of Rochester, 28 June.

October 77 (1996) 'The Interdisciplinary Project of Visual Culture' (Summer): 25–70.

Robb, Richard (1996) 'Virtual (Computer) Endoscopy: Development and Evaluation Using the Visible Human Datasets,' paper presented at the Visible Human Project Conference, NLM, Bethesda, MD. 7 October.

Rodowick, D.N. (1996) 'Visual Culture Questionnaire,' *October* 77 (Summer); 59–62.

Stacey, Jackie (1994) *Star Gazing: Hollywood Cinema and Female Spectatorship*. London: Routledge.

Wood, Christopher (1996) 'Visual Culture Questionnaire,' *October* 77 (Summer): 68–70.

May Joseph

KUNG FU CINEMA AND FRUGALITY

Ujamaa and Tanzanian youth in the 1970s

IN THE OPENING SCENE of his performance piece *In Between Space*, Shishir Kurup, a Los Angeles-based Asian American performance artist, narrates growing up in Mombasa, Kenya, in the 1970s:

> We live over here in Pandya House, a tenement building with shops and offices below. Over here is the Regal Cinema which exclusively plays American shoot-'em-ups, Italian spaghetti shoot-'em-ups, and Chinese Kung-Fu-'em-ups. Sam Peckinpah, Sergio Leone, Run-Run Shaw, Raymond Chow. Tickets are two shillings and forty cents for rows A–J (which work out at about a quarter in American cash), 3/6 for rows K–Z, and 4/8 for the balcony. In this theater Eastwood is badass, McQueen is cool, Bronson is tough, and Bruce Lee can kick all their asses. Shane and Shaft and Superfly and Cleopatra Jones. We hear names like Thalmas Rasulala and Lee Van Cleef. Eli Wallach is the Ugly, Yul Brynner the King, and I the kid with the open mouth stuffing popcorn down my throat. In the Indian film houses, Rajesh Khanna, 'Shotgun' Sinha, Dharmendra, reign supreme. Amitabh Bhachan isn't quite the god he is soon to become and Zeenat Aman is the babe of all our nocturnal emissions.[1]

What Kurup invokes for Mombasa could be found elsewhere in East Africa at this time. Seventies cinema had a transnational impact that intertwines broader ideological, nationalist, Pan-Africanist, and anticolonialist sentiments in the local cultural politics of production and consumption. In the midst of Cold War tensions, nationalist fervor, state sovereignty, and a visible Pan-African solidarity, East African

popular culture is a crucible in the competing international ideologies of socialism, communism, and capitalism across and within national borders. The simultaneous transnational figuration of these ideologies had an impact on local cultural politics within Third World socialisms.[2]

In Tanzania, for example, experiments in socialist democracy foregrounded education and cultural nationalism as primary tools for solidifying the fledgling state. Tanzanian youth were mobilized toward the broader goal of promoting a socialist youth culture. The harnessing of youth in the interest of national culture influenced possible subjectivities, pleasures, and forms of spectatorship. This in turn affected the styles and self-fashioning consumed and publicly exhibited by youth.

In this chapter I investigate some of the connections among diasporic South Asian youth culture, state socialism, and transnationalism by considering the immense appeal and wide circulation of Bruce Lee and kung fu cinema during the 1970s in Tanzania. I examine the early years of nation building through the mobilization of youth from the subjective standpoint of my experiences as a Tanzanian Asian youth under the Africanization and nationalization measures enacted in Dar es Salaam during the 1960s and 1970s.

The popular practices of *ujamaa*, Julius Nyerere's implementation of Tanzanian socialism, coalesce in provocative ways with the phenomenology of kung fu spectatorship. Juxtaposed, they generate a montage of urban Tanzanian youth culture around the 'performance of frugality.' By suggesting here that ideologies are enacted, I dislodge the structural/functionalist approach to socialism and instead probe the phenomenological avenues of self-invention for youth within the discourses of the state. In this chapter I unpack the realms of imaginative self-fashioning that shape Tanzanian Asian youth culture under African socialist modernity.[3]

From 1962 to 1985, Tanzania developed a uniquely pedagogical approach to state formation that was known as *ujamaa*. In his controversial policy paper, '*Ujamaa*: the basis of African socialism,' Nyerere distinguishes Tanzania's experiment in nation building, grounded in village communalism, from other strategies:

> *Ujamaa*, then, or 'familyhood,' describes our socialism. It is opposed to capitalism, which seeks to build a happy society on the basis of exploitation of man by man; and it is equally opposed to doctrinaire socialism which seeks to build its happy society on a philosophy of inevitable conflict between man and man. We in Africa have no more need of being 'converted' to socialism than we have of being 'taught' democracy. Both are rooted in our past – in the traditional society that produced us. Modern African socialism can draw from its traditional heritage the recognition of 'society' as an extension of the basic family unit.[4]

Ujamaa implemented 'villagization,' a system of rural development based on communal self-reliance.[5] This policy move asserted a number of ideological strategies aimed at decolonizing the state. Nyerere countered Western notions of the nuclear family by offering an African-derived conception of communalism stemming from indigenous kinship networks that are extended. He proposed *ujamaa* as a community-based system of development that shares available wealth rather than

accumulates it in the interests of the individual. *Ujamaa* was obviously a radical departure from capitalist forms of development, but also represented a shift in emphasis from Soviet and European socialism toward indigenous customs that shaped local practices of governance. *Ujamaa* villages would not be created through the violent collectivism of Soviet communism. Rather, local transformation would be accomplished through a paradigm of familyhood.[6]

The philosophical underpinnings of *ujamaa*, or self-reliance, were grounded in a destabilization of Western theories of modernization. For Nyerere, the dilemmas afflicting recently decolonized and exploited African states demanded specific local strategies of development. Consequently, Western periodization narratives, with their focus on urbanization imposed on newly independent states such as Tanzania, demanded critical reconsideration. The conscious effort to critique Western notions of modernity, combined with a policy of nonalignment articulated by the Bandung conference and Afro-Asian nations, generated alternative approaches to African modernity. *Ujamaa* was one such approach. As a radical measure to escape the dependency relationships of Western aid sources, this policy privileged the rural over the urban and attempted to redress class inequities by emphasizing the majority constituencies of peasants and workers over the minority urban bourgeoisie.[7]

As a theoretical argument, *ujamaa* functioned as a critique of modernity on several levels. It consciously attempted to create a nonaligned African socialist theory of economic development that was organic and people centered. It operated as an ideological vehicle for Africanization, by drawing on indigenous as well as international philosophies of social change in a uniquely Tanzanian model that privileged the agricultural majority. And it drew on tradition as a contingent, shifting, and inseparable part of the modernization process, as a corrective to the simple dichotomy of tradition versus modernity prevalent in modernization theories, where tradition implies backwardness.

Internal criticisms of the Tanzanian experiment dispelled utopian hopes of finding ways to resist Western forms of accumulation through the government creation of *ujamaa* villages. Instead, this vision of a pastoral communalism, democratic in spirit and free from the ills of landlordism, gave way to a complex hierarchy of centralized power. Women, children, and the urban and rural poor were marginalized in these socialist initiatives.[8] But during those electrifying early years, as policies were still unfolding, the air was thick with the promise of change.

Frugality and Tanzanian Asian youth

Urban youth emerged ambivalently under the sign of *ujamaa*, with its emphasis on rural development and the engagement of youth in economic self-reliance activities. On the one hand was a palpable feeling of social change: literacy programs, racial integration of the school system, Africanization of education through the introduction of Swahili as the medium of instruction, modernization of the curriculum with the introduction of new science, modern mathematics, and civics, which resulted in students trying to talk and behave like socialists. On the other hand was a distinct antiurban logic fueled by *ujamaa*'s principles. Teachers and pupils of primary and secondary schools in Dar es Salaam were obliged to practice socialist

tenets through agricultural projects, the goal of which was to inculcate a sense of responsibility toward the larger community, presumed to be agrarian. The resulting tensions created new sites of antagonism and invention for urban youth.[9]

The performance of frugality was one such avenue of self-invention that emerged in the tension between urban youth and antiurban policies. Frugality in *ujamaa* was a structure of feeling between the logic of consumption and the practice of anti-consumption under policies of economic self-reliance. As theorized by Nyerere, frugality was a strategy for culturally delinking the youthful state.[10] It offered opportunities for personhood, drawing on indigenous African socialism through the inculcation of a national consciousness of self-reliance. Sports, dance (*ngoma*), marching, farming, and national service were all aspects of this performance of frugality. These spheres of physical embodiment were practiced as state-implemented technologies of care for youth.

Rising anti-Asian and antiurban sentiment under intensive Africanizing measures connected the frugality of Tanzanian Asian youth culture to *ujamaa*. One site of this connection was the popularity of kung fu cinema during this time. The reception and translations of kung fu instantiate the struggles of frugality that shaped a non-African Tanzanian youth constituency under socialist modernity.

The early 1970s saw an influx of Hong Kong, Chinese, and American kung fu cinema into urban Tanzanian popular culture. As part of a larger international film market of Hindi films, Italian spaghetti Westerns, Soviet exports, American Westerns, and the very popular Blaxploitation films, Bruce Lee's *Enter the Dragon* (1973) generated a passion for kung fu among urban South Asian-Tanzanian youth. Popular song lyrics like 'Everybody was kung fu fighting,' posters of Bruce Lee on the streets of Dar es Salaam, the fetish for the nunchaku and black-cloth Maoist shoes, the speedy martial movements of beachside wrestling matches, side kicks, and one-finger push-ups – all were extravagantly popular. The Mao suits worn by groups of railway technicians from China and North Korea brought to Tanzania during the 1970s – and worn by Lee as well – carried a certain chic for local Asian youth. Images of Jim Kelly, Fred Williamson, Tamara Dobson, Pam Grier, Grace Jones, and Richard Roundtree also circulated as representations of 'America' or the 'West.'[11]

The heterogeneity of 1970s Tanzanian youth culture was inflected by an inherited colonialist logic of residential segregation. The popular youth cultures of minorities such as Asians were visible in Asian parts of the city, such as Mosque Street and Upanga. Bollywood (Hindi) cinema played at downtown movie houses like the New Chox, Avalon, and the Odeon, as well as the popular drive-in theater. Amitabh Bachan, Rajesh Khanna, and Zeenat Aman embodied a hip Indian diasporic popular sensibility, but the rise of Bruce Lee as a charismatic and diabolical Asian superhero operating between communist and capitalist economies ruptured the boundaries of an otherwise segregated urban Asian Tanzanian youth culture.

The popularity of Hong Kong and Chinese kung fu cinema, epitomized by Bruce Lee films, created a multiethnic spectatorship within the implicitly segregated city of Dar es Salaam. As an ambivalent sign of Maoist socialist and American self-invention, Lee's films opened up desire and pleasure within contradictory sites of citizenship such as the movie houses, the rapidly integrating movie audiences, and American popular culture itself. Lee and the cinema he popularized shifted the

binaries of the Black/white axis of race discourse in the reception of popular cinema by presenting a predominantly Asian visual field for a heterogeneous Tanzanian audience. In the process, Tanzanian spectatorship drew on new definitions of pleasure, social space, and emancipatory possibilities within an African-style socialism, forging a realm of visual modernity through the rhetoric of frugality and a radically new technology of the self. The economy of kung fu movement echoed a local aesthetics of the frugal, unadorned, but active socialist body, capable of serving the state. This empathy, combined with Maoist-inflected rhetoric and narratives of capitalist versus revolutionary, youth versus feudal lord, and decadence versus scarcity, resonated with the structure of Tanzanian socialist pedagogy.

Kung fu foregrounds an abhorrence of any technology other than the self as a means of juridical and revolutionary intervention, highlighting the importance of frugality as an everyday strategy. It does this through the striking absence of guns or bombs, a genre formula that is theatrically fastidious in its austere focus on the frugal body. By inscribing capitalism and decadence onto the body, socialist notions of self and spatiality emerge in Lee's films *Enter the Dragon*, *Fists of Fury* (or *The Big Boss*), *The Chinese Connection* (or *Fist of Fury)*, and *The Return of the Dragon*. In contrast to the deindividualized rhetoric of Tanzanian socialism, however, Lee valorizes the disenfranchised masses on whose behalf he fights but foregrounds the individualistic self as problem solver.

The question of what kind of pleasure this contradiction produces for socialist youth links kung fu cinema to Tanzanian socialist technologies of self. Kung fu spectatorship brings together the disjunctures among the material frugality of the socialist state, the aesthetic frugality of unadorned martial bodies combating capitalist evil (such as landlords), and the excess of the spectator consuming Hong Kong and American cinema in a culture of anticonsumption. Watching kung fu cinema stages the tensions generated by a desire for transnational circulation of commodities under conditions of scarcity. It performs the ambivalence of frugality as it invites spectators to consume globalizing commodities such as Hong Kong cinema, structuring a transnationally linked sphere of enjoyment.

Struggling between the seductive machines of First World technologies of the body and everyday life under conditions of frugality within African socialism, youth consumed kung fu, with its contradictory play on gender, sexuality, and masculinity. These dimensions were otherwise silenced under the centralized one-party state of the Tanzanian African National Union (later the Chama Cha Mapinduzi), whose privileged forms of cultural citizenship were inflected by its proletarian and agrarian-based policies of socialist belonging.

Decolonization, governmentality, and the invention of youth

The circulation of kung fu cinema in 1970s Tanzania reveals the particular methodological, ideological, and aesthetic dilemmas embedded in the category 'youth' during the first decades of decolonization in an African socialist state. The problem of theorizing 'youth' outside a European/US framework lies in the epistemological assumptions of Anglo-American youth subcultural theory, predicated on the

established sovereignty of the state within which forms of late-capitalist culture produce notions of self, education, leisure, location, community, hegemony, and rebelliousness. Consequently, much theorizing in youth studies of the 1970s and 1980s assumes certain institutional orthodoxies regarding the forms of state legitimation of cultural and legal citizenships, through which notions of youth culture as pathology and moral panic have emerged in Britain and the United States.[12]

The work of scholars of the Birmingham school of cultural studies, addressing representations of white and Black working-class youth in Britain, has been crucial to such an analysis.[13] Although the theories of the Birmingham school offer approaches to reading 'youth,' the particular contexts of socialist states such as Tanzania caution against drawing easy parallels between youth formations across national and political cultures. The heterogeneity of Tanzania's 120 ethnicities, for instance, complicates concepts of difference advanced by Anglo-American youth discourse. A dialogue of homogeneity and hybridity, of authenticity and inauthenticity, molded the discourse on race as these heterogeneous communities emerged as a socialist majority wary of its commercially successful non-African communities, such as Asians.

As opposed to the longer history of nation formation out of which Anglo-American subcultural theory emerges, the recentness of postcolonial sovereignty creates the epistemological and historical bind of theorizing youth within a contingent modernity-in-formation. The early writings of Nyerere are insightful here, providing ongoing political analysis of the institutional, cultural, and representational practices of colonial bureaucracies, that articulated 'young people' in discrete and obvious ways in the interests of the mother country.[14] To counter the debilitating neglect of youth in the colonial era, Nyerere proposed a radical approach to educating young people, initiating policies to update and Africanize the curriculum, introducing African history and Swahili as the language of instruction. He critiqued the anthropological model of Christian missionaries civilizing indigenous populations, through which the colonial bureaucracy sought to perpetuate itself. Instead, he proposed postcolonial pedagogical strategies of Africanization for decolonizing youth culture. Such a syncretic modern approach to cultural delinking was intended to reverse colonial penetration rather than presume monocultural isolation.

For Nyerere, education was crucial for decolonizing the state and consolidating the socialist nation. With the implementation of Swahili, a visibly socialist Swahili youth culture was forged as national culture. Schools were nationalized and generated a secular, nationalist, anticolonial youth culture. Under the secularity of nationalization, ethnically diverse schools coexisted, shaping varied conceptions of youth in relation to the state, to religions such as Islam, and to the intraethnic cultures within which youth existed in Dar es Salaam. Former colonial institutions such as the Boy Scouts and Girl Guides; technical institutes teaching needlework, cooking, and carpentry; the sports clubs; and Christian groups like the YWCA and YMCA articulated Tanzanians as 'youth.' Thus youth emerged as a diverse, polylingual, multidenominational constituency.

For Tanzanians in the 1960s, a hegemonic 'national' culture was still struggling to be articulated through delinking, nationalization, indigenization, vernacularization, and self-reliance.[15] 'Youth' was a founding category for the radically socialist state, and state policy demanded that the socialist commitments of youth be affirmed

through physical expressions of solidarity. These performances of socialist commitment, consolidated around projects of self-reliance, were mainly agricultural, where young socialists trained in notions of communal responsibility. Like Lenin and Mao, Nyerere prioritized youth in his experiments with African socialism – signaled by the Africanization of education – and while this focus situated youth in a powerful relation to the emergent state, expressive youth cultures had to negotiate multiple forms of co-optation or containment. The struggle to create a cohesive national youth culture in opposition to the colonial legacy of 'Englishness' fabricated by the machinery of schooling, church, jurisprudence, administration, and bureaucracy became a new orthodoxy against which subcultural forms emerged.[16]

The theory of youth conceived by Nyerere was informed by the anti-imperial strategies of many African intellectuals and revolutionaries, including Patrice Lumumba, Kwame Nkrumah, C.L.R. James, Walter Rodney, Frantz Fanon, Léopold Senghor, Samora Machel, Tom Mboya, and Ngugi wa Thiong'o. For Nyerere, youth was a pedagogy of nation formation. This contrasted with the colonial neglect of youth during the 1940s and 1950s. Under such contending ideological and cultural terrains of antagonism and desire, youth emerged as a new orthodoxy, a rhetoric of statehood both conformist and radical in its larger political aim.[17]

Nyerere's self-conscious theorization and implementation of youth culture in Tanzanian public life was dialogically linked to the international public sphere. His pedagogy of youth – the mobilization of youth in the interests of the state – should be viewed in the context of the instrumental role played by the internationalist youth movements of communist states in the Soviet sphere, China, and other Third World nations. His long-range goal was to forge alliances across African states to overcome the pressures of dependency economies, that surfaced as the new face of imperialism. Striving for a Pan-African post-nation-state federation, he deployed the language of radical social democracy on historically new terms – socialist, nationalist, and Pan-African. The resulting solidarities and contradictions of these three contending ideologies produced a locally vibrant African socialist youth modernity.[18]

Lenin-Mao-Nyerere: the performance of statehood

Ujamaa emerged as a new anti-imperial and egalitarian logic of self-help. Its central figure was the nation's youth, on whose shoulders rested the future of nation building. *Ujamaa* sought a self-reliant state that had decolonized ideologically, phantasmatically, and territorially. It was symbolized by school youth working in public spaces. Among other activities, such work involved tending the *shambas* (state-owned vegetable gardens), marching, planting trees along city roads, clearing public spaces, and maintaining school compounds.[19]

In The *Tasks of the Youth League*, Lenin locates youth as the fundamental base of the production of statehood and lays out a pedagogy for youth citizenship, arguing that 'we must deal in detail with the question of what we should teach the youth and how the youth should learn if it really wants to justify the name of communist youth, and how it should be trained so as to be able to complete and consummate what we have started.'[20] Nyerere's treatise on nation building closely follows Lenin's prescription for modern education, formulating a specifically Tanzanian-based model

for African socialism. Elaborating on what 'proletarian' culture might signify for Tanzania, Nyerere's foremost project was the modernization of education through the mobilization of youth. Interpreting Lenin's formula for educating the youth leagues by 'learning, organizing, uniting and fighting,' Nyerere introduced an array of activities to generate what Lenin calls the 'shock group' of youth who can help 'in every job . . . displaying initiative and enterprise.'[21]

Suburban vegetable gardens were central to this project. Lenin elaborates on the vegetable garden as a means of abolishing disparities between classes, particularly the intelligentsia, by dissolving the division between the theory and practice of communism. 'The members of the League should use every spare hour to improve the vegetable gardens, or to organize the education of young people in some mill or factory,' Lenin writes, in order that they may view labor differently from the way they did in the past.[22] This idea became central to the category of youth in Tanzanian socialism, as the policies of *ujamaa* approached the schooling of youth through the implementation of physical activities such as gardening in the name of nation building. Young socialists had to participate in grassroots economic self-reliance activities, of which agricultural projects that involved tilling the land were an integral part.[23]

Youth emerged as a decolonizing postcolonial public sphere through which the newly independent nation-state became manifest. Parades, marches, and *ngomas* (folk dances); children waving flags by roadsides as Nyerere and other state functionaries drove by; compulsory large-scale youth drills with clubs, hand gestures, sticks, and guns; and mandatory summer camps inked the schooling of youth to the creation of good citizens. Learning how to wield a *jembe* (hoe) and maintain a *shamba*, growing one's own vegetables, was a crucial component of the curriculum in many high schools. The use of the word *ndugu* (comrade) for both genders and the radical move to make Kiswahili the primary means of instruction at school and university were important corollaries. The compulsory marching every day before and after school and the regime of sweeping and dusting one's own school compounds followed Lenin's advocacy of youth organizing the cleaning of city blocks or villages. Hence one could observe the primary students of Dar es Salaam walking to school with brooms and school boxes. This was an elaborate and persuasive instrumentalization of the category youth within the national culture, and the shape of modernization under African socialism.[24]

Nyerere's visit to China in 1965, the publication of the Arusha Declaration in 1967, and the nationalization of banks and industries in the public and private sectors earlier that year consolidated his Leninist/Maoist notions for a new African democracy forged and sustained by youth. The establishment of organizations such as the Tanzanian National Service and policies such as 'Education for self-reliance' cohere with Maoist principles of producing the state through the training of young people as citizen-workers. Along with this ideological hybridization came an influx of cultural commodities in the guise of North Korean table tennis coaches; Chinese books, stationery, and shoes; Soviet mathematicians and physics teachers; Chinese engineers for the Tanzanian/Zambian railway project; Soviet export cinema; and kung fu cinema à la Raymond Chow, Lo Wei, Run-Run Shaw, and Warner Bros.[25]

Technologies of frugality: kung fu and the ambivalence of enjoyment

'Hong Kong invaded the U.S. film biz this weekend as "Rumble in the Bronx," starring Jackie Chan, and "Broken Arrow" directed by John Woo, scored a one-two punch at the box office,' wrote Andrew Hindes for *Variety* in February 1996.[26] *Rumble in the Bronx* soared to the top of the box-office hits with an estimated gross of $10 million, followed closely by the John Travolta vehicle *Broken Arrow* at $8.3 million. Retrostyle 1970s are back, complete with bell-bottoms and flared synthetics. Kung fu is making a 1990s return in New York, with tae kwon do, hapkido, kick boxing, karate, aero-boxing, Thai boxing, and Brazilian capoeira providing a range of martial art-inflected styles of choreography. Christian Slater quotes Bruce Lee in the opening sequence of *Broken Arrow*, and Jackie Chan comes into his own in the United States with *Rumble in the Bronx*, no longer a shadow of Lee, though citationally invoking him. Observing this, I am reminded of another time of plastic clothes, bell-bottoms, platform shoes, Afros, and Bruce Lee.

Lee's first film was *Fists of Fury* (originally titled *The Big Boss*; 1972), directed by Lo Wei and produced by Raymond Chow. This anticapitalist/antifeudal propagandist film is closely linked to populist socialist rhetoric that privileges the laborer or peasant, embodied most dramatically by Lee himself in his Chinese worker suits. Like the rest of his films, *The Big Boss* presents a field of contested class and race relations to a public of peasants and workers. Social space in Lee's films demarcates narratives of good versus evil, urban versus rural. There is the corrupt foreman of the ice factory in *The Big Boss*, the drug lord/capitalist entrepreneur Mr Han in *Enter the Dragon*, and Rome-based American mafiosi in *Return of the Dragon*.

The Big Boss did not attain great popularity in Tanzania until the success of Lee's Warner Bros. venture *Enter the Dragon* (1973), directed by Robert Clouse, produced by Weintraub and Heller in conjunction with Raymond Chow, and scored by Lalo Schifrin. This phenomenally successful film broke the predominantly Black/white cinematic field of race constructed by the deluge of classical Hollywood narratives in Dar es Salaam. The hegemony of Hollywood was interrupted only by a modest glut of Hindi films frequented by a largely Asian Tanzanian audience. Lee's international stardom problematized the narrow spectrum through which race was constituted in Tanzanian popular cinema. As both Mahmood Mamdani and Isaac Shivji note, this was a time of simmering anti-Asian sentiment, exacerbated by legislative moves to nationalize Asian businesses. These developments had far-reaching repercussions for a cultural politics of race in Tanzania.[27]

Enter the Dragon was spectacularly successful, playing to packed houses in Dar es Salaam throughout the early 1970s. Its seductively racist narrative provides an exciting sense of internationalism that in retrospect is merely a Hollywood rendition of the starving exotic Oriental enclave much fetishized by the British and Americans: Hong Kong as a colonial metropole. The aura of kung fu's internationalism in *Enter the Dragon* is a trans-Pacific fantasy, both Orientalist and pro-American, with chop-socking Asians, Shaolin temples, and chop-socking Westerners. The opening sequences locate Hong Kong as a cosmopolitan fetish of the Pacific – for capitalists, secret agents, martial artists from both the East and West, and drug

lords. John Saxon, Bob Wall, and Jim Kelly provide the spectrum of Westernness through which Lee's own transnational identity is realized, both Asian American and Hong Kong Chinese. In the film, Lee is an agent of the British government working against Chinese criminals. The Asian American Lee is joined by the Anglo-American John Saxon and the African American Jim Kelly, setting up an imperialistic relationship between travelers and natives, juxtaposing Vietnam refugees in Hong Kong Harbor with evil Chinese landlords, and martially trained youth against the cosmopolitan sportsmen/travelers from the West.

Enter the Dragon raises interesting questions about the visual and narrative ambiguity of spectatorial pleasure in a postcolonial context. The colonialist ideology of British and American hegemony in Hong Kong is barely concealed in the good Americans/bad Asians plot: the American trio's exploits in Hong Kong frame them as heroes liberating the people from exploitative landlords. For audiences in a nonaligned, anti-imperialist state such as Tanzania, this idea of 'the good' was discrepant enough, but the contradictions were heightened by local Tanzanian politics regarding landlordism and Africanizing measures. The issue of local landlordism was a crucial rallying point of economic nationalism. Hence the visual pleasure of restoring Western hegemony through the overthrow of local landlordism conflicted in diametrically opposing ways with issues of African sovereignty.

Another axis of spectatorial ambiguity is that posed by Jim Kelly, whose popularity as an African American actor provided a visual hook for Tanzanian spectatorship in more ways than one. Kelly flees police brutality and white supremacy in Los Angeles and belongs to a Black Power enclave in the form of a Black karate school. He exemplifies a notion of American cool that resonates with Tanzanian notions of Pan-African cool, as he wears red bell-bottoms and an Afro and embodies a style of politics in sync with Black nationalist sentiments in Dar es Salaam during the 1970s. Kelly complicates the politics of white and Asian American masculinities pitted against generic Oriental masculinity by introducing the violent race politics of Los Angeles. He marks the Pan-African connections to Asia through ideological solidarities with Third World struggles, the martial arts, Asian religions, and the transnational exchange of socialist kitsch. But, as Kelly's death in the film reduces the complexity of his narrative presence to a prior, stereotyped racist representation, it produces a resistant reading that inflects the closure of the film. In a sequence reminiscent of a lynching, Kelly's body is impaled on a hook with chains and lowered into a vat of acid. The stereotypical racist solution of the death scene negates the potentially imperialist fantasy tale of Westerners cleansing the world of evil. Instead, the haunting specter of racism in the imperial home fractures the colonialist self-righteousness behind 'Americans' rescuing the 'Orient.'

The film's gender politics are equally complex. Whereas at first it replicates the misogynist and sexist logic of early mainstream kung fu cinema through the production of women's bodies as objects of pleasure, the figure of Angela Mao, a hapkido black belt, as Bruce Lee's sister, Su Li, offers a new kind of representation. Mao kung fus her way through a battalion of Han's men, preferring suicide with a piece of glass to the horror of rape at the hands of the malevolent American, played by Bob Wall. Angela Mao embodies a new kind of socialism – an agent against patriarchy and traditional notions of femininity who dismantles the coordinates of gender role-playing as she opens up other ways of socializing women's

bodies. Mao creates a transgendered space outside familiar representational forms, performing the martial-socialist body of the comrade. Discarding gender binarisms, Mao enacts both the promise of kung fu, as a site of social militancy, and its failure. She enacts its promise by demonstrating that she can fight better than most men, with an indestructible sense of self. Her socialist body echoes closely with the popular transgendered practice of calling all persons – irrespective of gender – comrade or *ndugu*. Her death, however, performs its failure by reiterating the reductive ways that gender and sexuality work to subject women's and other minority bodies to violence.

The tensions of race, gender, ethnicity, and masculinity raised in *Enter the Dragon* foreground the transcultural misreadings through which Bruce Lee gained international popularity. The film highlights the complex ways in which Lee himself is situated as a hybrid Asian American, binationally affiliated, working in Hong Kong and California. Lee was an American citizen and had opened schools of jeet kune do in Seattle and Oakland. His multicultural clientele included such African Americans as karate champion Jim 'Kung Fu' Kelly, Lew Alcindor (who later took the name of Kareem Abdul-Jabbar), and the judoist Jesse Glover; Anglo-Americans such as Steve McQueen, James Coburn, and Stirling Silliphant; Asian Americans such as Japanese American judoist Taky Kimura and Filipino American escrimaist Dan Inosanto; and others, such as Roman Polanski.[28]

Tanzanian cultural politics of the early 1970s are also tied to the rabidly nationalist anti-immigrant sentiment expressed in Lee's films. He is pro-Chinese peasant, anti-Japanese, anti-Soviet, and anti-Western in *The Chinese Connection* (1972), directed by Lo Wei – a xenophobia expressed in the beatings of a Japanese Bushido boxer and a former Soviet champion boxer. Combined with the film's attempted critique of 1930s colonial Shanghai, this produces a confusing mélange of condemnation and racist stereotyping. The Japanese occupation of Shanghai and the northern provinces as depicted in *The Chinese Connection* resonates with the strong anti-Asian sentiment perpetuated at the time in Tanzania, situating the immigrant petit bourgeois entrepreneur in antagonistic relation to the interests of the nationalist masses.

In *Return of the Dragon* (1973), Lee plays a country bumpkin from Hong Kong who avenges the harassment meted out to his restaurateur relatives by an underworld ring of immigrants from the United States and other countries. Typical of most of his films, the climax is structured around a choreographed fight sequence, in this case his encounter with the American Chuck Norris in the Roman Coliseum. Lee asserts his anti-Western perspective by destroying all threats to his relatives' future in Rome, epitomized by Norris, only to discover that there is no place outside capital itself when he learns that his uncle is in league with the criminals.

Lee died before completing *The Game of Death* (1974), set in Bangkok, but its structuring ethnocentrism is nationalist in contradictory ways. Lee demonstrates the superiority of Chinese kung fu over other forms by decimating a Korean hapkido specialist, an escrima stylist, a Japanese samurai, and a Black boxer played by Kareem Abdul-Jabbar.[29] Jingoistic ideological content, bare-bones dialogue, and often atrocious production qualities – none of these detracts from Lee's kung fu performance. His choreography creates contradictory spaces for the participation of heterogeneous subjectivities that constitute the audience under the faceless charisma of statehood

itself. The power of his films lies in his cultish persona and brilliance of movement, but the popularity of his films in Tanzania accrued a narrative depth that the plot and diegesis could not.

Lee was clearly the first transnationally situated Asian American actor simultaneously working for very different markets in Hong Kong, Hollywood, and the Third World. His transnational interests created divergent pressures on his status as a megastar across Asia, Africa, and other Third World countries. The international economies of kung fu filmmaking and its distribution also blurred the distinctions among ethnicities and national contexts. For Tanzanian Asian youth, there were few or no distinctions among the films of Hong Kong, mainland China, and Warner Bros. Kung fu cinema was generically read as mainland Chinese or Maoist, and Chinese cinema was reduced to the kung fu genre.

Technologies of the self: Foucault's *askesis* and Nyerere's frugality

A reading of kung fu enables one to revisit the informal avenues of enjoyment under East African 1970s socialism. Bruce Lee's popularity as an *uchina* (Chinese hero) at this particular juncture is interesting for many reasons, one being that he privileges what I would call a technology of frugality, or the body as a weapon of frugality. Lee's technology of frugality was a philosophy of efficient and minimal action, whereby the opponent's weaknesses are utilized to fuel the self's power. For Lee, a little is enough. Frugality became a voluntary technology of plenty, an articulation of agency. Lee's cultivation of an aesthetics of frugality on-screen cohered with Nyerere's theory explained in a 1965 speech to the nation:

> In February I went . . . to China, and there I learned one very important thing . . . they are a frugal people . . . it would be very foolish of us . . . individually or as a nation, to appear as rich as a country like America. Everyone knows that we are not rich. And the only way to defeat our present poverty is to accept the fact that it exists, to live as poor people, and to spend every cent that we have . . . on the things which will make us . . . more educated in the future.[30]

Such a reading of China seems simplistic and reductive from the vantage point of the 1990s, as contemporary forms of capital and exchange have permeated even the much-desired frugality of that country. Still, such an aesthetics laid out by Nyerere has broad implications for a phenomenology of frugality through which youth forges avenues of enjoyment.

A phenomenology of frugality is structured around imaginative embodiments of little-as-enough, of anticonsumption, of which kung fu partakes. The choreography of kung fu trains the body as a weapon of vigilance. It hinges on a technology of self otherwise relegated to the state through the police, the military, sports, national youth service, and other forms of regulative socialization. Kung fu valorizes an aesthetics of self-governance closely aligned with forms of control that produce and sustain state-saturated societies such as Tanzania.[31] In such societies, the

individual, articulated as youth, is produced through various institutional regimes and practices as the vigilant and productive machine of the state. Youth becomes a technobody whose every action and enjoyment should be directed by a pedagogical practice of statehood.

One aspect of such an aesthetics of frugality is the ascetic and athletic care of the self. In his lectures on the technologies of the self, Michel Foucault discusses how the practice of *epimelesthai sautou* ('to take care of oneself,' 'the concern with the self') was a crucial philosophy in Hellenistic Greek cities.[32] Through a close reading of the Socratic dialogues, Foucault argues that Socrates considers his mission useful for the city, in fact 'more useful than the Athenians' military victory in Olympia – because in teaching people to occupy themselves with themselves, he teaches them to occupy themselves with the city.'[33] Foucault links the care of oneself and the city to Christian asceticism eight centuries later and its edict to know oneself.[34]

As part of this meditation, Foucault elaborates one of the three Stoic techniques of self, *askesis*, described as a remembering – not a disclosure – of the secret self: 'It's the memory of what you've done and what you've had to do.'[35] The two poles of this principle are *melete*, or meditation, and *gymnasia*, 'to train oneself.' As Foucault points out, there is a spectrum of intermediate possibilities as well.[36] Bruce Lee's choreography occupies this intermediary possibility of the care of the self, which by extension becomes a care of the youthful body in the city through a performance of gymnastic frugality, kung fu.

In Bruce Lee's films, the meditative self, physical training, and the juridical process work in mnemonic fashion to restore order to the chaotic youthful city. The striking presence of gangs of young men training in kung fu schools (whether Chinese or Japanese), the comparative absence of women as agents, and the group movement of youth across the city in search of justice link kung fu to notions of male sociality in the modern metropolis. Lee's choreography reads as a performance of informal juridical practices of urban youth. The fight sequences emphasize an urban reclusiveness, enacted in the crowded street, in public spaces like the Coliseum, or in the winding alleys of Macao, restoring order to the chaotic urban landscape. The economic theories of frugality advanced by Nyerere and Foucault's technologies of self merge in Bruce Lee's choreography of the self and the city.

Kung fu, radical historical subjects, and feminist imaginings

In a broader context, kung fu choreography embodies a viable technology of self for people of small frames, implicitly critiquing conventional masculinity. Though Lee's style of kung fu, wing chun fist, is popularly associated with male homo-sociality, its origins lie in a form developed by Yin Win Chung, a Buddhist nun from mainland China, that she invented as self-defense for females and people with small frames. Hsiung-Ping Chiao suggests that wing chun fist emphasizes speed as opposed to strength and notes that Lee learned it at age thirteen from Yip Man, the sixth-generation master of the wing chun fist school.[37] The privileging of speed over strength is an important factor in understanding the wing chun fist form in terms of a radical historical subject such as the martially trained Buddhist nun in

thirteenth-century China who first developed it. This provides an explicit link between feminism and kung fu, which opens arenas for the negotiation of gender through movement and choreography within kung fu history and as a visual representation of women breaking boundaries within public space.

The connections between kung fu and feminist interpretations of martial movements are not evident in the visually gendered identities of early kung fu cinema, much of which preserves the status quo of men as fighters and women as sexual objects. But although 1970s kung fu cinema maintains the dichotomy of docile women and warring men, the occasional ruptures are startlingly uncompromising and even empowering. For instance, the emergence of new historic subjects such as Angela Mao ('Lady Kung Fu,' discussed above), Black kung fu expert Tamara Dobson, and martial artists such as Chen Hsin, Chen Kuan-Tai, Meng Fei, Wang Tao, and Tanny dismantles orthodox notions of gender, valorizes androgyny, and creates transgendered choreographies, diminishing the conventional framing of male martial bodies.[38] These brief choreographic ruptures challenge stereotypes of women as weak, dependent, or victimlike by showing women decimating dozens of young men through dexterity, intelligence, extraordinary skill, and strength. Hollywood's Tamara Dobson, along with Hong Kong cinema's Angela Mao and Tanny, popularized muscular fighting bodies, martial movements, lesbian desire, and a campy style of femininity. Before lipstick feminisms came platform feminists, giving patriarchy the karate chops it never expected.

Kung fu-kicking special agent Cleopatra Jones (Tamara Dobson), six feet two inches tall with platform shoes and packing a cosmopolitan cool, demonstrates a connection between feminist critiques and a Black radicalism that is mobile and internationalist. In *Cleopatra Jones* (1973), the protagonist fights drugs in her own community and still finds time to organize antidrug maneuvers in Turkey. Her worldliness, her articulation of power and gender in visually novel terms, suggests other ways of being Black within capital. In *Cleopatra Jones and the Casino of Gold* (1975), she is partnered with dart-throwing British superagent Mei Ling Fong (played by Tanny), a historically new on-screen alliance grounded in lesbian desire. Actually, in this film power and desire are constructed along the axis of same-sex identification and antagonism among three women: Shelley Stevens, Dobson, and Tanny. The irreverently antipatriarchal undercurrent in the film's spectatorial field opened up alternative imaginings in 1970s youth culture: the martial art for small frames gained currency among teen feminists as self-defense and a technology of care *from* men.

Kung fu and the emergence of new historic subjects

Bruce Lee shattered the hermetic secrecy of kung fu by teaching it to anyone who wanted to learn the form, raising provocative questions about kung fu and race. Lee's master-student relationship with African Americans like Jesse Glover, Kareem Abdul-Jabbar, and Jim Kelly and the establishment of Black martial art schools in Los Angeles and elsewhere in California attest to the form's eclecticism, transnational malleability, and appeal to all frames and cultures. The widespread popularity of kung fu in Blaxploitation films links the martial art to Pan-Africanist and Black nation-

alist embodiments of the care of the self, in which the self becomes a tool of revolution, for fighting drugs, white hegemony, injustice, and the state. The films of actors/sportsmen like Jim Kelly, Tamara Dobson, Pam Grier, Jim Brown, Fred Williamson, Richard Roundtree (*Shaft*, 1972), Ron O'Neal (*Superfly*, 1972), and Kareem Abdul-Jabbar are noteworthy examples. Jim Kelly's *Black Belt Jones* (1972) features a Black karate school with a picture of Bruce Lee hanging, shrinelike, in the background. In *Enter the Dragon*, Kelly is seen leaving his fellow martial artists at a school in Los Angeles before going to Hong Kong, and the association of martial arts with the training of Black men to survive in a hostile police state is explicit.

The works of Michele Wallace, Gladstone Yearwood, bell hooks, Manthia Diawara, Mark Reid, and Ed Guerrero, among others, address the misogyny, sexism, and stereotyping of African Americans in Blaxploitation cinema of the 1970s, while also marking the possibilities these films held for the development of Black cinema.[39] Building on the analysis of such authors, it becomes possible to read the cultural capital of Blaxploitation cinema as it circulates and translates in ways that exceed its reception in the United States.

Early blaxploitation superheroes made possible a new kind of visual pleasure for Tanzanian Asian youth. The spectrum of martial art styles popularized by Bruce Lee's jeet kune do and other forms of karate and judo incorporated into kung fu by Kelly, Williamson, Brown, Dobson, and Abdul-Jabbar, presented a technology of self that was aesthetically synchronous with the conditions of frugality in Tanzanian popular culture. As a sophisticated choreography for a martially oriented militaristic dance, it suited the local emphasis on discipline and sport. This linking of kung fu to Black struggle in Blaxploitation films rearticulated resistance and revolution across ideological lines, and the Pan-African implications of Black struggle resonated with popular Tanzanian youth sentiments of the time, particularly in its practice of frugality as a style of movement. The body is the only machine of action: there are neither guns nor any other autonomous technologies apart from the self.

Kung fu cinema's connection to a diasporic schlock consciousness in the 1970s is complicated by its relations to race, gender, the Cold War, and the more transnational imaginings perpetuated through kung fu kitsch. Lee's films, in particular, are visually disorienting as the eclectic ethnicities of the actors and landscapes blur the distinctions between context and period. The visual field is 'Chinese.' However, the actors are of Thai, Malay, Japanese, and Chinese ethnicity; the landscapes are those of Hong Kong and Thailand; and the badly dubbed dialogue unwittingly creates a Brechtian alienation effect through its asynchronous sound.

Still, kung fu's connections to Tanzanian socialism, Black nationalisms, Bollywood fight sequences, emergent feminisms, and a diasporic youth consciousness of 1970s kitsch have returned today with a 1990s twist. Spinoffs from kung fu cinema have been more important than the genre itself, nostalgically evoked in the hyperviolence of contemporary Hollywood films. Its embeddedness in an aesthetics of frugality inadvertently raises the question of how frugality travels across national and political cultures. The globalizing influences of Hong Kong cinema and its particular translations in Tanzanian popular culture as a mediating space between scarcity and excess, between 'Asianness' and Tanzanian Asians, and between capitalist kitsch and socialist ideology open up the intricate transnational linkages in the circulation of meaning generated through the consumption of movies.

Tanzanian socialism took youth as central to its project. As A.G. Ishumi and T.L. Maliyamkono state, 'This ideological conditioning was carried to its extreme in the teaching of civics, a school subject dubbed Political Education since 1967, which resulted in virtually all pupils trying to talk, act or behave like socialists. This was indeed an ideological success, even though, in retrospect, it may have been more deceptive and pretentious than real.'[40] The particular embodiments, translations, and cultural capital of socialism were closely linked to the informal ways in which youth imbibed and made local forms of socialist desire, whether in antagonism or consent.

An important part of the mechanics of state formation was the performance of frugality, the emphasis on communal self-reliance as exemplified in the practice of *ujamaa*. As I have shown, there is a formal parallel between the performance of frugality and the youth culture of 1970s Tanzania. The gender ambiguity of win chung fist and the appeal of an explicit 'technology of self' to a consciousness of nation building offered a nascent transnational aesthetic of frugality for emerging expressive youth cultures.

With the state appointing itself as the home of youth through the rhetoric of family, and the head of state assuming the role of teacher or father of the nation, the paternalistic formulations of socialist practice became linked to state control. Whereas Nyerere's more stringent critics have dismissed his experiments in socialist pedagogy as authoritarian, I argue here for a more nuanced consideration of a critical and daring experiment in grassroots social transformation as it interfaces with global popular culture. The philosophy of self-reliance articulated in *ujamaa* was farsighted and utopian, but doomed to be structured as failure by the West. Instead of dismissing forms of postcolonial citizenship in peripheral states as failures, however, we need a more capacious reading of the kinds of desire, longing, and imaginative reinventions that fill up the abstract spaces of state formation.

Notes

1 Shishir Kurup, 'In Between Spaces,' in *Let's Get It On: The Politics of Black Performance*, ed. Cathrine Ugwu *et al.* (Bay Press, Seattle, 1995), 34.

2 Ali A. Mazrui, 'Cultural Forces in African Politics,' in *Africa and the West*, ed. Isaac James Mowoe, and Richard Bjornson (Westport, Conn., Greenwood Press, 1986). See also Ali A. Mazrui's *Cultural Forces in World Politics* (Nairobi: Heinemann, 1990) and *The African Condition* (Cambridge: Cambridge University Press, 1980).

3 While there were many spheres of youth practice, my observations are inflected primarily by my experiences as a Tanzanian youth schooled under *ujamaa* in Dar es Salaam and Arusha. The rhetoric of a classless and raceless society worked to conceal as well as to foreground the kinds of racisms and classisms that developed under the transforming structures of Tanzanian civil society.

4 Julius K. Nyerere, '*Ujamaa*: The Basis of African Socialism,' in *Freedom and Unity / Uhuru Na Umoja* (Dar es Salaam: Oxford University Press, 1966), 170.

5 Julius K. Nyerere, 'The Arusha Declaration,' in *Freedom and Socialism / Uhuru Na Ujamaa* (Dar es Salaam: Oxford University Press, 1968), 247.

6 Donatus Komba, 'Contribution to Rural Development: *Ujamaa* and Villagisation,' in *Mwalimu: The Influence of Nyerere*, ed. Cohn Legum and Geoffrey Mmari (Trenton, NJ: Africa World Press, 1995), 36.

7 See Joe Lugalla's excellent study of *ujamaa*'s effects on urbanization, 'The Post-Colonial State and the Urbanization Process, 1961–1993,' in *Crisis, Urbanization, and Urban Poverty in Tanzania: A Study of Urban Poverty and Survival Politics* (Lanham, Md.: University Press of America, 1995), 37–9. Lugalla emphasizes the neglect of urban restructuring through the ambivalent state policies toward urbanization during this time. Consequently, rather than benefiting the marginalized urban majority, urban planning in Dar es Salaam simply perpetuated the colonial legacy of town planning. See also Knud Erik Svendsen, 'Development Strategy and Crisis Management,' in *Mwalimu*, ed. Legum and Mmari, 109.

8 John Iliffe, 'Urban Poverty in Tropical Africa,' in *The African Poor: A History* (Cambridge: Cambridge University Press, 1987). See also Lugalla, *Crisis, Urbanization, and Urban Poverty in Tanzania*.

9 A.G. Ishumi and T.L. Maliyamkono, 'Education for Self-Reliance,' in *Mwalimu*, ed. Legum and Mmari, 52, 53, 54.

10 Nyerere, 'Frugality: 26 April 1965,' in *Freedom and Socialism*, 332.

11 Geoffrey Mmari, 'The Legacy of Nyerere,' in *Mwalimu*, ed. Legum and Mmari, 178. Mmari suggests that Nyerere's style in dress was considered a copy of Chairman Mao's. My observations are based on personal experience as a kung fu fan and spectator at many a wrestling match performed at Kivukoni Beach. Kung fu also inflected styles of dancing in Dar es Salaam, where simulated kung fu arm and leg movements were incorporated into the bumps, free style, and disco.

12 I am indebted to Gordon Tait's recent unpublished work on subcultural theory for laying out the groundwork on this issue.

13 See *The Empire Strikes Back: Race and Racisms in 70's Britain* (London: Hutchinson Education, 1982); Stuart Hall and Tony Jefferson, eds, *Resistance through Rituals* (London: Hutchinson, 1976).

14 Ishumi and Maliyamkono, 'Education for Self-Reliance,' 51–3.

15 Nyerere, *Freedom and Unity*, 162, 258, 316, 332.

16 Ibid., 159, 162, 323, 332.

17 See Ishumi and Maliyamkono, 'Education for Self-Reliance,' 47–9. They point out the serious educational poverty afflicting Tanganyika on the eve of independence; Nyerere, *Freedom and Socialism*, 262, 337, 385.

18 Dan Nabudere, 'The Politics of East African Federation, 1958–1965,' in *Imperialism in East Africa* (London: Zed Books, 1982), 111.

19 Nyerere, *Freedom and Socialism*, 256–7.

20 V.I. Lenin, *The Tasks of the Youth League* (Peking: Foreign Language Press, 1975), 3.

21 Ibid., 19.

22 Ibid., 18–20.

23 Ishumi and Maliyamkono, 'Education for Self-Reliance,' 52.

24 Schools such as Forodhani Primary School and Azania Secondary School in Dar es Salaam, as well as the Arusha Secondary School, implemented some of these practices.

25 The Arusha Secondary School was an interesting site in terms of the transnational flow of Soviet and African American teachers.

26 Andrew Hindes, 'Hong Kong Invasion at US Box Office (Feb 23–25),' *Variety*, 26 February 1996.

27 Mahmood Mamdani, *Imperialism and Fascism in Uganda* (Trenton, NJ: Africa World Press, 1984); and Isaac Shivji, *Class Struggles in Tanzania* (New York: Monthly Review Press, 1976).

28 Bruce Thomas, *Bruce Lee, Fighting Spirit* (Berkeley, Cal.: North Atlantic Books, 1994).

29 Hsiung-Ping Chiao, 'Bruce Lee: His Influence on the Evolution of the Kung Fu Genre,' *Journal of Popular Film and Television* 9, no. 1 (Spring 1981): 37–8.

30 Nyerere, 'Frugality,' in *Freedom and Unity*, 332–33.

31 The term *state-saturated societies* is borrowed from Samir Amin, who uses it to describe states in which ideologies permeate every aspect of everyday life, and whose institutional pervasiveness determines the lives of their citizens. Former communist and socialist societies are obvious examples. See Samir Amin, 'The System in Crisis: A Critique of Sovietism, 1960–1990,' in *Re-Reading the Postwar Period* (New York: Monthly Review Press, 1994).

32 Michel Foucault, *Technologies of Self* (Amherst: University of Massachusetts Press, 1988), 19.

33 Ibid., 20.

34 Ibid., 20–21.

35 Ibid., 35.

36 Ibid., 37.

37 Chiao, 'Bruce Lee,' 33.

38 I use the term *new historic subjects* to imply both the new political subjects and the historically new conditions that create new subjectivities, as Ernesto Laclau and Chantal Mouffe have elaborated on in *Hegemony and Socialist Strategy* (London: Verso, 1985).

39 See Ed Guerrero, *Framing Blackness* (Philadelphia: Temple University Press, 1993); Manthia Diawara, ed., *Black American Cinema* (New York: Routledge, 1993); and Mark Reid, *Redefining Black Film* (Berkeley and Los Angeles: University of California Press, 1993).

40 Ishumi and Maliyamkono, 'Education for Self-Reliance,' 53.

David Joselit

THE VIDEO PUBLIC SPHERE

*T*HE PERSONAL IS POLITICAL. Since the 1960s this phrase has been a rallying cry for social movements founded in identity. It is a creed in which progressive demands emerge from the specific social (and sometimes biological) experiences of a particular class of citizens. Identitarian activism thus posits a causal relationship between individual experience and political orientation. In the United States this convergence of the personal and the political is largely associated with various sorts of counter- or subcultures typically including people of color, women, lesbians, gay men, and other gender outlaws. But minoritized publics are not the only ones to link the personal with the political. Indeed, such articulations are among the fundamental modalities of mainstream power under late capitalism in which corporate and political bodies are rendered intimate and subjective. If sixties radicals and their progeny made the personal political, it is certainly true that since the mid-twentieth century the political has been made personal along a much broader social spectrum. One need only consider the escalation of sexual ethics (and sexual scandal) as a means of evaluating political candidates from the period of the philandering-but-tolerated John F. Kennedy to that of the philandering-but-excoriated William Jefferson Clinton. It is my belief that the emergence of broadcast television in the 1950s and its ubiquitous dissemination in the 1960s has greatly abetted this bilateral embrace of the personal and the political by producing a public sphere in which social questions are understood in terms of individual (and often fictionalized) dramas. It will be my assertion that television fosters a particular form of spectatorship: it creates a split or multiple identification, in which there is an approximate reflection of the viewer's experience, but also simultaneously, a re-channeling of this experience into a limited number of conventional and highly moralized narratives. This gap opened up between a spectator and his or her reflection provides a space for ideological formations to take root. The mechanisms of these identifications are typically veiled in broadcast television, but they are made explicit in certain

forms of video art. In this essay, I will take my cue from Fredric Jameson's insight that television and video art are dialectically linked: 'Commercial television is not an autonomous object of study; it can only be grasped for what it is by positioning it dialectically over against that other signifying system which we have called experimental video or video art.'[1]

The political dimension of fictional television narratives was made manifest recently in a fascinating struggle over minority representation on television dramas and sitcoms. Led by the NAACP (whose leadership was not without controversy),[2] a coalition of minority media activists demanded that the major networks include a greater number of people of color in television programming both on the screen and behind the camera. What is striking about this action is that the NAACP, one of the oldest and most venerable civil rights organizations in the United States, recognized that not only representation, but *representation in the entertainment industry* is integral to politics. Prime-time programming, perhaps even more than the constant stream of journalistic reporting on news networks such as CNN, was recognized as constituting an important site of political activism. In his 1995 book, *Watching Race: Television and the Struggle for 'Blackness,'* Herman Gray explores the cultural shifts which underlie the recent NAACP action.[3] He demonstrates how the changing demographics of television viewership in the 1980s led to an expansion of television dramas and sitcoms featuring black characters. In order to engage what they considered the rising proportion of African American viewers of network television – resulting in part from the migration of affluent audiences to cable programming – network executives and producers sought to develop programs that would appeal to black experience while not alienating white audiences. This reflexivity of programming and audience is itself an important lesson about the business of television. Alongside the proliferation of identity-based politics in the 1980s, there developed an analogous strategy in the mass media of 'narrowcasting,' in which programs were consciously addressed to specifically defined ethnic and socio-economic audiences. Network executives recognized that profits could be enhanced by more aggressively exploiting television's capacity to solicit idealized identifications between viewers and fictional characters. *The Cosby Show* was probably the most successful of this genre of programming, but its promotion of a split or hybrid form of identification attracted criticism from some African American intellectuals, If, on the one hand, it presented a positive image of an affluent black family, it also channeled black experience almost totally into standard middle- and upper-middle-class models of success. This is not to say that African Americans do not and should not be represented as embracing the American dream, but rather that *The Cosby Show* formulated a hybrid, and to many minds a conservative, identification in which blackness is reflected, but also re-narrativized, in a domesticated form profoundly reassuring to white viewers. The program consequently made little or no reference to the conditions of institutionalized racism and economic repression which is part of the experience of many African Americans. Its success nonetheless left the door open for activists to demand different and more diverse representations of black experience on television.

Instances of split-identification in television programming are legion, and are obviously not limited to representations of any particular racial or ethnic group. One of the most theoretically interesting models for re-narrativizing everyday

experience in television is the participatory talk show pioneered by Phil Donahue, who invented the format in 1967, as well as impresarios such as Oprah, Sally Jessy Raphael, Jerry Springer, and a multitude of others. In these programs, featured guests tend to be both 'ordinary' in their resemblance to other middle-class Americans and 'exceptional' in that their function is to narrate some form of transgressive or unconventional behavior. But despite the trappings of spontaneous discussion, the effect of these talk shows is to redirect subversive characteristics or activities into culturally acceptable forms. This occurs through the extraordinarily formulaic and repetitive comments of audience members, who tend to relentlessly censure unconventional lifestyles, as well as the anodyne and remarkably unimaginative pronouncements of psychologist-experts who inevitably serve up the same pablum for every type of supposed disorder. The genius of this participatory format – and perhaps the source of its enormous popularity – is the perfect self-reflexivity of its ideological labor. Ordinary people are being policed by other ordinary people. If one of the messages of this most banal form of voyeurism is that perversion exists everywhere under the tranquil surfaces of the middle class, by far the more important lesson is that we must domesticate these pervasive impulses and urges, and shape them into the narratives of normalcy which are blandly touted by resident experts. Like the chorus in a Greek tragedy, the audience laments and cajoles the actors, who are 'ordinary people' like themselves. And this split between the subversive and the hegemonic is exemplified in the person of the host him- or herself, who as the avatar of the 'regular guy' or 'woman just like me' literally and metaphorically adjudicates between the opposing selves of a split middle-class subject.

It is this process of identification with a 'perfected' and altered version of *oneself* which characterizes the televisual public sphere in the United States. Within the ostensible abundance of television programming there are a few core narratives which are repeated over and over again. This ideological work is all the more effective because it is experienced as profoundly apolitical – as belonging to the realm of consumer desire and entertainment. Herein lies the significance of closed-circuit video installations of the 1970s such as those of Peter Campus, Bruce Nauman, and Dan Graham. They make explicit – and disturbing – the cultural imperatives to occupy, or attain to, one's own externalized images. They demonstrate that the work of ideology has migrated into the ostensibly private and psychic realm of identification, but unlike network television, which seamlessly redirects these identifications toward conventional types, Campus's installations, for instance, reintroduce the experience of coercion and anxiety at the heart of televisual forms of interpellation. Campus, like Andy Warhol, worked extensively in the medium he would later take up as an artist. He was born in 1937, but first produced art in 1971 at the age of thirty-four. During most of the 1960s, he worked in film and television production, ultimately as a free-lance film editor. But like Warhol, Campus's entry into an art context involved a near-total reversal of formal strategies: instead of building on his skills as an editor to make works characterized by fast-paced montage, Campus's important early art projects deployed closed-circuit video feedback systems in which images of gallery viewers were immediately projected back to themselves in modified form. According to Roberta Smith, Campus was drawn to this technology in part because of its extraordinary capacity to bridge the distance between spectator and spectacle. In a 1979 catalogue, she wrote, 'The

Figure 40.1 Peter Campus, *Double Vision*, 1971
Photo courtesy of the artist.

potentialities of video hit Campus with particular force while watching NASA broad-
casts on television, where events like moon walks and rocket firings were recorded
by live, unmanned video cameras.'[4] Campus's fascination with the capacity of
video to bridge such incomprehensible distances – to provide live information from
as far away as the moon – might suggest a preoccupation with instantaneity, and
a McLuhanesque celebration of not just a global, but an *interplanetary* village.
However, it was rather the effects of *distanciation* which this apparent instantaneity
masks that became one of Campus's central themes.

 To this purpose, his closed-circuit video installations of the early 1970s confront
the viewer with a proliferation of nonidentical images of him- or herself. The suppos-
edly instantaneous moment of reflection – through the camera, as well as in mirrors
and by shadows – is expanded in time and space in order to admit a battalion of
others onto the ground of the self. In *Shadow Projection* (1974), for instance, a spec-
tator enters into a space where two alternate images or projections of her- or himself
are put into play: a shadow and a video image. A translucent screen is installed in
the center of the gallery. At one end opposite this screen is a bright light and camera.
Directly on axis with the camera and light, but on the other end of the gallery is a
video projector. When a spectator enters into the arena defined by the recording
and projection components of video equipment, the dyadic apparatus of light and
camera simultaneously throws a shadow onto the central screen and produces a
video image which is projected onto it from the other side of the gallery. The viewer
is keenly aware that she or he can increase the size and clarity of both shadow

and video image by moving closer or further away from the camera eye. The 'work' which is required of the spectator is therefore to superimpose one image perfectly upon the other in order to resolve their difference in size. The 'play' which the installation simultaneously enables is to widen this disparity, in what might be a pleasurable experience of an attenuated or asymmetrical self. What, then, is the place of the subject of representation in *Shadow Projection*? As we have already seen, the subject – or spectator – moves throughout the interior of the apparatus; within its defined circuit of representation she or he is given the option of reconciling shadow with image on the central screen, or of causing these alternate identifications to diverge. Campus thus finds a place for the individual's agency within representation. This is even more apparent in other installations of the same moment. In *Interface* (1972), for instance, the superimposition of shadow and video image which was deployed in *Shadow Projection* is conceived as an opposition between a mirror image and a video projection. As David Ross suggested in a 1974 catalogue, the proliferation of images of the same self functioned as an incitement of the viewer's own activity:

> Besides the ghostly evocations of the video image (made even less familiar by its lack of normal mirror flip-flop) which is superimposed over the reflection, the nature of the difference between images becomes increasingly the result of the viewer's active investigation. Physical explorations of the images and space defined by the light and the camera angle tend to lead the viewer into an improvisational choreography.[5]

These works dramatize the paradoxical position of the subject of representation – both within Campus's installations, and as I would argue, within media culture at large. For, if on the one hand, Campus allows for a degree of freedom and play on the part of the spectator caught within an apparatus of representation; on the other, he establishes a powerful imperative for the viewer/participant to resolve the differences between two or more alternate representations of his or her self. Campus thus resituates the performative opposition between spectator and spectacle within the identificatory drama of a single subject located in a *media* environment. In Campus's installations the spectator is the spectacle; visitors are submitted to a two-step process: first, they are caught by surprise by their own multiplied image – a confrontation which forces them to recognize their identity *as an image*. This leads to the second step – an effort to unify and claim these various images of the self in what David Ross calls an 'improvisational choreography.'

From the mid-1970s until he gave up the human figure altogether in the 1980s, Campus focused almost exclusively on the face. In a series of 10 × 10 foot (3 × 3 meter) slide projections from 1978 he likewise dispensed with video projection altogether. Instead of staging the drama of identification in a public gallery, in these works the interchange between camera and human subject took place in the ostensibly private realm of the artist's studio. For each projection Campus undertook a series of intense photo sessions, sometimes spanning several weeks. According to Smith, his instructions to the models were simply to 'project toward a point in the camera.'[6] If the drama of identification takes place offstage in these works – in the

artist's workshop – it nevertheless remains central to their significance. The social contradictions of identification are no longer spatialized as they were in Campus's closed-circuit video installations, but rather encoded in an extraordinarily unstable photographic surface. It is an obvious, but important fact that slide projections are composed not of solid matter, but entirely of light. Campus heightens this funda-mental evanescence of the image through a dramatic play of rich shadow across the monumental projected faces. If light makes these images possible, it is shadow which threatens to dissolve them into near unintelligibility: the coherence of each face is on the verge of collapsing into abstract patterns of black, white, and grey. The aporia of identification which motivated earlier works like *Shadow Projection* and *Interface* is thus transposed into the dematerialized topography of a surface composed of light. The viewer encounters a monumental human image which grotesquely decomposes: recognition is grossly interrupted, and identification is imagined as a labor of reconstruction.

In this essay I have argued that the televisual public sphere disseminates and normalizes a model of split identification in which the self confronts its noniden-tical representations. Within commercial television such splitting remains veiled in order to facilitate the viewer's assimilation of the consumerist, 'family-oriented' values which are axiomatic under late capitalism. On the other hand, in video art like Peter Campus's the contradiction between a spectator and his or her mechan-ical and cultural mediation is provocatively heightened. On one register, such a juxtaposition of television and video art is a relatively conventional avant-gardist critical move in which Campus's work (which also stands in for that of Nauman, Graham, and others) is shown to identify and represent social contradictions which would otherwise remain invisible. But on another register, my argument is less conventional in its methodology. For contrary to normal practice in the discipline of art history, I have attempted to challenge the stability of a *medium* as both the locus for historical genealogies and the privileged category for formal analysis.[7] I want to bring commercial television and video art – which share a technological apparatus but circulate in distinctly different institutional and discursive networks – into productive association. My aim is not simply to note that several artists have absorbed aspects of television and film through the appropriation of commercial footage or narrative conventions into their art, though such strategies are clearly relevant to my interests and crucial to a comprehensive history of video art in rela-tionship to television. But simply acknowledging that the discourse of television 'enters' into video art falls short of what I wish to claim: such an argument retains a dichotomous high/low division even as it pretends to render it irrelevant. Instead, I want to put pressure on an obvious but significant fact: that several different image-making practices can and do cohabit the same technology. In the case of video, such 'cohabitation' would encompass home movies, digital film, commercial tele-vision, Internet broadcasts, and video art. I am proposing – and this essay only partially and inadequately sketches such a project – that rather than assuming the stability of artistic media as objects of study, that we undertake a genealogy of partic-ular image technologies, without artificially dividing them into a priori categories such as 'television' and 'video' art.[8] The way I have attempted to do this is to take as my object a social condition – the status of identification in a media public sphere

– and to trace its manifestations across two sets of practices which cohabit the same medium. This is one of many possible approaches in which visual hierarchies are re-ordered so that terms like high and low – whether used in a spirit which is celebratory or damning – are replaced by a new type of critical analysis calibrated for a more complex array of visual modalities. Collectively we might call such approaches Visual Studies.

Notes

1 Fredric Jameson, 'Video,' in *Postmodernism or, The Cultural Logic of Late Capitalism* (Durham: Duke University Press, 1991), 76–7.

2 In brokering a deal with NBC to hire greater numbers of actors and writers of color, the NAACP was accused by Latino, Asian American, and Native American coalition partners of failing to represent their interests. For a description of the deal as well as the controversy (later resolved) which attended it, see Elizabeth Jensen, Greg Baxton, and Dana Calvo, 'NBC, NAACP in pact to boost minorities in television,' *Los Angeles Times*, January 1, 2000, A1, A11.

3 Herman Gray, *Watching Race: Television and the Struggle for 'Blackness'* (Minneapolis: University of Minnesota Press, 1995).

4 Roberta Smith, 'Dark light,' in *Peter Campus: Video-installationen, Foto-Installationen, Fotos, Videobander*, exhibition catalog (Cologne: Kölnischer Kunstverein; Berlin: Neuer Berliner Kunstverein, 1979), 32.

5 David A. Ross, 'Peter Campus: closed circuit video,' in *Peter Campus*, exhibition catalog (Syracuse: Everson Museum of Art, 1974), n.p.

6 Ibid., 28.

7 As I stated at the outset of this text, Fredric Jameson is an exception. In his efforts to analyze the relationship between broadcast television and video art Jameson proposes a critical move similar to the one I am advocating, but his argument tends toward what I've called an 'avant-gardist' direction by suggesting that video art is the dialectical negation (or complement) of commercial television.

8 Jonathan Crary has undertaken such a project regarding nineteenth-century vision. See his *Techniques of the Observer: On Vision and Modernity in the Nineteenth Century* (Cambridge, Mass.: MIT Press, 1990) and *Suspensions of Perception: Attention, Spectacle, and Modern Culture* (Cambridge: MIT Press, 1999).

Tara McPherson

RELOAD
Liveness, mobility and the web

Convergence on the digital coast

DURING THE HEYDAY of the dotcom years, otherwise known as the late 1990s, I spent some time attending many of the 'Digital Coast' events which the Los Angeles new media industry frenetically sponsored, events most often framed around a rhetoric of convergence that insisted on the inevitability of a collision between the internet and television, a vision of the future of the screen that in many ways wed the two media tightly together. While the earliest of these events framed television as the bad object to be overcome by all things web-like, a more symbiotic relationship between the two media quickly emerged.[1] Drawing on the tropes of television and the channel surfer, some 'convergence' executives began promoting what they called a 'lean back interactivity,' which, in their words, provides 'little snippets of interactivity to enhance the broadcast experience' (Pillar C6). Further described as a 'minimal interactivity,' this mode was promoted as an a 'enhancement' to the conventional broadcast which offered consumers a wider array of click-and-buy shopping. A 'give the buyer what she wants' logic buttressed the move, as Wink Communications chief technical officer (CTO) and chairman, Brian Dougherty, maintained that 'if the interactivity is so complex . . . consumers aren't going to want it.' Corporate chief executive officers (CEOs) proclaimed that 'the really cool digital application turns out to be about TV,' while the Pseudo website suggested that the web just may end up 'anointing talk shows as the killer app for next generation, two-way broadband networks.'

Such talk framed the web as a 'better' version of television, stressing particular aspects of the medium which illustrate its superiority to television while simultaneously linking the two media in a seemingly natural convergence. Here, the rhetoric revolved around notions of personalization and empowerment, focusing, in the words of Rob Tercek, the former vice-president of Digital Media at Columbia's

thanks to all the viewers
and the talent that made
Pseudo so special

Figure 41.1 Pseudo farewell screen, accessed December, 2000

Tristar Television Group, on the web as 'software that gets familiar with you.' He also insisted that 'controlling an audience' is an old idea more suited to broadcast than the niche markets of netcasting, which privilege 'a consumer-centric point of view.' Pseudo.com, a now-defunct New York interactive television company that until recently produced over sixty web-based television shows a week, promoted their programming as 'the next logical step in the development of entertainment media,' describing this 'major deconstruction of television into niche programming' as opening up the possibility for 'deeper, focused, interactive content tailored to individual interests, style and taste' (buzzwords courtesy of the old Pseudo website). DEN, the Digital Entertainment Network, another crashed and burned internet television venture that was LA's answer to Pseudo, included on its website a promotional video which presented DEN as a 'media revolution' intent on providing 'more interactive,' 'participatory entertainment.' The clip went on to castigate television's essentially passive format while celebrating 'the DEN' as providing 'what you want to watch when you want to watch it. It's completely in your control.' Chairman and CEO Jim Ritts championed both the customization the web would allow and DEN's capacity to meld a 'click-and-buy' element to more traditional modes of television viewing.[2]

Now, it's fairly easy to simply mock this rhetoric and certainly, after listening to DEN's president David Neuman talk about how 'empowering' and interactive it would be to click and buy Jennifer Aniston's sweater while watching an episode of *Friends*, I couldn't help doing so. I've written elsewhere about the degree to which this industrial rhetoric of convergence can actually work as self-fulfilling prophecy, obscuring larger questions about whether or not the internet is really (or really should be) tied to corporate traditions of US television while framing the internet as essentially a commercial medium, intent on servicing consumers rather than citizens. In his work on early radio, Tom Streeter reminds us that a similar logic of functionality and inevitability worked to close down alternative, grass-roots forms of radio, bringing broadcast firmly under corporate control in less than thirty years and lessening its potential as a democratizing technology. With this history in mind, it is certainly important to question corporate rhetoric, querying the seemingly natural links being forged between television and the internet by companies ranging from the privately owned DEN or Pseudo to the increasingly prevalent corporate mergers manifested in sites like MSNBC or CNN.

Yet, as I surfed DEN or Pseudo and eavesdropped at Hollywood cocktail parties, I did notice a certain connection between the corporate rhetoric and my own expe-

riences of the web, suggesting that there's a level of accuracy within the corporate business plans, a glimmer of possibility and promise buried deep within their hype. 'Choice,' 'presence,' 'movement,' 'possibility' are all terms which could describe the experiential modalities of websurfing. In fact, as I'll argue, a phenomenology of the web might focus on its capacity to structure three closely related sensations, sensations I call *volitional mobility*, *the scan-and-search*, and *transformation*. It's crucial to think of these modes as both specific to the medium of the web itself, as related to its materiality and, in some ways, independent from content, and also as ideologies packaged and promoted within certain websites, that is, as corporate strategies of narrative and structural address. What a medium like the web is or will be, in its very form, is not separate from the discourse which surrounds it and which structures particular conditions of possibility. Yet, if these discourses shape what the web might become, they are also shaped by the medium and its particular material forms (even as it's sometimes difficult to think of the virtual realms of the digital as material).

For now, I want to turn away from considerations of corporate hype and rhetoric and instead look at the web itself, trying to describe and understand the experiences it structures. In an article entitled 'Print is Flat, Code is Deep,' N. Katherine Hayles argues for the importance of media specific analyses, noting that 'it is time to turn again to a careful consideration of what difference the medium makes' (2). Her concern is to investigate the insights a specific look at hypertext might reveal for literary theory, a field Hayles describes as 'shot through with unrecognized assumptions specific to print' (1). I am interested in how a look at the specificity of the web as a broader cultural form might illuminate certain aspects of both that medium and of television theory, perhaps suggesting the limits of these theories for analyses of new media while also limning their usefulness to an analysis of the web.

This is not to imply, despite the conjectures of the new media executives at DEN and Pseudo to the contrary, that one medium is structurally and inherently superior to the other, that the web is indeed 'better.' Rather, television and the web do reference each other, and, as Hayles maintains, 'media-specific analysis attends both to the specificity of the form . . . and to citations and imitations of one medium in another. [These analyses are] attuned not so much to similarity and difference as to simulation and instantiation' (2). What follows is an investigation of the web as an interface between users and digital data, the ones and zeros of the infosphere. In some regards, I take this notion of interface quite literally, and, thus, my methodology builds on Hayles in one key respect. Rather than simply cataloging a typology of digital data focused primarily on its formal elements, I am also interested in exploring the specificity of *the experience of using the web, of the web as mediator between human and machine, of the web as a technology of experience*. Put differently, I am interested in how the web constitutes itself in the unfolding of experience. This necessarily entails an appreciation of the electronic form of the web: after all, a web browser is a interpreter of digital data, a translator of code, and this relation to digital data profoundly shapes how the user experiences the web and what it promises. A media specific analysis can move beyond a certain formalism to explore what's before us in the moment that we are in. This exploration will finally return us to the realm of the corporate and the economic, for any understanding of the

forms of and the experiences provided by the web must necessarily account for the role new media technologies play in the changing economic landscape characteristic of neo-Fordism and transnationalism. The web's ability to structure certain experiential modalities for the user also helps to situate that user within particular modes of subjectivity and within the networks of capital. While the political possibilities of these emergent modes of being cannot be specified in advance or in the abstract, their relation to corporate capital must be taken seriously.

Tara's phenomenology of websurfing

When I explore the web, I follow the cursor, a tangible sign of presence implying movement. This motion structures a sense of liveness, of immediacy, of the now. I open up my 'personalized' site at MSNBC: via 'instant' traffic maps (which, the copy tells me, 'agree within a minute or two' to real time), synopses of 'current' weather conditions, and individualized news bits, the website repeatedly foregrounds its currency, its timeliness, its relevance to me. A frequently changing tickertape scroll bar updates both headlines and stock quotes, and a flashing target floats on my desktop, signaling 'breaking news' whenever my PC's on, whether or not a web browser is open. The numerous polls or surveys that dot MSNBC's electronic landscape (they're called 'live votes') promise that I can impact the news in an instant; I get the results right away, no need to wait for the 10 p.m. broadcast. Just click. Immediate gratification. Even the waiting of download time locks us in the present as a perpetually unfolding now.

This sense of being in the moment is further enhanced by the chat rooms included in many television-centered websites, forums intended to fuse the sites more clearly to the television schedule, allowing the computer user to join the television audience by posing questions to talk show guests as live shows unfold on dual platforms. From E-Bay to E*Trade to ESPN, the web references the unyielding speed of the present, linking presence and temporality in a frenetic, scrolling now. We hit refresh. We feel time move. We wait for downloads. We still feel time move, if barely. Processors hum, marking motion.

Of course, we know liveness from television studies. In prescient theoretical investigations of television in the 1980s, work intent on distinguishing television from film, Jane Feuer observed that 'the differences between TV and . . . cinema are too great not to see television as a qualitatively different medium, but granted this' (12), she pursued what *was* specific to television, both as a form and as an ideological and industrial practice. Liveness (or, more crucially, its illusion) was her answer, and she skillfully illustrated how liveness was continually represented as a core ontological form of television when it might more accurately be seen as an ideology used in the promotion of television and its corporate manifestations. Liveness remains with us a key dimension of our experiences of the internet, a medium which also promotes itself as essentially up-to-the-minute (one need only hit 'reload' or follow the scrolling updates), ideology once again masquerading as ontology.

Of course, as with television, this much touted liveness is actually the *illusion* of liveness: though the weather conditions may indeed be up to date, most of the 'breaking news' I access via my personalized MSNBC front page is no more instant

than the news I would watch at 6 p.m. on KTLA. Indeed, many websites display a marked inability to keep up with the present, recycling older stories in order to take advantage of the vast databases which underwrite the web, old content repackaged as newness. But, as with television, what is crucial is not so much the *fact* of liveness as the *feel* of it. Many television-centric websites capitalize on television's historic ties to liveness and thus present liveness as a given, as an essential element of the medium.

We might say, to paraphrase Feuer, that the web 'positions the [surfer] into its imaginary of presence and immediacy' (14). Yet this is not just the same old liveness of television: this is liveness with a difference. This liveness foregrounds volition and mobility, creating a liveness on demand. Thus, unlike television which parades its presence before us, the web structures *a sense of causality* in relation to liveness, a liveness which we navigate and move through, often structuring a feeling that our own desire drives the movement. The web is about presence but an unstable presence: it's in process, in motion. Interestingly, as we imagine ourselves *navigating* sites, following the cursor, the web *feels* more mobile than television, even though it relies more often on text and still images than on the moving video of television. Furthermore, this is a sense of a connected presence in time. The web's forms and metadiscourses thus generate a circuit of meaning not only from a sense of immediacy but through yoking this presentness to a feeling of choice, structuring a mobilized liveness which we come to feel we invoke and impact, in the instant, in the click, reload. I call this sensation *volitional mobility*.

If television, in the words of Bob Stam, obliges the telespectator 'to follow a predetermined sequence' exhibiting 'a certain syntagmatic orthodoxy' (32), the web appears to break down the preordained sequencing of television, allowing the user to fashion her own syntagmas, moving from link to link with a certain illusion of volition. Our choices, perhaps our need to know, our epistemophilia, seem to move us through the space and time of the web, and this volitional mobility implies our transformation, shimmering with the possibility of change, difference, the new and the now. From the dress-up mannequins of the Gap to the instant quizzes and horoscopes on sites like BabyCenter or Pseudo, the click propels us elsewhere and along. Volitional mobility is more about momentum than about the moment. The extensive database capacities of the internet structure the field upon which this sense of volition and movement unfolds, permitting the web surfer to move back and forth through history and geography, allowing for the possibility (both real and imagined) of accident and juxtaposition to an even greater degree than television.

While this sense of volitional mobility seems to reside on the relatively analog surface of our monitor screens, a function of website design, the very form of digital data also helps underwrite this sensation. As Hayles notes, due to its very form, digital data is 'intrinsically more involved in issues of mapping and navigation' (15) than are most other media. Web browsers translate code on the fly, structuring a kind of mobility which does indeed respond to the click. Computers are processors; in a sense, mobile machines. There's a fluidity to digital data: processing involves data in motion. These processes of navigation or motion relate to the depth of electronic forms. At a simple level, there's code 'behind' a web page, underwriting a kind of perceived depth between code and the programs visible upon our screens, coding underwriting image and movement. A relatively simply program

may be hundreds of functions deep, yet the computer remembers and navigates these functions. As we roam the web, the computer remembers where we've been, even if we don't.

At the level of the interface, this sense of movement through space is most obvious in the various Quicktime virtual reality applications which dot our computer screens. A concrete example of the web's capacity to structure a sense of volitional spatial and temporal mobility is found on MSNBC's 'Kennedy Remembered' page, part of a multimedia repackaging of MSNBC's television program, *Time and Again*. At this site, a real-time plug-in called SurroundVideo allows me to move around Dallas's grassy knoll in a 3-D representational space via a fairly seamless patching together of digital photographs, navigating actual footage of the area. Once the image loads (waiting is also one of the web's temporalities), I am able to explore this Texan geographic terrain moving back and forth between the road, the book depository, the grassy arena. I am able to choose my own path with a click and drag of the mouse, zooming in and out for different perspectives and 'edits.' The sense of spatiality and mobility is fairly intense and certainly feels driven by my own desire. An even odder experience is created by clicking a button which maps black and white images of the 1963 assassination of the president *over* the color images, a slightly surreal collapse of space and time, still navigable. An archive of video and audio clips, various articles about JFK, transcripts of debates and speeches, and web visitors' own stories structure a roam-able space of JFK, evoking mediated memories of Camelot and a poignant affect of national loss and nostalgia. I am able to be both here (in LA) and there (in Dallas), both then (1963) and now (2002), but I am always present, moving, live, in command. For those not moved by mobile history, other SurroundVideo sites at MSNBC allow users to surf the solar system and tour the White House, each positioning the national via specific moments of geography and movement. Other websites tackle less hallowed ground: DEN offered up a virtual frat house in Quicktime format, designed to accompany the live (or replayed) webcast of its episodic series focused on campus life. While a given episode played out in a small video window, the websurfer could cruise the empty corridors of the frat house in a separate section of the browser, checking out sloppy rooms and communal showers, or post to an online chat which also shared the screen space. Here, the click-and-move mobility familiar from video games collided with the narrative world of television's teen dramas, all mapped out for maximum user navigability and choice. If early television promised to bring us the world, on the web, our own volition in relation to this travel gets foregrounded. Microsoft asks, 'Where do you want to go today?'

This sense of directed movement through space need not be so literal. The web is also a fly-through infoscape, a navigable terrain of spatialized data. The windows, folders and bookmarks which populate our desktops create individualized architectures for the infospheres of the web, building structures which allow us to inhabit realms of information, managing (or at least feeling as if we do) the vast database structures underwriting our web browsers. Search engines move through realms of data, more or less responding to our command. Chat structures information as a collaborative performance. Programs like Flash allow our cursors to activate lively sequences of motion via a simple rollover, charting movement in a colorful, pixilated dance and visualizing our mobility before we even click. Again, the cursor seems to

embody our trajectory, an expression of our movement and our will. We are increasingly aware of ourselves as databases, as part and parcel of the flow of information.

Pseudo and Den archived their episodic series, allowing a movement back through their 'broadcast' histories. The Pseudo web site insisted that 'you can search for and play any episode you want, any time you want.' This movement felt temporal, an aspect of the 'on-demand' nature of the web, as well as of its more material forms: its lack of fixity, its mutability, its variability. There's a sense of process to the web that does not simply equate to liveness but also to promises of change. E*Trade, email and E–Bay all manage time, producing and transforming temporalities; we feel connected to others within these temporal zones. There's a sense of presence with strangers. Community on the web, via chat but also auctions, is as much about meeting times as meeting places, as the empty chat rooms of Pseudo's archived shows suggested. This temporality can be multidirectional and also simultaneous, both forward and backward at once, taking timeshifting to a different level. Recycling on demand. Michael Nash has said that 'temporality connects our bodies to the computer' and joins us in digital space, via the 'dynamic of a connected presence.' We might see volitional mobility as the experience of choice (or its illusion) within the constraints of web space and web time.

This aspect of choice, of volition, is closely tied to what I categorize as a second modality of web experience, the *scan-and-search*. Writing in the 1970s, the British scholar Raymond Williams proposed the concept of 'planned flow' as 'the defining characteristic of broadcasting, simultaneously as a technology and as a cultural form' (86). Flow unites the disparate bits of information, advertising, and narrative comprising an evening's television into a seamless whole, establishing a planned sequence which is more important than the individual segments which might seem to categorize television programming. Thus, as viewers, we are as likely to say that we watched television as to say what we watched, indicating the power of televisual flow. As a conceptual framework, flow has been amply explored and debated within television theory, with Jane Feuer arguing that television might more accurately be seen as a dialectic of segment and flow (15) and with John Caldwell similarly challenging the notion that television watching might be characterized by flow's boundlessness (163).

While websurfing might seem to operate in a manner similar to flow, bringing the vast array of data that categorizes the web into an experiential sequence, segmentation on the web – what we might more accurately call 'chunking' – is not identical to the segmentation of television. The web's chunking is spatial as much as temporal; our experience of moving through these chunks may seem akin to our experience of television's flow, but this is also a boundlessness we feel we help create or impact. It structures a different economy of attention than that underwritten by flow. We move from the glance-or-gaze that theorists have named as our primary engagements with television (or film) toward the scan-and-search.[3] The scan-and-search is about a fear of missing the next experience or the next piece of data. Whereas this fear of missing something in the realm of television may cause the user to stay tuned to one channel, not to miss a narrative turn, this fear of missing in the web propels us elsewhere, on to the next chunk, less bound to linear time and contiguous space, into the archive and into what feels like navigable space that responds to our desire. We create architectures as we move through the web via bookmarks and location bars, structuring unique paths through databases and archives. This is not just

channel-surfing: it feels like we're wedding space and time, linking research and entertainment into similar patterns of mobility. The scan-and-search feels more active than the glance-or-gaze.

The web, less strictly a time-based and time-moving medium than broadcast, combines sequencing with discrete bits more robustly than television, encouraging the scan and the search as modes of engagement, structuring a spatialized and mobile subjectivity which feels less orchestrated than the subject hailed by televisual flow (a subject moving forward in time – or back with the VCR – but less likely to feel a movement elsewhere, spatially, a kind of sideways or lateral movement). With the web, we feel we create the sequences rather than being programmed into them. Feuer sees television's use of flow as imposing unity over fragmentation (including spatial fragmentation), but the web is less invested in such fictions of unity. While the web certainly is about structuring movement, particularly in sites like MSNBC or DEN, with careful attention paid to information architectures which strive to orchestrate the visitor's path through a site with precision, it does so while also structuring a heightened sense of choice and mobility through navigable spaces. The solicitation of our interaction overcomes a sense of disparate, chunked information, creating a feeling of mobility across data. DEN's site included the tagline 'All Available On Demand,' and its crowded browser windows demanded a different kind of attention than that of the glance while rarely sustaining a fixed gaze. We move through such sites searching and scanning, looking for the next thing.

The web's activation of our desire for what's next hints at a third modality of web experience, the promise of *transformation*. Janet Murray notes that transformation is a 'characteristic pleasure of digital environments' (154). She goes on to frame this particular pleasure via its relation to narrative structures (and narrative structures of a very particular kind), but we might instead think of transformation as endemic to the web in a broad sense, motivating an extensive variety of narrative and non-narrative forms. Of course, popular culture has long traded on the lure of transformation, from the glimmer of hope embodied in each sexy tube of MAC lipstick to the mighty morphing power rangers to the promise of the makeover in *Glamour*, *Oprah*, or *This Old House*. But computer culture introduces a new level of personalization and sense of choice in relation to transformation in forms as diverse as architectural cd-roms, the ill-fated Microsoft BOB, endless pink Barbie products, and the flash-enabled dress-up spaces of e-commerce. Even my MSNBC homepage or My Yahoo turn on transformation, as the faceless dataspaces of the web are made-over via my demands. Personalization holds out the tantalizing lure of transformation, remaking information into a better reflection of the self.

From the VR frat house of DEN to the countless 'live' chats which populate the internet, the movement of the web harbors hopes of transformation. Regardless of content, there's a haptic potential to these spaces, both the literal 3-D spaces of Quicktime VR and the seemingly flat spaces of chat, of scrolling text. When one enters the space of chat, the dialog that unfolds can equal a loss of self, structuring a transformative space. To borrow a phrase from Amelie Hastie (writing about doll houses), these environments are consumed by both the mind and the eye, an imagined space of possibility and change.

Again, this sensation is tied to the actual form of digital data, to programmability, to the fragmentation and recombination which Hayles notes as intrinsic to

the medium (9). Digital code is malleable and subject to manipulation, at levels both accessible and inaccessible to the average user. In a language as simple as HTML (which my UNIX-coding husband refuses to even call a programming language), changing the descriptor 'FFFFFF' to 'FF6600' on a lengthy block of code seemingly transforms the page from a predictable white to the bold orange so hot circa 2000. Likewise, a lone missing comma can override thousands of lines of code, producing only error messages and frustration. As web browsers render pages on the fly, trans-formation's literalized; code is broken down and reassembled; new forms appear possible, recombination rules.

But, before I get too carried away in the heady realms of possibility, it is well to sound a cautionary note. Both Marsha Kinder and Susan Willis have alerted us to the often illusory status of promises of transformation. As Willis notes in rela-tion to transforming toys, there is always the risk 'that everything transforms but nothing changes.' She describes toys that 'weld transformation to consumption' and ascribes the fascination with transforming toys to a 'utopian yearning for change which the toys themselves then manage and control' (cited in Kinder, 136). Thus, while the web may indeed foster the related sensations of volitional mobility, scan-and-search, and transformation, our understanding of these modalities needs another working through in order to discern how they underwrite particular spatialities and temporalities, enabling specific selves and particular publics.

On sensation and the corporation in the age of neo-Fordism

While volitional mobility, the scan-and-search, and transformation are at least partially structured by the very forms of digital data, our experience of these modes is also shaped by the more analog representations on our screens. For example, the MSNBC website is highly controlled, severely curtailing the user's movement in subtle yet limiting ways, and, yet, the promise and feeling of choice, movement, and liveness powerfully overdetermine its spaces. MSNBC.com self-consciously constructs itself as a projected fulfillment of what seems missing in the status quo (both on television and in real life), becoming a solution to the oft-voiced dilemma of having a hundred channels and still nothing to watch. We could say it promises everything and changes nothing.

The illusion of a mobilized liveness in a website like MSNBC actually masks the degree to which the site already stages a linear, largely unidirectional model of the internet, a model predicated on television's broadcast modes of information delivery and encouraged in web design manuals which illustrate modes of information archi-tecture orchestrated to move a user through a site in very predetermined fashion. Many entertainment executives have taken to pitching a model of internet access based on television's network structure. This model, predicted to come on-line in less than a decade, would limit internet access to three or four providers who would function much like television networks, offering their own programming, directing users to approved parts of the web, and limiting the capacity to post a home page or web program to specialized producers. While this may sound farfetched, small steps in this direction are already under way. For instance, if you want to cruise around the grassy knoll in MSNBC's recreated Dallas, you had better be using a Microsoft Internet Explorer browser. Netscape can't take you there.

The interfaces deployed by MSNBC (and most other commercial websites) suggest a sense of liveness and movement even while the very programming which underwrites them works to guide and impede the user's trajectory. The increasing popularity of 'portal' sites leads to a web architecture which works to constrict the surfer's movement, effectively detouring users along particular paths or containing them within particular sites. For instance, both MSNBC and AOL work as portal sites which make it hard to leave their confines, functioning as the kind of locked-in channel television executives have long dreamed about. The increasing vertical monopolies characterizing the mediascape as well as the death of smaller (if well-funded) players like DEN and Pseudo take the meaning of convergence to a new level, naturalizing the relationships between television and the web. Rather than simply accepting the link between these two media, theorists need to investigate the ideological implications of actual interfaces and other programming choices; we need to foreground the political effects of burying the author function within the code. The standardization of temporality and style via channels, regular programming, and published schedules are a central part of the history of television and radio's commercialization. Television's much-heralded 'flow' worked to move viewers through segments of televisual time, orchestrating viewership, and web programming could allow for an even more carefully orchestrated movement, all dressed up in a feeling of choice.

Another example of the illusory nature of the web's modalities could be drawn from search engines, powerful programs which promote the illusion that one is actively surfing the web. Of course, when you use a search engine, you're not really moving through the web but through fairly limited databases. You might say that these databases structure volitional mobility to mask their own algorithmic structure, giving users the sense of control and movement through cyberspace when really you don't even touch the web when you initiate a search. Rather, you remain within a contained database, usually cataloguing less than thirty to forty percent of the web as a whole, processes which increasingly privilege commercial sites, enacting a very particular politics of information and design.[4] All of which introduces questions of representation, underscoring that the analog representations on our screen are powerfully connected to life off-screen: certain constructions of space enable certain spheres of domination; digital metaphors and representations are powerful processors.

In corporate structure, technological form and modes of experience, the web and television increasingly interact in mutually supportive modes reinforcing what Margaret Morse has called the institutions of mobile privatization (118). If, as she maintains, freeways, malls, and televisions exist in a 'kind of sociocultural distribution and feedback system' (119), the web operates within this circuit of exchange, albeit with slightly adjusted modalities. Choice, personalization, and transformation are heightened as experiential lures, accelerated by feelings of mobility and searching, engaging the user's desire along different registers which nonetheless still underwrite neo-Fordist feedback loops. Eric Alliez and Michel Feher characterize the neo-Fordist economy as a shift away from the massive scale of factory production in the Fordist era toward a regime marked by a more supple capitalism. There is a move toward flexible specialization, niche marketing, service industries, and an increasing valorization of information, which is now awarded a status 'identical to the one assigned labor by classic capitalism: both a source of value and a form of merchandise' (316). The separation of the spaces and times of production

from those of reproduction (or leisure) which was central to an earlier mode of capitalism is replaced by a new spatio-temporal configuration in which the differences between work and leisure blur. This leads to a 'vast network for the productive circulation of information,' structuring people and machines as interchangeable, equivalent 'relays in the capitalist social machine.' Rather than being *subjected* to capital, the worker is now *incorporated* into capital, made to feel responsible for the corporation's success.

While Alliez and Feher first described this mode in 1987, locating its emergence in the late 1960s, their description of neo-Fordism brilliantly predicts the logic of the dotcom era. The fanatic and frenetic work habits of the denizens of Silicon Valley and the Digital Coast modeled the incorporation of the worker within capital, while the proliferation of networked existence via the internet, pagers, and cellular phones helped fuel the dissolution between the spatio-temporal borders of work and leisure. In the new networked economy, 'regular' readers help drive the databases of Amazon.com by freely posting their book or movie reviews and avid video game players help fuel corporate capital by posting homegrown game add-ons to corporate sites without compensation, succinctly illustrating their incorporation into capital and its flows. Likewise, we might see our web-enhanced experiences of volitional mobility, scan-and-search, and transformation as training us for a new neo-Fordist existence. Old (narrative) strategies of identification and point of view give way to information management and spatial navigation, underwriting the blur (or convergence) between research and entertainment that so characterizes much of life under the conditions of virtuality.

Thus, it's important to recognize that these emergent modes of experience are neither innocent nor neutral, simple expressions of the material forms of the digital. They model particular modes of subjectivity which can work all too neatly in the service of the shifting patterns of global capital. Yet, even if the mobility offered by a search engine or a corporate website is both technically limited and central to our incorporation into capital, this does not mean that search engines (or MSNBC for that matter) aren't experienced by their users as offering up choice and possibility; rather, it highlights the degree to which these experiences are doubly constructed, an element of both the very forms of the digital data and the ideology of mobility and change created by the sites themselves.

In conclusion, we might ask why, in a culture increasingly subject to simulation, volition (or its illusion) emerges as such a powerful modality of experience, such a visceral desire. If Walter Benjamin reminds us that early film served to drill the viewer in the modes of perception structured by the mechanical era, how do web spaces function as instructions for our bodily adaptation to virtuality? Mark Hansen has characterized the two main forms of experiential alienation of the digital age as the 'ubiquitous encounter with estranged, rootless images . . . and the loss of agency ensuing from the increasing distribution of perceptual and cognitive tasks into systems centrally involving non-human components' (9). In the face of these forces, then, the volitional mobility, the scan-and-search, and the transformation promised by the web might offer a glimmer of hope, a hope not entirely foreclosed by corporate rhetoric, the will of interactive companies like DEN and Pseudo, and the hegemony of Microsoft. While the 'click-and-buy' logic of DEN certainly overrides the ontology of volitional mobility with an illusory ideology of volition, that these modalities are also part of the *forms* of the web suggests a redemptive

possibility, if only in the ways they activate our very desire for movement and change, a desire that might be mobilized elsewhere.

Notes

1 I trace the emergence and stakes of this rhetoric of convergence in my 'TV predicts its future: on convergence and cybertelevision.' My theorization about the web's modalities took initial shape in that essay, and 'Reload' draws from and expands this earlier work.

2 During the dotcom boom, Pseudo was hailed by many as an excellent example of the web's capacity to leverage and improve upon conventional television. While the site, begun in 1994, did offer some innovative and interesting programming in a format which in actuality drew as much from radio as from television, it still was a victim of the new technology slowdown and of uncontrolled spending, having burned through in excess of $32 million in funding without becoming profitable (Blair). The site was officially shut down in September 2000, a closure described by *The New York Times* as 'one of the most visible casualties of the dot-com sector's downturn' (Meyers). The company's assets were purchased in January 2001 by INTV (www.intv.tv), another 'interactive television' company which maintains a circumscribed site at www.pseudo.com. This site promised an imminent (and unrealized) relaunch of Pseudo throughout fall of 2001. DEN (an acronym for the 'Digital Entertainment Network') was launched to incredible hype in Los Angeles and more clearly drew from television's series format. At its height, it had over 300 employees as well as investments by Microsoft, Dell Computer, NBC, and other large technology and entertainment companies. After speeding through more than $60 million in capital in about two years, DEN closed shop in June, 2000 amid heavily reported scandals, both financial and sexual.

3 In *Visible Fictions*, John Ellis argued that television viewing was more accurately characterized by the glance than by the sustained gaze that film theorists had posited as key to cinema's power and allure. This reading was at least partially based on television's domestic setting, a context likely to encourage distracted viewing. As John Caldwell notes, 'glance theory' now functions as a truism of television theory, although Caldwell argues that newer modes of televisuality do demand a more concentrated gaze and a less distracted viewer. I'd suggest that television might be seen as playing to both the glance and the gaze, depending on particular modes of programming, and that neither of these modes adequately explains how we engage with our web browsers.

4 The particularity of this politics of information and design is further driven home when one realizes that over 50 percent of the registered domain names for the Internet are in the United States and that 11 percent are in California. English is by far the predominant language on the web.

Bibliography

Alliez, Eric and Michel Feher, 'The Luster of Capital,' trans. Alyson Waters, *Zone 1 and 2* (1987): 315–59.

Blair, Jason, 'Remains of Pseudo.com Bought for Fraction of What It Spent,' *The New York Times*. January 25, 2001.

Caldwell, John T., *Televisuality: Style, Crisis and Authority in American Television*, New Brunswick: Rutgers University Press, 1995.

Ellis, John, *Visible Fictions: Cinema, Television, Video*, London: Routledge & Kegan Paul, 1982.

Feuer, Jane, 'The Concept of Live Television: ontology as ideology,' *Regarding Television: Critical Approaches, An Anthology*, ed. E. Ann Kaplan, Los Angeles: AFI, 1983, 12–23.

Hansen, Mark, 'Performing Affect: Interactive Video Art and the Cybernetic Body,' paper presented at the Interactive Frictions Conference, USC, Los Angeles, June 4, 1999. (Forthcoming in the *Interactive Frictions* anthology.)

Hastie, Amelie. 'History in Miniature: Colleen Moore's Dollhouse and Historical Recollection,' paper presented at the 1999 Society for Cinema Studies Conference, Palm Beach, Florida, April 15–18, 1999.

Hayles, N. Katherine, 'Print is Flat, Code is Deep,' paper presented at the Interactive Frictions Conference, USC, Los Angeles, June 4, 1999. (Forthcoming in the *Interactive Frictions* anthology.)

Kinder, Marsha, *Playing with Power in Movies, Television, and Video Games: From Muppet Babies to Teenage Mutant Ninja Turtles*, Berkeley: University of California Press, 1991.

Menn, Joseph, 'DEN Investigated on Alleged Fraud in Liquidation,' *Los Angeles Times*, August 2, 2000.

Meyers, Peter, 'In a Crisis, a Wireless Patch,' *The New York Times*, October 4, 2001.

Morse, Margaret, *Virtualities: Television, Media Art, and Cyberculture*, Bloomington: Indiana University Press, 1998.

Murray, Janet, *Hamlet on the Holodeck: The Future of Narrative in Cyberspace*, New York: Free Press, 1997.

Nash, Michael, Remarks at the Interactive Frictions Conference, USC, Los Angeles, June 6, 1999.

Pillar, Charles, 'Improved Technology May Finally Make Interactive TV a Go,' *Los Angeles Times*, November 16, 1998, C1.

Stam, Robert, 'Television News and Its Spectator,' *Regarding Television: Critical Approaches, An Anthology*, ed. E. Ann Kaplan, Los Angeles: AFI, 1983, 23–43.

Streeter, Thomas, *Selling the Air: A Critique of the Policy of Commercial Broadcasting in the United States*, Chicago: University of Chicago Press, 1996, 49–64.

Williams, Raymond, *Television: Technology and Cultural Form*, New York: Schocken, 1975.

Visual colonialism/Visual transculture

Introduction to part three

■ Nicholas Mirzoeff

FOR MANY YEARS the history of colonial expansion and the subsequent dramas of the postcolonial nations have been kept at arm's length by the West: important, certainly, but not the central issue of the day. But as the postmodern comes to seem more and more a thing of the past and the poststructuralism that caused such drama is being revised even by its proponents, the long histories of Western expansion and retreat seem ever more pertinent. The devastating events of September 11 make this only too apparent as outside armies return yet again to Afghanistan, a country that was never formally colonized but which has been fought over since the mid-nineteenth century. In the myriad reactions to the terrorist actions, one is noticeable in this context – the call to Muslims to 'remember Andalucia,' recalling the 'reconquest' of southern Spain by Christian forces that was completed in 1492. John Docker has mourned 1492 as a disaster in world history when the 'desire to be open, heterogeneous, tolerant of difference, pluralistic' gave way to 'sinister intolerance and xenophobia' (Docker 2001: 190). Despite the utopian tinge to his remarks, who can deny that we are in desperate need of what Docker calls *convivencia*, the ability of people of different backgrounds, faiths and ethnicities to live together? This has become a key problem of everyday life from Kabul to Sydney, from New York to Bradford, England, from Johannesburg to the Basque country of Spain. A new present requires a new past. What Achille Mbembe has called the crisis of the subject, which is also the crisis of modernity, began not in the Western capitals but in Cameroon, Lagos, the Caribbean, Mexico City, Buenos Aires and the other new metropolitan areas of global culture. This section looks, then, at the imbricated histories of visual colonialism and transculture.

(a) Visual colonialism

The colonial powers always claimed that their role centered on the three Cs enumerated by the missionary David Livingstone: commerce, Christianity and civilization. What the French called the 'civilizing mission' may seem like a mere excuse for the expansion of trade but the colonialists took their self-appointed mission very seriously. In order to understand what colonialism did, we need to understand what the colonists thought it was doing, how the colonized experienced it and then to make a judgment about how these different perceptions interacted. There was an immensely productive visual colonialism, ranging from maps, photographs and paintings to collections of indigenous arts and crafts. These objects were assembled in vast collections like those of the Musée de l'Homme in Paris, the Museum of Mankind in London, the American Museum of Natural History, the Musée du Congo Belge, Terveruen, and so on. Collectively, the visual culture of colonialism had a significant role to play in explaining, defining and justifying the colonial order. The essays in this section look at how this 'visualism,' to use Johannes Fabian's term, worked in practice. For Fabian, colonial society operated in accordance with John Locke's definition of observation: 'The perception of the mind [is] most aptly explained by words most closely related to the sight' (Locke, ch. 29, section 2). Within this framework, however, were multiple and sometimes competing layers of visualization.

In his essay examining visual practice in the colonization of Australia, Terry **Smith** identifies three 'practices of calibration, obliteration and symbolisation (specifically, aestheticisation)' that together composed the visual regime of colonization. By calibration, he refers to the processes of mapping and otherwise describing the physical environment. Obliteration describes the extensive effacement of the indigenous culture of Aboriginals and Torres Strait islanders, which was then partly concealed and partly forgotten by means of the strategy of symbolization, especially via the aesthetic. This thesis is then detailed in a history of the first representations of Sydney Cove after the First Fleet brought the first transported convicts to Australia in 1788, under the command of Captain Arthur Phillip. Smith shows how the British settlers' calibration of the coast and what has become Sydney Harbor obliterated both the indigenous culture and the representations of the transported. He then opens the possibility that contemporary Aboriginal art will allow us to reconstitute the Aboriginal 'mapping' of the land, provided that we remember that such picturing has a very different intent to colonial cartography: 'It is a visual provocation to ceremonial song, to the telling of elaborate narratives of how and why the Originary Beings created the earth and everything in it.' This practice could not have been more distinct from the European strategy of depicting 'pure' landscape from a disinterested and disembodied viewpoint. This difference continues to play itself out in contemporary Australian visual culture and the politics of settlement.

In the extract from his fascinating essay 'Orientalism and the Exhibitionary Order,' Timothy **Mitchell** shows how the visual representation of the 'Orient' in nineteenth-century anthropological exhibitions both created and displayed what he calls 'Orientalist reality' (Mitchell 1992). Orientalism is the name given by Edward Said

to the Western study of an imaginary place called the Orient that was variously located in any space from the Jewish East End of London to the European colonies in North Africa, the Middle East and Asia. In short, the Orient was not so much a physical space as the idea of everything exotic and other (Said 1978). Mitchell defines Orientalist reality 'as the product of unchanging racial or cultural essences,' which were held to be diametrically opposed to those of the 'West,' an equally imaginary place. These essences were displayed to a curious Western public at the repeated world's fairs and exhibitions of the period (1851–1914). What is particularly striking about Mitchell's essay is that he places this now familiar account in counterpoint with the views of Arab visitors to these exhibitions. Middle Eastern visitors found it curious that Westerners were so obsessed with 'spectacle' – a word for which they could find no equivalent in their own languages. No effort was spared to render the displays of Oriental life and culture 'realistic' but their value was in the end to serve as what one catalog called an object lesson. That lesson taught, as Mitchell puts it, that

> Objectiveness was a matter not just of visual arrangement around a curious spectator, but of representation. What reduced the world to a system of objects was the way their careful organization enabled them to evoke some larger meaning, such as History, or Empire, or Progress.

Mitchell terms this system the 'exhibitionary order,' which was able to put the varied and contradictory elements of 'race' and racial difference on display and hence give it coherence.

The exhibitionary order of visual colonialism extended into the everyday lives of both Europeans and indigenous peoples. No product could seem more innocent and everyday than the humble bar of soap. In this extract from her acclaimed book *Imperial Leather*, Anne **McClintock** shows that the remarkable growth of soap as a commodity in the nineteenth century was due in considerable part to its being perceived as the very essence of imperial culture. British readers may recall a brand of soap of the same title as McClintock's book. She argues that 'soap flourished not only because it created and filled a spectacular gap in the domestic market but also because, as a cheap and portable domestic commodity, it could persuasively mediate the Victorian poetics of racial hygiene and imperial progress' (McClintock 1995). A repeated theme in the mass advertising of the period showed a black child being washed with soap in the first frame and then becoming white below the neck in the second. Imperialism here literally washes away the stains of primitivism and 'the purification of the domestic body becomes a metaphor for the regeneration of the body politic.' Protestantism, commerce and civilization were thus all mobilized by the bar of soap, selling both the product and the political culture of imperialism.

Malek **Alloula** takes another everyday object – the postcard – and shows how it was a classic locus of Orientalism, which has long been a phantasm of the West: 'There is no phantasm, though, without sex and in this Orientalism . . . a central figure emerges, the very embodiment of the obsession: the harem' (Alloula 1986). In Arabic, *harim* means forbidden and thus also refers to the women's quarters of

many Islamic households, which are forbidden to strange men. Embroidering from four centuries of stories concerning the Imperial harem in Istanbul, however, the Western imagination had transformed every harem into a hotbed of sensuality and sexuality. France colonized Algeria in 1830, an operation documented at the time by the artist Eugène Delacroix and later depicted by countless Orientalist artists, led by figures like Horace Vernet and Eugène Fromentin. In the first decades of the twentieth century, the fine art genre of the odalisque, or Oriental nude, was displaced by a flood of popular postcards depicting the *algérienne*, the Algerian woman. **Alloula**, himself Algerian, studied this mass of now-discarded visual material in his classic study *The Colonial Postcard* in which he wants to 'return this immense post-card to its sender,' the French colonizer. He shows how the veiled Algerian woman was a provocation to the European photographer as her light clothing produced a 'whiteout' in the bright sun, a technical failure of the photograph to register strong differences of light and dark. The women's peephole gaze from behind the veil recalls the photographer's own gaze from behind the cloth of a tripod camera of the period and in a sense 'the photographer feels photographed . . . *he is dispossessed of his own gaze.*' The response is to remove the obstacle to the gaze – to obliterate it, in Terry Smith's terms – by raising the veil: 'he will unveil the veil and give figural expression to the forbidden.' Thus from the seemingly innocent postcards showing a woman slightly lifting her veil to the popular image of a half-naked Algerian woman, there is hardly a step. The colonial gaze must see and make an exhibition of these women, which is then rendered as the aesthetic. The erotic effect, such as it is, is beside the point in this operation of colonial visualism.

From the other side of the colonial color line, Suzanne **Preston Blier** gives an evocative account of how the operations of colonial power transformed one powerful genre of African art: the Fon *bocio* figure. In the Fon region of West Africa, slavery did not disappear with the end of the Atlantic slave trade but continued domesti-cally to supply labor for the palm-oil plantations that supplied the soap industry described by Anne McClintock. By 1900, as many as one-third of the population in the Danhome area were plantation slaves. The violence of slavery was powerfully expressed in the gagged and bound Fon *bocio* sculpted figures that contrasted point-edly with the smoothly rounded sculptural forms produced for the Fon nobility of the period. As Blier explains in this extract from her prize-winning book *African Vodun*, these sculptures 'offered a way of both accepting and refusing the negative by helping their users to "think-through-terror"' as [Michael] Taussig would say. . . . Art provides one way of uttering what is otherwise unutterable.' While Alloula regrets that the gaze of the Algerian women is nowhere represented in the post-cards (though it is present in the 1940s work of Algerian photographer Mohammed Dib), subaltern experience is given visible expression in the Fon *bocio* figure, as it is in Kongo *minkisi* power figures. Collectively these essays and extracts suggest that it might be more effective to replace such textual language of utterance and silence with the visual terminology of calibration, symbolization, exhibition, veiling and so on.

(b) Identity and transculture

In the curious world created by global capitalism, identity is in flux. The nation-state seems weaker as a result of such transnational bodies as the World Trade Organization and its related economic groupings like the North American Free Trade Agreement and the European Union. Increasingly workers in developed nations have found their negotiating positions undermined by the constant ability of capital to relocate. When a Hasbro toy factory in Canada was relocated to Tijuana, Mexico, in the early 1990s, its new workers probably did not suspect that before the decade was out the plant would again be transferred, this time to China. Labor everywhere has been forced to become migrant, so that the new symbol of the American working class is the Ryder moving truck rather than the shiny Thunderbird of the 1950s. At the same time, countries as disparate as Australia and Denmark are experiencing a revival of anti-immigrant nationalism, often backed by white working-class voters. Artists, critics and intellectuals have tried to resist this new essentialism by high-lighting the central role of what the Cuban critic Fernando Ortiz called 'transculture.' As noted in the Introduction, transculture – the violent collision of an extant culture with a new or different culture that reshapes both into a hybrid transculture that is itself then subject to transculturation – highlights those places where the carefully defined borders of identity become confused and overlapping, a task that requires new histories, new ideas and new means of representation.

For example, in her essay '"His Master's Obi": Machine Magic, Colonial Violence, and Transculturation,' Jill **Casid** interweaves theoretical analysis, a case-study of the Obeah trials in eighteenth-century Jamaica and the contemporary Caribbean diaspora. One of the effects of transculturation was to make it impossible to keep 'Africa' or 'Asia' safely 'over there' as a screen for the projection of difference: 'spectacles like the magic lantern opened up the dangerous prospect of otherness and difference within.' Looking at accounts of the 1760 rebellion by enslaved Africans against the British in Jamaica, Casid shows that British reports inaccurately insisted that Obeah – a syncretic 'system of belief in the transforma-tive powers of matter and the dissoluble boundaries between the living and the dead' – was a relic of African religion that had nothing to do with Jamaica itself. In order to counter the belief in Obeah, a performance of power in all its senses was staged in which rebel slaves found themselves the subject, in Bryan Edwards' contemporary account, of 'various experiments . . . with electrical machines and magic lanterns.' These had little effect except on one man 'who, after receiving some very severe shocks, acknowledged that "his master's *Obi* exceeded his own."' The machine-magic of the West was and is held to be superior to the spirit magic of its Others, a history Casid theorizes with the help of Michael Taussig's reading of Adorno and Horkheimer's *Dialectic of Enlightenment*. In this view, enlightened subjects are nonetheless 'invested in those objects that are taken to fantasmatically mirror what the self must overcome but, nonetheless, envies – access to the raw power of nature.' The rivalry of machine-magic to Obeah demonstrates that the 'colonial order required the effects of necromancy to power its machinery,' those very effects which slavery and colonization were in theory constructed to eliminate.

In her widely-cited essay, the artist and philosopher Adrian **Piper** considers her position as a living example of one of these anomalies. She is an African American, who also has European ancestry, and she happens to have light skin. This accident of skin causes many Euro-americans to doubt her ethnicity: 'Their ridicule and accusations then function both to disown and degrade you from their status, to mark you not as having *done* wrong but as *being* wrong.' Her very existence is a testament to the processes of transculture that many people on both sides of the color line are keen to deny. Interspersing her memoir with quotations from a wide range of literature and criticism, Piper shows that the question of 'passing' has been critical to American culture since slavery. Indeed, Phillip Roth's recent novel *The Human Stain* (2000) turns on the story of an African American professor, who has long passed for Jewish, being accused of racism. Piper's essay raises the question of how identity is to be defined, what its markers are and how we make visual judgments about people's invisible histories. To be considered Native American by federal agencies at least one-eighth of your ancestors must be Native American, while any African ancestry at all will mark you as 'black.' While the statistical data continues to be a source of controversy, Piper wrily notes that 'the fact is, however, that the longer a person's family has lived in this country [the USA], the higher the probable percentage of African ancestry that person's family is likely to have – bad news for the Daughters of the American Revolution.' Whereas countries like Jamaica are comfortable in accepting the hybrid past of all their citizens, most white Americans would distance themselves from accepting African ancestry. The internet is amply stocked with genealogy sites and libraries of all sorts are filled with people searching out their individual histories. After two or three generations, such family trees begin to become a matter of choice – this ancestor is 'yours' rather than that – and until those choices start to favor hybridity, the problems Piper highlights are likely to persist.

Piper notes in passing, as it were, the impersonality of relations between blacks and whites. Coco **Fusco** gives an account of one such deliberately staged encounter. To mark the 1992 quincentennial of Columbus's voyage to America, Fusco and Guillermo Gómez-Peña created a satirical re-enactment of the ethnographic display of human beings that was especially popular in the nineteenth and early twentieth centuries. They placed themselves on display in a cage, labeled as 'Two Undiscovered Amerindians,' supposedly hailing from an unknown island in the Gulf of Mexico called Guatinau. As Fusco reports in this extract from her book *English is Broken Here*, the consequences were not as they expected:

> A substantial portion of the public believed that our fictional identities were real ones ... [and] a substantial number of intellectuals, artists and cultural bureaucrats sought to deflect attention from the substance of our experiment to the 'moral' implications of our dissimulation.

Questions of 'passing' and cultural identity predominated over the historical and critical questions the artists had sought to raise. While some viewers were simply willing to accept that any such display in a museum or public space must be 'real,'

others were aware of the performance yet quickly 'felt entitled to assume the role of the colonizer.' The performers felt that 'the human exhibitions [of the past] dramatize the colonial unconscious of American society' and evoke disturbing parallels with the multicultural trope of celebrating diversity. But museum curators and other professionals wanted only to question the 'authenticity' of the performance rather than address such questions. Fusco concludes that 'the constant concern about our 'realness' revealed a need for reassurance that a 'true primitive' *did* exist, whether we fit the bill or not, and that she or he [be] visually identifiable.' These attitudes undercut the then prevalent 'happy multiculturalism' that is quickly receding from view and helps explain why it was so short-lived.

It may perhaps be from the former 'margins' of colonial culture that new energies can be found. After all, as many commentators have argued, the conditions now commonly known as postmodernism in the West have existed in Latin America and the Caribbean since the mid-twentieth century. It is no coincidence that Ortiz theorized transculture in the Caribbean but it is worth remarking the date – 1947 – long before such ideas were discussed in the West. The concluding essays in this section look at recent work in Africa and Latin America. In his important essay on photography in Africa, the critic, curator and artist Olu **Oguibe** reminds us that photography arrived in Africa in 1839, the same year that Talbot and Daguerre first demonstrated their devices. Photography, then, is African as it is American – or more exactly, photography was from the first a global medium. In its first instances, photography in Africa often revealed the worst aspects of the medium, especially its propensity to objectify the Other. In more recent times, Oguibe notes that 'photography is once more defined not simply by the camera but within the broader frame of the photographic medium, just as it was in the days of the hand-tinted photograph.' As Western photography comes to question its relationship to objectivity and the real, it finds itself approaching the condition of African photography. In a wide-ranging survey of photographic practices in the widest sense, Oguibe finds, for example, that in the case of Ere Ibjei (images of deceased twins) 'the Yoruba associate photography not with objectivity, but with the possibility and necessity of illusion.' Photography here and elsewhere is integrated with other visual media from sculpture to painting and is seen as being inherently 'manipulable rather than clinical.' Oguibe cites the important case of Rotimi Fani-Kayode, a Yoruba who worked extensively in Britain. Fani-Kayode used photography to represent the divine, especially the elusive trickster god Eshu, in images that are not simply realistic or illusions but a complex mix of both. Oguibe sees in such work 'the significatory possibilities of the emergent form; what we might call the substance of the image.'

In her study of the use of the sexualized allegory of the 'encounter' between Europeans and the indigenous peoples of Latin America, Orianna **Baddeley** shows how the image has radically changed meaning in recent times. In the first wave of independence in Mexico, for example, artists like Frida Kahlo and Diego Rivera asserted the power of the 'inviolate spirit of the Americas, the Tehuana.' But in a 1990 work by Julio Galan, *Tehuana*, the face is left blank like a fairground cut-out in 'a world where "authentic identity" has become something to buy at a souvenir

shop.' Just as Oguibe finds a play of emergent form in African photography, so does Baddeley see new strategies in Latin American art: 'To put it simply, the definition of what is imposed and what is inherited in cultural terms has shifted. Colonialism is not denied but clearly defined criteria of cultural identity are replaced by a series of questions.' Much the same might be said of the New York art world in 2001 (at least before September 11). A series of cultural metaphors and tropes are being played over again and within that repetition 'there is also a reordering, a reconstituting of meaning which makes the alien, familiar; the distant, close.' In the transcultural, violent global culture in which we are all ensconced, there is perhaps no other path.

Further reading

Alloula, Malek (1986) *The Colonial Harem*, Minneapolis: University of Minnesota Press.

Benítez-Rojo, Antonio (1996) *The Repeating Island: The Caribbean and the Postmodern Perspective*, Durham, NC: Duke University Press.

Blier, Suzanne Preston (1995) *African Vodun: Art, Psychology and Power*, Chicago: University of Chicago Press.

Chakrabarty, Dipesh (1999) *Provincializing Europe*, Princeton, NJ: Princeton University Press.

Docker, John (2001) *1492: The Poetics of Diaspora*, London: Continuum.

Docker, John and Fischer, Gerhard (2000) *Race, Colour and Identity in Australia and New Zealand*, Sydney: University of New South Wales Press.

Fabian, Johannes (1983) *Time and the Other*, Bloomington and London: Indiana University Press.

Fusco, Coco (1995) *English is Broken Here*, New York: New Press.

Gilroy, Paul (1993) *The Black Atlantic: Modernity and Double-Consciousness*, Cambridge, Mass.: Harvard University Press.

Genocchio, Benjamin (2001) *Fiona Foley: Solitaire*, Annandale, NSW: Piper Press.

Mbembe, Achille (2001) *On the Postcolony*, Berkeley and Los Angeles: University of California Press.

McClintock, Anne (1995) *Imperial Leather: Race, Gender and Sexuality in the Colonial Contest*, London and New York: Routledge.

Mitchell, Timothy (1992) 'Orientalism and the Exhibitionary Order,' in Nicholas Dirks (ed.), *Colonialism and Culture*, Ann Arbor: University of Michigan Press.

Oguibe, Olu and Enwezor, Okwui (2000) *Reading the Contemporary*, Cambridge, Mass.: MIT Press.

Ortiz, Fernando (1995 [1947]) *Cuban Counterpoint: Tobacco and Sugar*, Durham: Duke University Press.

Read, Alan (ed.) (1996) *The Fact of Blackness: Frantz Fanon and Visual Representation*, Seattle: Bay Press.

Said, Edward (1978) *Orientalism*, New York: Vintage.

—— (1993) *Culture and Imperialism*, New York: Knopf.

Young, Robert J.C. (2001) *Postcolonialism: A Historical Introduction*, Oxford: Blackwell.

(a) Visual colonialism

Terry Smith

VISUAL REGIMES OF COLONIZATION
Aboriginal seeing and European vision in Australia

WHAT WERE THE VISUAL REGIMES of colonization practiced in settler colonies such as those on the Australian, North and South American continents from the mid-sixteenth century to the mid-nineteenth century? I propose that a structure consisting of three major components – practices of calibration, obliteration and symbolization (specifically, aestheticization) – underlay the vagaries of style and circumstance. These components could be hidden by their apparent naturalness, or laid bare in their brash instrumentalism, while at other times they seemed so distinct as to constitute a prevailing visual order. I will explore the case of the British colonies of Terra Australis, but the interpretation may have validity for other settlements during this period.

Mapping of the oceans and landmasses, measurement of distances and of governmental and property boundaries, surveillance of peoples – all of these are practices of *calibration*. They are more than acts of noticing and naming, of fixing position and describing characteristics, after which the job of the observer is done, and he and his machinery of observation moves on. Rather, they initiate processes of continuous refinement, of exacting control, of maintaining order. They create the self-replicating conditions of a steady state, European-style. They are the bastions of a social structure that exists always on the cusp of collapse into disorder, even barbarism. Imperial expansion, economic necessity and the exigencies of practical settlement require nothing less than this constantly reflexive watchfulness.

Erasing the habitus, the imagery, the viewpoints and, eventually, the physical existence of indigenous peoples – these are practices of *obliteration*. This may take the form of violent extinguishment, or violation of ceremonial sites; of creating an environment in which the indigene can no longer live, leading to lassitude, a 'dying out' which puzzles its ignorant author; of unauthorized reproduction of Aboriginal designs to a literal scrawling of graffiti over sacred signs; of assimilating the indigene to the supposedly universal frameworks of Western rationality or setting him

and her at an unbridgeable distance – as a 'Noble Savage,' for example. These practices range from actual, brutal murder to an equally potent imaginary Othering. Art tends to serve the latter: it Others the real Other by abstracting the indigene by figuring 'the native' in kinds of representation at once comfortably familiar and wildly exotic. The actual otherness of the indigene is thereby screened from view.

Transforming the world of experience by treating selected parts of it, or certain relationships in it, as representative of an abstract idea (such as beauty) or of an ideological tendency (such as the rule of bourgeois law) is to practice symbolization. To subject the world to processes of representation which have been trialed in painting, sculpture, print-making and, eventually, photography is to apply to the world practices of *aestheticization*. This was done to an unprecedented degree, during the eighteenth and nineteenth centuries, by the visual regime known as the Picturesque. It was more than an artistic style, more even than an affection of English gentlemen wishing to swan about the countryside and the Continent looking for aspects which reminded them of famous paintings. It was an open form of visual journeying, a technique for stringing otherwise incompatible sights and sites together. It became indispensable to colonization, the 'human face' of imperialism. It spun charming appearances as garlands over the instrumental actualities of establishing colonies in foreign climates, of creating systems of control, of building ordered socialities.

The visual regimes of colonization, then, always involved a triangulation, a simultaneous crossing of the three perspectives: calibration, obliteration and symbolization. And each of these was itself a hardening against its own, always threatening double: against disorder, othering and the instrumental.

The picturesque at Sydney Cove

The first two known delineations of the British settlement which led to the foundation of the city of Sydney prefigure key elements of the contradictory perspectives which have shaped visual cultures in Australia ever since. The first fleet moved to a place that Governor Arthur Phillip named Sydney Cove on January 26, 1788. On March 1 Captain John Hunter and Lieutenant William Bradley carefully rendered the shoreline, the depths of water, and the positions of both the rudimentary buildings and the boats at harbour. Their chart can be fitted exactly into the world map centered on Greenwich. In his journal Hunter records, with the same linear instrumentalism, his first impressions of the harbour and the Cove:

> it had rather an unpromising appearance, on entering between the outer heads or capes that form its entrance, which are high, rugged, and perpendicular cliffs; but we had not gone far in, before we discovered a large branch extending to the southward; into this we went, and soon found ourselves perfectly land-locked, with a good depth of water.[1]

During April, the following month, the convict Francis Fowkes sketched the same place. Despite the detailing, coloring and coding added by engravers in London, it is obvious that Fowkes sees the place quite differently, that his priorities

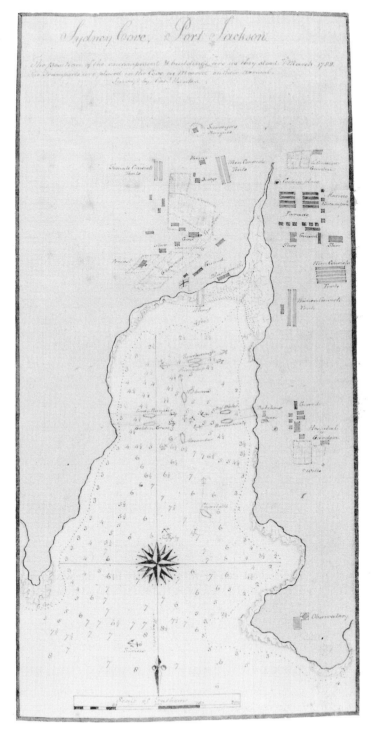

Figure 42.1 *Sketch of Sydney Cove* by John Hunter and William Bradley, in John Hunter, *An Historical Journal of Events at Sydney and at Sea 1787–1792*, London 1793, page 29, Mitchell Library, Sydney.

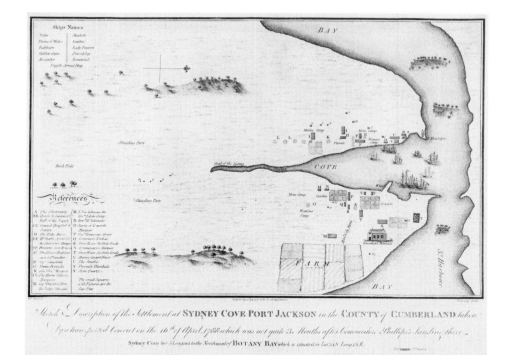

Figure 42.2 Francis Fowkes (attributed), *Sketch and Description of the Settlement at Sydney Cove taken by a transported convict on the 16th April 1788*, published R. Cribb, London, July 24 1789, hand coloured engraving, 31 × 91 cm, National Library of Australia, Canberra

are sites of work, living, and control, as well as food sources. His sketch evokes no larger vision, implies nothing beyond its vague borders. No written record of Fowkes's views survives.

Both Hunter and Fowkes made instrumental images, aids to survival. They converge stylistically, but only because they were both re-presented in the same, other place, that is London. Beneath these changes aimed at making them similar, we can discern the traces of original lines made by people in possession of quite different degrees, and kinds, of power.[2] The perspectives of people like Fowkes rarely appear in colonial representations of any kind – indeed, images of them, and of convicts as a class, are rare to the point not just of oversight but of repression. The practices of calibration, so clearly exemplified by Hunter's mapping, lead to their own kind of obliteration: they erase the perspectives of the victims and the slaves of imperialism.

Yet there is, already, another significant absence. Nowhere in the drawings of either man is there any sign that prior to their mapping of this place there had been others who, for many thousands of years, had lived in it, and represented their relationships to it. The approximately three thousand Dharug (Dharruk), Dharawal, and Kuring-gai peoples of the region had developed systems of marking their bodies, implements and shields with traditional designs, and of representing animals and spirit figures by charcoal drawings inside caves and by elaborate engravings into

open rock. But disease, murder and dispossession devastated their society, particularly the Cadigal and Eora tribes whose home was the Sydney Cove area. As the convict period drew to a close around 1850, less than three hundred remained in the region. While the large number of images of Aborigines by white settlers enable us to trace their perception of the original inhabitants, it is impossible to trace to the period an Aboriginal visualization of convictism, difficult indeed to source even imagery of the territory of its occurrence.[3]

Aboriginal 'mapping'

It is possible, however, to extrapolate backwards from practices of mapping in recent and contemporary Aboriginal representation. Given that every aspect of Aboriginal identity originates in the earth, takes form as a figuring of an aspect of a wide variety of relationships to the land, and constantly refers back to one's place as the foundation of being, then it is scarcely surprising that representations of territory constitute the most significant frameworks for sacred ceremony and are a frequently occurring subject in the many kinds of sacred/secular art forms which circulate beyond tribal communities to serve the burgeoning interest in contemporary Aboriginal art.[4] Nothing survives from the Sydney Cove region, but 'mappings' of those areas throughout the Australian continent in which Aboriginal communities remain active are commonplace.

They occur in all forms of Aboriginal art: in body marking for ceremony, as symbols on sacred message boards and burial poles, in sand paintings and in paintings using natural ochers on rock walls and on bark. There is rich evidence that these practices are many thousands of years old, the earliest forms dating to perhaps 40,000 years BP. They remain the primary content of art made by current Aboriginal artists who live and work in tribal settings. For those artists who live away from their communities, or who are the children of those separated from their families during the assimilationist period of the 1940s and 1950s, actual or psychic journeying is a frequent subject. In the work of Aboriginal artists living in the predominantly white cities and country towns the effects of dispossession are often registered as a traumatic yearning, in the art of Judy Watson, Tracey Moffatt, Gordon Bennett, and Fiona Foley, for example.[5]

Australian Aboriginal picturing of the land is, then, not a precise cartography, oriented north–south, east–west, nor set out in measured distances, with objects drawn to scale and events located exactly in time. It is a visual provocation to ceremonial song, to the telling of elaborate narratives of how and why the originary beings created the earth and everything in it, how the ancestor figures lived and where they went, their journeying, their acts, their example. These movements generated and differentiated the land; every landform, every element of the flora and fauna is evidence of their passage – and of their continuing presence, especially as their descendants re-enact their creativity in sacred ceremony and in sacred/secular art.[6]

In this context, meaning is conveyed on four different levels. Each of these has two aspects, and all operate simultaneously, reinforcing each other. The paintings work as a depiction through inherited forms and techniques of stories, events and

figures of sacred significance, as both the broad narrative involving many related people, and as a specific moment or moral particular to the ancestors of the artist; as a visual writing of a place owned by the dreamer-painter, including journeys across it, both by the sacred originators and by the artist as a hunter or gatherer; as a witness that the duty of representing or singing the dreaming has been done, thus constituting a restatement of title or deed to the land indicated; and finally as an individual interpretation of these duties and practices, varying somewhat, and thus keeping alive, the obligations and pleasures of painting. Self-expression is important, but less so than all the other reasons for painting.[7]

While not all examples of Aboriginal art display this degree of complexity and subtlety, many do so. A striking example is the painting *Warlugulong,* made in 1976 by two brothers, Clifford Possum and Tim Leura Tjapaltjarri. Both are from the Anmatyerre/Aranda language group, whose lands are vast tracts of the Central Desert, largely to the north and east of the town of Alice Springs. It is one of the first major statements to be made by artists working within the painting movement which began at Papunya, a settlement west of Alice, in 1971.[8] Within that tendency, artists use sticks or reeds to juxtapose dots of acrylic on canvas surfaces, in a manner which echoes the practice used in making ceremonial sand paintings, of depositing small mounds of differently colored sands or crushed vegetative matter such that the overall configuration sets out a sacred ground. Sand paintings of these sacred subjects have been made for many thousands of years. The normal practice is for them to be used as the central physical and spiritual focus of the ceremony, which can last for some hours or for many days, and then for them to be swept up or left to the elements.

'Warlugulong' is the name for fire, particularly a series of ancestor figure stories associated with fire in an area near the present-day town of Yuendumu, about 300 kilometers north-west of Alice Springs. Warlugulong is an actual site near Yuendumu where the ancestor man Lungkata, whose original form was the Blue-tongue Lizard, punished his two sons for killing and eating a sacred kangaroo by setting the bush alight. Its explosive flames may be seen in the center of the canvas, the tracks of human footprints above being left by the fleeing sons. The waving lines between concentric circles indicate another major narrative of origination: at the top of the image, the Great Snake Yarapiri is shown travelling from Winparku, 200 kilometers west of Alice, through limestone country. Other, lesser connected lines and circles relate to other snakes and snake men whose journeys through these regions were devoted to instructing locals in ceremonial matters.

The white emu tracks moving from the upper left to the lower centre of the painting indicate the path of an emu ancestor from near what is now Napperby Station (50 kilometers east of Yuendumu). He met with emu men from Walpiri regions nearby, and shared food with them, establishing the possibility of harmonious relationships between the Walpiri and the Anmateyrre. The brown human footprints through the lower right area recall happy exchanges of the prolific supplies of food in the region between women from the two tribes. The possum tracks along the bottom edge of the painting are traces of a less happy story: one of warring between possum men and hare wallaby men. The unlinked circles on the right relate to the killing of an euro (a hill kangaroo) by a wedge-tailed eagle. There are also a number of other narratives, ranging all the way back to the originary beings who

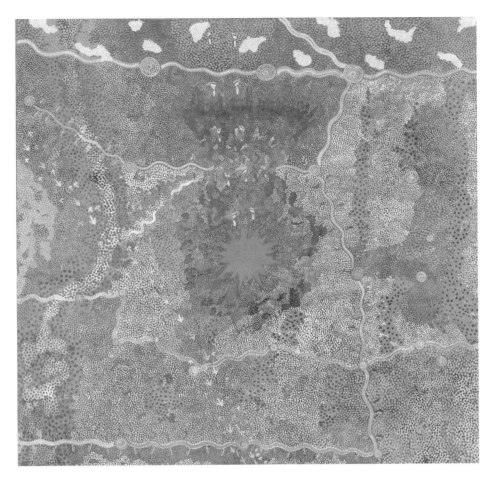

Figure 42.3 Clifford Possum Tjapaltjarri/Tim Leura Tjapaltjarri, *Warlugulong*, 1976. Synthetic polymer paint on canvas, 168.5 x 170.5 cm. Art Gallery of New South Wales, Copyright Aboriginal Artists Agency Limited. Photo: Christopher Snee for AGNSW

created this area, through the ancient ancestor figures to not so distant relatives of the present-day artists. The variegated patches of dots throughout the work evoke the kinds of country in which these events occurred: white areas indicate water, orange the color of sand, black the burnt-out areas, and so on.

These various stories are set out as inscribing an area of country, as literally making it what it is, as being alive within it. This means that the painting *Warlugulong* is a conceptual field of these occurrences, these memories, these continuing actualities. While all of the narratives depicted can be traced on actual ground – indeed, this is what much sacred ceremony consists of, it is an actual going over the same ground and then a convening in one place, around a sand painting of the whole ground, to ritualize the knowing of it – this painting does not set them out in the same spatial relationships one would expect to find in a European map. The artists changed the north–south axis in the case of each of the main stories shown: the two sons fled south but are shown as going upwards (north on a European map), Yarapiri

traveled south to north but is shown moving left to right (east to west on a European map). Taking just these two together requires a 'spinning in space above the landscape' on the part of a spectator who wishes to remain anchored, or better, a letting go of Western spectatorship.[9]

Aestheticization: land into landscape

Why were panoramic views of the newly settled colonies so popular during the late eighteenth, early nineteenth century? The many long, horizontal views of Sydney Cove, each one securely knowing that it would be succeeded by another, seem to be staging the processes of colonization, as if the emergent social order could be measured as it grows against an increasingly clearly understood natural topology. This is a technique of reportage, an extension of the necessary business of mapping the coastline. An aesthetic with great appeal to a maritime people, to a social order whose empire depended on control of the seas.

Many areas of Terra Australis were depicted as if they were recognizably like, or approximate to, specific English landscapes. This not only reinforces a sense of familiarity, it does so with a purpose: to promote free emigration to the colonies, an outcome greatly desired from the 1820s, becoming a necessity with the cessation of transportation in the 1840s. Joseph Lycett's *Views* are an early instance, and were continued in many publications and presentations, such as the London exhibitions of John Glover and John Skinner Prout. Related to this is the enthusiasm for literally transforming suitable areas of land into approximations of environments in England or Scotland, by imposing similar modes of cultivation in farming lands and laying out huge public garden spaces in the main cities (returning them to walk-through pasture, as it were, but in picturesque modes). Both of these processes shape *The Town of Sydney in New South Wales,* a set of watercolors made by Major James Taylor, probably in 1821 which trace a 360-degree panorama around Sydney Cove from what is now Observatory Hill. In London two years later three of them were printed as hand-coloured aquatints by Robert Havell & Sons and published by Colnaghi & Co. The set was intended as a gift to key government officials, to be purchased by the small group of gentlemen who collected books and prints of the colonies, and be of interest to those concerned with the current controversy about the political direction of the colony. At the same time, Taylor's 'designs' formed the basis of a full-scale display at Barker & Burford's Panorama in Leicester Square. The message is clear: Georgian order can bring English civilization to the wildest, and most distant, places on the earth. It is a utopia specific to Sydney Town: each figure encapsulates a particular dream of social mobility, of rising above the realities of harsh circumstances, exclusive class divisions, brutal systems of punishment and the ghostly presence of strange, dark otherness. This was possible, in fact, for some. In Major Taylor's vision it was happening to all, right before their eyes.[10]

By the 1850s an instrumental imagery returned, briefly, to prominence, especially with the pragmatics demanded by picturing of the goldfields of Victoria – a site which captured world attention, and attracted the adventurous from everywhere. During the 1860s, however, with the return of the pastoral industries to

economic, social and political pre-eminence, the evidently aesthetic category of the landscape became the preferred vehicle to release a set of symbolic purposes. This occurred most clearly in a genre of paintings which can only be called 'portraits of property.'

The master of this genre was the Swiss-born immigrant Eugene von Guérard. His Western District propertyscapes celebrate not just the results and rewards of decades of development, but something of the transformatory power of pastoralism as a set of practices for controlling natural forces so subtly successful that they become themselves an ordering principle – of people, animals, places and things. His 1864 image, *Yalla-y-Poora*, is outstanding among these. There is, certainly, a careful record of the signs of recent success: the Italianate style house, the imported trees and sulky. These are the superficies, the real question is: what is the setting which von Guérard has activated? The work of the farm is conveyed not through the static overall gestalt but through the visual journeying within it: in looking, we rehearse the processes of working over the land. We do so through the geometry underlining the narrative passages. Split into halves by an emphatic horizon line, the upper half of Grampians and sky shows the natural world changing slowly, majestically, relentlessly, according to a geo–logic, while the human industrial transformations below hang from the horizon in ways which could be agitated, even discordant, but are absorbed into a matching harmony by the figure-of-eight (a virtual Mobius strip) of the ornamental lake and the passages around and across it. This subdued but nevertheless vital drama unfolds before us, as we 'walk' across the few rocks in the foreground to join the traveler at the fence marvelling at the power – and the equivalence – of these two 'natural,' transcendent orders. Von Guérard shows this not only by picturing it, but also by subjecting the compositional potentialities of illusionistic naturalism to its limits. He creates here something close to the heart of painting's own paradoxical freezing of time, a

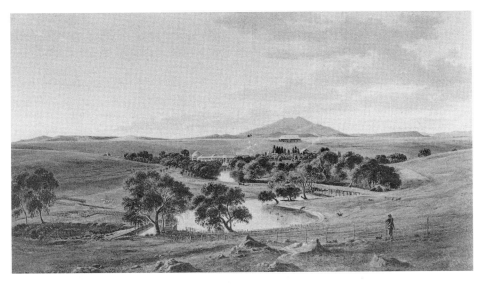

Figure 42.4 Eugene von Guérard, *Yalla-y-Poora Homestead*, 1864, oil on canvas, 69.9 × 121.9 cm, private collection, Melbourne.

nearly-still geometry of implacable change. This is a visual metaphor of pastoralism's processing of the land that will echo for nearly a century.[11]

Aestheticism reaches its most precise, calibrated form in works such as this. Everything that the natural world does, everything which human beings strive to do to it, is subject to the measuring eyes. But what an eye! There is no indigenous person to be seen, nor any traces of an indigenous presence on the surface or structure of this scene – the processes of obliteration have done their work. This scene was brought into this being by the labor of the colonizer, but this human effort has become something larger, more implacable. It has become a virtual civilization, a calibrating machine, a world imposed on the rawness of nature by perfect measurement itself. For a moment, we look at the world as presented by this picture, and see the world through the superhuman eye of this picture. Our merely human seeing disappears, and for a moment, virtually, we see with, and are ourselves, the eye of seeing itself – what von Guérard (fantasizing back to late medieval holy innocence, and in parallel with William Blake's joy to the world) would imagine to be the eye of God.

Triangulations/coincidences

The coincidence on the Australian continent since the late eighteenth century of its first people's creation of a rich culture in conditions of scarcity and the expansive, transformative marauding of European imperialism threw into sharp relief several divergent practices of seeing. I will conclude by highlighting the three that have occupied us here.

Colonists such as Hunter applied to this strange place a supra-human regime of measurement, one that was capable of fitting any phenomena that came before it into a frame. Each frame was a separate section of a larger whole, itself made up of a huge but finite number of similar sets: latitude, and soon longitude, calibrated from Greenwich. That which did not fit the frame, which was not measurable by such framing, was simply not seen, effectively obliterated. As settlement progressed to a point when it needed to introduce its own practices of selective forgetting, landscape became more and more prominent, both in actual journeying and in the distilled visitation of the painted image. Artistic landscapes 'improve' human observation, idealize it, aestheticize it. Sometimes, it induces such passages of reflexive engagement that it transcends itself to being, almost, a 'pure' kind of vision – seeing as if done by a disembodied eye. In contrast, Aboriginal representation of territory – as far as one can generalize from such a variety of practices among what were over 900 language groups (now 90) throughout the continent – does not calibrate in the senses of measure distance or plot exact location on the earth's surface. Nor does it use the landscape forms of either Western or Eastern traditions, except by occasional adoption and adaptation. It is the product of a group of people standing together, leaning over a piece of ground or bark or the prone body of a ritual relation, and, taking this surface as a field for evocation, making the marks – the signifying 'designs' – which trace how the larger surround – one's 'country' – came into being. Painting and singing continue this sacred ground into the present. Ceremony and art-making repeat the imbrication of the bodies and spirits of men

and women into the actual, and the reimagined, ground. It is a representing which preceded the era of colonization, and will supersede it. It is a murmuring and a mark-making which is incessant.

Note: This is a revised version of a chapter in Ulpiano Toledo Bezerra de Meneses, ed., *Paysage et Art*, papers of the conference 'Paisagem e Arte, a invençao da natureza, a evoluçao da olhar,' Comité Brasileiro de Historia da Arte, São Paulo, 2000.

Notes

1 John Hunter, *An Historical Journal of Events at Sydney and at Sea 1787–1792*, London, 1793, ed., J. Bach, Sydney, 1968, 29.

2 The *Sketch of Sydney Cove* by John Hunter and William Bradley was in Hunter's *Journal*; there is a copy in the Mitchell Library, Sydney. Fowkes's *Sketch and Description of the Settlement at Sydney Cove* was published in London by R. Cribb on July 24, 1789; a copy is in the National Library of Australia, Canberra. Both are discussed in the relevant entries in Joan Kerr, ed., *The Dictionary of Australian Artists: Painters, Sketchers, Photographers and Engravers to 1870*, Melbourne: Oxford University Press, 1992. More generally, studies such as mine owe much to Bernard Smith, *European Vision and the South Pacific 1768–1850*, London: Oxford University Press, 1960 (a major precursor to today's work in visual culture) and of course to scholars who have recently rethought the picturesque, especially John Barrell, Ann Bermingham, and Elizabeth Helsinger. See, for example, John Barrell, *The Dark Side of the Landscape: The Rural Poor in English Painting, 1730–1840*, Cambridge: Cambridge University Press, 1980; Ann Bermingham, *Landscape and Ideology: The English Rustic Tradition, 1740–1860,* Berkeley: University of California Press, 1986; Simon Pugh, ed., *Reading Landscape: Country–City–Capital*, Manchester: Manchester University Press, 1990; and W.J.T. Mitchell, ed., *Landscape and Power*, Chicago: University of Chicago Press, 1994.

3 Possible traces are discussed in F.D. McCarthy, *Catalogue of Rock Engravings in the Sydney-Hawkesbury District*, Sydney: New South Wales National Parks and Wildlife Service, 1983; Peter Stanbury and John Clegg, *A Field Guide to Aboriginal Rock Engravings, With Special Reference to Those Around Sydney*, Sydney University Press, 1990; Peter Turbett, *The Aborigines of the Sydney District Before 1788*, Kenthurst: Kangaroo Press, 1989.

4 See, for example, Fred R. Myers, *Pintupi Country, Pintupi Self: Sentiment, Place and Politics among Western Desert Aborigines*, Washington, DC and Canberra: Smithsonian Institution and Aboriginal Studies Press, 1986.

5 For good general introductions to Australian Aboriginal art, see, for example, Robert Edwards, *Australian Aboriginal Art*, Canberra: Australian Institute of Aboriginal Studies, 1974 and 1979; Peter Sutton, ed., *Dreamings: The Art of Aboriginal Australia*, New York and Melbourne: Viking, 1988; Jennifer Isaacs, *Arts of the Dreaming, Australia's Living Heritage*, Sydney: Lansdowne, 1984; Jennifer Isaacs, *Australian Aboriginal Painting*, Sydney: Craftsman House, 1989; Wally Caruana, *Aboriginal Art*, London: Thames & Hudson, 1993; and Howard Morphy, *Aboriginal Art*, London: Phaidon, 1998.

6 On 'mapping,' see particularly Peter Sutton, ed., *Dreamings* and Morphy, *Aboriginal Art*, chapter 4.

7 This is a reformulation of an account given in Terry Smith, 'From the desert,' chapter 15 of Bernard Smith with Terry Smith, *Australian Painting 1788–1990*, Melbourne: Oxford University Press, 1991.

8 Geoffrey Bardon, *Papunya Tula: Art of the Western Desert*, Melbourne: McPhee Gribble, 1991. See also Hetti Perkins, ed., *Papunya Tula: Genesis and Genius*, Sydney: Art Gallery of New South Wales, 2000.

9 Vivien Johnson, *The Art of Clifford Possum Tjapaltjarri*, Sydney: Gordon and Breach International, 1994, p. 54.

10 For more detailed discussion of this work see Robert Dixon, 'Colonial Newsreel' in Daniel Thomas, *Creating Australia, 200 Years of Art 1788–1988*, Adelaide: Art Gallery of South Australia, 1988, pp. 66–7; Elisabeth Imashev, 'Taylor, James,' in Joan Kerr, ed., *Dictionary of Australian Artists*, Melbourne: Oxford University Press, 1992, p. 780; Tim McCormick, ed., *First Views of Australia 1788–1825*, Sydney: David Ell Press, 1987; and Gordon Bull, 'Taking place: panorama and panopticon in the colonisation of New South Wales,' *Australian Journal of Art*, vol. XII, 1995, 75–95.

11 For further discussion of this work, and of the themes of this essay, see chapters 1 and 2 in my *Figuring the Ground: Colony, Nation and Landscape in Nineteenth Century Australian Art*, Sydney: Craftsman House, 2000.

Timothy Mitchell

ORIENTALISM AND THE
EXHIBITIONARY ORDER

I T IS NO LONGER unusual to suggest that the construction of the colonial order is related to the elaboration of modern forms of representation and knowledge. The relationship has been most closely examined in the critique of Orientalism. The Western artistic and scholarly portrayal of the non-West, in Edward Said's analysis, is not merely an ideological distortion convenient to an emergent global political order but a densely imbricated arrangement of imagery and expertise that organizes and produces the Orient as a political reality.[1] Three features define this Orientalist reality: it is understood as the product of unchanging racial or cultural essences; these essential characteristics are in each case the polar opposite of the West (passive rather than active, static rather than mobile, emotional rather than rational, chaotic rather than ordered); and the Oriental opposite or Other is, therefore, marked by a series of fundamental absences (of movement, reason, order, meaning, and so on). In terms of these three features – essentialism, otherness, and absence – the colonial world can be mastered, and colonial mastery will, in turn, reinscribe and reinforce these defining features.

Orientalism, however, has always been part of something larger. The nineteenth-century image of the Orient was constructed not just in Oriental studies, romantic novels, and colonial administrations, but in all the new procedures with which Europeans began to organize the representation of the world, from museums and world exhibitions to architecture, schooling, tourism, the fashion industry, and the commodification of everyday life. In 1889, to give an indication of the scale of these processes, 32 million people visited the Exposition Universelle, built that year in Paris to commemorate the centenary of the Revolution and to demonstrate French commercial and imperial power.[2] The consolidation of the global hegemony of the West, economically and politically, can be connected not just to the imagery of Orientalism but to all the new machinery for rendering up and laying out the meaning of the world, so characteristic of the imperial age.

The new apparatus of representation, particularly the world exhibitions, gave a central place to the representation of the non-Western world, and several studies have pointed out the importance of this construction of otherness to the manufacture of national identity and imperial purpose.[3] But is there, perhaps, some more integral relationship between representation, as a modern technique of meaning and order, and the construction of otherness so important to the colonial project? One perspective from which to explore this question is provided by the accounts of non-Western visitors to nineteenth-century Europe. An Egyptian delegation to the Eighth International Congress of Orientalists, for example, held in Stockholm in the summer of 1889, traveled to Sweden via Paris and paused there to visit the Exposition Universelle, leaving us a detailed description of their encounter with the representation of their own otherness. Beginning with this and other accounts written by visitors from the Middle East, I examine the distinctiveness of the modern representational order exemplified by the world exhibition. What Arab writers found in the West, I will argue, were not just exhibitions and representations of the world, but the world itself being ordered up as an endless exhibition. This world-as-exhibition was a place where the artificial, the model, and the plan were employed to generate an unprecedented effect of order and certainty. It is not the artificiality of the exhibitionary order that matters, however, so much as the contrasting effect of an external reality that the artificial and the model create – a reality characterized, like Orientalism's Orient, by essentialism, otherness, and absence. In the second half of the article, I examine this connection between the world-as-exhibition and Orientalism, through a rereading of European travel accounts of the nineteenth-century Middle East. The features of the kind of Orient these writings construct – above all its characteristic absences – are not merely motifs convenient to colonial mastery, I argue, but necessary elements of the order of representation itself.

La rue du Caire

The four members of the Egyptian delegation to the Stockholm Orientalist conference spent several days in Paris, climbing twice the height (as they were told) of the Great Pyramid in Alexandre Eiffel's new tower, and exploring the city and exhibition laid out beneath. Only one thing disturbed them. The Egyptian exhibit had been built by the French to represent a street in medieval Cairo, made of houses with overhanging upper stories and a mosque like that of Qaitbay. 'It was intended,' one of the Egyptians wrote, 'to resemble the old aspect of Cairo.' So carefully was this done, he noted, that 'even the paint on the buildings was made dirty.'[4] The exhibit had also been made carefully chaotic. In contrast to the geometric layout of the rest of the exhibition, the imitation street was arranged in the haphazard manner of the bazaar. The way was crowded with shops and stalls, where Frenchmen, dressed as Orientals, sold perfumes, pastries, and tarbushes. To complete the effect of the Orient, the French organizers had imported from Cairo fifty Egyptian donkeys, together with their drivers and the requisite number of grooms, farriers, and saddlers. The donkeys gave rides (for the price of one franc) up and down the street, resulting in a clamor and confusion so lifelike,

the director of the exhibition was obliged to issue an order restricting the donkeys to a certain number at each hour of the day. The Egyptian visitors were disgusted by all this and stayed away. Their final embarrassment had been to enter the door of the mosque and discover that, like the rest of the street, it had been erected as what the Europeans called a façade. 'Its external form was all that there was of the mosque. As for the interior, it had been set up as a coffee house, where Egyptian girls performed dances with young males, and dervishes whirled.'[5]

After eighteen days in Paris, the Egyptian delegation traveled on to Stockholm to attend the Congress of Orientalists. Together with other non-European delegates, the Egyptians were received with hospitality – and a great curiosity. As though they were still in Paris, they found themselves something of an exhibit. '*Bona fide* Orientals,' wrote a European participant in the Congress, 'were stared at as in a Barnum's all-world show: the good Scandinavian people seemed to think that it was a collection of *Orientals*, not of *Orientalists*.'[6] Some of the Orientalists themselves seemed to delight in the role of showmen. At an earlier congress, in Berlin, we are told that

> the grotesque idea was started of producing natives of Oriental countries as illustrations of a paper: thus the Boden Professor of Sanskrit at Oxford produced a real live Indian Pandit, and made him go through the ritual of Brahmanical prayer and worship before a hilarious assembly. . . . Professor Max Müller of Oxford produced two rival Japanese priests, who exhibited their gifts; it had the appearance of two showmen exhibiting their monkeys.[7]

At the Stockholm Congress, the Egyptians were invited to participate as scholars, but when they used their own language to do so they again found themselves treated as exhibits. 'I have heard nothing so unworthy of a sensible man,' complained an Oxford scholar, 'as . . . the whistling howls emitted by an Arabic student of El-Azhar of Cairo. Such exhibitions at Congresses are mischievous and degrading.'[8]

The exhibition and the congress were not the only examples of this European mischief. As Europe consolidated its colonial power, non-European visitors found themselves continually being placed on exhibit or made the careful object of European curiosity. The degradation they were made to suffer seemed as necessary to these spectacles as the scaffolded facades or the curious crowds of onlookers. The facades, the onlookers, and the degradation seemed all to belong to the organizing of an exhibit, to a particularly European concern with rendering the world up to be viewed. Of what, exactly, did this exhibitionary process consist?

An object-world

To begin with, Middle Eastern visitors found Europeans a curious people, with an uncontainable eagerness to stand and stare. 'One of the characteristics of the French is to stare and get excited at everything new,' wrote an Egyptian scholar who spent five years in Paris in the 1820s, in the first description of nineteenth-century Europe to be published in Arabic.[9] The 'curiosity' of the European is encountered in almost

every subsequent Middle Eastern account. Toward the end of the nineteenth century, when one or two Egyptian writers adopted the realistic style of the novel and made the journey to Europe their first topic, their stories would often evoke the peculiar experience of the West by describing an individual surrounded and stared at, like an object on exhibit. 'Whenever he paused outside a shop or show-room,' the protagonist in one such story found on his first day in Paris, 'a large number of people would surround him, both men and women, staring at his dress and appearance.'[10]

In the second place, this curious attitude that is described in Arabic accounts was connected with what one might call a corresponding *objectness*. The curiosity of the observing subject was something demanded by a diversity of mechanisms for rendering things up as its object – beginning with the Middle Eastern visitor himself. The members of an Egyptian student mission sent to Paris in the 1820s were confined to the college where they lived and allowed out only to visit museums and the theater – where they found themselves parodied in vaudeville as objects of entertainment for the French public.[11]

> They construct the stage as the play demands. For example, if they want to imitate a sultan and the things that happen to him, they set up the stage in the form of a palace and portray him in person. If for instance they want to play the Shah of Persia, they dress someone in the clothes of the Persian monarch and then put him there and sit him on a throne.[12]

Even Middle Eastern monarchs who came in person to Europe were liable to be incorporated into its theatrical machinery. When the Khedive of Egypt visited Paris to attend the Exposition Universelle of 1867, he found that the Egyptian exhibit had been built to simulate medieval Cairo in the form of a royal palace. The Khedive stayed in the imitation palace during his visit and became a part of the exhibition, receiving visitors with medieval hospitality.[13]

Visitors to Europe found not only themselves rendered up as objects to be viewed. The Arabic account of the student mission to Paris devoted several pages to the Parisian phenomenon of '*le spectacle*,' a word for which its author knew of no Arabic equivalent. Besides the Opéra and the Opéra-Comique, among the different kinds of spectacle he described were 'places in which they represent for the person the view of a town or a country or the like,' such as 'the Panorama, the Cosmorama, the Diorama, the Europorama and the Uranorama.' In a panorama of Cairo, he explained in illustration, 'it is as though you were looking from on top of the minaret of Sultan Hasan, for example, with al-Rumaila and the rest of the city beneath you.'[14]

The effect of such spectacles was to set the world up as a picture. They ordered it up as an object on display to be investigated and experienced by the dominating European gaze. An Orientalist of the same period, the great French scholar Sylvestre de Sacy, wanted the scholarly picturing of the Orient to make available to European inspection a similar kind of object-world. He had planned to establish a museum, which was to be

a vast depot of objects of all kinds, of drawings, of original books, maps, accounts of voyages, all offered to those who wish to give themselves to the study of [the Orient]; in such a way that each of these students would be able to feel himself transported as if by enchantment into the midst of, say, a Mongolian tribe or of the Chinese race, whichever he might have made the object of his studies.[15]

As part of a more ambitious plan in England for 'the education of the people,' a proposal was made to set up 'an ethnological institution, with very extensive grounds', where 'within the same enclosure' were to be kept 'specimens in pairs of the various races.' The natives on exhibit, it was said,

> should construct their own dwellings according to the architectural ideas of their several countries; their . . . mode of life should be their own. The forms of industry prevalent in their nation or tribe they should be required to practise; and their ideas, opinions, habits, and superstitions should be permitted to perpetuate themselves. . . . To go from one division of this establishment to another would be like travelling into a new country.[16]

The world exhibitions of the second half of the century offered the visitor exactly this educational encounter, with natives and their artifacts arranged to provide the direct experience of a colonized object-world. In planning the layout of the 1889 Paris Exhibition, it was decided that the visitor 'before entering the temple of modern life' should pass through an exhibit of all human history, 'as a gateway to the exposition and a noble preface.' Entitled 'Histoire du Travail,' or, more fully, 'Exposition retrospective du travail et des sciences anthropologiques,' the display would demonstrate the history of human labor by means of 'objects and things themselves.' It would have 'nothing vague about it,' it was said, 'because it will consist of an *object lesson*.'[17]

Arabic accounts of the modern West became accounts of these curious object-worlds. By the last decade of the nineteenth century, more than half the descriptions of journeys to Europe published in Cairo were written to describe visits to a world exhibition or an international congress of Orientalists.[18] Such accounts devote hundreds of pages to describing the peculiar order and technique of these events – the curious crowds of spectators, the organization of panoramas and perspectives, the arrangement of natives in mock colonial villages, the display of new inventions and commodities, the architecture of iron and glass, the systems of classification, the calculations of statistics, the lectures, the plans, and the guidebooks – in short, the entire method of organization that we think of as representation.

The world-as-exhibition

In the third place, then, the effect of objectness was a matter not just of visual arrangement around a curious spectator, but of representation. What reduced the

world to a system of objects was the way their careful organization enabled them to evoke some larger meaning, such as History or Empire or Progress. This machinery of representation was not confined to the exhibition and the congress. Almost everywhere that Middle Eastern visitors went they seemed to encounter the arrangement of things to stand for something larger. They visited the new museums, and saw the cultures of the world portrayed in the form of objects arranged under glass, in the order of their evolution. They were taken to the theater, a place where Europeans represented to themselves their history, as several Egyptian writers explained. They spent afternoons in the public gardens, carefully organized 'to bring together the trees and plants of every part of the world,' as another Arab writer put it. And, inevitably, they took trips to the zoo, a product of nineteenth-century colonial penetration of the Orient, as Theodor Adorno wrote, that 'paid symbolic tribute in the form of animals.'[19]

The Europe one reads about in Arabic accounts was a place of spectacle and visual arrangement, of the organization of everything and everything organized to represent, to recall, like the exhibition, a larger meaning. Characteristic of the way Europeans seemed to live was their preoccupation with what an Egyptian author described as 'intizam almanzar,' the organization of the view.[20] Beyond the exhibition and the congress, beyond the museum and the zoo, everywhere that non-European visitors went – the streets of the modern city with their meaningful facades, the countryside encountered typically in the form of a model farm exhibiting new machinery and cultivation methods, even the Alps once the funicular was built – they found the technique and sensation to be the same.[21] Everything seemed to be set up before one as though it were the model or the picture of something. Everything was arranged before an observing subject into a system of signification, declaring itself to be a mere object, a mere 'signifier of' something further.

The exhibition, therefore, could be read in such accounts as epitomizing the strange character of the West, a place where one was continually pressed into service as a spectator by a world ordered so as to represent. In exhibitions, the traveler from the Middle East could describe the curious way of addressing the world increasingly encountered in modern Europe, a particular relationship between the individual and a world of 'objects' that Europeans seemed to take as the experience of the real. This reality effect was a world increasingly rendered up to the individual according to the way in which, and to the extent to which, it could be made to stand before him or her as an exhibit. Non-Europeans encountered in Europe what one might call, echoing a phrase from Heidegger, the age of the world exhibition, or rather, the age of the world-as-exhibition.[22] The world-as-exhibition means not an exhibition of the world but the world organized and grasped as though it were an exhibition.

The certainty of representation

'England is at present the greatest Oriental Empire which the world has ever known,' proclaimed the president of the 1892 Orientalist Congress at its opening session. His words reflected the political certainty of the imperial age. 'She knows not only how to conquer, but how to rule.'[23] The endless spectacles of the

world-as-exhibition were not just reflections of this certainty but the means of its production, by their technique of rendering imperial truth and cultural difference in 'objective' form.

Three aspects of this kind of certainty can be illustrated from the accounts of the world exhibition. First there was the apparent realism of the representation. The model or display always seemed to stand in perfect correspondence to the external world, a correspondence that was frequently noted in Middle Eastern accounts. As the Egyptian visitor had remarked, 'Even the paint on the buildings was made dirty.' One of the most impressive exhibits at the 1889 exhibition in Paris was a panorama of the city. As described by an Arab visitor, this consisted of a viewing platform on which one stood, encircled by images of the city. The images were mounted and illuminated in such a way that the observer felt himself standing at the center of the city itself, which seemed to materialize around him as a single, solid object 'not differing from reality in any way.'[24]

In the second place, the model, however realistic, always remained distinguishable from the reality it claimed to represent. Even though the paint was made dirty and the donkeys were brought from Cairo, the medieval Egyptian street at the Paris exhibition remained only a Parisian copy of the Oriental original. The certainty of representation depended on this deliberate difference in time and displacement in space that separated the representation from the real thing. It also depended on the position of the visitor – the tourist in the imitation street or the figure on the viewing platform. The representation of reality was always an exhibit set up for an observer in its midst, an observing European gaze surrounded by and yet excluded from the exhibition's careful order. The more the exhibit drew in and encircled the visitor, the more the gaze was set apart from it, as the mind (in our Cartesian imagery) is said to be set apart from the material world it observes. The separation is suggested in a description of the Egyptian exhibit at the Paris Exhibition of 1867.

> A museum inside a pharaonic temple represented Antiquity, a palace richly decorated in the Arab style represented the Middle Ages, a cara-vanserai of merchants and performers portrayed in real life the customs of today. Weapons from the Sudan, the skins of wild monsters, perfumes, poisons and medicinal plants transport us directly to the tropics. Pottery from Assiut and Aswan, filigree and cloth of silk and gold invite us to touch with our fingers a strange civilization. All the races subject to the Vice-Roy [sic] were personified by individuals selected with care. We rubbed shoulders with the fellah, we made way before the Bedouin of the Libyan desert on their beautiful white dromedaries. This sumptuous display spoke to the mind as to the eyes; it expressed a political idea.[25]

The remarkable realism of such displays made the Orient into an object the visitor could almost touch. Yet to the observing eye, surrounded by the display but excluded from it by the status of visitor, it remained a mere representation, the picture of some further reality. Thus, two parallel pairs of distinctions were maintained, between the visitor and the exhibit and between the exhibit and what it

expressed. The representation seemed set apart from the political reality it claimed to portray as the observing mind seems set apart from what it observes.

Third, the distinction between the system of exhibits or representations and the exterior meaning they portrayed was imitated, within the exhibition, by distinguishing between the exhibits themselves and the plan of the exhibition. The visitor would encounter, set apart from the objects on display, an abundance of catalogs, plans, signposts, programs, guidebooks, instructions, educational talks, and compilations of statistics. The Egyptian exhibit at the 1867 exhibition, for example, was accompanied by a guidebook containing an outline of the country's history – divided, like the exhibit to which it referred, into the ancient, medieval, and modern – together with a 'notice statistique sur le territoire, la population, les forces productives, le commerce, l'effective militaire et naval, l'organisation financière, l'instruction publique, etc. de l'Egypte' compiled by the Commission Impériale in Paris.[26] To provide such outlines, guides, tables, and plans, which were essential to the educational aspect of the exhibition, involved processes of representation that are no different from those at work in the construction of the exhibits themselves. But the practical distinction that was maintained between the exhibit and the plan, between the objects and their catalog, reinforced the effect of two distinct orders of being – the order of things and the order of their meaning, of representation and reality.

Despite the careful ways in which it was constructed, however, there was something paradoxical about this distinction between the simulated and the real, and about the certainty that depends on it. In Paris, it was not always easy to tell where the exhibition ended and the world itself began. The boundaries of the exhibition were clearly marked, of course, with high perimeter walls and monumental gates. But, as Middle Eastern visitors continually discovered, there was much about the organization of the 'real world' outside, with its museums and department stores, its street facades and Alpine scenes, that resembled the world exhibition. Despite the determined efforts to isolate the exhibition as merely an artificial representation of a reality outside, the real world beyond the gates turned out to be more and more like an extension of the exhibition. Yet this extended exhibition continued to present itself as a series of mere representations, representing a reality beyond. We should think of it, therefore, not so much as an exhibition but as a kind of labyrinth, the labyrinth that, as Derrida says, includes in itself its own exits.[27] But then, maybe the exhibitions whose exits led only to further exhibitions were becoming at once so realistic and so extensive that no one ever realized that the real world they promised was not there.

The labyrinth without exits

To see the uncertainty of what seemed, at first, the clear distinction between the simulated and the real, one can begin again inside the world exhibition, back at the Egyptian bazaar. Part of the shock of the Egyptians came from just how real the street claimed to be: not simply that the paint was made dirty, that the donkeys were from Cairo, and that the Egyptian pastries on sale were said to taste like the real thing, but that one paid for them with what we call '*real* money.' The

commercialism of the donkey rides, the bazaar stalls, and the dancing girls seemed no different from the commercialism of the world outside. With so disorienting an experience as entering the façade of a mosque to find oneself inside an Oriental café that served real customers what seemed to be real coffee, where, exactly, lay the line between the artificial and the real, the representation and the reality?

Exhibitions were coming to resemble the commercial machinery of the rest of the city. This machinery, in turn, was rapidly changing in places such as London and Paris, to imitate the architecture and technique of the exhibition. Small, individually owned shops, often based on local crafts, were giving way to the larger apparatus of shopping arcades and department stores. According to the *Illustrated Guide to Paris* (a book supplying, like an exhibition program, the plan and meaning of the place), each of these new establishments formed 'a city, indeed a world in miniature.'[28] The Egyptian accounts of Europe contain several descriptions of these commercial worlds-in-miniature, where the real world, as at the exhibition, was something organized by the representation of its commodities. The department stores were described as 'large and well organized,' with their merchandise 'arranged in perfect order, set in rows on shelves with everything symmetrical and precisely positioned.' Non-European visitors would remark especially on the panes of glass, inside the stores and along the gas-lit arcades. 'The merchandise is all arranged behind sheets of clear glass, in the most remarkable order. . . . Its dazzling appearance draws thousands of onlookers.'[29] The glass panels inserted themselves between the visitors and the goods on display, setting up the former as mere onlookers and endowing the goods with the distance that is the source, one might say, of their objectness. Just as exhibitions had become commercialized, the machinery of commerce was becoming a further means of engineering the real, indistinguishable from that of the exhibition.

Something of the experience of the strangely ordered world of modern commerce and consumers is indicated in the first fictional account of Europe to be published in Arabic. Appearing in 1882, it tells the story of two Egyptians who travel to France and England in the company of an English Orientalist. On their first day in Paris, the two Egyptians wander accidentally into the vast, gas-lit premises of a wholesale supplier. Inside the building they find long corridors, each leading into another. They walk from one corridor to the next, and after a while begin to search for the way out. Turning a corner they see what looks like an exit, with people approaching from the other side. But it turns out to be a mirror, which covers the entire width and height of the wall, and the people approaching are merely their own reflections. They turn down another passage and then another, but each one ends only in a mirror. As they make their way through the corridors of the building, they pass groups of people at work. 'The people were busy setting out merchandise, sorting it and putting it into boxes and cases. They stared at the two of them in silence as they passed, standing quite still, not leaving their places or interrupting their work.' After wandering silently for some time through the building, the two Egyptians realize they have lost their way completely and begin going from room to room looking for an exit. 'But no one interfered with them,' we are told, 'or came up to them to ask if they were lost.' Eventually they are rescued by the manager of the store, who proceeds to explain to them how it is organized, pointing out that, in the objects being sorted and packed, the produce

of every country in the world is represented. The West, it appears is a place orga-
nized as a system of commodities, values, meanings, and representations, forming
signs that reflect one another in a labyrinth without exits.

[. . .]

Notes

This is a revised and extended version of 'The World as Exhibition,' *Comparative Studies
in Society and History* 31, (2) (April, 1989): 217–36, much of which was drawn from
the first chapter of *Colonising Egypt* (Cambridge: Cambridge University Press, 1988). I
am indebted to Lila Abu-Lughod, Stefania Pandolfo, and the participants in the
Conference on Colonialism and Culture held at the University of Michigan in May,
1989, for their comments on earlier versions.

1 Edward Said, *Orientalism* (New York: Pantheon, 1978).
2 Tony Bennett, 'The Exhibitionary Complex,' *New Formations* 4 (Spring, 1988):
 96. Unfortunately, this insightful article came to my attention only as I was
 completing the revisions to this article.
3 See especially Robert W. Rydell, *All the World's a Fair: Visions of Empire at American
 International Expositions, 1876–1916* (Chicago: University of Chicago Press, 1984);
 see also Bennett, 'Exhibitionary Complex,' op. cit.
4 Muhammad Amin Fikri, *Irshad al-alibba' ila mahasin Urubba* (Cairo, 1892), 128.
5 Fikri, *Irshad*, 128–29, 136.
6 R.N. Crust, 'The International Congresses of Orientalists,' *Hellas* 6 (1897): 359.
7 Ibid.: 351.
8 Ibid.: 359.
9 Rifa 'a al-Tahtawi, *al-A'mal al-kamila* (Beirut: al-Mu'assasa al-Arabiyya li-l-Dirasat
 wa-l-Nashr, 1973), 2: 76.
10 Ali Mubarak, *Alam al-din* (Alexandria, 1882), 816. The 'curiosity' of the European
 is something of a theme for Orientalist writers, who contrast it with the 'general
 lack of curiosity' of non-Europeans. Such curiosity is assumed to be the natural,
 unfettered relation of a person to the world, emerging in Europe once the loos-
 ening of 'theological bonds' had brought about 'the freeing of human minds'
 (Bernard Lewis, *The Muslim Discovery of Europe* [London: Weidenfeld & Nicholson,
 1982], 299). See Mitchell, *Colonising Egypt*, 4–5, for a critique of this sort of argu-
 ment and its own 'theological' assumptions.
11 Alain Silvera, 'The First Egyptian Student Mission to France under Muhammad
 Ali,' in *Modern Egypt: Studies in Politics and Society*, ed. Elie Kedourie and Sylvia
 G. Haim (London: Frank Cass, 1980), 13.
12 Tahtawi, *al-A'mal*, 2: 177, 119–20.
13 Georges Douin, *Histoire du règne du Khédive Ismaïl* (Rome: Royal Egyptian
 Geographical Society, 1934), 2: 4–5.
14 Tahtawi, *al-A'mal*, 2: 121.
15 Quoted in Said, *Orientalism*, 165.
16 James Augustus St John, *The Education of the People* (London: Chapman and Hall,
 1858), 82–83.
17 'Les origines et le plan de l'exposition,' in *L'Exposition de Paris de 1889*, 3
 (December 15, 1889): 18.

18 On Egyptian writing about Europe in the nineteenth century, see Ibrahim Abu-Lughod, *Arab Rediscovery of Europe* (Princeton: Princeton University Press, 1963); Anouar Louca, *Voyageurs et écrivains égyptiens en France au XIXe siècle* (Paris: Didier, 1970); Mitchell, *Colonising Egypt*, 7–13, 180 n. 14.

19 Theodor Adorno, *Minima Moralia: Reflections from a Damaged Life* (London: Verso, 1978), 116; on the theater, see, for example, Muhammad al-Muwaylihi, *Hadith Isa ibn Hisham, aw fatra min al-zaman*, 2nd edn (Cairo: al-Maktaba al-Azhariyya, 1911), 434, and Tahtawi, *al-A'mal*, 2: 119–20; on the public garden and the zoo, Muhammad al-Sanusi al-Tunisi, *al-Istitla'at al-barisiya fi ma'rad sanat 1889* (Tunis: n.p., 1891), 37.

20 Mubarak, *Alam al-din*, 817.

21 The model farm outside Paris is described in Mubarak, *Alam al-din*, 1008–42; the visual effect of the street in Mubarak, *Alam al-din*, 964, and Idwar Ilyas, *Mashahid Uruba wa-Amirka* (Cairo: al-Muqtataf, 1900), 268; the new funicular at Lucerne and the European passion for panoramas in Fikri, *Irshad*, 98.

22 Martin Heidegger, 'The Age of the World Picture,' in *The Question Concerning Technology and Other Essays* (New York: Harper & Row, 1977).

23 International Congress of Orientalists, *Transactions of the Ninth Congress, 1892* (London: International Congress of Orientalists, 1893), 1: 35.

24 Al-Sanusi, *al-Istitla'at*, 242.

25 Edmond About, *Le fellah: souvenirs d'Egypte* (Paris: Hachette, 1869), 47–48.

26 Charles Edmond, *L'Egypte à l'exposition universelle de 1867* (Paris: Dentu, 1867).

27 Jacques Derrida, *Speech and Phenomena and Other Essays on Husserl's Theory of Signs* (Evanston, Ill.: Northwestern University Press, 1973), 104. All of his subsequent writings, Derrida once remarked, 'are only a commentary on the sentence about a labyrinth' ('Implications: Interview with Henri Ronse,' in *Positions* [Chicago: University of Chicago Press, 1981], 5). My article, too, should be read as a commentary on that sentence.

28 Quoted in Walter Benjamin, 'Paris, Capital of the Nineteenth Century,' in *Reflections: Essays, Aphorisms, Autobiographical Writings* (New York: Harcourt Brace Jovanovich, 1978), 146–47.

29 Mubarak, *Alam al-din*, 818; Ilyas, *Mashahid Uruba*, 268.

Anne McClintock

SOFT-SOAPING EMPIRE
Commodity racism and imperial advertising

Soap is Civilization.
 (Unilever company slogan)

Doc: My, it's so clean.
Grumpy: There's dirty work afoot.
 (Snow White and the Seven Dwarfs)

Soap and civilization

A T THE BEGINNING of the nineteenth century, soap was a scarce and humdrum item and washing a cursory activity at best. A few decades later, the manufacture of soap had burgeoned into an imperial commerce; Victorian cleaning rituals were peddled globally as the God-given sign of Britain's evolutionary superiority, and soap was invested with magical, fetish powers. The soap saga captured the hidden affinity between domesticity and empire and embodied a triangulated crisis in value: the *undervaluation* of women's work in the domestic realm, the *overvaluation* of the commodity in the industrial market and the *disavowal* of colonized economies in the arena of empire. Soap entered the realm of Victorian fetishism with spectacular effect, notwithstanding the fact that male Victorians promoted soap as the icon of nonfetishistic rationality.

Both the cult of domesticity and the new imperialism found in soap an exemplary mediating form. The emergent middle-class values – monogamy ('clean' sex, which has value), industrial capital ('clean' money, which has value), Christianity ('being washed in the blood of the lamb'), class control ('cleansing the great unwashed') and the imperial civilizing mission ('washing and clothing the savage') – could all be marvelously embodied in a single household commodity. Soap

advertising, in particular the Pears soap campaign, took its place at the vanguard of Britain's new commodity culture and its civilizing mission.

In the eighteenth century, the commodity was little more than a mundane object to be bought and used – in Marx's words, 'a trivial thing.'[1] By the late nineteenth century, however, the commodity had taken its privileged place not only as the fundamental form of a new industrial economy but also as the fundamental form of a new cultural system for representing social value.[2] Banks and stock exchanges rose up to manage the bonanzas of imperial capital. Professions emerged to administer the goods tumbling hectically from the manufactories. Middle-class domestic space became crammed as never before with furniture, clocks, mirrors, paintings, stuffed animals, ornaments, guns, and myriad gewgaws and knick-knacks. Victorian novelists bore witness to the strange spawning of commodities that seemed to have lives of their own, and huge ships lumbered with trifles and trinkets plied their trade among the colonial markets of Africa, the East, and the Americas.[3]

The new economy created an uproar not only of things but of signs. As Thomas Richards has argued, if all these new commodities were to be managed, a unified system of cultural representation had to be found. Richards shows how, in 1851, the Great Exhibition at the Crystal Palace served as a monument to a new form of consumption: 'What the first Exhibition heralded so intimately was the complete transformation of collective and private life into a space for the spectacular exhibition of commodities.'[4] As a 'semiotic laboratory for the labor theory of value,' the World Exhibition showed once and for all that the capitalist system had not only created a dominant form of exchange but was also in the process of creating a dominant form of representation to go with it: the voyeuristic panorama of surplus as spectacle. By exhibiting commodities not only as goods but as an organized system of images, the World Exhibition helped fashion 'a new kind of being, the consumer and a new kind of ideology, consumerism.'[5] The mass consumption of the commodity spectacle was born.

Victorian advertising reveals a paradox, however, for, as the cultural form that was entrusted with upholding and marketing abroad those founding middle-class distinctions – between private and public, paid work and unpaid work – advertising also from the outset began to confound those distinctions. Advertising took the intimate signs of domesticity (children bathing, men shaving, women laced into corsets, maids delivering nightcaps) into the public realm, plastering scenes of domesticity on walls, buses, shopfronts, and billboards. At the same time, advertising took scenes of empire into every corner of the home, stamping images of colonial conquest on soap boxes, matchboxes, biscuit tins, whiskey bottles, tea tins and chocolate bars. By trafficking promiscuously across the threshold of private and public, advertising began to subvert one of the fundamental distinctions of commodity capital, even as it was coming into being.

From the outset, moreover, Victorian advertising took explicit shape around the reinvention of racial difference. Commodity kitsch made possible, as never before, the mass marketing of empire as an organized system of images and attitudes. Soap flourished not only because it created and filled a spectacular gap in the domestic market but also because, as a cheap and portable domestic commodity, it could persuasively mediate the Victorian poetics of racial hygiene and imperial progress.

Commodity racism became distinct from scientific racism in its capacity to expand beyond the literate, propertied elite through the marketing of commodity spectacle. If, after the 1850s, scientific racism saturated anthropological, scientific and medical journals, travel writing, and novels, these cultural forms were still relatively class-bound and inaccessible to most Victorians, who had neither the means nor the education to read such material. Imperial kitsch as consumer spectacle, by contrast, could package, market, and distribute evolutionary racism on a hitherto unimagined scale. No pre-existing form of organized racism had ever before been able to reach so large and so differentiated a mass of the populace. Thus, as domestic commodities were mass marketed through their appeal to imperial jingoism, commodity jingoism itself helped reinvent and maintain British national unity in the face of deepening imperial competition and colonial resistance. The cult of domesticity became indispensable to the consolidation of British national identity, and at the center of the domestic cult stood the simple bar of soap.[6]

Yet soap has no social history. Since it purportedly belongs in the female realm of domesticity, soap is figured as beyond history and beyond politics proper.[7] To begin a social history of soap, then, is to refuse, in part, to accept the erasure of women's domestic value under imperial capitalism. It cannot be forgotten, moreover, that the history of European attempts to impose a commodity economy on African cultures was also the history of diverse African attempts either to refuse or to transform European commodity fetishism to suit their own needs. The story of soap reveals that fetishism, far from being a quintessentially African propensity, as nineteenth-century anthropology maintained, was central to industrial modernity, inhabiting and mediating the uncertain threshold zones between domesticity and industry, metropolis and empire.

Soap and commodity spectacle

Before the late nineteenth century, clothes and bedding washing was done in most households only once or twice a year in great, communal binges, usually in public at streams or rivers.[8] As for body washing, not much had changed since the days when Queen Elizabeth I was distinguished by the frequency with which she washed: 'regularly every month whether she needed it or not.'[9] By the 1890s, however, soap sales had soared. Victorians were consuming 260,000 tons of soap a year, and advertising had emerged as the central cultural form of commodity capitalism.[10]

Before 1851, advertising scarcely existed. As a commercial form, it was generally regarded as a confession of weakness, a rather shabby last resort. Most advertising was limited to small newspaper advertisements, cheap handbills, and posters. After midcentury, however, soap manufacturers began to pioneer the use of pictorial advertising as a central part of business policy.

The initial impetus for soap advertising came from the realm of empire. With the burgeoning of imperial cotton on the slave plantations came the surplus of cheap cotton goods, alongside the growing buying power of a middle class that could afford for the first time to consume such goods in large quantities. Similarly, the sources for cheap palm oil, coconut oil, and cottonseed oil flourished in the imperial

plantations of West Africa, Malay, Ceylon, Fiji, and New Guinea. As rapid changes in the technology of soapmaking took place in Britain after midcentury, the prospect dawned of a large domestic market for soft body soaps, which had previously been a luxury that only the upper class could afford.

Economic competition with the United States and Germany created the need for a more aggressive promotion of British products and led to the first real innovations in advertising. In 1884, the year of the Berlin Conference, the first wrapped soap was sold under a brand name. This small event signified a major transformation in capitalism, as imperial competition gave rise to the creation of monopolies. Henceforth, items formerly indistinguishable from each other (soap sold simply as soap) would be marketed by their corporate signature (Pears, Monkey Brand, etc.). Soap became one of the first commodities to register the historic shift from myriad small businesses to the great imperial monopolies. In the 1870s, hundreds of small soap companies plied the new trade in hygiene, but by the end of the century, the trade was monopolized by ten large companies.

In order to manage the great soap show, an aggressively entrepreneurial breed of advertisers emerged, dedicated to gracing each homely product with a radiant halo of imperial glamor and racial potency. The advertising agent, like the bureaucrat, played a vital role in the imperial expansion of foreign trade. Advertisers billed themselves as 'empire builders' and flattered themselves with 'the responsibility of the historic imperial mission.' Said one: 'Commerce even more than sentiment binds the ocean-sundered portions of empire together. Anyone who increases these commercial interests strengthens the whole fabric of the empire.'[11] Soap was credited not only with bringing moral and economic salvation to Britain's 'great unwashed' but also with magically embodying the spiritual ingredient of the imperial mission itself.

In an ad for Pears, for example, a black and implicitly racialized coalsweeper holds in his hands a glowing, occult object. Luminous with its own inner radiance, the simple soap bar glows like a fetish, pulsating magically with spiritual enlightenment and imperial grandeur, promising to warm the hands and hearts of working people across the globe.[12] Pears, in particular, became intimately associated with a purified nature magically cleansed of polluting industry (tumbling kittens, faithful dogs, children festooned with flowers) and a purified working class magically cleansed of polluting labor (smiling servants in crisp white aprons, rosy-cheeked match girls and scrubbed scullions).[13]

None the less, the Victorian obsession with cotton and cleanliness was not simply a mechanical reflex of economic surplus. If imperialism garnered a bounty of cheap cotton and soap oils from coerced colonial labor, the middle-class Victorian fascination with clean, white bodies and clean, white clothing stemmed not only from the rampant profiteering of the imperial economy but also from the realms of ritual and fetish.

Soap did not flourish when imperial ebullience was at its peak. It emerged commercially during an era of impending crisis and social calamity, serving to preserve, through fetish ritual, the uncertain boundaries of class, gender and race identity in a social order felt to be threatened by the fetid effluvia of the slums, the belching smoke of industry, social agitation, economic upheaval, imperial competition, and anticolonial resistance. Soap offered the promise of spiritual

salvation and regeneration through commodity consumption, a regime of domestic hygiene that could restore the threatened potency of the imperial body politic and the race.

The Pears' campaign

In 1789 Andrew Pears, a farmer's son, left his Cornish village of Mevagissey to open a barbershop in London, following the trend of widespread demographic migration from country to city and the economic turn from land to commerce. In his shop, Pears made and sold the powders, creams, and dentifrices used by the rich to ensure the fashionable alabaster purity of their complexions. For the elite, a sun-darkened skin stained by outdoor manual work was the visible stigma not only of a class obliged to work under the elements for a living, but also of far-off, benighted races marked by God's disfavor. From the outset, soap took shape as a technology of social purification, inextricably entwined with the semiotics of imperial racism and class denigration.

In 1838 Andrew Pears retired and left his firm in the hands of his grandson, Francis. In due course, Francis' daughter, Mary, married Thomas J. Barratt, who became Francis' partner and took the gamble of fashioning a middle-class market for the transparent soap. Barratt revolutionized Pears by masterminding a series of dazzling advertising campaigns. Inaugurating a new era of advertising, he won himself lasting fame, in the familiar iconography of male birthing, as the 'father of advertising.' Soap thus found its industrial destiny through the mediation of domestic kinship and that peculiarly Victorian preoccupation with patrimony.

Through a series of gimmicks and innovations that placed Pears at the center of Britain's emerging commodity culture, Barratt showed a perfect understanding of the fetishism that structures all advertising. Importing a quarter of a million French centime pieces into Britain, Barratt had the name Pears stamped on them and put the coins into circulation – a gesture that marvelously linked exchange value with the corporate brand name. The ploy worked famously, arousing much publicity for Pears and such a public fuss that an Act of Parliament was rushed through to declare all foreign coins illegal tender. The boundaries of the national currency closed around the domestic bar of soap.

Georg Lukács points out that the commodity lies on the threshold of culture and commerce, confusing the supposedly sacrosanct boundaries between aesthetics and economy, money, and art. In the mid-1880s, Barratt devised a piece of breathtaking cultural transgression that exemplified Lukács' insight and clinched Pears' fame. Barratt bought Sir John Everett Millais' painting 'Bubbles' (originally entitled 'A Child's World') and inserted into the painting a bar of soap stamped with the totemic word Pears. At a stroke, he transformed the artwork of the best-known painter in Britain into a mass-produced commodity associated in the public mind with Pears.[14] At the same time, by mass reproducing the painting as a poster ad, Barratt took art from the elite realm of private property to the mass realm of commodity spectacle.[15]

In advertising, the axis of possession is shifted to the axis of spectacle. Advertising's chief contribution to the culture of modernity was the discovery that

by manipulating the semiotic space around the commodity, the unconscious as a public space could also be manipulated. Barratt's great innovation was to invest huge sums of money in the creation of a visible aesthetic space around the commodity. The development of poster and print technology made possible the mass reproduction of such a space around the image of a commodity.[16]

In advertising, that which is disavowed by industrial rationality (ambivalence, sensuality, chance, unpredictable causality, multiple time) is projected onto image space as a repository of the forbidden. Advertising draws on subterranean flows of desire and taboo, manipulating the investment of surplus money. Pears' distinction, swiftly emulated by scores of soap companies including Monkey Brand and Sunlight, as well as countless other advertisers, was to invest the aesthetic space around the domestic commodity with the commercial cult of empire.

Empire of the home: racializing domesticity

The soap

Four fetishes recur ritualistically in soap advertising: soap itself, white clothing (especially aprons), mirrors, and monkeys. A typical Pears' advertisement figures a black child and a white child together in a bathroom (Figure 44.1). The Victorian bathroom is the innermost sanctuary of domestic hygiene and by extension the private temple of public regeneration. The sacrament of soap offers a reformation allegory whereby the purification of the domestic body becomes a metaphor for the regeneration of the body politic. In this particular ad, a black boy sits in the bath, gazing wide-eyed into the water as if into a foreign element. A white boy, clothed in a

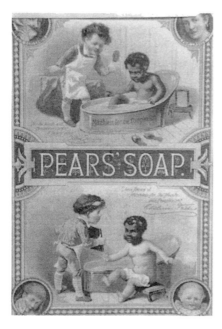

Figure 44.1 Advert for Pears' soap, 1880s

white apron – the familiar fetish of domestic purity – bends benevolently over his 'lesser' brother, bestowing upon him the precious talisman of racial progress. The magical fetish of soap promises that the commodity can regenerate the Family of Man by washing from the skin the very stigma of racial and class degeneration.

Soap advertising offers an allegory of imperial progress as spectacle. In this ad, the imperial topos that I call panoptical time (progress consumed as a spectacle from a point of privileged invisibility) enters the domain of the commodity. In the second frame of the ad, the black child is out of the bath and the white boy shows him his startled visage in the mirror. The black boy's body has become magically white, but his face – for Victorians the seat of rational individuality and self-consciousness – remains stubbornly black. The white child is thereby figured as the agent of history and the male heir to progress, reflecting his lesser brother in the European mirror of self-consciousness. In the Victorian mirror, the black child witnesses his predetermined destiny of imperial metamorphosis but remains a passive racial hybrid, part black, part white, brought to the brink of civilization by the twin commodity fetishes of soap and mirror. The advertisement discloses a crucial element of late Victorian commodity culture: the metaphoric transformation of imperial *time* into consumer *space* – imperial progress consumed at a glance as domestic spectacle.

The monkey

The metamorphosis of imperial time into domestic space is captured most vividly by the advertising campaign for Monkey Brand Soap. During the 1880s, the urban landscape of Victorian Britain teemed with the fetish monkeys of this soap. The monkey with its frying pan and bar of soap perched everywhere, on grimy hoardings and buses, on walls and shop fronts, promoting the soap that promised magically to do away with domestic labor: 'No dust, no dirt, no labor.' Monkey Brand Soap promised not only to regenerate the race but also to erase magically the unseemly spectacle of women's manual labor.

In an exemplary ad, the fetish soap-monkey sits cross-legged on a doorstep, the threshold boundary between private domesticity and public commerce – the embodiment of anachronistic space (Figure 44.2). Dressed like an organ-grinder's minion in a gentleman's ragged suit, white shirt, and tie, but with improbably human hands and feet, the monkey extends a frying pan to catch the surplus cash of passersby. On the doormat before him, a great bar of soap is displayed, accompanied by a placard that reads: 'My Own Work.' In every respect the soap-monkey is a hybrid: not entirely ape, not entirely human; part street beggar, part gentleman; part artist, part advertiser. The creature inhabits the ambivalent border of jungle and city, private and public, the domestic and the commercial, and offers as its handiwork a fetish that is both art and commodity.

Monkeys inhabit Western discourse on the borders of social limit, marking the place of a contradiction in social value. As Donna Haraway has argued: 'the primate body, as part of the body of nature, may be read as a map of power.'[17] Primatology, Haraway insists, 'is a Western discourse . . . a political order that works by the negotiation of boundaries achieved through ordering differences.'[18] In Victorian iconography, the ritual recurrence of the monkey figure is eloquent of a crisis in

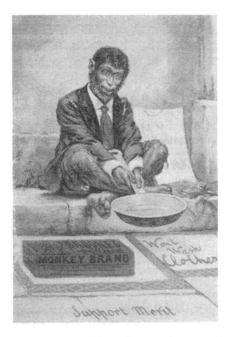

Figure 44.2 Advert for Monkey Brand Soap, 1880s

value and hence anxiety at possible boundary breakdown. The primate body became a symbolic space for reordering and policing boundaries between humans and nature, women and men, family and politics, empire and metropolis.

Simian imperialism is also centrally concerned with the problem of representing *social change*. By projecting history (rather than fate, or God's will) onto the theater of nature, primatology made nature the alibi of political violence and placed in the hands of 'rational science' the authority to sanction and legitimize social change. Here, 'the scene of origins,' Haraway argues, 'is not the cradle of civilization, but the cradle of culture . . . the origin of sociality itself, especially in the densely meaning-laden icon of the family.'[19] Primatology emerges as a theater for negotiating the perilous boundaries between the family (as natural and female) and power (as political and male).

The appearance of monkeys in soap advertising signals a dilemma: *how to represent domesticity without representing women at work*. The Victorian middle-class house was structured around the fundamental contradiction between women's paid and unpaid domestic work. As women were driven from paid work in mines, factories, shops, and trades to private, unpaid work in the home, domestic work became economically undervalued and the middle-class definition of femininity figured the 'proper' woman as one who did not work for profit. At the same time, a *cordon sanitaire* of racial degeneration was thrown around those women who did work publicly and visibly for money. What could not be incorporated into the industrial formation (women's domestic economic value) was displaced onto the invented domain of the primitive, and thereby disciplined and contained.

Monkeys, in particular, were deployed to legitimize social boundaries as edicts of nature. Fetishes straddling nature and culture, monkeys were seen as allied

with the dangerous classes: the 'apelike' wandering poor, the hungry Irish, Jews, prostitutes, impoverished black people, the ragged working class, criminals, the insane, and female miners and servants, who were collectively seen to inhabit the threshold of racial degeneration. When Charles Kingsley visited Ireland, for example, he lamented:

> I am haunted by the human chimpanzees I saw along that hundred miles of horrible country. . . . But to see white chimpanzees is dreadful; if they were black, one would not feel it so much, but their skins, except where tanned by exposure, are as white as ours.[20]

In the Monkey Brand advertisement, the monkey's signature of labor ('My Own Work') signals a double disavowal. Soap is masculinized, figured as a male product, while the (mostly female) labor of the workers in the huge, unhealthy soap factories is disavowed. At the same time, the labor of social transformation in the daily scrubbing and scouring of the sinks, pans and dishes, labyrinthine floors and corridors of Victorian domestic space vanishes – refigured as anachronistic space, primitive, and bestial. Female servants disappear and in their place crouches a phantasmic male hybrid. Thus, domesticity – seen as the sphere most separate from the marketplace and the masculine hurly-burly of empire – takes shape around the invented ideas of the primitive and the commodity fetish.

In Victorian culture, the monkey was an icon of metamorphosis, perfectly serving soap's liminal role in mediating the transformation of nature (dirt, waste, and disorder) into culture (cleanliness, rationality, and industry). Like all fetishes, the monkey is a contradictory image, embodying the hope of imperial progress through commerce while at the same time rendering visible deepening Victorian fears of urban militancy and colonial misrule. The soap-monkey became the emblem of industrial progress and imperial evolution, embodying the double promise that nature could be redeemed by consumer capital and that consumer capital could be guaranteed by natural law. At the same time, however, the soap-monkey was eloquent of the degree to which fetishism structures industrial rationality.

The mirror

In most Monkey Brand advertisements, the monkey holds a frying pan, which is also a mirror. In a similar Brooke's Soap ad, a classical female beauty with bare white arms stands draped in white, her skin and clothes epitomizing the exhibition value of sexual purity and domestic leisure, while from the cornucopia she holds flows a grotesque effluvium of hobgoblin angels. Each hybrid fetish embodies the doubled Victorian image of woman as 'angel in the drawing room, monkey in the bedroom,' as well as the racial iconography of evolutionary progress from ape to angel. Historical time, again, is captured as domestic spectacle, eerily reflected in the frying pan/mirror fetish.

In this ad, the Brooke's Soap offers an alchemy of economic progress, promising to make 'copper like gold.' At the same time, the Enlightenment idea of linear, rational time leading to angelic perfection finds its antithesis in the other time of

housework, ruled by the hobgoblins of dirt, disorder, and fetishistic, nonprogressive time. Erupting on the margins of the rational frame, the ad displays the irrational consequences of the idea of progress. The mirror/frying pan, like all fetishes, visibly expresses a crisis in value but cannot resolve it. It can only embody the contradiction, frozen as commodity spectacle, luring the spectator deeper and deeper into consumerism.

Mirrors glint and gleam in soap advertising, as they do in the culture of imperial kitsch at large. In Victorian middle-class households, servants scoured and polished every metal and wooden surface until it shone like a mirror. Doorknobs, lamp stands and banisters, tables and chairs, mirrors and clocks, knives and forks, kettles and pans, shoes and boots were polished until they shimmered, reflecting in their gleaming surfaces other object-mirrors, an infinity of crystalline mirrors within mirrors, until the interior of the house was all shining surfaces, a labyrinth of reflection. The mirror became the epitome of commodity fetishism: erasing both the signs of domestic labor and the industrial origins of domestic commodities. In the domestic world of mirrors, objects multiply without apparent human intervention in a promiscuous economy of self-generation.

Why the attention of surface and reflection? The polishing was dedicated, in part, to policing the boundaries between private and public, removing every trace of labor, replacing the disorderly evidence of working women with the exhibition of domesticity as veneer, the commodity spectacle as surface, the house arranged as a theater of clean surfaces for commodity display. The mirror/commodity renders the value of the object as an exhibit, a spectacle to be consumed, admired, and displayed for its capacity to embody a twofold value: the man's market worth and the wife's exhibition status. The house existed to display femininity as bearing exhibition value only, beyond the marketplace and therefore, by natural decree, beyond political power.

An ad for Stephenson's Furniture Cream figures a spotless maid on all fours, smiling up from a floor so clean that it mirrors her reflection. The cream is 'warranted not to fingermark.' A superior soap should leave no telltale smear, no fingerprint of female labor. As Victorian servants lost individuality in the generic names their employers imposed on them, so soaps erased the imprint of women's work on middle-class history.

Domesticating empire

By the end of the century, a stream of imperial bric-à-brac had invaded Victorian homes. Colonial heroes and colonial scenes were emblazoned on a host of domestic commodities, from milk cartons to sauce bottles, tobacco tins to whiskey bottles, assorted biscuits to toothpaste, toffee boxes to baking powder.[21] Traditional national fetishes such as the Union Jack, Britannia, John Bull, and the rampant lion were marshaled into a revamped celebration of imperial spectacle. Empire was seen to be patriotically defended by Ironclad Porpoise Bootlaces and Sons of the Empire soap, while Henry Morton Stanley came to the rescue of Emin Pasha laden with outsize boxes of Huntley and Palmers Biscuits.

Late Victorian advertising presented a vista of Africa conquered by domestic commodities.[22] In the flickering magic lantern of imperial desire, teas, biscuits,

tobaccos, Bovril, tins of cocoa and, above all, soaps beach themselves on far-flung shores, tramp through jungles, quell uprisings, restore order and write the inevitable legend of commercial progress across the colonial landscape. In a Huntley and Palmers' Biscuits ad, a group of male colonials sit in the middle of a jungle on biscuit crates, sipping tea. Moving toward them is a stately and seemingly endless procession of elephants, loaded with more biscuits and colonials, bringing teatime to the heart of the jungle. The serving attendant in this ad, as in most others, is male. Two things happen in such images: women vanish from the affair of empire, and colonized men are feminized by their association with domestic servitude.

Liminal images of oceans, beaches, and shorelines recur in cleaning ads of the time. An exemplary ad for Chlorinol Soda Bleach shows three boys in a soda box sailing in a phantasmic ocean bathed by the radiance of the imperial dawn. In a scene washed in the red, white, and blue of the Union Jack, two black boys proudly hold aloft their boxes of Chlorinol. A third boy, the familiar racial hybrid of clean-ing ads, has presumably already applied his bleach, for his skin is blanched an eerie white. On red sails that repeat the red of the bleach box, the legend of black people's purported commercial redemption in the arena of empire reads: 'We are going to use "Chlorinol" and be like de white nigger.'

The ad vividly exemplifies **Marx's** lesson that the mystique of the commodity fetish lies not in its use value but in its exchange value and its potency as a sign: 'So far as "the commodity" is a value in use, there is nothing mysterious about it.' For three naked children, clothing bleach is less than useful. Instead, the whiten-ing agent of bleach promises an alchemy of racial upliftment through historical contact with commodity culture. The transforming power of the civilizing mission is stamped on the boat-box's sails as the objective character of the commodity itself.

More than merely a *symbol* of imperial progress, the domestic commodity becomes the *agent* of history itself. The commodity, abstracted from social context and human labor, does the civilizing work of empire, while radical change is figured as magical, without process or social agency. Hence the proliferation of ads featuring magic. In similar fashion, cleaning ads such as Chlorinol's foreshadow the 'before and after' beauty ads of the twentieth century: a crucial genre directed largely at women, in which the conjuring power of the product to alchemize change is all that lies between the temporal 'before and after' of women's bodily transformation.

The Chlorinol ad displays a racial and gendered division of labor. Imperial progress from black child to 'white nigger' is consumed as commodity spectacle – as panoptical time. The self-satisfied, hybrid 'white nigger' literally holds the rudder of history and directs social change, while the dawning of civilization bathes his enlightened brow with radiance. The black children simply have exhibition value as potential consumers of the commodity, there only to uphold the promise of capitalist commerce and to represent how far the white child has evolved – in the iconography of Victorian racism the condition of 'savagery' is identical to the condition of infancy. Like white women, Africans (both women and men) are figured not as historic agents but as frames for the commodity, valued for *exhibition* alone. The working women, both black and white, who spent vast amounts of energy bleaching the white sheets, shirts, frills, aprons, cuffs, and collars of imperial clothes

are nowhere to be seen. It is important to note that in Victorian advertising, black women are very seldom rendered as consumers of commodities, for, in imperial lore, they lag too far behind men to be agents of history. Imperial domesticity is therefore a domesticity without women.

In the Chlorinol ad, women's creation of social value through housework is displaced onto the commodity as its own power, fetishistically inscribed on the children's bodies as a magical metamorphosis of the flesh. At the same time, military subjugation, cultural coercion, and economic thuggery are refigured as benign domestic processes as natural and healthy as washing. The stains of Africa's disobligingly complex and tenacious past and the inconvenience of alternative economic and cultural values are washed away like grime.

Incapable of themselves actually engendering change, African men are figured only as 'mimic men,' to borrow V.S. Naipaul's dyspeptic phrase, destined simply to ape the epic white march of progress to self-knowledge. Bereft of the white raiments of imperial godliness, the Chlorinol children appear to take the fetish literally, content to bleach their skins to white. Yet these ads reveal that, far from being a quintessentially African propensity, the faith in fetishism was a faith fundamental to imperial capitalism itself.

[. . .]

Notes

1 Karl Marx, 'Commodity Fetishism,' *Capital*, vol. 1 (New York: Vintage Books, 1977), p. 163.

2 See Thomas Richards' excellent analysis, *The Commodity Culture of Victorian Britain: Advertising and Spectacle, 1851–1914* (London: Verso, 1990), especially the introduction and ch. 1.

3 See David Simpson's analysis of novelistic fetishism in *Fetishism and Imagination: Dickens, Melville, Conrad* (Baltimore: Johns Hopkins University Press, 1982).

4 Richards, *The Commodity Culture*, p. 72.

5 Ibid., p. 5.

6 In 1889, an ad for Sunlight Soap featured the feminized figure of British nationalism, Britannia, standing on a hill and showing P.T. Barnum, the famous circus manager and impresario of the commodity spectacle, a huge Sunlight Soap factory stretched out below them. Britannia proudly proclaims the manufacture of Sunlight Soap to be: 'The Greatest Show On Earth.' See Jennifer Wicke's excellent analysis of P.T. Barnum in *Advertising Fiction: Literature, Advertisement and Social Reading* (New York: Columbia University Press, 1988).

7 See Timothy Burke, ' "Nyamarira That I Loved": Commoditization, Consumption and the Social History of Soap in Zimbabwe,' *The Societies of Southern Africa in the 19th and 20th Centuries: Collected Seminar Papers*, no. 42, vol. 17 (London: University of London, Institute of Commonwealth Studies, 1992), pp. 195–216.

8 Leonore Davidoff and Catherine Hall, *Family Fortunes: Men and Women of the English Middle Class* (London: Routledge 1992).

9 David T.A. Lindsey and Geoffrey C. Bamber, *Soap-Making. Past and Present, 1876–1976* (Nottingham: Gerard Brothers Ltd, 1965), p. 34.

10 Lindsey and Bamber, *Soap-Making*, p. 38. Just how deeply the relation between soap and advertising became embedded in popular memory is expressed in words such as 'soft-soap' and 'soap opera.' For histories of advertising, see also Blanche B. Elliott, *A History of English Advertising* (London: Business Publications Ltd., 1962); and T.R. Nevett, *Advertising in Britain. A History* (London: Heinemann, 1982).

11 Quoted in Diana and Geoffrey Hindley, *Advertising in Victorian England, 1837–1901* (London: Wayland, 1972), p. 117.

12 Mike Dempsey (ed.) *Bubbles: Early Advertising Art from A. & Pears Ltd.* (London: Fontana, 1978).

13 Laurel Bradley, 'From Eden to Empire: John Everett Millais' Cherry Ripe,' *Victorian Studies* vol. 34, no. 2 (Winter 1991), pp. 179–203. See also, Michael Dempsey, *Bubbles*.

14 Barratt spent £2,200 on Millais' painting and £30,000 on the mass production of millions of individual reproductions of the painting. In the 1880s, Pears was spending between £300,000 and £400,000 on advertising alone.

15 Furious at the pollution of the sacrosanct realm of art with economics, the art world lambasted Millais for trafficking (publicly instead of privately) in the sordid world of trade.

16 See Jennifer Wicke, *Advertising Fiction*, p. 70.

17 Donna Haraway, *Primate Visions: Gender, Race, and Nature in the World of Modern Science* (London: Routledge, 1989), p. 10.

18 Ibid., p. 10.

19 Ibid., pp. 10–11.

20 Charles Kingsley, Letter to his wife, 4 July 1860, in *Charles Kingsley: His Letters and Memories of His Life*, Frances E. Kingsley, ed., (London: Henry S. King and Co., 1877), p. 107. See also Richard Kearney (ed.) *The Irish Mind* (Dublin: Wolfhound Press, 1985); L.P. Curtis Jr, *Anglo-Saxons and Celts: A Study of Anti-Irish Prejudice in Victorian England* (Bridgeport: Conference on British Studies of University of Bridgeport, 1968); and Seamus Deane, 'Civilians and Barbarians,' *Ireland's Field Day* (London: Hutchinson, 1985), pp. 33–42.

21 During the Anglo-Boer War, Britain's fighting forces were seen as valiantly fortified by Johnston's Corn Flour, Pattison's Whiskey and Frye's Milk Chocolate. See Robert Opie, *Trading on the British Image* (Middlesex: Penguin, 1985) for an excellent collection of advertising images.

22 In a brilliant chapter, Richards explores how the imperial conviction of the explorer and travel writer, Henry Morton Stanley, that he had a mission to civilize Africans by teaching them the value of commodities, 'reveals the major role that imperialists ascribed to the commodity in propelling and justifying the scramble for Africa.' Richards, *The Commodity Culture*, p. 123.

Malek Alloula

FROM *THE COLONIAL HAREM*

The Orient as stereotype and phantasm

ARRAYED IN THE BRILLIANT colors of exoticism and exuding a full-blown yet uncertain sensuality, the Orient, where unfathomable mysteries dwell and cruel and barbaric scenes are staged, has fascinated and disturbed Europe for a long time. It has been its glittering imaginary but also its mirage.

Orientalism, both pictorial and literary, has made its contribution to the definition of the variegated elements of the sweet dream in which the West has been wallowing for more than four centuries. It has set the stage for the deployment of phantasms.

There is no phantasm, though, without sex, and in this Orientalism, a confection of the best and of the worst – mostly the worst – a central figure emerges, the very embodiment of the obsession: the harem. A simple allusion to it is enough to open wide the floodgate of hallucination just as it is about to run dry.

For the Orient is no longer the dreamland. Since the middle of the nineteenth century, it has inched closer. Colonialism makes a grab for it, appropriates it by dint of war, binds it hand and foot with myriad bonds of exploitation, and hands it over to the devouring appetite of the great mother countries, ever hungry for raw materials.

Armies, among them the one that landed one fine 5 July 1830 a little to the east of Algiers, bring missionaries and scholars with their impedimenta as well as painters and photographers forever thirsty for exoticism, folklore, Orientalism. This fine company scatters all over the land, sets up camp around military messes, takes part in punitive expeditions (even Théophile Gautier is not exempt), and dreams of the Orient, its delights and its beauties.

What does it matter if the colonized Orient, the Algeria of the turn of the century, gives more than a glimpse of the other side of its scenery, as long as

the phantasm of the harem persists, especially since it has become profitable? Orientalism leads to riches and respectability. Horace Vernet, whom Baudelaire justly called the Raphael of barracks and bivouacs, is the peerless exponent of this smug philistinism. He spawns imitators. Vulgarities and stereotypes draw upon the entire heritage of the older, precolonial Orientalism. They reveal all its presuppositions to the point of caricature.

It matters little if Orientalistic painting begins to run out of wind or falls into mediocrity. Photography steps in to take up the slack and reactivates the phantasm at its lowest level. The postcard does it one better; it becomes the poor man's phantasm: for a few pennies, display racks full of dreams. The postcard is everywhere, covering all the colonial space, immediately available to the tourist, the soldier, the colonist. It is at once their poetry and their glory captured for the ages; it is also their pseudo knowledge of the colony. It produces stereotypes in the manner of great seabirds producing guano. It is the fertilizer of the colonial vision.

The postcard is ubiquitous. It can be found not only at the scene of the crime it perpetrates but at a far remove as well. Travel is the essence of the postcard, and expedition is its mode. It is the fragmentary return to the mother country. It straddles two spaces: the one it represents and the one it will reach. It marks out the peregrinations of the tourist, the successive postings of the soldier, the territorial spread of the colonist. It sublimates the spirit of the stopover and the sense of place; it is an act of unrelenting aggression against sedentariness. In the postcard, there is the suggestion of a complete metaphysics of uprootedness.

It is also a seductive appeal to the spirit of adventure and pioneering. In short, the postcard would be a resounding defense of the colonial spirit in picture form. It is the comic strip of colonial morality.

But it is not merely that; it is more. It is the propagation of the phantasm of the harem by means of photography. It is the degraded, and degrading, revival of this phantasm.

The question arises, then, how are we to read today these postcards that have superimposed their grimacing mask upon the face of the colony and grown like a chancre or a horrible leprosy?

Today, nostalgic wonderment and tearful archeology (Oh! those colonial days!) are very much in vogue. But to give in to them is to forget a little too quickly the motivations and the effects of this vast operation of systematic distortion. It is also to lay the groundwork for its return in a new guise: a racism and a xenophobia titillated by the nostalgia of the colonial empire.

Beyond such barely veiled apologias that hide behind aesthetic rationalizations, another reading is possible: a symptomatic one.

To map out, from under the plethora of images, the obsessive scheme that regulates the totality of the output of this enterprise and endows it with meaning is to force the postcard to reveal what it holds back (the ideology of colonialism) and to expose what is represented in it (the sexual phantasm).

The Golden Age of the colonial postcard lies between 1900 and 1930. Although a latecomer to colonial apologetics, it will quickly make up for its belatedness and come to occupy a privileged place, which it owes to the infatuation it elicits, in the preparations for the centennial of the conquest, the apotheosis of the imperial epoch.

In this large inventory of images that History sweeps with broad strokes out of its way, and which shrewd merchants hoard for future collectors, one theme especially seems to have found favor with the photographers and to have been accorded privileged treatment: the *algérienne*.

History knows of no other society in which women have been photographed on such a large scale to be delivered to public view. This disturbing and paradoxical fact is problematic far beyond the capacity of rationalizations that impute its occurrence to ethnographic attempts at a census and visual documentation of human types.

Behind this image of Algerian women, probably reproduced in the millions, there is visible the broad outline of one of the figures of the colonial perception of the native. This figure can be essentially defined as the practice of a right of (over)sight that the colonizer arrogates to himself and that is the bearer of multiform violence. The postcard fully partakes in such violence; it extends its effects; it is its accomplished expression, no less efficient for being symbolic. Moreover, its fixation upon the woman's body leads the postcard to paint this body up, ready it, and eroticize it in order to offer it up to any and all comers from a clientele moved by the unambiguous desire of possession.

To track, then, through the colonial representations of Algerian women – the figures of a phantasm – is to attempt a double operation: first, to uncover the nature and the meaning of the colonialist gaze; then, to subvert the stereotype that is so tenaciously attached to the bodies of women.

A reading of the sort that I propose to undertake would be entirely superfluous if there existed photographic traces of the gaze of the colonized upon the colonizer. In their absence, that is, in the absence of a confrontation of opposed gazes, I attempt here, lagging far behind History, to return this immense postcard to its sender.

What I read on these cards does not leave me indifferent. It demonstrates to me, were that still necessary, the desolate poverty of a gaze that I myself, as an Algerian, must have been the object of at some moment in my personal history. Among us, we believe in the nefarious effects of the evil eye (the evil gaze). We conjure them with our hand spread out like a fan. I close my hand back upon a pen to write *my* exorcism: *this text*.

Women from the outside: obstacle and transparency

> The reading of public photographs is always, at bottom, a private reading.
> (Roland Barthes, *Camera Lucida*, 1981)

The first thing the foreign eye catches about Algerian women is that they are concealed from sight.

No doubt this very obstacle to sight is a powerful prod to the photographer operating in urban environments. It also determines the obstinacy of the camera operator to force that which disappoints him by its escape.

The Algerian woman does not conceal herself, does not play at concealing herself. But the eye cannot catch hold of her. The opaque veil that covers her intimates clearly and simply to the photographer a refusal. Turned back upon

himself, upon his own impotence in the situation, the photographer undergoes an *initial experience of disappointment and rejection.* Draped in the veil that cloaks her to her ankles, the Algerian woman discourages the *scopic desire* (the voyeurism) of the photographer. She is the concrete negation of this desire and thus brings to the photographer confirmation of a triple rejection: the rejection of his desire, of the practice of his 'art,' and of his place in a milieu that is not his own.

Algerian society, particularly the world of women, is forever forbidden to him. It counterposes to him a smooth and homogeneous surface free of any cracks through which he could slip his indiscreet lens.

The whiteness of the veil becomes the symbolic equivalent of blindness: a leukoma, a white speck on the eye of the photographer and on his viewfinder. *Whiteness is the absence of a photo, a veiled photograph, a whiteout, in technical terms.* From its background nothing emerges except some vague contours, anonymous in their repeated resemblance. Nothing distinguishes one veiled woman from another.

The veil of Algerian women is also seen by the photographer as a sort of perfect and generalized mask. It is not worn for special occasions. It belongs to the everyday,

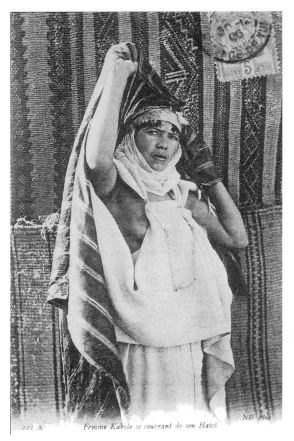

Figure 45.1 Kabyl woman covering herself with the haik (From Mallek Alloula, *The Colonial Harem*, Manchester University Press, 1985)

like a uniform. It instills uniformity, the modality of the impossibility of photography, its disappointment and deficiency of expression.

It will be noted that whenever a photographer aims his camera at a veiled woman, he cannot help but include in his visual field several instances of her. As if to photograph one of them from the outside required the inclusion of a *principle of duplication* in the framing. For it is always a group of veiled women that the photographer affixes upon his plate.

One may well wonder about this peculiarity since it could easily be overcome by technical means through the isolation and the enlargement of a detail. This everyday technique of printmaking is never used, however. Does this indicate, perhaps, that the photographer's frustration is generalized and not amenable to being directed toward one individual in the group? Does this mean that his frustration is an induced effect? The society he observes reveals to him the instinctual nature of his desire (voyeurism) and challenges him beyond the defenses of his professional alibi. The exoticism that he thought he could handle without any problems suddenly discloses to him a truth unbearable for the further exercise of his craft.

Here there is a sort of ironic paradox: the veiled subject – in this instance, the Algerian woman – becomes the purport of an unveiling.

But the veil has another function: to recall, in individualized fashion, the closure of private space. It signifies an injunction of no trespassing upon this space, and it extends it to another space, the one in which the photographer is to be found: public space.

These white islets that dot the landscape are indeed aggregates of prohibition, mobile extensions of an imaginary harem whose inviolability haunts the photographer-voyeur. They are scandalous, or at least perceived as being so. By their

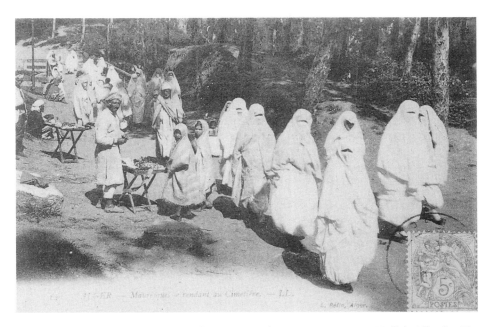

Figure 45.2 Moorish women on their way to the cemetery (From Mallek Alloula, *The Colonial Harem*, Manchester University Press, 1985)

omnipresence, they revive frustration. They also recall the existence of the well-known pseudo-religious taboo of the Muslims: the figural depiction of the human body prohibited by Islam.

These veiled women are not only an embarrassing enigma to the photographer but an outright attack upon him. It must be believed that the feminine gaze that filters through the veil is a gaze of a particular kind: concentrated by the tiny orifice for the eye, this womanly gaze is a little like the eye of a camera, like the photographic lens that takes aim at everything.

The photographer makes no mistake about it: he knows this gaze well; it resembles his own when it is extended by the dark chamber or the viewfinder. Thrust in the presence of a veiled woman, the photographer feels photographed; having himself become an object-to-be-seen, he loses initiative: *he is dispossessed of his own gaze*.

This varied experience of frustration is turned by the photographer into the sign of his own negation. Algerian society, particularly the feminine world within it, threatens him in his being and *prevents him from accomplishing himself as gazing gaze*.

The photographer will respond to this quiet and almost natural challenge by means of a double violation: he will unveil the veiled and give figural representation to the forbidden. This is the summary of his only program or, rather, his symbolic revenge upon a society that continues to deny him any access and questions the legitimacy of his desire. The photographer's studio will become, then, a pacified microcosm where his desire, his scopic instinct, can find satisfaction.

And so, now in the studio, adorned for the occasion, is one of the numerous models whom the photographer will have wear the veil. As if it were at once part of an exorcism or an act of propitiation, she is drawing the veil aside with both hands in a gesture of inaugural invitation that the photographer has staged (richness of dress, jewelry, smile, etc.), first for himself, and second for the viewer. Separated from the group that rendered her nondescript, the model is holding a pose, haloed in artistic soft focus, the metaphorical equivalent of intense exultation.

This is a determinant moment for what follows because this is where the machinery, or rather the machination, is set in motion. The entire distorting enterprise of the postcard is given here in schematic form. It is contained in the gesture of drawing the veil aside – a gesture executed at the photographer's command and destined to be followed by others. When she completes them, the *algérienne* will no longer have anything to hide.

Suzanne Preston Blier

VODUN ART, SOCIAL HISTORY AND THE SLAVE TRADE

A man without force is without the essential dignity of humanity.
(Frederick Douglass, *Life and Times*)

To have seen a country is not the same as to have lived it.
[Edumɛ kpokpo a, me edumɛ yiyi o]

(Gen proverb)

BETWEEN 1710 AND 1810 over a million slaves (principally of Fon, Aja, Nago, Mahi, Ayizo, and Gedevi descent) were exported on English, French, and Portuguese vessels out of the Bight of Benin and what was then called the Slave Coast of Africa (Curtin 1969: 228; Manning 1982: 335). This trade, which continued from the region in varying degrees through the end of the nineteenth century, contributed to one of the greatest intercontinental migrations in world history (Curtin 1967; Polanyi 1966; Law 1991). Many of those who were sent from this area were brought to Brazil and various Caribbean islands. The slave trade had dire consequences not only for the men and women who crossed the Atlantic but also for many of those who remained in Africa. In the kingdom of Danhome the acquisition and trading of slaves had assumed dimensions of a national industry. To a large extent, the Danhome state economy was based upon annual raids and military expeditions against neighboring groups and villages, the primary purpose of which was to capture men, and to a lesser extent women and children, who could be sold for profit.

In the course of these campaigns, which often took place soon after harvest, many people lost their lives immediately in confrontations with the Danhome troops; others lost their freedom, homelands, and dignity when they were taken prisoner and were brought to the Danhome capital, where they were either sold into slavery

or were kept as prisoners, later to be killed in state ceremonies or forced into involuntary life-long servitude in the state militia, court harems, plantation labor groups, or households of the governing elite.

Those fortunate enough to flee the advancing Danhome armies also suffered greatly. Most returned to their homes to find their farms burned, their granaries emptied, their animals stolen, or slaughtered, and their houses and temples destroyed. For them the answer often was further flight and hiding. With the famines that often followed, medical problems, infertility, and high infant mortality were rampant (see Manning 1982). The prime targets of the slave raids, primarily young men, were precisely the ones who would have been essential in providing the labor needed to rebuild and sustain the community. Without them, survival was tenuous. Although the situation often was dire, it would have been intolerable without a viable means of both comprehending and coping with the difficult conditions. This included the prominent use of *bocio* and *bo*. No matter what the misfortune, works of this type provided a means of personal and social response to the attendant problems or concerns.

The physical and psychological suffering experienced by persons living in (or near) the Danhome state during the period of international slavery was not to any degree dissipated when the slave trade was outlawed by European states in the nineteenth century. Coinciding with this ban was a new European demand for palm oil to be used in the industrial production of soap. This need was accompanied by the setting up of large oil palm plantations in Africa. In Danhome these plantations were worked by slaves overseen by the kings and other powerful persons. The slaves were obtained, as before, through warfare and raids. Thus at the same time that European states sought to end the horrors of international slavery, they simultaneously encouraged the acquisition and extensive use of slave labor within Africa for palm oil production. The social impact of this economic change was great, for by 1900 fully one-quarter to one-third of the population in the Danhome area were first- or second-generation slaves, many of whom were working on plantations (Manning 1982: 192).

With the French conquest of Danhome in 1894, the difficult conditions of rural peoples appear to have been little improved. Although the French were able to enforce a cessation of the slave raids that had been used to acquire plantation labor, colonial officials to a large degree reinforced and gave legitimacy to essential conditions of the past by allowing princes and newly appointed *cercle* chiefs to retain control over many of their former slaves and the lands they worked. As late as the 1930s, when Herskovits, along with several members of the Danhome aristocracy, visited a village of slave descendants, the latter showed clear indications of fear and discomfort (Herskovits 1967, 1: 103–4; Blier 1988: 140). As Patrick Manning points out in reference to the above incident (1982: 192), 'The heritage of slavery in this region where slavery and slave trade were so much a part of life for centuries is deeply and subtly ingrained.'

The fundamental links between individual disempowerment and emotional expressions thereof find ample evidence in *bocio*. Often bound tightly in cords, these works evoke the image of a prisoner. They suggest what the Fon call *kannumon*, 'thing belonging [in] cords,' i.e., the enslaved person. Such individuals, themselves

signifiers of personal demise, were potent reminders of the disturbing effects of war, poverty, insecurity, and loss of freedom. As Ahanhanzo Glélé, a descendant of the powerful nineteenth-century ruler King Glélé, notes (1974: 158): 'The *kannumon* came from several sources: regular wars (war prisoners), commerce (individuals bought from Hausa, Bariba, and Nago merchants), the ravaging of populations not under Agbome domination, and generally poor people in the state of dependence.'

The prominence of cords and binding in commoner *bocio* traditions is a poignant reference to the trauma which resulted from state-induced or supported violence. If slaves, ex-slaves, and the many others who were fearful of enslavement suggest what W.B. Friedman (1956: 175) calls potent 'bundles of power,' *bocio* can be said to represent these bundles in manifestly visual ways. *Bocio* arts, I maintain, were not merely intended to be reflections of violence and danger, but rather were thought to offer important strategies for responding to the difficult social conditions in which people found themselves at this time. These sculptures were not indifferent or adiaphoric to the sufferer's plight, but served as a means of readdressing wrongs and dissipating attendant anxiety.

Yet resolution of individual and social tension represents but one aspect of each sculpture's textual meaning, for these works also are provocative signifiers of the danger of leaving difficulties unresolved. Such works offered a way of both accepting and refusing the negative by helping their users to objectify conflict and to 'think-through-terror,' as Taussig would say (1987: 5). As Marcuse suggests (1978: 9), art provides one with a way of uttering what is otherwise unutterable, allowing one to escape from one's bondage however defined. *Bocio* through this means enabled area residents to gain a certain sense of control over the sometimes grave social, political, and physical conditions around them.

In several impassioned books on the difficulties of colonialism in Algeria, psychiatrist Frantz Fanon has argued (1968) that the psychological ills suffered by Algerians during their war for independence often were attributable to the horrors of the political situation in which they found themselves. In both precolonial and postcolonial Danhome, many inhabitants also suffered from various forms of psychological trauma. *Bocio* functioned in a certain sense as counterfoils and complements to such problems, responses to what Clifford Geertz discussed (1983: 55–70) in terms of psychopathology encouraged by social disorder. The visual power of *bocio* objects reveal in key respects the social and personal impact of such insecurity and disempowerment. This is an art in which a full range of anxieties is manifestly felt. And in so far as anxiety derives from the feeling of helplessness that fear evokes, *bocio* help to relieve related concerns in the face of life's lesser and greater traumas. Works of this sort no doubt were made and used prior to the slave trade. Indeed the specific problems which these works are commissioned to address include a range of personal and familial concerns which sometimes had little relation to war or slavery. None the less, these sculptures appear to have assumed special poignancy and meaning in the area owing to the often difficult circumstances promoted by the slave trade. Related images express what Marcuse calls (1978: 19–20) a 'consciousness of crisis' (*Krisenbewusstsein*).

The power of *bocio* counteraesthetics

Questions of the social and psychological grounding of *bocio* arts are addressed in provocative ways in the potent aesthetic concerns which they define. *Bocio* aesthetic criteria accordingly offer a unique ground against which to explore questions of art, power, and expression generally. Perhaps not surprising in light of the above discussion of political difference and distance, *bocio* aesthetic signification is closely bound up with societal (and countersocietal) values such as dissonance, force, destruction, decay, and danger. *Bocio* arts, as we will see, express not only an aesthetic of negativity, but also what Kristeva calls *frappe* or shock.

With these works, as in any art corpus identified so closely with social and psychological expression the aesthetic criteria used in sculptural evaluation are complex. The 'strong' object, explains Sagbadju (7.1.86), 'is not something of beauty.' Ayido observes similarly (5.2.86) that 'one does not need to carve a sculpture so that it is attractive in order to have it work.' In art as in life, two terms are employed by the Fon to indicate general attractiveness: *aco* and *dɛkpɛ*. The former refers to things which are ornamental, delicate, refined, decorative, dressed, and tidy, and the latter designates ideas of beauty, elegance, and attractiveness generally. The vast majority of commoner *bocio* clearly stand out in marked contrast to these two aesthetic ideals. These sculptures are not ornamental, refined, elegant, or attractive in any standard sense of the words. Nor do these figures conform to the variant secondary aesthetic criteria that are said by Fon artists to be important to them in evaluating beauty in sculptural form. The latter include qualities such as youthfulness (*dekpe* – beauty in Fon is synonymous with youth), smoothness (*didi*), completeness (*bisese*), and correctness (*pɛpɛ*). As we have seen within commoner *bocio*, there also is little to suggest youthful grace, surface polish, a sense of finish, or exacting anatomical detail.

These lacks are all the more striking in view of the strong emphasis in the kingly *bocio* arts which is given to refined features and attributes which are elegant, ornamental, polished, and exacting in form. Thus whereas Fon royal *bocio* arts conform in essential ways to local beauty criteria, commoner works emphasize counteraesthetic, even antiaesthetic values and features of ugliness. The counteraesthetics of commoner *bocio* arts are of considerable interest in this light because they constitute in essence the aesthetic of choice of the subaltern groups living in this area – the rural residents, nonroyals, and those generally suffering from the effects of disempowerment.

What is suggested here is that artists of commoner *bocio*, aware of the diminished political statuses of their patrons, to some extent reified the latter's positions by emphasizing certain counteraesthetic features in their arts. The two Fon terms used to indicate a negation or lack of beauty, *magnon* (which also signifies 'ignorant' and 'unschooled') and *gnlan kan* (designating 'bad' or 'beastly' – literally 'bad cord'), suggest a complementary emphasis on attributes perceived to be rural or outside the encultured mainstream, as defined by the elite. The artists, activators, and users of commoner *bocio*, by intentionally avoiding qualities associated with beauty and refinement in royal art contexts, promoted status difference through privileging antithetical forms of aesthetic expression. While associated concerns were never

discussed by local artists or *bocio* users, the visual differences between commoner and royal *bocio* aesthetic expression are striking.

Secondary aesthetic criteria employed to designate the lack or negation of beauty (*magnon* and *gnlan kan*) underscore these status differences in interesting ways. One feature said to characterize works showing a lack or negation of beauty is messiness (*gudu gudu*: disorderly, piggish, mixed up, troubled; from *gu*, designating things which are spoiled, corrupted, inutile, wasted, or negated). Commoner *bocio*, in conforming to this counteraesthetic of messiness and disorder, may in some way be seen to complement the confusion and disorder that defined many of their users' lives. In local divination sessions in which commoner *bocio* are discussed, these concerns come up with considerable frequency.

Three other values said to characterize commoner *bocio* counteraesthetics also have important sociopolitical and psychological complements. These include fury (*adan*), strength (*sien*, 'resistant,' 'solid'), and force (*hlon hlon*). Associated qualities are revealed most importantly in audience responses to *bocio* . . . Like *gudu*, 'disorderly,' the above also offer insight into *bocio* signification. Accordingly, *adanwato*, 'father of fury,' is the term frequently used to describe powerful people in the community who are able to bring their influence to bear on others living around them. . . . Each *bocio* serves similarly as an 'object of fury,' something which accords its users considerable power. Ancillary meanings of the term *adan*, the most important of which are audaciousness, anger, intrepidness, hardness, courage, coerciveness, and scolding (Segurola 1963: 4), also are of interest. In their roles as aggressive and protective forces, *bocio* display similar values. Supplemental associations of the Fon term *hlon hlon* ('force') carry provocative secondary meanings as well, in this case, of violence, vengeance, and vindictiveness (Segurola 1963: 227). These attributes complement at once the sometimes embattled social and political contexts in which such objects are made and the force that is thought to be necessary to counter danger and difficulties that lie in life's path.

The selection of *bocio* materials for their physical and metaphoric strength and the emphasis in these works on knotting and tying suggest in turn the strength (*sien*) which these objects are intended to express through their forms and functioning. The prominent use of raffia cord, with its characteristic solidity and resistance, is significant too, for comparable strength is essential to *bocio* roles in turning away danger and discord from their various owners. Appropriately ancillary meanings of the counteraesthetic term *sien* designate things which are courageous, insistent, secure, resistant, persevering, tenacious, forceful, severe, opinionated, hardheaded, and hardened (Segurola 1963: 471). Similar qualities are vital to *bocio* in their roles in helping one to survive or better one's condition in life. Seeing these and related visual properties within sculptural form no doubt gave local viewers a sense of assurance and security in the face of various difficulties. Through emphasizing aesthetics of shock which in various ways privilege conflict, contradiction, chaos, obscurity, mystery, and brute force, these works convey an emotional energy of considerable potency.

[. . .]

References

Blier, Suzanne Preston (1988) 'Melville J. Herskovits and the Arts of Ancient Dahomey', *Res* 16 (Autumn): 124–42.

Curtin, Philip D. (ed.) (1967) *Africa Remembered: Narratives by West Africans from the Era of the Slave Trade*, Madison: University of Wisconsin Press.

Curtin, Philip D. (1969) *The Atlantic Slave Trade: A Census*, Madison: University of Wisconsin Press.

Douglass, Frederick ([1883] 1972) *The Life and Times of Frederick Douglass*, New York: Bonanza Books.

Fanon, Frantz (1968) *The Wretched of the Earth*, trans. Constance Farrington, New York: Grove Press.

Friedman, W.B. (1956) 'Changes in Property Relations', *Transactions of the Third World Congress of Sociology*: 1–2.

Geertz, Clifford (1983) *Local Knowledge: Further Essays in Interpretive Anthropology*, New York: Basic Books.

Glélé, Maurice Ahanhanzo (1974) *Le Danxomè: Du pouvoir Aja à la nation Fon*, Paris: Nubia.

Herskovits, Melville J. [1938] (1967) *Dahomey: An Ancient West African Kingdom*, vols 1 and 2, Evanston, Ill: Northwestern University Press.

Law, Robin (1991) *The Slave Coast of West Africa 1550–1750: The Impact of the Atlantic Slave Trade on an African Society*, Oxford: Clarendon Press.

Manning, Patrick (1982) *Slavery, Colonialism, and Economic Growth in Dahomey, 1640–1960*, New York: Cambridge University Press.

Marcuse, Herbert (1978) *The Aesthetic Dimension: Toward a Critique of Marxist Aesthetics*, Boston: Beacon Press.

Polanyi, Karl, with Abraham Rotstein (1966) *Dahomey and the Slave Trade: An Analysis of an Archaic Economy*, Seattle: University of Washington Press.

Segurola, R. Père B. (1963) *Dictionnaire Fon-Française*, Cotonou, Republic du Ben Procure de L'Archidiocèse.

Taussig, Michael (1987) *Shamanism, Colonialism and the Wild Man*, Chicago: University of Chicago Press.

(b) Identity and transculture

Jill H. Casid

'HIS MASTER'S OBI'
Machine magic, colonial violence, and transculturation

Empire through the Magic Lantern

> . . . long before the era of high Victorian imperialism, Africa and the
> Americas had, become what can be called a porno-tropics for the
> European imagination – a fantastic magic lantern of the mind onto which
> Europe projected its forbidden sexual desires and fears.
>
> <div align="right">Anne McClintock, Imperial Leather</div>

Though psychoanalysis emerged in historical relation to imperialism, the feminist
and postcolonial critic Anne McClintock challenges us with a both/and proposition,
namely that it is possible to psychoanalyze colonialism in tandem with a decolo-
nization of psychoanalysis.[1] From McClintock's own use of Kristeva's notion of
abjection as 'something rejected from which one does not part' to Homi Bhabha's
formulation in 'Sly Civility' of the subject of colonial authority as never free of its
'scapegoat fantasy' that makes 'him' or the 'master' not a fortified castle but a 'fron-
tier station of joint occupation,' versions of the psychoanalytic concept of projection
have provided some of the main tools for postcolonial criticism.[2] I would like to
suggest further that the psychoanalytic concept of projection takes us not only
to an important problematization of the binaries of 'self' and 'other' but to the very
techniques, in a material sense, for their attempted production. Though McClintock
does not pursue her machine metaphor for the constitutive, internal role of abjured
fantasies about Africa and the Americas (and we might add Asia as well) for the
imperial subject, the quick, shorthand condensing utility of the magic lantern as
illustrative vehicle takes us to the inextricability, in the history of colonialism,
of the psychoanalytic concept of projection and machine technologies for casting an
image. The metaphor merits elaboration. Here the mind of the imperial subject is
a fantastic magic lantern and this magic lantern is fused with Africa and the Americas

in a double projection. The magic lantern provides such a ready theoretical vehicle for demonstrating the extent to which an 'Asia,' 'Africa,' or 'America' failed to function as a blank screen that stayed safely over there because this device was so fused and infused with what it mediated. The screen was also the wall of the darkened room. Othered parts of the world were a necessary part of the machinery by which Europe endeavored to cast out the hated, desired, and feared matter of its own machine imago.

European technologies of projection mediated colonial contacts through what many popular scenes of magic lantern demonstrations declared its materialization of a 'new world.' To produce an effect of imperial power, I argue that the European metropoles depended in the age of European expansion on technologies not merely of recording but of projection. The passive capturing of a semblance of likeness was not sufficient. Rather, delineation gave way to conjuration in the effort to give externalized form to European claims to superiority and then make those manifestations of power act on matter and bodies. Such attempted actualizations of authority through technological displays were not only to impress on bodies and matter but were made out of bodily and simulated 'contact' with the Others of empire. The production of imperial power as an effect of 'higher reason' and 'technological supremacy' required a transfer of aura away from the novelties and marvels associated with otherness and into the machines by which they were ostensibly demystified.

The conjuring effects of magic lantern displays were to confirm the rational sight of its metropolitan, European spectators by the darkened, apparitional inverse of their Cartesian vision. However, the magic lantern's traffic in the exotic and the occult through its apparitional imaging tricks also threatened. Presenting their beholders with an altered version of their model of rational vision, spectacles like the magic lantern opened up the dangerous prospect of otherness and difference within. The possibility of becoming Other or of being affected by the imagined Other threatened to reverse the primacy and directional influence between Europe's technologies and primitive magic. In the 1778 metropolitan European engraving by Carl Guttenberg with its caption *The Tea-Tax Tempest, or The Anglo-American Revolution* printed in English, German, and French, Father Time projects an image of revolt as explosive combustion with a magic lantern balanced on a giant globe. Africa and Native America in the guise of female warriors reduced to figures of astonishment look on in surprise as, in the midst of darkness, light diffuses into chaotic conflagration reducing to ash the difference between the imagined light of reason and primal, 'primitive' fire. The use of projected phantasmagoria of destruction through the magic lantern may be interpreted as part of the effort to stabilize the power relation between original and copy and center and periphery by ostensibly confirming the location of science and reason through the specter of its opposite in the form of its inverted double. Indeed, scenes such as the offering of a magic lantern with the Chinese emperor's face on a slide amongst a panoply of European science toys and gadgets presented to the imperial court in British satirist James Gillray's *The Reception of the Diplomatique and his suite at the court of Pekin* (1792) attempted to manage through parody the threat inherent in mimetic machines of imitation and conjuration. It may be just a joke that the hot air balloon impaled by the protruding corner of the pagoda is represented as a puncture right through the eye of the

screaming face painted on the balloon's surface. However, the subdued violence of these parodic efforts to dispel the menace that its projected shadows of 'otherness' (gendered and racialized) might dangerously reshape the European subject attest to the dependence and instability at the heart of European Enlightenment's idealized machine self-image.

'His master's Obi'

The very projection required for rational self-reflection also threatened to alter the imperial subject. To consider this precarious doubleness of the colonial machinery of dominance, I turn to focus on a case in eighteenth-century Jamaica that involved the imitative conversion of the magic of the colonial Other in an effort to extinguish, with the display of the power of European machines of projection, the possibility of slave revolution: the so-called 'Obeah trials' that took place in the wake of the slave insurrection of 1760 on the English colony of Jamaica. One of the most pervasive slave revolts, the so-called Tacky rebellion, took its name from a male slave Tacky whom the slave rebels believed could reverse the direction of any bullets fired at his body. Put down only after a prolonged and fierce resistance, the Tacky rebellion marked a significant turning point in British colonial attitudes toward the possibility of an organized overthrow of the plantation system or, in the words of Creole plantation owner Edward Long's 1774 *History of Jamaica,* 'the entire extirpation of the white inhabitants.'[3] The story of the revolt in Long's *History* is preoccupied by the role of magic practice in bringing the slaves together in an organized effort. Discussing the leadership attributed by colonial authorities to an 'Obeiah man or priest,' a 'Coromantyn' taken from the Gold Coast of Africa, Long's version of the uprising is fascinated by the capacity of fetishes and oaths to 'bind' atomized slaves into a conspiratorial unity around a belief in their invulnerability or the instability of conjuration between solemn founding oaths, pacts to overthrow, and the raising of spirits or the calling up of para- or supernatural powers.[4]

Current scholarship on Afro-Caribbean religions traces Obeah to the Ashanti-Fanti communities of the Gold Coast region of Africa, present-day Ghana. The term written variously in English as Obeah, Obiah, Obia, and Obi is thought to represent a corruption of the Ashanti word *obayifo* for witch or wizard. In the contemporary West Indies, the names 'obeah-woman' and 'obeah-man' are used interchangeably with the titles healer, doctor, and folk doctor.[5] While poisonous and healing compounds made out of animal and plant substances are central to the current practice of Obeah, these preparations attain their efficacy, the power to annihilate or revivify through the intervention of 'jumbies' or 'duppies,' ghosts or spirits of the dead conjured or taken on in a kind of double incarnation by its practitioners. Like Vodou, Obeah is also understood as a system of belief in the transformative powers of matter and the dissoluble boundaries between living and dead. Recent studies of Obeah emphasize its syncretic character as the product of encounter between various African, indigenous, and European belief systems and practices in the colonial Caribbean.

However, in the decades following the Tacky rebellion, British accounts attempt to displace Obeah – and its associated fetishes, secrecy, oaths, rituals under the veil

of night, and resurrecting and killing potions – out of the colonies and onto Africa, – representing Obeah as fully constituted prior to its transplantation by African-born slaves. Bryan Edwards's account of the Maroons (first published separately in 1796) writes of Obi among the escaped slaves who formed communities in the mountains of Jamaica as a practice originating in Africa:

> Concerning the Maroons, they are . . . attached to the gloomy super-stitions of Africa (derived from their ancestors) with such enthusiastick zeal and reverential ardour, as I think can only be eradicated with their lives. The Gentoos of India are not, I conceive, more sincere in their faith, than the negroes of Guinea in believing the prevalence of Obi* [*'A species of pretended magick], and the supernatural power of their Obeah men.[6]

Such descriptions associate Obi with a political threat to the colonial plantation system of Jamaica so intransigently rooted in bodies and place that it justifies the extermination of the Maroons. And yet the account attempts to dispel the magical power of that threat with a double displacement from the real. In this account Obi is neither local nor magical for it is Obi that is the 'pretended magick,' the imitation of magical practices. Bryan Edwards's 1793 *History, Civil and Commercial, of the British Colonies in the West Indies* reproduces an account of Obeah prefaced by an attribution which is to endow it with legal authority. The account, itself composed of other reports, was transmitted by the Agent of Jamaica to the Lords of the Committee of the Privy Council and subjoined to their report on the slave trade. Edwards attributes it to Edward Long. Obi threatened to the extent that it simulated and rivaled the colonial machinery of dominance that set out to eradicate it. Note the competitive phrasing in the very passage that is supposed to establish the report's authority on the basis of 'testimony' from black slaves themselves:

> As far as we are able to decide from our own experience and information when we lived on the island, and from the current testimony of all the Negroes we have ever conversed with on the subject, the professors of Obi are, and always were, natives of Africa, and none other; and they have brought the science with them from thence to Jamaica, where it is so universally practiced, that we believe there are few of the large estates possessing native Africans, which have not one or more of them.[7]

Edwards was elected a fellow of the Royal Society in London, the British academy of science, a year after the publication of his history.[8] The strategic use of the language of the metropole's academies, the naming of the practitioners of Obi 'professors' and their practices a 'science' may have functioned to distinguish professors as naive believers from authorized academicians and European science from that brought from Africa. Likewise, in the account about the outlawing of Obi that Edwards reproduces, the practitioners are referred to as 'professors of the Obeah art':

> In the year 1760, the influence of the professors of the Obeah art was
> such, as to induce a great many of the Negro slaves in Jamaica to engage
> in the rebellion which happened in that year, and which gave rise to the
> law which was then made against the practice of Obi.[9]

The name 'Professors of the Obeah art' may function ironically to characterize these
slaves as no different than the theatrical performers, showmen, and popularizers of
science parodied as sham authorities – Obeah operating as an adjective to mark the
difference between art and its supposed simulation, 'Obeah art.' But the phrasing
also attests to anxious competition, mimicry and counter-imitation, over whose
science and what arts of knowledge.

In 1760 a Koromantyn male slave was charged with rebellious conspiracy as an
'Obeah-man' and put to death. From that year until emancipation the practice of
Obeah was considered equivalent to conspiracy to overthrow and, hence, a capital
offense. And the invocation of that law does recur in colonial texts. However, colo-
nial accounts register disturbance that exacting the punishment of the law could not
accomplish the work of establishing the primacy and authority of European science
and its professors. The colonial machinery of domination fails, in the words of
Edwards's *History*, to extract what it desires:

> But neither the tenor of this law, the strict investigation which has ever
> since been made after the professors of Obi, nor the many examples of
> those who from time to time have been hanged or transported have hith-
> erto produced the desired effect.[10]

In the admission that the prohibitive inscription into law of magic or counter-science
as a threat to the state punishable by death failed to produce the desired effect, the
demands of colonial terrorizing open onto a certain insatiability, a need for repet-
itive execution. As this paragraph follows from a discussion of the Tacky rebellion,
'desired effect' might be understood as a statement of the wish on the part of colonial
authorities to eliminate any threat of rebellion. The immediate context of the repub-
lication of reports from thirty years previous in Edwards's *History* – the 1791 slave
revolt on Saint Domingue, the Haitian revolution, and war with France – made the
possibility of a colony-wide rebellion a more tangible threat.

And the reports republished in Edwards's *History* attempt to persuade its readers
that Obeah represents a threat that justifies colonial violence as a necessary response.
But the admission that the terror of this law failed to produce the desired effect
reverses the relation between Obeah practice and colonial violence. Edwards's
History betrays the anxiety that Obeah might 'flourish under persecution,' that its
practice was an organized response, a counter-art or science to the necromancy of
the colonial order and its brutality rather than its purported cause. To exorcize the
charge against the machinery of dominance revealed by the failure of colonial terror-
izing, the law's claim to order was exercised on the most resistant bodies – the
Koromantyn male slaves who refused to display what the colonial machinery needed
to demonstrate its effective power, that is, 'strong emotions of sympathetic
terror.'[11] The section of Edwards's *History* dedicated to Obeah culminates with an
account of the 'Obeah trials' attributed to the eye-witness of a white Creole

gentleman who sat in judgment on two of the trials. First, the account gives a description of the execution of the Koromantyn slave accused of Obeah:

> He bid defiance to the executioner, telling him, that 'It was not in the power of the White people to kill him.' And the Negroes (spectators) were greatly perplexed when they saw him expire.[12]

In the effort to display the 'power of the White people,' the *mise-en-scène* of the execution of the apparatus of colonial authority depends on a curious parenthetical 'Negroes (spectators).' One might say that if the execution of colonial law had any hope of impressing the slave population with its terror, then, of course, any assembly of black people (slaves and free blacks) in Jamaica would be the intended audience of such a spectacle. And the accounts reprinted by Edwards do attempt to position the black spectators as the objects of embodied sight on which the colonial machinery performed its pain-exacting effects of terror. For example, this account of the 'Obeah trials' is prefaced by the image of 'the stoutest among them [the black slaves] trembl[ing] at the very sight of the ragged bundle, the bottle or the egg-shells' used to characterize the practice of Obi. However, it is the British metropolitan public whose eyes the report claims to have opened while it establishes its claim to authority on the basis of the eye witness of a white planter who is supposed to have 'sat on these trials.'[13]

The 'trials' aimed to produce the kind of disabling, physically impressing fear or awe that might promise to produce a distinction between European colonial power and slave submission or, in other words, between a disembodied and un-affected eye of authority and an embodied gaze of primitive observance somatically vulnerable to the physical and psychically altering effects of terrorizing, power-producing spectacle. But the 'perplexity' of the spectators at the execution that was to rival the power-produced effects of Obeah sounds more like intellectual doubt. The report on 'Obeah practice' attributed to an absentee planter claims to have discovered the source of the high mortality rate on his Jamaican plantations in the thatched hut of an old slave woman. The narrative dramatically exposes the hut's interior walls and roof entirely covered by the suspended 'implements of her trade, consisting of rags, feathers, bones of cats, and a thousand other articles.'[14] The scene is mimicked in the description of the execution of one of the leaders of the 1760 slave revolt, an old Koromantyn male slave. The closest the colonial authorities manage to come to inducing a somatic response is the 'general panic' by which those involved in the 1760 rebellion were supposedly struck at the sight of this scene of his body 'hung up with all his feathers and trumperies about him.'[15] However, this 'general panic' was not sufficient.

In order to extract from the bodies of the black spectators an admission that might produce confirmation of a difference between rational sight as unmoved and a primitive form of observance that leaves the observer open to being altered, the trial account concludes with another show, a series of experiments with electrical machines and magic lanterns not on the body of the old slave woman but on the flesh of rebel black male slaves. The account reads:

Upon other Obeah-men, who were apprehended at that time, various experiments were made with electrical machines and magic lanterns, but with very little effect, except on one, who after receiving some very severe shocks, acknowledged that 'his master's *Obi* exceeded his own.'[16]

As an illuminating projection in the dark, the shining of light through a glass slider in order to throw a bright, spectral image onto a sheet or wall, the magic lantern held out the promise of enacting a mechanical version of enlightenment as a projective mechanism, the casting out of despised matter (superstition, falsity, etc.) which it theoretically not only displaced but deprived of its fiery charge. And it this kind of strategy that is called for in the passage on Obeah in James Grainger's long Georgic poem of the tropics *The Sugar-Cane (1764)* published a few years after the 1760 Obeah trials:

> In magic spells, in Obia, all the sons
> Of sable Afric trust: Ye sacred Nine!
> (For ye each hidden preparation know)
> Transpierce the gloom which ignorance and fraud
> Have render'd awful; tell the laughing world
> Of what these wonder-working charms are made.[17]

The demystifying technique of demonstrating the horror and then attempting to exorcize the aroused fear by a displacement achieved through a final exposure of the supposedly fraudulent mechanism to the derisive and now disbelieving gaze of the audience is precisely what the French showman E.G. Robertson claimed for the phantasmagoria show's magic-lantern projection of spirits of the dead in the context of the Parisian metropole of the 1790s.[18] But the coupling of the admission of 'very little effect' with 'severe shocks' compelling the acknowledgment that 'his master's Obi exceeded his own' in the Edwards account, indicates that the 'transpiercing' technics invoked by Grainger had to accomplish more in the magic-lantern show of the Obeah trials on the island of Jamaica than exercise a Manichean casting of light into darkness.

To gain knowledge in the form of a physical sign of acknowledgment that its machinery could work, the magic-lantern show included electrical machines so that the projection of light was accompanied by the body-penetrating projection of electrical jolts, literally piercing through black bodies with the display of the colonial machinery of dominance as sensate effects of power. The Obeah trials turn on the double sense in early modern usage of 'trial' as both legal proceeding and experiment. The use of the word 'experiments' for these performances in Edwards's account underscores this double sense to represent the Obeah trial in the terms of scientific method and the exacting of an 'acknowledgment' as the pursuit of knowledge or empirical sense data about causes and effects. Though the rhetoric of enlightenment science, like the projective machines themselves, may have endeavored to establish the difference between the proceedings as the exercise of an art or science of the penetration of mysteries and the discovery of truths and the exertion of brute force on matter, the colonial machinery of dominance extorted not

an admission of difference in kind, as in colonial science vs. black or primitive magic, but rather of degree – 'his master's Obi *exceeded* his own' [emphasis mine]. We should not ignore the effort to use irony as another part of the projective machinery, one that attempts to turn the Obeah-man, the arrested spectator of the magic-lantern show, and the black observers for whom he sat in, not only into the figure of vulnerable vision but its comic dupe of faith as well. But the directionality of these projections was not so easily manipulated. The slaves who, in these accounts, believed in an invulnerability to colonial terrorizing produced by rubbing them-selves with powder managed to resist giving over the effects that the colonial machinery desired such that they did, thereby, generate an effect of invincibility. And while the colonial authorities orchestrated with their magical machine lanterns and electrical apparatus at once a violent form of 'tactile knowing' and a projective fantasy of a disembodied and disinterested sight untouched by the very 'experi-ments' they too watched, any belief in the capacity of these devices to alter one set of spectators and not another required no less a leap of faith or rather a great conversion.

We cannot know what images were actually projected in the magic-lantern show of the Obeah trials in 1760 nor precisely what combination of electrical devices and projective technology were employed. William Hooper's compilation of exper-iments culled from previous collections on scientific demonstrations such as those by the Abbé Nollet and published in London in 1774 under the title of *Rational Recreations* provides one possibility – a course of experiments called 'Recreations in the Dark Chamber.' In this sequence of displays performed in the camera obscura, the electric apparatus replaces the candle, lamp, and solar rays as a light source to produce 'a great number of pleasing and surprising recreations in the dark.'[19] But, as Hooper describes, recreations such as 'The Globular Fires' may have been executed as 'beautiful spectacles' but they also had potentially dangerous physical effects. Using a globe and a cushion made of rubber placed atop a table connected by a string to a wheel in another room, the aim of 'The Globular Fires' was to produce the effect of circles of brilliant illumination or in Hooper's words 'torrents of flame.' Part of the performance was also tactile. As Hooper writes, 'If . . . a finger be brought within half an inch of the globe, it is sure to be struck very smartly; and there will often be a complete arch of fire from it to the rubber . . .'[20] Such participatory experiment on bodies may have been a source of knowledge production and amusement in the metropole.[21] And, beginning in Germany, elec-troshock was introduced at this time as a medical treatment for paralytics.[22] But the use of such a combination of optical spectacle and forced infliction of electro-shock in the colonies operated not as recreation in the sense of amusement but as an attempted recreation or reconstitution of authority and agency from Obeah magic to the machines themselves.

Morbid projection and transculturation

Deeplight projector hooked up on the subway tracks. I rigged it myself a long time ago. Keeps people out of our space. It's a tape I made of all us, dubbed on six waves so it looks like a lot more. You tripped my

beam when you came down the stairs, so we knew someone was there. We came to scare them off, in case the projection didn't do it. Smart, huh?

<div align="center">Nalo Hopkinson, Brown Girl in the Ring (1998)</div>

The Afro-Caribbean Toronto-based contemporary woman writer Nalo Hopkinson's first novel *Brown Girl in the Ring* explores a dystopian future of class, gender, and race-based colonization of metropolitan cities. Obeah practice of raising visions and duppies or spirits of the dead potently combines with other spectral machines of image projection, however low-tech and cobbled together, to form technologies of resistance at the hands of women transmigrants from the Caribbean to Canada.[23] Her remediation of Obeah as a counter-technology to the effort to control projection and yet appropriate Obeah as a means to produce dominating effects of terror upsets distinctions between science and magic, new and old, past and future. The duppies, dubbed tapes, and deeplight projection of this novel provide a helpful point of entry to the question of the significance of accounts of the Obeah trials, that is, to the contemporary pertinence of the critique of accounts of the formation of the modern observer and paradigms of rational vision they enable.

In *Mimesis and Alterity* (1993) the cultural anthropologist Michael Taussig reconceptualizes the history of modernity from a progressive narrative of European internal technological development to a colonial dialectic of sympathetic and terrorizing magic carried out as an imitative dance of so-called enlightenment and primitivism, science and occultism, between colonizing Europe and its projected Others in the period after the seeming watershed inventions of photography and the phonograph.[24] Taussig's retheorization of mimesis challenges historians of culture to rethink European models of vision as inseparable as much from touch and magic as from the colonial relations between Europe and its others. The 'tactile knowing' Taussig elaborates from the work of Walter Benjamin to find a way out of the deadly dynamics of colonial history also formed an essential part of colonial technics and its violent mimetic practices. I suggest we pay attention to the imbrication of the claims of empirical science with the dynamics of terrorizing magic in such early modern technologies of projection as the magic lantern and its use in combination with the application of an early version of electro-shock to flesh in areas of territorial occupation, specifically Jamaica in the wake of slave revolt on nearby Saint Domingue. Such attention encourages us to reconsider how 'tactile knowing' or the production of effects of knowledge and power through the contact of the machines of 'rational,' disembodied vision and bodily flesh was already central to the applied necromancy of empire in the early modern period. A consideration of the staged use of machines of projective illusion with machines for electro-shock in the Obeah trials to at once appropriate and violently dispel the physical prestige of the projected sense of invulnerability on the part of Koromantyn rebel male slaves in Jamaica allows us to develop historically and theoretically Taussig's suggestion that we look again at Theodor Adorno and Max Horkheimer's contention in 'Elements of Anti-Semitism: The Limits of Enlightenment,' that the machinery of dominance depended on 'the organized imitation of magic practices, the mimesis of mimesis.'[25]

'Elements of Anti-Semitism,' the culminating chapter of the *Dialectic of Enlightenment* (their collaborative account of the destructiveness internal to Enlightenment

and its technologies first published in 1947) centers on the function of a particular reproducible stereotype, the Jew. The repetitious production and circulation of this figure depends, they argue, on the seeming conundrum, 'They cannot stand the Jews, yet imitate them.'[26] From the example of the sacrifice of those identified with the exercise of the very bloody magic and exterminating rites carried out upon them, they make the suggestive argument that imitation and hatred are indistinguishably implicated in the mass production of the subject of technologized modernity. To do this they take up the psychoanalytic theory that the bounded ego is constituted on the basis of morbid projection, whereby aggressive and taboo wishes are displaced onto the outside world. In morbid projection the despised matter cast out onto external objects reflects back the subject's own abjected material in the form of imagined threats that must be eliminated. This negative construction of the subject does not merely depend on the expulsion of that which threatens the self's construction of stable borders, its own fears, anti-social, and self-annihilating wishes but on the mimicry of the very exterminating energy invested in those objects that are taken to mirror fantasmatically what the self must overcome but, nonetheless, envies – access to the raw power of nature.

The move in 'Elements of Anti-Semitism' to generalize this individual psychic dynamic into a collective paranoia that binds society into an imagined community on the basis of a waking nightmare does not take us far from what we recognize from Freud's essay on the uncanny and his *Totem and Taboo*. However, the understanding of this management of energies as an externalized technological mechanism of killing projection introduces an important twist. Let me emphasize what is buried here and yet I think merits re-examination. Note the language of technics:

> The purpose of the Fascist formula, the ritual discipline, the uniforms, and the whole *apparatus,* which is at first sight irrational, is to allow mimetic behavior. . . . This *machinery* needs the Jews [emphasis mine].[27]

The imitation of magic practices, the 'mimesis of mimesis,' or what Taussig calls the means by which culture makes itself second nature, is formulated as not just any kind of management but the machinic organization of psychic projection. The dynamic of morbid projection or paranoia emerges here as a social machine in the technical sense and one developed in the historical formation of modernity.

Adorno and Horkheimer's account of social systems of dominance as paranoid structures may have taken its pertinence from one effort at human extermination. However, the reach of their formulation extends further both geographically and historically. They assert that 'The established group always adopts a paranoiac attitude to others. The great empires and even organized humanity as such are not more advanced than headhunters in this respect.'[28] The opposition of the fantasized figures of 'organized humanity' and the 'headhunter,' however reversed in valuation, problematically maintain the terms of colonial discourse itself. However, I would like to argue that this analogy of how the paranoid subject is ultimately inseparable from the expelled object of its own disavowed fear and loathing to the self-consumptive mirroring of 'great empires' and 'headhunters' is, nonetheless, suggestive. Reading such a rhetorical device against the grain invites reconsideration of the Fascist formula as a social machine that took its techniques from an earlier

dark side of the Enlightenment or what we might call instead the colonial machinery of dominance. The essay confronts the contradiction inherent in the early modern development of the so-called scientific method that 'in a certain sense all perception is projection.'[29] In early modern scientific method's effort to at once distinguish subject and object and yet bridge the gulf between them, they suggest that control of automatized projection as a reflex reaction required further automization and mechanical systemization. The technological modernity of the conversion of bodies and environment into knowledge, surplus wealth, and effects of power that in the early modern period produced the very dynamics of imitating and yet ejecting and destroying its own hated matter, we might argue further, was generated in the contacts between Europe and its colonies.

But what kinds of machines for the control of this contradiction are inherent in rational judgment, in scientific method? The essay's own investment in rescuing a certain form of Enlightenment rationality is particularly striking in Horkheimer and Adorno's fascination with the nose as an open orifice and the sense of smell as a penetration of the subject which they contrast with sight. The essay asserts defensively, 'When we see we remain what we are, but when we smell we are overtaken by otherness.'[30] And yet in the ensuing effort to disentangle what they call 'false' or morbid projection from the projection required for the subject to get outside of itself to perform the very self-reflection that is to distinguish rational judgment, the very ability to differentiate, sight or perception is the battle ground and the saving sense. Self-reflection as the 'life of reason works as a conscious or controlled projection in which the subject gets outside of itself not in a union with the object but in the finding of a third position from which to reflect on or adjudicate a considered opposition between what is reflected in the eye as receptor (cast onto the retina) and the external object.'[31] Here we have the structure of optical devices such as the magic lantern used to project an image onto a wall or screen so that the subject as spectator might physically occupy that position of self-reflection between the imagined object and the perceptual image.

The possibility that the Enlightenment eye might be touched or permeated, as much as the archaic nose, by the sensual intrusion of the imagined object or the objectified Other and what they call its 'dazzling power' haunts this triangular setup. Adorno and Horkheimer's essay tries to distance this threat by calling it the 'hallucination of immediacy.'[32] In other words, by insisting that sensual immediacy or fusion is an hallucination, they attempt to distance seeing from the possibility of being taken over. They do concede that paranoia or morbid projection may be the 'dark side' of sight-based rational cognition. However, at the same time, they attempt to rescue projection as rational self-reflection from what they call morbid, paranoid, or false projection in order, perhaps, to align a salvaged form of rationality with their standpoint as critics (imagined to be situated outside the dynamics they describe). The essay mimics the early modern strategy it describes but, in so doing, gives us a sense of the stakes. Through the staging of the visual hallucination of immediacy, the waking dream or nightmare confusion of inner and outer worlds, self and Other generated in the organized imitation of magic practices, the technological mimesis of the apprehension of nature in scientific method's projective device was supposed to dispel this illusion and demonstrate how sight secures the disembodied and yet masculinized European subject against an identified external object.

Externalizing sight as a floating perceptual image functioned as a means of denying the bodily, its mortal and permeable substance, the abjected feminine and racialized Otherness within. But the machinic organization of the projective mechanism also inevitably set in motion the risk of objectifying, mortifying conversion. The effort expended in Adorno and Horkheimer's essay to distinguish the eye from a penetrable bodily orifice is useful in calling our attention to the very somatic dangers inherent in the disavowing ambitions of rational sight and its machinery.

In the case of the Obeah trials, converting slave resistance into submission entailed a transculturating mimicry of the very Obeah practices that the colonial state set out to extinguish. While the process of auratic transfer from Obeah practice to magic-lantern technology was publicly to produce a tangible distinction between an eye of reason and its disavowed vulnerability projected out onto black spectators as the abjectly embodied sight of primitive worship, this transfer of technologies of projection put the machine imago, the claimed rational vision, of the imperial subject at risk. The culminating obeisance to 'his master's Obi' in these trials marks not the difference between enlightenment science and primitive magic but the extent to which colonial order required effects of necromancy to power its machinery. Such a case of projection leading to transformation begins to collapse the distance and difference between metropole and colony and between machines for the production of empirical knowledge and technologies of thaumaturgy. When we set the technological invention of the rational Western subject back into the global field of its projected shadows and specifically the contested scene of its production, we see that this machine imago not only depended upon but was haunted by the specters of the machine-made nightmares between self and Other, metropole and colony, the claimed rationality of Protestantism and the primitive observance displaced onto Obeah, the syncretic Afro-Caribbean version of it that threatened from within.

Notes

1 Anne McClintock, 'The Lay of the Land: Genealogies of Imperialism,' in *Imperial Leather: Race, Gender, and Sexuality in the Colonial Contest*, New York: Routledge, 1995, 73–4.

2 McClintock, 71-4 and Homi K. Bhabha, 'Sly Civility,' in *The Location of Culture*, London: Routledge, 1994, 100.

3 Edward Long, *The History of Jamaica*, London: T. Lowndes, 1774, vol. 2, 451–2, 473. See also Michael J. Craton, *Testing the Chains: Resistance to Slavery in the British West Indies,* Ithaca: Cornell University Press, 1982.

4 Ibid.

5 Margarite Fernández-Olmos and Lizabeth Paravisini-Gebert, 'Introduction: religious syncretism and Caribbean culture,' in *Sacred Possessions: Vodou, Santería, Obeah and the Caribbean*, New Brunswick: Rutgers University Press, 1997, 6.

6 Bryan Edwards, *The proceedings of the governor and Assembly of Jamaica, in regard to the Maroon Negroes: published by order of the Assembly, to which is prefixed an introductory account, containing, observations on the disposition, character, manners, and habits of life, of the Maroons*, London: J. Stockdale, 1796.

7 Bryan Edwards, *The History, Civil and Commercial, of the British Colonies of the West Indies*, New York: Arno Press, 1972, vol. 2, 84.

8 Raymond Phineas Stearns, *Science in the British Colonies of America*, Urbana: University of Illinois Press, 1970, 381.

9 Edwards, *The History*, 91.

10 Ibid., 88.

11 Ibid., 65.

12 Ibid., 92.

13 Ibid., 88-9.

14 Ibid., 90.

15 Ibid., 88.

16 Ibid., 92.

17 James Grainger, *The Sugar Cane* 4: 381-6, in *The Works of the English Poets, from Chaucer to Cowper,* ed. Alexander Chalmers, London: J. Johnson, 1810, vol. 14, 507. The discursive construction of Obeah in British Romantic literature is discussed in Alan Richardson, 'Romantic voodoo: Obeah and British culture, 1797–1807' in *Sacred Possessions: Vodou, Santería, Obeah and the Caribbean*, ed. Margarite Fernández-Olmos and Lizabeth Paravisini-Gebert, New Brunswick: Rutgers University Press, 1997, 171–94. However, Richardson does not link Grainger's 'georgic of the tropics' written in response to his work as a doctor on the island and published in 1764 and the 'Obeah Trials' of 1760.

18 E.G. Robertson, *Mémoires récréatifs, scientifiques et anecdotiques du physicien-aéronaute E.G. Robertson, Connu par ses expériences de fantasmagorie*, Paris, 1840, vol. I.

19 William Hooper, *Rational Recreations*, London, 1774, vol. 3, 91.

20 Ibid., 95.

21 See, for instance, the 'description of the most entertaining experiments performed by electricity' in Joseph Priestley, *The History and Present State of Electricity, with Original Experiments*, London, 1767.

22 See, for example, the work of F.H. Winckler such as the French translation *Essai sur la nature, les effets et les causes de l'électricité, avec une description de deux nouvelles machines à électricité*, Paris, 1748.

23 Nalo Hopkinson, *Brown Girl in the Ring*, New York: Warner, 1998, 186.

24 Michael Taussig, *Mimesis and Alterity: A Particular History of the Senses*, New York: Routledge, 1993.

25 Theodor Adorno and Max Horkheimer, *Dialectic of Enlightenment*, trans. John Cumming, London: Verso, 1979, 185. The chapter is cited and discussed in Taussig, 63–6.

26 Adorno and Horkheimer, 183.

27 Ibid., 185.

28 Ibid., 197.

29 Ibid., 187.

30 Ibid., 184.

31 Ibid., 188–9.

32 Ibid., 194–5.

Adrian Piper

PASSING FOR WHITE, PASSING FOR BLACK

I T WAS THE NEW Graduate Student Reception for my class, the first social event of my first semester in the best graduate department in my field in the country. I was full of myself, as we all were, full of pride at having made the final cut, full of arrogance at our newly recorded membership among the privileged few, the intellectual elite, this country's real aristocracy, my parents told me; full of confidence in our intellectual ability to prevail, to fashion original and powerful views about some topic we represented to ourselves only vaguely. I was a bit late, and noticed that many turned to look at – no, scrutinize me as I entered the room. I congratulated myself on having selected for wear my black velvet, bell-bottomed pants suit (yes, it was that long ago) with the cream silk blouse and crimson vest. One of the secretaries who'd earlier helped me find an apartment came forward to greet me and proceeded to introduce me to various members of the faculty, eminent and honorable faculty, with names I knew from books I'd studied intensely and heard discussed with awe and reverence by my undergraduate teachers. To be in the presence of these men and attach faces to names was delirium enough. But actually to enter into casual social conversation with them took every bit of poise I had. As often happens in such situations, I went on automatic pilot. I don't remember what I said; I suppose I managed not to make a fool of myself. The most famous and highly respected member of the faculty observed me for a while from a distance and then came forward. Without introduction or preamble he said to me with a triumphant smirk, 'Miss Piper, you're about as black as I am.'

One of the benefits of automatic pilot in social situations is that insults take longer to make themselves felt. The meaning of the words simply don't register right away, particularly if the person who utters them is smiling. You reflexively respond to the social context and the smile rather than to the words. And so I automatically returned the smile and said something like, 'Really? I hadn't known that

about you' – something that sounded both innocent and impertinent, even though that was not what I felt. What I felt was numb, and then shocked and terrified, disoriented, as though I'd been awakened from a sweet dream of unconditional support and approval and plunged into a nightmare of jeering contempt. Later those feelings turned into wrenching grief and anger that one of my intellectual heroes had sullied himself in my presence and destroyed my illusion that these privileged surroundings were benevolent and safe; then guilt and remorse at having provided him the occasion for doing so.

Finally, there was the groundless shame of the inadvertent impostor, exposed to public ridicule or accusation. For this kind of shame, you don't actually need to have done anything wrong. All you need to do is care about others' image of you, and fail in your actions to reinforce their positive image of themselves. Their ridicule and accusations then function to both disown and degrade you from their status, to mark you not as having *done* wrong but as *being* wrong. This turns you into something bogus relative to their criterion of worth, and false relative to their criterion of authenticity. Once exposed as a fraud of this kind, you can never regain your legitimacy. For the violated criterion of legitimacy implicitly presumes an absolute incompatibility between the person you appeared to be and the person you are now revealed to be; and no fraud has the authority to convince her accusers that they merely imagine an incompatibility where there is none in fact. The devaluation of status consequent on such exposure is, then, absolute; and the suspicion of fraudulence spreads to all areas of interaction.

[. . .]

> She walked away. . . . The man followed her and tapped her shoulder.
> 'Listen, I'd really like to get to know you,' he said, smiling. He paused, as if expecting thanks from her. She didn't say anything. Flustered, he said, 'A friend of mine says you're black. I told him I had to get a close-up look and see for myself.'
> (Perry, *Another Present Era*, p. 19)

The irony was that I could have taken an easier entry route into this privileged world. In fact, on my graduate admissions application I could have claimed alumni legacy status and the distinguished family name of my paternal great-uncle, who had not only attended that university and sent his sons there, but had endowed one of its buildings and was commemorated with an auditorium in his name. I did not because he belonged to a branch of the family from which we had been estranged for decades, even before my grandfather – his brother – divorced my grandmother, moved to another part of the country, and started another family. My father wanted nothing more to do with my grandfather or any of his relatives. He rejected his inheritance and never discussed them while he was alive. For me to have invoked his uncle's name in order to gain a professional advantage would have been out of the question. But it would have nullified my eminent professor's need to tell me who and what he thought I was.

Recently I saw my great-uncle's portrait on an airmail stamp honoring him as a captain of industry. He looked so much like family photos of my grandfather

and father that I went out and bought two sheets' worth of these stamps. He had my father's and grandfather's aquiline nose, and their determined set of the chin. Looking at his face made me want to recover my father's estranged family, particularly my grandfather, for my own. I had a special lead: A few years previously, in the South, I'd included a phototext work containing a fictionalized narrative about my father's family – a history chock-full of romance and psychopathology – in an exhibition of my work. After seeing the show, a white woman with blue eyes, my father's transparent rosy skin and auburn-brown hair, and that dominant family nose walked up to me and told me that we were related. The next day she brought photographs of her family, and information about a relative who kept extensive genealogical records on every family member he could locate. I was very moved, and also astounded that a white person would voluntarily acknowledge blood relation to a black. She was so free and unconflicted about this. I just couldn't fathom it. We corresponded and exchanged family photos. And when I was ready to start delving in earnest, I contacted the relative she had mentioned for information about my grandfather, and initiated correspondence or communication with kin I hadn't known existed and who hadn't known that I existed or that they or any part of their family was black. I embarked on this with great trepidation, anticipating with anxiety their reaction to the racial identity of these long-lost relatives, picturing in advance the withdrawal of warmth and interest, the quickly assumed impersonality and the suggestion that there must be some mistake.

> The dread that I might lose her took possession of me each time I sought to speak, and rendered it impossible for me to do so. That moral courage requires more than physical courage is no mere poetic fancy. I am sure I should have found it easier to take the place of a gladiator, no matter how fierce the Numidian lion, than to tell that slender girl that I had Negro blood in my veins.
>
> (James Weldon Johnson, *The Autobiography of an Ex-Coloured Man*, (1912), p. 200)

These fears were not unfounded. My father's sister had, in her youth, been the first black woman at a Seven Sisters undergraduate college and the first at an Ivy League medical school; had married into a white family who became socially, politically and academically prominent; and then, after taking some family mementos my grandmother had given my father for me, had proceeded to sever all connections with her brothers and their families, even when the death of each of her siblings was imminent. She raised her children (now equally prominent socially and politically) as though they had no maternal relatives at all. We had all been so very proud of her achievements that her repudiation of us was devastating. Yet I frequently encounter mutual friends and colleagues in the circles in which we both travel, and I dread the day we might find ourselves in the same room at the same time. To read or hear about or see on television her or any member of her immediate family is a source of personal pain for all of us. I did not want to subject myself to that again with yet another set of relatives.

> Those who pass have a severe dilemma before they decide to do so, since a person must give up all family ties and loyalties to the black community in order to gain economic and other opportunities.
>
> (F. James Davis, *Who Is Black? One Nation's Definition* (1991), p. 143)

Trying to forgive and understand those of my relatives who have chosen to pass for white has been one of the most difficult ethical challenges of my life, and I don't consider myself to have made very much progress. At the most superficial level, this decision can be understood in terms of a cost-benefit analysis: Obviously, they believe they will be happier in the white community than in the black one, all things considered. For me to make sense of this requires that I understand – or at least accept – their conception of happiness as involving higher social status, entrenchment within the white community and corresponding isolation from the black one, and greater access to the rights, liberties and privileges the white community takes for granted. What is harder for me to grasp is how they could want these things enough to sacrifice the history, wisdom, connectedness and moral solidarity with their family and community they must sacrifice in order to get them. It seems to require so much severing and forgetting, so much disowning and distancing, not simply from one's shared past, but from one's former self – as though one had cauterized one's long-term memory at the moment of entry into the white community.

But there is, I think, more to it than that. Once you realize what is denied you as an African-American simply because of your race, your sense of the unfairness of it may be so overwhelming that you may simply be incapable of accepting it. And if you are not inclined toward any form of overt political advocacy, passing in order to get the benefits you know you deserve may seem the only way to defy the system. Indeed, many of my more prominent relatives who are passing have chosen altruistic professions that benefit society on many fronts. They have chosen to use their assumed social status to make returns to the black community indirectly, in effect compensating for the personal advantages they have gained by rejecting their family.

Moreover, your sense of injustice may be compounded by the daily humiliation you experience as the result of identifying with those African-Americans who, for demanding their rights, are punished and degraded as a warning to others. In these cases, the decision to pass may be more than the rejection of a black identity. It may be the rejection of a black identification that brings too much pain to be tolerated.

> All the while I understood that it was not discouragement or fear or search for a larger field of action and opportunity that was driving me out of the Negro race. I knew that it was shame, unbearable shame. Shame at being identified with a people that could with impunity be treated worse than animals.
>
> (Johnson, *The Autobiography of an Ex-Coloured Man*, (1912), p. 191)

The oppressive treatment of African-Americans facilitates this distancing response, by requiring every African-American to draw a sharp distinction between the person he is and the person society perceives him to be; that is, between who he is as an individual, and the way he is designated and treated by others.

> The Negro's only salvation from complete despair lies in his belief, the old belief of his forefathers, that these things are not directed against him personally, but against his race, his pigmentation. His mother or aunt or teacher long ago carefully prepared him, explaining that he as an individual can live in dignity, even though he as a Negro cannot.
> (John Howard Griffin, *Black Like Me* (1960), p. 48)

This condition encourages a level of impersonality, a sense that white reactions to one have little or nothing to do with one as a person and an individual. Whites often mistake this impersonality for aloofness or unfriendliness. It is just one of the factors that make genuine intimacy between blacks and whites so difficult. Because I have occasionally encountered equally stereotypical treatment from other blacks and have felt compelled to draw the same distinction there between who I am and how I am perceived, my sense of impersonality pervades most social situations in which I find myself. Because I do not enjoy impersonal interactions with others, my solution is to limit my social interactions as far as possible to those in which this restraint is not required. So perhaps it is not entirely surprising that many white-looking individuals of African ancestry are able to jettison this doubly alienated and alienating social identity entirely, as irrelevant to the fully mature and complex individuals they know themselves to be. I take the fervent affirmation and embrace of black identity to be a countermeasure to and thus evidence of this alienation, rather than incompatible with it. My family contains many instances of both attitudes.

There are no proper names mentioned in this account of my family. This is because in the African-American community, we do not 'out' people who are passing as white in the European-American community. Publicly to expose the African ancestry of someone who claims to have none is not done. There are many reasons for this, and different individuals cite different ones. For one thing, there is the vicarious enjoyment of watching one of our own infiltrate and achieve in a context largely defined by institutionalized attempts to exclude blacks from it. Then there is the question of self-respect: If someone wants to exit the African-American community, there are few blacks who would consider it worth their while to prevent her. And then there is the possibility of retaliation: not merely the loss of credibility consequent on the denials by a putatively white person who, by virtue of his racial status, automatically has greater credibility than the black person who calls it into question; but perhaps more deliberate attempts to discredit or undermine the messenger of misfortune. There is also the instinctive impulse to protect the well-being of a fellow traveler embarked on a particularly dangerous and risky course. And finally – the most salient consideration for me in thinking about those many members of my own family who have chosen to pass for white – a person who seeks personal and social advantage and acceptance within the white community so much that she is willing to repudiate her family, her past, her history, and her personal

connections within the African-American community in order to get them is someone who is already in so much pain that it's just not possible to do something that you know is going to cause her any more.

> Many colored Creoles protect others who are trying to pass, to the point of feigning ignorance of certain branches of their families. Elicited genealogies often seem strangely skewed. In the case of one very good informant, a year passed before he confided in me that his own mother's sister and her children had passed into the white community. With tears in his eyes, he described the painful experience of learning about his aunt's death on the obituary page of the *New Orleans Times-Picayune*. His cousins failed to inform the abandoned side of the family of the death, for fear that they might show up at the wake or the funeral and thereby destroy the image of whiteness. Total separation was necessary for secrecy.
>
> (Virginia R. Domínguez, *White by Definition:*
> *Social Classification in Creole Louisiana* (1986), p. 161)

> She said: 'It's funny about "passing." We disapprove of it and at the same time condone it. It excites our contempt and yet we rather admire it. We shy away from it with an odd kind of revulsion, but we protect it.'
> 'Instinct of the race to survive and expand.'
> 'Rot! Everything can't be explained by some general biological phrase.'
> 'Absolutely everything can. Look at the so-called whites, who've left bastards all over the known earth. Same thing in them. Instinct of the race to survive and expand.'
>
> (Nella Larsen, *Passing* (1929), pp. 185–86)

Those of my grandfather's estranged relatives who welcomed me into dialogue instead of freezing me out brought tears of gratitude and astonishment to my eyes. They seemed so kind and interested, so willing to help. At first I couldn't accept for what it was their easy acceptance and willingness to help me puzzle out where exactly we each were located in our sprawling family tree. It is an ongoing endeavor, full of guesswork, false leads, blank spots and mysteries. For just as white Americans are largely ignorant of their African – usually maternal – ancestry, we blacks are often ignorant of our European – usually paternal – ancestry. That's the way our slavemaster forebears wanted it, and that's the way it is. Our names are systematically missing from the genealogies and public records of most white families, and crucial information – for example, the family name or name of the child's father – is often missing from our black ancestors' birth certificates, when they exist at all.

> A realistic appreciation of the conditions which exist when women are the property of men makes the conclusion inevitable that there were many children born of mixed parentage.
>
> (Joe Gray Taylor, *Negro Slavery in Louisiana* (1963), p. 20)

Ownership of the female slave on the plantations generally came to include owning her sex life. Large numbers of white boys were socialized to associate physical and emotional pleasure with the black women who nursed and raised them, and then to deny any deep feelings for them. From other white males they learned to see black girls and women as legitimate objects of sexual desire. Rapes occurred, and many slave women were forced to submit regularly to white males or suffer harsh consequences. . . . as early as the time of the American Revolution there were plantation slaves who appeared to be completely white, as many of the founding fathers enslaved their own mixed children and grandchildren.

(Davis, *Who Is Black?*, (1991) pp. 38, 48–49)

So tracing the history of my family is detective work as well as historical research. To date, what I *think* I know is that our first European-American ancestor landed in Ipswich, Massachusetts, in 1620 from Sussex; another in Jamestown, Virginia, in 1675 from London; and another in Philadelphia, Pennsylvania, in 1751, from Hamburg. Yet another was the first in our family to graduate from my own graduate institution in 1778. My great-great-grandmother from Madagascar, by way of Louisiana, is the known African ancestor on my father's side, as my great-great-grandfather from the Ibo of Nigeria is the known African ancestor on my mother's, whose family has resided in Jamaica for three centuries.

I relate these facts and it doesn't seem to bother my newly discovered relatives. At first I had to wonder whether this ease of acceptance was not predicated on their mentally bracketing the implications of these facts and restricting their own immediate family ancestry to the European side. But when they remarked unselfconsciously on the family resemblances between us I had to abandon that supposition. I still marvel at their enlightened and uncomplicated friendliness, and there is a part of me that still can't trust their acceptance of me. But that is a part of me I want neither to trust nor to accept in this context. I want to reserve my vigilance for its context of origin: the other white Americans I have encountered – even the bravest and most conscientious white scholars – for whom the suggestion that they might have significant African ancestry as the result of this country's long history of miscegenation is almost impossible to consider seriously.

She's heard the arguments, most astonishingly that, statistically . . . the average white American is 6 percent black. Or, put another way, 95 percent of white Americans are 5 to 80 percent black. Her Aunt Tyler has told her stories about these whites researching their roots in the National Archives and finding they've got an African-American or two in the family, some becoming so hysterical they have to be carried out by paramedics.

(Perry, *Another Present Era*, p. 66)

Estimates ranging up to 5 percent, and suggestions that up to one-fifth of the white population have some genes from black ancestors, are probably far too high. If these last figures were correct, the majority of

Americans with some black ancestry would be known and counted as whites!

<div align="right">(Davis, Who Is Black?, (1991), pp. 21–22)</div>

The detailed biological and genetic data can be gleaned from a careful review of *Genetic Abstracts* from about 1950 on. In response to my request for information about this, a white biological anthropologist once performed detailed calculations on the African admixture of five different genes in British whites, American whites, and American blacks. American whites had from 2 per cent of one gene to 81.6 per cent of another. About these results he commented, 'I continue to believe 5 per cent to be a reasonable estimate, but the matter is obviously complex. As you can see, it depends entirely on which genes you decide to use as racial "markers" that are supposedly subject to little or no relevant selective pressure.' Clearly, white resistance to the idea that most American whites have a significant percentage of African ancestry increases with the percentage suggested.

> 'Why, Doctor,' said Dr. Latimer, 'you Southerners began this absorption before the war. I understand that in one decade the mixed bloods rose from one-ninth to one-eighth of the population, and that as early as 1663 a law was passed in Maryland to prevent English women from intermarrying with slaves; and, even now, your laws against miscegenation presuppose that you apprehend danger from that source.'
>
> <div align="right">(Harper, Iola Leroy, p. 228)</div>

> (That legislators and judges paid increasing attention to the regulation and punishment of miscegenation at this time does not mean that interracial sex and marriage as social practices actually increased in frequency; the centrality of these practices to legal discourse was instead a sign that their relation to power was changing. The extent of uncoerced miscegenation before this period is a debated issue.)
>
> <div align="right">(Eva Saks, 'Representing Miscegenation Law,'
Raritan (1991), pp. 43–44)</div>

The fact is, however, that the longer a person's family has lived in this country, the higher the probable percentage of African ancestry that person's family is likely to have – bad news for the D.A.R., I'm afraid. And the proximity to the continent of Africa of the country of origin from which one's forebears emigrated, as well as the colonization of a part of Africa by that country, are two further variables that increase the probability of African ancestry within that family. It would appear that only the Lapps of Norway are safe.

In Jamaica, my mother tells me, that everyone is of mixed ancestry is taken for granted. There are a few who vociferously proclaim themselves to be 'Jamaican whites' having no African ancestry at all, but no one among the old and respected families takes them seriously. Indeed, they are assumed to be a bit unbalanced, and are regarded with amusement. In this country, by contrast, the fact of African ancestry among whites ranks up there with family incest, murder, and suicide as one of the bitterest and most difficult pills for white Americans to swallow.

'I had a friend who had two beautiful daughters whom he had educated in the North. They were cultured, and really belles in society. They were entirely ignorant of their lineage, but when their father died it was discovered that their mother had been a slave. It was a fearful blow. They would have faced poverty, but the knowledge of their tainted blood was more than they could bear.'

(Harper, *Iola Leroy*, p. 100)

There was much apprehension about the unknown amount of black ancestry in the white population of the South, and this was fanned into an unreasoning fear of invisible blackness. For instance, white laundries and cleaners would not accommodate blacks because whites were afraid they would be 'contaminated' by the clothing of invisible blacks.

(Davis, *Who Is Black?*, (1991) p. 145)

Suspicion is part of everyday life in Louisiana. Whites often grow up afraid to know their own genealogies. Many admit that as children they often stared at the skin below their fingernails and through a mirror at the white of their eyes to see if there was any 'touch of the tarbrush'. Not finding written records of birth, baptism, marriage, or death for any one ancestor exacerbates suspicions of foul play. Such a discovery brings glee to a political enemy or economic rival and may traumatize the individual concerned.

(Domínguez, *White by Definition*, (1986), p. 159)

A number of years ago I was doing research on a video installation on the subject of racial identity and miscegenation, and came across the Phipps case of Louisiana in the early 1980s. Susie Guillory Phipps had identified herself as white and, according to her own testimony (but not that of some of her black relatives), had believed that she was white, until she applied for a passport, when she discovered that she was identified on her birth records as black in virtue of having $\frac{1}{32}$ African ancestry. She brought suit against the state of Louisiana to have her racial classification changed. She lost the suit, but effected the overthrow of the law identifying individuals as black if they had $\frac{1}{32}$ African ancestry, leaving on the books a prior law identifying an individual as black who had any African ancestry – the 'one-drop' rule that uniquely characterizes the classification of blacks in the United States in fact, even where no longer in law. So according to this longstanding convention of racial classification, a white who acknowledges any African ancestry implicitly acknowledges being black – a social condition, more than an identity, that no white person would voluntarily assume, even in imagination. This is one reason why whites, educated and uneducated alike, are so resistant to considering the probable extent of racial miscegenation.

This 'one-drop' convention of classification of blacks is unique not only relative to the treatment of blacks in other countries but also unique relative to the treatment of other ethnic groups in this country. It goes without saying that no one, either white or black, is identified as, for example, English by virtue of having some small fraction of English ancestry. Nor is anyone free, as a matter of social convention, to do so in virtue of that fraction, although many whites do. But even in the

case of other disadvantaged groups in this country, the convention is different. Whereas any proportion of African ancestry is sufficient to identify a person as black, an individual must have *at least* one-eighth Native American ancestry in order to identify legally as Native American.

Why the asymmetry of treatment? Clearly, the reason is economic. A legally certifiable Native American is entitled to financial benefits from the government, so obtaining this certification is difficult. A legally certifiable black person is *disentitled* to financial, social and inheritance benefits from his white family of origin, so obtaining this certification is not just easy, but automatic. Racial classification in this country functions to restrict the distribution of goods, entitlements and status as narrowly as possible, to those whose power is already entrenched. Of course this institutionalized disentitlement presupposes that two persons of different racial classifications cannot be biologically related, which is absurd.

> [T]his [one-drop] definition of who is black was crucial to maintaining the social system of white domination in which widespread miscegenation, not racial purity, prevailed. White womanhood was the highly charged emotional symbol, but the system protected white economic, political, legal, education and other institutional advantages for whites. . . . American slave owners wanted to keep all racially mixed children born to slave women under their control, for economic and sexual gains. . . . It was intolerable for white women to have mixed children, so the one-drop rule favored the sexual freedom of white males, protecting the double standard of sexual morality as well as slavery. . . . By defining all mixed children as black and compelling them to live in the black community, the rule made possible the incredible myth among whites that miscegenation had not occurred, that the races had been kept pure in the South.
>
> (Davis, *Who Is Black?*, pp. 62–63, 113–14, 174)

But the issues of family entitlements and inheritance rights are not uppermost in the minds of most white Americans who wince at the mere suggestion that they might have some fraction of African ancestry and therefore be, according to this country's entrenched convention of racial classification, black. The primary issue for them is not what they might have to give away by admitting that they are in fact black, but rather what they have to lose. What they have to lose, of course, is social status; and, in so far as their self-esteem is based on their social status as whites, self-esteem as well.

> 'I think,' said Dr. Latrobe, proudly, 'that we belong to the highest race on earth and the negro to the lowest.'
>
> 'And yet,' said Dr. Latimer, 'you have consorted with them till you have bleached their faces to the whiteness of your own. Your children nestle in their bosoms; they are around you as body servants, and yet if one of them should attempt to associate with you your bitterest scorn and indignation would be visited upon them.'
>
> (Harper, *Iola Leroy*, p. 227)

[. . .]

Coco Fusco

THE OTHER HISTORY OF
INTERCULTURAL PERFORMANCE

I N T H E E A R L Y 1 9 0 0 S , Franz Kafka wrote a story that began, 'Honored mem-
bers of the Academy! You have done me the honor of inviting me to give your
Academy an account of the life I formerly led as an ape.' Entitled 'A Report to an
Academy,' it was presented as the testimony of a man from the Gold Coast of Africa
who had lived for several years on display in Germany as a primate. That account
was fictitious and created by a European writer who stressed the irony of having to
demonstrate one's humanity; yet it is one of many literary allusions to the real
history of ethnographic exhibition of human beings that has taken place in the West
over the past five centuries. While the experiences of many of those who were
exhibited is the stuff of legend, it is the accounts by observers and impresarios that
constitute the historical and literary record of this practice in the West. My collab-
orator, Guillermo Gómez-Peña, and I were intrigued by this legacy of performing
the identity of an Other for a white audience, sensing its implications for us as
performance artists dealing with cultural identity in the present. Had things changed,
we wondered? How would we know, if not by unleashing those ghosts from a
history that could be said to be ours? Imagine that I stand before you then, as did
Kafka's character, to speak about an experience that falls somewhere between truth
and fiction. What follows are my reflections on performing the role of a noble savage
behind the bars of a golden cage.

 Our original intent was to create a satirical commentary on Western concepts
of the exotic, primitive Other; yet we had to confront two unexpected realities in
the course of developing this piece: (a) a substantial portion of the public believed
that our fictional identities were real ones; and (b) a substantial number of intel-
lectuals, artists, and cultural bureaucrats sought to deflect attention from the
substance of our experiment to the 'moral implications' of our dissimulation, or in
their words, our 'misinforming the public' about who we were. The literalism
implicit in the interpretation of our work by individuals representing the 'public

interest' bespoke their investment in positivist notions of 'truth' and depoliticized, ahistorical notions of 'civilization.' This 'reverse ethnography' of our interactions with the public will, I hope, suggest the culturally specific nature of their tendency toward a literal and moral interpretation.

When we began to work on this performance as part of a counter-quincentenary project, the Bush administration had drawn clear parallels between the 'discovery' of the New World and his 'New World Order.' We noted the resemblance between official quincentenary celebrations in 1992 and the ways that the 1892 Columbian commemorations had served as a justification for the United States' then new status as an imperial power. Yet, while we anticipated that the official quincentenary celebration was going to form an imposing backdrop, what soon became apparent was that for both Spain and the United States, the celebration was a disastrous economic venture, and even an embarrassment. The Seville Expo went bankrupt; the US Quincentenary Commission was investigated for corruption; the replica caravels were met with so many protestors that the tour was canceled; the Pope changed his plans and didn't hold mass in the Dominican Republic until after October 12; American Indian Movement activist Russell Means succeeded in getting Italian Americans in Denver to cancel their Columbus Day parade; and the film super-productions celebrating Columbus – from *1492: The Discovery* to *The Conquest of Paradise* – were box office failures. Columbus, the figure who began as a symbol of Eurocentrism and the American entrepreneurial spirit, ended up being devalued by excessive reproduction and bad acting.

As the official celebrations faded, it became increasingly apparent that Columbus was a smokescreen, a malleable icon to be trotted out by the mainstream for its attacks on 'political correctness.' Finding historical justification for Columbus's 'discovery' became just another way of affirming Europeans' and Euro-Americans' 'natural right' to be global cultural consumers. The more equitable models of exchange proposed by many multiculturalists logically demanded a more profound understanding of American cultural hybridity, and called for redefinitions of national identity and national origins. But the concept of cultural diversity fundamental to this understanding strikes at the heart of the sense of control over Otherness that Columbus symbolized, and was quickly cast as un-American. Resurrecting the collective memory of colonial violence in America that has been strategically erased from the dominant culture was described consistently throughout 1992 by cultural conservatives as a recipe for chaos. More recently, as is characterized by the film *Falling Down*, it is seen as a direct threat to heterosexual, white male self-esteem. It is no wonder that contemporary conservatives invariably find the focus on racism by artists of color 'shocking' and inappropriate, if not threatening to national interests, as well as to art itself.

Out of this context arose our decision to take a symbolic vow of silence with the cage performance, a radical departure from Guillermo's previous monologue work and my activities as a writer and public speaker. We sought a strategically effective way to examine the limits of the 'happy multiculturalism' that reigned in cultural institutions, as well as to respond to the formalists and cultural relativists who reject the proposition that racial difference is absolutely fundamental to aesthetic interpretation. We looked to Latin America, where consciousness of the repressive limits on public expression is far more acute than it is here, and found

many examples of how popular opposition has for centuries been expressed through the use of satiric spectacle. Our cage became the metaphor for our condition, linking the racism implicit in ethnographic paradigms of discovery with the exoticizing rhetoric of 'world beat' multiculturalism. Then came a perfect opportunity: In 1991, Guillermo and I were invited to perform as part of the Edge '92 Biennial, which was to take place in London and also in Madrid as the capital of European culture. We took advantage of Edge's interest in locating art in public spaces to create a site-specific performance for Columbus Plaza in Madrid, in commemoration of the so-called Discovery.

Our plan was to live in a golden cage for three days, presenting ourselves as undiscovered Amerindians from an island in the Gulf of Mexico that had somehow been overlooked by Europeans for five centuries. We called our homeland Guatinau, and ourselves Guatinauis. We performed our 'traditional tasks,' which ranged from sewing voodoo dolls and lifting weights to watching television and working on a lap-top computer. A donation box in front of the cage indicated that, for a small fee, I would dance (to rap music), Guillermo would tell authentic Amerindian stories (in a nonsensical language), and we would pose for Polaroids with visitors. Two 'zoo guards' would be on hand to speak to visitors (since we could not understand them), take us to the bathroom on leashes, and feed us sandwiches and fruit. At the Whitney Museum in New York we added sex to our spectacle, offering a peek at authentic Guatinaui male genitals for $5. A chronology with highlights from the history of exhibiting non-Western peoples was on one didactic panel and a simulated Encyclopedia Britannica entry with a fake map of the Gulf of Mexico showing our island was on another. After our three days in May 1992, we took our performance to Covent Garden in London. In September, we presented it in Minneapolis, and in October, at the Smithsonian's National Museum of Natural History. In December, we were on display in the Australian Museum of Natural History in Sydney, and in January 1993, at the Field Museum of Chicago. In early March, we were at the Whitney for the opening of the Biennial, the only site where we were recognizably contextualized as artwork. Prior to our trip to Madrid, we did a test run under relatively controlled conditions in the Art Gallery of the University of California, Irvine.

Our project concentrated on the 'zero degree' of intercultural relations in an attempt to define a point of origin for the debates that link 'discovery' and 'Otherness.' We worked within disciplines that blur distinctions between the art object and the body (performance), between fantasy and reality (live spectacle), and between history and dramatic re-enactment (the diorama). The performance was interactive, focusing less on what we did than on how people interacted with us and interpreted our actions. Entitled *Two Undiscovered Amerindians Visit . . .* , we chose not to announce the event through prior publicity or any other means, when it was possible to exert such control; we intended to create a surprise or 'uncanny' encounter, one in which audiences had to undergo their own process of reflection as to what they were seeing, aided only by written information and parodically didactic zoo guards. In such encounters with the unexpected, people's defense mechanisms are less likely to operate with their normal efficiency; caught off guard, their beliefs are more likely to rise to the surface.

Figures 49.1 and 49.2 Two Undiscovered Amerindians Visit Buenos Aires, 1994 (Photos courtesy: Coco Fusco)

Our performance was based on the once popular European and North American practice of exhibiting indigenous people from Africa, Asia, and the Americas in zoos, parks, taverns, museums, freak shows, and circuses. While this tradition reached the height of its popularity in the nineteenth century, it was actually begun by Christopher Columbus, who returned from his first voyage in 1493 with several Arawaks, one of whom was left on display at the Spanish Court for two years. Designed to provide opportunities for aesthetic contemplation, scientific analysis, and entertainment for Europeans and North Americans, these exhibits were a critical component of a burgeoning mass culture whose development coincided with the growth of urban centers and populations, European colonialism, and American expansionism.

In writing about these human exhibitions in America's international fairs from the late nineteenth and early twentieth centuries, Robert W. Rydell (author of *All the World's a Fair*; *Visions of Empire at American International Exhibitions, 1876–1916*) explains how the 'ethnological' displays of nonwhites – which were orchestrated by impresarios but endorsed by anthropologists – confirmed popular racial stereotypes and built support for domestic and foreign policies. In some cases, they literally connected museum practices with affairs of state. Many of the people exhibited during the nineteenth century were presented as the chiefs of conquered tribes and/or the last survivors of 'vanishing' races. Ishi, the Yahi Indian who spent five years living in the Museum of the University of California at the turn of the century, is a well-known example. Another lesser-known example comes from the US–Mexico War of 1836, when Anglo-Texan secessionists used to exhibit their Mexican prisoners in public plazas in cages, leaving them there to starve to death. The exhibits also gave credence to white supremacist worldviews by representing nonwhite peoples and cultures as being in need of discipline, civilization, and industry. Not only did these exhibits reinforce stereotypes of 'the primitive' but they served to enforce a sense of racial unity as whites among Europeans and North Americans, who were divided strictly by class and religion until this century. Hence, for example, at the Columbian Exhibition of 1893 in Chicago, ethnographic displays of peoples from Africa and Asia were set up outside 'The White City,' an enclosed area celebrating science and industry.

[. . .]

Our cage performances forced these contradictions out into the open. The cage became a blank screen onto which audiences projected their fantasies of who and what we are. As we assumed the stereotypical role of the domesticated savage, many audience members felt entitled to assume the role of the colonizer, only to find themselves uncomfortable with the implications of the game. Unpleasant but important associations have emerged between the displays of old and the multicultural festivals and ethnographic dioramas of the present. The central position of the white spectator, the objective of these events as a confirmation of their position as global consumers of exotic cultures, and the stress on authenticity as an aesthetic value, all remain fundamental to the spectacle of Otherness many continue to enjoy.

The original ethnographic exhibitions often presented people in a simulation of their 'natural' habitat, rendered either as an indoor diorama, or as an outdoor recreation. Eyewitness accounts frequently note that the human beings on display

were forced to dress in the European notion of their traditional 'primitive' garb, and to perform repetitive, seemingly ritual tasks. At times, nonwhites were displayed together with flora and fauna from their regions, and artifacts, which were often fakes. They were also displayed as part of a continuum of 'outsiders' that included 'freaks,' or people exhibiting physical deformities. In the nineteenth and early twentieth centuries, many of them were presented so as to confirm social Darwinist ideas of the existence of a racial hierarchy. Some of the more infamous cases involved individuals whose physical traits were singled out as evidence of the bestiality of nonwhite people. For example, shortly after the annexation of Mexico and the publication of John Stephens' account of travel in the Yucatan, which generated popular interest in pre-Columbian cultures, two microcephalics (or 'pinheads') from Central America, Maximo and Bartola, toured the United States in P.T. Barnum's circus; they were presented as Aztecs. This set off a trend that would be followed by many other cases into the twentieth century. From 1810–15, European audiences crowded to see the Hottentot Venus, a South African woman whose large buttocks were deemed evidence of her excessive sexuality. In the United States, several of the 'Africans' exhibited were actually black Americans, who made a living in the nineteenth century by dressing up as their ancestors, just as many Native Americans did dressing up as Sioux whose likenesses, thanks to the long and bloody Plains Wars of the late nineteenth century, dominate the American popular imagination.

For Gómez-Peña and myself, the human exhibitions dramatize the colonial unconscious of American society. In order to justify genocide, enslavement, and the seizure of lands, a 'naturalized' splitting of humanity along racial lines had to be established. When rampant miscegenation proved that those differences were not biologically based, social and legal systems were set up to enforce those hierarchies. Meanwhile, ethnographic spectacles circulated and reinforced stereotypes, stressing that 'difference' was apparent in the bodies on display. Thus they naturalized fetishized representations of Otherness, mitigating anxieties generated by the encounter with difference.

In his essay, 'The Other Question', Homi Bhabha explains how racial classification through stereotyping is a necessary component of colonialist discourse, as it justifies domination and masks the colonizer's fear of the inability to always already know the Other. Our experiences in the cage suggested that even though the idea that America is a colonial system is met with resistance – since it contradicts the dominant ideology's presentation of our system as a democracy – the audience reactions indicated that colonialist roles have been internalized quite effectively.

The stereotypes about nonwhite people that were continuously reinforced by the ethnographic displays are still alive in high culture and the mass media. Imbedded in the unconscious, these images form the basis of the fears, desires, and fantasies about the cultural Other. In 'The Negro and Psychopathology,' Frantz Fanon discusses a critical stage in the development of children socialized in Western culture, regardless of their race, in which racist stereotypes of the savage and the primitive are assimilated through the consumption of popular culture: comics, movies, cartoons, and so forth. These stereotypical images are often part of myths of colonial dominion (for example, cowboy defeats Indian, conquistador triumphs over Aztec Empire, colonial soldier conquers African chief, and so on). This dynamic also contains a sexual dimension, usually expressed as anxiety about white male

(omni)potence. In *Prospero and Caliban: The Psychology of Colonization*, Octave Mannoni coined the term 'Prospero complex' to describe the white colonial patriarch's continuous fear that his daughter might be raped by a nonwhite male. Several colonial stereotypes also nurture these anxieties, usually representing a white woman whose 'purity' is endangered by black men with oversized genitals, or suave Latin lovers, or wild-eyed Indian warriors; and the common practice of publicly lynching black men in the American South is an example of a ritualized white male response to such fears. Accompanying these stereotypes are counterparts that humiliate and debase women of color, mitigating anxieties about sexual rivalry between white and nonwhite women. In the past, there was the subservient maid and the overweight and sexless Mammy; nowadays, the hapless victim of a brutish or irrational dark male whose tradition is devoid of 'feminist freedoms' is more common.

These stereotypes have been analyzed endlessly in recent decades, but our experiences in the cage suggest that the psychic investment in them does not simply wither away through rationalization. The constant concern about our 'realness' revealed a need for reassurance that a 'true primitive' *did* exist, whether we fit the bill or not, and that she or he be visually identifiable. Anthropologist Roger Bartra sees this desire as being part of a characteristically European dependence on an 'uncivilized other' in order to define the Western self. In his book *El Salvaje en el Espejo/The Savage in the Mirror*, he traces the evolution of the 'savage' from mythological inhabitants of forests to 'wild' and usually hairy men and women who even in the modern age appeared in freak shows and horror films. These archetypes eventually were incorporated into Christian iconography and were then projected onto peoples of the New World, who were perceived as either heathen savages capable of reform or incorrigible devils who had to be eradicated.

While the structure of the so-called primitive may have been assimilated by the European avant-garde, the function of the ethnographic displays as popular entertainment was largely superceded by industrialized mass culture. Not unsurprisingly, the popularity of these human exhibitions began to decline with the emergence of another commercialized form of voyeurism – the cinema – and the assumption by ethnographic film of their didactic role. Founding fathers of the ethnographic filmmaking practice, such as Robert Flaherty and John Grierson, continued to compel people to stage their supposedly 'traditional' rituals, but the tasks were now to be performed for the camera. One of the most famous of the white impresarios of the human exhibits in the United States, William F. 'Buffalo Bill' Cody, actually starred in an early film depicting his Wild West show of Native American horsemen and warriors, and in doing so gave birth to the 'cowboy and Indian' movie genre, this country's most popular rendition of its own colonial fantasy. The representation of the 'reality' of the Other's life, on which ethnographic documentary was based and still is grounded, is this fictional narrative of Western culture 'discovering' the negation of itself in something *authentically* and *radically* distinct. Carried over from documentary, these paradigms also became the basis of Hollywood filmmaking in the 1950s and 1960s that dealt with other parts of the world in which the United States had strategic military and economic interests, especially Latin America and the South Pacific.

The practice of exhibiting humans may have waned in the twentieth century, but it has not entirely disappeared. The dissected genitals of the Hottentot Venus

are still preserved at the Museum of Man in Paris. Thousands of Native American remains, including decapitated heads, scalps, and other body parts taken as war booty or bounties, remain in storage at the Smithsonian. Shortly before arriving in Spain, we learned of a current scandal in a small village outside Barcelona, where a visiting delegation had registered a formal complaint about a desiccated, stuffed Pygmy man that was on display in a local museum. The African gentleman in the delegation who had initiated the complaint was threatening to organize an African boycott of the 1992 Olympics, but the Catalonian townspeople defended what they saw as the right to keep 'their own black man.' We also learned that Julia Pastrana, a bearded Mexican woman who was exhibited throughout Europe until her death in 1862, is still available in embalmed form for scientific research and loans to interested museums. This past summer, the case of Ota Benga, a Pygmy who was exhibited in the primate cage of the Bronx Zoo in 1906, gained high visibility as plans for a Hollywood movie based on a recently released book were made public. And at the Minnesota State Fair last summer, we saw 'Tiny Teesha, the Island Princess,' who was in actuality a black woman midget from Haiti making her living going from one state fair to another.

While the human exhibition exists in more benign forms today – that is, the people in them are not displayed against their will – the desire to look upon predictable forms of Otherness from a safe distance persists. I suspect after my experience in the cage that this desire is powerful enough to allow audiences to dismiss the possibility of self-conscious irony in the Other's self-presentation; even those who saw our performance as art rather than artifact appeared to take great pleasure in engaging in the fiction, by paying money to see us enact completely nonsensical or humiliating tasks. A middle-aged man who attended the Whitney Biennial opening with his elegantly dressed wife insisting on feeding me a banana. The zoo guard told him he would have to pay $10 to do so, which he quickly paid, insisting that he be photographed in the act. After the initial surprise of encountering caged beings, audiences invariably revealed their familiarity with the scenario to which we alluded.

We did not anticipate that our self-conscious commentary on this practice could be believable. We underestimated public faith in museums as bastions of truth, and institutional investment in that role. Furthermore, we did not anticipate that literalism would dominate the interpretation of our work. Consistently from city to city, more than half of our visitors believed our fiction and thought we were 'real'; at the Whitney, however, we experienced the art world equivalent of such misperceptions: some visitors assumed that we were not the artists, but rather actors who had been hired by another artist. As we moved our performance from public site to natural history museum, pressure mounted from institutional representatives obliging us didactically to correct audience misinterpretations. We found this particularly ironic, since museum staffs are perhaps the most aware of the rampant distortion of reality that can occur in the labeling of artifacts from other cultures. In other words, we were not the only ones who were lying; our lies simply told a different story. For making this manifest, we were perceived as either noble savages or evil tricksters, dissimulators who discredit museums and betray public trust. When a few uneasy staff members in Australia and Chicago realized that large groups of Japanese tourists appeared to believe the fiction, they became deeply disturbed,

fearing that the tourists would go home with a negative impression of the museum. In Chicago, just next to a review of the cage performance, the daily *Sun-Times* ran a phone-in questionnaire asking readers if they thought the Field Museum *should* have exhibited us, to which 47 per cent answered no, and 53 per cent yes. We seriously wonder if such weighty moral responsibilities are leveled against white artists who present fictions in nonart contexts.

Olu Oguibe

PHOTOGRAPHY AND THE
SUBSTANCE OF THE IMAGE

COMPARED TO ALL THE OTHER image-making techniques and preoccupations, what we loosely refer to as the visual arts, photography has come a long way in a very short time. Today the contraption that George Eastman built in Rochester, New York in 1888 to take advantage of the flexible celluloid roll-film, has so advanced and proliferated that we are offered models so inexpensive we can discard them after only one use, in the same manner as sanitary paper, thus completely belying the fact that just over 150 years ago it required a bill in the French parliament, sponsored and promoted by some of the most powerful minds of the age, to obtain a commission to acquire Daguerre's photographic equipment.[1] And the ever-burgeoning business enjoyed by photo-processing laboratories and drug-store counters around the world today show that our attachment to the photograph has not waned since that witty 1840 lithograph by Maurisset, *La Daguérreotypomanie*, in which Maurisset not only captures the craze for the photograph that caught Parisian society in 1839, but also predicts many of the developments that have since taken place in photographic history.[2] Photography has allowed us to share images of locations and sites as remote as the farthest corners of our galaxy and as intimate as the innards of our own bodies, and placed at our disposal records and likenesses of events and personalities both close and distant; the exhilarating moment of the first child's delivery as well as the sting of the hour of departure; the family group miniature for the office desk that signs our respectability, as well as images of the powerful that underline our own connections, or allegiance, to power.

Photography arrived in Africa on November 16, 1839, the same year that Daguerre announced his invention in France and less than two months after the English gentleman D.W. Seager made the first daguerreotype in America. And, but for the sabotage of the painter and amateur photographer Horace Vernet, the man who made those first images in Egypt in 1839, the earliest photographic images by an African could equally have appeared in the same year, produced by Vernet's

patron and benefactor, the Khedive and vice-regent of Egypt, Mehmet.[3] Mehmet, who naturally marveled at the image-making possibilities of the photographic process, lost little time in his desire to understand and take control of this process, to wrest from Vernet the power of the new technique, and to apply it to the reproduction and preservation of the images of his numerous spouses. To this we shall return presently. Soon after Vernet's pictures of Egypt appeared in Europe, photography and the camera became a permanent part of European campaigns of exploration in Africa, sometimes with relative success but often woefully unsuccessful and remarkably vain. Nicolas Monti has indeed suggested, and with much merit, that the culture of tourism has its very beginnings in the lucrative, European trade in photographic images of Africa. As adventurers and colonial personnel applied the facilities of the photographic process to the graphic representation of aspects of African and Maghrebian life, many were drawn to the continent not only by the geography thus revealed but also by a new, more convincing and eminently enticing portrayal of the alleged sensuality of the African. So successful was this commerce of images that by the turn of the twentieth century, the American photographer F. Holland Day was manufacturing studio images of 'Nubians' and 'Ethiopian Chiefs' shot in America and modeled by African Americans, a voyeuristic, typecasting practice that would eventually manifest, in its worst form, in the junglefication of Africa that preoccupied Hollywood in the century that followed.

As the voyeuristic camera made its incursion into Africa, so did the camera as an instrument of war. By 1855 the English photographer Roger Fenton had established the place of the camera as a tool of war reportage through his photographic coverage of the Crimean war, and by 1861 Matthew Brady had applied Scott-Archer's collodion process to the pictorial coverage of the American civil war, leaving for us moving images of loss and horror rather than records of triumph. In both cases the camera was, quite arguably, very much a journalistic instrument rather than part of a military campaign. In its earliest war-time use in Africa, however, the camera was a decidedly ideologically positioned tool on the side of incursion. In 1896 Edoardo Ximenes, an Italian journalist and co-founder of the magazine, *Illustrazione Italiana*, took war photography to Africa as a photo-reporter on the Italian campaign in Abyssinia.[4] Accounts of Ximenes's exploits in Abyssinia, to which we come presently, indicate a position weighted on the side of the Italian infringement upon that African nation. And Ximenes was not the first to introduce the photograph to Ethiopia. The man credited with introducing photography and the camera to Ethiopia in 1859, the German missionary Henry Stern, had himself been imprisoned for 'displeasing' Emperor Tewodros II, thus discouraging the use of the camera in that country until later in the century.[5] The camera would eventually play a fateful role in the politics of the great Abyssinian monarchy in the early twentieth century, ultimately leading to the fall of a monarch, for the first time in world history, and presaging the dubious employment of photography in the McCarthy era in America.[6]

Although Khedive Mehmet had acquired mastery of the daguerreotype process from Vernet shortly after its introduction in 1839, information on African photographers is scarce until the turn of the century. While this in itself does not, of course, indicate the absence of African practitioners of the art at that time, it is not until the turn of the century that we begin to find records and images specifically

attributed to them and which provide us with an insight into the nature and purposes of African photography. To explain this Nicolas Monti points to possible cultural impediments to the acceptance and propagation of the photographic medium, one of these being a superstitious misgiving with the camera and its magical abilities. This was a universally common phenomenon in the early years of photography. In Germany in 1839 the *Leipziger Stadtanzeiger* had qualified the very idea of photographic reproduction of the human image as blasphemy, insisting that 'Man is created in the image of God and God's image cannot be captured by any human machine.'[7] This, the Leipzig publication maintained, had been proven 'by a thorough German investigation.' Also, stock European accounts of superstitious responses to photography in Africa, narrated in nearly the same words in all cases, be it with the Khedive of Egypt or the Mulena Mukwae of the Lozi of south Central Africa, cannot be relied upon to provide us with a faithful representation of African attitudes to the photograph. Wherever open hostility developed towards the camera, it almost always had to do more with the invasive tactics of its European operators than with a peculiar African inability to understand or accept the medium. In our own times this has been the case among the Nuba of southern Sudan following the Nazi propagandist Leni Riefenstahl's staged documentaries in the area in the 1970s.[8]

Monti does, however, point to a more relevant and crucial political and cultural impediment to the development and acknowledgment of African photography in the nineteenth century. Writing about the photographic documentation of European colonies in Africa, Monti notes in *Africa Then* that 'the authorities who commissioned and financed a good part of the first photographic campaigns were, it seems, aware of the risk of "natives" getting possession of this means of expression and using it as an instrument of subversion by showing the true conditions of their people.'[9] It is worthy of note that, even in the face of opposition and active discouragement, Africans took possession of the camera and the photographic process, and before the end of the century a good number, some of whose identities have come down to us, had established fairly successful and lucrative practices around the continent. These would include N. Walwin Holm, who established his studio in Accra in 1883 and would be admitted into the British Royal Photographic Society in 1897, later moving on to Lagos to establish a legal practice; George Da Costa, who began professional practice in Lagos in 1895; F.R.C. Lutterodt, who established his practice in Accra in 1889 but would eventually travel and practice all over Central Africa during the 1890s; as well as a handful of photographers who were active at the turn of the century in Johannesburg and Cape Town, and in Addis Ababa among other cities.

By the early twentieth century photography was already a highly regarded profession all over Africa and studios existed in most cities that were established and run by professionals, many of whom were quite familiar with developments and practice especially in Europe. The case of George Da Costa, a highly successful administrator and salesman who gave up his position to study photography and establish a studio, is revealing. Described by Allister Macmillan in 1920 as 'the ablest and best-known professional photographer in Nigeria,'[10] Da Costa was manager of the Church Missionary Society bookshop in Lagos between 1877 and 1895, when he resigned and, having spent quite a sizable sum in training, took up photography, eventually becoming a photographer of remarkable achievement. Not only did the

colonial government entrust him with the photographic recording of the construction of the Nigerian railways, work for which he was equally acknowledged in London. In 1920 Da Costa worked with Allister Macmillan on his *Red Book of West Africa*, occasionally battling the hostile elements especially in Northern Nigeria. Da Costa's work brings to us a representation of his times quite remarkable in its variance from that on which the popular imagination was fed and shaped outside the continent. Rather than a society of 'cannibals' and 'heathens,' Da Costa's photographs of early twentieth-century Africa lead us to a cosmopolitanism steeped in awareness of other cultures, a world of burgeoning elite and savvy literati, a society of international merchants, high-flying attorneys, widely traveled politicians, newspaper tycoons and society ladies, the same images that we find in contemporary portrait painting of the period in Europe and North America. Quite remarkably, also, photography, having had a head start on portrait painting in Lagos, where the earliest significant work in that genre dates from only 1906, avoided the reputation of the spoiling antagonist that it came into in Europe, and was considered quite acceptable and adequate.[11]

In Freetown, Sierra Leone, the Lisk-Carew brothers set up a popular practice to cater to the needs of clients both local and expatriate. Of their business Allister Macmillan wrote in 1920: 'There is probably no establishment in Freetown that is visited by more passengers from the steamers than that of Messers Lisk-Carew Bros. The reason of its popularity is because of its extensive stock of postcard views of Freetown and Sierra Leone.' In Accra J.A.C. Holm, son of N. Walwin Holm, now an attorney in Lagos, Nigeria, took over his father's practice. Holm, who is described by Macmillan as 'an exponent of photography in all its branches,' had joined his father's photographic studio in 1906 aged eighteen, eventually taking over the business in 1919.[12] Holm would produce several images of Accra and its elite for *The Red Book of West Africa* in 1920. Other than Holm's, a number of smaller studios applied themselves to the demands of the growing urban population with its burgeoning elite. Photography was lucrative, and the photographer enjoyed a unique sense of place within the community, having access to the people, understanding their peculiar needs and demands on the medium, and thus enjoying their confidence and custom. The African photographer was also better placed than the foreigner to provide his services within specific cultural frames that made these available and affordable. With their privileged knowledge and location, as well as their ingenuity, photographers were able to devise novel uses for the medium and to introduce them within their communities and social circles.

By the early twentieth century, also, these photographers enjoyed the trust and acceptance of not only their communities but of expatriates as well. The advent of newspaper publishing and journalism at the turn of the twentieth century, and the growth of this industry as part of the nascent anti-colonial struggle in the 1930s, gave African photographers the opportunity to expand their practices and to gain greater exposure and respectability. Government yearbooks and projects employed the services of photographers and colonial functions and royal visits provided commissions. While a publication like the Amharic weekly, *Aimero*, relied heavily on the work of Armenian photographers, others like the *Lagos Weekly Record* and the *West African Pilot* relied on African photographers for their images. Others, like the London-published *West Africa Magazine*, begun in 1917, and trade journals

like the *Nigerian Teacher*, also used the work of African photographers for their illustrations.

In the decades that followed, master photographers such as Peter Obe in Nigeria, Peter Magubane in South Africa, Seydou Keita in Mali, and Mohammed Amin in Kenya, would emerge. Obe, perhaps his country's greatest-ever photographer, not only produced work for numerous African publications and clients, but provided for foreign news publications and photographic agencies as well. With a decidedly aesthetic intent, Obe approached every photographic moment with the weight of his technical and visual sophistication regardless of its ultimate utility, private or documentary. Mohammed Amin earned the recognition and respect not only of his clients in Kenya, but also of the establishment in Europe who valued and sought his work, as well as important personages and leaders from around the world. Regarded as the most influential news photographer of his time, Amin died recently in an airplane crash. Before his death Amin oversaw Camerapix, a vast archive which he founded in 1963 of his own, significant work, produced over three decades and representing mastery in every genre of photography, as well as Africa's largest image and audio resource. He was knighted by the British in 1992 for his contributions to news photography, and was named Cameraman of the Year in Britain in 1969. Magubane, who with David Goldblatt stands as the finest and most significant South African photographers of their generation, has brought that country and its people to the world, and enjoyed the reverence of the international photographic community. And so has Seydou Keita, who in the past decade has re-emerged, like the blues legend John Lee Hooker, as a master visionary with whom few others can compare in the twentieth century.

Just as the African condition in the late twentieth century is considerably defined by expatriation, so has the cartography of its photography metamorphosed and expanded. As cultural critics and historians are beginning to learn, it is not enough to look to the continent alone for its cultures, its art and music and literatures, for to do so is to sidestep a significant manifestation all around the world in the form of expatriate culture. Among the continent's most important contemporary photographers also belongs Rotimi Fani-Kayode, who in his brief life produced enough work to become the most significant and influential British photographer of his generation. Fani-Kayode worked principally within the traditions of Yoruba photography and image-making, yet helped define the British gay aesthetic in photography for the 1980s. Since his death at the age of 34 in 1989, hardly any other British photographer has had an equal influence on photography in that country. Unfortunately, a good body of Fani-Kayode's work was exposed to intervention and corruption after his death by a partner whose understanding of the image and of the photographic medium was essentially closed to the depth and criticality of meaning that Fani-Kayode brought to his art. Alex Hirst, who collaborated with Fani-Kayode while the latter was alive and inherited his estate, is a minor photo-artist himself, and has continued to manipulate and retouch many of the images left by Fani-Kayode, thus obliterating the unique aesthetic and cultural sensibilities which only Fani-Kayode could imbue them with.

In the 1980s and 1990s practice no longer restricted itself to the photograph, and photography was once more defined not simply by the camera but within the broader frame of the photographic medium or new or digital media, just as it was

in the days of the hand-tinted photograph when the camera belonged in a larger process of photographic image-making, and just as it always has been for Africans. Among artists working with this new understanding are notable photographers and new media artists such as Oladélé Bamgboyé, who has worked in Europe and North America; and Gordon Bleach, who teaches in Eastman's Rochester and has worked in his own country in Zimbabwe as well as in South Africa. Bamgboyé, a descendant of the legendary Yoruba sculptor Bamgboyé, and a distant protégé of both Fani-Kayode and the photographer and dancer Geoffrey Holder, whose work in photography is often mistakenly compared to that of Robert Mapplethorpe, brings his mastery of the entirety of the photographic media into explorations of the exoticized body, thereby closing off and placing photography's century-and-a-half-long exploitation of the African body under crisis.

In addition to the above-named are hundreds of thousands of professional photographers across Africa attending to the photographic demands of their localities and who, together with the above, provide us with material towards the formulation of a theory of African photography. Stephen Prague observes, for instance, that 'the large number of photographs available from individual Yorubas [sic] and from photographers' negative files form a vast visual data bank . . . [that] might be utilized in a number of ways.'[13] Also, despite the frequent lack of proper attribution and the occasional dubiousness of contending, often better-known Western photographers, some of whom are known to have scratched out attributions from images and appended their own imprints, it is the turn-of-the-nineteenth-century and the early twentieth-century that establish for us the earliest body of verifiable African work in photography, through which we are able to gain considerable insight into the general perception and application of the photographic medium by Africans before and after. And in these we find logical parallels to the West, as Prague equally points out about Yoruba photography, but even more interesting, peculiarities, also, that define a different understanding framed by a divergent philosophical perspective on the questions that have hitherto occupied the discourses of photography.

Photography and its discourses

Since its birth photography has been at the center of innumerable questions and contentions, most deriving from a rather peculiar, Western inclination to view the photographic process as different and separable from the rest of the body of human techniques and processes of image-making. Yet as an image-making process it is difficult, even futile, to ascribe to photography any uniqueness beyond the facility of replication and miniaturization by which it enables us to make the transfixed image readily available and portable. In cultures where the multiple was already a long-standing artistic tradition which developed to meet the demands of the community, and portability was the norm rather than exception, even this repeatability was only convenient rather than unique.

Much has been made in the history and criticism of photography, too, of its indexicality or fidelity to reality. On this, contemporary theorists of the medium remain as divided as its earliest commentators. For the intellectual and ruling circles

of late Enlightenment Europe photography proffered a mathematical exactitude of reality, a reducible, calculable mechanism for the scientific reproduction of nature. In *From Today Painting Is Dead*, Tristam Powell quotes the Victorian Lady Eastlake as remarking: 'What are nine tenths of these facial maps, called photographic portraits, but accurate landmarks and measurements for loving eyes and memories to deck with beauty and animate with expression, in perfect certainty that the ground plan is founded upon fact.'[14] Though we return to Lady Eastlake's comment presently, it nevertheless bears within it an element of a certain naive faith in the fidelity of the photograph which would pervade not only the aristocracy in the West but even more so, and with more dangerous and insidious consequences, the various institutions of science and the state. Resting on this supposed fidelity and transparency, whole disciplines came to rely upon the evidentiary potentials of the photograph, sociology appealing to it for concrete statistical purposes, anthropology for indubitable evidence of the evolutionary order of the human species and by extension, justification for its mission of salvage exploration outside Europe. Jurisprudence and the apparati of state control invented new systems of criminal cartography based on the consciously exaggerated faithfulness of photographic likeness; and the fundamental right to contest institutional truth was curbed by the supposed unimpeachability of the new tool.

Behind this rather essentialist and fundamentally flawed view of photography lay the myth of automatism, the rather interesting conviction that photography, unlike all the other techniques of representation, had through its supposed substitution of the machine for the human hand, finally and thankfully elided subjectivity and the fallibility of human agency. Writing over a hundred years after Lady Eastlake in 1971, the philosopher Stanley Cavell replicates this view with a deeper and more disturbing clinicality in his treatise on film and the photographic medium, *The World Viewed*:

> So far as photography satisfied a wish, it satisfied a wish not confined to painters, but a human wish, intensifying since the Reformation, to escape subjectivity and metaphysical isolation — a wish for the power to reach this world, having for so long tried, at last hopelessly, to manifest fidelity to another. . . . Photography overcame subjectivity in a way undreamed of by painting, one which does not so much defeat the act of painting as escape it altogether: by *automatism*, by removing the human agent from the act of reproduction.[15]

A few years later in 1974, Rudolf Arnheim wrote in 'On the Nature of Photography' of 'the fundamental peculiarity of the photographic medium; the physical objects themselves print their image by means of the optical and chemical action of light,' thus lending further philosophical authority to the concept of a mechanical, objective, process devoid of the compromise of human intervention.[16]

However, like Arnheim and others who have propagated this idea, Cavell builds his assertions on a number of fallacies, among which is the assumption that there is a human inclination to escape subjectivity, when on the contrary every indication is that the proclivity of the human species is to challenge the veracity of that which professes objectivity and seek beyond it. The second major fallacy behind Cavell's

position, and which Arnheim claims to be the fundamental principle in his argument, is the assertion that photography removes human agency from the image reproductive process. Rather than signing the absence of subjectivity or human agency in representation, photography, though mechanical, is on the contrary first and foremost a human invention entirely dependent on human manipulation from its beginning in the conception and manufacture of the photographic mechanism and its peripherals, to the conclusion of the image-making process in the form of the photograph. A great deal of literature has already been devoted to this.

The myth of the triumph of reason in the Enlightenment, upon which Cavell equally rests his assumption that there is an *a priori* human proclivity for objectivity, survives only when we ignore the very limited reach of the rationalist ideal, and overlook the fact that at no moment in the history of the Enlightenment from its beginnings to its demise in the age of High Modernism (during which Cavell writes in 1971) was there a popular submission to the pre-eminence of the rational. Instead, through the ages the inclination and focus of the human will was always in the opposite direction, toward a recognition and acceptance of the impossibility of objectivity.[17] Thus when Lady Eastlake speaks of the photographic image, she speaks of it not as an objective reproduction of reality, but as an evocation, as a cartograph, a 'map' whose acceptance rests upon the knowledge not that it is fact, but that its 'ground plan is based on fact.' And even when Ruskin speaks of the photographic image as 'a portable' reality, he speaks not of an objective reproduction of reality or what Arnheim has described as 'the manifest presence of authentic physical reality' but of a miniaturization, in other words a new reality that differs, quite essentially, from that which it evokes, if only by virtue of its portability.[18] In essence the only phenomenological invariable of photography is not the fable of transparency and mechanical objectivity, but the materiality of the photograph, the creation, in the photograph, of a new reality, a new, independent and concrete object on and in the form of paper or glass or any other of the innumerable surfaces upon which the photographic image may be placed, which then becomes part of reality rather than its replica.

More recent and perhaps even more intriguing, is the contention that the history and appeal of the photographic medium lies principally in the uniqueness of its process. Trailing the argument for mechanicality, André Bazin wrote in *What Is Cinema?*:

> the essential factor in the transition from the baroque to photography is not the perfecting of a physical process . . . rather [sic] does it lie in a psychological fact, to wit, in completely satisfying our appetite for illusion by a mechanical reproduction in the making of which man plays no part. The solution is not to be found in the result achieved, but in the way of achieving it.[19]

In their 1975 essay 'Photography, Vision and Representation,' Snyder and Allen note that 'The use of a machine to lay down lines and the reliance on the natural laws of refraction and chemical change to create pictures are viewed as the decisive differences (between photography and other processes of picture-making).'[20] Yet this position is historically inaccurate because it fails to acknowledge the origins of

the photographic process in the desire of the artist, whether the scene-painter Daguerre or the amateur landscapist Talbot, to achieve better, more personally or commercially viable, results. It is noteworthy that Talbot had named his invention calotypy, from the Greek *kalos* or beautiful, and in introducing Talbot's process to the Friday evening meeting of the Royal Institution in London on January 25, 1839, the inventor Michael Faraday aptly described it as 'the Art of Photogenic Drawing,' not failing to place the emphasis on the product, the drawing. From the *camera obscura* to the *camera lucida*, the artist's frustration with the fleeting image, and the desire to capture and preserve the form produced through reproductive contraptions remained the principal drive.

A second observation to the contrary is that, outside the minority sect of intellectuals and philosophers and the handful of practitioners who all along the line have sought to position themselves apart from the greater camera community through uncertain professional claims and guises, general interest in the photographic process always was and remains in the result, the end product, and the desire to take control of the process is driven by this interest in the product and its use. At no time, not even in the much-hyped era of modernist autonomism, did the vocation of image-making rest on a preoccupation with the nature and relevance of processes in and of themselves, as on the nature and value of the image. The efficacy and convenience of the photographic process, even the magicality that surrounded its early history, are subordinate to the true human appetite and fascination for the production of form, and the opportunity that photography provides for participation in the making of images. When a columnist wrote in the *Scientific American* in 1862 that photography contributes to human happiness a 'thousand fold more,' it had less to do with a fascination for light and science and chemicals than with a human desire to make and acquire images. In discussing photography in Africa, it should be of interest to look at the foregoing contentions in the context of the continent and its traditions of image-making and consumption.

The substance of the image

One of the most naturalistic traditions of image-making in Africa, beside the royal portraiture of ancient Ife, is the Ako funereal effigy tradition of the Owo of western Nigeria, a tradition which, as Rowland Abiodun observes in *Yoruba: Nine Centuries of African Art and Thought*, may date to earlier than the sixteenth century. Not long after the death of an important personage among the Owo, an event is arranged during which a life-size effigy of the deceased is attired in the dead man's or woman's clothing, and either interred or allocated to a shrine in memory of the dead. There is an insistence on verisimilitude in the portrayal, and this demand for faithfulness to the physical likeness of the dead, it has been pointed out, has its origins in antiquity.

The earliest western scholars of this memorial observance did not fail to dwell on the element of verisimilar representation especially within a culture of great stylization in sculpture, and in the light of known traditions, albeit outside, of refraining from the replication of likeness. Yet, Abiodun cautions us thus, and rightly so:

> The effigy with its Ako naturalism should not be judged for its photo-
> graphic realism, but for its efficacy within the context of the Ako
> ceremony, which is . . . to make the end of this life, and the beginning
> of the next one, honorable and dignifying for one's parents, whose good-
> will is needed by those still on earth.[21]

For this reason Abiodun has observed that the eyes of the effigies are always wide open, quite remarkably so, for the deceased to which they refer must keep awake on the other side, watchful over the living. To represent them otherwise would fail to emphasize this crucial element of the supplicatory act, and to do so is to run a risk of impeding the vigilance of the dead.

Despite its verisimilitude, Ako is not portraiture *as we know it*. Although portraiture in the Western tradition may venture beyond verisimilitude into the fictive territories of distortion or hyperbole, rarely does it turn to invocation or conjuration. Depending on the medium the portrait may veer between what we have come to describe, rather unwisely, as 'photographic' realism, and the borders of acceptable vanity. Yet it remains a recollection, the registration of an instant trans-fixed, which henceforth represents the past. Its phenomenological claims rest on its referentiality and terminality, and as a sign it is reflective. Even in its wildest departure from the frames of the verisimilar, as in nineteenth-century Western photo-portraiture when it was the portrait photographer's prerogative to incorpo-rate various signs of historical or religious configuration in order to imbue the middle class with the hitherto aristocratic attributes of grace, wealth, enlightenment, and soulfulness, portraiture *as we know it* remains a marker of memory. In Ako, however, we find a different manner of portraiture: we find representation as anticipation. The verisimilitude we are introduced to is a mediated gesture between faithfulness and faith, between reflection and projection, a configuration of representation as both reflection and invocation beyond the limitations of transparency, for that which projects, that which anticipates and conjures, though faithful it may still be, is never-theless no longer transparent since to be transparent is to convey that which already exists, that which precedes rather than supersedes the agency of its representation; to remain, as it were, within the reaches of death. As a sign Ako is prolegomenous and the essence of its verisimilitude is not indexicality or transparency, but efficacy, the fulfillment of intent beyond the materiality of the image.

This understanding fits within a broader aesthetic of essence where the image is 'true' as long as it efficaciously attends to the specifications of its application within an intricate matrix of cultural expectations. Whereas our conventional qualification of such circumstance would be that the image is successful, that is to say, that it fulfills its purpose, within this aesthetic success also equates truth. In other words the image is truthful or accurate if it fulfills its purpose. And this success is not restricted to the registration or indeed excavation of the phenome-nological contours of the subject through iconographic or iconological indexicality; it extends to the supersedure of the phenomenological and the substitution of the non-mimetic. Thus an image, including the photograph, though it may not visually portray or refer to a subject, may yet be applied to the representation of that subject as long as it sufficiently encapsulates the perceived or intended attri-butes of that subject.

A good example of this we find in another Yoruba ritual, *Gelede*, where matri-
archal images are produced to reflect youth, because the attribution of youth to the
elderly is flattering, and flattery as a lobbying strategy is the essence of Gelede. So
that, though the image may refer to or be directed at an individual, it behooves the
image-maker, nevertheless, to take the liberty to supersede the transparent and
redefine faithfulness so as to introduce what we might call the essential gesture.
Where necessary, the image-maker may depart entirely from the physically refer-
ential, in other words employ an image other than that of the object or target of
ritual flattery for as long as it is perceived, to embody the spiritual essence of that
target. Thus, whereas in conventional Western portraiture the search for *inner truth*
in a subject may extend to distortion and the mediation of the verisimilar but never
so far as to depart entirely from the confines of physically cognitive reference,[22]
within the aesthetic that governs Gelede in particular, and Yoruba representation
in general, it is precisely such departure that may constitute the necessary gesture
toward successful or accurate representation. The uniqueness of Ako within this
aesthetic, however, is in the fact that this liberty is contained by the need to produce
an image which the subject may recognize and identify with themselves. This in
itself constitutes a different gesture, what we might refer to as a *gesture of semblance*.

Ako introduces us to a philosophy of the image that invalidates the contest over
transparency or indexicality in the discourse of image-making, and one that is central
to our understanding of photography in Africa. The tradition of funereal effigies is
not restricted to the Owo and may indeed be found all over Africa, and it is
revealing, as it is understandable, that it is within this tradition of a gesture of
semblance that we find one of the earliest applications of photography by Africans.
As soon as a rapport with the camera was re-established in Ethiopia in the nine-
teenth century and photography was popularized, the medium was placed at the
service of funeral rites, and upon a death the likeness of the dead would be retrieved,
often replicated, and would be borne in the funeral procession. Citing Guèbré
Sellassie's remarkable *Chronique du règne de Menelik II Roi des rois d'Ethiopia*, published
in France in 1930–31, Richard Pankhurst wrote:

> It had been customary in funeral processions since time immemorial for
> mourners to display an effigy of the deceased, together with his horse
> and other valuable property. With the advent of the camera such arti-
> cles tended to be supplemented – and the effigy even replaced – by
> photographic portraits of the departed which mourners held high above
> their heads, while they wailed, ritualistically, and perhaps recounted
> episodes of the deceased's life and achievement.[23]

A notable occasion when this new prop of the mourning ritual was used was
the funeral in 1906 of the governor of Harar and cousin of Emperor Menelik, Ras
Makonnen, who was also father of the future and last monarch of Ethiopia, Ras
Tafari (Haile Selassie I). Though the practice was observed within the aristocracy
in the beginning, as the greater population gained access to photography, it became
part, also, of the popular culture of mourning. Such application of photography was
particularly evident during the dictatorship of the Dhegue in the 1970s and 1980s
under Colonel Mengistu Haile Mariam when the government presided over a decade

of war and mass extermination similar to the decade of the missing in Latin America. Families carried the portraits of their missing and dead in processions and wailing rituals, and often to the sites of excavations of mass graves where the photograph was not a mere effigy of the dead but also a totem of damnation.

Yet this practice had less to do with any greater faith in the accuracy of the photographic image, or interest in the photographic process, than with recognition of its convenient delivery of an image. It is not unworthy of note that the photographic image was named *se'el-fotograf* in Amharic: a term which translates exactly as 'photographic image' but also reminds us, in its specificity to two-dimensionality and reference to drawing and painting, of Faraday's 'photogenic drawing.' The Ethiopian painter Wossene Kosrof, an Amharic speaker, confirms that the singular word, *se'el*, could be applied to drawing, painting, design, and the photograph. Each without distinction is a two-dimensional image. Although within the realms of state politics in Ethiopia, the evidentiary capabilities of the photograph would be called into service time and again, as already mentioned, leading first to the fall of the prince and heir-apparent Lij Iyasu in 1916, and later to the forced abdication of Hailie Selassie in 1974, the broader understanding and application of photography was and remains rather referential and evocative. And though Iyasu was deposed supposedly on the strength of photographic evidence in 1916, several sources point to a popular conviction among the population that the implicated photograph was a forgery produced by an Armenian photographer in Addis Ababa at the behest of foreign intelligence operatives intent on the fall of the young prince,[24] thus signing not only the possibility of such discrepancy, but even more importantly, a lingering Ethiopian distrust of the supposed indexicality of the photographic image.

Another Yoruba practice to the service of which photography was called provides further insight into the general African position on the question of the transparency of the photographic image. Among the Yoruba of the old Oyo empire, the cult of twins is a prevalent practice that, according to records, certainly dates to earlier than the nineteenth century. For unique dietary reasons the Yoruba have the highest rates of twin births in the world, and in earlier times the fragility of twins led to high infant mortality. For deceased twins, therefore, a practice was begun which the British explorer Richard Lander described in 1826 as one of 'affectionate memorials.' Ere Ibeji, or twin images, are images in honor of the dead which the living nevertheless tend and nurture as though they were the child in whose honor they are made. Originally these were made in wood, produced by a sculptor whom the priest appoints, and upon production sacralized for its purposes. The twin mother would carry this with her in the same manner as she would a living child, and cases are known where several decades after the child's death, this image would be passed down the family unto a succeeding generation. In recent times commercially produced plastic dolls have been sacralized and put to same use, as John Picton has observed: a practice that in itself constitutes an important definition of the memorial image.

Even more relevant to our purposes is the employment of photography in the place of sculpture in this ritual memorial. It is not clear at what point in history the Yoruba began to use photographs as Ere Ibeji, but indications are that this may well date back to the late nineteenth or early twentieth century. A photographic image of the dead twin would be used in the same manner as a wooden Ibeji sculpture,

kept in the altar to twins and brought out for rituals. Where there are no images of the twins, a family may have the sculpture made, and then commission a photograph of the sculpture for convenience and better display in the home. However, where the human image is possible, no use or reference is made to the traditional wooden doll or effigy. Writing in his essay, 'Yoruba photography' in 1978, Stephen Sprague had this observation to make:

> Photographs are often made of twins and other children to hang in the parlor with the photographs of other family members. Then, if a child dies, there is a portrait by which to remember him. The procedure becomes more complex when one twin dies before their photograph is taken. If the twins were of the same sex, the surviving twin is photographed alone, and the photographer prints this single negative twice, so that the twins appear to be sitting side by side in the final photograph. If the twins were of opposite sexes, the surviving twin is photographed once in male clothing and once in female clothing. Sometimes these two exposures are made on separate negatives, which must then be printed together . . . the photographer attempts to conceal the line blending the two separate exposures in order to maintain the illusion of twins sitting together in a single photograph.[25]

And yet greater complication occurs when more than twins are involved. In what Sprague considers an unusual case involving triplets,

> the two brothers died and the surviving girl was photographed once as herself in girl's clothes and once in matching boy's clothes. . . . The photographer then printed the 'boy' image twice, once on either side of the girl, to give the proper illusion of triplets.

The result, which is not perceived as a trick but rather as a normal responsibility of the image-maker, is the most beautifully conceived photograph possible, and the most significant comment on the substance of the photographic image.

From the onset, as we can see from this and other examples, the Yoruba associate photography not with objectivity, but with the possibility and necessity of illusion or what we might otherwise regard as the fact of fiction. In the examples we have seen, the camera is first subordinated to the art of the sculptor through the use of photographic images of ritual sculpture in an interesting coalescence of fascination and disregard, before it is finally brought into service as an extension of the image-maker's tools. In the cult of twins, the fundamental requisite for the application as well as the effectiveness of the photographic medium is the re-definition of *objectivity*, or indeed the submission of photography to accepted definitions of objectivity – that is, the canonical rather than photographic *objective* – and the primacy of *faith* over faithfulness. By using the right apparel, the photographic image of the living twin becomes an image of the dead twin, also. The reverse of this, which is to have the image of the dead which is taken either in their life-time or on their deathbed representing them in a posthumous composition, would be acceptable in the West and has wide precedence in photographic history,

but it would be unimaginable or considered fraudulent to substitute an image of a living kin for a deceased one, which is precisely what obtains in the Yoruba instances that we have cited. And much as it may be argued that for the Yoruba the surrogate image remains that of the living twin, that is the figure before the camera, what is important is not the figure in front of the lens but that which emerges after the photographic moment. The obvious intent is not to concede transparency or indexicality to the photographic image, but instead to recognize, underline, and utilize its very nature as chimera.

In the 1980s Rotimi Fani-Kayode, who was of Yoruba ancestry, extended this tradition by applying photography to the imaging of Yoruba deities and principles connected with the cult of Abiku, the cyclic changeling fated to repeat death and rebirth, and especially of the most engaging yet singularly photogenic deity of the Yoruba, the divinity of ambiguity and fate, Esu. While the representation of deities may be restricted to the mimetic translation of myth, the integration of convoluted iconic and philosophical principles into pantheistic visual representation, in other words the generation of the iconic, demands fluid manipulation of medium even within the frames of canon. Few African divinities lend themselves to easy translation, and the employment of photography in the interpretation of the metaphysical rests on the premise that the medium possesses the flexibility to extend itself beyond mimesis, and sufficiently lends itself to the skill, and will, of not only the image-maker and the patron, but also of an intricate cultural matrix. In his recreations of Esu, Fani-Kayode captured the physical and conceptual essence of the trickster god: mischievousness, ambiguity, multi-sexuality, indeterminacy, perpetual mobility, and unpredictability, attributes that defy the confines of the mimetic trail and yield only to subjective intervention. Esu's smile/grin/grimace comes forth most unnervingly with the potentially wicked mischief of the divinity who deliberately sets friend against friend, violates his/her sibling in the presence of their mother, defies all prediction, and, most importantly, signifies the futility of absolutes, including the fiction of indexicality or visual truth.

For the Yoruba, therefore, the camera is not the detached mechanical contraption that supersedes human agency, as Cavell thought; nor is photography the peculiar process in which 'the objects themselves print their image by means of the optical and chemical action of light,' as Arnheim would ludicrously put it.[26] Instead, photography offered the unique ease of combining possibilities of precision that are otherwise not readily available to the human agent, with those of malleability required for the fulfillment of the essence of the image. Early in their acquaintance with photography, the Yoruba recognized and exploited the indispensability of human agency in the photographic process. In their use of photography, Yoruba photographers emphasize the affinity between photography and other image-making processes. A close look at one of the twin photographs that Sprague calls our attention to in his study in which a female twin poses as a male, in order to serve as a surrogate for her deceased male twin, indicates that the photographer manipulated the proportions in the photographs such that, though the images are of the same individual, the image of the female twin is smaller than that of the male. Through this simple yet highly ingenious technique, gender attributes and dissimilarities are codified, and the living twin's femininity is emphasized. In a second photograph, of the triplets referred to above, a different, even more sophisticated technique is

employed. By a subtle change in the sitting posture involving the placement of the knees, the figure is made to look shorter in her female image than in the male. This way her brothers, for whom she serves as photographic surrogate, appear bigger and taller in the final print. Here we find no evidence whatsoever of a mythical 'human wish to escape subjectivity . . . by *automatism*, by removing the human agent from the act of reproduction,' as Cavell would have us believe;[27] quite the contrary. There are no indications, either, of any concern for or interest in what Snyder and Allen describe as 'The use of a machine to lay down lines and the reliance on the natural laws of refraction and chemical change to create pictures . . .'[28] (a deconstructivist concept that, in any case, means absolutely nothing to either the average American or Yoruba maker or consumer of the photographic image). Instead, human agency is signed as an essential element of all image-making, including the photographic. Photography is regarded and employed in the same manner as sculpture, and, as the Ethiopians indicate in their choice of vocabulary, painting and drawing. In these cultures photography is simply another process of image-making, a process of *making* rather than *taking*.

This understanding of the photographic as indistinguishable at large from the rest of the image-making processes, and in particular as manipulable rather than clinical, further manifests in a fundamental distrust of the photographic medium among the Yoruba and other African cultures, an attitude one might best describe as one of requisite ambivalence. As Sprague equally illustrates in his essay, the record of the camera in itself is considered inadequate unless it fits a frame of canonical specifications of representation governing all image-making without exception. In portraiture including that of twins, for instance, the image in profile is considered inaccurate since it on one hand fails to register the totality of the individual's countenance and therefore of their personality and being, and on the other introduces an element of distrustfulness or timidity to their character. Thus the camera in and of itself is incapable of articulating the contours of accuracy, and the responsibility to direct this instrument toward *truth* ultimately rests with its human operator who is the real image-maker.

This returns us to the question of the significance of process in relation to the image. Again it is useful to recall, if only to dismiss it, Bazin's insistence in *What Is Cinema?* that

> the essential factor in the transition from the baroque to photography is not the perfecting of a physical process . . . rather does it lie in a psychological fact, to wit, in completely satisfying our appetite for illusion by a mechanical reproduction in the making of which man plays no part. The solution is not to be found in the result achieved, but in the way of achieving it.[29]

Chinua Achebe makes a seemingly parallel observation when he writes in *Hopes and Impediments* of 'the Igbo aesthetic value as process rather than product.'[30] But there ends the analogy, for *process* in Achebe's reading of the Igbo aesthetic specifically implies the *act* rather than the *means* of making, or indeed the act as distinct from the means since both are often of equal significance in the bid for efficacy. Where Bazin's theory rests on a precisionist equation predicated on scientific agency, that

is, the assumption that the application of a specific body or level of instrumentation would yield a calculable result with minimal human input, the aesthetic that Achebe articulates, on the other hand, places its accent on the details of the manual or human factor, on *making* rather than *registering*. Yet, much as the act is an essential element of the image-making process in Africa, it is nevertheless the product, the image, and its efficacy, its ability to satisfy demands largely unrelated to mechanical specifications, that ultimately count. Such is the condition of the image. And one could argue that this is essentially the case with either the photograph in the veneration of twins or the Amharic funeral procession, or Peter Magubane's photographs of mines and miners and Mohammed Amin's images of famine victims in Ethiopia, or indeed Fani-Kayode's images of the Yoruba deity of ambivalence. A preoccupation with the mechanical intricacies of the darkroom or the details of physics and chemistry and light have no place in the process and purpose of image-making beyond the striving for greater effectiveness.

From the foregoing one may attempt to articulate a theory of the photographic where its essence resides not in the details and mechanics of reproduction, but in the significatory possibilities of the emergent form. This we might call the substance of the image, for it is in the image, rather than the apparatus of its making, that the relevance of the medium is situated. The fallibility of this image is taken for granted, as is its subordination to the dictates of human agency, and this fallibility necessitates a frame of ambivalence. It is this ambivalence, often subsumed under the illusion of scientific verity in the West, that governs the production and consumption of the photographic image in Africa. Whether applied to the imaging of gods, the rituals and logistics of mourning, or indeed in the recovery of the literal moment, photography is perceived as lacking in inherent integrity, and thus open and available to the whims of power. Rather than the innocent register of a literal configuration evacuated of the extra-esthetic, the photographic image is rightly understood as a dominable site the frames of which must be guarded and contested for. In the end that which levels the photographic with the rest of the image-making processes, namely its lack of integrity, also underscores its significance, its substance.

The location of meaning

It is within this framework that we can meaningfully approach two revealing incidents that call attention to an important aspect of the photographic image in Africa upon which one may conclude. These are Khedive Mehmet's attempt to locate himself behind the lens and take control of the photographic process shortly after the arrival of the daguerreotype, and the reaction of members of the Ethiopian court to Edoardo Ximenes's application of the camera in Abyssinia, both mentioned earlier. Monti informs us that Vernet frustrated the Khedive's initial attempts at photography by supplying or using suspect chemicals on the resulting photographs, which meant that the images failed to register. This act of subterfuge earned him access to the forbidden territories of the monarch's women's quarters, since his expert services had to be engaged for a more reliable second attempt. Beyond this voyeuristic licence, however, the act also signaled the beginning of a contest between

the African and the outsider for photography as a tool, and for the photographic image. Obviously reluctant and displeased with the choice to grant Vernet access to the privacy of his wives' quarters, Mehmet also realized that in bringing so manipulable a medium as photography to bear upon the body of another, the presence behind the camera must be one with that other, must share, in a fundamental sense, a certain identity with her, or else the photographic encounter becomes an act of trespass and violation. In other words the Khedive's experience with Vernet initiated a struggle over authorship and its privileges, especially the details of power over the production of knowledge which determines the nature and uses of such knowledge. It was his awareness of these details and their ramifications that led the Khedive to retain all images and thus reassert his authority over them.

In *Africa Then*, Monti also mentions another incident in 1896 in which an Ethiopian nobleman protests at the copious use of the camera by Ximenes, noting rather ruefully that Ximenes had 'too much in his camera already,' and wondering whether he wanted 'to take away the whole country.'[31] Not only was Ximenes taking his photographs during a period of great political sensitivity, namely the Italian campaign against Abyssinia, thus constituting an intelligence threat, more importantly, his respondent was not unaware of the seamless possibilities of the loose image. Both Mehmet and the Ethiopian nobleman identified the manipulable image as the site of significance in the photographic process. Both understood that the primary element in this process is not the mechanical but the human agent, and like the Yoruba and their photographers, both knew that the contest for meaning in photography must occupy itself with the image itself and its substance.

Notes

1 See Gilbert George, *Photography: The Early Years*, New York: Harper & Row, 1980, pp. 25–6.
2 See Allan Sekula, 'The Body and the Archive' in Richard Bolton, ed., *The Contest of Meaning: Critical Histories of Photography*, Boston, Mass.: MIT Press, 1989, p. 344.
3 Nicolas Monti, ed., *Africa Then: Photographs 1840–1918*, New York: Alfred A. Knopf, 1987, p. 6.
4 Monti, p. 171.
5 Richard Pankhurst, 'The Political Image: The Impact of the Camera in an Ancient Independent African State,' in Elizabeth Edwards, ed., *Anthropology and Photography, 1860–1920*, New Haven and London: Yale University Press and the Royal Anthropological Institute, 1994, p. 234.
6 Ibid., pp. 234–41.
7 See John Tagg, *The Burden of Representation*, London: Macmillan Educational Books, 1988, p. 41.
8 James C. Faris, 'Photography, Power and the Southern Nuba' in Edwards, p. 216.
9 Monti, p. 8.
10 Allister Macmillan, *The Red Book of West Africa*, London: Frank Cass and Co., 1968.
11 The earliest portrait painter in Lagos was Aina Onabolu, whose first known studio portrait was painted in 1906. Onabolu would go on to produce portraits of many of the city's nobility over the next six decades.
12 Monti, p. 166.

13 Stephen F. Sprague, 'Yoruba Photography: How the Yoruba See Themselves,' *African Arts*, xii, 1, 1978, p. 59.

14 Tristam Powell, 'Fixing the Face' in David Bowen Thomas, ed., '*From Today Painting Is Dead': The Beginnings of Photography*, London: Victoria & Albert Museum, 1972, p. 10.

15 Stanley Cavell, *The World Viewed*, Cambridge, Mass.: Harvard University Press, 1971, pp. 21, 23.

16 Rudolf Arnheim, 'On the Nature of Photography,' *Critical Inquiry*, 1, 1974.

17 Despite the centrality of the 'truth' principle in modern Western religion, even Christianity is founded on faith rather than empirical certitude. In Paul's letter to the Corinthians he emphasizes the primacy of faith, that is, acceptance of that which is not seen or proven, in other words the antithesis of empiricism, which is after all the basis of all religious preoccupation, and which ultimately is the primary human disposition.

18 See Arnheim, p. 159.

19 André Bazin, *What Is Cinema?*, vol. 1, Berkeley and Los Angeles: University of California Press, 1967, p. 12.

20 Joel Snyder and Neil Walsh Allen, 'Photography, Vision, and Representation,' *Critical Inquiry,* 2, 1, 1975.

21 Rowland Abiodun, 'The Kingdom of Owo' in Drewal, Pemberton III and Abiodun, *Yoruba: Nine Centuries of African Art and Thought*, New York: Center for African Art, 1989, p. 104.

22 At least not until modernism when acquaintance with African notions of representation radically impacted Western ideas of portraiture and enabled certain streams of expressionism in portraiture such as we find in Picasso, Bacon, and de Kooning, none of which may be rightly considered conventional.

23 Pankhurst, op. cit., p. 234.

24 Ibid., pp. 234–41.

25 Sprague, op. cit., p. 57.

26 See Arnheim.

27 Cavell, op. cit., pp. 21, 23.

28 Snyder and Allen, op. cit.

29 See Bazin.

30 Chinua Achebe, 'The Igbo World and its Art' in Achebe, *Hopes and Impediments: Selected Essays 1965–87*, London: Heinemann, 1988.

31 Monti, p. 7.

Bibliography

Abiodun, Rowland, 'The Kingdom of Owo' in Drewal, Pemberton III, and Abiodun, *Yoruba: Nine Centuries of African Art and Thought*, New York: Center for African Art, 1989.

Achebe, Chinua, 'The Igbo World and its Art,' in Achebe, *Hopes and Impediments: Selected Essays 1965–87*, London: Heinemann, 1988.

Arnheim, Rudolf, 'On the Nature of Photography,' *Critical Enquiry* 1, September 1974.

Bazin, *What is Cinema?*, Berkeley and Los Angeles: University of California Press, 1967.

Cavell, Stanley, *The World Viewed*, New York, 1971.

Farris, James C., 'Photography, Power, and the Southern Nuba' in Elizabeth Edwards, ed., *Anthropology and Photography, 1860–1920*, New Haven and London: Yale University Press and the Royal Anthropological Institute, London, 1992.

Gilbert, George, *Photography: The Early Years*, New York: Harper & Row, 1980.

Macmillan, Allister, *The Red Book of West Africa*, London: Frank Cass and Co., 1968.

Monti, Nicholas, ed., *Africa Then: Photographs 1840–1918*, New York: Alfred A. Knopf, 1987.

Powell, Tristam, 'Fixing the Face' in David Bowen Thomas, ed., *'From Today Painting Is Dead': The Beginnings of Photography*, London, Victoria & Albert Museum, 1972.

Snyder, Joel and Neill Walsh Allen, 'Photography, Vision, and Representation,' *Critical Inquiry* 2, 1, September 1975.

Sprague, Stephen F., 'Yoruba Photography: How the Yoruba See Themselves,' *African Arts,* xii, 1, November 1978.

Tagg, John, *The Burden of Representation*, London: Macmillan Education, 1988.

Oriana Baddeley

ENGENDERING NEW WORLDS
Allegories of rape and reconciliation

T HE NEED TO DISCUSS the nature of the Latin American context, to deal with the disjunctions and incongruities of a post-colonial culture has become one of the most readily recognisable characteristics of twentieth century art from Latin America. Complex metaphors and symbolic languages have developed to define the interdependency of European and Latin American cultures, to offer some sort of explanation for the hybrid nature of Latin America. Within this category of cultural production, traditions of allegory have formed an important element. Allegory as a discursive medium is part of the heritage of Catholic evangelisation but also remains part of the visual vocabulary of many contemporary practitioners. In some ways the Renaissance appropriation of the classical past, from which many of our uses of allegory descend, was itself a model of cultural 'interaction.' As a model, it also puts an interesting gloss on the definitions of originality and replication so frequently of interest to artists working outside the defined mainstream. Re-using and re-ordering the visual languages of a distant culture to the needs of a different time and place cannot be seen as specific to Latin America but rather as symptomatic of an awareness of cultural multiplicity.

1992–1492

In the wake of 1992's quincentennial of the 'encounter,' attention has been focused anew on the point of contact between Europe and what Europeans called the 'New World.' To many artists, such as Maria Sagradini, the event served to highlight the continuing contradictions and inequality of this relationship. However, from whichever of the numerous complex and often conflicting perspectives adopted towards this historical moment, the quincentennial was a reminder of the essentially hybrid nature of Latin American culture.

Neither indigenous, nor European, Latin American culture has been balanced between a sense of belonging and of exclusion since the 'encounter.' The visualising of this finely poised relationship has traditionally encompassed the recognition of both conflict and power, a tipping of the scales in the direction of one ideological camp or the other. The art of the region's diverse constituencies determined that whichever visual language was adopted, it would carry a set of meanings beyond that of the artists' personal aesthetic. From the very first moments of contact between the two worlds, the power of visual languages to speak to the continent's different constituent cultures – the Spanish, the indigenous and the ever increasing 'mestizo' – was acknowledged. At the same time, the differing traditions of representation and symbolism remained recognisably culturally specific. In the period after the Mexican Revolution, a highly rhetorical stand was taken to the notion of interdependency, as artists such as the muralists attempted to construct what they saw as a new, assertively anti-colonial art form. For many contemporary artists, however, the notion of both conflict and affiliation goes deeper than the rights and wrongs of colonialism.

The rape of America

Traditionally, the encounter is discussed in ostensibly sexual terms. The eroticised Indian nude greeting the arrival of the Spanish conqueror with equanimity, represents a longstanding tradition of allegorical renderings of the colonial enterprise in the Americas. In a work such as Jan van de Straet's engraving from *c.*1600 of *Vespucci Discovering America*, the naked fertile America is quite literally discovered by the explorer Vespucci; the clothed, civilised European, Vespucci, bringing technology and knowledge to the available, desirable but primitive Americas.

This fantasy of colonial relations, intersecting as it does with traditional gender roles – Woman/passive vs Man/active; Woman/Nature vs Man/Technology – has functioned as a powerful metaphor within Latin American culture. In one form or other this gendering of the 'encounter' appears in many different Latin American contexts as an explanation of the hybrid nature of the post-colonial culture; the Indian mother taken by force by the European father, giving birth to the 'illegitimate,' mixed race, 'mestizo,' culture of Latin America.

The most famous version of this allegory of cultural origins is that of the Spanish conqueror Hérnan Cortes and his Indian interpreter/mistress, Malinche. From the sixteenth century on, the realities of Mexican colonial culture could be visualised via this relationship. The problematic figure of Malinche, half collaborator, half victim, manifests the ambivalent interrelationship of the conquered to the conqueror. In Antonio Ruiz's intricate, small painting, *The Dream of Malinche* (1939), Malinche's sleeping body metamorphoses into a microcosm of colonial Mexico. Traditionally, she is both pitied and despised but none the less she embodies the territories of the colonised. She forms part of the complex amalgam of allegorical Indian women referred to by Octavio Paz in his seminal discussion of the Mexican psyche *The Labyrinth of Solitude* (1950).[1] In this work Paz links the figure of Malinche to that of the 'Chingada,' a raped and beaten mother of popular slang, and discusses the cultural ramifications of the collective mother/victim/nation image.

It is this allegory of injured 'motherland' that is frequently referred to in the work of Frida Kahlo, who elides the notion of personal injury with that of the collective trauma of colonisation.[2] In *The Two Fridas* (1939) Kahlo depicts herself as the allegorical body of Mexico, literally split into two, yet interdependent; the injured infertile colonial body gaining strength from that of the strong fertile Indian woman. This Indian woman is not the compromised and despised 'mother' Malinche, but Kahlo's iconic image of the inviolate spirit of the Americas, the Tehuana.

In the period after the Mexican Revolution, the Tehuana came to represent an assertively post-colonial culture, the fertile unbowed body, closer in spirit to the 'Amazons' of sixteenth-century travelers' tales. She existed in direct opposition to the image of the brutalised Indian woman, raped by the European colonizers. She represented a pride in the indigenous past and a denial of cultural dependency. This glorification of the 'un-raped' Indian woman emerged simultaneously to the appropriation of the visual languages of popular art into the construction of an oppositional culture to that of the Eurocentric high art tradition.

In Diego Rivera's *Dream of a Sunday Afternoon in the Alameda Park*, the artist produced a work which constituted a personal manifesto for a new art. Rivera paints himself as a child (the art of the revolutionary future) nursed by the Tehuana (Kahlo) but parented by the 'popular' (in the form of the printer José Guadalupe Posada and his most famous creation, the skeletal lady 'La Caterina'). This allegorical 'family' is used to lay claim to a set of cultural values that conformed to Rivera's anti-colonialist aspirations. Past conflicts epitomised by the skeletal yet living figure of the Caterina, are seen as engendering a new, more positive future.

Contemporary Mexican artists appear highly conscious of the work of their predecessors and the use of allegory remains an important tool. But the mood has radically changed. Rivera's use of the popular and the indigenous to represent the dynamics of national identity is savagely inverted in Julio Galan's *Tehuana* (1990). Here the familiar costume of the Tehuana becomes an empty, bitter reminder of the hollowness of nationalist rhetoric. The blank gap for the face beckons like a fairground painting, waiting to be filled by any passing visitor, still a reference to the popular, but evoking a more random, less controllable force. Galan's is a world where 'authentic identity' has become something to buy at a souvenir shop. This is not so much a transformation of the allegorical body of the Tehuana, as a knowing rejection of the traditions of visualising the 'Latin American' identity. In this play upon the traditions of asserting a 'purer' identity, Galan attempts to escape the endlessly polarised positions of the gendered allegories of cultural interaction.

In a similarly bleak vein, Enrique Chagoya's *LA-K-LA-K* (1987), takes Posada's 'La Caterina' and unites her with a skeletal Mickey Mouse in a parody of Rivera's *Alameda* . . . self-portrait. The 'mother' culture claimed by Rivera has the bleak emptiness of Galan's *Tehuana*, the 'new art of the revolution', the sterility of Disney. Here again we are forced to recognise the mass marketing of the notion of authenticity, the impossibility of the 'pure' inviolate culture.

The battle seems no longer to be the simpler rejection of colonial culture espoused by the generation of Diego Rivera and the proponents of nationalist cultures within Latin America. The stark blacks and whites of Rivera's more jingoistic 'good Indians/bad Spaniards' have blurred to grey. To put it simply, the definition of what is imposed and what is inherited in cultural terms has shifted.

Colonialism is not denied but clearly defined criteria of cultural identity are replaced by a series of questions.

Guilt and reconciliation

The 'encounter/Rape/conquest' and its ensuing progeny, so often a theme within Latin American art, remains more than just a reference to a distant if crucial moment in history; it also becomes an allegorical reworking of the problematic position of the Latin American artist to the visual languages of a Eurocentric 'high art' tradition.

This tradition of the 'great artist' as the signifier of civilisation has itself been a focus of attention during the 1980s, an intrinsic part of the selfconscious games of postmodernism. However, in the work of Latin American artists, such as Alberto Gironella or Alejandro Colunga, these references are given an added meaning.

The roots of Latin America's colonial past grow from the same soil as Spain's 'golden age of painting'; for every Columbus, Cortes and Pissaro there was also a Titian, El Greco and Velázquez. As representative of Spanish culture at one of the most dramatic points in colonial history, the work of these 'Great Masters' takes on an added political dimension within a Latin American context.

In Colunga's *The Marriage of Chamuco & La Llorona*, the deliberately 'El Greco-esque' style of the artist's earlier work is present if subdued, while the theme is again that of hybrid identity. As with Chagoya, this work parodies the claims of the earlier generation and denies the notion of a transcendent culture emerging from the ashes of colonialism. Instead we are shown a 'family' of the insane and the vicious; Chamuco, the Christian devil imported by the Spaniards; and La Llorona, the 'Weeping Woman,' a figure descended from an Aztec death goddess, whose annual festival represents the trauma of conquest. This is not just the injured Chingada but an altogether more dangerous and uncontrollable 'mother' figure, who is said to roam the streets at night stealing children to revenge the loss of her own murdered offspring. Colunga's dark allegory points to the shared heritage of horror, a sort of 'a curse on all your houses.' There is no heroic victim, just a legacy of pain and cruelty.

The assigning of blame is also deliberately avoided by Alberto Gironella. His numerous reworkings of Velázquez's *Queen Mariana* dissect and reconstitute the body of this colonial queen, transforming aggressor into victim. In *Queen of Yokes*, the ghost of the Velázquez portrait fights with the vitality of the collage of popular references, as if trapped forever within the wrong painting. In inverting the traditions of the male/Spanish/colonizer allegory, Gironella also humanises the notion of power, focusing on more subtle notions of freedom and oppression. The Spanish Queen becomes as much a victim of her birth and her particular historical moment as Malinche.

While in Mexico the point of contact between the 'old world' and the 'new', and the metaphorical debate surrounding that moment has a continuing relevance. It is obvious that the conditions of the present have changed. Within other parts of Latin America the relationship to the history of colonialism has not always been so vociferous and yet this move towards a less polarised position is equally evident.

In a work such as *El Compromiso* (1982) by the Uruguayan painter José Gamarra, the scene is set in a fantasy coastline jungle *somewhere in Latin America*. The style of the painting is deliberately 'old master' with only its scale alerting the observer to its 'modernity.' In this faraway unreachable place the representatives of indigenous and colonial worldviews are locked in violent conflict. The priest cuts the throat of the feathered serpent while the native child stares unconcerned at a pet parrot. As an audience we are not asked to judge or take sides, we merely observe the progress of history. We cannot judge events taking place in a world created by writers and explorers, this lush jungle painted Rousseau-like by Gamarra from his studio in Paris. For Gamarra, the past is indeed another country, a place where injury and cruelty co-exist with hope and innocence. His Latin America is an Eden-like paradise on the point of corruption; the conquest a sort of 'fall of man.' Yet the event is inevitable and offered in explanation of the chaos and hurt of the present times, a distant starting point. This point is made not just by the subject matter but by the manipulation of the traditions of representing the unknown. Gamarra's bitter-sweet Utopias evoke the Latin America of European fantasy, it is a place without tangible existence yet is somehow familiar.

This same sense of familiarity pervades the work of the Argentine Miguel D'Arienzo. In his *La Conquista* [The Conquest] (1992), the violence of the 'encounter' is only passingly referred to in the figure of the Indian child aiming his

Figure 51.1 Miguel D'Arienzo, *The Conquest of America* (Courtesy of Miguel d'Arienzo)

bow at the distracted *conquistador*. Even this reference is ambivalent: is this an attack or are we observing the antics of some indigenous Cupid, whose magic arrow will turn the heart of the homesick Spaniard towards the Indian woman who gazes so solemnly at the spectator? 'See what is about to happen,' she seems to say, as we are confronted with the amoral inevitability of history. D'Arienzo's work is not, however, about Latin America's colonial past in any direct sense. Even more strongly than in Gamarra's work we are asked not to assign blame. The Spaniard arrives almost like Ulysses on the island of Circe, he is about to forget his past to lose himself in his 'new world'. In this sense D'Arienzo's work is all about memory and loss, his characters as they move from painting to painting (and many of his works pick up on the same characters), act out semi-forgotten moments in a past they no longer recall. Did they once belong to Titian or Goya? Was that gesture once played out in a painting by Velázquez or Tintoretto? Like a company of provincial players performing *The Tempest* in the Pampas, they act out a narrative, the meaning of which they have forgotten, while the lines and parts remain and are reconstituted into a new set of meanings. For D'Arienzo this seems to be the crux of the matter – that within replication there is also a reordering, a reconstituting of meaning which makes the alien, familiar; the distant, close.

The allegorical nature of D'Arienzo's work is made even more evident in his *Rape of America*, acting as it does as a conceptual counterpiece to the more traditional 'Rape of Europa' theme. The classical explanation of the origins of 'Europe' linked the notions of history, myth and sexuality into a complex allegory. In D'Arienzo's painting the power relations of the original are inverted. The transgressive lustful figure of the disguised Zeus, the bull, is still the central focus of the allegory. Here, however, he becomes not just the godly antagonist but the Spanish presence. D'Arienzo's bull seems more tragic than aggressive, his America a temptress not a victim. The scene evokes the spirit of the bullfight (a sport imported with enthusiasm by the Spaniards to their colonies) rather than that of an abduction and rape. The bull appears confused and wounded, dying a victim of its own obsession.

Figure 51.2 Miguel D'Arienzo, *The Rape of America* (Courtesy of Miguel d'Arienzo)

If the languages of allegory have formed an important part of the dialogue between the 'old world' and the 'new,' they have also served to highlight the culturally specific meanings of the power relations within the traditions of metaphor. In a time of changing valuations of identity, both sexual and ethnic, the shifting focus of these contemporary Latin American artists represents a complex and sensitive response to a world of change and uncertainty.

Notes

1 Octavio Paz, 'The Sons of La Malinche,' in his *The Labyrinth of Solitude*, trans. L. Kemp, Harmondsworth, Penguin, 1985.
2 Frida Kahlo, 'Body and Soul: Women and Post Revolutionary Messianism,' in J. Franco (ed.) *Plotting Women: Gender and Representation in Mexico*, London, Verso, 1989.

The gaze, the body and sexuality

Introduction to part four

■ Nicholas Mirzoeff

I N T H E F I R S T E D I T I O N of this Reader there was a part entitled 'Gender and Sexuality' and a separate part on 'Pornography'; now this seems to be reduced to a single part. In fact there is more work covering questions of gender and sexuality throughout the book. But the way in which it is covered has changed. One simple development has been the diffusion of the controversy over pornography, at least as a headline issue. The internet has taken porn from the public space of the street to the private realm of domestic computers, where censorship seems less appropriate. Further, queer activists have won the war of words in asserting the place of sexually explicit imagery in claiming and asserting sexual identity in the age of AIDS. At the same time, it no longer seems right to separate out work under the heading 'queer' as if to imply that all other gender scholarship is 'straight' or that there is no reciprocal relationship between representations of all forms of gender and sexual identities. At many universities what was once the Lesbian and Gay Society has become the Lesbian, Gay, Bisexual and Transgender Society. The name change indicates not only that 'queer' sexualities have diversified and extended their range beyond a simple opposition to 'straight' sexuality but also that the boundaries between and within concepts of gender and sexuality have collapsed.

(a) The gaze and sexuality

These new directions imply that it may now be possible to move the theorization of looking beyond the debate over the active/male gazer versus the passive/female object of the gaze. Inspired by the psychoanalytic theories of Jacques **Lacan**, gaze theory has allowed us to think about the ways in which looking is a form of power and how that power is both gendered and eroticized. Yet for all its importance, gaze

theory has had difficulties accounting for forms of looking that do not fit into its opposition between (straight) male looking and the feminine place of being looked at. Feminist and queer criticism is now accomplishing this important task in both contemporary and historical work, as the excerpts in this section suggest.

Beginning with the pioneering work of Michel Foucault (1978), historians of sexuality have shown that modern notions of sex and gender are historically constructed rather than being eternal expressions of stable truth. Thomas Lacquer describes how medicine came to define an essential difference between men and women only as late as the eighteenth century, breaking with the classical tradition of seeing the human body as essentially one type with two variations (Lacquer 1990). In her essay, taken from her forthcoming book *Art and Anatomy from Albinus to Charcot*, Anthea **Callen** quotes the physician Pierre Roussel, writing in 1775: 'The essence of sex is not confined to a single organ but extends, through more or less perceptible nuances, into every part.' What had previously been a simple inversion of genitalia (male/outside; female/inside) had become a distinguishing mark of every part of the human anatomy. At the same time, medical science came to believe that the condition of the human body could be interpreted visually under what Foucault called the 'diagnostic gaze.' It followed that the sexual difference between men and women must be fully visible. In a careful study of the content of form, Callen examines how the eighteenth-century anatomist Albinus made sexual difference a key aspect of his obsessively detailed engravings of the human skeleton, which none the less failed to find a practical application. Its pose was drawn from the classical statue known as the Apollo Belvedere, which Callen argues

> suggests an authority based on command both of the self, and of know-
> ledge; a mutually reinforcing self-control and control of the environment.
> These ideas are rehearsed by anatomist and engraver in the actual
> making of this image which, through the very process of its material-
> ization, enacts a man's claim to rational authority over (feminine)
> nature.

Far from being a dispassionate assemblage of artistic and medical knowledge, the skeleton engravings represent an incorporation of the new sexualized distinction among humans into the very structures of life itself.

From a psychoanalytic standpoint, such manoeuvres are no surprise, for reality is in the eye of the beholder. The art historian Tamar **Garb** shows how Freudian notions of difference can be used to explain historical dilemmas concerning the gaze in her interdisciplinary study of women artists and the reception of their work in the late nineteenth century (Garb 1993). In a century-long struggle women artists finally claimed the right to an equal art education in the period, only to be denied access to the life class where students drew the nude male figure. For the possibility of the female gaze actively consuming the male figure awakened the fear of castration evoked by what Garb calls 'the man's beholding of the *woman who looks*.' For Freud, castration was associated with 'the sight of something.' He held it to be axiomatic that 'probably no male human being is spared the terrifying shock of

threatened castration at the sight of the female genitals' (Freud 1959). The lack of a penis on the female body suggested that a body without a penis was possible and could be achieved by castration. Perhaps only in the rigid sexual binary established in the nineteenth century could such a psychic structure have seemed possible. In an art world that prized the capacity of art to 'transcend the physical,' the presence of women – who in a sense defined the physical – threatened to undermine the tremulous ideology of art's relationship to the 'natural,' that is to say, the division of the human into distinct, sexed types. Garb shows how these anxieties and dilemmas were worked out in a popular nineteenth-century short story of a woman artist painting a male model that is all the more significant for its very ordinariness.

The two subsequent extracts offer alternative histories of sexualized looking in the nineteenth century, inspired by queer theory. Queer has been productively defined by Eve Kosofsky Sedgwick as 'the open mesh of possibilities, gaps, overlaps, dissonances, and resonances, lapses and excesses of meaning when the constituent elements of anyone's gender, of anyone's sexuality aren't made (or can't be made) to signify monolithically' (1993: 18). As this 'definition' suggests, this version of queer destabilizes all forms of singular identity, whether of 'race,' ethnicity, or nationality, as well as those of gender and sexuality. Queer theory does for sexuality what deconstruction did for philosophy. Jacques Derrida has worked for forty years to show how binary oppositions tend to collapse into each other under rigorous examination, such that rather than finding identities to be based on difference, he has used the term *différance*, a fusion of the French words for differing and deferring. That is to say, difference is always already deferred, rather than existing in some pure state. While Derrida's work was for a long time criticized by Anglo-American philosophy for lacking relevance to the real world, his concepts are now informing an ongoing re-evaluation of identity politics.

In her book *Becoming* (1999), excerpted here, Carol **Mavor** looks at women looking at women. In a remarkable study of the photographs taken by the British aristocrat Lady Clementina Hawarden of her daughters in Victorian London, Mavor finds a certain feminine quality to photography itself, noting that 'the female body infinitely reproduces itself, like a photograph.' This reproductive quality has usually led the photograph to be classified as a machine product but Mavor shows how Hawarden reduplicates the image in terms of subject matter, form and medium. Her purpose is not so much to claim fetishism for women as it is to open new ways of thinking about femininity and photography. In reading one photograph of the young Clementina and her sister Isabella, Mavor provocatively writes: 'Clementina is becoming: she is coming into the sexuality and changing body of Isabella; she is coming into her own sexuality; and she is very becoming.' Her writing is at once sexy and taboo, breaking academic convention by admitting its own investment and challenging us to rethink the libidinal economy of the family. This is not, of course, to say that she in any way attributes actual sexual activity to these women, but rather to say that the patriarchal rendering of female desire by Freud and others has failed to account for its reduplicative nature.

In his survey of gay male spectatorship in photography and film from the nineteenth century to the present, Thomas **Waugh** further complicates the lexicon of

spectatorship (Waugh 1993). He shows that, while classic narrative cinema may deny the presence of the spectator, gay cinema has always been aware of its audience. He argues that three types of male body are offered to the homoerotic gaze. First was the ephebe, the young man with a slender androgynous figure, who was highly popular in the nineteenth century but has fallen under suspicion in the age of moral panics concerning child sexuality. Second was the 'he-man,' the muscular figure of the mature athlete that is as familiar from classical and neo-classical images of the body as from contemporary 'clones.' While these two body types have a history going back to ancient Greece, there is also a third body in gay cinema. This third body, 'the looking, representing subject, stood in for the authorial self as well as for the assumed gay spectator.' Waugh centers his discussion on the gay subject that actively gazes, rather than on its object. However, he does not argue that in itself the creation of a gay subject takes us beyond received patterns of sexuality. On the contrary, 'the same-sex imaginary preserves and even heightens the structures of sexual difference inherent in Western (hetero) patriarchal culture, but usually stops short of those structures' customary dissolution in narrative closure.' That is to say, rather than a binary difference being at work, there is a *différance* that leaves us without the closure of a wedding at the end. Waugh delineates a 'taxonomy of gay-authored cinema' created by directors who actively exploited the 'built-in ambiguity of the narrative codes of the art cinema.'

The question of ambiguity and identity is central to the concluding two essays in this section. In her essay 'Looking Good,' Reina **Lewis** examines how the ambiguous identifications at work in fashion photography operate when placed in publications explicitly aimed at a lesbian audience. For some time, mainstream magazines like *Vogue* have played with sexually ambivalent imagery in ways that the advertising industry terms 'gay-vague,' meaning that the images can be read in hetero- or homosexual ways, depending on the viewer's inclination. In such imagery, Lewis emphasizes, 'it is the act of interpretation itself that is eroticized.' Consequently, she no longer speaks of 'the' lesbian gaze but of a variety of viewpoints that might be taken by different women (and even some men) that can produce what she calls 'lesbian pleasure, a pleasure that would be available to anyone able to exercise a similar competency, whether lesbian or not.' At the same time, the development of a 'pink economy' – queer consumerism – has brought with it magazines explicitly intended for a lesbian readership that have taken on fashion as part of their editorial policy. In reading these magazines, Lewis examines how such fashion imagery works when same-sex pleasure is their overt, rather than covert, goal. She shows that the cultural politics of the lesbian community in Britain were in many ways hostile to the fashion industry, leading to a 'realist' mode of representation in such photography, aiming for a careful balance of ethnicities, ages, body types and so on. She concludes that 'some lesbian and gay readers demand unambiguous politically or aesthetically "safe" images, whereas they revel in transgressive, contradictory and subversive pleasures in the mainstream.' Although she is careful to emphasize the provisional nature of her conclusions, Lewis suggests that a unified theory of the gaze should be replaced with a study of 'the relationships between meanings.'

In Judith **Halberstam**'s reading of the popular film *Boys Don't Cry*, this new direction can be seen in film studies, the home of theories of the gaze for some thirty years. The very success of the film is testament to the changed cultural climate. Based on the life of Brandon Teena, a transgendered person from Nebraska, who was raped and murdered in 1993, after his 'female' anatomy was revealed, *Boys Don't Cry* placed gender ambiguity in the American heartland. The ambiguous 'third body' spectatorship that Waugh and Lewis found in art cinema or in minority groups was now being sold to the mainstream cinema audience – and winning Oscars. Halberstam's close reading of the cinematic structure of *Boys Don't Cry* is analogous to Mavor's long look at Hawarden's photographs. Again the reader is rewarded with a powerful new means of conceptualizing looking: in this instance, that which Halberstam calls 'the transgender gaze.' Halberstam shows that, under the direction of Kimberley Peirce, *Boys Don't Cry* first constructs a transgender gaze only to abandon it at the end. In a careful reconstruction of the central scene in which Brandon is violently 'revealed,' Halberstam identifies his girlfriend Lana's willingness 'to see what is not there (a condition of all fantasy) . . . as a refusal to privilege the literal over the figurative.' By contrast, when Brandon is forcibly examined in the bathroom, 'the film identifies the male gaze with that form of knowledge that resides in the literal.' What is so striking about the film as a representation of looking is that it does not leave things at this all-too-familiar binary. Rather, we see Brandon having an 'out of body' experience as a clothed Brandon looks on from the crowd at the tortured Brandon. Halberstam powerfully analyses this moment: 'In this shot/reverse shot sequence between the castrated Brandon and the transgender Brandon, the transgender gaze is constituted as a look divided within itself, a point of view that comes from two places (at least) at the same time, one clothed and one naked.' Further the possibility of a transgender subject position is made possible by the female gaze – that is to say, because 'Lana is willing to see him as he sees himself.' The utopian aspirations of the film were visualized in a series of time-lapse shots of the night sky in counterpoint with a romantic, Beat evocation of the Road as a means of escape and self-discovery. Perhaps inevitably – given that it was a Hollywood production – the film retreats from these positions, especially in the moment highlighted by Halberstam in which Brandon and Lana have sex after his rape by John and Tom. Here 'Brandon interacts with Lana *as if he were a woman*' and the couple become lesbians. The director defended this scene on the grounds that it was 'true to life' because Lana had told her it happened. At the same time, the film elided the third murder committed at Lisa Lambert's house – that of Philip Devine, a disabled African American man who had been dating Lana's sister – for fear of complicating the plot. If by the end of the film a certain normativity has been restored, *Boys Don't Cry* nonetheless attests to the possibilities that now exist for a reconfiguration of the gaze. Arguably, a transgender 'gaze' is no longer something so disciplinary as a gaze at all but an opening to other ways in which identity, looking and sexuality might be configured.

(b) Techobodies/technofeminism

It is worth recalling among this panoply of new scholarship on gender, sexuality and vision that it is not so long since it seemed important to reclaim vision as a feminist subject (separate from the issue of visual representation that has long been identified with feminist scholarship). In a key section of her now classic book *Simians, Cyborgs and Women* (1991), Donna **Haraway** used vision and the visual as a means of reconfiguring the academic totem of objectivity. She replaced what she called the 'conquering gaze from nowhere' with an insistence on the 'embodied nature of all vision,' challenging the orthodoxies of observational science, just as Descartes challenged the complacencies of scholasticism. Haraway argues that while vision is never found in the pure state suggested by the geometric lines used in Cartesian perspective, nor is everything simply relative. Replacing the disembodied view from above with the individual view from somewhere, she emphasizes that 'optics is a politics of positioning. ... Struggles over what will count as rational studies of the world are struggles over *how* to see.' Like Descartes, Haraway recognizes that understanding vision is central to what will be accepted as rational method. Unlike him, she overtly acknowledges that vision is always about power and positioning, meaning that any method must be partial in both senses of the term.

Following Haraway's lead – and that of other feminist scholars like Sandra Harding and Chéla Sandoval – has come an exciting rethinking of the embodiment of vision. For in an era when the body seems more analogous to the computer or at least the cyborg than the machine of earlier imaginations, it is no longer clear what the body itself might be. Indeed, new medical technology has transformed the ability to visualize the body to such an extent that, in Anne **Balsamo**'s striking phrase, 'these new visualization techniques transform the material body into a visual medium.' In this extract from her renowned essay 'On the Cutting Edge' (1992), Balsamo shows that feminist analyses of the medical classification of the female body into a series of potentially pathological fragments now have to be supplemented with an interpretation of cosmetic and reconstructive surgery. Rather than trying to delve deeper into the body as the medical gaze wants to do, these procedures concentrate solely on its surface appearance. They further short-circuit the traditional interpretation of beauty as the external representation of inner virtue, or its late capitalist counterpart that sees a 'good' body as the reward for hours of 'work' in the gym and suitable self-denial of food and other pleasures. At the same time, plastic surgery enforces aesthetic norms for the body, as Balsamo argues: 'Cosmetic surgery *literally* transforms the material body into a sign of culture.' While women have long had to contend with abstract standards of femininity and beauty, cosmetic surgeons can now apply these standards directly onto the body, based, in the terms of a standard textbook on the subject, on a 'scale of harmony and balance. . . . The harmony and symmetry are compared to a mental, almost magical, ideal subject, which is our base concept of beauty.' Unsurprisingly, the 'ideal face' turns out to be 'white,' northern European.

Balsamo concluded in 1992 that 'the body becomes the site at which women, consciously or not, accept the meanings that circulate in a popular culture about ideal beauty and, in comparison, devalue the material body.' In other words, if the

body you've got isn't right, 'get fixed.' What value should be placed on this change? Balsamo noted the widespread fashion for body-piercing, cyberpunk fantasies about technological prostheses – and one might add the cosmetic surgery performance art of Orlan – and suggested that we might need to move beyond a 'neoromantic wistfulness about the natural unmarked body' that is, after all, the guiding ideal of cosmetic surgery. It could also be said that indigenous peoples in the Americas, Africa and Oceania have many varied traditions of marking the body and there is a hint of racialized distinction in the desire for unmarked, that is to say white, perfection. Indeed, as essays like Balsamo's have been widely disseminated in Western culture, there have been several apparently paradoxical consequences. The falsity of plastic surgery is understood but has become accepted and even desired as such. As less invasive procedures like collagen and Botox shots have become available, the threshold of cost and social disruption involved has become much lower. In fact, far from there being a move towards more 'natural' bodies, men have also become subject to the regulatory norms. Popular magazines like *Men's Health* regularly put a muscular model, nude to the waist, on the cover. In such shots, the selling point is the 'six-pack abs,' or well-defined stomach muscles, of the model. One could read this in several ways. On the one hand, the casual acceptance of homoerotic imagery as a point of consumer desire is certainly an interesting and desirable development. On the other, the spread of an ever-more elusive and expensive version of the abstract 'normal' body might give us pause. One little noticed consequence of the September 11 attacks, according to the *New York Times*, was a dramatic increase in minor cosmetic surgery procedures: defiance of terrorism or compliance with the standards of beauty?

In an extract from her widely acclaimed book *Body Art*, Amelia **Jones** responds to these dilemmas by thinking of the body as a site of performance in the digital era. Jones argues that the Cartesian subject critiqued by Haraway has now been transformed 'into a dispersed, multiply identified postmodern subject both in theory and practice.' Taking an avowedly upbeat view of the possibilities afforded by new technology, Jones looks at the work of recent artists like Gary Hill and James Luna who have placed the body once again at the center of their work after the conceptually dominated 1980s. However, rather than simply returning to the live performance of earlier artists like Vito Acconci or Hannah Wilke, younger artists have tended to work with a technologically mediated subject that, in Jones's phrase, 'scatters the body/self across video screens.' This work was appropriate for a generation that could echo the American Indian artist James Luna in saying: 'I was born in a TV.' Soon to come will be the work of a new generation born in computers. Unlike some other commentators, Jones strikingly suggests that such 'recognition of the body/self as dispersed, multiple, and particularized has dramatically progressive potentialities, especially for women and other subjects historically excluded from the privileged category of "individual."' One remarkable instance of what this dispersal might look like was Bob Flanagan's proposed video piece *The Viewing*, in which a spectator could opt to turn on a video camera placed inside Flanagan's coffin and view his decaying corpse. This is no *memento mori* with its implied consolation of faith or philosophy but a radically new way to see the body as its

subject can never see it. As the title suggests, what matters is not the 'meat' of the body so often evoked in cyber discourse but the viewing of it. The body has become (fill in as preferred) vision/performance/virtual. Or simply say, the body is becoming.

Further reading

Balsamo, Anne (1996) *Technologies of the Gendered Body : Reading Cyborg Women*, Durham, NC: Duke University Press.

Butler, Judith (1997) *Excitable Speech: A Politics of the Performative*, London and New York: Routledge.

Cheang, Shu Lea, 'Brandon' web-based multi-layered narrative of Brandon Teena's life, http://brandon.guggenheim.org/ – accessed on 24 November 2001.

Foucault, Michel (1978) *A History of Sexuality: An Introduction*, New York: Vintage.

Freud, Sigmund (1959) 'Fetishism,' in *The Standard Edition of the Complete Psychological Works of Sigmund Freud*, J. Strachey (ed.), volume xix, London.

Fuss, Diana (1995) *Identification Papers*, London and New York: Routledge.

Garb, Tamar (1993) 'The Forbidden Gaze: Women Artists and the Male Nude in Late Nineteenth-Century France,' in Kathleen Adler and Marcia Pointon (eds), *The Body Imaged: The Human Form and Visual Culture since the Renaissance*, London and New Haven, Conn.: Cambridge University Press.

Halberstam, Judith (1999) *Female Masculinities*, Durham, NC and London: Duke University Press.

Haraway, Donna (1991) *Simians, Cyborgs and Women: The Reinvention of Nature*, London and New York: Routledge.

Harding, Sandra (1998) *Is Science Multicultural?: Postcolonialisms, Feminisms, and Epistemologies*, Indiana University Press.

Harding, Sandra and Narayan, Uma (eds) (2000) *Decentering the Center: Philosophy for a Multicultural, Postcolonial, and Feminist World*, Indiana University Press.

Horne, Peter and Lewis, Reina (1996) *Outlooks: Lesbian and Gay Sexualities and Visual Culture*, London and New York: Routledge.

Lacquer, Thomas (1990) *Making Sex: Body and Gender from the Greeks to Freud*, Cambridge, Mass.: Harvard University Press.

Mavor, Carol (1999) *Becoming: The Photographs of Clementina, Viscountess Hawarden*, Durham, NC and London: Duke University Press.

Muñoz, José (1999) *Disidentification: Queers of Color and the Performance of Politics*, Minneapolis: Minnesota University Press.

Sandoval, Chéla (2000) *Methodology of the Oppressed*, Minneapolis: University of Minnesota Press.

Sedgwick, Eve Kosofsky (1993) *Tendencies*, Durham, NC: Duke University Press.

Waugh, Thomas (1993) 'The Third Body: Patterns in the Construction of the Subject in the Gay Male Narrative Film,' in Martha Gever (ed.), *Queer Looks: Perspectives on Lesbian and Gay Film and Video*, London and New York: Routledge.

—— (1996), *Hard to Imagine*, New York: Columbia University Press.

Wilchins, Riki Anne (1997) *Read My Lips: Sexual Subversion and the End of Gender*, New York: Firebrand.

(a) The gaze and sexuality

Anthea Callen

IDEAL MASCULINITIES
An anatomy of power[1]

I N THE SEARCH for an affirmative answer to Montesquieu's question 'Does natural law submit women to men?', the question of the 'nature' of woman became a priority of Enlightenment research in the eighteenth century.[2] Human anatomy was an important focus of this preoccupation in medical science: the male body provided an anatomical norm against which femaleness could be construed.

The terms 'male' and 'female' here refer to biological distinctions of gender, with the proviso that the sciences are, in themselves, culturally produced and by no means ideologically neutral or trans-historical. I link the terms 'masculine' and 'feminine' to the cultural naming and attribution of human characteristics according to binary principles: they work to define difference with respect to gender in ways that valorise particular qualities over others. This process of differentiation is cultural, serving to position men and women within a hierarchical social order.

Visual representations of the body are particularly powerful in this respect: their impact is direct and immediate. They depend upon a common visual vocabulary – of marks, of lines, shading, and sometimes color – a vocabulary learned and as such admitting those with educational privilege to shared view and meaning which excludes others; all may look (if they have access to the image) but for some the body is 'foreign', undecipherable. In the present context I look here specifically at classicism – the language of an educated elite – as a style, and of the messages it contains. Visual images are, then, potent mediators of the lived experience of the body, our own and others, giving us ways of conceptualising and describing the bodily. In pictorial images we recognise likeness or difference; we identify ourselves, or find a different 'other,' an other which, equally powerfully, serves to reinforce our image of our own bodily existence. Yet however carefully observed, the represented body is an abstracted body: the product of ideas that are culturally and historically specific, and in which the social formation of the producer determines the appearance and meanings of the body; its meanings are then further modified

in the act of consumption. The making and meaning of the visual body's cultural message is, therefore, a dynamic process under constant re-vision.

My argument therefore assumes that there is no such thing as a 'natural' body: all bodies – whether an historical anatomy or a Raphael nude – are socially constructed; all are representations which embody a complex web of cultural ideas, including notions of race, class and gender difference. Our own bodies, and our experience of them are also culturally mediated. My particular interest is in the overlap between art and medicine in visualising the body, and most notably in anatomies which could serve the needs of both disciplines – anatomies which focused on the outwardly visible structures: the skeleton and superficial muscles. This essay concentrates on the skeleton, and my principal example for analysis is an Albinus *Human Skeleton*, published in Leiden in 1747.[3] The fact that 'human skeleton' refers to a male skeleton is symptomatic of the normative function of the male body in anatomical paradigms. My interest is in decoding the visual language of anatomies: the messages contained not simply in their subject matter, but in the choice and use of medium, of pose types, proportions, setting and accessories. What view of masculinity was constructed in medical and artistic anatomies, and how was that view materially embodied? In a close visual analysis of the Albinus, I want to show what such material can reveal.

In sixteenth- and seventeenth-century anatomies sexual difference was not a principal concern. Early eighteenth-century thinkers still considered the only anatomical differences between men and women were to be found in their sexual organs. Yet it is clear from extant examples that differentiation appears both in the choice of the sex of the subject depicted, and in the dissected examples selected for illustration. Thus the vast majority of 'in depth' dissections – of internal organs, veins, nervous system, etc. – depicted the male body, whereas the female body was used almost exclusively to illuminate woman's sexual difference – her reproductive organs and the gravid uterus.[4] The assumption implicit here was that male and female bodies are essentially the same, and that the male anatomy could represent both in all respects apart from reproduction.

However, by the mid-eighteenth century this assumption came under attack, as physiological bases for gender difference – for man's 'natural' superiority – were sought. In 1775, for example, the French physician Pierre Roussel reproached his colleagues for considering woman similar to man: 'The essence of sex is not confined to a single organ but extends, through more or less perceptible nuances, into every part.'[5]

Up until the early seventeenth century, then, the human skeleton was synony-mous with the male skeleton. Thus, although *gravida* images were common, the first known illustration of a female skeleton dates from 1583, in a crude engraving by Platter, redrawn and reversed in 1605 by Bauhin.[6] Detailed investigation of a distinctively female anatomy only began in the second half of the eighteenth century. As has been shown in respect of the Scot William Hunter's obstetrical atlas, published in 1774, 'seeing was knowing':[7] the visual held primacy, and illustrations of natural phenomena were taken to constitute reality. Thus the visual evidence of skeletons – or rather, and crucially, of their culturally mediated form as *illustrations* of skeletons – came to be used as objective scientific proof of woman's 'natural difference'. Given its long and unquestioned visual history and hegemony, the male

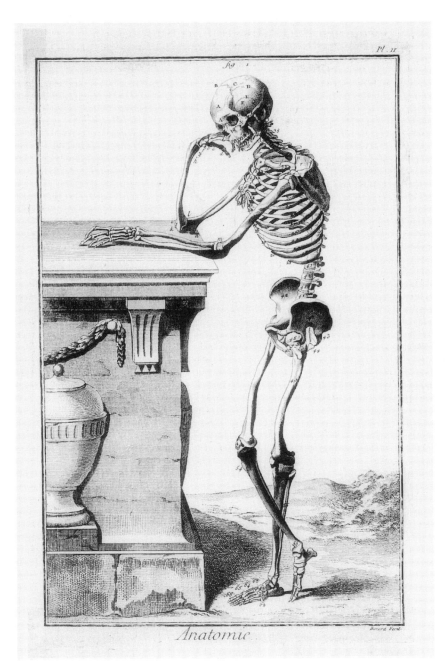

Figure 52.1 Lateral view of the human male skeleton, by Bernard, after Andrea Vesalius
(Courtesy the Wellcome Institute Library, London)

skeleton provided an established norm; it was thus against a male skeletal paradigm that the female skeleton came to be measured – and found wanting. In particular, medical and artistic authorities accepted the male skeleton by the Netherlandish anatomist Bernard Siegfried Albinus (Figure 52.1), which remained unsurpassed for at least three-quarters of a century. My analysis depends upon the view that anatomical prints, like all other visual images, work actively in the production of cultural values – in this case ideals of the male body and of masculinity.

Pose and proportions

Anatomies are, of course, representations of the human body – albeit bodies stripped in varying degrees to the skeleton. This Albinus figure – it is constructed as such – stands upright and gestures evocatively as if still living. The pose is meaningful both in the practical sense, in that it displays the skeletal structure in an informative manner, and discursively through its iconographic references. Set in a landscape, the figure's eloquent left index finger, the spread right hand, the tilt of the head and the classical *contrapposto* communicate the graceful melancholy of a Poussinesque *et in arcadia ego* (Figure 52.2). Such symbolism was common in anatomical prints, and can be seen even more explicitly in the Vesalius *memento mori* anatomy, 'Bones of the human body,' in which the male skeleton reflects upon a tomb (Figure 52.1).

The pose chosen for the Albinus figure is not accidental. Drawn directly from the classical tradition, in a form which would have been immediately recognisable to his elite, classically educated Enlightenment audience, it is based on the Apollo Belvedere (Figure 52.3) – according to Winckelmann the 'highest ideal of art among the works of antiquity that have escaped destruction':

> His build is sublimely superhuman, and his stance bears witness to the fullness of his grandeur. An eternal springtime, as if in blissful Elysium, clothes the charming manliness of maturity with grace and youthfulness, and plays with soft tenderness on the proud build of his limbs.[8]

A French writer following Winckelmann echoed these sentiments, finding the Apollo the Greek statue which, 'by his air of grandeur, stirs your passion, penetrates you and makes you sense the flash and brilliance of a super-human majesty which he sheds . . . all around him.'[9] Albinus's choice of pose thus intentionally imbued the male anatomical ideal with connotations of the Sun God – the god of intellectual, moral and, according to eighteenth-century thinkers, (homo)erotic en*light*enment.[10] Kenneth Clark was more circumspect in his admiration than his eighteenth-century precursors:

> [Apollo] was beautiful because his body conformed to certain laws of proportion and so partook of the divine beauty of mathematics . . . Since justice can only exist when facts are measured in the light of reason, Apollo is the god of justice, vanquisher of darkness.[11]

And hence ignorance. The Albinus anatomy thus signals reason dispelling ignorance, and simultaneously, the dark shadow of the other, the feminine. Commonly taken to represent the moment after the youthful Apollo's slaughter of the Pythian serpent with an arrow, for Winckelmann the sculpture was 'an ideal conflation of the austerely sublime and sensuously beautiful', with the 'potential to be the focus of competing fantasies of unyielding domination and exquisite desirability.'[12] The combination of supreme power and vulnerability identified in the Apollo Belvedere

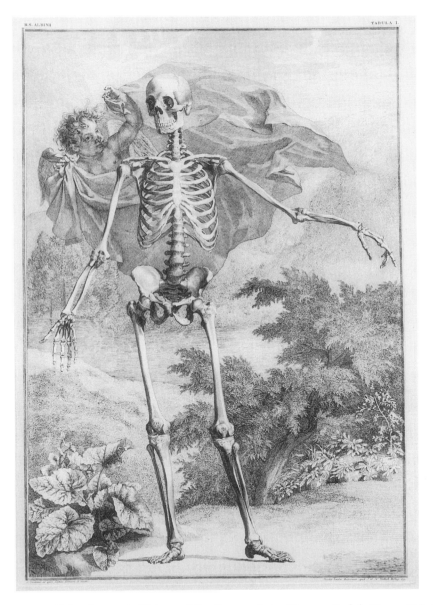

Figure 52.2 Bernard Albinus, 'The Bones of the Human Body' (From *Tabulae sceleti et musculorum corporis humani*, Leyden, 1747. Courtesy the Wellcome Institute Library, London)

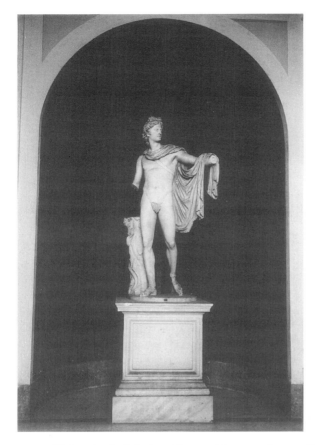

Figure 52.3 *Apollo Belvedere*, Vatican Museum, Rome (Courtesy of the Conway Library,
Courtauld Institute of Art)

by eighteenth-century writers, is reinforced in the image of the skeleton, where an
ambiguous mortality suggests both vulnerability and power.

Just as the Apollo was based on carefully calculated, 'mathematical' propor-
tions, so too – in the Renaissance Humanist tradition – was the Albinus skeleton.
The anatomist's approach fused a classical aesthetic with an almost obsessive
Netherlandish scientific empiricism. He was explicit about his methods in the
introduction to the 1747 volume, *Tabulae sceleti et musculorum corporis humani*,
pirated, in translation, in London in 1749.[13] Albinus chose his dead subject on the
basis of two criteria. First, the body's beauty – 'I cannot help congratulating
my good fortune' on finding the right corpse, he wrote. He emphasised the need
for the subject to be 'elegant and at the same time not too delicate; so as neither
to show a juvenile or feminine roundness and slenderness; nor on the contrary
an unpolished roughness and clumsiness.' Here is clear evidence of gender- and
class-specific determinants guiding Albinus's selection of an ideal, a Platonic
ideal, rather than purely scientific concerns. The second criterion was Albinus's
ideals of male proportion. These he then explicitly improved upon in the manner
of classical art:

As therefore painters, when they draw a handsome face . . . render the likeness the more beautiful [by removing blemishes]; so these things which were less perfect, [in the skeleton] were mended in the figures . . . care being taken at the same time that they should be altogether just.[14]

Just – 'fit, proper, accurate, precise, impartial'; the *justice* of Apollo.

The wish for a selective, idealised beauty was combined with a desire for mathematical precision in the accurate recording of the skeleton. Albinus's methods were novel, and extravagant in their cost and rigour. He suspended his anatomical example by a complex arrangement of ropes and pulleys, with rings in the ceiling, to establish the pose with its weight on the right foot: the classical *contrapposto*. A live model of comparable stature was posed alongside the skeleton, to enable Albinus to set up and correct its lifelike pose; by pulling the cords and using wedges, the position of the naturally articulated skeleton could be adjusted – a procedure which took some days to complete. 'Naturally articulated' means the bones still held together by the bodily materials, cartilage, etc., which held them together in life.

Albinus's engraver was Jan Wandelaar, and the artistic product of such a collaboration clearly depends greatly on both the skills of the artist and the quality of his relationship with the anatomist. The *Tabulae sceleti* took over twenty years to complete, so the two men worked closely over an extended period. Wandelaar lived in Albinus's house and was very much under the anatomist's direct authority: he was evidently a hard taskmaster. The copper plates were preceded by careful drawings. In order to save the engraver from stooping while working in front of his subject, his work was positioned on a tripod on a table. Effectively this also meant that the engraver did not have constantly to change his angle of vision and move his eyes from the line of the model when transferring his observations to the plate – hence the arrangement was designed to improve the accuracy of his pictorial record.

Albinus considered taking measurements from the skeleton too time-consuming:

I foresaw that the . . . [drawing] would be very incorrect . . . if it was taken off by merely viewing the original, as ingravers [*sic*] commonly do . . . [to take a measurement of every part] was an infinite task, nor could it possibly be done without some certain infallible rule to direct the ingraver.[15]

Albinus's solution was to use a more sophisticated version of Dürer's perspectival grid (Figure 52.4): in place of a single grid, Albinus used two nets, or grids of small cords. One grid was placed directly in front of the skeleton, the other, with squares a tenth the size, was positioned four 'Rhenish feet' (30.8 cm × 4) away from the skeleton.

The ingraver [*sic*] placing himself in the most proper situation near the skeleton . . . endeavoured to make some point where the cords of the lesser [net] . . . coincide to the eye with the corresponding decussating point in the cords of the greater one; and the part of the skeleton which was directly behind these points, he drew upon his plate

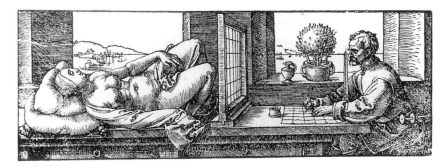

Figure 52.4 Albrecht Dürer's perspectival grid, 1525 (Courtesy of the Whit Library, Courtauld Institute of Art, and Graphische Sammlung Albertina, Vienna)

. . . which was similarly marked out. [He] was to find out a proper place for viewing [the skeleton] through the [nets], by means of a fixed hole, not very large; which by applying his eye to, he could see what parts of the skeleton answered to [the cords of the grid] . . . According to this method then (which as it answered the intention, so it occasioned an incredible deal of trouble to the ingraver) a fore view of the skeleton was first drawn as it stood.

This was followed by back and side views, at which point the skeleton was disarticulated and the bones cleaned completely, each one then being drawn to natural size, which served, he said, as practice for the artist.[16] This grid technique would, given the constraints of observing the subject with a single eye through a small hole (as in the Dürer), have required the engraver to adjust the positioning of the hole – his viewpoint – a number of times, sideways, and up and down, in order to piece together a view of the complete skeleton as a whole.[17] Simultaneously, Wandelaar would have had to maintain an equal viewing distance on the vertical skeleton, from top to toe: any change in the perpendicular angle of vision – and hence to the viewing distance from the skeleton – which would result from gazing up, down or across, would have produced distortions (parallax) in the final image. Albinus's method would have further complicated Wandelaar's work because of the need to take the eye from the hole while transferring the observed data to the depiction, and then to re-focus at the eye-hole.

It is clear from these meticulous procedures the degree of Albinus's concern with scientific precision in his anatomical figures. Of course, the chosen methods themselves also carry meaning. However accurate the grid system may in fact have been – and its success depended greatly on the talents of the engraver – Albinus's methods endowed him with the authority of a man of science. His search for precision was, as we have seen, wholly in keeping with eighteenth-century ideals of classical beauty: the divine beauty of mathematics, the beauty of harmony and symmetry and, in this context, the beauty of the masculine. The chosen proportions of the skeleton also conform to classical ideals of perfection: it is a figure of eight heads; in other words, the head divides seven times into the length of the body.

Composition and medium

Compositionally, the Albinus skeleton is positioned to fill the pictorial space. Placed close to the picture plane, it makes full use of the engraved surface of the plate. In the print, the skeleton's extremities reach close to the framing edge on all four sides, giving optimum display while creating a dynamic tension between figure and frame which heightens the sense of figural animation. Obviously the disposition of the figure is partly determined by the scientific purposes of the print – the need to inform the viewer by exposing the maximum information possible in a two-dimensional image. The pose permits a fair degree of empirical detail, but the limitations of the print medium and flatness exclude much of medical interest, not least the forms in-the-round of the bones: a series of different views (front, side and rear) of a skeleton are required to 'add up' to a fuller anatomical picture. Three-dimensional examples of human anatomy, like those in wax, can be far more informative but were primarily used for representing internal organs: the technical limits of the wax medium constrain its use in complete skeletons. Apart from the plaster cast reproductions after sculpted flayed figures (écorchés) which were in widespread use for teaching, anatomical sculptures, whether in wax or wood, were costly one-offs which did not offer the same potential for dissemination as the printed image.

The question of dissemination is in itself highly pertinent here, and a grand volume such as this initiated by Albinus himself (engraved surface of the plates in this series c.56 × 40 cm) were by no means cheap to produce or buy: the *Tabulae* took an estimated twenty-two years to complete; the engraving alone took eight years.[18] As far as professional medical usage was concerned, the most successful volumes tended to be the practical anatomies like Bauhin's *Theatrum anatomicum . . .* of 1605, a chunky quarto of 1,300 pages, which were relatively small and portable. The audience for anatomies like the Albinus was by no means exclusively medical; such exquisite images were greatly sought-after for gentlemen's cabinets of curiosities: well-off physicians, surgeons, men of letters, aristocrats and connoisseur-collectors acquired such tomes, but not medical students. Indeed, although human anatomy promised a greater understanding of the body's constituent parts, it had only limited practical application for the medical profession (with the exception of obstetricians and midwives) before the advent of anaesthetics, antiseptics and deep surgery in the late nineteenth century;[19] thus anatomical prints like those of Albinus were chiefly of intellectual, taxonomic and curiosity interest. And, I would argue, of great ideological importance.

Medical science and scientific accuracy were not the exclusive motives behind the Albinus print's conception. It does represent, however, a prototypical male nude. Whether nude or skeletal, the male figure in art is consistently shown as inhabiting and defining its own space. Here, the full-frontal view, the out-turned feet, the spread-eagled arms, all extend the male body to show man's ownership of the world around him.

The commanding pose of the Apollo Belvederesque skeleton communicates an expansive openness; but it is not open in the sense of receptive, rather of complacent self-assurance – notably paradoxical given that it is a skeleton. The pose suggests an authority based on command both of the self, and of knowledge; a mutually reinforcing self-control and control of the environment. These ideas are rehearsed by

anatomist and engraver in the actual making of this image which, through the very process of its materialisation enacts man's claim to rational authority over (feminine) nature: nature cleaned up, perfected, ordered and reduced to the cool engraver's medium – the crisp burin mark in copper, the classical certainties of line: 'black and white', as we say. Engraving requires absolute precision, for mistakes are not readily changed or erased: burnishing can be used to efface only the shallowest of cuts. The engraver's tool stands for the scalpel, its incision a metaphor for the process of dissection itself. The resulting engraved lines, paradoxically a mirror-image of the original subject reversed in the printing process, form a language connoting clarity, cleanliness and objectivity which gives the viewer an illusion of control over the 'natural' body in all its gory unpredictability. Equally, the physical disorder of the medium, the oily black printer's ink which gets everywhere and filthies the (craftsman) engraver's hands in the process of printing, is a gory mess contained in the workshop and rendered invisible in the perfection of the finished print: the viewer is intended to register the message rather than the medium. Such images, then, rehearse a macabre pantomime of human frailty; terror of the material body and its functions is laid bare and simultaneously contained within the reassuring conventions of the classical idiom: hence the body is returned to man's ownership.

The Apollo Belvedere embodies the notion of masculine authority: alert and commanding, he is literally a man of vision. Although the skull and 'gaze' of the Albinus figure are lowered, suggesting a more introspective demeanour, a greater interiority, reflection is posited as the product of *knowledge* (in this case of man's mortality) and knowledge ensures authority. Hence the historical link to the Belvedere provides, in this *memento mori*, an assurance of spiritual immortality thanks to man's enlightened state. The early Christian iconographic tradition, in which Apollo transforms into Christ, reinforces this reading of the Albinus skeleton. At the same time, the erect stature and almost arrogant dignity of the skeleton's pose ensure its embodiment of the Belvederesque ideal of a dominating masculinity. This is reinforced in the spatial arrangement of the skeleton in its setting. Where Albinus's elaborate copying methods eliminate a specific viewing position on the figure itself, Wandelaar's landscape setting – with its low horizon and thus viewpoint – constructs the spectator's eyeline as well below that of the skeleton. Thereby inscribed in a position of pictorial, and thence social and moral, inferiority, the spectator 'looks up' to/at the super-human perfection of the skeleton. However, where in the Belvedere the elegantly twisting torso is achieved by non-alignment of hips and shoulders, and sensual vitality is enhanced in the accentuated spinal 'S' curve, the Albinus is more squarely frontal and 'grounded,' suggesting a greater civic *gravitas*. In the equation domination–desirability which Winckelmann found exquisitely balanced in the Apollo Belvedere, the Albinus skeleton tips the balance away from the sensual (which arguably depends on flesh and muscle) and towards the powerful. Thus masculine power is idealised through the male anatomical figure's embodiment and subtle modification of particular classical associations, reminding the spectator to identify a normative masculinity with that formal idea.

By naturalising the Belvedere pose within a medical discourse which also served to inform artists and their patrons, Albinus underwrote the ideal physique of the classical statue with an authenticity guaranteed by the natural sciences. In this

reflexive relationship of meaning, the two figures are mutually validated and ensure each other's authority; so, too, the professional status of the anatomist himself. Artists sought both to give anatomical conviction to the forms of their male figures, and to imbue them with higher meaning; the Albinus–Apollo pose was thus the outstanding exemplar for full-length male portraiture of the period. The Apollo Belvedere had already been assigned this role in seventeenth-century France, when Charles Lebrun, Director of the Académie Royale de Peinture, adopted its pose for a victorious Louis XIV. Lebrun thus elaborated an iconography of the Absolute Monarch as sun-god which simultaneously affirmed the statue's privileged status while recuperating its authority within the visual language of the Académie. Democratised during the course of the eighteenth-century, aristocrats, professionals, politicians and bourgeois patriarchs alike were portrayed in this meaningful guise, which ascribed to them an elevated power and civic *gravitas* by association with classical authority. Employed throughout the West, the Belvedere was equally exploited in painted and sculpted portraits to authorise the power of, for example, politicians and the landed gentry in Britain (Ramsey, Reynolds and Gainsborough),[20] French Revolutionary heroism (David)[21] and New World leaders (Figure 52.5). Thus,

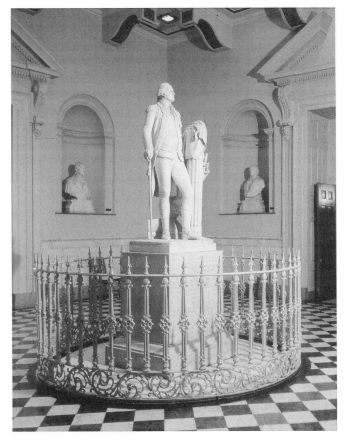

Figure 52.5 J.A. Houdon, Statue of George Washington, 1788–92 (Courtesy Bridgeman Art Library)

although the political inflection of the embodied meaning might be diametrically opposed according to time and place, the ubiquity of the Belvedere and its seemingly transparent legibility made it readily adaptable within a formula whose common denominator was patriarchal dominance.

Accessories

The Albinus print is not atypical in its inclusion of accessories not strictly required in a purely anatomical study; the anatomist argued that the landscape setting improved the illusion of relief in the skeleton, which certainly looks flatter in impressions printed without it. Thus Albinus explained that his backgrounds were not only to 'fill up the empty spaces . . . and make them appear more agreeable' but that they ensured 'the light and shade of the figures might be preserved and heightened and the figures themselves appear more raised and rounded.' He suggested that the plates be looked at through the cupped hand 'in the manner of a spy-glass,'[22] an idea which has parallels in the classical tradition of viewing Claudian landscapes. Not surprisingly, Albinus used Claudian pastoral settings, often complete with classical architecture; these motifs depended again on the particular skills of his engraver. Jan Wandelaar was also a botanical illustrator, and the accuracy of his empirical studies notable in the foreground details of the Albinus prints derived from this expertise. However, these elements also add a further layer of ideological meaning.

Setting the skeleton in a landscape has the effect of figuratively 'naturalising' the anatomist's vision: linking it with the natural world thereby makes it authentic; the 'natural world' in this context is, of course that of the natural sciences, a world ordered by masculine reason and not 'untamed' nature. The scientific authority of the image is further validated by the inclusion of Wandelaar's detailed, precise renderings of natural flora and fauna in the Enlightenment manner of the botanical taxonomist; their very abundance stands in poignant contrast to the skeleton. Their iconographic significance adds weight to the anatomist's theme – the thorns of gorse and bramble are a reminder of Christ's Passion.

Most startling, however, is a small winged putto or angel holding a dark billowing shroud; like a sinister cloud of shading, which throws the pale skeleton into relief, the putto unveils for the viewer this fascinating, macabre, but at the same time wholly convincing scientific display. The shadow of death falls, quite literally, across the infant face, plunging it into obscurity in yet another reminder of mortality. It is significant that female skeletons were rarely represented as embodying the *memento mori* theme (we have seen the Platter/Bauhin example which carries an hourglass); they were commonly represented as not privy to knowledge: the female skeleton bore the material, the reproductive, rather than the productive, spiritually or intellectually meaningful symbolism.

Ideal scientific anatomies such as the Albinus skeleton were rarely divorced from connotations of the *memento mori*; as Ludmilla Jordanova argues,

> Lessons about death are often contained in the gesture and position of the figure, and the background and accompanying objects. These are far from extraneous to the image: on the contrary, it is they that render it

meaningful. They frame the image, give it a location and guide the viewer as to what he should attend to.[23]

In such images the artist/anatomist dissects the dead, she argues, 'in order to reveal, lay bare and ultimately comprehend the living.' But their meaning goes beyond straight revelation, or even the 'unveiling' of some pre-existing cultural construct: these images are directly implicated in the production of cultural meaning. Thus I would posit a much more active ideological role for pictorial anatomies, which here can be seen to construct a certain ideal of masculinity as universal and normal – and such ideals of masculinity have a formative impact on the ordering or reinforcing of hierarchical or social roles. Anatomies like the Albinus, then, worked actively within the complex socio-historical developments which, by the final years of the eighteenth century, culminated in a polarisation of cultural gender distinctions.

Notes

1 I am particularly grateful to Michael Rosenthal for sharing his ideas with me, and for reading and suggesting changes to the present essay. Beyond the remit here, the links between anatomy and race are addressed in A. Callen, *The Spectacular Body: Science, Method and Meaning in the Work of Degas*, New Haven and London, 1995, ch. 1, and will be pursued in greater depth in A. Callen, *Art and Anatomy from Albinus to Charcot* (Yale, in preparation).

2 Quoted in L. Schiebinger, 'Skeletons in the Closet: The First Illustrations of the Female Skeleton in Eighteenth-Century Anatomy', in C. Gallagher and T. Lacquer (eds), *The Making of the Modern Body*, California, 1987, p. 43.

3 Analysis here refers to the text of the shorter, London reprinted edition in English of Albinus's *Tables of the Skeleton and Muscles of the Human Body* (1749).

4 For example, Guidi, *De anatome*, 1611, title-page.

5 Schiebinger, op. cit., p. 51.

6 See K.B. Roberts and J.D.W. Tomlinson, *The Fabric of the Body: European Traditions of Anatomical Illustration*, Oxford, pp. 220–25 and plate 54, pp. 23–1.

7 L. Jordanova, 'Gender, Generation and Science: William Hunter's Obstetrical Atlas', in W.F. Bynum and R. Porter (eds), *William Hunter and the Eighteenth-Century Medical World*, Cambridge, 1985, p. 385.

8 *Geschichte*, p. 392, quoted in A. Potts, *Flesh and the Ideal: Winckelmann and the Origins of Art History*, New Haven and London, 1994, p. 118.

9 François Raguenet on the Apollo Belvedere, 1700, quoted in F. Haskell, *Rediscoveries in Art,* London, 1976, p. 109, n. 71 (my translation).

10 See Potts's discussion of the homoerotic in relation to classical sculpture in eighteenth-century France, in Potts, *Flesh and the Ideal*; on the Apollo Belvedere, esp. pp. 118ff.; beyond the bounds of the present essay, I pursue the theme of the homoerotic in relation to male anatomies in *Art and Anatomy from Albinus to Charcot* (Yale, in preparation).

11 K. Clark, *The Nude*, Harmondsworth, 1970, p. 26.

12 Potts, op. cit., p. 118.

13 It is on this edition that the present discussion depends.
14 Albinus, London edn 1749, quoted in Roberts and Tomlinson, op. cit., pp. 324–25.
15 Quoted in ibid., p. 324.
16 Quoted and paraphrased in ibid.
17 For his eye to take in the complete figure, Wandelaar needed to be placed at a distance from his subject equivalent to three times its height: e.g. for a 6-foot figure, 18 feet away.
18 Roberts and Tomlinson, op. cit., p. 322.
19 Ibid., p. 623.
20 Cf. D. Solkin, 'Great Pictures or Great Men? Reynolds, Male Portraiture, and the Power of Art', *Oxford Art Journal*, vol. 9, no. 2, pp. 42ff., and A. Smart, *Allan Ramsey*, 1992, pp. 81ff.
21 See Potts, op. cit., esp. pp. 223–30.
22 Roberts and Tomlinson, op. cit., pp. 326–27.
23 Jordanova, 'William Hunter . . .', op. cit., pp. 411–12.

Tamar Garb

THE FORBIDDEN GAZE
Women artists and the male nude in
late nineteenth-century France

I N 1883 CHARLES AUBERT, author of mildly titillating, sometimes smutty
pulp fiction, published a short story with a woman artist as its central character.
This was one of thirteen tales of sex and seduction by the same author, entitled *Les
Nouvelles amoureuses*, which were to be collated into one volume in 1891 and illus-
trated by Jul. Hanriot, the engraver who had provided a frontispiece and engraving
to accompany the 1883 publication (Figure 53.1).

The story begins as a conversation between the narrator and a prim, self-
righteous, older woman who expresses outrage at the request of the wealthy young
Isabelle, the heroine of the tale, to see the body of a naked man. She, and the reader,
are assured of the innocence of the heroine's motive by the revelation that she is
an artist, incarcerated in her luxurious Parisian *hôtel* and closely guarded by her
mother-in-law, while her husband, a captain, is away at sea. To pass away her time
in her husband's absence she has turned to painting religious scenes and has been
thrown into a state of utter confusion and distress by being offered a commission
to paint a St Sebastian.

From the beginning, therefore, the story invokes a range of anxieties and poten-
tial threats. What is primarily articulated at this stage in the narrative, albeit in a
disingenuous tone of concern, is the threat to the modesty of the woman artist, repre-
sentative here of upper-middle-class femininity, who is caught in an impossible
situation in which she is bound to be compromised. A classic staging of resistance
(her piety, innocence and loneliness are stressed) and the inevitable path to seduc-
tion (beneath the veil is a rampant and unfulfilled desire) is set up. What subtends
the linear narrative thrust, which in itself has only the richness of banality as its
defence, are subtle and deeply rooted anxieties which invoke the power structures
at stake in the scopic field as encoded in narrative and image in *fin-de-siècle* Paris.

One cannot underestimate the banal or the repetitive as historical material. For
in the clichéd resolutions and cheap gratifications offered by much caricature and

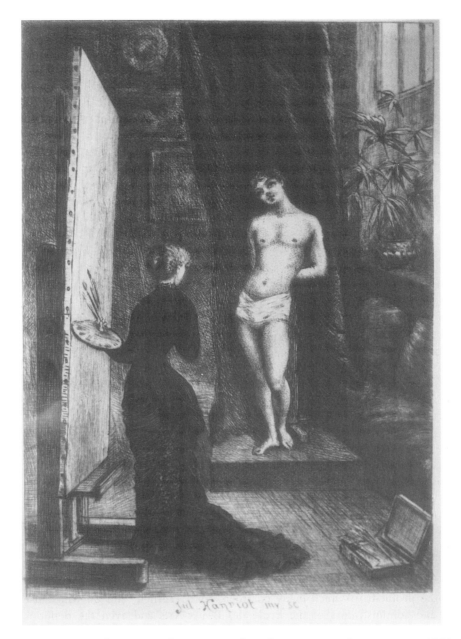

Figure 53.1 Jul. Hanriot, frontispiece of Book V, *Les Nouvelles amoureuses*, 1883

popular fiction, of which this story is a typical example, lies a form of cultural repression which renders anxieties manageable even as it veils and occludes them.

The potentially comic situation of the woman artist in close proximity to an undressed or semi-dressed male figure offered ample opportunity for smutty humor and caricature throughout the century. In an early nineteenth-century image a young woman with eyes modestly downcast is told to remember that she is painting history by her stern and rather lecherous-looking teacher as she is confronted by the full

frontal nudity of the less-than-ideal male model. In a much later caricature from *Gil Blas*, the predictable scene of seduction and deception is staged in the temporary absence of the older male chaperone/authority figure. Here the power of the woman artist to possess the world with her sight is contained by the reinscription of her as object of seduction, admired and exchanged, often unconsciously, between men. In keeping with contemporary narrative structures, the expectation which is set up in our story is that Isabelle, after some resistance, will be seduced.

The prohibition which gave Aubert's story its frisson was tenaciously defended by the art establishment during this period. But the disquiet that the prospect of a woman viewing the body of a naked man provoked is surely based on more than the protection of women's chastity required for their exchange and circulation in the interests of the bourgeois family. At any rate, even if this lies at the heart of the social order, it is not primarily the protection of women and their modesty which is at stake here but the preservation of masculinity as it is lived out in different social spheres. Discursively this may, of course, masquerade as beneficence towards women.

Aubert's story was published during a period of heated debate over women's involvement in art and their exclusion from state-funded Fine Art education. The *Union des femmes peintres et sculpteurs*, founded in 1881, campaigned vigorously for women's admission to the *Ecole des Beaux-Arts*, and women journalists and artists poured scorn on what they saw as a reactionary and exclusive art establishment. There were those who saw no sense in the case which apparently sought to protect women by their exclusion from the life-class whilst they were free to visit the art galleries of the world and behold, unscathed, the painted image of the male nude. The debates raged in the Ecole, in the press and in the Chamber of Deputies itself. Many reasons were given for women's exclusion from the Ecole, including their ostensible innate inability to work in the higher genres because of their limited powers of abstraction. Other reasons cited were the overcrowding of the artistic profession, the expense that the provision of Fine Art education for women would entail, the need for women to contribute to the threatened industries of luxury goods, decorative arts and traditional light crafts, and even the threat of depopulation which the advent of the professional woman would, it was believed, only exacerbate, if not by her refusal to have children then by the deterioration of her reproductive capacities which would inevitably result from excessive mental stimulation.

But the problem to which many commentators returned, and on which the teachers and administrators of the Ecole des Beaux-Arts and even the deputies in the Chamber were to dwell repeatedly, was the issue of the life-class. Why was the prospect of mixed life-classes such a threat during this period and how could the anxieties they provoked be resolved? The ready-made solution of fiction, that of seduction in the interests of salacious humour, mild sexual excitation or the appeasement of anxiety, available to the predictable Aubert were, of course, not on offer as strategies of containment in the realm of public debate, however much their concerns occupied the same dialogical field.

The devices mobilised by Aubert to assure the minimum disruption to the phallic order in the face of threat are not quite as simple as one might expect. The focus of anxiety in the story centres on the problematics of looking and sight, for it is

through these that power is encoded or subverted. It is through the usurping of a culturally forbidden look that the gaze, which polices looking, is momentarily threatened and rendered vulnerable. But it is not only the woman's look that is potentially dangerous. In the man's beholding of the *woman who looks* lies a much deeper threat, for it is through the unveiling of the threat of castration, linked here, as in the case of the Medusa's head, 'to the sight of something', to quote Freud, that masculinity is potentially at risk. The effect of Medusa's power, her 'evil look', is that it not only kills or devours but blinds as well (Freud 1955).

Isabelle's problem when first mooted by Aubert, is framed as a problem of sight: 'elle desirait voir un jeune homme' (Aubert 1883: 10). The obstacles facing her seemed insurmountable. The house in which she was confined was guarded by her mother-in-law and no young man would have been allowed to enter her private quarters, although she had had no problem in having women models to sit for her. More difficult even than such practical problems were the fears and resistances which she built up in the processes of thinking about the prospect of beholding a naked man. Would she have the courage to look at the model, would she dare to confront his body with her eye? Would he not triumph at her discomfort and delight in her difficulties, and how would she cope with her own inadmissible desires which must be repressed at all costs? These are the thoughts, according to our narrator, which go through the young woman's mind but, instead of dissuading her from her course, make her obsessed by it. At this point Aubert introduces an intermediary male figure, a corrupt old picture seller from Montmartre who supplies Isabelle with equipment and models. He is brought in to resolve the conflict and promises, at a considerable cost, to smuggle a male model into her quarters for her. He is described as 'a superb young man, the ideal of beauty and elegance, gentle and well brought up' (Aubert 1883: 21). At first Isabelle resists resolutely but she is persuaded to accept him by the vital piece of information that, though possessed of magnificent eyes, the young man has been blind from birth. This fills her with comfort and relief: 'Elle pourrait voir sans être vue' (Aubert 1883: 22). This is perhaps the moment to reveal that the title of the story is, appropriately, *L'aveugle*.

Momentarily we are offered a complete inversion of traditional power relations in the visual field: a woman in possession of the gaze, a beautiful male body providing the unthreatening spectacle. But this fantasy, at least on behalf of the reader, is short lived, for no sooner are we offered this vision of a world turned upside down than we are assured that patriarchy is still intact and an elaborate trick is about to be played on the vulnerable and unknowing Isabelle. The model turns out, of course, to be a starving artist called Charles Morose, in the debt of our dealer/intermediary, who is promised to be released from his debts if he agrees to pretend to be blind and be smuggled in a crate, for a period of thirty days, into the studio of the beautiful woman who is too modest to dare view a model who can see her.

It is this symbolic inversion of the natural order which the story must both play out and undermine. The tempering of Isabelle's power comes early on in this potentially dangerous scenario and is achieved by the usual means. Overcome by the young man's beauty as he strips down in order to put on his drapery, Isabelle faints and is caught in his arms, coming to with her head on his naked breast.

From very early on, therefore, the woman's power as an artist, as encoded in the engraving at the beginning of the 1883 edition, is contained by her weakness as

a woman. The model's vulnerability, his nakedness, the 'effeminate' pose which he is forced to adopt and his incapacitating blindness, is assuaged by the power beneath his masquerade which even the innocent Isabelle suspects but never admits. At the same time, however, the relationship of looks in an engraving like that in Figure 53.1 points to a source of anxiety which is never quite articulated in this context but surfaces, as we shall see, elsewhere. Whilst the play-acting of the model requires the adoption of the ethereal, abstracted expression of the St Sebastian, traditionally constructed in representation as a feminised male, the attention of the woman artist is firmly fixed on his covered genitals.

Which are the forbidden gazes at stake here? On the one hand the story must contain and police female sexuality, reinscribe it as lack, and subordinate it to male desire if order is to be maintained. The inevitable seduction, Isabelle's transformation from artist into amorous woman, will assure this and invest in masculinity the power which is its due. The seduction scene itself is ultimately dependent upon the reinscription of Isabelle as the object of the look. At the beginning of the story, the artist is described as being dressed formally, in black silk and firmly corseted in keeping with the laws of etiquette. Gradually, however, the heat of the studio and the knowledge that her model is blind allow her to discard the corset and to dress less formally.

This makes for her easy narrative objectification as we are treated to long descriptions of the gradual slipping of her gown off her shoulder and the slow but climactic revelation of her nipple, while she, unawares, is absorbed in her work. All that she notices is a movement in the model's drapery, the origins of which she does not quite understand, but which unsettles her. Her power is further undermined by the reinscription of the model as artist. In her absence he corrects her drawing and improves the painting so that it turns out by the end to be the best work she has ever done. The model/artist transcends his objectification by becoming master of his own image. The man transcends his humiliation by having an erection.

But the frightening spectacle of a woman who usurps power, whilst able to be diffused effectively in fiction through the fantasy of seduction, is not quite so easily contained within the discourses of art education and administration. One of the ways in which fear in men is managed, according to Freud, is via the erection: 'it offers consolation to the spectator: he is still in possession of a penis, and the stiffening reassures him of the fact.' Or put another way: 'To display the penis (or any of its surrogates) is to say: "I am not afraid of you. I defy you. I have a penis"' (Freud 1955: 273–74). The erection therefore can function as a defence in a situation where power is usurped or horror is invoked. The objectification of the male model and the empowerment of the woman artist is discursively constructed as one such situation.

The entry of women into the life-class at the Ecole des Beaux-Arts would, it was felt, lead to a major disruption. As Gérôme stated in 1890 (p. 318), it was impossible to admit women and men into the same classes as work would suffer. Proof of this was the fact that when the art students had, approximately once a month, to work from a female model, they worked much less well. The very presence of women, even in this subordinate role, was disruptive to the high seriousness of an all-male community and its commitment to the transcendent qualities of art.

But the appearance of a female art student, an equal, was potentially much more threatening than the presence of working-class women used as models in relation to whom the young male art students could unite in predictable pranks and sexual innuendoes. The form of male bonding perceived to be under threat by women's entry to the Ecole is encoded in contemporary photographs of the ateliers of the Ecole. In [one] . . . the young art students pose in serried ranks, anonymous in their masculine costume, together with their teacher who kneels in the front row. Behind them on the walls are their nude studies, draped or naked. In this representation, the life studies can be read as the referent to the art which ostensibly draws these men together. It was this apparent harmony which the entry of women threatened. Pedagogical principles and lofty aspirations required, therefore, that in the Ecole itself and the associated School at Rome, women be almost entirely excluded.

Amongst the traditionalists, what needed to be preserved was the capacity of art, conceived in this context in terms of the threatened academic doctrine of idealism to transcend the physical. What was needed to perform this transformation was serious training, developed powers of intellectual abstraction and an ability to see beyond immediate visceral experience. There was serious doubt as to whether women were capable of this. In their presence art risked being reduced while the model's physicality would be emphasised. In a contemporary caricature, the absurd underpants, portly figure and Venus-like pose of the [male] model are juxtaposed with the artists, represented as shrewish wife and skinny daughter, who are rendered as incapable of transforming nature into art as the model is of evoking the great hero Achilles.

Supporters of women's entry to the Ecole, like Jules Antoine of L'Art et Critique, argued that the situation of the life-class 'gives a sort of impersonality to the model which becomes no more than the object to be drawn' (Antoine 1890: 344). In their view, the sex of the artist should not affect this. Art transformed the naked into the nude, and thereby occluded its sexual connotations. It came rather to signify the pure, the ideal.

But others were not so easily reassured. They felt that for this basic but fragile tenet of academic doctrine to be sustained, the person who would need protecting was not the woman artist and her modesty, but the male model. The writer for the Moniteur des Arts explained the resistance to women's entry as stemming from 'a concern for the male models, who in front of the pretty little faces, blonde hair and laughing eyes of the young women artists, would not be able to conserve their "sang froid"' (Sainville 1890: 325). It was the gaze of the model that had to be forbidden. For if the model was to become aroused, who would testify to the transcendence of the nude over the naked? One deputy speaking in the Chamber in 1893 even alluded to an allegedly American practice of making the male model wear a mask as a way out of a tricky situation.

In this context the memoirs of Virginie Demont-Breton, one of the chief campaigners for the entry of women into the Ecole, are instructive. Reporting on a meeting of the sub-commission set up at the Ecole itself in 1890 to debate the issue, the conflicting claims of the transcendent powers of Art on the one hand, and the assertion of male virility on the other, come into open conflict. Mme Demont-Breton recounts that while she was addressing the meeting, the architect Charles

Garnier suddenly cried out that it was absolutely impossible to put men and women under the same roof at all: 'this would put the fire near to the powder . . . and would produce an explosion in which art would be completely annihilated.' He was quickly attacked by the sculptor Guillaume, who allegedly exclaimed: 'You don't know what you are saying. When an artist works, does he think about anything else but the study in which he is passionately engaged . . . ? In the school we envisage, there will be no men and women, but artists animated by a noble and pure spirit.' Garnier was not satisfied with this vision and retorted: 'It is possible that you, O Great Sculptor, you are made of marble and wood like your statues, but if I had seen a pretty little feminine face next to my easel at twenty years, to hell with my drawing. O! Guillaume. You are not a man!' To which Guillaume is said to have exclaimed: 'O! Garnier. You are not an artist!' (Demont-Breton 1926: 198–99).

It is the presence of women who apparently bring this otherwise harmonious conjunction of art and masculinity into conflict. To assuage castration anxiety, male virility must assert itself. But in so doing the edifice of the already waning academic establishment and the repression on which its pedagogy is founded is at risk. Masculinity needs the erection as reassurance. Art needs an occlusion/diminution of the penis if the phallic order/ideal is to remain intact. When women were finally admitted into the Ecole in 1897, after having been hounded out of the school by some of their future colleagues with cries of 'Down with women,' the ateliers still remained closed to them, and life drawing and anatomy lessons were segregated, with male models neatly tucked into their much maligned underpants.

It is only in the fantasy world of fiction that resolution is potentially absolute. Scolded by Isabelle for the strange movement in his drapery, Charles is armed with one of her absent husband's arrows and told to keep still. The humiliation is too much for him. In a dramatic gesture he wounds himself in the chest with the arrow. Finally castrated, the model appears about to become the martyr he has been imitating. But his masculinity is restored by a contrite Isabelle who prostrates herself before him and declares her love. The charade is over. The danger is gone. All that is needed now is the annihilation of the absent sea-captain. In a gruesome narrative twist which invokes the implicit violences involved in the maintenance of social order, he is conveniently devoured by a band of savage negresses. The story is ultimately haunted and framed therefore by the excessive fantasy of an untamed voracious femininity, out there on the margins of civilisation, but one which threatens to invade its closely policed boundaries. At the moment of the tale's resolution, this grotesque disposal of the final obstacle, the legitimate husband, reveals the fear of feminine power that the story has done everything to contain but which seeps out, in a displaced form, at its edges.

References

Antoine, J. (1890) *L'Art et critique*, reprinted in *Moniteur des Arts*, 1917.
Aubert, C. (1883) 'L'aveugle', *Les Nouvelles amoureuses*, Paris.
Demont-Breton, V. (1926) *Les Maisons que j'ai connues*, Paris.

Freud, S. (1955) 'Medusa's Head' (1940/1922), in *The Standard Edition of the Complete Psychological Works of Sigmund Freud*, J. Strachey (ed.), volume XVIII, London.

Gérôme, J.L. (1890) 'Les Formes à l'Ecole des Beaux-Arts', *Moniteur des Arts*, 12 September: 318.

Sainville (1890) 'Chronique de la semaine', *Moniteur des Arts*, 1913, 325.

Carol Mavor

REDUPLICATIVE DESIRES

ALLOW ME TO BEGIN with four stories – four images – four mirror images, even – of what it means to look at and through the photographs of Clementina Hawarden.

One

The professor of art and her prize student were looking at lovely and sensual slides of Hawarden's photographs of her daughters. Flashing through the repetitive, though always captivating, images, the two women sat still in the darkened room, quietly remarking on the subtle gestures between the sisters: a pull on a lock of hair, a squeeze on an arm. The professor told her student that the photographs were about love between women and love of the self and self-love performed for the gaze of the mother. The student, a young poet on her way to graduate school in New York, told the art professor that her writing professor had once told her that 'young women often write their first stories about an erotically charged, fantasized, twin sister.' The art professor was disappointed to hear that these stories were always terrible.

Two

The young professor felt that she had finally grown up. Her advisor from graduate school had been invited to lecture at the university where she taught. Proud of her new independence as a real professor, she invited her advisor to her seminar. On the day of the seminar, her advisor showed up wearing the same dress as she. This made her feel all hot and embarrassed, as if they had been discovered as mother and daughter, or sisters, or as the perverse subjects of a Diane Arbus photograph.

Yet, she also felt a certain delight, an almost sexual charge, from their presence in duplication. The class members tried not to be obvious with their inevitable double takes. She fed their desire (and maybe her own) by telling them that the whole thing was planned.

Three

The big party was at the famous professor's big house. Everyone looked smart and seemed to be working on their second Ph.D. rather than their first. Afterward, an older female professor felt compelled to tell her what the other women graduate students had been asking about her: 'Was her femininity serious or parody?' With a sinking feeling inside her stomach and with a big smile and a roll of her eyes on her outside, she quipped, 'Of course it's parody.' But in her mind, she thought, 'My God, I really don't know. But I'm never wearing a Laura Ashley dress again.'

Four

She walked into the office and the chairman pulled her aside. He began making some remarks about her student – how the student dressed differently now – how the student had changed her hair. Continuing on, laughing yet serious, and full of odd suspicion, he asked her where she got that dress anyway. She lied, of course. She would rather die than tell him that two of her students had given it to her. 'You know,' he said, after masterfully managing to weave together her style of dress, her student's style of dress, and the kind of critical theory that she had been introducing to her students, 'you gotta watch out for those Professor-Wanna-Bes, not all of them are capable of the demands of critical theory.' But what he was really saying was 'One of you is enough!'[1]

If Clementina Hawarden (a mother of eight) has taught me anything, it is that one is never enough.

In Hawarden's excessively productive world, whether through her production of eight children, or through her production of hundreds of images of her daughters, or even through her fetishization of select feminine objects within the pictures themselves, the female body infinitely reproduces itself, like a photograph.

Hawarden displays women as *ontologically* fetishistic by picturing passion as a kind of feminine doubling of the mother herself, as simulation. For example, the photographs that focus on mirrored images in actual mirrors and windows as mirrors suggest not only feminine narcissism, but also the mirroring of the mother through the daughters (Figure 54.1).[2] And by matching, twinning, and coupling girls with objects that suggest the sensuous femininity of her daughters, Hawarden fetishistically simulates her body and, in turn, those of her daughter.[3] Consider, for example, the familiar curvy vase that suggests Clementina's own blossoming breasts, turned-in waist, and hands on hips as handles made bountiful through pleats, gathers, and layers of sensual fabric – doubly so, in that we see her in the jug and in the mirror. Or see Isabella as a reflective collectomania[4] of feminine things: in the (Pandora's[5])

Figure 54.1 Isabella in fancy dress, 'the mirroring of the mother through the
daughters,' Clementina, Viscountess Hawarden, c. 1862, *Untitled*,
courtesy of the Board of Trustees of the Victoria and Albert Museum,
London.

box decorated with shells that perches atop a table crowned by a narrow-figured
vase that suggests her own slim lines; in the string of pearls; in the jeweled button;
in the epergne (this time, it is not filled with fruit); in the two tiaras, one she wears
on her head, the other she clenches to her breast. Consider the concertina[6] that
spreads its bellows like Clementina's own skirt.

Such doubling, twinning, coupling, mirroring that is already inherent to the
work is doubly emphasized by Hawarden's frequent production of stereoscopic
photographs. One example is the stereo of a young Isabella in eighteenth-century-

style dress. Isabella, in a billowy dress pregnant with excess, poses alongside a Gothic-style desk. The picture features Isabella as one with a spillage of girl metaphors: an Indian cabinet from whose open drawers flow eye-catching beads, an easel-back mirror that perches on the desk like an empty picture frame waiting to be filled with the image of this beautiful girl. Flowers are everywhere: she holds a bouquet of them in her hand; she wears a flower wreath on her head; another wreath of flowers decorates the plant stand; a lone flower sleeps on the carpet.[7] And thanks to her mother's stereoscopic camera, such feminine reduplication (performed by objects and daughter alike) is pictured not once, but twice.

Hawarden displays women as ontologically fetishistic, but does she, in the words of Emily Apter, 'feminize the fetish'? Naomi Schor, among the first to inscribe the fetish with the female body, would say no. Schor understands the female fetish, rather, as a perversion stolen from men, as simulacrum. Apter, on the other hand and in direct response to Schor, takes such objects as Guy de Maupassant's fiction and Mary Kelly's *Postpartum Document* as 'real' female fetishes that prove women to be perverts in their own right. Though I am drawn to Apter's brilliant writing on the ways female fetishism has been limited and misunderstood as a 'simulacrum' of the 'real' male perversion – or as a perversion stolen from men, 'a sort of "perversion theft"' – my path is somewhat different.[8] Rather than arguing whether or not Hawarden's maternal love objects are simulation or thievery, or whether or not Hawarden is necessarily a deviant by her own (female) right, this chapter makes palpable the curious relationship between Hawarden's fetishistic photographs and the conceptual framework of femininity itself. My analysis of Hawarden's photographs does not so much pull the feminized fetish into view as perform its reduplicative desire.[9]

Whereas the word *duplicate* is used in various ways – as an adjective to describe something as 'being the same as another,' as a noun that defines 'either of two things that exactly resemble each other,' as a verb that emphasizes the process 'to make double or twofold' – the definition of the verb *reduplicate* is 'to make or perform again.'[10] I am engaged with the action of reduplicate's (re)performative character. Hawarden's photographs use her daughters to reperform Hawarden's desire again and again: through the repetition of her daughters, who are themselves repetitions of her (especially Clementina); through the fetishistic objects – such as the Gothic-style desk, whose elaborately carved legs mirror daughter Clementina's own ringlets, or the concertina, the vase, the guitar – objects that appear to stand in for an absent daughter, as if the daughter and the object were sisters, as if the daughter and the object were a couple; through the reflected images of her daughters in the mirror that Hawarden often used as a prop; and through the endless repetition of the photograph itself, as is beautifully registered in the image of Clementina and Isabella sharing a photograph of Florence.[11]

If we look closer at this curious image of the two older girls with a photograph of their younger sister, Clementina seems to hold an insistent desire for Isabella. In fact, Clementina appears actually to have pushed Isabella into the corner of the picture so as to be on top of her, as if she were a camera's close-up lens. In opposition to Isabella's space of tight confinement, the empty space behind Clementina gives her body a certain driving force, mirroring the push of her own bustle, the play of her flirtatious hair ribbon. Clementina's eyes focus on Isabella's escaping

tendrils, which amorously play on what I know to be, from other photographs, a beautiful white neck. Inhaling the perfume of her sister's prissy prettiness, Clementina displays what seems to be an unremitting eroticism. The essence of her body, quietly, yet insistently, requires that her sister share her sweet looks. Clementina's hand pertinaciously poised on her sister's shoulder pulls Isabella in as she simultaneously pushes against her. Isabella's gaze is elsewhere, but her neck is tickled by Clementina's gaze: a breath not from her mouth, nor from her nose, but from her eyes. Silent, odorless, hot. The back of Clementina's expressive hands touch and fit into that beautiful space below Isabella's breasts. Clementina is becoming: she is coming into the sexuality and changing body of Isabella; she is coming into her own sexuality; and she is very becoming. Isabella will not be able to hold her stiff Victorian ladyhood much longer. Eroticism pushes out the picture's overt narrative of staged grief, like a crinoline under a skirt, a crinoline that they share with each other and with their mother.

As Peggy Phelan has demonstrated, the photograph, like the female body itself, is infinitely reproducible. They are ontological equivalents.[12] There is no real singular woman hiding behind the masquerade of womanliness, just as there is no singular photograph.[13] In Hawarden's photographs, the relationship between the category of woman, the photograph, and the female fetish reflect each other's reflections, constituting a supra-*mise en abyme*.

Indeed, Hawarden houses 'femininity as always already stolen' (a tantalizing phrase that I have already stolen from Leslie Camhi).[14] Like the nineteenth-century department store that would become so spectacular toward the end of the century, with its elaborate displays of silks, gloves, hats, laces, and more, Hawarden displays for the viewer her beautiful collection of dresses and accessories, the beautiful bodies of her girls, and her collection of small and tiny objects that go in and out of view of the camera's eye (the silver cup, the Gothic desk, the wooden doll, the toy village), which are either held in a hand, perched on Hawarden's desk, presented on her table, stuck in the drawer of her Indian cabinet, or placed on the mantel. Hawarden's desire, like that of the Victorian female kleptomaniac, is contagious. I want a collection (girls, dresses, objects, photographs) of my own. I take what is already stolen (thereby ridding me of any guilt) and reduplicate its desire in my (writing) body.

Mother/daughter/doll

As girls, many of us had a collection of dolls. It is hard to say whether or not Hawarden as a girl possessed such things; the Victorian commodification of childhood with all of its ensuing products, such as dolls and books and clothes and perambulators, was more the stuff of her daughters' lives than of hers. But once grown, Hawarden played with her daughters like dolls. As objects dressed to entice and to invite play, Hawarden's pictures of her lovely daughters beckon touching, dressing, redressing, combing, brushing, hugging. Hawarden's daughters, as part-objects of the mother/photographer, *mirror* not only each other but also their mother. Hawarden's imaging of her girls as dolls represents not only an appetite for beautiful things, an appetite for young feminine bodies, but also an appetite for

self (in that the daughters are born into a culture that makes them into little mothers). I am reminded of Christina Rossetti's 'Goblin Market' (1859). Like Hawarden's photographs, the poem fecundates with the delicious fruits of a doubling, ripe, adolescent, female body:

> Apples and quinces,
> Lemons and oranges,
> Plump unpecked cherries,
> Melons and raspberries . . .
> Figs to fill your mouth.[15]

Halfway through the poem, Lizzie – the twinned 'little mother' to her self-same sister Laura – offers herself as (homo)erotic sacrament, cooing and wooing:

> Did you miss me?
> Come and kiss me.
> Never mind my bruises,
> Hug me, kiss me, suck my juices
> Squeezed from goblin fruits for you.
> Goblin pulp and goblin dew.
> Eat me, drink me, love me;
> Laura make much of me.[16]

Hawarden's sensual, maternal appetite for her girls is not unlike that of Lizzie and Laura for each other: both represent an eating of the other and an eating of the self.

Like the mother of twelve-year-old Janey ('Petal Pie') in Kirsty Gunn's haunting contemporary novel, *Rain* (1994), Hawarden knew that her daughters, especially (perhaps) her daughter Clementina, would become her: 'Sitting at her dressing-table that night, somewhere under her smooth expression she knew it. That I would take her limbs, her hair. That some day I would become her, smooth with cosmetics and calm to the mirror's surface.'[17] I know that, as a child, my own mother imagined me as a miniature copy of herself and I have always felt in turn that I was her mirror. Our connected identities register my birth as never complete. Through such pro*longing* of the Oedipal period, the mother identifies with her mother once again, longs for her and her lost childhood, becomes mother and child, and makes her own child a fetishistic object in an attempt to satisfy her double loss. (Because the child is 'cut' from the mother, the child marks maternal loss; yet the child also makes the mother feel whole again and thereby marks maternal plenitude. As a result, the child really is a mother's fetish par excellence.) The birth of a girl, especially, is an everlasting process of reduplication between mother and child, between stereoscopic images. (One of my students recognized this complex imaging and reimaging in an old high school photograph of her mother and wrote: 'Not only does it have a sense of aura because it is old, but because it is my mother/me. Like the multiple photographic copies of this image, I am a copy of my mother.'[18])

Luce Irigaray has argued that a female's desire for the mother is one of connection and reduplication, so much so that it has affected women's gestures and play. Spinning around Freud's famous *fort-da* story (which features Freud's grandson Ernst

throwing a spool on a string back and forth as a symbolic mother-object whose coming and going he can control), Irigaray claims that this kind of male-gendered play, which distances the child from the mother's body, is difficult, if not impossible, for a girl.[19] Few girls can reduce their mother's image, their own reduplicative image, to that of a reel. Rather than physically throwing a (symbolic) reel on a string back and forth, many little girls dramatize their situation of close proximity to the body of the mother by replaying (the mother) with dolls. Drawn to the mother-centered imaginary over the father-ruled symbolic, the little girl *plays* out her situation and reproduces around and within her an energetic circular movement that protects her from abandonment, attack, depression, loss of self. Spinning around is also, but in my opinion secondarily, a way of attracting. The girl describes a circle while soliciting and refusing access to her territory. She is making a game of this territory she has described with her body.[20]

Hawarden's photography is girl play with a camera. Her photographs dramatize a close proximity to her own mother, who was also fond of fancy dress.[21] A scrapbook compiled by Hawarden's mother contains engraved clippings from 'serial publications such as Heath's *Book of Beauty* and Finden's *Byron's Beauties*' and must have 'nurtured' this shared and multigenerational love of sartorial drama.[22] Likewise, Hawarden turned her daughters into (glass and paper) dolls. Together, mother-daughter/daughter-mother play in a circle described by mother as camera eye. The photographs give us access to this inviting territory. Yet, like a mother's arms around her child or a child's arms around her doll, or like a jump rope that whisks its way above a girl's head and under her feet, we are at the same time refused access.

In one stereograph, Clementina plays with her jump rope while being held by her mother's camera. The rope, by traveling from the grasp of one hand and then up to the other, makes a beautiful U: it mimics the looseness and playful pleasure of Clementina's one-side-only ponytail, which itself (like string, yarn, or cord) serpentines its way down from her ear to her breast to her waist. The jump rope bars us from Clementina, just as the balcony, with its short stone wall, bars her from the outside world. Such markers (rope, stone wall) magnify the intensity of the privacy of Hawarden's undecorated rooms, our limits to discovering the secrets at hand, and photography's own trick of giving way to a real space that is unreal.

In yet another jump-rope picture, Isabella has her back to the camera and Clementina faces out with her eyes down. Between the two sisters, they hold the jump rope: it makes a short, dark, squat (umbilical) ∪ that *draws* them together. The picture looks staged. The balcony, in this picture and many others, juts out from the Hawarden home and makes a platform stage for the girls. Here, as they often do, they perform play as a play. Interpretations flow. The jump rope becomes the cord to a camera shutter. Barthes suddenly, though not unexpectedly, emerges on-stage and insists that his clever line be heard: 'A sort of umbilical cord [une sorte de lien ombilical] links the body of the photographed thing to my gaze.'[23] Irigaray spins out from the wings while skipping rope and blurts out: 'If the mother – and girls' identities in relation to her – is invoked in girls' play, and if they choose to play with a cord, they skip around, while turning the cord over their bodies. . . They describe a circular territory around themselves, around their bodies.'[24]

Figure 54.2 'Clementina in a dark riding habit and . . . Isabella in an off-the-shoulder white dress,' Clementina, Viscountess Hawarden, *Untitled*, courtesy of the Board of Trustees of the Victoria and Albert Museum, London.

Playing in an oedipal continuum, refusing the abandonment of the circular gestures and circular inscriptions of a maternalized territory, Hawarden's pictures of her doll-like daughters reinscribe, recite the mother-daughter continuum of a love of same. Hawarden's body is there; it is just, as Mary Kelly has remarked in regard to our cultural distancing of the maternal body, '*too close to see.*'[25]

In the photograph of Clementina in a dark riding habit and her sister Isabella in an off-the-shoulder white dress, two self-same daughters come full circle as mirroring images of dark and light, Nycteris and Photogen, masculine and feminine, the object of desire and her pursuer (Figure 54.2).[26] Isabella, inside the Hawarden home with her back toward us, hair prim and proper, keeps her body protected and out of our view. Clementina, outside the window frame, outside the interior of the home, out on the porch, with her hair loose, opens her body for Isabella and toward us. The differences between Isabella and Clementina enhance the subtle touching that is going on between these women. For though Clementina's gaze into Isabella's eyes is enough to make the viewer blush, it is her bare right hand that causes me to swoon. Stripped of the dark glove that her left hand so

openly displays, Clementina's lovely ungloved hand ever so softly but firmly clenches Isabella's right arm. I can feel the pressure. Like Lizzie and Laura in 'Goblin Market,' the Hawarden sisters seem to be offering two ways of life in one twinning body: that of the 'mindful' Lizzie/Isabella, whose controlled feminine desire stands 'white and golden . . ./Like a lily in a flood,' and that of 'curious Laura'/darling, adventurous Clementina, who 'sucked and sucked and sucked the more/Fruits which that unknown orchard bore;/She sucked until her lips were sore.'[27] Like rings around a stone cast into a pond, the circles of Clementina's hat and brim, the circle of the black lace sash that cinches Isabella's small circle of a waist, the circle of their skirts, the circling of Isabella's rolled hair that wraps the curve of her beautiful head – all serve to echo the more general and prohibitory halo that the sisters have materially and gesturally inscribed around themselves. 'Like two pigeons in one nest,' Isabella and Clementina create an inviting bower into which we, as wingless outsiders, cannot enter.[28]

Look again at the photograph in which Clementina and Florence are caught as if recreating a tableau vivant from Delacroix's *The Death of Sardanapalus* where circles are, again, repeated. Clementina's arms not only bury her gaze but also encircle her face, like the tiara that she so sweetly wears. Florence's left arm gestures around not only to shut her eyes with pretty fingers but also to partially complete the fragment of a curve that her left arm begins; together, her lovely round arms, crowned by the circles of her puff sleeves, give rise to the suggestion of a tender moon. Like Ophelia, Florence's head is encircled by a wreath. Like a lover, Florence's fingers twirl Clementina's tendrils. Like Dante Gabriel Rossetti's woodblock design for the frontispiece of his sisters *Goblin Market and Other Poems*, Clementina and Isabella photographically repeat the touch, the curling up of Lizzie and Laura. All fabric and skirts, curls and crowns, they nestle together, they nest together: no sight, just touch all around. Out of the picture and into the erotic circles of my own ear, I hear and feel Clementina and Florence murmuring, whispering, repeating, reduplicating Lizzie and Laura as they softly chant all of 'Goblin Market''s 567 lines of female sexuality over and over:

> Folded in each other's wings,
> They lay in their curtained bed:
> Like two blossoms on one stem,
> Like two flakes of new-fall'n snow,
> Like two wands of ivory
> Tipped with gold for awful kings.
> Moon and stars gazed in at them,
> Wind sang to them lullaby,
> Lumbering owls forbore to fly,
> Not a bat flapped to and fro
> Round their rest:
> Cheek to cheek and breast to breast
> Locked together in one nest.[29]

[. . .]

Notes

1 My telling of these stories of female desire has been highly influenced by Mary
 Kelly's own storytelling in her artist's project *Interim* (New York: New Museum
 of Contemporary Art, 1990), especially those told the initial portion of the project
 entitled 'Corpus' (1984–5).
2 The topic of Hawarden's use of mirrors is the subject of Chapter 3 [in the original].
3 My understanding of women's ontological fetishism as represented through such
 patterns of behavior as 'narcissistic displays of isolated body parts' or performing
 'doll-like affectations' has been informed by Emily Apter. See especially *Feminizing
 the Fetish* (Ithaca, NY: Cornell University Press, 1991), 104.
4 The term is Apter's and will be further elaborated in Chapter 4 [in the original].
5 Dodier, catalogue raisonné, photograph D639, has also suggested the Pandora
 reading of this image, emphasizing that 'the shell-covered box is [also] an example
 of the type of handicraft which Victorian women were encouraged to take up.'
6 A concertina is a small, hexagonal accordion with a bellows and buttons for keys.
7 Dodier, catalogue raisonné, photograph D224.
8 Naomi Schor, quoted in Apter, *Feminizing the Fetish,* 104. See Naomi Schor,
 'Female fetishism: The Case of George Sand,' in *The Female Body in Western Culture,*
 ed. Susan Rubin Suleiman (Cambridge, Mass.: Harvard University Press, 1986),
 371. Apter sees Elizabeth Grosz's conception of lesbian fetishism as a novel and
 important exception to the typically male-centered perceptions of female
 fetishism. See Grosz's 'Lesbian Fetishism,' in *Fetishism as Cultural Discourse. Gender,
 Commodity, and Vision,* ed. Emily Apter and William Pietz (Ithaca, NY: Cornell
 University Press, 1993), 101–15.
9 Craig Owens, 'Photography *en abyme,*' *October* 5 (summer 1978), has also made
 use of the term 'reduplicate' in relationship to photography. His perspective, like
 mine, focuses on photography's relationship to the mirror and especially to the
 concept of *mise en abyme*; however, issues of sexuality are, at most, only distantly
 visible in his text, and with its emphasis on linguistic theory, his writing does not
 touch upon feminist theory, the maternal body, nor psychoanalysis. For more on
 Owens's important article, see Chapter 3 below [in the original].
10 All definitions are from *Webster's Seventh New Collegiate Dictionary* (Springfield,
 Mass.: G. & C. Merriam Co., 1963).
11 The image looks to be, according to Dodier, D392 in the Victoria and Albert
 Museum collection.
12 Peggy Phelan, *Unmarked* (London: Routledge, 1993).
13 See Joan Riviere's famous essay, 'Womanliness as a masquerade,' *International
 Journal of Psycho-analysis* 10 (1929): 303-13.
14 Leslie Camhi, 'Stealing Femininity: Department Store Kleptomania as Sexual
 Disorder,' *differences: A Journal of Feminist Cultural Studies* 5, no. 1 (1993): 39.
15 Rossetti, 'Goblin Market,' in *The Complete Poems of Christina Rossetti*, 11.
16 Ibid., 23.
17 Kirsty Gunn, *Rain* (New York: Grove Press, 1994), 79–80.
18 Melanie Pipes, unpublished essay, 1994.
19 Freud's *fort-da* story is in *Beyond the Pleasure Principle*, 14–16.
20 Luce Irigaray, 'Gesture in Psychoanalysis,' in *Sexes and Genealogies*, trans. Gillian
 C. Gill (New York: Columbia University Press, 1993), 98.

21 Dodier, 'An Introduction to the Life and Work of Clementina, Viscountess Hawarden (1822–1865).'

22 Ibid.

23 Barthes, *Camera Lucida*, 81.

24 Irigaray, 'Gesture in Psychoanalysis,' 98.

25 Kelly, *Interim*, 55.

26 Photogen and Nycteris are characters of 'light' and 'dark' in George MacDonald 'The Day Boy and the Night Girl' (1879), in *Victorian Fairy Tales: The Revolt of the Fairies and Elves,* ed. Jack Zipes (London: Methuen, 1987), 175–208.

27 Rossetti, 'Goblin Market,' 14.

28 Ibid., 16.

29 Ibid.

Thomas Waugh

THE THIRD BODY
Patterns in the construction of the subject in gay male narrative film

Prelude: Victorian gay photography and its invisible subject

NINETEENTH-CENTURY HOMOEROTIC photography established a constellation of three types in its construction of the male body. The three bodies can be glimpsed through the photographs of Wilhelm von Gloeden, the Prussian aesthete and archetypal gay Victorian who worked in Taormina, Sicily, until his death in 1931. Two objects of the homoerotic gaze, the ephebe and the 'he-man' (the adolescent youth and the mature athlete, respectively) constituted polar figures in his work. The ephebe, Ganymede, was by far the most popular body type in the erotic repertory of the Victorian gay imaginary. He reflected both cultural justifications derived from the classical pastoral model, and economic and social realities of the period. The ephebe in drag was an important subcategory: cross-gender motifs offered not only an image of nineteenth-century sexological theories of the 'Urning,' or the 'third sex,' a biological in-between, but also a matter-of-fact acknowledgement of the marketplace scale of erotic tastes. The cross-dressed ephebe may also have functioned as an alibi for that homosexuality that dared not fully assume the dimensions of same-sex desire, a reassurance for the masculine-gendered body and identity of the discreet spectator (not to mention the producer and censor).

The ephebe was predominant in von Gloeden, and there were only occasional appearances of the 'he-man,' the Hercules who substitutes maturity for pubescence, squareness for roundness, stiff, active, untouchability for soft, passive accessibility. Apparently not von Gloeden's cup of tea, the he-man was nevertheless very popular with other Victorian photographers, and omnipresent in other cultural spheres, from the Academy to the popular press and postcard industry, that is, in media that were on the surface more respectably homosocial than homosexual.

These two bodies together predicated in turn a third body, an implied gay subject, the invisible desiring body of the producer-spectator – behind the camera, in front of the photograph, but rarely visualized within the frame. The third body, the looking, representing subject, stood in for the authorial self as well as for the assumed gay spectator.

The Victorian homoerotic pattern of visualized objects and invisible subjects replicated those structures of Otherness and sexual difference inherent in all patriarchal Western culture. In fact, in gay culture, as we shall see, those structures seemed even exaggerated, as if to offset the sameness of the same-sex relation, to unbalance the tedious symmetry of the Narcissus image. The ephebe addressed the phallic spectator as older, stronger, more powerful, active, just as surely as the female photographic object addressed its gender opposite, the heterosexual male spectator. At the same time, the he-man object addressed the more 'feminized,' passive body of the homoerotic spectator. As for all the other variables entering Victorian gay iconography, from implied distinctions of class, age, and gender role to Orientalist and classical trappings, these clearly accentuated and elaborated on the basic built-in structures of difference.

In Victorian gay photography the third body, the gay subject, became visible only in the minor genre of the self-portrait. Von Gloeden and his American

Figure 55.1 A rare convergence of ephebe and he-man in the photography of Wilhelm von Gloeden

Figure 55.2 Self-portrait of von Gloeden as a Christ in disguise

contemporary Holland Day, both adopting the drag of Christ, anticipated the element of costume and disguise in the gay self-portrait in its later photographic manifestations of our century (think of George Platt Lynes and Robert Mapplethorpe).

Twentieth-century gay cinema and its visible subject

In the twentieth century, it is gay male filmmakers, competing with photographers as prophets of the homosexual body, who most definitely take up the job of constructing the gay subject. In the gay-authored narrative cinema, as gay themes become more and more explicit after the Second World War, filmmakers replace the alibis of their photographer precursors with an agenda of self-representation and self-definition. At the same time, they unfreeze the iconicity of the photographic body with the identificatory drive of narration and characterization. From his obscure corner in the photographic corpus, the third body finally enters the foreground of the image, alongside the ephebe and the he-man, the objects of his desire. In the new configuration of character types, the cinema provides two points of entry for the gay spectator: a site for identification with the narrative subject, and a site for specular erotic pleasure in his object.

Within a gay narrative universe that remains remarkably constant across the seventy-five year span of my cinematic corpus, 1916–90, the gay subject consistently

accomplishes twin functions. On the one hand, he enacts a relationship of desire – constituted through the specular dynamics basic to the classical narrative cinema, the diegetic and the extra-diegetic gaze – and on the other, he enacts certain narrative functions that are more specific to the gay imaginary. These functions often have a literally *discursive* operation within the diegetic world. To be specific, the gay subject takes on one of, or a combination of, several recurring social roles, namely those of the artist, the intellectual, and/or the teacher. In other words, to complete the mythological triangle, Ganymede and Hercules are figured alongside, and are imagined, represented, and desired by, a third body type that is a hybrid of oracle, centaur, mentor . . . and satyr.

The gay subject looks at and desires the object within the narrative. As artist-intellectual he also bespeaks him, constructs him, projects him, fantasizes him, in short, *represents* him. He fucks with him rarely, alas, seldom consummating his desire as he would within the master narrative of the (hetero) partriarchal cinema built on the conjugal drive. The dualities set up by both photographers and filmmakers – mind and body, voice and image, subject and object, self and other, site for identification and site for pleasure – these dualities remain literally separate. For the most part, narrative denouements, far from celebrating union, posit separation, loss, displacement, sometimes death, and, at the very most, open-endedness. Yet, at the same time, the denouement may also involve an element of identity transformation or affirmation. In fact the assertion of identity, the emergence from the closet (to use a post-Stonewall concept), is often a basic dynamic of the plot, usually paired with an acceptance of the above separation, and signalled by telling alterations in the costumes that we shall come to in a moment. Through all of these patterns, the same-sex imaginary preserves and even heightens the structures of sexual difference inherent in Western (hetero) patriarchal culture but usually stops short of those structures' customary dissolution in narrative closure. In other words, the protagonists of this alternative gay rendering of the conjugal drive, unlike their hetero counterparts, seldom end up coming together. We don't establish families – we just wander off looking horny, solitary, sad, or dead. Or, as I said with denunciatory fervor along with everyone else in the 1970s, gay closures are seldom happy endings (Waugh 1977).

Costumes

The physicality of the gay subject is cloaked, like Grandfather von Gloeden in various corporal, vestimentary, and narrative costumes, which are in sharp contrast to the sensuous idealized bareness of his object, whether the he-man's squareness or the ephebe's androgynous curves. The third body puts on costumes as readily as the objects of his desire take them off. The element of costume has several resonances. First, it is obviously a disguise, a basic term of homosexuals' survival as an invisible, stigmatized minority. Second, it operates to desexualize the subject within an erotophobic regime in which nudity articulates sexual desirability. Finally, costume is a cultural construction, which sets up the nudity of the object as some kind of idealized natural state, but at the same time acknowledges the historical contingency and discursive provenance of sociosexual identity, practice, and fantasy.

Figure 55.3 The disguise and mortality of the gay subject in *Death in Venice*, 1971 (Dir.
Luchino Visconti; Courtesy Warner Bros)

The costumes of the gay subject are familiar markers from the repertory of
cinematic realism, drawing singly or in combination from a roster of attributes, each
attribute predicating its opposite in the narrative object of desire. Thus we have:

1 *age* as opposed to the greater *youth* of the object (e.g. *Mikael* or *Montreal Main*);
2 *class privilege* as opposed to *peasant, proletarian or lumpen* affinities (e.g. *Ludwig*
 or *Ernesto*);
3 *cultural-racial privilege* as opposed to identities that are *less white*, or *less European*
 (e.g. *Arabian Nights*, *Prick Up Your Ears*, and *Mala Noche*);
4 *clothing* connoting all of the above, as opposed to *nudity* (e.g. *A Bigger Splash*
 or *Flesh*);
5 *bodily condition*, by which I mean markers such as eyeglasses, makeup, obesity,
 disease, and mortality, as opposed to *beauty*, *strength*, and *health* (e.g. *Death in
 Venice*, *Caravaggio*);
6 *gender role* as opposed to its complement (this pair is a reversible term; if the
 subject is feminized, the object is often masculinized, and vice versa, with
 narrative oppositions of active–passive or powerful–submissive assigned either
 in the traditional gender configuration (e.g. *Flesh*, *The Naked Civil Servant*); or
7 its *inverse*, that is, with the object exerting control over the subject (e.g.
 Querelle, *Sebastiane*).

Shifting ground

All of these narrative functions and layers of narrative costumes constitute a mosaic of the gay self, the third body, which subtends the corpus of the gay-authored narrative cinema from the First World War to the present. Certain films stand out as prototypes of successive generations of the gay imaginary. Under the shadow of the German civil rights campaign of the Scientific Humanitarian Committee (1897–1933), the pair of films based on the gay novel *Mikael*, by Mauritz Stiller (1916) and Carl Dreyer (1924) respectively, together with the German social-reform narrative feature *Anders als die Anderen* (1919), produce the jilted artist and the violinist blackmail victim as the first gay subjects of the cinema.

In the considerably more repressed period after the Second World War, the works of Anger, Fontaine, and Warhol elaborate obliquely on the pattern. They tease out heightened and ambiguous tensions with spectator voyeurism and construct a gay subject that is partly obscured, displaced, or off-screen. In the early 1970s, Visconti's *Death in Venice* and Pasolini's 'Trilogy of Life' converge as a final cele-bration of a departed (fantasized?) sexual regime, as if to deny the rumblings of Stonewall (not to mention the women's movement) on the other side of the Atlantic. Their younger contemporaries, like Larkin, Hazan, Peck, Fassbinder (*Germany in Autumn*), and Benner situate the gay subject within a complex, curiously antiseptic universe where visions of post-Stonewall affirmation are often achieved at a cost. Interestingly, in all of these latter films, the gay subjects' strong nonsexual rela-tionships with women rival the inter-male subject–object sexuality for dramatic space.

Finally, the flood of 1980s updates – the British pair *Caravaggio* and *Looking for Langston* dispelling the shadow of Section 28, the Canadian *Urinal*, the Dutch *A Strange Love Affair*, the Spanish *Law of Desire*, the numerous American entries from *Abuse* to *Torch Song Trilogy* – are all eclectic, postmodern renditions of the tradi-tional configuration of the gay artist-intellectual, situated on various strata of the cultural hierarchy and in different relations to gay subcultural constituencies. These entries of the last prolific decade all reflect (implicitly or explicitly) shifting sensi-bilities and cultural-political strategies in the face of the antigay backlash and the Pandemic. Significantly, all reclaim the sensuous Pasolinian eroticism which the Stonewall pioneers had somehow downplayed.

As for the object types, Victorian iconography has undergone a radical shift as twentieth-century gay male culture has evolved. The predominant icon of the modern gay erotic imaginary, the he-man (in his postwar ghetto incarnations as 'trade,' 'clone,' and bodybuilder) has gradually supplanted the ephebe, in both his straight and 'in-betweenist' shapes. Aside from some important exceptions, the ephebe is now relegated to stigmatized specialty tastes within gay culture. When young Thomas Mann imagined an ephebe at the center of his novella *Death in Venice* in 1911, he was in stride with his generation, but when old Luchino Visconti trans-lated that vision literally onto the screen sixty years later, it now seemed nostalgic and anachronistic within the rapidly changing gay cultural context. It is symbolically apt that the professorial protagonist of *A Strange Love Affair* supplants his original ephebe object with the latter's decidedly bearish old dad. The decline of the ephebe stems perhaps from the tightening taboos on pedophilia within sociomedical-juridical

discourse, but no doubt more fundamentally from changing conceptions of the economic role and sexual identity of the child, and the emergence of youth culture with its (post-)pubescent subject. No doubt as well, the gay imaginary has dared more and more to desire (and represent the desire for) objects with no alibi of femininity, but the trend away from the ephebe was clear well before Gay Liberation took hold. One perhaps symptomatic development of postwar gay sensibilities is the emergence of a hybrid object, the body of the he-man with the mind of the ephebe, incarnated archetypally by (Little!) Joe Dallesandro and the cowboy hustlers of *The Boys in the Band* and *Midnight Cowboy* (the last decade may have mercifully reversed that trend). Regardless, the object type of our dreams may have fluctuated, but the figure of the artist-intellectual remains an all-embracing constant.

The queen

One important variation of the gay artist figure is the queen, whether aggressively lustful or passively pining. Though the queen does not always have the obvious discursive narrative function of the artist-intellectual, no one will deny that she discourses in her active way in the construction of gender, body, and identity. The queen inherits gender markers from her Victorian third-sex precursor, the ephebe in drag, but these markers now adorn the gay subject rather than the gay object. In some manifestations, the queenly subject may even push gender markers into the realm of biology, whether real or silicone, whether as transvestite, transsexual, or even as heterosexual woman, all incarnating to a greater or lesser degree the desiring gay male subject. Though Molly Haskell (1974) and Pauline Kael (1981) thought they'd cleverly unmasked the insidious phenomenon of gay men hiding in the bodies of heterosexual heroines in Tennessee Williams and George Cukor respectively, in fact the most vivid recurring example in the corpus comes from the Warhol-Morrissey oeuvre. Here, queens as biologically diverse as Taylor Meade and Holly Woodlawn join 'real women' Jane Goforth and Viva in playing the gay male subject, often competing for (though never obtaining) the films' limp and sleepy dreamboat objects like Joe Dallesandro.

The artist

What does it mean for the gay subject to be translated so often as a figure operating diegetically as a discursive agent, namely as artist or intellectual or queen? No doubt many factors are in play. On the one hand, two ideals are inherited from precinematic gay literary traditions: first the ideal of pedagogic Eros, the Socratic intergenerational initiation (the two silent adaptations of *Mikael* present a mentor relationship where the sexual object is simultaneously artistic apprentice and model), and second the aesthete or dandy, member of a refined and sensitive elite. Wilde's *Picture of Dorian Gray* may not have been the first work to posit artistic representation as some kind of metaphoric analogue of gay identity, and the artist-intellectual as the gay prototype, but it is undoubtedly the Ur-text of the third body narratives.

On the other hand, a documentary dimension to the artist figure is also signif-
icant in so far as he embodies a sociological acknowledgment of a sector where gays
traditionally are disproportionately visible, sheltered, and nurtured. More specifi-
cally, an autobiographical discourse can be read on a quite literal level. What else
to make of Visconti, in his sixties, undertaking his final progression of portraits of
aging artistic figures: composer, patron, and connoisseur, respectively in *Death in
Venice*, *Ludwig*, and *Conversation Piece*? The autobiographical possibility is dramatically
foregrounded in that small group of 'avant-garde' works, mostly nonfiction, by
Werner Schroeter, R.W. Fassbinder, George Kuchar, Rosa von Praunheim, Derek
Jarman, and Curt McDowell, where the filmmaker plays himself as gay artist literally
integrating sexual expression and artistic creation. Of course, Pasolini's performance
as artist in two installments of his trilogy is a unique and sublime variation of this
pattern in narrative fiction. The autobiographical reading of the gay artist figure may
be better understood by comparing it with the important role of autobiographical
writing in the cultural affirmations of other disenfranchised groups, from women
to blacks.

Another perspective on the artist figure assumes an analogy between the
Romantic moment of artistic inspiration/crisis and the gay ritual of coming out.
Pasolini's *Teorema* does exactly that, when aspiring painter Pietro has sex with
Terence Stamp and calls into question his entire vocation: Action Painting becomes
Piss Art (Stamp as homoerotic object has had a similar devastating impact in other
films as well, from *Billy Budd* to *Far from the Madding Crowd*, and his androgynous

Figure 55.4 Autobiography: the filmmaker Curt McDowell's hands in *Loads*

compatriots, Dirk Bogarde and Michael York, have shown similar propensities – there's a thesis in there somewhere).

Perhaps at a more profound psychosexual level is the issue of empowerment, both individual and collective. Does the artistic control of model and scenario, guaranteed by professional protocol, social status and/or class privilege, translate into a fantasy of general sexual empowerment in a hostile social setting? Does specific sexual control of the body of the loved one represent a symbolic victory over repression?

The incarnation of the gay subject as artist connotes a sense of presence in the world that is one of thought and feeling as opposed to action; of desire rather than consummation; of representing as if in revenge for the nonrepresentation of gayness in official culture; of observation as if in retaliation for the increasing surveillance we have been subjected to from the start of this chronology.

Narrative role: the look and the voice

Sexual looking is, of course, a highly charged activity in our culture, all the more so for the same-sex look that ventures outside of certain carefully controlled areas (such as sport). The artist figure, then, at the most pragmatic level, has recourse to a traditional high-status alibi, and thereby legitimizes sexual looking and representation. Furthermore, the artist-intellectual is traditionally an outsider type in our culture (as is the queen in her simultaneous embrace and rejection of disguise). The artist's outsider vantage point fuses with that of the sexual outlaw in patriarchal culture. The image of Caravaggio watching the goings-on of the papal court, or of Aschenbach on the porch of the Venice hotel, is that of both the alienated artist charting the machinations of social power from the wings, and the gay man tuning into the sexual undercurrents of his surroundings. The gay artist figure exposes and concentrates the networks of sexual looking and being-looked-at within gay narrative and within gay culture, and, in fact, within Western patriarchal culture as a whole.

Two interesting variations in the scenario of the look must also be noted:

1 *The return of the look of the sexual object.* The subject's model, initiate, or sexual object looking back can be a key moment in the narrative of the third body, hinting tantalizingly at the possible union of subject and object. Remember Tadzio's complicit look back as *Death in Venice* draws to a close – a look of acceptance and reciprocity, perhaps a challenge to the act of voyeurism as well (this look back is incidentally a key addition that Visconti brought to the Mann novella). In some cases, the returned look of the object can so dominate or unsettle or overturn the narrative structure that an entirely new narrative mythos emerges, the object as subject – as in Fassbinder's groundbreaking *Querelle* or its realist precursor *Fox and His Friends*, or in Derek Jarman's *Sebastiane.* More literal instances are those moments in 1980s' works like *Looking for Langston* and *Law of Desire*, where the object looks directly at the camera and the spectator, thus subverting both the subject-object dynamic and the narrative syntax of voyeuristic pleasure.

2 *The voice of the subject.* In many cases, the look of the gay subject is activated by or signified by his voice, namely through the mechanism of disembodied voice-over narration. It might be argued that the preponderance of voice-over narrations in gay fictional cinema reflects only the low-budget artisanal level of the production, as in *My Hustler* or *Loads*, or in physique movie mogul Dick Fontaine's overdubbing of his classic erotic shorts with a giddy voice-over by queenly commentator Glory Holden. However, the voice-over has lingered as an aesthetic strategy in nonartisanal cinema, throughout entire films such as *Looking for Langston* or in key moments such as the porn-dubbing opening sequence of *Law of Desire*.

The voice-over, emitting from the body of author-subject as he retreats once more behind the camera, may impart a level of retroactive self-reflexivity, as in *Caravaggio* and *Loads*. This voice may also enact a simultaneous sports-casting relationship to the erotic action of the camera's gaze, as in *My Hustler*, or the gay cable video genre represented by a mid-1980s New York work like *How to Seduce a Preppie* (Rick X). With both options, the effect is to amplify the outsider status of the gay subject, to cement the irreconcilability of subject and object, and to indulge in a deliriously self-conscious game of voyeurism that at the same time problematizes and exults in the subject's look. In *Langston* and *Querelle*, external and literary voices engage in a multivocal address of and by the gay subject. The often disembodied quotations and overlapping voices create a distancing, multivalent effect.

The erotic cinema

Many of the foregoing titles, because of the oblique or direct eroticism of their address, call for a momentary digression to consider how the third body pattern pertains to that disreputable mirror of the narrative cinema, the erotic cinema proper. Since no gay fiction is far from the erotic impulse that is central to all gay (popular) culture, it is not surprising that the third body makes an appearance in the erotic cinema as well, yet with an important inflection. Here, the gay subject is both absent and present: absent as in the erotic photograph, even in the pinup layout's narrative modes, for the gay subject seems invisible and is assumed to be off-screen. Yet the gay subject is also present, in the sense that subject and object within the diegesis are often fused, and these roles are dispersed interchangeably among all the bodies within the frame. It is a question, to paraphrase Mingus, the legendary, pseudonymous, porn reviewer of the *New York Native*, of confusion and ambiguity between the men we want to be and the men we want to love, in other words, between subject and object. Mingus goes on to argue that this confusion emerged with what I've called the decline of the ephebe, which he situates in the late 1950s, before which there was a clear dichotomy between adolescent object and 'dirty old john over thirty' (the exact point of this historical threshold needs further study at the very least). Nevertheless, this current (con)fusion of subject and object is highlighted by the artist-intellectual figures who people the porno formulas. For they are indeed stock characters in gay film, including the writer-researcher (usually of porno novels), the photographer, and the journalist. The list

expands if one includes the porno world's variations on the Socratic mentor: the track coach, the sex doctor, and the Marine officer. With these figures, who are homoerotic objects as well as subjects, most of the tensions of difference that structure the licit fiction disappear; artist and model, subject and object, self and other, he-man and third body, become all but indistinguishable in bodily construction (except for the occasional differences in race, age, body, consciousness, and sometimes other factors that recall but usually don't replicate the original structures of opposition). In this minimization of difference, it is interesting to locate gay eroticism's most essential distinctiveness alongside heterosexual eroticism, in whose narrative world difference is always visualized at its most extreme form, that is, as *gender* difference.

Positive image/happy ending, or the failure of gay liberation criticism

The foregoing attempt at a taxonomy of gay-authored narrative cinema as a transhistorical, transcultural corpus, this project of defining the gay subject as third body, as incarnation of difference and enactor of representation, is not without methodological stresses. Aside from the dangers of gay essentialism lurking in any cross-cultural and transhistorical study, does this taxonomy in fact constitute genre criticism without a genre (in the sense that the necessary continuing dialogue between genre author and genre audience would seem missing with this retroactively constructed, discontinuous corpus that is the gay art cinema)? Is this auteur criticism without an auteur (in the sense that the gay author is constructed collectively and retroactively on the basis of thematic consistence and biographical knowledge that in many cases are invisible to the ordinary spectator)? Or is this a structuralist inventory of narrative archetypes and functions without the necessary mythological coherence of a discrete host culture (unless the international network of gay subcultures that are the pillar of the 'art cinema' constituency can be considered a coherent 'culture')? (Of course, these problems tend to dissolve with the 1980s corpus, since the new breed of young gay directors have been very much plugged into their gay constituency, and the international circuit of gay festivals has begun to consolidate something like real gay genres, gay audiences, and gay authors, arguably for the first time in our history.)

What is clear amid this methodological tentativeness is that traditional gay liberation criticism, as exemplified in the post-Stonewall decade by the ethic-aesthetic of the positive image, would see, and has usually seen, the foregoing corpus as irredeemable traffic in negative stereotypes. A familiar litany of 'bad images' can readily be drawn up from the films I've discussed: the young, silenced, and objectified sex object, attracting but never reciprocating the lustful gaze of the aging, bourgeois, libertine predator; the sensitive yet self-destructive artist; the wilting pansy; the dead queer.

In short, the 'positive image' perspective founders before this corpus assembled around authorship and sexual orientation, and has no power to explain the irresistible attraction by gay authors to images that seem harmful in the viewfinders of movement ideologues. Is the attraction to the 'negative image' by the gay author

simply a question of self-oppression, as we assumed in the 1970s? Or is it a kind of existential reappropriation of stigma, a Genetesque, defiant inoculation against the denigration of the stereotype? Is it a preference for the exclusive marginality of the damned, rather than the anonymous absorption entailed by the civil rights/gay liberation platform? Is it a Pasolinian refusal of the consumerism and conformism of the liberal utopia? Or is it simply, as Dyer would have it, the adaptation by an invisible minority of the only available system of coding for self-definition (Dyer, 'Homosexuality and Film Noir' 1977)? All of these possibilities no doubt enter into play, but too often we have avoided them, relying instead on reductive moralism instead of criticism.

For all of the indisputable magnitude of the late Vito Russo's contribution to gay cultural history, as a populist polemicist he did have certain blind spots around gay authors of the art cinema. Russo's famous 'Necrology' of the cinema's dead queers in *The Celluloid Closet* contains not a few gay authors (though several obvious entrants have inexplicably been sifted out, such as Fassbinder and Pasolini). His dismissal of *Ludwig* ('Sleeping with a stable boy rots your teeth') is a scandalous rejection of one of the few serious, gay-authored works to attempt to imagine nineteenth-century cultural and sexual sensibilities (Russo 1987: 336). But Russo was not alone: remember the fierce polemics in many gay community newspapers around Fassbinder's *Fox*, around semi-mainstream films, from *La Cage aux Folles* to *Kiss of the Spider Woman*, and around Dyer's and Jack Babuscio's useful articles on 'camp.' Even Dyer seemed to contradict his own sensible discussion of stereotypes and a social typing strategically useful for the gay liberation project of self-definition by his later uncharacteristically moralistic broadside against Pasolini's *Arabian Nights* (Dyer, 'Stereotyping,' 1977; Dyer, 'Pasolini,' 1977). My own record is by no means spotless in this regard: I still cringe when I remember my 1978 denunciation of *Sebastiane* for its 'cloyingly pompous stylization, visual and dramatic vacuum,' and 'tawdry jumble of s-m formulae,' with the parting shot that 'the only thing that distinguishes *Sebastiane* from the realm of the soft core is the honesty of the latter.' In short, while the positive-image gay critic has usually been dead-on in his targeting of the *Cruisings* of the (hetero) patriarchal entertainment industry and has effectively revolutionized the reception of mainstream media within gay culture, he has too often gunned for the fragile butterflies of gay expression within the art cinema as well, and with counterproductive effect. Of course, feminists, too, have had to grapple with the negative image issue: for example, over the past decade, New York lesbian independents Lizzie Borden, Sheila McLaughlin, and Su Friedrich have insisted on dealing upfront in their films with previously 'negative' iconography of woman as victim, sex worker, butch/femme, and nun respectively.

Our uneasy relationships with the tragic or ironic sensibilities of the great gay art-house filmmakers of the post-Stonewall generation continue – from Visconti and Pasolini to Fassbinder and Almodovar (our relationship with cult gay authors from Morrissey-Warhol to Waters has been only marginally better). Our reluctance to become the gay constituency they deserved has been due in no small way to the failure of a whole generation of gay critics to understand the contradictions of the international art cinema marketplace within which so many of these authors were circulated.

The institution of the art cinema stalled the development of a discrete gay constituency in two ways: through the ambivalence of its discourse, and through the crossover constitution of its audience. Textually speaking, the art house/ film festival product usually offers a something-for-everyone blend of intellectualism and ambiguity, and an aura of recuperable marginality. The 'exotic' articulation of taboo desire alongside its simultaneous disavowal, this cinema hovers on a tightrope between high-cultural status and subversive subcultural chic. Gay cinephiles are offered a mixed package, just the right blend of melodramatic catharsis, social justification provided through visibility alone, and finally an adequate dose of skin, albeit ultimately frustrated through the forever-receding closure of the open ending.

The demographic mosaic of the art house audience also enters the picture. If the gay spectator cements his identification with the gay subject through the voyeuristic sighting of the gay object, non-gay spectators, one can speculate, attach their voyeuristic fix on the gay subject himself, shaped through discourses of stereotype, freakshow, and pathos/victimization. For non-gay constituencies and critics, gay directors' tragic sensibilities seemed a tautological adjunct of marginality. Meanwhile, straight critics actively stifled gay discourses around these films, either through homophobic panic, liberal tolerance ('I'm so matter-of-fact and cool that sexual orientation doesn't have to be mentioned'), or allegorical exegesis ('This film is not about gayness, it's about fill-in-the-blank'). If the built-in ambiguity of the narrative codes of the art cinema allowed gay authors space to create, it denied them the chance to nurture a continuous and coherent gay audience. Instead, we remained invisible and covert spectators, a divided and discontinuous audience.

The inadequate critical context set the tone for the expectations and tastes of gay audiences in the rare moments when they were constituted as a discrete group, most often through the gay festivals that started cropping up in large markets in the 1970s (a similar abdication of critical responsibility affected the other discrete gay market, the porno scene). Even seasoned gay festival audiences still lean towards the happy-ending, positive-image standard, with a preference for *intimiste* domestic or romantic melodramas with open – but not *too* open – endings; and this after almost two decades of gay programming. Some post-Liberation gay filmmakers have excelled within the melodrama genre – think of Frank Ripploh, the late Bill Sherwood, the late Artie Bressan, or Quebec's Michel Tremblay (in his screenwriter's hat) – namely through developing strong and authentic emotional hooks on lifestyle issues within the ghetto. The melodrama's validity as a format of gay popular culture is without question, having delivered some of the 1980s' undisputed masterpieces. However, the development of the gay melodrama hardly constituted the appearance 'at last' of *the* gay cinema, as each successive new work from *Taxi Zum Klo* to *Longtime Companion* was greeted by both gay and straight blurbists. As for the Pandemic's impact on the mythic landscape, ACT UP's exemplary cultural politics may have stimulated a new creative energy in the cultural margins and on community levels, but the health crisis's impact on feature-length independent fiction has been largely to enrich this important melodrama tradition – think of *Buddies*, *Death in the Family*, and *Parting Glances*, all precursors of that mother of all melodramas, *Longtime Companion*.

Reinventing the third body/gay subjects in the 1980s and 1990s

Aside from this healthy melo current, the third body pattern maintained its currency at the end of the 1980s, and is still in the process of being reinvented by the young, post-Stonewall authors (who are still incidentally far ahead of their critical constituency for the most part, though the gap may be closing). In another context, Richard Dyer describes this work as 'post-affirmation,' 'films that manage to deconstruct without auto-destructing, that leave behind without anguish the fixed identifiers affirmed by earlier films, that seem to enjoy the struggle with definitions of identity as an ongoing process' (Dyer 1990: 284). In the recent renditions of the third body films, the separation of subject and object is no longer a given, nor is the fixity of observer status, the immutability of difference, or the infinite deferral of closure. The gay subject emerges now dialectically, for example, as a comic subject rather than tragic, through parodic quotation or through reversals. Risks are taken with 'dangerous' or negative imagery (I am sure that for Almodovar the concept of the positive image is an inscrutable aberration of Protestantism), sexual pleasure is reclaimed and celebrated as much as it is problematized, humor and anger are as characteristic as the melancholy of yore.

Fassbinder's relentless exploration of the subjectivity of the object and the power dynamics of desire in *Fox*, *In a Year of Thirteen Moons*, and *Querelle*, and Jarman's not-dissimilar experiment in *Sebastiane*, have now proven to be prophetic of a whole spectrum of work, from the haunting *L'Homme Blessé* (Patrice Chéreau, 1983) to the infuriating *A Virus Knows No Morals*. Meanwhile, Jarman's idols Genet and Pasolini reawaken as the presiding spirits of the end of the century.

Jarman's two non-white compatriots Hanif Kureishi and Isaac Julien both explode the patterns of subject–object difference predicated on white, middle-class subject and racial Other, superimposing contradictory grids of identity, involving race, class, gender, and sex, and making new connections and coalitions from grid to grid. Julien goes further than Kureishi's fundamentally populist, realist framework to disperse the subject, and yet collectivize him at the same time, disallowing the individualist readings encouraged by art cinema's fetishization of psychological realism.

While Julien reclaims the gay subject from buried racial, cultural, and sexual history, John Greyson reclaims dozens of them, offering his historical reconstructions of everyone from Aschenbach and Kipling to Foucault and (Rock) Hudson. This video artist offers essayistic hypernarrative formats, matter-of-factly peopled by self-conscious and lascivious gay artist-intellectual subjects from the pre-Stonewall era, who have come back to haunt the post-Liberation gay sensibility. Is this recuperation of gay history or a tongue-in-cheek postmodern version of the old gay community ritual of citing the famous fags of history from Plato to Liberace (a self-affirming ritual which in any case has undoubtedly been more responsible for the momentum of the 'third body' narrative than I have acknowledged)? Whatever, in *Urinal*, Greyson's first feature film, Sergei Eisenstein tries to seduce not an object type but another subject, Langston Hughes. More at home in the toilet stall than the art house, he squints through a glory hole, not at an ephebe or he-man, but at the parade of gay artist subjects who now become recycled as postmodern pastiche, at the ferment of

sexual politics in the cultural horizon of the present, at the collapse of the public and the private and, at the same time, happily, at the still-undiminished, infinite, and delirious possibilities of the (homo)sexual body.

Three of Greyson's subjects are lesbian artists, sketched with his traditionally impeccable gender parity. Greyson however certainly did not invent the lesbian third body narrative. In fact the sudden emergence of a flood of lesbian-authored variants of the form in the mid-1980s, each with its own incarnation of the artist-intellectual subject, made a major contribution to its reinvention. The list includes works by Su Friedrich, Patricia Rozema, Elfi Mikesch, Lizzie Borden, Sheila McLaughlin, Léa Pool, Chantal Akerman, and perhaps Sally Potter, with associate status for Liliana Cavani and Jill Godmilow (for her non-lesbian-authored, nonsexual Gertie and Alice). Donna Deitch has a place, albeit tenuous, in our category as well, since Desert Hearts occupies the borderland between art film narrative and pop romance, and Helen Shaver's status as an intellectual is more a question of script exposition and wardrobe than of narrative function. Léa Pool's A Corps Perdu (Straight to the Heart, 1988), her follow-up to Anne Trister, may also belong as a lesbian-authored version of the gay male third body narrative, with the subject this time a photographer. This is not to say that the specularization of eroticism, the problematization of subject–object relations, or the autobiographical resonances in the lesbian films are identical to the gay male formulations – far from it. Whether the lesbian films constitute a transmigration or spontaneous combustion, whether or not they confirm the pattern as a basic cultural structure of same-sex sexuality, or as just a genre of art cinema with a new lease on life, they clearly second Greyson's demonstration that the third body narrative – the subject as artist-intellectual and gender transgressor – is large and flexible enough to absorb each generation's and each constituency's particular mythic projection and political challenges.

The continuous thread from von Gloeden and Stiller on through Jarman and Greyson is of course neither as continuous or as threadlike as might be inferred. The new breed of the 1980s notwithstanding, the battles are far from over. The spurts and starts sometimes seem as uneven as ever, especially as the crisis in non-Hollywood film financing deepens around the world, gay or straight, and the flourishing gay festival circuit still can't finance a single feature budget. The lures of success are also as insidious as ever (will the Poison of today become the Tie Me Up Tie Me Down of tomorrow?), and the bowdlerization of gay history in the mainstream biopic seems as obnoxious as ever (was Charlton Heston's Michelangelo in The Agony and the Ecstasy really any worse than the recent Canadian Whitman travesty Beautiful Dreamers or the Hollywood 'straightening out' of Sir Richard Burton in Mountains of the Moon?). Still, for all the continued lurching back and forth, in and out of the closet threshold zone of self-censorship dictated by state-supported art film financing, for all the occasional rubbing thin of the 'third body' thread, it shows surprisingly little danger of unraveling in the 1990s. For gay and now lesbian artists and audiences, the narrative art cinema, poised halfway between the quagmires of Hollywood and the uncompromising nontheatrical fringes of the radical avant-garde, continues to be an indispensable forum for confronting the world and ourselves.

The third body: a select filmography of the gay male subject as artist, intellectual, and queen

Titles are in approximate chronological order; works are presumed gay- or bisexual-authored, with authorship sometimes defined to include scriptwriter or, in the case of adaptations, author of original source material.

Mauritz Stiller, *The Wings* (*Vingarne*) (Sweden, 1916); sculptor – first adaptation of Herman Bang's gay novel *Mikael*.

Richard Oswald and Magnus Hirschfeld, *Anders als die Anderen* [*Different from the Others*] (Germany, 1919); musician.

Carl Dreyer and Herman Bang, *Mikael* (Germany, 1924); painter – second adaptation of *Mikael*.

Jean Cocteau, *Blood of a Poet* (France, 1930); *Orphée* (1949); *Le Testament D'Orphée* (1959); more-or-less autobiographical variations on gay artist as subject.

S.M. Eisenstein, *Ivan the Terrible* (USSR, 1944–46); Czar as proto-gay subject/looker, bodyguards as objects.

Kenneth Anger, *Fireworks* (US, 1948); hybrid formula includes photo-object protagonist.

Dick Fontaine (US, 1950s–60s); physique narrative shorts, many with artist subjects, some narrated by queen voice-over.

Andy Warhol and Paul Morrissey, *My Hustler* (US, 1965); queens compete for object.
Lonesome Cowboys (US, 1968); queens compete for cowboy object.
Flesh (US, 1968); hustler object surrounded by queens and photographer.
Trash (US, 1969); queen and hustler.

Pier Paolo Pasolini, *Teorema* (Italy, 1968); episode around painter/son Pietro.
'Trilogy of Life' (Italy):
The Decameron (1971); PPP as Giotto.
The Canterbury Tales (1972); PPP as Chaucer.
Arabian Nights (1974); episode around Arab poet Abu-Nuwas, etc.

Luchino Visconti, *Death in Venice* (Italy, 1971); composer.
Ludwig (Italy, 1973); patron.
Conversation Piece (Italy, 1974); connoisseur/collector.

John Schlesinger, *Midnight Cowboy* (US, 1969); hybrid melodrama includes gay object as protagonist.
Sunday Bloody Sunday (UK, 1971); hybrid melodrama includes doctor/art-lover as gay subject.

R.W. Fassbinder, *Beware the Holy Whore* (Germany, 1970); filmmaker.
Fox and His Friends (Germany, 1975); prole underdog as object-protagonist surrounded by subject types.
Germany in Autumn (Germany, 1978); RWF episode has real-life filmmaker as subject.
In the Year of Thirteen Moons (Germany, 1978); transsexual.
Querelle (Germany, 1982); sailor as object–protagonist, officer as subject/representer/looker.

Frank Vitale, *Montreal Main* (Canada, 1974); photographer and ephebe.

Jack Hazan, *A Bigger Splash* (UK, 1974); painter and model.

Ryan Larkin, *A Very Natural Thing* (US, 1974); a romantic melodrama with both photographer and teacher as protagonists.

Derek Jarman, *Sebastiane*, (UK, 1976); hybrid includes centurion as gay subject and martyr as gay object/protagonist.

The Tempest (UK, 1979); magician/impresario.

Caravaggio (UK, 1986); painter.

Richard Benner, *Outrageous* (Canada, 1977); *Too Outrageous* (1988); drag performer.

Arturo Ripstein, *A Limitless Place* (Mexico, 1977); drag queen subject.

Jack Gold and Quentin Crisp, *The Naked Civil Servant* (UK, 1977); queen.

Ron Peck, *Nighthawks* (UK, 1978); teacher.

Rosa von Praunheim, *Army of Lovers or the Revolt of the Perverts* (Germany, 1979); documentary author as subject.

Guy Hocquenghem and Lionel Soukaz, *Race d'Ep* (France, 1979); episodes around von Gloeden and Hirschfeld.

Salvatore Samperi and Umberto Saba, *Ernesto* (Italy, 1979); student subject, autobiographical core.

Curt McDowell, *Loads* (US, 1980); documentary author as subject.

Frank Ripploh, *Taxi Zum Klo* (Germany, 1980); domestic melo with teacher subject.

Werner Schroeter, *La Répétition Generale* (France, 1980); documentary author as subject.

The Rose King (Germany, 1986); mother and son compete for ephebe.

Arthur Bressan, *Abuse* (US, 1982); filmmaker and ephebe.

Paul Verhoeven and Gerard Reve, *The Fourth Man* (Netherlands, 1983); writer.

Gus Van Sant, *Mala Noche* (US, 1985); countercultural subject and Chicano ephebe.

Hector Babenco and Herman Puig, *Kiss of the Spider Woman* (US/Brazil, 1985); queen/cinephile as gay subject.

Takis Spetsiotis, *Meteor and Shadow* (Greece, 1985); poet.

Eric de Kuyper, *A Strange Love Affair* (Netherlands, 1985); film studies teacher and ephebe.

Stephen Frears and Hanif Kureishi, *My Beautiful Laundrette* (UK, 1985); entrepreneur.

Bill Sherwood, *Parting Glances* (US, 1986); musician, editor, porn writer.

Michel Tremblay and Jean-Yves Laforce, *Le Coeur Découvert* [*The Heart Exposed*] (Québec, 1987); domestic melo, teacher and actor subjects, child object?

Stephen Frears and Joe Orton, *Prick Up Your Ears*, (UK, 1987); non-gay adaptation of playwright's diaries.

Pedro Almodovar, *Law of Desire* (Spain, 1987); filmmaker.

Isaac Julien, *Looking for Langston* (UK, 1988); poet.

John Greyson, *Urinal* (Canada, 1988); Eisenstein, Mishima, Hughes, Wilde, etc.

Harvey Fierstein, *Torch Song Trilogy* (US, 1989); drag performer.

Marlon Riggs, *Tongues Untied* (US, 1990); autobiographical elements, poet persona.

References

Dyer, Richard. 'Homosexuality and Film Noir,' *Jump Cut* 16 (1977), pp. 18–21.

—— *Now You See It: Studies on Lesbian and Gay Film* (London: Routledge, 1990).

—— 'Pasolini and Homosexuality,' in Paul Willemen (ed.), *Pier Paolo Pasolini* (London: BFI, 1977) pp. 57–63.

—— 'Stereotyping,' in Dyer (ed.), *Gays and Film* (London: BFI, 1977) pp. 27–39.

Haskell, Molly. *From Reverence to Rape: The Treatment of Women in the Movies* (New York: Holt, Rinehart and Winston, 1974).

Kael, Pauline. Review of *Rich and Famous*, in *The New Yorker*, October 26, 1981, rpt. Kael, *Taking It All In* (New York: Holt, Rinehart and Winston, 1984) pp. 247–48.

Mingus (pseud.). *The New York Native*, undated, untitled clipping, *c*.1985.

Russo, Vito. *The Celluloid Closet*, revised edn (New York: Harper and Row, 1987).

Waugh, Thomas. 'Films by Gays for Gays,' *Jump Cut* 16 (1977), pp. 14–16.

—— 'Sebastiane', *The Body Politic* (March, 1978).

Reina Lewis

LOOKING GOOD
The lesbian gaze and fashion imagery

Abstract

THIS PAPER IS CONCERNED with the different forms of pleasure and iden-
tification activated in the consumption of dominant and subcultural print media.
It centres on an analysis of the lesbian visual pleasures generated through the reading
of fashion editorial in the new lesbian and gay lifestyle magazines. This considera-
tion of the lesbian gaze is contrasted to the lesbian visual pleasures obtained from
an against the grain reading of mainstream women's fashion magazines. The devel-
opment of the lesbian and gay lifestyle magazines, in the context of the pink pound,
produces a situation in which an eroticized lesbian visual pleasure is the overt remit
of the magazine, rather than a clandestine pleasure obtained through a transgressive
reading of dominant cultural imagery. In contrast to the polysemic free-play of
fashion fantasy by which readers produce lesbian pleasure in the consumption of
mainstream magazines, responses to the fashion content in the lesbian magazine *Diva*
suggest that in a subcultural context readers deploy a realist mode of reading that
demands a monosemic positive images iconography. The article uses the concept of
subcultural competency to consider the different ways lesbians read mainstream and
subcultural print media and suggests that the conflict over *Diva*'s fashion spreads
may be linked to changing patterns of identification and the use of dress for recog-
nizability.

Keywords

lesbian; fashion; gaze; consumption; lifestyle.

Introduction

One of the results of the growth and recognition of the pink economy in the late 1980s was the establishment of a number of lesbian and gay 'lifestyle' magazines in the UK and North America in the early 1990s (this would include in the UK *Diva*, *Attitude*, *Phase*, and in the USA and Canada, *Out*, *Girlfriends*, *Curve*, formerly *Deneuve*). Although they often had some overtly political content (from articles on lesbian mothers to coverage of Pride) these journals did not see lesbian and gay or queer identities only in political terms. In contrast to previous campaigning journals, the new titles mixed politics and consumption in a move that was in keeping with the new recognition of the pink pound (whose advertising revenue was crucial to them). More and more mainstream and gay-run businesses realized the potential of extending 1980s niche marketing techniques to include gay and, to a lesser extent, lesbian consumers (Clark 1993). As Frank Mort has demonstrated, this increase in consumer possibilities meant that lesbian and gay individuals grew increasingly familiar with the idea that consumption itself marked out ways of participating in a gay life (Mort 1996). The emphasis on lifestyle in these magazines was part of this formation.

I am interested here in how readers consume the magazines, particularly in the ways in which lesbians consume the fashion coverage in *Diva* (with some comparison to other journals and to gay male readers). Looking at fashion allows me to think about the specificity of a lesbian visual pleasure and forms of identification in an area of cultural consumption traditionally aimed at women. Previously with Katrina Rolley, I had analysed how lesbians could extract visual pleasures from mainstream fashion magazines such as *Vogue* and *Elle* (Lewis and Rolley 1996). In this article I want to extend that discussion to consider what happens when fashion, with all its expected pleasures, moves to a venue where same-sex pleasure is the overt rather than covert remit of the publication.

For lesbian magazines, which often inherited a feminist perspective, the inclusion of fashion was a conspicuous departure from previous feminist publications, whose opposition to the fashion industry is legendary. But it was not only a greater adherence to feminist politics that separated out lesbian and gay magazines: the economic base that supported the new commercialized lifestyles and identities was unequal too. As Mort points out, the power of the pink pound was mainly seen as male – with far fewer services aimed at lesbians – and the mode of metropolitan gay life inscribed in the pink and style press relied on (and created opportunities for), shops and bars that mainly catered for male markets. Lesbians, who as women often, but not always, have less (disposable) income, were inevitably seen as a bad financial bet. So the opportunities for advertising, commercial tie-ins, etc. in *Diva* were far less. The new identification-as-consumption model of the pink pound was not embraced by all and to some extent the feminist politics of *Diva* produced an ambivalent attitude to the pink pound's valorization of shopping.

The different consumer habits assumed in lesbians and gay men (which also determine the magazine's access to clothes for fashion editorial) as well as their reading of the fashion images can be related to their different historical relationships to fashion. Whilst lesbians have in recent decades invested heavily in an anti-fashion and anti-consumerism politics and aesthetics – now under review with

the advent of the lipstick lesbian – gay men have historically marked out their iden-
tity through sartorial savvy, ritualized consumption, and investment in a discourse
of taste. Whatever the vogue for 'real' men or dressing down, gay men's maga-
zines do not have to overcome an antipathy to the very idea of fashion in the way
that a lesbian and particularly a feminist lesbian publication does. But, whatever the
attitude to fashion, dress as a marker of identity is hugely significant in the everyday
lives of lesbians and gay men: clothes function as a marker of recognizability to other
gays or as a method of passing (which may itself be gay-coded for those in the know,
whilst safely enough secured as heterosexual for those to whom one cannot risk
being known). Moreover, as consumers of each other's appearance, there is a plea-
sure to be had in recognizing and being recognized. For these reasons, clothes have
an importance in the lives of lesbians and gays – whether or not they consider them-
selves fashionable – that is rarely experienced by heterosexuals, however much they
may affiliate to alternative networks of style and subcultural identities (on the related
passings of sexual and racialized identifications see Walker 1993).

But, new departure as their fashion pages may have been, the lesbian lifestyle
magazines were not starting with a blank slate. Although fashion was rarely seen on
the pages of *Spare Rib*, many lesbians had been reading mainstream fashion maga-
zines for years, without forgetting their lesbian selves as they turned the page. As
Katrina and I argued, fashion editorial in mainstream magazines regularly used visual
codes that foregrounded the possibility of a lesbian visual pleasure (see also Clark
1993). These codes typically broke down into four sections: images which refer-
ence era/locales known to have lesbian historical significance (Brassai's Paris or Vita
Sackville West-style English country homes); gendered coupling of female models
where they take on a male/female dynamic; or cross-dressing where female models
take on male codes; and twinning or mirroring. This reading is based on a recog-
nition that the fundamental contradiction of female magazine consumption – in
which women are tutored in looking at, admiring and identifying with other
women's bodies – is a potentially eroticized experience for all women readers, not
just lesbians. The fashion magazine is widely understood to be a world without men,
yet one that is animated by them. Men's conspicuous absence from fashion imagery
is in direct relation to their presumed central role in the lives of the female addressee
of the magazine: it is for 'his' eyes that the magazines' consumers study the arts of
beauty and dress.

It was part of my argument in that piece that the lesbian viewer is engaged in
a mode of narcissistic identification with the beautiful woman in the image which
– relying on the implicit awareness of other lesbian viewers who, like her, gaze at
the beautiful woman – produces a desire both to be and to have the displayed
woman. As I gaze at the model, I may simultaneously at a fantasy level desire to be
like her, and desire to have her and, moreover, desire to be, as she is, the recip-
ient of another woman's desiring gaze. Further, in the 'all female' world of the
fashion magazine, the logic of a female desiring gaze produces what I call a para-
digmatically lesbian viewing position for any woman, whether or not she is
consciously lesbian identified. The tradition of an overtly heterosexual rationale in
the magazine world plus the commonplace trivialization of fashion (see Evans and
Thornton 1989) recoups this subversive position to the point where it is quite clearly
not an uncomfortable experience for a heterosexual viewer to gaze at female flesh

in this way. She can, after all, imagine that she is looking at them in order to learn how to make herself that desirable for her man. (For a different reading of mainstream magazines' invocation and disavowal of a lesbian reading position, see Fuss 1992.) But it does not police against lesbian pleasure.

It is clear that one of the elements that animated this analysis was the idea of imagined interpretive communities of other lesbians. We were thinking of reception in social terms, in which the psychic mechanisms of fantasy activated by the viewing experience are also socially structured. In this instance, the experience of pleasure seemed to rest on recognizable lesbian visual codes and on the activity of a transgressive, and often narrativized, reading. But what happens when that reading is not transgressive, when a same-sex narrative is the denoted, not the connoted, of the text?

Theorizing the reader of lesbian and gay lifestyle journalism

Now that we had overtly 'lesbian' fashion pages, how much did the putative lesbian 'we' like what we saw? The 'we' who looks is very important. Meaning does not reside in the image itself, but is generated in the interaction between viewer and text in which the codes of the text will be more or less decipherable to different viewers, depending on their historical and cultural moment. In this case, I need to be clear that there is no such thing as 'the' lesbian gaze, singular; since all lesbians are differentiated by class and racializing terms. But we can recognize the impact of such larger formations as subcultural groupings within which the individual lesbian subject may sometimes identify.

Caroline Evans and Lorraine Gamman also make a case for the importance of what they call subcultural competencies (Evans and Gamman 1995). These are what make the lesbian viewer able, for example, to recognize the lesbian subcultural referents and cross-gendered lesbian erotics connoted by a 'Napoleon and Josephine' narrative in *Vogue Italia* (where two women maintain an eroticized butch/femme dynamic sumptuously styled as the historical pair in a suitably lush and imperial setting). Evans and Gamman emphasize that the pleasure apparently produced by the code under discussion does not reside *in* the representation, but in the activity of decoding it. In other words, it is the act of interpretation itself that is eroticized, driven in part by the thrill of detecting a lesbian pleasure in the mainstream location. This means that there is no such thing as a preordained lesbian gaze, so much as a gaze that is able to decode lesbian subcultural referents, variable and shifting as they are: it is the exercise of a subcultural competency that produces lesbian pleasure, a pleasure that would be available to anyone able to exercise a similar competency whether lesbian or not (Evans and Gamman 1995: 35).

This for them can apply equally to the reading of dominant or subcultural texts. I am concerned with the specificities of each: in the case of a 'dominant' text like *Vogue*, I absolutely agree that the eroticization comes via the exercise of a subcultural competency. But this pleasure is heightened into a thrill by the sense of transgression that comes from constructing an alternative narrative. In the case of lesbian magazines, where the same subculturally recognizable codes are the denoted rather than

the connoted of the text, they read differently and sometimes, I think, produce less visual pleasure. Context is all.

This may be in part due to production values (money on the page) which in the case of smaller lesbian and gay magazines struggling to get advertising are generally much lower than the mainstream glossies. The high cost luxury mise-en-scène that is part of the visual pleasure of mainstream fashion coverage is absent from most lesbian and gay products such as *Diva* or free papers, *Boyz*, or the *Pink*. One exception to this is the British gay magazine *Attitude*, which is notable for its glossy and gorgeous fashion editorial and is generally more visual-led (in keeping with previous staff experience on the now-defunct gay journal *Square Peg*, which was known for its visuals). At this point, I should also report that of the cluster of titles available in the UK in 1994 (*Shebang*, *Phase*, *Diva*, *Attitude*) only half have survived, and they have only been running for two years. So I want to signal both the newness of the field (magazines are still trying things out and establishing a sense of their readership) and the method-ological implications of trying to make deductions from such a small field. This places a terrible burden of representation on my sample, especially when compared to our earlier sample from the mainstream media where we were able to analyse five titles over ten years. So this piece is necessarily rather more exploratory in nature: my comparisons of British and American, and lesbian and gay and mixed magazines, can only be suggestive at this stage.

Although I am primarily talking about lesbian visual pleasure, the comparison with mixed and gay magazines can be illuminating. It has been much documented that in recent years the male body has been objectified in popular culture in ways that were previously thought to be associated with the female body alone. As Mark Simpson discusses, all of this illustrates an increasing willingness on the part of mainstream popular culture to flirt with homoerotic pleasures (Simpson 1994). Gay lifestyle magazines do it in reverse: in seeking to sell homosexuality as lifestyle they overtly celebrate their readers' participation in mainstream culture (as consumers if nothing else), rather than speaking to them in a cocoon of fantasized gay separation.

This means that essential advertising revenue is possible; especially as more and more mainstream advertising campaigns look increasingly at home in a gay venue. I always thought that the advert for vodka (bottom right, Figure 56.1) was homo-erotically charged, but once seen in *Attitude*, it looks just perfect for the gay bedroom wall. So, when we look at the editorial fashion coverage in gay lifestyle magazines we are viewing in the context of the increased queering of popular culture (Simpson 1994) plus the crossover of queer-inflected representations into the queer space of the magazine itself. This raises questions about preferred and alternative meanings. During the single reading experience of flicking through a lesbian or gay magazine, viewers are engaged in reading dominant representational codes which may be more or less overtly open to same-sex pleasures (whether it is a vodka advert or a publicity shot of kd lang on the cover of *Diva*) and in reading editorial images that have an overtly gay 'meaning.' To consume a lesbian or gay lifestyle magazine is thus an experience of reading simultaneously with and against the grain, and of re-reading previously consumed images which, like the vodka advert in *Attitude*, are now over-laid with overtly homoerotic connotations in their new gay context. But one of the things that marks out *Diva* as different from *Attitude* is that it gets far less main-stream advertising and hence revenue. In keeping with the prevalent assumption

Figure 56.1 Crossover images (Photographer: Simon Pattle)

that lesbians never have any money to spend, very few mainstream advertising campaigns use *Diva*. Mainstream advertising only comes *Diva*'s way when a specifically lesbian audience is sought (for example, adverts for the pop group the Buffalo Girls and for the film *Carrington*). But not always even then: the lesbian market for kd lang's 1995 album was so obviously secure that the record company decided no wooing was necessary and refused *Diva* an advert or an interview.

Diva does of course carry a mix of advertising and editorial content. But the relationship of the fashion editorial to this mix of copy seems different from the image of a complex and highly sophisticated reading practice, revelling in contradiction in a properly queer and, at times, postmodern way that the other gay magazines construct and/or welcome. *Phase*'s first spread included a tongue-in-cheek homage to lesbian chic (top right, Figure 56.1), reproduced from *Out* magazine, USA. This not only highlights the role of consumption as a gay activity, but also invites the *Phase* reader to identify themself [*sic*] as one who will recognize the iconic nature of the popular cultural examples of lesbian chic on display. In contrast, *Diva* got a mixed response to its fashion coverage.

Founded in 1994, *Diva* initially included fashion spreads but has dropped them temporarily from its contents. Editor Frances Williams anticipated that her audience would to some extent apply a realist mode of consumption, so her decision to use ethnically diverse models and 'real' people was not motivated by her own preferences alone. This was coupled with an intent to introduce a greater diversity of lesbian images into what she thought had become a rather stale iconography.

Although some readers responded positively to the fashion pages, I was surprised at the level of complaints they generated: in nearly every case this was based on a realist mode of reception. Criticism centred on the non-representativeness of the models; the problems of objectification; the apparent unsuitability of the clothes featured for accepted/stereotypical/easily recognizable lesbian styles; and the cost of the clothes. Yet, presumably, some of the readers of *Diva* also read *Vogue* and are used to a non-literal consumption of fashion spreads. A feature on lesbian club promoters and bar staff reveals not only their own style choices but also their overview of the increasing fashion literacy and range of options on the lesbian scene (albeit in London only). Their comments suggest that for some lesbians the move away from a style orthodoxy is potentially liberating and some readers did indeed welcome the inclusion of fashion. But the level of negative feedback did leave me wondering what happens to the critical faculties of readers when faced with a lesbian *mise-en-scène*, considering that they must also read some sort of mainstream imagery against the grain, even if not specifically fashion imagery?

My suspicion that readers have different expectations of gay-produced imagery is borne out by Murray Healy's observation that the gay free papers *Pink* and *Boyz* got complaints when the men they pictured were not standard 'real man' beefcake. As Healy observes, if you want challenging, alternative images of masculinity go to *L'Uomo Vogue* not to the gay press.[1] Again, a positive images iconography is demanded. It seems that some lesbian and gay readers demand unambiguous politically or aesthetically 'safe' images in the gay press whereas they revel in transgressive, contradictory and subversive pleasures in the mainstream. If the exercise of subcultural competencies in the reading of the dominant is eroticized through a relationship of power and knowledge (I know something 'they' don't), why is this pleasure sacrificed in the consumption of gay/subcultural texts? And in what ways is this situation different for lesbian and gay readers? Where the lesbian demand for positive images, though in itself a fantasy of representability and wholeness, is based on the possibility of literal identification, the 'real' man demanded in *Boyz* is implicitly understood as a central fantasy of subcultural iconography. So whilst both lesbian readers of *Diva* and gay readers of *Boyz* are demanding an impossible monovalency of the image, they do it in quite distinct ways.

This anxiety about the polysemic nature of imagery in the consumption of the subcultural is at odds with a homoerotic reading of the dominant which relies on the multivalency of the image for the possibility of a queer pleasure. Is the readers' desire for closure in *Diva* something that is anchored in the codes of *Diva*'s imagery, or is it brought to the images by the readers, i.e. in opposition to the magazine's preferred reading? Why, when the advent of *Diva* coincides with a dramatic change in lesbian style, do its fashion pages get a hard time, in contrast to the evidently thriving fashion content at *Attitude*, whose reception is quite different again from that of *Boyz*?

Style counsel: fashion, reading and identification in *Diva*

One of the first spreads in *Diva* was entitled 'Naughty but nice' (Figure 56.2). Here the 'naughty' overtly refers to the devilish horns worn by the models. But it also

Figure 56.2 Naughty but Nice (Photographer: Simon Pattle)

suggests that the revealing clothes may themselves be naughty. Yet, when we turn the page to discover the 'nice' we find a far less demure picture: maintaining sexualized body contact at all times the two models are now in a rougher, dykier, street-style, posing with an in-your-face knowingness for the camera. On one level this suggests a carnivalesque reversal, in which the grotesque of the lesbian body is inverted as 'nice,' whilst something approximating 'proper' femininity is demonized as 'naughty.' This might be called the magazine's preferred reading, in which an audience assumed to have lesbian subcultural competencies would decode the visual pun of the title. But the spread offers another reading that, rather than problematizing the very idea of a binary divide by ridiculing its constituent terms, re-naturalizes the dichotomy by presenting a lesbian binarism in which the more masculine, dyke-referential style of the 'nice' is normatized, whilst the femmier, mainstream fashion of the 'naughty' is presented as subculturally transgressive. Although all the clothes are from a London designer shop, the styling of the 'nice' is quite easily recognizable as a lesbianized version of what was a current club look. The jeans, the leather trousers and big leather belts cut against the cutesy T-shirts and the baby blue satin of the jacket, securing a lesbian-coding for those in the know. But both images are presented as potentially desirable for the reader.

In the following edition we see a composite of the naughty/nice narrative ('Subscribe', Figure 56.2). This provides a recognizable lesbian coding alongside a signification of up-to-the-minute style and awareness about lesbian dress debates, as well as a parodic but still effectively eroticized assertion of active lesbian desire. The top figure's gaze out at the viewer (a look that is echoed in the main spread) invites identification and participation. The luscious cleavage at the bottom of the frame is de-objectified (in the pejorative sense) through the model's ownership of her self-display, signified by the parodic performance of ecstasy and re-affirmed by the playful surround of the other horned figure. It is precisely the multiplicity of referents in this image (satyrs, cherubs, dykes, postmodern self-referential butch-femme) that makes it so potentially pleasurable *and* that helps it to overcome the anticipated qualms of those sections of *Diva*'s readership assumed to be concerned about the objectification of the female body. In this, it is clear that the visual language of the fashion spreads is determined to a significant extent by the editor, stylist and photographer's sense of the attitudes of their readers. Some of this may be informed by direct feedback on *Diva* (letters, questionnaires), or based on indirect (word of mouth) reader-response, or come tangentially through hearing responses to images outside the pages of the magazine. In all these ways is their sense of the imaginary boundaries in which they operate constructed.

My sense of *Diva*'s readers is based on conversations with the editor, with women I know who read it, and on the response of non-magazine readers to whom I have shown the photographs. The differing attitudes I saw and heard to dress, desire and the role of reading in the formation of identity suggest two distinct but potentially overlapping modes of reception. One regards lesbianism as an authentic identity based on lived experience outside the magazine, which readers expect *Diva* to properly reflect and represent. This identity is often predicated on the separation from and resistance to dominant models of heterosexual femininity, frequently signified by a refusal of mainstream women's fashion. The other constructs identity *through* reading and *then* seeks social spaces in which that identity can be lived out and recognized, often through the appropriation of mainstream women's fashion.

For this second group, the sense of community engendered by the magazine is paramount. The selective use of mainstream fashion fosters an identity that is initially shared with an imagined interpretive community of readers and then developed experientially in social spaces (like clubs) with others who can decode it. Although the potential to be decoded by others is obviously key, it seems that this type of reader is able to deal both with the swift changes of style and fragmented identifications associated with postmodernity and with the fact that they may not be recognizable. It is no coincidence that these dress codes and senses of identity are predominantly associated with younger women, whose sense of self has been formed in a different and less oppositional relationship to the media than previous generations.

Diva obviously needs to appeal to both sets of readers. In the 'Gotta Lotta Socca' spread (top right, Figure 56.3) the play with imagery has gone: recognizability is key. So, in this spread the subcultural referents are dominant. This, along with the 'real' looking models, produces something almost ethnographic in its documentation of an enshrined (British) lesbian icon: the footballing dyke. In magazine terms,

the 'Socca' spread – with its awkward models and patent lack of artifice – is more akin to a lesbian version of teen magazines' 'readers in shopping malls' or to low-brow women's magazines like *Bella* than to high fashion fantasy. Although 'Socca' offers a significant consumer opportunity (buying football strips/sportswear is never cheap) it is clearly not exhorting its readers to enter fancy boutiques in the way that even the 'nice' was earlier. Rather, the football spread facilitates the living out of a more traditionally subcultural lesbian identity through the experience of buying men's clothes in the mainly male domain of the football sports emporium. This potential for resistance is not so simply available in the environs of a trendy fashion shop where almost anything will go.

Although the footballers might be great role models, their anti-erotic becomes even more pronounced in contrast to the presentation of the athlete's impressive physique (centre left, Figure 56.3). This is not because footballers are not eroti-cized as objects of lesbian desire: indeed they are. But the imputation of an eroticized relationship between them becomes impossible once they must symbolize a resisting subcultural position that is founded on a refusal to join in the 'patriarchal' objecti-fication of women's bodies. In other words, they have simultaneously to be beyond recuperation by a male voyeuristic gaze and to be objects of desire for a lesbian reader. But this must be coded in a classed and masculinized style of androgyny that has typically been resistant to an overtly eroticized objectification (not least because this is seen as implicitly femininizing) in ways that may not apply to femmier

Figure 56.3 Real Lesbians? (Photographer: Simon Pattle)

personae (which may often be more overtly presented for erotic contemplation). The awkwardness with which the 'Socca' models respond to their physical proximity looks authentic, not staged, and seems to be borne out in the difficulty of the quandary. But it may also speak to a butch occupation of space, the visual pleasures of which are beyond my recuperation, since one of my 'respondents' did find the 'Socca' spread sexy. So, what different sorts of reader pleasure and/or identification do these different spreads produce? Is the blokey mateyness of the footballers conducive to a butch identification and pleasure where the parodic glamour of 'naughty but nice' is not?

I think that one of the pleasures of *Diva* is the assumed authenticity of the models. They are always identified by name, and in some cases are constructed as the authentic owners of the style they model. The 'Tank Girl' models (bottom right, Figure 56.3) are thanked as fans, further emphasizing the documentary nature of the feature. It is the magazine's policy to use only lesbian models and photographers, driven in part by a feminist desire to provide work for women and lesbians, but also by the pragmatic analysis that it is harder to get 'straight' models to snuggle up realistically for the camera. This brings me back to the subcultural competencies that were in operation in the consumption of *Vogue*. If *Diva* does not identify the models as lesbian, how is the reader expected to know? In part it can be explained by the bodies, which are not stereotypically perfect, and the determined representation of a variety of ethnicities, which draws attention to a politicized affirmative action aesthetic (even as it may activate codes that eroticize the 'exoticism' of ethnic difference). Mainstream magazines do periodically use 'real' women or non-stereotypically beautiful models, but the exceptional nature of these instances signals their deviation from the normal rule. The out lesbian model Jenny Shimizu is an interesting case in point here: her visible ethnicity (in a world where white does not register as ethnic) and intertextually decodable lesbianism, via interviews and features, make her an exotically different visual spectacle which can be effectively contrasted with other model bodies and personae. It also signifies an up-to-the-minute association with fashionable lesbian chic. The fact that she presents as a butch dyke and not a glamour femme only reinforces her authenticity and heightens the transgressive appeal of using a lesbian model who deviates not only from the norm but also from the overexposed media creature of the (femme) lipstick lesbian of lesbian chic (see also O'Sullivan 1994).

But the details of dress, hair and the relations between the pictured women in magazines such as *Diva* are also important, as is the quality of the gaze directed out of the frame towards the reader. I may not get as much pleasure from these as I do from *Vogue*, but I am never in any doubt about their lesbian address. They position me as a lesbian addressee, producing a position of empathy and also of desire. Whilst, for a generation of women reared on the icon of the unobtainable supermodel, the very approachability of these models may be their downfall, as the magazine's lesbian addressee, it is their reality-effect that draws me in. Would this be legible to a reader without the appropriate subcultural competencies?

I feel in many ways that the *Diva* spreads grapple with the same problem as do my friends and I; how to look fashionable and move with the changing trends, whilst still signifying as lesbian? At one time it was relatively easy: you wore whatever you wanted and combined it with big shoes or boots. But then everyone started wearing

Doc Martens and footwear's lesbian coding was undermined. Now it is harder, plus there is a whole generation of lesbians who do not have the same agenda about recognizability and who share a dress aesthetic that owes more to mainstream than to feminist stylistics. The outrage caused by *Diva*'s foray into disparate styles may attest to a struggle over meaning that is lived out through representation and the consumption of material culture.

'We're here, we're queer and we're not going shopping'?: Representing queerness in other lifestyle magazines

In contrast to *Diva*, *Attitude* can play with a male relationship to fashion that is clearly eroticized and fantastic and can, presumably, draw on what Mort identifies as the homosocial spaces and reading habits previously constructed by the men's style press of the 1980s (Mort 1996). There is little recourse to authenticity or documentary in these examples from *Attitude* (Figure 56.4). The splendour of the dressed male figure is more closely akin to the unobtainable glamour of the supermodel, whilst the eroticization of the model is made abundantly clear in the regular inclusion of fashion editorial for perfume 'Heaven Scent' (centre left, Figure 56.4). In this instance, the erotic takes precedence. As Simpson observes, it is perfume/after-shave adverts in the mainstream media that have produced the most overt and

Figure 56.4 Glamour Boys (Photographer: Simon Pattle)

narcissistic objectification of the naked male torso. But where homoeroticized perfume adverts in the mainstream produce a troublingly queer ambivalence in which the homoerotic desire for the male body must be to some extent disavowed (Simpson 1994), their presence as editorial in *Attitude* produces the erotic as the dominant meaning: an unproblematic source of pleasure.

We can no longer simply talk about preferred and alternative meanings when the makers of mainstream aftershave adverts clearly know they are producing polysemic and queer imagery – the problem becomes one of relationships *between* meanings, in which the viewer's decoding activities may operate from a variety of positions each of which utilizes a different set of competencies that may be addressed by the text. It is hard to imagine a naked perfume promotion in *Diva*, although the American magazine *Girlfriends* regularly contains a centrefold and a variety of overtly eroticized images. But *Girlfriends* is also more adventurous in its fashion coverage, with spreads that seem to me to be more eroticized than those in *Diva*.

This greater ease, or willingness to play, with fashion may be because of the different attitudes to consumption in American feminism, where feminists have been more likely to organize campaigns around women's power as consumers than in the UK. Or it may simply be that *Diva* is not aiming for the erotic and *Girlfriends*, which features much pro-sex content and is associated with the *On Our Backs* crowd, is. But it is also to do with the more developed narratives of the *Girlfriends*' spreads. This investment in narrative produces similar possibilities for visual pleasure as those Katrina and I detected in mainstream magazines. The range of lesbian positionalities signified within each narrative affords a variety of points of access, identification and objectification.

In some magazines, fashion replaces or has a similar status to erotica, which was previously the place where style and visual transgression were housed. What, one might wonder, is the relationship between visuals in *Girlfriends* that are coded as fashion, those identified as erotic, and others, that are labelled as 'portfolio' (artists' photographs which are also style-driven in content)?

The ambivalence that seems to be possible in *Attitude* but not in *Diva* may also be linked to the ownership of the look at the point of production: where *Diva* uses only lesbian photographers, *Attitude* and *Girlfriends* feature photographers of both genders and unspecified sexual orientation. Kobena Mercer, in his analysis of the homosexual pleasures available to him in Mapplethorpe's difficult and ambiguous images of black men, argues that it matters very much who is looking (Mercer 1994). He insists that it is Mapplethorpe's insertion of himself into the subcultural scene he represents (via the self-portraits) that allows him to construct himself and hence the viewer as both owner and object of the homoerotic gaze, leading to a 'participatory observation' and 'ironic ethnography' (Mercer 1994: 195). But in *Attitude* we do not know if the photographer is gay, although they are certainly gay-literate. In *Diva* we do know that the photograph's point of origin is female and can assume from the politics of the magazine that this is lesbian. In *Girlfriends* we know that sometimes the photographer is male. But here, another set of subcultural competencies associated with a lesbian sadomasochism and a pro-sex discourse can intervene to assert a cross-gender, cross-sexuality community of interest that protects a male-produced image from charges of invalidity. In terms

of the specific subcultural competencies that are mobilized by *Girlfriends* (its adverts, editorial and features), the inclusion of male photographers' erotic lesbian images becomes an assertion of a lesbian identity that transgresses a subcultural orthodoxy coded variously as vanilla, lesbian and feminist.

If fashion is an arena noted for the transience and instability of its meaning and values, what is its relationship to a field of cultural production driven in part by a desire for certainty (there must be a mass of subjects who identify as lesbian or gay in order to provide a market for the product), where some readers welcome ambivalence in the dominant but are inclined to be anxious about it when encountered in the subcultural? Mercer argues that ambivalence signals the presence of an ideological struggle over meaning. In relation to dominant definitions, this has the potential to be politically progressive: for him, the indecipherability of Mapplethorpe's pictures of black men reveals the ambivalence of the racial fetishization (in which black men are both feared and adored) against which stereotype the very foundations of whiteness as an identity rest. But, in the case of lesbian and gay lifestyle magazines, the destabilization produced by the ambivalent fashion image is not of a dominant norm, but of a subcultural identity that often sees itself as already counter-hegemonic. So what does the recognition of ambivalence give us in this instance? Well, it suggests that lesbian and gay modes of reading are varied and operate differently in different contexts. But it also suggests that this contingency does not just depend on the object consumed but also on the stability of the consumer's sense of self. Without the surety of a dominant heterosexual stereotype to transgress, lesbianism becomes worryingly hard to detect.

Conclusion: dress, recognizability and transgression

It seems that in the case of fashion spreads, lesbian visual pleasure disappears when it is with the grain. Fashion, perhaps, has an easier potential to provide pleasure for gay men, for whom an interest in fashion is often still coded as transgressive, than for lesbians, many of whom experienced fashion as a route to heterosexual conformity. Of course, other forms of lesbian culture, such as film and literature, do manage to produce lesbian pleasures with the grain. So what is specific about fashion? If it is the exercise of a subcultural competency in the act of interpretation that produces pleasure, rather than only the image itself, then maybe fashion with all its potential for visual splendour also needs to evoke narrative? It may be the potential to construct fantasy through narrativized readings that ensures the eroticized lesbian pleasures in the consumption of fashion imagery. Certainly, some narratives can more easily be made to bear same-sex investments than others, but it is probably the absence of narrative in many *Diva* spreads that accounts for their lukewarm reception. Of course, effectively constructing the sort of rich and evocative narrative structures that are so pleasurable in mainstream fashion spreads also tends to cost money, so access to higher production values as well as editorial choice would have an impact here. But it does seem that the more suggestive a spread was, the more my totally unrepresentative group of viewers liked them. But an investment in narrative need not necessarily have to be against the grain, although the reception of gay magazines suggests that lesbian and gay consumers do prefer to read

oppositionally. This may be a learned habit, shared with other groups marginalized from or 'misrepresented' in dominant forms of culture (hooks 1992), but it does not explain why many heterosexuals, who might be seen as not very marginal, also prefer the connoted to the denoted. If there is a specifically subcultural investment in oppositional reading practices, how does this transfer to artifacts with subcultural conditions of production?

In this light, the mixed response to the introduction of fashion into new lesbian and gay lifestyle magazines needs to be situated in relation to other visuals in gay-produced culture, to dominant images of lesbians and gays and to changing dominant images of femininity and masculinity, as well as to the increasingly problematic relationship of style to identity for lesbian subcultures. When identity can no longer be decoded from appearance, fashion is both a newly available playground and a danger zone of irrecognizability.

Note

1 Murray Healy, conference presentation at Postmodern Times, City University, July 1995.

References

Clark, Danae (1993) 'Commodity Lesbianism' in Abelove, Barale and Halperin (eds), *The Lesbian and Gay Studies Reader*, London: Routledge.

Evans, Caroline, and Gamman, Lorraine (1995) 'The Gaze Revisited, or Reviewing Queer Viewing' in Burston and Richardson (eds), *A Queer Romance: Lesbians, Gay Men and Popular Culture*, London: Routledge.

—— and Thornton, Minna (1989) *Women and Fashion: A New Look*, London: Quartet.

Fuss, Diane (1992) 'Fashion and the Homospectatorial look,' *Critical Inquiry* vol. 18, Summer, pp. 713–37.

hooks, bell (1992) *Black Looks: Race and Representation*, London: Turnaround.

Lewis, Reina, and Rolley, Katrina (1996) '(A)dressing the Dyke: Lesbian Looks and Lesbians Looking' in Horne and Lewis (eds), *Outlooks: Lesbian and Gay Sexualities and Visual Culture*, London: Routledge.

Mercer, Kobena (1994) *Welcome to the Jungle: New Positions in Black Cultural Studies*, London: Routledge.

Mort, Frank (1996) *Cultures of Consumption: Masculinities and Social Space in Late Twentieth-Century Britain*, London: Routledge.

O'Sullivan, Sue (1994) 'Girls Who Kiss Girls and Who Cares?' in Hamer and Budge (eds), *The Good, the Bad and the Gorgeous: Popular Culture's Romance with Lesbianism*, London: Pandora.

Simpson, Mark (1994) *Male Impersonators*, London: Cassell.

Walker, Lisa M. (1993) 'How to Recognize a Lesbian: the Cultural Politics of Looking Like What You Are,' *Signs: Journal of Women in Culture and Society*, vol. 18, no. 4.

Judith Halberstam

THE TRANSGENDER GAZE IN
BOYS DON'T CRY

IN HER STYLISH ADAPTION of the true life story of Brandon Teena, the director Kimberley Peirce very self-consciously constructs what can only be called a 'transgender gaze.' *Boys Don't Cry* establishes the legitimacy and the durability of Brandon's gender not simply by telling the tragic tale of his death by murder but by forcing spectators to adopt, if only for a short time, Brandon's gaze, a transgender gaze.[1] The transgender gaze in this film reveals the ideological content of the male and female gazes and it disarms, temporarily, the compulsory hetero-sexuality of the romance genre. Brandon's gaze, obviously, dies with him in the film's brutal conclusion but Peirce, perhaps prematurely, abandons the transgender gaze in the final intimate encounter between Lana and Brandon. Peirce's inability to sustain a transgender gaze opens up a set of questions about the inevitability and dominance of both the male/female and the hetero-homo binary in narrative cinema.

One remarkable scene, about half-way through the film, clearly foregrounds the power of the transgender gaze and makes it most visible precisely where and when it is most threatened. In a scary and nerve-wracking sequence of events, Brandon finds himself cornered at Lana's house.

John and Tom have forced Candace to tell them that Brandon has been charged by the police with writing bad checks and that he has been imprisoned as a woman. John and Tom now hunt Brandon, like hounds after a fox, and then they begin a long and excruciating interrogation of Brandon's gender identity. Lana protects Brandon at first by saying that she will examine him and determine whether he is a man or a woman. Lana and Brandon enter Lana's bedroom, where Lana refuses to look as Brandon unbuckles his pants telling him: 'Don't . . . I know you're a guy.' As they sit on the bed together, the camera now follows Lana's gaze out into the night sky, a utopian vision of an elsewhere into which she and Brandon long to escape. The camera cuts back abruptly to 'reality' and a still two-shot of Brandon

in profile and Lana behind him. As they discuss their next move, the camera draws back slowly and makes a seamless transition to place them in the living room in front of the posse of bullies. This quiet interlude in Lana's bedroom establishes the female gaze, Lana's gaze, as a willingness to see what is not there (a condition of all fantasy) but also as a refusal to privilege the literal over the figurative (Brandon's genitalia over Brandon's gender presentation). The female gaze, in this scene, makes possible an alternative vision of time, space and embodiment: time slows down while the couple linger in the sanctuary of Lana's private world, her bedroom; the bedroom itself becomes an otherworldly space framed by the big night sky and containing the perverse vision of a girl and her queer boy lover; and the body of Brandon is preserved as male, for now, by Lana's refusal to dismantle its fragile power with the scrutinizing gaze of science and 'truth.' That Lana's room morphs seamlessly into the living room at the end of this scene, alerts the viewer to the possibility that an alternative vision will subtend and undermine the chilling enforcement of normativity that follows.

Back in the living room – the primary domestic space of the family – events take an abrupt turn towards the tragic. Brandon is shoved now into the bathroom, a hyper-real space of sexual difference, and he is violently depantsed by John and Tom, and then restrained by John while Tom roughly examines his crotch. The brutality of John and Tom's action here is clearly identified as a violent mode of looking and the film identifies the male gaze with that form of knowledge which resides in the literal. The brutality of the male gaze, however, is more complicated than simply a castrating force; John and Tom not only want to see the site of Brandon's castration, more importantly they need Lana to see it. Lana kneels in front of Brandon, confirming the scene's resemblance to a crucifixion tableau, and refuses to raise her eyes, declining, again, to look at Brandon's unveiling.

At the point when Lana's 'family' and 'friends' assert their heteronormative will most forcefully upon Brandon's resistant body, however, Brandon rescues himself for a moment by regaining the alternative vision which he and Lana shared moments earlier in her bedroom. A slow-motion sequence interrupts the fast and furious quasi-medical scrutiny of Brandon's body, and shots from Brandon's point of view reveal him to be in the grips of an 'out of body' experience. Light shines on Brandon from above and his anguished face peers out into the crowd of onlookers who have gathered at the bathroom door. The crowd now includes a fully clothed Brandon, a double, who returns the gaze of the tortured Brandon impassively. In this shot/reverse-shot sequence between the castrated Brandon and the transgender Brandon, the transgender gaze is constituted as a look divided within itself, a point of view that comes from two places (at least) at the same time, one clothed and one naked. The clothed Brandon is the Brandon who was rescued by Lana's refusal to look; he is the Brandon who survives his own rape and murder; he is the Brandon to whom the audience is now sutured, a figure who combines momentarily the activity of looking with the passivity of the spectacle. And the naked Brandon is the Brandon who will suffer, endure but finally expire.

Kaja Silverman has called attention to cinematic suture as 'the process whereby the inadequacy of the subject's position is exposed in order to facilitate new insertions into a cultural discourse which promises to make good that lack.'[2] Here in *Boys Don't Cry,* the inadequacy of the subject's position has been presented as a

Figure 57.1 Hilary Swank as Brandon Teena, with Chloe Sevigny as Lana,
in *Boys Don't Cry* (Courtesy of the Kobal Collection)

precondition of the narrative and so this scene of the split transgender subject, which would ordinarily expose 'the inadequacy of the subject's position,' actually works to highlight the *sufficiency* of the transgender subject. So, if usually the shot/reverse-shot both secures and destabilizes the spectator's sense of self, now the shot/reverse-shot involving the two Brandons serves both to destabilize the spectator's sense of gender stability and to confirm Brandon's manhood at the very moment that he has been exposed as female/castrated.

Not only does *Boys Don't Cry* create a transgender subject position which is fortified from the traditional operations of the gaze and conventional modes of gendering but it also makes the transgender subject dependent upon the recognition of a woman. In other words, Brandon can be Brandon because Lana is willing to see him as he sees himself (clothed, male, vulnerable, lacking, strong, passionate), and she is willing to avert her gaze when his manhood is in question. With Brandon occupying the position in the romance which is usually allotted to the male hero and the male gaze, the dynamics of looking and gendered being are permanently altered. If usually it is the female body that registers lack and insufficiency and powerlessness, in *Boys,* it is Brandon who represents the general condition of incompleteness, crisis and lack, and it is Lana who represents the fantasy of wholeness, knowledge and pleasure. Lana can be naked without trauma while Brandon cannot; she can access physical pleasure in a way that he cannot, but he is depicted as mobile and self-confident in a way that she is not. Exclusion and privilege cannot be assigned neatly to the couple on the basis of gender hierarchies or class hierarchies; power, rather, is shared between the two subjects and she agrees to misrecognize him as male while he sees through her social alienation and unhappiness and recognizes her as beautiful, desirable and special.

By deploying the transgender gaze and joining it to an empowered female gaze in *Boys Don't Cry*, director Kimberly Peirce, for most of the film, keeps the viewer trained upon the seriousness of Brandon's masculinity, the authenticity of his presentation as opposed to its elements of masquerade. But abruptly, towards the end of the film, Peirce suddenly and catastrophically divests her character of his transgender gaze and converts it to a lesbian and therefore female gaze. In a strange scene which follows the brutal rape of Brandon by John and Tom, Lana comes to Brandon as he lies sleeping in a shed outside of Candace's house. In many ways the encounter between the two that follows seems to extend the violence enacted upon Brandon's body by John and Tom since Brandon now interacts with Lana *as if he were a woman*. Lana, contrary to her previous commitment to his masculinity, seems to see him as female and she calls him 'pretty' and asks him what he was like as a girl. Brandon confesses to Lana that he has been untruthful about many things in his past and his confession sets up the expectation that he will now appear before Lana as his 'true' self. Truth here becomes sutured to nakedness as Lana disrobes Brandon tentatively saying that she may not know 'how to do this.' 'This' seems to refer to having sex with Brandon as a woman. They both agree that his whole journey to manhood has been pretty weird and then they move to make love. While earlier Peirce created quite graphic depictions of sex between Brandon and Lana, now the action is hidden by a Hollywood dissolve as if to suggest that the couple are now making love as opposed to having sex.

The scene raises a number of logical and practical questions about the representation of the relationship between Brandon and Lana: First, why would Brandon want to have sex within hours of a rape? Second, how does the film pull back from its previous commitment to his masculinity here by allowing his femaleness to become legible and significant to Lana's desire? Third, in what ways does this scene play against the earlier more 'plastic' sex scenes in which Brandon used a dildo and wouldn't allow Lana to touch him? And, fourth, how does this scene unravel the complexities of the transgender gaze as they have been assembled in earlier scenes between Brandon and Lana?

When asked in an interview about this scene, Peirce reverts to a very tired humanist narrative to explain this extraordinary scene and she says that after the rape, Brandon could not be either Brandon Teena or Teena Brandon and so he becomes truly 'himself' and in that scene 'receives love' for the first time as a human being.[3] Peirce claims that Lana herself told her about this encounter and therefore it was true to life. In the context of the film however, which has made no such commitment to authenticity, the scene ties Brandon's humanity to a particular form of naked embodiment that in the end requires him to be a woman.

Ultimately, in *Boys Don't Cry*, the double vision of the transgender subject gives way to the universal vision of humanism; the transgender man and his lover become lesbians and the murder seems to be simply the outcome of a vicious homophobic rage. Given the failure of nerve that leads Peirce to conclude her film with a humanist scene of love conquers all, it is no surprise that she also sacrificed the racial complexity of the narrative by erasing the story of the other victim who died alongside Brandon and Lisa Lambert. Philip DeVine, a disabled African American man has in general received only scant treatment in media accounts of the case, despite the connections of at least one of the murderers to a white supremacist group.[4]

Now, in the feature film, the death of DeVine has been rendered completely irrelevant to the narrative that has been privileged. Peirce claimed that this subplot would have complicated her film and made the plot too cumbersome – but race is a narrative trajectory that is absolutely central to the meaning of the Brandon Teena murder. DeVine was dating Lana Tisdale's sister Leslie and had a fight with her the night he showed up at Lisa Lambert's house in Humboldt County. His death was neither accidental nor an afterthought; his connection to Leslie Tisdale could be read as a similarly outrageous threat to the supremacy and privilege of white manhood that the murderers Lotter and Nissen rose to defend. By taking DeVine out of the narrative and by not even mentioning him in the original dedication of the film ('To Brandon Teena and Lisa Lambert'),[5] the film-maker sacrifices the hard facts of racial hatred and transphobia to a streamlined humanist romance: Peirce, in other words, reduces the complexity of the murderous act even as she sacrifices the complexity of Brandon's identity.

The murders, in the end, are shown to be the result of a kind of homosexual panic and Brandon is offered up as an 'everyman' hero who makes a claim on the audience's sympathies, first by pulling off a credible masculinity but then by seeming to step out of his carefully maintained manhood to appear before judge and jury in the naked flesh as female. By reneging on the film's earlier commitment to the transgender gaze and by ignoring altogether the possibility of exposing the whiteness of the male gaze, *Boys* falls far short of the alternative vision that was articulated so powerfully and shared so beautifully by Brandon and Lana in Lana's bedroom.

Notes

1 Patricia White has argued that the gaze in *Boys* is Lana's all along. I think in the first two-thirds of the film, the gaze is shared between Lana and Brandon but I agree with White that the film's ending transfers the gaze from Brandon's to Lana's with some unpredictable consequences. See White, 'Girls Still Cry,' *Screen* (Vol. unknown, No. unknown) 122–8.

2 Kaja Silverman, 'Suture' in *The Subject of Semiotics* (New York: Oxford University Press, 1983), 236.

3 Interview with Terry Gross on Fresh Air, PBS Radio.

4 See Aphrodite Jones, *All S/he Wanted* (New York: Pocket Books, 1996), 154.

5 In the review copy of the film I saw, *Boys* was dedicated 'To Brandon Teena and Lisa Lambert.' This dedication seems to have been removed later on, possibly because it so overtly referenced the erasure of Philip DeVine.

(b) Technobodies/ Technofeminism

Donna Haraway

THE PERSISTENCE OF VISION

[I] WOULD LIKE to proceed by placing metaphorical reliance on a much maligned sensory system in feminist discourse: vision. Vision can be good for avoiding binary oppositions. I would like to insist on the embodied nature of all vision, and so reclaim the sensory system that has been used to signify a leap out of the marked body and into a conquering gaze from nowhere. This is the gaze that mythically inscribes all the marked bodies, that makes the unmarked category claim the power to see and not be seen, to represent while escaping representation. This gaze signifies the unmarked positions of Man and White, one of the many nasty tones of the word *objectivity* to feminist ears in scientific and technological, late industrial, militarized, racist, and male dominant societies, that is, there, in the belly of the monster, in the United States in the late 1980s. I would like a doctrine of embodied objectivity that accommodates paradoxical and critical feminist science projects: feminist objectivity means quite simply *situated knowledges*.

The eyes have been used to signify a perverse capacity – honed to perfection in the history of science tied to militarism, capitalism, colonialism, and male supremacy – to distance the knowing subject from everybody and everything in the interests of unfettered power. The instruments of visualization in multinationalist, postmodernist culture have compounded these meanings of dis-embodiment. The visualizing technologies are without apparent limit; the eye of any ordinary primate like us can be endlessly enhanced by sonography systems, magnetic resonance imaging, artificial intelligence-linked graphic manipulation systems, scanning electron microscopes, computer-aided tomography scanners, colour-enhancement techniques, satellite surveillance systems, home and office VDTs, cameras for every purpose from filming the mucous membrane lining the gut cavity of a marine worm living in the vent gases on a fault between continental plates to mapping a planetary hemisphere elsewhere in the solar system. Vision in the technological feast becomes unregulated gluttony; all perspective gives way to infinitely mobile vision,

which no longer seems just mythically about the god-trick of seeing everything from nowhere, but to have put the myth into ordinary practice. And like the god-trick, this eye fucks the world to make techno-monsters. Zoe Sofoulis (1988) calls this the cannibal-eye of masculinist, extra-terrestrial projects for excremental second birthing.

A tribute to this ideology of direct, devouring, generative, and unrestricted vision, whose technological mediations are simultaneously celebrated and presented as utterly transparent, the volume celebrating the 100th anniversary of the National Geographic Society closes its survey of the magazine's quest literature, effected through its amazing photography, with two juxtaposed chapters. The first is on 'Space,' introduced by the epigraph, 'The choice is the universe – or nothing' (Bryan 1987: 352). Indeed. This chapter recounts the exploits of the space race and displays the colour-enhanced 'snapshots' of the outer planets reassembled from digitalized signals transmitted across vast space to let the viewer 'experience' the moment of discovery in immediate vision of the 'object.' These fabulous objects come to us simultaneously as indubitable recordings of what is simply there and as heroic feats of techno-scientific production. The next chapter is the twin of outer space: 'Inner Space,' introduced by the epigraph, 'The stuff of stars has come alive' (Bryan 1987: 454). Here, the reader is brought into the realm of the infinitesimal, objectified by means of radiation outside the wave lengths that 'normally' are perceived by hominid primates, i.e. the beams of lasers and scanning electron microscopes, whose signals are processed into the wonderful full-colour snapshots of defending T cells and invading viruses.

But of course that view of infinite vision is an illusion, a god-trick. I would like to suggest how our insisting metaphorically on the particularity and embodiment of all vision (though not necessarily organic embodiment and including technological mediation), and not giving in to the tempting myths of vision as a route to disembodiment and second-birthing, allows us to construct a usable, but not an innocent, doctrine of objectivity. I want a feminist writing of the body that metaphorically emphasizes vision again, because we need to reclaim that sense to find our way through all the visualizing tricks and powers of modern sciences and technologies that have transformed the objectivity debates. We need to learn in our bodies, endowed with primate color and stereoscopic vision, how to attach the objective to our theoretical and political scanners in order to name where we are and are not, in dimensions of mental and physical space we hardly know how to name. So, not so perversely, objectivity turns out to be about particular and specific embodiment, and definitely not about the false vision promising transcendence of all limits and responsibility. The moral is simple: only partial perspective promises objective vision. This is an objective vision that initiates, rather than closes off, the problem of responsibility for the generativity of all visual practices. Partial perspective can be held accountable for both its promising and its destructive monsters. All Western cultural narratives about objectivity are allegories of the ideologies of the relations of what we call mind and body, of distance and responsibility, embedded in the science question in feminism. Feminist objectivity is about limited location and situated knowledge, not about transcendence and splitting of subject and object. In this way we might become answerable for what we learn how to see.

These are lessons which I learned in part walking with my dogs and wondering how the world looks without a fovea and very few retinal cells for color vision, but with a huge neural processing and sensory area for smells. It is a lesson available from photographs of how the world looks to the compound eyes of an insect, or even from the camera eye of a spy satellite or the digitally transmitted signals of space probe-perceived differences 'near' Jupiter that have been transformed into coffee-table colour photographs. The 'eyes' made available in modern technological sciences shatter any idea of passive vision; these prosthetic devices show us that all eyes, including our own organic ones, are active perceptual systems, building in translations and specific *ways* of seeing, that is, ways of life. There is no unmediated photograph or passive camera obscura in scientific accounts of bodies and machines; there are only highly specific visual possibilities, each with a wonderfully detailed, active, partial way of organizing worlds. All these pictures of the world should not be allegories of infinite mobility and interchangeability, but of elaborate specificity and difference and the loving care people might take to learn how to see faithfully from another's point of view, even when the other is our own machine. That's not alienating distance; that's a *possible* allegory for feminist versions of objectivity. Understanding how these visual systems work, technically, socially, and psychically ought to be a way of embodying feminist objectivity.

Many currents in feminism attempt to theorize on the grounds for trusting especially the vantage points of the subjugated; there is good reason to believe vision is better from below the brilliant space platforms of the powerful (Hartsock 1983; Sandoval n.d.; Harding 1986; Anzaldúa 1987). Linked to this suspicion, this chapter is an argument for situated and embodied knowledges and against various forms of unlocatable, and so irresponsible, knowledge claims. Irresponsible means unable to be called into account. There is a premium on establishing the capacity to see from the peripheries and the depths. But here lies a serious danger of romanticizing and/or appropriating the vision of the less powerful while claiming to see from their positions. To see from below is neither easily learned nor unproblematic, even if 'we' 'naturally' inhabit the great underground terrain of subjugated knowledges. The positionings of the subjugated are not exempt from critical re-examination, decoding, deconstruction, and interpretation; that is, from both semiological and hermeneutic modes of critical enquiry. The standpoints of the subjugated are not 'innocent' positions. On the contrary, they are preferred because in principle they are least likely to allow denial of the critical and interpretative core of all knowledge. They are savvy to modes of denial through repression, forgetting, and disappearing acts – ways of being nowhere while claiming to see comprehensively. The subjugated have a decent chance to be on to the god-trick and all its dazzling – and, therefore, blinding – illuminations. 'Subjugated' standpoints are preferred because they seem to promise more adequate, sustained, objective, transforming accounts of the world. But *how* to see from below is a problem requiring at least as much skill with bodies and language, with the mediations of vision, as the 'highest' techno-scientific visualizations.

Such preferred positioning is as hostile to various forms of relativism as to the most explicitly totalizing versions of claims to scientific authority. But the alternative to relativism is not totalization and single vision, which is always finally the unmarked category whose power depends on systematic narrowing and obscuring.

The alternative to relativism is partial, locatable, critical knowledges sustaining the possibility of webs of connections called solidarity in politics and shared conversations in epistemology. Relativism is a way of being nowhere while claiming to be everywhere equally. The 'equality' of positioning is a denial of responsibility and critical enquiry. Relativism is the perfect mirror twin of totalization in the ideologies of objectivity; both deny the stakes in location, embodiment, and partial perspective; both make it impossible to see well. Relativism and totalization are both 'god-tricks' promising vision from everywhere and nowhere equally and fully, common myths in rhetorics surrounding science. But it is precisely in the politics and epistemology of partial perspectives that the possibility of sustained, rational, objective enquiry rests.

So, with many other feminists, I want to argue for a doctrine and practice of objectivity, that privileges contestation, deconstruction, passionate construction, webbed connections, and hope for transformation of systems of knowledge and ways of seeing. But not just any partial perspective will do; we must be hostile to easy relativisms and holisms built out of summing and subsuming parts. 'Passionate detachment' (Kuhn 1982) requires more than acknowledged and self-critical partiality. We are also bound to seek perspective from those points of view that can never be known in advance, which promise something quite extraordinary, that is, knowledge potent for constructing worlds less organized by axes of domination. In such a viewpoint, the unmarked category would *really* disappear – quite a difference from simply repeating a disappearing act. The imaginary and the rational – the visionary and objective vision – hover close together. I think Harding's plea for a successor science and for postmodern sensibilities must be read to argue that this close touch of the fantastic element of hope for transformative knowledge and the severe check and stimulus of sustained critical enquiry are jointly the ground of any believable claim to objectivity or rationality not riddled with breathtaking denials and repressions. It is even possible to read the record of scientific revolutions in terms of this feminist doctrine of rationality and objectivity. Science has been utopian and visionary from the start; that is one reason 'we' need it.

A commitment to mobile positioning and to passionate detachment is dependent on the impossibility of innocent 'identity' politics and epistemologies as strategies for seeing from the standpoints of the subjugated in order to see well. One cannot 'be' either a cell or molecule – or a woman, colonized person, labourer, and so on – if one intends to see and see from these positions critically. 'Being' is much more problematic and contingent. Also, one cannot relocate in any possible vantage point without being accountable for that movement. Vision is *always* a question of the power to see – and perhaps of the violence implicit in our visualizing practices. With whose blood were my eyes crafted? These points also apply to testimony from the position of 'oneself.' We are not immediately present to ourselves. Self-knowledge requires a semiotic-material technology linking meanings and bodies. Self-identity is a bad visual system. Fusion is a bad strategy of positioning. The boys in the human sciences have called this doubt about self-presence the 'death of the subject,' that single ordering point of will and consciousness. That judgement seems bizarre to me. I prefer to call this generative doubt the opening of non-isomorphic subjects, agents, and territories of stories unimaginable from the vantage point of the cyclopian, self-satiated eye of the master subject. The Western eye has fundamentally been

a wandering eye, a traveling lens. These peregrinations have often been violent and insistent on mirrors for a conquering self – but not always. Western feminists also *inherit* some skill in learning to participate in revisualizing worlds turned upside down in earth-transforming challenges to the views of the masters. All is not to be done from scratch.

The split and contradictory self is the one who can interrogate positionings and be accountable; the one who can construct and join rational conversations and fantastic imaginings that change history. Splitting, not being, is the privileged image for feminist epistemologies of scientific knowledge. 'Splitting' in this context should be about heterogeneous multiplicities that are simultaneously necessary and incapable of being squashed into isomorphic slots or cumulative lists. This geometry pertains within and among subjects. The topography of subjectivity is multidimensional; so, therefore, is vision. The knowing self is partial in all its guises, never finished, whole, simply there and original; it is always constructed and stitched together imperfectly, and *therefore* able to join with another, to see together without claiming to be another. Here is the promise of objectivity: a scientific knower seeks the subject position not of identity, but of objectivity; that is, partial connection. There is no way to 'be' simultaneously in all, or wholly in any, of the privileged (subjugated) positions structured by gender, race, nation, and class. And that is a short list of critical positions. The search for such a 'full' and total position is the search for the fetishized perfect subject of oppositional history, sometimes appearing in feminist theory as the essentialized Third World Woman (Mohanty 1984). Subjugation is not grounds for an ontology; it might be a visual clue. Vision requires instruments of vision; an optics is a politics of positioning. Instruments of vision mediate standpoints; there is no immediate vision from the standpoints of the subjugated. Identity, including self-identity, does not produce science; critical positioning does, that is, objectivity. Only those occupying the positions of the dominators are self-identical, unmarked, disembodied, unmediated, transcendent, born again. It is unfortunately possible for the subjugated to lust for and even scramble into that subject position – and then disappear from view. Knowledge from the point of view of the unmarked is truly fantastic, distorted, and so irrational. The only position from which objectivity could not possibly be practiced and honoured is the standpoint of the master, the Man, the One God, whose eye produces, appropriates, and orders all difference. No one ever accused the God of monotheism of objectivity, only of indifference. The god-trick is self-identical, and we have mistaken that for creativity and knowledge, omniscience even.

Positioning is, therefore, the key practice grounding knowledge organized around the imagery of vision, as so much Western scientific and philosophic discourse is organized. Positioning implies responsibility for our enabling practices. It follows that politics and ethics ground struggles for the contests over what may count as rational knowledge. That is, admitted or not, politics and ethics ground struggles over knowledge projects in the exact, natural, social, and human sciences. Otherwise, rationality is simply impossible, an optical illusion projected from nowhere comprehensively. Histories of science may be powerfully told as histories of the technologies. These technologies are ways of life, social orders, practices of visualization. Technologies are skilled practices. How to see? Where to see from? What limits to vision? What to see for? Whom to see with? Who gets to have more

than one point of view? Who gets blinkered? Who wears blinkers? Who interprets the visual field? What other sensory powers do we wish to cultivate besides vision? Moral and political discourse should be the paradigm of rational discourse in the imagery and technologies of vision. Sandra Harding's claim, or observation, that movements of social revolution have most contributed to improvements in science might be read as a claim about the knowledge consequences of new technologies of positioning. But I wish Harding had spent more time remembering that social and scientific revolutions have not always been liberatory, even if they have always been visionary. Perhaps this point could be captured in another phrase: the science question in the military. Struggles over what will count as rational accounts of the world are struggles over *how* to see. The terms of vision: the science question in colonialism; the science question in exterminism (Sofoulis 1988); the science question in feminism.

The issue in politically engaged attacks on various empiricisms, reductionisms, or other versions of scientific authority should not be relativism, but location. A dichotomous chart expressing this point might look like this:

universal rationality	ethnophilosophies
common language	heteroglossia
new organon	deconstruction
unified field theory	oppositional positioning
world system	local knowledges
master theory	webbed accounts

But a dichotomous chart misrepresents in a critical way the positions of embodied objectivity which I am trying to sketch. The primary distortion is the illusion of symmetry in the chart's dichotomy, making any position appear, first, simply alternative and, second, mutually exclusive. A map of tensions and resonances between the fixed ends of a charged dichotomy better represents the potent politics and epistemologies of embodied, therefore accountable, objectivity. For example, local knowledges have also to be in tension with the productive structurings that force unequal translations and exchanges – material and semiotic – within the webs of knowledge and power. Webs *can* have the property of systematicity, even of centrally structured global systems with deep filaments and tenacious tendrils into time, space, and consciousness, the dimensions of world history. Feminist accountability requires a knowledge tuned to resonance, not to dichotomy. Gender is a field of structured and structuring difference, where the tones of extreme localization, of the intimately personal and individualized body, vibrate in the same field with global high-tension emissions. Feminist embodiment, then, is not about fixed location in a reified body, female or otherwise, but about nodes in fields, inflections in orientations, and responsibility for difference in material-semiotic fields of meaning. Embodiment is significant prosthesis; objectivity cannot be about fixed vision when what counts as an object is precisely what world history turns out to be about.

How should one be positioned in order to see in this situation of tensions, resonances, transformations, resistances, and complicities? Here, primate vision is not

immediately a very powerful metaphor or technology for feminist political-epistemological clarification, since it seems to present to consciousness already processed and objectified fields; things seem already fixed and distanced. But the visual metaphor allows one to go beyond fixed appearances, which are only the end products. The metaphor invites us to investigate the varied apparatuses of visual production, including the prosthetic technologies interfaced with our biological eyes and brains. And here we find highly particular machineries for processing regions of the electromagnetic spectrum into our pictures of the world. It is in the intricacies of these visualization technologies in which we are embedded that we will find metaphors and means for understanding and intervening in the patterns of objectification in the world, that is, the patterns of reality for which we must be accountable. In these metaphors, we find means for appreciating simultaneously *both* the concrete, 'real' aspect and the aspect of semiosis and production in what we call scientific knowledge.

I am arguing for politics and epistemologies of location, positioning, and situating, where partiality and not universality is the condition of being heard to make rational knowledge claims. These are claims on people's lives; the view from a body, always a complex, contradictory, structuring and structured body, versus the view from above, from nowhere, from simplicity. Only the god-trick is forbidden. Here is a criterion for deciding the science question in militarism, that dream science/technology of perfect language, perfect communication, final order.

Feminism loves another science: the sciences and politics of interpretation, translation, stuttering, and the partly understood. Feminism is about the sciences of the multiple subject with (at least) double vision. Feminism is about a critical vision consequent upon a critical positioning in inhomogeneous gendered social space. Translation is always interpretative, critical, and partial. Here is a ground for conversation, rationality, and objectivity – which is power-sensitive, not pluralist, 'conversation.' It is not even the mythic cartoons of physics and mathematics – incorrectly caricatured in anti-science ideology as exact, hyper-simple knowledges – that have come to represent the hostile other to feminist paradigmatic models of scientific knowledge, but the dreams of the perfectly known in high-technology, permanently militarized scientific productions and positionings, the god-trick of a Star Wars paradigm of rational knowledge. So location is about vulnerability; location resists the politics of closure, finality, or, to borrow from Althusser, feminist objectivity resists 'simplification in the last instance.' That is because feminist embodiment resists fixation and is insatiably curious about the webs of differential positioning. There is no single feminist standpoint because our maps require too many dimensions for that metaphor to ground our visions. But the feminist standpoint theorists' goal of an epistemology and politics of engaged, accountable positioning remains eminently potent. The goal is better accounts of the world, that is, 'science.'

Above all, rational knowledge does not pretend to disengagement: to be from everywhere and so nowhere, to be free from interpretation, from being represented, to be fully self-contained or fully formalizable. Rational knowledge is a process of ongoing critical interpretation among 'fields' of interpreters and decoders. Rational knowledge is power-sensitive conversation (King 1987):

knowledge:community::knowledge:power
hermeneutics:semiology::critical interpretation:codes.

Decoding and transcoding plus translation and criticism: all are necessary. So science becomes the paradigmatic model not of closure, but of that which is contestable and contested. Science becomes the myth not of what escapes human agency and responsibility in a realm above the fray, but rather of accountability and responsibility for translations and solidarities linking the cacophonous visions and visionary voices that characterize the knowledges of the subjugated. A splitting of senses, a confusion of voice and sight, rather than clear and distinct ideas, become the metaphor for the ground of the rational. We seek not the knowledges ruled by phal-logocentrism (nostalgia for the presence of the one true Word) and disembodied vision, but those ruled by partial sight and limited voice. We do not seek partiality for its own sake, but for the sake of the connections and unexpected openings that situated knowledges make possible. The only way to find a larger vision is to be somewhere in particular. The science question in feminism is about objectivity as positioned rationality. Its images are not the products of escape and transcendence of limits, i.e. the view from above, but the joining of partial views and halting voices into a collective subject position that promises a vision of the means of ongoing finite embodiment, of living within limits and contradictions, i.e. of views from somewhere.

References

Anzaldúa, Gloria (1987) *Borderlands/La Frontera*, San Francisco: Spinsters/Aunt Lute.
Bryan, C.D.B. (1987) *The National Geographic Society: 100 Years of Adventure and Discovery*, New York: Abrams.
Harding, Sandra (1986) *The Science Question in Feminism*, Ithaca: Cornell University Press.
Harding, Sandra and Hintikka, Merill (eds) (1983) *Discovering Reality: Feminist Perspectives on Epistemology, Metaphysics, and Philosophy of Science*, Dordrecht: Reidel.
Hartsock, Nancy (1983) 'The feminist standpoint: developing the ground for a specif-ically feminist historical materialism,' in Harding and Hintikka (eds) (1983), pp. 283–310.
King, Katie (1987) 'Canons without innocence,' University of California at Santa Cruz, PhD thesis.
Kuhn, Annette (1982) *Women's Pictures: Feminism and Cinema*, London: Routledge & Kegan Paul.
Mohanty, Chandra Talpade (1984) 'Under western eyes: feminist scholarship and colonial discourse,' *Boundary* 2, 3 (12/13): 333–58.
Sandoval, Chela (n.d.) *Yours in Struggle: Women Respond to Racism, a Report on the National Women's Studies Association*, Oakland, CA: Center for Third World Organizing.
Sofoulis, Zoe (1988) 'Through the lumen: Frankenstein and the optics of re-origination,' University of California at Santa Cruz, Ph.D. thesis.

Anne Balsamo

ON THE CUTTING EDGE
Cosmetic surgery and the technological
production of the gendered body

The biotechnological reproduction of gender

AMONG THE MOST intriguing new body technologies developed during the
decade of the 1980s are techniques of visualization that redefine the range of
human perception. New medical imaging technologies such as laparoscopy and
computer tomography (CT) make the body visible in such a way that its internal
status can be accessed before it is laid bare or opened up surgically. Like the tech-
niques that enable scientists to encode and read genetic structures, these new
visualization technologies transform the material body into the visual medium. In
the process the body is fractured and fragmented so that isolated parts can be visually
examined: the parts can be isolated by function, as in organs or neuron receptors,
or by medium, as in fluids, genes, or heat. At the same time, the material body
comes to embody the characteristics of technological images.

When the human body is fractured into organs, fluids, and genetic codes, what
happens to gender identity? In a technologically deconstructed body, where is gender
located? Gender, like the body, is a boundary concept; it is at once related to the
physiological sexual characteristics of the human body (the natural order of the body)
and to the cultural context within which that body 'makes sense.' The widespread
technological refashioning of the 'natural' human body suggests that gender too
would be ripe for reconstruction. Advances in reproductive technology already
decouple the act of procreation from the act of sexual intercourse. Laparoscopy has
played a critical role in the assessment of fetal development, with the attendant
consequence that the fetal body has been metaphorically (and sometimes literally)
severed from its natural association with the female body and is now proclaimed
to be the new, and most important obstetric patient. What effects do these
biotechnological advances have on cultural definitions of the female body? As is
often the case when seemingly stable boundaries (human/artificial, life/death,

nature/culture) are displaced by technological innovation, other boundaries are more vigilantly guarded. Indeed, the gendered boundary between male and female is one border that remains heavily guarded despite new technologized ways to rewrite the physical body in the flesh. So that it appears that while the body has been recoded within discourses of biotechnology and medicine as belonging to an order of culture rather than of nature, gender remains a naturalized point of human identity. As Judy Wajcman reminds us: 'technology is more than a set of physical objects or artefacts. It also fundamentally embodies a culture or set of social relations made up of certain sorts of knowledge, beliefs, desires, and practices.'[1] My concern here is to describe the way in which certain biotechnologies are ideologically 'shaped by the operation of gender interests' and, consequently, how these serve to reinforce traditional gendered patterns of power and authority. When Judith Butler describes the gendered body as 'a set of repeated acts within a highly rigid regulatory frame that congeal over time to produce the appearance of substance,' she identifies the mechanism whereby 'naturalized' gender identities are socially and culturally reproduced.[2]

Carole Spitzack suggests that cosmetic surgery actually deploys three overlapping mechanisms of cultural control: inscription, surveillance, and confession.[3] According to Spitzack, the physician's clinical eye functions like Foucault's medical gaze; it is a disciplinary gaze, situated within apparatuses of power and knowledge, that constructs the female figure as pathological, excessive, unruly, and potentially threatening. This gaze disciplines the unruly female body by first fragmenting it into isolated parts – face, hair, legs, breasts – and then redefining those parts as inherently flawed and pathological. When women internalize a fragmented body image and accept its 'flawed' identity, each part of the body then becomes a site for the 'fixing' of her physical abnormality. Spitzack characterizes this acceptance as a form of confession.

> In the scenario of the cosmetic surgeon's office, the transformation from illness to health is inscribed on the body of the patient. . . . The female patient is promised beauty and re-form in exchange for confession, which is predicated on an admission of a diseased appearance that points to a diseased (powerless) character. A failure to confess, in the clinical setting, is equated with a refusal of health; a preference for disease.[4]

But the cosmetic surgeon's gaze does not simply *medicalize* the female body, it actually redefines it as object for technological reconstruction. In her reading of the women's films of the 1940s, Mary Ann Doane employs the concept of the 'clinical eye' to describe how the technologies of looking represent and situate female film characters as the objects of medical discourse. In Doane's analysis, the medicalization of the female body relies on a surface/depth model of the body whereby the physician assumes the right and responsibility of divining the truth of the female body – to make visible her invisible depths. The clinical gaze of the physician reveals the truth of the female body in his act of looking through her to see the 'essence' of her illness. According to Doane, the clinical eye marks a shift in the signification of the female body, from a purely surface form of signification to a depth model of

signification. She traces this shift through a reading of the difference between main-stream classical cinema and the woman's film of the 1940s.[5]

In examining the visualization technologies used in the practice of cosmetic surgery, we can witness the process whereby new biotechnologies are articulated with traditional and ideological beliefs about gender – an articulation that keeps the female body positioned as a privileged object of a normative gaze that is now not simply a medicalized gaze ('the clinical eye'), but also a technologized view. In the application of new visualization technologies, the relationship between the female body and the cultural viewing apparatus has shifted again; in the process, the clinical eye gives way to the deployment of a technological gaze. This application of the gaze does not rely on a surface/depth model of the material body, whereby the body has some sort of structural integrity as a bounded physical object. In the encounter between women and cosmetic surgeons, it is not so much the inner or essential woman that is looked at; her interior story has no truth of its own. Both her surface and her interiority are flattened and dispersed. Cosmetic surgeons use technological imaging devices to reconstruct the female body as a signifier of ideal feminine beauty. In this sense, surgical techniques literally enact the logic of assembly line beauty: 'difference' is made over into sameness. The technological gaze re-fashions the material body to reconstruct it in keeping with culturally determined ideals of feminine beauty.

Cosmetic surgery and the inscription of cultural standards of beauty

Cosmetic surgery enacts a form of cultural signification where we can examine the literal and material reproduction of ideals of beauty. Where visualization technologies bring into focus isolated body parts and pieces, surgical procedures carve into the flesh to isolate parts to be manipulated and resculpted. In this way cosmetic surgery *literally* transforms the material body into a sign of culture. The *discourse* of cosmetic surgery offers provocative material for a discussion of the cultural construction of the gendered body because, on the one hand, women are often the intended and preferred subjects of such discourse, and on the other, men are often the bodies doing the surgery. Cosmetic surgery is not then simply a discursive site for the 'construction of images of women,' but in actuality, a material site at which the physical female body is surgically dissected, stretched, carved, and reconstructed according to cultural and eminently ideological standards of physical appearance.

There are two main fields of plastic surgery. Whereas *reconstructive* surgery works on catastrophic, congenital or cancer-damage deformities, *cosmetic* or aesthetic surgery is often an entirely elective endeavour. And whereas reconstructive surgery is associated with the restoration of health, normalcy, and physical function, cosmetic surgery is said to improve self-esteem, social status, and sometimes even professional standing.

All cosmetic surgery implicitly involves aesthetic judgements of facial proportion, harmony, and symmetry. In fact, one medical textbook strongly encourages plastic surgeons to acquire some familiarity with classical art theory so that they are

better prepared to 'judge human form in three dimensions, evaluate all aspects of the deformity, visualize the finished product, and plan the approach that will produce an optimal result.'[6] Codifying the aspects of such an 'aesthetic sense' seems counter-intuitive, but in fact, there is a voluminous literature that reports the scientific measurement of facial proportions in an attempt to accomplish the scientific determination of aesthetic perfection. According to one plastic surgeon, most cosmetic surgeons have some familiarity with the anthropological fields of anthropometry and human osteology. Anthropometry, which is defined in one source as 'a technique for the measurement of men, whether living or dead,' is actually a critically important science used by a variety of professional engineers and designers. One example of practical anthropometry is the collection of measurements of infants' and children's bodies for use in the design of automobile seat restraints. Of course it makes a great deal of sense that measurement standards and scales of human proportions are a necessary resource for the design of products for human use; in order to achieve a 'fit' with the range of human bodies that will eventually use and inhabit a range of products from office chairs to office buildings, designers must have access to a reliable and standardized set of body measurements. But when the measurement project identifies the 'object' being measured as the 'American negro' or the 'ideal female face,' it is less clear what practical use these measurements serve.

If anthropometry is 'a technique for the measurement of men,' the fascination of plastic surgeons is the measurement of the ideal. One well-cited volume in a series published by the American Academy of Facial Plastic and Reconstructive Surgery, titled *Proportions of the Aesthetic Face* (by Nelson Powell and Brian Humphreys) proclaims that it is a 'complete sourcebook of information on facial proportion and analysis.'[7] In the Preface the authors state:

> The face, by its nature, presents itself often for review. We unconsciously evaluate the overall effect each time an acquaintance is made. . . . This [impression] is generally related to some scale of beauty or balance. . . . The harmony and symmetry are compared to a mental, almost magical, ideal subject, which is our basic concept of beauty. Such a concept or complex we shall term the 'ideal face.'[8]

According to the authors, the purpose of this text is quite simple: to document, objectively, the guidelines for facial symmetry and proportion. Not inconsequentially, the 'Ideal Face' depicted in this book – both in the form of line drawings and in photographs – is of a white woman whose face is perfectly symmetrical in line and profile [Figure 59.1]. The authors claim that although the 'male's bone structure is sterner, bolder, and more prominent . . . the ideals of facial proportion and unified interplay apply to either gender.' And as if to prove the point, they provide an illustration of the ideal male face in the glossary. As I discuss later, this focus on the female body is prevalent in all areas of cosmetic surgery – from the determination of ideal proportions to the marketing of specific cosmetic procedures. The source or history of these idealized drawings is never discussed. But once the facial proportions of these images are codified and measured, they are reproduced by surgeons as they make modifications to their patients' faces. Even though they work with faces that are individually distinct, surgeons use the codified measurements

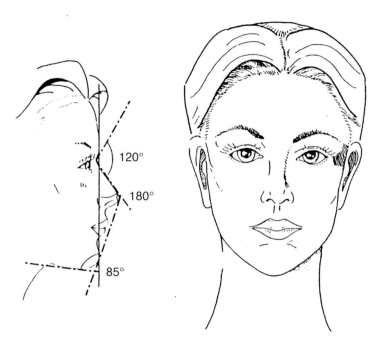

Figure 59.1 'Angles and proportions of the ideal female face' diagrams, 1984 (Courtesy of Thieme Medical Publishers)

as a guideline for the determination of treatment goals in the attempt to bring the distinctive face in alignment with artistic ideals of symmetry and proportion.

The treatment of race in this book on 'ideal proportions of the aesthetic face' reveals a preference for white, symmetrical faces that heal (apparently) without scarring. On the one hand the authors acknowledge that 'bone structure is different in all racial identities' and that 'surgeons must acknowledge that racial qualities are appreciated differently in various cultures,' but in the end they argue that 'the facial form [should be] able to confer harmony and aesthetic appeal regardless of race.'[9] It appears that this appreciation for the aesthetic judgement 'regardless of race' is not a widely shared assumption among cosmetic surgeons. Napoleon N. Vaughn reports that many cosmetic surgeons 'mindful of keloid formation and hyper-pigmented scarring, routinely reject black patients.'[10] But the issue of scar tissue formation is entirely ignored in the discussion of the 'proportions of the aesthetic face.' Powell and Humphreys implicitly argue that black faces can be evaluated in terms of ideal proportions determined by the measurement of Caucasian faces, but they fail to address the issue of post-surgical risks that differentiate black patients from Caucasian ones. Although it is true that black patients and patients with dark ruddy complexions have a greater propensity to form keloid or hypertrophic scars than do Caucasian patients, many physicians argue that black patients who are shown to be prone to keloid formation in the lower body are not necessarily prone to such formations in the facial area and upper body; therefore a racial propensity for keloid formation should not be a reason to reject a black patient's request for facial cosmetic surgery. And according to Arthur Sumrall, even though 'postoperative dyschromic

changes and surgical incision lines are much more visible in many black patients and races of color than their Caucasian counterpart,' these changes and incision lines greatly improve with time and corrective cosmetics.[11] As an abstraction the 'aesthetic face' is designed to assist surgeons in planning surgical goals; but as a cultural artifact, the 'aesthetic face' symbolizes a desire for standardized ideals of Caucasian beauty.

It is clear that any plastic surgery invokes standards of physical appearance and functional definitions of the 'normal' or 'healthy' body. Upon closer investigation we can see how these standards and definitions are culturally determined. In the 1940s and 1950s, women reportedly wanted 'pert, upturned noses,' but according to one recent survey this shape has gone out of style. 'The classic, more natural shape is the ultimate one with which to sniff these days.'[12] The obvious question becomes, what condition does the adjective 'natural' describe? In this case we can see how requests for cosmetic reconstructions show the waxing and waning of fashionable desires; in this sense, 'fashion surgery' might be a more fitting label for the kind of surgery performed for nonfunctional reasons. But even as high fashion moves toward a multiculturalism in the employ of nontraditionally beautiful models, it is striking to learn how great is the demand for cosmetic alterations that are based on Western markers of ideal beauty. In a *New York Times Magazine* feature, Ann Louise Bardach reports that Asian women often desire surgery to effect a more 'Western' eye shape.[13] Indeed, in several medical articles this surgery is actually referred to as 'upper lid Westernization,' and is reported to be 'the most frequently performed cosmetic procedure in the Orient.'[14] The surgeons explain:

> An upper lid fold is considered a sign of sophistication and refinement to many Orientals across all social strata. It is not quite accurate to say that Orientals undergoing this surgery desire to look Western or American; rather, they desire a more refined Oriental eye. . . . An upper lid Westernization blepharoplasty frequently is given to a young Korean woman on the occasion of her betrothal.

Although other surgeons warn that it is 'wise to discuss the Oriental and Occidental eye anatomy in terms of differences *not* defects,'[15] at least one other medical article on this type of surgery was titled 'Correction of the Oriental Eyelid.'[16] In terms of eyelid shape and design, the authors do not comment on how the 'natural' Oriental eye came to be described as having a 'poorly defined orbital and periorbital appearance'; thus, when their Oriental patients request 'larger, wider, less flat, more defined, more awake-appearing eyes and orbital surroundings,' these surgeons offer an operative plan for the surgical achievement of what is commonly understood to be a more Westernized appearance.[17] In discussing the reasons for the increased demand for this form of blepharoplasty 'among the Oriental,' Marwali Harahap notes that this technique became popular after the Second World War; this leads some surgeons to speculate that such a desire for Westernized eyes 'stem[s] from the influence of motion pictures and the increasing intermarriage of Asian women and Caucasian men.'[18]

[. . .]

Cosmetic surgery as a technology of the gendered body

In recent years, more men are electing cosmetic surgery than in the past, but often in secret. As one article reports: 'previously reluctant males are among the booming number of men surreptitiously doing what women have been doing for years: having their eyelids lifted, jowls removed, ears clipped, noses reduced, and chins tightened.' One cosmetic surgeon elaborates the reasons that men are beginning to seek elective cosmetic surgery:

> A middle-aged male patient – we'll call him Mr. Dropout – thinks he has a problem. He doesn't think he's too old for the lovely virgins he meets, but he wants to improve things. . . . When a man consults for aging, generally he is not compulsive about looking younger but he seeks relief from one or more specific defects incidental to aging: male pattern baldness . . . forehead wrinkling . . . turkey-gobbler neck. There are many things that can be done to help the aging man look younger or more virile.[19]

According to yet another cosmetic surgeon, the reason for some men's new concern about appearance is 'linked to the increasing competition for top jobs they face at the peak of their careers from women and Baby Boomers.'[20] Here the increase in male cosmetic surgery is explained as a shrewd business tactic: 'looking good' connotes greater intelligence, competence, and desirability as a colleague. Charges of narcissism, vanity, and self-indulgence are put aside; a man's choice to have cosmetic surgery is explained by appeal to a rhetoric of career enhancement: a better-looking body is better able to be promoted. In this case, cosmetic surgery is redefined as a body management technique designed to reduce the stress of having to cope with a changing work environment, one that is being threatened by the presence of women and younger people. While all of these explanations may be true in the sense that this is how men justify their choice to elect cosmetic surgery, it is clear that other explanations are not even entertained: for example, what about the possibility that men and women are becoming more alike with respect to 'the body beautiful,' that men are engaging more frequently in female body activities, or even simply that a concern with appearance is not solely a characteristic of women? What about the possibility that the boundary between genders is eroding? How is it that men avoid the pejorative labels attached to female cosmetic surgery clients?

In their ethnomethodological study of cosmetic surgery, Diana Dull and Candace West examine how surgeons and patients 'account' for their decisions to elect cosmetic surgery.[21] They argue that when surgeons divide the patient's body into component parts and pieces, it enables both 'surgeons and patients together [to] establish the problematic status of the part in question and its "objective" need of "repair".'[22]

But Dull and West go on to argue that this process of fragmentation occurs in 'tandem with the accomplishment of gender' which, in relying upon an essentialist view of the female body as always 'needing repair,' understands women's choice for cosmetic surgery as 'natural' and 'normal' and as a consequence of their (natural) preoccupation with appearance. Because their 'essential' natures are defined very

differently, men, on the other hand, must construct elaborate justifications for their decision to seek cosmetic alterations. This analysis illuminates one of the possible reasons why men and women construct different accounts of their decision to elect cosmetic surgery: the cultural meaning of their gendered bodies already determines the discursive rationale they can invoke to explain bodily practices. Where the bodies and faces of male farmers and construction workers, for example, are excessively 'tanned' due to their constant exposure to the sun as part of their work conditions, their ruddy, leathery skin is not considered a liability or deformity of their male bodies. In contrast, white women who display wrinkled skin due to excessive tanning are sometimes diagnosed with 'The Miami Beach Syndrome,' and as one surgeon claims: 'we find this type of overly tanned, wrinkled skin in women who not only go to Miami every year for three or four months, but lie on the beach with a sun reflector drawing additional rays to their faces.'[23] It is no surprise then, that although any body can exhibit the 'flaws' that supposedly justify cosmetic surgery, discussion and marketing of such procedures usually construct the female body as the typical patient. Such differential treatment of gendered bodies illustrates a by-now familiar assertion of feminist studies of the body and appearance: the meaning of the presence or absence of any physical quality varies according to the gender of the body upon which it appears. Clearly an apparatus of gender organizes our seemingly most basic, natural interpretation of human bodies, even when those bodies are technologically refashioned. Thus it appears that although technologies such as those used in cosmetic surgery can reconstruct the 'natural' identity of the material body, they do little to disrupt naturalization of essentialized gender identity.

Wendy Chapkis amplifies this point when she writes:

> However much the particulars of the beauty package may change from decade to decade – curves in or out, skin delicate or ruddy, figures fragile or fit – the basic principles remain the same. The body beautiful is woman's responsibility and authority. She will be valued and rewarded on the basis of how close she comes to embodying the ideal.[24]

In the popular media, advertisements for surgical services are rarely, if ever, addressed specifically to men. In a 1988 advertising campaign for the Liposuction Institute in Chicago, every advertisement features an illustration of a woman's (saddlebag) thighs as the 'before' image of liposuction procedures. And of course, many cosmetic alterations are designed especially for women: tattooed eyeliner marketed as 'the ultimate cosmetic'; electrolysis removal of superfluous hair; and face creams. An advertising representative for DuraSoft explains that the company has begun marketing their colored contact lenses specifically for black women, ostensibly because DuraSoft believes that 'black women have fewer cosmetic alternatives,' but a more likely reason is that the company wants to create new markets for its cosmetic lenses. So whereas 'being a real man requires having a penis and balls' and a concern with virility and productivity, being a real woman requires buying beauty products and services.[25]

And yet women who have too many cosmetic alterations are pejoratively labeled 'scalpel slaves' to identify them with their obsession for surgical fixes. Women in their later thirties and forties are the most likely candidates for repeat plastic surgery.

According to *Psychology Today* the typical 'plastic surgery junkie' is a woman who uses cosmetic surgery as an opportunity to 'indulge in unconscious wishes.'[26] *Newsweek* diagnoses the image problems 'scalpel slaves' have:

> Women in their 40s seem particularly vulnerable to the face-saving appeal of plastic surgery. Many scalpel slaves are older women who are recently divorced or widowed and forced to find jobs or date again. Others are suffering from the empty-nest syndrome. 'They're re-entry women,' says Dr. Susan Chobanian, a Beverly Hills cosmetic surgeon. 'They get insecure about their appearance and show up every six months to get nips and tucks. . . . Plastic-surgery junkies are in many ways akin to the anorexic or bulimic,' according to doctors. 'It's a body-image disorder,' says [one physician]. 'Junkies don't know what they really look like.' Some surgery junkies have a history of anorexia in the late teens, and now, in their late 30s and 40s, they're trying to alter their body image again.[27]

The naturalized identity of the female body as pathological and diseased is culturally reproduced in media discussions and representations of cosmetic surgery services. Moreover, the narrative obsessively recounted is that the female body is flawed in its distinctions and perfect when differences are transformed into sameness. But in the case of cosmetic surgery the nature of the 'sameness' is deceptive because the promise is not total identity reconstruction – such that a patient could choose to look like the media star of her choice – but rather the more elusive pledge of 'beauty enhancement.' When cosmetic surgeons argue that the technological elimination of facial 'deformities' will enhance a woman's 'natural' beauty, we encounter one of the more persistent contradictions within the discourse of cosmetic surgery: namely the use of technology to augment 'nature.'

[. . .]

Conclusion

Through the application of techniques of inscription, surveillance, and confession, cosmetic surgery serves as an ideological site for the examination of the technological reproduction of the gendered body. A primary effect of these techniques is to produce a gendered identity for the body at hand, techniques that work in different ways for male bodies than for female bodies. In its encounters with the cosmetic surgeon and the discourse of cosmetic surgery, the female body becomes an object of heightened personal surveillance; this scrutiny results in an internalized image of a fractured, fragmented body. The body becomes the vehicle of confession; it is the site at which women, consciously or not, accept the meanings that circulate in popular culture about ideal beauty and, in comparison, devalue the material body. The female body comes to serve, in other words, as a site of inscription, a billboard for the dominant cultural meanings that the female body is to have in postmodernity.

For some women, and for some feminist scholars, cosmetic surgery illustrates a technological colonization of women's bodies; for others, a technology women

can use for their own ends. Certainly, as I have shown here, in spite of the promise cosmetic surgery offers women for the technological reconstruction of their bodies, such technologies in actual application produce bodies that are very traditionally gendered. Yet I am reluctant to accept as a simple and obvious conclusion that cosmetic surgery is simply one more site where women are passively victimized. Whether as a form of oppression or a resource of empowerment, it is clear to me that cosmetic surgery is a practice whereby women consciously act to make their bodies mean something to themselves and to others. A different way of looking at this technology might be to take seriously the notion I suggested earlier: to think of cosmetic surgery as 'fashion surgery.' Like women who get pierced-nose jewellery, tattoos, and hair sculptures, women who elect cosmetic surgery could be seen to be using their bodies as a vehicle for staging cultural identities. Even though I have argued that cosmetic surgeons demonstrate an unshakable belief in a Westernized notion of 'natural' beauty, and that the discourse of cosmetic surgery is implicated in reproducing such idealization and manipulation of 'the natural,' other domains of contemporary fashion cannot be so idealized. The anti-aesthetics of cyberpunk and slacker fashion, for example, suggest that feminists, too, might wish to abandon our romantic conceptions of the 'natural' body – conceptions that lead us to claim that a surgically refashioned face inevitably marks an oppressed subjectivity. As body piercing and other forms of prosthesis become more common – here I am thinking of Molly Million's implanted mirrorshades and Jael's naildaggers – we may need to adopt a perspective on the bodily performance of gender identity that is not so dogged by neoromantic wistfulness about the natural, unmarked body.

Notes

1 Judy Wajcman (1991) *Feminism Confronts Technology*, University Park: Pennsylvania State University Press, p. 149.
2 Judith Butler (1990) *Gender Trouble: Feminism and the Subversion of Identity*, London: Routledge.
3 Carole Spitzack (1988) 'The Confession Mirror: Plastic Images for Surgery,' *Canadian Journal of Political and Social Theory*, 12 (1–2): 38–50.
4 Spitzack, p. 39.
5 Mary Ann Doane (1986) 'The Clinical Eye: Medical Discourses in the "Woman's Film" of the 1940s,' in *The Female Body in Western Culture: Contemporary Perspectives*, Susan Suleiman (ed.), Cambridge, MA: Harvard University Press, pp. 152–74.
6 Stewart D. Fordham (1984) 'Art for Head and Neck Surgeons,' in *Plastic and Reconstructive Surgery of the Head and Neck*, Paul H. Ward and Walter E. Berman (eds), Proceedings of the Fourth International Symposium of the American Academy of Facial Plastic and Reconstructive Surgery, *Volume 1: Aesthetic Surgery*, St Louis: C.V. Mosby Company, pp. 3–10, quotation is from p. 5.
7 Nelson Powell DDS, MD and Brian Humphreys MD (1984) *Proportions of the Aesthetic Face*, New York: Thieme-Stratton Inc.
8 Powell and Humphreys, p. 51.
9 Powell and Humphreys, p. 4.

10 Napoleon N. Vaughn (1982) 'Psychological Assessment for Patient Selection,' *Cosmetic Plastic Surgery in Nonwhite Patients*, Harold E. Pierce MD (ed.), New York: Grune & Stratton, pp. 245–51.

11 Arthur Sumrall, 'An Overview of Dermatologic Rehabilitation: The Use of Corrective Cosmetics,' in Pierce (ed.), pp. 141–54.

12 'Classic Schnozz is 80s nose', Jackie White, *Chicago Tribune*, 8 July 1988, section 2: 1, 3.

13 Ann Louise Bardach (1988) 'The Dark Side of Cosmetic Surgery: Long Term Risks are Becoming Increasingly Apparent,' *The New York Times Magazine*, 17 April: 24–25, 51, 54–58.

14 Bradley Hall, Richard C. Webster and John M. Dobrowski, 'Blepharoplasty in the Oriental,' in Ward and Berman (eds), pp. 210-25. Quotation is from p. 210.

15 Richard T. Farrior and Robert C. Jarchow, 'Surgical Principles in Face-Lift,' in Ward and Berman (eds), pp. 297–311.

16 J.S. Zubiri (1981) 'Correction of the Oriental Eyelid,' *Clinical Plastic Surgery* 8: 725.

17 Hall, Webster and Dobrowski, p. 210.

18 Marwali Harahap MD, 'Oriental Cosmetic Blepharoplasty,' in Pierce (ed.), pp. 77–97. Quotation is from p. 78.

19 Michael M. Gurdin MD (1971) 'Cosmetic Problems of the Male,' in *Cosmetic Surgery: What it Can Do for You*, Shirley Motter Linde MS (ed.), New York: Award Books, pp. 24–32.

20 Suzanne Dolezal (1988) 'More men are seeking their future in plastic – the surgical kind,' *Chicago Tribune*, 4 December, section 5: 13.

21 Diana Dull and Candace West (1991) 'Accounting for Cosmetic Surgery: The Accomplishment of Gender,' *Social Problems* 38 (1), February: 54–70.

22 Dull and West: 67.

23 The quotation is from Blair O. Rogers MD, author of the chapter 'Management after Surgery in Facial and Eyelid Patients,' in Linde (ed.), pp. 53–61.

24 Wendy Chapkis (1986) *Beauty Secrets: Women and the Politics of Appearance*, Boston, MA: South End Press, p. 14.

25 Carol Lynn Mithers (1987) 'The High Cost of Being a Woman,' *Village Voice*, 24 March: 31.

26 Annette C. Hamburger (1988) 'Beauty Quest,' *Psychology Today*, May: 28–32.

27 'Scalpel Slaves Just Can't Quit', *Newsweek*, 11 January 1988: 58–59.

Amelia Jones

DISPERSED SUBJECTS AND THE DEMISE OF THE 'INDIVIDUAL'
1990s bodies in/as art

The individual as an entity is invalid. . . . The individual as the end-product of heredity and environment is incomplete. Individualism is dead.

— Harry Gamboa, Jr., 1987[1]

Technology is a force of nature and it can't be stopped.
— Anonymous Technofan, *Los Angeles Times*, 1996[2]

[With new technologies] the self is no longer the object but the creation of the medium.

— Bruce Yonemoto, 1996[3]

I HAVE MADE CLAIMS in this book [Jones'] for the powerful historicity and political potential of body art: its implication of both productive and receptive bodies in history. Of primary importance in this particular history is the intersection between the effusion of body-oriented work in the 1960s and 1970s and the development of new models of embodied but also decentered subjectivity in the interwoven discourses of phenomenology, feminism, and poststructuralism. As the words of activist and artist Harry Gamboa suggest, this new experience of subjectivity as *embodied* rather than transcendental, as *in process*, as engaged with and contingent on others in the world, and as multiply identified rather than reducible to a single, 'universal' image of the self intersects as well with the revolutionary challenges to patriarchal culture and cold war ideologies of individualism by the civil, new left, students', women's, and gay/lesbian rights movements from the late 1950s onward.[4]

As we have seen, while the rights groups put their bodies on the activist lines and mobilized new modes of discourse to challenge their marginalization and oppression, philosophical and theoretical critiques of Cartesianism reconceived the subject

as simultaneously decentered (never fully coherent within herself or himself) and embodied (rather than pure 'cogito'). At the same time, new communications, travel, and biotechnologies, the decolonization of the so-called third world, and the massive shift toward global multinational capitalism began to shatter the illusory edifice of autonomous individualism subtending Western patriarchy, transforming the modernist subject (the 'I' of the Cartesian *cogito ergo sum*) into a dispersed, multiply identified postmodern subject both in theory and in practice. The experience and understanding of subjectivity have been completely transformed, the universality and coherence of the mythical notion of the individual thrown in question – not least because it has become clear that this 'individual' is hardly universal but has long implied a normative subject who is, in Audre Lorde's terms, 'white, thin, male, young, heterosexual, Christian, and financially secure.'[5] As Gamboa playfully suggests, the new mode of articulation of subjectivity might be rendered as 'I think, therefore I hesitate.'[6]

As body artists have clearly recognized, this is a historical context in which the body – as activist, as multiply identified, as a social enactment of a subject who is particularized beyond norms and stereotypes – plays a central role. This activist body so central to social movements and to art practice in the 1960s and early 1970s faded from view, however, in the increasingly commercialized environment of the later 1970s and 1980s art world (centered in New York City). As I suggested earlier, mainstream art discourse in the 1980s was largely characterized by a turn away from the body – a refusal of the fetishizing effects of the male gaze by the majority of the most prominent feminist practices and writings about art, a refusal that oddly paralleled a return to large-scale (and eminently commodifiable) oil paintings in the higher echelons of the art market.[7] This turn away from the body was also in some ways unfortunately coincident with the disembodied politics of the Reagan-Thatcher era, characterized by political retrenchment and reactionary, exclusionary economic and social policies and by the scrupulous avoidance of addressing the effects of such policies on the increasingly large numbers of bodies/selves living below the poverty line.[8]

Conversely, the 1990s have witnessed a dramatic return to art practices and written discourses involving the body; while – once again – they are hardly universally or unequivocally progressive in their implications, these works do begin to acknowledge the deep implications of the politics of representation in relation to the embodied subject (as opposed to the abstracted – conceptual rather than engaged – subject implied by dominant theories of the 1980s). This final chapter will explore the historical and political implications of this return, engaging in a number of recent body-oriented projects to explore the new modes of body/self articulation in the increasingly technologized and urban environment in which we live.[9] I propose this chapter as an explicitly utopian finale, reading body-oriented practices in their most progressive light as radically opening out subjectivity beyond even the explored and perhaps exploded dualities of earlier feminist and other body art.

This recent body-oriented work is both linked to earlier body art works and distinct from the earlier practices in its strategies, contexts, and emphases. Most often, the artists who have come to the fore in the past decade deploy multimedia, installation, and photographic technologies, eschewing live performance altogether.[10] While the earlier artists had focused obsessively (if, in the case of the male

artists, often unconsciously or uncritically) on the body's role in self-other relations through structures of narcissism and the rhetoric of the pose, these younger artists tend to explore the body/self as technologized, specifically *un*natural, and fundamentally unfixable in identity or subjective/objective meaning in the world: indeed, they articulate the body/self as what some have called 'posthuman.'[11] This 'posthuman' body/self is thoroughly particularized, its gender, sexuality, sexual orientation, race, ethnicity, class, and other identifications insistently enunciated within the intersubjective structures established by the body-oriented practice.[12]

This mediated, multiply identified, particularized body/self proclaims the utter loss of the 'subject' (in this case the fully intentional artist) as a stable referent (origin of the artwork's meaning). Works by Gary Hill and James Luna are exemplary of the way in which 1990s body-oriented practices enact the dispersed subject of the contemporary era. The technologized bodies presented by artist Gary Hill are *literally* fragmented and dispersed across space, and their mediation through video technology is aggressively marked, while James Luna's ironic intersections of the modes of body art, video technology, and ethnographic display dramatically dislocate the notion of the particularly identified subject (in this case 'the Indian' as well as the 'male artist'), as fixable in material or conceptual terms.

Hill's *Inasmuch As It Is Always Already Taking Place*, which was installed at the Museum of Modern Art in New York in 1990, consists of sixteen black and white monitors (varying from half an inch to twenty-one inches) embedded in a cavernous inset in the gallery wall; various abstracted life-sized body parts, each displayed on a single monitor, move almost imperceptibly to a barely audible voice accompanied by the rustle of turning pages and other ambient sounds.[13] The body is both abstracted and 'documentary' (almost frozen in black and white parts, congealed via the photographic trace into indexical markers of a body in space) and yet 'real,' moving, alive, and seemingly directly observed (by hand-held camera). Each monitor, writes one observer, 'is thus the site of the body which appears on the screens as immutably present and yet outside actual time. . . . Presence is brought to betray a haunting absence.'[14]

Expanding on the practice of earlier video pioneers such as Bill Viola, Hill produces work that typifies what is specific about 1990s body-oriented work, especially in its move away from single-channel video (developed for amateur and artistic use around 1965) and one-time performances toward technologies that multiply and fragment the body across spaces that are dramatically nonperspectival and so anti-Cartesian.[15] No 'original' body is assumed at any point of such a project, no body to be 'freed' from oppressive representations (as would have been the case in much early feminist body art and theories of representation). As Jacques Derrida has observed of Hill's work, it reveals 'that there is not and never has been a direct, live presentation.'[16] The multiplied video images mark the body as having always been both an instantiation of the self and yet never fixable or present in any securable way; further, Hill produces the body/self as deeply inflected by and through technology: the video screen *becomes* the skin/the body (the skin is 'stretched across the screens like a taut membrane').[17] There appears to be something nostalgic or melancholic about Hill's body-oriented works, which, much like Viola's, present beautiful, if ghostly, images of an embodied yet fragmented self.[18] But they also fissure the body/self/other relation in complicated ways: rather than asserting or

Figure 60.1 Gary Hill, *Inasmuch As It Is Always Already Taking Place*, 1990 (Photography by Alison Rossiter, Courtesy Museum of Modern Art, New York).

reinforcing the 'coherence' of the body as a repository for a unified cogito, Hill's works scatter the body/self across video screens.[19] There is no graspable, coherent subject to be ascertained from Hill's video installations, only fragmented bodily signs to be engaged by recognizing one's own incoherence.

James Luna has mobilized technology explicitly within a revised politics of identity, stressing the link between the technologized body/self (the body/self dispersed through technology) and the particularized body/self. Expanding on some of the ideas he explored in his provocative *Artifact Piece* of 1987 (where the artist laid himself in a display case at the San Diego Museum of Man, posing as an 'artifact' of 'Indian' authenticity),[20] Luna presented *Dream Hat Ritual* at the Santa Monica Museum of Art in 1996, engaging spectators in an interactive formation of 'American' identities.[21] This piece suggestively performs, rather than 'represents'or 'presents,' the Native American subject. Artifacts – crutches floating in the air and cowboy hats adorned with patterns taken from Native American weaving – and video imagery interrelate to enact the 'Indian' in a technologized ethnographic display as culturally particular but never fixed, as both 'self' (raised within modernized Native American lifestyles and customs) and 'other' (situated for the past five centuries relative to dominant Anglo culture).[22]

The artifacts, while bizarre and unexpected, still draw on the codes of 'authenticity' necessary to the ethnographic display; at the same time, they complicate the conventional usage of such codes (to confirm the primitive status of the culture so referenced) through their absurdity and symbolic suggestion of the crippling of the Native American spirit (both from internalized self-conceptions and from external racism) in US culture. The video monitors stacked in the center of the exhibition (just where the average viewer would expect a tepee to be) confirm this point: on the monitors flickers the sad image of a campfire, a 'virtual' fire that has no warmth; meanwhile, on a sound track, sounds of nature are interspersed with Marvin Gaye's 1971 hit *What's Going On?* and on a screen, images of traditional Luiseño dances (Luna's tribe), the heavens, and Luna adopting various personas in previous performances are projected. Luna's piece makes a generational (intracultural) point as well as an intercultural one about the tensions between white and Native American ways of life. While the older generations of Native Americans could claim to have

been born in a tepee (their status as 'Indians' thus confirmed), Luna notes that his generation, raised within the sad accoutrements of suburbanized America (debased even further by the impoverished life of the reservation), was 'born . . . in a TV.'[23]

In *Dream Hat Ritual* Luna ironicizes the very conception of a 'Native American' while at the same time insisting that an exploration of such a potential subject (always pluralized) must continue. Elements from Native American rituals are combined with items signaling clichéd ideas of authentic Indianness – both explicitly marked as mediated through the inexorable effects of tourism and postmodern technology (the video screen replaces the campfire, and all of the lights, fans, cords, and wires powering the installation are exposed). Unlike Hill, who fragments and techno-logizes the embodied subject but does not explicitly explore its particularity (thus tending, like most white artists, to hover dangerously close to a suggestion of 'universality'), Luna produces a site where particularity is both contested and affirmed. His subtle and ironic approach to stereotypes both dislocates outsiders' assumptions about Native Americans (as 'primitives' or 'alcoholics,' and certainly not as intellectuals or artists) and refuses prescriptive notions expressed within his community of how Native Americans must be articulated or defined ('You're never Indian enough to some people,' Luna has said).[24] The stereotypical Indian is shown to be both a phantasm (internalized and perpetuated by those who identify as such and projected outward as well as received by mainstream Anglo culture) and a polit-ically strategic subject position (but one to be adopted only tactically and with an eye toward the inevitably partial and compromised nature of its cultural power). Luna's work articulates the particularized subject *through* technology, marking the way in which the dispersed subject is the effect not only of political changes (the challenges of the rights movements) but also of massive shifts in technology and institutional power.

Reading through Luna, I would like to look at the return to the body in 1990s practice and theory as a return to a notion of the embodied subject as necessarily particularized and engaged in the social: as necessarily politicized (if in a manner not recognizable by previous models of activist political engagement inflected by an instrumentalized Marxism) *through* its embodied and particularized relation to other subjects in the social arena. Artists in the 1990s return to the body in such a way that they assist in the dislocation of the modernist, Cartesian subject or 'indi-vidual' that has also begun to take place through technological and political transformations. (I am well aware that this claim is rather utopian; the *effects* of these works will of course depend on how they are contextualized and who experiences and engages with them.) As I have argued throughout this book, the interrogation of the Cartesian subject or 'individual' is the single most pressing philosophical question of our time. The 'individual,' these artists (along with Gamboa) insist, no longer exists as such in this fin-de-millennial age of multina-tional capitalism, virtual realities, postcolonialism, and cyborg identity politics. In the words of Mark Poster, the 'mode of information' characteristic of our era puts into question precisely

> the very shape of subjectivity: its relation to the world of objects, its
> perspective on that world, its location in that world . . . [T]he subject
> is no longer located in a point in absolute time/space, enjoying a phys-

ical, fixed vantage point from which rationally to calculate its options. Instead it is multiplied by databases, dispersed by computer messaging and conferencing, decontextualized and reidentified by TV ads, dissolved and materialized continuously in the electronic transmission of symbols. . . . The body then is no longer an effective limit of the subject's position . . . [raising the questions] where am I and who am I? In these circumstances I cannot consider myself centered in my rational, autonomous subjectivity or bordered by a defined ego, but I am disrupted, subverted and dispersed across social space.[25]

This subject of what Poster calls the 'second media age,'[26] in which technologies of communications are transformed beyond the unidirectional, hierarchized structures of broadcast journalism toward multidirectional informational exchanges (including the Internet and interactive CD-ROMs), is dispersed and technologically inflected. Phenomenologically speaking, in the words of Vivian Sobchack, communications and biotechnologies inflect the very 'structure of meanings and metaphors in which subject-object relations are cooperative, co-constitutive, dynamic, and reversible.' Technologies such as the computer have 'profoundly changed the temporal and spatial shape and meaning of our life-world and our own bodily and symbolic sense of ourselves,' transforming us as *subjects* and turning us into what I am calling particularized or technologized ('techno') subjects.[27]

As Luna's piece suggests, the technosubject is deessentialized and can no longer be conceived as definable in terms of fixed terms of identity relating to the visual appearance of a singularized, so-called material body. This technosubject is, as suggested, intimately connected to the multiplicitous subjectivities put into play by movements critiquing the modernist 'individual'; it is embodied yet multiple and insistently *particularized* according to various shifting coordinates of identity that specify its cultural positioning (positioning that is never stable or determinable in advance but that has particular meanings from moment to moment). Through its particular corporeal enactments, in always *reversible* relationships to others, this deessentialized, dispersed technosubject is radically politicized and works to politicize these others it engages. The very means by which recent body-oriented art explores and enacts bodies *as* deessentialized and dislocated subjectivities (video, computerized modes of interactivity, installation, and other photographic technologies) confirm Poster's observations that the body/self is 'disrupted subverted and dispersed across social space.' While some, still attached to older, Marxian models of social engagement (which rely on a conception of the subject as a fully centered and intentional 'individual' capable of willfully producing social change), view this shift as unequivocally negative, I suggest that the recognition of the body/self as dispersed, multiple, and particularized has dramatically progressive potentialities, especially for women and other subjects historically excluded from the privileged category of 'individual.'

In her essay 'A Cyborg Manifesto' Donna Haraway argued just this point in her description of the confluence of the destabilization of the modernist 'individual' through explosive developments in technology and a radical politics of nonnormative subjectivity. For Haraway, the post-Cold War period, in which a new kind of power (of 'polymorphous information system') drives the emerging world order,

is one of the 'cyborg' – 'a kind of disassembled and reassembled, postmodern collective and personal self.' Part machine, part human, the cyborg marks the transition beyond the 'plot of original unity' on which previous models of the subject have been founded by theories such as Marxism, psychoanalysis, and feminism. In the culture of the cyborg,

> [i]t is no accident that the symbolic system of the family man . . . breaks up at the same moment that networks of connection among people on the planet are unprecedentedly multiple, pregnant, and complex. . . . In the 'Western sense', the end of man is at stake. . . . The dichotomies between mind and body, animal and human, organism and machine, public and private, nature and culture, men and women, primitive and civilized are all in question ideologically.[28]

As Félix Guattari has suggested, rather than participate in our own alienation by throwing up our hands in despair at the dependence of the subject on 'a multitude of machinic systems,' we might more productively explore contemporary culture to look for 'a way out of the dilemma of having to choose between unyielding refusal or cynical acceptance of this situation.'[29] Recent body-oriented practices, like body art from the 1960s and early 1970s, I suggest, can be engaged to just such an end. By performing subjects that are embodied (if fragmented), artists have engaged with the social, embodying and so particularizing and politicizing self/other and self/world relations. By exploring some of this recent work through a model I will develop as a feminist 'technophenomenology,' I hope to provide a convincing and optimistically progressive way of understanding the dispersed body/self of the end of the millennium.

[. . .]

Conclusion: technophenomenology

In this section I have attempted to move beyond what are ultimately still formalist or structural conceptions of postmodernism (defined through strategies of production such as allegory, Brechtian distanciation, and so on) to identify what I see as a profound shift in contemporary life: a gradual but dramatic change in the way in which we conceive and, indeed, experience the gendered, sexualized, racialized, classed, and otherwise particularized body/self (including our own) in its contingency on the other and the world.

I have suggested that we can engage with the body art works of Acconci, Wilke, and their contemporaries, and with the body-oriented practices developed more recently, to rethink the premises of art critical and art historical discourse, which still continue to read works of art (body art or otherwise) by imputing presumably intentionally embedded meanings to them and inferring a full subjectivity at their 'origin' (the artist) as well as at their 'destination' (the interpreter herself). Such a feminist phenomenological engagement (one that acknowledges our own contingency, particularities, and vulnerabilities) would also entail a radical revision of the broader understanding of postmodern culture and of subjectivity and identity in the

most profound sense. In this sense, art historians, theorists, and critics can learn from the very technologies that have informed and have been formed by younger generations of artists who present 'posthuman,' dispersed subjects in their work: high-tech media act via *interfaces* that mark the artwork as a site of the exchange between subjects, the site of joining between subjects and objects, the locus where intersubjectivity reverses into what Vivian Sobchack has called *interobjectivity* and vice versa.[30]

Like Aguilar, Flanagan and Rose explore the reversibility of intersubjectivity and interobjectivity in relation to death. A final *Memento Mori* trilogy involving three different casket installations – *Video Coffin*, *Dust to Dust*, and *The Viewing* – grapples with Flanagan's own mortality through technologies of representation that produce his body in relation to ours, projecting his image/his body outward to those who engage with the piece.[31] In *Video Coffin* (1994) the head of a casket (decorated with icons of death such as bullets and body parts) is laid open to show a text ('I was promised an early death, but here I am, some forty years later, still waiting') and to expose a video monitor with a loop of Flanagan's face. Approaching the flower-bedecked casket, the visitor is compelled to move closer and closer to view the 'dead' Flanagan, only to find her or his face *replacing* Flanagan's. The jarring effect of this replacement (the 'dead' artist becomes the 'dead' spectator) underlines one's engagement with Flanagan as profoundly, inextricably intersubjective *and* interobjective (we 'experience' both Flanagan and ourselves through the technologized medium of video, which, in turn, places us in the position of the corpse – body

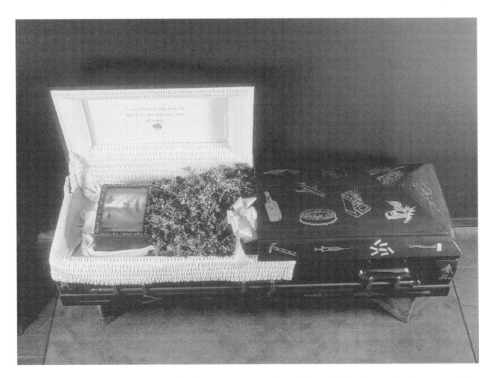

Figure 60.2 Bob Flanagan and Sheree Rose, *Video Coffin*, 1994, from the *Memento Mori* Trilogy (Photography by and courtesy of Sheree Rose).

without 'self'). Like all of Flanagan and Rose's works, this piece profoundly ques-
tions the assumption that death resides elsewhere, outside the subject, highlighting
the fact that the luxury of this assumption is withheld from the chronically ill, such
as Flanagan.

Neither of the two proposed additional 'caskets' has yet been completed.[32] *Dust
to Dust* would involve a simple pine box (like the one Flanagan was actually buried
in) with the entire lid open to show a mound of confetti. On closer look, the visitor
would realize that the 'confetti' is actually thousands of minuscule photographs of
Flanagan (taken primarily by Rose) from various stages of his life (in Flanagan's
words, 'viewers [could] . . . scoop up hand fulls [*sic*] of the tiny squares so that they
are literally holding another person's life history in the palm of their hands'). Again,
the intersubjective and interobjective domains are intertwined as the visitor expe-
riences her or his own embodied subjectivity (which is simultaneously objectivity)
in relation to tiny objects/images that represent Flanagan in his multiplicitous frag-
mentation. The piece would also literalize the dispersal of the subject that occurs
with death and, viewed within the context of Rose's photographic work, would
speak of the ontological function of photography in relation to human memory (we
feel that with a photograph we can stave off the total loss – the feeling of emotional
amputation – that occurs with a person's death).

Finally, *The Viewing* is almost impossible to fathom in its original formulation,
developed before Flanagan's death (he died before it could be completed). As orig-
inally conceived, the piece was to document the decomposition of Flanagan's body
through the placement of a video camera in his coffin underground.[33] The camera
would be hooked into a monitor placed in a gallery or other public place, to be
accessed at will by visitors apprised of its 'contents' (that is, it would be up to the
viewer whether or not to turn the monitor on – whether or not to engage with
this body, bereft of a 'self'). *The Viewing* (even the title highlights a visual relation-
ship to the body/self of the other) proposes an nth-degree interrogation of the
relationship of the body to the self: for it is only in death that the body is stripped
of its inexorable role as instantiation of the *cogito*. Watching this body return to the
earth, we would be compelled to acknowledge our dependence on the flesh to
sustain our existence (the fact that the self cannot survive the body is proof not of
the self's transcendence but of its incontrovertible contingency on the body). At
the same time, we might also become acutely aware that Flanagan does still 'exist'
in and through the others who have engaged him (in particular, Rose), marking the
contingency and embeddedness of the self on/in the other.

In *The Viewing*, Flanagan takes body art to its extreme, 'performing' – through
video technology – after his living self is dead. The rotting of the corpse itself
is the final enactment of Flanagan (and begs the timeless philosophical question, Is
this dead body Flanagan at all?). Further, the trilogy surfaces the fact that, while
death is experienced purely individually, it is the moment that most aggressively
highlights the ways in which our embodied existence and self-understanding
bears entirely on our relationships with others.

I note again, at some length, the eloquent observations of Jacques Derrida on
this subject, returning us (through death and the body/self) to the narcissistic dimen-
sions of body art and subjectivity in general:

[W]hat do we mean by 'in us' when, speaking at the death of a friend, we declare that from now on everything will be situated, preserved, or maintained in us, only 'in us,' and no longer on the other side, where there is nothing more. All that we say of the friend, then, and even what we say *to him*, to call or recall him, to suffer for him with him – all that remains hopelessly *in* us or *between* us the living, without ever crossing the mirror of a certain speculation. Others would speak too quickly of a totally interior speculation and of 'narcissism.' But the narcissistic structure is too paradoxical and too cunning to provide us with the final word. It is a speculation whose ruses, mimes, and strategies can only succeed in supposing the other – and thus in relinquishing in advance any *autonomy*. . . .

Everything remains 'in me' or 'in us,' 'between us,' upon the death of the other.

Everything is entrusted *to me . . . to the memory*.[34]

Thus, it is the very *narcissism* of the performance of the self that inexorably engages the self in the other: our self-conception, our self-performance can only take place through our phenomenological assumption of subjectivity (or moments of subjective engagement) via others in the world. Flanagan's project, by evacuating the cognitive element of the self and leaving only the body as meat, begs the issue of intersubjectivity on the most profound level, enacting the very process by which we work through the death of a loved one: as we (in theory) watch Flanagan's body decay, we extrapolate back to our remembrances of his live 'subject.'[35] The subject 'is' only always in relation to the perceptions/memories of others.

I have already explored at length how the earlier body art projects exacerbated this reversibility (this, in Merleau-Ponty's terms, chiasmic intertwining of subject and object). The work I have discussed in this chapter ultimately points to an expansion of the phenomenological relation to a technophenomenological relation that intertwines intersubjectivity with interobjectivity: we are enworlded via the envelopment of our bodies in space, the touch of our hands on a keyboard, the stroke of our gaze on the video screen. Seemingly paradoxically, given the conventional association of technology with disembodiment and disengagement from the world, recent body-oriented practices have increasingly mobilized and highlighted this reversibility, using the artists' own body/self as both subject and object, as multiplicitous, particular, and unfixable, and engaging with audiences in increasingly interactive ways. As I engage with it here, this work parallels what Sobchack identifies as 'the dual structure of passion and the subjectively-grounded reversibility of body and world' that necessarily entails politicized subjects – subjects who acknowledge their own immanence, their own capacity for being objectified in relation to the world.

Rather than projecting immanence onto the *other*, such a practice embraces the flesh (but specifically as enworlded and intersubjectively determined rather than somehow 'essential' or in itself transcendent). Sobchack cites David Levin on the flesh as 'the elemental matrix, the texture, the field or dimensionality of our being: that "medium" in the depths of which subject and object . . . mirror . . . each other' in a relation of reversibility.[36] While earlier feminists such as Wilke and Schneemann

might be said to have recognized their own objectification vis-à-vis the world and to have attempted to reverse it into subjectivity (or at least to meliorate its effects by taking on a subjective stance), I would like to end by suggesting that more recent body-oriented works extend this radical project to make us increasingly aware of our own state of simultaneous intersubjectivity and interobjectivity, with the latter understood to be 'a structure of engagement with the *materiality of things* in which we recognize *what it subjectively feels like to be objectively embodied*' in a highly technologized world.[37]

Such an acknowledgment forces us to experience ourselves as not only *in* the world, but as also *belonging* to it and thus *owing it something:* as fully contingent bodies/selves who are responsible for the effects our behaviors and perceptions have on others and aware of our reactions to other subjects and objects in the world.[38] This technophenomenological understanding of the body/self poses it as deeply socialized and politicized. It urges us to rethink the ways in which we make sense of contemporary art and to expand our experience of postmodernism; as well, it encourages us to reevaluate the way in which we comprehend subjectivity itself.

Notes

1 Harry Gamboa, from the script for the play 'Ismania' in Gamboa, *Urban Exile: Collected Writings of Harry Gamboa Jr.*, ed. Chon Noriega (Minneapolis: University of Minnesota Press, forthcoming). As Marshall McLuhan puts it in his epochal *Understanding Media* (1964; Cambridge, Mass. and London: MIT Press, 1996), 'individualism is not possible in an electronically patterned and imploded society'(51).

2 Quoted by Amy Harmon in 'Daily Life's Digital Divide,' *Los Angeles Times*, July 3, 1996, A10.

3 This is a paraphrase from Bruce Yonemoto's presentation for 'Video Chronologies,' (a panel organized by Erika Suderburg, sponsored by the Lannan Foundation, and held at Los Angeles Contemporary Exhibitions, October 19, 1996. I participated on this panel, along with Yonemoto, David James, and Carol Anne Klonarides.

4 See the essays on the impact of the rights movements in *The 60s without Apology*, ed. Sohnya Sayres *et al.* (Minneapolis: University of Minnsota Press, 1984).

5 Audre Lorde, 'Age, Race, Class, and Sex: Women Redefining Difference' (1984), reprinted in *Out There: Marginalization and Contemporary Culture*, ed. Russell Ferguson *et al.* (New York: New Museum of Contemporary Art; Cambridge, Mass. and London: MIT Press, 1990), 282.

6 Gamboa, 'Ismania,' manuscript page 27; Gamboa has his character Ismaniac continue with a postmodern existentialism: 'Existence is relative to measurement: Moments, days years, eons, and it is all over in an instant./I exist, therefore I am anxious about the nonexistence that awaits me. I exist and it all seems so random.'

7 See Benjamin Buchloh's polemic regarding what he sees as the reactionary political implications of the return to large-scale representational oil painting in the 1980s, 'Figures of Authority, Ciphers of Regression: Notes on the Return of Representation in European Painting' (1981), reprinted in *Art after Modernism: Rethinking Representation*, ed. Brian Wallis (New York: New Museum of Contemporary Art;

Boston: Godine, 1984), 107-36. Of course, as others have pointed out, painting is not inherently reactionary (no more than are body art, Brechtian practices, etc.). The main point here is that, within the context of the 1980s in Europe and the United States, the body dropped out of radical artistic practice, finding a place only in representational (and highly commodified) paintings that rendered it in idealized, fetishized, or otherwise nostalgic ways.

8 This is by no means to suggest that 1980s feminist art practice and discourse have in any simple way promoted the same politics – simply that there is a disconcerting confluence of ideas intersecting in a generalized anxiety about the body in this period. I discuss this unfortunate ideological confluence in my essay 'The "sexual politics" of *The Dinner Party*: A Critical Context,' in *Sexual Politics: Judy Chicago's Dinner Party in Feminist Art History*, ed. Amelia Jones (Los Angeles: UCLA/Armand Hammer Museum of Art; Berkeley and Los Angeles: University of California Press, 1996), 82–118.

9 At this point, I replace the term 'body art' with 'body-oriented practices'; the 1990s work often involves complex strategies relating to the body (fragmenting it, symbolizing it, rendering it through highly distorting technologies of representation) that justify discussing the work as oriented toward, but not necessarily including, the artist's own body.

10 It is tempting to define these artists as a younger generation. as I will tend to do here; however, it is worth stressing that there are too many overlaps in age group for this characterization to be entirely accurate. Many of the most interesting figures now working with body-oriented practices are in their mid-forties to early fifties, the same age as some of those who were initially visible in the early 1970s are now; often, an artist who has been working with the body since the 1970s (such as Maureen Connor) will only have come to be fully appreciated in the 1990s, now that the body is again viewed as a vital site of exploration.

11 By using the term *posthuman* I mean to stress the rejection of human*ism* (with all the romantic mythology that this entails) enacted by this work. Numerous scholars have used this term. See, for example, Jeremy Gilbert-Rolfe's 'The Visible Post-Human,' in *Beyond Piety: Critical Essays on the Visual Arts 1986–1993* (New York and Cambridge: Cambridge University Press, 1995), and Kathleen Woodward, citing Andrew Ross, in 'From Virtual Cyborgs to Biological Time Bombs: Technocriticism and the Material Body,' *Culture on the Brink: Ideologies of Technology*, ed. Gretchen Bender and Timothy Druckrey (Seattle: Bay Press, 1994), 49.

12 While inevitably I use labels to designate various 'identities' throughout this chapter, these labels are meant as provisional indicators of self-consciously adopted positionalities and not finally determinable in the effects they seem to propose.

13 For a full description of this piece, see Lynne Cooke, 'Postscript: Re-Embodiments in Alter-Space,' *Gary Hill* (Seattle: Henry Art Gallery, University of Washington, 1994), 82–83.

14 Ibid., 85.

15 For a brief history of video art, see John G. Hanhardt and Maria Christina Vilaseñor, 'Video/Media Culture of the Late Twentieth Century,' *Art Journal 54*, no. 4 (winter 1995): 20–25. It should be noted that earlier body art did sometimes use multiple video monitors, but the single-channel video and performance art formats (as well as the performative photograph) were far more common until the 1980s and 1990s.

16 Derrida, 'Videor' (1990), *Resolutions: Contemporary Video Practices*, ed. Michael Renov and Erika Suderburg (Minneapolis: University of Minnesota Press, 1996), 74. Other major figures who have begun to employ video in an aggressively spatial, phenomenological way that engages the body include Tony Oursler, Dorit Cypis, Joe Santarromana, and Bruce and Norman Yonemoto. The work of these artists, as well as that of Faith Wilding (whose ongoing artistic and theoretical explorations of bodies and technology have been inspirational to me), has deeply informed this chapter.

17 Cooke, 'Postscript,' 82.

18 This body is not always Anglo, and not always Hill; especially in his more recent pieces – such as *Tall Ships* (1992) – he includes a range of other people, men and women, old and young, white, black, Asian, etc.

19 David Joselit criticizes Hill for being nostalgic and for supporting the tendency of media to escape into fantasy in his unpublished essay, 'Gary Hill: Between Cinema and a Hard Place.' I would expand Joselit's notion of nostalgia to take issue with Hill's work on the basis that it avoids particularizing the body, as much of the most effective recent work does (hence, nostalgically looking to a notion of universality). While multiplying types of bodies in his works, he still presents them as vague figures that seem to want to stand in for humanity in general. At the same time, Hill's pieces such as *Inasmuch As* can be seen to defer any final delivery of a body that secures the subject in a Cartesian relation (thus, while the niche that holds the monitors might at first seem to promise to cohere the video images into a singular representation of an 'individual,' it merely exacerbates the impossibility of such cohesion in the perception of the viewer, who negotiates the multiplicity of body fragments as conveyed through the screen of video/of fantasy).

20 For more on this piece, see Andrea Liss, 'The Art of James Luna: Postmodernism with Pathos,' *James Luna Actions & Reactions: An Eleven Year Survey of Installation/ Performance Work 1981–1992* (Santa Cruz: University of California, Mary Porter Sesnon Art Gallery, 1992), 8–9; and Leah Ollman, 'Confronting All the Demons,' *Los Angeles Times* (June 16, 1996), Calendar section, 58–59. Luna's body was labeled with tags identifying the marks on his body in terms of clichés associated with Native Americans (scars, for example, were identified as the result of excessive drinking and brawling).

21 Another major project exploring this interactive dimension of the constitution of Western identities in oppositional relation to 'primitive' otherness is Coco Fusco and Guillermo Gómez-Peña's *Two Undiscovered Amerindians Visit . . .* (with the final word of the title to be filled in with the name of each venue of the performance), performed internationally in the early 1990s. Fusco and Gómez-Peña performed in a large cage, with outlandish kitsch-primitive outfits and behavior, to unsuspecting crowds who most often interpreted the piece as a 'real' ethnographic display. Central to the effect was the aspect of *engagement*, whereby, spectators become participants in the construction of 'otherness.' Fusco discusses the implications of this piece in her important essay 'The Other History of Intercultural Performance,' in *English Is Broken Here: Notes on Cultural Fusion in the Americas* (New York: New Press, 1995), 37–64, see chapter 49.

22 Crutches may refer to the frequent occurrence of diabetes on Indian reservations (diabetes often necessitates amputation); this possibility is mentioned in the Santa Monica Museum press release for *Dream Hat Ritual* (1996).

23 Luna stated that he made the born-in-a-TV claim in response to an Indian elder, who noted that he was born in a tepee. From Luna's lecture/performance in

conjunction with *Dream Hat Ritual* at the Santa Monica Museum, July 12, 1996.

24 Ibid. Trinh T. Minh-ha is clear on the dangers of the discourse of authenticity, which, in the context of tourism and postcolonialism, 'turns out to be a product that one can buy, arrange to one's liking, and/or preserve. . . . Today, planned authenticity is rife; as a product of hegemony and a remarkable counterpart of universal standardization, it constitutes an efficacious means of silencing the cry of racial oppression.' See *Woman, Native, Other: Women, Postcoloniality, and Feminism* (Bloomington and Indianapolis: Indiana University Press, 1989), 88, 89.

25 Mark Poster, *The Mode of Information: Poststructuralism and Social Context* (Chicago: University of Chicago Press, 1990), 15–16.

26 Poster, *The Second Media Age* (Cambridge: Polity Press, 1995).

27 Vivian Sobchack, 'The Scene of the Screen: Envisioning Cinematic and Electronic "Presence,"' *Materialities of Communication*, ed. Hans Gumbrecht and K. Ludwig Pfeiffer (Stanford, Cal.: Stanford University Press, 1994), 85, 83. Sobchack includes as well transportation technologies such as the automobile. I differ from Sobchack in some of the specifics of her comparison of photography, film, and computer technologies (in particular, as will be clear in this chapter, her argument that electronic representation 'denies the human body its fleshly presence and the world its dimensions' (105); I see the 'disembodiment' as a *desire* rather than as an achieved state) but am indebted to her for the basic phenomenological model I've attempted to apply to recent body art. She is one of the few cultural theorists with a deep knowledge and appreciation of phenomenology, and her work has been inspirational to this study. See her essays 'Beating the Meat/Surviving the Text, or How to Get Out of This Century Alive,' in *Body & Society* 1, no. 3–4, special issue titled *Cyberspace, Cyberbodies, Cyberpunk, Cultures of Technological Embodiment* (1995): 205–14; and her acerbic critique of technoeuphoria, 'New Age Mutant Ninja Hackers: Reading *Mondo 2000*,' in *Flame Wars: The Discourse of Cyberculture*, ed. Mark Dery (Durham, NC and London: Duke University Press, 1994), 11–28.

28 Donna Haraway, 'A Cyborg Manifesto: Science, Technology, and Socialist-Feminism in the Late Twentieth Century,' in *Simians, Cyborgs, and Women: The Reinvention of Nature* (New York and London: Routledge, 1991), 161, 163, 151, 160, 163.

29 Félix Guattari, 'Regimes, Pathways, Subjects,' *Incorporations*, special edition of *Zone* 6, ed. Jonathan Crary and Sanford Kwinter (New York: Zone, 1992), 16.

30. Sobchack, 'The Passion of the Material: Prolegomena to a Phenomenology of Interobjectivity,' forthcoming in her *Carnal Thoughts: Bodies, Texts, Scenes, and Screens* (Berkeley and Los Angeles: University of California Press), manuscript pages 12–13; I thank Sobchack for sharing this manuscript with me. As Mark Poster points out, Walter Benjamin's epochal essay 'The Work of Art in the Age of Mechanical Reproduction' (1936) argues that there is a reversible engagement between author and audience *through* the new technologies of photography and film. Poster argues, through Benjamin, that the mediation of technology shifts the point of identification from the performer (in 'live' theater) to the technology, promoting a 'critical stance' by 'undermining one of the chief means [the hierarchization of author and audience] by which art championed . . . authoritarian politics' (Poster, *The Second Media Age*, 13). As I have theorized live performance as *not* having ontological priority over the 'mediated' presentations of film and other technological means of reproduction, I agree only that these new technologies have

increasingly heightened our awareness of the contingency and mediated quality of all subjects (whether in live or taped/photographed performances). Thus, it seems to me that Benjamin's brilliance lay in part in his ability to see at a very early date how this mediation was changing the way we view *all* representations (including those staged by the previous 'auratic' arts) and, I would add, correlatively the way we experience subjectivity itself. Benjamin's essay is reprinted in *Illuminations*, tr. Harry Zohn, ed. Hannah Arendt (New York: Schocken, 1968), 217–51.

31. All of the information and quotes on the trilogy come from Flanagan's project description for a Guggenheim fellowship (1995) and from Rose's revised version of this proposal (1996).

32. Rose hopes to complete them both eventually. *Video Coffin*, the only realized piece, was presented in the exhibition *Narcissistic Disturbance*; see *Narcissistic Disturbance*, ed. Michael Cohen (Los Angeles: Otis Gallery, Otis College of Art and Design, 1995), 28–29, 31.

33. Rose is planning to revise *The Viewing* so that she can complete it, replacing the actual body of Flanagan with a video approximation of his body decaying. Rose has also introduced a further element, staging the piece in a 'mausoleum' including her huge balloon 'sculpture' of Flanagan in bondage with an erection – the *Boballoon* (this was exhibited in the exhibition *On Camp/Off Base*, organized by Kenjiro Okazaki, at the Tokyo International Exhibition Center in Japan in August 1996). This addition to the casket trilogy is a brilliant comment on Rose's (and to a certain extent the audience's) new relationship to Flanagan, who continues to 'exist' for us through his artistic 'presence' (interestingly, in this case, passed *through* Rose, as from the beginning of his artistic career). The 20 foot *Boballoon* is a fitting memorial to an artist, collaborator, and (for Rose) partner of many years who explored his own suffering but never took himself too seriously; with this piece, Rose very sensitively continues the legacy of their work together by humorously (but cuttingly) rendering Flanagan as a huge vessel of (hot?) air, floating above us all.

34. Jacques Derrida, *Memories for Paul de Man*, tr. Cecile Lindsay et al. (New York: Columbia University Press, 1989), 32–33.

35. My relationship to Flanagan was, indeed, personal (as is my relationship to Connor, Aguilar, and Harris). It is for this reason that the grief I feel at viewing him dying in the film is acute and indescribable, in part *because* I have thus incorporated his suffering (to a certain extent) – as well as Rose's traumatic sense of loss – into my own experience of my father, who died in a hospital virtually indistinguishable from that housing Flanagan in his last days. Death comes to be experienced multiply in a relay effect of horrific loss. (I articulate my loss of my father and anticipate that of my brother-in-law, who died very suddenly in 1997, in 'Love and Mourning: Who Am I since You Are No Longer?' *Framework* 7, n. 2 (1995): 14–19.)

36. Sobchack, 'The Passion of the Material,' 12. She is citing Levin's 'Visions of Narcissism,' in *Merleau-Ponty Vivant*, ed. M. C. Dillon (Albany: State University of New York Press, 1991), 67.

37. Sobchack, 'The Passion of the Material,' 16.

38. Ibid., 17. Sobchack cites Levin again on the promotion of a 'self-developing socialization, eliciting fron the deep order of our embodiment it inherent capacity to turn experiences of social relationship into an assumption of the *position* identified with the other' (19); from Levin, 'Visions of Narcissism.' 70–71.

Notes on contributors

Malek Alloula is the author of *The Colonial Harem* (1986).

Louis Althusser was a philosopher and Marxist activist.

Arjun Appadurai is Professor of Anthropology and of South Asian languages and civilizations at the University of Chicago. He is the author of *Modernity at Large: Cultural Dimensions of Globalization* (1996).

Oriana Baddeley teaches art history at Camberwell School for the Arts. She is the author of *Drawing the Line: Art and Cultural Identity in Contemporary Latin America* (1989), with Valerie Fraser.

Anne Balsamo researches at the Xerox Parc. She is the author of *Technologies of the Gendered Body: Reading Cyborg Women* (1996).

Roland Barthes was the author of such key texts as *Mythologies* and *Image-Music-Text*.

Geoffrey Batchen teaches at the CUNY Graduate Center, Alberquerque, and publishes widely on issues in photography, cyberculture and visual theory.

Jean Baudrillard is Professor of Sociology at the University of Paris X, Nanterre.

Jonathan L. Beller teaches at the University of California, Santa Cruz and has published widely on film and attention theory.

Suzanne Preston Blier teaches art history at Harvard University. She is the author of *African Vodun: Art, Psychology and Power* (1995).

Lisa Bloom is a visual culture critic. She teaches at the University of California, San Diego.

Judith Butler teaches in the Department of Rhetoric at the University of California, Berkeley. She is the author of *Gender Trouble* (1990) and *Bodies That Matter* (1993).

Anthea Callen is the Director of the Nottingham Institute for Research in Visual Culture and the Chair of the Visual Culture department at Nottingham University. She is the author of *The Spectacular Body: Science, Method and Meaning in the Work of Degas*, (Yale University Press, 1995) and *The Art of Impressionism: Painting Technique and the Making of Modernity* (Yale University Press, 1995).

Thomas J. Campanella is an urbanist, historian and cultural critic. He holds a Ph.D. in Urban Studies and PLanning from MIT.

Néstor García Canclini publishes widely on issues concerning postmodernism and Latin American art and culture. His publications include *Hybrid Culture: Strategies for Entering and Leaving Modernity* (1995).

Lisa Cartwright teaches in the Department of Communications, University of California, San Diego. She is the author of *Screening the Body: Tracing Medicine's Visual Culture* (1995).

Jill H. Casid is a photographer and art historian. She teaches in the Visual Culture program at the University of Wisconsin, Madison.

Wendy Hui Kyong Chun is an assistant professor of Modern Culture and Media at Brown University. She has studied both Systems Design Engineering and English Literature, which she combines and mutates in her current work on digital media. She is completing a manuscript on the crisis of disciplinary and regulatory power brought about by high-speed telecommunications networks, entitled *Sexuality in the Age of Fiber Optics*. She is organizing the Archaeology of Multi-Media Project, and her writings have appeared/will appear in *differences*, *New Formations*, and *Asian America.net* (eds. Sau-ling Wong and Rachel Lee), amongst other places.

Omayra Cruz is a Ph.D. candidate in the Department of Literature at the University of California, San Diego. Her research addresses considerations of genre and US racial formation in popular film and literature. She is an Editor for the *Journal of Visual Culture* (Sage, 2002) and serves on the editorial board of *parallax* (Routledge/Taylor & Francis).

Guy Debord was a critic, author and activist, and leading member of the Situationist International.

René Descartes was a 17th century mathematician, scientist and philosopher.

W.E.B. Dubois (1868–1963) was one of the founders of the National Association for the Advancement of Colored People, a Harvard Ph.D. and a lifelong activist.

Frantz Fanon was a critic, psychoanalyst and revolutionary.

John Fiske taught in the Communications Department at the University of Wisconsin. His publications include *Understanding Popular Culture* (1989) and *Media Matters* (1996).

Michel Foucault was the author of *Discipline and Punish: The Birth of the Prison* (1979).

Anne Friedberg teaches film studies at the University of California, Irvine and is a member of the Visual Studies program. She is the author of *Window Shopping: Cinema and the Postmodern* (1993).

Coco Fusco is a New York-based interdisciplinary artist and writer. She explores intercultural and interrracial dynamics through a variety of experimental media, performance and journalism. She is the author of *the bodies that were not ours* (2001). Her videos include *Pochnovela*, *The Couple in the Cage* and *Havana Postmodern*. She is Associate Professor in the School of Visual Art at Columbia University.

Tamar Garb teaches art history at University College, London. She is the author of *Sisters of the Brush: Women's Artistic Culture in Late Nineteenth-century Paris* (1994).

Raiford Guins is Visiting Assistant Professor in the Film Studies Program at the University of California, Irvine. He is a Founder and the US Principal Editor for the *Journal of Visual Culture* (Sage, 2002), serves on the editorial board of *parallax* (Routledge/Taylor & Francis), and is currently editing a book with Sage entitled, *Popular Culture: A Reader*.

Judith Halberstam is Professor of Literature at UC San Diego where she teaches gender studies, queer theory, film and literature. She has written on gothic literature, postmodernism, masculinity and queer performance. She is currently working on books on drag kings and transgender politics. She is also the film reviewer for *Girlfriends* magazine.

Donna Haraway is a Professor in the History of Consciousness Board at the University of California, Santa Cruz. Her most recent book is *Modest Witness@ Second Millenium FemaleMan meets Oncomouse* (1997).

N. Katherine Hayles is Professor of English at the University of California, Los Angeles. She is the author of *Chaos Bound: Orderly Disorder in Contemporary Science and Literature*.

Amelia Jones is Professor of Art History at the University of California, Riverside. Her many publications include *Body Art/Performing the Subject* (1998) and *En-gendering Duchamp* (1994).

David Joselit is Professor in the Department of Art History and the Ph.D. program in Visual Studies at the University of California, Irvine. He is the author of *Infinite Regress: Marcel Duchamp 1910–41*.

May Joseph is Associate Professor at the Pratt Institute, New York City. She is the author of *Nomadic Identities: The Performance of Citizenship* (1999).

Jacques Lacan was a psychoanalyst and founder of the Ecole de Paris.

Reina Lewis teaches in the Department of Cultural Studies at the University of East London. She is the author of *Gendering Orientalism: Race, Femininity and Representation* (1996).

Lev Manovich is an artist and critic, teaching at the University of California, San Diego. He has published *Languages of New Media* (2001) and his website at http://www.manovich.net has recent essays for downloading.

Karl Marx (1818–1883) was a legendary writer and activist.

Carol Mavor is Professor of Art History at the University of North Carolina, Chapel Hill.

Anne McClintock is Professor of English and Women's Studies at the University of Wisconsin, Madison. She is the author of *Imperial Leather: Race, Gender and Sexuality in the Colonial Contest* (1995).

Marshall McLuhan, author and cultural critic, was the originator of the slogans 'the medium is the message' and 'the global village'.

Tara McPherson is an Assistant Professor of Gender Studies and Critical Studies in USC's School of Cinema-TV, where she teaches courses in television, new media, and contemporary popular culture. Her writing has appeared in numerous journals, including *Camera Obscura*, *The Velvet Light Trap*, *Discourse*, and *Screen*, and in edited anthologies such as *Race and Cyberspace*, *Virtual Publics*, and *Basketball Jones*. She is co-editor, along with Henry Jenkins and Jane Shattuc, of *Hop on Pop: The Politics and Pleasures of Popular Culture* (forthcoming, Duke University Press) and is currently completing *Reconstructing Dixie: Race, Place and Femininity in the Deep South*, also for Duke. Co-organizer of a recent new media conference, *Interactive Frictions*, Tara was among the organizers of *Race in Digital Space*, a USC-MIT conference held in April 2001. Her new media research focuses on issues of convergence, race, and representation.

Kobena Mercer is a writer and critic in London, teaching at Middlesex University. He is the author of *Welcome to the Jungle: New Positions in Black Cultural Studies* (1994).

Toby Miller is Professor in the Department of Cinema Studies at New York University. His many publications include *Contemporary Australian Television* (1994) and *The Avengers* (1997). He is co-editor of the journal *Social Text*.

Nicholas Mirzoeff is Professor of Art History and Comparative Studies at Stony Brook University. He is the author of *An Introduction to Visual Culture* (1999) and editor of *Diaspora and Visual Culture* (2000). He is a board member of the College Art Association. Email: nmirzoeff@notes.cc.sunysb.edu

Timothy Mitchell is Associate Professor of Politics and Director of the Hagop Kevorkian Center for Near Eastern Studies at New York University. He is the author of *Colonizing Egypt* (1988) and *Questions of Modernity* (1998).

W.J.T. Mitchell is Professor of English and Visual Culture at the University of Chicago and is editor of the journal *Critical Inquiry*.

Joanne Morra teaches at Central St Martin's College of Art and Design, London. She has published on translation, Bruegel and the visual arts, and is working on Rauschenberg and fifties American culture. She is a Founder of *parallax* (Routledge/Taylor & Francis) and Founder and UK Principal Editor for the *Journal of Visual Culture* (Sage, 2002).

Lisa Nakamura teaches in the visual culture proram at the University of Wisconsin-Madison. She is the author of *_Cybertypes: Race, Ethnicity, and Identity on the Internet_* Routledge, 2002. She is a co-editor of *Race In Cyberspace* (Routledge, 2000) and her work appears in *Unspun: Key Terms for the World Wide Web and Culture*, ed. Thomas Swiss, New York: New York University Press, 2001, *The Cybercultures Reader*, ed. David Bell, New York and London: Routledge Press, 2000, and *Reload: Rethinking Woman + Culture*, eds. Austin Booth and Mary Flanagan, Cambridge: MIT Press, 2001.

Olu Oguibe is an independent artist, critic and curator. He lives in New York.

Lisa Parks is an Associate Professor in the Department of Film Studies at the University of California at Santa Barbara. She is the author of *Cultures in Orbit: Satellites and the Televisual* (forthcoming from Duke University Press) and co-editor of *Planet TV: A Global Television Reader* (2002, NYU Press) and *Red Noise: Television Studies and Buffy the Vampire Slayer* (forthcoming Duke University Press). She serves on the editorial board of The Velvet Light Trap and the advisory board of CULTSTUD-L and has produced programs for Paper Tiger TV. She is producer of a DVD called *Experiments in Satellite Media Arts* with Swiss artist Ursula Biemann, and is developing an online gallery called *Satellite Crossings*.

Adrian Piper teaches philosophy at Wellesley College and is a widely exhibited artist. Her collected essays, *Out Of Order, Out Of Sight*, were published in 1996.

Ann Reynolds teaches art history at the University of Texas, Austin. Her book on Robert Smithson, *Learning from New Jersey* is forthcoming with MIT Press.

Irit Rogoff heads the Visual Culture program at Goldsmiths College, University of London. Her most recent book is *Terra Infirma: Geography and Visual Culture* (2000).

Andrew Ross is Professor and Director of the American Studies Program at New York University. His books include *No Respect* (1989), *Strange Weather* (1991), *The Chicago Gangster Theory of Life* (1994), and *Real Love: Essays for Cultural Justice* (1998).

Marquard Smith teaches in the School of Art, Film and Visual Media at Birkbeck College, University of London. He is a Founder of the cultural theory journal *parallax* (Routledge/Taylor & Francis) and a Founder and the Editor-in-Chief of the *Journal of Visual Culture* (Sage, 2002).

Terry Smith is Andrew Mellon Professor of Contemporary Art in the Department of the History of Art and Architecture at the University of Pittsburgh. He is the author of a number of books, most recently *Figuring the Ground: Landscape, Colony and Nation in Nineteenth Century Australian Art* and *Transformations: Modernism and Aboriginality in Twentieth Century Australian Art* (both Craftsman House, Sydney 2001), and editor of many others including *In Visible Touch: Modernism and Masculinity* (Power Publications and the University of Chicago Press, 1997), *First People, Second Chance: The Humanities and Aboriginal Australia* (Australian Academy of the Humanities, 1999) and *Impossible Presence: Surface and Screen in the Photogenic Era* (Power Publications and the University of Chicago Press, 2001). A foundation Board member of the Museum of Contemporary Art, Sydney, he is also a researcher into visual arts practice, patronage and policy.

Ella Shohat is Professor of Film Studies at New York University. She is co-editor of *Dangerous Liaisons: Gender, Nation and Postcolonial Reflections* (1997).

Robert Stam is Professor of Cinema Studies at New York University and Acting Director of the Center for the Study of Culture, Media and History. His most recent book is *Tropical Multiculturalism: A Comparative History of Race in Brazilian Cinema and Culture* (Duke University Press).

Marita Sturken is Associate Professor at the Annenberg School for Communication at the University of Southern California. She is the author of *Tangled Memories: The Vietnam War, the AIDS Epidemic, and the Politics of Remembering* (1997).

Michele Wallace is an activist, author and critic. She teaches at CUNY and her many publications include *Black Macho* and *Invisibility Blues*.

Thomas Waugh teaches film studies at Concordia University. His *Hard to Imagine: Gay Male Eroticism in Photography and Film from their Beginnings to Stonewall* was published in 1996.

Index